CW00916908

TOPOGRAPHICAL BIBLIOGRAPHY OF ANCIENT EGYPTIAN HIEROGLYPHIC TEXTS, RELIEFS, AND PAINTINGS

THE THEBAN NECROPOLIS

TOPOGRAPHICAL BIBLIOGRAPHY OF ANCIENT EGYPTIAN HIEROGLYPHIC TEXTS, RELIEFS, AND PAINTINGS

I. THE THEBAN NECROPOLIS
PART 1. PRIVATE TOMBS

BY

The late BERTHA PORTER

AND

ROSALIND L. B. MOSS, B.Sc. (Oxon.), F.S.A.

Assisted by
ETHEL W. BURNEY

SECOND EDITION
REVISED AND AUGMENTED

GRIFFITH INSTITUTE
ASHMOLEAN MUSEUM, OXFORD
1994

Revised edition first published 1960 by the Oxford University Press
Re-issued by the Griffith Institute 1970
Re-printed in this format 1985 and 1994
ISBN 0 900416 15 7

RE-PRINTED IN GREAT BRITAIN
by The Alden Press Ltd.,
Oxford, 1994

CONTENTS

TOMBS

APPENDIXES

INDEXES

MAPS

LIST OF MAPS

(at end)

INTRODUCTION

SINCE the publication of the first volume of this Bibliography in 1927, so much new material has appeared that it has been found necessary to make a complete revision of the Theban necropolis and to divide it into two sections, Part 1 containing only the private numbered tombs with the similar tombs now lost, and Part 2 the rest of the necropolis. The latter, entitled Royal Tombs and Smaller Cemeteries, now in the press, includes the Valleys of the Kings and Queens, the Antef and Dynasty XVII cemeteries at Dra' Abû el-Naga', various other cemeteries and burials, secular buildings such as the Deir el-Medîna village site and the Palace of Amenophis III, and a summary of the numerous graffiti on the cliffs.

The 409 private tombs dealt with in the present volume bear the official numbers of the Antiquities Service, 1–334, as listed in Gardiner and Weigall, *A Topographical Catalogue of the Private Tombs of Thebes* (1913) with a Supplement by Engelbach (1924), to which must be added articles by Bruyère and Davies in *Ann. Serv.* xxv (1925), pp. 174–7, 239–41, and Fakhry in *Ann. Serv.* xlvi (1947), pp. 38–45, bringing the number up to 367; more recent discoveries have produced additional tombs, the last two uncovered in the spring of 1959.

This edition differs in many respects from its predecessor, and the scope has been enlarged to provide a brief description of all scenes in accessible tombs, many still unpublished, together with tomb-plans, and maps showing their position in the necropolis. In these descriptions the registers are given in Roman numerals in heavy type, and the bibliographical references in a separate paragraph, arranged according to the registers. In order to save repetition, the names of parents and wife of the tomb-owner, and references to lists of titles in Sethe, *Urkunden*, and Černý, *Répertoire onomastique*, without detailed analysis, have been entered at the beginning of the tomb. Owing to the numerous additions most of the scenes have had to be renumbered, but the paragraph numbers of the 1st edition appear in brackets, so that previous quotations can be easily traced. Besides the references to new publications, it has been thought worth while to include certain important series of photographs, notably those taken by Harry Burton for the New York Metropolitan Museum of Art, by the Chicago Oriental Institute, and by Professor Siegfried Schott. Of the tombs without numbers known to older copyists (*a–uu* of the original edition), several have been rediscovered and are now included in the official series. Readers will notice the omission of extraneous objects of other periods found in or near the tombs, notably the Royal Cache of coffins in No. 320; these have been transferred to Part 2 of this volume under their appropriate sites.

For details of unpublished scenes and other new material, various sources have been consulted, especially the notebooks of the late N. de G. Davies, the

excavation-records and photographs of the New York Metropolitan Museum and the University Museum at Philadelphia, and notes made in the actual tombs and in museums by Mrs. Burney and myself. The tomb-plans are not drawn to scale, and are only intended to indicate the positions of the scenes; most are taken from publications, or from drawings supplied by Monsieur Stoppelaëre and the Antiquities Service. A list of plans with their sources is given after the Introduction, and here too will be found a list of abbreviations of published and unpublished material quoted or consulted.

It has also been possible to make a selective subject-index of tomb-scenes (Appendix A). This is followed by a list (Appendix B) of the paintings made by Mrs. N. de G. Davies for the New York Metropolitan Museum and for Sir Alan Gardiner (the latter set now distributed among museums): those already published in colour are omitted here, and will be found in the tombs concerned. Other appendixes (C, D, E) contain classifications of tombs according to date and site, and the tomb-numbers used by certain earlier Egyptologists. The indexes include as usual kings, private names, and divinities, and also objects in museums arranged numerically, and a short Various index.

The transliteration of Ancient Egyptian words has presented considerable difficulty. It has been found necessary to amend the names of Theban tomb-owners (originally based on the Gardiner and Weigall Catalogue) to correspond with the rest of the Bibliography; in order to avoid confusion several somewhat old-fashioned but familiar forms have been retained. There still remain many inconsistencies, but it is hoped that the forms used will be readily recognizable by Egyptologists, and at the same time will avoid the technical spelling which is not easily intelligible to non-specialists.

As usual we have received help from a large number of our colleagues. We particularly desire to thank the Antiquities Service for their assistance at Thebes, where accommodation in the rest-house was provided and several blocked tombs specially opened for our benefit, and the chief inspectors Labib Habachi and Abd el-Qader Muhammed for providing us with details of recent discoveries. The hospitality extended to us by Mr. and Mrs. Davies at Qurna, and the assistance given by the members of Chicago House at Luxor, greatly facilitated our task, and we also profited by the experience of Mr. Davies's many years at Thebes, and by the expert knowledge of Monsieur Bruyère for the Deir el-Medîna area. The synopsis of tomb-scenes and verification of inscriptions owe much to the kind co-operation of Professor Säve-Söderbergh and to researches on the spot by Messrs. Mekhitarian, Janssen, Stoppelaëre, and James. The excavation-records of the New York Metropolitan Museum and the University Museum at Philadelphia were placed at our disposal during two visits to the U.S.A., and we are most grateful to the staff of those museums, to the Chicago University Oriental Institute, and to Professor S. Schott for allowing us to consult their important series of photographs. Our thanks are also due to Frau

Scharff for presenting her husband's Theban notes to the Griffith Institute for our use. Again we are much indebted to the many authors who have dealt with our difficulties or supplied us with advance information of their forthcoming publications, and to our assistants, Miss Helen Murray and Mrs. Yeaxlee, who have been responsible for much of the detailed work involved in the preparation of the manuscript. Above all we wish to thank Professor Černý for his ever-ready help with names and titles, and for much welcome advice on the general arrangement of this volume; our work has been considerably lightened by consultation with him at every and any moment concerning the innumerable problems which have arisen during the years of preparation.

Finally we gratefully acknowledge the skill and helpfulness of the Oxford University Press, and especially thank the printers for their competent handling of the typographical complications, and the readers for their minute care and attention to detail.

R. L. B. MOSS

Oxford, November 1959

LIST OF SOURCES OF PLANS

Published

Full references will be found in each tomb.

Tombs 98, 145, 367, 385. — *Ann. Serv.*

Tomb 344. — *B.I.F.A.O.*

Tombs 1–10, 210–14, 216, 218–20, 250, 265–8, 290–2, 298, 322–3, 325, 327, 329–30, 335–6, 338–40, 354, 356–7, 359–61. — BRUYÈRE, *Rapports.*

Tombs 31, 40, 42, 49, 51, 52, 55, 60, 70, 75, 82, 83, 86, 89, 90, 93, 100, 103, 112, 133, 154, 181, 187–8, 217, 226, 324, 331, 341, 346, 362–3, 403. — DAVIES publications.

Tombs 33, 242, 388. — DUEMICHEN, *Der Grabpalast des Petuamenap.*

Tombs 97, 342–3, 345. — *Liv. Ann.*

Tombs 215, 255, 277–8. — *M.I.F.A.O.*

Tombs 279, 308, 311. — *M.M.A. Bull.*

Tombs 81, 84–5, 87–8. — *Mém. Miss.*

Tombs 282–3. — *Penn. Mus. Journal.*

Tombs 17, 48, 73, 155. — SÄVE-SÖDERBERGH, *Private Tombs at Thebes*, i.

Unpublished

Tombs 408–9. — EGYPTIAN ANTIQUITIES DEPARTMENT.

Tomb 34. — P. BARGUET.

Tombs 189–96, 364, 405–7. — CHICAGO UNIV. ORIENTAL INSTITUTE EPIGRAPHIC SURVEY, LUXOR.

Tombs 37, 404. — HAY MSS.

Tombs 284–6, 288–9, 300, 302, 305, 307. — PHILADELPHIA UNIV. MUS.

Tombs 125, 127. — Prof. T. SÄVE-SÖDERBERGH.

Tombs 11–15, 18–25, 30, 32, 35–6, 38–9, 41, 43–5, 50, 54, 56–9, 61–9, 71–2, 74, 101–2, 104–11, 122–3, 130, 137–44, 147–53, 156–61, 164–7, 169, 171–2, 174–80, 182–4, 186, 200–1, 209, 221–4, 232–3, 239, 241, 247–9, 251, 253–4, 256–62, 264, 271–3, 275–6, 284–6, 288, 294–6, 332, 368–72, 375–6, 378–9, 387, 390–1, 393–5, 405. — A. STOPPELAÈRE.

Tomb 197. — WILKINSON MSS.

LIST OF ABBREVIATIONS

I. *Publications*

Ä.Z.	Zeitschrift für Aegyptische Sprache und Alterthumskunde.
Aeg. Inschr.	Aegyptische Inschriften aus den königlichen Museen zu Berlin, edited by Gunther Roeder. 2 vols., 1901–24.
Aeg. und Vorderasiat. Alterthümer	Aegyptische und Vorderasiatische Alterthümer aus den königlichen Museen zu Berlin, 1895–7.
Amtliche Berichte	Amtliche Berichte aus den königlichen (preußischen) Kunstsammlungen, 1880–1919, continued as Berliner Museen, Berichte aus den preußischen Kunstsammlungen.
Ann. Mus. Guimet	Annales du Musée Guimet, 1880–1909.
Ann. Serv.	Annales du Service des Antiquités de l'Égypte.
Ausf. Verz.	Königliche Museen zu Berlin. Ausführliches Verzeichnis der aegyptischen Altertümer und Gipsabgüsse. 1899.
B.I.F.A.O.	Bulletin de l'Institut français d'archéologie orientale du Caire.
Baikie, *Eg. Antiq.*	Baikie (James), Egyptian Antiquities in the Nile Valley. 1932.
Baud, *Dessins*	Baud (Marcelle), Les Dessins ébauchés de la nécropole thébaine (*M.I.F.A.O.* lxiii). 1935.
Berend, *Prin. Mon. . . . Florence*	Berend (William B.), Principaux monuments du Musée égyptien de Florence. 1882.
Berliner Museen Berichte	See Amtliche Berichte.
Bibl.	This publication.
Bibl. Ég.	Bibliothèque égyptologique contenant les Œuvres des Egyptologues français . . . publiée sous la direction de G. Maspero. 1893, &c.
Boreux, *Guide*	Musée national du Louvre. Département des antiquités égyptiennes. Guide-catalogue sommaire. 2 vols., 1932.
Brief Descr.	Cairo Museum. A Brief Description of the Principal Monuments. See also Descr. sommaire (French edition, with plates).
Brooklyn Mus. Five Years	Brooklyn Museum. Five Years of Collecting Egyptian Art, 1951–1956. Catalogue of the Exhibition, 11 Dec. 1956 to 17 Mar. 1957.
Brugsch, *Recueil*	Brugsch (Heinrich), Recueil de monuments égyptiens. 1st part, 1862.
Brugsch, *Thes.*	Brugsch (H.), Thesaurus Inscriptionum Aegyptiacarum. 1883–91.
Bruyère, *Rapport*	Bruyère (Bernard), Rapport sur les fouilles de Deir el Médineh. (Fouilles de l'Institut français d'archéologie orientale du Caire.) 1924–1953.
Bruyère, *Tombes théb.*	Bruyère (B.), Tombes thébaines de Deir el Médineh à décoration monochrome (*M.I.F.A.O.* lxxxvi). 1952.
Bull. Inst. Ég.	Bulletin de l'Institut Égyptien, 1859–1918, continued as Bulletin de l'Institut d'Égypte.
Bull. des Mus. roy.	Bulletin des Musées royaux d'art et d'histoire. Brussels.

CAMPBELL, *Mirac. Birth*	CAMPBELL (COLIN), The Miraculous Birth of King Amon-Hotep III. 1912.
CAPART, *Documents*	CAPART (JEAN), Documents pour servir à l'étude de l'art égyptien. 2 vols., 1927–31.
CAPART, *Propos*	CAPART (J.), Propos sur l'art égyptien. 1931.
Cat. Caire	Catalogue général des antiquités égyptiennes du Musée du Caire.
ČERNÝ, *Rép. onom.*	ČERNÝ (JAROSLAV), Répertoire onomastique de Deir el-Médineh (Documents de fouilles de l'Institut français d'archéologie orientale du Caire, xii). 1949.
CHAMP., *Mon.*	CHAMPOLLION (JEAN FRANÇOIS), Monuments de l'Égypte et de la Nubie. 4 vols., 1835–45.
CHAMP., *Not. descr.*	As above, Notices descriptives. 2 vols., 1844–79.
CHAMPDOR	DAVIES (NINA), Ancient Egyptian Paintings, adapted by A. CHAMPDOR, La Peinture égyptienne ancienne, in Art et archéologie, 1954.
Chic. O.I.C.	Chicago University Oriental Institute Communications.
Comptes rendus	Académie des Inscriptions et Belles-Lettres. Comptes Rendus.
DAVIES, *Town House*	DAVIES (NORMAN DE GARIS), The Town House in Ancient Egypt, in New York, Metropolitan Museum Studies, i, pt. 2. 1929.
DAVIES (NINA), *Anc. Eg. Paintings*	DAVIES (NINA), Ancient Egyptian Paintings. 3 vols., 1936.
DAVIES (NINA), *Eg. Paintings* (Penguin)	DAVIES (NINA), Egyptian Paintings. King Penguin Books, 71. 1954.
Descr. de l'Égypte, Ant.	Description de l'Égypte ou Recueil des observations et des recherches qui ont été faites en Égypte pendant l'expédition de l'armée française. Antiquités (Planches). 5 vols., 1809–22.
Descr. sommaire	Cairo Museum. Description sommaire des principaux monuments (French edition of Brief Descr.). 1956.
DESROCHES-NOBLECOURT, *Religions ég.*	DESROCHES-NOBLECOURT (CHRISTIANE), Les Religions égyptiennes, in L'Histoire générale des religions.
DRIOTON and HASSIA, *Temples and Treasures*	DRIOTON (ÉTIENNE) and HASSIA, Temples and Treasures of Egypt, in Art et style, 1954.
DRIOTON, *Temples et trésors*	DRIOTON (É.), Temples et trésors de l'Égypte, in Art et style, 20, 1951.
DUEMICHEN, *Flotte*	DUEMICHEN (JOHANNES), Die Flotte einer aegyptischen Koenigin. 1868.
DUEMICHEN, *Hist. Inschr.*	DUEMICHEN (J.), Historische Inschriften alt-aegyptischer Denkmäler. 2 parts, 1867–9.
DUEMICHEN, *Oasen*	DUEMICHEN (J.), Die Oasen der libyschen Wüste. 1877.
FABRETTI, ROSSI, and LANZONE, *R. Mus. di Torino*	FABRETTI (A.), ROSSI (F.), and LANZONE (R. V.), Regio museo di Torino. Antichità egizie. 1882.
FARINA, *Pittura*	FARINA (GIULIO), La Pittura egiziana. 1929.
FARINA, *R. Mus. di Torino*	FARINA (G.), Il Regio Museo di Torino. Sezione egizia. 1931 and 1938.
GARDINER and WEIGALL, *Cat.*	GARDINER (ALAN H.) and WEIGALL (ARTHUR E. P.), A Topographical Catalogue of the Private Tombs of Thebes, 1913, and Supplement by R. ENGELBACH, 1924.

Guide (Sculpture)	British Museum. A Guide to the Egyptian Galleries (Sculpture). 1909.
HAYES, *Scepter*	HAYES (WILLIAM C.), The Scepter of Egypt, i (1953), ii (1959).
HELCK, *Urk.*	HELCK (HANS WOLFGANG), continuation of SETHE, Urkunden der 18. Dynastie (STEINDORFF, Urkunden des ägyptischen Altertums, iv). 1955, &c.
HERMANN, *Stelen*	HERMANN (ALFRED), Die Stelen der thebanischen Felsgräber der 18. Dynastie (Ägyptologische Forschungen, 11). 1940.
Hiero. Texts	Hieroglyphic Texts from Egyptian stelae, &c., in the British Museum. Pts. 1–8, 1911–39. (Part 7 by H. R. HALL, Part 8 by I. E. S. EDWARDS.)
I.L.N.	Illustrated London News.
J.A.O.S.	Journal of the American Oriental Society.
J.E.A.	Journal of Egyptian Archaeology.
J.N.E.S.	Journal of Near Eastern Studies.
JÉQUIER, *Frises*	JÉQUIER (GUSTAVE), Les Frises d'objets des sarcophages du Moyen Empire (*M.I.F.A.O.* xlvii). 1921.
JÉQUIER, *Hist. Civ.*	JÉQUIER (G.), Histoire de la civilisation égyptienne des origines à la conquête d'Alexandre. 1913.
KEES, *Ägypten*	KEES (HERMANN), Ägypten (OTTO, Handbuch der Altertumswissenschaft, iii, pt. 1, vol. iii, Kulturgeschichte des Alten Orients, 1). 1933.
KUENTZ, *L'Oie du Nil*	KUENTZ (CHARLES), L'Oie du Nil (Chenalopex Aegyptiaca) dans l'antique Égypte, in Archives du Mus. d'hist. nat. de Lyon, xiv. 1926.
L. D.	LEPSIUS (RICHARD), Denkmäler aus Aegypten und Aethiopien. 12 vols., 1849–59.
L. D. Text	As above, Text. 5 vols., 1897–1913.
LANGE, *Ägypten*	LANGE (KURT), Ägypten. Landschaft und Kunst. 1943.
LANGE, *Äg. Kunst*	LANGE (K.), Ägyptische Kunst. 1939.
LANGE, *Lebensbilder*	LANGE (K.), Lebensbilder aus der Pharaonenzeit. 1952.
LANZONE, *Diz.*	LANZONE (RIDOLFO VITTORIO), Dizionario di mitologia egizia. 2 vols., 1881–5.
LHOTE and HASSIA, *Chefs-d'œuvre*	LHOTE (ANDRÉ) and HASSIA, Les Chefs-d'œuvre de la peinture égyptienne. 1954.
LIEBLEIN, *Dict.*	LIEBLEIN (JOHANNES), Dictionnaire de noms hiéroglyphiques en ordre généalogique et alphabétique. 1871, and Supplément, 1892.
Liv. Ann.	University of Liverpool. Annals of Archaeology and Anthropology.
M.I.F.A.O.	Mémoires publiés par les membres de l'Institut français d'archéologie orientale du Caire. 1902, &c.
M.M.A. Bull.	The Bulletin of the Metropolitan Museum of Art, New York.
MASPERO, *L'Arch. ég.*	MASPERO (GASTON C. C.), L'Archéologie égyptienne. 1887 and 1907.
MASPERO, *Guide*	MASPERO (G. C. C.), Guide du visiteur au Musée du Caire. 4th ed. 1915.

MASPERO, *Hist. anc.* MASPERO (G. C. C.), Histoire ancienne des peuples de l'Orient classique. 3 parts, Les origines; Les premières mêlées; Les empires. 1895–9.

Mém. Miss. Mémoires publiés par les membres de la Mission archéologique française au Caire.

MEYER, *Fremdvölker* Photographs described in MEYER (EDUARD), Bericht über eine Expedition nach Ägypten zur Erforschung der Darstellungen der Fremdvölker, in Sitzungsb. der königlich Preußischen Akademie der Wissenschaften, Berlin, 1913, pp. 769–801. (References in *Bibl.* are to photographs, not to pages of the Bericht.)

Mitt. D.O.G. Mitteilungen der Deutschen Orient-Gesellschaft zu Berlin.

Mitt. Kairo Mitteilungen des Deutschen Instituts für ägyptische Altertumskunde in Kairo.

Mitt. Vorderasiat. Ges. Mitteilungen der Vorderasiatischen Gesellschaft.

Mon. Piot Fondation Piot, Monuments et Mémoires publiés par l'Académie des Inscriptions et Belles-Lettres.

Nachr. Akad. Göttingen Nachrichten der Akademie der Wissenschaften in Göttingen. i. Philologisch-historische Klasse.

NAGEL, *Céramique* NAGEL (GEORGES), La Céramique du Nouvel Empire à Deir el Médineh, i (Documents de fouilles de l'Institut français d'archéologie orientale du Caire, x). 1938.

NORTHAMPTON, &c., *Theban Necropolis* NORTHAMPTON (5th MARQUESS OF), SPIEGELBERG (WILHELM), and NEWBERRY (PERCY E.), Report on some excavations in the Theban Necropolis during the winter of 1898–9. 1908.

O.L.Z. Orientalistische Literaturzeitung.

ORCURTI, *Cat.* ORCURTI (PIER CAMILLO), Catalogo illustrato dei monumenti egizi del regio museo di Torino. 1882.

P.S.B.A. Proceedings of the Society of Biblical Archaeology. 1879–1918.

Penn. Mus. Journ. University of Pennsylvania. The Museum Journal.

PETRIE, *Arts and Crafts* PETRIE (WILLIAM M. FLINDERS), The Arts and Crafts of Ancient Egypt. 1909.

PETRIE, *Racial Types* Photographs described in PETRIE, Racial Photographs from the Ancient Egyptian Pictures and Sculptures, in British Association Report, 1887, pp. 439–49.

PIEHL, *Inscr. hiéro.* PIEHL (KARL), Inscriptions hiéroglyphiques en Europe et en Égypte. 3 series, 1886–95.

PIERRET, *Rec. d'inscr.* PIERRET (PAUL), Recueil d'inscriptions inédites du Musée égyptien du Louvre, in Études égyptologiques, ii, 1874, viii, 1878.

PRISSE, *L'Art égyptien* PRISSE D'AVENNES (A. C. T. É.), Histoire de l'art égyptien d'après les monuments. 1878.

PRISSE, *Mon.* PRISSE D'AVENNES (A. C. T. É.), Monuments égyptiens. 1847.

R.E.A. Revue de l'Égypte ancienne, 1927–31, continued as Revue d'Égyptologie.

RANKE, *Meisterwerke* RANKE (HERMANN), Meisterwerke der ägyptischen Kunst. 1948.

Rec. de Trav.	Recueil de Travaux relatifs à la philologie et à l'archéologie égyptiennes et assyriennes. 1870–1923.
Rendiconti Lincei	Rendiconti della Reale Accademia dei Lincei. Classe di scienze morali, storiche e filologiche.
Rev. Arch.	Revue Archéologique.
ROSELLINI, *Mon. Civ.*	ROSELLINI (IPPOLITO), I Monumenti dell' Egitto e della Nubia. Monumenti Civili. 1834.
ROSELLINI, *Mon. Stor.*	As above, Monumenti Storici. 1832.
SACHS, *Musikinstrumente*	SACHS (CURT), Die Musikinstrumente des Alten Ägyptens (Staatliche Museen zu Berlin, Mitteilungen aus der Ägyptischen Sammlung, iii). 1921.
SCHÄFER and ANDRAE, *Kunst*	SCHÄFER (HEINRICH) and ANDRAE (WALTHER), Die Kunst des Alten Orients (Propyläen-Kunstgeschichte, 2). 1925, 1930, 1942.
SCHIAPARELLI, *Funerali*	SCHIAPARELLI (ERNESTO), Il Libro dei Funerali degli antichi egiziani (Reale Accademia dei Lincei). 1882–90.
SCHIAPARELLI, *Mus. . . . Firenze*	SCHIAPARELLI (E.), Museo archeologico di Firenze. Antichità egizie. Pt. 1, 1887.
SCHIAPARELLI, *Relazione*	SCHIAPARELLI (E.), Relazione sui lavori della Missione archeologica italiana in Egitto (1903–20). 2 vols., 1924–27.
SCHMIDT, *Sarkofager*	SCHMIDT (V.), Sarkofager, Mumiekister og Mumiehylstre i det Gamle Ægypten. Typologisk Atlas. 1919.
SCHOTT, *Das schöne Fest*	SCHOTT (SIEGFRIED), Das schöne Fest vom Wüstentale. Festbräuche einer Totenstadt. (Akademie der Wissenschaften und der Literatur, Abhandlungen der geistes- und sozialwissenschaftlichen Klasse, Jahrgang 1952, Nr. 11. Mainz.)
SETHE, *Untersuchungen*	SETHE (KURT), Untersuchungen zur Geschichte und Altertumskunde Aegyptens. 1896, &c.
SETHE, *Urk.* iv.	SETHE (K.), Urkunden der 18. Dynastie. 1906–9.
SHARPE, *Eg. Inscr.*	SHARPE (SAMUEL), Egyptian Inscriptions from the British Museum and other sources. 2 series, 1837–55.
SMITH, *Art . . . Anc. Eg.*	SMITH (WILLIAM STEVENSON), Art and Architecture in Ancient Egypt. 1958.
STEINDORFF, *Blütezeit*	STEINDORFF (GEORG), Die Blütezeit des Pharaonenreichs. 1900, 1926.
STEINDORFF, *Kunst*	STEINDORFF (G.), Die Kunst der Ägypter. Bauten, Plastik, Kunstgewerbe. 1928.
STEINDORFF and WOLF, *Gräberwelt*	STEINDORFF (G.) and WOLF (WALTHER), Die thebanische Gräberwelt (Leipziger Ägyptologische Studien, 4). 1936.
TARCHI, *L'Architettura*	TARCHI (UGO), L'Architettura e l'arte nell' antico Egitto.
Trans. Int. Cong. Or.	Transactions of the International Congress of Orientalists.
Trans. Roy. Soc. Lit.	Transactions of the Royal Society of Literature.
VANDIER, *Egypt*	VANDIER (JACQUES), Egypt. Paintings from Tombs and Temples (Unesco World Art Series, 2). 1954.
VANDIER, *Guide*	VANDIER (J.), Musée du Louvre. Le Département des antiquités égyptiennes. Guide-sommaire. 1948 and 1952.
VANDIER, *Manuel*	VANDIER (J.), Manuel d'archéologie égyptienne. Vols. i–iii, 1952–8.

VERCOUTTER, *L'Égypte* [&c.]	VERCOUTTER (JEAN), L'Égypte et le monde égéen préhellénique (Institut français d'archéologie orientale, Bibliothèque d'étude, 22). 1956.
WEIGALL, *Anc. Eg. . . . Art*	WEIGALL (ARTHUR E. P.), Ancient Egyptian Works of Art. 1924.
WERBROUCK, *Pleureuses*	WERBROUCK (MARCELLE), Les Pleureuses dans l'Égypte ancienne. 1938.
WILKINSON, *M. and C.*	WILKINSON (J. GARDNER), The Manners and Customs of the Ancient Egyptians. First edition, 3 vols., 1837; 2nd series, 2 vols. and vol. of plates, 1841. New edition (BIRCH), 3 vols., 1878.
WINLOCK, *Excavations*	WINLOCK (HERBERT EUSTIS), Excavations at Deir el Bahri 1911–1931. 1942.
WINLOCK, *Models*	WINLOCK (H. E.), Models of Daily Life in Ancient Egypt from the Tomb of Meket-Reᶜ at Thebes. 1955.
WINLOCK, *Rise and Fall*	WINLOCK (H. E.), The Rise and Fall of the Middle Kingdom in Thebes. 1947.
WRESZ., *Atlas*	WRESZINSKI (WALTER), Atlas zur altägyptischen Kulturgeschichte. 3 vols., 1915, &c.
YOUNG, *Hieroglyphics*	YOUNG (THOMAS), Hieroglyphics collected by the Egyptian Society. 2 vols., 1823–8.
Z.D.M.G.	Zeitschrift der Deutschen Morgenländischen Gesellschaft.

II. *Unpublished sources*

ALINARI photos.	Taken by Fratelli Alinari, Florence. Egyptian objects in Florence Museum.
BANKES MSS.	Property of Mr. Ralph Bankes, Kingston Lacy, Wimborne, Dorset. William John Bankes was in Egypt between 1812 and 1825, and led an expedition to Egypt and Nubia in 1821 which included Linant de Bellefonds and Ricci.
BURTON MSS.	In the British Museum, Add. MSS. 25613–75. James Burton was in Egypt and Nubia between 1820 and 1839.
CARTER MSS.*	Papers of Howard Carter (1873–1939).
CHIC. OR. INST. photos.	Taken by the Chicago University Oriental Institute Epigraphic Survey, Luxor, Egypt.
DAVIES MSS.*	Notebooks, &c., of Norman de Garis Davies (1865–1941), extensively used for this publication.
DEVÉRIA squeezes	In the Louvre. Made by Théodule Devéria in Egypt between 1858 and 1866.
DEVÉRIA MSS.	In Paris, Collège de France. Papers of Théodule Devéria.
F.E.R.E. photos.	In Brussels, Fondation égyptologique Reine Élisabeth. Photographs from various sources.
GOLENISHCHEV MSS.*	Copies of inscriptions, made in Egypt by Vladimir Golenishchev (1856–1947).

* Property of the Griffith Institute, Ashmolean Museum, Oxford.

GR. INST. ARCHIVES, photos.*	Photographs from various sources.
HAY MSS.	In the British Museum, Add. MSS. 29812–60, 31054. Robert Hay of Linplum and his artists made the drawings, &c., in Egypt and Nubia between 1824 and 1838.
HORSFALL photos.*	Taken by Capt. Robin Horsfall in 1911–12.
HOSKINS MSS.†	Property of Sir Alan Gardiner. George Alexander Hoskins was in Egypt and Nubia in 1832–3 and 1860–1.
LANE MSS.	In the British Museum, Add. MSS. 34080–8. Edward William Lane was in Egypt and Nubia in 1825–8 and 1833–5.
LEPSIUS MS.†	Diary of Richard Lepsius, from Oct. 30 to Dec. 7, 1844, discovered too late for use in L. D. Text.
M.M.A. photos.	In New York, Metropolitan Museum of Art. Taken by the Egyptian Expedition. Prints of Series T in the Griffith Institute, Ashmolean Museum, Oxford.
MARBURG INST. photos.	In Marburg Institute, Germany.
MOND photos.*	Collection of photographs made by Sir Robert Mond.
NESTOR L'HÔTE MSS.	In Paris, Bibliothèque Nationale, Nouvelles Acquisitions françaises, 20394–415. Nestor l'Hôte was in Egypt in 1828–9, 1838–9.
NEWBERRY MSS.*	Papers of Percy Edward Newberry (1869–1949).
PETRIE Ital. photos.*	Taken by Sir Flinders Petrie in Florence, Turin, and Bologna Museums.
PHILAD. drawings	In Philadelphia, University Museum. Drawings by Ahmed Yusef.
PHILAD. photos.	In Philadelphia, University Museum. Taken by the Egyptian Expedition.
PRISSE MSS.	In Paris, Bibliothèque Nationale, Nouvelles Acquisitions françaises, 20419, 20430–3. Prisse d'Avennes was in Egypt from 1840 to 1846 (?).
PRUDHOE MSS.	Property of the Duke of Northumberland at Alnwick Castle. Journal of Lord Prudhoe, afterwards the fourth Duke, and drawings chiefly of Upper Nubia by Major Felix, in 1828 and later.
DE RICCI MSS.	In Paris, Collège de France. Papers of Seymour de Ricci (1881–1942).
ROSELLINI MSS.	In Biblioteca Universitaria, Pisa. Rosellini was in Egypt in 1828–9.
SCHOTT photos.†	Negatives of Theban tombs. Taken by Prof. Siegfried Schott, University of Göttingen.
SEYFFARTH MSS.	In New York, Brooklyn Museum. Tracings, squeezes, &c., of objects in museums, made by Gustav Seyffarth (1796–1855).
SPIEGELBERG Diary	Property of W. F. Edgerton, Chicago University Oriental Institute. Diary of Wilhelm Spiegelberg, 7 Nov. 1898 to 9 Feb. 1899.
SPIEGELBERG squeezes*	Made by Wilhelm Spiegelberg in 1895.

* Property of the Griffith Institute, Ashmolean Museum, Oxford.
† On temporary loan to the Griffith Institute.

Wilbour MSS.	In New York, Brooklyn Museum. Charles Wilbour was in Egypt in 1880–91.
Wild MSS.*	James William Wild, architect, was attached to the Lepsius Expedition in 1842 and later Curator of the Soane Museum. Presented by his daughters.
Wilkinson MSS.†	Sir J. Gardner Wilkinson was in Egypt and Nubia between 1821 and 1831, and in 1841–2, 1848–9, and 1855. Lent by Mrs. Godfrey Mosley.
Williams rubbings*	Rubbings from objects in the British Museum, &c., made by John Williams between 1830 and 1840. Presented by his grandson, the Rev. J. F. Williams.

* Property of the Griffith Institute, Ashmolean Museum, Oxford.
† On permanent loan to the Griffith Institute.

NOTE TO READERS

Registers are counted from the top and numbered in Roman figures, heavy type; scenes are numbered in Arabic figures, heavy type.

Destroyed scenes or details are indicated by square brackets.

Numbers in round brackets at the beginning of a paragraph refer to position on plans.

Attention is specially drawn to general references at the beginning of certain tombs, where titles in Sethe, *Urkunden*, and Černý, *Répertoire onomastique*, are also grouped.

When authors are quoted without the title of the book, the full reference will be found at the beginning of the tomb.

Original copies and publications only are as a rule included, though secondary ones are given in special cases.

I. NUMBERED TOMBS

1. SENNEZEM ⸢ ⸣, Servant in the Place of Truth. Dyn. XIX.

Deir el-Medîna.

Father, Kha‘bekhnet ⸢ ⸣ (name on fragment, BRUYÈRE, *Rapport* (*1927*), fig. 34 [4]). Wife, Iyneferti ⸢ ⸣.

Plan, p. 2. Map VII, E–3, d, 8.

Court with Chapels.

BRUYÈRE, *Rapport* (*1924–1925*), pp. 190–2, with view and plan, figs. 126–7; (*1928*), pp. 134–5, with view, pl. xiii [1]; (*1930*), reconstruction, on pl. xxxii [middle right]. Cf. ČERNÝ, *Rép. onom.* p. 1, note 1.

Chapel of Sennezem.

Fragments of lucarne-stela from pyramid. Text, BRUYÈRE, *Rapport* (*1930*), p. 92 [1].

North Chapel. Son Khons ⸢ ⸣.

Names and titles, ČERNÝ, *Rép. onom.* pp. 1–2 [upper], with key-plan, p. 1.

(1) Two registers. I, Couple. II, Son (of Sennezem) Kha‘bekhnet (tomb 2) and wife. (2) Man before [bark], and remains of funeral procession. (3) Guardian in Book of Gates. (4) Remains of funeral procession, including kneeling man holding mummy.

Pyramidion, in Turin Mus. 1622. LANZONE, *Diz.* pl. clxxx, p. 459. Texts, FABRETTI, ROSSI, and LANZONE, *R. Mus. di Torino*, pp. 173–4; MASPERO in *Rec. de Trav.* ii (1880), pp. 191–2 [lxxxii]; names, LIEBLEIN, *Dict.* No. 790, cf. Supp. p. 970. See ORCURTI, *Cat.* ii, p. 14 [1]; BRUYÈRE, *Rapport* (*1928*), p. 135.

Burial Chambers of Sennezem.

TODA, *Son Notém en Tebas* (Madrid, 1887), passim (also published in *Boletín de la Real Academia de la Historia*, x [ii], Madrid, Feb. 1887, pp. 91–148), and TODA, *A través del Egipto*, pp. 273–5, 385–6, all with same pls.; CAMPBELL, *Mirac. Birth*, pp. 133–76; MASPERO in *Bull. Inst. Ég.* 2 Sér. vii (1886), pp. 201–8 (reprinted, *Bibl. Ég.* i, pp. 225–31). Translation of part of TODA's account, and list of names in the tomb, DARESSY in *Ann. Serv.* xx (1920), pp. 147–60.

Doorway at foot of shaft. Outer jambs and inner right jamb, titles of deceased. Thicknesses, invocation of Osiris.

Titles, ČERNÝ, *Rép. onom.* p. 2 [lower].

Innermost Chamber.

View, SMITH, *Art . . . Anc. Eg.* pl. 164; M.M.A. photos. T. 2754–5. Walls and ceiling, GR. INST. ARCHIVES, photos. DM. 1. 1–15. Names and titles, ČERNÝ, *Rép. onom.* pp. 2–9, with key-plan, p. 2.

(5) [1st ed. 1, 2] Outer lintel, double-scene, deceased adores bark of Atum. Jambs with outer thicknesses and soffit, titles of deceased and invocations of Osiris and Rē‘-Harakhti. Inner thicknesses, Akru on left, and *išd*-tree with cat slaying serpent on right. Inner soffit, deceased adores horizon-disk held by arms of Nut.

See CAMPBELL, *Mirac. Birth*, pp. 173–5. Lintel and left jamb with thickness and soffit, in Berkeley, California Univ. Mus. 6.19871, LUTZ in *Oriens. The Oriental Review*, i [2], April

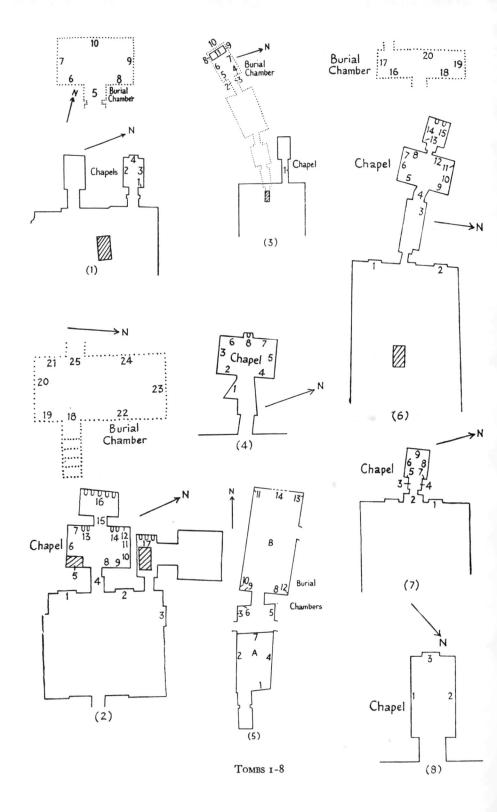

TOMBS 1-8

1926, pls. i–iv, pp. 17, 20. Inner thicknesses and soffit, M.M.A. photos. T. 2734–7, 2755; cat and serpent, and personified horizon-disk, SMITH, *Art* . . . *Anc. Eg.* pls. 165, 166 [A]; cat and serpent, DAVIES in *M.M.A. Bull.* Pt. ii, Nov. 1921, fig. 11, cf. p. 28. Texts, TODA, *Son Notém*, pp. 19, 32–5; texts of lintel, DARESSY in *Ann. Serv.* xx (1920), p. 150; names of deceased and wife, WILBOUR MSS. 2 F. 27 [lower].

Wooden door, from this entrance, in Cairo Mus. Ent. 27303. Outer face, two registers, **I,** deceased, wife, and relatives, before Osiris and Maʿet, **II,** relatives before Ptaḥ-Sokari-Osiris and Isis. Inner face, two registers, **I,** deceased and wife playing draughts, **II,** eleven columns of text.

See MASPERO, *Guide* (1915), p. 510 [4912]; *Brief Descr.* No. 2006. Texts of outer face, TODA, *Son Notém*, pp. 20–1; names, BRUYÈRE, *Tombes théb.* p. 53 [3]. Inner face, TODA, *Son Notém*, pl. facing p. 30; draughts-playing, WRESZ., *Atlas*, i: 418.

(6) [1st ed. 3] Two registers. **I,** Mummy on couch between Isis and Nephthys as hawks. **II,** Sons (one offering 🜊) before relatives, and son Bunakhtef 𓏎𓃀𓐠𓂝𓎛 libating to deceased and family.

TODA, *Son Notém*, pl. facing p. 35 [right], cf. pp. 39–40, 42–5; CAMPBELL, *Mirac. Birth*, pls. facing pp. 141, 168, cf. pp. 140–1, 168–70; M.M.A. photos. T. 2739, 2755 [middle]; CHIC. OR. INST. photo. 3354. **II,** incomplete, LHOTE and HASSIA, *Chefs-d'œuvre*, pl. 38; libating-scene, VANDIER, *Egypt*, pl. xxxii; daughter under wife's chair, MEKHITARIAN, *Egyptian Painting*, pl. on p. 151.

(7) [1st ed. 4] Tympanum, Anubis-jackals. Scene below, deceased and wife adore Gods of Underworld.

TODA, *Son Notém*, p. 57 with pl.; CAMPBELL, op. cit. pp. 139–40 with pl.; CAPART and WERBROUCK, *Thèbes*, fig. 251; SCHARFF in OTTO, *Handbuch der Archäologie*, i, pl. 89 [4]; FARINA, *Pittura*, pl. clxxi; PIJOÁN, *Summa Artis*, iii (1945), pl. xxix [lower]; LHOTE and HASSIA, op. cit. pl. 149; DRIOTON, *Temples et trésors*, pl. 16; M.M.A. photos. T. 2740, 2755; CHIC. OR. INST. photo. 3351. Left part, WEIGALL, *Anc. Eg.* . . . *Art*, 258 [upper]. Texts, WILBOUR MSS. 2 G. 34 [top and middle].

(8) [1st ed. 7] Two registers. **I,** Deceased and wife adore guardians of Gates (the ten *šbḫt*). **II,** Relatives.

TODA, *Son Notém*, pl. facing p. 35 [left], cf. pp. 36–9, 40–2; M.M.A. photos. T. 2738, and on 2754; CHIC. OR. INST. photo. 3352; omitting deceased and wife, CAMPBELL, *Mirac. Birth*, pls. facing pp. 152 [lower], 170, cf. pp. 150–5, 170–1.

(9) [1st ed. 6] Tympanum, baboons adore bark of Rēʿ. Four registers below, **I–IV,** Fields of Iaru.

TODA, *Son Notém*, pp. 45–7 with pl.; CAMPBELL, *Mirac. Birth*, pp. 159–67 with pl.; CAPART and WERBROUCK, *Thèbes*, fig. 250; FARINA, *Pittura*, pl. clxx; STEINDORFF and WOLF, *Gräberwelt*, pl. 14 [a]; *L'Égypte. Art et Civilisation*, Série 57 (1951), pl. 10; LHOTE and HASSIA, *Chefs-d'œuvre*, pls. 69, 70; SAMIVEL and AUDRAIN, *The Glory of Egypt*, pl. 75; M.M.A. photos. T. 2745–7, 2754; CHIC. OR. INST. photo. 3350. **I–IV,** DE RACHEWILTZ, *Incontro con l'arte egiziana*, pl. 64, p. 79; incomplete, LANGE, *Äg. Kunst*, pls. 120–1. Part of **II** to **IV,** WRESZ., *Atlas*, i. 19 a; LANGE, *Lebensbilder*, pl. 64; DESROCHES-NOBLECOURT, *Religions ég.* fig. on p. 304 [top left]. Part of **III** and **IV,** WEIGALL, *Anc. Eg.* . . . *Art*, 257. Ploughing in **III,** GROENEWEGEN-FRANKFORT, *Arrest and Movement*, pl. xli [b], p. 118; MEKHITARIAN, *Egyptian Painting*, pl. on p. 149. Some plants in **IV,** SCHOTT, *Altägyptische Liebeslieder*, pl. 9.

(10) [1st ed. 5] Three scenes. **1**, Anubis tending mummy on couch with text from Book of the Dead. **2**, Deceased squatting before Osiris. **3**, Deceased led by Anubis.

TODA, *Son Notém*, pp. 48–55 with pl.; M.M.A. photos. T. 2741–4; CAMPBELL, *Mirac. Birth*, pp. 136–9, 141–6, with pl. facing p. 143 (scene **2**). **1** and **2**, CHIC. OR. INST. photos. 3353, 3355; omitting deceased, LHOTE and HASSIA, *Chefs-d'œuvre*, pls. at end 11, 41, 142. **1**, LANGE, *Äg. Kunst*, pl. 117; PIJOÁN, *Summa Artis*, iii (1945), pl. xxix [upper]; DESROCHES-NOBLECOURT, op. cit. fig. on p. 241; VIOLLET and DORESSE, *Egypt*, pl. 151. Osiris, BRUYÈRE, *Rapport (1935–1940)*, Fasc. iii, fig. 15, cf. p. 122.

Frieze-texts. TODA, *Son Notém*, pp. 45, 56.

Vaulted ceiling, eight scenes. Outer half, **1**, Rēc-Ḥarakhti, Atum on back of calf, and two trees, **2**, deceased adores three demons, **3**, deceased adores Gods of Underworld and serpent on horizon, **4**, deceased adores Thoth and two demons. Inner half, **5**, tree-goddess scene, **6**, deceased and wife adore gods of the sky, **7**, *Benu*-bird and Rēc-Ḥarakhti with Ennead in bark, **8**, deceased opens Gates of the West.

CAMPBELL, *Mirac. Birth*, pp. 146–50 with four pls. and pp. 156–9 with two pls.; M.M.A. photos. T. 2748–53. **1** and **6**, LHOTE and HASSIA, *Chefs-d'œuvre*, pls. 156–7. **6**, SAMIVEL and AUDRAIN, *The Glory of Egypt*, pl. 47. **7**, WILBOUR MSS. 2 G. 34 [bottom]. Texts (incomplete), TODA, *Son Notém*, pp. 58–63.

Finds. In Innermost Chamber.

TODA, *Son Notém*, pp. 2–6; DARESSY in *Ann. Serv.* xx (1920), pp. 151–6. Objects in New York, M.M.A., id. ib. xxviii (1928), pp. 7–10; *A Handbook of the Egyptian Rooms* (1911), pp. 119–20; WINLOCK in *M.M.A. Bull.* x (1915), p. 29. Some objects in Cairo Mus., see MASPERO, *Guide* (1915), pp. 343 [3368 A, B], 524 [5227–31], 542 [5515–18].

Objects of deceased. In Cairo Museum.

Outer coffin on sledge, with scenes from Book of the Dead, Ent. 27301, inner coffin and mummy-case, Ent. 27308. See *Brief Descr.* Nos. 2001, 2003. Outer coffin, SCHMIDT, *Sarkofager*, figs. 625–7, 630 (from drawings by Lady St. Aubyn); *Benu*-bird, and deceased with two *bas*, from scenes, LHOTE and HASSIA, *Chefs-d'œuvre*, pls. 63, 162; see MASPERO, *Guide* (1915), p. 393 [3797]; titles, LIEBLEIN, *Dict.* Supp. No. 2247.

Masks, see MASPERO, *Guide* (1915), p. 452 [4273–4]. Canopic-box, Ent. 27307. Two ushabti-coffins, 48411–12, NEWBERRY, *Funeral Statuettes and Model Sarcophagi (Cat. Caire)*, pl. xvii (No. 48411), pp. 348–51; (another, formerly Golenishchev Collection 3853 b, is in Moscow, State Pushkin Mus. of Fine Arts, I.1.a. 1662).

Chair naming son Khacbekhnet, Ent. 27256. CAPART, *Propos*, fig. 84; id. *L'Art égyptien*, iv, pl. 755. Titles, LIEBLEIN, *Dict.* Supp. No. 2261. See MASPERO, *Guide* (1915), p. 511 [4925].

Bed, Ent. 27254. See id. ib. p. 525 [5255].

Six walking-sticks, Ent. 27310. GABRA in *Mélanges Maspero*, i, pp. 573–7 with pl. [A, C–F, H]. Text of D, BRUYÈRE, *Mert Seger*, p. 265 [bottom, 2°].

Architectural instruments, Nos. 1934, 1940, wooden cubit-measure, No. 1941, &c. See MASPERO, *Guide* (1915), p. 542 [5515–18]. One for verifying levels, CAPART in *Chronique d'Égypte*, xvi (1941), fig. 5, cf. pp. 200–1. Text of cubit-measure, CARTER MSS. v. 2 [d].

Objects of family.

Objects of wife Iyneferti. Coffin and inner lid, dedicated by son Khons, and mask, in New York, M.M.A. 86.1.5, 6, HAYES, *Scepter*, ii, fig. 264; see DARESSY in *Ann. Serv.* xxviii

(1928), p. 9. Wooden box with leaping gazelle, in Cairo Mus. Ent. 27271, CAPART, *L'Art égyptien*, iv, pl. 756; id. *Propos*, fig. 85. Canopic-box and stools, in Cairo Mus. Ent. 27306, 27255 A, B. Toilet-box and vase, in New York, M.M.A. 86.1.7, 9.

Objects of son Khaʿbekhnet (tomb 2). Ushabti-box, in New York, M.M.A. 86.1.16, PHILLIPS in *M.M.A. Bull.* N.S. vi (1948), fig. on p. 210 [right]. Ushabti-box with Khaʿbekhnet (probably same man) seated and wife Êsi, in Copenhagen, Nat. Mus. 3506, MOGENSEN, *Inscriptions hiéroglyphiques du Musée National de Copenhague*, pl. xxv [43], p. 82 [lower]; SCHMIDT, *Sarkofager*, fig. 631; *Guide. Oriental and Classical Antiquity* (1950), pl. 4, p. 23 [20, C]; names, BRUYÈRE, *Tombes théb.* p. 53 [5]; see *Antiksamlingen, Vejledning for Besøgende* (1935), No. 62. Ushabti-box with similar scene, formerly Golenishchev Collection 3548, now in Moscow, State Pushkin Mus. I.1.a. 1920, PAVLOV, *Iskusstvo Drevnego Vostoka*, fig. on p. 3; [PAVLOV and MATE], *Pamiatniki Iskusstva Drevnego Egipta*, pl. 70. Canopic-box, in Madrid, Mus. Arqueológico Nacional, 15222, TODA, *Son Notém en Tebas*, fig. on p. 64.

Objects of Êsi, wife of Khaʿbekhnet (?). Coffin, in Cairo Mus. Ent. 27309, see *Brief Descr.* No. 2000. Canopic-box, in Cairo Mus. Ent. 27304.

Objects of son Khons. Outer coffin on sledge, with scenes from Book of the Dead, in Cairo Mus. Ent. 27302; scenes of deceased with wife throwing bone for game of draughts, and tree-goddess, SCHMIDT, *Sarkofager*, figs. 628-9; Khons adoring Akru and [Meḥitwert]-cow, with Anubis tending mummy on couch with Isis and Nephthys and *bas* below, LHOTE and HASSIA, *Chefs-d'œuvre*, pl. at end 12; titles, LIEBLEIN, *Dict.* Supp. No. 2248; see MASPERO, *Guide* (1915), p. 393 [3796]; *Brief Descr.* No. 2002. Middle and inner coffins, canopic-box, and mask (probably belonging), in New York, M.M.A. 86.1.1-4; inner coffin, *A Handbook to the Egyptian Rooms* (1911), fig. 50, cf. p. 120; HAYES, *Scepter*, ii, fig. 265; canopic-box, id. ib. fig. 266. Ushabti-box, in Cairo Mus.; two faces, TURAIEV, *Jaščiki dlja egipetskich pogrebal'nych statuetok, nazyval'nych 'ušebti'*, pl. v [1], p. 5. Three walking-sticks, in Cairo Mus. Ent. 27310, GABRA in *Mélanges Maspero*, i, pp. 574-7 with pl. [B, G, I]; text of I, BRUYÈRE, *Mert Seger*, p. 265 [bottom, 1°].

Objects of Tamake(t) ⌐🗕🗕🗕, wife of Khons. Coffin, in Berlin Mus. 10832; winged Nut from lid, ERMAN, *Die ägyptische Religion* (1905), Abb. 72, (1909), Abb. 78; id. *Die Religion der Ägypter*, Abb. 86; BONNET, *Reallexikon der ägyptischen Religionsgeschichte*, Abb. 134; texts, *Aeg. Inschr.* ii. 323-9; see *Ausf. Verz.* p. 174. Lid of inner coffin, in Berlin Mus. 10859, *Aeg. und Vorderasiat. Alterthümer*, pl. 28; MASPERO, *Hist. anc. Les premières mêlées*, fig. on p. 520 [left]; SCHMIDT, *Sarkofager*, fig. 732 (from *Aeg. Alterthümer*); head, MÖLLER, *Die Metallkunst der alten Ägypter*, Abb. 13, cf. p. 43; see *Ausf. Verz.* pp. 174-5. Canopic-box, in Cairo Mus. Ent. 27305.

Painted box of son Raʿmosi 🗕🗕🗕, in Berlin Mus. 10195; text, *Aeg. Inschr.* ii. 274; see *Ausf. Verz.* p. 197. Ushabti-box of Raʿmosi, in New York, M.M.A. 86.1.15. Ushabti-box of Paraʿemnekhu 🗕🗕🗕, Servant in the Place of Truth, in New York, M.M.A. 86.1.14, PHILLIPS in *M.M.A. Bull.* N.S. vi (1948), fig. on p. 210 [left]; HAYES, *Scepter*, ii, fig. 274. Stool of Mosi 🗕🗕🗕, Child of the royal tomb, in Cairo Mus. Ent. 27290.

Other Finds.

Lintel, double-scene, Khons before Sobk, and deceased before Mertesger. BRUYÈRE, *Rapport* (1930), pl. xxv [1], pp. 93-94 [1].

Upper part of left jamb of deceased with adjoining thickness. Texts, id. ib. fig. 29, cf. pp. 95-6 [3].

[Ostracon with hieratic text of the beginning of the Story of Sinuhe is in Cairo Mus. 25216.]

2. KHA'BEKHNET 🔲𐤟J𐤟🔲, Servant in the Place of Truth. Temp. Ramesses II.

Deir el-Medîna. (L. D. Text, No. 107.)

Parents, Sennezem (tomb 1) and Iyneferti. Wives, Saḥte 𐤟𐤟𐤟𐤟𐤟𐤟 and (probably) Êsi 𐤟𐤟𐤟 (see supra, p. 5).

Plan, p. 2. Map VII, E–3, c, 8.

L. D. Text, iii, p. 292; BRUYÈRE, Tombes théb. pp. 22–56, with plan of Burial Chamber, fig. 2; BRUYÈRE, Rapport (1927), pp. 50–1, with plans, fig. 38 and on pl. i; GAUTHIER in Ann. Serv. xix (1920), pp. 10–11. Names and titles, ČERNÝ, Rép. onom. pp. 10–37, with key-plans, pp. 10, 33.

Courts.

(1) Remains of stela.

(2) Stela, with double-scene at bottom, deceased on left, father on right, both kneeling with hymns to Rēʿ.
Names and titles, ČERNÝ, Rép. onom. pp. 10 [upper], 11 [upper].

(3) Stela, bark of Rēʿ adored by baboons at top, and three registers of double-scenes below. **I,** Deceased before four divinities. **II,** Father and family before Horus and Satis, and deceased and family before Amūn and Queen ʿAḥmosi Nefertere. **III,** Deceased adoring with hymn to Rēʿ.
GR. INST. ARCHIVES, photo. 1987. Texts, ČERNÝ, Rép. onom. pp. 32–3; hymns, BRUYÈRE, Tombes théb. p. 55, cf. 53–4.

Chapel. Walls, GR. INST. ARCHIVES, photos. DM. 2. 1–15.

Hall.

(4) Left thickness, two registers, **I,** father kneeling adores Min and [goddess], **II,** brother Khons and wife offer to parents (with monkey under chair of mother), and hymn to Rēʿ. Right thickness, two registers, **I,** deceased kneeling offers candles to Min and Isis, **II,** deceased and wife offer to parents. Soffit, titles.
Deceased and wife in **II** on right, GR. INST. ARCHIVES, photo. 1728; wife and offerings, SCHOTT photos. 3588–9.

(5) [1st ed. entrance-wall] Four registers. **I,** Ceremonies in Temple of Mut at Karnak with divine barks and avenue of crio-sphinxes. **II,** Two offering-scenes. **III,** Abydos pilgrimage before Osiris, and brother Khons and wife before god. **IV,** Weighing-scene, Khons led by Ḥarsiēsi and wife by Anubis, and funeral procession with sarcophagus and male mourners.
GR. INST. ARCHIVES, photos. 1988–90. Sketch of **I,** HAY MSS. 29821, 145 verso [lower]– 146 [upper]; ČERNÝ, Rép. onom. p. 25. Texts, id. ib. pp. 23–7 [B′]; name and titles of Penbuy (tomb 10) in **II,** BRUYÈRE, Tombes théb. p. 63 [middle].

(6) Four registers. **I,** Father and relatives adore Ḥathor-cow in shrine. **II** and **III,** Banquet. **IV,** Funeral procession.
GR. INST. ARCHIVES, photo. 1991. Names of three female mourners in **IV,** BRUYÈRE, Rapport (1926), p. 66.

(7) Three registers. **I** (partly behind statue at (13)), Deceased (?) and family before Osiris, Isis, and Ḥathor. **II** and **III,** Offering-scenes.
GR. INST. ARCHIVES, photo. 1992.

(8) [1st ed. 4] Three registers. **I,** Parents adore Ptaḥ and Anubis. **II,** Man offers to Raʿmosi (tomb 7) and wife, and man offers to parents of deceased. **III,** Ḳaḥa (tomb 360) with wife and offerings.

II, and parents in **I,** id. ib. photo. 1993 [right]. Texts of Raʿmosi and wife, WILKINSON MSS. v. 115 verso [right].

(9) [1st ed. 3] Three registers. **I,** Deceased with wife offers on braziers to statue of Amenophis I in palanquin carried by priests, and statue of Amūn. **II,** Son Mosi censes before deceased and wife. **III,** Family.

I–II, GR. INST. ARCHIVES, photo. 1993 [left]. **I,** L. *D.* iii. 2 [b]; ČERNÝ in *B.I.F.A.O.* xxvii (1927), fig. 13, cf. pp. 167–8 [b]; omitting wife, PRISSE, *Mon.* pl. xxix. Head of deceased in **II,** SCHOTT photo. 3586. Texts, LEPSIUS MS. 399 [middle lower]–400 [top]; HAY MSS. 29821, 145 verso [upper].

(10) [1st ed. 2] Four registers. **I,** Deceased offers to two rows of kings, queens, and princes, in Berlin Mus. 1625. **II,** Deceased and daughter adore Ptaḥ and goddess, and man offers to deceased and wife. **III,** Family before deceased and wife. **IV,** Family before parents of deceased.

I, L. *D.* iii. 2 [a]; LEPSIUS, *Auswahl der wichtigsten Urkunden des ägyptischen Altertums,* pl. xi [top]; PRISSE, *Mon.* pl. iii; YOUNG, *Hieroglyphics,* pl. 97; WILKINSON, *Extracts from several Hieroglyphical Subjects,* pl. v [lower], p. 28; BURTON, *Excerpta Hieroglyphica,* xxxv (from copy by HAY); BURTON MSS. 25644, 9 verso to 11; WILKINSON MSS. v. 115; HAY MSS. 29821, 144–5, cf. 29824, 7. Texts, *Aeg. Inschr.* ii. 190–2; CHAMP., *Not. descr.* i, pp. 864–6 [to p. 571]; DARESSY, *Les Listes des princes* [&c.] in *Recueil d'études égyptologiques dédiées à . . . Champollion,* pp. 283–96. See *Ausf. Verz.* pp. 155–6. Divinities in **II,** GR. INST. ARCHIVES, photo. 1994 [right].

(11) [1st ed. 1] Four registers. **I,** [Deceased] before statue of Amenophis I in palanquin carried by priests, and statue of Amūn, both protected by Maʿet. **II,** Two couples (belonging to (12)). **III,** Deceased led by Anubis, and wife led by Horus, to Osiris and Isis. **IV,** Offering-scenes.

I, L. *D.* iii. 2 [c]; PRISSE, *Mon.* pl. xxviii; ČERNÝ in *B.I.F.A.O.* xxvii (1927), fig. 14, cf. p. 167 [a]. **II,** GR. INST. ARCHIVES, photos. 1994 [left], 1995.

(12) [1st ed. rear wall] Four registers. **I** (partly behind statue at (14)), Double-scene, [deceased] before Theban Triad, and before Amenophis I, ʿAḥmosi Nefertere, and Princess Merytamūn. **II** (continued from (11)), Rēʿ-Ḥarakhti and Osiris seated. **III** and **IV,** Offering-scenes to family, with Anubis seated in **IV.**

GR. INST. ARCHIVES, photos. 1984–6. Royalties in **I,** HAY MSS. 29821, 144 [top]; WILKINSON MSS. v. 116 [2]. **II,** NAGEL, *Céramique,* i, fig. 177, cf. p. 202, note 131. Texts of **I,** ČERNÝ in *B.I.F.A.O.* xxvii (1927), p. 173.

(13) Seated statue of parents, with relatives in relief on seat, and man adoring beyond (by doorway).

GR. INST. ARCHIVES, photos. 1983 [left], 1992.

(14) Seated statue of deceased and wife with relatives in relief on seat, and offering-text to Mertesger beyond (by doorway).

GR. INST. ARCHIVES, photo. 1983 [right]. Offering-text, BRUYÈRE, *Mert Seger,* pp. 144 [near top], 266 [top].

Inner Room.

(15) At top, bark of Rēꜥ. Lintel, double-scene, deceased and wife offer to Theban Triad. Jambs, texts, with Khons and wife below on left, and deceased and wife below on right. Left thickness, three registers, **I,** father and Khons adore bark of Rēꜥ, **II,** parents adoring, **III,** Khons, wife, and daughter, adoring, with hymns to Rēꜥ in **II** and **III.**

Lintel and jambs, GR. INST. ARCHIVES, photo. 1983 [middle]. Titles from lintel, LEPSIUS MS. 399 [middle upper]. Hymn in **III,** BRUYÈRE, *Tombes théb.* p. 48 [bottom].

(16) [1st ed. 5–6] Two double-statues, Osiris with Isis, and with Ḥathor, and Ḥathor-cow protecting [King] in centre.

Sketch, WILKINSON MSS. v. 115 verso [left].

Pyramid.

Lucarne-stela, in Brit. Mus. 555. Three registers, **I,** bark of Rēꜥ-Ḥarakhti, **II,** deceased adores royal statue and Ḥathor-cow in mountain, **III,** deceased and wife kneeling with hymn to Ḥathor.

British Museum. Tablets and other Egyptian Monuments from the Collection of the Earl of Belmore (1843), pl. xix; *Guide (Sculpture),* p. 174 [630] with fig.; *Guide to the Egyptian Collections* (1930), fig. 108; *Hiero. Texts,* vii, pl. 31. Texts, MASPERO in *Rec. de Trav.* ii (1880), pp. 189–90 [lxxvi]; names, LIEBLEIN, *Dict.* No. 999.

Burial Chamber [1st ed. 2 B]. Walls and ceiling, GR. INST. ARCHIVES, photos. DM. 2b. 1–13.

(17) Above stairs. Statues of Rēꜥ (?) and Osiris, with Ḥathor-cow protecting seated King in centre.

BRUYÈRE, *Tombes théb.* fig. 1, cf. p. 22.

(18) Above inner doorway. Ḥaꜥpi and offerings.

Id. ib. pl. iv [left], pp. 32, 44 [bottom right].

(19) Deceased and wife kneeling offer *uzat* to Thoth as baboon.

Id. ib. pl. iv [right], pp. 31, 44 [bottom left].

(20) [1st ed. 7] Tympanum, winged Isis. Two scenes below, **1,** Khepri and Osiris with fish-nome sign, **2,** Anubis tending mummy in form of fish on couch, between small figures of Isis and Nephthys and Sons of Horus.

BRUYÈRE, *Tombes théb.* pls. xi, xii, pp. 31, 39–40, 44 [middle], 47. **1** and **2,** BRUYÈRE in *B.I.F.A.O.* xxviii (1929), fig. 4, cf. pp. 46–8. **2,** FOUCART in *Bull. Inst. Ég.* 5 Sér. xi (1918), pl. iii, pp. 276–7; STEINDORFF and WOLF, *Gräberwelt,* pl. 14 [b], p. 65; FARINA, *Pittura,* pl. clxxiv; LHOTE and HASSIA, *Chefs-d'œuvre,* pl. at end 13.

(21) Father with mother censes and libates to Ptaḥ-Nebmaꜥet and Mertesger squatting.

BRUYÈRE, *Mert Seger,* fig. 132, cf. p. 266; id. *Tombes théb.* pl. x, pp. 38, 46 [bottom]. Father and Ptaḥ-Nebmaꜥet, NAGEL, *Céramique,* i, fig. 150, cf. p. 179.

(22) Three scenes. **1,** Neith making *nini* and Selkis with water before Horus as Western hawk. **2,** Deceased and wife before Ptaḥ and Maꜥet. **3,** Deceased with wife offers on brazier to Anubis and Western Ḥathor.

BRUYÈRE, *Tombes théb.* pls. v, vi, pp. 32–4, 45 [top and middle].

(23) Tympanum, winged Nephthys. Scene below, Anubis tending mummy on couch between Nephthys and Isis, with tree-goddess at each end holding stela of Osiris on left, and of Ḥekzet on right.

Id. ib. pl. vii, pp. 29, 34–5, 44 [middle], 45 [bottom]. Sketch of Nephthys, WILKINSON MSS. v. 132 [middle upper].

(24) Three scenes. **1,** Khons and wife before Rēʿ, Osiris, and Amenophis I. **2,** Deceased and wife before Amenophis I (twice represented) and ʿAḥmosi Nefertere. **3,** Deceased and wife before Ptaḥ-Sokari and Tefnut.

BRUYÈRE, *Tombes théb.* pls. viii [lower], ix [lower right], pp. 36–7. **1** and **2,** ČERNÝ in *B.I.F.A.O.* xxvii (1927), pl. i [1, 2], p. 168. Names of gods in **1,** and royalties in **2,** WILKINSON MSS. v. 132 [top and middle lower].

(25) Entrance to Inner Room. Lintel, cartouches of Amenophis I, ʿAḥmosi Nefertere, [Meryt]amūn, and Men[tuḥotp]-[Nebḥepet]rēʿ, and Buto of Depet as serpent.

BRUYÈRE, *Tombes théb.* pl. ix [lower left], pp. 37–8, 46 [middle right]. Lintel, HAY MSS. 29830, 35, 29848, 64 [bottom]; cartouches, WILKINSON MSS. v. 132 [bottom].

Texts between scenes. BRUYÈRE, op. cit. p. 44 [top]; ČERNÝ, *Rép. onom.* pp. 34 [top], 35 [4° left, middle, and B'].

Frieze-texts. Two lines (with names of workmen in lower line), BRUYÈRE, op. cit. pp. 40–1, 49; ČERNÝ, op. cit. pp. 36 [bottom]–37 [top].

Base. Texts, BRUYÈRE, op. cit. pp. 47–8 [1–3]; ČERNÝ, op. cit. p. 36 [top and middle]; parts mentioning Mertesger, BRUYÈRE, *Mert Seger,* pp. 266–7.

Vaulted ceiling, eight scenes. Outer half, **1,** Meḥitwert-cow by pool and shadow of deceased, **2,** wife adores Anubis, **3,** deceased led by Anubis to pyramid-tomb with *ba* above door, **4,** Ptaḥ-Sokari in bark, with deceased and wife adoring staircase below. Inner half, **5,** Osiris in bark, **6,** horizon-disk held by arms of Nut with personified *zad*-pillar and Tefnut as lion with cobra below, **7,** deceased adores Ḥu and Ka on back of calf, **8,** deceased adores Thoth.

BRUYÈRE, *Tombes théb.* pls. ii, iii, viii [upper], ix [upper], pp. 25–31, 42–3.

Finds

Lower part of jamb of deceased. BRUYÈRE, *Rapport (1930),* fig. 30, cf. p. 96 [4].

3. PESHEDU 𓍿𓃭𓎬𓃀𓏤, Servant in the Place of Truth on the west of Thebes. (Also owner of tomb 326.) Ramesside.

Deir el-Medîna.

Parents, Menna 𓏭𓃀 and Ḥuy 𓈖𓇋𓇋𓏤. Wife, Nezemtbeḥdet 𓊹𓏤𓏭𓃀𓏤.

Plan, p. 2. Map VII, E–3, c, 7.

Court with Chapel.

BRUYÈRE, *Rapport (1924–1925),* pp. 61–3, with plan, pl. vii, and view, fig. 38.

(1) Sketch, man before god. Id. ib. fig. 39.

Burial Chambers.

CAMPBELL, *Mirac. Birth,* pp. 177–98. Plan, section, and view, HAY MSS. 29843, 90–2; plan, NASH in *P.S.B.A.* xxiii (1901), pl. i, pp. 360–1. Tracings, sketches, &c., HAY MSS.

29854, 76–98, 166–212, 29843, 93–5. Names and titles, ČERNÝ, *Rép. onom.* pp. 38–43, with key-plan, p. 38.

Innermost Chamber. Walls with scenes and texts from Book of the Dead, and ceiling, GR. INST. ARCHIVES, photos. DM. 3. 1–13.

(2) and (3) [1st ed. 1, 2] Thicknesses, Anubis-jackal on each. Soffit, text.

See CAMPBELL, *Mirac. Birth*, pp. 178–9. Right thickness, BRUYÈRE, *Rapport (1924–1925)*, fig. 15, cf. p. 25; *I.L.N.* Oct. 10, 1925, fig. on p. 674 [upper right]. Text, HAY MSS. 29843, 102.

(4)–(5) [1st ed. 7, 3, 8] Tympanum, Ptaḥ-Sokari as winged hawk in bark and sons Menna and Ḳaḥa kneeling and adoring. Scenes below, left of doorway, deceased under palm-tree drinking from pool, right of doorway, three rows of parents and other relatives (belonging to (6)) with small tree-goddess scene in top row.

LHOTE and HASSIA, *Chefs-d'œuvre*, pl. i on p. 9, pl. 139; CAMPBELL, *Mirac. Birth*, pp. 195, 189–91 with pl., 185–6 with pl. Incomplete, HAY MSS. 29843, 92 [top left], 106, and texts, 104 [lower], 104 verso [top and middle left]. Ḳaḥa, deceased, and some relatives, WEIGALL, *Anc. Eg. . . . Art*, 259; deceased, WRESZ., *Atlas*, i. 111; NASH in *P.S.B.A.* xxiii (1901), pl. ii after p. 360; FARINA, *Pittura*, pl. clxxii; DONADONI, *Arte egiziana*, fig. 156.

(6) [1st ed. 4] Anubis-jackal, deceased and family adore Horus as hawk, with Anubis tending mummy on couch beyond with divine bark above.

HAY MSS. 29843, 92 [lower middle], and texts, 96 [top], 98 verso to 99, 100 verso [lower] to 101. Deceased and family, CAMPBELL, *Mirac. Birth*, pl. facing p. 178, cf. pp. 179–85.

(7) [1st ed. 6] Deceased with small daughter adores Rēꜥ-Ḥarakhti, Atum, Khepri, and Ptaḥ, with dressed *zad*-pillar.

See id. ib. pp. 191–2, 193–4. Deceased and Rēꜥ-Ḥarakhti, DRIOTON and HASSIA, *Temples and Treasures*, cover. Texts, HAY MSS. 29843, 92 [upper middle], 96 [bottom], 100 verso [upper] to 101.

(8) and (9) Abydos pilgrimage, deceased and wife with child in boat.

See CAMPBELL, *Mirac. Birth*, pp. 195–6. Boat at (9), LHOTE and HASSIA, *Chefs-d'œuvre*, pl. xvi.

(10) [1st ed. 5] Tympanum, Osiris seated in front of mountain, and Horus as hawk, *uzat* with torches and deceased kneeling below, on left, and demon with torches on right.

VANDIER, *Egypt*, pl. xxiv; HAY MSS. 29843, 92 [top right], 93 [top], and texts, 104 [upper], 104 verso [middle and bottom right]. Hawk, *uzat*, and deceased, LHOTE and HASSIA, *op. cit.* pl. iii. See CAMPBELL, *op. cit.* pp. 196–8.

(11) Fragments of sarcophagus with texts of Book of the Dead, deceased adoring, Negative Confession, assessors, and Anubis tending mummy on couch.

See BRUYÈRE, *Rapport (1924–1925)*, pp. 27–8, cf. fig. 18 [left]. Texts, HAY MSS. 29843, 96–7 verso, 102 verso to 103 verso, 105.

Vaulted ceiling. South half, Osiris, Isis, Nut, Nu, Nephthys, Geb, Anubis, Wepwaut, and litany of Rēꜥ. North half, Osiris, Thoth, Ḥathor, Rēꜥ-Ḥarakhti, Neith, Selkis, Anubis, Wepwaut.

See CAMPBELL, *Mirac. Birth*, pp. 186–9, 192–4. South half, HAY MSS. 29843, on 92 [lower middle], 107.

Finds

Offering-table of son Menna, in Cairo Mus. Temp. No. 9.6.26.1. Nash in *P.S.B.A.* xxiii (1901), pl. iii, p. 361. See CAMPBELL, op. cit. p. 178.

4. KEN [hieroglyphs], Chiseller of Amūn in the Place of Truth. (Perhaps also owner of tomb 337.) Temp. Ramesses II.

Deir el-Medîna. (*L. D. Text*, No. 106.)

Parents, Thonūfer [hieroglyphs], Chiseller of Amūn in the Khenu, and Maʿetnefert [hieroglyphs]. Wives, Nefertere [hieroglyphs] and Ḥenutmeḥyt [hieroglyphs].

Plan, p. 2. Map VII, E–3, c, 8.

To be published by CLÈRE. BRUYÈRE, *Rapport (1924–1925)*, pp. 179–82, with plan, pl. x. Names and titles, ČERNÝ, *Rép. onom.* pp. 44–50, with key-plan, p. 44.

Chapel. Walls, GR. INST. ARCHIVES, photos. DM. 4. 1–3.

(1) Thickness. Niche with statuettes of deceased and Nefertere.
BRUYÈRE, *Rapport (1924–1925)*, fig. 120, cf. p. 179.

(2) Deceased and Ḥenutmeḥyt seated, with her son kneeling below her chair, and ends of some scenes at (3).
GR. INST. ARCHIVES, photo. 2010.

(3) Four registers. **I**, Funeral procession to mummies at pyramid-tomb. **II** and **III**, Man offers to relatives (two figures at (2)). **IV**, Man offers to Anubis (at (2)), and Abydos pilgrimage with deceased and family in boat.
GR. INST. ARCHIVES, photo. 2011. Girl carrying child in **I**, BRUYÈRE, *Rapport (1924–1925)*, fig. 121, cf. p. 180. Text above procession, LÜDDECKENS in *Mitt. Kairo*, xi (1943), p. 132 [63] (from copy by SETHE).

(4) [1st ed. 3] Son Meryrēʿ offers onions to deceased and Nefertere with small daughter.
GR. INST. ARCHIVES, photo. 2012. Texts, WIEDEMANN in *P.S.B.A.* viii (1886), p. 230 [bottom].

(5) Two registers. **I**, Parents, deceased, and wives, before [Ptaḥ] and Maʿet. **II**, Men offer to [deceased and Ḥenutmeḥyt], and to [deceased] and Nefertere.
GR. INST. ARCHIVES, photo. 2009.

(6) [1st ed. 1] Two registers. **I**, Ramesses II with Paser (tomb 106), and Raʿmosi (tomb 7) on adjoining wall, offers image of Maʿet to Rēʿ-Ḥarakhti. **II**, Couple before Osiris and Ḥarsiēsi.
ČERNÝ in *B.I.F.A.O.* xxvii (1927), pl. iv [2 left], p. 174; GR. INST. ARCHIVES, photo. 2013. Texts, WIEDEMANN in *P.S.B.A.* viii (1886), p. 230 [i].

(7) Two registers. **I**, Deceased with tree-goddess behind him, kneels before Osiris with Thoth-standard and [Isis]. **II**, Deceased, Ḥenutmeḥyt, and her son, before Anubis, Ḥathor, Amenophis I, and ʿAḥmosi Nefertere.
ČERNÝ, op. cit. pl. iv [1, and 2 right], p. 174; GR. INST. ARCHIVES, photo. 2014. **I**, See BRUYÈRE, *Rapport (1924–1925)*, p. 179 [3].

(8) [1st ed. 2] Niche. Lintel, double-scene, deceased and wife before Rēʿ-Ḥarakhti and before Osiris. Jambs, text, and deceased kneeling at bottom. Rear wall, ʿAḥmosi Nefertere, and Princess Merytamūn, on either side, and statue of Ḥathor-cow protecting Amenophis I in centre.

ČERNÝ, op. cit. pl. iv [2 middle], p. 174. Rear wall, WILKINSON MSS. v. 120 [upper]. Texts, WIEDEMANN in *P.S.B.A.* viii (1886), pp. 231–2.

Vaulted ceiling. Centre, two scenes, 1, deceased, and 2, wife, each adoring bark of Rēʿ. South side, deceased kneeling adores Rēʿ-Ḥarakhti. North side, wife adores two demons of day and night.

Finds

Stela, son purifies deceased with Nefertere, and performs Opening the Mouth ceremony before mummies at tomb, probably from here, in Copenhagen Nat. Mus. B 3 (AA.d.11). *Antiksamlingen,·Vejledning for Besøgende* (1935), p. 16 [32] with fig.; MOGENSEN, *Inscriptions hiéroglyphiques du Musée National de Copenhague*, pl. xvii [27], pp. 26–9; BUHL, *Orientalia før 1851* in Copenhagen Nat. Mus. Antik-Cabinettet 1851 (1951), fig. 13, cf. p. 188. Texts, MASPERO in *Rec. de Trav.* ii (1880), pp. 193 [bottom]–194 [top]; PIEHL in *Rec. de Trav.* i (1870), pp. 136–7 [2, No. 13]; SCHMIDT (V.), *Textes hiéroglyphiques du Musée de Copenhague*, pp. 8–10; names, LIEBLEIN, *Die aegyptischen Denkmäler in St. Petersburg* [&c.], pl. xxvi [28]; id. *Dict. Supp.* No. 2054. See SCHMIDT (V.), *Østerlandske Indskrifter fra den Kongelige Antiksamling*, pp. 10–11; *Guide. Oriental and Classical Antiquity* (1950), p. 24 [23, A].

Fragments of two stelae, one with deceased offering jar, the other with names of wives. BRUYÈRE, *Rapport (1927)*, figs. 11 [1], 7 [2], cf. pp. 22, 14.

Offering-table of deceased and wives. BRUYÈRE, *Rapport (1924–1925)*, fig. 122, cf. p. 182.

5. NEFERʿABET ⟦𓀀𓏤𓏤𓃀𓆓⟧, Servant in the Place of Truth on the west of Thebes. Ramesside.

Deir el-Medîna.

Parents, Neferronpet ⟦𓀀𓆑⟧ and Maḥi ⟦𓈖𓏏𓀗⟧ (name on stela in Brit. Mus. 150, see infra, p. 14). Wife, Taēsi ⟦𓂋𓃀𓐍⟧.

Plan, p. 2. Map VII, E–3, e, 5.

Burial Chambers.

VANDIER, *La Tombe de Nefer-abou* (M.I.F.A.O. lxix), passim, with plans, sections, and views, pls. i–iv [1]; BRUYÈRE, *Rapport (1926)*, pp. 85–6, with plan, fig. 61. Names and titles, ČERNÝ, *Rép. onom.* pp. 51–7, with key-plan, p. 51.

Chamber A. View, *I.L.N.* Oct. 10, 1925, fig. on p. 674 [lower]. Walls, GR. INST. ARCHIVES, photos. DM. 5a. 1–5.

(1) Left half. Tympanum, Anubis-jackal. Scene below, son Nezemger ⟦𓊪𓏭𓃀𓀀⟧ offers vase to deceased and wife.

VANDIER, pls. iv [2], v [2], pp. 12, 15, 28 [a], 36 [iii].

(2)–(3) Son Neferronpet with relatives adores Rēʿ-Ḥarakhti as hawk, and double *uzat* beyond doorway.

VANDIER, pls. viii, ix [lower], pp. 14, 31 [c].

(4) Deceased with relatives adores Ḥatḥor-cow in mountain and Anubis.
VANDIER, pls. vi, vii [lower right], pp. 13–14, 29–30 [B]. Eight male relatives, BRUYÈRE, *Rapport (1934–1935)*, Pt. 2, fig. 74.

(5) Neḥeḥ with torch.
VANDIER, pl. vii [lower left], pp. 14–15.

(6) Osiris and Mertesger as serpent, and remains of winged Isis below.
VANDIER, pl. v [1], cf. iv [1], pp. 15, 31 [d], 36 [iv]; Mertesger, BRUYÈRE, *Mert Seger*, fig. 77, cf. p. 267.

(7) Platform with four demons at each end.
VANDIER, on pl. iv [1], p. 7, cf. p. 15, note 1.

Frieze-text. Id. ib. pp. 27–8 [B].
Ceiling. Anubis, Thoth, and Sons of Horus. Id. ib. pls. vii [upper], ix [upper], pp. 15–16, 27 [A], 32–5.

Chamber B. Walls, GR. INST. ARCHIVES, photos. DM. 5 b. 1–14.

(8)–(9) Tympanum, Isis and Nephthys kneeling, one at each end. Scenes below (belonging to scenes on side-walls), left of doorway, relatives, right of doorway, son Neferronpet and wife.
VANDIER, pls. xxii, xxiii, x [1 left, 2 right], fig. 1, cf. pp. 18, 24.

(10)–(11) Sons of Horus (continued from (9)).
Id. ib. pls. x [1], xi [upper], pp. 16, 41–2 [iii].

(12)–(13) Deceased with relatives (some at (8)) adores Anubis.
Id. ib. pls. x [2], xi [lower], pp. 16–18, 39–40. Anubis, FOUCART in *B.I.F.A.O.* xxiv (1924), pl. xxiv [lower].

(14) Tympanum, winged Nephthys adored by deceased and by son Neferronpet. Scene below, Nephthys and Isis as hawks, and Neḥeḥ and Zet with torches, on either side of two recumbent mummies.
VANDIER, pls. xx, xxi, pp. 23–4, 45–6; omitting son, SCHOTT photos. 5753–6.

Frieze-texts, VANDIER, pp. 37–8; part of west side, BRUYÈRE, *Mert Seger*, p. 267 [bottom].
Vaulted ceiling [part, 1st ed. p. 194, west wall], eight scenes. East half, **1,** winged disk above Osiris, **2,** Amenophis I before Mertesger (?) and goddess, **3,** Rēᶜ-Ḥarakhti seated, **4,** winged hawk with *smn*-goose in front of mountain. West half, **5,** Nut making *nini* to Osiris, **6,** tree-goddess scene and deceased kneeling before Rēᶜ-Ḥarakhti as hawk on shrine, with Akru below, **7,** deceased kneeling purified by Ḥarsiēsi and Thoth, **8,** deceased opens Gates of the West.
VANDIER, pls. xii–xix and frontispiece, pp. 18–23 [1–8]. **1, 3, 4, 6,** SCHOTT photos. 5757–60. **1,** FOUCART in *B.I.F.A.O.* xxiv (1924), pl. xxiv [upper]. **2,** ČERNÝ in *B.I.F.A.O.* xxvii (1927), pl. v, pp. 174–5; BRUYÈRE, *Mert Seger*, fig. 75, cf. p. 268 [top]. **6** and **7,** BRUYÈRE, *Rapport (1924–1925)*, figs. 65, 99, cf. pp. 99, 149. *Smn*-goose in **4,** KUENTZ, *L'Oie du Nil*, fig. 11, cf. p. 10.

Pyramid.

Lucarne-stela from niche in south face, with bark of Atum and [deceased] before Mertesger as serpent below, in Louvre E. 13993.

VANDIER, pl. xxvii [2], p. 52 [d, 1]; BRUYÈRE, *Rapport (1929)*, fig. 38, cf. pp. 82–3; id. *Mert Seger*, fig. 73, cf. p. 144.

Finds. Probably from here.

Broken stela, with deceased and son Neferronpet kneeling before Mertesger as serpent at top, and ceremonies before mummy and funeral procession (including 'Nine friends') below, in Brit. Mus. 150. VANDIER, pl. xxv [right], p. 48 [c]; BRUYÈRE, *Mert Seger*, fig. 74, cf. pp. 145–7, note 1; omitting Mertesger, WILLIAMS rubbings, iv. 132–4. See *Guide (Sculpture)*, p. 204 [742].

Two blocks from stela or wall, relatives before son Neferronpet and wife, and before deceased and wife, in Cairo Mus. Temp. Nos. 30.12.31.1, 2. VANDIER, pl. xxiv, pp. 50–1 [c, a (2–3)].

Part of wooden board of deceased, in Brit. Mus. 65593.

6. NEFERḤŌTEP 𓀀𓏺𓏺 and son NEBNŪFER 𓏺𓏺𓏺, Foremen in the Place of Truth. Temp. Ḥaremḥab to Ramesses II.

Deir el-Medîna. (L. *D. Text*, No. 101.)
Wife (of Neferḥōtep), Iymau 𓏺𓏺𓏺𓏺𓏺𓏺; (of Nebnūfer), Iy 𓏺𓏺𓏺.

Plan, p. 2. Map VII, E–3, c, 6.

To be published by WILD. Plan, BRUYÈRE, *Rapport (1924–1925)*, on pl. ii; *(1928)*, on pl. i. Names and titles, ČERNÝ, *Rép. onom.* pp. 58–63 with key-plan, p. 58; of owners and wives, LEPSIUS MS. 391 [top]; part, L. *D. Text*, iii, p. 291 [near bottom]; WIEDEMANN in *P.S.B.A.* viii (1886), p. 228 [e].

Court.

(1) and (2) [Two stelae.]

Chapel. Walls at (3), (5)–(6), and (10), GR. INST. ARCHIVES, photos. DM. 6. 1–3.

Passage.

(3) Jars and naos, with fragment of text on ceiling above.

Hall.

(4) Remains of text above doorway, and soffit with birds.

(5)–(6) [1st ed. 1, entry moved to beginning of tomb] Two registers. **1,** Deceased adores *ka*, Neferḥōtep offers to Sito-serpent 𓏺𓏺𓏺 as uraeus on legs, and Neferḥōtep and wife before offerings. **II,** Men and woman before couples, including deceased and wife.

Titles of Nakhi and Mesu in **II,** BRUYÈRE, *Rapport (1935–1940)*, Fasc. iii, p. 15 [3] (called tomb 7).

(7)–(8) Deceased, with wife holding *menat*, and small daughter, adores [Osiris] with winged goddess.

(9) [1st ed. 2] Three registers. **I,** Akru, and [man] before Osiris. **II,** People before goddess. **III,** Man and woman adoring, and four men with bags.

Akru, WILKINSON, *M. and C.* 2 Ser. Supp. pl. 29 [6] = ed. BIRCH, iii, pl. xxii [5]; WILKINSON MSS. v. 119 [top].

(10) Two registers. **I,** Two scenes, Nebnūfer and wife, **1,** playing draughts, **2,** kneeling before [divinity]. **II,** Offering-scene before Nebnūfer holding ⏚ with [wife] and her mother.

(11)–(12) Deceased with wife holding sistrum adores Rēʿ-Ḥarakhti.

Shrine.

(13)–(14) Two registers. **I,** People before Anukis and Rēʿ-Ḥarakhti as hawk. **II,** People adoring. (15) [1st ed. 3] Two registers. **I,** [Deceased and family] before Khnum, Anukis, Satis, uraeus, and Horus as hawk. **II,** Three couples before [divinities].

Vaulted ceiling. Two tree-goddess scenes with baboons, and kneeling goddess, respectively, and titles of Nebnūfer and parents.

Burial Chamber. Walls, GR. INST. ARCHIVES, photos. DM. 6. 4–7.

(16)–(17) Deceased and wife adore shrine with squatting divinities. (18) Deceased and wife and text from Book of the Dead with assimilation of parts of the body to squatting divinities at bottom. (19) Five registers, Fields of Iaru. (20) Two registers, Book of Gates, **I,** deceased, **II,** wife, each before five guardians with knives.

Finds

Relief, double-scene, Nebnūfer and wife with son and daughters offering bouquet of Amūn to them in left half, and with woman and boy offering to them in right half, in Brit. Mus. 447. WILLIAMS rubbings, iv. 113. See *Guide (Sculpture)*, p. 193 [700].

7. RAʿMOSI ⌐°𓏤𓏤𓏤, Scribe in the Place of Truth (also owner of tombs 212 and 250). Temp. Ramesses II.

Deir el-Medîna. (L. *D. Text*, No. 99.)

Parents, Amenemḥab 𓇋⸗𓎡⸗𓏤 and Kakaia 𓏏𓏏𓄿𓏏. Wife, Mutemwia 𓆓𓎦𓏤.

Plan, p. 2. Map VII, E–3, c, 6.

Plan, BRUYÈRE, *Rapport (1924–1925)*, on pl. ii; *(1928)*, on pl. i. Names and titles, ČERNÝ, *Rép. onom.* pp. 64–5, with key-plan, p. 64.

Court.

(1) Stela, Ḥathor and bark, with [text] below.

Chapel.

(2) Outer lintel, double-scene, deceased adores bark of Atum and Rēʿ-Ḥarakhti with arms of Nut. Outer thicknesses, left side, deceased with text, right side, personified *zad*-pillar (?). Soffit, Nut in tree-goddess scene.

Details of bark, BRUYÈRE, *Rapport (1924–1925)*, fig. 100, cf. p. 147. Titles, LEPSIUS MS. 390 [near top].

(3) Two registers. **I,** Man adores Amenophis I, ʿAḥmosi Nefertere, Ḥaremḥab, and Tuthmosis IV. **II,** [A god].

Cartouches of Amenophis I, ČERNÝ in *B.I.F.A.O.* xxvii *(1927)*, p. 175 [top].

(4) Deceased and two women.

(5) and (6) Three registers. **I,** Three people before couple, and deceased and wife with incense before Sokari and goddess. **II,** Funeral procession. **III,** Abydos pilgrimage.

Name of wife, LEPSIUS MS. 390 [middle upper right].

(7) and (8) [1st ed. 2] Two registers. **I,** Three scenes, **1,** bull slaughtered, **2,** bark with Osiris between Isis and Nephthys, **3,** deceased before bark of Sokari. **II,** Two scenes, **1,** people offer to deceased and wife, **2,** deceased adores *Benu*-bird in bark.

Text of deceased, and *Benu*-bird, SETHE in *Ä.Z.* xlv (1908), p. 85.

(9) [1st ed. 1] Stela, three registers. **I,** Ramesses II, followed by Paser (tomb 106), and deceased, offers incense to Theban Triad in mountain. **II,** Deceased, wife, and parents, adore Osiris, Ptaḥ, Horus, Isis, and Min-Kamutf. **III,** Deceased, mother, wife, and another woman, adore Anubis, Isis, and Nephthys, and two Ḥathor-cows in mountain.

GR. INST. ARCHIVES, photo. 2016. **I,** SCHOTT photo. 3101. Theban Triad and Ḥathor-cows, WILKINSON MSS. v. 120 [lower]. Texts in **I,** WIEDEMANN in *P.S.B.A.* viii (1886), p. 229 [g]; texts of Paser and deceased, *L. D. Text,* iii, p. 291.

Finds

Offering-table of deceased and son Ḳenḥirkhopshef, probably from here, in Louvre, E. 13998. BRUYÈRE, *Rapport (1923–1924),* pl. xii [top left], pp. 46–7 [3], cf. ib. *(1935–1940),* Fasc. iii, p. 14 [1].

8. KHAʿ ☱, Chief in the Great Place. Temp. Amenophis II, Tuthmosis IV, and Amenophis III.

Deir el-Medîna. (*L. D. Text,* No. 96.)

Wife, Meryt 𓄿𓇋𓇋𓂝𓏏.

Plan, p. 2. Map VII, E–3, d, 6.

Chapel.

VANDIER D'ABBADIE, *La Chapelle de Khâ* in *Deux Tombes de Deir el-Médineh* (*M.I.F.A.O.* lxxiii), pp. 1–18, with plan and section, figs. 1, 2, and views, pls. i, ii; SCHIAPARELLI, *Relazione,* ii, pp. 181–7, with view of interior, fig. 164; BRUYÈRE, *Rapport (1923–1924),* pp. 53–6, with plan and section, on pl. xiv, cf. pls. i, ii; *(1924–1925),* pp. 50–1, 194, with plan, pl. iv, and view of exterior, fig. 3; *L. D. Text,* iii, pp. 289–90; BURTON MSS. 25639, 42 verso [bottom]; plan, section, and view of interior, WILD MSS. ii. A. 151–5, i. C. 11. Some texts, including names of Neferḥab[ef] 𓆑𓏤𓂋, Overseer of works, and wife, WILBOUR MSS. 2 F. 28; names and titles, ČERNÝ, *Rép. onom.* pp. 66–8, with key-plan, p. 66; of deceased and wife, WILKINSON MSS. v. 168 [middle]. Hieratic graffito (now destroyed), *L. D.* vi. 22 [2], and *Text,* iii, p. 289 [bottom]; see VANDIER D'ABBADIE, p. 8 [5]. Details of frieze, SCHOTT photos. 6598–9.

(1) [1st ed. 1] Deceased with wife, daughter fastening his collar, son with offerings before them, and two registers, **I,** female musicians with lute and harp, &c. (two dancing), and [guests], **II,** attendants and [guests].

VANDIER D'ABBADIE, pls. iv–vii, ix [1], xiii, xiv [upper], xvi, pp. 5–7 [2], 12–13 [5]. Musicians, EBERS, *Aegypten,* ii. 360 [lower]; Eng. ed. ii. 325 [lower]; PRISSE, *Mon.* pl. xliv

[lower]; lutist, WILKINSON, *M. and C.* ii. 301 (No. 222) = ed. BIRCH, i. 482 (No. 247); SCHOTT photo. 6594. Mirror under wife's chair, id. ib. 6595. Names and texts, LEPSIUS MS. 386 [middle and bottom], 387.

(2) [1st ed. 2] Deceased, wife, and daughter, with offering-bringers (with garlanded bull), offer flowers to Osiris-Onnophris.

VANDIER D'ABBADIE, pls. viii, ix [2], x [1], frontispiece, pp. 7 [3], 13 [6]. Texts (some now destroyed), LEPSIUS MS. 385 [middle lower and bottom]; names and titles of deceased and wife, WIEDEMANN in *P.S.B.A.* viii (1886), p. 228 [d]; titles of wife, L. *D. Text*, iii, p. 290 [a].

(3) Tympanum, bouquet and Anubis-jackals. Stela below, in Turin Mus. 1618. At sides, two registers, I, deceased kneeling with bouquet, II, Neferḥab[ef] and wife seated, on left side, and priest offering, on right side.

VANDIER D'ABBADIE, pls. ii, iii, xv, pp. 5 [1], 11 [4]. Tympanum, SCHOTT photo. 6597; texts, LEPSIUS MS. 386 [near top]. Stela, VANDIER D'ABBADIE, pl. xi [right], pp. 13–14; SCHIAPARELLI, *Relazione*, ii, fig. 165, cf. p. 184; see FABRETTI, ROSSI, and LANZONE, *R. Mus. di Torino*, p. 172; ORCURTI, *Cat.* ii, p. 32 [40]; texts, MASPERO in *Rec. de Trav.* iv (1883), p. 143 [xiii]; part, LEPSIUS MS. 386 [top]; names, LIEBLEIN, *Dict.* No. 805.

Frieze-text, VANDIER D'ABBADIE, pp. 10–11 [2–3]; ČERNÝ, *Rép. onom.* p. 68 [middle]; LEPSIUS MS. 385 [middle upper], 388 [top].

Ceiling. Decoration and text, VANDIER D'ABBADIE, pls. x [2], xiv [2], pp. 9–10 [1]; SCHIAPARELLI, *Relazione*, ii, fig. 166, cf. p. 184; WILD MSS. i. C. 12; SCHOTT photos. 3104–5, 6600–1; text, PIEHL, *Inscr. hiéro.* 1 Sér. cxlv [B]; LEPSIUS MS. 385 [near top].

Pyramidion, four faces, deceased kneeling with hymn to Rēʿ, in Louvre, E. 13988. VANDIER D'ABBADIE, pl. xi [1–4], pp. 14–15; BRUYÈRE, *Rapport (1922–1923)*, pls. xv, xvi, pp. 51–4; PILLET, *Thèbes. Palais et nécropoles*, fig. 111.

Burial Chambers. In opposite cliff.

SCHIAPARELLI, *Relazione*, ii, pp. 1–180, with plan and section, fig. 6; BRUYÈRE, *Rapport (1923–1924)*, pp. 53–6, with plan and section, on pl. xiv, cf. pls. i, ii.

Sarcophagus Chamber. Contents, found by SCHIAPARELLI in 1906, now in Turin Museum. Objects of deceased.

Sarcophagus and two coffins, Sup. 8210, 8316, 8318. SCHIAPARELLI, *Relazione*, ii, figs. 17–18, 21–4, 26, cf. pp. 17–27; innermost coffin, FARINA, *R. Mus. di Torino* (1931), 60 [lower], (1938), 68 [left].

Statue, Sup. 8335, found on chair, Sup. 8333. SCHIAPARELLI, figs. 32–6, 8, cf. pp. 64–71; statue, ALDRED, *New Kingdom Art in Ancient Egypt*, pl. 48; CAROTTI, *L'Arte dell'antico Egitto*, fig. 234; LAURENT-TÄCKHOLM, *Faraos blomster*, pl. on p. 116; upper part, FARINA, op. cit. (1931), 59 [lower left], (1938), 67 [upper left]. Title, VANDIER D'ABBADIE in *Deux Tombes de Deir el-Médineh (M.I.F.A.O. lxxiii)*, p. 16 [bottom].

Ten boxes, Sup. 8378, 8600, 8593, 8615, 8314, 8421, 8450, 8514–15, 8527, SCHIAPARELLI, figs. 43 [upper], 58, 60–1, 107, cf. pp. 77, 89–90, 123–4. Three with son Nakht offering to deceased and wife, Sup. 8212–13, 8617, and one with couple offering to deceased and wife, Sup. 8613, id. ib. figs. 109–12, cf. pp. 125–9; No. 8613, FARINA, op. cit. (1931), 58 [lower], (1938), on 66 [upper].

Alabaster perfume-vase and jar, Sup. 8385, 8323, SCHIAPARELLI, figs. 42 [upper right], 120 [upper], cf. pp. 77, 136. Two metal situlae, Sup. 8394, 8244, on figs. 52, 118, cf. pp. 83–4, 135. Silver filter and bronze vase-stand, Sup. 8392, 8524, figs. 52 [top and middle left], 126 [upper middle], cf. pp. 83–4, 143. Pottery vases, Sup. 8224, 8356–7, figs. 141–2, cf. p. 159.

Ushabti-coffin, Sup. 8338, SCHIAPARELLI, fig. 37 [upper], cf. p. 71. Two sticks, Sup. 8417–18, fig. 55, cf. p. 87. Two three-legged stools, Sup. 8505–6, on figs. 97–8, cf. p. 117. Two tables, Sup. 8257–8, fig. 100, cf. p. 118.

Other objects.

Sarcophagus, coffin, box, and wig-box, of wife, Sup. 8517, 8470, 8479, 8493. SCHIAPARELLI, figs. 28–30, 72–3, 75–6, cf. pp. 28–31, 101; coffin and boxes, FARINA, *R. Mus. di Torino* (1931), on 58, 60 [upper], (1938), on 65, 67 [lower].

Metal situla of son Userḥēt, *waʿb*-priest of the Queen-mother Mutnefert, *ka*-servant of the statue of Princess Sitamūn, Sup. 8231. SCHIAPARELLI, fig. 158, cf. pp. 173–4.

Draughtsboard, with Benermerut ⌇, Servant of Amūn, offering to his father Neferḥabef and mother, Sup. 8451. SCHIAPARELLI, figs. 159–62, cf. pp. 175–9; KEES, *Kulturgeschichte des Alten Orients* (in OTTO, *Handbuch der Altertumswissenschaft*, iii, Pt. 1, vol. 3), i, *Ägypten*, pl. 30 [a], p. 95.

Sticks of Neferḥabef and Khaʿemwēset ⌇, Head of the Great Seat, Sup. 8551, 8625. SCHIAPARELLI, fig. 163, cf. pp. 179–80.

Gold cubit-measure of Amenophis II, Sup. 8647. Id. ib. figs. 154–6, cf. pp. 168–73. Texts, HELCK, *Urk.* iv. 1509–10 (from SCHIAPARELLI).

Electrum cup of Amenophis III, Sup. 8355. SCHIAPARELLI, fig. 157, cf. p. 173.

9. AMENMOSI ⌇, Servant in the Place of Truth, Charmer of scorpions. Ramesside.

Deir el-Medîna.

Wife, Tent-hōm ⌇.

Plan, p. 20. Map VII, E–3, c, 8.

BRUYÈRE, *Rapport (1924–1925)*, pp. 184–5, with plan on pl. x. Names and titles, ČERNÝ, *Rép. onom.* pp. 69–74, with key-plan, p. 69.

Court.

(1) [1st ed. 1] Stela, three registers. **I,** Goddess and deceased before Anubis-jackal. **II,** Deceased offers to sun-disk and horizon-disk before Ḥathor suckling child. **III,** Deceased led by Anubis, and offerings before Osiris.

II, WILKINSON MSS. v. 119 [lower]. Disks, WILKINSON, *M. and C.* 2 Ser. Supp. pl. 29 [5] = ed. BIRCH, iii, pl. xxii [4]; WILKINSON, *Materia Hieroglyphica*, pl. iv [figs. 3, 4]. Names, ČERNÝ, *Rép. onom.* p. 70 [Stèle 2].

(2) Stela, three registers. **I,** Man kneeling before bark. **II,** People offer to mummies at pyramid-tomb. **III,** Banquet.

Names in **II** and **III,** ČERNÝ, *Rép. onom.* p. 69 [Stèle 1].

Chapel.

(3) Three registers. **I,** Nut in tree-goddess scene with deceased and wife. **II,** Twelve men with staves. **III,** People adore [god].

Grasshopper in **I**, KEIMER in *Ann. Serv.* xxxii (1932), fig. 41, cf. p. 135.

(4) Two remaining registers. **I**, Part of funeral procession. **II**, Abydos pilgrimage.

(5) [1st ed. 3] Three registers. **I**, Weighing-scene, with Thoth as baboon. **II** and **III**, Female relatives.

GR. INST. ARCHIVES, photo. DM. 9. 1. Text of **I**, WIEDEMANN in *P.S.B.A.* viii (1886), pp. 229–30 [h]; text of Maꜥet, LEPSIUS MS. 398 [bottom].

(6) [1st ed. 2] Two registers. **I** and **II**, Banquet.

Two scenes of offering onions to deceased and wife in **I**, SCHOTT photo. 3100; second scene, SCHOTT in NELSON and HÖLSCHER, *Work in Western Thebes* (*Chic. O.I.C.* No. 18), fig. 35, cf. p. 80. Text of offering onions, KEIMER in *Egyptian Religion*, i (1933), pp. 52–3 [2]. Title of deceased, PIEHL in *Ä.Z.* xxi (1883), p. 131 [7].

(7) Deceased and wife offer to Osiris and Horus.

Ceiling. Outer half, [deceased] before Rēꜥ-Ḥarakhti. Inner half, two scenes, **1**, deceased kneels before bark with sun-disk, **2**, deceased and wife adoring.

Finds

Fragments of lintel, deceased offers to Osiris and [Anubis]. BRUYÈRE, *Rapport (1927)*, fig. 11 [2], cf. p. 16.

10. PENBUY ⬚𓎛𓃀𓃀 and KASA 𓎡𓄿, Servants in the Place of Truth. Temp. Ramesses II.

Deir el-Medîna. (*L. D. Text*, No. 97.)

Father (of Penbuy), Iri 𓇋𓂋 (name from offering-table of Penbuy, in Turin Mus. 1559). Wives (of Penbuy), Amentetusert 𓇋𓏏𓇾𓂋𓏏 and Irnūfer 𓂋𓈖𓄤; (of Kasa), Bukhaꜥnef 𓃀𓎛𓐍𓂝𓈖𓆑.

Plan, p. 20. Map VII, E–3, c, 5.

BRUYÈRE, *Rapport (1923–1924)*, pp. 61–4, with plan and sections, pl. xvii, cf. ii; BRUYÈRE, *Tombes théb.* pp. 57–65, with plan and section, p. 58, fig. 3, and view of exterior, pl. xiii; *L. D. Text*, iii, pp. 290–1. Names and titles, ČERNÝ, *Rép. onom.* pp. 75–83, with key-plans, pp. 75, 82; WILBOUR MSS. 2 F. 27 [upper].

Chapel.

(1) [1st ed. 1] Three registers. **I**, Couples (one with cat and goose under chair) and offerings. **II**, Offering-scenes and people with candles. **III**, Foreleg-rite at pyramid-tomb.

Cat and goose in **I**, ABERCONWAY, *A Dictionary of Cat Lovers*, fig. on p. 292 [lower] (from DAVIES drawing, GR. INST. ARCHIVES, photo. 1456). Men with candles in **II**, DAVIES in *J.E.A.* x (1924), pl. vi [8], p. 12.

(2) Seated woman. (3) Four registers, **I**, people offer to Kasa with wife and daughter, **II–IV**, [offering-scenes], and remains of Abydos pilgrimage in **IV**.

(4) [1st ed. 2–3] Three registers. **I**, Kasa, son, and family, (before divinities at (5)). **II**, Offering-scenes and people with candles before Kasa, wife, and relatives (one with full-faced cat under chair). **III**, Funeral procession to pyramid-tomb, with group of relatives with staves.

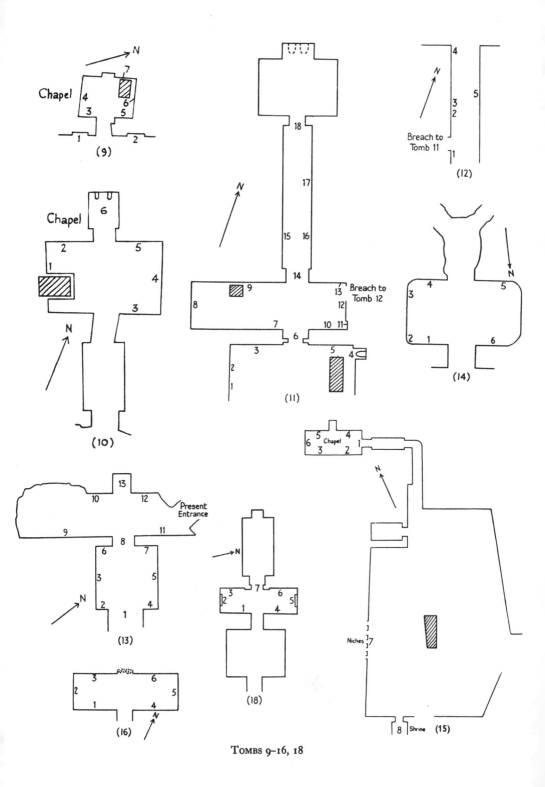

TOMBS 9–16, 18

Two sisters at right end of **II**, WEGNER in *Mitt. Kairo*, iv (1933), pl. xxviii [b]; people with candles before Kasa and wife, DAVIES in *J.E.A.* x (1924), pl. v [7], p. 12. Cat, ABERCONWAY, op. cit. fig. on p. 292 [upper] (from DAVIES drawing, GR. INST. ARCHIVES, photo. 1457). Names of two sisters, Kasa, and son, LEPSIUS MS. 388 [middle and bottom].

(5) [Osiris] and Ḥatḥor (belonging to (4)).

Frieze on side-walls. At (1), three scenes, **1**, Penbuy and wife playing draughts, **2**, couple beside pools, **3**, *išd*-tree and cat slaying serpent. At (4), five scenes, **1**, people adore Amenophis I and ʿAḥmosi Nefertere, **2**, Horus with goddess, **3**, bark of Amūn, **4**, Khnum, **5**, Ptaḥ with Sekhmet.
Draughts-playing scene (probably this), HAY MSS. 29834, 123 [lower]. Cartouches and names in **1** at (4), WIEDEMANN in *P.S.B.A.* viii (1886), p. 226 [a].

Ceiling, remains of four registers, each originally with four scenes. **I**, Winged scarab. **II**, Two scenes, **1**, couple kneeling with text, **2**, Isis and Nephthys kneeling adore Western emblem. **III**, Two scenes, **1**, Meḥitwert-cow by pool with hawk, **2**, horizon-disk between kneeling man and serpent. **IV**, Three scenes, **1** and **2**, couples kneeling, **3**, man kneeling before pool.

Shrine.
(6) [1st ed. 4, 5] Niche. Left wall, three registers, **I**, Ramesses II, followed by Paser (tomb 106), and Raʿmosi (tomb 7), before Ptaḥ and Ḥatḥor, **II**, Penbuy and brother Penshenʿabu before Amenophis I, ʿAḥmosi Nefertere, [Sethos I?], Ramesses I, and Ḥaremḥab, **III**, Penbuy, Kasa, and his son, adore Ḥarsiēsi. Right wall, three registers, **I**, Ramesses II and [Paser] adore Ḥatḥor-cow in mountain, **II**, Kasa and son before Sethos I, Ramesses I, and Ḥaremḥab, **III**, Kasa, Penbuy, and his son, before Thoth. Rear wall, [statues of Osiris and Horus]. Frieze and ceiling, texts.
II on side-walls, *L. D.* iii. 173 [c, b]. Royalties on left wall, and Ḥatḥor-cow and Kings on right wall, WILKINSON MSS. v. 113 [omitting top right]. Cartouches of Ramesses I and II and Ḥaremḥab on left wall, LEPSIUS MS. 389 [near top and middle]. Cartouches on right wall, WILKINSON, *Extracts from several Hieroglyphical Subjects*, pl. i [7].

Burial Chamber of Penbuy.
Vaulted ceiling. Anubis, Thoth, and Sons of Horus before [Anubis-jackal].
BRUYÈRE, *Tombes théb.* pl. xiv, pp. 57–62. Titles, including name of wife Irnūfer, ČERNÝ, *Rép. onom.* pp. 82–3.

Finds
Fragment from wall or stela, Ptaḥmosi and son Bek[enkhons]. BRUYÈRE, *Rapport (1923–1924)*, fig. 6 [2], cf. p. 62.

11. ḌHOUT 〄, Overseer of the treasury, Overseer of works. Temp. Ḥatshepsut to Tuthmosis III.

Draʿ Abû el-Nagaʿ. (*L. D. Text*, No. 1.)
Mother, Dediu 〄.

Plan, p. 20. Map II, D–6, j, 1.

L. *D. Text*, iii, pp. 237–8. Plan, SÄVE-SÖDERBERGH in *Mitt. Kairo*, xvi (1959), Abb. 1. Fragments of autobiographical text, offering-list, &c., from walls, SPIEGELBERG DIARY, 83–99 [1–124], 110–11 [126–47], 112 [top], 113 [149]. Titles, SETHE, *Urk.* iv. 448–9 (140), a and h on frieze at (16)–(17), b at (11), c at (1), g at (2), i at (13), k at (10).

Court.

(1) Two registers. I, Offerings and cryptographic text. II, Two men with ointment and cloth, harpist, and two women with sistra and *menats*, before deceased.

NORTHAMPTON, &c. *Theban Necropolis*, pls. x [left], xi [10–13], pp. 7*–12* after p. 40 (by SETHE); GR. INST. ARCHIVES, photo. 1683. Omitting deceased, SCHOTT photos. 3768–9, 3771, 3773–5. Man with cloth, harpist, and first woman, HICKMANN in *Bull. Inst. Ég.* xxxiv (1953), fig. 5, cf. p. 239; id. in *Archiv Orientální*, xx (1952), pl. l [3], p. 452; id. *Musicologie pharaonique*, fig. 5, cf. p. 107; id. *45 Siècles de Musique*, pl. xxx [A]; harpist and women, WEGNER in *Mitt. Kairo*, iv (1933), pl. iv [a], pp. 96–7; harpist, SCHOTT in *Mélanges Maspero*, i, fig. 2, cf. p. 460.

(2) [1st ed. 1] Two registers. I, Cryptographic text and offerings. II, Priest with offerings before [deceased].

NORTHAMPTON, &c. *Theban Necropolis*, pls. x [right], xi [1–9], pp. 3*–6* after p. 40 (by SETHE). Offerings in I and II, SCHOTT photos. 8673, 3777.

(3) Stela (upper part destroyed), deceased with hymn to Amūn.

GR. INST. ARCHIVES, photo. 1731 [left]; SCHOTT photo. 8674. Hymn, SETHE, *Urk.* iv. 444–7 (139).

(4) Statue with offering-text on apron.

(5) [1st ed. 2] 'Northampton stela', deceased with autobiographical text.

NORTHAMPTON, &c. *Theban Necropolis*, pl. i (frontispiece), pp. 15–17; GR. INST. ARCHIVES, photo. 1731 [right]. Text, SPIEGELBERG in *Rec. de Trav.* xxii (1900), pp. 118–19, cf. 115–17, 120–5; SETHE, *Urk.* iv. 419–31 (136); parts, L. *D.* iii. 27 [10, 11] (called ʿAsâsîf Temple), cf. *Text*, iii, p. 238, note 1; LEPSIUS MS. 421 [middle]–422 [top].

Hall.

(6) [1st ed. 3] Outer left jamb, hymn to Rēʿ and deceased seated at bottom. Left thickness, deceased, preceded by father (?), adoring with hymn to Amen-rēʿ.

Jamb, GR. INST. ARCHIVES, photo. 1731 [middle]. Thickness, SÄVE-SÖDERBERGH in *Mitt. Kairo*, xvi (1958), Abb. 4, cf. p. 287.

(7) Remains of chariot and men.
Id. ib. Abb. 5, cf. p. 287.

(8) [1st ed. 4] Fragments of [stela], and remains of 'Address to the living' with autobiographical text.

Text, SETHE, *Urk.* iv. 441–4 (138).

(9) Two offering-bringers before [deceased], with goose under chair.

(10) [1st ed. 9] Deceased, mother, and man (with monkey eating fig under chair), receive three rows of offerings and men with bulls. Sub-scene, guests, harpist with song, male singer, dancing monkey, female lutist (?), and male dancer.

SÄVE-SÖDERBERGH, op. cit. Abb. 2, 3, cf. pp. 280-7. Deceased and mother, CHIC. OR. INST. photo. 10284.

(11) [1st ed. 8] Titles of deceased.

(12) [1st ed. 7] Stela with autobiographical text and 'Appeal to visitors'.
NORTHAMPTON, &c. *Theban Necropolis*, pl. xxxiv. Texts, SETHE, *Urk.* iv. 431-41 (137).

(13) [1st ed. 6] Two registers. **I,** [Fishing and fowling]. **II,** Remains of vintage with treading grapes.
Text, id. ib. 450-1 (142) A.

Passage.

(14) [1st ed. 5] Text on outer left jamb, id. ib. 450 (141) A.

(15) Three registers. **I,** Offerings and text. **II-III,** Abydos pilgrimage.
SÄVE-SÖDERBERGH in *Mitt. Kairo*, xvi (1958), Abb. 6, cf. pp. 288-9; two boats, SCHOTT photos. 3779-82, 6589-91, cf. 6592.

(16) [1st ed. 12] Two registers. **I,** Offering-list. **II,** Deceased on foot hunting wild bull, ostriches, &c., in desert.
II, SÄVE-SÖDERBERGH, op. cit. Abb. 7, cf. pp. 289-90; ostriches, SCHOTT photos. 3783, cf. 6588. Text, SETHE, *Urk.* iv. 451 (142) B.

(17) [1st ed. 11] Two registers. **I,** Rites before mummies. **II,** Deceased seated with offering-list.

(18) [1st ed. 10] Entrance to Shrine. Lintel and left jamb, offering-texts.
Text on lintel, SETHE, *Urk.* iv. 450 (141) B.

Demotic graffiti concerning Ptolemaic ibis-burials (cf. DRAʿ ABÛ EL-NAGAʿ in *Bibl.* i², Pt. 2, in the Press). NORTHAMPTON, &c. *Theban Necropolis*, pls. xxviii [27], xxix [20-3], pp. 22-3.

Finds

Objects of deceased.

Four canopic-jars, in Florence Mus. 2222-5. Title, SETHE, *Urk.* iv. 1002 (296) v, cf. 1000 J-M.

Alabaster vases. Two in Leyden Mus. H. 229 and 386, LEEMANS, *Aegyptische Monumenten van het Nederlandsche Museum van Oudheden te Leyden*, ii, pls. lviii, lxv; No. H. 229, STRICKER in *Oudheidkundige Mededeelingen van het Rijksmuseum van Oudheden te Leiden*, N.R. xxiv (1943), pl. iv [top left], fig. 32 [229], cf. pp. 76-8; texts, DEVÉRIA in *Mémoires de la société impériale des antiquaires de France*, xxiv, 3 Sér. iv, pp. 78-80 (reprinted, *Bibl. Ég.* iv, pp. 37-9); SETHE, *Urk.* iv. 1001 (296) d, n, cf. 1000 C, D. One in Louvre, N. 1127, DEVÉRIA, op. cit. *Mém.* p. 83 (*Bibl. Ég.* p. 41); SETHE, *Urk.* iv. 1001 (296) e, cf. 1000 B. Four in Turin Mus. 3225-8, PETRIE ITAL. photos. 186-7; texts, SETHE, *Urk.* iv. 1001-2 (296) c, f, i, k, cf. 1000 E-H; texts of three, MASPERO in *Rec. de Trav.* iv (1883), p. 137 [xxvii lower]; incomplete, BRUGSCH, *Thes.* 1424 [13]; see FABRETTI, ROSSI, and LANZONE, *R. Mus. di Torino*, pp. 440-1; ORCURTI, *Cat.* ii. 178 [upper, 3, 4, 6, 8].

Gold dish, presented to deceased as general by Tuthmosis III, in Louvre, N. 713. BOREUX, *Guide*, ii, pl. xlv [lower], pp. 341-2; VANDIER, *Guide* (1948), on pl. xi [2], p. 48, (1952), on

pl. xi [2], p. 49; MASPERO, *L'Arch. ég.* (1887), fig. 275, (1907), fig. 299; BIRCH, *Mémoire sur une patère égyptienne* [&c.] in *Mémoires de la société impériale des antiquaires de France*, xxiv, 3 Sér. iv, pp. 1–74 with fig. (reprinted, *Bibl. Ég.* ix, pp. 225–74 with fig.); VERNIER, *La Bijouterie et la joaillerie* (*M.I.F.A.O.* ii), pl. xx; DESROCHES, *L'Art égyptien au Musée du Louvre*, 25th pl. [top]; id. *Le Style égyptien*, pl. lii [lower]; RAGAI, *L'Art pour l'art dans l'Égypte antique*, pl. 40 [71]; STEINDORFF, *Kunst*, 297; CAPART, *L'Art égyptien*, iv, pl. 669 [lower]; LEFÉBURE in *L'Amour de l'art*, xxviii, fig. on p. 178 [upper]; SAINTE FARE GARNOT, *L'Égypte* in *Histoire générale de l'art*, fig. on p. 73 [lower]. Text, SETHE, *Urk.* iv. 999 (295); MASPERO, *Études égyptiennes*, i, p. 69, note 2; WILKINSON MSS. xxiv. 35 [lower]; DEVÉRIA MSS. C. 7 [14]. See PIERRET, *Catalogue de la salle historique*, pp. 86–7 [358].

Silver dish (incomplete), from Anastasi and Raifé Collections, in Louvre, E. 4886. DE-VÉRIA in *Mémoires de la société impériale des antiquaires de France*, xxiv, 3 Sér. iv, fig. on p. 87 (reprinted, *Bibl. Ég.* iv, fig. on p. 44). Text, SETHE, *Urk.* iv. 1001 (296) a, cf. 1000 A; part, MASPERO, *Études égyptiennes*, i, p. 69, note 3. See BOREUX, *Guide*, ii, p. 348; VANDIER, *Guide* (1948), p. 57, (1952), p. 58; PIERRET, op. cit. pp. 87–8 [359]; LENORMANT, *Catalogue d'une collection d'antiquités égyptiennes . . . Anastasi* (1857), p. 80 [956]; id. *Description des antiquités . . . collection . . . Raifé* (1867), p. 41 [380].

Bronze dagger, in Darmstadt, Hessisches Landesmuseum. MÖLLER, SCHUBART, and SCHÄFER, *Ägyptische Goldschmiedearbeiten*, fig. on p. 23 [e]; PETRIE in *Ancient Egypt* (1930), fig. on p. 101 [24] (from MÖLLER, &c.); WOLF, *Die Welt der Ägypter*, pl. 88 [upper]. Texts, SETHE, *Urk.* iv. 1001 (296) g, h, 1002 (297) a, b, cf. 1001 Q; DE RICCI MSS. D. 61, 41 [A]; part, WIEDEMANN in *P.S.B.A.* xiii (1891), p. 34 [1].

Stone palette, in Leyden Mus. I. 287. LEEMANS, *Aegyptische Monumenten van het Neder-landsche Museum van Oudheden te Leiden*, ii, pl. xcv. Text, MASPERO, *Études égyptiennes*, i, p. 69, note 3; SETHE, *Urk.* iv. 1002 (296) l, (297) c, cf. 1001 O.

Alabaster palette, in Turin Mus. Sup. 6227. PETRIE ITAL. photo. on 161. Texts, SETHE, *Urk.* iv. 1001–2 (296) b, p, cf. 1000 N; MASPERO in *Rec. de Trav.* iv (1883), p. 137 [xxvii upper].

12. ḤRAY ☥ ⸗ 𓏤𓏤, Overseer of the granary of the King's wife and King's mother ʿAḥḥotp. Temp. Amosis to Amenophis I (?).

Draʿ Abû el-Nagaʿ. (CHAMPOLLION, No. 51, L. D. Text, No. 2.)

Mother, ʿAḥmosi, see ROSELLINI MSS. 284. G 61.

Plan, p. 20. Map II, D–6, j, 1.

Hall. Left wall, SPIEGELBERG squeezes.

(1)–(2) Three registers. I–III, Funeral procession, including mummy on couch in bark with priests, *teknu*, and mummers.

Group with mummy in II, and Anubis and Osiris in III, SCHOTT photos. 3784–5; two mourners, WERBROUCK, *Pleureuses*, figs. 98, 126, cf. pp. 22–3.

(3)–(4) [1st ed. 1] Deceased with offering-list and family, woman squatting on chair facing him, and son ʿAḥmosi, followed by relatives, offering to him, with lectors above.

Incomplete, SCHOTT photos. 3786, 8675–7, 8678–82. Names of two sons and three daughters, L. D. Text, iii, p. 238 [middle lower]; names of some relatives, LEPSIUS MS. 422 [middle lower]–423 [top].

(5) Two registers. **I**, Offering-bringers. **II**, Deceased on foot hunting in desert.
WEGNER in *Mitt. Kairo*, iv (1933), pl. iv [b], p. 79. Dog seizing gazelle (?) in **II**, SCHOTT photo. 8683.

Frieze-text. Part, CHAMP., *Not. descr.* i, p. 543; L. D. *Text*, iii, p. 238 [middle upper]; LEPSIUS MS. 422 [middle upper].

Demotic graffiti concerning Ptolemaic ibis-burials (cf. Dra' Abû el-Naga' in *Bibl.* i², Pt. 2, in the Press). NORTHAMPTON, &c. *Theban Necropolis*, pl. xxx [28–30], p. 22.

13. SHUROY ∫⧘⧙⧚⧛⧜, Head of brazier-bearers of Amūn. Ramesside.
Dra' Abû el-Naga'.
Wife, Wernūfer ⧘⧙⧚⧛⧜.
Plan, p. 20. Map I, C–7, a, 9.

Vestibule.
(1) Thicknesses, deceased and wife adoring.
Left thickness, BAUD, *Dessins*, pl. ii [left], pp. 67–8.

(2)–(3) Two registers. **I**, Book of Gates with deceased and wife adoring divinities. **II**, Sketches, deceased and wife adore [divinities], and King and Queen (cartouches blank) with Western emblem.
Deceased and wife before ass-headed god in **I**, and King, Queen, and emblem, in **II**, BAUD, *Dessins*, pl. ii [right], fig. 19.

(4)–(5) Two registers. **I**, Book of Gates with adoration of demons. **II**, Deceased and wife adore Ma'et, and adore Rē'-Ḥarakhti.
II, SCHOTT photos. 4986–8.

(6) and (7) Dressed *zad*-pillar on Western emblem at (6) and on Eastern emblem at (7).
SCHOTT photos. 4983–5; *zad*-pillar at (7), CHIC. OR. INST. photo. 10305.

Hall.
(8) Outer jambs, texts. Thicknesses, sketches of wife on left, and of deceased on right.
Jambs, SCHOTT photos. on 4983, 4985. Deceased, BAUD, *Dessins*, fig. 18.

(9) Four registers. **I**, Offering-bringers with vegetables. **II**, Deceased and relatives in garden. **III** and **IV**, Funeral procession, including servants with food-tables (some resting) in **III**, and child-dancers in **IV**.
CHIC. OR. INST. photos. 10306–9, 2977. Incomplete, SCHOTT photos. 4972–82; parts, WERBROUCK, *Pleureuses*, pl. xxxix, figs. 5, 152, cf. p. 23; female mourners before mummy in **IV**, BAUD, *Dessins*, fig. 17.

(10) Two registers. **I**, Priest with Opening the Mouth instruments and lector, and female mourner before mummy. **II**, Deceased kneeling with braziers before Ḥathor-cow in mountain.
SCHOTT photos. 4927–8. Mourner, WERBROUCK, *Pleureuses*, fig. 151. Deceased, BAUD, *Dessins*, pl. i, pp. 65–6.

(11) Two registers. **I**, Offering-bringers before [deceased and wife] **and** banquet with

clappers. **II,** Deceased and wife and couple seated with bouquets, and man drinking from siphon.

Clappers, offerings, man with siphon, and bouquet, Schott photos. 4931, 4933.

(12) Two registers. **I,** Thoth with [deceased] reports to Osiris with Isis and Nephthys. **II,** Man censing and libating before offerings.

I, Schott photo. 4930.

(13) Niche. Left wall, women. Right wall, man squatting, deceased offering on braziers, followed by wife, and man.

Right wall, Schott photo. 4929.

14. Huy ⸐〈〈, *wa⸢b*-priest of 'Amenophis, the favourite of Amūn'. Ramesside. Dra⸢ Abû el-Naga⸢.

Plan, p. 20. Map I, C–7, a, 10.

Hall.

(1)–(2) Three registers. **I,** Priests before royal statues (two in palanquins). **II,** Female mourners, and priest before royal statues. **III,** Deceased and wife seated, pool with trees, and man with offerings before Osiris and three goddesses.

Omitting Osiris and goddesses, Gr. Inst. Archives, photos. 1969–70 (by Stoppelaère). **I** and **II,** Baud, *Dessins,* pl. iii [middle and left], pp. 69–70; left part of **I,** and pool, Schott photos. 4925–6; mourners, Werbrouck, *Pleureuses,* figs. 6, 177, cf. p. 23.

(3) Two registers. **I,** Female mourner and [boat] at pyramid-tomb, assessors, and weighing-scene. **II,** Priests and mourners before mummy at tomb.

Gr. Inst. Archives, photos. 1971–3 (by Stoppelaère). Scene at tomb in **I,** Baud, *Dessins,* pl. iii [right], fig. 20; Davies (Nina) in *J.E.A.* xxiv (1938), fig. 24, cf. p. 40. Female mourners in **II,** Werbrouck, *Pleureuses,* figs. 7, 63, 135.

(4) Horus reports to [Osiris].

(5) Priest censes before statues of Amenophis I and [⸢Aḥmosi Nefertere] in palanquins carried by priests with mourners below.

Chic. Or. Inst. photos. 10324–5; omitting mourners, Schott photos. 4923–4.

(6) Two registers. **I,** Two scenes, **1,** deceased and man, **2,** deceased and wife adore ram-head of Amūn in shrine, with [two offering-bringers]. **II,** Remains of funeral procession with sarcophagus in boat.

Ram-head, Schott photo. 4921.

Frieze, Anubis-jackals, with *sa*-emblems and *zad*-pillars. Baud, *Dessins,* on pl. iii, p. 70. Ceiling. Centre, double-scene, deceased adores bark of Sokari.

15. Tetiky ⸐〈⸑〈〈, King's son, Mayor in the Southern City. Early Dyn. XVIII. Dra⸢ Abû el-Naga⸢.

Parents, Ra⸢ḥotp, Overseer of the harîm of the Lake (i.e. Fayûm), and Sensonb 〈...〉. Wife, Senbi 〈...〉.

Plan, p. 20. Map II, D–5, j, 5.

CARNARVON and CARTER, *Five Years' Explorations at Thebes*, pp. 2–4, 12–13, with views and plan, pls. i, ii; DAVIES in *J.E.A.* xi (1925), pp. 10–18. Photographs, CARTER MSS. I. J. 131–45.

Chapel.

(1) Tympanum, double-scene (right part destroyed), Queen ʿAḥmosi Nefertere, followed by [female and male attendants], with brazier and libation before Ḥathor-cow. Offering-bringers below, each side of doorway.

DAVIES, pl. ii, p. 14; left part, CARNARVON and CARTER, pl. vi [1], p. 16.

(2)–(3) Funeral procession, with mummers, obelisks, rites in garden, *teknu*, and coffin carried by two of the 'Nine friends'.

CARNARVON and CARTER, pls. vii–ix, p. 17; DAVIES, pl. v, pp. 16–18.

(4) Two registers. **I,** Deceased and wife (?) under tree with girl offering food to them, winnowing, laden donkeys, heaping and recording grain, and ʿAḥmosi, Scribe of the estate, at right end. **II,** Remains of reaping.

DAVIES, pl. iv [top right, middle, and bottom], p. 16. Men with donkeys, CARNARVON and CARTER, pl. v [2], p. 15.

(5) Deceased and wife, with dog under chair, grand-daughters (?) before them, and banquet with guests and female relatives.

DAVIES, pl. iv [top], pp. 15–16; left end, CARNARVON and CARTER, pl. v [1], p. 15.

(6) Tympanum, double-scene, deceased, with butcher, offers on brazier before Osiris. [Stela] below with man offering to couple at left side, and deceased offering to parents at right side.

Id. ib. pl. vi [2], p. 16; right half, DAVIES, pl. iii, pp. 14–15.

Frieze-text. CARNARVON and CARTER, on pls. iv [2], v [1], vii–ix, pp. 15, 16; DAVIES, on pls. iv, v.

Court.

(7) Niches. Ushabti-coffins of parents and family, found *in situ* here and in the Pit, CARNARVON and CARTER, pls. x, xi, cf. i [1], ii, pp. 2–3, 13, 19–21 (by NEWBERRY). Others, found later *in situ* here, one in Liverpool Inst. Arch. E. 1601, others in Cairo Mus.; names, DAVIES, pp. 12–13.

Shrine.

(8) Left wall, man picking grapes. Right wall, man offers to seven people. Rear wall, [man] offering, and alabaster vases below.

CARNARVON and CARTER, pl. iii, p. 12; left wall, CAPART, *Documents*, i, pl. 76 [A]; id. *L'Art égyptien*, iii, pl. 495.

Finds

Fragment of stela, deceased with family before a divinity. Names, DAVIES, p. 12.

Offering-table of deceased, in Brit. Mus. 1511. CARNARVON and CARTER, pl. xii [1], p. 21 (by NEWBERRY); *Hiero. Texts*, viii, pl. i [left], p. 1.

16. PANEḤESI 𓀀𓏏𓏲 Prophet of 'Amenophis of the Forecourt'. Temp. Ramesses II.
Draʿ Abû el-Nagaʿ.
Wife, Ternūte 𓂋𓏏𓈖𓏌𓏏.

Plan, p. 20. Map II, D–6, g, 3.

BAUD and DRIOTON, *Le Tombeau de Panehsy* in *Tombes thébaines. Nécropole de Dirâʿ Abu'n-Naga* (*M.I.F.A.O.* lvii. 2), pp. 1–50.

Hall.

(1) and (2) Two registers. **I,** Book of Gates, five scenes, deceased and wife adore guardians and Ennead. **II** (destroyed at (2)), Funeral procession.
BAUD and DRIOTON, figs. 2–4, 6–9; M.M.A. photos. T. 1208–9. **I,** CHIC. OR. INST. photos. 10296–7.

(3) [1st ed. 1] Two registers. **I,** Deceased libates offerings before temple of Amen-rēʿ. **II,** Horus reports to Osiris.
BAUD and DRIOTON, figs. 5, 10, cf. pp. 13–14, 20, 22; M.M.A. photo. T. 1207; CHIC. OR. INST. photo. 10298. **I,** SCHOTT photos. 4212–13; omitting deceased, WRESZ., *Atlas*, i. 113.

(4) [1st ed. 7–6] Two registers (ending on east wall). **I,** Priest and two squatting women before deceased and wife with *ba*s, and tree-goddess scene with *ba*. **II,** Agriculture, including laden donkey, deceased seated under tree, and tree-felling.
BAUD and DRIOTON, figs. 19, 20, 22–4, cf. pp. 36–47; M.M.A. photos. T. 1203, 1210–11; CHIC. OR. INST. photos. 10301–4. Tree-goddess scene in **I,** and part of **II,** WRESZ., *Atlas*, i. 61, 72, 112, 114 [right]; tree-goddess scene, SPIEGEL in *Mitt. Kairo*, xiv (1956), pl. xvi [2], p. 205; SCHOTT photo. 4221. Second group of ploughing, and tree-felling, FARINA, *Pittura*, pl. clxi; second group of ploughing, ROSTEM in *Ann. Serv.* xlviii (1948), fig. 8, cf. p. 172; man reaping, and man with donkey, MEKHITARIAN, *Egyptian Painting*, pl. on p. 145; man with donkey, CAPART, *Documents*, i, pl. 23 [lower]; CAPART and WERBROUCK, *Thèbes*, fig. 195 (from WRESZINSKI).

(5) [1st ed. 5–4] Two registers. **I,** Deceased and wife with bouquet adore [Ḥathor-cow] in mountain with stelae. **II,** Two rows of procession carrying Great Vase of Amūn with bouquet of Amūn from temple, upper row headed by Nebsumenu (tomb 183) with braziers before tree, lower row by deceased and brother Paḥesi 𓀀𓏏𓏏, Singer of the altars of Amūn, before palisade.
BAUD and DRIOTON, figs. 16, 17, cf. pp. 30–8; M.M.A. photos. T. 1204, 1212; CHIC. OR. INST. photos. 10300–1. **II,** and deceased and wife in **I,** SCHOTT photos. 4217–20; mountain, and priests at temple, WRESZ., *Atlas*, i. 114 [left].

(6) [1st ed. 3–2] Two registers. **I,** Two scenes, **1,** deceased and wife adore bark of Sokari, **2,** deceased with wife censes and libates with offerings and bouquet before statue of Amenophis I in palanquin with bouquet. **II,** Two scenes, **1,** [deceased and wife] adore Anubis, **2,** deceased and wife with bouquet adore Amenophis I and ʿAḥmosi Nefertere.
BAUD and DRIOTON, figs. 11–15, cf. pp. 22–30; M.M.A. photos. T. 1205–6. **I, 2, II, 2,** and bark in **I, 1,** CHIC. OR. INST. photos. 10299–300; bark and statue in **I,** SCHOTT photos. 4214–16.

Frieze. Horizontal bouquets as decoration at (4), BAUD and DRIOTON, fig. 21, cf. pp. 40–1. Deceased kneeling before Anubis-jackal at (5), id. ib. fig. 18, cf. pp. 35–6; M.M.A. photos. T. 1204 [top], 1213.

Ceiling, decoration and text. BAUD and DRIOTON, fig. 1, cf. pp. 7–8; CHIC. OR. INST. photo. 10305. Grape-decoration, CAPART, *Documents*, i, pl. 76 [B].

17. NEBAMŪN 𓈖𓏤𓐍, Scribe and physician of the King. Temp. Amenophis II (?).
Draʿ Abû el-Nagaʿ.
Parents, Nebseny 𓐍𓏤𓏭𓏭, Judge, and Amenḥotp (?). Wife, Ta . . . nûfer 𓄿𓏤𓏭𓏤𓏤.
Plan, p. 30. Map II, D–6, g, 1.

SÄVE-SÖDERBERGH, *Four Eighteenth Dynasty Tombs (Private Tombs at Thebes*, i), pp. 22–32, with plan on pl. xxix; MÜLLER in *Mitt. Vorderasiat. Ges.* ix (1904), pp. 113–50 (Heft 2, pp. 1–38).

Hall.

(1) Left thickness, deceased. Inner lintel, Western emblem between Anubis-jackals. Text on thickness, SÄVE-SÖDERBERGH, pl. xxviii [1], p. 22.

(2) Two scenes. **1,** Deceased with wife offers on braziers. **2,** Man offers bouquet of Amūn to deceased and wife (with monkey eating fruit and onions under chair). Sub-scene, offering-bringers.
Head of wife in **1,** and texts, SÄVE-SÖDERBERGH, pls. xxi [B], xxviii [3, 4], p. 23; head of wife, jars, and burnt-offerings, in **1,** and bouquet in **2,** SCHOTT photos. 8639 bis–8642.

(3) [1st ed. 1] Four registers. **I,** Deceased offers to parents with small girl carrying mirror and kohl-pot, and girl offers drink to deceased (?). **II,** Female guests and singers, girl with shoulder-harp, and male lutist. **III,** Male guests. **IV,** Man boring beads.
II, girl with mirror in **I,** girl-attendant in **III,** and texts, SÄVE-SÖDERBERGH, pls. xxi [C, D, E], xxviii [5, 6], p. 28. **I–III** (omitting right end), SCHOTT photos. 4190–1, 8643, with details, 4082, 4192, 7466–70. Deceased with parents in **I,** and musicians in **II,** CHIC. OR. INST. photos. 10284–5. **II** and **III,** WRESZ., *Atlas*, i. 116; FARINA, *Pittura*, pl. xci; musicians, HICKMANN in *Bull. Inst. Ég.* xxxv (1954), fig. 43, cf. p. 347; id. in *Cahiers d'histoire égyptienne*, Sér. vi [5, 6], (1954), fig. 12, cf. p. 275; id. *45 Siècles de Musique*, pl. xxx [B].

(4) [1st ed. 2, 3] Deceased with attendant inspects three registers. **I–II,** Men filling granaries, and recording corn, with girl offering wine to deceased beyond. **III,** Men and women baking and brewing. Sub-scene, grinding, &c., and bringing cloth.
SÄVE-SÖDERBERGH, pl. xxii, pp. 24–5. Omitting deceased and offering-scene, WRESZ., *Atlas*, i. 63, 125 (called tomb 24).[1] Granaries, recording corn, baking, &c., CHIC. OR. INST. photos. 10285–7; granaries and recording corn, FARINA, *Pittura*, pl. xc; ROSTEM in *Ann. Serv.* xlviii (1948), fig. 17, cf. p. 176; LUNDSGAARD, *Ægypten gennem tre Aartusinder*, fig. 9; SCHOTT photos. 7471–2, and details from lower scenes, 4083–4, 4187–9. Right end of sub-scene (sketched), BAUD, *Dessins*, fig. 21.

(5) Deceased holding palette with priest offering to him, and three registers, **I–III,** banquet, with girl-flutist in **III.** Sub-scene, offering-bringers before couple.
Upper part of deceased and texts, SÄVE-SÖDERBERGH, pls. xxi [A], xxviii [2], p. 23; deceased, JONCKHEERE, *Les Médecins de l'Égypte pharaonique*, fig. 14 [upper], cf. pp. 51 [43], 160. Two groups, man offering to guest, in **II,** SCHOTT photos. 8644–5.

[1] For WRESZ., *Atlas*, i. 126 (called by him tomb 24, and incorrectly placed here in *Bibl.* i, 1st ed.), see tomb 100 (19).

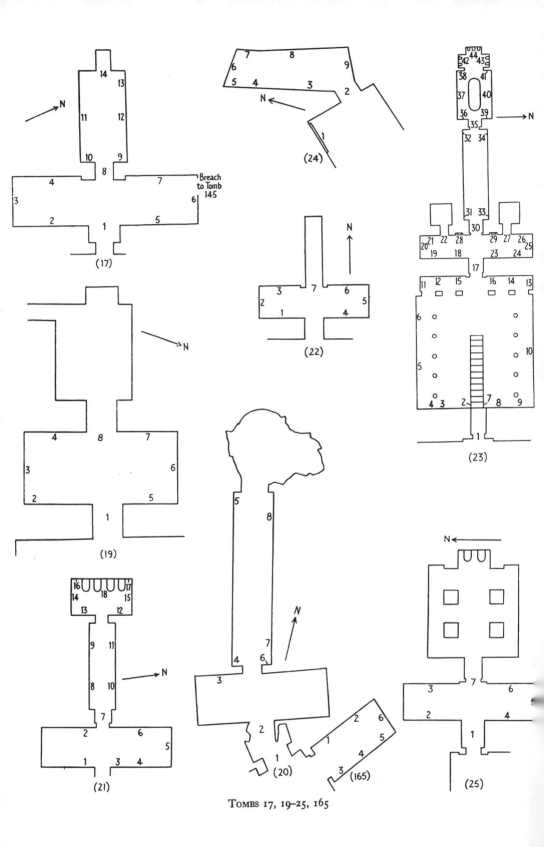

TOMBS 17, 19–25, 165

(6) Double-scene, deceased adores Osiris, and adores Anubis. Sub-scene, man censing and libating offerings, and offering-bringers.

HERMANN, *Stelen*, pl. 10 [c], pp. 87–8; SCHOTT photo. 9248. See SÄVE-SÖDERBERGH, p. 27.

(7) [1st ed. 4] Deceased with brother offering papyrus-bouquet to him, and two registers. **I**, Syrians, including women and children bringing vases. **II**, Man offering drink to Syrian chief and wife (possibly consultation of deceased as physician), and two men with vases. Sub-scene, Syrian sailing-boat and two carts drawn by humped bulls.

SÄVE-SÖDERBERGH, pl. xxiii, pp. 25–7. Omitting deceased, MEYER, *Fremdvölker*, 730–3. **I** and **II**, MÜLLER in *Mitt. Vorderasiat. Ges.* ix (1904), pls. i–iv, pp. 121–50 (Heft 2, pp. 9–38); WRESZ., *Atlas*, i. 115; BOSSERT, *The Art of Ancient Crete*, p. 290 [550]; incomplete, SCHOTT photos. 7473–7. Man with chief and wife in **II**, JONCKHEERE, op. cit. fig. 14 [lower], cf. pp. 51 [43], 160. Chief and wife, ANDRAE, *Die jüngeren Ischtar-Tempel in Assur*, fig. 66, cf. p. 85; wife, BOSSERT, *Altkreta*, fig. on p. 245 [339]. Syrians in **II**, CHIC. OR. INST. photo. 10288; cup and silver vase, VERCOUTTER, *L'Égypte* [&c.], pls. liv [398], lviii [428], pp. 344–5, 351. Sailing-boat, SÄVE-SÖDERBERGH, *The Navy of the Eighteenth Dynasty* in *Uppsala Universitets Årsskrift* (1946), No. 6, fig. 10 (from MÜLLER), cf. pp. 55–6.

Ceiling. Texts of deceased, SÄVE-SÖDERBERGH, *Four . . . Tombs*, pl. xxvii [left], p. 29.

Inner Room.

(8) Outer lintel, double-scene, deceased and wife adore Anubis, and adore Osiris, jambs, texts. Thicknesses, deceased and wife, with hymn to Rēᶜ on left thickness.

Texts, SÄVE-SÖDERBERGH, pl. xxviii [7–11], pp. 29, 30.

(9) and (10) Four registers, each side of entrance, men with funeral outfit, &c. Incomplete, SCHOTT photos. 4194–5. See SÄVE-SÖDERBERGH, p. 30 [O, P].

(11) [1st ed. 5] Four registers. **I–IV**, Funeral procession to Western goddess, including victim in **II**, Abydos pilgrimage in **III**, [*teknu*] and mummers in **IV**.

SÄVE-SÖDERBERGH, pls. xxiv–xxv, pp. 30–1. Omitting goddess, WERBROUCK, *Pleureuses*, pl. iii, and fig. 65, cf. pp. 24, 129. Left and right ends, CHIC. OR. INST. photos. 10289–91. Sailing-boat in **III**, SCHOTT photo. 4193. Mummer and text of sledge in **IV**, MÜLLER in *Mitt. Vorderasiat. Ges.* ix (1904), pp. 114–15 (Heft 2, pp. 2–3).

(12) Four registers. **I–III**, Rites before mummy. **IV**, Offering-bringers.
SÄVE-SÖDERBERGH, pl. xxvi, p. 31.

(13) Two registers. **I**, [Priest] with offering-list and offerings before deceased and wife. **II**, Similar scene, before parents.

Texts, id. ib. pl. xxix [1, 2], p. 31.

(14) Painted niche. Left wall, man offers to couple, right wall, man offers bouquet to parents, rear wall, deceased and wife (?). Left of niche, Osiris and offerings, right of niche, Anubis.

Texts, id. ib. pl. xxix [3–5], p. 32.

Ceiling. Texts of deceased, id. ib. pl. xxvii [right], pp. 29–30.

18. BAKI 𓃾𓏤𓏏, Chief servant who weighs the silver and gold of the estate of Amūn. Temp. Tuthmosis III or earlier.

Dra' Abû el-Naga'.

Father, a Scribe of counting of cattle of Queen 'Aḥmosi Nefertere. Wife, Mosi 𓏏𓏤 .

Plan, p. 20. Map I, C–7, e, 7.

GAUTHIER in *B.I.F.A.O.* vi (1908), pp. 163–71, with plan, fig. 2.

Hall.

(1) [1st ed. 1] Five registers. I–III, Banquet with guests and offering-list. IV, [Granary]. V, Remains of flax-pulling.

I–III, GAUTHIER, pl. xiii, p. 170. Two girls at right end of II, SCHOTT photo. 8764.

(2) [1st ed. 2] Stela with remains of text. At left side, four registers, offering-bringers. Texts, GAUTHIER, pp. 167–8; HERMANN, *Stelen*, pp. 18*–19* [upper] (from GAUTHIER).

(3) [1st ed. 3] Two registers. I and II, Weighing metal vases, and recording jars. GAUTHIER, pl. xii. Weighing, PETRIE, *Qurneh*, pl. xxxv; CHIC. OR. INST. photo. 10310; SCHOTT photo. 8765.

(4) [1st ed. 6] Two registers. I, Son, with man and squatting woman, offers to deceased, wife, and daughter. II, Deceased offers to parents, and remains of banquet, with jars, and female dancer with double-pipe and clapper.

Goose under chair and squatting woman in I, and deceased and remains of banquet in II, PETRIE, *Qurneh*, pls. xxxiv, xxxvii [upper], p. 11; goose, KUENTZ, *L'Oie du Nil*, fig. 28; CHIC. OR. INST. photo. 10310; SCHOTT photo. 8766; dancer and clapper, HICKMANN, *45 Siècles de Musique*, pl. xxxi [A]; SCHOTT photo. 8763. Texts, GAUTHIER, pp. 168–9.

(5) [1st ed. 5] Stela with double-scene, deceased kneels before Anubis-jackal, and remains of offering-text below. At sides, Western goddess on left, and Eastern goddess on right. Text, GAUTHIER, pp. 166–7.

(6) [1st ed. 4] Two registers. I, Deceased and family fishing and fowling. II, Deceased and wife inspect vintage (filling wine-jars, picking and treading grapes), with preparing and netting fowl below.

I, GAUTHIER, pl. xi, pp. 169–70; WRESZ., *Atlas*, i. 117. Birds above papyrus in I, and men filling jars and preparing fowl in II, PETRIE, *Qurneh*, pls. xxxvi, xxxvii [lower], p. 11. Text in I, PIEHL, *Inscr. hiéro.* 1 Sér. c [A].

(7) Entrance to Inner Room. Lintel, double-scene, deceased adores Osiris, and adores Anubis.

See GAUTHIER, pp. 170–1.

Ceiling. Texts, GAUTHIER, pp. 165–6.

19. AMENMOSI 𓇋𓏠𓈖𓄤𓏤, First prophet of 'Amenophis of the Forecourt'. Temp. Ramesses I to Sethos I (?).

Dra' Abû el-Naga'.

Wife, Iuy 𓇋𓅱𓇋𓇋𓂝, Chief of the harîm of Amenophis.

Plan, p. 30. Map I, C–7, c, 9.

FOUCART, *Le Tombeau d'Amonmos* in *Tombes thébaines. Nécropole de Dirâʿ Abûʾn-Naga* (*M.I.F.A.O.* lvii. 3), Pts. i and iv (ii and iii unpublished), *passim*, including scenes copied by Hay (since destroyed). Plan, id. ib. Pt. i, fig. 1 facing p. 2. Copies of scenes, by BAUD, with restorations from HAY MSS., are in Brussels, Mus. roy. du Cinquantenaire. Fragments from scenes, FOUCART, Pt. iv, pl. xxxiii [B–D].

Hall. Views, M.M.A. photos. T. 1011–12.

(1) Soffit. Offering-list and text, FOUCART, Pt. iv, pl. xxxiv.

(2) Wife seated.
Id. ib. pl. i [C], Pt. i, fig. 3, cf. pp. 2–4.

(3) [1st ed. 1] Three registers, Valley Festival and funeral procession (left part destroyed). **I,** [Bark of Mut] and bark of Amen-rēʿ towed on canal, [statue of 'Amenophis of the Fore-court' in palanquin carried by priests], and men acclaiming. **II,** Bark with statue of ʿAḥmosi Nefertere dragged from temple. **III,** ['Nine friends', sarcophagus] dragged by men and oxen, with female mourners, and men with funeral outfit.

FOUCART, *Amonmos*, Pt. iv, pls. ii–viii, figs. 4–6, on pp. 25, 37, 83, cf. pp. 180–2; M.M.A. photos. T. 1005, 1011 [left and middle], 1118; SCHOTT photos. 1486, 1488, 4934, 4936–9, 4943–8; HAY MSS. 29851, 190–204; bark of Amen-rēʿ, FOUCART, *Un Temple flottant* [&c.] in *Mon. Piot*, xxv (1921–2), fig. 1, cf. p. 147; id. in *B.I.F.A.O.* xxiv (1924), pl. xiv; SCHOTT in NELSON and HÖLSCHER, *Work in Western Thebes, 1931–33* (*Chic. O.I.C.* No. 18), fig. 30, cf. p. 73; CHIC. OR. INST. photo. 10345. Man hauling rope in **I,** PETRIE, *Arts and Crafts*, fig. 77. Mourners and men and oxen dragging in **III,** LICHTHEIM in *J.N.E.S.* vi (1947), pl. vii [B], p. 174, note 41; mourners, WERBROUCK, *Pleureuses*, figs. 10, 139, cf. p. 25; WEGNER in *Mitt. Kairo*, iv (1933), pl. xxiv [a].

(4) [1st ed. 2, 3] Three registers, Festival of Amenophis I and funeral procession. **I,** Two scenes, **1,** [bark of Amenophis I on lake with female mourners, and men dragging royal statue], **2,** single-stick and wrestling, and bark with statue of Tuthmosis III before his temple. **II,** Two scenes, **1,** [deceased and priest before two rows of seated Kings and Queens], **2,** bark of ʿAḥmosi Nefertere towed on lake with trees, heaps of offerings, and female mourners, and two statues of Amenophis I in palanquins with priests in front of temple. **III,** [Butchers] and cow with [mutilated calf, male relatives, lector with Opening the Mouth instruments, three priests] pouring libation before mummies and stela at pyramid-tomb, and deceased with son Beknay 𓀀𓏏𓇌𓏤 and wife adore Ḥatḥor-cow in mountain protecting King.

FOUCART, *Amonmos*, Pt. iv, pls. ix–xvi (some from HAY and CHAMPOLLION); *Brooklyn Mus. Annual Report for 1935*, fig. on p. 38 [lower] (from painting by BAUD); HAY MSS. 29844 A, 203, 205, 29848, 69, 29851, 205–27, 29853, 203, 206–9, 29854, 1. Right half, M.M.A. photos. T. 1006, 1011 [right], 1119; CHIC. OR. INST. photos. 10345–7; SCHOTT photos. 1487, 4951–5, 4970–1. **I, 2,** and **II, 2,** WRESZ., *Atlas*, i. 118; FARINA, *Pittura*, pl. clvi. Single-stick and wrestling in **I, 2,** ROSELLINI, *Mon. Civ.* pl. ciii [upper, middle, and right]; DAVIES in *M.M.A. Bull.* Pt. ii, Dec. 1923, fig. 18, cf. p. 50; VANDIER D'ABBADIE in *Ann. Serv.* xl (1940), figs. 52, 55, cf. pp. 468, 477; single-stick, WILKINSON, *M. and C.* ii. 439 (No. 311) = ed. BIRCH, ii. 72 (No. 339); wrestling, WEIGALL, *Anc. Eg. . . . Art*, 251 [upper]. **II, 1,** ROSELLINI, *Mon. Stor.* xlv [3], cf. Text, iii, Pt. i, pp. 305–7; CHAMP., *Mon.* clxxxiv [2]; **II, 2,** HÖLSCHER, *Excavations at Ancient Thebes, 1930/31* (*Chic. O.I.C.* No. 15), fig. 4, cf. p. 8. Cow and calf in **III,** WEIGALL in *J.E.A.* ii (1915), fig. 2 (from HAY), cf. p. 10; relatives, lector, mourners,

and mummies, WERBROUCK, *Pleureuses*, figs. 8, 64, 146, cf. p. 25; mourners and mummies at tomb, WEGNER in *Mitt. Kairo*, iv (1933), pl. xxiii [b]; SCHOTT photo. 4950; stela and tomb, FISHER in *Penn. Mus. Journ.* xv (1924), fig. on p. 40; DAVIES (Nina) in *J.E.A.* xxiv (1938), fig. 6, cf. p. 36; tomb, PETRIE, *Qurneh*, pl. xxxviii [bottom left], p. 11.

(5) [1st ed. 8, 9] Two registers, Book of Gates and funeral ceremonies. **I**, Weighing-scene, and Horus with assessors, leading deceased and wife, reports to Osiris and winged Isis. **II**, Three scenes, **1**, [priest] libates to deceased and wife, **2**, female mourner, **3**, [two priests before deceased and wife] at pyramid-tomb.

FOUCART, *Amonmos*, Pt. iv, pls. xvii (from HAY)–xix; M.M.A. photo. T. 1010. Left part of **I** and **II**, HAY MSS. 29851, 152–62. **II**, *Brooklyn Mus. Annual Report for 1935*, fig. on p. 38 [upper] (from painting by BAUD). Jars in stand in **II**, PETRIE, *Qurneh*, pl. xxxviii [top middle], p. 11; SCHOTT photo. 4968.

(6) [1st ed. 6, 7] Two registers. **I**, Double-scene, right half, [deceased, with son Beknay and wife], censes and libates to Rēʿ-Ḥarakhti-Atum, Amenophis I, Ḥatḥor, and Western goddess, left half, [deceased, mother, and daughter (?)] before three divinities and King. **II**, Two scenes, **1**, priest, lector, and female mourners, before deceased and wife at pyramid-tomb, **2**, son Beknay, followed by priest, son Panefernekhu ⟨hieroglyphs⟩ as lector, and female mourners, offers bouquet to deceased and wife, and tree-goddess scene with *bas* drinking and *Benu*-bird behind them.

FOUCART, *Amonmos*, Pt. iv, pls. xx and xx bis (from HAY), xxi–xxv; M.M.A. photo. T. 1009, and on 1012; HAY MSS. 29851, 163–71, 185–9; parts, SCHOTT photos. 4942, 4964–5, 4967, 4969. **II, 1**, WRESZ., *Atlas*, i. 120; mourners, WERBROUCK, *Pleureuses*, figs. 172–3.

(7) [1st ed. 4, 5] Two registers. **I**, Statue of Amenophis I in palanquin carried from his temple and acclaimed by priests and priestesses with sistra and tambourines, and small scenes of servants with food in booths above. **II**, Two scenes, each before deceased and wife seated in front of pyramid-tomb, **1**, priest, lector, and female mourners, **2**, son Beknay, man with bouquet, and man with vase.

FOUCART, *Amonmos*, Pt. iv, pls. xxvi–xxxii (partly from HAY); M.M.A. photos. T. 1008, and on 1012. **I**, omitting temple, SCHOTT photos. 4940–1, 4956–60; statue carried from temple, WRESZ., *Atlas*, i. 119; DAVIES (Nina), *Anc. Eg. Paintings*, ii, pl. lxxxv; HAY MSS. 29851, 172–84; pylon of temple, SPIEGELBERG, *Zwei Beiträge zur Geschichte und Topographie der thebanischen Nekropolis*, fig. on p. 3; tablet on pylon, HAY MSS. 29848, 71 [top]. Sketches of offering-bringers and woman from left end, BAUD, *Dessins*, fig. 22. Offerings in **II, 1**, and **II, 2**, incomplete, SCHOTT photos. 4961–3; tomb in **1**, and man with vase in **2**, PETRIE, *Qurneh*, pl. xxxviii [right, and upper left], p. 11; tomb, DAVIES (Nina) in *J.E.A.* xxiv (1938), fig. 5, cf. p. 36.

(8) Entrance to Inner Room. Lintel, double-scene, priest offers to deceased and wife. FOUCART, *Amonmos*, Pt. iv, pl. xxxiii [A]; M.M.A. photo. T. 1007.

20. MENTUḤIRKHOPSHEF ⟨hieroglyphs⟩, Fan-bearer, Mayor of Aphroditopolis. Temp. Tuthmosis III (?).

Draʿ Abû el-Nagaʿ.

Mother, Taysent ⟨hieroglyphs⟩.

Plan, p. 30. Map I, C–7, a, 10.

DAVIES, *Five Theban Tombs*, pp. 1–19, with plan and section, pl. xv; MASPERO, *Tombeau de Montouhikhopshouf* in VIREY, *Sept Tombeaux thébains* (*Mém. Miss.* v, 2), pp. 435–68.

Entrance.

(1) Fragments of outer lintel, jambs, and north thickness, with remains of texts, DAVIES, pl. xiii [A], pp. 2, 3, 7.

Hall.

(2) Inner jambs, texts with deceased seated at bottom.
DAVIES, pl. xiii [B, C], pp. 3, 7.

(3) Sketch of Bes.
BAUD, *Dessins*, fig. 28.

Passage.

(4)–(5) Deceased inspects three registers. **I–III,** Funeral ceremonies, including seven of the 'Nine friends' carrying coffin, *teknu*, and 'raising the olive-tree' in **I,** priestesses in **II,** butchers and victims in pits in **II** and **III,** and Nubian captives in **III.** Sub-scene, funeral procession, including *teknu*, and ram in shrine, before deceased and mother, with dog held by monkey under chair.

DAVIES, pls. ii–x, xi [6], xiv [right upper, and fragments 1, 2, 4–7, 9–11], xvi [upper left, lower], cf. key-plan on pl. xiv, and pp. 9–19, with fig.; MASPERO, figs. 1–12, pp. 436–62, and pl. Man kneeling before pit with offerings in **III,** SCHOTT photo. 4099. Men striking resonant sticks in sub-scene, HICKMANN in *Bull. Inst. Ég.* xxxvii (1956), p. 113, fig. 45. Block with man and offerings, from Rustafjaell Collection, in Brit. Mus. 910, DAVIES, pls. xi [1], iv [left], p. 9, note 4; *Sotheby Sale Cat.* Dec. 19–21, 1906, pl. ix [11]; see *Guide* (*Sculpture*), p. 134 [473]. Fragment with offerings is in Cairo Mus. Ent. 43369.

(6) Remains of four registers, men with ointment (probably here).
DAVIES, pls. xiv [left], xvi [upper right], p. 9.

(7) [Deceased] on foot with attendants hunting in desert, including wild sheep and ass giving birth. Sub-scene, [men bringing game].
DAVIES, pl. xii [middle and right], cf. pl. i, pp. 8–9. Block with stag's head on recto, and text on verso, in Cairo Mus. Ent. 43367 a, b, DAVIES, pls. i [1], xi [5], p. 8, note 1; *Encyclopédie photographique de l'art. Mus. Caire*, pl. 152; HILZHEIMER in BORCHARDT, *Das Grabdenkmal des Königs S'aṣhu-reʿ*, Abb. 27 (called Prince Mentuḥirkhopshef). Three fragments, with gazelle and wild ass, are in Cairo Mus. Ent. 51952.

(8) Offering-list ritual and offering-bringers before deceased and brother (?), with dog crouching under chair.
DAVIES, pls. xi (omitting fragments 1, 5, 6), xii [left], xiv [3], pp. 7–8; part, BAUD *Dessins*, figs. 25–7.

Ceiling. Fragments, DAVIES, pl. xiii [F–H], pp. 4–5.

21. USER †|⌣, Scribe, Steward of Tuthmosis I. Temp. Tuthmosis I.
Sh. ʿAbd el-Qurna.
Wife, Bakt 𓏏𓃂𓅓.

Plan, p. 30. Map V, D–4, g, 8.

DAVIES, *Five Theban Tombs*, pp. 20–7, with plan and section, pl. xviii.

Hall.

(1) Man with jar. (2) Deceased, wife, and boy. (3) [Deceased offering].
See DAVIES, pp. 21–2.

(4) Heifers threshing and men carrying corn.
DAVIES, pl. xix [1], p. 22.

(5) Remains of stela, double-scene at top, deceased adoring and Anubis-jackal.
DAVIES, pl. xx [3], p. 22; HERMANN, *Stelen*, p. 58, Abb. 7, and p. 19* [lower]. Text,
HELCK, *Urk.* iv. 1497–8 [top] (from DAVIES and HERMANN).

(6) Text in destroyed scene.
See DAVIES, p. 22.

Ceiling. Text, DAVIES, pls. xix [4, columns 2–6 from left], xx [2], pp. 22–3.

Passage.

(7) Lintels and jambs, [texts], with [deceased seated] below on outer jambs.
See DAVIES, pp. 21, 23.

(8) Five registers, I–V, funeral procession to [Western goddess], including [Abydos pil-
grimage] in **I**, sacred oars, two priests purifying man seated on jar, obelisks, rites in garden,
and harîm, in **IV**, and cloaked priest 'waking' and victims in **V**.
DAVIES, pls. xx [top left], xxi, pp. 24–5. Purification in **IV**, CHIC. OR. INST. photo. 10367;
GRDSELOFF, *Das ägyptische Reinigungszelt*, Abb. 7 (from DAVIES), cf. pp. 32–3. Trees, pool,
and shrine, in **IV**, SCHOTT photo. 8450. Title of deceased in **I**, HELCK, *Urk.* iv. 1499 [bottom]
(from DAVIES).

(9) [Two sons offer to deceased and wife.]
DAVIES, pl. xx [1], p. 24. Text of one son, HERMANN, *Stelen*, p. 14* [77].

(10) [Deceased] in chariot hunting in desert. Sub-scene, men bringing game, including
hyena on pole and ostrich.
DAVIES, pls. xxii–xxiv, p. 23; CHIC. OR. INST. photos. 10368–71. Gazelle in desert, and
men bringing hares and ostrich, SCHOTT photos. 7134–9; man with ostrich, LEIBOVITCH,
La Plume d'autruche in *Formes et Couleurs*, xi [1], (1949), fig. 10.

(11) Rites before mummies.
DAVIES, pl. xx [4], pp. 23–4.

Inner Room.

(12) [1st ed. 1] [Man] offers to deceased holding bouquet of Amūn.
DAVIES, pl. xxviii [left], pp. 25–6; SCHOTT photos. 5943–4, 7245–6, 8454–6. Deceased,
MACKAY in *J.E.A.* x (1924), pl. ix [1], pp. 41–2. Offerings, CHIC. OR. INST. photo. 10372.
Texts, HELCK, *Urk.* iv. 1499 [middle] (from DAVIES).

(13) [Man] offers to deceased holding bouquet of Amūn, with dog under chair.
DAVIES, pl. xxvii, pp. 25–6. Head of deceased, and jar in offerings, SCHOTT photos. 7244,
4330.

(14) Daughter offers bowl to deceased and wife with dog under her chair.
DAVIES, pl. xxvi, p. 26. Deceased and wife, SCHOTT photos. 7242, 8451, 5946, and details,
4332, 5945, 8452–3, 8457. Offerings, CHIC. OR. INST. photo. 10372. Text of deceased and
wife, HELCK, *Urk.* iv. 1498 [middle] (from DAVIES).

(15) As at (14).

DAVIES, pl. xxv, cf. xxviii [bottom right], p. 26. Daughter, SCHOTT photos. 5942, 4329; arm of daughter, bowl, &c., id. *Altägyptische Liebeslieder*, pl. 14. Text of daughter, HELCK, *Urk.* iv. 1498 [bottom]–1499 [top] (from DAVIES).

(16) Two registers, a daughter in each.
See DAVIES, p. 21.

(17) As at (16).
DAVIES, pl. xix [2], p. 21. **II**, SCHOTT photos. 4331, 5947.

(18) Statues of two seated couples.
DAVIES, pl. xix [3], p. 21.

Ceiling. Texts, DAVIES, pl. xix [4, left column], pp. 26–7.

22. WAḤ 𓏲𓂝𓎛, Royal butler. Partly usurped by Mery[amūn] [𓇓𓏤]𓈖𓇋𓇋, Eldest son of the King. Temp. Tuthmosis III (?).

Sh. ʿAbd el-Qurna.
Wife (of Mery[amūn]), Ḥatshepsut 𓆓𓄿𓏏𓈙𓊪𓏏.

Plan, p. 30. Map V, D–4, i, 8.

Plan, MOND in *Ann. Serv.* vi (1905), p. 75, fig. 10.

Hall. View, M.M.A. photo. T. 3021.

(1) Two scenes. **1**, Deceased (or brother) with family offers on braziers, with butchers below offerings. **2**, [Man] with offering-list offers to couple and family. Sub-scene, deceased with attendant receives produce.

M.M.A. photos. T. 3012–13; SCHOTT photos. 8530–5, 3139–40, and details, 4679, 4683–5, 3138. Translation of text of burnt-offering in **1**, SCHOTT, *Das schöne Fest*, p. 866 [39]. Sub-scene, WRESZ., *Atlas*, i. 62.

(2) Stela with double-scene at top, deceased adores Osiris. At sides, three registers, **I** and **II**, offering-scenes (including girl offering *menat* in **I** on right), **III**, offering-bringers.

HERMANN, *Stelen*, pl. 3 [c], pp. 5*–6* [32–4], 37, 69; M.M.A. photo. T. 3014; SCHOTT photos. 8536, 4681. **II** and **III** on left, BAUD, *Dessins*, figs. 32–3.

(3) [1st ed. 2] Deceased and wife with [man] offering to them, and three registers, **I–III**, male harpists, clappers, and offering-bringers.

M.M.A. photos. T. 3015–16. **I–III**, WRESZ., *Atlas*, i. 121 [B]; **I** and **II**, FARINA, *Pittura*, pl. lxxxvi. Standing harpist in **I**, HICKMANN in *Bull. Inst. Ég.* xxxv (1954), fig. 5, cf. p. 313; id. *45 Siècles de Musique*, pl. xxxi [D]. Clappers and first offering-bringer in **II**, SCHOTT photo. 4680. Text above deceased and wife, MOND in *Ann. Serv.* vi (1905), p. 75.

(4) [1st ed. 5] Four registers, banquet, **I–II** with man offering to deceased, wife, and daughter, **III–IV** with similar scene. **I–IV**, Guests and musicians (women dancing with double-pipe and lyre in **I**, male lutist in **II**, woman with tambourine, clapper, and small Nubian girl dancing in **III**, and male harpist in **IV**).

M.M.A. photos. T. 3008–11. Deceased, wife, and daughter, in **III–IV**, MACKAY in *J.E.A.* iv (1917), pl. xvi [6], p. 81. **I–IV**, WRESZ., *Atlas*, i. 76 a, b; **I** and **II**, SCHOTT photos. 4686,

3135–7, 3161–3, 5531–6, 5885–6, 8544–6. Female musicians and first guest in **I**, DAVIES (Nina), *Anc. Eg. Paintings*, i, pl. xxvi (CHAMPDOR, Pt. iii, 9th pl.); DAVIES (Nina), *Eg. Paintings* (Penguin), pl. 2; HICKMANN, *45 Siècles de Musique*, pl. xxxi [C]. Girl with vase in **I**, and harpist in **IV**, BAUD, *Dessins*, figs. 29–31. Women and girl in **III**, LHOTE and HASSIA, *Chefs-d'œuvre*, pl. 121; BRUYÈRE, *Rapport (1934–1935)*, Pt. 2, fig. 56 [right], cf. p. 113.

(5) [1st ed. 4] Two registers. **I**, Deceased with family fishing and fowling. **II**, Deceased inspects vintage, with netting and preparing fowl below.

WRESZ., *Atlas*, i. 40, 68, 121 [A]; CAPART and WERBROUCK, *Thèbes*, fig. 186 (from WRESZIN-SKI); M.M.A. photo. T. 3007, cf. 3021; SCHOTT photos. 3158, 4671–4, 8541. **I**, MACKAY in *J.E.A.* iv (1917), pl. xvii [5, 6], p. 82. Fragment of text of Mery[amūn] in **I** and text above deceased in **II**, MOND in *Ann. Serv.* vi (1905), p. 75 [bottom].

(6) [1st ed. 3] Deceased and wife with [man] offering to them, and four registers. **I–IV**, Guests, clappers, and male and female harpists. Sub-scene, men bringing provisions and preparing drink.

M.M.A. photos. T. 3018–20. **I–IV**, and men bringing provisions, WRESZ., *Atlas*, i. 122; SCHOTT photos. 8538, 3160, with details, 3154–7, 4677–8, 8537, 8539–40, 8542–3. Harpists and guest in **IV**, BAUD, *Dessins*, pl. iv (called tomb 20), p. 83. Vase in front of foot of deceased, VERCOUTTER, *L'Égypte* [&c.], pl. xxxvi [242], p. 310.

(7) Entrance to Inner Room. Outer lintel and jambs, offering-texts.
M.M.A. photo. T. 3017.

23. THAY 𓀁𓃀𓏭𓏭𓂻, also called To 𓏏𓂝, Royal scribe of the dispatches of the Lord of the Two Lands. Temp. Merneptaḥ.

Sh. ʿAbd el-Qurna. (L. D. Text, No. 38.)

Parents, Khaʿemteri 𓂋𓏏𓂝𓈉, Scribe of soldiers, and Tamy 𓂝𓃀𓏭𓏭𓈖. Wives, Raʿya 𓂋𓏭𓃀𓏏, Chief of the harîm of Sobk, and Nebttaui 𓏏𓂝.

Plan, p. 30. Map V, D–4, i, 9.

L. D. Text, iii, pp. 252–3. Rediscovered by WILBOUR, see id. *Travels in Egypt*, pp. 55–6. Sketch-plan and names, WILBOUR MSS. 2 A. 62–3, 2 F. 22 [middle right].

Court. View, M.M.A. photo. T. 610.

(1) Outer left jamb and all thicknesses, remains of text, with [deceased kneeling] on thicknesses. (2) Deceased kneeling adores Osiris.

(3) Two registers. **I**, Deceased kneels before a god and goddess. **II**, Deceased gives bouquet to wife at house, and deceased arriving in chariot, with men acclaiming and girls playing tambourines.

Deceased and wife at house, DAVIES, *Town-House*, fig. 7, cf. p. 246.

(4) [1st ed. 1] Two registers. **I**, [Deceased before a god]. **II**, Pharaoh's 'Foreign Office'. **II**, BORCHARDT in *Ä.Z.* xliv (1907–8), Abb. 1, cf. pp. 59–61.

(5) Two registers. **I**, Deceased. **II**, Priest with text of good wishes and [ritual-scene] in Fields of Peace.

(6) [1st ed. 2] Man offers to deceased seated.
Monkey attacking goose under chair, WRESZ., *Atlas*, i. 123 [B].

(7) Deceased adores goddess, and [marsh-scene] beyond.

(8) [1st ed. 4] Two registers. **I,** [Deceased kneels before a god.] **II,** Priest censes and libates offerings to deceased and Ra‹ya with text of New Year Festival.
Altar with New Year candle and five tapers in **II,** DAVIES in *J.E.A.* x (1924,) pl. vii [14], pp. 12–13; SCHOTT photo. 9099.

(9) Tree-goddess scene. (10) Remains of scenes with divinities at bottom.

Portico.

(11) Deceased. (12) Four scenes, man offers to statues of deceased. (13) Priest before mummy.

(14) [1st ed. 3] Three registers. **I,** Deceased (?) adoring and long hieratic text of self-praise. **II,** Scribes and priests seated with offerings, man before three priests, and preparation of mummies. **III,** Four scenes, man offers to statues of deceased.
II, DAWSON in *J.E.A.* xiii (1927), pl. xvii (from drawing by DAVIES), pp. 46–7; preparation of mummies, WRESZ., *Atlas*, i. 124; M.M.A. photos. T. 1911–12 (including hieratic text in I).

(15) Stela, two registers. **I,** Relatives before mummy. **II,** Hymn to Amūn. At sides, text. SCHOTT photo. 3616.

(16) Stela, two registers, double-scenes. **I,** Deceased adores Osiris, and adores Rēꜥ-Ḥarakhti. **II,** Priest offers to, and purifies, a god. Below stela, hymn to Osiris, and at sides, text.
Hymn and text, SCHOTT photo. 3615.

Hall.

(17) Outer jambs, deceased at bottom, and text beyond each jamb.

(18) Deceased with courtiers (including two viziers) rewarded before Merneptah with souls of Pe and Nekhen and winged goddess. Remains of sub-scene, bull with decorated horns.
Cartouches, L. *D. Text*, iii, p. 252 [upper middle left].

(19) Deceased adores Ḥathor making *nini*. (20) Entablature with Ḥathor-heads, and stela with *zad*-pillar between two figures of deceased, and personified *zad*-pillar on each side upheld by deceased kneeling.

(21) [1st ed. 5] Three registers. **I,** Deceased, followed by wife, censes and libates with offerings. **II,** Deceased offers flowers to [standards] in kiosk. **III,** Two scenes, **1,** tree-goddess scene, **2,** priest censes offerings, with candle and two torches, before deceased and wife.
Offerings, candle and torches, and deceased, in **III,** SCHOTT photo. 3614; candle and torches, DAVIES in *J.E.A.* x (1924), pl. vii [13], p. 12, note 2.

(22) Entrance to South Chapel. Above doorway, baboons adoring and souls of Pe and Nekhen before bark containing Merneptaḥ offering to Atum. Right of doorway, two registers, **I,** Western goddess in mountain making *nini* (?), **II,** wife seated.
Scene above doorway, DUEMICHEN, *Hist. Inschr.* ii, pl. xliv [f].

(23) Two registers. **I**, Two scenes, 1, deceased offers to Ptaḥ and goddess, 2, deceased adores Thoth and Maʿet. **II**, Book of Gates, deceased adores demons in shrines.

(24) [1st ed. 6] Three registers. **I**, Deceased adores Amenophis I and ʿAḥmosi Nefertere. **II**, Book of Gates, deceased adores demons in shrines. **III**, Deceased libates to couple.
I, *L. D.* iii. 199 [d].

(25) [Stela] with entablature and remains of offering-scenes. At sides, personified *zad*-pillar with deceased adoring below.

(26) Three registers. **I–II**, Book of Gates, **I**, deceased offers to Nefertem and to bark of Sokari, **II**, deceased before demons in shrines. **III**, Lutist with song, priest libating, and offering-list, before deceased and wife. Sub-scene, ploughing, threshing (?).

(27) Entrance to North Chapel. Outer lintel, deceased offers bouquet to Osiris and Isis, left jamb, two registers, **I**, demon with knife, **II**, woman seated.
Text on jamb, WILBOUR MSS. 2 F. 22 [bottom].

(28) and (29) Two statues, with Anubis-jackal above at (28).

Passage.

(30) Outer lintel, double-scene, deceased adores Osiris and Isis, and adores Osiris and Anubis, left jamb, remains of *zad*-pillar.
Text of deceased and Raʿya on lintel, WILBOUR MSS. 2 F. 22 [middle left].

(31)–(32) [1st ed. 7] Two registers. **I**, [Deceased] before Nefertem-emblem supported by Kings, deceased and wife with four boxes of coloured cloth before bark of Sokari, Thoth as baboon in shrine, and weighing-scene. **II**, Funeral procession with sarcophagus dragged by oxen, funeral outfit, mourners, two viziers, male relatives, cow and mutilated calf, [tomb with portico], and [deceased] embraced by Western goddess.
View showing right part, GR. INST. ARCHIVES, photo. 1208 A. Middle of **I**, and relatives with calf in **II**, SCHOTT photos. 2157–8, 3611–13; calf, WEIGALL in *J.E.A.* ii (1915), fig. 3, cf. p. 10; mourners, WRESZ., *Atlas*, i. 123 [A]; WERBROUCK, *Pleureuses*, pl. xxxvii, fig. 153, cf. pp. 26–7; M.M.A. photo. T. 1910; portico, DAVIES (Nina) in *J.E.A.* xxiv (1938), fig. 13, cf. p. 38. Block with part of Western goddess, in Berlin Mus. 14220, SCHARFF, *Götter Ägyptens*, pl. 32; text, *Aeg. Inschr.* ii. 218; see *Ausf. Verz.* p. 148.

(33)–(34) [1st ed. 9–8] Two registers. **I**, Book of Gates, including deceased and wife adoring Ptaḥ-Sokari and emblems in shrines, and bull and seven cows with sacred oars, deceased and wife led by Horus to Osiris with Isis and Nephthys, and deceased and wife before Osiris and winged Maʿet. **II**, [Man] offers to deceased and Raʿya, brother offers to deceased, Nebttaui, and relatives, deceased offers to parents and relatives.
Parents in **II**, *L. D.* iii. 199 [g], cf. *Text*, iii, p. 253. Texts of leading-scene in **I**, and of parents in **II**, DUEMICHEN, *Hist. Inschr.* ii, pl. xliv [d, e, ll. 4–9].

Inner Room.

(35) Entablature, with Anubis-jackal at each end. Jambs, texts. Right thickness, Anubis.
View, GR. INST. ARCHIVES, photo. 1208 A.

(36) Deceased adores Ḥathor.

(37) [1st ed. 10] Priests with offering-list before deceased and wife, and litany.
Litany, SCHOTT photo. 3610. Titles of deceased, DUEMICHEN, *Hist. Inschr.* ii, pl. xliv [c, left, six columns].

(38) Deceased with bouquet. (39) Deceased receives life from Western goddess.

(40) [1st ed. 11] Thoth with image of Maʿet, followed by Horus and deceased with Raʿya before Osiris, Maʿet, and Western goddess.
Names, and titles of Raʿya, DUEMICHEN, op. cit. pl. xliv [c, right, three columns].

(41) Deceased with offerings.

Granite sarcophagus. GR. INST. ARCHIVES, on photo. 1208 A.

Shrine. Details and sketch-plan, WILBOUR MSS. 2 A. 62–3.

(42) [part, 1st ed. 12, incorrectly placed in entrance] Niche with statues of couple. Left wall, deceased censing and libating, right wall, Hathor-cow in mountain.
Text of deceased, DUEMICHEN, *Hist. Inschr.* ii, pl. xliv [b].

(43) [part, 1st ed. 15] Niche with statues of couple. Left wall, Hathor-cow in mountain, protecting Ramesses II, right wall, [deceased].
Left wall, L. D. iii. 199 [h], cf. *Text,* iii, p. 253; omitting King, LANZONE, *Diz.* pl. cccxxi [1], p. 896.

(44) [1st ed. 13, 14] Niche with statues of Osiris, goddess, and hawk-headed god. Left wall, ʿAhmosi Nefertere, right wall, Amenophis I.
Walls, L. D. iii. 199 [e, f], cf. *Text,* iii, p. 253.

24. NEBAMŪN ⟨𓈖𓏏𓊵⟩ ⌣, Steward of the royal wife Nebtu. Temp. Tuthmosis III.
Draʿ Abû el-Nagaʿ.
Parents, Tetires 𓂝𓏏𓈖𓏏 ⊂⊃ and Ipu ⟨𓄿𓏏𓎛𓏏⟩. Wife, Resti 𓂋𓏏 ⊂⊃ 𓏏.
Plan, p. 30. Map I, C–7, a, 10.
BOURIANT in *Rec. de Trav.* ix (1887), pp. 95–9 [75]. Titles, SETHE, *Urk.* iv. 152–3 (61), 1–2 on ceiling, 3 at (8), 4 at (3)–(4), 5 at (6).

Court.
(1) False door.

Hall.
(2) Thicknesses, [deceased and wife]. Inner jambs, texts.
Texts on thicknesses, BOURIANT, p. 95 [middle lower].

(3)–(4) [1st ed. 1] Deceased and wife, son with offering-list before them, and four registers. I–II, Funeral procession to Western goddess (including Abydos pilgrimage in I, and oxen dragging [coffin], and *teknu* in II). III, Rites before mummies. IV, Agriculture (including pigs and oxen treading grain, and men pulling flax).
IV, CHIC. OR. INST. photos. 10316–17. Pigs, WRESZ., *Atlas,* i. 97 [upper]; NEWBERRY in *J.E.A.* xiv (1928), pl. xix [2], p. 219; incomplete, NORTHAMPTON, &c. *Theban Necropolis,* p. 14, fig. 15. Texts, BOURIANT, pp. 97–8; text of oxen in II, LÜDDECKENS in *Mitt. Kairo,* xi (1943), pp. 72–3 [27] (from copy by SETHE).

(5) [Deceased] and wife seated, with text above, and six groups of [wrestlers] below. See Bouriant, p. 98.

(6) [1st ed. 2] Niche. Left wall, [deceased purified].
Texts, Bouriant, p. 99 [middle].

(7) [Deceased on foot] hunting in desert.
See Bouriant, p. 99 [top].

(8) [1st ed. 3] Four registers. I,`[Deceased and family fishing and fowling]. II–III, Deceased and wife with son offering to them, and banquet, including harpists with song. IV, Deceased and wife receiving produce of Delta, and vintage.
　　Deceased and wife in II–III, Schott photos. 8684–5. Texts, Bouriant, p. 98 [bottom]; text in IV, Sethe, *Urk.* iv. 152–3 (62). Translation of part of song, Schott, *Das schöne Fest*, p. 893, note 1.

(9) [1st ed. 4] Stela. Double-scene at top, deceased kneeling adores Anubis and Osiris, and text, including autobiography, 'Address to the living', and mention of Valley Festival.
　　Gr. Inst. Archives, photo. 1730. Text, Schott photo. 4098; Bouriant, pp. 95–7; Sethe, *Urk.* iv. 145–52 (60).

Ceiling. Texts, Bouriant, p. 99 [lower].

25. Amenemḥab 〔𓏏𓏤𓎟〕, First prophet of Khons. Ramesside.
　　ʿAsâsif.
　　Wife, Tausert 𓄿𓏏𓊪𓏏𓁹, Chief of the harîm of Khons.
　　　　　　　　　　　Plan, p. 30. Map IV, D–5, c, 6.
Hall.

(1) Outer lintel, double-scene, deceased and wife adore Rēʿ-Ḥarakhti and Maʿet, and adore Osiris and Isis, jambs, offering-texts. Thicknesses, deceased and wife adoring with hymn to Amen-rēʿ on left thickness, and hymn to Osiris on right.

(2) Two registers. I, Deceased led by Thoth and Horus to Anubis and Western goddess, and two pools with divinities. II, Priest before Osiris.

(3) Two registers. I, Deceased and wife before Rēʿ-Ḥarakhti. II, Mummies at pyramid-tomb with Ḥathor-cow in mountain.

(4) Two registers. I, Book of Gates, deceased kneeling before divinities, deceased and wife led, weighing-scene, and Thoth reporting to Osiris and Isis. II, Three scenes, each with deceased and wife, **1**, kneeling before [divinity?], **2**, before house and garden with pool, **3**, seated.

(5) Two registers, offering-scenes.

(6) People before Osiris and two goddesses.

(7) Entrance to Inner Room (blocked). Outer lintel, double-scene, [deceased before divinities], jambs, text.

26. KHNEMEMḤAB ⟨hieroglyphs⟩, Overseer of the treasury in the Ramesseum in the estate of Amūn. Temp. Ramesses II.

ʿAsâsîf. (L. D. *Text*, No. 29.)

Wife, Meryēsi ⟨hieroglyphs⟩.

Plan, p. 44, cf. p. 292, key-plan. Map IV, D–5, a, 6.

Façade. View, Gr. Inst. Archives, photo. 1209.

(1) Stela, deceased adores Rēʿ-Ḥarakhti and Maʿet, and hymn to Amen-rēʿ-Ḥarakhti.

(2) Stela, deceased adores Osiris and Western goddess, and remains of hymn to Osiris.

Hall.

(3) Outer jambs, titles and deceased seated at bottom, with column of text, year 5 of Sethos II (added later) on each side. Outer thicknesses, texts. Left inner thickness, deceased adoring and wife holding sistrum and papyrus-stalk, with hymn to Rēʿ-Ḥarakhti. Right inner thickness, Ḥuy and wife Iryy (?) (or perhaps Iryiry) ⟨hieroglyphs⟩ adoring with hymn to Osiris.

Left inner thickness, Gr. Inst. Archives, photo. 1727.

(4) Deceased, wife, and couple, before Osiris and Anubis.

(5) [1st ed. 1] Two registers. I, Scenes in Book of Gates. II, Deceased adores bull and seven cows with sacred oars.

Name and titles in I, L. D. *Text*, iii, p. 249.

(6) Deceased and wife adoring, and deceased and wife before Osiris, Isis, and Nephthys. (7) Inmutf-priest before Horus (?) and Anubis (unfinished). (8) Two registers, I, deceased offers to Rēʿ-Ḥarakhti, Atum, Shu, Nut, and a god, II, seated couple, and man censing and libating to deceased and wife. (9) Deceased and wife adore Rēʿ-Ḥarakhti, Maʿet, and Western goddess.

Inner Room.

(10) Outer lintel, deceased at left end, jambs, text, with deceased seated below. Thicknesses, deceased and [wife], with hymn to Rēʿ on left thickness.

27. SHESHONĶ ⟨hieroglyphs⟩, Chief steward of the divine adoratress ʿAnkhnesneferebrēʿ. Temp. Apries and Amasis.[1]

ʿAsâsîf. (Inaccessible.)

Parents,[1] Ḥarsiēsi ⟨hieroglyphs⟩, Chamberlain of the divine adoratress, and Tahibet ⟨hieroglyphs⟩ (from cone).

Map II, D–5, h, 8.

Burton MSS. 25639, 11, with plan and elevation; Wild MSS. ii. C. 8–15, with plan and sketches; plan, section, and elevation, Hay MSS. 29821, 84–5; Bankes MSS. ii. A. 3–4; plan, section, and views, Prisse, *L'Art égyptien*, i, 46th pl. [5–7, and bottom] 'Nécropole de Thèbes'. Brick structures, Wilkinson, *M. and C.* ii. 131 (No. 119) = ed. Birch, i. 368 (No. 139); Wilkinson MSS. ii. 58 [lower]; Hay MSS. 29821, 112, 117; Lane MSS. 34085,

[1] According to Christophe in *Ann. Serv.* liv (1956–7), pp. 83–100, but see Lichtheim in *J.N.E.S.* vii (1948), p. 166.

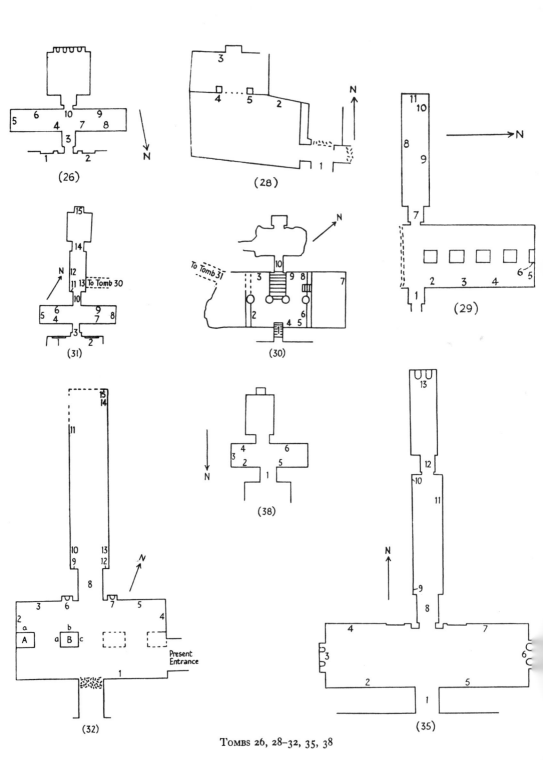

(26)

(28)

(29)

(31)

(30)

To Tomb 31

To Tomb 30

(32)

Present
Entrance

(38)

(35)

Tombs 26, 28–32, 35, 38

14. Views, M.M.A. photos. 8 A, 173 (showing statue-bases in front of main entrance), 2 A, 93.

Stairway to entrance.

On each side, deceased with staff leaving tomb, and long texts.

M.M.A. photos. 9 A, 35–8, 40–3. Deceased on right, LANSING and HAYES in *M.M.A. Bull.* Pt. ii, Jan. 1937, fig. 3, cf. p. 5.

Entrance.

Outer left jamb, text of deceased. Outer right jamb, text of son Ḥarsiēsi, Chamberlain of the divine adoratress, Head of secrets of the god's wife Nitocris in the House of Purification. Thicknesses, remains of texts.

Finds

Jambs with Menkheper, Mayor of Memphis, [temp. Amenophis III], seated, left one, re-used in Court, now in New York, M.M.A. 36.3.272, right one in Cairo Mus. Ent. 66284. Left jamb, LANSING and HAYES, op. cit. fig. 6, cf. pp. 4–5; HAYES, *Scepter*, ii, fig. 166; M.M.A. photos. 9 A, 29, 30.

Doorway with text of son Ḥarsiēsi on right jamb, found in a store-chamber. M.M.A. photos. 9 A, 39.

Granite altar of Ramesses II. BURTON MSS. 25639, 10 verso; HAY MSS. 29821, 49 [top left].

28. ḤORI 🐦𝄐, Officer of the estate of Amūn. Ramesside.
 ʿAsâsif.

Plan, p. 44. Map IV, D–5, c, 6.

Hall.

(1) Outer lintel, double-scene, deceased before a king. (2) Crown of [a god], with hieratic text of year 3 below, giving title. (3) Anubis-jackal. (4)–(5) Architraves with remains of offering-text.

Ceiling. Outer part, winged scarab on dressed *zad*-pillar adored by baboons with Isis and Nephthys, and deceased kneeling at sides. Inner part, hawk on Western emblem adored by six gods with Isis and Nephthys, and deceased kneeling at sides.

29. AMENEMŌPET 𓍹𓎟𓅆𓏏𓏤, called PAIRI 𓊪𓇋𓏤, Governor of the town, Vizier. (Also owner of tomb 48 in the Valley of the Kings.) Temp. Amenophis II.
 Sh. ʿAbd el-Qurna. (HAY, No. 15.)
 Parents, [ʿAḥmosi] Ḥumay (tomb 224) and Nub. Wife, Wertmaʿetef 𓄅𓏏𓂋.

Plan, p. 44. Maps V and VI, E–4, d, 1.

HAY MSS. 29824, 60, 60 verso.

Hall.

(1) Left thickness, deceased with wife offers incense and ointment 'to Rēʿ'.

(2) Deceased offers on braziers.

Translation of text of consecrating offerings to *ka* of Amenophis II, SCHOTT, *Das schöne Fest*, p. 864 [32].

(3) [1st ed. 2] Text of vizier's duties.

FARINA, *Le Funzioni del Visir Faraonico* [&c.] in *Rendiconti Lincei*, xxvi (1916), folding sheet [A] (from copy by GARDINER), cf. p. 925; comparison with other versions, DAVIES, *The Tomb of Rekh-mi-rēʿ at Thebes*, pls. cxix, cxxii [A], pp. 88–94.

(4) [1st ed. 1] Deceased with scribes, harpist, lutist, &c., 'hearing petitions' in judgement hall, and four rows of men approaching.

See id. ib. p. 32, note 76. Staves of office, HAY MSS. 29823, 55.

(5) and (6) Texts.

Pillars, remains of texts. Architrave between south pillar and wall, double-scene, deceased with offerings before Osiris.

Passage.

(7) Lintels, texts.

(8) [1st ed. 3] Two registers. **I–II**, Guests and harpist, and offerings to deceased and relatives, including parents, brother Sennūfer (tomb 96) with his wife Sentnay, and Paser, son of deceased.

Harpist, SCHOTT in *Mélanges Maspero*, i, pl. i [6], p. 460, note; HICKMANN, *45 Siècles de Musique*, pl. xxxi [B]; SCHOTT photos. 4133, 4133 a. Names and titles, HELCK, *Urk*. iv. 1439–40, B, 2; LEPSIUS MSS. 339 [upper]; names of Sentnay and Paser, NEWBERRY in *P.S.B.A.* xxii (1900), p. 60 [middle].

(9) [1st ed. 4] Two registers. **I–II**, Funeral procession before deceased, including priests with jars, men bringing bulls and goats, victims, pits, and butchers.

Omitting deceased, DAVIES, *Five Theban Tombs*, pl. xliii, p. 16, note 4, p. 17, note 1. Text of deceased, HELCK, *Urk*. iv. 1439, B, 1 (from DAVIES).

(10) Father.

(11) Two registers, left part destroyed. **I**, Deceased libates before Osiris. **II**, Niche, and man with bouquet and offerings.

Finds

Water-colour palette of deceased, probably from here, in New York, M.M.A. 48.72. HAYES in *M.M.A. Bull.* N.S. vii (1948), fig. on p. 60 [lower].

30. KHENSMOSI ⊜⥜𓏏𓀭𓏤, Scribe of the treasury of the estate of Amūn. Ramesside.

Sh. ʿAbd el-Qurna.

Wife, Ḥenutenkhunet 𓂋𓏤𓅓𓊖𓏏𓏤.

Plan, p. 44. Map VI, E–4, i, 2.

Hall.

(1) Left thickness, remains of hymn. Right thickness, [deceased before a god] with text.

(2) [1st ed. 1] Four registers. **I–II**, Book of Gates. **III–IV**, Funeral procession, with deceased kneeling before bark in **I**, and deceased offering to mummy in **II**, oxen dragging chest,

priests with Opening the Mouth instruments before mummies at pyramid-tomb with stela, and Ḥathor-cow in mountain, in **III**, and oxen dragging boat with deceased and wife, female mourners, and offering-bringers, in **IV**.

I, Chic. Or. Inst. photo. 3994. **III** and **IV**, Baud, *Dessins*, fig. 34; **III**, omitting chest and oxen, Wresz., *Atlas*, i. 127; mourners and mummies, Werbrouck, *Pleureuses*, figs. 12, 13, cf. p. 27.

(3) [Offering-bringers.] (4) Deceased with son Khensnakht adoring.

(5) Three registers. **I**, Deceased and two women before Rē᷄-Ḥarakhti and goddess. **II**, Deceased and wife seated and table of offerings. **III**, Couple, and deceased and wife playing draughts.

Draughts-playing, Chic. Or. Inst. photo. 3995; Schott photo. 1923.

(6) Two offering-scenes with couples. (7) [False door.] (8) Two registers, **I**, Osiris, **II**, man. (9) Deceased and wife.

(10) Entrance to Inner Room. Outer lintel, titles of [deceased and wife].

Architraves. Deceased kneeling adores divine bark drawn by jackals.
Ceiling. Outer part, centre, bark of Rē᷄ adored by baboons and jackals, and deceased adoring Rē᷄-Ḥarakhti on mountain, left side, birds, right side, birds with eggs.

Finds

Fragment of stela (?) with two female mourners. Werbrouck, *Pleureuses*, fig. 11, cf. p. 27.

31. **Khons** ●♭🐍, called To ☰, First prophet of Menkheperrē᷄ (Tuthmosis III). Temp. Ramesses II.

Sh. ʿAbd el-Qurna. (L. *D. Text*, No. 51.)
Parents, Neferḥōtep, First prophet of Amenophis II, and Tausert ꜣ🐍⸙🐍, Songstress of Monthu. Wives, Ruia ⸙🐍 and Mutia 🐍🐍 or May ⸙🐍.
Plan, p. 44. Map VI, E–4, h, 2.

Davies and Gardiner, *Seven Private Tombs at Ḳurnah*, pp. 11–30, with plan, pl. xxi [lower]; L. *D. Text*, iii, pp. 262–4; Mond and Emery in *Liv. Ann.* xiv (1927), p. 30, with plan on pl. xxxiii.

Court.

(1) and (2) Stelae with offering-scenes.
See Davies and Gardiner, p. 11 and note 2.

Hall.

(3) Thicknesses, deceased, mother, and son (and daughter on left thickness), adoring with hymn to Rē᷄. Soffit, pigeons.
Davies and Gardiner, pls. x, xx [middle], pp. 12, 25; M.M.A. photos. T. 2171, 2181, 2564.

(4), (5), (6) [1st ed. 1, 2, 3] Festival of Monthu, four scenes. **1** (at (4)), Usermontu, Vizier, and his brother Ḥuy, Prophet of Monthu, offer to bark of Monthu, all in bark towed by two military boats abreast (single-stick contest on deck), with father of deceased and three sons

censing and libating above. **2** (at (4)), Deceased offers to bark of Tuthmosis III in kiosk.
3 (at (5)), Arrival of bark of Monthu with Usermontu and Ḥuy and two tugs (with single-
stick contest), followed by priests and priestesses, including Userḥẹt, Steward of Queen
Teye. **4** (at (6)), Arrival of bark of Monthu carried by priests at Temple of Armant (showing
statue of hawk protecting King), and deceased with *ba* libating to [bark] in shrine. Sub-scene
at (4) and (5), lector, followed by four women, censing and libating with torches and candle
to deceased and mother (?), and priest before deceased with May, Tausert, and her daughter,
remains of rites on island, and priests censing and libating to relatives.

DAVIES and GARDINER, pls. xi–xiii, on xx [top], pp. 12–18; M.M.A. photos. T. 2176–80,
2182–7; CHIC. OR. INST. photos. 2982, 2984–6; SCHOTT photos. 2180, 2793–6, 2798, 4077,
5862–73, 6289–99, 8071–5, 8091–5, 8098–9. **3** (omitting top), and Temple in **4**, MOND and
MYERS, *Temples of Armant*, pl. ix [3–6], p. 15 (from SCHOTT photos.); bark of Monthu in **3**,
LHOTE and HASSIA, *Chefs-d'œuvre*, pl. at end 20. Torches and candle in sub-scene, DAVIES
in *J.E.A.* x (1924), pl. vii [10], p. 12, note 2; SCHOTT photo. 8096. Texts, L. *D. Text*, iii,
pp. 263 [middle], 264 [top, and bottom right]; name of door on Temple, SETHE, *Urk.* iv.
829–30 [231, lower].

(7) [1st ed. 6] Two registers. **I**, Deceased, mother, and Usermontu, in weighing-scene,
with assessors above, and deceased and mother (?) led by Ḥarsiẹsi to Osiris, Isis, and Neph-
thys. **II**, Funeral procession, including priests, Usermontu as lector, Opening the Mouth
instruments, mourners, and cow with mutilated calf, before mummies at pyramid-tomb
with stela.

DAVIES and GARDINER, pl. xvi, pp. 21–2; M.M.A. photos. T. 2172–5. Deceased with
Ḥarsiẹsi in **I**, LHOTE and HASSIA, *Chefs-d'œuvre*, pl. 147; parts of weighing-scene, SCHOTT
photos. 2175, 2797, 2799; **II**, SCHOTT photos. 8068–70; priests at tomb, WRESZ., *Atlas*,
i. 131; CAPART and WERBROUCK, *Thèbes*, fig. 243 (from WRESZINSKI); tomb and stela, DAVIES
(Nina) in *J.E.A.* xxiv (1938), fig. 11, cf. p. 37; female mourners, WERBROUCK, *Pleureuses*,
pl. xxvii [right], figs. 14, 122–3, 131, cf. p. 28 and figs. on 2nd page after p. 159; cow and calf,
SCHOTT photo. 2800. Text of Ḥarsiẹsi in **I**, and names of priests in **II**, L. *D. Text*, iii, pp. 263
[top], 262 [bottom left]; texts of priests, SCHIAPARELLI, *Funerali*, ii, pp. 292–3 [xiv].

(8) [1st ed. 5] Three registers. **I** and **II**, Festival of Tuthmosis III, with royal bark in
procession before Temple, received by priests and priestesses (songstresses of Monthu).
III, Herdsmen with dogs bringing cows and goats before deceased, Ruia, and family, with
standard of estate of Tuthmosis IV in front.

DAVIES and GARDINER, pl. xv, pp. 19–21; WRESZ., *Atlas*, i. 128–30; FARINA, *Pittura*,
pl. clxxxii; M.M.A. photos. T. 2193–4; CHIC. OR. INST. photo. 2983. **I** and **II**, WERBROUCK,
Pleureuses, pl. xxvi [lower], p. 28; SCHOTT photos. 4078–81, 6300–1, 8059–66, and details
of **III**, 2176, 8067. Names of deceased, wife, and son, in **III**, L. *D. Text*, iii, p. 262 [bottom
right].

(9) Deceased and family before Osiris and Anubis.
DAVIES and GARDINER, pl. xiv, p. 19; M.M.A. photos. T. 2189–92; details, SCHOTT
photos. 2177–9, 8076–8. Text of son Khaʿemwẹset, L. *D. Text*, iii, p. 262 [B].

Passage.
(10) [1st ed. 4] Outer lintel, double-scene, deceased, Maỵ and son, before Rēʿ-Ḥarakhti
and Anubis, and deceased, mother, and son, before Osiris and Isis. Left thickness, User-
montu, Vizier, [wife (?), and son]. Right thickness, [deceased, son Usermontu, and Ruia].

Davies and Gardiner, pls. xix [upper], xxi [upper], p. 22; M.M.A. photo. T. 2188. Name of May, L. *D. Text*, iii, p. 263 [near top].

(11) and (12) [Priests, followed by harpist, offer bouquet of Amūn to deceased and two men.]
Davies and Gardiner, pl. xvii [lower], pp. 22–3.

(13) [Deceased receives bouquet of Amūn at Temple of Monthu.]
Id. ib. pl. xvii [upper], p. 23.

Ceiling. Texts, id. ib. pl. xx [left and right], pp. 25–6 with fig. 4.

Shrine.

(14) Outer lintel and jambs, [offering-formulae], with decorative bouquets beyond jambs. Thicknesses, [woman] on each. Soffit, ducks with nests and locusts.
See Davies and Gardiner, p. 23. Soffit, id. ib. pl. xix [lower], p. 25; Werbrouck in *Mélanges Maspero*, i, fig. 1, cf. p. 21; Lhote and Hassia, *Chefs-d'œuvre*, pl. 59; *Egypt Travel Magazine*, No. 10 (May 1955), fig. on p. 45 [lower]; M.M.A. photo. T. 2198; Schott photos. 6303–4.

(15) Niche. Lintel, double-scene, [deceased and wife] before Anubis-jackal. Left wall, deceased offers bouquet of Amen-rēc to Mentuḥotp-Nebḥepetrēc, right wall, deceased before Western goddess, rear wall, deceased censes and libates to Osiris and Anubis.
M.M.A. photos. T. 2195–7. Left and rear walls, Davies and Gardiner, pls. xli [left], xviii, p. 24; left wall, Lhote and Hassia, op. cit. pl. 135; rear wall, Schott photo. 8100.

Finds

Block with head of deceased, Schott photo. 6302.

32. Ḍhutmosi 𓀀𓏤, Chief steward of Amūn, Overseer of the granaries of Upper and Lower Egypt. Temp. Ramesses II.
 Khôkha.
 Wife, Ēsi 𓂋𓏤.

 Plan, p. 44. Map IV, D–5, c, 9.
Hall.

(1) Two registers, Book of Gates, with guardians in shrines and small ritual scenes.
(2) Entablature, three registers, double-scenes, **I**, deceased kneels before a god, **II**, deceased seated and three Hathor-heads, **III**, deceased adores Nefertem-emblem.

(3) Three registers, Book of Gates. **I**, Deceased and wife, and Horus reporting to Osiris and Isis. **II**, Ritual scenes. **III**, Offering-scenes to deceased and wife and couples.
Name of wife in **I**, Lepsius MS. 288 [lower right].

(4) As at (2). (5) As at (1).

(6) and (7) Statues with Anubis-jackals above.
Title of deceased above (6), Lepsius MS. 288 [upper].

Pillars. A (*a*) Deceased with staff. B (*a*) [Deceased before Hathor], (*b*) deceased before Thoth, (*c*) deceased before Atum.
Titles of Hathor on B (*a*), Lepsius MS. 288 [lower left].

Passage.

(8) Outer lintel, baboons adore bark of Rēꜥ, with deceased and wife kneeling at each end. Inner lintel, deceased adores bark of Rēꜥ, with winged disk above.

(9) Pools (?) in ritual scene. (10)–(11) Three scenes, **1,** family offer to deceased and family in front of tree, **2,** marsh-scene with couple seated below, and large pool, **3,** deceased and wife adoring. (12) Mythological scenes.

(13)–(14) Two registers. **I,** Scenes in Book of Gates (?). **II,** Funeral rites (?) with deceased embraced by Western goddess at pyramid-tomb.

Deceased and goddess at tomb, SCHOTT photos. 3889–90.

(15) Decorative bouquet.

Burial Chamber. Ceiling, texts.

33. PEDAMENŌPET �â▢╤▢, Prophet, Chief lector. Saite.

'Asâsîf. (L. D. Text, No. 20.)

Mother, Namenkhēsi ▢▢▢, Sistrum-player of Amūn. Wife, Tedi ▢▢▢.

Plan, p. 52. Map IV, D–5, c, 4–5.

DUEMICHEN, *Der Grabpalast des Patuamenap,* Pt. i, pls. i–xvii, Pt. ii, passim, Pt. iii, pls. i–iv, xxx, xxxi (remaining plates not from this tomb); after re-opening in 1936, VON BISSING in *Ä.Z.* lxxiv (1938), pp. 2–26; MASPERO, *Le Tombeau de Pétéménophis* in *Revue de l'histoire des religions,* xxxvi (1897), pp. 406–10 (reprinted, *Bibl. Ég.* xxix, pp. 1–6); WILKINSON, *Topography of Thebes,* pp. 129–33; L. D. *Text,* iii, pp. 244–5; BURTON MSS. 25639, 13 [lower]; HAY MSS. 29824, 69–72.

Plan and section, DUEMICHEN, *Grabpalast,* Pt. i, frontispiece; *Descr. de l'Égypte, Ant.* ii, pl. 39 [1–4], and on pl. 38; ROSELLINI, *Mon. Civ.* pl. i [3–6]; PRISSE, *L'Art égyptien,* i, 9th pl. 'Hypogée . . . Pétamounôph', cf. *Texte,* pp. 355–6; DUEMICHEN in *Ä.Z.* xxi (1883), pl. ii, p. 14; WILKINSON MSS. xlv. A. 2–3a; HAY MSS. 29821, 101–3, 130; plan, POCOCKE, *A Description of the East,* i, pl. xxxiv [A] facing p. 100; parts, BURTON MSS. 25639, 13 [upper], 25644, 126, 126 verso, 128; LANE MSS. 34088, 51. View of enclosure-wall, LANSING in *M.M.A. Bull.* Pt. ii, July 1920, fig. 5, cf. p. 12. Sketches, NESTOR L'HÔTE MSS. 20402, 73–4. Titles of deceased from Forecourt, WILKINSON MSS. xlvi. G. 4. Text of Rēꜥ-Ḥarakhti, and text with titles of deceased, from an underground room, GOLENISHCHEV MSS. 1 [a, b].

Forecourt. See VON BISSING, p. 3.

(1) Head of deceased on squared background.

(2) Text.

Part with cartouche of Ḥaremhab, L. D. *Text,* iii, p. 245 [middle]; WILKINSON MSS. v. 171 [middle].

Vaulted Portal. See VON BISSING, pp. 3–4.

(3) [Deceased with man offering to him], and four registers. **I–IV,** [Offering-list with ritual, offering-bringers, and butchers].

Kneeling priest, *Descr. de l'Égypte, Ant.* ii, pl. 47 [11]; butchers, and offering-bringers, WILKINSON MSS. xix. 11 [a–g] (squeezes); three butchers, WILKINSON, *M. and C.* ii. 375 (No. 273) = ed. BIRCH, ii. 26 (No. 297).

(4) Deceased with [man] offering to him, and four registers. **I–IV**, Offering-list with ritual and offering-bringers.

Duemichen, *Grabpalast*, Pt. i, pls. iii, iv, pp. 7–8; von Bissing, Abb. 2–5, cf. pp. 3–4; two offering-bringers, Wilkinson MSS. xix. 11 [h, i] (squeezes); part of ritual, id. ib. v. 165 [bottom right]. Titles of deceased and name of mother, L. *D*. iii. 282 [f] and *Text*, iii, p. 245; Wilkinson MSS. v. 165 [bottom left].

Frieze-text. Part at (4), Duemichen, *Grabpalast*, Pt. i, pl. ii [a], p. 7.

Ceiling. Text in centre, id. ib. pl. ii [e], p. 7.

Hall I. See von Bissing, pp. 4–7.

Walls and pillars. Texts of Book of the Dead.

(5) Entablature, jambs with text and deceased seated at bottom, and thicknesses, deceased kneeling adores Rēᶜ-Ḥarakhti.

View of doorway, von Bissing, Abb. 1, cf. pp. 4–5; part, Borchardt, *Ägyptische Tempel mit Umgang* in *Beiträge zur ägyptischen Bauforschung* [&c.], Heft 2, Abb. 10, cf. pp. 29–30; sketches of doorway and left thickness, Wild MSS. ii. A. 137–9. Texts of thicknesses, Lepsius MS. 256 [lower]; of right thickness, and beginning of hymn to Rēᶜ on jamb (?), Wilkinson MSS. v. 171 [top right], 229 [middle].

(6) At top, tree-goddess scenes.

One scene, Wilkinson MSS. xxii. 32.

Hall II. See von Bissing, pp. 7–9, cf. Abb. 6.

(7) Entablature, hawks' heads and *zad*-pillar. Thicknesses, deceased with staff leaves tomb (followed by goddess on left thickness). Inner jambs, texts.

Entablature, Burton MSS. 25644, 127. Text on left thickness, Duemichen, *Grabpalast*, Pt. i, pl. ii [d], p. 7.

(8) Four registers. **I–IV**, Mythological scenes, including men bringing cow and calf and man adoring *Benu*-bird in **II**, and boats in **IV**. (9) [Large scene.] (10) Man before three gods. (11) [Divinities.] (12) Sacred oar, bull, and seven cows, with offering-list below.

Pillars. B (*a*), (*b*), (*c*) Texts. D (*a*) Man adoring and table of offerings, (*b*) text.

Hall III. See von Bissing, pp. 9–11.

(13) Entablature, and thicknesses with deceased with staff on left and wife on right.

Thicknesses, von Bissing, Abb. 7, 8, cf. pp. 9–10; text of deceased, Duemichen, *Grabpalast*, Pt. i, pl. ii [b], p. 7; titles, L. *D*. iii. 282 [g], cf. *Text*, iii, p. 245; text of wife on right, Lepsius MS. 256 [upper right].

(14) At top, five figures of deceased with staff, and texts on each side of doorway.

(15) and (16) Texts of Book of the Dead.

Duemichen, *Grabpalast*, Pt. ii, pls. xxiv–xxix, pp. 51–6.

(17) Deceased and wife seated, and jars on stands. (18) Five (?) registers, jars. (19) False door with offering-bringers on each side.

Hall IV. See von Bissing, pp. 11–12.

(20) Outer lintel, text and deceased and mother seated, jambs, offering-formulae. Left

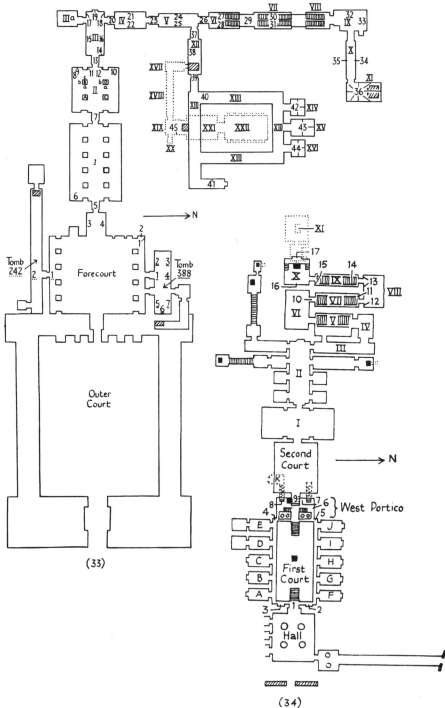

TOMBS 33, 34, 242, 388

thickness, deceased led by Anubis and Maᶜet followed by Apis-bull in mountain. Right thickness, texts of Book of the Dead. Inner lintel, jars, and deceased and wife seated.

Outer doorway and thicknesses, DUEMICHEN, *Grabpalast*, Pt. i, pl. i, pp. 5–7, Pt. ii, pls. xxii, xxiii, p. 51.

(21) Texts.
Id. ib. Pt. ii, pls. xvi–xx, pp. 44–50.

(22) Garments, necklaces, sacred oils, &c., with texts below.
Id. ib. Pt. i, pls. xiv–xv, pp. 43–4.

Hall V. See VON BISSING, pp. 12–13.

(23) Outer lintel, double-scene, offering-bringers before deceased seated, jambs, texts. Left thickness, two registers, **I**, priest with vases, necklaces, and ritual instruments before deceased, **II**, [offering-scene]. Right thickness, deceased and mother seated before offerings. Inner lintel and jambs, texts, with deceased seated at bottom.

Jambs and thicknesses, DUEMICHEN, *Grabpalast*, Pt. ii, pls. xiv, xv, xxi, pp. 43–4, 46–7, 50, Pt. i, pl. xvii, pp. 46–7, with text on right thickness, Pt. i, pl. ii [c], p. 7.

(24) Butchers and rites before mummies on frieze, and texts below.
Id. ib. Pt. ii, pls. i–v, pp. 2–10; one scene, WILKINSON MSS. v. 193 [bottom right].

(25) Similar scenes and texts, and deceased with great list of offerings, offering-list ritual (including statue of deceased carried by two priests), and deceased seated with seven sacred oil-jars at right end.

DUEMICHEN, *Grabpalast*, Pt. ii, pls. vi–xiii, pp. 10–43, Pt. i, pl. xiii [b] (oil-jars). Parts of ritual-texts, SCHIAPARELLI, *Funerali*, ii, pp. 13 [D], 42–65 [D], 210–26 [D], and parts of texts of offering-list, pp. 314–50 [D].

Room VI. See VON BISSING, pp. 13–14.

(26) Outer lintel, double-scene, offering-bringers before mother, and before deceased, jambs, text with deceased seated at bottom. Above inner doorway, Anubis kneeling and ape-headed demon, with deceased kneeling before ram-headed gods in shrine below.

Outer doorway, DUEMICHEN, *Grabpalast*, Pt. i, pl. xvi, pp. 45–6.

(27) Deceased, Isis, Horus, demons, god with pelican-beak, &c. (28) Deceased.

Room VII. See VON BISSING, p. 14.

(29) Entrance-wall, deceased with text. (30) and (31) Isis and other divinities.

Room IX. See VON BISSING, pp. 14–15.

(32) Deceased kneeling before false door.

(33) Weighing-scene, with Maᶜet, Thoth, monster, &c., before Osiris.
Details, VON BISSING, Abb. 9, 10.

Room X. See VON BISSING, p. 15.

(34) Text of Book of the Dead, and offering-list with ritual before deceased seated.
DUEMICHEN, *Grabpalast*, Pt. i, pls. v–xii, pp. 8–43; one priest, WILKINSON MSS. v. 150 [middle]. Parts of ritual-texts, SCHIAPARELLI, *Funerali*, ii, pp. 82–3, note 3 [D], pp. 149–52 [D].

(35) Frieze. Small scenes and offering-text below.

Room XI. See VON BISSING, pp. 15–16.

(36) Text of Book of the Dead on all walls and jambs, with two Anubis-jackals on south wall.

South wall and part on east wall, DUEMICHEN, *Grabpalast*, Pt. iii, pls. xxx, xxxi. See MASPERO in *Revue de l'histoire des religions*, xxxvi (1897), pp. 409–10 (reprinted, *Bibl. Ég.* xxix, pp. 5–6).

Room XII. See VON BISSING, p. 16.

(37) Outer lintel, deceased seated with two registers of offerings, jambs, text with deceased seated at bottom. Left thickness, texts. Right thickness, deceased seated. Inner lintel and jambs, text of lighting the torch, and Sons of Horus with torches.

Outer lintel, DUEMICHEN, *Grabpalast*, Pt. i, pl. xiii [a], p. 43. Inner doorway, id. ib. Pt. iii, pls. i, ii; part, id. in *Ä.Z.* xxi (1883), pl. i, pp. 13–15; see MASPERO, op. cit. pp. 406–9 (*Bibl. Ég.* pp. 2–5).

(38) Book of Gates with scenes.
DUEMICHEN, *Grabpalast*, Pt. iii, pl. iii.

Corridor XIII. See VON BISSING, pp. 16–22.

(39) Thicknesses, deceased and small son.
Left thickness, L. *D.* iii. 282 [h]; titles, LEPSIUS MS. 255 [top].

Outer walls. Texts of Books of Imi-Duat, the Night, Gates, and Aker.
See PIANKOFF in *B.I.F.A.O.* xlvi (1947), pp. 74–6, with key-plan, fig. 1 (from DUEMICHEN). Text on south wall near entrance, DUEMICHEN, *Grabpalast*, Pt. iii, pl. iv; speech of Horus from 7th hour of Book of the Night, PIANKOFF, *Le Livre du Jour et de la Nuit*, pp. 52–3 [P], p. 51, note 3.

(40) Bark of Rēꜥ.
VON BISSING, pl. ii [a], p. 21; CHIC. OR. INST. photo. 3976.

(41) Bark of Rēꜥ dragged by divinities.

Inner walls. In shape of a sarcophagus, with false doors and divinities in small niches on all sides, and protecting goddesses at corners, (*a*) Shentayt, (*b*) Neith, (*c*) Selkis, (*d*) Hathor, (*e*) Maꜥet, (*f*) Nut, (*g*) Nephthys, (*h*) Isis.

Texts, PIANKOFF in *B.I.F.A.O.* xlvi (1947), pp. 76–86, with plan, fig. 2, cf. figs. 3, 4; VON BISSING, pp. 16–21, with plan, Abb. 11; plan and section of part, BORCHARDT, *Ägyptische Tempel mit Umgang* in *Beiträge zur ägyptischen Bauforschung* [&c.], Heft 2, Abb. 18, cf. p. 55. Section showing one side with false doors, niches, protecting goddesses, &c., WILKIN-SON MSS. xlv. A. 3. Sketch, DUEMICHEN, *Grabpalast*, Pt. i, frontispiece [upper right]; sketch with one goddess, and elevations, Hay MSS. 29821, 102 [lower], 104. Shentayt and Neith, with names of all the goddesses, WILKINSON MSS. v. 165 [middle]. False door and niche in east wall, VON BISSING, pl. i [a, b], p. 17, note 1, p. 20; CHIC. OR. INST. photos. 3977–8.

Room XIV. See VON BISSING, p. 22.

(42) Left wall, destroyed scene with name of god Ruruti 𓎛𓎛. Right wall, deceased before Sokari, Nut, Osiris, Isis, [Horus, Thoth]. Rear wall, remains of double-scene, and Ptah in shrine and Ptah-Sokari.

Astronomical ceiling.

Room XV. See VON BISSING, pp. 22–3.

(43) Left wall, offerings before Osiris Ḥemag. Right wall, offerings before Ptaḥ with bark of Sokari and Isis. Rear wall, double-scene, deceased and wife offer to Osiris Ḥemag. Ptaḥ, bark, and Isis, VON BISSING, pl. ii [b]; CHIC. OR. INST. photo. 3979.

Room XVI. See VON BISSING, p. 23.

(44) Left wall, offerings before Ptaḥ Khentiḥatnub and bark of Sokari. Right wall, offerings before Sokari Khentiḥatnub and Sons of Horus. Rear wall, double-scene, two figures of Ptaḥ Khentiḥatnub, Horus, and Ptaḥwepni on left, and Nut, Isis, Nephthys, and Ruruti on right.

Underground Rooms

Rooms XVII–XIX. See VON BISSING, pp. 23–4.

Walls, Book of Caverns.

Key-plan, PIANKOFF in *B.I.F.A.O.* xlvi (1947), fig. 1 (from DUEMICHEN) on p. 75. Texts of 1st division, id. ib. xli (1942), pls. ii, iii–ix [P], pp. 1, 6–7; of 2nd division, xlii (1944), pls. xi–xxvi [P], pp. 3–4; of 3rd division, xlii, pls. xxviii–xxxvii [P], pp. 15–29; of 4th division, xlii, pls. xxxix–xlix [P], pp. 30–43; of 5th division, xlii, pls. l, lii–lxxix [P], pp. 44–62; of 6th division, xliii (1945), pls. lxxx–cxx [P], cxxii–cli [P], pp. 1–48.

(45) Resurrection of Osiris with Horus presenting sceptre.
See PIANKOFF in *B.I.F.A.O.* xlvi (1947), p. 87. Bark of Rēꜥ with gods of the sky, see THOMAS in *J.E.A.* xlii (1956), p. 70 [c g] with note 5.

Astronomical ceiling in Room XIX. See PIANKOFF in *B.I.F.A.O.* xlvi (1947), p. 87.

Sarcophagus Chamber XXII. See VON BISSING, p. 23.

Walls. Book of Imi-Duat.
CHIC. OR. INST. photos. 10455–66. 5th division, PIANKOFF in FIRCHOW, *Ägyptologische Studien (Grapow, 70. Geburtstag)*, 1955, pl. ii, pp. 245–6; see PIANKOFF in *B.I.F.A.O.* xlvi (1947), p. 87; 12th division, on east wall, id. *The Tomb of Ramesses VI*, p. 312 with fig. 87.

Astronomical ceiling. CHIC. OR. INST. photos. 9790–8.

Blocks from Walls

Head of deceased, in Brussels, Mus. roy. du Cinquantenaire, E. 3057. CAPART, *L'Art égyptien*, iii, pl. 597; id. in *Bull. des Mus. roy.* 2 Sér. i (1908), fig. 9, cf. p. 78; id. *Documents*, i, pl. 92; id. *Donation d'antiquités égyptiennes aux musées royaux de Bruxelles*, fig. 9, cf. pp. 27–8; *Département égyptien. Album*, pl. 40; PRISSE, *L'Art égyptien*, ii, 29th pl. [4] 'Hauts fonctionnaires . . .', cf. *Texte*, p. 407; PAVLOV, *Skulpturniportret v drevnem Egipte*, pl. facing p. 44. See LOUKIANOFF in *Ann. Serv.* xxxvii (1937), p. 229 [x].

Deceased paddling canoe, and mythological regions, in [Fields of Iaru]. WILKINSON MSS. v. 171 [top left], 164 [bottom].

Head of deceased, in Munich, Ägyptische Sammlung, Inv. 2832.

Text of deceased, in Washington, Smithsonian Institution, 1420, acquired from GLIDDON in 1844. *Bull. of the National Institution*, iii (1844), p. 230 [4]; DE RICCI MSS. D. 45, 21.

Head of a woman. *Descr. de l'Égypte*, *Ant.* ii, pl. 47 [12, 13].

Remains of offering-scenes, from Halls I or II, in Cairo Mus. PIANKOFF in *B.I.F.A.O.*
xlvi (1947), fig. 9, cf. pp. 91–2.

Text of Rēᶜ-Ḥarakhti, in Brit. Mus. 786. See LOUKIANOFF, op. cit. p. 229 [ix]; *Guide*
(*Sculpture*), p. 232 [839].

Finds. Probably from here.

Statue of deceased, in Syracuse Mus. See LOUKIANOFF in *Ann. Serv.* xxxvii (1937), p. 228
[vii]. Text, WIEDEMANN in *P.S.B.A.* xxiii (1901), pp. 249–50.

Two basalt torsos of deceased, in Cairo, Michaelidis Collection. PIANKOFF in *B.I.F.A.O.*
xlvi (1947), figs. 5–7, cf. pp. 88–9.

Red granite offering-table, from Amherst Collection, in Brussels, Mus. roy. du Cinquan-
tenaire, E. 5811. See LOUKIANOFF, op. cit. p. 230 [xi]; *Sotheby Sale Cat.* June 13–17, 1921,
No. 201. Text, SPELEERS, *Recueil des inscriptions égyptiennes*, p. 87 [332].

34· MENTUEMḤĒT ▦◳◿, Fourth prophet of Amūn in Thebes. Temp. Taharqa
and Psammetikhos I.

'Asâsîf.

Parents, Esptaḥ, Prophet of Amūn, Mayor of the City, and Esenkhebi ◸◠◦◲◱◲◱ .
Wives, Uzarenes ◲◳◱, Sistrum-player of Amen-rēᶜ (name in tomb), Eskhons ◲◦◲◱
and Shepetenmut ◱◲◳◱ (names from cones).

Plan, p. 52. Map IV, D–4, j, 3.

BARGUET, GONEIM, and LECLANT, *Le Palais funéraire de Montouemhat à l'Assassif*, in
preparation; LECLANT in *Orientalia*, N.S. xix (1950), pp. 370–2, xx (1951), pp. 473–4 [c],
xxii (1953), p. 88 [c], xxiii (1954), p. 66 [b]. View, HAY MSS. 29821, 110.

Hall east of First Court.

Pillars. Titles of deceased on abaci.

First Court.

View, LECLANT in *Orientalia*, N.S. xix (1950), pl. li [28], xx (1951), pl. lxiii [36], xxiii
(1954), pl. xx [18].

(1) Outer lintel, double-scene, Psammetikhos I (in centre) before Osiris, and before
Rēᶜ-Ḥarakhti. Jambs and thicknesses, texts, with deceased as priest before offerings on
inner thicknesses.

(2) Niche. Statues of deceased and wife with entablature above, man offering to deceased
on left wall, and to wife on right wall, and offering-bringer below.

(3) Niche. Lower part of statues of deceased and mother.

LECLANT in *Orientalia*, N.S. xix (1950), pl. li [29], p. 371; *Jaarbericht, Ex Oriente Lux*,
No. 13 (1953–4), pl. lxiii [lower], p. 295.

Five granite offering-tables, see LECLANT in *Orientalia*, N.S. xix (1950), p. 372 [top].
One of deceased, LECLANT, *Montouemhat*, Doc. 26 and pl. (in the Press); BARGUET, GONEIM,
and LECLANT, in *Ann. Serv.* li (1951), pp. 491–3 [i], with fig. 1 and pl. i. One of wife Uzarenes,
daughter of Piᶜankhy-har ◯◦◲◲◱◲◳ , id. ib. pp. 493–4 [ii], with fig. 2, and pl. ii.
Another of deceased, id. ib. pp. 494–6 [iii], and pl. iii; LECLANT, *Montouemhat*, Doc. 27

(in the Press). One of Psherenmut ⬛𓄿⬝𓅓 , Prophet of Amūn in Thebes, Prophet of Harpo-crates, probably son of deceased, BARGUET, &c. in *Ann. Serv.* li (1951), pp. 497–8 [iv], and pl. iv. One of Pesdimen 𓄓 𓎛𓏲 , Sacristan in the estate of Mut, Head of followers, id. ib. pp. 499–501 [v] and pl. v; LECLANT, *Enquêtes sur les sacerdoces et les sanctuaires égyptiens* [&c.], pls. xiv–xv, pp. 59–66 [iv, B]; see LECLANT in *Orientalia*, N.S. xx (1951), p. 473 [c].

Two offering-tables with offerings in relief, BARGUET, GONEIM, and LECLANT, in *Ann. Serv.* li (1951), pl. vi [a–c], pp. 503–4 [vi, vii].

Entrances to Chapels on north and south sides.

Large bound-papyrus emblems, and Karian texts between entrances on south side.

One emblem, LECLANT in *Orientalia*, N.S. xix (1950), pl. lii [30], p. 371.

Chapel A. (Unfinished.)

Outer lintel, priest with offering-bringers offers to deceased, jambs, texts with deceased seated at bottom.

Chapel B.

Outer doorway as in Chapel A. Left thickness, hymn with deceased adoring below. Inner lintel and jambs, texts.

Upper part of deceased on outer left jamb, LECLANT in *Orientalia*, N.S. xx (1951), pl. lxiii [35]. Deceased on thickness, in Cleveland Mus. 51.281, WUNDERLICH in *Cleveland Mus. Bull.* xxxix, March 1952, fig. on cover, cf. p. 44; see LECLANT in *Orientalia*, N.S. xxiii (1954), p. 66 [b].

Left wall, deceased adoring and litany with seventy-two names of Osiris. Right wall, deceased consecrating offerings, and litany with seventy-four demons.

See LECLANT in *Orientalia*, N.S. xix [3] (1950), p. 371 [middle]; xxiii (1954), p. 66, note 5.

Rear wall. Niche with offering-bringers on each side.

Chapel C.

See SCHEIL, *Le Tombeau de Montou-m-hat* in *Mém. Miss.* v [2], pp. 613–23 with plan.

Outer doorway as in Chapel A. Inner lintel and jambs, texts.

Texts of inner doorway, SCHEIL, p. 614; KRALL, *Studien* [&c.], III, *Tyros und Sidon* in *Sitzungsb. der Kaiserlichen Akademie der Wissenschaften, Wien*, Phil. Hist. Kl. cxvi (1888), Heft 1, pp. 708–9 [A′–C′].

Side-walls, three registers of offering-bringers and offering-list before deceased, with butchers below (ancient copy of scenes in Deir el-Baḥri, Dyn. XVIII Temple, see ERMAN in *Ä.Z.* lii (1915), pp. 90–3).

SCHEIL, pls. i, ii, pp. 615–23. Texts above deceased, KRALL, op. cit. p. 710 [I′, H′].

Rear wall, niche. Lintel and jambs, titles of deceased.

Titles, SCHEIL, p. 615; KRALL, op. cit. pp. 709–10 [D′–G′].

Chapel D.

Outer doorway as in Chapel A. Inner lintel and jambs, texts.

Side-walls, three registers of female offering-bringers, and offering-list ritual, before deceased, with offering-bringers below (and lectors with haunches on east wall).

Entrance to Inner Room. Lintel, jambs, and drum, texts, with offering-bringers beyond each jamb.

Chapel E. ʿAkiu ⟨𓉐⟩, Hereditary prince, Chancellor, Sole beloved friend, Great royal acquaintance. (*Bibl.* i, 1st ed. p. 190, tomb Z, Kiu; L. *D. Text*, No. 24.)

See L. *D. Text*, p. 246. Rediscovered, see FAKHRY in *Ann. Serv.* xlvi (1947), p. 34 [B, 3]; LECLANT in *Orientalia*, N.S. xix (1950), p. 371. Titles, LEPSIUS MS. 245 [bottom].

Outer right jamb, deceased seated. Inner lintel and jambs, texts.
Lintel, LEPSIUS MS. 244 [middle].

Side-walls, three registers of women with offerings and animals and lectors with haunches, and great offering-list with ritual, before [deceased seated].
Texts above deceased, id. ib. 244 [bottom].

Entrance to Inner Room. Lintel, jambs, and drum, texts, with four offering-bringers beyond each jamb.
Texts, id. ib. 245 [top and middle].

Chapel F.
Outer doorway as in Chapel A. Thicknesses, Irḥepiaut ⟨𓎛𓇋𓆭𓏤⟩, Head bowman of cavalry, Head of the stable of the Lord of the Two Lands.

Side-walls, deceased facing out at inner ends.

Chapels G (of Mentuemḥēt), H, I, J. (Unfinished.)
Outer doorways as in Chapel A.

West Portico.
(4) and (5) [Offering-bringers.]

(6) Four registers, funeral procession. **I,** Sledge dragged. **II,** Bringing funeral outfit including chariots. **III,** Victims and mourners. **IV,** Abydos pilgrimage, &c.
Block, two boats with female mourners, probably from here, in Cleveland Mus. 51.282, WUNDERLICH in *Cleveland Mus. Bull.* xxxix, March 1952, fig. on p. 50, cf. p. 44; *Cleveland Mus. of Art. In Memoriam Leonard C. Hanna, Jr.* pl. 218 A; see LECLANT in *Orientalia*, N.S. xxiii (1954), p. 66 [b].

(7) False door of deceased with scene in centre, and on sides bull and seven cows, and sacred oars with demon behind each.

Chapel K. South of Entrance to Second Court.
(8) Above outer doorway, man offers to couple on left, and seated couple on right, with wife at right end below. Left jamb, gazelle's head with serpent above. Staircase, text on each side, with demons. Inner jambs and entrance-wall, texts, right wall, text with demons.

Second Court.
(9) Outer jambs, texts. Thicknesses, texts and deceased adoring. Inner lintel, texts.

Underground Chambers

KRALL, *Studien* [&c.], III, *Tyros und Sidon* in *Sitzungsb. der Kaiserlichen Akademie der Wissenschaften, Wien*, Phil. Hist. Kl. cxvi (1888), Heft 1, pp. 704–5.

Staircase VII.

(10) Texts of deceased, father, wife, and her mother Seshepmut 𓈖𓏏𓀭.
KRALL, op. cit. pp. 707–8.

(11) Text of wife. Id. ib. p. 707 [K].

Room VIII.

(12) Titles of deceased and wife (name lost). Id. ib. p. 705 [B, C].

(13) Left of doorway, deceased led by Anubis with Maꜥet, and Meḥitwert-cow in mountain. Right of doorway, text.
Part of text, id. ib. pp. 706–7 [H, I].

Staircase IX.

Walls, text with titles of deceased. Id. ib. pp. 705–6 [E, F, G].

Stela with titles. See id. ib. p. 706 [near bottom].

(14) Butchers.
LECLANT in *Orientalia*, N.S. xxii (1953), pl. xi, figs. 21, 22, cf. p. 88 [c].

Room X. View, id. ib. pl. xii, fig. 23.

(15) Left of entrance, titles of deceased and parents. KRALL, op. cit. p. 705 [D].

(16) Statue of father in niche. Text, id. ib. p. 705 [A].

(17) Statue of Osiris in niche.
HABACHI in *Ann. Serv.* xlvii (1947), pl. xxxii (called tomb of Pedamenemopet), pp. 277–8 (called tomb 36).

North and south walls, kneeling statues in niches. East wall, squatting statues in niches.

Sarcophagus Chamber XI. (Entered through shaft in Room X.)

View, LECLANT in *Orientalia*, N.S. xxii (1953), pl. xii, fig. 24.
Astronomical ceiling. CHIC. OR. INST. photos. 10115–22.

Reliefs now in Museums

Men in canoes gathering papyrus, perhaps from here, in Boston Mus. 72.692. SMITH (W. S.), *Ancient Egypt as represented in the Museum of Fine Arts* (1942), fig. 102 [left], cf. p. 157, (1952), fig. 101, cf. p. 157; id. in *Boston Mus. Bull.* xlvii (1949), fig. 7, cf. p. 25.
Female offering-bringer, in Cambridge, Fitzwilliam Mus. E.G.A. 3000.1943.
Four in Chicago Or. Inst. Men in canoe, No. 17973. Two adjoining blocks, fishing with draw-net, and female offering-bringers, Nos. 17974–5; No. 17974, WILSON, *The Burden of Egypt*, fig. 32 a, cf. p. 294. Two girls quarrelling (ancient copy of scene in tomb 69), No. 18828.
Fourteen in Cleveland, Ohio, Mus. of Art. See WUNDERLICH in *Cleveland Mus. Bull.* xxxix, March 1952, pp. 44–7. Deceased as priest with staff, No. 49.492, *Archaeology*, vi [4] (Winter, 1953), fig. on p. 196; *Cleveland Mus. of Art. In Memoriam Leonard C. Hanna, Jr.* pl. 218 B. Prophet and lector with offerings, No. 49.494, and marsh-scene with genets and birds, No. 49.498, WUNDERLICH, op. cit. figs. on p. 49. Man adoring, and men capturing

bull, Nos. 51.280, 283, *Cleveland Mus. of Art Handbook* (1958), figs. 6, 8; No. 51.280, *Cleveland Mus. Bull.* xxxix (June 1952, Pt. 2), fig. on cover, cf. p. 142. Two seated figures, No. 49.493, three blocks with offering-bringers, Nos. 49.495–7, speared fish, No. 49.499, men with funeral outfit, No. 51.284, small head, No. 51.285, and blocks, two with priests in funeral rites, Nos. 51.286–7. (For Nos. 51.281–2, see supra, Chapel B, and West Portico.)

Text of fowling-scene, in Florence Mus. 2604. PETRIE ITAL. photo. 204 [lower left]; text, SCHIAPARELLI, *Mus. . . . Firenze*, pp. 316–17 [1590]; BEREND, *Prin. mon. . . . Florence*, p. 98 (called tomb of Seti I); see MIGLIARINI, *Indication succincte des monuments égyptiens*, p. 29 (called tomb of Seti I); LEGRAIN in *Rec. de Trav.* xxxv (1913), pp. 215–16 [Doc. 45]; PETRIE, *A History of Egypt*, iii, p. 305. Other fragments, mostly agricultural scenes, No. 7612, a–n.

Deceased with servants and block with Anubis (joined in error), in Kansas City, William Rockhill Nelson Gallery of Art, 48.28. Deceased and one servant, *The William Rockhill Nelson Collection* (1949), fig. on p. 15 [upper] (called Dyn. XVIII); SMITH, *Art . . . Anc. Eg.*, pl. 182 [A].

Eight in New York, Brooklyn Mus. Three (possibly from same wall): girl removing thorn from foot of another, with woman arranging figs and nursing child below, No. 48.74 (ancient copy of scene in tomb 69), harpist and singer, No. 49.17, steward and scribe, No. 49.18, COONEY in *J.N.E.S.* ix (1950), pls. xiv, xiii, xvi, pp. 193–201; No. 48.74, SMITH, op. cit. pl. 180; WOLF, *Die Kunst Aegyptens*, Abb. 683; No. 49.17, KECK in *Brooklyn Mus. Bull.* xix [3], 1958, fig. on p. 7. Five others: boat-building, No. 51.14, three gods holding serpent, No. 51.230, man leading bull, man delivering calf, and man picking lotuses, Nos. 55.3.1–3, *Brooklyn Mus. Five Years*, pls. 53–5 [32, A–D, 33], pp. 28–31.

Man cleaning fish, with two offering-bringers below, and text of a fourth prophet of Amūn above, in San Francisco, California, De Young Memorial Mus.

Female offering-bringer with text of a Mayor of the city, and upper part of seated couple, in Seattle, Washington, Art Mus. Nos. Eg. 11.39–40.

Head of a man, in Toledo, Ohio, Mus. of Art. Cf. *The Art Quarterly*, Spring 1958, p. 83.

Marsh-scene, with two registers, I and II, genets and birds, probably from here, in Vatican Mus. 288. BOTTI and ROMANELLI, *Le Sculture del Museo Gregoriano Egizio*, pl. liii [111], p. 64; I, WRESZ., *Atlas*, iii, Textabb. 41, 5, cf. pp. 82–3; RANKE, *The Art of Ancient Egypt*, and BREASTED, *Geschichte Ägyptens*, 189. Butterfly in II, KEIMER in *Ann. Serv.* xxxvii (1937), fig. 210, cf. p. 160. See MARUCCHI, *Il Museo Egizio Vaticano*, p. 116 [125]; SMITH (W. S.) in *Boston Mus. Bull.* xlvii (1949), p. 25.

Finds. Probably from here.

Statues of guardian-demons.

Nine statues, dedicated by deceased, sometimes thought to come from Saite Chapels at Medînet Habu (*Bibl.* ii, p. 177), but see LECLANT, *Montouemhat*, Documents 17–23 (in the Press).

1 and 2 (LECLANT, Doc. 21 and 18). Duamutf seated with [Ḳebḥsenuf], and two guardians, one standing, one squatting, black granite, in Cairo Mus. 39273–4 (*Bibl.* ii, p. 177). DARESSY, *Statues de Divinités* (*Cat. Caire*), pl. lx, pp. 318–19; see LEGRAIN in *Ann. Serv.* viii (1907), pp. 125–6.

3 (LECLANT, Doc. 20). Imset and Ḥepy, in Berkeley, California Univ. Mus. of Anthropology, 5.363. LUTZ, *Egyptian Statues and Statuettes*, pl. 1 [b], p. 1; id. in *J.A.O.S.* xlvi (1926), pl. facing p. 312.

4 (LECLANT, Doc. 17). Medes-guardian in cloak holding knife, with lion in relief on side, black granite, in Athens, Nat. Mus. 112. Sketch and text, WILBOUR MSS. 2 G. 36 [lower] (at dealer's in Luxor in 1886); text, LEGRAIN in *Ann. Serv.* viii (1907), pp. 122–5 [xlvii]. See LOUKIANOFF in *Bull. Inst. Ég.* xxi (1939), p. 260, note 1 [8].

5 (LECLANT, Doc. 19). Three baboon-guardians, two seated, one standing, formerly von Bissing Collection, and Hague, Scheurleer Mus., now in Berlin Mus. 23729. VON BISSING in *Ä.Z.* lxviii (1932), pp. 110–11 with fig.; cf. ANTHES in *Ä.Z.* lxxiii (1937), p. 25, note 1; see LEGRAIN in *Ann. Serv.* viii (1907), p. 126 (at dealer's).

6 (LECLANT, Doc. 23). Statue-base of two guardians, black granite, in Antiquities House at Medînet Habu.

7 (LECLANT, Doc. 22, and probably 22 bis [1st item]). Lower part of three demons holding lizards, black granite, in Besançon, Mus. d'Archéologie et des Beaux Arts, 890.I.87 (Exhib. No. 37). See WIEDEMANN in *Rec. de Trav.* viii (1886), p. 69 [12, middle] (at French House at Luxor in 1886, probably this statue); LEGRAIN in *Rec. de Trav.* xxxv (1913), p. 214 [Doc. 43] (at dealer's in Luxor in 1913, probably this statue).

8 (LECLANT, Doc. 22 bis [2nd item]). Guardians. See CAPART in *Revue de l'histoire des religions*, lix (1909), p. 66 (in possession of Sheikh Faraq at Giza in 1907).

9 (LECLANT, Doc. 22 bis [3rd item]). Group. Cf. LEGRAIN in *Rec. de Trav.* xxxv (1913), p. 214 (Doc. 43) (at dealer's in Cairo).

Various.

Ivory statuettes of man and woman, in New York, Brooklyn Mus. Nos. 48.170, 49.166. COONEY in *J.N.E.S.* ix (1950), pls. xvii, xviii, pp. 201–3.

Stamped brick [LECLANT, Doc. 36], in Cairo Mus. LEGRAIN, op. cit. p. 213 [Doc. 41].

35. BEKENKHONS 𓎢𓎡𓎤𓎥𓎦, First prophet of Amūn. Temp. Ramesses II.

Dra' Abû el-Naga'. (CHAMPOLLION, No. 45, L. D. Text, Nos. 10, 11.)
Parents, Roma 𓏤𓏤, First and second prophet of Amūn, and Roma 𓏤', Singer of Amūn.
Wife, Mertesger 𓏤𓐠𓐡𓐢, Chief of the harîm of Amūn.

Plan, p. 44. Map II, D–6, c, 1.

CHAMP., *Not. descr.* i, p. 538 with plan; L. D. Text, iii, p. 240; FISHER in *Penn. Mus. Journ.* xv (1924), p. 43; see ROSELLINI MSS. 284, G 58. Views, PHILAD. photos. 34804–5, 34809, 34817, 34831, 34937. Description and copies of texts by GREENLEES are in Philadelphia Univ. Mus. Opening the Mouth scenes, see SCHIAPARELLI, *Funerali*, i, p. 307 [xxx]. Name of wife, LEPSIUS MS. 224 [bottom].

Hall.

(1) Outer right jamb, remains of text. Left thickness, two registers, **I**, wife, **II**, offerings before couple with monkey under wife's chair, and two *ba*-birds on shrine behind. Right thickness, deceased.

(2) Three registers. Offering-list ritual before [deceased and wife].

(3) Niche with seated statues of deceased and wife, and side-walls with priest censing offerings and offering-list. Above niche, entablature with Ḥathor-head, and at each side of niche, ritual-texts and offering-scene.

Left side-wall, PHILAD. photo. 34904.

(4) Two scenes. **1**, Offering-list ritual before deceased. **2**, Baboons and *ba* adore horizon-disk, with [stela] below.

1, PHILAD. photos. 34905–6.

(5) Deceased and wife offering and offering-scenes.

Wife, FISHER in *Penn. Mus. Journ.* xv (1924), pl. facing p. 28; PHILAD. photo. 34912, and drawing, 70.

(6) Niche with seated statues of deceased and wife. Above niche, entablature with Hathor-head. Left of niche, priests before statue of deceased (one purifying it), with son at bottom. Right of niche, [harpist].

(7) Two registers. **I**, Western goddess in front of tomb in mountain, seven scenes of rites before deceased, and bark with Maᶜet and divinities. **II**, [Stela] and man with ritual-texts.

Passage.

(8) Outer lintel, double-scene, deceased and wife (both cut out on left) kneel before Osiris, and before Anubis, jambs, text with deceased seated at bottom. Outer thicknesses, text. Inner thicknesses, deceased adores Osiris on right, and [god] on left.

Lintel, jambs, and inner thicknesses, PHILAD. photos. 34855, 34903, 34909–10. Text on right half of lintel, LEFEBVRE, *Histoire des Grands Prêtres*, p. 136, note 1; texts on outer thicknesses, LEPSIUS MS. 224 [near bottom]; on left thickness, CHAMP., *Not. descr.* i, p. 538 [A].

(9)–(10) Offering-list with ritual, and wife below.

(11) Entablature with double-scene, deceased kneeling before god, and Hathor-head in centre below.

HAY MSS. 29824, 5 verso; PHILAD. photo. 34915.

Inner Room.

(12) Remains of entablature. (13) Niche with two uninscribed statues.

PHILAD. photos. 34902, 34911.

Pyramid. Views, PHILAD. photos. 39945, 39976–7, 39980, 39982.

South doorway. Thicknesses, titles of deceased and wife. Soffit, name of deceased. Inner lintel, two Anubis-jackals, and remains of double-scene below, deceased adores Osiris.

Titles on left thickness, *L. D. Text*, iii, p. 240 [10, 11].

East wall, remains of long hymn to Osiris.

Frieze and ceiling, texts of deceased.

Sarcophagus, from Valentia and Mayer Collections, in Liverpool City Mus. M. 13864. SCHMIDT, *Sarkofager*, figs. 622–4. Texts and figures, WILBOUR MSS. 2 D. 16–19; names and titles, LIEBLEIN in *Ä.Z.* vi (1868), p. 12; id. *Dict.* No. 941. See GATTY, *Cat. of the Mayer Collection*, i (1879), pp. 26–7 [117]; *Handbook and Guide to the Egyptian Collection . . . Liverpool* (1932), p. 58 [42]; WEILL in *Mon. Piot.* xxv (1921–2), pp. 421–3.

Torso of deceased. *Descr. de l'Égypte, Ant.* ii, pl. 80 [8, 11], cf. *Texte*, x, p. 226. See VARILLE in *Ann. Serv.* xl (1940), p. 641.

Finds. Probably from here.

Wooden scribe's palette in form of *ḥes*-vase, in Louvre, N. 3018. Both sides, DEVÉRIA in *Rev. Arch.* N.S. xx (1869), fig. on p. 308, and pl. xix facing p. 348 (reprinted, *Bibl. Ég.*

v, pp. 265–70 with fig. and pl. xi); recto, PRISSE, *L'Art égyptien, Texte,* fig. on p. 136. See BOREUX, *Guide,* ii, p. 611.

For statue of deceased in Munich Glyptothek, 45 (1st ed. p. 69), see Karnak Miscellaneous, *Bibl.* ii² (in preparation).

36. IBI 𓃀𓏤𓏤𓏤, Chief steward of the divine adoratress. Temp. Psammetikhos I.

'Asâsîf. (CHAMPOLLION, No. 56, L. *D. Text,* No. 25.)

Parents, ʿAnkh-ḥor 𓀔𓈖, Divine father, and De-ubasteiri 𓏭𓊖𓏤𓏏𓄿𓏥, variant Teiri 𓇋𓏤𓏥. Wife, Shepenernūte (name in tomb 196).

<div align="center">Plan, p. 64. Map IV, D–5, b, 5.</div>

SCHEIL, *Le Tombeau d'Aba* in *Mém. Miss.* v [2], pp. 624–56, with plan on p. 624; CHAMP., *Not. descr.* i, pp. 553–6; L. *D. Text,* iii, p. 247; NESTOR L'HÔTE MSS. 20396, 121 verso; ROSELLINI MSS. 284, G 65–7 (giving names of parents at (1)). Some texts, HAY MSS. 29847, 97; titles of deceased, BRUGSCH, *Recueil,* pl. lxviii [n].

Vestibule.

(1) Offering-bringers and offering-list before deceased seated. Sub-scene, female offering-bringers with gazelle, &c., before deceased standing.

M.M.A. photos. T. 961–3, 983 [middle]; SCHEIL, pp. 627–30 [z], and pl. i (deceased, offering-list, and part of sub-scene). Text above deceased seated, GOLENISHCHEV MSS. 2 [l].

(2) [1st ed. 1] Statue-niche with titulary of Psammetikhos I and Nitocris.

L. *D.* iii 270 [b]; M.M.A. photo. T. 964; WILKINSON MSS. xvii. H. 16 [left]; HAY MSS. 29847, 95. Texts, incomplete, CHAMP., *Not. descr.* i, pp. 553 [A–C], 855 [to p. 553 last line] with C; BURTON MSS. 25654, 61; LEPSIUS MS. 254 [left]; GOLENISHCHEV MSS. 2 [m]. See SCHEIL, p. 627 [Y].

(3) [1st ed. 2] Two registers. I, Deceased seated with gazelle under chair. II, Offering-bringers and son Pedeḥor[resnet] 𓂋𓈖𓏤[𓎛𓏏𓏤] (tomb 196) before deceased.

M.M.A. photo. T. 965 [left]. See SCHEIL, pp. 626–7 [F'].

(4) [1st ed. 4] Two registers. I, Deceased adores Rēʿ-Ḥarakhti. II, Penbasa (?) 𓈖𓃀𓏤𓈖𓏥.

M.M.A. photo. T. 966 [right]. Texts in I, LEPSIUS MS. 253 [bottom]; GOLENISHCHEV MSS. 2 [k]; text of Rēʿ-Ḥarakhti, BRUGSCH, *Recueil,* pl. lxviii [k]. See SCHEIL, pp. 625–6 [F].

Ceiling. Titles of deceased, SCHEIL, p. 625 [middle].

Hall. View, M.M.A. photo. T. 984; HAY MSS. 29821, 129.

(5) [1st ed. 3, 5, 6] Outer lintel and jambs, texts. Left thickness, deceased adoring. Right thickness, deceased offers on braziers 'to Amen-rēʿ'. Inner lintel, double-scene, [Psammetikhos I] before Osiris, and before Horus, with deceased and man at right end. Inner jambs, texts.

M.M.A. photos. T. 965–8, 983. Braziers held by [deceased] and braziers among offerings on right thickness, SCHOTT photos. 8686–7. Text on outer lintel, BRUGSCH, *Recueil,* pl. lxviii [1 a]; LEPSIUS MS. 253 [middle]; text of deceased on right thickness, id. ib. 253 [top]; some texts on inner jambs, BRUGSCH, *Thes.* 1430–1 [a–d]. See SCHEIL, pp. 626 [x], 630–2 [x].

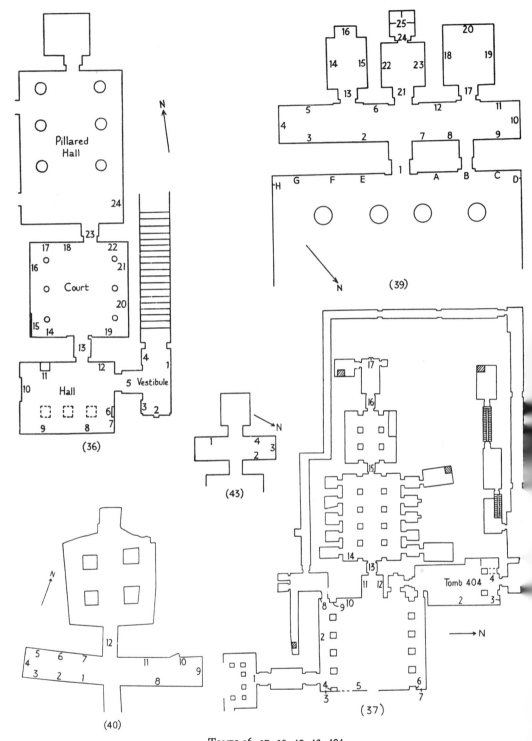

TOMBS 36, 37, 39, 40, 43, 404

(6) Ḥathor-pillar with text.

M.M.A. photo. T. 982 [left].

(7) [1st ed. 7] Four priests offer to deceased and mother. Sub-scene, son and three priests before deceased.

M.M.A. photo. T. 982 [right]. Text, LEPSIUS MS. 251 [middle]; GOLENISHCHEV MSS. 2 [g]; omitting two lines on left, CHAMP., *Not. descr.* i, p. 857 [to p. 554, l. 10]; WILKINSON MSS. ii. 8 [bottom middle left]. See SCHEIL, pp. 632–3 [T].

(8) [1st ed. 8] Deceased inspects five registers of industries. **I**, Sandal-makers, sculptors, and metal-workers. **II**, Chariot-makers, joiners, and vase-polishers. **III**, Potters, joiners, sculptors, and goldworkers. **IV**, Metal-workers with blow-pipes, weighing metal, men carrying plank, and boat-builders. **V**, [Boat-builders] and scribes. Sub-scene, offering-bringers.

M.M.A. photos. T. 975–7, 979–81. Omitting deceased, SCHEIL, pls. iii–v, figs. 1–7, pp. 635–9; WRESZ., *Atlas*, i. 132–40, 55. Deceased and **I–V**, DAVIES, *Deir el-Gebrâwi*, i, pls. xxiv–xxv. Deceased, MACKAY in *J.E.A.* iv (1917), pl. xviii [3], pp. 83–4; BAUD, *Dessins*, fig. 13; GHALIOUNGUI in *Ann. Serv.* xlvii (1947), pl. vi [left], p. 39. **I–V**, WILKINSON MSS. iii. 24. **I**, incomplete, CAILLIAUD, *Arts et métiers*, pls. 9 [9–11], 10 [1, 3–5], 20; ROSELLINI, *Mon. Civ.* xlv [5], lii [3], lxiv [4]; sandal-makers, CHAMP., *Mon.* clxxxii; sculptor with statuette, GOLENISHCHEV MSS. 2 [h]. **II**, incomplete, CAILLIAUD, op. cit. pls. 7, 9 [1, 7], 11; chariot-makers, CHAMP., *Mon.* clxxxi [1, 4], cxcii [1, 2]; ROSELLINI, *Mon. Civ.* xliv [4]; WILKINSON, *M. and C.* i. 349 (No. 54) = ed. BIRCH, ii. 231 (No. 64); vase-makers, SCHÄFER and ANDRAE, *Kunst*, 434 [1], 2nd and 3rd eds. 450 [1] (all from WRESZINSKI). **III**, incomplete, CAILLIAUD, op. cit. pls. 9 [3–4, 8], 12, 13; CHAMP., *Mon.* clxxx [1–4], clxxxi [2], clxxxiii [1, 2]; ROSELLINI, *Mon. Civ.* xlvi [8, 9], xlvii [1], li [1, 2]; joiner, GOLENISHCHEV MSS. 2 [i]; goldworkers, WILKINSON, *M. and C.* iii. 223 (No. 374 a) = ed. BIRCH, ii. 235 (No. 414). **IV**, incomplete, CAILLIAUD, op. cit. pls. 2, 9 [2], 17, 42; metal-workers, WILKINSON, *M. and C.* iii. 89 (No. 349, 2) = ed. BIRCH, ii. 140 (No. 380, 2); men with plank, and boat-builders, ROSELLINI, *Mon. Civ.* xliv [2], xlvii [5], li [3]; boat-builders, CHAMP., *Mon.* clxxxiii [3]. Overseer and scribe in **V**, CAILLIAUD, op. cit. pl. 9 [5, 6]. Text of deceased, BRUGSCH, *Recueil*, pl. lxviii [b]; PIEHL, *Inscr. hiéro.* 1 Sér. cxliii [γ β]; LEPSIUS MS. 251 [top left]; GOLENISHCHEV MSS. 2 [d]. Texts of sandal-makers in **I**, LEPSIUS MS. 251 [top right]. Some texts in **III**, BRUGSCH, *Recueil*, pl. lxviii [c, d, e]. Some texts in sub-scene, CHAMP., *Not. descr.* i, p. 858 [to p. 556, l. 8].

(9) [1st ed. 9, 10] Deceased seated in kiosk inspects five registers. **I–V**, Male dancers, musicians (singers, two male harpists, and flutist), and games, including 'mora' and draughts. Sub-scene, offering-bringers.

M.M.A. photos. T. 974, 978; see SCHEIL, pp. 633–5 [0]. Deceased, SCHOTT photo. 9038. **I–V**, WILKINSON MSS. ii. 8 [lower left]. **I** and **II**, SCHEIL, pl. ii. Musicians and dancers in **I–IV**, WILKINSON, *M. and C.* ii. 236 (No. 189), 239 (No. 194), 336 (No. 238), 337 (No. 240, 1–3) = ed. BIRCH, i. 440 (No. 214), 443 (No. 219), 506 (No. 263), 507 (No. 265, 1–3). Parts of **III** and **IV**, CHAMP., *Mon.* clxxxi [3]; dancers, harpist, and flutist, CAILLIAUD, *Arts et métiers*, pl. 40. **V**, WILKINSON, *M. and C.* i. 44 (No. 3, c, d) (called Beni Ḥasan), ii. 417 (No. 292, 1, 2), 419 (No. 294, 2) = ed. BIRCH, i. 32 (No. 2, c, d), ii. 55 (No. 317), 57 (No. 319, 2); CHAMP., *Not. descr.* i, pp. 555–6 [A–C]; 'mora' and draughts, WILKINSON MSS. ii. 20 [middle right]; 'mora', SCHOTT photo. 9037; see RANKE in *Sitzungsb. Heidelberger Akad. Wissenschaften*, Phil. hist. Kl. 1920 [4], pp. 9–14. Texts and details, CHAMP., *Not. descr.* i, pp. 555, 857–8; text above deceased, and texts in **I** and **V**, BRUGSCH, *Recueil*, pl. lxviii [f–h]; texts above deceased and above **II**, GOLENISHCHEV MSS. 2 [e, f].

(10) [1st ed. 11, 12] Statue-niche. At sides, titulary of Psammetikhos I, Nitocris, and Shepenwept, and 'Appeal to visitors'.

SCHEIL, pl. vi [middle and left], p. 640 [B]; M.M.A. photos. T. 972-3, 984 [middle]. Niche, CHAMP., *Mon.* cliii [1], and *Not. descr.* i, p. 856; L. *D.* iii. 270 [c]; WILKINSON MSS. xvii. H. 16 [right]; LEPSIUS MS. 250 [lower]. Texts, GOLENISHCHEV MSS. 1 [c], 2 [a–c]; text on niche, BRUGSCH, *Thes.* 1430 [upper]; part of 'Appeal', BRUGSCH, *Recueil*, pl. lxviii [m].

(11) [1st ed. 13] Hathor-pillar, with autobiographical text on left, and bull and seven cows on right with souls of Nekhen beyond them.

M.M.A. photos. T. 970-1; omitting pillar, SCHEIL, pls. vi [right], vii [left], p. 641 [a]. Bull and cows, WILKINSON MSS. ii. 8 [lower right]. Texts, LEPSIUS MS. 249 [lower]-250 [upper]; titles of deceased and names of parents from text below cows, L. *D. Text*, iii, p. 247 [a].

(12) Souls of Pe, with mummified Rēʿ-Harakhti, and four sacred oars behind them.

SCHEIL, pl. vii [right], p. 641 [aʹ]; M.M.A. photo. T. 969 [right].

[Two Hathor-pillars] in middle of Hall. See SCHEIL, p. 642; CHAMP., *Not. descr.* i, p. 554; texts (presumably from here), invocations of Osiris, Monthu, &c., LEPSIUS MS. 252 [middle and left]; of Osiris, WILKINSON MSS. ii. 8 [bottom middle right]; of Monthu, BRUGSCH, *Recueil*, pl. lxviii [l].

Ceiling. Offering-text, SCHEIL, p. 642.

Court. Views, M.M.A. photos. T. 997-8.

(13) [1st ed. 14 and 15] Outer lintel, uncle and offering-bringers before deceased seated, jambs, texts with deceased seated at bottom. Thicknesses, deceased adoring with text. Inner lintel, Horus-name of Psammetikhos I between Osiris and Rēʿ-Harakhti, with deceased at each end, and jambs, remains of texts with cartouches of Psammetikhos I and Nitocris.

M.M.A. photos. T. 969-70, 985-8, cf. 984, 998; see SCHEIL, pp. 640 [P], 642 [P]. Inner doorway and frieze-text, WILKINSON MSS. iii. 19. Title of uncle on outer lintel, BRUGSCH, *Thes.* 1431 [near top]; texts of outer right jamb and left thickness, LEPSIUS MS. 249 [upper and right]; royal titles on inner right jamb, id. ib. 248 [bottom].

(14) [1st ed. 16] Two registers. Priest with attendants, **I**, offers to deceased and mother (as Teiri), **II**, offers flowers to deceased.

M.M.A. photo. T. 988 [right]. Deceased and mother in **I**, MACKAY in *J.E.A.* vii (1921), pl. xxiv [2], p. 165. Text, SCHEIL, pp. 643-4 [Kʹ]; PIEHL, *Inscr. hiéro.* 1 Sér. cxlii [Y a]; part, BRUGSCH, *Recueil*, pl. lxviii [i]; names, LEPSIUS MS. 247 [bottom right]; name of mother, L. *D. Text*, iii, p. 247 [top middle].

(15) [1st ed. 17] Statue-niche with cartouches of Nitocris and Shepenwept III.

L. *D.* iii. 271 [a]; M.M.A. photos. T. 989 [left], cf. 998; HAY MSS. 29847, 96. Texts, SCHEIL, p. 644 [Rʹ]; LEPSIUS MS. 248 [middle]; GOLENISHCHEV MSS. 2 [j].

(16) Deceased seated with offering-list and ritual-text concerning Nefertem-emblem. Sub-scene, offering-bringers.

M.M.A. photos. T. 989-90; main scene, and texts of sub-scene, SCHEIL, pl. viii, pp. 645-6. Text above deceased, LEPSIUS MS. 247 [bottom left]; ritual-text, see NAVILLE in *Ann. Serv.* xvi (1916), pp. 187, 189.

(17) Six registers. I–V, Funeral procession, (including *teknu* in **II**, victims and 'Nine friends' in boat in **III–IV**, and Abydos pilgrimage in **V**). **VI**, Deceased adores [god].

M.M.A. photos. T. 991 [left], 993. **I–IV**, and text of **VI**, SCHEIL, pl. ix, pp. 651–3 [T], and fig. 9.

(18) Stela, deceased adores Osiris and goddess, and texts.

M.M.A. photo. T. 991. Texts, SCHEIL, pp. 653–4.

(19) Two registers. **I**, Son Pedeḥorresnet with attendants offers bouquet to deceased and mother. **II**, Priests, including son Pedepeneferenirtef ☐ ☐⟋⟍, with tables of offerings before deceased and mother.

M.M.A. photo. T. 987 [left]. Texts, SCHEIL, pp. 642–3 [K]; text of Pedeḥorresnet, LEPSIUS MS. 248 [top].

(20) [1st ed. 20] Two registers. **I**, Double-scene, son (?) offers bouquet to deceased. **II**, Son . . . monthu before deceased with three rows of hunting (including lions) and agriculture between them. Sub-scene, agriculture, including ploughing and waiting chariot.

M.M.A. photos. T. 995–6. Hunting and agriculture in **II**, WRESZ., *Atlas*, i. 141; hunting, DAVIES, *Deir el Gebrâwi*, i, pl. xxv. Text of deceased in **I**, and part of hunting, SCHEIL, pp. 647–8 [R], fig. 8; kneeling archer and gazelle, and porcupine, SCHOTT photos. 8688–9.

(21) Seven registers. I–VII, Funeral procession, including *teknu* in **I**, boat and mourners in **II**, 'Nine friends' and chariot carried in **IV**, cow and calf in **V**, and shrine with Sons of Horus dragged in **VI**.

M.M.A. photos. T. 994–5. See SCHEIL, pp. 648–50. Male mourner and jars in stands in **VII**, SCHOTT photo. 8690.

(22) Two registers. **I**, Son (?) offers to deceased and mother. **II**, Deceased and mother with offerings before stela with [Anubis] at top.

M.M.A. photo. T. 992 [right]. Texts, SCHEIL, pp. 650–1 [S].

Frieze. Text on north wall, SCHEIL, p. 654 [near top]; above inner doorway at (13), L. *D.* iii. 270 [a].

Ceiling. Text, SCHEIL, p. 654 [upper middle].

Pillared Hall. View, M.M.A. photo. T. 1000.

(23) [1st ed. 18, 19] Outer lintel, text, with deceased adoring at right end, and jambs, 'Address to the living' (mentioning Valley Festival), with deceased seated at bottom. Left thickness, deceased with hymn to Osiris-Onnophris.

M.M.A. photo. T. 991–2, 1001. Texts, SCHEIL, pp. 650 [P'], 654 [P']; cartouche of Nitocris on lintel, L. *D. Text*, iii, p. 247 [middle left]; part of text on right jamb, FOUCART in *B.I.F.A.O.* xxiv (1924), p. 107.

(24) Two registers, double-scenes. **I**, Priest with others censes and libates to deceased. **II**, Isis on left, Nephthys on right, each followed by Anubis with cloth.

M.M.A. photo. T. 999.

Columns. Offering-texts, SCHEIL, pp. 654–5.

Frieze and ceiling, remains of text. Frieze-text, SCHEIL, p. 655 [bottom].

Lid of sarcophagus, in Turin Mus. 2202. BUHL, *Late Eg. . . . Stone Sarcophagi*, pp. 122–4 [G, b 3], fig. 73 [top], pl. ix. Details, LANZONE, *Diz.* pls. clxxvi [3], clxxxvi [3], p. 176, fig. 1. Texts, PIEHL, *Inscr. hiéro.* 1 Sér. lxxxiv–lxxxvi [D]; titles, BRUGSCH, *Thes.* 1429 [lower, 30]; names, LIEBLEIN, *Dict.* No. 1319. See FABRETTI, ROSSI, and LANZONE, *R. Mus. di Torino*, pp. 292–3; ORCURTI, *Cat.* i, pp. 76–7 [3].

37. ḤARUA 𓏏𓎟 , Chief steward of the god's wife Amenardais I. Saite.
'Asâsîf. (CHAMPOLLION, No. 54, L. D. Text, No. 23.)
Parents, Pedemut 𓊪𓏏𓅓, Scribe, and Estawert 𓏏𓎛𓏤 (names from statues, in Berlin Mus. 8163, see infra, p. 69, and Cairo Mus. Ent. 36711).

Plan, p. 64, cf. p. 292, key-plan. Map IV, D-5, a, 4.

CHAMP., *Not. descr.* i, pp. 551–2; L. D. *Text*, iii, pp. 245–6; LEPSIUS MS. 246 [2]. Plan, POCOCKE, *A Description of the East*, i, pl. xxxiv [B], p. 100; HAY MSS. 29821, 83, and view 109.

Portico.
(1) Outer lintel and left jamb. Texts.
Lintel, and top of jamb, BAUD, *Dessins*, figs. 36–7; lintel, LEPSIUS MS. 247 [top].

Court.
(2) Man with staff. (3) Two registers, **I,** man offers to Rēꜥ-Ḥarakhti, **II,** hymn. (4) Deceased with text. (5) Man with text. (6) Deceased carrying jar, and text. (7) Mummy on couch, with disk and rays above, and text below on each side, mentioning deceased as real royal acquaintance. (8) Two registers, **I,** sacred oils and unguents, **II,** offerings and ritual objects, and man seated.

(9) Pilaster. Mummy on couch with *ba*-bird above and titles of deceased below.

(10) Stela. At top, priest performing Opening the Mouth rite, and lector.
See SCHIAPARELLI, *Funerali*, ii, p. 307 [xxxii].

(11) and (12) Frieze-text, with title of deceased.

Outer Hall. Texts on side-walls and rear wall.
(13) Remains of entablature, with offering-formulae and titles of deceased on each side of it, thicknesses, hymns (?). (14) Deceased seated with table of offerings and offering-list.

Inner Hall.
(15) Left thickness, deceased led by Anubis. Right thickness, texts.

Shrine.
(16) Left thickness, deceased with Western goddess led by Anubis, right thickness, texts. (17) False door with statue of Osiris.

Finds. Probably from here.

Block-statuette of deceased, in Louvre, A. 84. GREENE, *Fouilles exécutées à Thèbes* [&c.], pls. x, xi; BOSSE, *Die menschliche Figur*, pl. iii [53]; GUNN and ENGELBACH in *B.I.F.A.O.* xxx

(1930), pl. vi, pp. 802–10, cf. 793 [vi]. Texts, SHARPE, *Eg. Inscr.* 2 Ser. 35; PIEHL in *Journal Asiatique*, 7ᵉ Sér. xvii (1881), pp. 159–78; titles, BRUGSCH, *Thes.* 1462 (120). See BOREUX, *Guide*, i, p. 58; VANDIER, *Guide* (1948), p. 66 [2], (1952), p. 67.

Block-statuette of deceased, in Berlin Mus. 8163. GUNN in *B.I.F.A.O.* xxxiv (1934), pp. 135–42 with pl. Text, EBERS in *Z.D.M.G.* xxvii (1873), pp. 137–46; GUNN and ENGELBACH in *B.I.F.A.O.* xxx (1930), pp. 802–10, cf. 793 [vii] (from EBERS). See *Ausf. Verz.* pp. 255–6.

38. ZESERKARAʿSONB ⟨⟩, Scribe, Counter of the grain in the granary of divine offerings of Amūn. Temp. Tuthmosis IV.

Sh. ʿAbd el-Qurna.
Wife, Wazronpet.

Plan, p. 44. Maps IV, V, D–4, j, 9.

SCHEIL, *Le Tombeau de Ratʿeserkasenb* in *Mém. Miss.* v [2], pp. 571–9, with plan, p. 571.

Hall.

(1) [1st ed. 1] Left thickness, deceased and wife adoring with hymn to Rēʿ.

Hymn, SCHEIL, p. 572 [a′]; KUENTZ in *B.I.F.A.O.* xxi (1923), p. 120 [1]; HAY MSS. 29844 A, 7 [top left].

(2) [1st ed. 2] Deceased, followed by wife, son with papyrus-bouquet, and three rows of sons and attendants, pours incense on offerings. Sub-scene, food-table, butchers, and offering-bringers.

SCHEIL, end-plate i, pp. 572–3 [a]; FARINA, *Pittura*, pl. cvi; M.M.A. photo. T. 1079; SCHOTT photos. 2085–7, 2095–8, 2139–40, 2148, 2675–6, 5561–4, 6633–41, 6690, 7305–6, 8547–50; HAY MSS. 29851, 254, 286–8, 292–301; 29853, 168–73. Second row of attendants, and part of sub-scene, WEIGALL, *Anc. Eg. . . . Art*, 157 [3, 4]; girl with dates in third row, and butchers, MEKHITARIAN, *Egyptian Painting*, pls. on pp. 69, 66. Texts, KUENTZ, op. cit. pp. 121–2 [2–7]; HELCK, *Urk.* iv. 1637–8 [upper]; names, HAY MSS. 29844 A, 7 [middle].

(3) [1st ed. 3] Three registers. I, Measuring crop. II, Deceased offering on braziers to Termuthis, and servants with food (including sheaf with quails) before deceased seated in booth. III, Harvest and ploughing before deceased standing, including winnowing with offerings to harvest-deity.

SCHEIL, pl. iv, pp. 576–9 [c]; MASPERO, *Égypte*, fig. 292; FARINA, *Pittura*, pl. cvii; M.M.A. photo. T. 1080; details, SCHOTT photos. 2083–4, 2088–9, 2091, 2145–6, 2677, 6642–52, 7307–10; HAY MSS. 29851, 265–8, 269 (reversed), 270–82; 29852, 151; 29853, 167; part, WRESZ., *Atlas*, i. 11 [a], 142, 143 [A, B]. I and II (omitting right end), VAN DER WAERDEN, *Science Awakening*, pl. i. I, BERGER in *J.E.A.* xx (1934), pl. x [3], pp. 55–6; DONADONI, *Arte Egizia*, fig. 111; right end of I, and burnt-offerings in II, MASPERO, *Hist. anc. Les Origines*, figs. on pp. 120–1; deceased before Termuthis in II, SCHOTT in NELSON and HÖLSCHER, *Work in Western Thebes, 1931–33* (*Chic. O.I.C.* No. 18), fig. 44; WEGNER in *Mitt. Kairo*, iv (1933), pl. xv [b]; burnt-offerings, SCHOTT, *Das schöne Fest*, p. 785, Abb. 4. Winnowing in III, CAPART and WERBROUCK, *Thèbes*, fig. 209 (from WRESZINSKI); harvest-deity, DAVIES, *The Tomb of Nakht at Thebes*, fig. 11. Texts, KUENTZ in *B.I.F.A.O.* xxi (1923), pp. 123–5 [8–14]; texts in II, HELCK, *Urk.* iv. 1640 [top].

(4) [1st ed. 4] Two registers. **I,** Two sons and daughter with bouquets before deceased and wife. **II,** Offering-bringers with grapes and dates.

SCHEIL, pl. i, p. 574 [e]. Deceased and wife, MARBURG INST. photo. 86939. First son, SCHOTT photo. 8557. Texts, KUENTZ in *B.I.F.A.O.* xxi (1923), pp. 126–7 [15–17]; HAY MSS. 29844 A, 7 [bottom].

(5) [1st ed. 6] Deceased with wife offers on braziers before offerings, with offering-bringers below.

M.M.A. photo. T. 1081; omitting offerings, BAUD, *Dessins*, pl. v, pp. 86–7. Deceased, MEKHITARIAN, *Egyptian Painting*, pl. on p. 29. Details, SCHOTT photos. 2156, 6653–5. Text, SCHEIL, pp. 573–4 [b]; KUENTZ, op. cit. p. 127 [18]; HELCK, *Urk.* iv. 1639 [near bottom].

(6) [1st ed. 5] Three registers. **I–II,** Deceased and wife with two daughters offering necklace and wine to them, offerings, female guests, and female musicians (harp, lute, double-pipe, and lyre) and clappers (ancient copy of scene in tomb 75). **III,** Deceased and wife, offering-bringers, and male guests.

SCHEIL, pls. ii, iii, and end-pl. ii, pp. 574–6 [f]; M.M.A. photos. T. 1082–4; omitting some guests, HICKMANN, *45 Siècles de Musique*, pl. xxxii; details, SCHOTT photos. 2099, 2100, 2135, 2137, 2144, 2155, 4687–95, 4697–4703, 6656–64, 7311, 8551–6; HAY MSS. 29851, 248–53, 255–64, 283–5, 289–91; 29852, 148; 29853, 134–6, 180–2, 185–9. **I–II,** WRESZ., *Atlas*, i. 144–5; FARINA, *Pittura*, pls. civ, cv; guests, CAPART, *L'Art égyptien*, iii, pl. 524 [lower]; daughters, maid, first guest, and musicians, VANDIER, *Egypt*, pls. xvii–xix; daughters and harpist, WEGNER in *Mitt. Kairo*, iv (1933), pl. xvi [a]; RANKE, *Meisterwerke*, pl. 45; LANGE, *Lebensbilder*, pl. 43, and *Pyramiden, Sphinxe, Pharaonen*, pl. 24 (both from SCHOTT photo.); LANGE and HIRMER, *Aegypten*, pl. 151; LHOTE and HASSIA, *Chefs-d'œuvre*, pl. 117; offerings, maids, first guest, and musicians, WEIGALL, *Anc. Eg. . . . Art*, 158–9; DAVIES (Nina), *Anc. Eg. Paintings*, i, pls. xxxvi, xxxvii (CHAMPDOR, Pt. iii, 1st and 4th pls.); daughter's hand with wine, SCHOTT, *Altägyptische Liebeslieder*, pl. 13; offerings, maids, and first guest, CAPART, *Le Paysage et les scènes de genre*, fig. 44; id. *Schoonheidschatten uit Oud-Egypte*, Abb. 22; maids and first guest, PIJOÁN, *Summa Artis*, iii (1945), fig. 471; MEKHITARIAN, *Egyptian Painting*, pl. on p. 67; LANGE and HIRMER, *Aegypten*, pl. 150; CHAMPDOR, *Thèbes aux Cent Portes*, fig. on p. 163; upper part of a guest and a maid (recently cut out), FAKHRY in *Ann. Serv.* xlvi (1947), pl. vii, cf. p. 33, fig. 7; the maid, de RACHEWILTZ, *Incontro con l'arte egiziana*, pl. 63, p. 78; musicians, CHAMPDOR, op. cit. fig. on p. 122; PIJOÁN, *Summa Artis*, iii (1945), fig. 469; BYVANCK, *De Kunst der Oudheid*, pl. xl, fig. 144, cf. p. 273; HICKMANN in *Ann. Serv.* l (1950), fig. 3 (probably from SCHEIL), cf. p. 534; SCOTT in *M.M.A. Bull.* N.S. ii (1944), fig. on p. 160; id. *The Home Life of the Ancient Egyptians*, fig. 34; TAYLOR, *Fifty Centuries of Art*, fig. on p. 5 [middle]; PRITCHARD, *The Ancient Near East in Pictures*, fig. 208; DRIOTON, *La Danse dans l'ancienne Égypte* in *La Femme Nouvelle* (Cairo, Oct. 1948), fig. on p. 32; id. in *Egyptian Education Bureau, London. The Bulletin*, No. 35 (1949), 1st pl. [upper] after p. 64; VALLON, *Que savons-nous de la musique pharaonique?* in *Formes et Couleurs*, xi [1] (1949), 6th fig.; harpist, and lyre player, SACHS, *Musikinstrumente*, Abb. 50, 88 (from WRESZINSKI); double-pipe and lyre players, LHOTE and HASSIA, *Chefs-d'œuvre*, pl. 127; double-pipe player, CLARK in *M.M.A. Bull.* N.S. iii, Summer 1944, fig. on p. 25; lyre player and clappers, BRUYÈRE, *Rapport (1934–1935)*, Pt. 2, figs. 55, 60. Texts, KUENTZ in *B.I.F.A.O.* xxi (1923), pp. 128–30 [19–27] (called Wall D'); incomplete, HELCK, *Urk.* iv. 1638 [lower]–1639 [middle], 1639 [bottom], 1640 [middle].

39. PUIMRĒᶜ ⳩, Second prophet of Amūn. Temp. Tuthmosis III.

Khôkha. (L. D. *Text*, No. 18.)

Parents, Puia ⳩ and Neferiᶜoḥ. Wives, Tanefert and Sensonb.

Plan, p. 64. Map IV, D–5, d, 7.

DAVIES, *The Tomb of Puyemrê at Thebes*, passim, with plans, sections, and elevations, vol. i, pls. iv, v, vol. ii, pls. lxxiii–lxxvii. View, DAVIES in *M.M.A. Bull.* Pt. ii, May 1917, fig. 31, cf. p. 27; M.M.A. photos. T. 713–14, 429. Titles, SETHE, *Urk.* iv. 527 (170) a–g.

Portico. DAVIES, *Puyemrê*, i, pp. 4–7, with view, pl. iii [B].

A–H. Stelae (A–C and E–G, autobiographical texts), with panels of text between them. Elevation of A–C and E–G, DAVIES, *Puyemrê*, ii, pl. lxxv. See id. ib. i, pp. 39–42, ii, pp. 43–7, and pls. lxvi (stelae A and E), lxvii (stela E), lxviii (stela D), lxix (stelae C and F), lxx (stela H, and fragments of others).

Columns. Remains of text of deceased. DAVIES, *Puyemrê*, ii, pl. lxxii [46–55], p. 65.

Intercolumnar walls. Remains of scenes, including banquet and deceased purified by two priests.

Id. ib. ii, pls. lxxi, lxxii, pp. 55, 63–5, i, pp. 5–6.

Hall.

(1) Right thickness, [deceased].
See DAVIES, *Puyemrê*, i, p. 36, note 2.

(2) [Deceased] with staff and remains of text.
Id. ib. i, pl. xxii, p. 37.

(3) [1st ed. 1] Six registers. **I–III**, Garden, and remains of bringing produce and cattle to [deceased]. **IV–VI**, [Deceased] inspects workshops of the Temple of Amūn and agricultural scenes, including makers of chariots and bows in **IV**, metal-workers and ploughing in **V**, carpenters, jewellers, stone-vase workers, ploughing, and attendants with horses and [chariot] in **VI**.

DAVIES, *Puyemrê*, i, pls. xxi [2–7], xxiii–xxviii, pp. 55–7, 66–76. Craftsmen in **IV–VI**, WRESZ., *Atlas*, i. 151–4; some, M.M.A. photos. T. 632–40; craftsmen in **IV** and **V**, and ploughman in **V**, MEYER, *Fremdvölker*, 789–90, 635; men with bull-headed vase in **V**, STOPPELAÈRE, *Introduction à la peinture thébaine* in *Valeurs*, Nos. 7–8 (1947), pl. 1; two bull-headed vases and another, VERCOUTTER, *L'Égypte* [&c.], pls. xli [283–4], xlvii [345], pp. 321, 333. Drilling beads in **VI**, DAVIES in *M.M.A. Bull.* Pt. ii, May 1917, fig. 36, cf. p. 30; man hacking and attendants in **VI**, M.M.A. photo. T. 641.

(4) Hymn to gods with autobiographical texts and two priests in [offering-list ritual].
DAVIES, *Puyemrê*, i, pls. xxix [1, 2], xxi [1], pp. 31–4; M.M.A. photo. T. 626.

(5) [1st ed. 2] Six registers. **I–III**, Banquet with guests and female [musicians], including woman with lyre. **IV–VI**, Recording produce of South Lands before [deceased] for Treasury of Amūn, including Nubians with cattle, gold, and ivory, monkeys and baboons, and Egyptians with linen.
DAVIES, *Puyemrê*, i, pls. xli, xlii [1, 3, 4], xliii, pp. 54–5, 102–4. **IV–VI**, WRESZ., *Atlas*, i. 148.

(6) Two registers. **I**, Overseers present *menat*, cartouche-vase held by baboon, &c., to [deceased]. **II**, Deceased inspects weighing and recording gifts of gold and incense to temple, with list of temples.

DAVIES, *Puyemrê*, i, pls. xlii [2], xl, pp. 102–3, 92–6, cf. pl. xxx [3].

(7) Two registers. **I**, Son offers bouquet of Amūn to [deceased] and Sensonb. **II**, Deceased and 'Appeal to visitors'.

DAVIES, *Puyemrê*, i, pls. ix [lower right], viii [2], xx, pp. 24, 36–9.

(8)–(9) [1st ed. 6, 7] Two registers. **I**, Three scenes, **1**, deceased, with Tanefert (with monkey eating dates under her chair), inspects three rows of produce of marsh-lands, **2**, deceased spearing hippopotamus, **3**, deceased and family fishing and [fowling]. **II**, Deceased standing with Sensonb inspects three rows, 1st, bringing geese, ducks, and cranes, and netting fowl, 2nd, herdsmen bringing cattle and bringing and netting fish, 3rd, vintage with sealing wine-jars, pressing and treading grapes, [bringing horses, cut through by doorway], and papyrus-harvest.

DAVIES, *Puyemrê*, i, pls. viii [3], ix [upper, and lower left], x–xix, pp. 48–53, 61–6. Plants and nest in **I**, **2**, KEIMER in *R.E.A.* ii (1929), figs. 3 and 57 (from DAVIES), cf. pp. 212, 246. **II**, WRESZ., *Atlas*, i. 13, 30, 54, 146–7, 157; M.M.A. photos. T. 627–31; part, MEYER, *Fremdvölker*, 786–8; details, SCHOTT photos. 8698–8702; cattle, WEGNER in *Mitt. Kairo*, iv (1933), pl. v [a]; right group in papyrus-harvest, CAPART and WERBROUCK, *Thèbes*, fig. 202. Text above wine-press, mentioning ʿApiru, see SÄVE-SÖDERBERGH in *Orientalia Suecana*, i [1/2], (1952), p. 5.

(10) [1st ed. 5] Two registers. **I**, Double-scene, [man] offers to parents of deceased, and to deceased and Sensonb, with panel in centre. **II**, Deceased on foot hunting in desert, and men bringing game.

DAVIES, *Puyemrê*, i, pls. vi [upper], vii, viii [1], pp. 34–6, 45–8. **I**, HERMANN, *Stelen*, Abb. 11 (from DAVIES), p. 6* [35]. Texts in **I**, LEPSIUS MS. 257; of parents, L. D. *Text*, iii, p. 243 [middle left].

(11) [1st ed. 4] Six registers. [Deceased] receives produce, in **I–III** from Retenu, 'Road of Horus', and the Oases, and in **IV–VI** from Punt.

DAVIES, *Puyemrê*, i, pls. xxx [4], xxxi–xxxiii [B], xxxiv, xi [3], pp. 24, 79–87. Omitting deceased, MEYER, *Fremdvölker*, 780–5. **I–III**, WRESZ., *Atlas*, i. 150; DUEMICHEN, *Oasen*, pl. i. **III** and **IV**, M.M.A. photo. T. 642. Texts, SETHE, *Urk.* iv. 523–4 (169), A, B; texts of **I–III**, LEPSIUS MS. 258–9 [upper]; text of deceased in **IV–VI**, DUEMICHEN, *Oasen*, pl. ii [a]; part, L. D. *Text*, iii, p. 243 with a.

(12) [1st ed. 3] Two registers. **I**, Deceased seated receives officials with temple-gifts, including obelisks, floral vases, shrines, &c. **II**, Deceased standing inspects recording of Northern tribute, including weighing, officials, three Syrians, and a Kefti.

DAVIES, *Puyemrê*, i, pls. xxxv–xxxix, frontispiece, xxxiii [A], pp. 96–101, 24, 87–92. **I**, omitting vases, L. D. iii. 39 [c]; first obelisk, BREASTED in *Ä.Z.* xxxix (1909), pl. iii [3], p. 58; floral vase with frog and shrines, WRESZ., *Atlas*, i. 34, 155 [A]; vase with frog, M.M.A. photo. T. 643. **II**, WRESZ., *Atlas*, i. 149; CAPART and WERBROUCK, *Thèbes*, fig. 93 (from WRESZINSKI); scales, L. D. iii. 39 [d]; Syrians and Kefti, MEYER, *Fremdvölker*, 779; DAVIES in *M.M.A. Bull.* Pt. ii, May 1917, fig. 35, cf. p. 28; GRESSMANN, *Altorientalische Bilder zum alten Testament*, pl. vi [20]; PRITCHARD, *The Ancient Near East in Pictures*, fig. 2; WOLF,

Die Kunst Aegyptens, Abb. 455; M.M.A. photo. T. 644; Kefti, Bossert, *Altkreta* (1923), fig. on p. 245 [338], and *The Art of Ancient Crete*, fig. on p. 285 [540] (both from Meyer); Davies in *Liv. Ann.* vi (1914), pl. xviii, pp. 84–6; Vercoutter, *L'Égypte* [&c.], pls. ii [70], xxvi [187], pp. 205–7, 285. Texts in **I**, and above scales in **II**, Sethe, *Urk.* iv. 525–6 (169) c, 1–4; *L. D. Text*, iii, p. 244 [middle]; Lepsius MS. 259 [lower], 260 [middle].

Ceiling. Texts, Davies, *Puyemrê*, i, pl. vi [lower], cf. ii, p. 48.

South Chapel. [1st ed. c].

(13) Outer lintel and jambs, remains of text.
Id. ib. ii, pl. lxii [lower], pp. 3–4.

(14) [1st ed. 15] and (15) Sons and daughters with New Year gifts before deceased and wife (Sensonb on left wall, Tanefert on right wall).

Davies, *Puyemrê*, ii, pls. lxiii–lxv [A], pp. 39–40. Head of Sensonb, Davies in *M.M.A. Bull.* Pt. ii, May 1917, cover; M.M.A. photo. T. 648; Schott photos. 9035–6.

(16) Niche. Outer door-framing, texts. Rear wall, double-scene, deceased and wives seated.

Davies, *Puyemrê*, ii, pl. lxii [upper], p. 38.

Ceiling. Texts, id. ib. pl. xlix [right], p. 40.

North Chapel. [1st ed. A].

(17) [1st ed. 8] Entablature with decoration, outer lintel and jambs, texts. Thicknesses, two registers, man bringing offerings in each. Above inner doorway, tympanum, Abydos pilgrimage, with three registers, **I–III**, funeral scenes (continued at (19)) on each side of doorway: left side, **I**, four of the 'Nine friends', **II**, men with *teknu*, **III**, gods in shrines, right side, **I**, man offers to hawk-standard and shrine (?), **II**, mummers and rites in garden, **III**, attendants lighting tapers.

Davies, *Puyemrê*, ii, pls. xliv (frontispiece)–xlvi, lxxviii [A], p. 3, i, pl. xxx [A], pp. 5–10. Outer doorway, Schäfer and Andrae, *Kunst*, 1st ed. 317, 2nd and 3rd ed. 329 (all from Davies); Capart and Werbrouck, *Thèbes*, fig. 120 (from Davies); Davies in *M.M.A. Bull.* Pt. ii, March 1918, fig. 11, cf. p. 14; M.M.A. photos. T. 623, 428.

(18) [1st ed. 9] Offering-list and offerings, with ritual-text concerning Nefertem-emblem, before deceased.

Davies, *Puyemrê*, ii, pls. xlix–l, pp. 5, 10, 11. Ritual-text, Naville in *Ann. Serv.* xvi (1916), p. 191 (from copy by Golenishchev); Kees in *Ä.Z.* lvii (1922), pp. 96–113 [P] (from copy by Davies).

(19) [1st ed. 11] Three registers. **I–III**, Funeral procession to Western goddess (continued from (17)), including pool and victim in **III**.

Davies, *Puyemrê*, ii, pl. xlvii, pp. 5–7; M.M.A. photo. T. 959.

(20) [1st ed. 10] Tympanum, two Anubis-jackals, and stela below (in Cairo Mus. 34047), with remains of funeral outfit and ritual-texts on each side.

Davies, *Puyemrê*, ii, pls. xlviii (reconstruction), li, pp. 8–10; M.M.A. photo. T. 624. Stela, Lacau, *Stèles du Nouvel Empire* (*Cat. Caire*), pl. xxviii, pp. 80–2; von Bissing, *Denkmäler ägyptischer Sculptur*, Text to pl. 17, fig. 3; Pillet, *Thèbes. Palais et nécropoles*, fig. 13; M.M.A. photo. T. 430; see Maspero, *Guide* (1915), p. 191 [752].

Frieze and ceiling. Texts, DAVIES, *Puyemrê*, ii, pls. xlvii, xlix, p. 5.

Central Chapel. [1st ed. B]. (L. D. *Text*, No. 19.)

(21) [1st ed. 12] Outer jambs, titles. Thicknesses, son with bouquet of Amūn. Inner lintel, double-scene, singers with hymn, jambs, three registers of butchers.

See DAVIES, *Puyemrê*, ii, pp. 15–17, 25, and i, pl. xxx [1] (south thickness), ii, pl. lii (inner doorway). Texts on thicknesses, LEPSIUS MS. 260 [bottom]; on south thickness, L. D. *Text*, iii, p. 244 [19] (said to be from adjoining tomb).

(22) [1st ed. 13] Two registers. I, Two scenes, 1, priestesses of Ḥathor offer *menat*s and Ḥathor-emblems to deceased, 2, men before [deceased]. II, Two scenes, 1, deceased pours oils on burnt-offerings, 2, priest with offerings before deceased and wife.

DAVIES, *Puyemrê*, ii, pls. liv, lv, pp. 17–19, 20–6. Priestesses, vases, and burnt-offerings, M.M.A. photos. T. 645–7; vases and burnt-offerings in II, 1, WRESZ., *Atlas*, i. 155 [B], 156; vases, DAVIES in *M.M.A. Bull.* Pt. ii, May 1917, p. 28, fig. 34; lower part of priestess in I, and vases and burnt-offerings in II, SCHOTT photos. 8691–7. Title of deceased in I, 1, LEP-SIUS MS. 261 [top left].

(23) Two registers. I, Two scenes, 1, priestesses of Ḥathor offer sistra and *menat*s to deceased, 2, men before deceased. II, Two scenes, 1, [*sem*-priest] offers nine sacred oils, lamps, and burnt-offerings, 2, [deceased], and lector before deceased.

DAVIES, *Puyemrê*, ii, pl. liii, pp. 19–20, 22–6. Titles of deceased from I, 2, LEPSIUS MS. 261 [top right].

Ceiling. Texts, DAVIES, *Puyemrê*, ii, pl. lvii [lower], p. 26.

Shrine.

(24) [1st ed. 14] Outer jambs, text, with remains of four registers beyond, each with an offering-bringer. Inner lintel, titles, jambs, remains of spells with priest offering cloth and lighting lamp.

DAVIES, *Puyemrê*, ii, pls. lvi, lvii [upper], lxxviii [B], pp. 26–30; M.M.A. photos. T. 625, 958. Outer doorway, DAVIES in *M.M.A. Bull.* Pt. ii, May 1917, fig. 33, cf. p. 28.

(25) Side-walls, offering-list and ritual before deceased and wife (Tanefert on left, Sensonb on right). Rear wall, double-scene, deceased kneels before Western goddess, and before Osiris.

DAVIES, *Puyemrê*, ii, pls. lviii, lix, pp. 28–9, 30–1.

Ceiling. Texts, id. ib. pl. lx, pp. 31–3.

Finds[1]

Lower part of block-statue of deceased, probably from the Shrine. Id. ib. pl. lxxix [F], i, p. 14; M.M.A. photo. 5A. 37.

Lower part of seated statue of deceased, probably from here, in Florence Mus. 6310. Name and titles, SCHIAPARELLI, *Mus. . . . Firenze*, pp. 463–4 [1721].

Painted wooden stand with pool and ducks. DAVIES, *Puyemrê*, ii, pl. lxx [5, 6], i, pp. 15–16.

[1] Statuette in Berlin Mus. 10266, *Bibl.* 1st ed. p. 75, is an ushabti, and omitted.

Sandstone block with hieratic text mentioning Tuthmosis III. GR. INST. ARCHIVES, photo. 1098. See DAVIES, *Puyemrê*, ii, p. 60.

Fragment of painted bas-relief with palms, in Cairo Mus. Ent. 43368.

40. AMENḤOTP 〔☰⏥〕, called ḤUY ⏤〳〵, Viceroy of Kush, Governor of the South Lands. Temp. Amenophis IV to Tutʿankhamūn.

Qurnet Muraʿi. (CHAMPOLLION, A, L. *D. Text*, No. 110.)

Mother, Wenḥo 𓈖𓏏𓇯𓏤.

<p style="text-align:center">Plan, p. 64. Map VIII, F–3, h, 3.</p>

DAVIES (Nina) and GARDINER, *The Tomb of Ḥuy, Viceroy of Nubia in the Reign of Tutʿankhamūn*, with plan and sections, pls. ii, iii; WILKINSON, *Topography of Thebes*, pp. 135–8; CHAMP., *Not. descr.* i, pp. 477–80; L. *D. Text*, iii, pp. 301–6, with plan. Texts, HELCK, *Urk.* 2064–73 (792).

Hall. Views, M.M.A. photos. T. 1188, 1201–2.

(1) [1st ed. 1] Two registers. **I**, Deceased with two rows of family (including mother and two sons) returns to barge (twice represented), received by three rows of officials with produce. **II**, Officials, sailors, female dancers, and musicians (two with tambourines). Sub-scene, bringing produce.

DAVIES and GARDINER, pls. x [left], xi–xv, xxxix [5–8], pp. 14–18, 21, and figs. 2, 3 (from HAY); M.M.A. photos. T. 1194–7. Barges in **I**, WRESZ., *Atlas*, i. 165; lower barge and men with bags in **I**, HAY MSS. 29851, 340–6; lower barge, DAVIES (Nina), *Anc. Eg. Paintings*, ii, pl. lxxxii; id. *Eg. Paintings* (Penguin), pl. 15; top row of officials, PETRIE, *Racial Types*, 789 (sheet xvi); details of barges, SCHOTT photos. 4669, 4860–1; WILKINSON MSS. v. 180 [top]. Texts, BRUGSCH, *Thes.* 1137–8; part, L. *D. Text*, iii, p. 305 [middle]; LEPSIUS MS. 355 [top and middle].

(2) [1st ed. 2] Deceased inspects five registers of Nubian tribute, including women and children. **I–V**, Bringing, weighing, and recording, gold, &c.

DAVIES and GARDINER, pls. x [middle], xvi, xvii, p. 19; WRESZ., *Atlas*, i. 162–4; M.M.A. photos. T. 1193–4 [right], 1198–9. Parts of **I** and **III**, CHIC. OR. INST. photos. 10376–8. Some Nubians, PETRIE, *Racial Types*, 791–2 (sheet xvi).

(3) Deceased inspects five registers, transport of produce. **I–IV**, Freight-ships. **V**, Recording freight.

DAVIES and GARDINER, pls. x [right], xviii, pp. 19–20; M.M.A. photos. T. 1190–2. **I**, CHIC. OR. INST. photo. 10379. Texts of two scribes in **V**, WILKINSON MSS. xxi. D. 4.

(4) Two registers. **I**, Double-scene, deceased with libation and offerings before Anubis, and before Osiris. **II**, Stela (blank) with deceased seated and offerings at each side. Sub-scene, remains of bakers (two female).

DAVIES and GARDINER, pl. xxxvi, pp. 31–2; M.M.A. photo. T. 1189. Texts, HERMANN, *Stelen*, pp. 7*–8* [41–5].

(5) [1st ed. 3] [Deceased] arrives from Nubia, and six registers, **I–VI**, each with transport-ship.

DAVIES and GARDINER, pls. xxxi–xxxiii, pp. 26–7; L. *D.* iii. 116 [b]; *I.L.N.* Dec. 30, 1922, fig. on p. 1056 [top right]; M.M.A. photos. T. 1186–7. **I–IV**, WRESZ., *Atlas*, i. 42. **I, II, IV**,

CHIC. OR. INST. photos. 10379–81. **II** and **IV**, SCHOTT photos. 8772–3. **II**, PETRIE, *Racial Types*, 790 (sheet xvi); OTTO, *Ägypten. Der Weg des Pharaonenreiches*, Abb. 17. **III**, DUEMICHEN, *Flotte*, pl. xxviii [2]. **IV**, WILKINSON, *M. and C.* iii. 195 (No. 369) = ed. BIRCH, ii. 213 (No. 407); WILKINSON MSS. v. 180 [middle]; restoration, ENGELBACH, *The Problem of the Obelisks*, fig. 23, cf. p. 63. Text in **I**, PIEHL, *Inscr. hiéro.* 1 Sér. cxliv [A β]; L. *D. Text*, iii, p. 303 [a].

(6) [1st ed. 4] Deceased as fan-bearer receives four registers of Nubian tribute. **I**, Princess standing, chiefs of Miˤam, and Wawat, princess in ox-chariot, captives, and women with children. **II**, Chiefs of Kush, attendants bringing giraffe and bulls with decorated horns (Nubian heads). **III**, Chiefs of Kush, fan-bearers, and men bringing bull with decorated horns (bowl with plants and fish). **IV**, Men and women acclaim deceased at house. Sub-scene, offering-bringers.

DAVIES and GARDINER, pls. xxiii [left], xxiv [left], xxvii–xxx, xxxiv [middle and bottom], cf. xxxix [10–11], pp. 21–6, 30. Omitting sub-scene, L. *D.* iii. 117; WRESZ., *Atlas*, i. 158 [left and middle], 160–1; FARINA, *Pittura*, pl. cxlvi [left and middle]; *I.L.N.* Dec. 30, 1922, figs. on p. 1056 [middle, and bottom left]; M.M.A. photos. T. 1179–85; HAY MSS. 29851, 347–68; WILKINSON MSS. ii. 35 [left]. **I–III**, MASPERO, *Hist. anc. Les premières mêlées*, fig. on p. 232; MEYER, *Fremdvölker*, 582–8; PETRIE, *Racial Types*, 784–8 (sheet xvi). **I** and **II**, CAPART and WERBROUCK, *Thèbes*, fig. 35 (from WRESZINSKI); DAVIES in *M.M.A. Bull.* Pt. ii, Dec. 1923, fig. 12, cf. p. 48, and Dec. 1924, figs. 7, 8, cf. p. 49; CHIC. OR. INST. photos. 10381–5; NESTOR L'HÔTE MSS. 20404, 52, 67–71, cf. 20396, 132 (head of chief behind standing princess). **II** and middle of **I**, DAVIES (Nina), *Anc. Eg. Paintings*, ii, pls. lxxix–lxxxi (lxxix and lxxxi, CHAMPDOR, Pt. iii, 6th pl., Pt. iv, 9th pl.); parts, LANGE, *Lebensbilder*, pls. 36, 38. **I**, omitting princess in chariot, SCHOTT photos. 8769–71; princess in chariot, chiefs, and attendants, CAPART, *L'Art égyptien*, iii, pl. 556; SMITH, *Art . . . Anc. Eg.* pl. 144 [A]; princess and chiefs, PRISSE, *L'Art égyptien*, ii, 54th pl. 'Arrivée . . . d'une princesse', cf. *Texte*, p. 422; princess, WILKINSON, *M. and C.* iii. 179 (No. 366) = ed. BIRCH, i. 235 (No. 67), ii. 202 (No. 400); BLACKMAN and ROEDER, *Das Hundert-Torige Theben*, pl. 18; PRUDHOE MSS. i. 185. Chief of Kush kneeling in **II**, WILKINSON, *M. and C.* i. 385 (No. 69, 13 c) = ed. BIRCH, i. 259 (No. 84, 13 c); WILKINSON MSS. ii. 15 [14 c]. Nubians with giraffe in **II**, MEKHITARIAN, *Egyptian Painting*, pl. on p. 121. Texts and details, CHAMP., *Not. descr.* i, pp. 478 [with A, B]–479 [with A]; L. *D. Text*, iii, pp. 302–4 [middle], cf. LEPSIUS MS. 356 [bottom], 419 [middle and bottom].

(7) [1st ed. 5, 6] Two scenes. **1**, Deceased kneeling and Nubian tribute (including bowls of precious stones, shields, and chariot) and set pieces (one with giraffes). **2**, Deceased before Tutˤankhamūn. Sub-scene, offering-bringers.

DAVIES and GARDINER, pls. xxii, xxiii [right], xxiv–xxvi, xxxiv [top and middle], pp. 21–3. **1** and **2**, L. *D.* iii. 117 [right]–118, cf. *Text*, iii, p. 302; M.M.A. photos. T. 1177–8; WILKINSON MSS. ii. 35 [right]. **1**, WRESZ., *Atlas*, i. 159; MEYER, *Fremdvölker*, 580–1; shields, WILKINSON, *M. and C.* i. 298 (No. 17) = ed. BIRCH, i. 198 (No. 22); top of set piece with giraffes, MASPERO, *L'Arch. ég.* (1887), fig. 283, (1907), fig. 309; id. *Hist. anc. Les premières mêlées*, fig. on p. 235; PETRIE, *Racial Types*, 783 (sheet xvi); NESTOR L'HÔTE MSS. 20396, 126. **2**, *I.L.N.* Dec. 30, 1922, fig. on p. 1056 [bottom right].

(8) [1st ed. 11, 12] Three scenes. **1**, Three registers, **I–III**, appointment of deceased as Viceroy before Tutˤankhamūn in kiosk, **I**, Chief treasurer announces appointment, **II**, deceased receives seal of office, **III**, courtiers, sailors, and officials. **2**, Deceased holding

bouquets with two sons, and men acclaiming. **3,** Deceased with [wife], and offering-bringers below, pours myrrh on altar, followed by offering-bringers, soldiers, clappers, lutist and dancers. Sub-scene, remains of three registers before deceased, **I,** recording horses, cattle, and geese, with fort of Faras (?) beyond, **II,** branding (?) cattle, goats, and donkeys, **III,** branding, and female harpist (?).

DAVIES and GARDINER, pls. iv–ix, xxxix [1–4, 9], xl, pp. 10–14, 20–1; NESTOR L'HÔTE MSS. 20396, 123–5, 127–9, 134, 20404, 22–4, 77–8, 81; incomplete, AMÉLINEAU, *Histoire de la sépulture et des funérailles,* ii, in *Ann. Mus. Guimet,* xxix (1896), pls. lxxx, lxxxi (from NESTOR L'HÔTE), pp. 582, 584. **1** and **2,** M.M.A. photos. T. 1166–71. Fan-bearer and courtiers in **1, I,** CHIC. OR. INST. photo. 10386; deceased receiving seal in **1, II,** NEWBERRY, *Scarabs,* pl. ii. Details and texts, BRUGSCH, *Thes.* 1133 [A]–1137 [top left]; text of appointment, PIEHL, *Inscr. hiéro.* 1 Sér. cxlv [left, A δ]; texts of son Paser in **2,** and of deceased in **3,** L. D. *Text,* iii, pp. 305 [α], 306 [upper].

(9) [1st ed. 10] Space for stela, left blank. At each side, four registers, **I–IV,** priests performing rites before deceased, including presentation of *ka* in **I** on left and purification of deceased in **II** on right.

DAVIES and GARDINER, pl. xxxv, p. 31; M.M.A. photo. T. 1172, cf. 1201. Texts, SCHIAPARELLI, *Funerali,* ii, pp. 293–4 [xv]; HERMANN, *Stelen,* pp. 13*–14* [69–76].

(10) [1st ed. 9] [Deceased] adores Osiris.

DAVIES and GARDINER, pl. xxi [upper (omitting fragment b)], p. 30; M.M.A. photo. T. 1173. Text of deceased, PIEHL, *Inscr. hiéro.* 1 Sér. cxliv [A γ].

(11) [1st ed. 7, 8] Deceased offers precious stones, &c., to Tutʿankhamūn, and two registers, **I,** deceased followed by two chiefs of Upper Retenu, and two rows of Syrians with tribute (lion, horse, &c.), **II,** floral vases and vases with bull and ibex heads, and deceased receiving Syrians. Sub-scene, offering-bringers.

DAVIES and GARDINER, pls. xix (from LEPSIUS papers), xx, xxi [fragment b and sub-scene], pp. 28–30; L. D. iii. 115, 116 [a]; *I.L.N.,* Dec. 30, 1922, figs. on p. 1056 [top left and middle]; M.M.A. photos. T. 1174–6; NESTOR L'HÔTE MSS. 20396, 121, 122, 20404, 53, 55–60; deceased in **I** and **II,** man with vase at right end of **I,** and vases and foreigners in **II,** MEYER, *Fremdvölker,* 589–91, 618; floral vase (in front of deceased) in **I,** PRISSE, *L'Art égyptien,* ii, 79th pl. [8] 'Vases cratériformes'; Syrians in **I,** HAY MSS. 29851, 369–86; three, MASPERO, *Hist. anc. Les premières mêlées,* fig. on p. 151; 2nd Syrian in **II,** BRUGSCH, *Geographische Inschriften altägyptischer Denkmäler,* ii, pl. ii, fig. 16; Syrian vase in **II,** VERCOUTTER, *L'Égypte* [&c.], pl. xlv and p. 330 [335, called 329]. Texts, L. D. *Text,* iii, p. 304 with α.

(12) [1st ed. 13] Entrance to Inner Room. Left thickness, [deceased] with hymn to Ptaḥ before [Osiris].

DAVIES and GARDINER, pl. xxxvii, p. 32.

Ceiling. Texts, DAVIES and GARDINER, pl. xxxviii, cf. i [upper], pp. 4, 32–3; part, BRUGSCH, *Thes.* 1133 [middle]; PIEHL, *Inscr. hiéro.* 1 Sér. cxliv [A a]. Titles of deceased as decoration, DAVIES and GARDINER, pl. i [lower], p. 4; M.M.A. photo. T. 1200.

Finds

Lower part of black granite kneeling statue of deceased holding stela, found in pit in Qurnet Muraʿi in 1931, now in Louvre, E. 14398. ALLIOT in *B.I.F.A.O.* xxxii (1932),

pls. i [1], ii [2], pp. 70 [7], 74–9, with fig. 10. Text, HELCK, *Urk.* iv. 1635 (549), (from ALLIOT).
See VANDIER, *Manuel*, iii, pp. 472, 676 (called in error Deir el-Medîna).
 Fragments of black granite triple-statue, name lost. See DAVIES and GARDINER, p. 34.

41. AMENEMŌPET 〔≡◊°⌐〕, called IPY 〔🐦°◊◊〕, Chief steward of Amūn in the
 Southern City. Temp. Ramesses I to Sethos I (?).
 Sh. ʿAbd el-Qurna. (CHAMPOLLION, No. 35.)
 Parents, Nefertiu 〔⥮⌐◊〕, Judge, and Iny 〔🐦⥮◊◊◊〕, Songstress of the Theban Triad.
 Wife, Nezem(t) 〔⌐◊〕.

 Plan, p. 80. Maps IV, V, D–4, j, 9.

 CHAMP., *Not. descr.* i, pp. 526–7 with plan; ROSELLINI MSS. 284, G 49, with plan, G 48.

Court. Views, M.M.A. photos. T. 606–7.

 (1) Three registers, I–III, funeral ceremonies and procession, including deceased purified
by four priests with personified *zad*-pillar, and deceased with offerings before bark of Sokari,
in **I**, priest libating tomb, scene with mooring-post, and dragging shrines, in **II**, and treasury
at end of **II** and **III**. (2) Tree-goddess scene.

 (3) Stela, three registers. **I,** Double-scene, deceased adores Atum, and adores Osiris.
II, Double-scene, priest before deceased. **III,** Hymn to Rēʿ.
 M.M.A. photo. T. 1878 [left].

 (4) Three registers. **I,** Bark of Rēʿ. **II,** Baboons and *ba*s adoring. **III,** Deceased and wife
kneeling and adoring with hymn to Osiris-Onnophris. (5) Deceased adores Rēʿ-Ḥarakhti
with hymn to Rēʿ.
 M.M.A. photos. T. 1878 [right]–1881.

 (6) Stela, three registers. **I,** Double-scene, deceased before Rēʿ-Ḥarakhti, and before
Osiris. **II,** Double-scene, priest censing and libating to deceased as mummy. **III,** Hymn to
Rēʿ. At right side, deceased adoring.
 M.M.A. photos. T. 1882–3.

 (7) Stela, three registers. **I,** Double-scene, deceased adores Atum, and adores Osiris-
Onnophris. **II,** Hymn to Osiris-Onnophris. **III,** Double-scene, man offers to deceased. At
left side, deceased adoring.
 M.M.A. photos. T. 1884–5. Texts, SCHOTT photo. 3617.

 (8), (9), (10) [1st ed. 1] Pillars, with Osiride statues in niches and offering-formulae.
 M.M.A. photos. T. 606–7, and 1877 (at (8)).

Hall.
 (11) Outer lintel, double-scene, deceased and wife adore Osiris, and adore Anubis, jambs,
remains of offering-texts. Outer thicknesses, texts. Inner thicknesses, deceased and wife on
left, and deceased and wife before Osiris on right.
 Outer doorway (incomplete), M.M.A. photos. T. 1883 [right], 1884 [left]. Titles on left
inner thickness, LEPSIUS MS. 293 [top].

 (12) Remains of funeral procession.

(13) Stela, three registers. I, Deceased and wife adore Osiris and Western Ḥatḥor. II, Long offering-text. III, Man and woman with offerings before deceased and wife.

M.M.A. photo. T. 1886. Text, GOLENISHCHEV MSS. 14 [b]; title of Ḥatḥor, LEPSIUS MS. 294 [top right]; titles of deceased, parents, and wife, from framing, WILKINSON MSS. xvii. H. 19 verso [left].

(14) [1st ed. 2] Five registers. I–IV, Funeral procession, including setting up obelisks in I, *teknu* in II, cow and mutilated calf, priests with female mourners before mummies at pyramid-tomb with portico, and deceased embraced by Western goddess, in III, statues of deceased offered to and carried by eight priests to tomb, and deceased led by Nephthys and Isis, in IV. V, Book of Gates, including deceased and wife led by Anubis to portal, assessors in shrines, and presentation by Thoth to Osiris and Rēꜥ-Ḥarakhti.

M.M.A. photos. T. 1887–93; SCHOTT photos. 3618–27, 3629, 5770–3, 5775. III and IV, incomplete, WRESZ., *Atlas*, i. 166–7; parts, WERBROUCK, *Pleureuses*, figs. 15, 16, cf. pp. 29–30. III, ROSELLINI, *Mon. Civ.* cxxxii [1]; priests and mourners before mummy, PRISSE, *L'Art égyptien*, ii, 45th pl. [upper] 'Fragments . . . funéraires', cf. *Texte*, p. 418; tomb and deceased with Western goddess, DAVIES (Nina) in *J.E.A.* xxiv (1938), fig. 7, cf. pp. 36–7; sketch of tomb, LEPSIUS MS. 293 [middle]. Priests and mourners before statue in IV, CHAMP., *Mon.* clxxxviii [1]; ROSELLINI, *Mon. Civ.* cxxxii [2].

(15) Three registers, funeral procession and Book of the Dead. I, Two rows, rites in garden, men with funeral outfit, people in canoes, &c., before gods in shrines. II, Tree-goddess scene with *ba*s drinking, &c., and Fields of Iaru. III, Deceased and wife before shrine with four mummiform gods, and remains of scene with candles before deceased and wife.

M.M.A. photos. T. 1896–7, 1909.

(16) [1st ed. 3] Three registers. I, Assessors in shrines. II, Weighing-scene with Thoth as baboon and monster, deceased led by Anubis, and kneeling before Osiris with goddess. III, Deceased and wife offer boxes of coloured cloth to bark of Sokari, and adore King and Queen (?).

M.M.A. photos. T. 1894–5, 1898. Weighing-scene, CHAMP., *Not. descr.* i, p. 849, cf. pp. 526–7.

(17) Three registers. I, House with trees, and people acclaiming deceased arriving in chariot. II, Boats, men, and cattle. III, Couple seated, overseer, scribe, two men reaping, couple before pool, with trees and boats.

See CHAMP., *Not. descr.* i, p. 526 (called Paroi A).

(18) Stela, two registers. I, Deceased adores Osiris and Anubis. II, Long offering-text. At sides, seated people.

Omitting scenes at left side, M.M.A. photo. T. 1899. Names and titles from text on stela, WILKINSON MSS. xvii. H. 19 verso [top]; beginning of text, GOLENISHCHEV MSS. 14 [a].

(19) Three registers. I, Osiris-emblem adored by baboons, *ba*s, &c., with Nephthys and Isis, and deceased and wife. II, Deceased and wife led by Anubis and Wast to Western goddess making *nini*. III, Two boats, and two men offering bundle of onions to deceased and wife.

(20) [1st ed. 4] Two registers. I, Procession to Temple. II, Carpenters making mask, &c., preparation of mummies, and priest libating mummies, before deceased and wife.

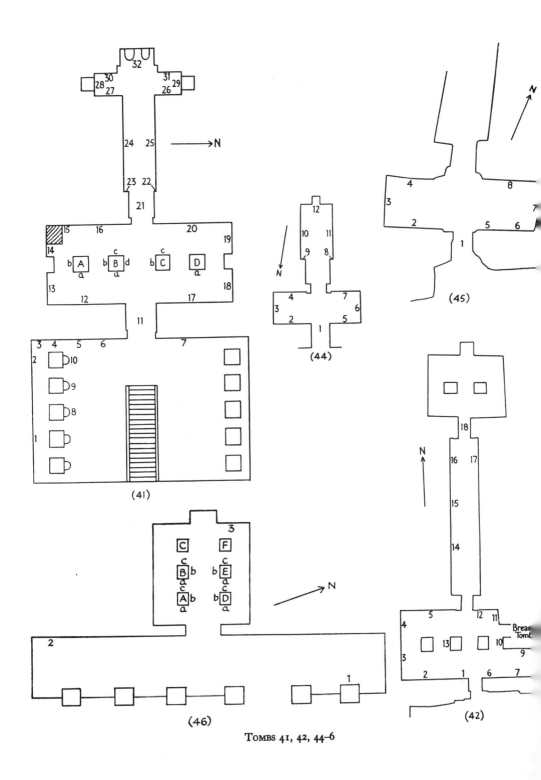

TOMBS 41, 42, 44–6

Carpenters and preparation of mummies in **II**, CAILLIAUD, *Arts et métiers*, pl. 8 [1–6]; ROSELLINI, *Mon. Civ.* cxxvi [1–6]; parts, CHAMP., *Mon.* ccccxv [1, 2]; DAWSON in *J.E.A.* xiii (1927), p. 47, fig. 1, cf. pl. xviii.

Pillars.

A (*a*) Deceased adores Anubis, and men with offerings below, (*b*) deceased led by Anubis, and deceased and wife adore pyramid-tomb and [Hathor] below.
Deceased led by Anubis, M.M.A. photo. T. 1902.

B (*a*) Woman adores Osiris, with deceased and men with flowers below, (*b*) wife before Hathor, and [man and woman before offerings] with [hymn to Buto] below, (*c*) deceased adoring, (*d*) deceased adores Anubis.
Wife before Hathor, M.M.A. photo. T. 1901.

C (*b*) Deceased adores Osiris, and men with bouquets below, (*c*) deceased adores Osiris-emblem.
M.M.A. photos. T. 1900, 1904.

D (*a*) Deceased adores Anubis, and men with bouquet ; and offerings below.
M.M.A. photo. T. 1903.

Passage.

(21) Outer lintel, double-scene, deceased and wife before Osiris and Anubis, and before Osiris and Isis, jambs, texts. Thicknesses, deceased adoring and hymns to Osiris, with sub-scene, offering-list ritual (destroyed on right).
Upper part of deceased on left thickness, M.M.A. photo. T. 1905.

(22) and (23) Man on each side of doorway.

(24) Three registers, Book of Gates. **I**, Scenes, including deceased before dressed *zad*-pillar and *dua*-emblem, sacred oars, bull and seven cows, and assessors with Negative Confession. **II** and **III**, Deceased before divinities in shrines, and deceased adores Osiris with winged Western goddess.

(25) Two registers, Book of Gates. **I, II,** Assessors, and deceased and wife adoring gods.

Shrine.

(26) Wife seated. (27) Deceased and wife seated.

(28) and (29) Niches with Anubis-jackal on each side, and priest below.
Niche at (29), M.M.A. photo. T. 1906 [right].

(30) and (31) Deceased and wife seated before offerings.
M.M.A. photos. on T. 1906–7.

(32) Niche with seated statues of deceased and wife. Lintel, double-scene, horizon-disk adored by gods, baboons, and deceased and wife, jambs, and return walls beyond, bouquets. Side-walls, sketches, deceased on left, wife on right, offer to shrine.
M.M.A. photos. T. 1907–8; statues, VIOLLET and DORESSE, *Egypt*, pl. 154.

Red granite sarcophagus of deceased, in Bankes Collection, at Kingston Lacy, Wimborne, Dorset.

42. Amenmosi 〖▭𓏏𓏤𓏤〗, Captain of troops, Eyes of the King in the Two Lands of the Retenu. Temp. Tuthmosis III to Amenophis II.

Sh. ʿAbd el-Qurna.

Wife, Ḥenuttaui ▽▬ .

Plan, p. 80. Maps IV, V, D–4, j, 8.

Davies, *The Tombs of Menkheperrasonb, Amenmosĕ, and another*, pp. 27–34, with plan and section, pl. xxxii.

Hall.

(1) Deceased and wife adoring.
M.M.A. photos. T. 3429–31 [left]. Titles, Davies, pl. xlvi [D], p. 31.

(2) Two registers. **I**, [Deceased and wife with son offering bouquet of Amūn to them], and three rows of guests and musicians (clappers and kneeling harpist), and jars in stands. **II**, [Deceased and wife with girl offering to them] and three rows of offering-bringers (?).
M.M.A. photos. T. 3431 [right], 3432. Part of **I–II**, Davies, pl. xxxviii [lower left], pp. 31–2; jars, Schott photos. 8558–9. Texts of offering-scene, Davies, pl. xlvi [F]; Helck, *Urk.* iv. 1507–8 [top] (from Davies).

(3) Two registers. **I**, [Son offers to deceased]. **II**, Deceased acclaimed by five priests with personified *zad*-pillar, and deceased purified by four priests.
M.M.A. photo. T. 3433. **II**, and text of son in **I**, Davies, pls. xxxvii, xlvi [C], p. 31.

(4) [1st ed. 1, moved to west wall] Four registers. **I**, Chief of the Lebanon and Syrians with floral vase, precious stones, and two humped bulls, and Syrian fort. **II**, Soldiers and scribes. **III**, Destroyed. **IV**, Remains of chariot and attendants.
M.M.A. photo. T. 3434. **I** and **II**, Davies, pl. xxxvi, pp. 30–1; Wresz., *Atlas*, i. 168; Farina, *Pittura*, pl. lxxxi; Meyer, *Fremdvölker*, 636, 799–801. Remains of text, Helck, *Urk.* iv. 1508 [middle upper] (from Davies).

(5) [1st ed. 2] Tuthmosis III (?) on throne with Nine Bows on base, deceased offering floral vase with frog to him, and four registers, **I–IV**, Syrians with tribute, including woman with a child, floral vases and vases with lion-handles and lions' heads, horses and chariots.
Davies, pls. xxxiii–xxxv, pp. 28–9; M.M.A. photos. T. 3435–6. Omitting deceased and King, Baud, *Dessins*, pls. vi, vii [A], p. 88; omitting King, Wresz., *Atlas*, i. 88 a; Meyer, *Fremdvölker*, 801 A–804, 637. Vase in **II**, Vercoutter, *L'Égypte* [&c.], pl. xlv and p. 331 [329, called 335].

(6) [Deceased offers on braziers.]
Titles, Davies, pl. xlvi [E], p. 32.

(7) Two registers. **I**, [Deceased and wife]. **II**, [Man before deceased].
Text above deceased in **II**, Davies, pl. xlvi [B], p. 32.

(8) Two registers. **I**, [Deceased and wife] adore Osiris. **II**, [Deceased and wife] before Anubis.
M.M.A. photo. T. 3428. Texts of **I**, Davies, pl. xlvi [A], p. 32; of deceased and wife, Helck, *Urk.* iv. 1508 [middle lower] (from Davies).

(9) and (10) Remains of deceased fowling and fishing.
Part at (10), M.M.A. photo. T. 3437 [right]. See Davies, pp. 32–3.

(11) Painted stela, double-scene, [deceased?] offers to Tuthmosis III, and (probably) to Amenophis II.

M.M.A. photo. T. 3437 [left]. See DAVIES, p. 33 [top].

(12) Unfinished scene, offerings before deceased and wife.

See DAVIES, p. 33.

(13) Pillar. Woman offers to deceased.

See DAVIES, p. 28.

Passage.

(14) Five registers. I–V, Funeral procession, including statue of deceased and royal statues carried, statue of deceased anointed by priests, *teknu*, and dancers in I.

DAVIES, pl. xxxviii [upper, and lower right], p. 33; M.M.A. photos. T. 3442–3, 3446 [left].

(15) Five registers, I–V, priests performing rites with mummies before Western goddess, including butchers and two cloaked priests 'sleeping' and 'waking' in IV–V.

M.M.A. photos. 3441, 3445.

(16) Three registers. I, *Sem*-priest offers to deceased and wife. II–III, Men with joints, tapers, and ointment, and butchers, before deceased and wife.

M.M.A. photos. T. 3440, 3444. Three men with tapers and jars in II, SCHOTT photo. 4284. Titles in I, DAVIES, pl. xlvi [G], p. 33; of deceased, HELCK, *Urk.* iv. 1508 [near bottom] (from DAVIES).

(17) Two registers (unfinished). I, *Sem*-priest offers to deceased and wife. II, Woman seated.

M.M.A. photo. T. 3438. Priest, BAUD, *Dessins*, fig. 38. See DAVIES, pp. 33–4.

(18) Entrance to Inner Room. At top, cartouches of Tuthmosis III and Amenophis II. Lintel, double-scene, deceased before Anubis, jambs, offering-texts with deceased seated at bottom.

DAVIES, pl. xxxix, p. 34; M.M.A. photo. T. 3439. Titles of deceased on lintel, HELCK, *Urk.* iv. 1508 [bottom] (from DAVIES).

43. NEFERRONPET ⟨⟩, Overseer of the kitchen of the Lord of the Two Lands. Temp. Amenophis II (?).

Sh. 'Abd el-Qurna.

Plan, p. 64. Map V, D–4, g, 7.

Hall. (Recently restored.)

(1) Two rows of guests before deceased and wife.

Right part, GR. INST. ARCHIVES, photo. 1517. Female guests, MEKHITARIAN, *Egyptian Painting*, pl. on p. 35; SCHOTT photos. 2764, 7248–50.

(2) Deceased with wife and attendants offers on braziers.

Parts, SCHOTT photos. 8458–61. Translation of offering-text of deceased, SCHOTT, *Das schöne Fest*, p. 862 [20].

(3) Deceased with bouquet before Tuthmosis III and Amenophis II in kiosk.
BAUD, *Dessins*, pl. viii, p. 91; SCHOTT photos. 2758–9, 2762, 7256–8.

(4) Deceased with bouquets and geese before a King in kiosk.
BAUD, *Dessins*, fig. 39; SCHOTT photos. 2760–1, 2763, 7251–5.

44. AMENEMḤAB 〔𓎟𓏏𓏭〕, *warb*-priest-in-front of Amūn. Ramesside.
Sh. ʿAbd el-Qurna.
Father, Ḥori 𓅱𓏭, *warb*-priest of Amūn. Wife, Isumut 〔𓏭𓏏𓏭〕.
Plan, p. 80. Map V, D–4, i, 9.

Hall.

(1) Left thickness, Rēʿ-Ḥarakhti. (2) Man feeding cattle.

(3) [Stela.] At sides, two registers, deceased adores a god (Rēʿ-Ḥarakhti and Atum on left, and [a god] and Thoth on right).

(4) Two registers. **I**, Deceased and wife with table of offerings, baboons, and souls of Pe and Nekhen, before bark of Rēʿ. **II**, Three scenes, **1**, deceased with incense and libation before ram-standard of Amūn held by Paser, Divine father of the ram-standard, **2**, son ʿA-amūn 𓏏𓏭𓏏 and wife Ḥathor adore Nefertem, **3**, deceased and wife adore bark of Ptaḥ-Sokari.
Baboons, souls, and bark, in **I**, SCHOTT photo. 7302. **II**, **1**, NELSON and HÖLSCHER, *Work in Western Thebes 1931–33* (*Chic. O.I.C.* No. 18), fig. 21, cf. p. 50; SCHOTT photos. 2674, 7304. **II**, **3**, HERMANN in *Mitt. Kairo*, vi (1936), pl. 5 [b], p. 29; bark of Ptaḥ-Sokari, SCHOTT photo. 7303. Texts of standard in **II**, **1**, BRUYÈRE, *Mert Seger*, p. 80, note 3.

(5) Three registers. **I**, Deceased adores Ptaḥ and Sekhmet, and with wife offers incense and libation to Amenophis I and ʿAḥmosi Nefertere. **II–III**, Deceased and wife with priest (in **II**) and son ʿA-amūn (in **III**) offering to them, and banquet.

(6) Stela with entablature, double-scene, deceased adoring. At sides, dressed *zad*-pillars with deceased adoring below.
SCHOTT photos. 7300–1.

(7) Three registers, Book of Gates. **I**, [Weighing-scene]. **II**, Deceased and wife before assessors in shrines. **III**, Funeral procession with priests and mourners before mummy held by Anubis at pyramid-tomb.
Tomb, DAVIES (Nina) in *J.E.A.* xxiv (1938), fig. 22, cf. p. 39.

Ceiling. Decoration and texts, with winged scarab in front centre.

Inner Room.

(8) and (9) Three registers each side of doorway, [man] offering to deceased. (10) Two scenes, **1**, deceased led by Anubis to [Osiris], **2**, Thoth, followed by deceased and wife and another couple, reports to Osiris.

(11) Three registers. **I**, Two scenes, **1**, priest offers to deceased and wife, **2**, man offers to deceased, wife, and woman. **II–III**, Funeral procession, including shrines carried, bark of Sokari and two boats, before mummy held by Western goddess.
Men with shrine and female mourners in **II**, BORCHARDT in *A.Z.* lxiv (1929), pl. i [1], pp. 12–13.

(12) Niche with entablature. Side-walls, deceased offering. Rear wall, Osiris-emblem between two ram-standards of Amūn. On each side of niche, deceased adoring Ptaḥ-Sokari-Osiris, and below niche, deceased, wife, and offerings.

45. DḤOUT 🪶, Steward of the First prophet of Amūn, Mery (tomb 95), temp. Amenophis II. Usurped by DḤUTEMḤAB 🪶, Head of the makers of fine linen (?) of the estate of Amūn, temp. Ramesses II (?).

Sh. ʿAbd el-Qurna.

Mother (of Dḥout), Dḥout 🪶. Parents (of Dḥutemḥab), Unnūfer 🪶, Head of weavers of the Temple of Amūn, and Ēsi 🪶. Wife (of Dḥutemḥab), Bek-khons 🪶, Songstress of the Theban Triad.

Plan, p. 80. Map VI, E–4, f, 4.

DAVIES and GARDINER, *Seven Private Tombs at Ḳurnah*, pp. 1–10, with plan and section, pl. i; SCHOTT in *Ä.Z.* lxxv (1939), pp. 100–6; MOND in *Ann. Serv.* vi (1905), p. 82, with plan, fig. 18 [right].

Hall.

(1) Thicknesses, fallen blocks, deceased, and woman with sistrum.
See DAVIES and GARDINER, p. 4.

(2) [1st ed. 1] Two registers. I, Deceased and wife with priest and man with calf before them, and guests. II, Funeral procession, including carrying shrine, funeral outfit, female mourners, and cow with mutilated calf.
DAVIES and GARDINER, pl. v, pp. 8–9; M.M.A. photos. T. 531–2; CHIC. OR. INST. photos. 6086–7. Deceased and wife in I, and details in II, SCHOTT photos. 7497–9. II, omitting right end, WERBROUCK, *Pleureuses*, pl. xxvi [upper], figs. 17, 170, cf. pp. 31, 157; two female mourners beside coffin, MEKHITARIAN, *Egyptian Painting*, pl. on p. 144.

(3) [1st ed. 2] Two registers. I, Dḥout and wife adore Nefertem-emblem (supported by five kings) in shrine, and adore bark of Sokari in shrine. II, [Ceremonies before mummy held by Anubis] at pyramid-tomb, and Ḥathor-cow in mountain.
DAVIES and GARDINER, pls. vi, vii, pp. 8–9; M.M.A. photo. T. 539; CHIC. OR. INST. photo. 6088. Bark-scene, and emblem, SCHOTT photos. 2185, 7500.

(4) [1st ed. 3] Dḥutemḥab and wife adore Amen-rēʿ-Ḥarakhti and [winged Maʿet].
DAVIES and GARDINER, pl. viii, p. 9; M.M.A. photo. T. 538; CHIC. OR. INST. photos. 6089–90. Wife, WEGNER in *Mitt. Kairo*, iv (1933), pl. xxvii [b]; SCHOTT photo. 3079. Texts, MOND in *Ann. Serv.* vi (1905), p. 83 [top].

(5) [1st ed. 7] Dḥout, with wife and attendant with bouquet, offers on braziers. Sub-scene, offering-bringers, butchers, and foreleg-rite.
DAVIES and GARDINER, pl. ii [right], pp. 4–5; M.M.A. photo. T. 528; CHIC. OR. INST. photo. 6095. Wife and attendant, SCHOTT in *Ä.Z.* lxxv (1939), pl. xii [a], p. 105; SCHOTT photos. 3073, 5051–2, and details, 7492, 7494–5, 8145–6. Text, MOND, op. cit. p. 84 [top]; HELCK, *Urk.* iv. 1415 [bottom]–1416 [top].

(6) [1st ed. 6] Two registers. I, Dḥout and mother with table of offerings. II, Dḥutemḥab offers bouquet to parents.

DAVIES and GARDINER, pl. ii [left], p. 5; SCHOTT in *Ä.Z.* lxxv (1939), pl. xi [a, b], pp. 102–3; M.M.A. photos. T. 448, 529–30; CHIC. OR. INST. photo. 6094; SCHOTT photos. 2186, 3074, 5053–5, and details, 7493, 7496, 8147–8. **I**, DAVIES in *M.M.A. Bull.* vi (1911), fig. 7, cf. p. 58; DAVIES (Nina), *Anc. Eg. Paintings*, i, pl. xxxv (CHAMPDOR, Pt. i, 2nd pl.); jars in **I**, and presentation of bouquet in **II**, SCHOTT, *Das schöne Fest*, Abb. 16, 13, cf. pp. 831, 815. Texts, MOND, op. cit. p. 84 [near top]; text of Dhout, HELCK, *Urk.* iv. 1415 [middle].

(7) Two registers. **I** and **II**, Priest with family offers libation to Dhutemhab and wife in each.

DAVIES and GARDINER, pl. iii, pp. 5–6; SCHOTT in *Ä.Z.* lxxv (1939), pl. xi [c], p. 103; JÉQUIER, *Hist. civ.* fig. 232; M.M.A. photos. T. 533–5; CHIC. OR. INST. photo. 6093; SCHOTT photos. 5049–50, 3075.

(8) [1st ed. 4, 5] Two registers. **I**, [Mut-Sekhmet-Bubastis], with wife and daughter of deceased offering sistra and *menat*s to her, and three rows of guests. **II**, Two scenes, **1**, son with offering-bringers offers bouquet of Amūn to Dhutemhab, **2**, Dhutemhab and wife seated, with remains of usurped text of offering bouquet of Amūn.

DAVIES and GARDINER, pl. iv, pp. 6–8 with figs. 2, 3. **I**, and **II, 1**, M.M.A. photos. T. 449, 536–7; CHIC. OR. INST. photos. 6091–2; parts, SCHOTT in *Ä.Z.* lxxv (1939), pls. xi [d], xii [b–d], xiii [a–d], pp. 102–5; SCHOTT photos. 2187–8, 3076–8, 5046–8, 7478, 7490–1, 8149–50; guests and jars in **I**, WRESZ., *Atlas*, i. 169; girl and two guests, MEKHITARIAN, *Egyptian Painting*, pl. on p. 64; jars in top row, SCHOTT, *Das schöne Fest*, Abb. 17, cf. p. 832. Texts, MOND in *Ann. Serv.* vi (1905), p. 83 [middle, and bottom]; usurped text in **II, 2**, HELCK, *Urk.* iv. 1416 [bottom].

Frieze, Dhutemhab and wife kneeling adore Anubis-jackal at (2) and (4), and Hathor-heads at (3).

DAVIES and GARDINER, on pls. v–viii, pp. 5, 8; part at (2) and (3), MACKAY in *Ancient Egypt* (1920), fig. on p. 113 [10, 11], cf. pp. 115, 119, 121.

Ceiling. Rēʿ-Harakhti as hawk on Western emblem adored by two baboons, souls of Pe and Nekhen, two winged demons, and Isis and Nephthys, each with *ba*. Below, [Dhutemhab] adoring. DAVIES and GARDINER, pl. ix, pp. 9–10; CHIC. OR. INST. photo. 6420.

46. RAʿMOSI � glyphs, Steward, Overseer of the granaries of Upper and Lower Egypt. Temp. Amenophis III (?).

Sh. ʿAbd el-Qurna.
Wife, Nefertkhaʿ [glyphs].

Plan, p. 80. Map V, D–4, f, 10.

Titles, HELCK, *Urk.* iv. 1995 (753).

Portico.

(1) Wife offers ointment to deceased at New Year Festival of Nehebkau.
Texts with mention of deceased as singer of Queen ʿAhmosi Nefertere, WILKINSON MSS. v. 75 [top right, top middle].

(2) [Man] offers to deceased and [wife?].

Hall.

(3) Deceased adores Osiris.

Pillars.

A (*a*) and (*c*) Remains of texts, (*b*) [deceased offers on braziers]. B (*a*) and (*c*) Remains of texts, (*b*) [deceased]. D (*a*) Deceased followed by son, (*b*) deceased and wife adoring, (*c*) deceased with staff and wife going forth 'to see the sun-disk'. E (*a*) Three women with sistra, (*b*) head of [deceased], (*c*) [deceased] purified.

Titles of deceased and wife at D (*c*), WILKINSON MSS. v. 74 [bottom middle], 75 [top left]; text of daughter Tiy at E (*a*), and fragments of text at (*b*), (*c*), id. ib. 74 [lower right].

Architrave between D and E. Line of text.

47. USERḤĒT ⌑, Overseer of the royal harîm. Temp. Amenophis III.

Khôkha. (Inaccessible.)

Parents, Neḥ ⌑, Judge, and Senenu ⌑. Wife, Maiay ⌑.

Map IV, D–5, a, 9.

RHIND, *Thebes. Its Tombs and their Tenants*, pp. 124–39; CARTER in *Ann. Serv.* iv (1903), pp. 177–8.

Façade.

Two rows of cones, with name of deceased.

See RHIND, op. cit. pp. 136–8 with fig.

Hall.

Left of entrance to Inner Room. Deceased with attendant offers necklaces, &c., to Amenophis III and Teye (head in Brussels) in kiosk with Nine Bows on base.

Upper part of Teye, *in situ*, CARTER in *Ann. Serv.* iv (1903), pl. ii, p. 177; STEINDORFF, *Blütezeit* (1926), Abb. 46; MASPERO, *New Light on Ancient Egypt*, pl. facing p. 294; id. *Égypte*, fig. 329; WEIGALL, *The Treasury of Ancient Egypt*, pls. xxvi–xxvii; CAPART in *Bull. des Mus. roy.* 2 Sér. i (1908), pp. 9–11 with figs. 1, 2, and pl. Head, in Brussels, Mus. roy. du Cinquantenaire, E. 2157, CAPART, *Documents*, i, pl. 47; id. *Schoonheidsschatten uit Oud-Egypte*, fig. 23; id. *Le Temple des Muses*, fig. on p. 119; *Bruxelles. Mus. roy. Département égyptien. Album* (1934), pl. 34; *Bruxelles. Mus. roy. Album*, fig. 30; DE MORANT, *Le Musée égyptien de Bruxelles* in *La Nature*, June 1, 1936, fig. 4, cf. p. 519; BORCHARDT, *Der Porträtkopf der Königin Teje*, Bl. 5; SCHÄFER and ANDRAE, *Kunst*, 352 [2], 2nd ed. 368 [2], 3rd ed. 372 [right] (all from BORCHARDT); *Burlington Fine Arts Club. Catalogue . . . of Ancient Egyptian Art* (1922), pl. xii (reversed), p. 63; WEIGALL, *Anc. Eg. . . . Art*, 179 [3]; PIJOÁN, *Summa Artis*, iii (1945), fig. 360; RANKE, *Meisterwerke*, pl. 49; ALDRED, *New Kingdom Art in Ancient Egypt*, pl. 80; SAINTE FARE GARNOT, *L'Égypte* in *Histoire générale de l'Art*, fig. on p. 90 [lower right]; WOLF, *Die Kunst Aegyptens*, Abb. 479. Text of deceased, HELCK, *Urk.* iv. 1880 (679); part, SÄVE-SÖDERBERGH, *Four Eighteenth Dynasty Tombs (Private Tombs at Thebes*, i), p. 39, note 4 (from copy by SETHE).

Left thickness of entrance to Inner Room. Name and title of deceased, CARTER in *Ann. Serv.* iv (1903), p. 177.

48. AMENEMḤĒT ⌑, called SURERO ⌑, Chief steward, At the head of the King, Overseer of the cattle of Amūn. Temp. Amenophis III.

Khôkha.

Parents, Ith-taui 𓏏𓄿, Overseer of the cattle of Amūn, and Mut-tuy ⌍𓏏𓄿𓏏𓏏, Royal concubine.

Plan, p. 90. Map IV, D-5, c, 9.

SÄVE-SÖDERBERGH, *Four Eighteenth Dynasty Tombs* (*Private Tombs at Thebes*, i), pp. 33-49, with plan, pl. lxii; DAVIES in *M.M.A. Bull.* x (1915), pp. 230-4, with plan, fig. 1; plan, id. *The Tomb of Nakht at Thebes*, fig. 1.

Portico. View, PILLET, *Thèbes. Palais et nécropoles*, fig. 98; M.M.A. photos. T. 397-8, 2140.

(1) [part, 1st ed. 1] Outer jambs (left jamb fragmentary), two remaining registers, Amenophis III before Amen-rēᶜ in each, I, with *nu*-pot, II, with flowers. Thicknesses, [deceased and mother] adoring with hymn to Rēᶜ. Inner left jamb, two remaining registers, I, deceased before Isis, II, deceased before Nephthys.

SÄVE-SÖDERBERGH, pls. l [B], li, liv, lv [C], pp. 35, 45-6. Left thickness, DAVIES in *M.M.A. Bull.* Pt. ii, Dec. 1923, fig. 9, cf. p. 45; M.M.A. photo. T. 1097.

(2) Two registers. I, Five scenes, 1-5, deceased (replaced by text in 3 and 5) adoring, 1, [Geb], 2, [Nut], 3, [god], 4, Osiris, 5, Isis. II, Five scenes, 1 and 2, destroyed, 3, [lectors before statue of deceased], 4, remains of butchers and priests before statue of deceased, 5, great offering-list with ritual before statue of deceased, and scenes of priests taking statue out of shrine beyond it (including statue carried by two priests).

SÄVE-SÖDERBERGH, pls. xliv-xlix, pp. 41, 43-4.

(3) [1st ed. 2] Two registers. I, Three scenes, Amenophis III celebrates harvest-festival, 1, King with fan-bearer, offering at granary, 2, King with *ka*, consecrating offerings, 3, King with *ka* and offerings and measuring-cords before serpent-headed Termuthis suckling King as child and Termuthis as serpent protecting King. II, Three niches, with King offering and adoring on each side.

SÄVE-SÖDERBERGH, pls. xli, xlii, pp. 41-3. Middle of I and II, M.M.A. photo. T. 412; granary, DAVIES in *M.M.A. Bull.* Pt. ii, Nov. 1929, fig. 10, cf. p. 48; both figures of Termuthis, WILKINSON MSS. v. 126 [upper]. Offering-text in I, 3, HELCK, *Urk.* iv. 1907 [middle].

(4) [1st ed. 3] [Deceased, preceded by fan-bearer and followed by eight representations of himself with staves and bouquets, offers pectoral] to Amenophis III on throne in kiosk, with scenes of King slaying foes, sphinx trampling foes, and Nine Bows with name-rings, on base of kiosk, and [statuettes of lion and sphinx] on steps.

SÄVE-SÖDERBERGH, pls. xxxi, xxxiii, xxxiv [A], xl, pp. 36-8, 41. Scenes on kiosk, M.M.A. photos. T. 415, 1086-7; Nine Bows, MEYER, *Fremdvölker*, 791-3; details, SCHOTT photos. 3943-5, 8560-2.

(5) Deceased, with mother and offering-bringers, pours incense on braziers, and remains of scenes beyond the offering-bringers.

SÄVE-SÖDERBERGH, pl. l [A], pp. 44-5.

(6) Remains of double-scene, Amenophis III followed by *ka*.

SÄVE-SÖDERBERGH, pl. xliii [A], p. 43, cf. pl. xliii [B] (fragment with ram in shrine, possibly from here).

(7) [1st ed. 4] Deceased before Amenophis III in kiosk (similar to kiosk at (4)) and five registers of New Year gifts, with large figure of deceased holding sphinx beyond. **I**, Remains of statues of Amenophis III and Teye, with chairs and couches at right end. **II**, Remains of royal statues. **III**, Destroyed. **IV**, Two scenes, each with [deceased?], men dragging royal statues, and sets of vases and bowls. **V**, Couches in shrines, two statues of hippopotamus-goddess, two of Bes, and two of lions.

SÄVE-SÖDERBERGH, pls. xxx, xxxii, xxxiv [B]-xxxix, pp. 33, 36-40; M.M.A. photos. T. 413-14, 1096, 1098-9, 2141. Parts, SCHOTT photos. 3479, 3937-9, 8563-70. King in kiosk, DAVIES in *M.M.A. Bull.* x (1915), fig. 4, cf. p. 230; MEYER, *Fremdvölker*, 794-8; STEINDORFF and WOLF, *Gräberwelt*, pl. 11; WEGNER in *Mitt. Kairo*, iv (1933), pl. xix. Statues of King standing on Nubian, and standing Queen, in **IV**, BORCHARDT, *Allerhand Kleinigkeiten*, Bl. 11, Abb. 4, 5. Statue of Bes in **V**, BRUYÈRE, *Rapport (1934-1935)*, Pt. 3, fig. 38 (from SCHOTT photo.), cf. p. 107, note 1. Three Asiatic name-rings, PILLET, *Thèbes. Palais et nécropoles*, fig. 102; Libyan and name-ring, WRESZ., *Atlas*, ii. 50 a, Beibild 10. Remains of text of deceased (with Sethe's restoration), HELCK, *Urk.* iv. 1906-7 (701). For uninscribed stela of later date above the scene, see SÄVE-SÖDERBERGH, pp. 40-1.

Pillars. Texts on first and second pillars, right of entrance, SÄVE-SÖDERBERGH, pl. lx [right], pp. 48-9; part, HELCK, *Urk.* iv. 1906 (700).

Fragments from walls, SÄVE-SÖDERBERGH, pl. lvii [bottom], pp. 44, 48.

Fragments of architraves and of capital, id. ib. pls. lviii [middle and bottom], lix, pp. 47, 49.

Passage. View, BORCHARDT, *Allerhand Kleinigkeiten*, Bl. 11, Abb. 2, 3; M.M.A. photo. T. 411.

(8) Three doorways. Outer jambs of north doorway, remains of scenes, deceased adoring divinity. Left thicknesses of north and south doorways, deceased adoring with hymn to Rēʿ. SÄVE-SÖDERBERGH, pls. lii, liii, lv [A, B], pp. 46-7.

Inner Hall. Views and section, id. ib. pl. lxiii, p. 33, note 5; views, M.M.A. photos. T. 2168-9.

(9) [1st ed. 5, but entry moved to tomb 93] Three doorways, with cats on sculptured entablatures.

SÄVE-SÖDERBERGH, pl. lvi, p. 48; M.M.A. photos. T. 2170, 410. North doorway, HERMANN in *Ä.Z.* lxxiii (1937), pl. viii [a], pp. 68, 71. One cat, *Descr. de l'Égypte, Ant.* ii, pl. 45 [14], cf. Text, x, p. 164.

Texts from architraves and vaulted ceiling, including list of festivals, and names of parents, SÄVE-SÖDERBERGH, pl. lx [left], p. 49.

Finds

Fragments of lintels, one with double-scene, deceased kneeling before Anubis-jackal, and others with Horus-name and cartouches of Amenophis III. SÄVE-SÖDERBERGH, on pls. lvii [top and middle], lviii [top], pp. 47-8.

Fragment of red granite statue of deceased, with double-scene on front, Amenophis III before Amen-rēʿ and goddess. SÄVE-SÖDERBERGH, pl. lxviii [A, C], p. 34; M.M.A. photo. T. 385; titles, HELCK, *Urk.* iv. 1906 (699).

Fragment of grey granite statue of deceased. SÄVE-SÖDERBERGH, pl. lxviii [B], p. 34.

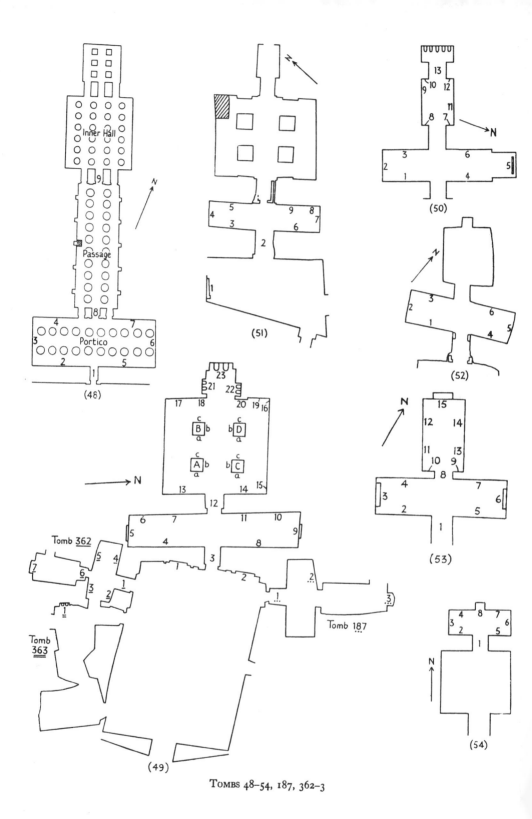

TOMBS 48–54, 187, 362–3

Two fragments with cartouches of Amenophis III, found in Inner Room. SCHOTT photos. 8572–3.

Fragment of relief with head of Queen Teye. SÄVE-SÖDERBERGH, pl. lxiv [B], p. 34, note 3; M.M.A. photo. T. 384.

Blue glaze armlet of Amenophis IV (?), sunk in S.S. Arabic in 1915. See SÄVE-SÖDER-BERGH, p. 34, note 4.

49. NEFERḤŌTEP ⸢☖⸣, Chief scribe of Amūn. Probably temp. Ay.

Khôkha. (CHAMPOLLION, No. 53, HAY, No. 11.)

Parents, Neby ⸢☖⸣, Servant of Amūn, and Iuy ⸢☖⸣. Wife, Merytrēᶜ ⸢☖⸣.

Plan, p. 90. Map IV, D–5, d, 8.

DAVIES, *The Tomb of Nefer-ḥotep at Thebes*, passim, with plans and sections, i, pls. vi, viii, and views, pl. i; id. in *M.M.A. Bull.* Pt. ii, Nov. 1921, pp. 19–28, with view, fig. 1; CHAMP., *Not. descr.* i, pp. 546–51, with plan; WILKINSON, *Topography of Thebes*, pp. 157–60; HAY MSS. 29824, 9–10.

Court. View, M.M.A. photo. T. 1916.

(1) and (2) Stelae (right one destroyed). Left stela, bark of Rēᶜ at top, and two registers, **I**, double-scene, deceased with wife adores Osiris and Western goddess, and adores Anubis and Eastern goddess, with *zad*-pillar in centre, **II**, offering-text and hymn to Amen-rēᶜ.

Left stela, DAVIES, *Nefer-ḥotep*, i, pl. xxxiv, pp. 48–50.

Hall.

(3) [1st ed. 1, 2] Outer lintel, double-scene, deceased, wife, and parents, before Osiris and Anubis, and before Osiris and Ḥathor, jambs, offering-texts. Thicknesses, deceased and wife with hymns to Rēᶜ, and mention of Valley Festival on left side.

Lintel, see DAVIES, *Nefer-ḥotep*, i, pp. 50, 51, with jambs and thicknesses, pls. ii, iii, xxxv–xxxvii, pp. 50–4. Thicknesses, M.M.A. photos. T. 879, 1917–21; left one, BURTON MSS. 25644, 106–7; right one, DAVIES in *M.M.A. Bull.* Pt. ii, Nov. 1921, fig. 10, cf. p. 28, and Dec. 1923, p. 50, fig. 16. Deceased and wife on right thickness, PRISSE, *L'Art égyptien*, ii, 15th pl. 'Scribe . . . d'Ammon', cf. *Texte*, pp. 400–1; sistrum (held by wife), WILKINSON, *M. and C.* ii. 323 (No. 230, 1) = ed. BIRCH, i. 497 (No. 255, 1); WILKINSON MSS. v. 126 [bottom right]. Hymns and titles, CHAMP., *Not. descr.* i, pp. 546 [A–C], 547 [A], 854 [A]; titles, &c., from left jamb and thicknesses, LEPSIUS MS. 265 [bottom], 268 [lower].

(4) [1st ed. 3] Two registers, funeral procession. **I**, Coffin dragged, *teknu*, &c., and deceased embraced by Western goddess. **II**, Four of the 'Nine friends', mourners, and men in booths with food-tables, before Ḥathor-cow in mountain.

DAVIES, *Nefer-ḥotep*, i, pls. xx, xxi, lx [B] (from HAY), pp. 42–3; HAY MSS. 29823, 10–15. Female mourners in **I** and **II**, WILKINSON MSS. v. 117–18; in **I**, id. *Materia Hieroglyphica*, Pt. ii, pl. iv [top right]; LANE MSS. 34088, 27; in **II**, WILKINSON, *M. and C.* i. 256 (No. 7) = ed. BIRCH, i. 167 (No. 7).

(5) Stela, Osiris and Western goddess facing Anubis. At sides, two registers. **I**, Grandfather, **II**, wife, on left. **I**, Deceased, **II**, [man?], on right.

DAVIES, *Nefer-ḥotep*, i, pls. lv [B], xix [A], pp. 57–9.

(6) [1st ed. 4] Two registers. **I**, Two scenes, **1**, servants with gifts and wife returning, **2**, wife with attendants in garden receives rewards from Queen in royal harîm. **II**, Deceased in chariot returning, and attendants with gifts at house. Sub-scene, two rows, banquet, with servants in garden bringing food, guests, and preparation of drink, in upper row, and men bringing provisions to house, and female dancers and tambourine-players, in lower row.

DAVIES, *Nefer-ḥotep*, ii, pl. i [left], and i, pls. xiv–xviii, v [B] (from HAY), pp. 22–7; omitting harîm and part of sub-scene, WRESZ., *Atlas*, i, pl. 172. **I** and **II**, M.M.A. photos. T. 1927–9. **I**, incomplete, DAVIES in *M.M.A. Bull.* Pt. ii, Nov. 1921, figs. 2–4, cf. pp. 21–4. **I**, **2**, CHAMP., *Mon.* clxxiv; ROSELLINI, *Mon. Civ.* lxviii [2]; MASPERO, *L'Arch. ég.* (1887), fig. 164, (1907), fig. 173; FARINA, *Pittura*, pl. cxlviii. Harîm, tree, and sistrum in **I**, **2**, attendant in **II**, female guest vomiting, musicians, and dancers, in sub-scene, WILKINSON, *M. and C.* ii. 119 (No. 108), 142 (No. 128), 323 (No. 230, 2), iii. 70 (No. 346), ii. 167 (No. 146), 240 (No. 195) = ed. BIRCH, i. 359 (No. 128), 376 (No. 148), 497 (No. 255, 2), ii. 127 (No. 375), i. 392 (No. 167), 443 (No. 220); WILKINSON MSS. v. 109 [right], 128 [lower left], 126 [middle right], 127 A [left], 107 [lower right], 129 [upper left]; harîm, DAVIES, *Town House*, fig. 3, cf. pp. 241–4; CHIC. OR. INST. photos. 2987–9 (including garden); HAY MSS. 29823, 1–9; woman drinking from jar (by tree) in **I**, **2**, CAILLIAUD, *Arts et métiers*, pl. 59; guest vomiting, HAY MSS. 29823, 24; musicians and dancers, CHAMP., *Mon.* clxxxvi [1]; ROSELLINI, *Mon. Civ.* xcix [2]; CAILLIAUD, *Arts et métiers*, pl. 40 A [lower]. Hieratic graffiti in front of chariot in **II**, WILKINSON MSS. v. 129 [lower left].

(7) [1st ed. 5] Two registers, servants with gifts, courtiers, and fan-bearers, and deceased rewarded with attendants, before Ay (?) and Queen (name lost) in balcony with [captives] on base.

DAVIES, *Nefer-ḥotep*, ii, pl. i [right], and i, pls. ix, x (from HAY), xi–xiii, lx [A], lxi [E, G], pp. 19–22 with fig. 7.

(8) [1st ed. 8] Three registers, funeral procession. **I**, Boats with mourners, provisions, &c., and priests before mummies at pyramid-tomb. **II**, Deceased and wife inspect funeral outfit. **III**, Deceased and wife inspect making of coffin.

DAVIES, *Nefer-ḥotep*, i, pls. xxii–xxvii, lxi [A–D, F, H], pp. 39–41, 45–7, and pl. v [A] (from HAY); ii, pls. iv, v. **I**, WILKINSON, *M. and C.* 2 Ser. Supp. pl. 84, cf. iii. 363 (No. 402), 387 (No. 417, 2–4) = ed. BIRCH, iii, pl. lxvii facing p. 447, cf. ii. 334 (No. 442), 352 (No. 457, 2–4); WILKINSON MSS. ii. 11 [upper]; HAY MSS. 29823, 33–4, 36–7, 40, 45–9; omitting texts, DUEMICHEN, *Flotte*, pl. xxx. Boats, M.M.A. photos. T. 1922–6. Boats and mourners (incomplete), CHAMP., *Mon.* clxxii [1, 2], clxxiii [1, 2], cf. *Not. descr.* i, pp. 547–8; ROSELLINI, *Mon. Civ.* cxxx [1, 2], cxxxi [1, 2]; DAVIES in *M.M.A. Bull.* Pt. ii, Nov. 1921, figs. 6, 7, cf. pp. 26–7; LÜDDECKENS in *Mitt. Kairo*, xi (1943), pp. 99–116 [45–51], with Abb. 36–42; WERBROUCK, *Pleureuses*, figs. 18, 19, cf. pp. 32–3; female mourners, GROENEWEGEN-FRANKFORT, *Arrest and Movement*, pl. xxxvi, p. 95; male mourners, CAILLIAUD, *Arts et métiers*, pl. 58. Tomb, showing frieze of cones, DAVIES (Nina) in *J.E.A.* xxiv (1938), fig. 4, cf. p. 36; BORCHARDT in *Ä.Z.* lxx (1934), Abb. 2 (from DAVIES), cf. p. 26. **III**, HAY MSS. 29823, 35, 38–9, 41, 50; parts, WILKINSON, *M. and C.* iii. 183 (No. 368) = ed. BIRCH, iii, pl. lxxii facing p. 474; WILKINSON MSS. ii. 16 [bottom]; MASPERO, *L'Arch. ég.* (1887), fig. 253, (1907), fig. 275.

(9) Above [stela], double-scene, deceased adores Anubis, and deceased with brazier before Osiris. At sides, deceased seated with food-table (destroyed on left).

DAVIES, *Nefer-ḥotep*, i, pls. xxviii, xxix, xix [B], pp. 56–7.

(10) Three registers. **I–III,** Offering-bringers, with priest libating to deceased and wife in **III.** Sub-scene, female mourners.

Id. ib. ii, pl. ii [right], and i, pls. xxxi [right], xxxiii, cf. pp. 55–6.

(11) [1st ed. 7] Osiris and Ḥatḥor with deceased and wife offering flowers to them, and three registers, **I,** men with flowers and garlanded bull, and offering-bringers, **II,** blind singers and priestesses of Ḥatḥor, **III,** offering-bringers with figs. Sub-scene, libation-priest with offering-list ritual and offering-bringers.

DAVIES, *Nefer-ḥotep*, ii, pl. ii [middle and left], and i, pls. xxx–xxxi [right], xxxii, pp. 54–6. Man with bull in **I,** and hieratic graffiti in front of Osiris, WILKINSON MSS. v. 107 [bottom left], 129 [right]. Priestesses in **II,** HAY MSS. 29823, 42–3.

Ceiling. Texts, DAVIES, *Nefer-ḥotep*, i, pls. lviii, lix, pp. 66–9.

Pillared Hall. View, M.M.A. photo. T. 1941; HAY MSS. 29823, 112.

(12) [1st ed. 6] Outer lintel, as at (3), jambs, offering-texts, with usurping-text on right jamb. Left thickness, deceased meets dead parents. Right thickness, [tree-goddess] scene. Soffit, flying ducks and butterflies.

DAVIES, *Nefer-ḥotep*, i, pls. xxxviii–xl and lvi (jambs, thicknesses, and soffit), pp. 5, 15, 43–4, 51–2. Usurping-text, id. ib. fig. 8; WILKINSON MSS. v. 122 [middle].

(13) Deceased with wife and daughters (?) pours incense on offerings. Sub-scene, offering-bringers led by blind singer.

See DAVIES, *Nefer-ḥotep*, i, p. 59.

(14) Deceased with wife and women with flowers consecrates offerings. Sub-scene, offering-bringers.

M.M.A. photo. T. 1937. See DAVIES, *Nefer-ḥotep*, i, p. 59.

(15)–(16) [1st ed. 13–10] Two registers. **I,** Four scenes, **1,** deceased receives bouquet [of Amūn] in Temple of Karnak, **2,** deceased gives the bouquet to his wife in the Temple-gardens, **3,** sailing-boats, **4,** scribes registering slaves, papyrus-gathering, and cattle branded and grazing. **II,** Temple-storehouses with wine-cellar, and four rows of scenes including scribes recording produce, garden with shadûfs, vintage with offerings to Termuthis, and Temple-workshops with carpenters, weavers, and baking.

DAVIES, *Nefer-ḥotep*, ii, pls. iii, vi, and i, pls. iv, xli–xlix, lx [c (from HAY), E], pp. 28–38; M.M.A. photos. T. 1930–6; HAY MSS. 29823, 16–23, 25–32; right part, WRESZ., *Atlas*, i. 171. **I, 1, 2,** WILKINSON, *M. and C.* ii. 129 (No. 116) = ed. BIRCH, i. 366 (No. 136); WILKINSON MSS. ii. 11 [bottom]; BURTON MSS. 25644, 100–1. Upper boat in **I, 3,** DAVIES in *M.M.A. Bull.* Pt. ii, Nov. 1921, fig. 9, cf. p. 20. Part of papyrus-gathering in **I, 4,** KEIMER in *Egypt Travel Magazine*, No. 26 (Sept. 1956), fig. 12, cf. p. 27; cattle, BURTON MSS. 25644, 102. Shadûfs, vintage, man opening box, and loom, in **II,** WILKINSON, *M. and C.* ii. 4 (Nos. 74–5), 155 (No. 141), iii. 176 (No. 365, 3), 135 (No. 354, 2) = ed. BIRCH, i. 281 (Nos. 93–4), 385 (No. 161), ii. 200 (No. 399, 3), 171 (No. 387, 2); WILKINSON MSS. v. 127 [left], 127 A verso, 122 [near bottom], 128 [lower right]; loom, ROTH, *Ancient Egyptian and Greek Looms (Halifax, Bankfield Museum Notes,* 2nd Ser. No. 2), fig. 14 (from drawing by DAVIES), cf. pp. 14–15; one shadûf, CHAMP., *Mon.* clxxxv [3]; ROSELLINI, *Mon. Civ.* xl [2]; CAILLIAUD, *Arts et métiers*, pl. 33 A [1]. Wine-press in **II,** id. ib. pl. 34; ROSELLINI, *Mon. Civ.* xxxviii [2]; PRISSE, *L'Art égyptien, Texte,* fig. on p. 271. Man with sack and carpenters in **II,** WILKINSON MSS. v. 122 [bottom], 127 [lower right], ii. 30 verso [near bottom right].

(17) Deceased offers bouquet to Osiris and Western goddess. Sub-scene, offering-stands.
M.M.A. photo. T. 1938 [left]. See DAVIES, *Nefer-ḥotep*, i, p. 60.

(18) Stela, two registers, **I**, [man] offers to Osiris seated and Western goddess, **II**, [man]
offers to couple. Above stela, Anubis-jackals.
M.M.A. photo. T. 1938 [right]. See DAVIES, *Nefer-ḥotep*, i, pp. 59–60.

(19) Two registers. **I**, Deceased with wife offers on brazier to Osiris and goddess. **II**, De-
ceased offers on brazier to Anubis (unfinished).
See id. ib. p. 60.

(20) Pilaster. Deceased embraced by Western goddess. Sub-scene, offering-bringers.
See id. ib. p. 60, with text, pl. lxi [L].

Shrine.

(21) Niche with seated statues of unnamed couple. Right of niche, b⸗ ⸗quet, and at top
remains of blind singers and [man] pouring incense before Osiris.
See DAVIES, *Nefer-ḥotep*, i, p. 65.

(22) Niche with seated statues of unnamed couple. Left of niche, two registers, **I**, deceased
offers incense and libation to Osiris, **II**, female mourners. At top, kiosk containing Ḥathor-
cow in mountain protecting King, and (above niche), deceased and family.
Id. ib. i, frontispiece [right], pls. liv, lx [D], lxi [J, P], pp. 65–6; id. in *M.M.A. Bull.*
Pt. ii, Nov. 1921, fig. 8 [right], cf. p. 28; M.M.A. photo. T. 880 [right].

(23) [1st ed. 9] Central niche with seated statues of deceased and wife.
DAVIES, *Nefer-ḥotep*, i, frontispiece [left], cf. pl. lv [A], pp. 12–14 with fig. 4, and pp. 64–5;
id. in *M.M.A. Bull.* Pt. ii, Nov. 1921, fig. 8 [left], cf. p. 28; M.M.A. photos. T. 880 [left],
and on 1941.

Pillars. See CHAMP., *Not. descr.* i, pp. 549–50.

A (*a*) [1st ed. 14] Three registers, **I**, deceased with brazier and wife, **II**, butchers, **III**, offer-
ings. (*b*) [1st ed. 15] Deceased offers on braziers to Rēʿ-Ḥarakhti. (*c*) Wife holding bouquet
with attendants and children.
See DAVIES, *Nefer-ḥotep*, i, pp. 62–3, with pls. lii (face *c*), liii [B] (face *b*). Title of wife
at (*c*), CHAMP., *Not. descr.* i, p. 550.

B (*a*) Three registers, **I**, deceased pouring incense, and wife with bouquet, **II**, butchers,
III, blind clappers. (*b*) Three registers, **I**, deceased offers on braziers to Osiris, **II** and **III**,
offering-bringers. (*c*) Deceased with wife offers on brazier, and offering-bringers below
before man with braziers.
See DAVIES, *Nefer-ḥotep*, p. 64, cf. pl. lxi [K].

C (*a*) [1st ed. 18] Deceased with wife offering on brazier, and servant presenting ointment
to them, with text mentioning Amenophis I and ʿAḥmosi Nefertere. (*b*) [1st ed. 17] De-
ceased offers bouquets to Amenophis I and ʿAḥmosi Nefertere. (*c*) Deceased with staff goes
forth to Valley Festival.
DAVIES, *Nefer-ḥotep*, i, pls. l, li, liii [C], pp. 60–2, ii, pl. vii (face *a*). (*a*), (*b*), M.M.A.
photos. T. 1939–40. (*a*) WEGNER in *Mitt. Kairo*, iv (1933), pl. xxiv [b]; BURTON MSS.
25644, 103–5. Texts on (*a*) and (*b*), LEPSIUS MS. 266–7; text on (*a*), and offering-text on (*b*),

CHAMP., *Not. descr.* i, pp. 549 [A, B], 855 [A], cf. 854 [to p. 550, l. 2]; text on (*a*), WILKINSON MSS. v. 116 [4, 5].

D (*a*) [1st ed. 16] Three registers, **I**, deceased with [wife] pours incense on braziers, **II**, butchers, **III**, offering-bringers. (*b*) [Deceased offers bouquet to Anubis], with offering-bringers and female clappers below. (*c*) Deceased and wife adoring, with priest and offering-bringer before priest with brazier below.

See DAVIES, *Nefer-ḥotep*, i, pp. 63–4. Text at (*b*), id. ib. pl. liii [A]; CHAMP., *Not. descr.* i, pp. 855 [B], cf. 854 [to p. 550, l. 3]; offering-text at (*b*), LEPSIUS MS. 268 [upper].

Finds

Brick with names of deceased and wife. WILKINSON MSS. xvii. D. 10, b [top left].

50. NEFERḤŌTEP ⌸, Divine father of Amen-rēꜥ. Temp. Ḥaremḥab. Sh. ꜥAbd el-Qurna.

Parents, Amenemōnet ⌸, Divine father of Amūn, and Takhaꜥt ⌸, Chief of the harîm of Amūn. Wife, Rennutet ⌸.

Plan, p. 90. Map VI, E–4, i, 2.

BÉNÉDITE, *Tombeau de Neferhotpou* in *Mém. Miss.* v [2], pp. 489–540, with plan and section, figs. 1, 2; MOND and EMERY in *Liv. Ann.* xiv (1927), pp. 26–8, with plan, fig. 21. Texts, HELCK, *Urk.* iv. 2177–9 (853).

Hall.

(1) [1st ed. 1] Two registers. **I**, Guests and daughter offering. **II**, Two men before [deceased and wife].

BÉNÉDITE, pl. i, pp. 494–6. Daughter under chair, and head of female guest, CAILLIAUD, *Arts et métiers*, pls. 60, 62. Heads and text in **I**, DUEMICHEN, *Hist. Inschr.* ii, pl. xl d [α and γ].

(2) [1st ed. 2] Two registers. **I**, May ⌸, Overseer of the treasury, as fan-bearer, followed by the governors of Upper and Lower Egypt, before Ḥaremḥab, deceased rewarded, and deceased and Parennūfer ⌸, Divine father of Amūn, congratulated by father, with text of year 3. **II**, Son, followed by men with flowers, censes and libates to deceased and wife.

BÉNÉDITE, pl. v, pp. 496–502, cf. pp. 534–5, note 2, pp. 535–6, note 1; HAY MSS. 29844 A, 194; HOSKINS MSS. iii. 42, 64, 66, cf. i. 67, 68 [upper]; omitting right end, GR. INST. ARCHIVES, photo. 1552. **I**, DUEMICHEN, *Hist. Inschr.* ii, pl. xl e; BRUGSCH, *Recueil*, pl. xxxvii (incomplete); King with attendants and May, BANKES MSS. ii. A. 6; King, deceased, and May, CAILLIAUD, *Arts et métiers*, pls. 46, 48, 54.

(3) [1st ed. 3] Three registers. **I**, Son offers to parents and relatives, and priest before [deceased and wife]. **II**, Harpist with two songs and female lutist. **III**, Guests with attendants (unfinished).

BÉNÉDITE, pl. ii, pp. 502–10; GR. INST. ARCHIVES, photos. 1549–51. I and **II**, DUEMICHEN, *Hist. Inschr.* ii, pls. xl c, xl d [ε], xl a; HAY MSS. 29844 A, 195; HOSKINS MSS. iii. 43, 53, 65, 67. **II**, HICKMANN, *45 Siècles de Musique*, pl. xxxiii; SCHOTT photos. 3326–7, 3441. Head of female relative in **I**, and harpist and lutist in **II**, CAILLIAUD, op. cit. pls. 61, 44, 55. Texts, HAY MSS. 29827, 80–1 verso. First song, GARDINER in *P.S.B.A.* xxxv (1913),

pp. 166–9; see Lichtheim in *J.N.E.S.* iv (1945), pp. 197–8 [3]. Second song, id. ib. pls. i, ii, pp. 198–201 [4].

(4) Fragments replaced on wall (some drawn in ink). Two registers, **I**, deceased led by Horus to Osiris and two goddesses, **II**, Negative Confession and assessors.

(5) [1st ed. 5] Stela (replaced). Two registers, **I**, double-scene, deceased before Rēʿ-Ḥarakhti, and before Osiris, **II**, libation-priest before mummy with lector, and female mourner, and priest with offerings.

(6) [1st ed. 4] Two registers. **I**, Offering-scenes, with names of relatives. **II**, Men with bouquets, and text.
See Bénédite, p. 515. Head and text of deceased in **I**, Duemichen, *Hist. Inschr.* ii, pl. xl d [δ]. Five men in **II**, Schott photos. 1921, 2642–3.

Ceiling. Texts, and boukrania-decoration with grasshoppers in centre and decoration with name and title of deceased on each side.
Bénédite, pl. vi [1, 2], pp. 511–12, and figs. a–e; Jéquier, *Décoration égyptienne*, p. 17, figs. 7, 8; Prisse, *L'Art égyptien*, i, 30th pl. [upper] 'Légendes et symboles', 31st pl. [4] 'Postes fleuronnées', 33rd pl. [lower] 'Bucrânes', cf. *Texte*, pp. 367–9; Davies (Nina), *Anc. Eg. Paintings*, ii, pls. lxxxiii, lxxxiv; Hay MSS. 29821, 51 [top]; boukrania, Davies (Nina), *Eg. Paintings* (Penguin), p. 14, fig. 2; Riefstahl, *Patterned Textiles in Pharaonic Egypt*, fig. 52, cf. p. 43; part, Keimer in *Ann. Serv.* xxxiii (1933), fig. 79, cf. p. 113; Wilkinson MSS. v. 105 [bottom]. Decoration with name and title, Duemichen, *Flotte*, pl. xxxiii; Poulson, *Aegyptens Kunst*, fig. 29, cf. p. 57.

Frieze-texts in north half, Bénédite, on pp. 513–14, figs. f–h; at (2), Duemichen, *Hist. Inschr.* ii, pl. xl d [β, parts of ll. 2 and 3].

Passage.

(7)–(8) Remains of texts, Bénédite, p. 517, figs. j, k.

(9)–(10) [1st ed. 6–7] Four registers. **I–IV**, Festival-texts with ritual scenes including Abydos pilgrimage in **I** and **II**, and Festival of Sokari with bark, and cat and monkey under chair of wife, in **III**.
Bénédite, pl. iii, pp. 517–28, figs. l, m. **I–III**, Hoskins MSS. iii. 69, 70, cf. i. 68 [lower]. **I**, Duemichen, *Altaegyptische Kalenderinschriften*, pls. xxxv–xxxviii; second boat in **I** and boat in **II** with text, id. *Flotte*, pl. xxxi [a, ll. 31–73]; right boat in **I**, bark of Sokari and deceased with wife in **III**, Schott photos. 1918–19, 2641; one sailing-boat, Cailliaud, *Arts et métiers*, pl. 4; boat in **II** and bark of Sokari in **III**, Pillet, *Thèbes. Palais et nécropoles*, fig. 91; Chic. Or. Inst. photo. 2990; bark, Schott in Nelson and Hölscher, *Work in Western Thebes, 1931–33* (Chic. *O.I.C.* No. 18), fig. 38, cf. p. 81.

(11) [1st ed. 8] [Harpist] with song before deceased and wife with [son] and daughter.
Bénédite, pl. iv, pp. 528–31; Duemichen, *Hist. Inschr.* ii, pl. xl; deceased, wife, and daughter, Wegner in *Mitt. Kairo*, iv (1933), pl. xxv [a]; deceased, wife, and part of song, Hoskins MSS. iii. 68, i. 64. Song, Stern in *Ä.Z.* xi (1873), pp. 58–63, cf. 72–3; Müller, *Die Liebespoesie der alten Ägypter*, pl. i; Lichtheim in *J.N.E.S.* iv (1945), pl. vii, pp. 178, 195–7 [2]; Schott photos. 3323–5; Golenishchev MSS. 7 [a, b].

(12) Tree-goddess scene (replaced on wall).

Ceiling. Text, Bénédite, p. 516, fig. 1.

(13) Shrine. Thicknesses, deceased (with wife, on left).
See Bénédite, pp. 533–4, figs. N, O.

51. Userhēt ⌐⌐, called Neferḥabef ⌐⌐, First prophet of the royal *ka* of
Tuthmosis I. Temp. Sethos I.

Sh. ʿAbd el-Qurna.

Parents, Khensemhab ⌐⌐ and Tausert ⌐⌐, Songstress of Monthu.
Wife, Ḥatshepsut ⌐⌐, called Shepset.

Plan, p. 90. Map VI, E–4, i, 2.

Davies, *Two Ramesside Tombs at Thebes*, pp. 3–30, with plan and section, pl. iii, and view,
pl. ii [B]; Mond in *Ann. Serv.* vi (1905), pp. 69–71, with plan and section, fig. 4.

Court. View, M.M.A. photo. T. 1088.

(1) Stela, remains of funeral ceremonies before mummy, with offering-text below.
Davies, pl. xix [6], pp. 3, 28–9. Female mourner, Werbrouck, *Pleureuses*, fig. 94, cf.
p. 35.

Hall. View, Davies, pl. iv.

(2) Right thickness, deceased with hymn to Rēʿ.
Remains of texts, Davies, pl. xix [3, 5], p. 4.

(3) [1st ed. 1] Three registers. I, Four scenes, 1, deceased led by Anubis, 2, weighing-
scene with deceased in scales and monster, 3, deceased kneeling before Osiris and Western
goddess, 4, deceased kneeling, souls of Pe and Nekhen, and baboons, adore Rēʿ-Ḥarakhti
as hawk on Western emblem and Isis making *nini*. II, Funeral procession with ceremonies
before mummies, and deceased (name changed to Amenmosi) before Western goddess in
front of pyramid-tomb with bouquets. III, Waiting chariot and stands of food, and wife with
attendants acclaiming deceased rewarded before Temple (?).
Davies, pls. xiii, vi [B], xiv, pp. 24–8, and pl. xix [2] (graffito behind Western goddess in
I, 3). I and II, M.M.A. photos. T. 576–7. Deceased in I, 2, and details of 3, coffin, mourners,
&c., in II, and deceased and women in III, Schott photos. 3209–10, 5110–15, 6064–5.
Name of Amenmosi in II, Mond in *Ann. Serv.* vi (1905), p. 70 [3].

(4) [1st ed. 2] Two registers. I, Ancestors (Imḥōtep, Vizier, Ḥepusonb, and Khensemhab)
adore Monthu. II, Deceased and wife angling beneath vine.
Davies, *Two . . . Tombs*, pl. xv, pp. 20–2. Vine, Davies in *M.M.A. Bull.* Pt. ii, July 1920,
fig. 12, cf. p. 28; Schott photo. 3208. Text, Mond, op. cit. on p. 69.

(5) [1st ed. 3] Three registers, Festival procession of Tuthmosis I. I, Men bringing sup-
plies, and deceased leaving Temple adores royal bark. II, Royal statue dragged, and in bark
on lake. III, Deceased receives funeral outfit with masks, &c.
Davies, *Two . . . Tombs*, pls. xvi, xvii [B], pp. 22–4, cf. pl. xix [4]. I and II, M.M.A.
photo. T. 586. Statue dragged, Wresz., *Atlas*, i. 173 (called tomb 50). Fan-bearer and female
mourners in II, Werbrouck, *Pleureuses*, pl. xxiii, p. 35. Details in I and III, Schott photos.
6066–7. Text, Mond, op. cit. on p. 69.

(6) [1st ed. 7, 8] Two registers. I, Four scenes, 1, deceased adoring, 2, ʿAkheperkareʿsonb ⊙|⚏U‾⏗ kneeling purified by eight priests, 3, deceased kneels before three Ogdoads, 4, Thoth reports to Osiris with Anubis. II, Deceased with ʿAkheperkareʿsonb and Nebmeḥyt ⧛⎮⎮⧜ as priests, and three priestesses, pours ointment on offerings before Monthu and Mertesger.

DAVIES, *Two . . . Tombs*, pls. xi, xii [A], xvii [A], pp. 12–15; M.M.A. photos. T. 570–5. I, 1–3, SCHOTT photos. 3216, 5103–6, 6057–63; 1 and 2, FARINA, *Pittura*, pl. clvii; BLACKMAN in *J.E.A.* v (1918), pl. xix, pp. 121–2. Monthu and Mertesger in II, BRUYÈRE, *Mert Seger*, fig. 86; Nebmeḥyt, priestess, and Mertesger, SCHOTT photos. 3217, 5107–8; priests and priestesses, DAVIES in *M.M.A. Bull.* vi (1911), fig. 4, cf. p. 58; LHOTE and HASSIA, *Chefs-d'œuvre*, pls. 131, 134; Nebmeḥyt and priestesses, PIJOÁN, *Summa Artis*, iii (1945), fig. 613; Nebmeḥyt, DAVIES in *J.E.A.* iv (1917), pl. l [1 a], p. 238, note 4; priestesses, HICKMANN, *45 Siècles de Musique*, pl. xxxiv; first priestess, WEGNER in *Mitt. Kairo*, iv (1933), pl. xxvii [a]. Names of priests and priestesses, MOND in *Ann. Serv.* vi (1905), pp. 69–70.

(7) [1st ed. 6] Deceased with wife and mother in tree-goddess scene with *ba*s drinking. Sub-scene, double-scene, Abydos pilgrimage, with deceased and wife before Osiris, and before Anubis.

DAVIES, *Two . . . Tombs*, pls. i (frontispiece), ix, x, pp. 15–19; BAIKIE, *Eg. Antiq.* pl. xxiii [upper]; STEINDORFF and WOLF, *Gräberwelt*, pl. 13 [a]; RANKE, *Meisterwerke*, pl. 58; FARINA, *Pittura*, pls. clix, clx; WOLF, *Die Kunst Aegyptens*, Abb. 579; M.M.A. photos. T. 578–9; SCHOTT photos. 5096–8, with details, 3205, 3212–15, 3218, 5880–4, 6056. Main scene, CAPART and WERBROUCK, *Thèbes*, fig. 247; CAPART in GLANVILLE, *The Legacy of Egypt*, pl. 8 [fig. 10]; DAVIES (Nina), *Anc. Eg. Paintings*, ii, pl. lxxxvii (CHAMPDOR, Pt. iii, 7th pl.); DAVIES (Nina), *Eg. Paintings* (Penguin), pl. 16; WEGNER in *Mitt. Kairo*, iv (1933), pl. xxvii [c]; DE BUCK in *Mededeelingen en Verhandelingen, 'Ex Oriente Lux'*, No. 7 (1947), fig. on p. 19; BYVANCK, *De Kunst der Oudheid*, pl. xlvii [fig. 162], cf. p. 310. Upper part of wife and mother, DAVIES in *M.M.A. Bull.* vi (1911), cover, cf. p. 58; CAPART, *L'Art égyptien*, iii, pl. 575; LANSING in *M.M.A. Bull.* xxv (1930), fig. on p. 1; RANKE, *The Art of Ancient Egypt*, and BREASTED, *Geschichte Aegyptens*, 265; LANGE, *Ägypten*, pl. 114; id. *Pyramiden, Sphinxe, Pharaonen*, pl. 26; id. *Lebensbilder*, pl. 42; LANGE and HIRMER, *Aegypten*, pl. 205; MEKHITARIAN, *Egyptian Painting*, pl. on p. 136; LUNDSGAARD, *Farao's Lov og Ret*, pl. facing p. 32; ZADOKS-JOSEPHUS JITTA, *Het Nabije Oosten*, pl. 22. Birds in tree, MEKHITARIAN, op. cit. pl. on p. 137; *ba*s, DESROCHES-NOBLECOURT, *Religions ég.* fig. on p. 251 [top right].

(8) [1st ed. 5] Four registers. I–III, Priests libating with female mourners and offerings to deceased and wife, in each, including torches and candles in III. IV, Similar scene before Nebmeḥyt and wife.

DAVIES, *Two . . . Tombs*, pls. v [right], xii [B], pp. 11–12; M.M.A. photos. 580–1. I–III, WERBROUCK, *Pleureuses*, pls. xxiv, xxv, figs. 143, 174–6, 178–9, cf. pp. 35–6. I, III, IV, SCHOTT photos. 5878–9, 3221, 5100–2. I, II, FARINA, *Pittura*, pl. clviii [right]; LHOTE and HASSIA, *Chefs-d'œuvre*, pl. 34. III, and mourners in I and II, CAPART, *Documents*, i, pl. 64; mourners in I, SCHOTT, *Altägyptische Liebeslieder*, pl. 24; MEKHITARIAN, *Egyptian Painting*, pl. on p. 135; priests in II, id. ib. pl. on p. 132; mourners, torches, &c., in III, DAVIES in *J.E.A.* x (1924), pl. v [1], p. 9; mourners, LHOTE and HASSIA, op. cit. pl. 30.

(9) [1st ed. 4] Two registers. I, Deceased with two wives and son pours ointment on offerings before Osiris with two goddesses. II, Deceased with mother[-in-law?] Ḥenuttaui, wife, and daughter, offers on braziers to Tuthmosis I and ʿAḥmosi Nefertere.

DAVIES, *Two . . . Tombs*, pls. v [middle and left], vi [A], vii, viii, pp. 6–10; M.M.A. photos. T. 582–5. I, incomplete, SCHOTT photos. 3206–7, 5099, 5109, 5874–7; wives and small son, FARINA, *Pittura*, pl. clviii [left]; PIJOÁN, *Summa Artis*, iii (1945), pl. xxviii (called Tomb of Two Sculptors); upper part of second wife, MEKHITARIAN, *Egyptian Painting*, pl. on p. 31. Deceased and family in II, WINLOCK, *Bas-Reliefs from the Temple of Rameses I at Abydos*, fig. 9, cf. p. 46; RANKE, *Meisterwerke*, pl. 59 [a]; deceased and mother, DAVIES (Nina), *Anc. Eg. Paintings*, ii, pls. lxxxviii, lxxxix (CHAMPDOR, Pt. i, 9th pl., Pt. iv, 3rd pl.); deceased, CHAMPDOR, *Thèbes aux Cent Portes*, fig. on p. 115; mother and small daughter, SCHOTT photos. 3219–20, cf. 3211. Texts of Sethos I and Ramesses II on dress of deceased in I and II, MOND in *Ann. Serv.* vi (1905), pp. 70–1.

Frieze, Ḥathor-heads and Anubis-jackals. DAVIES, pl. xviii [A], p. 6; MACKAY in *Ancient Egypt* (1920), fig. 9, cf. p. 120.

Ceiling, decoration and texts. DAVIES, pl. xviii [B, C], pp. 5, 29–30.

52. NAKHT 〰️, Scribe, Astronomer of Amūn. Temp. Tuthmosis IV (?).
Sh. ʿAbd el-Qurna.
Wife, Tawi 〰️.

Plan, p. 90. Map V, D–4, h, 10.

DAVIES, *The Tomb of Nakht at Thebes*, passim, with plan and section, p. 37, fig. 5; MASPERO, *Tombeau de Nakhti* in *Mém. Miss.* v [2], pp. 469–85, with plan, fig. 1; plan and section, DAVIES in *M.M.A. Bull.* x (1915), p. 235, fig. 5.

Hall.

Views of west half, DAVIES, *Nakht*, pl. vi; SCHÄFER and ANDRAE, *Kunst*, 346, 2nd and 3rd eds. 362 (all from DAVIES); MEKHITARIAN, *Egyptian Painting*, pl. on p. 18; CHAMPDOR, *Thèbes aux Cent Portes*, fig. on p. 161. Views of east half, DAVIES, *Nakht*, pl. vii; MASPERO in *Mém. Miss.* v, pl. ii; CAROTTI, *L'Arte dell'antico Egitto*, fig. 235; LANSING in *M.M.A. Bull.* xxv (1930), fig. on p. 4; *Brit. Mus. Guide to the Egyptian Collections* (1909), pl. xv, (1930), fig. 140; *Brit. Mus. Wall Decorations of Egyptian Tombs*, fig. on p. 16; VON BISSING, *Einführung in die Geschichte der ägyptischen Kunst*, pl. xv [1].

(1) [1st ed. 1, 2] Two scenes. 1, Deceased with wife pours ointment on offerings, with butchers below. 2, Three registers, I–III, agriculture, before deceased seated, including winnowing with offerings to harvest-deity in I, sheaves with quails and pigeons in II, and pulling flax in III. Sub-scene, sowing, hacking, ploughing, and felling trees, before deceased seated.

DAVIES, *Nakht*, pls. xi [B], xviii–xxi, pp. 51–3, 60–6; MASPERO in *Mém. Miss.* v, pl. iv, figs. 2, 3 (called B in error), cf. pp. 476–9; BAIKIE, *A Century of Excavation* [&c.], pl. 24; M.M.A. photos. T. 502 [left], 504, 514–17. Head of wife in 1, SCHOTT, *Altägyptische Liebeslieder*, pl. 7; MEKHITARIAN in *Chronique d'Égypte*, xxxi (1956), fig. 21, cf. p. 245; SCHOTT photo. 5890; offerings in 1, LHOTE and HASSIA, *Chefs-d'œuvre*, pl. xii. 2, and sub-scene, CAPART and WERBROUCK, *Thèbes*, figs. 183 [upper], (from WRESZINSKI), 194 [upper], 207 (from DAVIES); WRESZ., *Atlas*, i. 176–7 (omitting both figures of deceased); 2, and deceased in sub-scene, TARCHI, *L'Architettura*, pl. 55 [left]. 2, and right part of sub-scene, WEIGALL, *Anc. Eg. . . . Art*, 151, 154 [upper]; LHOTE and HASSIA, op. cit. pls. 72–3, 75, 78, 82–3; 2, with man ploughing and man felling in sub-scene, SCHOTT photos. 5888–9, 5891, 7267–71.

2, I–II and deceased, PIER, *Inscriptions of the Nile Monuments*, fig. 25, cf. p. 66; **I** and **II**, VIOLLET and DORESSE, *Egypt*, pl. 149; **I**, and left part of sub-scene, JÉQUIER, *Hist. Civ.* figs. 251, 260; **III**, and right half of sub-scene, FARINA, *Pittura*, pl. cii; DAVIES in *M.M.A. Bull.* vi (1911), fig. 5, cf. p. 58; RANKE, *Meisterwerke*, pl. 43; ROSTOVTZEFF, *A History of the Ancient World*, i, pls. xlv [2], xlvi [1]; PRITCHARD, *The Ancient Near East in Pictures*, fig. 91. Sheaf with quails in **2, II**, CAPART in *Comptes rendus* (1936), fig. 2, cf. p. 25. Packing sheaves in pannier, and girl pulling flax, in **2, III**, MEKHITARIAN, *Egyptian Painting*, pls. on pp. 73, 75; packing sheaves, PETRIE, *Arts and Crafts*, fig. 71, cf. p. 57; ROSTEM in *Ann. Serv.* xlviii (1948), fig. 9, cf. pp. 172–3. Sub-scene, SCHÄFER and ANDRAE, *Kunst*, 351 [upper], 2nd and 3rd eds. 367 [upper] (all from DAVIES); man drinking, MEKHITARIAN, *Egyptian Painting*, pl. on p. 78. Texts, HELCK, *Urk.* iv. 1604 [bottom], 1605 [top].

(2) [1st ed. 3] False door, with three registers at sides, kneeling offering-bringers. Sub-scene, double-scene, tree-goddess [Nut] with bouquet and offering-bringer before offerings.
DAVIES, *Nakht*, pls. viii, ix, x [B], pp. 46–9; MASPERO in *Mém. Miss.* v, pl. i, pp. 471–3 [A]; WRESZ., *Atlas*, i. 52 [a]; TARCHI, *L'Architettura*, pl. 55 [right]; CAPART and WERBROUCK, *Thèbes*, fig. 249; FARINA, *Pittura*, pls. c, ci [lower]; BYVANCK, *De Kunst der Oudheid*, pl. xliii [fig. 153], cf. p. 273; BRUNNER, *Ägyptische Kunst*, Abb. 68; M.M.A. photos. T. 506, 502 [right]. Second offering-bringer on left, DAVIES in *M.M.A. Bull.* vi (1911), fig. on p. 53 [lower]. Tree-goddess on left, and offerings, LHOTE and HASSIA, *Chefs-d'œuvre*, pls. 42, 46; upper part, SCHOTT photo. 7272. Texts of offering-bringers, HERMANN, *Stelen*, p. 10* [52–7], cf. Abb. 10.

(3) [1st ed. 4–5] Four registers, banquet, **I–II**, and two men offering to deceased and wife, **III–IV**, and son offering bouquets to deceased and wife, with cat eating fish under chair. **I–IV**, Guests and musicians (blind harpist in **II**, and women with harp, lute, and double-pipe, in **IV**).
DAVIES, *Nakht*, frontispiece, pls. x [A], xv–xvii, pp. 55–9; MASPERO in *Mém. Miss.* v, figs. 6, 7, cf. pp. 484–5 (said in error to be on opposite wall); HICKMANN, *45 Siècles de Musique*, pls. xxxv, xxxvi; M.M.A. photos. T. 503 [left], 510, 511 A, B. **I–IV**, BAIKIE, *Eg. Antiq.* pl. xxi [lower], p. 561; FARINA, *Pittura*, pls. xcviii, xcix; LANGE and HIRMER, *Aegypten*, pl. 147. **II** and **III**, WEIGALL, *Anc. Eg. Art*, 153; PIJOÁN, *Summa Artis*, iii (1945), fig. 468; part, WOLF, *Die Kunst Aegyptens*, Abb. 465. **II**, WRESZ., *Atlas*, i. 175 [A]; DAVIES in *M.M.A. Bull.* vi (1911), fig. on p. 53 [upper]; LHOTE and HASSIA, *Chefs-d'œuvre*, pls. 125–6, and pl. xiii (called tomb of Menna); omitting some guests, CAPART and WERBROUCK, *Thèbes*, figs. 113–15 (from paintings by CRANE and DAVIES); HAMANN, *Ägyptische Kunst*, Abb. 247, cf. pp. 230–1; guests, VANDIER, *Egypt*, pls. xxv, xxvi; PETRIE, *Arts and Crafts*, fig. 74, cf. p. 58; LANGE, *Lebensbilder*, pl. 40; some guests, CAPART, *Propos*, fig. 72; KUSCH, *Aegypten im Bild*, Abb. 127; WOLF, *Die Welt der Ägypter*, pl. 69; SCHOTT, *Altägyptische Liebeslieder*, pl. 15; VIOLLET and DORESSE, *Egypt*, pl. 146; SCHOTT photos. 7281–2. Blind harpist, MEKHITARIAN, *Egyptian Paintings*, pl. on p. 70; LANGE, *Äg. Kunst*, pl. 113. **III** and **IV**, COTTRELL, *Life under the Pharaohs*, fig. 14. Deceased with wife and musicians, WRESZ., *Atlas*, i. 175 [B], 43. Son, musicians, and offerings, VIOLLET and DORESSE, *Egypt*, pl. 145; son and musicians, DAVIES in *M.M.A. Bull.* vi (1911), fig. 6, cf. p. 58; text of son, HELCK, *Urk.* iv. 1604 [middle]. Musicians with offerings above, BÉNÉDITE, *L'Art égyptien dans ses lignes générales*, pl. xxix; SCHÄFER and ANDRAE, *Kunst*, pl. xvi (from DAVIES); LANGE, *Ägypten*, pl. 109; VALLON, *Que savons-nous de la musique pharaonique?* in *Formes et Couleurs*, xi [1] (1949), 5th fig.; *L'Égypte. Art et Civilisation*, Sér. 4 bis (1951), pl. 12; STRÖMBOM,

Egyptens Konst, fig. 109; Schott photos. 5892–3, 5895, 7273–5, 7277–80; musicians, Tyn-
dale, *Below the Cataracts*, pl. facing p. 202; Weigall, *Anc. Eg. . . . Art*, 152; Pijoán, *Summa
Artis*, iii (1945), fig. 470; Ranke, *Meisterwerke*, pl. 44; Wolf, *Die Welt der Ägypter*, pl. 68;
Lugn, *Konst och Konsthantverk i Egypten*, fig. 57, cf. p. 29; Kusch, *Ägypten im Bild*, Abb.
126; Hamann, *Ägyptische Kunst*, Abb. 248, cf. pp. 230–1; Hickmann in *Bull. Inst. Ég.*
xxxv (1954), figs. 4, 19, cf. pp. 312, 326–7; Lhote and Hassia, *Chefs-d'œuvre*, pl. 116;
Vandier, *Egypt*, pl. xxix; Mekhitarian, *Egyptian Painting*, pl. on p. 33; Wolf, *Die Kunst
Aegyptens*, Abb. 466; woman with double-pipe and lutist, Schott, *Altägyptische Liebeslieder*,
pls. 18, 19; lutist and harpist, Samivel and Audrain, *The Glory of Egypt*, pl. 76; lutist,
Hickmann in *Egypt Travel Magazine*, No. 19, Feb. 1956, on p. 7 [lower]. Cat, Davies in
M.M.A. Bull. vi (1911), fig. on p. 71; Weigall, *Anc. Eg. . . . Art*, 150; Capart and Wer-
brouck, *Thèbes*, fig. 167 (from Davies painting); Farina, *Pittura*, pl. ci [upper]; Davies
(Nina), *Eg. Paintings* (Penguin), pl. 3; Pierson, *De achttiende Dynastie van Oud-Egypte*,
pl. facing p. 129; Lugn, *Konst och Konsthantwerk i Egypten*, fig. 58; Phillips, *Ancient Egyptian
Animals* (1948), fig. 24; Zadoks-Josephus Jitta, *Het Nabije Oosten*, pl. 23.

(4) [1st ed. 7] Deceased, with wife (unfinished) and offering-bringers, pours ointment on
offerings.
 Davies, *Nakht*, pls. xi [A], xii, pp. 50–1; Maspero in *Mém. Miss.* v, fig. 5, cf. pp. 483–4;
M.M.A. photos. T. 512–13. Deceased, wife, and offerings, Capart and Werbrouck,
Thèbes, fig. 179 (from Davies); deceased and wife, Mackay in *J.E.A.* iv (1917), pl. xv [6],
p. 79; Ghalioungui in *Ann. Serv.* xlvii (1947), pl. vi [right], p. 39; wife and details of offer-
ings, &c., Schott photos. 5574–5, 7298; upper part of wife, Lhote and Hassia, *Chefs-
d'œuvre*, pl. 112. Text, Helck, *Urk.* iv. 1604 [top].

(5) Two registers. **I**, Offering-bringers and priests with tapers and ointment before de-
ceased and wife. **II** (unfinished), Part of offering-list ritual, four priests with offerings before
couple.
 Davies, *Nakht*, pls. xiii, xiv, pp. 53–5; Maspero in *Mém. Miss.* v, pl. ii, pp. 473–5 [E];
M.M.A. photos. T. 501 [right], 505; parts, Schott photos. 7297, 7299; deceased and wife,
Mekhitarian in *Chronique d'Égypte*, xxxi (1956), figs. 16, 17, 20, cf. pp. 241–2, 244.

(6) [1st ed. 6] Two registers. **I**, Deceased and wife receive offerings with fowl, &c., and
deceased and family fowling and fishing. **II**, Deceased and wife receive produce of marsh-
lands with men bringing fowl and fish, vintage, and netting and preparing fowl.
 Davies, *Nakht*, pls. xxii–xxvi, pp. 66–70; Maspero in *Mém. Miss.* v, pl. iii (incomplete),
fig. 4, cf. pp. 479–83 [D]; M.M.A. photos. T. 458, 501 [left], 503 [right], 507–9. Incomplete,
Maspero, *New Light on Ancient Egypt*, fig. facing p. 28; Farina, *Pittura*, pl. ciii; Cottrell,
The Lost Pharaohs, pl. 29; Caldwell, *The Ancient World*, pl. facing p. 90 [bottom]. **I and II**,
omitting deceased and wife, Wresz., *Atlas*, i. 174, 178; Davies in *M.M.A. Bull.* vi (1911),
figs. 3, 4, cf. p. 58; Capart and Werbrouck, *Thèbes*, figs. 184, 208; Lhote and Hassia,
Chefs-d'œuvre, pl. xv and pls. 45, 52–3, 56, 85–6, 88–9. **I**, omitting fishing, Tarchi, *L'Archi-
tettura*, pl. 56 [upper]; fowling and fishing, Maspero, *Hist. anc. Les origines*, fig. on p. 297;
Ranke, *Meisterwerke*, pl. 47; Pijoán, *Summa Artis*, iii (1945), fig. 466 (called British
Museum); Brunner, *Ägyptische Kunst*, Abb. 69; Alford in *Rhode Island School of Design,
Museum Notes*, v [7], Dec. 1947, 2nd fig.; fowling, Gayet, *Itinéraire illustré de la Haute
Égypte*, fig. 86; Davies (Nina), *Anc. Eg. Paintings*, i, pl. xlvii; id. *Eg. Paintings* (Penguin),
pl. 10; Viollet and Doresse, *Egypt*, pl. 144; fishing, Vandier, *Egypt*, pl. xxviii; Schott

photos. 5565–73, 7283–7; wife with chick in fowling-scene, SCHOTT, *Altägyptische Liebes-lieder*, pl. 11; birds above marsh, MEKHITARIAN, *Egyptian Painting*, pl. on p. 71. **II**, omitting deceased and wife, SCHOTT photos. 7288–96; produce and men bringing fowl and fish, DRIOTON and HASSIA, *Temples and Treasures*, pl. 11; vintage, and netting and preparing fowl, DAVIES (Nina), *Anc. Eg. Paintings*, i, pl. xlviii (CHAMPDOR, Pt. v, 4th pl.); DAVIES (Nina), *Eg. Paintings* (Penguin), pl. 6; LANGE, *Lebensbilder*, pl. 24; BYVANCK, *De Kunst der Oudheid*, pl. xlv [fig. 158], cf. p. 273; ROSTOVTZEV, *A History of the Ancient World*, i, pl. xlvi [2]; STRÖMBOM, *Egyptens Konst*, fig. 157, cf. p. 184; LAURENT-TÄCKHOLM, *Faraos blomster*, pls. on pp. 224–5; *L'Égypte. Art et Civilisation*, Sér. 4 bis (1951), pl. 11; VIOLLET and DORESSE, *Egypt*, pl. 147; picking and treading grapes, PRITCHARD, *The Ancient Near East in Pictures*, fig. 156; picking, KUSCH, *Ägypten im Bild*, Abb. 125; PAILLE in *Bull. des Musées de France* (1949), p. 198, fig. 3; treading, BRUYÈRE, *Rapport (1935–1940)*, Pt. iii, fig. 14. Texts, HELCK, *Urk.* iv. 1605 [middle]–1606.

Finds

Statuette of deceased holding stela with hymn to Rēꜥ, sunk in S.S. Arabic in 1915. DAVIES, *Nakht*, pl. xxviii, fig. 6, cf. pp. 36–9; id. in *M.M.A. Bull.* x (1915), fig. on p. 223; *Ancient Egypt* (1916), fig. on p. 85; M.M.A. photos. T. 591 (*in situ*), 592–4, and series 4 A, 6–7. Text of stela, HELCK, *Urk.* iv. 1603 (from DAVIES).

Brick of deceased, DAVIES, *Nakht*, fig. 9, cf. p. 42 [18].

53. AMENEMHĒT ⟨𓍑𓏤𓎼𓃀⟩, Agent of Amūn. Temp. Tuthmosis III.

Sh. ꜥAbd el-Qurna. (CHAMPOLLION, No. 16 bis, *L. D. Text*, No. 78.)

Parents, Yotefnūfer ⟨𓃭𓏤𓎛⟩, Agent of Amūn, and Tetiemnūter ⟨𓉐𓅓𓊹⟩. Wife, Sebknakht ⟨𓎟𓈖𓃀⟩.

Plan, p. 90. Maps V and VI, E–4, g, 1.

CHAMP., *Not. descr.* i, pp. 512–13. Titles and name of wife, HAY MSS. 29848, 66; ROSELLINI MSS. 284, G 56, 56 verso; titles, SETHE, *Urk.* iv. 1224 (363) a and b at (2), c and d on cones.

Hall.

(1) Outer jambs, deceased seated at bottom. Thicknesses, deceased adoring with hymns to Rēꜥ.

M.M.A. photos. T. 3213–16. Thicknesses, SCHOTT photos. 8220–1.

(2) [1st ed. 1] Four registers, banquet, **I–II**, and girl offering to deceased, wife (with monkey under chair), and daughter, **III–IV**, and [girl] before parents of deceased with daughter. **I–IV**, Guests and musicians, including song above clappers in **I**, harpist in **II**, man vomiting, female flutist, and girl dancing, in **III**, and female tumblers in **IV**. Sub-scene, offering-bringers.

M.M.A. photos. T. 3221–3; CHIC. OR. INST. photos. 6421–3; incomplete, SCHOTT photos. 6309–12, 8222–8, 8912–13. Harpist in **II**, and girl dancing in **III**, HICKMANN, *45 Siècles de Musique*, pl. xxxix. **III** and **IV**, incomplete, WRESZ., *Atlas*, i. 179; group with man vomiting in **III**, and woman with sistrum and *menat* in **IV**, SCHOTT, *Das schöne Fest*, pls. iv, xi, pp. 805, 840, 894 [141]. Tumblers in **IV**, DAVIES in *M.M.A. Bull.* Pt. ii, Feb. 1928, fig. 4, cf. p. 61; HAY MSS. 29852, 246. Titles of deceased, wife, and parents, CHAMP., *Not. descr.* i, p. 512 [A'–D]; names of deceased and wife, LEPSIUS MS. 350 [bottom].

(3) [1st ed. 2] Stela with remains of long text. At sides, five registers, **I**, priest libating, **II–V**, priests offering.

M.M.A. photo. T. 3224.

(4) [1st ed. 3] Four registers, **I–II**, and two men offering to deceased standing with staff, **III–IV**, and [similar (?) scene]. **I–IV**, Agriculture, including winnowing in **I**, pulling flax in **II**, felling trees in **III**, and boat in **IV**.

M.M.A. photos. T. 3225–6. I–IV, CHIC. OR. INST. photos. 6424–5. Winnowing, WRESZ., *Atlas*, i. 180 [A]; SCHOTT photo. 7663.

(5) [1st ed. 6] Three registers. **I**, Two scenes, **1**, deceased on foot, with attendant holding dog, hunting wild bulls, ostriches, &c., in desert, **2**, deceased and wife receive game, including hyena and ostrich. **II**, Banquet with female guests before deceased, wife, and girl. **III**, Deceased with staff, preceded by two rows of men with provisions and lector carrying royal statuette.

M.M.A. photos. T. 3217–20, 3247; CHIC. OR. INST. photos. 6431–2, 6138; figures and details, SCHOTT photos. 6305–8, 7658, 8232–8. I, WRESZ., *Atlas*, i. 53 a; SMITH, *Art . . . Anc. Eg.* pls. 99 [B], 101. Deceased hunting, PRISSE, *L'Art égyptien*, ii, 24th pl. 'Chasse à Tir . . .'; animals, CHAMP., *Mon.* clxxi; ROSELLINI, *Mon. Civ.* xv.

(6) [1st ed. 5] Stela, long text, and scene at top, deceased, with son carrying female statuette, offers bouquet to statues of ʿAḥmosi-Ḥenut-tameḥ and mother Queen Inḥaʿpi (tomb 320) with small boy under her chair, followed by nurse (possibly Rēʿi, see DEIR EL-BAḤRI, *Bibl.* i², Pt. 2, in the Press). At sides, five registers, **I**, priest libating, **II–V**, priests offering.

HERMANN, *Stelen*, pl. 9 [d] (from SCHOTT photo.), Abb. 8, cf. pp. 60–3, 76; M.M.A. photos. T. 3230–1, cf. 3214; CHIC. OR. INST. photo. 6430; SCHOTT photo. 8231. Scene, *L. D.* iii. 8 [a], cf. *Text*, iii, p. 282. Texts, BOURIANT in *Rec. de Trav.* xiv (1893), pp. 71–3; long text, SETHE, *Urk.* iv. 1217–23 (362); names, CHAMP., *Not. descr.* i, p. 513 [A, B].

(7) [1st ed. 4] Four registers. **I**, Double-scene, deceased with family fishing and fowling, with deceased spearing hippopotamus beyond. **II–IV**, Deceased seated receives produce of marsh-lands, including netting fowl and fish in **II** and **III**, and vintage in **IV**.

M.M.A. photos. T. 3228–9, 3246; CHIC. OR. INST. photos. 6426–9; figures and details, SCHOTT photos. 7659–62, 8229–30. I, WRESZ., *Atlas*, i. 77 a. Texts, HAY MSS. 29848, 67.

Inner Room.

(8) Outer lintel, double-scene, deceased kneeling with offerings before Anubis-jackals, jambs, offering-texts. Inner lintel, girl prepares bed.

Outer doorway, M.M.A. photo. T. 3227.

(9) [1st ed. 9] Five registers. **I**, Women pounding and grinding grain. **II–V**, Baking.

M.M.A. photos. T. 3233 [left], 3245. I, WRESZ., *Atlas*, i. 87 b with note 8, 180 [B]; SCHOTT photos. 7664–5.

(10) Two remaining registers. **I**, Man fanning wine-jars. **II**, Brewing.

M.M.A. photo. T. 3233 [right].

(11) and (12) Four registers, funeral procession, **I** and **II** to Western goddess and Osiris, **III** and **IV** to deceased and wife, including Abydos pilgrimage, *teknu*, dragging sarcophagus, carrying funeral outfit, and statue purified, in **I–III**, and Opening the Mouth ceremony, rites in garden, mummers, dancers, and setting up obelisks, in **IV**.

M.M.A. photos. T. 3240–4; CHIC. OR. INST. photos. 6434–42. Part of procession, GRIFFITHS in *Kush*, vi (1958), pl. xxxii (from M.M.A. photo.), facing p. 112. Deceased and wife, SCHOTT photo. 8239; mourners and priest before mummy in **IV**, WERBROUCK, *Pleureuses*, figs. 21, 127–8, cf. p. 36; pools and mummers in **IV**, WRESZ., *Atlas*, i. 181; sketch of men in shrine in **IV**, LEPSIUS MS. 351 [upper].

(13) [1st ed. 8] Four registers. **I–II**, Rites before mummies (including butchers and two priests carrying statuette in **II**). **III**, Guests (continued at (14)). **IV**, Remains of scene, two women adoring, and brother as charioteer.
M.M.A. photos. T. 3234–6, cf. 3232 [right]. **I–III**, CHIC. OR. INST. photos. 6446–7. **IV**, SCHOTT photos. 8241–2.

(14) [1st ed. 7] Two registers. **I**, Deceased, wife, and parents, with man offering to them, and guests. **II**, [Man] offers to two couples.
M.M.A. photos. T. 3236–8; CHIC. OR. INST. photos. 6443–5. Names in **II**, CHAMP., *Not. descr.* i, p. 843 [to p. 513, l. 14]. Two titles, BOURIANT in *Rec. de Trav.* xiv (1893), on p. 71; SETHE, *Urk.* iv. 1225 [bottom].

(15) False door containing niche with scene below it, offerings between four men and four women seated on ground. Lintel of false door, double-scene, deceased kneeling adores Osiris, and adores Anubis, jambs, text. Beyond jambs, four registers, priests offering, and deceased seated below.
M.M.A. photos. T. 3239, cf. 3232 [left]; SCHOTT photo. 8240.

54. HUY ⟨⟩, Sculptor of Amūn, temp. Tuthmosis IV to Amenophis III (?). Usurped by KENRO ⟨⟩, *waᶜb*-priest, Head of the magazine of Khons, early Dyn. XIX.
Sh. ʿAbd el-Qurna.
Wife (of Ḥuy), Taenheruensi ⟨⟩, (of Kenro), Tarenenu ⟨⟩, Chief of the harīm of Amūn.

Plan, p. 90. Map V, D–4, f, 10.

Name and title, MOND in *Ann. Serv.* v (1904), p. 103 [6] with note 2.

Hall.

(1) Thicknesses, Ḥuy and wife adoring, with hymn to Rēᶜ added by Kenro on right. Wife on left thickness, SCHOTT photos. 3062, 8273.

(2) Four registers. **I**, Male mourners and sarcophagus dragged. **II**, 'Nine friends', chest dragged (with Anubis added), and female mourners. **III**, Destroyed. **IV**, Remains of sailing-boat in [Abydos pilgrimage].
I and **II**, DAVIES, *The Tomb of Two Sculptors at Thebes*, pl. xxxi [1], pp. 43, 44; WERBROUCK, *Pleureuses*, pl. vii [upper], pp. 3, 6–7; CHIC. OR. INST. photo. 6448; SCHOTT photos. 3743–7, 3752, 7501–4. **II**, BAUD, *Dessins*, fig. 42. 'Nine friends' and male and female mourners, LÜDDECKENS in *Mitt. Kairo*, xi (1943), pp. 95–7 [40–2] with Abb. 32–4.

(3) [1st ed. 1] Painted stela of Ḥuy with texts. At sides, offering-scenes, including priest (sketch) offering onions to deceased and wife on left, and priest purifying deceased and wife on right. At bottom, female mourners and offerings before son Khonsuy ⟨⟩ and wife.

HERMANN, *Stelen*, pl. 10 [a, b], (from SCHOTT photos.), and pp. 12*–13* [62–6]; CHIC. OR. INST. photo. 6139; SCHOTT photos. 3064–5, 3751, 7505–7. Lower scene on left, KEIMER in *Cahiers d'histoire égyptienne*, Sér. iii [4] (1951), fig. 3 (from SCHOTT photo.), cf. pp. 354–5; priest purifying and priest offering onions, BAUD, *Dessins*, figs. 40–1. Scene at bottom, id. ib. pl. ix [A], pp. 98–9; mourners, WERBROUCK, *Pleureuses*, figs. 20, 116, cf. fig. on 2nd page after p. 159, and p. 37; torch (in offerings), DAVIES in *J.E.A.* x (1924), pl. v [3], p. 10.

(4) Two registers. **I,** Kenro as *sem*-priest censes to mummies, and offers to Ḥuy and wife. **II,** Kenro, with wife and couple, offers on braziers to Hathor-cow in mountain.

CHIC. OR. INST. photos. 6449–51, 6452 [left].

(5) [1st ed. 2] Four registers. **I,** Kenro with family censes and libates to Amenophis I and ꜥAḥmosi Nefertere. **II,** Kenro followed by offering-bringers and scribe censes and libates to Osiris. **III,** Lectors, Ḥuy, and market-scene. **IV,** Bringing and piling grain before Termuthis in front of granary.

CHIC. OR. INST. photos. 6457–9. **I,** omitting family, DAVIES in *M.M.A. Bull.* Pt. ii, Dec. 1922, fig. 5, cf. p. 54. **III,** and Kenro before Osiris in **II,** SCHOTT photos. 7508–12.

(6) Three registers, funeral procession (partly destroyed). **I,** Dragging sarcophagus. **II,** Remains of boats. **III,** Man adoring *zad*-pillar, and Anubis-jackal. Sub-scene, reaping and winnowing before tomb or granary.

Right end of **I–IV,** CHIC. OR. INST. photo. 6456. Details in **I,** and *zad*-pillar in **III,** SCHOTT photos. 3753–4. Texts of oxen dragging in **I,** LÜDDECKENS in *Mitt. Kairo*, xi (1943), pp. 93–5 [38–9] (from copies by SETHE).

(7) Two registers. **I,** Two priests, with offering-bringers and men bringing cattle, perform Opening the Mouth ceremony before mummy held by Anubis at pyramid-tomb. **II,** Two scenes, **1,** couple cense and libate before Kenro and wife, **2,** son offers bouquet to deceased.

I, and **II, 1,** CHIC. OR. INST. photos. 6453–5. **I,** incomplete, SCHOTT photos. 6053–5.

(8) Niche. Side-walls, Kenro and wife. Below niche, tree-goddess scene, with Kenro and wife seated drinking on left and adoring on right, son drinking under chair of Kenro, and *ba* drinking below tree.

Tree-goddess scene, CHIC. OR. INST. photo. 6452 [middle].

55. RAꜥMOSI ⬭𓏏𓏛, Governor of the town and Vizier. Temp. Amenophis IV.

Sh. ꜥAbd el-Qurna. ('Stuart's Tomb.')

Parents, Neby ⬭𓏤𓏜𓏜, Overseer of the cattle of Amūn in the Northern District, and Ipuia 𓏜𓆱𓃀𓏤𓏜𓈐. Wife, Mery(t)ptah 𓏛𓏤𓈖𓏜𓏜.

Plan, p. 106. Map VI, E–4, g, 2.

DAVIES, *The Tomb of the Vizier Ramose*, passim, with plans and sections, pls. i, ii, cf. lvi; STUART, *Egypt after the War*, pp. 369–92; BOURIANT in *Rev. Arch.* N.S. xliii (1882), pp. 279–84; id. in *Rec. de Trav.* vi (1885), pp. 55–6; YEIVIN in *Liv. Ann.* xiii (1926), pp. 3–4, 6–11, with plans and sections, pls. iii, iv; MOND and EMERY in *Liv. Ann.* xiv (1927), pp. 14–22. Inscribed fragments, DAVIES, *Ramose*, pl. xliii.

Court.

(1) Two stelae (unfinished). HERMANN, *Stelen*, pl. 2 [d], p. 25; MOND and EMERY, op. cit. pl. vi [b], p. 15.

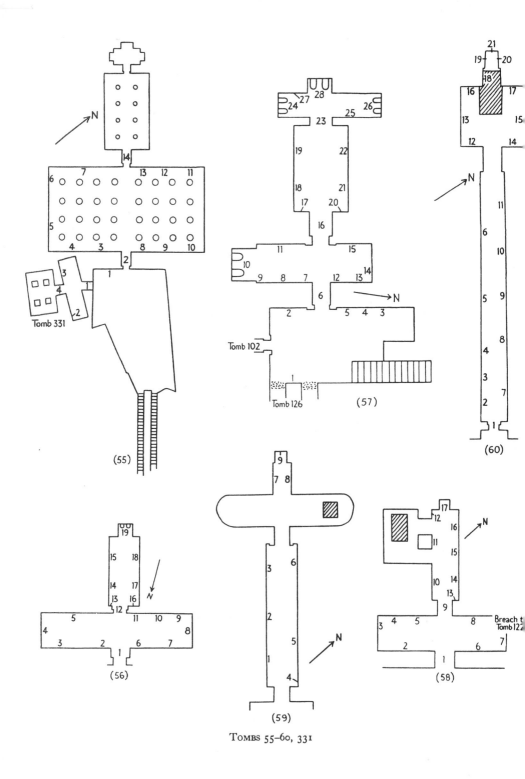

TOMBS 55-60, 331

Hall. View, YEIVIN, op. cit. pl. v; M.M.A. photos. T. 2709–11, 1236.

(2) Outer lintel, [deceased] kneeling adoring, jambs, remains of texts with [deceased] seated at bottom. Left thickness, [deceased and wife] adoring with hymn to Rēᶜ. Right thickness, deceased with staff entering. Inner jambs, remains of hymns and titles.

DAVIES, *Ramose*, pls. iii–v, xli [2, 3], cf. xliii [88], lv [1, 2, 5], pp. 35–6, 37. Left thickness, MOND and EMERY in *Liv. Ann.* xiv (1927), pl. x [right]. Inner jambs, M.M.A. photos. T. 1237, 1676, 2701. Texts on right outer jamb, and on left thickness, CHIC. OR. INST. photos. 7273, 7340, 8491; title from right inner jamb, SCHOTT photos. 7543–4.

(3) [1st ed. 1] Deceased consecrates offerings, followed by two registers, I, [officials], II, three officials with papyrus-stalks. Sub-scene, three male singers with song, butchers, and offering-bringers.

DAVIES, *Ramose*, pls. vi, vii, xiii [2], xlvi, xlvii [right], pp. 13–14; M.M.A. photos. T. 547–8, 1035, 1260, 1676–81, 2701; CHIC. OR. INST. photo. 6376. Omitting deceased, SCHOTT photos. 1899–1901, 1906–7, 5897, 5932–6, 7545–8. Second and third officials in II, CAPART and WERBROUCK, *Thèbes*, fig. 164; CAPART, *Propos*, fig. 126; id. *L'Art égyptien*, iii, pl. 539; WEIGALL, *Anc. Eg. . . . Art*, 187; PIJOÁN, *Summa Artis*, iii (1945), pl. xi facing p. 272; GROENEWEGEN-FRANKFORT, *Arrest and Movement*, pl. xl, p. 105; WEYNANTS-RONDAY in *Chronique d'Égypte*, xv (1940), fig. 4, cf. p. 59; ALDRED, *New Kingdom Art in Ancient Egypt*, pl. 100. Second official in II, LUGN, *Konst och Konsthantverk i Egypten*, fig. 59; GALASSI in *Critica d'arte*, N.S. ii (1955), fig. 277, cf. p. 350; DE RACHEWILTZ, *Incontro con l'arte egiziana*, pl. 51, p. 61; upper part, SCHARFF in OTTO, *Handbuch der Archäologie*, i, pl. 88 [2], p. 571; STEINDORFF and WOLF, *Gräberwelt*, frontispiece; ROBICHON and VARILLE, *En Égypte*, pl. 126; LANGE, *Äg. Kunst*, pl. 75; LANGE and HIRMER, *Aegypten*, pl. 174; CHAMPDOR, *L'Égypte des Pharaons*, pl. on p. 149; BRUNNER, *Ägyptische Kunst*, Abb. 16; SMITH, *Art . . . Anc. Eg.* pl. 111. Singers with song in sub-scene, SCHOTT, *Das schöne Fest*, pl. v, p. 809; CHIC. OR. INST. photo. 7322; song, HELCK, *Urk.* iv. 1778; some offering-bringers, LANGE, *Lebensbilder*, pl. 61; DESROCHES-NOBLECOURT, *Religions ég.* fig. on p. 306 [top left]; one, WOLF, *Die Welt der Ägypter*, pl. 73; VIOLLET and DORESSE, *Egypt*, pl. 153; details, LANGE, *Äg. Kunst*, pls. 77, 118.

(4) [1st ed. 2] Two registers. I, Guests before deceased (with goose under chair), wife, and parents. II, Four couples before deceased and wife, and brother Amenḥotp, daughter, and wife (with cat and goose under chair).

DAVIES, *Ramose*, pls. viii–xii, xlvii [left], cf. lv [3], pp. 15–17; M.M.A. photos. T. 549–52, 1029–35, 1682, 2702–3; SCHOTT photos. 5616, 5618–23, 5625–36, 6078, and details, 5896, 5918–21, 5925–31, 5937, 7549–50. Goose in I, KUENTZ, *L'Oie du Nil*, fig. 24, cf. p. 42. Deceased and wife, and Amenḥotp, wife, and daughter, in II, CAPART and WERBROUCK, *Thèbes*, fig. 168; omitting deceased, STEINDORFF, *Blütezeit* (1926), fig. 112; HAMANN, *Ägyptische Kunst*, Abb. 244, cf. p. 227. Amenḥotp, PILLET, *Thèbes. Palais et nécropoles*, fig. 100.

All guests, CHIC. OR. INST. photos. 3344, 6377–80, 7271. Four couples in II, LANGE and HIRMER, *Aegypten*, pls. 168–73; 2nd, 3rd, and 4th couples, ALDRED, *New Kingdom Art in Ancient Egypt*, pl. 99; 2nd and 3rd couples, CAPART and WERBROUCK, *Thèbes*, fig. 166; NEWBERRY in ROSS, *Art of Egypt*, pl. on p. 168 [2]; 3rd and 4th couples, STEINDORFF, *Kunst*, pl. on p. 236. 1st couple, WRESZ., *Atlas*, i. 182; BORCHARDT and RICKE, *Egypt*, pl. 169; VON BISSING in *Sitzungsb. der bayerischen Akademie der Wissenschaften*, Philos.-philol. hist. Klasse (1914), pl. iv, p. 8; WEIGALL, *Anc. Eg. . . . Art*, 186 [upper]; LANGE, *König Echnaton und die Amarna-Zeit*, pl. 6; HAMANN, *Ägyptische Kunst*, Abb. 243, cf. p. 227;

SCHOTT, *Altägyptische Liebeslieder*, pl. 5; SAMIVEL and AUDRAIN, *The Story of Egypt*, pls. 80, and 92 (head of wife, reversed); head of man, DRIOTON, *Temples et trésors*, pl. 13; WEGNER in *Mitt. Kairo*, viii (1939), pl. 36 [b], p. 228. 2nd couple, CAPART, *L'Art égyptien*, iii, pl. 540; GILBERT, *La Poésie égyptienne*, pl. xv; head of wife, LANGE, *Äg. Kunst*, pl. 76; KUSCH, *Ägypten im Bild*, Abb. 128. 3rd couple, STEINDORFF and SEELE, *When Egypt ruled the East*, fig. 58, cf. p. 182; WOLF, *Die Kunst Aegyptens*, Abb. 482; man, LANGE, *Äg. Kunst*, pl. 74; head, MACKAY in *J.E.A.* vii (1921), pl. xxiv [4], pp. 164, 165; BYVANCK, *De Kunst der Oudheid*, pl. xlii [fig. 149], cf. p. 275; horse-hieroglyph in title, CHIC. OR. INST. photo. 7323. 4th couple, PIJOÁN, *Summa Artis*, iii (1945), fig. 441; LANGE, *Pyramiden, Sphinxe, Pharaonen*, pl. 25; DAUMAS, *Amour de la vie* [&c.] in *Études Carmélitaines* (1951), pl. facing p. 112; CHAMPDOR, *Thèbes aux Cent Portes*, fig. on p. 51; heads, KERNAGHAN in *Art and Archaeology*, xxxi (1931), figs. on p. 254 (from copy by LINDON SMITH); LINDON SMITH, *Tombs, Temples and Ancient Art*, pl. facing p. 96 [upper].

Texts, HELCK, *Urk.* iv. 1783 [bottom]–1788.

(5) [1st ed. 3–4] Two registers, funeral procession to Western goddess, including priestess at tomb, *teknu*, and four prophets in **I**, and priests before mummies at tomb (with cones in position), priestesses, male and female mourners, 'Nine friends', and officials, in **II**.

DAVIES, *Ramose*, pls. xxiii–xxvii, xlix, pp. 21–6; HAMANN, *Ägyptische Kunst*, Abb. 245; M.M.A. photos. T. 543–6, 675, 1068–9; CHIC. OR. INST. photos. 2843–5, 7272, 7275; incomplete, VON BISSING in *Sitzungsb. der bayerischen Akademie der Wissenschaften*, Philos.-philol. hist. Klasse (1914), pls. ii, iii, p. 8; BAIKIE, *Eg. Antiq.* pl. xxiv [lower]; WEGNER in *Mitt. Kairo*, iv (1933), pl. xxii; FARINA, *Pittura*, pls. cxxxviii–xl; LANGE and HIRMER, *Aegypten*, pls. 164–5. **II**, incomplete, SCHOTT photos. 4416–26, 5850–5, 5860, 6079–90, 7554–9, 8900–11, 9039–43. Scenes at tombs in **I** and **II**, and title of goddess, STUART, *Egypt after the War*, pls. lvii–lviii (both reversed), xxviii [13], cf. pp. 369–71; tomb in **II**, DAVIES (Nina) in *J.E.A.* xxiv (1938), fig. 3, cf. p. 36. Offering-bringers in *II*, DAVIES (Nina), *Anc. Eg. Paintings*, ii, pl. lxxi; men with funeral outfit, and mourners, id. ib. pls. lxxii, lxxiii (CHAMPDOR, Pt. ii, 4th pl., Pt. v, 2nd pl.); LINDON SMITH, *Tombs, Temples and Ancient Art*, pl. facing p. 96 [lower]; RANKE, *Meisterwerke*, pl. 46; KERNAGHAN in *Art and Archaeology*, xxxi (1931), fig. on p. 253; DRIOTON and HASSIA, *Temples et trésors*, pl. 12; LHOTE and HASSIA, *Chefs-d'œuvre*, pls. 21–3, 25; MEKHITARIAN, *Egyptian Painting*, pls. on pp. 114–15; first man and mourners, WOLF, *Die Kunst Aegyptens*, Abb. 475; men with outfit, SCOTT, *The Home Life of the Ancient Egyptians*, fig. 11; mourners and relatives, WERBROUCK, *Pleureuses*, pl. xii, figs. 93, 96, 99, 103, 108, 144, 166, and on 2nd p. after p. 159, cf. pp. 38–9; mourners, WRESZ., *Atlas*, i. 8 a; STEINDORFF, *Blütezeit* (1926), Abb. 110; id. *Kunst*, pl. on p. 237; STEINDORFF and WOLF, *Gräberwelt*, pl. 12 [b]; BÉNÉDITE, *L'Art égyptien dans ses lignes générales*, pl. xxx; CAPART, *Propos*, fig. 31, cf. p. 40; RANKE, *The Art of Ancient Egypt*, and BREASTED, *Geschichte Aegyptens*, 260; BORCHARDT and RICKE, *Egypt*, pl. 165; LANGE, *Lebensbilder*, pl. 52; id. *Ägyptischer Totenkult* in *Atlantis*, Nov. 1940, fig. on p. 630; LÜD-DECKENS in *Mitt. Kairo*, xi (1943), pl. 16, pp. 97–9 [43–4], with Abb. 35; PIJOÁN, *Summa Artis*, iii (1945), fig. 461; HAMANN, *Ägyptische Kunst*, Abb. 246; SCHOTT, *Altägyptische Liebeslieder*, pl. 23; BRUNNER, *Ägyptische Kunst*, Abb. 15; ROBICHON and VARILLE, *En Égypte*, pl. 124; DONADONI, *Arte egizia*, fig. 152; COTTRELL, *The Lost Pharaohs*, pl. 28; PRITCHARD, *The Ancient Near East in Pictures*, fig. 638; DAVIES (Nina), *Eg. Paintings* (Penguin), pl. 12.

Texts of Western goddess and of right part of **I** and **II**, PIEHL in *Ä.Z.* xxv (1887), pp. 38–9 [b]; texts of prophets in **I**, and of male mourners, 'Nine friends', and officials, in **II**, HELCK, *Urk.* iv. 1788 [bottom]–1789 [middle]; texts of priests in **II**, SCHIAPARELLI, *Funerali*, ii,

p. 292 [xiii]; SANDMAN, *Texts from the time of Akhenaten* (*Bibliotheca Aegyptiaca*, viii), p. 140 [cxxix] (from PIEHL).

(6) [1st ed. 5] Two registers. I, Deceased and wife with hymn adore Osiris and [divinities]. II (unfinished), Four figures of deceased before tomb and gates (once with offering-bringer and foreleg-rite).

DAVIES, *Ramose*, pls. xxii, xxviii [2], pp. 21, 26–7; M.M.A. photos. T. 1036–7, 2708. Texts in I, PIEHL in *Ä.Z.* xxv (1887), pp. 37–8 [a]; HELCK, *Urk.* iv. 1776; SANDMAN, op. cit. p. 139 [cxxviii] (from PIEHL).

(7) [1st ed. 6, 7] Four unfinished figures of deceased with standards offering bouquets of the Theban Triad and of Rēʿ-Ḥarakhti to Amenophis IV and Maʿet in kiosk with Nine Bows on base.

DAVIES, *Ramose*, pls. xxix–xxxi, l–lii [left], lv [4], pp. 27–30; M.M.A. photos. T. 1024–8. Omitting 3rd and 4th figures of deceased, CHIC. OR. INST. photos. 7330–1; omitting 2nd to 4th, STUART, *The Funeral Tent of an Egyptian Queen*, pls. 7, 15 [left] (frontispiece), 16, 19 (reversed), 27; id. *Egypt after the War*, pls. 7 (marked 6), 15 [left], 16, 19 (reversed), 27, 28 [11], pp. 376–8, 390. King and Maʿet, WERBROUCK in *Bull. des Mus. roy.* 3 Sér. vi (1934), fig. 29, cf. p. 44; GHALIOUNGUI in *Ann. Serv.* xlvii (1947), fig. 2, cf. p. 32; SMITH, *Art . . . Anc. Eg.* pl. 115; upper part, VON BISSING in *Sitzungsb. der bayerischen Akademie der Wissenschaften*, Philos.-philol. hist. Klasse (1914), pl. v, p. 9; SCHÄFER in *Amtliche Berichte*, xl (1918–19), Abb. 115, cf. pp. 223–4; KOEFOED-PETERSEN, *Ægyptens Kætterkonge og hans Kunst*, fig. 10, cf. p. 37. All figures of deceased, SCHOTT photos. 7551–3; 1st and 2nd, MACKAY in *J.E.A.* iv (1917), pls. xv [3], xvi [1], pp. 77–80, and vii (1921), pl. xxiv [3] (arm of 3rd), cf. p. 164; BAUD, *Dessins*, pl. x, pp. 102–3. Nine Bows, MEYER, *Fremdvölker*, 638–40; heads of 2nd Bow from left, in Sambon Collection, and 5th, in Brussels, Mus. roy. du Cinquantenaire, E. 2485, WERBROUCK in *Bull. des Mus. roy.* 3 Sér. vi (1934), figs. 30, 28, cf. pp. 44–6; head of 5th, *Bruxelles, Musées royaux. Album*, fig. 33; CAPART in *Bull. des Mus. roy.* 2 Sér. iii (1910), fig. 2 (called tomb of Khaʿemḥēt), cf. p. 37; see *Chronique d'Égypte*, ix (1934), pp. 189–91; 8th from left, CHIC. OR. INST. photo. 7324. Texts of King and Maʿet, SANDMAN, *Texts from the time of Akhenaten* (*Bibliotheca Aegyptiaca*, viii), p. 138 [cxxvi]; texts of deceased with hymn to the King's *ka*, HELCK, *Urk.* iv. 1780 [middle]–1781; part, PIEHL in *A.Z.* xxi (1883), p. 129 [c].

(8) Deceased with wife and offering-bringers pours incense on brazier. Sub-scene, offering-bringers and butchers.

DAVIES, *Ramose*, pls. xiii [1], xiv, xv, xliv, pp. 14–15; M.M.A. photos. T. 1237–8, 1242, 1246, 1255–6; CHIC. OR. INST. photos. 3345, 3347, 6372–3. Deceased, wife, and details, SCHOTT photos. 1902–4, 5900–6, 5913–14, 5898, 6076, 7536–7; deceased and butchers, MOND and EMERY in *Liv. Ann.* xiv (1927), pl. x [left]; herbs among offerings, SCHOTT, *Das schöne Fest*, Abb. 9, cf. p. 790; three offering-bringers in 3rd row, CAPART, *L'Art égyptien*, iii, pl. 538.

(9) [1st ed. 12] Two registers. I, Three girls with sistra and *menats* before deceased and wife. II, Statue of deceased purified by two priests and acclaimed by four others.

DAVIES, *Ramose*, pls. xviii, xxi [right], xlviii, and frontispiece, pp. 20–1; M.M.A. photos. T. 1238–9, 1242, 1247, 1251–4, 1257–9; SCHOTT photos. 5907–8, 5915, 6068–77, 8891–3. I, BAIKIE, *Eg. Antiq.* pl. xxiv [upper]; id. *A History of Egypt*, ii, pl. xix; WEGNER in *Mitt. Kairo*, iv (1933), pl. xxi [a]; CHIC. OR. INST. photo. 3346. Girls in I, CAPART, *L'Art égyptien*,

iii, pl. 537. **II,** Lange and Hirmer, *Aegypten*, pls. 166–7; Schott in *Nachr. Akad. Göttingen* (1957), No. 3, pl. iv [b], p. 85; statue, Emery in *J.E.A.* xi (1925), pl. x, p. 125; Chic. Or. Inst. photo. 6208. Texts in **I,** Helck, *Urk.* iv. 1779–80 [top].

(10) Two registers. **I,** Two rows of priests with ointment before deceased (with [goose] under chair) and wife, and parents. **II,** *Sem*-priest with offering-list ritual before deceased and wife and Amenḥotp and wife.

Davies, *Ramose*, pls. xvi, xvii, xix–xxi [left], pp. 17–20; M.M.A. photos. T. 1236, 1239–41, 1243–5, 1247–50; Chic. Or. Inst. photos. 6374–5; Schott photos. 5909–12, 5916–17, 5922–3, 8894–6. Titles of deceased in **II,** Helck, *Urk.* iv. 1790 [D].

(11) Deceased receives bouquets from the Temple.

Davies, *Ramose*, pl. xxxviii, p. 34; Baud, *Dessins*, pl. xi [right], p. 103. Men with bouquets, Davies in *M.M.A. Bull.* Pt. ii, Dec. 1923, fig. 14 [right], cf. p. 46.

(12) [1st ed. 11] Two registers. **I,** Deceased rewarded, and deceased with attendants acclaimed by courtiers. **II,** Deceased receives courtiers and foreign delegates (Nubians, Asiatics, and a Libyan).

Davies, *Ramose*, pls. xxxiv [right], xxxv, xxxvi [right], xxxvii, liv, pp. 34–5; Baud, *Dessins*, pls. xi [middle], xii–xiv, pp. 103–7; M.M.A. photos. T. 540–2, 1015–16, 1525–32. **II,** Capart, *Documents*, ii, pl. 68, i, pl. 72; id. *L'Art égyptien*, iii, pl. 541; id. in Glanville, *The Legacy of Egypt*, pl. 9 [fig. 11], cf. p. 103; Davies in *M.M.A. Bull.* Pt. ii, Dec. 1924, figs. 4–5, cf. pp. 47–9. Deceased with courtiers, Smith, *Art . . . Anc. Eg.* pl. 116 [B]. Foreign delegates, Meyer, *Fremdvölker*, 805; four on right, Prisse, *L'Art égyptien*, ii, 4th pl. 'Fac-simile d'une esquisse épurée', cf. *Texte*, p. 395; Ranke, *The Art of Ancient Egypt*, and Breasted, *Geschichte Aegyptens*, 266 (called tomb of Sethos I); Petrie, *Arts and Crafts*, fig. 78, cf. p. 60; id. *Egypt* in *Encyclopaedia Britannica*, 11th ed. (1910), pl. iv [50]; Weigall, *Anc. Eg. . . . Art*, 186 [lower]; Farina, *Pittura*, pl. clv; Lange, *Lebensbilder*, pl. 39; Murray, *The Splendour that was Egypt*, pl. lxxix [5]; de Keyzer, *Beschavings Geschiedenis van het Oude Oosten*, pl. i facing p. viii (called tomb of Sethos I); head of Libyan, Bates, *The Eastern Libyans*, fig. 35, cf. p. 130. Texts in **I,** Helck, *Urk.* iv. 1782 [middle].

(13) [1st ed. 10] Deceased kneeling and prostrate, and deceased standing below, before Amenophis IV and Nefertiti with Aten-rays in palace-window, followed by six registers, **I–VI,** officials and male and female fan-bearers.

Davies, *Ramose*, pls. xxxii–xxxiv [left], xxxvi [left], lii [right], liii, pp. 30–3; Stuart, *Nile Gleanings*, pls. v (inaccurate), pp. 82–4, cf. pl. xxxiv (head of an official). Omitting deceased standing, M.M.A. photos. T. 1016–20. All figures of deceased, Baud, *Dessins*, pl. xi [left], and fig. 43. King, Queen, and **I–III,** Davies in *M.M.A. Bull.* Pt. ii, Dec. 1923, fig. 2, cf. p. 41; Capart and Werbrouck, *Thèbes*, fig. 149; Wegner in *Mitt. Kairo*, iv (1933), pl. xxi [b]; Chic. Or. Inst. photos. 3348, 7274. King and Queen, Schäfer in *Amtliche Berichte*, xl (1918–19), Abb. 116, cf. pp. 223–4; von Bissing in *Sitzungsb. der bayerischen Akademie der Wissenschaften*, Philos.-philol. hist. Klasse (1914), pl. vi, p. 9; Ghalioungui in *Ann. Serv.* xlvii (1947), fig. 5, cf. p. 34; Koefoed-Petersen, *Ægyptens Kætterkonge og hans Kunst*, fig. 11, cf. p. 37; Smith, *Art . . . Anc. Eg.* pl. 116 [A]; head of King and some officials and fan-bearers, Stuart, *Egypt after the War*, and id. *The Funeral Tent of an Egyptian Queen*, pls. 17, 20–1; officials and fan-bearers in **II–III,** Hamann, *Ägyptische Kunst*, Abb. 252; in **IV** and **V,** von Bissing, *Denkmäler ägyptischer Sculptur*, pl. 81 [a]; Weigall, *Anc. Eg. . . . Art*, 188; Strömbom, *Egyptens Konst*, fig. 152, cf. p. 179; in **IV,** Pijoán, *Summa Artis*, iii (1945), fig. 438; official on right in **VI,** Lange, *Lebensbilder*, pl. 28.

See BREASTED in *Ä.Z.* xl (1902–3), p. 107. Texts of deceased, HELCK, *Urk.* iv. 1781 [bottom]–1783 [middle].

(14) [1st ed. 8, 9, 13, 14] Entrance to Inner Room. Outer lintel, double-scene, deceased before [Horus-name and cartouches of Amenophis III], jambs, remains of texts, with deceased seated below. Left thickness, deceased and [wife] entering with hymn to Rēᶜ. Right thickness, deceased with staff returns to tomb with autobiographical text and hymn to gods of Zazat.

DAVIES, *Ramose*, pls. xxviii [1], xxxix–xli [1], lii [middle], pp. 36–8; M.M.A. photos. T. 1019, 1021–3, 2694–2700. Left thickness, CHIC. OR. INST. photo. 7195. Cartouches and some texts on lintel, and titles from thicknesses, PRISSE MSS. 20419, 261 [top and middle]; texts on thicknesses and ends of lintel, PIEHL in *Ä.Z.* xxi (1883), pp. 127–9 [a, b], 129–30 [d], xxv (1887), p. 39 [c]; HELCK, *Urk.* iv. 1777–8 [top], 1789–90 [A–C]; texts on lintel and right thickness, SANDMAN, *Texts from the time of Akhenaten* (*Bibliotheca Aegyptiaca*, viii), pp. 137–40 [cxxv, cxxvii, cxxx], (from PIEHL); parts of text on right thickness, GOLENISHCHEV MSS. 14 [n]; details of text on left thickness, SCHOTT photos. 8898–9; title of wife, STUART, *Egypt after the War*, pl. 28 [10], p. 369.

Fragments from ceiling, architrave, and abacus, DAVIES, *Ramose*, pl. xlv, pp. 38–40.

56. USERḤĒT ⌐◻⌐, Royal scribe, Child of the nursery. Temp. Amenophis II.
 Sh. ʿAbd el-Qurna. (L. *D. Text*, No. 81.)
 Wife, Mutnefert ⌐◻⌐, Royal concubine.

 Plan, p. 106. Map VI, E–4, f, 3.

 L. *D. Text*, iii, pp. 283–4; MOND in *Ann. Serv.* vi (1905), pp. 67–9, with plan, fig. 3 [bottom].

Hall.

(1) Outer lintel, double-scene, deceased and wife before Osiris, jambs, texts. SCHOTT photo. 8195.

(2) [1st ed. 1] Deceased, followed by wife and mother with bouquets, libates offerings. SCHOTT photos. 5063, 8126–9. Texts, HELCK, *Urk.* iv. 1478 [bottom]; of deceased, WILKINSON MSS. v. 219 [middle].

(3) [1st ed. 2] Five registers. I–III, Inspecting cattle before deceased, including overthrowing bulls in III. IV, V, Carrying corn, reaping, and women pulling flax, before deceased.
 Omitting deceased and right end, WRESZ., *Atlas*, i. 187–8. I–III, CAPART and WERBROUCK, *Thèbes*, fig. 203 (from WRESZINSKI); FARINA, *Pittura*, pl. lxxxiii. II–IV, CHIC. OR. INST. photo. 2851; incomplete, SCHOTT photos. 2050–1, 5064–6, 7561–5, 7666–7. Texts, HELCK, *Urk.* iv. 1476–7 [middle], 1477 [bottom]–1478 [top].

(4) [1st ed. 3] Double-scene, deceased offers bouquet of Amūn to Amunezeḥ (tomb 84) and wife on left, and to couple on right. Stela below, with two registers at sides, I and II on left, priest purifies statues of deceased, I and II on right, lector performs Opening the Mouth rite.
 HERMANN, *Stelen*, pl. 9 [e], pp. 9*–10* [48–51], 11* [58–61]; CHIC. OR. INST. photo. 6141;

SCHOTT photos. 2052, 5067, 8130. Texts of double-scene, HELCK, *Urk.* iv. 1479 [middle], 1477 [near bottom]; name of Amunezeḥ, SETHE, *Urk.* iv. 962 (279). Part of text of priest in **I** on left, WILKINSON MSS. v. 219 [top right].

(5) [1st ed. 4] Deceased and wife with two daughters offering necklace and cup and son offering bouquet to them, and four registers, **I–IV**, banquet with musicians (male harpist, female lutist and clapper) in **II**, and monkeys under chairs.

Omitting part of banquet, SCHOTT photos. 1908–10, 1912–13, 2054, 2059–60, 3094–6, 3977, 5061, 8131, 8197–9, 8917. Offering-scene, DRIOTON and HASSIA, *Temples et trésors*, pl. 19. Daughters and banquet, CHIC. OR. INST. photos. 6460–3. Ewer and vase on stand (in front of deceased), JÉQUIER, *Frises*, p. 119, fig. 317; SCHOTT, *Das schöne Fest*, Abb. 18, cf. p. 835. Two boy-attendants in **IV**, MEKHITARIAN, *Egyptian Painting*, pl. on p. 25. Text of daughters and son, mentioning Valley Festival, HELCK, *Urk.* iv. 1479 [top], 1480 [top]; part, WILKINSON MSS. v. 219 [bottom].

(6) Deceased with wife offers on braziers.

Deceased and offerings, CHIC. OR. INST. photo. 6464; offerings and braziers, SCHOTT photos. 1914–15, 5070, 5079, 8136–8, 8140, 8196, 8914; braziers, SCHOTT, *Das schöne Fest*, Abb. 1, cf. p. 781; incense-mould in form of calf, NELSON and HÖLSCHER, *Work in Western Thebes 1931–33* (*Chic. O.I.C.* No. 18), fig. 22. Text of deceased and wife, HELCK, *Urk.* iv. 1479 [bottom].

(7) Three registers. **I**, Offering-scene, and three men with bouquets (belonging to (6)). **II**, Man offering to women nursing children. **III**, Offering-bringers (belonging to (6)).

Offering-scene, CHIC. OR. INST. photo. 6465. **I**, incomplete, and **II**, SCHOTT photos. 1991, 5071, 5073–4, 5116–19, 8141–3.

(8) Stela, double-scene, deceased before Osiris, and text below. At sides, three registers, **I**, men with branches and offerings, **II**, and **III**, fan-bearers and soldiers (belonging to (9)), on left, and **I–III**, men with branches and offerings, on right.

HERMANN, *Stelen*, pls. 3 [d], 7 [a, b] (from SCHOTT photos.), p. 5* [29]; CHIC. OR. INST. photo. 6140; SCHOTT photos. 1987–8, 4403–4, 5076, 8200, 8915. **II** on left, WEGNER in *Mitt. Kairo*, iv (1933), pl. xi [b]; staff with pendant, FAULKNER in *J.E.A.* xxvii (1941), pl. vi [30], pp. 16–17 (from drawing by NINA DAVIES).

(9) [1st ed. 6] Deceased offers bouquet and fruit to Amenophis II in kiosk.

CHIC. OR. INST. photo. 2848. Text, HELCK, *Urk.* iv. 1478 [middle].

(10) Four registers. **I–II**, Four rows of men seated with cakes in front of storehouse. **III–IV**, Men bringing provisions to storehouse.

WRESZ., *Atlas*, i. 186 [right]; CHIC. OR. INST. photo. 2852; parts, SCHOTT photos. 1911, 8133–5, 8916.

(11) [1st ed. 5] Four registers. **I–III**, Inspection of recruits. **IV**, Men, including barbers, seated under trees.

WRESZ., *Atlas*, i. 186 [left], 44; CHIC. OR. INST. photo. 2992. **I–III**, FARINA, *Pittura*, pl. lxxxiv. **IV**, CAPART and WERBROUCK, *Thèbes*, fig. 204 (from WRESZINSKI); part, DAVIES in *M.M.A. Bull.* Pt. ii, Dec. 1926, fig. 11, cf. pp. 13–14; LHOTE and HASSIA, *Chefs-d'œuvre*, pl. 96; PRITCHARD, *The Ancient Near East in Pictures*, fig. 80; SCHOTT photos. 1916, 3980, 7669–70.

Inner Room.

(12) Outer lintel, double-scene, deceased before Osiris, and before Anubis, jambs, offering-texts.

(13), (14), (15) [1st ed. 7–9] Two registers. **I,** Military escort (on entrance-wall), deceased in chariot hunting animals (including hyena) in desert, deceased with family fowling, and fishing. **II,** Three women (on entrance-wall), deceased and wife receive produce of marshlands, men fowling with draw-net, and vintage with offerings to Termuthis.

Omitting scene with Termuthis, WRESZ., *Atlas*, i. 1, 12, 26 a, 38, 183–5. Omitting parts on entrance-wall, CHIC. OR. INST. photos. 2849, 2846, 2991. Hunting-scene and receiving of produce, FARINA, *Pittura*, pl. lxxxii; BAIKIE, *Eg. Antiq.* pl. xxiii [lower]; id. *A History of Egypt*, ii, pl. xvi [2]. Hunting-scene, LANGE and HIRMER, *Aegypten*, pl. 141; GROENEWEGEN-FRANKFORT, *Arrest and Movement*, pl. xliii; deceased, DAVIES in *M.M.A. Bull.* Pt. ii, Dec. 1922, fig. 7, cf. p. 54; LINDON SMITH, *Tombs, Temples and Ancient Art*, pl. facing p. 80 [upper]; animals, SCHOTT photos. 3093, 7566–70; hare and fox, MEKHITARIAN, *Egyptian Painting*, pls. on pp. 58–9; wolf, DE RACHEWILTZ, *Incontro con l'arte egiziana*, pl. 60, p. 76. Deceased fowling, DRIOTON and HASSIA, *Temples and Treasures*, pl. 9; SCHOTT photo. 3092. Men dragging net, bringing fowl, and treading grapes, SCHOTT photos. 2058, 3524, 3528; treading grapes, MEKHITARIAN, *Egyptian Painting*, pl. on p. 61.

(16), (17), (18) [part, 1st ed. 10] Three registers. **I–III,** Funeral procession, including priest with Opening the Mouth instruments, and booths with wine-jars, in **I,** bringing funeral outfit with chariot and led horse in **II,** and boats in **III.**

Middle and right part, CHIC. OR. INST. photos. 2847, 2850, 6466; parts, SCHOTT photos. 1994–7, 2056–7, 3090–1, 3529, 3978–9, 7572–7, 8918–27. Female mourners and relatives in **I,** WERBROUCK, *Pleureuses*, fig. 22, cf. p. 39; omitting one, WEGNER in *Mitt. Kairo*, iv (1933), pl. xi [a]; kneeling mourner on right, MEKHITARIAN, op. cit. pl. on p. 63. Parts of **I** and **II,** including four jars (one with horse-decoration), NAGEL in *J.E.A.* xxxv (1949), pl. xii, pp. 129–31. Men with horse and chariot in **II,** LANGE, *Lebensbilder*, pl. 27; WEGNER, op. cit. pl. xi [c]; DAVIES in *M.M.A. Bull.* Pt. ii, Dec. 1922, fig. 8, cf. p. 56. Two sailors (on boat) in **III,** MEKHITARIAN, op. cit. pl. on p. 27.

(19) Niche with [statues of deceased and wife].

57. KHAʿEMḤĒT ☐☐☐, called MAḤU ☐☐, Royal scribe, Overseer of the granaries of Upper and Lower Egypt. Temp. Amenophis III.

Sh. ʿAbd el-Qurna. (L. D. Text, No. 80.)

Wife, Tiyi ☐☐☐.

Plan, p. 106. Map VI, E–4, g, 3.

LORET, *La Tombe de Khâ-m-hâ* in *Mém. Miss.* i, pp. 113–32, with plan, pl. i; L. D. Text, iii, p. 283; MOND in *Ann. Serv.* vi (1905), pp. 66–7, with plan, fig. 3 [middle]. Texts from ceiling, details from scenes, and cartouches, NESTOR L'HÔTE MSS. 20413, 4th and 8th cartons.

Thirty squeezes (made before 1844), in Boston Mus. 86.213, see DUNHAM in *J.A.O.S.* lvi (1936), pp. 174–7 with pls. i [V, E, T, G], ii [M, AA, BB, U]. Positions in tomb: A at (6), M at (10), B, R, V, W, DD, at (11), P, Z, at (12), Y at (13), E, AA, at (16), D, G, H, T, X, at (18) and (19), O, CC, at (20), C, F, I, L, N, S, U, BB, at (21) and (22), J, K, at (24), Q at (27).

Texts now destroyed. Offering-text, BRUGSCH, *Recueil*, pl. lxvii [2]. Thirteen columns of text, DEVÉRIA squeezes, 6168, 30.

Court. View, M.M.A. photo. T. 809.

(1) [1st ed. 1] Stela, Dyn. XIX. Two registers. Suemmerenḥor ☥⸗, Custodian, censes and libates to Osiris and Western goddess in **I**, and adores Anubis in **II**.
MOND in *Ann. Serv.* vi (1905), pl. i (reversed), p. 67.

(2) Deceased censes and libates with hymn.
M.M.A. photo. T. 808 [left]. Texts, HELCK, *Urk.* iv. 1850-1 [A].

(3) [1st ed. 2] Stela, deceased purifies shrine containing four protecting goddesses and Sons of Horus, with canopic-jars below.
MOND, op. cit. pl. ii, p. 67; part of upper part, SCHOTT photos. 8888-90; deceased, SCHOTT in *Nachr. Akad. Göttingen* (1957), No. 3, pl. vi [b], p. 85.

(4) Lower part of stela with remains of purification scene, and Opening the Mouth instruments and jars below.
M.M.A. photo. T. 810; HERMANN, *Stelen*, pl. 12 [b]; instruments, and jars, SCHOTT photos. 1963-4; instruments, JÉQUIER, *Frises*, fig. 836.

(5) Deceased adores with hymn.
M.M.A. photo. T. 808 [right]; SCHOTT photo. 1965. Texts, HELCK, *Urk.* iv. 1851-3 [B].

Hall. See LORET in *Mém. Miss.* i, pp. 114-21.

(6) [part, 1st ed. 3] Outer jambs, text with deceased seated at bottom. Left thickness, deceased (upper part in Berlin Mus. 14504, replaced by cast) adoring with hymn to Rēʿ.
M.M.A. photos. T. 808 [middle], 811. Left thickness, PRISSE, *L'Art égyptien*, ii, 14th pl. [lower left] 'Types et portraits' (reversed); with cast, BAIKIE, *Eg. Antiq.* pl. xxv [upper]; TZARA and SVED, *L'Égypte face à face*, 54 [left]; LANGE and HIRMER, *Aegypten*, pl. 153; upper part, MACKAY in *Ann. Serv.* xiv (1914), pl. i, p. 89; DRIOTON and SVED, *Art égyptien*, fig. 79; original (in Berlin), PIJOÁN, *Summa Artis*, iii (1945), fig. 377; HERMANN in *Berliner Museen Berichte*, lxi (1941), Abb. 4, cf. p. 4. Texts on right jamb and left thickness, LORET, op. cit. pp. 114-15 [A]; text on Berlin block, *Aeg. Inschr.* ii. 102.

(7) [1st ed. 4] Deceased offers on braziers to 'Amen-rēʿ-Ḥarakhti'. Sub-scene, butchers and three offering-bringers, with offerings below.
WRESZ., *Atlas*, i. 196-7; M.M.A. photos. T. 813-14; MARBURG INST. photo. 86965 [left]. Deceased, LINDON SMITH, *Tombs, Temples and Ancient Art*, pl. facing p. 81. Offering-bringers, CAPART and WERBROUCK, *Thèbes*, fig. 165; CAPART, *Propos*, fig. 127, cf. p. 180; PETRIE, *The Making of Egypt*, pl. lxxvii [3], p. 155; DE WIT, *Oud-Egyptische Kunst*, fig. 120, cf. p. 196; 1st and 2nd, SCHOTT photos. 6036-7; 2nd, CARNARVON and CARTER, *Five Years' Explorations at Thebes*, fig. 7, cf. p. 10; PETRIE, *Arts and Crafts*, fig. 61, cf. p. 53; LAGIER, *À travers la Haute Égypte*, fig. 41. Texts of main scene, LORET in *Mém. Miss.* i, p. 116 [c] (ll. 5-8 now lost); texts of sub-scene, HELCK, *Urk.* iv. 1843 [bottom]-1844 [upper].

(8) [1st ed. 5] Two remaining registers, **I** and **II**, remains of measuring crop and recording grain. Sub-scene, deceased with two offering-bringers (one holding sheaf with quails) offers on braziers to serpent-headed Termuthis suckling King as child.

M.M.A. photos. T. 813, 815–16; MARBURG INST. photo. 86965 [middle]; incomplete, SCHOTT photos. 2162, 2165, 3198, 6035, 6038–9. Sub-scene, PRISSE, *Mon.* pl. xlii; WRESZ., *Atlas,* i. 198; CAPART and WERBROUCK, *Thèbes,* fig. 162 (from WRESZINSKI); CAPART, *L'Art égyptien,* iii, pl. 534; HERMANN in *Mitt. Kairo,* viii (1939), pl. 28 [a], pp. 173–4; SCHOTT in NELSON and HÖLSCHER, *Work in Western Thebes 1931–33 (Chic. O.I.C.* No. 18), fig. 45, cf. p. 88; BAIKIE, *A History of Egypt,* ii, pl. xv [lower]; HAMANN, *Ägyptische Kunst,* Abb. 242; DESROCHES-NOBLECOURT, *Religions ég.* fig. on p. 232 [lower]; CHIC. OR. INST. photo. 2993. Omitting Termuthis, PILLET, *Thèbes. Palais et nécropoles,* fig. 87 [left]; Termuthis and King, LANZONE, *Diz.* pl. clxxxix [1], p. 475; PRISSE MSS. 20430, 188. Upper part of deceased, PETRIE, *Arts and Crafts,* fig. 7, cf. p. 20. Texts, HELCK, *Urk.* iv. 1842 [middle lower], 1844 [lower]; texts of sub-scene, BRUGSCH, *Recueil,* pl. lxvii [1]; id. *Thes.* 303; part, L. *D. Text,* iii, p. 283.

(9) [1st ed. 6] Two remaining registers. **I, II,** Unloading freight-ships, and market. L. *D.* iii. 76 [a]; WRESZ., *Atlas,* i. 199–200; M.M.A. photos. 817–18; MARBURG INST. photo. 86965 [right]; SCHOTT photos. 1974, 2166, 3199–3202, 7606–9. Ships, DUEMICHEN, *Flotte,* pl. xxix [middle and bottom]; BAIKIE, *Eg. Antiq.* pl. xxv [lower right]; id. *A History of Egypt,* ii, pl. xv [upper right].

(10) [1st ed. 7, 8, 9] Niche containing statues of deceased and Imḥōtep, Royal scribe, with wife of deceased in relief between them. Side-walls, litany and offering-list (repeated at (24), (26), and (28)), and deceased offering with Opening the Mouth text on right side-wall. Left of niche, butchers. Right of niche, victims. M.M.A. photo. T. 812. Wife, SCHOTT photo. 6040. Victims, WRESZ., *Atlas,* i. 201. Texts, LORET in *Mém. Miss.* i, pp. 117–19; part on right wall, SCHIAPARELLI, *Funerali,* ii, p. 281 [iii].

(11) [1st ed. 10, 11] Deceased with three registers, **I–III,** men bringing cattle, before Amenophis III (head in Berlin Mus. 14442, replaced by cast) in kiosk, with sphinx slaying captive on arm of throne, captives on side of throne, and Nine Bows on base of kiosk. WRESZ., *Atlas,* i. 88 b [1], 206; M.M.A. photos. T. 819–24, cf. 812. King in kiosk, L. *D.* iii. 77 [c]; omitting Nine Bows, CAPART, *L'Art égyptien,* iii, pl. 531; LANGE, *Äg. Kunst,* pl. 71. Head (in Berlin), BORCHARDT in *Mitt. D.O.G.* No. 57 (March 1917), Abb. 15, cf. p. 14; STEINDORFF in *Ä.Z.* liii (1917), Abb. 5, cf. p. 62; PIJOÁN, *Summa Artis,* iii (1945), fig. 344; BYVANCK, *De Kunst der Oudheid,* pl. xlii [fig. 150], cf. p. 275; GHALIOUNGUI in *Ann. Serv.* xlvii (1947), fig. 3, cf. p. 32; LANGE, *König Echnaton und die Amarna-Zeit,* pl. 3; PRITCHARD, *The Ancient Near East in Pictures,* fig. 395. Throne, SCHOTT photos. 2163–4; sphinx on arm, PRISSE, *L'Art égyptien,* ii, 35th pl. [7] 'Types de Sphinx'. Nine Bows, WILKINSON MSS. xi. 171–2. **I–III,** PRISSE, op. cit. 21st pl. 'Dénombrement des bœufs', cf. 14th pl. [upper left] 'Types et portraits'. **I,** SCHÄFER and ANDRAE, *Kunst,* 353 [1], 2nd ed. 369 [1], 3rd ed. 373 [1] (all from WRESZINSKI); RAGAI, *L'Art pour l'art dans l'Égypte antique,* pl. 3 [5]; SCHOTT photos. 7603–5; calves, STUART, *Egypt after the War,* pl. 44. **III,** CAPART, *L'Art égyptien,* iii, pl. 532; SCHÄFER in *Berliner Museen Berichte,* xlix (1928), Heft 2, cover, cf. p. 37; two men with calves, CHAMPDOR, *Thèbes aux Cent Portes,* fig. on p. 15; WOLF, *Die Kunst Aegyptens,* Abb. 478; heads, WEIGALL, *Anc. Eg. Art,* 179 [2]; CAPART and WERBROUCK, *Thèbes,* fig. 163; ROBICHON and VARILLE, *En Égypte,* pl. 125; DRIOTON and HASSIA, *Temples and Treasures,* pl. 10; SMITH, *Art . . . Anc. Eg.* pl. 110 [B]; SCHOTT photo. 1977. Texts, HELCK, *Urk.* iv. 1841 (from L. *D.*); texts above deceased, and bull's head (now

lost) from top of kiosk, WILKINSON MSS. v. 218 [upper]; text (in front of King), and numbers (in front of deceased), BRUGSCH, *Thes.* 1122 [bottom]–1123 [top]; numbers, SCHOTT photo. 1978.

(12) [1st ed. 13] Deceased offers on braziers.
LORET in *Mém. Miss.* i, pl. iii; WRESZ., *Atlas,* i. 189 [right], 190; SCHÄFER and ANDRAE, *Kunst,* 353 [2], 2nd ed. 369 [2], 3rd ed. 373 [2] (all from WRESZINSKI); M.M.A. photo. T. 832. Brazier and offerings, SCHOTT, *Das schöne Fest,* pl. ii, Abb. 2, cf. p. 786. Text above deceased, LORET in *Mém. Miss.* i, p. 116 [d]; HELCK, *Urk.* iv. 1842 [bottom]–1843 [middle]; GOLENISHCHEV MSS. 4 [b].

(13) [1st ed. 13] Three registers. **I,** Deceased inspects men measuring crop. **II,** Waiting chariots, with preparation of food under trees at each end. **III,** Two rows, waiting mule-chariot, man asleep under tree, boy playing pipe, carrying and threshing grain. Sub-scene, two rows, agriculture, including felling trees, and winnowing with offerings to harvest-deity, before deceased seated.
PRISSE, *Mon.* pls. xl, xli; id. *L'Art égyptien,* ii, 19th pl. 'Arpentage des terres', 20th pl. 'Travaux agricoles', 23rd pl. [lower] 'Attelages', 14th pl. [lower right] 'Types et portraits'; WRESZ., *Atlas,* i. 9, 26 c [11], 51 a, 189 [left], 191–5; M.M.A. photos. T. 831, 833–6; CHIC. OR. INST. photos. 2994–5; SCHOTT photos. 1968–72, 7584–97, 7610–17. **I, II,** and part of sub-scene, CAPART and WERBROUCK, *Thèbes,* figs. 183 [lower], 206 (both from WRESZINSKI). **I,** BERGER in *J.E.A.* xx (1934), pl. x [1], cf. p. 54; deceased, *L. D.* iii. 77 [e]. **II** and **III,** HICKMANN, *45 Siècles de Musique,* pl. xxxvii; **II** and upper row of **III,** ROSTEM in *Ann. Serv.* xlviii (1948), figs. 10, 11, cf. p. 173; FARINA, *Pittura,* pl. cxxxiii; ALDRED, *New Kingdom Art in Anc. Egypt,* pls. 89, 90. **II,** EBERS, *Aegypten,* ii, fig. on p. 273 [lower], Engl. ed. ii, fig. on p. 247 [lower]; omitting right end, *L. D.* iii. 77 [b]; chariots and men, STUART, *Nile Gleanings,* pl. xxxix, pp. 296–7; chariot and man, TZARA and SVED, *L'Égypte face à face,* 30. **III** and part of sub-scene, CAPART, *L'Art égyptien,* iii, pl. 535; upper row in **III,** JÉQUIER, *Hist. civ.* fig. 241; chariot and man asleep, STUART, *Nile Gleanings,* pl. xxviii; SMITH, *Art . . . Anc. Eg.* pl. 110 [A]. Parts of sub-scene, *L. D.* iii. 77 [d]; PERROT and CHIPIEZ, *Histoire de l'art dans l'antiquité,* i, fig. 473; detail of offering to harvest-deity, DAVIES, *The Tomb of Nakht at Thebes,* fig. 12, cf. p. 63.

(14) Remains of three registers, man offering to deceased and wife (?).
M.M.A. photo. T. 830. Texts, LORET in *Mém. Miss.* i, p. 120 [h].

(15) [1st ed. 12] Deceased with three registers, **I–III,** officials of Upper and Lower Egypt, rewarded by Amenophis III (head in Berlin Mus. 14503, replaced by cast) in kiosk on throne similar to throne at (11), with text of year 30.
L. D. iii. 76 [b]; PRISSE, *Mon.* pl. xxxix; id. *L'Art égyptien,* ii, 18th pl. 'Hommage à Aménophis III', cf. *Texte,* p. 402, and 14th pl. [upper right] 'Types et portraits', 35th pl. [6] 'Types de sphinx', cf. *Texte,* p. 411; WRESZ., *Atlas,* i. 203–5; M.M.A. photos. T. 825–9; MARBURG INST. photos. 86967, 86970, 87089–91; see LORET, op. cit. p. 120 [j]. Deceased and **I–III,** MASPERO, *Hist. anc. Les origines,* fig. on p. 265; CAPART, *L'Art égyptien,* iii, pl. 533; SCHOTT photos. 1966–7, 3203, 7578–83, 7598–602; deceased and **II–III,** DAVIES in *M.M.A. Bull.* Pt. ii, Dec. 1923, fig. 15, cf. p. 46; upper part of deceased and **II,** STEINDORFF, *Kunst,* fig. on p. 234; GALASSI in *Critica d'arte,* N.S. ii (1955), fig. 276, cf. p. 350; WEIGALL, *Anc. Eg. Art,* 177, 179 [1]; deceased, STUART, *Nile Gleanings,* pl. 25; OTTO, *Ägypten. Der Weg des Pharaonenreiches,* Abb. 16 a; DESROCHES-NOBLECOURT, *Le Style égyptien,*

pl. xliii [right]. **II,** VON BISSING, *Denkmäler ägyptischen Sculptur*, pl. 81 [b]; PIJOÁN, *Summa Artis*, iii (1945), fig. 375; part, BORCHARDT and RICKE, *Egypt*, fig. on p. 168; one head, VON BISSING, *Altägyptische Lebensweisheit*, Abb. 4. **III,** PILLET, *Thèbes. Palais et nécropoles*, fig. 101; part, DESROCHES-NOBLECOURT in *L'Amour de l'art*, xxviii [iii], fig. on p. 209; block with two heads, in Brussels, Mus. roy. du Cinquantenaire, E. 2484, CAPART, *Documents*, i, pl. 48; id. in *Bull. des Mus. roy.* 2 Sér. iii (1910), fig. 4, cf. p. 37. King, PETRIE, *A History of Egypt*, ii, fig. 119; MASPERO, *Hist. anc. Les premières mêlées*, fig. on p. 297; HAMANN, *Ägyptische Kunst*, Abb. 241. Head (in Berlin), STEINDORFF, *Blütezeit* (1900), Abb. 40; GRESSMANN, *Altorientalische Bilder zum Alten Testament*, pl. xxvii [63]; JEREMIAS, *Das Alte Testament im Lichte des Alten Orients* (1904), Abb. 68, (1906), Abb. 106; SCHÄFER and ANDRAE, *Kunst*, 352 [1], 2nd ed. 368 [1], 3rd ed. 372 [1]; SCHÄFER, *Ägyptische Kunst* in *Kunstgeschichte in Bildern*, i, fig. on p. 18 [5]; id. *Amarna in Religion und Kunst*, pl. i; BORCHARDT in *Mitt. D.O.G.* No. 57 (March 1917), Abb. 14, cf. p. 14; SPIEGELBERG, *Geschichte der ägyptischen Kunst* (*Der alte Orient, Ergänzungsband*, i, 1903), Abb. 68, cf. p. 71; WORRINGER, *Ägyptische Kunst*, pl. 24; SPRINGER, *Handbuch der Kunstgeschichte, Die Kunst des Altertums*, 12th ed. (1923), fig. 100, cf. p. 42; RANKE, *Meisterwerke*, pl. 48; RAGAI, *L'Art pour l'art dans l'Égypte antique*, pl. 48 [83]; STRÖMBOM, *Egyptens Konst*, fig. 156; LANGE, *König Echnaton und die Amarna-Zeit*, pl. 1; *Kunsthalle Basel. Schaetze altaegyptischer Kunst, 27 Juni–13 Sept. 1953*, 11th fig., cf. p. 57 [147]; PRITCHARD, *The Ancient Near East in Pictures*, fig. 394. Colonnettes of kiosk, WILD MSS. ii. A. 9. Nine Bows on base of kiosk, VERCOUTTER in *B.I.F.A.O.* xlviii (1949), pl. i [2], p. 111.

Texts, BRUGSCH, *Thes.* 1121 [bottom]–1122 [middle]; HELCK, *Urk.* iv. 1841 [bottom]–1842 [middle upper]; text above deceased, GOLENISHCHEV MSS. 4 [a].

Ceiling. Texts in right part, LORET in *Mém. Miss.* i, pl. ii [1], p. 121 [k].

Passage. See id. ib. pp. 121–30.

(16) Outer lintel, double-scene, deceased before Osiris and Isis, and before Osiris and Nephthys, jambs, offering-texts. Left thickness, remains of text at bottom (replaced). Right thickness, long texts including 'Appeal to visitors'.

Right half of lintel, DUNHAM in *J.A.O.S.* lvi (1936), pls. i [b], ii [b], pp. 175–6 [E, AA]. Jambs and right thickness, M.M.A. photos. T. 1120, on 824–5; right thickness, VARILLE in *Ann. Serv.* xl (1940), pl. lxv, pp. 601–6. Texts, LORET, pp. 121–3 [l–n]; of thickness, HELCK, *Urk.* iv. 1845–9.

(17) Deceased. (18) and (19) [part, 1st ed. 14, 15] Remains of three registers, **I–III,** funeral procession and ceremonies (including foreleg-rite) before Western goddess with [cryptographic text] behind her in **I,** 'Nine friends', male mourners, and men with funeral outfit, in **II,** and boats in **III,** all before Osiris and Western goddess with men in booths with food-tables and female mourners below them.

M.M.A. photos. T. 838–41. Rite before Western goddess with cryptographic text in **I,** Osiris with Western goddess, text, and scenes below, DEVÉRIA squeezes, 6165, ii. 111, 6166, i. 69–72; omitting cryptographic text and scenes below Osiris, WRESZ., *Atlas*, i. 210 [B], 211; cryptographic text, DRIOTON in *Revue d'Égyptologie*, i (1933), pl. i (from DEVÉRIA squeeze), pp. 2–14; ll. 1–3, DEVÉRIA in *Bibl. Ég.* v, pp. 53–5 [ii]. Osiris with goddess and scenes below, LORET in *Mém. Miss.* i, pl. iv, pp. 124–5 [p]; SCHOTT photos. 1975–6, 1979; part, LÜDDECKENS in *Mitt. Kairo*, xi (1943), pl. 15, pp. 13–14; Osiris and goddess, WEIGALL, *Anc. Eg. Art*, 178; LANGE, *Ägypten*, pl. 95. Female mourners, WRESZ., *Atlas*, i. 210 [A]; STUART, *Nile Gleanings*, pl. 26; WERBROUCK, *Pleureuses*, pl. ix [right], figs. 105, 114, 23 (now

destroyed, from Devéria squeeze), cf. pp. 39–40. Two blocks, relatives in boats in **III,** in Brussels, Mus. roy. du Cinquantenaire, E. 2164, BERGER in *Bull. des Mus. roy.* 3 Sér. v (1933), figs. 13–15, cf. pp. 108–10; reconstruction, *Chronique d'Égypte,* ix (1934), fig. 1, cf. p. 189; one block, Bruxelles, Mus. roy. *Département égyptien. Album* (1934), pl. 35.

(20) Damaged scene, deceased purified and acclaimed by priests.
M.M.A. photo. T. 837. See LORET in *Mém. Miss.* i, pp. 123–4 [o].

(21) and (22) [1st ed. 16–18] Deceased with staff, Fields of Iaru, part of text of Book of the Dead, statue of deceased purified by priest, and deceased with Anubis-standard adores [god]. Sub-scene, Abydos pilgrimage to tomb (including horse and chariot in boat), and priest with female mourners censing and libating before chair with bouquets in centre.
M.M.A. photos. T. 843–7. Detail of statue of deceased, LORET, op. cit. pl. ii [2], p. 125. Block with purification-text, in Berlin Mus. 14637, *Aeg. Inschr.* ii. 249–52; DEVÉRIA squeeze, 6165, ii. 112. Sub-scene, WRESZ., *Atlas,* i. 207–9; scene before chair, CAPART and WER-BROUCK, *Thèbes,* fig. 244 (from WRESZINSKI); WERBROUCK, *Pleureuses,* figs. 24, 107, cf. p. 41. Texts, LORET in *Mém. Miss.* i, pp. 125–7 [q]; GOLENISHCHEV MSS. 4 [c, h]. Variants of Book of the Dead, NAVILLE, *Das aegyptische Todtenbuch,* ii, pp. 252–7 [Tb] (from copy by BOURIANT), cf. *Einleitung,* pp. 110–11.

Frieze-text on right wall, LORET, op. cit. p. 127 [middle].
Ceiling. Texts, id. ib. pp. 129–30.

Inner Room. See LORET in *Mém. Miss.* i, pp. 131–2.

(23) Outer lintel, double-scene, deceased kneeling, with part of text of Book of the Dead, adores souls of Pe and of Nekhen, left jamb, deceased 'entering Ro-setau'. Left thickness, [deceased] adoring.
Lintel and jamb, M.M.A. photos. T. 842, 848, on 1652. Texts, LORET, op. cit. pp. 127–9 [r, s], 131 [t]. Variants of Book of the Dead, NAVILLE, op. cit. pp. 259–60 [Tb] (from copy by BOURIANT).

(24) Niche with statues of deceased and woman. Side-walls, litany and offering-list (as at (10)) with oryx below on left wall, and victims below on right wall.
M.M.A. photos. T. 849 [left], 1655. See LORET, op. cit. p. 131 [u].

(25) [1st ed. 21] Upper part of deceased with staff, in Berlin Mus. 2063, replaced by cast. L. D. iii. 77 [a]; *Aeg. und Vorderasiat. Alterthümer,* pl. 21; *Ausf. Verz.* Abb. 31, cf. pp. 147–8; WRESZ., *Atlas,* i. 49 b [5]; MASPERO, *Hist. anc. Les premières mêlées,* fig. on p. 528; STEINDORFF, *Blütezeit,* Abb. 45; FECHHEIMER, *Die Plastik der Ägypter* (1914), pl. 139, (1923), pl. 149; LANGE, *König Echnaton und die Amarna-Zeit,* pl. 7; MURRAY, *The Splendour that was Egypt,* pl. lxxvi [1]; STRÖMBOM, *Egyptens Konst,* fig. 155, cf. p. 182; GALASSI in *Critica d'arte,* N.S. ii (1955), fig. 275, cf. p. 350; WILKINSON MSS. v. 219 [top left]. Head, PETRIE, *A History of Egypt,* ii, fig. 125; id. *Egypt* in *Encyclopaedia Britannica,* 11th ed. (1910), ix, pl. iv [47].

(26) [part, 1st ed. 20] Niche with statues of deceased as Maḥu, Scribe of ⌐⌐⌐, and wife. Side-walls, litany and offering-list (as at (10)).
Text, GOLENISHCHEV MSS. 4 [g]; litany and offering-list, WRESZ., *Atlas,* i. 212; names, LORET in *Mém. Miss.* i, p. 131 [v]; HELCK, *Urk.* iv. 1853 [middle lower]; name and title of Maḥu, WILKINSON MSS. v. 218 [lower middle].

(27) Deceased adoring (the statues at (28)).

M.M.A. photo. on T. 849. Text, LORET, op. cit. p. 132 [y]; part, WILKINSON MSS. v. 218 [lower left].

(28) [1st ed. 19] Niche with statues of deceased and Imḥōtep, Royal scribe, with wife of deceased in relief between them. Side-walls, remains of litany and offering-list (as at (10)), in Berlin Mus. 14635–6.

Statues and wife, M.M.A. photos. T. 850, 1652–4; wife, WRESZ., *Atlas*, i. 202. Texts of statues, LORET, op. cit. p. 131 [x]; names, WILKINSON MSS. v. 218 [lower right]; text of Imḥōtep, HELCK, *Urk.* iv. 1853 [middle upper]; LEPSIUS MS. 351 [bottom]; offering-list, *Aeg. Inschr.* ii. 243–9.

Finds

Fragment of diorite statue of deceased. Text, MOND in *Ann. Serv.* vi (1905), p. 67.

Relief, head of deceased, in Berlin Mus. 22439. *Berliner Museen Berichte*, xlix (1928), fig. on p. 119; STEINDORFF, *Kunst*, fig. on p. 235 [right].

58. Name unknown, temp. Amenophis III. Usurped by AMENḤOTP 〔▭⬤〕, Over-seer of the prophets of Amūn, and his son AMENEMŌNET 〔▭⬤〕, Temple-scribe of the Temple of Ramesses 'Beloved like Amūn', Dyn. XX.

Sh. ʿAbd el-Qurna. (L. D. Text, No. 43.)

Wife (of Amenemōnet), Ḥenutʿanensu 〔▭〕[ᴧ]⬤.

Plan, p. 106. Map V, D-4, f, 9.

Names and sketches, WILKINSON MSS. v. 75 [middle and bottom]. See L. *D. Text*, iii, p. 258.

Hall.

(1) Left thickness, remains of text. (2) Three registers, **I**, Book of Gates vignettes, **II–III**, offering-scenes.

(3) Three registers. **I**, Book of Gates vignettes, deceased and wife adoring a god, and led by a god, [weighing-scene] with six assessors, and deceased and wife presented by Horus to [Osiris]. **II**, Wife (belonging to scene at (2)), offering-scene, and squatting harpist before couple. **III**, Funeral ceremonies, cow and [mutilated calf], foreleg-rite and man kneeling (unfinished), and below, priests before [mummies] at mountain.

Foreleg-rite, BAUD, *Dessins*, fig. 44.

(4) Two registers. **I**, Text and offering-list above offerings. **II**, Man and offerings.

(5) [Original owner] with priest (sketched), before Amenophis III and Ḥathor.

Priest, BAUD, *Dessins*, fig. 46. Title of Ḥathor, WILKINSON MSS. v. 75 [bottom right].

(6) [1st ed. 1] and (7) Three registers. **I**, Book of the Dead vignettes (including *ba*s and Akru with deceased and wife playing draughts), and text at (6), with cartouche of Ramesses I. **II**, Deceased, wife, and family, before a [god], and deceased, wife, and three daughters, before Osiris and goddess. **III**, Deceased before shrine with Negative Confession and priest censing before ram-standard and Osiris-emblem.

Sketch of *ba*s, Akru, and draughts-playing, WILKINSON MSS. v, on 75 [bottom].

(8) Two registers. **I,** Book of the Dead vignettes. **II,** Original owner and wife with squatting divinities before Amenophis III and Maꜥet in kiosk (original scene), with prostrate Syrians on base of kiosk.

Syrians, DAVIES (Nina), *Anc. Eg. Paintings*, ii, pl. lx. Papyrus flower (in front of King), SCHOTT photo. 7082.

Inner Room.

(9) Left thickness, deceased and wife. Right thickness, deceased before [Osiris]. Soffit, winged scarab, adored by Isis and Nephthys kneeling, with Amenemōnet kneeling below on each side.

(10) Three registers. **I,** Two scenes, **1,** deceased and wife before Rēꜥ-Harakhti and Maꜥet, **2,** deceased and wife before Osiris with his emblem. **II,** Offering-scenes. **III,** Man censing and libating to couple, and couple kneeling before tree-goddess.

(11)–(12) [1st ed. 2–3] Two registers (cut through), **I,** deceased and wife, followed by women, before Osiris-Onnophris and goddess, **II,** people before Mut-Tuēris. (13) Three registers, man offers to statue of deceased in each.

(14) Two registers (unfinished). **I,** Two scenes, **1,** deceased and wife before divine bark, **2,** deceased and wife presented by kneeling Thoth to Osiris and Horus with assessors. **II,** Two scenes, **1,** *sem*-priest offers to deceased and wife, **2,** man offers to Hathor (?). Sub-scene, procession of men and women to a god.

Osiris, Horus, and assessors, BAUD, *Dessins*, fig. 45.

(15) Imitation shrine, with double-scene, deceased kneeling before a god, on entablature. (16) Two registers, **I,** deceased and wife, **II,** man offers to seated couple.

(17) Niche. Side-walls, deceased offering, rear wall, double-scene, Sons of Horus before Osiris on left, and his emblem before Osiris on right. At sides of niche, three registers, **I–III,** including deceased adoring Anubis in **II** on left, and deceased before *zad*-pillar in **II** on right.

Frieze at (10)–(12), Hathor-heads and Anubis-jackals.
Cf. MACKAY in *Ancient Egypt* (1920), p. 121.

Ceiling. Outer part, bark of Rēꜥ adored by two baboons, and deceased kneeling on each side. Centre, deceased kneeling adoring, on each side, with hymn. Inner part, decoration and texts.

Grape-decoration, JÉQUIER, *Décoration égyptienne*, pl. xxix [44].

59. ḲEN ⸗ △ ⸗, First prophet of Mut, Mistress of Asher. Early Dyn. XVIII.
Sh. ꜥAbd el-Qurna.
Parents, . . . n, Overseer of the granary, and Tuiu ⸗⸗, Royal concubine. Wife, Meryt ⸗⸗.

Plan, p. 106. Map V, D–4, e, 9.

Passage.

(1) Deceased adoring with wife (sketched) and hymn to Rēꜥ-Harakhti.

(2) Remains of funeral procession.
Vases and part of boat, SCHOTT photos. 8463–4.

(3) [1st ed. 1] Two registers. **I**, Priest offers to deceased and wife, with monkey eating dates under her chair. **II**, Priest offers to father and mother, with dog under chair, and remains of banquet, with men and one woman brewing and cooking at bottom.

Three guests, including brother Amenemḥab, SCHOTT photos. 8466–7, monkey and other details, 8465, 8468–9, and man cooking goose, 3862. Brewing and cooking, WRESZ., *Atlas*, i. 22 [a]. Names and titles of relatives, WILKINSON MSS. v. 76; LEPSIUS MS. 307 [lower]–308 [top].

(4) Deceased and wife adoring. (5) Three registers, remains of agriculture. (6) Two registers, deceased and wife, and two couples, seated.

Ceiling, texts.

Shrine.

(7) and (8) On each wall, *sem*-priest with seated relatives offers to deceased and wife.

(9) Niche. Rear wall, double-scene, man with offerings.

Vaulted ceiling, line of text.

60. ANTEFOḲER 𓍹𓂝𓈖𓏏𓆑𓀀𓃀𓐍𓂋𓏏𓏤𓏭𓏭𓆑, Governor of the town and Vizier, and mother, SENT ⸗ 𓂝𓈖𓆟, Prophetess of Ḥathor. Temp. Sesostris I.

Sh. ʿAbd el-Qurna. (*L. D. Text*, No. 42.)

Wife (of Antefoḳer), Sitsisobk 𓊃𓏏𓋴𓃀𓎡. Mother (of Sent), Dui 𓅲𓏭𓆟𓏥.

Plan, p. 106. Map V, D–4, e, 9.

DAVIES, *The Tomb of Antefoḳer* [&c.], passim; plan and section, pl. i. Hieratic graffiti, Dyn. XVIII, id. ib. pls. xxxv–xxxvii, pp. 27–9 (by GARDINER), cf. pp. 8, 11, note 2.

Passage. View, M.M.A. photo. T. 1360.

(1) Outer jambs, left, text with Sent seated below, right, remains of deceased (?).

Left jamb, DAVIES, pl. xxxviii [lower right], cf. p. 4; M.M.A. photo. T. 1361; Sent, SCHOTT photo. 5284.

(2) Three registers. **I**, Picking grapes, fruit-tree, and man watering. **II**, Female dancers and tumblers. **II**, Filling granary.

DAVIES, pl. xv, p. 10.

(3) [Deceased before Sesostris I.]

DAVIES, pl. xvi, pp. 16–17.

(4) [1st ed. 1] Abydos pilgrimage, with flying geese in front of boat with deceased and Sent, and butcher, on board.

DAVIES, pls. xvii, xviii [upper], xx, pp. 19–20; M.M.A. photos. T. 1379–80, 1385. Texts, LEPSIUS MS. 306 [middle and bottom]; part, BRUGSCH, *Thes.* 244.

(5)–(6) [1st ed. 2] Three registers. **I–III**, Funeral procession before [deceased] and Sent. **I**, Procession by water and land with priestesses of Ḥathor, dancers, and [harpist]. **II**, Coffin and royal statues carried, priests, mummers, priests of Ḥathor with castanets, woman flutist and clapper, and seated guests. **III**, Sarcophagus dragged and *teknu*.

DAVIES, pls. xviii [lower], xix, xxi–xxiv [upper], xxv, pp. 20–3; M.M.A. photos. T. 1373–8, 1381–4. Female dancers in **I**, FARINA, *Pittura*, pl. xxxiv; WRESZ., *Atlas*, i. 45; SCHÄFER and ANDRAE, *Kunst*, 284 [upper], 2nd and 3rd ed. 296 [upper] (all from DAVIES); RAGAI, *L'Art pour l'art dans l'Égypte antique*, pl. 10 [24]; MEKHITARIAN, *Egyptian Painting*, pl. on p. 13; WOLF, *Die Kunst Aegyptens*, Abb. 330; part of two dancers on left, SCHOTT photo. 5273. Men dragging and three people with raised arms in **I**, WERBROUCK, *Pleureuses*, pl. ii [lower], p. 41. Priests with castanets in **II**, FARINA, *Pittura*, pl. xxxv; flutist (drawn as man), HICKMANN in BLUME, *Die Musik in Geschichte und Gegenwart*, Abb. 10, cf. p. 321.

(7) Four registers. **I**, Three girls before deceased. **II**, Winnowing and tree. **III**, Threshing with oxen and carrying grain. **IV**, Reaping.
DAVIES, pl. iii, pp. 9–10, 11.

(8) [1st ed. 3] Double-scene, [deceased fishing and fowling], with hippopotami in water below, and men netting fish and fowl. Sub-scene, ploughing, sowing, and hacking.
DAVIES, pls. iv–v, v A [lower], p. 11; WRESZ., *Atlas*, i. 213–14; M.M.A. photos. T. 1362–5. Part of netting scene, CAPART, *L'Art égyptien*, iii, pl. 481.

(9) [1st ed. 4] Deceased on foot with attendant hunting animals (including wild bulls, hyena, lynx, and wild sheep) in desert. Sub-scene, men bringing provisions, and tree.
DAVIES, pls. v A [upper], vi, vii, frontispiece, pp. 12–13, figs. 1, 2; WRESZ., *Atlas*, i. 215–16; M.M.A. photos. T. 1366–8. Main scene, SCHÄFER and ANDRAE, *Kunst*, 289, 2nd and 3rd ed. 301 (all from DAVIES). Animals, RAGAI, *L'Art pour l'art dans l'Égypte antique*, pl. 24 [48]; FARINA, *Pittura*, pl. xxxiii; caracal (lynx), KEIMER in *Ann. Serv.* xlviii (1948), fig. 5 (reversed, from DAVIES), cf. pp. 383–4.

(10) [1st ed. 5] Four registers. **I**, Leather-workers. **II–IV**, Preparation of food, with butchers, bakers, brewers, and cooks.
DAVIES, pls. viii–ix A, xi–xii A, pp. 11, 12, 14–16; WRESZ., *Atlas*, i. 217 [right], 220–1; CAPART and WERBROUCK, *Thèbes*, fig. 210 (from WRESZINSKI); M.M.A. photos. T. 1369–70. **I** and **II**, FARINA, *Pittura*, pl. xxxvi. Two men pounding in **III**, JÉQUIER, *Frises*, fig. 780.

(11) [1st ed. 6] Deceased and wife inspect four registers of New Year gifts. **I–III**, Vases, jewellery, &c. **IV**, Geese, crane, calf, and bull.
DAVIES, pls. x, xiii, xiv, pp. 16–18; M.M.A. photos. T. 1370 [left]–1372. **I–IV**, WRESZ., *Atlas*, i. 217 [left]–219; *nub*-collar on stand in **III**, JÉQUIER, *Frises*, fig. 157, cf. p. 61 with note 3.

Frieze-text on north wall. DAVIES, on pls. v–x, xiv, pp. 11–12. Titles at (11), L. D. *Text*, iii, p. 258.

Hall. View, M.M.A. photos. T. 1393–4.

(12) Three registers. **I, II**, Offering-bringers. **III**, Butchers.
DAVIES, pl. xxvi, p. 25; M.M.A. photo. T. 1388.

(13) [Deceased] and Sent (?) with offering-list and offerings, and three registers, **I–II**, offering-list ritual, **III**, male and female harpists and songs (hymn to Hathor).
M.M.A. photo. T. 1389. **I–III**, DAVIES, pls. xxviii, xxix, pp. 23–5.

(14) Three registers. **I**, Male and female harpists with songs. **II**, Offering-bringers. **III**, Butchers, and overthrowing bull.

M.M.A. photos. T. 1386-7. **I**, and overthrowing bull in **III**, DAVIES, pls. xxiv [lower], xxvii, pp. 23-4.

(15) As at (13), but **III** destroyed.
DAVIES, pls. xxxi [lower], xxxii, p. 23; M.M.A. photo. T. 1392.

(16) False door, with girl offering to Sent. (17) False door, with [Sent] on each half.
DAVIES, pls. xxx, xxxi [upper], pp. 23, 25-6; M.M.A. photos. T. 1390-1.

Shrine.

(18)-(19) Three registers. **I, II,** Vases, necklaces, &c. **III,** Girl filling cup from wine-jar, and girl offering mirror and ointment to Sent.
DAVIES, pl. xxxiii, p. 26; M.M.A. photo. T. 1395.

(20) [Deceased] and Sent.
M.M.A. photo. T. 1396. See DAVIES, p. 26.

(21) Remains of false door of Sent.
DAVIES, pl. xxxiv, p. 26.

Seated statue of Sent, probably originally in outer part of shrine, now at its entrance.
DAVIES, pls. xxxviii [lower left], xxxix [lower], pp. 2, 26; EVERS, *Staat aus dem Stein*, i, pl. 20, ii, pl. i [31]; M.M.A. photo. T. 1393.

61. USER ⌐, Governor of the town and Vizier. (Also owner of tomb 131.) Temp. Tuthmosis III.
Sh. ʿAbd el-Qurna. (*L. D. Text*, No. 44.)
Parents, ʿAmethu (tomb 83) and Taʿamethu. Wife, Thuiu.
Plan, p. 124. Map V, D-4, f, 9.
To be published by SÄVE-SÖDERBERGH in *Private Tombs at Thebes*.

Passage.

(1) Two registers, funeral procession, **I**, shrine dragged, **II**, men with staves and funeral outfit. (2) [Offering-list] and remains of [guests].

Ceiling. Offering-text to Onnophris in left part, SETHE, *Urk.* iv. 1037-8 (315) A, B. Names and titles of deceased in right part, id. ib. 1040 (316) A, g-k; part (SETHE, h), LEPSIUS MS. 306 [top right].

Inner Room.

(3) Deceased seated.

(4) Two registers. **I,** Guests. **II,** Daughter ʿAḥmosi offers to [deceased and wife].
Names, *L. D. Text*, iii, p. 258.

(5) [1st ed. 3] Two registers. **I,** Four daughters bringing oils. **II,** Sons bringing ointment.
I, SCHOTT photos. 7106-8.

(6) [1st ed. 2] Two registers. **I-II,** Guests and offerings before [deceased] and wife.
Deceased and wife, SCHOTT photo. 7109. Name of wife, see *L. D. Text*, iii, p. 258 [3].

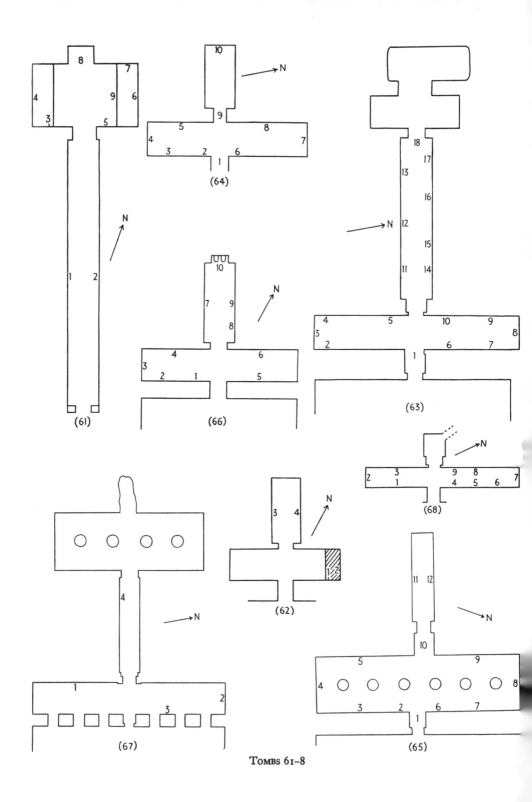

TOMBS 61-8

(7) [Deceased] and wife with two girls offering cloth, women offering ointment, and jars below.

Girls and jars, SCHOTT photos. 7110–16.

(8) [1st ed. 1] Above doorway to recess, double-scene, deceased offers to Anubis-jackal, with [Western goddess] on left, and Eastern goddess on right.

Eastern goddess, SCHOTT photo. 7117. Titles of deceased, SETHE, *Urk.* iv. 1039–40 (316) A, a, e.

(9) On side of mastaba, offering-list with ritual.

Ceiling. Text with name of father, SETHE, *Urk.* iv. 493 (160) A, a, b.

Burial Chamber.

Plan and section, MOND in *Ann. Serv.* vi (1905), fig. 7, cf. p. 73.
Walls, Book of Imi-Duat. Part, id. ib. pl. iii.

62. AMENEMWASKHET ⟨≡⟩, Overseer of the Cabinet. Temp. Tuthmosis III (?).
Sh. ʿAbd el-Qurna.

Plan, p. 124. Map V, D–4, f, 8.

Hall.

(1) and (2) Remains of texts, with name and title.

Inner Room.

(3) Funeral procession to [Western goddess].

(4) Four registers. I and II, Guests. III, Servants with provisions and animals. IV, Rites before mummies.

Names of guests, HELCK, *Urk.* iv. 1644 B.

Ceiling. Name and titles of deceased, id. ib. 1644 A.

63. SEBKHOTP ⟨≡⟩, Mayor of the Southern Lake and the Lake of Sobk. Temp. Tuthmosis IV.

Sh. ʿAbd el-Qurna. (L. D. *Text*, No. 48.)

Father, Min ⟨≡⟩, Overseer of the seal. Wife, Meryt ⟨≡⟩, Nurse of the King's daughter Tiʿa, ⟨≡⟩, Chief of the harîm of Sobk of Shedty.

Plan, p. 124. Map V, D–4, f, 6.

L. D. *Text*, iii, pp. 261–2; WILD MSS. ii. A. 128, with plan. Names and titles, SPIEGEL-BERG in *Ä.Z.* lxiii (1928), pp. 114–15 (from copy by NEWBERRY). Views of interior, M.M.A. photos. T. 2756–7.

Hall.

(1) Thicknesses (sketches), deceased with wife and small son on left, and woman with sistrum on right, inner right jamb, texts. (2) [Man] with offerings before deceased and wife.

(3) Remains of stela, double-scene at top, [deceased] with offerings adores Anubis-jackal. At sides, two registers, I–II, [offering-bringers] and deceased with offering-formula. At bottom, jars and offerings.

HERMANN, *Stelen*, pl. 4 [a] (from SCHOTT photo.), pp. 39, 69; M.M.A. photos. T. 2769–70, on 2757; SCHOTT photo. 4347. Sketch before destruction, WILD MSS. ii. A. 125. Fragment, two offering-bringers from **II** on left, in New York, M.M.A. 30.2.1, HAYES, *Scepter*, ii, fig. 85. Title of deceased and name of father from sides, LEPSIUS MS. 300 [top].

(4) At bottom, marching soldiers, [deceased], and remains of long text.
Soldiers, M.M.A. photo. T. 2768.

(5) Fragments, Tuthmosis IV with *ka*, on throne with Nine Bows on base.
M.M.A. photos. T. 2767, on 2757. Nine Bows, seen by MEYER in tomb 65, now replaced, MEYER, *Fremdvölker*, 754; CHIC. OR. INST. photo. 10339.

(6) [Deceased and Menna, Overseer of sealers.]
Title of Menna, HELCK, *Urk.* iv. 1583 [bottom].

(7) [1st ed. 5] Texts above [deceased inspecting granaries], and men with ointment.
M.M.A. photos. T. 2758–9. Texts, PIEHL, *Inscr. hiéro.* 1 Sér. cxxiv–cxxv [N, a]; HELCK, *Urk.* iv. 1582 [upper]; SCHOTT photos. 4345–6.

(8) Remains of text of inspecting incense, and jars at top.
M.M.A. photo. T. 2760; SCHOTT photos. 4342–4; text, HELCK, *Urk.* iv. 1584 [top].

(9) [1st ed. 2–4] Fragments replaced. Foreigners with tribute, including decorative vases with heads of gazelle and ibex, Asiatic, cheetah, man bringing statuette of bull (with hieratic graffito below his arm), and Nubian woman with four babies on her back, before deceased (with hieratic graffito in front of him).
M.M.A. photos. T. 2761–4. Omitting deceased, MEYER, *Fremdvölker*, 624–6, 753. Man with cheetah, man with statuette of bull, and Nubian woman, CHIC. OR. INST. photos. 10341–2; Nubian woman, and vases, WRESZ., *Atlas*, i. 35, 223 [A]; SCHOTT photos. 4136, 4341; vases, DAVIES (Nina), *Anc. Eg. Paintings*, i, pl. xliii; statuette of bull and head of man carrying it, VERCOUTTER, *L'Égypte* [&c.], pls. xii [117], lxi [456, called 457 in error], pp. 227, 358.
Blocks probably from here:
Two registers, **I–II**, Syrians with children and tribute, including floral vases, and vases with heads of ibex and griffin, in Brit. Mus. 37991. MASPERO, *Hist. anc. Les premières mêlées*, fig. on p. 283; WRESZ., *Atlas*, i. 56 a [left]; WEIGALL, *Anc. Eg. Art*, 160 [lower]; STEINDORFF, *Blütezeit* (1900), Abb. 27; DAVIES (Nina), *Anc. Eg. Paintings*, i, pl. xlii (CHAMPDOR, Pt. i, 3rd pl.); HALL, *The Ancient History of the Near East*, pl. xv [1]; *Cambridge Ancient History. Plates*, i. 135 [b]; PRITCHARD, *The Ancient Near East in Pictures*, fig. 47. **II**, SCHÄFER and ANDRAE, *Kunst*, 350 [2], 2nd ed. 366 [2], 3rd ed. 366 [1]; PIJOÁN, *Summa Artis*, iii (1945), fig. 462; CHAMPDOR, *Thèbes aux Cent Portes*, fig. on p. 133. Two Syrians with vases in **I**, TUFNELL, INGE, and HARDING, *Lachish*, ii, pl. xv [lower], p. 59; statuette of recumbent bull in **I**, VERCOUTTER, *L'Égypte* [&c.], pl. lxi [457, called 456 in error], p. 358; two Syrians with vases in **II**, WRIGHT, *Biblical Archaeology*, fig. 49 [middle], cf. p. 85. See *Guide (Sculpture)*, p. 146 [519]; *Guide to the Third and Fourth Egyptian Rooms* (1904), p. 21 [1]; *Wall Decorations of Egyptian Tombs*, p. 13.
Three blocks in Brit. Mus.; two offering-bringers, No. 919, bead-makers, No. 920, and Nubians with tribute, No. 922. *Wall Decorations of Egyptian Tombs*, figs. 7–9, cf. pp. 14–15 [5, 6, 8]; *Guide to the Egyptian Collections* (1909), figs. on pp. 99, 175, and pl. xvi, cf. p. 175.

(1930), fig. 141, cf. p. 258, fig. 73, cf. p. 145, and fig. 88, cf. p. 167; see *Guide (Sculpture)*, pp. 146 [517–18], 147 [520]; No. 920, Gosse, *The Civilization of the Ancient Egyptians*, fig. 43; parts of Nos. 920 and 922, Davies (Nina), *Egyptian Tomb Paintings*, pls. 3, 4.

Nubians with children and two Syrians below (probably from same scene as block in Brit. Mus. 37991, see supra), in Florence Mus. 7608. Wresz., *Atlas*, i. 56 a [middle].

Nubians with tribute and children. Id. ib. 56 a [right].

(10) [1st ed. 1] Deceased offers floral vase with frog, &c., to [Tuthmosis IV] on throne with captives on base.

M.M.A. photos. T. 2765–6. Captives, vases, &c., Chic. Or. Inst. photos. 10339–41; captives, and vase with necklace and palettes, Meyer, *Fremdvölker*, 750–2; vase, Wresz., *Atlas*, i. 223 [B]; Schott photo. 4135; Vercoutter, *L'Égypte* [&c.], pl. lv [402], p. 345.

Ceiling. Texts, Piehl, *Inscr. hiéro.* 1 Sér. cxxv [N β, γ].

Passage.

(11) and (12) Texts, and remains of five registers, I–V, funeral procession to [Western goddess], including funeral outfit (with chariot) and statuettes (two royal and one of deceased) carried in I, Abydos pilgrimage in III–IV, victims, man hoeing, and man setting up obelisk, in V.

M.M.A. photos. T. 2783–9. Part of men with outfit, Schott photos. 4338–40; two foreign vases carried in outfit, Vercoutter, *L'Égypte* [&c.], pls. xxxvi [243], xliii [307], pp. 310, 324. Titles of deceased and wife from boat in IV, Helck, *Urk.* iv. 1584 [bottom].

(13) Two registers. I, [Deceased], wife with sistrum and *menat*, and two seated couples, before [Osiris-Onnophris and Anubis]. II, Deceased and wife (holding *menat* with prenomen of Tuthmosis IV).

M.M.A. photos. T. 2779–82. Parts, Schott photos. 4169–70, 4336–7. Sistrum, Jéquier, *Frises*, fig. 214. Title of wife, Lepsius MS. 301 [middle].

(14) [1st ed. 8] At bottom, hacking ground and ploughing.

Wresz., *Atlas*, i. 20; M.M.A. photo. T. 2771.

(15) Remains of deceased spearing fish, with two attendants.

M.M.A. photo. T. 2772. Text, Helck, *Urk.* iv. 1584 [middle].

(16) [1st ed. 7] Garden with trees and pool, and deceased and wife and tree-goddess scene on each side.

Wresz., *Atlas*, i. 222; Capart and Werbrouck, *Thèbes*, fig. 248 (from Wreszinski); Farina, *Pittura*, pl. xcvii; M.M.A. photo. 2773; Chic. Or. Inst. photos. 2853, 10343–4. Upper part, Schott photos. 4172–5; tree-goddess scene on right with trees below, Spiegel in *Mitt. Kairo*, xiv (1956), pl. xv [1], pp. 203–4; pool, Schott, *Altägyptische Liebeslieder*, pl. 8. Texts and sketch of tree-goddess on right, Lepsius MS. 300 [lower], 301 [top]; texts, Piehl, *Inscr. hiéro.* 1 Sér. cxxv [N δ, ε, ζ]; texts of tree-goddess scene on left, L. D. Text, iii, p. 262 with a.

(17) [1st ed. 6] [Son Paser] with three rows, offering-bringers, offers [bouquet of Amūn] to [deceased and wife with princess Tiʿa on lap], and seated relatives below.

M.M.A. photos. T. 2774–7. Offering-bringers, Chic. Or. Inst. photo. 2854; top row, Davies (Nina), *Anc. Eg. Paintings*, i, pl. xliv (Champdor, Pt. i, 4th pl.); Lange, *Ägyptischer*

Totenkult in *Atlantis*, Nov. 1940, fig. on p. 637; SCHOTT photos. 4171, 4335. Texts, L. *D. Text*, iii, pp. 261 with a, 262 [top]; HELCK, *Urk.* iv. 1582 [lower]-1583 [middle]; SCHOTT photos. 4333-4.

(18) Entrance to Inner Room. Framing of [entablature], M.M.A. photo. T. 2778.

Ceiling. Texts, M.M.A. photos. T. 2790-2; names and titles of deceased and father, L. *D. Text*, iii, p. 261; of father, SETHE, *Urk.* iv. 1028-9 (310).

64. ḤEKERNEḤEḤ ⌐○⌐, Nurse of the King's son Amenḥotp. Temp. Tuthmosis IV.

 Sh. ʿAbd el-Qurna. (L. *D. Text*, No. 47.)
 Father, Ḥekreshu, Tutor of the King's son.
 Plan, p. 124. Map V, D-4, f, 7.

 CHAMP., *Not. descr.* i, pp. 569-71 with plan; L. *D. Text*, iii, pp. 259-61. Views of interior, M.M.A. photos. T. 2824-5. Hieratic graffito (now lost), BURTON MSS. 25644, 15.

Hall.

(1) Thicknesses, [deceased] adoring and [wife].

(2) [1st ed. 1] Deceased with [young prince] pours ointment on burnt-offerings on braziers.
 M.M.A. photo. T. 2812; incomplete, SCHOTT photos. 2765, 8367. Text of deceased, mentioning Valley Festival, HELCK, *Urk.* iv. 1573 [lower]-1574 [top]; titles, CHAMP., *Not. descr.* i, p. 863 [B]; L. *D. Text*, iii, p. 261 [middle].

(3) [part, 1st ed. 2] Two scenes. 1, Father of deceased (?) with young prince on his knee. 2, Man offers bouquet of Amūn to father of deceased.
 M.M.A. photo. T. 2813. Texts of 1, L. *D. Text*, iii, p. 261 [top]; text of man in 2, HELCK, *Urk.* iv. 1574 [near top].

(4) [Stela] with remains of double-scene, Anubis-jackal and offerings.
 M.M.A. photo. T. 2814.

(5) [1st ed. 3] Father offers full-blown papyrus to Tuthmosis IV and *ka* in kiosk with captives on base.
 M.M.A. photos. T. 2815-16, 2825. King, CHIC. OR. INST. photo. 2996. Text of father, HELCK, *Urk.* iv. 1574 [middle]; titles, L. *D. Text*, iii, p. 260 [a]; part, CHAMP., *Not. descr.* i, p. 863 [C].

(6) [Deceased offers on braziers] and offerings with butchers below.
 M.M.A. photo. T. 2811; incomplete, SCHOTT. photos. 8368, 8372-3.

(7) [1st ed. 5] Deceased with princes offers bouquet of Amūn to father with young prince on his knee, and captives on prince's footstool.
 L. D. iii. 69 [a]; NEWBERRY in *J.E.A.* xiv (1928), pl. xii, pp. 84-5 with fig. 2; M.M.A. photo. T. 2820; incomplete, SCHOTT photos. 2767, 4134. Father and prince, CHIC. OR. INST. photo. 10335; BURTON MSS. 25644, 13, 14; ROSELLINI MSS. 284, G 47 verso. Texts, HELCK, *Urk.* iv. 1572-3 [upper]; text of father, CHAMP., *Not. descr.* i, p. 863 [A], cf. pp. 570-1 [Paroi F]; LEPSIUS MS. 302 [middle right]; cartouches on pectorals and texts of princes, L. *D. Text*, iii, p. 260 [middle].

(8) [1st ed. 4] Deceased, followed by men with bouquets and fruit, offers bouquet to Tuthmosis IV and *ka* in kiosk with two Asiatics on side of throne.

M.M.A. photos. T. 2817-19. Man with bouquets and fruit, *ka*, and throne, SCHOTT photos. 8369-71, 2766.

Ceiling. Texts, M.M.A. photos. on T. 2821-3; part, L. *D.* iii, on 69 [a], and *Text*, p. 260 [near bottom]; PIEHL, *Inscr. hiéro.* I Sér. cxli–cxlii [U]; HELCK, *Urk.* iv. 1574 [bottom].

Inner Room.

(9) Thicknesses, deceased (unfinished) leaving, and [deceased] entering.

M.M.A. photos. T. 2826-7. Translation of text of entering, SCHOTT, *Das schöne Fest*, p. 873 [70].

(10) Niche. Lintel, remains of double-scene, deceased before Anubis-jackal, side-walls, three offering-scenes.

Cf. M.M.A. photo. on T. 2825.

Finds

Kneeling statue of deceased holding stela. Text, NEWBERRY MSS. PEN/V/FA, I.

65. NEBAMŪN ⟨☐☐⟩, Scribe of the royal accounts (?) in the Presence, Overseer of the granary, temp. Ḥatshepsut (?). Usurped by IMISEBA ⟨☐☐☐⟩, Head of the altar, Head of the temple-scribes of the estate of Amūn, temp. Ramesses IX.

Sh. ʿAbd el-Qurna. (CHAMPOLLION, No. 60, L. *D. Text*, No. 40, WILKINSON, No. 1, 'Aïchesi' of Prisse.)

Parents, Amenḥotp, Head of scribes of the Temple of Amen-rēʿ in Karnak, and Mutemmeres ⟨☐☐⟩. Wife, Te(n)tpapersetha ⟨☐☐☐⟩.

Plan, p. 124. Map V, D–4, g, 8.

CHAMP., *Not. descr.* i, pp. 558–69 with plan; L. *D. Text*, iii, pp. 255–6. Plan and section, WILD MSS. i. C. 8, ii. A. 101, 107–8; plan, WILBOUR MSS. 2 F. 22 [top].

Hall. View, M.M.A. photos. T. 1719–20.

(1) Left thickness, [deceased] adoring. Soffit, decoration and texts.

(2) [1st ed. 1] Six registers. **I,** Deceased with attendant offers bouquet before altars, and prostrate Nubians with tribute and gold set-piece with fort and trees at top. **II–VI,** Decorative vases (including vases with Asiatics and Nubians, and with heads of Bes, of dog, of ibexes, and of horses), gold rings, &c.

MEYER, *Fremdvölker*, 755-7; M.M.A. photo. T. 1704; CHIC. OR. INST. photos. 2857, 10348-50. Right part, WRESZ., *Atlas*, i. 224-5. Set-piece in **I,** SCHOTT photo. 7354; fort, CHAMP., *Mon.* ccccxxxvi [bottom right], cf. *Not. descr.* i, p. 561 [A]; ROSELLINI, *Mon. Civ.* lxxxviii [6]; HAY MSS. 29852, 272, 278, 287. Some vases, &c., in **II–VI,** CHAMP., *Mon.* clxviii [1–3]; ROSELLINI, *Mon. Civ.* lviii [1–7]; PRISSE, *L'Art égyptien*, ii, 85th pl. 'Vases en or . . . cloisonné', 86th pl. 'Rithons . . .' [1–6], 95th pl. 'Vases . . . quatre vases' [1–4], 96th pl. 'Vases . . . six vases' [2, 4–6], cf. *Texte*, pp. 436–8, 442–3; CAILLIAUD, *Arts et métiers*, pls. 24 [1, 2], 24 A [1, 2]; WILKINSON, *M. and C.* ii. 347 (No. 248), 348 (No. 249, 1, 2) = ed. BIRCH, ii. 6 (No. 272), 7 (No. 273, 1, 2); WILKINSON MSS. ii. 56; vases and necklace, HAY MSS. 29852, 267, 285–6, 290, 293–7, 300, 302–3, 29853, 132, and other vases, probably from here,

29852, 273, 288–9, 291–4, 298–9; foreign vases, including griffin's head, VERCOUTTER, *L'Égypte* [&c.], pls. xxxvi [241], xxxviii [263], xxxix [268], xlii [296], lix [436], pp. 310, 315–17, 323, 353; vases in **II** and wand in **IV**, SCHOTT photos. 3439, 7355–6.

(3) [1st ed. 2] Ramesses IX censes bark of Amen-rēᶜ carried by priests and followed by Ḥatḥor holding uraeus-sceptres (superimposed on Osiris).

M.M.A. photos. T. 1705–7; CHIC. OR. INST. photos. 2997, 3000, 10351; GR. INST. ARCHIVES, photos. 1974–7 (from painting by NINA DAVIES in New York, M.M.A.); incomplete, SCHOTT photos. 6697–6702. Collar on prow of bark, WILD MSS. ii. A. 118. Texts, CHAMP., *Not. descr.* i, p. 560; part of text of Amen-rēᶜ, GOLENISHCHEV MSS. 14 [f]; Horus-name and cartouches, LEPSIUS MS. 295 [bottom].

(4) [1st ed. 3] Ramesses IX censes and libates with bouquet and offerings to bark on stand with twelve statues of deceased kings, all in kiosk with two floral colonnettes.

L. *D.* iii. 235, cf. *Text*, iii, p. 255; M.M.A. photos. T. 1708–9; CHIC. OR. INST. photos. 2998–9, 10351, 10354; GR. INST. ARCHIVES, photos. 1978–82 (from painting by NINA DAVIES in New York, M.M.A.). Ramesses IX, offerings, and bark, SCHOTT photos. 6691–6. Sketch of statues, NESTOR L'HÔTE MSS. 20396, 71. Colonnette, PRISSE, *L'Art égyptien*, i, 19th pl. [1] 'Colonnettes en bois', cf. *Texte*, p. 363; HAY MSS. 29852, 247–9; WILD MSS. ii. A. 109, 111, with decoration on kiosk, 113 [lower]. Text at top (above stern), CHAMP., *Not. descr.* i, p. 859 [to p. 563, l. 3]. Cartouches of statues, id. ib. p. 563; WILKINSON MSS. v. 72–3 [top]; LEPSIUS MS. 296 [upper].

(5) [1st ed. 4] Deceased with hymn to Osiris, followed by wife, parents, and other relatives with flowers, censes and libates to Osiris and Maᶜet. Sub-scene, industries, including leather-workers and sculptors.

M.M.A. photos. T. 1710–13. Part of hymn, GOLENISHCHEV MSS. 14 [e]. Texts of deceased and relatives, L. *D. Text*, iii, p. 256 with *a*; LEPSIUS MS. 296 [bottom]–297 [middle]; texts of Maᶜet and some relatives, CHAMP., *Not. descr.* i, pp. 568 [A], 862 [to p. 568, l. 21]; part of text above offerings, SCHOTT photos. 7357–8.

(6) Three registers. **I**, Man offers to Queen in palace-window. **II**, Remains of female tumblers. **III**, Earlier relief, offerings before temple (?).

M.M.A. photo. T. 1703. **I**, SCHOTT photo. 7353. Sketch of **II**, DAVIES in *M.M.A. Bull.* Pt. ii, Feb. 1928, fig. 14, cf. p. 68.

(7) [part, 1st ed. 10] Ramesses IX censes before barks of Theban Triad carried by priests (superimposed on earlier relief of deceased inspecting produce of northern marsh-lands with chiefs from Delta), and three registers, behind the King, **I**, statues of divinities followed by priests, **II**, priests (two carrying royal statuette) and drummer, **III**, [courtiers].

M.M.A. photos. T. 1699–1702, 3154. Bark of Amen-rēᶜ and **I**, CHIC. OR. INST. photos. 10354–5, 2855. Right part of **I** and **II**, SCHOTT photo. 7352; drummer and title of priest in **I**, CHAMP., *Not. descr.* i, p. 562 [A, B].

(8) and (9) [1st ed. 5–9¹] Theban Triad in kiosk, deceased with libation and offerings before them with litany to Amen-rēᶜ above, and (behind deceased) harpist, clapper (?), lutist, portable statuettes of [ᶜAḥmosi Nefertere] in shrine and of Amenophis I in palanquin, and four registers, **I–IV**, priests in procession of Vase of Amūn (including royal statuette carried), and men bringing provisions (including remains of weighing thread (?) before 'treasury of the Temple of Amūn' in **III**). Sub-scene, female relatives seated.

¹ Chairs, PRISSE, *L'Art égyptien*, ii, 89th pl., in *Bibl.* 1st ed. p. 95 (8), are not in this tomb.

M.M.A. photos. T. 1714–18. Deceased with musicians and shrine, L. *D.* iii. 236 [a]; deceased with part of procession, SCHOTT photos. 1490 a, 4140–7, 4151–4, 7359; vase with cartouches before table of offerings, HAY MSS. 29852, 274; casket with cartouches (above the offerings), CHAMP., *Mon.* clvi [2]; ROSELLINI, *Mon. Civ.* lxxv [1]; details of kiosk and shrine, WILD MSS. ii. A. 115 [right], 123; musicians and shrine, HICKMANN, *45 Siècles de Musique*, pl. xl; musicians, DENON, *Voyage dans la basse et la haute Égypte*, pl. 135 [27–9] (reversed); WILKINSON, *M. and C.* ii. 270 (No. 205) = ed. BIRCH, i. 462 (No. 230); SCHOTT in *Mélanges Maspero*, i, pl. ii [2, 4], p. 461; BRUYÈRE, *Rapport (1934–1935)*, Pt. 2, fig. 63, cf. p. 117; CHIC. OR. INST. photo. 10352; SCHOTT photos. 4137–9; HAY MSS. 29852, 281–3; NESTOR L'HÔTE MSS. 20404, 73; BANKES MSS. ii. B. 27; harpist and lutist, *Descr. de l'Égypte, Ant.* ii, pl. 44 [6]. Royal statuettes, PRISSE, *L'Art égyptien*, ii, 88th pl. 'Palanquins', cf. *Texte*, p. 439; HAY MSS. 29852, 275–7; NESTOR L'HÔTE MSS. 20404, 50; CHIC. OR. INST. photo. 10353; statuette of King, CHAMP., *Mon.* clvi [3]; ROSELLINI, *Mon. Civ.* lxxv [2]; BANKES MSS. ii. A. 13 (tracing). **I–IV,** CHIC. OR. INST. photos. 2856, 2858, 10352–3. Priests with ram-head vase of Amūn, HAY MSS. 29852, 268, 279–80, 284; vase, CHAMP., *Mon.* clvi [1]. Litany and text of libating, LEPSIUS MS. 297 [bottom], 298 [top]; texts and details, CHAMP., *Not. descr.* i, pp. 563–8, 859 [middle]–862; names of priests in **I,** L. *D. Text*, iii, p. 256 [top]; titles of Queen, WILKINSON MSS. v. 79 [bottom].

Columns. Abaci of columns C and D, each with bark of Rēc facing central aisle, and texts on other faces.

One bark, M.M.A. photo. on T. 1719. See THOMAS in *J.E.A.* xlii (1956), p. 69 [Bl.] with note 3.

Architraves. Titles of deceased, CHAMP., *Not. descr.* i, p. 559; L. *D. Text*, iii, p. 255; BRUGSCH, *Thes.* 1428 [top].

Ceiling. Centre, outer part, divinities, baboons, and *ba*s, adoring winged scarab and personified *zad*-pillar, inner part, double-scene, sphinxes adoring sun-disk, and deceased kneeling adoring horizon-disk. Sides, bird-decoration and texts.

M.M.A. photos. T. 1692–8, 3152–3. Inner part of centre, and sides, CHIC. OR. INST. photos. 3001, 10355–9; inner part, CHAMP., *Not. descr.* i, p. 559 [middle with A]; sides, SCHOTT photos. 7360–3. Pigeons between wall and column A, FOŘTOVÁ-ŠÁMALOVÁ in *Archiv Orientální*, xx (1952), pl. xxix [2], p. 249. Ducks between column F and wall, CHAMP., *Mon.* ccccxxxvii quat. [lower left]; ROSELLINI, *Mon. Civ.* lxxii [23]; PRISSE, *L'Art égyptien*, i, 35th pl. [middle] 'Ornementation . . . Thèbes', cf. *Texte*, p. 370; MASPERO, *L'Arch. ég.* (1887), fig. 20, (1907), fig. 21; WILD MSS. ii. A. 94. Vertical texts with hymns, PIEHL, *Inscr. hiéro.* 1 Sér. cxl–cxli [T with a, β].

Inner Room.

(10) Outer jambs, dressed *zad*-pillars. Left thickness, remains of offering-list.
Left jamb, M.M.A. photo. on T. 1713.

(11) Two registers. **I,** Five barks of Rēc (with deceased adoring in two). **II,** Three remaining scenes, **1,** deceased and wife before Osiris with Isis and Nephthys, **2,** deceased and wife before Nefertem-emblem on shrine, **3,** deceased and man before bark of Sokari.
M.M.A. photos. T. 3155–9.

(12) Two registers, Book of Gates. **I,** Five barks of Rēc, one with baboon adoring Khepri, and four with deceased adoring. **II,** Five scenes, **1,** Nephthys and Isis adore sun-disk, **2,** sun-disk with four squatting divinities, **3,** deceased adores ibis, **4,** Akru, **5,** double-scene, deceased adores gate.

M.M.A. photos. T. 3160–4. Title of Neith (presumably from here), SETHE in *Ä.Z.* xliii (1906), p. 145.

Frieze. Emblems and personified *zad*-pillar.

Ceiling. Boukrania-decoration, &c., and text.

Boukrania (also on soffit of entrance), CHAMP., *Mon.* ccccxxxvii ter [bottom middle]; ROSELLINI, *Mon. Civ.* lxxi [18]; PRISSE, *L'Art égyptien*, i, 33rd pl. [upper], 'Ornementation . . . bucrânes', *Texte*, p. 369; FOŘTOVÁ-ŠÁMALOVÁ in *Archiv Orientálni*, xx (1952), pl. xxii [4], p. 236; WILD MSS. ii. A. 97.

For fragment with foreigners found here [1st ed. p. 96], see supra, tomb 63 (5).

66. ḤEPU 𓀀𓀀, Vizier. Temp. Tuthmosis IV.
Sh. 'Abd el-Qurna.
Wife, Rennai 𓈖𓏏𓀀.

Plan, p. 124. Map V, D–4, g, 8.

To be published by SÄVE-SÖDERBERGH in *Private Tombs at Thebes*.

Hall.

(1) Text above two [women].

(2) [1st ed. 1] Six registers, industries before two figures of [deceased], I–VI, sculptors, leather-workers, metal-workers, and vase-makers, including bull's-head vase and kneeling royal statue in I, and gold vulture, ibex-head vase, and chariot, in II.
M.M.A. photos. T. 1685–9; CHIC. OR. INST. photos. 10360–6; omitting left end, GR. INST. ARCHIVES, photos. 1447, 1447A. I–VI, WRESZ., *Atlas*, i. 226–9. I and II, incomplete, SCHOTT photos. 3987–92, 4168. Bull's-head vase in I, VERCOUTTER, *L'Égypte* [&c.], pl. xl [273], p. 318. Text of upper figure of deceased, HELCK, *Urk.* iv. 1576 [middle].

(3) Four registers. I–II, Offering-list and ritual before [deceased]. III–IV, Priests and butchers before [deceased].
M.M.A. photo. T. 1690. Text of upper figure of deceased, HELCK, *Urk.* iv. 1576 [bottom]–1577 [top].

(4) Unfinished procession of men with branches, and [group of prostrate men].
Men with branches, M.M.A. photo. T. 1691.

(5) Remains of banquet with harpist in top register.

(6) [1st ed. 2] Remains of text of installation as vizier before [Tuthmosis IV], and remains of recording produce on right.
Text, SETHE, *Die Einsetzung des Veziers* [&c.] in *Untersuchungen*, v (2), pp. 62–3 (from copy by DAVIES); GARDINER in *Rec. de Trav.* xxvi (1904), pp. 1–19; DAVIES, *The Tomb of Rekh-mi-rēꜥ at Thebes*, ii, pls. cxvi–cxviii [H].

Inner Room.

(7) [Deceased and wife] with son offering to them, and remains of four registers, I–IV, funeral procession and ceremonies, including offering-list ritual in I, and [men] before shrine in IV. Sub-scene, men bringing forelegs, &c., to deceased and attendants.
Five offering-bringers in sub-scene, SCHOTT photo. 8462; GR. INST. ARCHIVES, photos. 1444–6.

(8) [1st ed. 3] Three registers. **I**, Wine-jars and offerings to Termuthis. **II**, Picking grapes with trees beyond. **III**, Catching fowl in draw-net.

II and **III**, Wresz., *Atlas*, i. 230.

(9) Remains of fishing and fowling with fish below, and men netting fish at bottom. Details, Schott photos. 8528–9.

(10) Niche with seated statues of deceased and wife (uninscribed).

67. Hepusonb ⟨hieroglyphs⟩, First prophet of Amūn. Temp. Ḥatshepsut.

 Sh. ʿAbd el-Qurna. (L. *D. Text*, No. 50.)

 Parents, Ḥepu ⟨hieroglyphs⟩, Third lector of Amūn, and ʿAḥḥotp ⟨hieroglyphs⟩, Royal concubine. Wife, Amenḥotp (name from Silsila, L. *D.* iii. 28 [4 b]).

 Plan, p. 124. Map V, D–4, g, 8.

 To be published by Säve-Söderbergh in *Private Tombs at Thebes*.

Hall.

 (1) Two registers. **I**, Men felling trees in Punt (?). **II**, Remains of boat.

 Gr. Inst. Archives, photo. 1449. See Davies in *M.M.A. Bull.* Pt. ii, Nov. 1935, p. 47, note 1.

 (2) [1st ed. 1] Stela. Remains of text, Sethe, *Urk.* iv. 487–8 (156), A, B.

Pillar.

 (3) [1st ed. 2] Two registers. **I–II**, Remains of industries, with chariot-makers.

 Gr. Inst. Archives, photo. 1448. Texts, Sethe, *Urk.* iv. 488 (156) D.

Passage.

 (4) [Deceased.]

 Texts of parents, L. *D. Text*, iii, p. 262 [middle upper]; titles of father, Sethe, *Urk.* iv. 471 (151) b, 488 (156), c, b.

Inner Room.

 Central pillars. Deceased with offerings, on abaci.

68. [Per?]enkhmūn ⟨hieroglyphs⟩, *waʿb*-priest of Amūn of Karnak, and of Mut of Asher, Dyn. XX. Usurped by Espaneferḥor ⟨hieroglyphs⟩, Head of the temple-scribes of the estate of Amūn, temp. Siamūn.

 Sh. ʿAbd el-Qurna.

 Father (of Espaneferḥor), Iufenamūn ⟨hieroglyphs⟩. Wife (of Espaneferḥor), Tabekenmut ⟨hieroglyphs⟩, Singer of the . . . of Mut.

 Plan, p. 124. Map V, D–4, g, 9.

Hall. Scenes usurped by Espaneferḥor.

 (1) Two registers. **I**, Two scenes, **1**, deceased and man adore divine barks (unfinished), **2**, deceased with wife offers on braziers to three Ḥathor-cows each in stall. **II**, Offering-bringers.

 Barks, Schott photo. 7314. **I**, **2**, Davies (Nina) in *J.E.A.* xxx (1944), pl. vii, p. 64.

(2) Remains of stela with double-scene, deceased in shrine. At sides, dressed *zad*-pillars.

(3) Deceased and [man (replacing figure of wife)] with bouquets before Rēᶜ-Ḥarakhti and [goddess].
Bouquets, SCHOTT photo. 4164.

(4) Three registers. I, Nefertem-emblem in shrine, and deceased and man adore bark of Sokari. II–III, Banquet.
I, omitting man, SCHOTT photos. 7312–13.

(5) Three registers. I, Man, and couple adoring. II and III, Son before deceased and wife.

(6) Son Hor 𓀀 and priest offer to deceased with scribe's box under chair, and wife with monkey (?) under chair, and long text with good wishes for the after-life.
Texts, SCHOTT photos. 4165–7; names and titles, ČERNÝ in *Ann. Serv.* xl (1940), pp. 237–8 [upper].

(7) Entablature, two registers. I, Double-scene, deceased kneeling before Osiris and Nephthys, and before Osiris and Isis. II, Ḥathor-head in centre, with deceased seated, and *zad*-pillar on each side.
Titles of deceased and name of father, id. ib. p. 238 [lower].

(8) Deceased, wife and others, with bouquets before Osiris-Onnophris, [Isis, and Nephthys].
Man and women with sistra, WEGNER in *Mitt. Kairo*, iv (1938), pl. xxix [b].

(9) Top of dressed *zad*-pillar.

Ceiling. Hymn to Osiris in north part, and remains of titles of [Per(?)]enkhmūn.
Titles, ČERNÝ in *Ann. Serv.* xl (1940), p. 236.

69. MENNA 𓏠𓈖𓈖𓀀, Scribe of the fields of the Lord of the Two Lands of Upper and Lower Egypt. Temp. Tuthmosis IV (?).
Sh. ʿAbd el-Qurna.
Wife, Ḥenuttaui 𓊹𓎛𓏏𓏏𓂝.
Plan, p. 136. Map V, D-4, g, 9.
CAMPBELL, *Two Theban Princes*, pp. 85–106.

Hall. View, MOND, *A Method of Photographing Mural Decorations* in *The Photographic Journal*, lxxiii, Jan. 1933, fig. on p. 15 [upper]; M.M.A. photos. T. 805–7.

(1) Thicknesses, deceased, with wife and daughter, adoring, with hymn to Amen-rēᶜ and mention of Valley Festival on left thickness.
See CAMPBELL, op. cit. pp. 85–6. Translation of hymn, SCHOTT, *Das schöne Fest*, p. 858 [4].

(2) [1st ed. 1, 2] Four registers, agriculture, I–II before deceased seated and offerings (including honey), III–IV with daughters as royal concubines holding sistra before deceased

seated. **I,** Measuring crop, defaulters brought to deceased, and laden boat. **II,** Officials, waiting chariot, recording, deceased inspecting winnowing, and oxen threshing. **III,** Deceased inspects reaping, carrying corn, with two girls quarrelling and boy playing pipe, &c. **IV,** Men and oxen ploughing, girl removing thorn from girl's foot, pulling flax, &c.

M.M.A. photos. T. 771–7; CHIC. OR. INST. photos. 2869, 2871, 2878, 2881, 2883, 2888. Incomplete, WRESZ., *Atlas*, i. 231–4, 25 a; CAPART and WERBROUCK, *Thèbes*, figs. 112, 197, 200; SCHOTT photos. 2150, 2195–6, 3166–8, 3170–1, 3190–2, 5638–9, 5650–2, 7140–59, 7187–8, 7190–200, 7210, 7212–15. Deceased with offerings in upper scene, KEIMER in *Egypt Travel Magazine*, No. 30, Feb. 1957, p. 28, fig. 10. **I–III,** LHOTE and HASSIA, *Chefs-d'œuvre*, pls. xi, xiv, and pls. 71, 74, 76–7, 79, 87; left half, STEINDORFF, *Kunst*, fig. on p. 232; CAPART, *L'Art égyptien*, iii, pls. 520–1; PIJOÁN, *Summa Artis*, iii (1945), pl. xxiv [lower] (called tomb of Nakht). Right half of **I–III,** LANGE, *Ägypten*, pl. 107. Left half of **I–II,** CAMPBELL, *Two Theban Princes*, 1st pl. after p. 86; LYONS, *The Cadastral Survey of Egypt 1892–1907*, pl. i; part and right half, FARINA, *Pittura*, pls. cxxi–ii. **II–III,** DAVIES (Nina), *Anc. Eg. Paintings*, i, pls. l, li (CHAMPDOR, Pt. 5, 3rd pl.); right half, CAPART, *Le Paysage et les scènes de genre*, fig. 47; id. *Propos*, fig. 128. Right half of **II–IV,** Hickmann, *45 Siècles de Musique*, pl. xxxviii. Measuring in **I,** BORCHARDT in *Ä.Z.* xlii (1905), Abb. 1, cf. p. 70; BERGER in *J.E.A.* xx (1934), pl. x [4], p. 54; DROWER in SINGER, HOLMYARD, and HALL, *A History of Technology*, i, fig. 354 (from drawing by NINA DAVIES), cf. p. 540; VIOLLET and DORESSE, *Egypt*, pl. 148. Defaulters in **I,** CAMPBELL, *Two Theban Princes*, pl. facing p. 88 [top]; VON BISSING, *Altägyptische Lebensweisheit*, Abb. 6. Offerings in **I,** MEKHITARIAN, *Egyptian Painting*, pl. on p. 88.

Parts of **II–IV.** Chariot in **II,** OTTO, *Ägypten. Der Weg des Pharaonenreiches*, Abb. 28 [c]; WEIGALL, *Anc. Eg. . . . Art*, 155; WOLF, *Die Welt der Ägypter*, pl. 63 [lower], p. 94; FARINA, *Pittura*, pl. cxxiii; LANGE, *Lebensbilder*, pl. 26 (called tomb of Userhēt). Deceased with winnowing and carrying corn in **II–III,** DAVIES (Nina), *Eg. Paintings* (Penguin), pl. 7. Threshing and heaping in **II–III,** SAMIVEL and AUDRAIN, *The Glory of Egypt*, pls. 77–8; MEKHITARIAN, *Egyptian Painting*, pls. on pp. 76–7, with woman and child under tree, pl. on p. 79. Recording and winnowing in **II,** BORCHARDT and RICKE, *Egypt*, pls. 166–7; winnowing and threshing, LANGE, *Lebensbilder*, pls. 22–3. Sycamore-tree with figs in **III,** KEIMER in *Egypt Travel Magazine*, No. 29, Jan. 1957, p. 27, fig. 13. Right part of **III** and upper part of **IV,** WEIGALL, *Anc. Eg. . . . Art*, 156 [lower]. Girls quarrelling and removing thorn, and men combing (?) flax in **III–IV,** PETRIE in *Ancient Egypt* (1914), pl. facing p. 49, cf. p. 96; id. *Arts and Crafts*, fig. 70; id. *The Making of Egypt*, pl. lxxviii [2]; men carrying corn, girls, man asleep, &c., SMITH, *Art . . . Anc. Eg.* pl. 109; men, and girls, DE RACHEWILTZ, *Incontro con l'arte egiziana*, pl. 61, p. 76; girls, CAMPBELL, *Two Theban Princes*, pl. facing p. 88 [middle and bottom]. Two daughters in **III–IV,** CAMPBELL, *Two Theban Princes*, 2nd pl. after p. 86; MASPERO, *Égypte*, fig. 289; DAVIES (Nina), *Anc. Eg. Paintings*, ii, pl. liii. Sistrum, SCHOTT, *Das schöne Fest*, Abb. 11, cf. p. 806. Texts of deceased and daughters, HELCK, *Urk.* iv. 1607 [bottom]–1608 [middle].

(3) [1st ed. 3] Deceased and wife with two attendants adore Osiris. Sub-scene, offering-bringers, and two men lighting burnt-offerings.

CAMPBELL, *Two Theban Princes*, pl. facing p. 90; HERMANN, *Stelen*, pl. 10 [d]; DRIOTON, *Temples et trésors*, pl. 10; LHOTE and HASSIA, *Chefs-d'œuvre*, pl. xvii; M.M.A. photo. T. 778; CHIC. OR. INST. photo. 2873; SCHOTT photos. 2160, 2197, 3173, 3175, 4247, 4251, 5653–6, 5658, 7160–2, 7189, 7201–3, 7216–18. Omitting left part, FARINA, *Pittura*, pl. cxix; ROEDER, *Volksglaube im Pharaonenreich*, pl. 14. Main scene, CAPART and WERBROUCK, *Thèbes*,

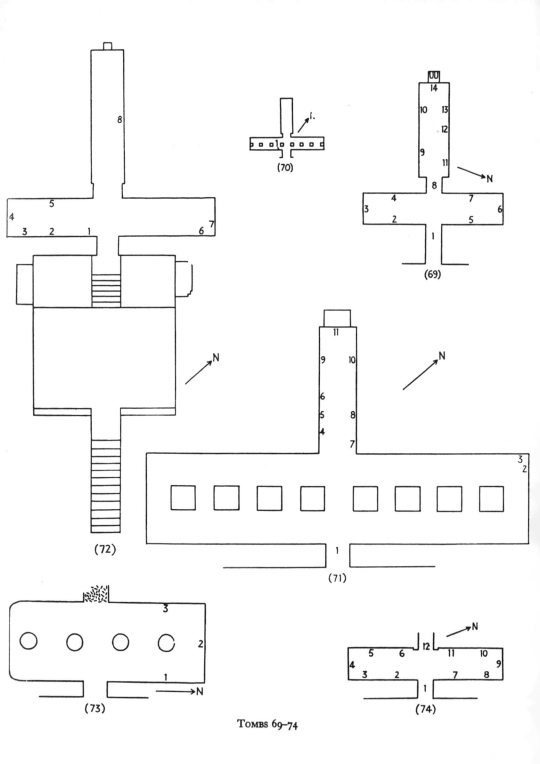

Tombs 69–74

fig. 148. Detail of lighting burnt-offering in sub-scene, SCHOTT, *Das schöne Fest*, Abb. 6, cf. p. 787. Texts of deceased and wife, HELCK, *Urk.* iv. 1608 [bottom]–1609 [top].

(4) Two registers, remains of banquet. **I**, Deceased and wife. **II**, Couple seated. M.M.A. photo. T. 779; incomplete, SCHOTT photos. 3174, 4252–3, 7205. Couple in **II**, MEKHITARIAN in *Chronique d'Égypte*, xxxi (1956), fig. 14, cf. p. 240. Fragment replaced, girl offering wine, in **II**, SCHOTT, *Altägyptische Liebeslieder*, pl. 17; id. photo. 7206.

(5) Two scenes. **1**, Deceased offers on braziers, followed by wife and sons and daughters with bouquets. **2**, Man offers bouquet to deceased and wife. Sub-scene, offering-bringers, butchers, and three clappers with song. M.M.A. photos. T. 768, 800–1; CHIC. OR. INST. photos. 2872, 2879, 2887; SCHOTT photos. 2161, 2199–200, 3946–8, 4176–86 a, 5659–60, 5671, 5674–7, 7168–86, 7204; see CAMPBELL, *Two Theban Princes*, pp. 90–2. 2nd and 3rd sons with text of Dyn. XXI usurpation, BAUD, *Dessins*, pl. xxxiii, pp. 234–5; last three sons, WEGNER in *Mitt. Kairo*, iv (1933), pl. xiv [a]; last three daughters, DAVIES (Nina), *Anc. Eg. Paintings*, i, pl. lii (CHAMPDOR, Pt. i, 6th pl.); CAPART, *L'Art égyptien*, iii, pl. 522; GILBERT, *La Poésie égyptienne*, pl. xi; last but one, MEKHITARIAN, *Egyptian Painting*, pl. on p. 92. Incense in dish with spoon (held before deceased) in **1**, and translation of song in sub-scene, SCHOTT, *Das schöne Fest*, Abb. 7, cf. pp. 787, 870 [61]. Wife in **2**, MEKHITARIAN in *Chronique d'Égypte*, xxxi (1956), fig. 23, cf. pp. 246–7; head, id. *Egyptian Painting*, pl. on p. 94. Offering-bringer with antelope in subscene, id. ib. pl. on p. 87. Name and title of 1st son in **1**, HELCK, *Urk.* iv, on 1609 [middle lower, 1st text].

(6) [1st ed. 5] Stela, three registers of double-scenes, **I**, Anubis before Osiris and Western goddess on left, and Rēc-Ḥarakhti with Ḥathor on right, **II**, seated couples, **III**, deceased and wife adoring, followed by priest. At sides, two registers, man and woman, adoring. CAMPBELL, *Two Theban Princes*, pl. facing p. 92; WEGNER in *Mitt. Kairo*, iv (1933), pl. xiv [b]; HERMANN, *Stelen*, pl. 6 [a], p. 60; M.M.A. photo. T. 769; CHIC. OR. INST. photo. 2875; SCHOTT photos. 2201, 3181–2, 3951, 4226, 4248–50, 5668–70. Man (on right) and two women adoring, WEIGALL, *Anc. Eg. . . . Art*, 156 [upper]; woman on right, LANGE, *Ägypten*, pl. 115; id. *Lebensbilder*, pl. 55; DAVIES in *M.M.A. Bull.* Pt. ii, Dec. 1922, fig. 6, cf. p. 54; LHOTE and HASSIA, *Chefs-d'œuvre*, pl. 43; COTTRELL, *Life under the Pharaohs*, fig. 19.

(7) [1st ed. 4] Two registers. **I**, Deceased and wife with man offering bouquet to them, and two rows of guests, with deceased, wife, and two men, with offerings before building at right end of upper row. **II**, Deceased and wife with priests in offering-list ritual before them, and two rows of men bringing ointment, with priest and men with vases and candles before deceased and wife at right end. M.M.A. photos. T. 770, 802–4; CHIC. OR. INST. photos. 2874, 2876–7; SCHOTT photos. 3176–80, 3193–4, 4228–32, 4234–46, 5661–7, 7163–7, 7207, 7219. See CAMPBELL, *Two Theban Princes*, p. 92. Deceased and wife on left in **I**, MASPERO, *Égypte*, fig. 288; STOPPELAÈRE in *Ann. Serv.* xl (1940), pl. cxlv, p. 947. Offerings in lower row in **I**, BORCHARDT in *A.Z.* lxviii (1932), pl. v [top left], p. 76 note 1; priests in ritual in lower row of **II**, HICKMANN, *45 Siècles de Musique*, pl. cvi [c]; SPIEGEL in *Mitt. Kairo*, xiv (1956), pl. xiii [2], p. 198; two men with candles in **II**, DAVIES in *J.E.A.* x (1924), pl. v [4], pp. 10–11.

Inner Room. View, M.M.A. photo. T. 789.

(8) Left thickness, deceased and wife leave tomb for Valley Festival.

See CAMPBELL, *Two Theban Princes*, pp. 93-4. Translation of text, SCHOTT, *Das schöne Fest*, p. 873 [71].

(9) Four registers. **I–II**, Offering-bringers, funeral outfit (including statuettes) carried, boats with mourners, 'Nine friends', sarcophagus dragged, &c., to Western goddess. **III–IV**, Priests, butchers, shrines, canoes, in procession to Anubis.

M.M.A. photos. T. 780–1, 795–9; CHIC. OR. INST. photos. 2867–8, 2870, 2884. Details, SCHOTT photos. 4155–60, 4162–3, 5727–37, 5742–51, 7235–41. See CAMPBELL, op. cit. pp. 94–8. Boat with three female mourners in **II**, and boats before Anubis in **III–IV**, WERBROUCK, *Pleureuses*, pl. v, figs. 132, 141–2, cf. p. 42; boat with mourners in **II**, LANGE, *Lebensbilder*, pl. 48; boats and butchers at left end of **II** and **III**, LHOTE and HASSIA, *Chefs-d'œuvre*, pl. at end 15.

(10) Deceased, with Thoth writing and weighing-scene, before Osiris. Sub-scene, offering-bringers and man lighting burnt-offerings.

M.M.A. photo. T. 794; CHIC. OR. INST. photo. 2886. Main scene, CAMPBELL, *Two Theban Princes*, pl. facing p. 98; WEGNER in *Mitt. Kairo*, iv (1933), pl. xiii [a]; weighing before Osiris, WOLF, *Die Welt der Ägypter*, pl. 56 [upper]; scales, and priest with offerings in sub-scene, SCHOTT photos. 4161, 5738–9, 5741.

(11) [1st ed. 9] Three registers. **I**, Abydos pilgrimage. **II** and **III**, Rites before mummy, with two cloaked priests 'sleeping' and 'waking', each before mummy, and bouquets offered to mummy held by priest at left end. Sub-scene, offering-bringers.

M.M.A. photos. T. 791–3, 787–8. See CAMPBELL, *Two Theban Princes*, pp. 100–3. Right part, MASPERO, *L'Arch. ég.* (1887), fig. 151, (1907), fig. 157. Left part of **I** and **II**, STEINDORFF and WOLF, *Gräberwelt*, pl. 7 [b]. **I**, and women in sub-scene, SCHOTT photos. 5679–92, 5694, 5718–22, 7208, 7220–4. Left (sailing) boat in **I**, FARINA, *Pittura*, pl. cxxiv; LANGE, *Lebensbilder*, pl. 49; MEKHITARIAN, *Egyptian Painting*, pl. on p. 80; SAINTE FARE GARNOT in *L'Amour de l'art*, xxviii, fig. on p. 239 [middle upper]. Right boat in **I**, ROBICHON and VARILLE, *En Égypte*, pl. 123; man taking soundings, MEKHITARIAN, op. cit. pl. on p. 81. Cloaked priests before mummies, CAMPBELL, op. cit. pl. facing p. 102 [bottom]; THOMAS in *Ancient Egypt* (1923), fig. on p. 47.

(12) [1st ed. 8] Deceased and family fishing and fowling. Sub-scene, offering-bringers.

CAPART and WERBROUCK, *Thèbes*, figs. 169, 185; CAPART, *Le Paysage et les scènes de genre*, fig. 13; BAIKIE, *A History of Egypt*, ii, pl. xvi [1]; PIJOÁN, *Summa Artis*, iii (1945), pl. xxiv [upper] (called tomb of Nakht); M.M.A. photos. T. 784–6, 785 A; CHIC. OR. INST. photo. 2885; incomplete, SCHOTT photos. 3183, 3186–8, 3195–6, 4072–5, 4348–50, 5695–5717, 7209, 7225–34; left half, SAMIVEL and AUDRAIN, *The Glory of Egypt*, pl. 79. Main scene, CAMPBELL, *Two Theban Princes*, pp. 103–4 with pl.; WRESZ., *Atlas*, i. 2 a, iii, p. 246, Textabb. 108, 1; CAPART, *L'Art égyptien*, iii, pl. 519; BAIKIE, *Eg. Antiq.* pl. xxii [upper]; FARINA, *Pittura*, pl. cxx; DAVIES (Nina), *Anc. Eg. Paintings*, ii, pl. liv (CHAMPDOR, Pt. i, 5th pl.); BLACKMAN and ROEDER, *Das Hundert-torige Theben*, pl. 3; LANSING in *M.M.A. Bull.* xxv (1930), fig. on p. 5; HAYES, *Daily Life in Ancient Egypt* in *Nat. Geog. Mag.* lxxx (1941), fig. on p. 471; LHOTE and HASSIA, *Chefs-d'œuvre*, pls. 54–5; LANGE and HIRMER, *Aegypten*, pl. 146.

Birds, fish, and crocodile, in water, birds, cat, and ichneumon, above, and fish speared, MEKHITARIAN, *Egyptian Painting*, pls. on pp. 82–3, 89; bird in water, SCHOTT, *Altägyptische Liebeslieder*, pl. 12; birds above, ROBICHON and VARILLE, *En Égypte*, pl. 122; VANDIER,

Egypt, pl. xxiii. Birds, fish, and daughter picking flower, WOLF, *Die Kunst Aegyptens*, Abb. 469. Wife and daughters in left boat, PETRIE, *The Making of Egypt*, pl. lxxviii [1]; id. *Arts and Crafts*, fig. 73, cf. p. 58; *Ancient Egypt* (1914), fig. on p. 95; WEIGALL, *Anc. Eg.... Art*, 157 [1]; daughter holding birds, DRIOTON and HASSIA, *Temples and Treasures*, pl. 16; MEKHITARIAN, op. cit. pl. on p. 93; LHOTE and HASSIA, *Chefs-d'œuvre*, pl. 57; daughter picking flower, DAVIES in *M.M.A. Bull.* Pt. ii, Dec. 1923, fig. 10 [upper], cf. p. 46; DAVIES (Nina), *Anc Eg. Paintings*, ii, pl. lv; WEGNER in *Mitt. Kairo*, iv (1933), pl. xiii [b]. Three offering-bringers, and man with calf, in sub-scene, LHOTE and HASSIA, op. cit. pls. 47, 67.

(13) Two registers. **I, II**, Relatives offer to deceased and wife.

M.M.A. photos. T. 790, 783; CHIC. OR. INST. photo. 2880. See CAMPBELL, *Two Theban Princes*, pp. 104–6. Women offering in **I** and **II**, SCHOTT photos. 3184, 5723–4, 5726. Name and title of son in **I**, and title of deceased in **II**, HELCK, *Urk.* iv. 1609 [middle lower, 2nd text].

(14) [1st ed. 6, 7] Niche containing lower part of seated double-statue of deceased and wife, with entablature above. At sides, two registers, offering-bringers.

MASPERO, *Hist. anc. Les premières mêlées*, fig. on p. 519; CAPART and WERBROUCK, *Thèbes*, fig. 138; HERMANN, *Stelen*, pl. 1 [c] (from SCHOTT photo.), p. 21; WOLF, *Die Kunst Aegyptens*, Abb. 454; M.M.A. photo. T. 782; CHIC. OR. INST. photo. 2882; SCHOTT photos. 3189, 5740; see CAMPBELL, op. cit. p. 106. Upper part of statue of wife, in Cairo Mus. Ent. 36550, MASPERO, *Egyptian Art*, pls. facing pp. 178, 180; id. in *Revue de l'art ancien et moderne*, xvii (1905), pp. 401–4 with pl. (reprinted, *Essais sur l'art égyptien*, figs. 73–4); id. *Égypte*, fig. 326; CAPART, *L'Art égyptien* (1911), pl. 167; *The Cambridge Ancient History. Plates*, i, cf. p. 139 [c]; PETRIE, *The Making of Egypt*, pl. lxxvii [1]; id. in *Ancient Egypt* (1914), p. 96 with two pls., cf. cover (from cast); BOREUX, *L'Art égyptien*, pl. xxxv; PIJOÁN, *Summa Artis*, iii (1945), fig. 586; *Encyclopédie photographique de l'art. Mus. Caire*, pl. 88; DRIOTON and SVED, *Art égyptien*, fig. 76; VANDIER, *Egyptian Sculpture*, pl. 79; MALRAUX, *Le Musée imaginaire de la sculpture mondiale*, pl. 62. See MASPERO, *Guide* (1915), p. 129 [430].

70. Usurped by AMENMOSI 𓊃𓏤, Overseer of sandal-makers (?) of the estate of Amūn. Dyn. XXI.

Sh. ʿAbd el-Qurna.

Father, Suʿawiamūn 𓏤𓊃𓈖𓏏𓀭, same title. Wife, Kefenu 𓊃𓈖𓏤𓀭.

Plan, p. 136. Map V, D–4, e, 8.

Hall.

(1) Deceased and wife followed by relatives adore [Osiris].

Frieze, squatting gods.

71. SENENMUT 𓊃𓈖, Chief steward, Steward of Amūn. (Also owner of tomb 353.) Temp. Ḥatshepsut.

Sh. ʿAbd el-Qurna. (*L. D. Text*, No. 46.)

Parents, Raʿmosi 𓊪𓏤 and Ḥatnefer(t) 𓊃𓏏𓀭 (for burial, see SHEIKH ʿABD EL-QURNA, *Bibl.* i², Pt. 2, in the Press).

Plan, p. 136. Map V, D–4, e, 7.

WINLOCK in *M.M.A. Bull.* Pt. ii, March 1932, pp. 21-2, with view, fig. 12; LANSING and HAYES in *M.M.A. Bull.* Pt. ii, Jan. 1937, p. 5, with plan of front part on fig. 8; MÜLLER, *Egyptological Researches*, i, pp. 12–18.

Hall. View, M.M.A. photo. T. 2667; of north corner, SMITH, *Art . . . Anc. Eg.* pl. 102 [A]; M.M.A. photo. T. 695.

(1) Part of inner lintel, brother Minḥotp, *waʿb*-priest, offers to deceased and parents, (walled up on site).
See HAYES, *Ostraka and Name Stones* [&c.], p. 10, notes 22, 23.

(2) [1st ed. 3] At top, remains of autobiographical text, with two remaining soldiers at left end.
MÜLLER, *Egyptological Researches*, i, pl. 4 [d], pp. 14–15 with fig.; M.M.A. photo. T. 2671. Soldiers, HERMANN in *Mitt. Kairo*, vi (1936), pl. 7 [b]. Text, SETHE, *Urk.* iv. 399 (127) A.

(3) [1st ed. 2] At top, six Keftiu (three remaining), 1st with sword, others with vases (one with boukrania-decoration) in [tribute-scene].
HAY MSS. 29822, 33, 29852, 269, 301. Keftiu, vases, and sword (some from HAY), VERCOUTTER, *L'Égypte* [&c.], pls. i–ii [65–9], xiv [124–7], xxxv [231–2], xliii [309], xlv–xlvi [330, 342], liii [390], lix [430], lxii [462], pp. 203–5, 243–5, 306–7, 325, 330, 332, 343, 352, 359. Remaining Keftiu, MÜLLER, op. cit. pls. 5–7; WRESZ., *Atlas*, i. 235; MEYER, *Fremdvölker*, 742; HALL in *Annual of the British School at Athens*, x (1903–4), figs. 1, 2, cf. pp. 154–7, and xvi (1909–10), frontispiece, and pl. xiv (from HAY), cf. pp. 254–7; id. in *P.S.B.A.* xxxi (1909), pl. xvi, p. 140; id. in *J.E.A.* i (1914), pl. xxxiii [1] (from HAY), p. 201; id. in *Brit. Mus. Quarterly*, i (1926–7), pl. lii [upper], p. 94, and in *Essays in Aegean Archaeology presented to Sir Arthur Evans*, pl. iii facing p. 40 (both from painting by NINA DAVIES); HALL, *The Ancient History of the Near East* (1950), pl. xviii [lower], p. 293, note 1; KING and HALL, *Egypt and Western Asia* [&c.], pp. 360–1 with fig.; DAVIES in *M.M.A. Bull.* Pt. ii, March 1926, fig. 2, cf. p. 46; DAVIES (Nina), *Anc. Eg. Paintings*, i, pl. xiv; MOND, *A Method of Photographing Mural Decorations* in *The Photographic Journal*, lxxiii, Jan. 1933, pl. facing p. 10 [lower]; BOSSERT, *Altkreta*, figs. 333–4; id. *The Art of Ancient Crete*, figs. 536–7 (one from HAY); HAMMERTON, *Universal History of the World*, ii, fig. on p. 758 (from painting by NINA DAVIES); FIMMEN, *Die Kretisch-Mykenische Kultur*, Abb. 176, cf. p. 184; SMITH, *Art . . . Anc. Eg.* pl. 102 [B]; M.M.A. photos. T. 695–6.

Vases, HALL in *Annual of the British School at Athens*, viii (1901–2), figs. 4–8, cf. pp. 172–3; WAINWRIGHT in *Liv. Ann.* vi (1914), pls. xi [78], xiii [97–9, 101–3], pp. 34 ff.; four (two now destroyed), WILKINSON MSS. v. 105 [upper]; three, PRISSE, *L'Art égyptien*, ii, 76th pl. [2, 6, 9] 'Vases . . . de Kafa', cf. *Texte*, p. 432; two, WILKINSON, *M. and C.* ii. 349 (No. 250, 1, 2) = ed. BIRCH, ii. 7 (No. 274, 1, 2). Detail of dress of last Keftiu, VON LICHTENBERG in *Mitt. Vorderasiat. Ges.* xvi (1911), Abb. 23, cf. p. 114 (Heft 2, p. 50).

Frieze at (2)–(3) [1st ed. 1–3], Hathor-heads and text below.
WRESZ., *Atlas*, i, on 235; HERMANN in *Mitt. Kairo*, vi (1936), pl. 7 [b], p. 24; SMITH, *Art . . . Anc. Eg.* pl. 103 [A]; M.M.A. photos. T. 2673, on 695–6, 2671; Hathor-heads, MACKAY in *Ancient Egypt* (1920), pl. facing p. 97 [6], p. 122; text and one head, MÜLLER, *Egyptological Researches*, i, pl. 3 [lower], fig. on p. 14; head, WILKINSON, *M. and C.* ii, pl. vii [13] facing p. 125 = ed. BIRCH, i, pl. viii [13] facing p. 363; WILD MSS. ii. A. 136.

Architrave at north end. Inner face, M.M.A. photo. T. 2672. Text, MÜLLER, op. cit. i, pl. 4 [b, c].

Ceiling. Right half, texts, id. ib. pl. 4 [a]; SETHE, *Urk.* iv. 401–2 (127) D, F; parts, M.M.A. photos. T. 2668–70; names of parents, L. *D. Text*, iii, p. 259.

Inner Room. View, M.M.A. photos. T. 2677, 2692.

(4)–(8) Rock-stelae. Titles, SETHE, *Urk.* iv. 402 (127) E, 1 at (8), 2 at (6), 3 at (5), 4 at (7).

(4) Three with titles of deceased as steward, and as great steward, L. *D.* iii. 25 bis [b, e]·M.M.A. photos. T. 2160–2; two as steward, MÜLLER, *Egyptological Researches*, i, pl. 3 [3, ₊₁·(5) One with title of deceased as overseer of the granary, and names of parents, L. *D.* iii. 25 bis [f]; MÜLLER, op. cit. pl. 3 [5]; M.M.A. photo. T. 2166; incomplete, WILKINSON MSS. v. 104 [bottom, 2nd from left]. (6) Two, one with title erased and names of parents, one with title of deceased as steward, M.M.A. photos. T. 2165, 2163; former, L. *D.* iii. 25 bis [d]. (7) One with title of deceased as overseer of royal works, L. *D.* iii. 25 bis [c]; MÜLLER, op. cit. pl. 3 [2]; M.M.A. photo. T. 2164; WILKINSON MSS. v. 104 [bottom, 3rd from left]. (8) One with title of deceased as great steward and names of parents, HERMANN in *Mitt. Kairo*, vi (1936), pl. 7 [c]; MÜLLER, op. cit. pl. 3 [6]; WILKINSON MSS. v. 104 [bottom left].

(9) [1st ec' Two registers. I, Brother Senimen (tomb 252) and his wife Senemiʿoḥ seated before offerings with list. II, Offering-bringers.

M.M.A. photos. T. 2685–7, M. 16. C. 5. Names and titles, SETHE, *Urk.* iv. 418 (134 bis) A.

(10) Remains of funeral procession with statues dragged (?).

M.M.A. photos. T. 2689–91.

(11) Statue-niche and stela below (in Berlin Mus. 2066) with small scene, deceased seated with parents, and texts, including part of Book of the Dead, and at left side bull with seven cows, at right side Anubis and gods of sacred oars.

Niche, M.M.A. photos. T. 2692–3; block with female relative ʿAḥḥotp seated on ground, in New York, M.M.A. 36.3.239, LANSING and HAYES in *M.M.A. Bull.* Pt. ii, Jan. 1937, fig. 51, cf. p. 36; M.M.A. photos. M. 16. C. 8, 10, with other fragments, offering-bringers, &c., 1–4, 6, 7. Stela, L. *D.* iii. 25 bis [a], cf. *Text*, iii, p. 259; HERMANN, *Stelen*, pl. 1 [a], p. 18. Texts, *Aeg. Inschr.* ii. 92–6. See *Ausf. Verz.* p. 160.

Frieze-text on left wall. SETHE, *Urk.* iv. 399–400 (127) B.

Ceiling. Texts, M.M.A. photos. on T. 2674–6, 2678–84; parts, SETHE, *Urk.* iv. 400–1 (127) C; MÜLLER, *Egyptological Researches*, i, pl. 3 [1].

Fragments of quartzite sarcophagus, in New York, M.M.A. 31.3.95, WINLOCK in *M.M.A. Bull.* Pt. ii, March 1932, fig. 15, cf. p. 22; restoration, HAYES in *J.E.A.* xxxvi (1950), pls. iv–viii, pp. 19–23.

For block-statue of deceased with small princess Neferureʿ, in Berlin Mus. 2296, thought by Lepsius to come from niche in this tomb, see KARNAK, *Bibl.* ii² (in preparation).

Exterior. Above tomb.

Rock-cut block-statue of deceased with small princess Neferureʿ. M.M.A. photo. M. 16. C. 437; GR. INST. ARCHIVES, photo. 32.

Finds

Fragments of red granite stela. M.M.A. photo. M. 16. C. 9.

Name-stones of deceased with incised texts. M.M.A. photos. M. 16. C. 11–24. Four in New York, M.M.A. 36. 3. 240–3, HAYES, *Ostraka and Name Stones* [&c.], pl. xxxi [xxxiv, xxxv], pp. 49 [lxii], 50 [lxxx]. Two in Cairo Mus. Ent. 66266–7, id. ib. pl. xxxi [lxvi, lxxxvi], pp. 50–1.

Name-stones of deceased with painted texts, M.M.A. photos. M. 16. C. 25–49. Six in New York, M.M.A. 36.3.244–9, HAYES, op. cit. pls. xxxii [xx, xxvii, xl], xxxiii [lxxi], p. 50 [lxxviii, lxxix]. Three in Cairo Mus. Ent. 66268–70, id. ib. pls. xxxii [lx], xxxiii [lxxxvii, lxxxviii], pp. 49, 51.

Mummy-cloths of brother Senimen (tomb 252). M.M.A. photos. M. 16. C. 84–6.

72. RĒꜥ ⌒⊙, First prophet of Amūn in the Mortuary Temple of Tuthmosis III. Temp. Amenophis II.

Sh. ꜥAbd el-Qurna. (L. *D. Text*, No. 45.)

Parents, ꜥAḥmosi 𓀀, [First] prophet of Amūn, and Rēꜥy ⊙𓂋𓂋, Royal concubine.

Plan, p. 136. Map V, D–4, e, 7.

L. *D. Text*, iii, pp. 258–9. View of exterior, HERMANN, *Stelen*, pl. 2 [e]. Titles of deceased, HELCK, *Urk.* iv. 1459 [middle upper].

Hall.

(1) Deceased offers on braziers (?) with offerings on behalf of Tuthmosis III, with butcher and man below.

Details of offerings, SCHOTT photos. 8470–3. Text of deceased, HELCK, *Urk.* iv. 1459 [top].

(2) Three registers. I–III, Remains of banquet, with harpist in II.
III, SCHOTT photo. 4370.

(3) Two registers. I, [Deceased seated]. II, Men approach house with offerings to Termuthis as serpent at top.

(4) Three registers. I, [Amenophis II in chariot] hunting ibex, ostriches, &c., in desert. II, Military escort. III, Men bringing game.

See DAVIES in *M.M.A. Bull.* Pt. ii, Nov. 1935, pp. 49–50.

(5) [1st ed. 1] [Deceased], followed by three brothers with standards and offering-bringer, offers bouquet of Amūn to Amenophis II and his mother Queen Merytrēꜥ.

King and Queen, L. *D.* iii. 62 [b]. Texts, HELCK, *Urk.* iv. 1368 (406, 1), 1457–8; texts of offering and of King and Queen, WILKINSON MSS. v. 104 [top right].

(6) [Deceased] seated in booth and [deceased and family] spearing fish.

Text of deceased in booth and name of mother, HELCK, *Urk.* iv. 1458 [bottom].

(7) [Deceased] offers to [Osiris].

Inner Room.

(8) [1st ed. 2] Four registers. I–IV, Remains of ri· before mummy (including Opening the Mouth with offering-list and butchers in I) an·1 · eral procession.

Opening the Mouth texts, SCHIAPARELLI, *Funer..'i* , p. 285 [v].

Frieze. Title of deceased as First prophet of Tuthmosis III as decoration, WILKINSON MSS. v. 104 [middle right]; cf. L. *D. Text*, iii, p. 259 [near top, left].

Coffin of deceased (containing mummy of Ramesses VI), found in Royal tomb 35 (Amenophis II), now in Cairo Mus. 61043. DARESSY, *Cercueils des Cachettes royales* (*Cat. Caire*), pl. lxiv, pp. 224–6; SCHMIDT, *Sarkofager*, fig. 574 (called 61085). Names, LEGRAIN, *Répertoire généalogique et onomastique du Musée du Caire*, No. 174. See MASPERO, *Guide* (1915). p. 403 [3861]; LORET in *Bull. Inst. Ég.* 3 Sér. ix (1898), p. 112 [8].
Statue of deceased, seen here by Davies. Text, Davies Notebook, 1, p. 75.

Finds

Sandstone jamb of deceased, in Berlin Mus. 2067. Text, *Aeg. Inschr.* ii. 220; name and titles, L. *D. Text*, iii, p. 259 [near top, right]; HELCK, *Urk.* iv. 1459 [middle lower].

73. AMENHOTP (?),[1] Overseer of works on the two great obelisks in the Temple of Amūn, Chief steward, Veteran of the King. Temp. Ḥatshepsut.
Sh. ʿAbd el-Qurna.

Plan, p. 136. Map V, D–4, e, 8.

SÄVE-SÖDERBERGH, *Four Eighteenth Dynasty Tombs* (*Private Tombs at Thebes*, i), pp. 1–10, with plan on pl. ix.

Hall.

(1) [1st ed. 5–7] Three scenes. **1**, Son (?) offers bouquet [of Amūn] to deceased with ibex under chair and attendants. **2**, Deceased and family fowling and fishing. **3**, Three registers, I–III, offering-bringers with bulls, honey (?), &c., before deceased (with monkey under his chair) and wife. Sub-scene, man making net, men netting, bringing, and [cleaning] fish, and tending bee-hives.

1, 2, and sub-scene, SÄVE-SÖDERBERGH, pls. vii, viii, ix [B, and ll. 4, 5], pp. 8–10. Son (?) and deceased in **1**, and men bringing and [cleaning] fish in sub-scene, SCHOTT photos. 4357, 8480–1; ibex in **1**, and sub-scene, CHIC. OR. INST. photo. 10334. Texts, SETHE, *Urk.* iv. 462–3 (145) D–G.

(2) [1st ed. 4] Tympanum, kneeling man and hawk protecting royal name, with scene below, [deceased] with attendants, and New Year gifts (continued at (3)) including two [obelisks], beds, vases, and statuette of Ḥatshepsut kneeling in front of a god.
Omitting tympanum, SÄVE-SÖDERBERGH, pls. vi, ix [A], pp. 6–8. Texts, SETHE, *Urk.* iv. 459–62 (145) C.

(3) [1st ed. 1–3] Two scenes (continued from (2)). **1**, [Deceased] inspects four registers, I–IV, New Year gifts for the Temple of Amūn, including royal statuettes (Ḥatshepsut kneeling between Sekhmet and Amūn, Satis nursing young Ḥatshepsut with Amūn, and Thoth writing with Ḥatshepsut kneeling between Wert-Ḥekau and Khnum, Queen smiting captive, Queen embraced by Amūn, Anukis nursing young Ḥatshepsut with Amūn in palanquin, and Ḥatshepsut between Atum and Amūn), chariots, bows, large shrines, &c., with remains of garlanded bulls for Festival of Apet below. **2**, Deceased offers collars as New Year gifts to [Ḥatshepsut with *ka*].

[1] According to GARDINER and WEIGALL, *Cat.* p. 22 [1], cf. Supplement, p. 14, and HABACHI in *J.N.E.S.* xvi (1957), p. 90. See SÄVE-SÖDERBERGH, p. 1 (name considered uncertain).

SÄVE-SÖDERBERGH, pls. i–v, ix [ll. 1–3], pp. 2–6. Parts of **1, I–III,** SCHOTT photos. 8474–7; deceased with collars and text, and left end of **I–IV,** HABACHI in *J.N.E.S.* xvi (1957), fig. **2,** cf. pp. 91–2. Statuette of Queen, Sekhmet, and Amūn, in **1, II,** BORCHARDT in *Bull. de la Société archéologique d'Alexandrie,* N.S. vi (1928), pl. v [lower], pp. 351–2. Statuette of Anukis, Queen, and Khnum, in **1, III,** CHIC. OR. INST. photo. 10335. **2,** SCHOTT photos. 4359–60. Texts, SETHE, *Urk.* iv. 455–9 (145) A 1, 2, B; titles, NEWBERRY in *P.S.B.A.* xxxv (1913), p. 157 [3].

74. THANUNY 🏺, Royal scribe, Commander of soldiers. Temp. Tuthmosis IV.

Sh. ʿAbd el-Qurna. (CHAMPOLLION, No. 3, L. *D. Text,* No. 53.)
Wife, Mutiriy 𓀀, Songstress of Thoth and Neḥemʿawat.

Plan, p. 136. Map V, D–4, e, 8.

SCHEIL, *Le Tombeau de Djanni* in VIREY, *Sept Tombeaux thébains* (*Mém. Miss.* v, 2), pp. 591–603, with plan on p. 591; CHAMP., *Not. descr.* i, pp. 484–7; L. *D. Text,* iii, pp. 264–5. Titles of deceased and wife, ROSELLINI MSS. 284, G 4.

Hall. View, M.M.A. photos. T. 2075, 2077.

(1) [1st ed. 1, 2, 14] Thicknesses, deceased and wife adoring leave tomb on left, and representation of door and deceased returning from Festival of Amūn on right. Inner jambs, offering-texts.

Omitting door, M.M.A. photos. T. 2069 [right], 2075, 2077; SCHOTT photos. 8374–5. Texts, SCHEIL, p. 592; part, PIEHL, *Inscr. hiéro.* I Sér. cvii [D β, γ]; SETHE, *Urk.* iv. 1009–10 (299) F, G; text on left jamb, SETHE, *Urk.* iv. 1014 (300) B, c, d.

(2) [1st ed. 3–4] Deceased with wife, and offerings with butchers below, offers on braziers, followed by lutist and remains of four rows of offering-bringers.

M.M.A. photos. T. 2070–1. Omitting offering-bringers, CHIC. OR. INST. photo. 2892. Details, SCHOTT photos. 3881–4, 4373–4, 8376–80. Lutist, CHAMP., *Mon.* clvii [4]; ROSELLINI, *Mon. Civ.* xcv [1]; HAY MSS. 29853, 183–4; NESTOR L'HÔTE MSS. 20404, 72. Altar (with the offerings), JÉQUIER in *Rec. de Trav.* xxxii (1910), fig. 4, cf. p. 168. Lutist, HICKMANN, *45 Siècles de Musique,* pl. xli [A]. Offering-text above deceased, and text of lutist, SCHEIL, p. 593 [middle]; SETHE, *Urk.* iv. 1008–9 (299) E 1, 2; beginning, FOUCART in *B.I.F.A.O.* xxiv (1924), p. 108; titles of wife, L. *D. Text,* iii, p. 265 [a].

(3) [1st ed. 5] Man, with woman and two rows of people, offers bouquet of Amūn to deceased and wife.

M.M.A. photos. T. 2072–3. Deceased, wife, and man, CHIC. OR. INST. photo. 2891. Texts and details, SCHOTT photos. 3879–80, 8381–3; texts, SCHEIL, pp. 593 [bottom]–594 [top]; text above deceased, SETHE, *Urk.* iv. 1011–12 (299) I, 1; part, PIEHL, *Inscr. hiéro.* I Sér. cvii [D a]; text above wife, L. *D. Text,* iii, p. 265 [top right].

(4) [1st ed. 6] Painted stela. At sides, three registers, deceased seated and offerings.

HERMANN, *Stelen,* pl. 8 [c] (from SCHOTT photo.), pp. 6*–7* [36–40]; M.M.A. photos. T. 2074, cf. 2075; SCHOTT photos. 3885, 4371, 8384. Texts, SCHEIL, pp. 594–5 [B]; titles from sides, SETHE, *Urk.* iv. 1015 (300) B, f, 1017 (301) f–k.

(5) [1st ed. 7] Four registers. **I–IV**, Military parade, including standard-bearers, standard with wrestlers on it, Nubian soldiers, trumpeter, and drummer, before deceased seated on cushions and deceased standing.

M.M.A. photos. T. 2053–60; CHIC. OR. INST. photos. 2889, 10336–7. See SCHEIL, pp. 598–600 [c]. Details, CHAMP., *Not. descr.* i, pp. 484–6. Omitting deceased, WRESZ., *Atlas*, i. 236, 23 a (incomplete). I and parts of others, SCHOTT photos. 3872–4, 3877–8, 4375–7, 8385–9. Soldiers in **I** and **II**, FARINA, *Pittura*, pl. cxvii; CHAMP., *Mon.* clvii [1, 5, 6]; ROSELLINI, *Mon. Civ.* cx [3–5]; CAILLIAUD, *Arts et métiers*, pl. 43 A [3–5]; right end of **I**, WILKINSON, *M. and C.* ii. 34 (No. 86) = ed. BIRCH, i. 301 (No. 105); WILKINSON MSS. v. 93 [upper]. **II**, incomplete, BRUYÈRE, *Rapport (1934–1935)*, Pt. 3, fig. 31, cf. p. 97; group with standard, DAVIES (Nina), *Anc. Eg. Paintings*, i, pl. xlv (CHAMPDOR, Pt. iv, 1st pl.); MEKHITARIAN, *Egyptian Painting*, pl. on p. 97; standard with wrestlers, FAULKNER in *J.E.A.* xxvii (1941), pl. iv [6], p. 15. **III–IV**, incomplete, CAPART and WERBROUCK, *Thèbes*, fig. 199 (from WRESZINSKI). [Standards with cartouches] (held by two leaders) in **III**, CHAMP., *Mon.* clvii [3, left and right]; one, ROSELLINI, *Mon. Stor.* Text, iii, Pt. i, pl. iv [7] facing p. 202, cf. p. 209. Trumpeter and drummer in **IV**, ROSELLINI, *Mon. Civ.* cxvi [3, 4]; drummer, CHAMP., *Mon.* clvii [2]; WILKINSON, *M. and C.* ii. 267 (No. 203) = ed. BIRCH, i. 460 (No. 228); DAVIES (Nina), op. cit. pl. xlvi. Texts, SETHE, *Urk.* iv. 1005–6 (299) A; text of deceased, CHAMP., *Mon.* clvii [3, upper middle]; BRUGSCH, *Thes.* 1152 [near bottom]; SCHEIL, p. 598 [lower middle].

(6) [1st ed. 8] Deceased offers bouquet of Amūn to [Tuthmosis IV] with Nine Bows on base of throne.

M.M.A. photos. T. 2060–1. Text above deceased, SCHEIL, p. 598 [upper middle]; SETHE, *Urk.* iv. 1007–8 (299) D. Nine Bows, SCHEIL, p. 598 [top]; CULLIMORE in *Trans. Roy. Soc. Lit.* ii (1834), 2nd pl. at end [top]; CHAMP., *Mon.* clvii [3, lower middle], and *Not. descr.* i, pp. 830–1 [to p. 486, l. 7]; WILKINSON MSS. v. 93 [lower]; NESTOR L'HÔTE MSS. 20404, 72; ROSELLINI MSS. 284, G 5; Nos. 1–6, L. D. *Text*, iii, p. 265 [middle]; Nos. 1, 2, 6, 9, ROSELLINI, *Mon. Stor.* Text, iii, Pt. i, pl. iv [8, a–d] facing p. 202, cf. p. 210.

(7) [1st ed. 13] [Deceased with wife], and offerings with butchers below, offers on braziers, followed by four rows of [offering-bringers] with male lutist in top row.

M.M.A. photos. T. 2068–9. Offerings, butchers, lutist, SCHOTT photos. 4378–9, 8393–5; lutist, HICKMANN, *45 Siècles de Musique*, pl. xli [B]; NESTOR L'HÔTE MSS. 20404, 72. Text, SCHEIL, p. 596 [middle].

(8) [1st ed. 12] Deceased, with wife adoring and three attendants, offers on braziers to Osiris.

M.M.A. photos. T. 2066–7. Deceased and Osiris, CHIC. OR. INST. photo. 2890. Attendant with yoke and jars below, SCHOTT photos. 8391–2. Texts, SCHEIL, pp. 595–6 [top]; of deceased and wife, SETHE, *Urk.* iv. 1010 (299) H.

(9) [1st ed. 11] Remains of stela, double-scene, deceased kneeling adores Osiris, and adores Anubis, with autobiographical text below. At sides, four registers, **I–III**, offering-bringers, **IV**, tree.

HERMANN, *Stelen*, pl. 7 [d] (from SCHOTT), p. 20* [upper]; M.M.A. photos. T. 2076–7; SCHOTT photos. 4372, 8978. Texts (incomplete), SCHEIL, pp. 596–7 [E]; autobiographical text, SETHE, *Urk.* iv. 1002–5 (298); ll. 11–15, 17–18, CHAMP., *Not. descr.* i, pp. 831–2 [to p. 487, l. 13]; BRUGSCH, *Thes.* 1151; MASPERO in *Rec. de Trav.* iv (1883), p. 130.

(10) [1st ed. 10] Deceased inspects four registers, recording, **I–II**, recruits, **III–IV**, bulls and horses.

M.M.A. photos. T. 2063–5. Left part of **I–II**, WEGNER in *Mitt. Kairo*, iv (1933), pl. xii [b]. Parts of **I, II, IV**, SCHOTT photos. 4381–2, 8390. **III–IV**, WRESZ., *Atlas*, i. 237; man leading bulls and first horse, MEKHITARIAN, *Egyptian Painting*, pls. on pp. 96, 98–9. Texts, SCHEIL, pp. 601 [middle]–602 [F]; CHAMP., *Not. descr.* i, p. 487 [top]; SETHE, *Urk.* iv. 1006–7 (299) B; MASPERO in *Rec. de Trav.* iv (1883), p. 131.

(11) [1st ed. 9] Deceased with Syrian decorative vase before [Tuthmosis IV].

Deceased, M.M.A. photo. T. 2062 [left]. Text, SCHEIL, p. 601 [top]; CHAMP., *Not. descr.* i, p. 831 [to p. 487, l. 10]; SETHE, *Urk.* iv. 1007 (299) C; BRUGSCH, *Thes.* 1152 [bottom]–1153 [top]; SCHOTT photo. 4380; part of text, LEPSIUS MS. 303 [bottom].

(12) Entrance to Inner Room. Outer lintel and left jamb, remains of texts.

Frieze-text, SCHEIL, pp. 602–3 [A, D, C]; SETHE, *Urk.* iv. 1013–14 (300) A, B a, b, 1015–16 (301) a, c; part of D, PIEHL, *Inscr. hiéro.* I Sér. cviii [D δ].

Ceiling. Texts (incomplete), SCHEIL, p. 603; SETHE, *Urk.* iv. 1014–15 (300) b, e, g, 1016–17 (301) b, d, e.

Finds

Stela of deceased, dedicated by son Ḥaty 𓏤𓏤𓏤, Scribe, in Turin Mus. 1644. Texts, MASPERO in *Rec. de Trav.* iv (1883), p. 129; titles, SETHE, *Urk.* iv. 1018 (302); names, LIEBLEIN, *Dict.* No. 806, cf. Supp. p. 960; BRUGSCH, *Thes.* 1152 [top]. See FABRETTI, ROSSI, and LANZONE, *R. Mus. di Torino*, p. 182; ORCURTI, *Cat.* ii, pp. 32–3 [41].

Fragment of relief, with titles of deceased and names of relatives, in Turin Mus. 1643. Texts, MASPERO, op. cit. p. 129 [bottom]; titles, SETHE, *Urk.* iv. 1018 (303); names, LIEBLEIN, *Dict.* No. 534. See FABRETTI, op. cit. pp. 181–2; ORCURTI, *Cat.* ii, p. 36 [51, 1st object].

75. AMENḤOTP-SI-SE 𓇓𓏤𓂝𓄿, Second prophet of Amūn. Temp. Tuthmosis IV.

Sh. ʿAbd el-Qurna. (CHAMPOLLION, No. 2, L. D. *Text*, No. 54, HAY, No. 4.)
Mother, Paʿa 𓈖𓏤. Wife, Roy 𓏏𓏤𓏤𓏤.

Plan, p. 148. Map V, D–4, e, 8.

DAVIES, *The Tombs of Two Officials of Tuthmosis the Fourth*, pp. 1–18, with plan and section, pl. iii; CHAMP., *Not. descr.* i, pp. 481–3; L. D. *Text*, iii, p. 265; ROSELLINI MSS. 284, G 3.

Hall. View, M.M.A. photo. T. 2097.

(1) [1st ed. 1] [Deceased] with sons and attendants inspects four registers, workshops of Amūn. **I–III**, Weighing gold, carpenters and sculptors. **IV**, Jewellers.

DAVIES, pls. vii, viii, x [upper], pp. 10–11, 15; M.M.A. photos. T. 2087–9. Omitting deceased, CHIC. OR. INST. photos. 2895, 2897, 2900; BURTON MSS. 25644, 71–3; WILKINSON MSS. ii. 8 [top]; HAY MSS. 29822, 48, 50. **I–IV**, omitting weighing, WRESZ., *Atlas*, i. 241 [left], 242. **I** and part of **II**, SCHOTT photos. 5216–18. Weighing in **I**, WILKINSON, *M. and C.* ii. 10 (No. 78) = ed. BIRCH, i. 285 (No. 97); WILKINSON MSS. v. 104 [left]. Three sculptors in **I** and **II**, CHAMP., *Mon.* clxxxvi [2, 3]; ROSELLINI, *Mon. Civ.* xlv [6, 7]. Bead-makers in

IV, Davies in *M.M.A. Bull.* Pt. ii, Dec. 1920, fig. 9, cf. p. 38. Text of deceased, Sethe, *Urk.* iv. 1212–13 (360) E. Title of Zeserkara'sonb, Scribe, and text of weighing in **I**, Lepsius MS. 313 [bottom]; part, Brugsch, *Recueil*, pl. lxvi [bottom]; Champ., *Not. descr.* i, p. 483 [top].

(2) [1st ed. 2] Deceased inspects four registers. **I–III**, Recording grain. **IV**, Chariot-makers (belonging to (1)) and measuring crop.
Davies, *Two Officials*, pls. ix, x [lower], pp. 11–12; Wresz., *Atlas*, i. 241 [right], 243; M.M.A. photos. T. 2086–7; Chic. Or. Inst. photos. 2894, 2899; Hay MSS. 29822, 49, 51. **I, III, IV** (incomplete), Schott photos. 2063–4, 3696–7, 5214–15. **III**, Wilkinson, *M. and C.* ii. 46 (No. 90) = ed. Birch, i. 308 (No. 109); Wilkinson MSS. ii. 19 [bottom middle]. Measuring in **IV**, Borchardt in *Ä.Z.* xlii (1905), Abb. 2, cf. p. 71; Lyons, *Cadastral Survey of Egypt 1892–1907*, pl. ii facing p. 50. Text of deceased, Sethe, *Urk.* iv. 1213–14 (360) F; Lepsius MS. 304 [upper right].

(3) [1st ed. 3, 4] [Deceased], rewarded and displaying three rows of royal gifts to Temple of Amūn (including royal statuettes, ram-headed staves and vases, &c.), offers bouquet of Amūn to [Tuthmosis IV] with *ka*.
Davies, *Two Officials*, pls. xi, xii, pp. 12–15; M.M.A. photos. T. 2083–5. Deceased and some gifts, Hay MSS. 29822, 56–61, 29852, 155–6; gifts, omitting collars, Baud, *Dessins*, pls. xv, xvi [A]; collars, vases, and harp, Schott photos. 3694–5, 5221; gazelle-headed vase at bottom, Vercoutter, *L'Égypte* [&c.], pl. lvii [417], p. 348. Representation of electrum porch in front of Fourth Pylon at Karnak, in 2nd row, see Yoyotte in *Chronique d'Égypte*, xxviii (1953), pp. 28–30 with fig. 7. Texts, Sethe, *Urk.* iv. 1210–12 (360) C 1, 2, D 1–3.

(4) [1st ed. 7] Five registers. **I–V**, Banquet before [deceased and wife], including servants with provisions in **I**, man with bouquets, female musicians (with harp, lute, double-pipe, lyre, and tambourine), and small dancer, in **III**, decorated vases and seated musicians (woman with double-pipe and clappers) in **IV**, and arrival in chariot in **IV–V**.
Davies, *Two Officials*, pls. i (frontispiece), iv–vi, xviii, pp. 5–8; M.M.A. photos. T. 2090–4; Hay MSS. 29822, 52–3. Omitting some male guests and chariot, Schott photos. 2065–7, 2070, 3701, 3704, 4052, 5190–2, 5194–5204. Stands with vases and drinking-vessels (in front of deceased), Schott, *Das schöne Fest*, Abb. 19, cf. p. 840. Female guests and attendants (below deceased), Baud, *Dessins*, pl. vii [B]. Offerings and guests in **II**, Chic. Or. Inst. photos. 2896, 2898. **III–V**, Wresz., *Atlas*, i. 239–40; omitting vases and offerings, Wilkinson, *M. and C.* ii. 211 (No. 176), 235 (No. 187) = ed. Birch, i. 424 (No. 201), 439 (No. 212); Wilkinson MSS. ii. 18 [left]. **III**, Burton MSS. 25644, 23–5; Hay MSS. 29852, 149–50, 152–4, 159; musicians, Champ., *Mon. Civ.* xcviii [3]; Cailliaud, *Arts et métiers*, pl. 40 A [1–6]; Nestor l'Hôte MSS. 20404, 76; harpist and lutist, Hickmann, *45 Siècles de Musique*, pl. xlii [B]; lutist, Bruyère, *Rapport (1934–1935)*, Pt. 2, fig. 65, cf. p. 118; girl with tambourine, Hickmann in *Ann. Serv.* li (1951), fig. 2, cf. p. 321. Vases in **IV**, Prisse, *L'Art égyptien*, ii, 82nd pl. [5–7], 'Jarres et amphores'; Hay MSS. 29852, 157–8, 29853, 166–7. Arrival in chariot in **IV–V**, Farina, *Pittura*, pl. xcvi. Texts, Sethe, *Urk.* iv. 1214–16 (360) H; titles of deceased and wife, Lepsius MS. 312 [bottom left]; some names in **III–IV**, Champ., *Not. descr.* i, pp. 482 [A–D], 830 [A]; texts of Zeserkara'sonb, Scribe, and of groom, in **IV**, Wilkinson MSS. v. 273 [top left].

(5) [1st ed. 6] Stela, at top, deceased purified by four priests, with personified *zad*-pillar and Western emblem. At sides, four registers, **I–IV**, offering-scene and men with provisions.
Davies, *Two Officials*, pl. xv, p. 16; Hermann, *Stelen*, pl. 6 [b], pp. 63–6; M.M.A. photos.

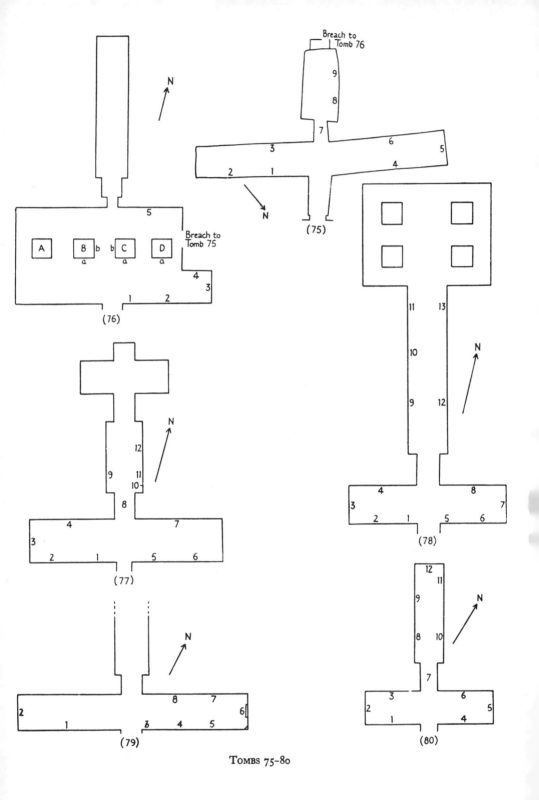

TOMBS 75–80

T. 2096–7. Name and title of deceased, CHAMP., *Not. descr.* i. 830 [B], [to p. 482, last line but one]; part of text in **IV** on right, LEPSIUS MS. 312 [bottom right].

(6) [1st ed. 5] Procession received by wife, daughters, and other songstresses of Amūn, holding sistra, with three rows of men holding papyrus-stalks approaching temple-pylon with colossal statues, and autobiographical text.

DAVIES, *Two Officials*, pls. ii [lower], xiii, xiv, pp. 8–10; M.M.A. photos. T. 2078–82, 2095. Omitting 3rd row of men, WRESZ., *Atlas*, i. 6 a, 238; incomplete, SCHOTT photos. 2069, 3703, 5207–13. Wife and daughters, DAVIES in *M.M.A. Bull.* Pt. ii, Nov. 1921, fig. 5, cf. p. 24, note 3. Pylon and some men, FARINA, *Pittura*, pl. xcv; pylon, CHAMP., *Not. descr.* i, p. 482; BORCHARDT in SETHE, *Untersuchungen*, v (1912), Abb. 18, cf. p. 28, note 1; statues at pylon, HAY MSS. 29822, 54; middle row of men, and women with sistra at bottom, CHIC. OR. INST. photo. 2893; part, WILKINSON MSS. ii. 13 [top right]. Texts, SETHE, *Urk.* iv. 1208–10 (360) A, B; names of daughters, and inscribed sistrum, LEPSIUS MS. 313 [top and middle].

Inner Room.

(7) [1st ed. 8] Right thickness, deceased leaving tomb 'to see Amūn when he rises'.
See DAVIES, *Two Officials*, p. 18. Text, SETHE, *Urk.* iv. 1216 (360) I.

(8) [1st ed. 10] Two registers, funeral ceremonies. **I**, Two scenes, **1**, [priest] and two female mourners before empty chair in booth, **2**, remains of Abydos pilgrimage. **II**, Similar scene to **I**, **1**, and procession of priests and two men with candles.

DAVIES, *Two Officials*, pl. xvii, p. 17; M.M.A. photo. T. 2099. Sailing-boat in **I**, **2**, and priests in **II**, SCHOTT photos. 2072, 5223, 5225. Men with candles, DAVIES in *J.E.A.* x (1924), pl. v [2], p. 10; WILKINSON MSS. v. 92 [top right]; HAY MSS. 29822, 55.

(9) [1st ed. 9] [Priest] offers to deceased and wife.

DAVIES, *Two Officials*, pl. xvi, p. 17; M.M.A. photo. T. 2098. Text, SETHE, *Urk.* iv. 1214 (360) G; titles, LEPSIUS MS. 304 [upper left].

76. THENUNA ▭▭▯, Fan-bearer on the right of the King. Temp. Tuthmosis IV.
Sh. ʿAbd el-Qurna. (CHAMPOLLION, No. 1, WILKINSON, No. 17, L. D. Text, No. 55.)
Wife, Nebttaui ▽▭.

Plan, p. 148. Map V, D–4, d, 8.

CHAMP., *Not. descr.* i, pp. 480–1; WILKINSON, *Topography of Thebes*, pp. 148–9. Plan, BOURIANT in *Rec. de Trav.* xi (1889), p. 156.

Hall.

(1) [1st ed. 6] Deceased offers on braziers.

M.M.A. photo. T. 2100; braziers on altar, SCHOTT photo. 8399. Text, BOURIANT, op. cit. p. 157 [a]; PIEHL, *Inscr. hiéro.* 1 Sér. cviii–cix [E γ]; HELCK, *Urk.* iv. 1579 (517); LEPSIUS MS. 314 [top right]; titles, BRUGSCH, *Recueil*, pl. lxvi [3]; part, CHAMP., *Not. descr.* i, p. 480; L. D. Text, iii, p. 266 [a].

(2) [1st ed. 5] Deceased inspects four registers, **I–IV**, recording cattle.

M.M.A. photo. T. 2101. Incomplete, WRESZ., *Atlas*, i. 244; FARINA, *Pittura*, pl. cxvi; HAY MSS. 29818, 38. **I–IV**, CHIC. OR. INST. photo. 2901. Cowherd in **I**, MEKHITARIAN, *Egyptian Painting*, pl. on p. 113. Scribes, and **IV**, SCHOTT photos. 3692, 5239, 5242–3,

8398, 8400; two scribes and overseer, WILKINSON, *M. and C.* iii. 315 (No. 386, a–c), 2 Ser. i. 128 (No. 439) = ed. BIRCH, ii. 296 (No. 425, a–c), 445 (No. 482); WILKINSON MSS. v. 92 [top left].

(3) [1st ed. 4] Man offers bouquet of Amūn to deceased. Sub-scene, offering-bringers.

M.M.A. photo. T. 2102; SCHOTT photos. 3691, 5244, 8396–7. Vases in sub-scene, HAY MSS. 29852, 147, 29853, 165. Text, BOURIANT in *Rec. de Trav.* xi (1889), p. 157 [b]; HELCK, *Urk.* iv. 1578 (517); ll. 1–5, PIEHL, *Inscr. hiéro.* 1 Sér. cviii [E a]; ll. 5–12, BRUGSCH, *Recueil*, pl. lxvi [2 a].

(4) [1st ed. 3] Three registers. I, Parents seated. II, [Couple seated]. III, Two women seated on ground.

M.M.A. photo. T. 2103 [middle]. I and III, SCHOTT photos. 5250–1. Text, BOURIANT, op. cit. p. 157 [c].

(5) [1st ed. 1, 2] Tuthmosis IV and Ḥathor in kiosk with deceased offering pectoral to them, and four registers, I–IV, New Year gifts, including [gold statuettes of Tuthmosis IV censing before himself and his mother Queen Tiʿa], jewellery, floral vases, and sphinxes.

M.M.A. photos. T. 2104–5; CHIC. OR. INST. photos. 2899–2900; SCHOTT photos. 3693, 5228–30, 5236–7, 5252, 5255–9. I–IV, WRESZ., *Atlas*, i. 46 [a]; SÄVE-SÖDERBERGH, *Four Eighteenth Dynasty Tombs (Private Tombs at Thebes*, i), pl. lxxii, and fig. 1, cf. pp. 50–1; CAPART and WERBROUCK, *Thèbes*, fig. 107 (from WRESZINSKI); HAY MSS. 29852, 167–71, 176–93, 29853, 193, 195. Statuette of Queen, and bracelets, CHAMP., *Not. descr.* i, p. 481. Two vases, ROSELLINI, *Mon. Civ.* lix [9, 10]; floral vase, PRISSE, *L'Art égyptien*, ii, 79th pl. [11], 'Vases cratériformes'; details of two foreign vases, VERCOUTTER, *L'Égypte* [&c.], pl. lv [405 a, b], p. 345. Necklace in II, JÉQUIER, *Frises*, fig. 179. Decoration of kiosk and colonnette, HAY MSS. 29852, 172–5. Remains of text of deceased, HELCK, *Urk.* iv. 1577 (517).

Pillars.

B (a) [1st ed. 7] Deceased with staff, and wife. (b) [1st ed. 8] Deceased and wife with text of Valley Festival, and three offering-bringers with bouquets and birds below.

M.M.A. photos. T. 2106, 2108 [left]; SCHOTT photo. 8401. Texts, BOURIANT in *Rec. de Trav.* xi (1889), p. 158 [h, i]; omitting part of (b), HELCK, *Urk.* iv. 1581 C, D (517); text of (a), CHAMP., *Not. descr.* i, p. 829 [to p. 480, l. 22]; name of wife at (b), LEPSIUS MS. 314 [top left].

C (a) [1st ed. 10] Deceased with staff going forth. (b) [1st ed. 9] Deceased and wife offering, and three offering-bringers below.

M.M.A. photos. T. 2107, 2108 [right]. Texts, BOURIANT, op. cit. p. 158 [f, g]; omitting part of (b), HELCK, *Urk.* iv. 1580 A, B (517); text of (b), PIEHL, *Inscr. hiéro.* 1 Sér. cviii [E β].

D (a) [1st ed. 11] Deceased with staff and [wife] going forth 'to see the sun-disk', and three offering-bringers below.

M.M.A. photo. T. 2109; offering-bringers, SCHOTT photo. 5260. Text, BOURIANT, op. cit. p. 158 [e]; part, BRUGSCH, *Recueil*, pl. lxvi [2 b].

77. PTAḤEMḤĒT ⎡□⎤ 𓏏 𓄿 ⎡⟶⎤, Child of the nursery, Overseer of works in the Temple of Amūn, Standard-bearer of the Lord of the Two Lands. Usurped

by ROY 〰𓏭𓏭, Overseer of sculptors of the Lord of the Two Lands. Temp. Tuthmosis IV.

Sh. ʿAbd el-Qurna. (CHAMPOLLION, No. 8 bis, L. *D. Text*, No. 62.)
Wife (?) (of Ptaḥemḥēt), Meryt 𓏭𓏭𓏭. Wife (of Roy), Raʿḥuy 〰𓏭𓏭𓏭𓏭.

Plan, p. 148. Map V, D–4, d, 9.

CHAMP., *Not. descr.* i, pp. 497–8. MOND photos. of all walls.

Hall.

(1) [1st ed. 1] [Roy], followed by wife with sistrum and *menat* and [man] with bouquet, pours ointment on braziers. Sub-scene, sketch of food and meat, and man offering haunch.
SCHOTT photos. 4397, 8274–6. Sistrum, JÉQUIER, *Frises*, fig. 213. Sub-scene, BAUD, *Dessins*, pl. xvii, pp. 115–16. Titles, L. *D. Text*, iii, p. 272.

(2) Three registers. **I,** Two girls with sistra and *menats* [before deceased?]. **II,** Guests at banquet. **III,** Offering-bringers.
I–II, SCHOTT photos. 4396, 4398.

(3) Stela, double-scene at top, [deceased and wife] adore Western goddess, and adore Osiris. At sides, two registers, **I–II,** priest offers to couple.
SCHOTT photos. 4394–5.

(4) [1st ed. 2] Two offering-bringers, and [deceased] displaying royal gifts to Temple, with naos, ritual jars, &c., above him, before Tuthmosis IV in kiosk with captives with name-rings (blank) on base.
Naos, jars, &c., SCHOTT photo. 8277; naos and ten captives (sketch), BAUD, *Dessins*, figs. 47–8. Text of Temple of Tuthmosis IV, HELCK, *Urk.* iv. 1599 (525) (name wrongly restored as Amenemḥab); L. *D. Text*, iii, p. 272; titles, CHAMP., *Not. descr.* i, pp. 497 [bottom], 498 [A].

(5) [1st ed. 5] [Deceased], followed by man with bouquet, offers on braziers.
SCHOTT photos. 4015, 8279–81. Brazier, KYLE in *Rec. de Trav.* xxxi (1909), fig. 3, cf. p. 53; JÉQUIER in *Rec. de Trav.* xxxii (1910), fig. 2, cf. p. 167. Text of deceased, HELCK, *Urk.* iv. 1600 [upper].

(6) [1st ed. 4] Two registers. **I–II,** Banquet before deceased, including musicians (female harpist and lutist, and male clapper) with song in **I.**
Incomplete, SCHOTT photos. 4016–18, 6897–9, 8282. Female guests and attendants in **I,** PRISSE, *Mon.* pl. xlv; one group, WILKINSON, *M. and C.* iii. 389 (No. 417 a) = ed. BIRCH, ii. 353 (No. 458); WILKINSON MSS. ii. 20 [bottom right]. Girl-attendant in fringed garment in **II,** WEGNER in *Mitt. Kairo*, iv (1933), pl. xviii [c]. Song in **I,** and names of three male guests in **II,** HELCK, *Urk.* iv. 1601 (525); names, LEPSIUS MS. 319 [middle upper].

(7) [1st ed. 3] Two registers. **I,** [Deceased] with military escort before Tuthmosis IV. **II,** Offering-bringers.
I, SCHOTT photo. 8278.

Passage.

(8) Above inner doorway, double-scene, [deceased] with bouquet and offerings before Anubis.

(9) Remains of funeral procession, with Abydos pilgrimage at bottom. Rowing-boat·and prow of another, SCHOTT photo. 8283.

(10) Sketch of squatting scribe.
BAUD, *Dessins*, fig. 49.

(11) At top, [deceased] fowling.
WEGNER in *Mitt. Kairo*, iv (1933), pl. xviii [a]. Text, HELCK, *Urk.* iv. 1600 [lower].

(12) At top, men carrying fish, and at bottom, vintage with offerings to Termuthis.
WEGNER, op. cit. pl. xviii [a left, b]; SCHOTT photos. 4019–20.

78. ḤAREMḤAB ⟨𓀏𓈖𓏤𓅓𓏤⟩, Royal scribe, Scribe of recruits. Temp. Tuthmosis III to Amenophis III.

Sh. ʿAbd el-Qurna. (CHAMPOLLION, No. 4, L. D. *Text*, No. 57, WILKINSON, No. 16, HAY, No. 23.)

Mother, Esi 𓄿𓏤𓁐. Wife, Ithuy ⟨𓄿𓏤𓁐⟩.

Plan, p. 148. Map V, D–4, d, 9.

BOURIANT, *Tombeau de Harmhabi* in VIREY, *Sept Tombeaux thébains* (*Mém. Miss.* v, 2), pp. 413–34, with plan, p. 415, fig. 1; CHAMP., *Not. descr.* i, pp. 487–92, with plan; WILKINSON, *Topography of Thebes*, pp. 144–8; cf. L. D. *Text*, iii, pp. 269–70. View of interior, M.M.A. photo. T. 1967.

Hall.

(1) [Deceased with wife offers on braziers?]
BOURIANT, on pl. i [left]; M.M.A. photo. T. 1954. Title, BRUGSCH in *Ä.Z.* xiv (1876), p. 100 [middle lower].

(2) [1st ed. 1] Deceased and wife seated, with two girls followed by female musicians (lutists and harpist) offering floral vases to them, and remains of banquet. Sub-scene, offering-bringers with bulls (one garlanded).
BOURIANT, pl. i, p. 428; M.M.A. photos. T. 1952–3. Main scene, CHIC. OR. INST. photos. 6142, 7867–9; girls, musicians, and men with garlanded bull, SCHOTT photos. 2129, 6882–4, 8404; napkin held by first girl, JÉQUIER, *Frises*, fig. 325; MEKHITARIAN in *Mitt. Kairo*, xv (1957), pl. xli [1], p. 189; girls and musicians, WRESZ., *Atlas*, i. 91 c [12, 13]; WILKINSON, *M. and C.* ii. 237 (No. 191) = ed. BIRCH, i. 441 (No. 216); WILKINSON MSS. ii. 22 [bottom]; musicians, HICKMANN, *45 Siècles de Musique*, pl. xlii [c]. Texts, HELCK, *Urk.* iv. 1594 [bottom]–1595.

(3) Stela, two registers, I, double-scene, deceased adores Anubis and [deceased] adores Osiris, II, [offering-scene] to couple on left.
BOURIANT, fig. 3, cf. pp. 425–6; M.M.A. photo. T. 1958. Texts of I, HERMANN, *Stelen*, p. 8* [46–7], cf. 39.

(4) [1st ed. 2] Tuthmosis IV and goddess in kiosk with deceased preceded by fan-bearers offering bouquet to him, and four registers, I–III, recording recruits, preparation of provisions, and doorway (of storehouse) of Tuthmosis IV, IV, three brothers with flowers, and men with bull (with decorated horns), ibex, and hare.

BOURIANT, pl. iii, pp. 419–20; M.M.A. photos. T. 1959–62; CHIC. OR. INST. photos. 2902–3, 3004, 6143, 7863–7. Fan-bearers, and **I–IV**, SCHOTT photos. 2127–8, 3855–6, 6885–9, 6900–2, 7018–19, 8405–6. **I–III**, WRESZ., *Atlas*, i. 245–6; HAY MSS. 29823, 95–6; BURTON MSS. 25644, 19, 33. Boat-standard in **I**, FAULKNER in *J.E.A.* xxvii (1941), pl. v [10], p. 15; men eating, and man offering to squatting man in **II**, CHAMP., *Mon.* clix [1, 2]; ROSELLINI, *Mon. Civ.* cxvi [1, 2]; men filling baskets of bread in **II**, and doorway in **III**, FARINA, *Pittura*, pl. cxi; seated men with provisions in **II**, and scribe in **III**, MEKHITARIAN in *Mitt. Kairo*, xv (1957), pls. xxxix [3], xlii [1], p. 189; scribes with recruits, and doorway in **III**, WILKINSON, *M. and C.* ii. 33 (No. 85), 102 (No. 96, 1) = ed. BIRCH, i. 300 (No. 104), 346 (No. 115, 1); WILKINSON MSS. ii. 14 [bottom, right and middle]; man with ibex and hare in **IV**, DAVIES (Nina), *Anc. Eg. Paintings*, i, pl. xxxviii; id. *Eg. Paintings* (Penguin), pl. 5; MEKHITARIAN, *Egyptian Painting*, pl. on p. 104. Text of brothers in **IV**, HELCK, *Urk.* iv. 1592 [bottom]–1593 [top].

(5) [Deceased] with offering-bringers offers on braziers (?).

BOURIANT, pl. ii [right], with fig. 4, cf. pp. 427–8; M.M.A. photos. T. 1955–6 [right]; SCHOTT photos. 8407–10. Chicks (below altar), MEKHITARIAN in *Mitt. Kairo*, xv (1957), pl. xxxix [1], p. 188. Text, HELCK, *Urk.* iv. 1593 [middle].

(6) [1st ed. 4] Two registers. **I**, [Deceased and mother (?)], with girl offering vase to them, and remains of guests. **II**, Deceased with small princess [Amenemōpet] as royal concubine on his knee, and mother with ibex under her chair, with two girls offering floral vases to them, and female lutists and dancer, guests, and attendants. Sub-scene, offering-bringers, butchers, and blind male musicians (singer, lutist, and harpist).

BOURIANT, pl. ii, pp. 426–7; WRESZ., *Atlas*, i. 251–2, 39 a; M.M.A. photos. T. 1956–7; SCHOTT photos. 2130–4, 2191–2, 3851–3, 5181–2, 6871–81, 8411–15. **I** and **II**, BURTON MSS. 25638, 62. **II** and sub-scene, WILKINSON, *M. and C.* ii. 194 (No. 160, 3), pl. xii facing p. 222 = ed. BIRCH, i. 411 (No. 182, 3), pl. xi facing p. 431; FARINA, *Pittura*, pls. cix, cx; WILKINSON MSS. ii. 16 verso; group with girls adjusting ear-rings in **I**, now destroyed, BURTON MSS. 25644, 34; WILKINSON MSS. ii. 19 [bottom right]; HAY MSS. 29823, 110, 29853, 103. **II**, MASPERO, *L'Arch. ég.* (1887), fig. 163, (1907), fig. 172; HOREAU, *Panorama d'Égypte et de Nubie*, fig. on p. 20 verso [bottom]; JÉQUIER, *Hist. Civ.* fig. 257 (omitting some guests); deceased with princess in **II**, DESROCHES-NOBLECOURT in SCHAEFFER, *Ugaritica*, iii, p. 201, fig. 170 (from BOURIANT); musicians and guests, SACHS, *Musikinstrumente*, Abb. 66; musicians, CHAMP., *Mon.* clix [3], cf. cliv [2], and *Not. descr.* i, p. 833 [A]; ROSELLINI, *Mon. Civ.* xcvi [2]; DAVIES in *M.M.A. Bull.* Pt. ii, Feb. 1928, fig. 3, cf. p. 61; HICKMANN, *45 Siècles de Musique*, pl. xlii [A]; BURTON MSS. 25644, 20–2; lutists, STRÖMBOM, *Egyptens Konst*, fig. 110; details, MEKHITARIAN in *Mitt. Kairo*, xv (1957), pls. xxxix [4], xl, xli [2], xlii [2, 3], pp. 189, 190. Musicians in sub-scene, DAVIES in *M.M.A. Bull.* Pt. ii, Dec. 1923, fig. 11 [upper middle], cf. p. 47; HICKMANN, op. cit. pl. xlii [D]; harpist, SCHOTT in *Mélanges Maspero*, i, pl. i [2], p. 461; singer, MEKHITARIAN, *Egyptian Painting*, pl. on p. 102; two butchers (one now destroyed) with heads of oxen, WILKINSON, *M. and C.* ed. BIRCH, ii. 460 (No. 492). Texts, HELCK, *Urk.* iv. 1591–2; text above deceased and mother in **II**, LEPSIUS MS. 314 [bottom].

(7) Stela, with Wepwaut-jackal and man libating below on right half.

BOURIANT, fig. 2, cf. pp. 424–5.

(8) [1st ed. 3] [Tuthmosis IV on throne with goddess in kiosk, and deceased] bringing five registers, **I–V**, foreign tribute. **I** and **II**, Egyptians with tribute and horses. **III**, Syrians with

vases, including one with ram. **IV**, Nubians with produce, women and children. **V**, Dancing Nubians with trumpeter and drummer received by Egyptian soldiers, and Nubians with cattle.

BOURIANT, pl. iv, pp. 422–3; M.M.A. photos. T. 1963–6 [left]. Throne [with sphinx trampling Asiatic, on arm], HAY MSS. 29823, 104–6; sketch of sphinx, WILKINSON MSS. v, on 150; colonnette of kiosk, PRISSE, *L'Art égyptien*, i, 19th pl. [3] 'colonnettes en bois'. **I–V**, CHIC. OR. INST. photos. 2904, 7870–5. **I**, SCHOTT photo. 5183. **III–IV**, CHAMP., *Mon.* clviii [1, 2]; WRESZ., *Atlas*, i. 247–8; MEYER, *Fremdvölker*, 743–7; parts, BURTON MSS. 25644, 18, 27, 25638, 63; part of **III**, JÉQUIER, *Hist. Civ.* fig. 248; three Syrians on right in **III**, WILKINSON MSS. v. 91 [upper]; ram-vase on stand, SCHOTT photo. 3888; lion-headed vase, VERCOUTTER, *L'Égypte* [&c.], pl. xxxvii [250], p. 312. **IV** and **V**, WILKINSON MSS. ii. 7 [lower middle and bottom]; four Nubians with skins and ivory in **IV** (part now gone), BURTON MSS. 25644, 26; **V**, SCHOTT photos. 3854, 3887, 7021–3; Nubian women with children in **IV**, and Nubian dancers in **V**, WILKINSON, *M. and C.* i. 404 (No. 73, 3–6), ii. 264 (No. 201) = ed. BIRCH, i. 272 (No. 88, 3–6), 458 (No. 226); women with children, and men with cattle in **IV**, BAUD, *Dessins*, pl. xviii, p. 120; women with children, DAVIES (Nina), *Anc. Eg. Paintings*, pl. xxxix; SCHOTT photo. 7020; Nubian dancers in **V**, GALASSI, *Tehenu*, p. 133, figs. 117–18; CAPART and WERBROUCK, *Thèbes*, fig. 205 (from WRESZINSKI); BRUNNER-TRAUT, *Der Tanz im alten Ägypten*, Abb. 40, cf. p. 72; first three dancers, FARINA, *Pittura*, pl. cxii; HAY MSS. 29853, 103; third dancer, DAVIES in *M.M.A. Bull.* Pt. ii, Dec. 1923, fig. 8, cf. p. 46; DAVIES (Nina), op. cit. pl. xl (CHAMPDOR, P̣t. iii, 5th pl.); DRIOTON, *La Danse dans l'ancienne Égypte* in *La Femme Nouvelle*, Oct. 1948 (Cairo), fig. on p. 31; id. in *Egyptian Education Bureau. London. The Bulletin*, No. 35 (1949), 2nd pl. after p. 64; MEKHITARIAN, *Egyptian Painting*, pl. on p. 105; CHAMPDOR, *Thèbes aux Cent Portes*, fig. on p. 175; drummer, SACHS, *Musikinstrumente*, Abb. 38 (from BOURIANT, but called Luxor). Text in **I**, CHAMP., *Not. descr.* i, p. 489; texts in **II** and **IV**, HELCK, *Urk.* iv. 1592 [near bottom].

Passage.

(9) [1st ed. 5] Four registers. **I–III**, Funeral procession, including oxen with decorated horns dragging sarcophagus, 'Nine friends', and *teknu*, in **I**, statuettes of deceased and of *ba*-bird and funeral outfit carried in **II**, and chariot with horse and chariot carried in **III**. **IV**, Abydos pilgrimage.

BOURIANT, pl. v [upper], pp. 430–1; WILKINSON, *M. and C.* 2 Ser. Supp. pl. 83, cf. iii. 387 (No. 417, 1) = ed. BIRCH, iii, pl. lxvi facing p. 444, cf. ii. 352 (No. 457, 1); M.M.A. photos. T. 1968–70; CHIC. OR. INST. photos. 6099–6101, 7875, 7881–4; BURTON MSS. 25638, 50 verso–60, 25644, 31–2; WILKINSON MSS. ii. 48; HAY MSS. 29823, 97–101, 29853, 121; incomplete, SCHOTT photos. 2076–7, 3838–45, 3847, 5167–74, 6890, 6907–9, 7024–5. Right part of **I–III**, WERBROUCK, *Pleureuses*, pl. vii [lower], figs. 67, 113, cf. pp. 42–3; parts of **II–IV**, BAUD, *Dessins*, figs. 50–2; men dragging [*teknu*], and mourners in **I** and **IV**, WEGNER in *Mitt. Kairo*, iv (1933), pl. xvii [a, b]; some mourners, MEKHITARIAN, *Egyptian Painting*, pls. on pp. 100–1; upper mourners in **IV**, LHOTE and HASSIA, *Chefs-d'œuvre*, pl. 33; necklace carried by man at left end of **II**, JÉQUIER, *Frises*, fig. 144; three boats in **IV**, LÜDDECKENS in *Mitt. Kairo*, xi (1943), pp. 76–82 [30 a, 30 b], with Abb. 25; third boat from left, WILKINSON, *M. and C.* ed. BIRCH, ii. 211 (No. 405). Texts of boats, BURTON MSS. 25644, 36; part, CHAMP., *Not. descr.* i, pp. 834–5 [to p. 491]; BRUGSCH, *Recueil*, pl. lxvi [1 a, c, d, e].

(10) [Man] with offering-list, offering, and papyrus-bouquet, before [deceased] and wife.

BOURIANT, pl. v [upper right and lower left], p. 432; M.M.A. photos. T. 1970 [right]–1972 [left]; CHIC. OR. INST. photos. 6098–9; bouquet, SCHOTT photo. 6910. Titles of deceased, HELCK, *Urk.* iv. 1595–6 [A].

(11) [1st ed. 6] Funeral outfit and weighing-scene with Thoth and Maᶜet before assessors with cartouches of Tuthmosis III and IV and Amenophis II and III above them, and Osiris.

BOURIANT, pl. v [lower, middle and right], pp. 432–3; M.M.A. photos. T. 1972 [right]–1974; CHIC. OR. INST. photos. 6096–7, 7885–6; WILKINSON MSS. ii. 38. Weighing-scene and Osiris, L. *D.* iii. 78 [a, b]; weighing-scene and text, BURTON MSS. 25638, 61, 25644, 37; outfit, SCHOTT photos. 5175–6; necklace and *wesekh*-collar, JÉQUIER, *Frises*, figs. 143, 187. Text in weighing-scene, HELCK, *Urk.* iv. 1589–90; part and cartouches, CHAMP., *Not. descr.* i, pp. 835 [to p. 492, l. 5], 492 [A]; BRUGSCH, *Recueil*, pl. lxvi [1 b]; DE ROUGÉ, *Inscr. hiéro.* ccxlix [right]; NEWBERRY in *P.S.B.A.* xxv (1903), p. 295; WILKINSON MSS. v. 80 [bottom]; cartouches, ROSELLINI, *Mon. Stor.* Text, i, pl. ii facing p. 205 [iii]; YOUNG, *Hieroglyphics*, pl. 98 [7]; IDELER, *Hermapion*, pl. xx [lower middle].

(12) [1st ed. 8] Three registers before deceased and wife. I–II, Rites before mummies, including dragging two mummies to shrine. III, Offering-list ritual and butchers. Sub-scene, servants with animals (including humped bull) and provisions.

BOURIANT, pl. vi [lower, and upper right], pp. 428–9; M.M.A. photos. T. 1975–7; dragging mummies to shrine and other details, SCHOTT photos. 3857, 5179–80, 6891, 6906. I–III, CHIC. OR. INST. photo. 6102; left part of I, WILKINSON, *M. and C.* 2 Ser. ii. 385 (No. 494) = ed. BIRCH, iii. 429 (No. 626); WILKINSON MSS. v. 90 [upper]. Sub-scene, HAY MSS. 29823, 108–9, 111. Opening the Mouth texts in II, SCHIAPARELLI, *Funerali*, ii, pp. 287–8 [vii]; texts above deceased and wife, HELCK, *Urk.* iv. 1596 [B]; LEPSIUS MS. 315 [bottom].

(13) [1st ed. 7] Deceased and family fowling and fishing. Sub-scene, netting fowl (with group of pelicans) and netting fish.

BOURIANT, pl. vi [upper, middle, and left], pp. 429–30; WRESZ., *Atlas*, i. 70, 249–50; M.M.A. photos. T. 1978–84; CHIC. OR. INST. photos. 6103–4, 7876–80; details, SCHOTT photos. 2074–5, 5177–8; of birds, MEKHITARIAN in *Mitt. Kairo*, xv (1957), pls. xxxix [2], xli [3], pp. 188, 190. Fowling, BURTON MSS. 25644, 35 verso; fish speared, papyrus-clump, and small daughter, LHOTE and HASSIA, *Chefs-d'œuvre*, pl. 58; daughter, WEGNER in *Mitt. Kairo*, iv (1933), pl. xvi [b]; part of papyrus-clump with butterfly at left end, KEIMER in *Ann. Serv.* xxxvii (1937), pl. xxvi, p. 162; grasshopper on papyrus-clump at right end, CHAMP., *Mon.* ccclxiii bis [middle left] (called Beni Hasan); ROSELLINI, *Mon. Civ.* xiv [9]; grasshopper, WILKINSON, *M. and C.* iii. 50 (No. 340, 21) = ed. BIRCH, ii. 113 (No. 369, 21); KEIMER in *Ann. Serv.* xxxii (1932), p. 132, fig. 32, and xxxiii (1933), pl. xiii [a], p. 102; MEKHITARIAN, *Egyptian Painting*, pl. on p. 103; WILKINSON MSS. v. 89 [bottom left] (papyrus-clump above perhaps from another tomb); detail of fish, SMITH, *Art . . . Anc. Eg.* pl. 108 [A]. Sub-scene, WILKINSON, *M. and C.* iii. 37 (No. 333) = ed. BIRCH, ii. 102 (No. 361); WILKINSON MSS. ii. 19 [top and middle left]; HAY MSS. 29823, 102–3, 107; SCHOTT photos. 3834–7, 6892–6, 6903–5; draw-net with fish, FARINA, *Pittura*, pl. cxiii; part, LHOTE and HASSIA, *Chefs-d'œuvre*, pl. 92; boat with fish in rigging (fragment in Florence Mus. 2470, see infra), FORBES in SINGER, &c., *A History of Technology*, i, fig. 164, cf. p. 265 (drawn by NINA DAVIES from WILKINSON MSS.); trapper and pelicans, PETRIE, *Arts and Crafts*, fig. 69; CAPART and WERBROUCK, *Thèbes*, fig. 201; DAVIES (Nina), *Anc. Eg.*

Paintings, i, pl. xli; LHOTE and HASSIA, *Chefs-d'œuvre*, pl. 84; trapper and pelican, DAVIES in *M.M.A. Bull.* Pt. ii, Dec. 1923, fig. 6, cf. p. 46; pelicans, CHAMP., *Mon.* ccclxiii bis [top left] (called Beni Hasan); ROSELLINI, *Mon. Civ.* xiv [2]. Texts of main scene, HELCK, *Urk.* iv. 1593 [bottom]–1594 [middle].

Blocks in Museums

In Florence Mus. 2470–4. Texts, BEREND, *Prin. Mon. . . . Florence*, pp. 3–6; see SCHIAPARELLI, *Mus. . . . Firenze*, pp. 317–20 [1591–5]; ROSELLINI, *Oggetti di antichità egiziane*, pp. 50–1 [51]; MIGLIARINI, *Indication succinte des monuments égyptiens*, p. 58. No. 2470, part of fishing-boat (cf. supra (13)), MINTO, *Il Regio Museo archeologico di Firenze*, fig. on p. 28 [lower]; CAROTTI, *L'Arte dell'antico Egitto*, fig. 236. No. 2471, son Pewaḥ 𓈖𓏏𓁐 and woman offering, DONADONI, *Arte egizia*, pl. ii facing p. 18; Pewaḥ, WILKINSON MSS. v. 141 [top middle]. Nos. 2472–3, female mourner before mummies, and two kneeling female mourners and two girls, WERBROUCK, *Pleureuses*, pls. xix, xx, pp. 86–7; GALVANO, *L'Arte egiziana antica*, figs. 65, 55. No. 2474, fragment of ceiling with grape-decoration.

Frame of stela, with Wepwaut-jackals at top, and double-scene, deceased kneeling adoring, in Louvre, C. 68–70, (from DROVETTI excavations), SEYFFARTH MSS. v. 4223; DEVÉRIA squeezes, 6167. ii, 139–40, i, 40. Texts, CHASSINAT in *Mém. Miss.* v [2], pp. 486–8; titles, HELCK, *Urk.* iv. 2088 [F]. See BOREUX, *Guide*, i, p. 84; PIERRET, *Rec. d'inscr.* ii. 57 [lower].

79. MENKHEPER 𓏠𓂓 or MENKHEPERRAʿSONB ☉𓏠𓂓𓊪𓋴, Overseer of the granary of the Lord of the Two Lands, *waʿb*-priest in the Mortuary Temple of Tuthmosis III. Temp. Tuthmosis III to Amenophis II (?).

Sh. ʿAbd. el-Qurna. (CHAMPOLLION, No. 7, *L. D. Text*, No. 60.)
Father, Minnakht (tomb 87).

Plan, p. 148. Map V, D–4, d, 9.

VIREY, *Tombeau de Menkheper* in VIREY, *Sept Tombeaux thébains* (*Mém. Miss.* v, 2), pp. 323–36, with plan, p. 322; CHAMP., *Not. descr.* i, pp. 495–6; *L. D. Text*, iii, pp. 271–2; HAY MSS. 29824, 85. MOND photos. of all walls. Name and titles, WILKINSON MSS. v. 81 [upper middle right]; ROSELLINI MSS. 284, G 11–12.

Hall.

(1) [1st ed. 1–2] Deceased with attendants inspects four registers, **I–IV**, offerings for Festival of Amūn. **I**, Destroyed. **II**, Man driving bull. **III**, Man driving geese. **IV**, Men bringing ducks and eggs.

II and **III**, WRESZ., *Atlas*, i. 255 [B]. **III** and **IV**, SCHOTT photos. 4011, 8285. Texts, SETHE, *Urk.* iv. 1201 (354) A.

(2) [Imitation false door.] Three registers at left side, **I** and **II**, man offering to deceased in each, **III**, [man purifying deceased]. Remains of butchers at bottom on right.

(3) [1st ed. 10] Deceased offers on braziers, and six registers, **I–VI**, jars, offerings, braziers, man with foreleg before altar, and butchers.

CHIC. OR. INST. photo. 6472. Part, SCHOTT photos. 2102, 8290–3. Altar in **V**, JÉQUIER in *Rec. de Trav.* xxxii (1910), fig. 3, cf. p. 168. Remains of text, VIREY, p. 336; name and titles, SETHE, *Urk.* iv. 1204 (355) C.

(4) [1st ed. 9] Deceased and family fishing and fowling. Sub-scene, preparing birds.

See Virey, pp. 335–6. Main scene, Chic. Or. Inst. photo. 6471; fowling, Wresz., *Atlas*, i. 253; birds, Schott photos. 3683, 7066, 8294–5; dragon-fly at top, Champ., *Mon.* ccclxiii bis [bottom left] (called Beni Hasan); Rosellini, *Mon. Civ.* xiv [10]. Texts, Sethe, *Urk.* iv. 1202–3 (354) d, e.

(5) [1st ed. 8] Deceased inspects three registers, I–III, bringing produce, and vintage, with offering to Termuthis in II. Sub-scene, netting fish and carrying birds.

Virey, fig. 6 (giving imaginary reconstruction of fourth register), cf. pp. 332–5; Chic. Or. Inst. photos. 2906, 6470. Deceased, Mackay in *J.E.A.* x (1924), pl. ix [2], p. 41. I–III, Wresz., *Atlas*, i. 256; details in II and III, Schott photos. 3681–2, 7067–8; picking grapes in III, Jéquier, *Hist. Civ.* fig. 243 (called Pehsoukher). Text of deceased, Golenishchev MSS. 14 [h]; titles, Sethe, *Urk.* iv. 1204 (355) b.

(6) [1st ed. 7] Stela with autobiographical text.

Schott photos. 7069, 8289. Text, Virey, pp. 330–1; Sethe, *Urk.* iv. 1191–1200 (353); Helck, *Urk.* iv. 1515–38, c; Piehl, *Inscr. hiéro.* i Sér. cxxxvi–ix [s a]; part, Lüddeckens in *Mitt. Kairo*, xi (1943), pp. 43–5 [19].

(7) [1st ed. 5–6] Deceased with father and family inspects six registers, I–VI, funeral outfit (presented by King). Sub-scene, men bringing statuettes and funeral mask to seated people.

Chic. Or. Inst. photo. 2905. I–VI, Wresz., *Atlas*, i. 257; details of offerings, and deceased with family, Virey, pp. 327–9, figs. 2–5; part, Schott photos. 3672–5, 3679–80, 7081, 8288. Opening the Mouth instruments in I, see Schiaparelli, *Funerali*, ii, p. 294 [xviii]. Necklace in V, Jéquier, *Frises*, fig. 146. Texts of deceased and father, Piehl, *Inscr. hiéro.* i Sér. cxl [s β]; Sethe, *Urk.* iv. 1202 (354) c, 1204 (355) d, 1181 (347); title of father, Champ., *Not. descr.* i, p. 839 [to p. 496, l. 13]; *L. D. Text*, iii, p. 271 [β].

(8) [1st ed. 3–4] Deceased and wife with son Nebenmaʿet, Temple-scribe in the Mortuary Temple of Tuthmosis III, offering 'bouquet of Amūn in Ḥenketʿankh' to them, and three registers, banquet, with female musicians (double-pipe, lyre, and harp), and child dancer in I, clappers in II, male harpist in III, at Valley Festival. Sub-scene, bringing and preparing food, including men filling jars, cooks, and butcher's shop.

Chic. Or. Inst. photos. 2907, 6467–9. Offering-scene and texts, Virey, pp. 323–6 with fig. 1; details, Schott photos. 3670–1, 3677–8, 7070–80, 8286–7. I–III, and sub-scene (incomplete), Wresz., *Atlas*, i. 254, 255 [A], 47. Women with double-pipe and lyre, and dancer, in I, and harpist in III, Hickmann, *45 Siècles de Musique*, pl. xliii; harpist, Schott in *Mélanges Maspero*, i, pl. i [1], p. 460; Hickmann in *Bull. Inst. Ég.* xxxiv (1953), fig. 4, cf. p. 239; id. *Musicologie pharaonique*, fig. 4, cf. p. 107. Basket of bread in sub-scene, Schott, *Das schöne Fest*, pl. vii, p. 832. Part of texts of deceased and son, Sethe, *Urk.* iv. 1201 (354) B 1, 2, 1203–4 (355) a; Lepsius MS. 320 [top and middle]; part of text of son, *L. D. Text*, iii, p. 271 [γ]; title of son, Champ., *Not. descr.* i, pp. 496 [A], 839 [to p. 496, l. 1]; Piehl, *Inscr. hiéro.* i Sér. cxl [s γ]; hieratic text above scribe at left end of sub-scene, Sethe, *Urk.* iv. 1203 (354) F.

80. Dḥutnūfer ☧, Overseer of the treasury, Royal scribe. (Also owner of tomb 104.) Temp. Amenophis II.

Sh. ʿAbd el-Qurna. (Champollion, No. 6, L. D. Text, No. 59, Hay, No. 21.) Wife, Takhaʿt ☧.

Plan, p. 148. Map V, D–4, d, 9.

CHAMP., *Not. descr.* i, pp. 494–5 with plan; plan and sketches, HAY MSS. 29824, 82 verso–84 verso. MOND photos. of all walls. Titles of deceased and wife, ROSELLINI MSS. 284, G 10; L. D. *Text*, iii, p. 271 [middle].

Hall.

(1) Remains of titles of deceased and wife.

(2) Deceased and girl in [fishing and fowling scene].
BAUD, *Dessins*, fig. 53.

(3) [Priest], and girl holding sistrum and *menat*, with offerings and offering-list before deceased and [wife].
Menat, JÉQUIER, *Frises*, fig. 201. Text of deceased, HELCK, *Urk.* iv. 1476 [middle upper].

(4) Deceased offers on braziers with butchers below, and three registers behind him, I and II, men bringing food, ointment, flowers, birds, &c., III, remains of banquet, girl with sistrum and *menat* and [guests], before two men and woman. Sub-scene, laden boats.
CHIC. OR. INST. photo. 6109. Omitting sub-scene, HAY MSS. 29824, 83 [upper]. Left part of III, and sub-scene, SCHOTT photos. 2114, 7033–4.

(5) [Stela.] At sides, three registers (destroyed on right). I, Deceased kneeling with incense. II–III, Offering-bringers.

(6) [1st ed. 1] Deceased, wife, and small sister, with man offering bouquet of Amūn to them, and three registers, I–III, guests and musicians, including harpist in I, and female lutist, clapper, and lyre-player (all dancing), in III.
CHIC. OR. INST. photos. 6105–8. Incomplete, SCHOTT photos. 2121, 2190, 7026–32; deceased, MACKAY in *J.E.A.* x (1924), pl. ix [3], p. 41. Harpist in I, and musicians in III, HICKMANN, *45 Siècles de Musique*, pl. xliv; musicians, WRESZ., *Atlas*, i. 259 [upper]; HAY MSS. 29823, 74, 29824, 83 [lower]; BURTON MSS. 25638, 75; lutist, ROSELLINI, *Mon. Civ.* xcvi [3]; HICKMANN in *Ann. Serv.* lii (1952), pp. 172–5 with figs. 7, 8; clapper, HICKMANN in *Bull. Inst. Ég.* xxxvii (1956), fig. 4, cf. p. 70; lyre-player, CHAMP., *Mon.* cxc [2]; ROSELLINI, *Mon. Civ.* xcvi [1 right]. Ewer and basin, and food-table, CHAMP., *Not. descr.* i, p. 839 [to p. 494, l. 14]; *menat*, and ewer and basin, JÉQUIER, *Frises*, figs. 202, 318. Texts, HELCK, *Urk.* iv. 1475 [bottom], 1476 [top, and middle lower]; names and titles, LEPSIUS MS. 319 [middle lower, bottom right]; of deceased and wife, CHAMP., *Not. descr.* i, p. 838 [to p. 494, l. 8]; text of sister, L. D. *Text*, iii, p. 271 with a.

Inner Room.

(7) Outer lintel, remains of deceased and wife, jamb, offering-formula. Left thickness, [deceased] and wife (sketched).
Wife on thickness, BAUD, *Dessins*, fig. 54.

(8) [1st ed. 2] Deceased with staff receives three registers, I–II, bringing and weighing Nubian tribute of gold and ivory, III, recording grain.
CHIC. OR. INST. photos. 3005, 6112–13. I–III, WRESZ., *Atlas*, i. 50, 261 [A]; HAY MSS. 29848, 82–3, 29824, 83 verso–84, 29823, 75–6; weighing in I, CHAMP., *Mon.* cliv [3]; right part of III, SCHOTT photos. 7035–7. Text of deceased, HELCK, *Urk.* iv. 1475 [middle].

(9) Two registers, each with [priest] offering to deceased and wife.

(10) [1st ed. 5, 6] Three registers. **I**, Rites before mummy. **II**, Funeral procession, including butchers, and priests before mummy. **III**, Waiting chariot, laden boat, house with garden, and men bringing provisions.

CHIC. OR. INST. photos. 6110–11, 6153; HAY MSS. 29824, 84. Rites in **I**, see SCHIAPARELLI, *Funerali*, ii, pp. 291–2 [xii]. **II** and **III**, incomplete, SCHOTT photos. 7038–46; middle part, WRESZ., *Atlas*, i. 260; female mourners in **II**, WERBROUCK, *Pleureuses*, pl. iv [upper], figs. 100, 118, cf. fig. on 2nd page after p. 159, and pp. 43–4; house in **III**, DAVIES, *Town House*, fig. 2, cf. p. 236; HAY MSS. 29848, 84 [top].

(11) [1st ed. 4] Daughter offers to deceased, wife, and sister.
Head of daughter, HAY MSS. 29824, 84 verso.

(12) [1st ed. 3] Deceased adores Osiris.
HAY MSS. 29824, 84 verso [bottom].

81. INENI 〔𓈖𓏘𓏤〕 [1st ed. Anena], Overseer of the granary of Amūn. Temp. Amenophis I to Tuthmosis III.

Sh. ʿAbd el-Qurna. (CHAMPOLLION, No. 5, WILKINSON, No. 14, HAY, No. 8.)
Parents, Ineni 〔𓈖𓏘𓏤〕, Judge, and Sit-dhout 𓏏𓋴𓈖𓃗. Wife, ʿAhhotp 𓂝𓎛𓊵, called Thuiu 𓏏𓄿𓅱𓏏𓆑.

Plan, p. 160. Map V, D–4, d, 9.

BOUSSAC, *Le Tombeau d'Anna* (*Mém. Miss.* xviii), 16 plates, with plan, section, and elevation, 1st and 8th plates; WILKINSON, *Topography of Thebes*, pp. 143–4; CHAMP., *Not. descr.* i, pp. 492–4, with plan of inner part. MOND photos. of all walls. Names of deceased and wife, WILKINSON MSS. v. 80 [upper middle]; HAY MSS. 29824, 49–50 verso; ROSELLINI MSS. 284, G 8–9.

Portico.
(1) Deceased with staff.
BOUSSAC, 9th pl. [right]; SCHOTT photo. 8931.

(2) [1st ed. 1] Stela with autobiographical text.
Remaining lower part, BOUSSAC, 16th pl.; blocks replaced, SCHOTT photo. 2044; GR. INST. ARCHIVES, photo. 1690. Text, BOURIANT in *Rec. de Trav.* xii (1892), pp. 106–7; SETHE, *Urk.* iv. 53–62 (20).

(3) [1st ed. 2] Deceased with attendants inspects four registers, **I** and **II** destroyed, **III–IV**, Treasure of Amūn weighed and recorded with list of temples.
BOUSSAC, 3rd pl., cf. 2nd; CHIC. OR. INST. photos. 6114–15. **III–IV**, WRESZ., *Atlas*, i. 263; SCHOTT photos. 2043, 5184–6; *wesekh*-collar and *menat*, JÉQUIER, *Frises*, figs. 178, 200. Text of deceased, and list of temples, SETHE, *Urk.* iv. 70–1 (24) 2.

(4) [1st ed. 3] (Unfinished, squared background.) Deceased inspects five registers, **I–V**, bringing produce for Temple of Amūn. **I–II**, Remains of recording cattle. **III–IV**, Linen brought to scribes. **V**, Recording grain.
BOUSSAC, 4th pl., cf. 2nd; CHIC. OR. INST. photos. 2908, 6114. **II–V**, WRESZ., *Atlas*, i. 264. Text, BRUGSCH, *Recueil*, pl. xxxvi [2]; SETHE, *Urk.* iv. 71–2 (24) 3.

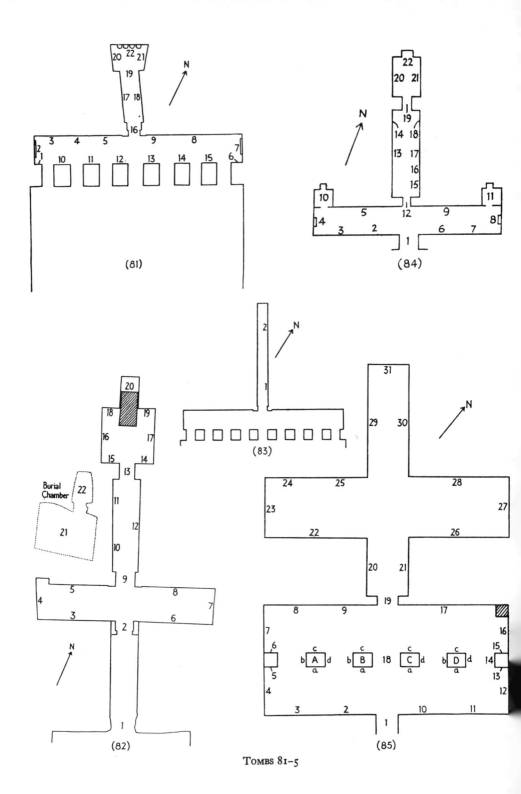

(81)

(84)

(83)

Burial
Chamber

(82)

(85)

TOMBS 81-5

(5) [1st ed. 4] Deceased with relatives inspects five registers, I–V, recording of foreign tribute. I–II, Nubians with women and children. III, Destroyed. IV, Syrians (one with bear) with women and children. V, Egyptians with Syrian produce.

Boussac, 5th pl., cf. 2nd; Wresz., *Atlas*, i. 265–6, 267 [A], 88 c [7 a]; Chic. Or. Inst. photo. 2913. I–V (omitting scribes), Meyer, *Fremdvölker*, 748–9. IV, Müller, *Egyptological Researches*, i, pls. 8–11, cf. ii, p. 184, and fig. 64; two women with children, Davies in *M.M.A. Bull.* Pt. ii, Dec. 1930, fig. 10 [left], cf. p. 38. Two men with jar on pole in V, *Descr. de l'Égypte, Ant.* ii, pl. 46 [3] (reversed). Texts of deceased and wife, Piehl, *Inscr. hiéro.* 1 Sér. cxxix–cxxx [Q δ]; Golenishchev MSS. 4 [f]; of deceased, Sethe, *Urk.* iv. 69–70 (24) 1; part, Brugsch, *Recueil*, pl. xxxvi [3].

(6) [1st ed. 8] Two registers. I, Bringing fish to deceased. II, Netting fish.

Boussac, 12th pl. [left]. II, Wresz., *Atlas*, i. 262 [B].

(7) [1st ed. 7] Stela, autobiographical text.

Mond photo. Text, Bouriant in *Rec. de Trav.* xiv (1894), pp. 73–4; Sethe, *Urk.* iv. 62–6 (21).

(8) Deceased with wife fishing and [fowling], with hippopotamus, birds, and fish, in water. Sub-scene, remains of vintage with [wine-press], men filling jars, and bringing grapes and produce of marsh-lands.

Boussac, 7th pl., cf. 2nd.

(9) [1st ed. 6] Deceased with dog under his chair and relatives, receives five registers, I–V, men bringing animals and fowl. I, Geese and cranes, II, donkeys, III, goats, rams, and pigs, IV–V, cattle (including bulls fighting in IV).

Boussac, 6th pl., cf. 2nd. Some donkeys, Burton MSS. 25638, 64; donkey and foal, and goats, Hay MSS. 29853, 122–3; donkey braying, and two rams butting, Wilkinson MSS. v. 90 [lower left], 149 [top]; two goats, pigs, and swineherd, id. ib. ii. 19 [middle right]; left ram, Chic. Or. Inst. photo. 10810; pigs and swineherd, Wilkinson, *M. and C.* iii. 34 (No. 332) = ed. Birch, ii. 100 (No. 360); swineherd and group of pigs, Maspero, *Hist. anc. Les origines*, fig. on p. 64; Newberry in *J.E.A.* xiv (1928), pl. xix [1], p. 219. Text of deceased, Sethe, *Urk.* iv. 72 (24) 4.

Pillars.

(10) [1st ed. 11] Deceased on foot with dog hunting animals (including hyena) in desert. Sub-scene, deceased with three attendants shooting gazelle.

Boussac, 9th pl. [left]; Wresz., *Atlas*, i. 262 [A]; M.M.A. photos. T. 2642–3; Chic. Or. Inst. photo. 2909. Animals in main scene, Lhote and Hassia, *Chefs-d'œuvre*, pl. 51; dog and hyena, Schott photos. 2123, 3687; details, Smith, *Art . . . Anc. Eg.* pl. 100 [B].

(11) [1st ed. 10] Four registers, house and garden. I, List of trees, man before deceased and wife, and palms. II, Trees. III, Trees and pool. IV, House with storehouses.

Boussac, 11th pl. [right]; Wresz., *Atlas*, i. 60 a; Chic. Or. Inst. photo. 2910; Maspero, *Hist. anc. Les origines*, figs. on pp. 201, 315 [upper]. IV, Id. *L'Arch. ég.* (1887), fig. 8, (1907), fig. 9; Prisse, *L'Art égyptien, Texte*, fig. on p. 218; Scott, *The Home Life of the Ancient Egyptians*, fig. 3 (from painting by Nina Davies); Paille in *Bull. des musées de France*, No. viii, Oct. 1949, fig. 1, cf. p. 197. List of trees, Brugsch, *Recueil*, pl. xxxvi [1]; Sethe, *Urk.* iv. 73–4 (24) 5.

(12) Deceased seated with offering-list, offerings, &c.
BOUSSAC, 11th pl. [left]; CHIC. OR. INST. photo. 2912.

(13) Similar scene, destroyed.
BOUSSAC, 10th pl. [right].

(14) Two remaining registers, agriculture. **I**, Sowing and ploughing. **II**, Pulling l ax.
BOUSSAC, 10th pl. [left]. **II**, SCHOTT photo. 2117.

(15) [1st ed. 9] Four remaining registers, harvest. **I**, Heaping grain. **II**, Oxen threshing.
III, Carrying corn. **IV**, Reaping.
BOUSSAC, 12th pl. [right]; CHIC. OR. INST. photo. 2911. **II–IV**, WRESZ., *Atlas*, i. 58. **III**
and **IV**, SCHOTT photo. 2042. **III**, JÉQUIER, *Hist. Civ.* fig. 259.

Ceiling. Texts, PIEHL, *Inscr. hiéro.* 1 Sér. cxxix [Q α–γ]; parts, SETHE, *Urk.* iv. 66–7 (22),
69 (23) 5 b.

Passage. View, HAY MSS. 29823, 113.

(16) [1st ed. 5] Outer lintel, double-scene, [deceased] before Western goddess and Anubis,
with list of festivals at ends, jambs, five registers, **I–V**, rites before statues of deceased.
BOUSSAC, 13th pl., cf. 2nd. Texts on jambs, SCHIAPARELLI, *Funerali*, ii, pp. 290–1; HER-
MANN, *Stelen*, pp. 15*–16* [78–87].

(17) [1st ed. 12, 13] Deceased and wife with [brother Paḥery] offering to them, and four
registers, **I–IV**, funeral procession, including Abydos pilgrimage and sarcophagus dragged
by oxen in I and II, rites in garden and statuettes carried in **III**, and *teknu* and mummers
in **IV**.
BOUSSAC, 14th pl.; HAY MSS. 29822, 83–6, 29824, 40, 49, 49 verso; parts, WILKINSON
MSS. ii. 6 [lower right], 7 [upper]; BURTON MSS. 25644, 46, 47–9, 53. Sailing-boat and
shrine with mummy on sledge in **I**, mourners and man before mummy in shrine in **II**, and
pond with palm-tree in **III**, WILKINSON, *M. and C.* iii. 208 (No. 373), 2 Ser. ii. 422 (No. 502)
and 383 (No. 492), ii. 145 (No. 131) = ed. BIRCH, ii. 224 (No. 411), iii. 451 (No. 635) and
428 (No. 624), i. 378 (No. 151). Shrine with mourners in **I**, and three mourners in **II**,
WERBROUCK, *Pleureuses*, figs. 25–6, 133, 140, cf. p. 44. Left part of **III**, WRESZ., *Atlas*, i.
261 [B]. Text at top, BURTON MSS. 25644, 54; of I and II, CHAMP., *Not. descr.* i, p. 836
[to p. 493, l. 4]; part, LEPSIUS MS. 317 [middle]; name and titles of deceased, wife, [and
brother], WILKINSON MSS. ii. 6 [lower middle]; of deceased and wife, LEPSIUS MS. 317
[top]; of deceased, SETHE, *Urk.* iv. 68 (23) 3; BRUGSCH, *Recueil*, pl. lxv [5].

(18) [1st ed. 14] Deceased and wife with brother Paḥery and offering-list ritual before
them.
Omitting Paḥery, HOSKINS MSS. i. 58. Sketch of ritual, HAY MSS. 29824, 50, 29822, 89.
Texts, WILKINSON MSS. ii. 6 [upper middle]; texts of deceased and wife, and name of
Paḥery, CHAMP., *Not. descr.* i, pp. 492, 836 [to p. 493, l. 2]; of deceased, SETHE, *Urk.*
iv. 67 (23) 1. Offering-list ritual, SPIEGEL in *Mitt. Kairo*, xiv (1956), pl. xiii [1], p. 195;
offering-list, DUEMICHEN, *Hist. Inschr.* ii, pl. vi; id. *Der Grabpalast des Patuamenap*, i, pls.
xviii–xxvi [o].

Ceiling. Texts, PIEHL, *Inscr. hiéro.* 1 Sér. cxxx [Q ε–η]; some titles, SETHE, *Urk.* iv. 67–9
(23) 2, 5 a; part [PIEHL ζ], LEPSIUS MS. 318 [left].

Shrine.

(19) [part, 1st ed. 17] Three registers each side of inner doorway, **I–III**, offering-bringers. **III**, on left, man with gazelle, and on right, man with calf, SCHOTT photos. 8419, 8416; gazelle, HAY MSS. 29822, 91.

(20) [1st ed. 15] Four registers, **I–IV**, banquet with musicians (including [male harpist] in **III** and female clappers in **IV**) before deceased, with wife and dog behind him.
BOUSSAC, 15th pl. **I–IV**, SCHOTT photo. 8417. Dog, CHAMP., *Mon.* ccccxxviii [bottom right]; ROSELLINI, *Mon. Civ.* xvii [10]; WILKINSON, *M. and C.* iii. 32 (No. 331, 2) = ed. BIRCH, ii. 99 (No. 359, 2); BURTON MSS. 25644, 51, 52; WILKINSON MSS. ii. 29 [bottom middle]; HAY MSS. 29822, 90. Harpist, HAY MSS. 29822, 88. Names of guests and musicians, CHAMP., *Not. descr.* i, pp. 837–8 [to p. 493, l. 18]; WILKINSON MSS. ii. 30 verso [upper middle].

(21) [1st ed. 16] Remains of four registers, **I–IV**, banquet (with brother Paḥery and two male harpists in **I**) before deceased, with wife and her daughter behind him.
I, SCHOTT photo. 8418; harpists, ROSELLINI, *Mon. Civ.* xcvi [1 left]; WILKINSON, *M. and C.* ii. 234 (No. 186) = ed. BIRCH, i. 438 (No. 211); BURTON MSS. 25644, 46 verso, 50; WILKINSON MSS. ii. 20 [middle bottom]; HAY MSS. 29822, 87. Titles of deceased, probably here, BRUGSCH, *Recueil*, pl. lxv [4]; names of wife and guests, CHAMP., *Not. descr.* i, p. 837 [to p. 493, l. 13]; WILKINSON MSS. ii. 30 verso [top].

(22) Seated statues of deceased, wife, and parents.

Finds

Fragment of relief, deceased with remains of text, in Florence Mus. 6391. See SCHIA-PARELLI, *Mus. . . . Firenze*, pp. 508–9 [1795].

82. AMENEMḤĒT ⟨𓏠𓈖𓏏⟩, Scribe, Counter of the grain of Amūn, Steward oʻ the Vizier. Temp. Tuthmosis III.

Sh. ʿAbd el-Qurna. (*L. D. Text*, No. 56, HAY, No. 16.)

Parents, Dhutmosi 𓏏𓏏𓏏, Overseer of lands, and Antef 𓇋𓈖𓏏𓆑. Wife, Beketamūn 𓏠𓈖𓆑.

Plan, p. 160. Map V, D–4, e, 9.

DAVIES (Nina) and GARDINER, *The Tomb of Amenemḥēt*, passim, with plan and section, pls. xxxiii, xxxiv; *L. D. Text*, iii, pp. 266–9; HAY MSS. 29824, 60 verso–65. Titles of deceased, SETHE, *Urk.* 1050–3 (320) C, D.

Entrance.

(1) Lintel and jambs, remains of texts.
See DAVIES and GARDINER, p. 10.

Hall.

(2) Lintels and jambs (outer destroyed), remains of texts.
Id. ib. pl. xxxi [bottom left], pp. 10–11, 13, 26.

(3) [1st ed. 1] At top, relatives at banquet before User (tombs 61, 131) and wife.

DAVIES and GARDINER, pl. iii, pp. 31–3. Heads of girls [offering to guests], SCHOTT photo. 7089. Texts, LEPSIUS MS. 308 [middle and bottom]; titles of User, SETHE, *Urk.* iv. 1042–3 (317) D.

(4) [1st ed. 2] Two registers. **I**, Deceased offers food to ancestors. **II**, Deceased offers food to architect and artists of tomb, and [others].

DAVIES and GARDINER, pls. vii, viii, pp. 34–7. Father in **I**, WILKINSON MSS. v. 88 [top middle]. Texts, SETHE, *Urk.* iv. 1054–6 (321) A, B; texts of **I**, LEPSIUS MS. 309.

(5) [1st ed. 3–4] Deceased and [wife], son [Amenemḥēt] with offerings before them, and five registers, **I–V**, banquet at New Year Festival, including female musicians (one with double-pipe) and dancer with castanets in **I**, male harpist and female clappers with songs in **II**, bulls fighting, and man bringing bull in **IV**.

DAVIES and GARDINER, pls. iv–vi [A], pp. 40–2. Offerings, SCHOTT, *Das schöne Fest*, pl. viii, p. 832; id. photo. 7085. Musicians in **I** and **II**, HICKMANN in *Cahiers d'histoire égyptienne*, Sér. vi [5, 6] (1954), fig. 9, cf. pp. 273–4; id. *45 Siècles de Musique*, pl. xlv [B]; SCHOTT, *Altägyptische Festdaten in Mainz. Akad. Wissenschaften und Literatur. Abhand. der geistes- und sozialwissenschaftlichen Klasse* (1950), No. 10, pl. 4, p. 951; SCHOTT photos. 7086–8. **IV**, and harpist in **II**, WILKINSON, *M. and C.* ii. 274 (No. 207), 444 (No. 315) = ed. BIRCH, i. 464 (No. 232), ii. 75 (No. 343); WILKINSON MSS. ii. 14 [top right], v. 88; bulls fighting, WRESZ., *Atlas*, i. 15; FARINA, *Pittura*, pl. lix; LHOTE and HASSIA, *Chefs-d'œuvre*, pl. 66; HAY MSS. 29823, 58, 59. Texts (incomplete), SETHE, *Urk.* iv. 1056 (321) C, 1061–2 (321) G 1, 2; LEPSIUS MS. 310; titles of deceased, SCHOTT photo. 7084; name of harpist, WILKINSON, *Materia Hieroglyphica*, Pt. ii, pl. vii [24].

(6) [1st ed. 8] [Deceased] offers to [ʿAmethu (tomb 83), and wife].

Texts, DAVIES aḥd GARDINER, pl. xxxi [middle upper], p. 34.

(7) [1st ed. 7] [Deceased on foot with wife] hunting gazelle in desert.

DAVIES and GARDINER, pl. ix, p. 31. Part, WEGNER in *Mitt. Kairo*, iv (1933), pl. viii [a]. Text of hunting, DAVIES (Nina), *Anc. Eg. Paintings*, i, pl. xviii; SETHE, *Urk.* iv. 1062 (321) H.

(8) [1st ed. 5, 6] [Deceased spearing] hippopotamus, with magical text, and [deceased fishing and fowling], with cleaning and netting fish below. Sub-scene, picking grapes, watering, and repairing canoes.

DAVIES and GARDINER, pls. i, i A, ii, and frontispiece, pp. 26–30. Hippopotamus, and birds above papyrus-clump, DAVIES (Nina), *Anc. Eg. Paintings*, i, pls. xix, xx; FARINA, *Pittura*, pls. lvii, lviii; birds, WEIGALL, *Anc. Eg. . . . Art*, p. 140; BYVANCK, *De Kunst der Oudheid*, pl. xliv [fig. 155], p. 272. Man repairing canoe, MEKHITARIAN, *Egyptian Painting*, pl. on p. 42. Text above deceased, SETHE, *Urk.* iv. 1062 (321) I; text above hippopotamus, GOLENI-SHCHEV MSS. 8 [b].

Ceiling. Texts, DAVIES and GARDINER, pl. xxx [A–G], cf. xxxii [E, F], pp. 42–4; part, DUEMICHEN, *Altaegyptische Kalenderinschriften*, pl. xli [d]; names of deceased and father, LEPSIUS MS. 311 [top].

Passage.

(9) Outer lintel and right jamb, texts of going forth 'to see the sun-disk'. Right thickness, [deceased and wife] going forth 'to see his house of the living'. Inner lintel and jambs, remains of texts.

Texts, DAVIES and GARDINER, pl. xxxi [right, and middle right], pp. 42, 44–5.

(10) [1st ed. 9] Five registers. I–V, Funeral procession to Western goddess, including bringing funeral outfit with royal statuettes and statuettes of deceased in **I**, Abydos pilgrimage in **I** and **II**, dancers and *teknu* in **II**, oxen with decorated horns and 'Nine friends' in **III**, and pool with victims in **IV**.

DAVIES and GARDINER, pls. x [left]–xiii, pp. 46–54; sketch, HAY MSS. 29824, 64 verso–65. Abydos pilgrimage (incomplete), SCHOTT photos. 7090–2; boats in **I**, WILKINSON MSS. ii. 13 [top left]. Tomb in **II**, DAVIES (Nina) in *J.E.A.* xxiv (1938), fig. 1, cf. p. 36. **III**, omitting priests and sarcophagus, LÜDDECKENS in *Mitt. Kairo*, xi (1943), pp. 46–68 [20 a, b, 21–2, 24] with Abb. 15, 18, 20, 22; group dragging sarcophagus in **III**, WILKINSON MSS. ii. 13 [middle]; BURTON MSS. 25644, 45, 45 verso.

(11) [1st ed. 10] [Son Amenḥotp as *sem*-priest offers to deceased and wife with small offering-list.]

DAVIES and GARDINER, pls. x [right], xxxi [middle left], pp. 61–2. Titles of deceased and wife, L. D. *Text*, iii, p. 266 [middle].

(12) [1st ed. 11, 12] Deceased and wife, [son Amenemḥēt as *sem*-priest] with offerings and offering-list before them, and five registers, **I–II**, banquet with musicians (man with lute, and women with harp and double-pipe) with songs, **III**, offering-bringers with ointment, **IV–V**, rites before mummies and small offering-list.

DAVIES and GARDINER, pls. xiv–xvii, pp. 57–67. **I** and **II**, WRESZ., *Atlas*, i. 268; left end, FARINA, *Pittura*, pl. lvi. Musicians and some guests, BAIKIE, *Eg. Antiq.* pl. xxii [lower]; id. *A History of Egypt*, ii, pl. xviii [1]; musicians and two groups of guests, WILKINSON, *M. and C.* ii. 214 (No. 178), 220 (No. 182), 234 (No. 185) = ed. BIRCH, i. 426 (No. 203), 430 (No. 207), 438 (No. 210); WILKINSON MSS. ii. 13 [bottom left]; musicians, DAVIES (Nina), *Anc. Eg. Paintings*, i, pl. xvii; MOND in *The Photographic Journal*, N.S. lvii, [Jan. 1933, fig. on p. 16 [bottom]; HICKMANN in *Cahiers d'histoire égyptienne*, Sér. vi [5, 6] (1954), figs. 8, 10, 11, cf. pp. 273–4; id. *45 Siècles de Musique*, pl. xlv [A, C, D]; SCHOTT photos. 7093–5; HAY MSS. 29823, 57, 29853, 106. Two scenes in **V**, WILKINSON MSS. ii. 13 [bottom right]. Texts of **I–III**, SETHE, *Urk.* iv. 1057–9 (321) D 1–10; titles of deceased and wife, texts of musicians in **I**, and of [harpist] in **II**, LEPSIUS MS. 311 [lower]; texts of Opening the Mouth in **IV–V**, SCHIAPARELLI, *Funerali*, ii, pp. 285–7 [1°–12°].

Ceiling. Text, DAVIES and GARDINER, pls. xxxii [G], xxx [right], p. 68.

Inner Room.

(13) Outer and inner doorways, remains of texts. Thicknesses, [deceased] adores [Anubis]. DAVIES and GARDINER, pls. xxxi [top left], xxviii [lower], xxix [bottom left and near bottom right], pp. 67–9.

(14)–(15) [1st ed. 13, 14, 17] Two registers. **I**, Double-scene, left half, banquet with [harpist] before deceased and wife, right half, female mourners (with two tumblers?), and priest before mummy on couch in shrine, with pile of bread, before deceased and wife. **II**, Left of doorway, remains of autobiographical stela (superimposed on scene with funeral outfit, and girl preparing bed (?)), right of doorway, autobiographical stela, year 28 of Tuthmosis III (superimposed on deceased and [man] playing draughts, with preparation of wine below).

DAVIES and GARDINER, pls. xxiv–xxvi, xxix [upper], pp. 69–73. Female mourners and priest in **I**, WEGNER in *Mitt. Kairo*, iv (1933), pl. viii [b]; WILKINSON MSS. ii. 14 [middle];

tumbler˙(?), WERBROUCK, *Pleureuses*, fig. 182, cf. pp. 44–5; DAVIES in *M.M.A. Bull.* Pt. ii, Feb. 1928, fig. 12 [left], cf. p. 68; HAY MSS. 29853, 106. Lines 45–8 of text at (14), SETHE, *Urk.* iv. 1048–9 (319). Text of stela at (15), PIEHL in *Ä.Z.* xxi (1883), pp. 131–2 [8]; SETHE, *Urk.* iv. 1043–8 (318); line 1 with year 28, L. *D.* iii. 38 [f].

(16) [1st ed. 15] Four registers. **I,** [Son Useramūn as *sem*-priest], preceded by large offering-list with ritual, offers to [deceased and wife]. **II,** Seated relatives. **III,** Festival of Ḥathor: [deceased and wife] with three chantresses of Ḥathor offering *menat*s and sistra to them, and female clapper, man leaping, clapper, and two priests of Ḥathor with castanets. **IV,** Offering-bringers with provisions, crane, gazelle, and bull.

DAVIES and GARDINER, pls. xviii–xx, pp. 73–9, 94–6, 98–100. Offering-list, DUEMICHEN, *Der Grabpalast des Patuamenap*, Pt. i, pls. xviii–xxvi [n]; id. *Hist. Inschr.* ii, pl. v [e]. **III,** SCHOTT photos. 7097–7105; third chantress, SCHOTT, *Das schöne Fest*, Abb. 12, cf. p. 808; clappers, dancer, and priests, PRISSE, *Mon.* pl. xliv [top]; WRESZ., *Atlas*, i. 267 [B]; GROSS in *Rev. Arch.* 4 Sér. xxiii (1914), fig. 2, cf. p. 334; omitting one priest, WILKINSON, *M. and C.* ii. 257 (No. 198) = ed. BIRCH, i. 454 (No. 223); BURTON MSS. 25638, 74; WILKINSON MSS. ii. 14 [top middle]; HAY MSS. 29823, 56; priests, clappers, and dancer, LHOTE and HASSIA, *Chefs-d'œuvre*, pls. 128–9; female clapper and dancer, DAVIES in *M.M.A. Bull.* Pt. ii, Feb. 1928, fig. 1, cf. p. 60; *menat* worn by second priest, JÉQUIER, *Frises*, fig. 203. Man with bull, and two female offering-bringers in **IV,** MEKHITARIAN, *Egyptian Painting*, pl. on p. 40. Texts of **III** and text above **IV,** SETHE, *Urk.* iv. 1059–60 (321) E 1–3, F 1.

(17) [1st ed. 16] Four registers. **I,** [Son] Amenemwaskhet offers to deceased and wife with offering-list ritual. **II,** Relatives. **III,** Epagomenal Days Festival, men with torches and ointment. **IV,** People with provisions, gazelle, and bull.

DAVIES and GARDINER, pls. xxi–xxiii, pp. 73–9, 96–100. Last man with torch in **III,** SCHOTT photo. 7096. Man with grapes and pomegranates, and woman leading gazelle, in **IV,** MEKHITARIAN, *Egyptian Painting*, pls. on title-page and on p. 41; woman with gazelle, LHOTE and HASSIA, *Chefs-d'œuvre*, pl. 48; HAY MSS. 29823, 60. Texts above **IV,** SETHE, *Urk.* iv. 1061 (321) F 2.

(18) and (19) Deceased kneeling with wine, before Eastern goddess at (18), and before Western goddess at (19).
DAVIES and GARDINER, pl. xxvii (left), pp. 100–1.

(20) Niche, with entablature above outer doorway, and [statues of deceased and wife]. Right wall, fragment of offering-list. Ceiling, remains of text.
Id. ib. pls. xxviii [upper], on xxix [bottom], pp. 101–2.

Ceiling. Texts, id. ib. pl. xxvii [right], cf. pl. xxxii [A, C], pp. 101–2; SETHE, *Urk.* iv. 1062–4 (322) A–E.

Burial Chamber.
DAVIES and GARDINER, p. 11, with plan and section, pl. xxxiv.

(21) [1st ed. 18–23] All walls, Book of the Dead, and pyramid-texts, &c., in cursive hieroglyphs, including deceased kneeling with ointment and taper below niche.
DAVIES and GARDINER, pls. xxxvii–xlvi, pp. 103–7; parts, L. *D.* iii. 38 [e], *Text*, iii, pp. 267 [bottom]–269. See NAVILLE, *Das aegyptische Todtenbuch, Einleitung*, p. 110. Text below niche, SCHIAPARELLI, *Funerali*, ii, p. 287 [13°]; GOLENISHCHEV MSS. 8 [a], and other texts, 8 [c, d].

(22) [1st ed. 24–6] Niche. Left wall, son Amenemḥēt as *sem*-priest, with other children, offers to deceased and wife. Right wall, similar scene before deceased and mother. Rear wall, text of Book of the Dead with bull and sacred cows below.

DAVIES and GARDINER, pls. xxxv, xxxvi, p. 108. Texts, GOLENISHCHEV MSS. 9 [a–d]; names and titles, L. *D.* iii. 38 [g], and *Text*, iii, pp. 266 [bottom with β], 267 [α].

Finds

Ushabti-box, New York, Brooklyn Mus. 50.130, *Sale Catalogue*, New York, 1947, *Notable Egyptian Art*, p. 72 with fig., No. 300; COONEY in *Brooklyn Mus. Bull.* xii [2], Winter 1951, fig. 3, cf. pp. 4–6.

Wooden ceremonial sickle, with text of deceased, probably from here, in New York, Brooklyn Mus. 48.27, id. ib. figs. 4, 5, cf. pp. 7–8.

83. ʿAMETHU ⟨hieroglyphs⟩, called ʿAḤMOSI ⟨hieroglyphs⟩, Governor of the town and Vizier. Early temp. Tuthmosis III.

Sh. ʿAbd el-Qurna. (L. *D. Text*, No. 41, WILKINSON, No. 64.)
Wife, Taʿamethu ⟨hieroglyphs⟩ (name in tomb 131).

Plan, p. 160. Map V, D–4, e, 9.

Plan, L. *D. Text*, iii, p. 257; DAVIES, *The Tomb of Nakht at Thebes*, i, p. 19, fig. 3.

Portico.

Ceiling. Remains of titles, SETHE, *Urk.* iv. 489–92 (158) A–E; part, PIEHL in *Ä.Z.* xxi (1883), p. 131 [6].

Inner Room.

(1) At top, rites before mummies.

(2) [1st ed. 1] Titles of son User (tombs 61 and 131), SETHE, *Urk.* iv. 1041–2 (317) A.

84. AMUNEZEḤ ⟨hieroglyphs⟩, First royal herald, Overseer of the gate, temp. Tuthmosis III. Partly usurped by MERY (tomb 95), temp. Amenophis II.

Sh. ʿAbd el-Qurna. (CHAMPOLLION, No. 11, L. *D. Text*, No. 71, WILKINSON, No. 31, HAY, No. 19.)
Parents (of Amunezeḥ), Sidḥout ⟨hieroglyphs⟩, Judge, and Resi ⟨hieroglyphs⟩. Wife (of Amunezeḥ), Ḥenutnefert ⟨hieroglyphs⟩.

Plan, p. 160. Map V, D–4, d, 10.

VIREY, *Tombeau d'Am-n-treh* in VIREY, *Sept Tombeaux thébains* (*Mém. Miss.* v, 2), pp. 337–61, with plans, pp. 337, 339 (ceilings), and in *Rec. de Trav.* vii (1886), pp. 32–46, with plans, pp. 34, 35 (ceilings); CHAMP., *Not. descr.* i, pp. 503–4, with plan; HAY MSS. 29824, 78–9 verso; ROSELLINI MSS. 284, G 18; plan, WILD MSS. ii. A. 80. Titles of deceased, L. *D. Text*, iii, p. 278 [13]; SETHE, *Urk.* iv. 956–62 (278).

Hall.

(1) Outer jambs, remains of hymns. Thicknesses, deceased and wife adoring with hymn on each.
Hymn on right thickness, VIREY in *Mém. Miss.* v, p. 338, and *Rec. de Trav.* vii, p. 34.

(2) [1st ed. 1] Officials bringing cattle.

Remains of texts, SETHE, *Urk.* iv. 953 (277) C.

(3) [1st ed. 2] Offerings and offering-list before deceased with son, and at bottom, man seated on ground, and [man] offering to deceased.

Upper part, CHIC. OR. INST. photo. 6116. Text, VIREY in *Mém. Miss.* v, p. 344, and *Rec. de Trav.* vii, pp. 41–2; part, SETHE, *Urk.* iv. 960–1 (278) q, w.

(4) [1st ed. 3] Stela. Double-scene, deceased offers to cartouches of Tuthmosis III, with 'Address to visitors' and autobiographical text below.

CHIC. OR. INST. photo. 6117. Upper part, M.M.A. photo. T. 1871. Scene, and text at sides, VIREY in *Mém. Miss.* v, pp. 344–6 and fig. 1. Scene, HERMANN, *Stelen*, Abb. 6 (from VIREY), cf. p. 38. Texts, VIREY in *Rec. de Trav.* vii, pp. 38–9; autobiographical text, SETHE, *Urk.* iv. 937–41 (276).

(5) [1st ed. 4] Three registers. I–II, [Deceased] and Nubians with tribute, including giraffe, cheetah, baboon, and monkey, before [Tuthmosis III]. III, Remains of Nubians.

I–III, MÜLLER, *Egyptological Researches*, ii, pls. 29–35, pp. 50, 51, 55, figs. 6–8. I–II, M.M.A. photo. T. 1869; WRESZ., *Atlas*, i. 270; MEYER, *Fremdvölker*, 740–1; WILKINSON MSS. ii. 36 [left]; HAY MSS. 29823, 81; parts, SCHOTT photos. 8420–2. I, DAVIES (Nina) in *J.E.A.* xxviii (1942), pl. v, pp. 50–2; giraffe and man, NESTOR L'HÔTE MSS. 20404, 74; giraffe and monkey, MINUTOLI, *Reise zum Tempel des Jupiter Ammon* [&c.], pl. xii, fig. 9. Nubians with cheetah, and with skin and ivory, in II, BANKES MSS. ii. A. 8; last Nubian, BAUD, *Dessins*, fig. 55. Texts, SETHE, *Urk.* iv. 947–50 (277) A; text above II, PIEHL, *Inscr. hiéro.* 1 Sér. cxxxiv [R θ]. See VIREY in *Mém. Miss.* v, pp. 347–8, and *Rec. de Trav.* vii, pp. 42–3.

(6) Two registers, each an attendant with food.

(7) [1st ed. 7] Deceased with brother Khaʿemwēset, Fourth lector in the Temple of Tuthmosis I, offering bouquet of Amūn to him, and remains of three registers, I–III, banquet, including woman with double-pipe.

Khaʿemwēset, three guests, and woman with double-pipe, SCHOTT photos. 7015, 8423–4. Title of Khaʿemwēset, VIREY in *Mém. Miss.* v, p. 361, and *Rec. de Trav.* vii, p. 41; SETHE, *Urk.* iv. 136 (54) B; LEPSIUS MS. 338 [middle lower].

(8) [1st ed. 6] Stela (usurped by Mery). Double-scene, [deceased] offers to Osiris, and hymns to Rēʿ, 'Address to the dead', and remains of autobiographical text.

VIREY in *Mém. Miss.* v, pp. 357–9 with fig. 6, and *Rec. de Trav.* vii, pp. 38, 39–41; M.M.A. photo. T. 1872; CHIC. OR. INST. photo. 2916. Scene, HERMANN, *Stelen*, Abb. 5 (from VIREY), cf. p. 38. Text, PIEHL, *Inscr. hiéro.* 1 Sér. cxxx–cxxxii [R a]; SETHE, *Urk.* iv. 941–6 (276 bis); hymns to Rēʿ, and titles, BRUGSCH, *Monumens de l'Égypte*, pl. iv [1 a, b].

(9) [1st ed. 5] [Deceased] and two registers, I–II, Syrians with tribute, including horses and chariots, bear, and decorative vases, before [Tuthmosis III].

I–II, WRESZ., *Atlas*, i. 269; MEYER, *Fremdvölker*, 738–9; MÜLLER, *Egyptological Researches*, ii, pls. 23–8, with text, p. 42, fig. 5; DAVIES (N. M. and N.) in *J.E.A.* xxvii (1941), pl. xiii, pp. 96–8; omitting left end, M.M.A. photo. T. 1870. Syrians and horses in I, FARINA, *Pittura*, pl. lxiii; two men and horse, DAVIES in *M.M.A. Bull.* Pt. ii, Dec. 1930, fig. 8 [left], cf. p. 36; heads, &c., HAY MSS. 29853, 110. Syrian with bear in II, HAY MSS. 29823, 71;

WILKINSON MSS. v. 100 [left]. Text and description, VIREY in *Mém. Miss.* v, pp. 355–7 [top], and *Rec. de Trav.* vii, pp. 43–4; texts, SETHE, *Urk.* iv. 950–3 (277) B. (For scenes of pylons, vintage, &c., said to be here in CHAMP., *Not. descr.* i, p. 504, see tomb 90 (8).)

Ceiling, texts. Outer band, VIREY in *Mém. Miss.* v, pp. 338 [1], 340 [10], and *Rec. de Trav.* vii, p. 36 [4, 5]; PIEHL, *Inscr. hiéro.* 1 Sér. cxxxiii–cxxxiv [R δ, η], cf. p. 108. Central band, VIREY in *Mém. Miss.* v, pp. 339–41 [3, 11], and *Rec. de Trav.* vii, pp. 35–6 [2, 3]; PIEHL, op. cit. cxxxiii–cxxxiv [R γ, ζ]. Inner band, VIREY in *Mém. Miss.* v, pp. 339–40 [2, 9], and *Rec. de Trav.* vii, pp. 36–7 [6, 7]; PIEHL, op. cit. cxxxii–cxxxiii [R β, ε].

South Chapel.

(10) [1st ed. 8, 9] Side-walls. [Man] offers to deceased and mother on left wall, and to deceased and father on right wall.

Deceased and mother, M.M.A. photo. T. 1873; WILD MSS. i. C. 19 [left]. Texts of both walls and ceiling, VIREY in *Mém. Miss.* v, pp. 346, 340 [4], and *Rec. de Trav.* vii, pp. 46, 37 [9]; part, SETHE, *Urk.* iv. 955 (277) E 3; names of parents, LEPSIUS MS. on 338 [middle].

North Chapel.

(11) [part, 1st ed. 10, 11] Outer left jamb, deceased entering tomb. Right side-wall, deceased and father (unfinished), and priest offering to deceased and wife.

Texts, VIREY in *Mém. Miss.* v, p. 357 [near top, and middle]; see id. in *Rec. de Trav.* vii, p. 46.

Passage.

(12) Inner jambs, offering-texts. VIREY in *Mém. Miss.* v, p. 355, and *Rec. de Trav.* vii, p. 44.

(13) [1st ed. 12] Three registers, with usurpation by Mery. I–III, Funeral procession to Western goddess, including man carrying statuette in I, and butchers in II. Sub-scene, rites before mummy, &c.

See VIREY in *Mém. Miss.* v, pp. 348–51 with figs. 2–4. Unfinished figure with squared background in III, BAUD, *Dessins*, fig. 56. Opening the Mouth rites in sub-scene, see SCHIAPARELLI, *Funerali*, ii, p. 295 [xx].

(14) [1st ed. 13] Two registers. I, Brother Khaᶜemwēset offers bouquet of Amūn 'of Tuthmosis I in Khenmetᶜankh' to [deceased and wife]. II, [Brother offers bouquet of Amūn to parents].

I, SCHOTT photo. 8425. Texts, VIREY in *Mém. Miss.* v, pp. 351–2, and *Rec. de Trav.* vii, p. 45; SETHE, *Urk.* iv. 136 (54) C, 955 (277) E 2. Translation of offering-text, SCHOTT, *Das schöne Fest*, p. 882 [102].

(15) [1st ed. 16] Deceased in chariot hunting in desert, and remains of animals. Sub-scene, [bringing game].

WEGNER in *Mitt. Kairo*, iv (1933), pl. ix; CHIC. OR. INST. photos. 2914–15. Deceased in chariot, VIREY in *Mém. Miss.* v, fig. 5; WILKINSON, *M. and C.* i. 340 (No. 51) = ed. BIRCH, i. 226 (No. 59); WRESZ., *Atlas*, i. 26 b [5]; M.M.A. photo. T. 1875; SCHOTT photo. 8426; remains of animals, SCHOTT photos. 7016–17. Texts, VIREY in *Mém. Miss.* v, pp. 354–5, and *Rec. de Trav.* vii, p. 44; PIEHL, *Inscr. hiéro.* 1 Sér. cxxxiv–cxxxv [R ι]; BRUGSCH, *Recueil*, pl. lxv [1]; SETHE, *Urk.* iv. 955 (277) F; part, WILKINSON MSS. v. 98 [bottom right].

(16) Deceased and [wife] (usurped by Mery and his [mother]) inspect three registers of Delta produce, presented by brother Khaᶜemwĕset with bouquet of Amūn.

M.M.A. photos. T. 1874-5 [extreme left]; CHIC. OR. INST. photo. 6119. Khaᶜemwĕset and offerings, SCHOTT photo. 8427. Texts, VIREY in *Mém. Miss.* v, pp. 353-4, and *Rec. de Trav.* vii, pp. 44-5; PIEHL, *Inscr. hiéro.* 1 Sér. cxxxv [R κ, λ]; SETHE, *Urk.* iv. 953-5 (277) D, E 1, 136 (54) A.

(17) [1st ed. 15] [Deceased fishing and fowling.]
Birds in papyrus, M.M.A. photo. T. 1874 [left]; SCHOTT photo. 8428. Text, SETHE, *Urk.* iv. 956 (277) G. See VIREY in *Mém. Miss.* v, p. 353, and *Rec. de Trav.* vii, p. 45.

(18) [1st ed. 14] Two registers. **I,** [Man] with offering-list and offerings before deceased and wife. **II,** Man offers to deceased and father.

CHIC. OR. INST. photo. 6118. Texts, VIREY in *Mém. Miss.* v, pp. 352-3, and *Rec. de Trav.* vii, p. 45.

Ceiling. Text, VIREY in *Mém. Miss.* v, p. 340 [8], and *Rec. de Trav.* vii, p. 37 [13]; PIEHL, *Inscr. hiéro.* 1 Sér. cxxxv [R μ].

Shrine.

(19) Inner jambs, remains of three registers (**II** and **III** destroyed on right), **I,** female offering-bringer with tree on head, **II,** offering-bringers, **III,** two men. (20) [1st ed. 17] Deceased [and wife], (unfinished), and offerings. (21) Deceased with man, and offerings.

(22) Niche, with Anubis-jackal above on right, and two registers on each side, **I,** seated god, **II,** seated man.

Ceiling. Texts, VIREY in *Mém. Miss.* v, p. 340 [5, 6], and *Rec. de Trav.* vii, p. 37 [10, 11]; PIEHL, *Inscr. hiéro.* 1 Sér. cxxxv-cxxxvi [R ν, ξ]; LEPSIUS MS. 338 [bottom]; east side, CHAMP., *Not. descr.* i, p. 503 [bottom].

85. AMENEMḤAB ⟨⟩, called MAḤU, Lieutenant-commander of soldiers. Temp. Tuthmosis III to Amenophis II.

Sh. ᶜAbd el-Qurna. (CHAMPOLLION, No. 12, HAY, No. 20.)
Mother, Tetires. Wife, Baki, Chief royal nurse.

Plan, p. 160. Map V, D-4, d, 10.

VIREY, *Le Tombeau d'Amenemheb* in VIREY, *Sept Tombeaux thébains* (*Mém. Miss.* v, 2), pp. 224-85, with plan, p. 226; PIEHL, *Inscr. hiéro.* 1 Sér. pp. 87-92, with plan, p. 88. Sketch-plan, texts, and details, WILBOUR MSS. 2 F, 34-5; sketches, HAY MSS. 29824, 80-2. Name of wife, ROSELLINI MSS. 284, G 19.

Hall. Views, M.M.A. photos. T. 2566-7, 2587.

(1) Inner lintel and jambs, remains of offering-formulae.
VIREY, pp. 228, 253.

(2) [1st ed. 1] Three registers before deceased in front of storehouse of Amenophis II. **I–III,** Registration and provisioning of troops, including standard-bearer and horse in **II.** Sub-scene, scribes, and preparation of food.

M.M.A. photo. T. 2568 [left]; CHIC. OR. INST. photo. 2918; VIREY, pp. 228–30 with figs. 1 (called 4), 2. I–III, WRESZ., *Atlas*, i. 94 a; I–II (incomplete), SCHOTT photos. 6926–8; horse-standard in II, FAULKNER in *J.E.A.* xxvii (1941), pl. v [13], p. 16. Texts, PIEHL, *Inscr. hiéro.* I Sér. cxiii [F ψ]; SETHE, *Urk.* iv. 905 (269) w, 911–12 (270) F 1, and text of scribe, F 2.

(3) Deceased inspects recording of provisions, with tree in sub-scene.
M.M.A. photo. T. 2568 [right]. Texts, VIREY, pp. 130–1; SETHE, *Urk.* iv. 911 (270) F 3–4.

(4) Two registers. I and II, Deceased seated in each.
M.M.A. photo. T. 2580. I, SCHOTT photo. 8296.

(5) Woman offers bouquet (?) to deceased (?).
SCHOTT photo. 8297.

(6) Deceased.
M.M.A. photo. T. 2581. Text, VIREY, p. 232.

(7) [1st ed. 2] [False door] with double-scene above, deceased with wife offers on braziers to Anubis-jackal.
M.M.A. photo. T. 2579. Texts, VIREY, pp. 232–3; titles of wife, SETHE, *Urk.* iv. 922 (271) n.

(8) At top, officers and recruits.
M.M.A. photo. T. 2578 [left]. See VIREY, p. 234.

(9) [1st ed. 3] [Wife with followers] offers bouquet of Amūn to Amenophis II in kiosk.
M.M.A. photos. T. 2577–8. Texts, VIREY, pp. 235–6; SETHE, *Urk.* iv. 922–5 (272) A, cf. 920 (271) a.

(10) [1st ed. 11] Deceased with wife offers on braziers, followed by couple and attendants. Sub-scene, offering-bringers.
M.M.A. photo. T. 2569; SCHOTT photos. 8298–8301, and details, 6923, 6940–4, 6977. Texts, SETHE, *Urk.* iv. 898 (269) a, 914–15 (270) H, 925 (272) C; texts above offerings, and texts of deceased and wife, VIREY, pp. 253–5; PIEHL, *Inscr. hiéro.* I Sér. cxiii [F ω]; id. in *Ä.Z.* xxi (1883), p. 135 [12, a]; GOLENISHCHEV MSS. 4 [d].

(11) [1st ed. 10] Deceased and wife with son offering bouquet of Amūn to them, and two registers, I–II, male musicians (three harpists and a lutist), [female musicians and dancers], and guests (one with monkey under chair). Sub-scene, two rows of men bringing provisions to guests.
M.M.A. photo. T. 2570; incomplete, SCHOTT photos. 8300 [left], 8302–6, 4005, 4116–22, with details, 6911–13, 6924–5. Musicians in I–II, HICKMANN, *45 Siècles de Musique*, pl. xlvi [A, B]; musicians in I, HAY MSS. 29823, 73; harpist, CHAMP., *Mon.* cliv [1]. Texts, VIREY, pp. 251–3; SETHE, *Urk.* iv. 915–17 (270) K 1 a, b, 3, 4, 922 (271) k; text of son, and above deceased and wife, PIEHL, *Inscr. hiéro.* I Sér. cix–cx [F η, θ].

(12) [1st ed. 9] Upper part of stela, double-scene, deceased adores [Osiris]. At sides, deceased offers on braziers.
HERMANN, *Stelen*, pl. 6 [e], p. 39; M.M.A. photo. T. 2571. Deceased on left side, SCHOTT photo. 6914. Texts, VIREY, pp. 249–51; titles on left side, SETHE, *Urk.* iv. 900 (269) h.

(13) [1st ed. 8] Three registers. **I**, [Man] offers bouquet of Amūn to deceased. **II**, [Wife]. **III**, Girl before [deceased seated].

M.M.A. photo. T. 2595. Texts, VIREY, pp. 248–9; of **I**, SETHE, *Urk.* iv. 916 (270) K 2, 904 (269) r; PIEHL, *Inscr. hiéro.* I Sér. cix [F ε, ζ].

(14) [1st ed. 7] [Man] adores jackal-headed Anubis seated above pylon.

M.M.A. photo. T. 2596; SCHOTT photos. 6975–6. Texts, VIREY, p. 248; PIEHL, op. cit. cix [F γ, δ]; titles, SETHE, *Urk.* iv. 904 (269) s.

(15) Two registers. **I**, Two offering-bringers. **II**, Woman with bouquet.

M.M.A. photo. T. 2594. See VIREY, p. 246, and fig. 4 [bottom right] (bouquet and text). Text of woman, PIEHL, op. cit. cix [F β].

(16) [1st ed. 6] Two registers. **I**, Amenophis II, followed by deceased with bouquet, and wife, before Osiris. **II**, Deceased (?) with bouquet and [people with flowers] before wife suckling prince.

M.M.A. photo. T. 2572; CHIC. OR. INST. photo. 2925; parts, SCHOTT photos. 6915–17, 6973–4. **I**, VIREY, fig. 4, pp. 245–7. Texts of deceased and wife, PIEHL, *Inscr. hiéro.* I Sér. cix [F a]; SETHE, *Urk.* iv. 899 (269) c, 915 (270) I, 920–1 (271) c.

(17) [1st ed. 5] Tuthmosis III in kiosk and deceased before him, with autobiographical text and three registers, **I–III**, Syrians (called Upper Retenu, Keftiu, and Mennus) with vases, women, and children.

M.M.A. photos. T. 2573–5; CHIC. OR. INST. photos. 2920, 2933. Omitting deceased, VIREY, pp. 237–44, with fig. 3 and three pls. (by GAYET), cf. p. 244, note 7. Colonnette of kiosk with bull's head, PRISSE, *L'Art égyptien*, i, 18th pl. [5] 'Colonnettes . . . xviii^e et xix^e dynasties' (probably this). **I–III**, DAVIES in *J.E.A.* xx (1934), pl. xxv, pp. 189–92 (including group of donkeys at right end of **I**); WRESZ., *Atlas*, i. 4; MEYER, *Fremdvölker*, 594–5; FARINA, *Pittura*, pl. lxxii; HAY MSS. 29823, 72. Syrians, foreign vases (one with bull's head), &c., VERCOUTTER, *L'Égypte* [&c.], frontispiece [verso bottom], pls. xiii [119–23], xxvii–xxviii [191–7], xl [276], xlv [333], xlviii–xlix [360, 364], lxiv [490], pp. 228–9, 287–8, 319, 330, 336–7, 365. **I** and **II**, PRITCHARD, *The Ancient Near East in Pictures*, fig. 46. Some Syrians, SCHOTT photos. 4004, 6919–22. Vases and gold rings in **III**, WAINWRIGHT in *Liv. Ann.* vi (1914), pl. xi [75–7], cf. pl. xii, and pp. 34 ff.; details, MÜLLER in *Mitt. Vorderasiat. Ges.* ix (1904), pl. v, p. 161 (Heft 2, p. 49). Autobiographical text, EBERS in *Z.D.M.G.* xxx (1876), pls. i–iii, pp. 410–16, xxxi (1877), pp. 439–70; id. in *Ä.Z.* xi (1873), pp. 3–9, cf. 64; CHABAS in *Mélanges égyptologiques*, iii [2], pls. xvi, xvii (from EBERS), pp. 279–305, cf. STERN in *Ä.Z.* xiii (1875), p. 174; MÜLLER, *Egyptological Researches*, i, pls. 33–9; SETHE, *Urk.* iv. 890–7 (268); part, GOLENISHCHEV MSS. 6; texts of Syrians, SETHE, *Urk.* iv. 907–8 (270) A 2–5.

Pillars.

A (a), (b) Deceased seated. (c) [1st ed. 12] At top, hymn to Amenophis II. (d) [1st ed. 13] Two registers, **I**, girl before deceased with staff and wife 'visiting tomb', **II**, deceased between mother and wife.

(a), (c), (d), M.M.A. photos. T. 2582–4; (d), SCHOTT photos. 8307, 8310. Texts, VIREY, pp. 283–5 [P]; text on (c), SETHE, *Urk.* iv. 900 (269) e, 910 (270) E, and on (d), id. ib. 904–5 (269) t, v, 918–19 (270) N, 922 (271) i; text on (c) and in **I** on (d), PIEHL, *Inscr. hiéro.* I Sér. cxii–cxiii [F χ, φ].

B (*a*) [1st ed. 14] Deceased before wife with young prince on her lap. (*b*) [1st ed. 15] Two registers, **I**, [deceased] purified by [priests], **II**, priest and personified *zad*-pillar acclaiming deceased. (*c*) [1st ed. 16] Deceased adoring with hymn to Amenophis II.

M.M.A. photos. T. 2588 [left], 2587, 2585 [right]. **I** at (*a*), SCHOTT photo. 8308. Texts, VIREY, pp. 277–8 [o]; PIEHL, *Inscr. hiéro.* 1 Sér. cxii [F σ, τ, υ]; text at (*c*) and titles at (*a*), SETHE, *Urk.* iv. 900 (269) f, 905–6 (269) y, 909–10 (270) D; text of wife at (*a*), CHAMP., *Not. descr.* i, p. 505 [A].

C (*a*) [1st ed. 19] Deceased offers bouquet of Amūn at New Year Festival to wife suckling young prince. (*c*) [1st ed. 20] Deceased adoring with hymn to Tuthmosis III. (*d*) [1st ed. 21] Deceased with staff goes forth 'to visit garden'.

M.M.A. photos. T. 2588 [right], 2585 [left], 2589, on 2587. (*a*), SCHOTT photo. 8309. (*c*) and (*d*), CHIC. OR. INST. photos. 2931 [right], 2917 [left]. Texts, VIREY, pp. 279–80 [o']; SETHE, *Urk.* iv. 899–902 (269) d, l, 908–9 (270) c, 918 (270) M, 920 (271) b, 925 (272) B; texts of (*c*) and (*d*) and of wife at (*a*), PIEHL, *Inscr. hiéro.* 1 Sér. cxi [F ξ, ν, μ]; of (*d*), GOLENISHCHEV MSS. 4 [e].

D (*a*) [1st ed. 22] Man offers linen to deceased and wife with monkey under chair. (*b*) [1st ed. 23] Three registers each before deceased and wife, **I**, girls with sistra and *menats*, **II**, boys with onions, **III**, man with offering-list. (*c*) [1st ed. 24] Deceased adoring with hymn to Tuthmosis III. (*d*) [1st ed. 25] Deceased entering tomb, and girl with *menat*.

M.M.A. photos. T. 2590, 2592 [right], 2593, 2591. (*a*), (*b*), and girl in (*c*), SCHOTT photos. 4003, 4114, 6929–33, 8311; (*b*) and (*c*), CHIC. OR. INST. photos. 2917 [right], 2931 [left]. Texts, VIREY, pp. 280–3 [P']; SETHE, *Urk.* iv. 901–5 (269) k, n, p, q, x, 908 (270) B, 917 (270) K 5, 6, 919 (270) O, 922 (271) l, m; texts of (*c*), (*d*), and **II** at (*b*), PIEHL, *Inscr. hiéro.* 1 Sér. cx [F ι, κ, λ].

(18) [1st ed. 17, 18] Doorway between Pillars B and C. Outer lintel, double-scene, deceased and wife before Osiris-Onnophris. Inner lintel, deceased fighting with hyena, and jambs, decorative bouquets.

M.M.A. photos. T. 2588, 2585–6; VIREY, pp. 256–9, 277, with pl. (hyena-fight, by GAYET), figs. 5, 15. Outer lintel, CHIC. OR. INST. photo. 2921; text, PIEHL, *Inscr. hiéro.* 1 Sér. cxi–cxii [F o–ρ]; part, SETHE, *Urk.* iv. 921–2 (271) d, h. Hyena-fight, WRESZ., *Atlas*, i. 21; DAVIES (Nina) in *J.E.A.* xxvi (1940), pl. xvi [b], p. 82; MACKAY in *Journal of the Palestine Oriental Society*, ii [3], pp. 171–4 with fig.; SMITH, *Art . . . Anc. Eg.* pl. 107 [A].

Ceiling. Remains of text, VIREY, p. 256; M.M.A. photo. on T. 2588.

Passage.

(19) [1st ed. 4, 26–8, 31] Outer lintel, double-scene, son before deceased and wife, jambs, remains of offering-formula. Thicknesses, deceased offering. Inner lintel, double-scene, deceased and wife with incense and libation before Osiris and Isis, jambs, offering-texts. Soffit, texts.

M.M.A. photos. T. 2576, 2597–9. Outer lintel, CHIC. OR. INST. photo. 2922. Texts, VIREY, pp. 259–62, 276–7 with fig.; titles of deceased and wife, SETHE, *Urk.* iv. 900 (269) g, 902 (269) m, 906 (269) z, 921 (271) e, f; text of right thickness, PIEHL, *Inscr. hiéro.* 1 Sér. cxiii [F ω].

(20) [1st ed. 29] Deceased, wife, son, and his wife, all seated, inspect funeral outfit. Sub-scene, seated people.

M.M.A. photos. T. 2600–1. Outfit, VIREY, fig. 6; SCHOTT photos. 6978–9; *wesekh*-collar at top, JÉQUIER, *Frises*, fig. 186. Texts, VIREY, pp. 264–5; PIEHL, *Inscr. hiéro.* I Sér. cxxvi–cxxvii [o β, γ]; SETHE, *Urk.* iv. 912–14 (270) G.

(21) [1st ed. 30] A *sem*-priest with offering-list and offering-bringer before deceased, wife, and couple (woman destroyed). Sub-scene, banquet.

M.M.A. photos. T. 2602–3; details, SCHOTT photos. 6980–1, 8934–7; *sem*-priest and offering-bringer, CHIC. OR. INST. photo. 2926; *sem*-priest and texts, VIREY, fig. 14, pp. 274–6. Texts, PIEHL, *Inscr. hiéro.* I Sér. cxxv–cxxvi [o α]; titles of deceased and wife, EBERS in *Z.D.M.G.* xxx (1876), pp. 400–2; SETHE, *Urk.* iv. 899 (269) b, 921 (271) g.

Inner Room.

(22) [1st ed. 32] Five registers (lower part destroyed), funeral procession to Western goddess, including funeral outfit with chariot, &c., and servants with food in booths in **I**, mummy on bier with Anubis in **II**, boat with officials in **III**, setting up obelisks in **IV**, and men bringing provisions on yokes in **V**.

M.M.A. photos. T. 2608–11; CHIC. OR. INST. photos. 2919, 2923. Procession (incomplete), SCHOTT photos. 4123–7, 6991–6. Men dragging, and female mourners, in **II**, LÜDDECKENS in *Mitt. Kairo*, xi (1943), pl. 13 [a] (from SCHOTT photo.), p. 15. See VIREY, pp. 265–7.

(23) [Deceased] and wife with [long text] offer to Osiris.
M.M.A. photo. T. 2606. See VIREY, p. 267 [KL].

(24) [1st ed. 33] Deceased with wife spearing [hippopotamus].
WRESZ., *Atlas*, i. 271; WILKINSON, *M. and C.* iii. 72 (No. 347) = ed. BIRCH, ii. 129 (No. 377) (reversed); DAVIES, *Tomb of Puyemrê*, i, fig. 1, cf. p. 51; M.M.A. photos. T. 2612–13. Deceased, VIREY, fig. 7, cf. p. 267 [LM]; spear, WILKINSON MSS. xvii. H. 18; coil of rope, SCHOTT photo. 4128. Text, SETHE, *Urk.* iv. 904–5 (269) u.

(25) Deceased with staff, and wife.
M.M.A. photo. T. 2614. See VIREY, p. 267 [near bottom].

(26) [1st ed. 35] Three registers. **I**, Fowling with draw-net, and bringing birds. **II**, Netting and preparing [fish]. **III**, Deceased receives men with produce [of marsh-lands].
M.M.A. photo. T. 2607. **I–II**, WRESZ., *Atlas*, i. 24; FARINA, *Pittura*, pl. lxxiii; netting fowl and netting fish, SCHOTT photos. 6988–90. See VIREY, pp. 273–4 [κ′, J′].

(27) Deceased and family [fowling] and fishing. Sub-scene, attendants bringing produce.
M.M.A. photo. T. 2605. Some birds above marsh, SCHOTT photos. 6986–7. Text, VIREY, p. 273 [L′, κ′]; PIEHL, *Inscr. hiéro.* I Sér. cxxvii [o δ]; SETHE, *Urk.* iv. 917–18 (270) L.

(28) [1st ed. 34] Deceased with [wife] and [man] with offering-list and offerings before them, and three registers, **I–III**, guests and musicians (male and female harpists, women with flute and lyre, in **III**). Sub-scene, guests, and attendants bringing provisions.
M.M.A. photos. T. 2615–17, cf. 2604 [right]. **I–III** and sub-scene, CHIC. OR. INST. photo. 2924; **I–III**, WRESZ., *Atlas*, i. 272; FARINA, *Pittura*, pl. lxxv. Girl-attendant with guests at right end of **II**, and musicians in **III**, SCHOTT photos. 4000–2, 6982–5, 8938–9; musicians, BRUYÈRE, *Rapport (1934–1935)*, Pt. 2, fig. 59; HICKMANN, *45 Siècles de Musique*, pl. xlvi [c]; woman with lyre, WILKINSON, *M. and C.* ii. 291 (No. 217, 1) = ed. BIRCH, i. 476 (No. 242, 1); WILKINSON MSS. ii. 23 [top right]; lyre, HAY MSS. 29853, 124. Texts, VIREY, pp. 271–3; text of deceased, SETHE, *Urk.* iv. 902–3 (269) o.

Shrine. View, M.M.A. photo. T. 2604 [left].

(29) [1st ed. 36] [Priest] before upright mummy in kiosk, lector with ritual implements, and three registers, **I** and **III**, servants with food-tables and booths with wine-jars, **II**, funeral procession with coffin dragged by men and oxen.

M.M.A. photos. T. 2624–7. **I, II,** and lector, CHIC. OR. INST. photos. 2928, 2930. **I–III,** incomplete, SCHOTT photos. 3996–9, 4129–30, 6997–7007. See VIREY, pp. 267–8 and figs. 8, 9 (part of **I** and **II**). Coffin on sledge and lector, WILKINSON MSS. ii. 23 [top middle and left]; coffin, id. *M. and C.* 2 Ser. ii. 412 (No. 500) = ed. BIRCH, iii. 445 (No. 632). Titles of deceased as Maḥu, SETHE, *Urk.* iv. 906 (269) aa, bb.

(30) [1st ed. 37] Two scenes. **1,** Deceased and wife standing inspect garden with trees and pool. **2,** Deceased and wife seated receive two registers of garden produce. Sub-scene, men bringing animals (bull, gazelle, and ibex) and provisions.

M.M.A. photos. T. 2618–22; incomplete, CHIC. OR. INST. photos. 2927, 2929, 2932; details, SCHOTT photos. 3995, 4131–2, 7008–14, 8940–3. Garden, WRESZ., *Atlas,* i. 66; trees, FARINA, *Pittura,* pl. lxxiv; LAURENT-TÄCKHOLM, *Faraos blomster,* pl. on p. 209. See VIREY, pp. 269–71, figs. 10–13 (garden and details). Text of deceased, SETHE, *Urk.* iv. 900–1 (269) i.

(31) Four registers. **I,** Anubis-jackals. **II,** Osiris (left of small niche). **III–IV,** Offerings. M.M.A. photo. T. 2623.

86. MENKHEPERRAʿSONB ⟨𓉔𓊃𓏤𓏤⟩, First prophet of Amūn. (Also owner of tomb 112.) Temp. Tuthmosis III.

Sh. ʿAbd el-Qurna.

Parents, Amenemḥēt and Taōnet 𓀀𓏏𓏤𓊖, King's nurse.

Plan, p. 176. Map V, D–4, e, 9.

DAVIES, *The Tombs of Menkheperrasonb* [&c.], pp. 1–17, with plan and section, pl. ii; VIREY, *Le Tombeau de Ramenkhepersenb* in VIREY, *Sept Tombeaux thébains (Mém. Miss.* v, 2), pp. 197–215, with plan, p. 198; WILBOUR, *Travels in Egypt,* p. 288, with plan; PIEHL, *Inscr. hiéro.* 1 Sér. pp. 102–5.

Hall.

(1) [1st ed. 1] Remains of five registers. **I–II,** Female singers with sistra and *menats*, and male singers, with songs before deceased, with three rows beyond, men with bouquets of Amūn (for named temples), and offering-bringers in unfinished scene. **III–V,** Agriculture, including measuring crop, priests offering to [Amūn and Termuthis (?)], reaping and carrying corn.

DAVIES, pls. xvii, xviii, pp. 13–15; CHIC. OR. INST. photos. 6473–4. Texts, VIREY, pp. 214–15; SETHE, *Urk.* iv. 927–8 (273) d, 935 (274) F 1, 2.

(2) [Tuthmosis III] in kiosk.

Text, VIREY, p. 200, cf. DAVIES, p. 2.

(3) [1st ed. 7] Deceased [offers on braziers] with offerings and altars below.

DAVIES, pls. xiv [right], xv [right], xvi, p. 13. Text, VIREY, pp. 213–14; SETHE, *Urk.* iv. 926–7 (273) c, 934 (274) E.

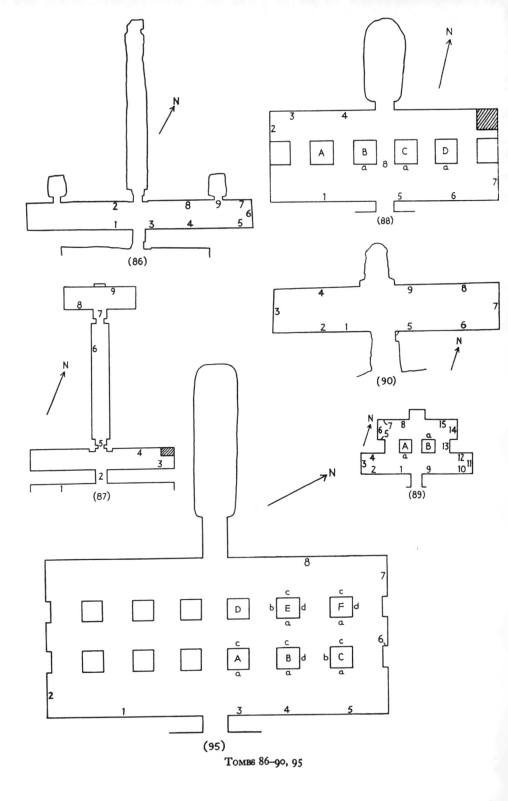

Tombs 86–90, 95

(4) [1st ed. 6] [Deceased] inspects remains of six registers, bringing animals, **I–III,** cattle (including humped bull in **III**), **IV,** goats, **V,** geese, **VI,** men carrying produce and fowl.

DAVIES, pls. xiii, xiv [left], xv [left], pp. 12–13. I–VI, CHIC. OR. INST. photos. 2937, 9955. **I–III,** M.M.A. photo. T. 1773. Remains of text, SETHE, *Urk.* iv. 934 (274) D. See VIREY, p. 213.

(5) [1st ed. 5] Deceased inspects three registers, **I–III,** temple-workshops, with recording and weighing metal and malachite. **I,** Leather-workers. **II,** Carpenters. **III,** Metal-workers, including gold stand of Tuthmosis III.

DAVIES, pls. x–xii, xxi, pp. 11–12; M.M.A. photos. T. 1774–6; CHIC. OR. INST. photos. 2935–6, 7894–9. See VIREY, pp. 208–13, with details, figs. 3–11. I–III, WRESZ., *Atlas,* i. 41, 17 [a], 69 [a], 78 [a], 79–82; FARINA, *Pittura,* pl. lxi; three chariot-makers, DONADONI, *Arte Egizia,* fig. 112; makers of bows and arrows, WOLF, *Die Bewaffnung des altägyptischen Heeres,* pl. 22. Texts, SETHE, *Urk.* iv. 928 (273) e, 932–3 (274) C 1–3; of deceased, PIEHL, *Inscr. hiéro.* 1 Sér. cxxviii–cxxix [P ϵ].

(6) [1st ed. 4] Deceased receives four registers, **I–IV,** produce of Koptos and Kush. I–II, Recording and weighing gold. **III,** Bringing game (including ostriches). **IV,** Heaps of turquoise, &c., from [eastern?] desert.

DAVIES, pls. ix, xix [B], pp. 10–11; M.M.A. photo. T. 1777; CHIC. OR. INST. photo. 2934. Text, PIEHL, op. cit. cxxvii [P á]; SETHE, *Urk.* iv. 931 (274) B. See VIREY, pp. 206–8.

(7) Four registers. **I,** [Picking] grapes before deceased. **II,** Wine-jars in storehouse. **III–IV,** Remains of bringing produce and bulls (one garlanded).

DAVIES, pl. viii, pp. 9–10. See VIREY, p. 206.

(8) [1st ed. 2, 3] [Tuthmosis III] in kiosk, [deceased] with four rows of decorative vases (including floral vases with frog and pigeon) offering bouquet of Amūn to him at New Year Festival, and five registers, **I–V,** northern tribute. **I,** Chiefs of Keftiu, Hittites, and Tunip, with Keftiu bringing statues of bulls, vases with bulls' heads and with boukrania-decoration, bead necklaces, lapis-lazuli, &c. **II,** Chief of Kadesh and Syrians with malachite, vases, &c., women and children. **III,** Bringing horses and chariots. **IV,** Remains of bringing chariots, &c. **V,** Bringing produce of Oases.

DAVIES, pls. i (frontispiece), iii–vii, xx, pp. 2–9; CHIC. OR. INST. photos. 2938–40, 7887–93; part, VIREY, pp. 201–6, pl. i, figs. 1, 2. Omitting [King], WRESZ., *Atlas,* i. 273–7; MÜLLER, *Egyptological Researches,* ii, pls. 1–22, p. 32, note 1, with fig. 4; MEYER, *Fremdvölker,* 596–600, 721–2. Vases and I–IV, M.M.A. photos. T. 1778–81; vases and head of one of the Keftiu, WAINWRIGHT in *Liv. Ann.* vi (1914), pls. xi [54–74], on xiii, xv [11, 12], xvi [27], pp. 34 ff., 57, 67. I and **II,** SMITH, *Art . . . Anc. Eg.* pl. 105; parts, BOSSERT, *Altkreta,* figs. 340–2; id. *The Art of Ancient Crete,* figs. 542–4, cf. 541; id. *Altanatolien* (1942), fig. 743; DAVIES (Nina), *Anc. Eg. Paintings,* i, pls. xxi (CHAMPDOR, Pt. v, 7th pl.), xxii–xxiv; MÜLLER in *Jahrbuch des Deutschen Archäologischen Instituts,* xlii (1927), Abb. 9–11, cf. pp. 20–2; ROEDER in *Der Alte Orient,* xx (1919), Abb. 3–5, cf. pp. 5, 19; Keftiu and Syrians with details, VERCOUTTER, *L'Égypte* [&c.], pls. ix–xi [98–108], xix–xxvi [157, 164, 168–9, 172–3, 175–6, 180–3, 188], xxxiii–xxxiv [224, 229], pp. 219–93. Parts of **I,** HALL in *Essays in Aegean Archaeology presented to Sir Arthur Evans,* pl. iv (by NINA DAVIES), pp. 31–41; id. *The Civilisation of Greece in the Bronze Age,* figs. 262–3, cf. pp. 200–1; *Cambridge Ancient History. Plates,* i. 151 [a] (by NINA DAVIES); KÖSTER in *Der Alte Orient,* Beiheft i (1924), pl. iii [lower], p. 31; DAVIES in *M.M.A. Bull.* Pt. ii, Dec. 1930, figs. 2 [left], 3, cf. pp. 31–2;

BYVANCK, *De Kunst der Oudheid*, pl. xliii [fig. 154], p. 272. Parts of **II**, MEKHITARIAN, *Egyptian Painting*, pl. on p. 49; VON LICHTENBERG in *Mitt. Vorderasiat. Ges.* xvi (1911), Abb. 24, cf. pp. 117–18 (Heft 2, pp. 53–4); PRITCHARD, *The Ancient Near East in Pictures*, fig. 48. Vases (including heads of lions, bulls, and jackal, and two with lion-handles) in **I** and **II**, and sword and two elephant-tusks held by Keftiu in **I**, VERCOUTTER, *L'Égypte* [&c.], pls. xxxv–lviii [234, 247–8, 256, 266, 272, 280, 285, 306, 308, 312, 316–18, 322–4, 326–8, 334, 350–4, 380, 394, 404, 419–20, 426–7], lxii [463], lxvi [503–4], pp. 307–51, 359, 366; statuette of bull carried by Kefti in **I**, WEIGALL in *J.E.A.* iv (1917), fig. on p. 187; jackal-head vase in **I**, DAVIES in *M.M.A. Bull.* Pt. ii, March 1926, fig. 6 [H], cf. p. 46; VERCOUTTER, op. cit. pl. lxi [455], p. 358. **III**, FARINA, *Pittura*, lxii. Texts, PIEHL, *Inscr. hiéro.* 1 Sér. cxxvii–cxxviii [P β–δ]; SETHE, *Urk.* iv. 928–30 (274) A 1–4; text of deceased, WILBOUR MSS. 2 F. 36.

(9) Entrance to North Chapel. Lintel, remains of text, DAVIES, pl. xix [A], p. 2.

87. MINNAKHT ⟨hieroglyphs⟩, Overseer of the granaries of Upper and Lower Egypt, Overseer of horses of the Lord of the Two Lands, Royal scribe. Temp. Tuthmosis III.

Sh. 'Abd el-Qurna. (HAY, No. 17.)
Father, Sen-dhout ⟨hieroglyphs⟩.

Plan, p. 176. Map V, D–4, d, 9.

VIREY, *Tombeau de Khem-nekht* in VIREY, *Sept Tombeaux thébains* (*Mém. Miss.* v, 2), pp. 314–21, with plan, p. 314. MOND photos. of all walls. Fragment of text from a hymn, SETHE, *Urk.* iv, on 1193 [right]; HELCK, *Urk.* iv. 1526 (485) G.

Court.

(1) Brick stela. MOND and EMERY in *Liv. Ann.* xiv (1927), pl. xxxvii [a], p. 33; HERMANN, *Stelen*, pl. 2 [c], p. 25.

Hall.

(2) Fragments of lintel, found in Court, MOND and EMERY, pl. xxxvii [b].

(3) Remains of [deceased] inspecting bulls, with butcher at bottom.

(4) [1st ed. 2] [Deceased seated, man] with offering-list and offerings before him, and remains of banquet.
Three guests, HAY MSS. 29848, 82. Remains of text, VIREY, p. 316 [E', D']; titles of deceased, BRUGSCH, *Recueil*, pl. lxv [2]; SETHE, *Urk.* iv. 1177 (343) A a.

Ceiling. Text, VIREY, p. 315; BRUGSCH, *Recueil*, pl. lxv [3]; SCHOTT photo. on 7047.

Passage.

(5) [1st ed. 1, but references moved to Ceiling of Hall] Outer lintel, double-scene, [deceased] before Osiris and Isis, and deceased before Anubis and Western goddess. Thicknesses, zad-pillar with [Isis], and with Nephthys, kneeling at bottom.
Lintel, VIREY, fig. 1, cf. pp. 315–16. Titles of deceased, LEPSIUS MS. 322 [middle right].

(6) [1st ed. 3] Remains of offering-scene before [deceased with daughter].
Fragment of text, VIREY, p. 317 [G–H]; SETHE, *Urk.* iv. 1178 (343) A f.

Inner Room.

(7) [1st ed. 4] Outer lintel, double-scene, son Menkheper (tomb 79) in left half, and [son?] in right half, offer to deceased.

VIREY, fig. 2, cf. pp. 317–18; HAY MSS. 29848, 82. Titles, SETHE, *Urk.* iv. 1177–8 (343) A b, d, 1205 (357) a, b; some, LEPSIUS MS. 322 [middle left].

(8) [1st ed. 5] Deceased with son Menkheper offering papyrus-staff bouquet of Rēꜥ-Ḥarakhti to him, and four registers. **I**, Funeral ceremonies with men carrying chest, butchers, and priest with incense and libation before deceased in kiosk. **II–IV**, Garden with boat on lake and house, servants with food in booths, and butcher. Sub-scene, female tumbler (?) and mourners, and provisions brought to two seated men.

M.M.A. photos. T. 1782–5; SCHOTT photos. 4100–13, 7051–65. See VIREY, pp. 318–20 [J, K], figs. 3–10. Papyrus-staff bouquet, SCHOTT, *Das schöne Fest*, Abb. 14, cf. p. 816. **II–IV** and sub-scene, incomplete, FARINA, *Pittura*, pl. lv; LÜDDECKENS in *Mitt. Kairo*, xi (1943), pl. 14, p. 10; garden and house, WRESZ., *Atlas*, i. 278; DAVIES (Nina), *Anc. Eg. Paintings*, i, pl. xxv; house and part of garden, LHOTE and HASSIA, *Chefs-d'œuvre*, pl. 100; part of **III**, **IV**, and sub-scene, WEGNER in *Mitt. Kairo*, iv (1933), pl. vi [b]; WOLF, *Die Kunst Aegyptens*, Abb. 474; part of **III–IV**, BYVANCK, *De Kunst der Oudheid*, pl. xliv [fig. 157], pp. 272, 274; left part of **IV**, and sub-scene, WERBROUCK, *Pleureuses*, pl. iv [lower], figs. 101, 109, 129–30, 138, 171, 181, cf. fig. on 2nd page after p. 159, and p. 46. Butchers in **I**, and mourners, HAY MSS. 29823, 61–2, 29824, 74; some mourners, LHOTE and HASSIA, *Chefs-d'œuvre*, pls. 28–9; mourner at left end, MEKHITARIAN, *Egyptian Painting*, pl. on p. 45. Texts of deceased and son, SETHE, *Urk.* iv. 1177–8 (343) A c, B, 1205 (357) c.

(9) [1st ed. 6] Upper part of deceased and wife (?) seated (unfinished).

BAUD, *Dessins*, fig. 57; SCHOTT photo. 7050. Text, VIREY, p. 321 [M, L]; titles, SETHE, *Urk.* iv. 1178 (343) A e.

Burial Chamber (east of tomb 79).

Plan and section, MOND in *Ann. Serv.* vi (1905), fig. 11, cf. pp. 75–6.
Walls. Texts of Book of the Dead. Id. ib. pls. iv–ix, p. 76. Titles of deceased with name of father, SETHE, *Urk.* iv. 1178–9 (344).

Finds

Seat of black granite statue of deceased, probably from here, in Cairo Mus. Texts, DARESSY in *Rec. de Trav.* xvi (1894), p. 43 [xcii]; SETHE, *Urk.* iv. 1182–5 (348).

88. PEḤSUKHER 𓍋𓏤𓈇𓏺𓏭, called THENENU 𓏭𓏤𓄿, Lieutenant of the King, Standard-bearer of the Lord of the Two Lands. Temp. Tuthmosis III to Amenophis II.

Sh. ꜥAbd el-Qurna. (CHAMPOLLION, No. 8, L. *D. Text*, No. 61.)
Wife, Neit 𓏏𓏤, Chief royal nurse, Governess of the god.

Plan, p. 176. Map V, D–4, d, 9.

VIREY, *Le Tombeau de Pehsukher* in VIREY, *Sept Tombeaux thébains* (*Mém. Miss.* v, 2), pp. 286–310, with plan, p. 286; CHAMP., *Not. descr.* i, p. 496. Titles of deceased and wife, ROSELLINI MSS. 284, G 12 verso–13; L. *D. Text*, iii, p. 272 [middle]; GOLENISHCHEV MSS. 14 [p].

Hall. MOND photos. of all walls.

(1) [1st ed. 1, 2] Two scenes. **1,** Deceased in front of palace inspects three rows of soldiers. **2,** Deceased inspects three rows of provisions. Sub-scene, three registers, agriculture, **I,** filling granary, and harvest, **II,** sowing and ploughing, **III,** remains of bringing fruit from storehouse.

WRESZ., *Atlas,* i. 279–81; VIREY, pp. 288–93, figs. 1–7; SCHOTT photos. 2103–4, 4387–9, 4393, 8312–13; omitting left part of sub-scene, CHIC. OR. INST. photos. 6120, 3006. Sub-scene, **I,** WILKINSON, *M. and C.* ii. 136 (No. 122), 2 Ser. i. 89 (No. 431) = ed. BIRCH, i. 371 (No. 142), ii. 422 (No. 474); WILKINSON MSS. ii. 12 [bottom]; granary, MASPERO, *L'Arch. ég.* (1887), fig. 41, (1907), fig. 42; second plough, BAUD, *Dessins,* fig. 58. Text in **1,** and of deceased in **2,** HELCK, *Urk.* iv. 1459–60 [top], 1463 [near top]; part in **1,** CHAMP., *Not. descr.* i, p. 497 [right].

(2) [Offering-scenes and false door] with offering-bringer on left.
Remains of false door, see VIREY, p. 294, note 1 [FG, but called EG].

(3) [1st ed. 3] Remains of four registers, **I–IV,** recording recruits.
CHIC. OR. INST. photos. 6476–7. **I, II,** and **IV,** M.M.A. photos. T. 1788–9; SCHOTT photos. 4390–1. See VIREY, pp. 294–5, figs. 8, 9.

(4) [1st ed. 4] [Deceased with wife offers bouquet of Amūn to Amenophis II in kiosk.]
Text, CHIC. OR. INST. photo. 6475; VIREY, pp. 295–6; HELCK, *Urk.* iv. 1460 [middle]; PIEHL, *Inscr. hiéro.* i Sér. pl. c [B *a*]; SCHOTT photo. 4392.

(5) [part, 1st ed. 6] Deceased with wife offers on braziers, with butchers below. Sub-scene, picking grapes and preparing fowl (belonging to (6)).
CHIC. OR. INST. photo. 6121 [right]; SCHOTT photos. 2105, 4383–5, 8315–17. Butchers, SCHOTT, *Das schöne Fest,* pl. iii, p. 795. Sub-scene, WRESZ., *Atlas,* i. 16, 282; M.M.A. photo. T. 1786; preparing fowl, WILKINSON, *M. and C.* ii. 127 (No. 115) = ed. BIRCH, i. 364 (No. 135); WILKINSON MSS. v. 97. Texts, VIREY, pp. 305–6; HELCK, *Urk.* iv. 1462 [bottom]–1463 [top]; texts of deceased, CHAMP., *Not. descr.* i, p. 497 [A]; LEPSIUS MS. 320 [botom].

(6) [part, 1st ed. 6] Deceased and [wife] with Maḥu ⹀, Second prophet of Amūn, offering bouquet of Amūn to them, and four registers, banquet. Sub-scene, man bringing bull, fowl in draw-net, and offering-bringers (continued from (5)).
See VIREY, pp. 303–5, and fig. 11 (part of sub-scene). Main scene, SCHOTT photos. 8315 [left], 8318; deceased and [wife], WRESZ., *Atlas,* i. 283; deceased, Maḥu, and fowl in draw-net, CHIC. OR. INST. photos. 6145, 6121 [left]. Texts, HELCK, *Urk.* iv. 1460–1, A, B; titles, L. D. *Text,* iii, p. 272 [middle right]; LEPSIUS MS. 321 [top]; of wife, CHAMP., *Not. descr.* i, p. 839 [to p. 496, l. 23].

(7) [1st ed. 5] Stela, double-scene at top, [deceased kneels before Osiris, and before Anubis], and offering-text below with hymn to Rēꜥ. At sides, five registers (destroyed on right), **I–IV,** deceased kneeling with liquid offerings, **V,** offerings.
VIREY, pp. 297–302, fig. 10 (before destruction, omitting **V**); HERMANN, *Stelen,* pl. 3 [a] (from SCHOTT photo.), pp. 1*–2* [1–10], 20* [lower]–24* (from copy by SETHE), cf. pp. 12, 35, Abb. 3 (from VIREY); M.M.A. photo. T. 1787; CHIC. OR. INST. photo. 6144; SCHOTT photos. 4386, 8314. Texts, PIEHL, *Inscr. hiéro.* i Sér. ci–civ [β]; HELCK, *Urk.* iv. 1515–38 (485) A, with titles of deceased, 1463 [bottom] (from VIREY); ll. 1–6, DUEMICHEN, *Altaegyptische Kalenderinschriften,* pl. xli [b]; ll. 5–6, BRUGSCH, *Monumens de l'Égypte,* pl. xvii [iii].

Pillars.

B (*a*) Three registers (unfinished), each before deceased and wife, **I**, man with bouquet, **II**, girl with sistrum, **III**, [man].

See VIREY, p. 307, with bouquet on fig. 12. **II**, SCHOTT photo. 8319.

C (*a*) Three registers, each before deceased and wife, **I**, son Amenḥotp offers bouquet, **II**, son Amenmosi, **III**, man offers bouquet.

VIREY, p. 308 with fig. 13. **I**, SCHOTT photo. 8320. Text of Amenḥotp, HELCK, *Urk.* iv. 1461 [near bottom].

D (*a*) Three registers, each before deceased and wife, **I**, [son Amenḥotp offers bouquet of Amūn], **II**, [son Amenmosi] offers, **III**, man offers bouquet.

See VIREY, pp. 308–10. **III**, SCHOTT photo. 8321. Titles, LEPSIUS MS. 321 [middle]–322 [top]. Texts, HELCK, *Urk.* iv. 1461 [bottom]–1462 [middle], 1463 [middle lower].

(8) Doorway between central pillars. Outer lintel, double-scene, deceased and wife adore Osiris, jambs, offering-texts.

See VIREY, p. 307.

Finds

Black granite kneeling statue of deceased with stela, probably from here, in Edinburgh, Royal Scottish Museum, 1910. 75. *Guide to the Collection of Egyptian Antiquities* (1913) and (1920), pl. iv (called Qen-tu); ALDRED, *New Kingdom Art in Ancient Egypt*, pl. 43; VANDIER, *Manuel*, iii, pl. clx [3], p. 668; head, GOSSE, *The Civilization of the Ancient Egyptians*, fig. 104.

89. AMENMOSI 〔▨𓀀𓏤〕, Steward in the Southern City. Temp. Amenophis III.
Sh. ʿAbd el-Qurna.

Plan, p. 176. Map V, D–4, c, 10.

DAVIES (Nina M. and N. de G.) in *J.E.A.* xxvi (1940), pp. 131–6, with plan, fig. 1.

Hall. MOND photos. of all walls.

(1) [1st ed. 1] [Deceased] pours incense on offerings with jars below.
See DAVIES, p. 132 [B]. Titles, SETHE, *Urk.* iv. 1024 (305) G a, b.

(2) Three scenes, **1**, [deceased with goddess (?)], **2**, [deceased] fishing and fowling, **3**, man offers bouquet to deceased. (3) Osiris, with two registers on left, deceased kneeling in each, and three registers on right, **I**, Anubis, **II**, Western goddess, **III**, Ḥathor.
See DAVIES, p. 132 [B, D].

(4) [1st ed. 2] Deceased (represented three times) inspects six registers, **I–VI**, preparing and recording (probably) gums and incense (including moulds of humped bull, two oryxes, and obelisks, in **IV**).
DAVIES, pl. xxii, pp. 132–3 [F]; omitting right end, CHIC. OR. INST. photo. 2948. **II–IV**, SCHOTT photos. 8430–8. Left part of **IV–VI**, WRESZ., *Atlas*, i. 286.

(5)–(6) [1st ed. 3] Four registers, funeral procession. **I–III**, Bringing funeral outfit, oxen dragging sarcophagus, and chest carrried on poles. **IV**, Offering-bringers, and sailing-boat in Abydos pilgrimage.

CHIC. OR. INST. photo. 2942. Chest carried on poles and female mourner in **II**, WER-BROUCK, *Pleureuses*, figs. 27, 117, cf. pp. 46–7. Sailing-boat in **IV**, SCHOTT photo. 8439. See DAVIES, p. 134 [L, M]. Texts, SETHE, *Urk.* iv. 1023–4 (305) F.

(7) [1st ed. 4] Two registers, **I–II**, rites before mummies. Sub-scene, offering-bringers (belonging to (8)).
CHIC. OR. INST. photo. 2946. See DAVIES, p. 134 [N left]. Texts of sub-scene, SETHE, *Urk.* iv. 1022 (305) D.

(8) [1st ed. 5] Two men offer bouquets to [deceased].
Men, SCHOTT photo. 8440. See DAVIES, p. 134 [N right]. Texts, SETHE, *Urk.* iv. 1022–3 (305) E 1, 2.

(9) [1st ed. 9] [Deceased], followed by four offering-bringers with gum, offers on braziers with offerings, and butchers below.
CHIC. OR. INST. photo. 6146; incomplete, SCHOTT photos. 8429, 8445–7. See DAVIES, pp. 131–2 [A]. Text, SETHE, *Urk.* iv. 1022 (305) C.

(10) Deceased and two female relatives (unfinished) with man offering bouquet to them, and three registers, banquet. Sub-scene, man offers to [couple], men carrying jar on poles, and men bringing garlanded bull.
Omitting right part, CHIC. OR. INST. photo. 2941. See DAVIES, p. 132 [A].

(11) Remains of stela, with double-scene at top, deceased before Osiris, and before Maʿet. At sides, [men offering to deceased].
CHIC. OR. INST. photo. 2943. See DAVIES, p. 132 [C].

(12) Two registers. **I**, [Deceased and wife] before Osiris. **II**, [Probably deceased purified by priest], and [offering-bringers].
See DAVIES, p. 132 [E].

(13) Tapers with stand before [deceased seated].
Tapers, DAVIES in *J.E.A.* x (1924), pl. vii [15], cf. p. 13 note; SCHOTT photo. 8448. See DAVIES in *J.E.A.* xxvi (1940), p. 133 [J].

(14) [1st ed. 8] Four registers. **I–II**, Incense, &c., and Puntite chiefs and men with produce of Punt, including two cheetahs, before [deceased] and attendants. **III–IV**, Men with produce, soldiers, and donkeys laden with produce for barter, followed by [deceased] in chariot and attendants.
DAVIES in *J.E.A.* xxvi (1940), pl. xxv, p. 136 [P]; CHIC. OR. INST. photo. 2947; WRESZ., *Atlas*, i. 284. **I–II**, omitting attendants, SCHOTT photos. 8442–4.

(15) [1st ed. 6, 7] Amenophis III and Ḥathor in kiosk with [deceased] presenting three registers, **I–III**, decorative vases (bulls' heads), lion's head, gold, and foreigners with tribute. **I**, Syrians with vases and chariots. **II**, Nubians with gold, incense, hunting dogs, monkeys, and women with children. **III**, Egyptian military escort.
I–III, CHIC. OR. INST. photo. 2944; SCHOTT photo. 8441; left part, WRESZ., *Atlas*, i. 285. **I–II**, and man with sack in **IV**, DAVIES in *J.E.A.* xxvi (1940) pls. xxiii, xxiv, pp. 134–6 [O], and fig. 2. Left part of **I–II**, MEYER, *Fremdvölker*, 763; ḥes-vase in **I**, VERCOUTTER, *L'Égypte* [&c.], pl. xlix [366], p. 337. Text of deceased, SETHE, *Urk.* iv. 1022 (305) B.

Pillars.

A (a) [Deceased seated.]
See DAVIES, p. 133 [G].

B (a) [1st ed. 10, moved here] [Dece⸱⸱ ⸱⸱ with fan before young deified Tuthmosis III
in kiosk (unfinished).
DAVIES in *M.M.A. Bull.* Pt. ii, Dec. 1924, fig. 6, cf. p. 52; CHIC. OR. INST. photo. 2945.
King, M.M.A. photo. T. 1165. See DAVIES in *J.E.A.* xxvi (1940), p. 134 [K]. Text of King,
SETHE, *Urk.* iv. 1021–2 (305) A.

90. NEBAMŪN 𓈖𓏏𓏤𓏤, Standard-bearer of (the sacred bark called) 'Beloved-of-
　　Amūn', Captain of troops of the police on the west of Thebes. Temp. Tuth-
　　mosis IV to Amenophis III.
　　Sh. ʿAbd el-Qurna. (CHAMPOLLION, No. 9 bis, L. *D. Text*, No. 63, HAY, No. 22.)
　　Wives, Sensenbut 𓇗𓏏𓆑𓊖 and Tiy 𓇋𓇋𓏏.
　　　　　　　　　Plan, p. 176. Map V, D–4, c, 9.

DAVIES, *The Tombs of Two Officials of Tuthmosis the Fourth*, pp. 19–38, with plan and
section, pl. xix; CHAMP. *Not. descr.* i, pp. 502–3; L. *D. Text*, iii, pp. 272–3; ROSELLINI MSS.
284, G 13 verso to 16. Names of daughters, NESTOR L'HÔTE MSS. 20404, 63.

Hall.
　　(1) [1st ed. 1 on plan but entry moved to 2] [Deceased and wives] followed by daughter
Segerttaui as royal concubine.
　　DAVIES, pl. xxii, pp. 25, 28. Daughter, SCHOTT photo. 6815. Text of daughter, LEPSIUS
MS. 323 [top]; HELCK, *Urk.* iv. 1623 [middle].

　　(2) [1st ed. 2] Deceased and Sensenbut with two daughters offering floral vases to them,
and three registers, I–II, [guests] and piles of wine-jars, III, female clappers and musicians
(with double-pipe, harp, two dancing with lutes). Sub-scene, offering-bringers.
　　DAVIES, pls. xxiii, xxxvii [upper] (from HAY), pp. 27–9. Musicians, two vases, deceased
and wife, and wine-jars, SCHOTT photos. 6807–13, 6816–18. Clappers and musicians, WRESZ.,
Atlas, i. 91 c [9]; musicians, WILKINSON, *M. and C.* ii. 236 (No. 188) = ed. BIRCH, i. 440
(No. 213); WILKINSON MSS. v. 94; BURTON MSS. 25638, 67; harpist and lutists, HAY MSS.
29843, 176; sketch of full-faced clapper, NESTOR L'HÔTE MSS. 20404, 64 [bottom]. Ewer
and vase (in front of deceased), HAY MSS. 29823, 92. Hands of first daughter and of one
musician, MEKHITARIAN in *Mitt. Kairo*, xv (1957), pl. xlii [2, 3], pp. 191–2. Right part of
sub-scene (now destroyed), HAY MSS. 29823, 89; lotus-vase, WRESZ., *Atlas*, i. 18 [a]. Texts,
HELCK, *Urk.* iv. 1623 [bottom]–1624 [middle]; of deceased and family, LEPSIUS MS. 323
[middle].

　　(3) [1st ed. 3] Two registers. I, Chariot and [King] in royal barge. II, [Crowd of recruits
before house of deceased].
　　DAVIES, pls. xxiv, xxv, pp. 37–8; HAY MSS. 29823, 84. I, SCHOTT photo. 6814; chariot,
BAUD, *Dessins*, fig. 59; part of barge, NESTOR L'HÔTE MSS. 20404, 64 [top]. Crowd in II,
BURTON MSS. 25644, 30; sketch, WILKINSON MSS. xi. 168. Text, HELCK, *Urk.* iv. 1620
[bottom].

(4) [1st ed. 4] Two scenes. **1**, Yuny 𓊪𓈎𓏺𓏺, Royal scribe, presents commission and gazelle-standard to deceased, followed by troops, with text of year 6. **2**, Deceased adores [Tuthmosis IV] in kiosk with boat-standard. Sub-scene, offering-bringers (including garlanded bull) met by soldiers.

DAVIES, pls. xxvi, xxvii, xxxvii [lower], pp. 34–7; HAY MSS. 29823, 83, 85, and gazelle-standard, 29853, 107. **1**, **2**, BURTON MSS. 25638, 65–6. Troops, WRESZ., *Atlas*, i. 287. Soldiers with standards in **1**, JÉQUIER, *Hist. Civ.* fig. 249; standards, trumpeter, and one soldier, WILKINSON, *M. and C.* i. 294 (No. 15, 8, 10), 301 (No. 20), ii. 261 (No. 200) = ed. BIRCH, i. 195 (No. 20, 8, 10), 200 (No. 25), 457 (No. 225); WILKINSON MSS. v. 90 [bottom right], 92 [bottom right]. Texts, HELCK, *Urk.* iv. 1618–20 [top]; text of year 6, CHAMP., *Not. descr.* i, pp. 841–2 [to p. 502, l. 7]; text above deceased in **2**, LEPSIUS MS. 323 [bottom].

(5) Deceased offers on braziers, preceded by lutist with song, and followed by Tiy and daughter Iuy, and remains of sons with offerings.

DAVIES, pl. xx [right], pp. 24–5. Son at top, and title 'standard-bearer' above deceased, SCHOTT photos. 6819–20. Texts of deceased, wife, and Iuy, LEPSIUS MS. 325 [middle upper]; of deceased, wife, and lutist, HELCK, *Urk.* iv. 1621 [bottom]–1622 [upper].

(6) [1st ed. 8] Deceased and Tiy with daughter Weret offering to daughter Segerttaui as royal concubine seated in front of them, and three registers, **I–III**, remains of banquet, with musicians (male and female lutists). Sub-scene, butchers with offering-bringers, and captain of police reporting to deceased seated under tree.

DAVIES, pl. xxi, pp. 25, 28–30. Attendant before son Khaᶜemwēset (now destroyed) in **I**, and names of family, WILKINSON MSS. v. 95 [upper right, and lower]–96 [top]. Left part of sub-scene, HAY MSS. 29823, 91. Texts (incomplete), HELCK, *Urk.* iv. 1621 [top], 1622 [lower]–1623 [top]; text above deceased and wife, and names of two granddaughters, LEPSIUS MS. 324 [bottom], 325 [top]; names in hieratic, BURTON MSS. 25644, 38–9; HAY MSS. 29853, 125.

(7) [1st ed. 7] Stela with [offering-scene] and text below. At sides, four registers, a priest performing funeral rites before deceased (once with wife), including purification and offering torches.

DAVIES, pls. xxxv, xxxvi, p. 26. Text of stela, and some texts from sides, HERMANN, *Stelen*, pp. 13* [67–8], 25*–6* [upper] (from DAVIES), cf. p. 82; text of stela, HELCK, *Urk.* iv. 1625 [bottom]–1628.

(8) [1st ed. 6] Four registers. **I**, Offering-bringers, butchers, picking grapes, pool with trees, and two servants, before Temple of Amenophis III. **II–III**, Bringing and treading grapes, offering to Termuthis as serpent, wine-jars, servants with food before deceased, and soldiers before wife Tiy and her daughter, with house at right end. **IV**, Cattle branded, and recorded before deceased seated with attendants.

DAVIES, pls. xxx–xxxiv, pp. 30–3; WRESZ., *Atlas*, i. 48 a, 289. **I–III**, FARINA, *Pittura*, pl. cxv; **I–III**, incomplete, and branding-scene in **IV**, SCHOTT photos. 6824–36; **I–III**, omitting left end, CAPART and WERBROUCK, *Thèbes*, fig. 119 (from WRESZINSKI); BURTON MSS. 25644, 28 verso to 29; HAY MSS. 29823, 87; picking grapes, pool, treading grapes, and Termuthis, house, and branding cattle, WILKINSON, *M. and C.* ii. 148 (No. 135), pl. x [1] opposite p. 152 (not in BIRCH edition), 121 (No. 110), iii. 10 (No. 321) = ed. BIRCH, i. 381 (No. 155), 361 (No. 130), ii. 84 (No. 349); picking grapes, pool, and Temple, in **I**, WILKINSON MSS. ii. 6 [top]; details, CHAMP., *Not. descr.* i, p. 504; part of picking grapes,

MEKHITARIAN, *Egyptian Painting*, pl. on p. 106; butcher in **I**, and man bringing grapes in **II**, DAVIES in *M.M.A. Bull.* Pt. ii, Dec. 1923, fig. 7, cf. pp. 40, 46; detail of man bringing grapes, MEKHITARIAN, *Mitt. Kairo*, xv (1957), pl. xlii [4], p. 191; treading grapes, Termuthis, &c., in **II**, BURTON MSS. 25638, 68; HAY MSS. 29823, 88; men bringing and treading grapes, and offerings to Termuthis, NESTOR L'HÔTE MSS. 20404, 65–6. House in **II–III**, MASPERO, *L'Arch. ég.* (1887), fig. 5, (1907), fig. 6; DAVIES, *Town House*, fig. 10, cf. p. 248; WILKINSON MSS. v. 95 [upper left]; wife and daughter in front of house, LEPSIUS MS. 324 [top]. **IV**, HAY MSS. 29823, 90; branding cattle, SCHÄFER and ANDRAE, *Kunst*, 358 [lower], 2nd ed. 374 [lower], 3rd ed. 368 [upper] (all from DAVIES); WILKINSON MSS. ii. 6 [near top]. Texts, HELCK, *Urk.* iv. 1621 [middle], 1624 [near bottom]–1625 [near bottom].

(9) [1st ed. 5] [King] with deceased (holding boat-standard and papyrus-bouquet and preceded by two fan-bearers) presenting Syrian tribute to him, and three registers, **I–III**, Syrians, including captives and horses. Sub-scene, remains of soldiers and [royal chariot].

DAVIES, pls. xxviii, xxix, xx [bottom left], pp. 33–4; HAY MSS. 29823, 86, 93. Head of deceased with standard, and captives and horses in **I–II**, SCHOTT photos. 6821–3. **I–III**, WRESZ., *Atlas*, i. 288; MEYER, *Fremdvölker*, 762; Syrian with tribute at right end of **I**, MEKHITARIAN, *Egyptian Painting*, pl. on p. 109; heads of 2nd and 4th Syrians in **II**, VERCOUTTER, *L'Égypte* [&c.], pl. xii [114–15], p. 226; standard with papyrus-bouquet, and Syrians in **II**, MEKHITARIAN in *Mitt. Kairo*, xv (1957), pls. xli [4], xliii [1, 4], pp. 191–2. Texts, HELCK, *Urk.* iv. 1620 [middle].

Ceiling. Texts, DAVIES, pl. xxxviii, p. 20.

Finds

Fragments (re-buried) of sandstone statue-group of deceased, wife, and children, and of right end of a sandstone lintel (probably from niche), with deceased and Tiy adoring. See DAVIES, pp. 21–2.

91. Captain of the troops . . ., Overseer of horses. Temp. Tuthmosis IV to Amenophis III.

Sh. 'Abd el-Qurna. (CHAMPOLLION, No. 8 ter, L. D. *Text*, No. 65, HAY, No. 13.)

Plan, p. 186. Map V, D–4, b, 10.

CHAMP., *Not. descr.* i, pp. 498–9; L. D. *Text*, iii, pp. 273–4; HAY MSS. 29824, 58 verso to 59.

Hall. MOND photos. of all walls.

(1) Remains of text above [deceased].

(2) Remains of fowling and fishing.
Birds above papyrus-clump, SCHOTT photo. 6792. Text, HELCK, *Urk.* iv. 1598 [bottom]–1599 [top].

(3) [1st ed. 1] [Amenophis III] and two fan-bearers, with Ḥathor holding *menat* and [deceased] offering bouquets of full-blown papyrus before him, and three registers, **I–III**, tribute and kneeling and prostrate Nubians. Sub-scene, Nubians with ivory and skins, and soldiers, met by men with leopard.

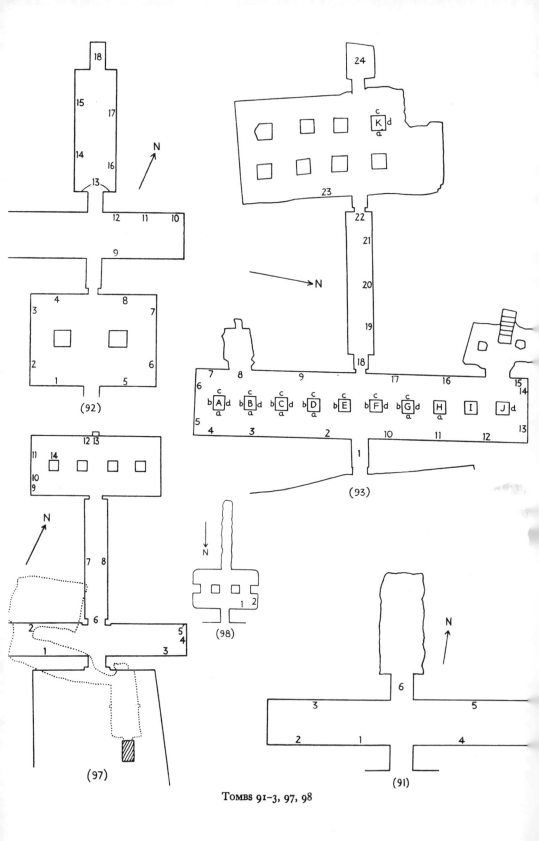

TOMBS 91–3, 97, 98

I–III and sub-scene (incomplete), WRESZ., *Atlas*, i. 292–3. I–III, MEYER, *Fremdvölker*, 761. Ḥatḥor, [deceased], and leopard-skin from offerings, SCHOTT photos. 6789–91. Full-blown papyrus, L. *D. Text*, iii, p. 273 [bottom] (probably here). Nubians in sub-scene, HAY MSS. 29823, 51; Nubian and leopard, BURTON MSS. 25644, 142.

(4) [1st ed. 5] [Deceased] followed by [wife] and man with papyrus-bouquet offers on braziers, and unfinished banquet beyond. Sub-scene, offering-bringers.

Man with bouquet, and details, SCHOTT photos. 6806, 8323–5. One brazier, JÉQUIER in *Rec. de Trav.* xxxii (1910), p. 167, fig. 1. Text of deceased, HELCK, *Urk.* iv. 1598 [middle]; incomplete, CHAMP., *Not. descr.* i, p. 840 [near top].

(5) [1st ed. 2–4] Tuthmosis IV with Ḥatḥor holding necklace and [deceased] offering bouquets of full-blown papyrus before him, and four registers, I–IV, foreigners with tribute. I–II, Decorative vases (including bulls' heads), Asiatics (some prostrate) including chiefs of Mitanni and Hittites. III–IV, Nubian soldiers and men with horses.

Papyrus-bouquets, SCHOTT photo. 8322; one bouquet, WILKINSON, *M. and C.* 2 Ser. ii. 367 (No. 478, 8) = ed. BIRCH, iii. 418 (No. 611, 8); WILKINSON MSS. v. 96; LEPSIUS MS. 326 [top]. Necklace of King, WILKINSON MSS. v. 131. Vases, and chiefs with an Asiatic behind each pair in I–II, CHAMP., *Mon.* clx [1]; WRESZ., *Atlas*, i. 290; MEYER, *Fremdvölker*, 758–60; incomplete, SCHOTT photos. 6801–5; chiefs and first two Asiatics in I, BOSSERT, *Altanatolien* (1942), fig. 744; detail of one Asiatic, MÜLLER, *Asien und Europa*, fig. on p. 298 [top left]; vases, HAY MSS. 29853, 139, 29854, 3–5, 8–10; some, PRISSE, *L'Art égyptien*, ii, 77th pl. 'Vases . . . Asiatiques', cf. *Texte*, pp. 432–3; WILKINSON MSS. ii. 22 [middle]; two vases with bulls' heads, VERCOUTTER, *L'Égypte* [&c.], pl. xl [274–5], p. 319; one vase, CHAMP., *Mon.* ccccxxii [14]; ROSELLINI, *Mon. Civ.* lvii [11]. Man with horses and man with shield in IV, SCHOTT photos. 6793–4; horses, WRESZ., *Atlas*, i. 291. Texts above Asiatics, and text on throne, HELCK, *Urk.* iv. 1597–8 [top], 1599 [middle]; incomplete, CHAMP., *Not. descr.* i, pp. 839–40 [to p. 499, l. 10]; part, WILKINSON MSS. v. 150 [top].

(6) Entrance to Inner Room. Outer lintel, double-scene, deceased and wife before Osiris.

92. SUEMNUT ⫙⧎⧰⊛⁓, Royal butler clean of hands. Temp. Amenophis II.

Sh. ʿAbd el-Qurna. (L. *D. Text*, No. 67.)

Parents, Iamnūfer ⟨⟩⧈⧖, Mayor of Neferusi, and Meryt ⧵⟨⟨⌐, Songstress of Thoth. Wife, Kat ⧉⧈⌐⧘.

Plan, p. 186. Map V, D–4, c, 10.

BAUD, *Dessins*, pp. 138–50. Names and titles of deceased, wife, and parents, GOLENISHCHEV MSS. 14 [o]; of deceased and wife, L. *D. Text*, iii, p. 274 [middle]. MOND photos. of all walls.

Outer Hall.

(1) [1st ed. 1] Four registers. I, Deceased with wife and offering-bringers offers on brazier. II–IV, Banquet with musicians (including female lutist) and girl offering to deceased and wife.

CHIC. OR. INST. photo. 6122; parts, SCHOTT photos. 6843–4, 6851, 8944–6. Brazier and offerings in I, KYLE in *Rec. de Trav.* xxxi (1909), fig. 2, cf. p. 52. Lutist in II, DAVIES in *M.M.A. Bull.* Pt. ii, Feb. 1928, fig. 6, cf. p. 61. Texts of deceased and wife in I, LEPSIUS

MS. 327 [middle and bottom]; of deceased, and of girl offering, HELCK, *Urk.* iv. 1452 [middle], 1450 [middle and bottom]. Translation of offering-text of deceased, SCHOTT, *Das schöne Fest*, p. 862 [21].

(2) [1st ed. 2] Eight registers. **I–V**, Brewing and preparation of drink before deceased seated on left. **VI–VIII**, Preparation and bringing of food (including honey) to deceased standing on right.

WRESZ., *Atlas*, i. 295–7; CHIC. OR. INST. photos. 2949, 2952, 2974–6; parts, SCHOTT photos. 3498–500, 5143–51, 6845–50, 8949–50. Jars in **II**, and man polishing jar in **IV**, PRISSE, *L'Art égyptien*, ii, 82nd pl. [1–4] 'Jarres et Amphores', cf. *Texte*, pp. 434–5. Texts of deceased, and of brewer in **I**, HELCK, *Urk.* iv. 1449 [lower], 1450 [top], 1451 [top].

(3) [1st ed. 3, wrongly on north wall] Two registers. **I**, *Sem*-priest (sketched) before deceased, wife, and child. **II**, Man with offering-bringers offers bouquets to couple with monkey under chair.

CHIC. OR. INST. photos. 2953, 6128. *Sem*-priest, NESTOR L'HÔTE MSS. 20404, 61. Titles of deceased in **I**, HELCK, *Urk.* iv. 1452 [top].

(4) Deceased wearing fly-decoration and wife adore [Osiris] (unfinished scene).

BAUD, *Dessins*, fig. 62; CHIC. OR. INST. photo. 6123. Text in front of deceased, MACKAY in *J.E.A.* iv (1917), pl. xviii [4], p. 85.

(5) [1st ed. 5] Two registers, unfinished. **I**, Scribes and defaulters before deceased. **II**, Scribes recording produce before deceased. Sub-scene, butchers (sketched).

I and **II**, WRESZ., *Atlas*, i. 31 a; CAPART and WERBROUCK, *Thèbes*, fig. 180 (from WRESZINSKI); FARINA, *Pittura*, pl. xcii; KIELLAND, *Geometry in Egyptian Art*, fig. 5; CHIC. OR. INST. photo. 6124; WILD MSS. i. C. 17 [left]. **I**, and deceased in **II**, BAUD, *Dessins*, pl. xix, and fig. 61; **I**, omitting deceased, MASPERO, *L'Arch. ég.* (1887), fig. 174, (1907), fig. 183; PRISSE, *L'Art égyptien*, ii, 1st pl. [4] 'Ancien Canon . . .', cf. *Texte*, p. 394; part of **I**, and scribe in **II**, MACKAY in *J.E.A.* iv (1917), pls. xviii [1], xvi [3], pp. 77–8; part of **I**, SCHOTT photo. 6861; man carrying animal at right end of **I**, NESTOR L'HÔTE MSS. 20404, 51; scribe and man in **II**, WILKINSON MSS. v. 159; sketch of horse at right end of **II**, CAPART, *Documents*, i, pl. 67 [B].

(6) Deceased inspects men on ladders, with stack of loaves, and booths with trays of food. CHIC. OR. INST. photo. 2951; SCHOTT photos. 6842, 3501. Text, HELCK, *Urk.* iv. 1449 [upper].

(7) and (8) [1st ed. 4] Deceased, with jars and offering-bringers with bulls, &c., behind him, presents six registers, gifts of vases, furniture, royal statuettes, &c., to Amenophis II with Ḥatḥor (unfinished).

Omitting King and Ḥatḥor, CHIC. OR. INST. photo. 2950; SCHOTT photos. 3495–7, 3502, 6837–41. King and Ḥatḥor, BAUD, *Dessins*, fig. 63. Royal statuettes at (7), WRESZ., *Atlas*, i. 29 a. Text of deceased, HELCK, *Urk.* iv. 1451 [middle].

Inner Hall.

(9) Man with four attendants (sketched) offers to deceased and wife.

WILD MSS. I. C. 18; man and three attendants, BAUD, *Dessins*, pl. xx; MACKAY in *J.E.A.* iv (1917), pls. xvi [2], xviii [2], pp. 77–8, 80; man, MASPERO, *Égypte*, fig. 291; part of offerings, SCHOTT photos. 6856–7.

(10) Four registers (sketched), vintage. **I–II,** Sealing wine-jars. **III,** Bringing grapes. **IV,** Offering to Termuthis and treading grapes.

BAUD, *Dessins*, pl. xxii; CHIC. OR. INST. photo. 6127. **I, II,** and **IV,** SCHOTT photos. 6859, 6855.

(11) [1st ed. 6] Deceased and family fowling and fishing (unfinished).

WRESZ., *Atlas*, i. 294; BAUD, *Dessins*, pl. xxi; MACKAY in *J.E.A.* iv (1917), pl. xvii [1, 2], pp. 82–3; CAPART, *L'Art égyptien*, iii, pl. 515; FARINA, *Pittura*, pl. xciii; CHIC. OR. INST. photo. 6126. Fowling-scene, PRISSE, *L'Art égyptien, Texte*, fig. on p. 125. Deceased spearing [fish], WILD MSS. i. C. 17 [right]; details, SCHOTT photos. 6858, 6854, 6860.

(12) Deceased with family receives produce of marsh-lands.

CHIC. OR. INST. photo. 6125. Fish, birds, and man bringing fish, BAUD, *Dessins*, figs. 64–5; SCHOTT photos. 6852–3.

Passage.

(13) Three registers, each side of doorway. **I–III,** An offering-bringer in each (one carrying a male, and one a female, statuette, on right).

BAUD, *Dessins*, pl. xxiii.

(14) [1st ed. 7] Four registers, **I–IV,** funeral procession to Osiris and Western goddess, including funeral outfit and royal statuettes in **I,** *teknu* and 'Nine friends' in **II,** dancers and victims in **III,** Abydos pilgrimage and statues of deceased and wife dragged in **IV.**

HORSFALL photo. G. 3. Omitting left end of **IV,** CHIC. OR. INST. photos. 6133–5; parts, SCHOTT photos. 3503–6, 5158–64, 6862–5. Man 'spreading table' in **III,** JÉQUIER in *B.I.F.A.O.* vii (1910), fig. 1, cf. p. 89.

(15) Two registers. **I,** [Man] with offerings and offering-list before deceased and wife. **II,** Man offers to seated couple.

I, CHIC. OR. INST. photo. 6132.

(16) Five registers. **I–V,** Rites before two mummies, and groups of butchers.

Id. ib. 6129–30; details, SCHOTT photos. 3523, 5165–6.

(17) [1st ed. 8, 9] Deceased and wife, [man] offering to them, and three registers, **I–III,** banquet, with parents, followed by guests and female musicians (double-pipe, and dancing with lyre and harp). Sub-scene, offering-bringer, and man offering to guests.

Omitting left end of **IV,** CHIC. OR. INST. photos. 6147–9; guests and details, SCHOTT photos. 3509–18, 5152–7; musicians in **III,** WRESZ., *Atlas*, i. 259 [lower] (called tomb 80); BRUYÈRE, *Rapport (1934–1935)*, Pt. 2, fig. 56 [left]. Text before [man] offering, SCHIAPARELLI, *Funerali*, ii, p. 291 [xi]; text above parents, LEPSIUS MS. 328 [top]; HELCK, *Urk.* iv. 1451 [bottom].

(18) Niche. Outer lintel, double-scene, deceased and wife kneeling adore Anubis-jackal, with Western and Eastern emblems in centre, jambs, two registers, a remaining offering-bringer on each. Side-walls, each with unfinished scene, girl, followed by two rows of offering-bringers, offers to deceased with wife and daughter. Rear wall, jars at bottom.

Outer doorway, CHIC. OR. INST. photo. 6131.

Finds. Probably from here.

Sandstone lintel and block of deceased, rebuilt into pavement of Chapel of Wazmosi (cf. *Bibl.* ii, p. 157).

93. ḲENAMŪN 〈𓏤𓎸𓂧𓃀〉, Chief steward of the King. Temp. Amenophis II.

Sh. 'Abd el-Qurna. (CHAMPOLLION, No. 8 quater, L. *D. Text*, No. 68, WILKINSON, No. 33, HAY, No. 18.)

Mother, Amenemōpet 〈𓏤𓇋𓏠𓈖𓅓𓊪𓏏〉, Royal nurse. Wife, Tadedetes ◦𓄿𓂝𓏏𓈖.

Plan, p. 186. Maps V and VI, E–4, c, 1.

DAVIES, *The Tomb of Ḳen-Amūn at Thebes*, i, ii, passim, with plans and sections, i, pls. i–iii [A], cf. lxx (key-plan); CHAMP., *Not. descr.* i, pp. 499–501, with plan, p. 499; L. *D. Text*, iii, pp. 274–8; WILKINSON, *Topography of Thebes*, pp. 149–50 [33]; HAY MSS. 29824, 74–7 verso. Titles of deceased, HELCK, *Urk.* iv. 1401–3 [A–P].

Outer Hall. Views, DAVIES, i, pl. vii; M.M.A. photos. T. 1277–8, 1164.

(1) Outer lintel, deceased and wife adoring, jambs, [deceased] seated. Thicknesses, deceased and wife (?) adoring. Inner lintel, offering-texts.
See DAVIES, i, p. 3, and pl. xxxviii [D] (text of inner lintel), p. 56.

(2) [Deceased with wife and offering-bringers] offers on braziers.
Incomplete, DAVIES, i, pls. xxxvii, xxxviii [A, left], pp. 38–9; M.M.A. photo. T. 2037.

(3) [1st ed. 1] [Deceased] inspects five registers, I–V, procession of statues to temples and tomb. I–III, Statues of deceased dragged with priest performing rites, male and female dancers and female singers, priestesses holding sistra and dancing, and men with branches. IV, Royal barge towing boat with statue acclaimed by nude boys with branches. V, Priests, kneeling male singers, and butchers.
DAVIES, i, pls. xxxviii [A, right], xxxix–xlii [A, B], lxviii [B], pp. 39–42, ii, pl. xli A; M.M.A. photos. T. 649–51, 1155, 2038–9. I–III, CHIC. OR. INST. photos. 9970–5; some female dancers in I and III, RIEFSTAHL, *Patterned Textiles in Pharaonic Egypt*, figs. 16, 46, cf. pp. 12, 40; HAY MSS. 29823, 68, 29853, 96; two, DAVIES in *M.M.A. Bull.* Pt. ii, Feb. 1928, fig. 8, cf. p. 66; pair of men with branches and four priestesses in III, SCHOTT photos. 5140–2. Text of dragging statues, HELCK, *Urk.* iv. 1397–8.

(4) [1st ed. 2] [Deceased] adores Osiris-Onnophris and Western goddess in kiosk.
DAVIES, i, pl. xliii, pp. 42–3. Osiris and goddess, M.M.A. photo. T. 2040. Colonnette and architrave of kiosk, PRISSE, *L'Art égyptien*, i, 20th pl. [lower right] 'Détails de Colonnettes en Bois', cf. *Texte*, p. 363; lion-heads and Bes-head capital of colonnette, DAVIES in *M.M.A. Bull.* Pt. ii, March 1918, fig. 26, cf. p. 19.

(5) Stela, double-scene, offerings before Osiris and Eastern goddess, and before Anubis and Western goddess, with offering-text below. At sides, three registers, I, deceased adoring, II–[III], offering-bringers.
DAVIES, i, pls. xliv, xxv [B], pp. 43–4; HERMANN, *Stelen*, Abb. 4, 9, pp. 36–7, 69, with texts, pp. 26* [lower]–27* [upper], 4* [26–8] (all from DAVIES); M.M.A. photos. T. 2041–2. Text, HELCK, *Urk.* iv. 1404–6.

(6) Deceased and wife with man offering bouquet to them, and guests. (7) [Man before deceased and mother (?).]
Texts, DAVIES, i, pl. xxv [C, E, F, G], p. 44.

(8) Entablature with cats, above entrance to South Chapel.

DAVIES, i, pls. vi [B], xxv [A], pp. 3–4; PRISSE, *L'Art égyptien*, i, 12th pl. [1] 'Couronnements de Portes intérieures', cf. *Texte*, p. 358; M.M.A. photos. T. 664, 1163 [left]; CHIC. OR. INST. photo. 9967.

(9) [1st ed. 3] Amenophis II and [Maᶜet] in kiosk with captives with name-rings on base of throne, and [deceased] offering gold set-piece with monkeys in dôm-palms, and four registers, I–IV, New Year gifts, to them. I, Offering-bringers and statuettes of Amenophis II, Ḥatshepsut, and Tuthmosis I. II, Offering-bringers and vases (including floral vase with frog and vases in shape of oryx, ibex, and gazelle), necklaces, &c. III–IV, Troops with standard-bearers, one leading dog, and remains of gifts including sphinxes, chariots, &c.
DAVIES, i, pls. xi–xxiv, pp. 22–32, ii, pls. xi A, xxii A. I–III, omitting left end, L. *D.* iii. 63 [a], 64 [aj]; M.M.A. photos. T. 657–63, 665, 1157–8, 2043–5; CHIC. OR. INST. photos. 9956–67. Colonnette, &c., of kiosk, PRISSE, *L'Art égyptien*, i, 20th pl. [lower left] 'Détails de Colonnettes en Bois', cf. *Texte*, p. 363. Captives, MEYER, *Fremdvölker*, 764–5; name-rings, L. *D. Text*, iii, p. 276; heads of Kefti and Mennus, VERCOUTTER, *L'Égypte* [&c.], pl. xi [109–10], p. 224. Set-piece, DAVIES (Nina), *Anc. Eg. Paintings*, i, pl. xxxiii; incomplete, DAVIES in *M.M.A. Bull.* Pt. ii, March 1918, fig. 29, cf. p. 20. Left part of I–III, FARINA, *Pittura*, pl. lxxxix; parts, WRESZ., *Atlas*, i. 303–6. Statuette of Amenophis II in Nubian dress in I, ALDRED in *M.M.A. Bull.* N.S. xv (1957), fig. on p. 145 [lower], cf. p. 142; statuette of Ḥatshepsut, CHAMP., *Mon.* clx [2]; cartouches and description of I, LEPSIUS MS. 328 [middle]–329 [top]. Part of II–IV, MEYER, *Fremdvölker*, 766–71. Vases from left end of I–II, PRISSE, *L'Art égyptien*, ii, 78th pl. [1] 'Vases de Diverses Matières', 80th pl. 'Vases en Verre Opaque', cf. *Texte*, p. 434; HAY MSS. 29823, 66–7, 29853, 118. Whip, weapon, and ivory dish with duckling, DAVIES in *M.M.A. Bull.* Pt. ii, March 1918, figs. 27–8, cf. p. 19. Texts of deceased and of I–II, HELCK, *Urk.* iv. 1390–4; text above set-piece (reversed), CHAMP., *Not. descr.* i, p. 500 [B].

(10) [Deceased consecrating offerings] and text.
DAVIES, i, pl. xxvi [left], p. 38.

(11) [Deceased] inspects recording produce of Delta, with food (including honey), fowl (including cranes), fish, and cattle, by scribes with branding instruments.
DAVIES, i, pls. xxvi [right]–xxxii, and frontispiece, pp. 33–4; parts, M.M.A. photos. T. 652, 1152; details, CHIC. OR. INST. photos. 9977–9. Lotus with hornets among produce, DAVIES in *M.M.A. Bull.* Pt. ii, March 1918, fig. 30, cf. p. 22. Texts, HELCK, *Urk.* iv. 1394, 1396 [bottom], 1400 [upper].

(12) [1st ed. 8] [Deceased] with attendants inspects bringing of cattle. Sub-scene, remains of war-ships.
DAVIES, i, pls. xxxiii–xxxvi, pp. 34–5; M.M.A. photos. T. 653, 1153–4, 2035–6. Attendants, cattle, and ships, CHIC. OR. INST. photos. 9976, 9979–80; attendants, SCHOTT photos. 5135–6; three, WRESZ., *Atlas*, i. 300 [A]; HAY MSS. 29823, 65. Lower row of cattle, DAVIES (Nina), *Anc. Eg. Paintings*, i, pl. xxxii. Text of deceased, HELCK, *Urk.* iv. 1394–5.

(13) Remains of red granite stela. See Davies, i, p. 43.

(14) [1st ed. 7] Two registers. I, Ritual-text, and text of tree-goddess scene. II, Remains of tree-goddess scene and three rows of offering-list ritual.

Texts in **I** and sycamore-tree in **II**, DAVIES, i, pls. xlv [B], xlvi, pp. 45–6; tree, M.M.A. photo. T. 2052. Names of Ennead from ritual-text, L. *D. Text*, iii, p. 274; BRUGSCH, *Geographische Inschriften altägyptischer Denkmäler*, i, pl. lvii [1224]; id. *Recueil*, pl. lxiv [4]; incomplete, id. *Thes.* 725 [10].

(15) [1st ed. 6] Two registers. **I**, Offering-list. **II**, Garden with trees and pool, and [house]. Sub-scene, offering-bringers, with garlanded oxen and gazelle.

M.M.A. photos. T. 654, 2047–9; **I** and **II**, DAVIES, i, pls. xlv [A], xlvii, pp. 46–7 with note 1. Pool, WRESZ., *Atlas*, i. 300 [B]; CHIC. OR. INST. photo. 9981.

(16) [1st ed. 4, 5] [Deceased with Peḥsukher] (tomb 88), followed by female attendants and female lutist with song, before his mother nursing young King holding captives. Sub-scene, remains of harp, girl-clappers, [girl] leaping, and pool.

DAVIES, i, pls. ix, x, lxviii [A, C, E], pp. 19–22, ii, pls. ix A, x A; M.M.A. photos. T. 2046, 655–6, 1151; CHIC. OR. INST. photos. 9981–2; WILKINSON MSS. ii. 32. [Deceased, Peḥsukher], mother, and young King, L. *D.* iii. 62 [c]; mother and King, CHAMP., *Mon.* clx [3]; PRISSE, *L'Art égyptien*, ii, 53rd pl. 'Amounôph et sa Gouvernante', cf. *Texte*, p. 422; WRESZ., *Atlas*, i. 298; DAVIES (Nina), *Anc. Eg. Paintings*, i, pl. xxix (CHAMPDOR, Pt. ii, 6th pl.); HAY MSS. 29823, 64, 29844 A, 216. Captives, WILKINSON, *M. and C.* 2 Ser. ii. 345 (No. 474) = ed. BIRCH, iii. 403 (No. 603). Attendants and lutist, WRESZ., *Atlas*, i. 299; lutist with song, SCOTT in *M.M.A. Bull.* N.S. ii (1944), figs. on pp. 162 (drawn by LINDSLEY HALL), 163; lutist, PRISSE, op. cit. 6oth pl. 'Joueuse de Mandore', cf. *Texte*, p. 424; WILKINSON, *M. and C.* ii. 299 (No. 221) = ed. BIRCH, i. 481 (No. 246); MACKAY in *J.E.A.* iv (1917), pl. xv [7], p. 77; CAPART and WERBROUCK, *Thèbes*, fig. 189 (from WRESZINSKI); upper part, HICKMANN in *Ann. Serv.* lii (1952), fig. 6, cf. p. 172; KRAEMER in *American Journal of Archeology*, 2 Ser. xxxv [2] (1931), fig. 4, cf. p. 138; SCHOTT photo. 5137. Texts, HELCK, *Urk.* iv. 1395–6 (421); right part, L. *D. Text*, iii, p. 275 with α; text above first attendant, CHAMP., *Not. descr.* i, p. 500 [A].

(17) Text of appointment of deceased as chief steward of the King.

DAVIES, i, pl. viii, pp. 17–19; HELCK, *Urk.* iv. 1385–90.

Pillars.

A (*a*) Man anoints and offers ointment to deceased and wife. (*b*) Two registers, **I**, woman offers *menat*s, wands, and sistra, to deceased and wife, **II**, man offers bouquet of Amūn to deceased. (*c*) Remains of deceased and mother. (*d*) Two registers, **I**, remains of three rows of guests before deceased, **II**, remains of texts.

Texts, DAVIES, i, pls. lxv [B], lvii [B], xxv [H], pp. 50–1.

B (*a*) Two registers, **I**, [man before deceased], **II**, priests dragging [statue of deceased]. (*b*) [1st ed. 9] Seven registers, preparing food and drink, **I–III**, baking, **IV**, brewing, **V**, vase-making, **VI**, butchers, **VII**, cooking. (*c*) Three registers, **I**, [deceased and wife] angling, **II**, man bringing bulls, **III**, man feeding oxen. (*d*) Three registers, **I**, bracelets and collars, **II**, [offering-table] (superimposed on harpist-scene), **III**, pool in [garden] with man filling watering-pot.

DAVIES, i, pls. lx, lviii, lix [A], lxi [A, E], lxii [A], cf. vii, pp. 51–2. (*b*), (*c*), M.M.A., photos. T. 666–7, 1163–4, 1156. (*b*), WRESZ., *Atlas*, i. 301–2; CHIC. OR. INST. photos. 9968–70. Texts at (*a*) **II**, and (*c*) **I**, HELCK, *Urk.* iv. 1398, 1397 [lower].

C (*a*) [Deceased embracing woman.] (*b*) Two registers, **I**, [man] offers tapers to [deceased], **II**, man offers ointment and incense, &c., to deceased. (*c*) Four registers, **I–IV**, performing rites before [statue] of deceased. (*d*) Deceased adoring.

See DAVIES, i, p. 52. (*b*), and (*c*) **II**, DAVIES, pl. lxi [D, F], and texts of (*b*) **II**, (*c*) **I**, and (*d*), pls. lxi [B, C], lvii [C].

D (*a*) Remains of titles. (*b*) Two registers, **I**, deceased offers on braziers to Termuthis as serpent, **II**, man offers to deceased. (*c*) Two registers, **I**, **II**, deceased purified by priests.

See DAVIES, i, p. 53. (*b*) **I** and (*c*) **I**, DAVIES, pls. lxiii, lxiv. Texts of (*b*) **I**, HELCK, *Urk.* iv. 1399 [A, B]. Text of (*b*) **II**, DAVIES, pl. lxii [B].

E (*b*) [Deceased leaving tomb.] (*c*) Three registers, **I–III**, priest offers natron to deceased. Texts, DAVIES, i, pls. lxv [A], lxii [C, D], pp. 53–4.

F (*b*) Remains of texts. (*c*) Man with bouquet. (*d*) Text from Spell 25 of pyramid-texts. Texts, DAVIES, i, pls. lvii [A], xxv [D], lxvi, p. 54.

G (*a*) Titles. (*b*) Remains of hymn [to Rēʿ]. (*c*) Basket of food. (*d*) Wife offers ointment for Neḥebkau Festival to deceased.

(*d*) and texts of (*a*) and (*b*), DAVIES, i, pls. lix [B], lxvii [A, B], pp. 54–5; text of wife in (*d*), HELCK, *Urk.* iv. 1399 [middle].

H (*a*) Remains of text.
DAVIES, i, pl. lxvii [J], p. 55.

J (*d*) Two registers, **I**, **II**, remains of preparation of ointments.
DAVIES, i, pl. lxvii [H], p. 55.

Architraves, texts on both faces. Id. ib. pl. xlii [C, D], p. 57.
Ceiling. Texts, id. ib. pls. iii [B], xxxviii [B, C, E], pp. 57–8.

Passage. View, DAVIES, i, pl. vi [A]; M.M.A. photo. T. 1162.

(18) Thicknesses, deceased, with graffito on right thickness. Tympanum above inner doorway, double-scene, deceased offering to Osiris, with sunshade in centre.

Tympanum, DAVIES, i, pl. v [A], pp. 56–7; M.M.A. photo. T. 440. Remains of texts on thicknesses, and graffito, DAVIES, i, pl. lxvii [E, C, D], p. 47.

(19) [1st ed. 10] Remains of deceased and son on foot, hunting in desert (including ostriches and wild ass giving birth).

DAVIES, i, pls. xlviii–l, p. 37, ii, pl. xlviii A; HAY MSS. 29823, 69–70. Some animals, WRESZ., *Atlas*, i. 65; DAVIES in *M.M.A. Bull.* Pt. ii, March 1918, figs. 31–3, cf. pp. 20–2; DAVIES (Nina), *Anc. Eg. Paintings*, i, pls. xxx, xxxi; M.M.A. photos. T. 668–9, 1161; CHIC. OR. INST. photos. 9983–4. Details, SMITH, *Art . . . Anc. Eg.* pl. 108 [B].

(20) Deceased, with mother and attendants, fishing and [fowling]. Sub-scene, remains of cleaning fish and netting fowl.

DAVIES, i, pls. li, lii [right], liii, pp. 35–7, ii, pl. li A. Main scene, M.M.A. photos. T. 439 [right], 670–1, 2050. Upper row of attendants, MEKHITARIAN, *Egyptian Painting*, pl. on p. 54; CHIC. OR. INST. photo. 9985. Texts of main scene, HELCK, *Urk.* iv. 1397 [upper].

(21) Four registers. **I–IV**, Female guests at [banquet].

DAVIES, i, pl. lii [left], p. 36; M.M.A. photos. T. 439 [left], 1159. **I** and **II**, CHIC. OR. INST. photo. 9985.

Ceiling. Texts, DAVIES, i, pl. liv [B, C], pp. 58–9 (called D, E).

Inner Hall. View of west wall, M.M.A. photo. T. 1279.

(22) Tympanum above outer doorway, double-scene, Anubis-jackal with offerings and personified Western emblem with jar, and *sekhem*-emblem in centre.
DAVIES, i, pl. lvii [D], p. 56; M.M.A. photo. on T. 1162.

(23) [1st ed. 11] Two sons with offerings, offering-list, and bouquet of Amūn, before deceased (?), wife, and man.
DAVIES, i, pl. liv [A], p. 48; M.M.A. photos. T. 437–8, 2051. Text, PIEHL, *Inscr. hiéro.* I Sér. cxv [F]; HELCK, *Urk.* iv. 1399 [top].

Pillar K (*a*) Libation-vases before [deceased] (sketch with squared background). (*c*) Jars before deceased with staff. (*d*) Deceased seated and offerings.
See DAVIES, i, pp. 55–6, with texts of (*c*) and (*d*), pl. lv [C, B].
Fragments with text from a pillar, DAVIES, i, pl. lxv [C], p. 56; HELCK, *Urk.* iv. 1400 [lower].

(24) [1st ed. 12–14] Niche. Thicknesses, deceased, and on each side of inner doorway, offering-texts and three registers (destroyed on right side), deceased with offerings, including sheaves with quails. Left wall, [priest] and [woman] holding sistrum, with offerings and list before [deceased and mother?]. Right wall, [two men] with offerings and list before [deceased and wife?]. Rear wall, double-scene, [deceased] offers to Osiris (with graffito near hand), and to Anubis, with sunshade in centre. Ceiling, text.
See DAVIES, i, pp. 48–9. Side and rear walls, id. ib. pls. lvi [A, B], lv [A], cf. lxvii [F, G]; M.M.A. photos. T. 434–6, 674. Texts, incomplete, PIEHL, *Inscr. hiéro.* I Sér. cxiv–cxv [E, α (ceiling), β and γ (right half of rear wall), δ and ε (right wall), ζ and η (left wall, omitting offering-list)], and p. 93; offering-list on right wall, MOND in *Ann. Serv.* vi (1905), p. 86; text on ceiling, DAVIES, i, pl. iii [C], p. 59.

94. RAʿMOSI ⌣°⸢𓅓𓏤𓏭⸣, called ʿAMY ⸢𓈖𓏭𓏭⸣, First royal herald, Fan-bearer on the right of the King. Temp. Amenophis II (?).
Sh. ʿAbd el-Qurna.
Mother, Sent 𓊪⸢𓈖𓏤⸣.

Plan, p. 196. Maps V and VI, E–4, c, 1.

Titles of deceased, HELCK, *Urk.* iv. 1465 [C, D].

Hall.

(1) [1st ed. 1] Deceased with offering-bringers offers on braziers 'to Amen-rēʿ'.
Deceased and upper row of offering-bringers, SCHOTT photos. 8326–9, 8951–2. Texts, HELCK, *Urk.* iv. 1464 (449); of deceased, PIEHL, *Inscr. hiéro.* I Sér. cxv [H]; titles of deceased, LEPSIUS MS. 330 [top].

(2) Three registers of offering-bringers before deceased and mother.
Incomplete, SCHOTT photos. 8330–2. Text, HELCK, *Urk.* iv. 1465 [A].

(3) Three registers. **I**, Offering-bringers. **II**, Offering-stands with a gazelle below. **III**, Man bringing bull and man carrying bread.

SCHOTT photo. 8333.

(4) Stela (unfinished), double-scene at top, Osiris and offerings, with Western goddess in centre. At sides, three registers, **I**, man adoring, **II** and **III**, offering-bringers.

See HERMANN, *Stelen*, p. 72.

Pillars.

C (*a*) Text of deceased. D (*a*) Priest performs Opening the Mouth rite before deceased.

C (*a*), HELCK, *Urk.* iv. 1465 [B].

Architrave, outer face. Between C and D, double-scene, deceased adores Osiris, and adores Anubis. Between F and north wall, offering-text.

95. MERY ꜣ, First prophet of Amūn. (See also usurpation in tomb 84.) Temp. Amenophis II.

Sh. 'Abd el-Qurna. (CHAMPOLLION, No. 14, L. D. *Text*, No. 70, HAY, No. 14.)

Parents, Nebpeḥtireꜥ, First prophet of Min of Koptos, and Ḥunay(t), Chief nurse of the Lord of the Two Lands (name from tomb 84). Wife, Dey.

Plan, p. 176. Maps V and VI, E-4, c, 1.

WILKINSON, *Topography of Thebes*, pp. 150 [bottom]–151; CHAMP., *Not. descr.* i, p. 505 [S]; HAY MSS. 29824, 59 verso–60.

Hall.

(1) [1st ed. 1, 2] Deceased and mother with dog under her chair, two men offering to them, and four registers, **I**, guests, **II**, female musicians and dancers, **III**, dancer and clappers (?), **IV**, harpist with male lutist and musician (?), group of female musicians, and guests. Sub-scene, offering-bringers, heap of offerings, ducks, &c., and attendant before male guests.

SCHOTT photos. 3829–33 a, 8334–48. **II**, CHAMP., *Mon.* clxxv [1]; ROSELLINI, *Mon. Civ.* xcviii [1]; WILKINSON, *M. and C.* ii. 329 (No. 236) = ed. BIRCH, i. 501 (No. 261); HAY MSS. 29823, 54, 29843, 175; omitting right figure, DAVIES in *M.M.A. Bull.* Pt. ii, Feb. 1928, fig. 5, cf. p. 65; PRISSE, *L'Art égyptien*, ii, 7th pl. [upper] 'Musiciennes et Danseuses'; WILKINSON MSS. ii. 19 [bottom left]. Harpist in **IV**, SCHOTT in *Mélanges Maspero*, i, pl. i [5], cf. p. 460. Men and jars, HAY MSS. 29823, 53. Text, HELCK, *Urk.* iv. 1414 (from L. D. *Text*), 1571 [4]; titles of deceased and mother, L. D. *Text*, iii, p. 278 [12]; name of mother, ROSELLINI MSS. 284, G 21.

(2) Remains of scene, man before [deceased?].

SCHOTT photo. 8349.

(3) Man offering.

(4) Deceased inspects recording of cattle and goats.

Text, HELCK, *Urk.* iv. 1570 [1].

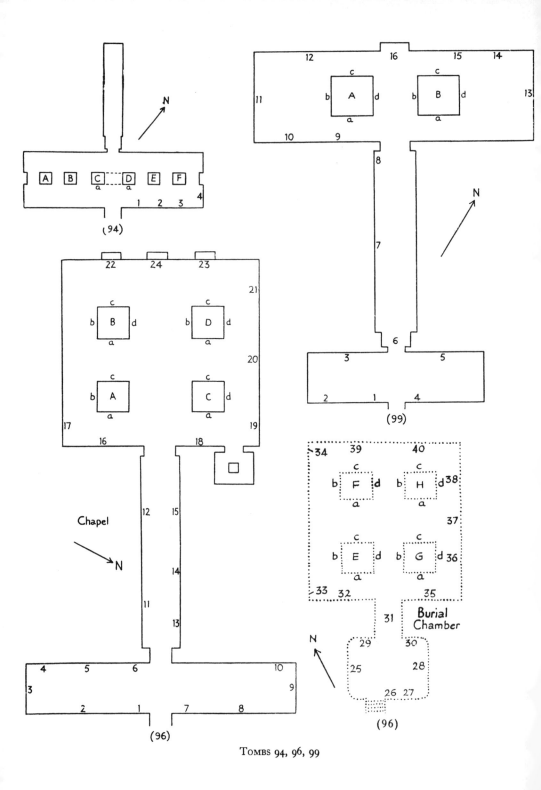

TOMBS 94, 96, 99

(5) [1st ed. 3] Deceased inspects six registers, industries. **I–II**, Weighing gold and making chariots. **III–IV**, Weighing gold, and metal-working, vase-making, &c. **V**, Drilling beads, and vases. **VI**, Servants with food.

I–IV, Wresz., *Atlas*, i. 307, 59 a. Part of **I–II**, Rosellini, *Mon. Civ.* xliv [3] (registers transposed); parts, Wilkinson, *M. and C.* i. 350 (No. 55), 343 (No. 52) = ed. Birch, i. 232 (No. 65), 227 (No. 60); Wilkinson MSS. v. 166 [lower]; Hay MSS. 29823, 52. **IV** and parts of **III**, Schott photos. 5132–4, 8351–6; two polishers in **III**, and two chisellers in **IV**, Wilkinson MSS. ii. 30 verso [bottom left], v. 167 [top]; one chiseller, Rosellini, *Mon. Civ.* xlix [3]; upper vase with gazelle-head and other vases in **IV**, Wilkinson, *M. and C.* ii. 346 (No. 247, 1), 343 (No. 244), 349 (No. 250, 4) = ed. Birch, ii. 5 (No. 271, 1), 2 (No. 268), 7 (No. 274, 4); Wilkinson MSS. v. 166 [upper]; vases (including two with bulls' heads), Vercoutter, *L'Égypte* [&c.], pls. xli [286–7], liv–lviii [395–7, 399, 418, 429], pp. 321–2, 344–5, 348, 351; upper vase with gazelle-head, Champ., *Mon.* ccccxxii [33]; Rosellini, *Mon. Civ.* lvii [37] (reversed); another vase in **IV**, Prisse, *L'Art égyptien*, ii, 78th pl. [8] 'Vases de Diverses Matières'; Wilkinson MSS. v. 168. Servant with food in **VI**, Schott photo. 8357. Text of deceased, Helck, *Urk.* iv. 1571 [3].

(6) Text of deceased on pilaster.

(7) Offering-scene.
Offerings, Schott photo. 8350.

(8) [Man] with squared background.

Pillars.

A (a) Titles of deceased. (c) [Deceased and wife] going forth 'to see Amūn'.
Text at (a), Helck, *Urk.* iv. 1571 [5]. Translation of text mentioning Amūn of Iaᶜb-akhet (probably Temple of Amenophis II) at (c), Schott, *Das schöne Fest*, pp. 797, 872 [69].

B (a) [1st ed. 5] Text. (d) Text of New Year Festival, with tapers on stand.
Text at (a), Schiaparelli, *Funerali*, ii, p. 295 [xxi, a]. Tapers at (d), Schott photo. 8358.

C (c) Two registers. **I**, Deceased with offerings. **II**, Deceased followed by mother consecrates offerings for 'Amen-rēᶜ-Ḥarakhti and Amenophis II'.
Text of deceased in **II**, Helck, *Urk.* iv. 1570 [2].

E (a) [1st ed. 4] Text. Schiaparelli, op. cit. p. 296 [xxi, b].

B (c), C (a), (b), E (b), (c), (d), F (a), (c), (d) Texts above [deceased].

96. Sennūfer ⳾, Mayor of the Southern City. Temp. Amenophis II.
 Sh. ʿAbd el-Qurna. (Champollion, No. 13, Wilkinson, No. 34, Hay, No. 12.)
 Parents, [ʿAḥmosi] Ḥumay (tomb 224) and Nub. Wives, Sentnay ⳾ and Sentnefert ⳾, Royal nurses, and Meryt ⳾.

 Plan, p. 196. Maps V and VI, E–4, d, 1.

 Champ., *Not. descr.* i, p. 505; Hay MSS. 29824, 57–8. Titles (position not found), Helck, *Urk.* iv. 1430 [K].

Hall.

(1) Deceased with Sentnay offers on braziers to 'Amen-rēᶜ of Karnak'.
Texts of deceased, Helck, *Urk.* iv. 1418, 1426 [near top].

(2) Two registers. **I** and **II**, [Deceased and Sentnay]. Sub-scene, offering-bringers and offerings before two couples.

Titles of Sentnay, HELCK, *Urk.* iv. 1434 [top, B, 1st line] (incorrectly called ⳼𓅱𓆯).

(3) Remains of stela. At sides, three registers of offering-scenes.

Part of texts of deceased adoring from right side, HERMANN, *Stelen*, p. 16* [88] (from copy by DAVIES), pp. 39–40; titles of deceased, HELCK, *Urk.* iv. 1427 [near bottom, A].

(4) [1st ed. 1] Garden of the Temple of Amūn with pools and house, and gate of Amen- ophis II. Sub-scene, remains of vintage, with man treading grapes, and offerings to Ter- muthis.

Omitting sub-scene, ROSELLINI, *Mon. Civ.* lxix; WILKINSON, *M. and C.* ii. 143 (130) = ed. BIRCH, i. 377 (150); MASPERO, *Hist. anc. Les origines*, fig. on p. 295 (from ROSELLINI); MAS- PERO, *L'Arch. ég.* (1887), fig. 11, (1907), fig. 12 (called tomb of 'Anna'); BANKES MSS. ii. A. 15. Temple and house, DAVIES, *Town House*, fig. 8, cf. pp. 246–8.

(5) [1st ed. 2] Deceased with flowers and ducks.

Text, NEWBERRY in *P.S.B.A.* xxii (1900), p. 61; HELCK, *Urk.* iv. 1417–18.

(6) Deceased offers four registers, **I–IV**, New Year gifts (chiefly statuettes of Amenophis II, with one of Queen Merytrēꜥ), to [Amenophis II] in kiosk.

Gifts, DAVIES in *M.M.A. Bull.* Pt. ii, Dec. 1928, fig. 6, cf. p. 46. Texts, HELCK, *Urk.* iv. 1417 (432).

(7) Deceased with [wife] offers on braziers to 'Osiris Onnophris'.

(8) Banquet (left part), two registers. **I**, Deceased and wife, with cat and haunch under chair. **II**, Attendants and guests.

Names of couple in **II**, HELCK, *Urk.* iv. 1433 [near bottom, A].

(9) [Stela] with double-scene above it, right half, daughter offers to deceased and Sentnay. At sides, remains of offering-bringers and offering-scenes.

Text of daughter, HELCK, *Urk.* iv. 1423 [middle lower].

(10) Two registers. **I**, Granary of Amūn, with Amenophis II celebrating harvest-festival, with palm-trees, butchers, &c. **II**, Offering-bringers.

I, DAVIES in *M.M.A. Bull.* Pt. ii, Nov. 1929, fig. 8, cf. pp. 41–6.

Ceiling, offering-texts. Titles of deceased, HELCK, *Urk.* iv. 1428 [D].

Passage.

(11) Two scenes. **1**, Four remaining registers, agriculture before deceased, **I**, winnowing and storing corn in granary, **II**, threshing and winnowing, **III**, carrying sheaves of corn and oxen threshing, **IV**, [measuring crop]. **2**, Recording crop before deceased standing with staff.

Texts, HELCK, *Urk.* iv. 1418–20 [top]; of scribe in **IV**, id. ib. 1434 [middle, A].

(12) [1st ed. 3, 4] Deceased offers bouquet of Amūn to his brother Amenemōpet, called Pairi (tomb 29), with wife.

Texts, HELCK, *Urk.* iv. 1424 [A, B], 1438 (436) A; part, NEWBERRY in *P.S.B.A.* xxii (1900), pp. 59–60.

(13) Two registers. I and II, Deceased inspects recording produce of marsh-lands.

Text of deceased in II, HELCK, *Urk.* iv. 1421 [middle]; of two scribes, id. ib. 1434 [middle, B].

(14) Deceased with family fishing and fowling.

Texts, HELCK, *Urk.* iv. 1421 [bottom]–1422 [top]; text of Sentnay, id. ib. 1434 [top, B, 3rd line].

(15) Deceased and Sentnay with [man] offering to them, and four registers, I–IV, guests, with male and female harpists in III.

Texts of deceased and wife, id. ib. 1422 [middle], 1434 [top, B, 2nd line].

Ceiling, texts. Titles of deceased, id. ib. 1428–9 [E, F]; autobiographical text in east part, id. ib. 1425 [middle]–1426 [top].

Inner Hall.

(16) Two registers, I, two men offer to deceased and Sentnefert, II, rites before mummy. (17) Funeral ceremonies with remains of two registers of priests with statue-groups dragged, in front of deceased and wife seated. (18) Men carrying funeral outfit and statuettes to Osiris and Ḥathor with deceased and Sentnefert seated beyond.

(19) Three registers. I, Abydos pilgrimage. II, Building with large jars, men (first with brazier) and offerings. III, [Deceased and Sentnefert].

Title of Sentnefert, HELCK, *Urk.* iv. 1434 [C, 1st line].

(20) False door with painted entablature.

(21) Lutist, couple, and two rows of seated people, before deceased and Sentnay, with offerings below.

Names of couple, HELCK, *Urk.* iv. 1433 [near bottom, B].

(22) Above niche. Left part, deceased consecrates offerings before parents. Right part, grandson, with male lutist and harpist and girl with shoulder-harp, offers bouquet of Amūn to deceased and Sentnay seated.

Texts of left part, and of grandson, HELCK, *Urk.* iv. 1423 [bottom], 1432 [middle].

(23) Above niche. Left part, [priest] with female musician and male harpist offers to deceased and wife. Right part, priest with offering-list consecrates offerings before parents.

(24) Niche with entablature, cf. diagram, DAVIES in *M.M.A. Bull.* Pt. ii, Dec. 1928, fig. 5, cf. p. 46. Side-walls, remains of ritual scenes. Rear wall, daughter offers to deceased.

Pillars. A–D.

Upper register, I.

A (*a*) Man offers bouquet to deceased, (*b*) man offers to deceased, (*c*) girl offers food to deceased. B (*a*) Girl offers bouquet to deceased, (*b*) girl offers tapers to deceased, (*c*) man offers to deceased, (*d*) man offers ointment to deceased. C (*a*) Woman offers to deceased, (*c*) woman offers food to deceased, (*d*) girl offers food to deceased. D (*a*) Girl offers *kherp*-sceptre and bracelets (?) to deceased, (*c*) girl offers cloth to deceased, (*d*) man offers bouquet to deceased.

Titles at A (*b*), HELCK, *Urk.* iv. 1429–30 [H]; at C (*d*), 1423 [middle upper]; at D (*c*), (*d*), 1430–1 [L, O].

Lower register, **II** (scenes much destroyed).
A (*a*) Texts, (*b*) and (*c*) deceased and wife on each. B (*a*), (*b*), (*d*) Titles, (*c*) man. C (*a*), (*c*), (*d*) Titles. D (*a*) Titles, (*b*), (*c*) deceased and wife on each.
Titles at A (*b*) and (*c*), HELCK, *Urk.* iv. 1434 [C, 2nd line], 1431 [M], 1430 [I]; at B (*b*), 1422–3 [top]; at C (*a*) and (*c*), 1432 [Q], 1429 [G]; at D (*d*), 1431 [N].
Titles from a pillar, id. ib. 1431 [P].

Ceiling. Titles of deceased as Steward of Amenophis I, Leader of the Festival of Tuthmosis I, &c., HELCK, *Urk.* iv. 1427–8 [B, C]. See NEWBERRY in *P.S.B.A.* xxii (1900), p. 60 [bottom].

Probably from here.
Block, double-scene, deceased adoring with hymn before Osiris, and [deceased] before Anubis, in Florence Mus. 7637. MINTO, *Il regio Museo archeologico di Firenze*, fig. on p. 24 [upper]; PETRIE ITAL. photo. 206 [middle]. Texts, PELLEGRINI in *Rec. de Trav.* xx (1898), pp. 86–7 [16].
Four model jars with titles of deceased and wife, and vase of deceased, are in New York, M.M.A. 32.2.2–6 and 25.7.40.

Burial Chamber. [1st ed. tomb 96 B] 'Tombeau des Vignes'. (L. *D. Text*, No. 72.)
VIREY in *Rec. de Trav.* xx (1898), pp. 211–23, with plan, fig. 1; xxi (1899), pp. 127–33, 137–49; xxii (1900), pp. 83–97. Heads and details, HAY MSS. 29852, 196–7, 199–241, 29853, 197–9, 202. Titles of deceased and Meryt, L. *D. Text*, iii, p. 279 [top].

Antechamber.
(25) [Daughter Mut-tuy ⟨hieroglyphs⟩], followed by two rows of priests with offerings (including bread, torches, and linen), offers two necklaces to deceased.
VIREY in *Rec. de Trav.* xx, fig. 2, cf. pp. 211–13; M.M.A. photo. T. 2519; omitting deceased, SCHOTT photos. 3809–11, 3908. One necklace, JÉQUIER, *Frises*, fig. 145. Texts of deceased and daughter, LEPSIUS MS. 331 [top]; titles of deceased, HELCK, *Urk.* iv. 1427 [A].

(26) Deceased.
VIREY in *Rec. de Trav.* xx, on fig. 3 [right], cf. p. 214; M.M.A. photo. on T. 2515 [right]; CHIC. OR. INST. photo. on 3366 [right].

(27) and (28) [part = 1st ed. 2] Deceased with daughter Mut-tuy inspects two registers, **I–II**, funeral outfit, followed by deceased with staff entering. **I**, Men with collars, statuettes, mask, and chests. **II**, Priest libating offerings, and men bringing jars and bed.
VIREY in *Rec. de Trav.* xx, fig. 3, cf. pp. 213–14; M.M.A. photos. T. 2515–16; CHIC. OR. INST. photos. 3365–6. Omitting **II**, SCHOTT photos. 3814–18, 3909–11, 3913. Left half of scene, FARINA, *Pittura*, pl. lxxviii. Texts of both figures of deceased and of daughter, LEPSIUS MS. 330 [lower]; of daughter, L. *D. Text*, iii, p. 279 [a]; of men with outfit in **I–II**, HELCK, *Urk.* iv. 1426 [bottom, A–C].

(29) [1st ed. 1] and (30) Deceased adoring (destroyed at (30)) and Sentnefert with sistrum and *menat* each side of doorway.

VIREY in *Rec. de Trav.* xx, fig. 4, cf. pp. 214–15; M.M.A. photos. T. 2514, 2517–18; SCHOTT photos. 3812–13, 3819. Texts, LEPSIUS MS. 331 [middle]; titles of deceased at (29), HELCK, *Urk.* iv. 1427 [B].

Hall. View, HICHENS, *Egypt and its Monuments*, pl. facing p. 166; SPRINGER, *Handbuch der Kunstgeschichte*, i, *Die Kunst des Altertums* (1923), fig. 115, cf. p. 46; M.M.A. photo. T. 2533.

(31) Left thickness, remains of text, and block with text of deceased and wife (built in sideways). Right thickness, blocks, with offerings (built in sideways) and two columns of text (upside down). Soffit, block built in, deceased adoring and wife. Inner doorway, Anubis-jackals on pylons at top, and offering-texts on lintel and jambs.

M.M.A. photos. T. 2521 [middle], 2553–7, cf. 2514. See VIREY, pp. 215 [bottom], 219–20. Inner doorway, VIREY, fig. 6; CHIC. OR. INST. photo. 3361 [middle]. Text of deceased on right thickness, HELCK, *Urk.* iv. 1427 [C].

(32) Two scenes. **1,** Deceased with staff followed by Meryt goes forth 'to see the sun-disk'. **2,** Deceased and Meryt seated.

VIREY in *Rec. de Trav.* xx, fig. 7, cf. pp. 220–1; SCHÄFER, *Ägyptische Kunst* in *Kunstgeschichte in Bildern*, i, fig. on p. 11 [5]; FARINA, *Pittura*, pl. lxxx; PIJOÁN, *History of Art*, i, fig. 115; M.M.A. photo. T. 2520; SCHOTT photos. 5302–8. Omitting deceased in **1,** WEGNER in *Mitt. Kairo*, iv (1933), pl. x [b]. Deceased in **1,** CHIC. OR. INST. photo. 3361 [right]; text, LEPSIUS MS. 335 [bottom].

(33)–(34) [1st ed. 3, 4] Osiris-Onnophris and Western Ḥathor with deceased and Meryt before them, and three registers, **I,** oxen with sarcophagus and men bringing funeral outfit, **II,** men dragging shrines with statues, victims, &c., **III,** dancers, ceremonies, and shrines (including setting up obelisks, *tekmu*, and statues purified).

VIREY in *Rec. de Trav.* xx, fig. 8, cf. p. 221, and xxi, figs. 9, 12, 13 [lower], cf. pp. 127–33; M.M.A. photos. T. 2529–31. Left part, CHIC. OR. INST. photos. 3356, 3363. Osiris and Ḥathor, parts of **I–III,** and sistrum (on wife's arm), SCHOTT photos. 5309–26, 5353. Setting up obelisks and *tekmu* in **III,** CAMPBELL, *Two Theban Princes*, pl. facing p. 102 [middle]. Texts of deceased and title of Meryt, HELCK, *Urk.* iv. 1424 [bottom], 1434 [top, A, 1st line].

(35) [1st ed. 8 on plan, but entry moved to (32)] Son as priest censes and libates before deceased and Meryt.

VIREY in *Rec. de Trav.* xxii, figs. 20–1, cf. pp. 86–7; M.M.A. photos. 2521–2; SCHOTT photos. 5285–8, 5290. Deceased and wife, VIOLLET and DORESSE, *Egypt*, pl. 150; wife, MEKHITARIAN in *Chronique d'Égypte*, xxxi (1956), fig. 22, cf. pp. 245–6. Texts, LEPSIUS MS. 332 [top and middle].

(36) [1st ed. 7] Deceased with Meryt purified by *sem*-priest.

VIREY in *Rec. de Trav.* xxii, fig. 19, cf. pp. 83–6; STEINDORFF and WOLF, *Gräberwelt*, pl. 9 [b]; BAIKIE, *A History of Egypt*, ii, pl. xviii [2]; FARINA, *Pittura*, pl. lxxvii; PIJOÁN, *Summa Artis*, iii (1945), pl. xxvii facing p. 452; CAPART and WERBROUCK, *Thèbes*, fig. 245; LANGE, *Ägypten*, pl. 111; id. *Ägyptischer Totenkult* in *Atlantis*, Nov. 1940, fig. on p. 633 [right]; id. *Lebensbilder*, pl. 47; SCHOTT in *Nachr. Akad. Göttingen* (1957), No. 3, pl. v a, p. 85; M.M.A. photo. T. 2523; CHIC. OR. INST. photo. 3357; SCHOTT photos. 5291–4, 8953–4. Text of deceased, HELCK, *Urk.* iv. 1425 [top]; text above priest, LEPSIUS MS. 332 [bottom].

(37) [1st ed. 6] Book of the Dead. Mummy on couch with Anubis and *ba* between Neph-thys and Isis, and text with vignettes (including 'living *bas*' and Sons of Horus).

VIREY in *Rec. de Trav.* xxi, fig. 18, cf. pp. 145–9; WRESZ., *Atlas*, i. 309; CAPART and WER-BROUCK, *Thèbes*, fig. 171 (from WRESZINSKI); M.M.A. photo. T. 2524. Texts of mummy of deceased at bottom on left, and of *ba* on right, LEPSIUS MS. 333 [left, and top right].

(38) Deceased and Meryt adore Osiris and Anubis.

VIREY in *Rec. de Trav.* xxi, fig. 17, cf. p. 145; M.M.A. photos. T. 2525, 2532; SCHOTT photos. 5295–9.

(39) [Priest], with three registers of priests with *ḥes*-vases and torches, libates offerings before deceased (with inscribed bed on stand under his chair), and [Meryt].

VIREY in *Rec. de Trav.* xxi, figs. 14, 15 [left], cf. pp. 137–41; M.M.A. photos. T. 2527–8; CHIC. OR. INST. photo. 3362; SCHOTT photos. 3823, 5327–9. Bed, HAY MSS. 29852, on 194.

(40) [1st ed. 5] Three registers, funeral procession before deceased seated with [Meryt]. **I–II**, Abydos pilgrimage. **III**, Men dragging [sledge with statue].

VIREY in *Rec. de Trav.* xxi, figs. 15 [right], 16, cf. pp. 141–4. Omitting deceased, M.M.A. photos. T. 2526–7. CHIC. OR. INST. photo. 3358; SCHOTT photos. 3824, 5300–1, 5351. **I–II**, WRESZ., *Atlas*, i. 308; FARINA, *Pittura*, pl. lxxix; EDGERTON in *The American Journal of Semitic Languages and Literatures*, xxxix (1922–3), fig. 9, cf. pp. 123–6; rowing-boat in **I**, SAUNERON, *Les Prêtres de l'Ancienne Égypte*, fig. on pp. 102–3; sailing-boat in **II**, VIOLLET and DORESSE, *Egypt*, pl. 152. Mirror (under chair of deceased), HAY MSS. 29851, 198, 29853, 201; armlets (of deceased), id. ib. 29852, 198. Texts of **I–II**, LEPSIUS MS. 333 [bottom]–334 [middle]:

Pillars. E–H. See VIREY in *Rec. de Trav.* xxii, pp. 87–96.

E (*a*) Meryt offers ointment (?) to deceased. (*b*) Meryt offers food to deceased. (*c*) Meryt offers flowers to deceased with small daughter. (*d*) [1st ed. 9] Deceased and Meryt under *iśd*-tree.

VIREY in *Rec. de Trav.* xxii, figs. 22 [left], 23 [right], 26 [right], 29 [left]; M.M.A. photos. T. 2548–52, and on 2533 [left]. (*c*), (*d*), and Meryt at (*a*) and (*b*), SCHOTT photos. 5330–4, 3827–8. (*d*), CAMPBELL, *The 'Gardener's Tomb' at Thebes*, frontispiece; WEIGALL, *Anc. Eg. Art*, 148 [left]; LANGE, *Ägypten*, pl. 110; id. *Lebensbilder*, pl. 46; LHOTE and HASSIA, *Chefs-d'œuvre*, pl. 68; CHIC. OR. INST. photo. 3360. Texts of Meryt at (*c*) and of deceased at (*d*), LEPSIUS MS. 337 [bottom right], 338 [top].

F (*a*) Meryt offers flowers to deceased. (*b*) Meryt with small daughter offers sistrum to deceased. (*c*) Meryt offers myrrh to deceased. (*d*) Tree-goddess scene with Anubis-jackals at top.

VIREY in *Rec. de Trav.* xxii, figs. 28 [left], 23 [left], 24 [right], 29 [right]; M.M.A. photos. T. 2543–7. (*a*) and (*d*), daughter at (*b*), and deceased at (*c*), SCHOTT photos. 3821, 3826, 5340–4. Tree-goddess at (*d*), SCHOTT, *Altägyptische Liebeslieder*, pl. 10. Tree and texts at (*d*), and texts of Meryt at (*a*) and (*b*), LEPSIUS MS. 337 [top right, middle, and bottom left].

G (*a*) Meryt offers cup to deceased. (*b*) Meryt before deceased. (*c*) Meryt offers cloth to deceased. (*d*) Deceased acclaimed by four kneeling priests, and personified *zad*-pillar.

Virey in *Rec. de Trav.* xxii, figs. 22 [right], 27 [right], 26 [left], 25 [left]; M.M.A. photos. T. 2535–8. Upper part at (*a*), Lhote and Hassia, *Chefs-d'œuvre*, pl. 143. (*b*), (*c*), and deceased at (*a*), Schott photos. 5335–9. (*d*), Chic. Or. Inst. photo. 3359. Title of Meryt at (*a*), Helck, *Urk.* iv. 1434 [top, A, 2nd line]. Texts (incomplete) at (*d*), Lepsius MS. 336 [top].

H (*a*) Meryt offers cup to deceased. (*b*) [1st ed. 10] Meryt offers necklace to deceased. (*c*) Meryt offers pectorals to deceased. (*d*) Deceased purified by four priests.
Virey in *Rec. de Trav.* xxii, figs. 28 [right], 27 [left], 24 [left], 25 [right]; M.M.A. photos. T. 2539–42. (*a*), (*b*), (*c*), Schott photos. 3822, 5345–50. (*d*), Chic. Or. Inst. photo. 3364. Deceased at (*a*), Mekhitarian in *Chronique d'Égypte*, xxxi (1956), fig. 18, cf. pp. 242–3. Texts of deceased and heart-pendants with cartouches of Amenophis II at (*b*), Lepsius MS. 337 [top left], 336 [bottom]; pendants and head of deceased, Hay MSS. 29852, 194–5; pendants, Wild MSS. ii. A. 51 [lower]. Box at (*c*), Hay MSS. 29851, 198. Texts at (*d*), Lepsius MS. 336 [middle lower].

Ceiling, grape-decoration with winged vulture and texts. Virey in *Rec. de Trav.* xx (1898), fig. 5, cf. pp. 216–19, xxi (1899), fig. 13 [upper], cf. p. 132; M.M.A. photos. on T. 2532–4. Vulture and grape-decoration, Schott photo. 8955; part of grape-decoration, Mekhitarian, *Egyptian Painting*, pl. on p. 53.

Finds
Inscribed fragments, including block with deceased and Sentnefert, M.M.A. photos. T. 2558–9.

97. **Amenemḥēt** 𓈖𓂋𓏏𓀀, First prophet of Amūn. Temp. Amenophis II (?).
Sh. ʿAbd el-Qurna.
Father, Ḏḥutiḥotp, *waʿb*-priest, Overseer of sandal-makers of the Temple of Amūn.
Plan, p. 186. Map V, D–4, d, 10.

Gardiner in *Ä.Z.* xlvii (1910), pp. 87–99, with plan, fig. 1. Plan of south part and Burial Chambers, Mond and Emery in *Liv. Ann.* xvi (1929), pl. lxxxi. Titles of deceased, Helck, *Urk.* iv. 1412–13 [A–E].

Hall.
(1) Remains of text. (2) [Scene of inspection.] (3) [Offering-bringers with fruit and flowers.]
See Gardiner, pp. 89 [F, E], 88 [A].

(4) Remains of stela, with man kneeling at top, and offering-text. (5) Remains of text. Texts, id. ib. pp. 88–9 [B, C].

Passage.
(6) Outer lintel, [Western hawk and Anubis-jackal]. (7) At top, men carrying loin-cloths in [funeral procession], and remains of frieze-text. (8) At top, priest and lector before mummy, with frieze-text.
Texts, Gardiner, pp. 89–90 [D, G, H].

Ceiling. Offering-texts, id. ib. pp. 90–1; part, Helck, *Urk.* iv. 1412 [upper].

Inner Room.

(9) Stela with autobiographical text.

GARDINER, pl. i, pp. 92–7 [K]. Text, HERMANN, *Stelen*, pp. 27* [lower]–29* (from GAR-DINER); HELCK, *Urk.* iv. 1408–11.

(10) [Deceased] purified by four priests. (11) and (12) Remains of texts.
Texts, GARDINER, pp. 97–8 [L, M, N].

(13) Niche, with Anubis-jackals above, and man offering at top on each side.
Text of Anubis on right, id. ib. p. 98 [lower middle].

(14) Pillar, remains of hymn.
Id. ib. pp. 91–2 [J].

Ceiling, offering-texts. Id. ib. pp. 98–9.

Burial Chambers.

Coffin of Thu ═𝄐, Royal sandal-maker of Amūn, Dyn. XVIII. MOND and EMERY in *Liv. Ann.* xvi (1929), pls. xliv–xlv, pp. 56–8 [62].

For intrusive coffins, Saite, see SHEIKH 'ABD EL-QURNA, *Bibl.* i², Pt. 2, in the Press.

98. KAEMḤERIBSEN 𓄿𓏤𓏤, Third prophet of Amūn. Temp. Tuthmosis III to Amenophis II (?).

Sh. 'Abd el-Qurna. (CHAMPOLLION, No. 9, L. D. *Text*, No. 69.) (Inaccessible.)
Mother, a Chief nurse of the Lord of the Two Lands. Wife, Ḥenuttaui ▽🝔.

Plan, p. 186. Maps V and VI, E–4, c, 1.

FAKHRY in *Ann. Serv.* xxxiv (1934), pp. 83–6, with plan, fig. 1; CHAMP., *Not. descr.* i, p. 501. Names and titles, L. D. *Text*, iii, p. 278.

Hall.

(1) [1st ed. 1] Two scenes. **1,** Two daughters with bouquets following their [mother].
2, Two daughters with attendant offer bouquet of Amūn 'in his beautiful Festival of the West' to deceased and wife.

FAKHRY, pl. [2], pp. 84–6. Texts, incomplete, CHAMP., *Not. descr.* i, p. 840 [to p. 501, ll. 21 and 24]; texts of **2,** HELCK, *Urk.* iv. 1500 (472) (from FAKHRY).

(2) Deceased adores Osiris.
FAKHRY, pl. [1], p. 84. Text, HELCK, *Urk.* iv. 1500 [bottom]–1501 [top] (from FAKHRY).

99. SENNŪFER 𓏤𓏤𓏤, Overseer of the seal, Overseer of the gold-land of Amūn. Temp. Tuthmosis III.

Sh. 'Abd el-Qurna.
Mother, Sit-dḥout 𓏤🝔. Wife, Taimau ○𓆓𓆓𓆓.

Plan, p. 196. Maps V and VI, E–4, d, 1.

Titles, SETHE, *Urk.* iv. 539–42 (175) a, b, m, on Pillar B, c on ceiling of Inner Room, d and l at (15), e on ceiling of Hall, f–i on ceiling of Passage, k at (6).

Hall.

(1) [Deceased] offers on [braziers].

(2) [1st ed. 1] Deceased receives treasure.
Text, SETHE, *Urk.* iv. 536–7 (174) A.

(3) [1st ed. 2] Deceased before Tuthmosis III receives mandate to go to Lebanon.
Text, id. ib. 532–4 (173) A.

(4) Top of scene, deceased inspects workshops.

(5) [1st ed. 4] [Deceased], with remains of two registers, horses, soldiers, a Syrian, and Egyptians dragging heavy [object], reports return with tribute from Lebanon to [Tuthmosis III].
Text, id. ib. 534–6 (173) B; id. *Eine ägyptische Expedition* [&c.] in *Sitzungsb. der königlich preussischen Akademie. Berlin,* Phil.-Hist. Cl. xv (1906), pp. 359–60.

Ceiling. See NEWBERRY in *P.S.B.A.* xxii (1900), p. 62 [top].

Passage.

(6) [1st ed. 3] Lintel, double-scene, [deceased] adores Osiris.

(7) and (8) [1st ed. 5, 6] [Receiving cattle], and [deceased inspecting funeral outfit and statues].
Fragmentary texts, SETHE, *Urk.* iv. 537–8 (174) B, C.

Inner Room.

(9) [1st ed. 7] Autobiographical text.
SETHE, *Urk.* iv. 529–31 (172); SCHOTT photo. 8359.

(10) Girl prepares bed, with candle, statue of Bes, baskets, and toilet-box.
BRUYÈRE, *Rapport (1934–1935),* Pt. 3, fig. 39 (from SCHOTT photo.), cf. p. 107, note 1; SCHOTT photo. 8360.

(11) Top register, men with funeral outfit in [funeral procession].
SCHOTT photos. 8361–2.

(12) Top of offering-list and text.

(13) [1st ed. 9] Fragment of hymn to Osiris.
SETHE, *Urk.* iv. 543–4 (176).

(14) Two registers. **I,** Male and female offering-bringers. **II,** Remains of rites before mummy.
SCHOTT photo. 8364.

(15) [part, 1st ed. 8] Two priests with offering-list before deceased and wife.
Sem-priest and offerings, SCHOTT photo. 8363.

(16) Above niche, double-scene, deceased before Anubis-jackals.

Pillars.

A (*a*) [1st ed. 10] [Deceased] receives New Year gifts from [wife] and [family]. (*b*)–(*d*) Remains of texts.

Texts at (*a*), SETHE, *Urk.* iv. 538–9 (174) D; SCHOTT photos. 8365–6.

B (*a*) [1st ed. 12], (*b*), (*c*), (*d*) [1st ed. 11] Remains of titles of deceased.

For statue of deceased [1st ed. p. 128], in Brit. Mus. 48, see *Bibl.* ii, p. 160 (incorrectly called Ḳen-nūfer).

100. REKHMIRĒʿ ⟨hieroglyphs⟩, Governor of the town and Vizier. Temp. Tuthmosis III to Amenophis II.

Sh. ʿAbd el-Ḳurna. (CHAMPOLLION, No. 15, L. *D. Text*, No. 58, WILKINSON, No. 35.)
Parents, Neferweben ⟨hieroglyphs⟩, [Vizier], *waʿb*-priest of Amūn, and Bet ⟨hieroglyphs⟩. Wife, Meryt ⟨hieroglyphs⟩.

Plan, p. 208. Maps V and VI, E–4, d, 1.

DAVIES, *The Tomb of Rekh-mi-rēʿ at Thebes*, passim, with plan and section, ii, pl. vi; id. *Paintings from the Tomb of Rekh-mi-rēʿ at Thebes*, passim, with key-plan, pl. xxi; VIREY, *Le Tombeau de Rekhmara* (*Mém. Miss.* v, 1), passim, with plan, p. 2; NEWBERRY, *The Life of Rekhmara*, passim, with plan and sections, pl. i; CHAMP., *Not. descr.* i, pp. 505–10; L. *D. Text*, iii, pp. 270–1; WILKINSON, *Topography of Thebes*, pp. 151–7; BALCZ, *Zur Komposition der Malereien im Grabmal des Wesirs Rechmire* in *Belvedere*, viii [10], (1925), pp. 74–86, figs. 1–10 (from WRESZINSKI); ROSELLINI MSS. 284, G 22–5 verso, with plan; plan and section, DAVIES, *The Tomb of Nakht at Thebes*, fig. 2, cf. p. 16. Scenes, HAY MSS. 29817, 1–64, 29821, 68–81, 29827, 69–76, 29852, 1–145, 29853, 142, 161, 164, 29854, 317–26 (for equations, see DAVIES, *Rekh-mi-rēʿ*, i, pp. 95–6). Titles, SETHE, *Urk.* iv. 1169–73 (339) a–x.

Hall.

(1) Inner lintel and jambs, offering-texts.
DAVIES, *Rekh-mi-rēʿ*, ii, pl. vii, pp. 8–9.

(2) [1st ed. 1–3] Two scenes. **1**, [Deceased with goose under chair] in judgement hall inspects five rows of officials, two messengers, appellants, &c., with text of duties of Vizier. **2**, Five registers, tax-collection, **I–V**, recording produce of Upper Egypt, including cattle and gold in **I** and **II**, monkeys in **I**, goats, pigeons, and honey, in **II**, and weighing gold in **IV**.
DAVIES, *Rekh-mi-rēʿ*, ii, pls. xxiv–xxxii, cf. xlvii [3], and vol. i, pp. 30–6, 88–94, and pl. i facing p. 8; M.M.A. photos. T. 1522–3, 2007–12, cf. 2561. **1**, and **2, I–IV**, NEWBERRY, pls. ii–v, pp. 22–9; **1**, VIREY, pls. ii, iii, pp. 19–27; officials, WRESZ., *Atlas*, i. 331; CAPART and WERBROUCK, *Thèbes*, fig. 87 (from WRESZINSKI); FARINA, *Pittura*, pl. lxx; 2nd and 3rd rows of officials, CHIC. OR. INST. photo. 9999. Vizier-text, SETHE, *Urk.* iv. 1103–17 (328); see FARINA, *Le Funzioni del Visir Faraonico* [&c.] in *Rendiconti Lincei*, xxvi (1916), pp. 923–74. Other texts, SETHE, *Urk.* iv. 494 (160) D C, 1117–28 (329–30) A; text above [deceased], L. *D. Text*, iii, p. 270 [upper]; place-names, see GARDINER, *Ancient Egyptian Onomastica*, pls. xxiv–xxvi [ii], cf. Text, i, pp. 45–7.

(3) [1st ed. 4] Autobiographical text.
DAVIES, *Rekh-mi-rēʿ*, ii, pls. xi, xii, cf. vol. i, pp. 79–84; NEWBERRY, pls. vii, viii, p. 33; SETHE, *Urk.* iv. 1071–85 (325); GARDINER in *Ä.Z.* lx (1925), pp. 62–76 (texts h and n transposed); M.M.A. photo. T. 2005.

(4) [1st ed. 5, 6] [Deceased] with attendants inspects five registers, **I–V**, recording foreign tribute. **I**, People of Punt with produce and animals (baboon, ibex, monkey, and cheetah) and incense-trees. **II**, Keftiu with decorative vases (one ibex-headed), and heads of bull, dog, and lion. **III**, Nubians with animals (leopard, baboon, monkeys, giraffe, cattle, and dogs). **IV**, Syrians with tribute including decorative vases, chariot, horses, bear, and elephant. **V**, Groups of Nubian and Syrian men, women, and children, with military escort.

DAVIES, *Rekh-mi-rēʿ*, ii, pls. xvi–xxiii, cf. vol. i, pl. ii facing p. 27, and pp. 17–30 with figs. 1–6; id. *Paintings*, pls. i–xii, xxii; M.M.A. photos. T. 2025–34, 2562. See CHAMP., *Not. descr.* i, pp. 506–9, 843.

I–V, VIREY, pls. iv–viii, pp. 28–44; HOSKINS, *Travels in Ethiopia* (1835), pp. 327–34 with 4 pls.; WRESZ., *Atlas*, i. 334–7; AMÉLINEAU, *Histoire de la sépulture et des funérailles* in *Ann. Mus. Guimet*, xxix (1896), pls. lxx–lxxiv, pp. 561–73; MEYER, *Fremdvölker*, 627–31, 772–8; WILKINSON MSS. iii. 27; incomplete, CHIC. OR. INST. photos. 9986–99. **I–IV**, WILKINSON, *M. and C.* i, pl. iv facing p. 406 = ed. BIRCH, i, pls. ii A, B, after p. 38; left half of **III–V**, CAPART and WERBROUCK, *Thèbes*, fig. 92 (from WRESZINSKI); FARINA, *Pittura*, pl. lxxi.

Cheetah in **I**, CHAMP., *Mon.* ccccxxviii bis [bottom left]; ROSELLINI, *Mon. Civ.* xxiii [7]. **II**, including palimpsest figures discovered recently, VERCOUTTER, *L'Égypte* [&c.], frontispiece [recto], pls. v–ix [82–97], xvii–xxv [142–56, 158–63, 165–7, 170–1, 174, 177–9], xxxii–xxxiv [213–23, 225–8], pp. 211–19, 249–77, 290–3; omitting palimpsest, BOSSERT, *Altkreta* (1923), Abb. 335–7; id. *The Art of Ancient Crete*, Abb. 545–8. Some Keftiu, MEYER, *Geschichte des Altertums*, ii, pls. ii [lower], iii [top left] (from HAY), cf. p. 107; CHAMP., *Mon.* cxci (1st of 2 pls. marked cxci [1]; ROSELLINI, *Mon. Stor.* clix [2]; WILKINSON, *M. and C.* i. 385 (No. 69, 1) = ed. BIRCH, i. 259 (No. 84, 1) (reversed); VON LICHTENBERG in *Mitt. Vorderasiat. Ges.* xvi (1911), Abb. 2, 3, 16, 20, cf. pp. 97–9, 107, 112 (Heft 2, pp. 33–5, 43, 48); MASPERO, *Hist. anc. Les premières mêlées*, fig. on p. 193; WAINWRIGHT in *Liv. Ann.* vi (1914), pl. xvii, p. 77; DAVIES in *M.M.A. Bull.* Pt. ii, Dec. 1924, fig. 1, cf. p. 46, Dec. 1930, fig. 2 [right], cf. pp. 31–2; *Cambridge Ancient History. Plates*, i. 155 [a], and HALL in *Brit. Mus. Quarterly*, i (1926–7), pl. lii [lower] (both from painting by NINA DAVIES); WILKINSON MSS. vii. 26 [upper], ii. 15 [1].

Vases carried by Keftiu and in heap of tribute, in **II**, including vases with heads of lion, griffin, dog, bull, gazelle, and ibex, and with lion-handles, VERCOUTTER, *L'Égypte* [&c.], pls. xxxvii–lix [245, 257, 260, 265, 271, 302–5, 319, 321, 338–40, 355, 359, 361–3, 367, 369, 377–8, 381, 383, 393, 400–1, 407–9, 414–15, 421, 423, 425, 431–2], pp. 311–53; some vases in **I** and **II**, CHAMP., *Mon.* cxci (1st of 2 pls. marked cxci [2–6, 7 (reversed)–15], ccccxxii (most of the vases), ccccxxv [top, middle right]; ROSELLINI, *Mon. Civ.* lvii [4, 14, 17–20, 23, 25–8, 30–2, 36, 38–42], lxii [3, 5]; PRISSE, *L'Art égyptien*, ii, 74th pl. [13] 'Choix de vases . . .', 75th pl. 'Vases du pays de Kafa', 76th pl. [4, 5, 7, 10] 'Vases . . . de Kafa', 83rd pl. [left, 2nd vase] 'Collection de vases . . .', cf. *Texte*, pp. 431–2, 435; WILKINSON, *M. and C.* ii. 346 (No. 247, 2, 3), 349 (No. 250, 5–7), iii. 258 (No. 378, 1, 2) = ed. BIRCH, ii. 5 (No. 271, 2, 3), 7 (No. 274, 5–7), 258 (No. 418, 1, 2); WAINWRIGHT in *Liv. Ann.* vi (1914), pls. ix–x [1–53], xiii, xv [14], xvi [28], pp. 34 ff.; DAVIES in *M.M.A. Bull.* Pt. ii, March 1926, fig. 3, cf. p. 46. Daggers, leather bags, necklaces, metal-ingots, lapis-lazuli, and elephant-tusks in **II**, VERCOUTTER, *L'Égypte* [&c.], pls. lxii–lxvi [464–7, 472–3, 475–6, 484–6, 491–6, 502 a, b (called 501 b in error)], pp. 359–66.

Scribe and tribute in **III**, DAVIES (Nina), *Anc. Eg. Paintings*, i, pl. xvi (part, CHAMPDOR, Pt. ii, 9th pl.); basket of gold bags, WILKINSON, *M. and C.* ii. 344 (No. 245) = ed. BIRCH, ii. 3 (No. 269).

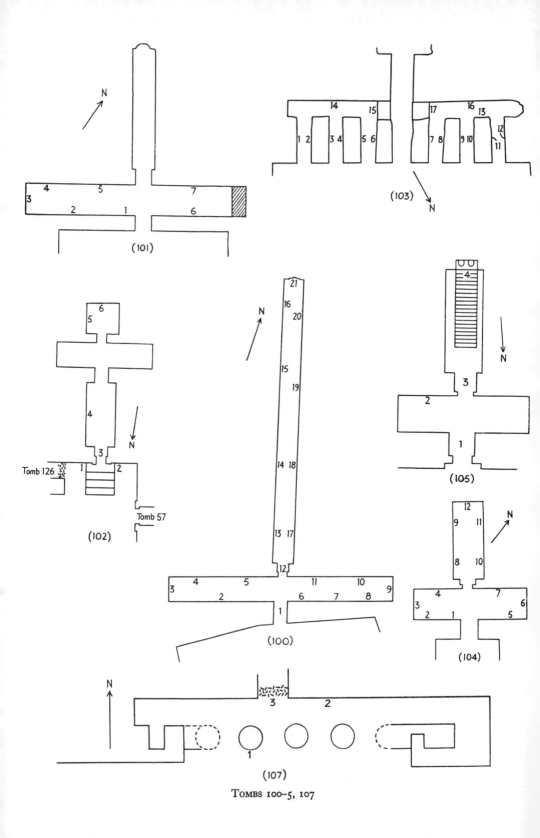

TOMBS 100–5, 107

Nubians with leopard and baboon in **III**, Davies in *M.M.A. Bull.* Pt. ii, Dec. 1924, fig. 2, cf. pp. 46–7; with leopard and giraffe, ROSELLINI, *Mon. Civ.* xxii [2, 4]; with giraffe, cattle, and dogs, LHOTE and HASSIA, *Chefs-d'œuvre*, pl. 50 [upper]; with giraffe and monkey, WEGNER in *Mitt. Kairo*, iv (1933), pl. vii [b]; WILKINSON MSS. v. 225 [top]; with giraffe, CHAMP., *Mon.* clxxvi [3]; CAILLIAUD, *Arts et métiers*, pl. 66 [1]; SMITH, *Art . . . Anc. Eg.* pl. 106 [upper]; dogs, PHILLIPS, *Ancient Egyptian Animals* (1948), fig. 16.

Vases in **IV**, PRISSE, *L'Art égyptien*, ii, 79th pl. [1–3] 'Vases cratériformes'; 3rd and 4th Syrians, CHAMP., *Mon.* clxxxix; DAVIES in *M.M.A. Bull.* Pt. ii, Dec. 1924, fig. 3, cf. p. 46; 4th Syrian, WILKINSON MSS. v. 225 [middle right]. Syrians with chariot, bear, and elephant, CHAMP., *Mon.* clxxvi [1, 2], ccccxxxviii [2]; ROSELLINI, *Mon. Civ.* xxii [3, 5], cxxii [2]; WILKINSON MSS. ii. 17 B [top middle], v. 226 [top]; with elephant and chariot, CAILLIAUD, *Arts et métiers*, pls. 66 [2], 43 B [11]; with elephant and bear, MASPERO, *Hist. anc. Les premières mêlées*, fig. on p. 285; with chariot, WILKINSON, *M. and C.* i. 346 (No. 53 b) = ed. BIRCH, i. 230 (No. 63); with horses and bear, LHOTE and HASSIA, *Chefs-d'œuvre*, pl. 50 [lower]; man with horses, SMITH, *Art . . . Anc. Eg.* pl. 106 [lower]; DAVIES in *M.M.A. Bull.* Pt. ii, Dec. 1930, fig. 8 [right], cf. p. 36.

Two women (Nubian and Syrian) with children in **V**, id. ib. fig. 10 [right], cf. p. 38; two Syrian women with children, MASPERO, *Hist. anc. Les premières mêlées*, fig. on p. 155; one, WILKINSON, *M. and C.* i. 403 (No. 72) = ed. BIRCH, i. 272 (No. 87).

Texts (of whole scene), BRUGSCH, *Thes.* 1110–13; SETHE, *Urk.* iv. 1093–1103 (327), 1–6; WILKINSON MSS. vi. 67–71; of deceased, *L. D.* iii. 39 [b]; HAY MSS. 29827, 76 verso; part, CHAMP., *Not. descr.* i, p. 506 [A].

(5) [1st ed. 7] [Deceased] with installation-text as Vizier before [Tuthmosis III with *ka*]. DAVIES, *Rekh-mi-rēʿ*, ii, pls. xiii–xv, cf. cxvi–cxxii (collation of texts), and vol. i, pp. 15–17, 84–8; NEWBERRY, pls. ix, x, pp. 33–4; M.M.A. photo. T. 2024. Text, SETHE, *Urk.* iv. 1086–93 (326); id. *Die Einsetzung des Veziers* in *Untersuchungen*, v [2], passim; part, VIREY, pp. 43–4, note 5. See GARDINER in *Rec. de Trav.* xxvi (1904), pp. 1–19.

(6) [part, 1st ed. 11] [Deceased] inspects five registers, tax-collection, **I–V**, recording produce of Lower Egypt, including pigeons, gold, and honey, and men bringing bulls with calves and goats.

DAVIES, *Rekh-mi-rēʿ*, ii, pls. xxxiii–xxxv, xl [1], cf. xlvii [2], and vol. i, p. 33; NEWBERRY, pl. vi, pp. 26–7, 30–3; M.M.A. photos. T. 2013–14. Honey and corn in **I**, WILKINSON MSS. vi. 66 [top]. First man with gold rings and bull (now partly destroyed) in **II**, id. ib. v. 224 [top right], and text, vi. 66 [middle]. Texts, SETHE, *Urk.* iv. 1128–39 (330) B; VIREY, pp. 171–2; place-names, see GARDINER, *Ancient Egyptian Onomastica*, pls. xxiv–xxvi [ii], cf. Text, i, pp. 45–7.

(7) [part, 1st ed. 11] [Deceased] inspects five registers, **I–V**, temple-workshops and provisions. **I** and **II**, Royal statues (including King running and consecrating and female sphinx), and funeral outfit. **III**, Bringing provisions, &c. **IV**, Baking and cooking. **V**, Remains of brewing (?).

DAVIES, *Rekh-mi-rēʿ*, ii, pls. xxxvi–xxxviii, xli [3], cf. xlvii [2], and vol. i, pp. 36–9 with fig. 7; **I–IV**, NEWBERRY, pl. xxii, pp. 38–9; M.M.A. photos. T. 2015–17. Some statues in **I** and **II**, DAVIES in *M.M.A. Bull.* Pt. ii, Dec. 1926, figs. 6, 7, cf. p. 12. Cook at right end of **IV**, WILKINSON MSS. v. 224 [top left]. Texts, VIREY, p. 171; SETHE, *Urk.* iv. 1155–7 (333) 1–4.

(8) [Deceased] inspects five registers. **I**, [Recording cattle]. **II**, [Measuring crop]. **III**, Carrying corn. **IV**, Bringing animals, reaping, plucking flax. **V**, Ploughing and sowing.

DAVIES, *Rekh-mi-rēʿ*, ii, pls. xxxix, xl [2], cf. xlvii [2], and vol. i, pp. 39–40; M.M.A. photos. T. 2018–19. Texts, SETHE, *Urk.* iv. 1160–1 (336); VIREY, p. 170.

(9) [1st ed. 10] Two registers. **I,** [Son Menkheperraʿsonb], seated Viziers (grandfather ʿAmethu (tomb 83) and uncle User (tomb 61)) with their wives, and four rows of relatives, before [deceased and wife]. **II,** Similar scene, [son Amenḥotp], son Neferweben, and Baki, with their wives and relatives.

DAVIES, *Rekh-mi-rēʿ*, ii, pls. ix, x, cf. vol. i, pp. 14–15; NEWBERRY, pl. xi, pp. 34–5; M.M.A. photo. T. 2006. See VIREY, pp. 169–70. Names and titles of ʿAmethu and User, SETHE, *Urk.* iv. 494 (160) D a, 1042 (317) C.

(10) [1st ed. 9] [Deceased] inspects five registers, **I–V,** produce of the 'Road of Horus' and marsh-lands. **I,** Bringing wild animals (ibex, oryx, wild bulls, and hyenas on poles), with a hunting dog. **II,** Vintage, including men treading grapes with hymn to Termuthis. **III,** Bringing and preparing fowl and fish. **IV,** Fishing with draw-net. **V,** Bringing produce, including honey.

Deceased and **I–IV,** DAVIES, *Rekh-mi-rēʿ*, ii, pls. xliv–xlvi [1], cf. xlvii [1], and vol. i, pp. 41–2; M.M.A. photos. T. 2020–2 [right]. Vintage, incomplete, WRESZ., *Atlas*, i. 338.

(11) Remains of two scenes, [deceased] hunting in desert, and fowling. **1,** Game, including ostriches, wild bulls, and hyenas, in stockade in desert. **2,** Birds above papyrus-swamp.

DAVIES, *Rekh-mi-rēʿ*, ii, pls. xli [1, 2]–xliii, cf. xlvii [1], and vol. i, pp. 40–1; M.M.A. photos. T. 2022 [left], 2023. See VIREY, p. 169 [K–L]. **1,** CHIC. OR. INST. photo. 10000; middle part, DAVIES in *M.M.A. Bull.* Pt. ii, March 1932, fig. 10, cf. p. 60.

Ceiling. Texts, DAVIES, *Rekh-mi-rēʿ*, ii, pls. xlvi [2, A–C, E, F], cxiii [C], cf. vol. i, pp. 11–12.

Passage. View, M.M.A. photo. T. 1650.

(12) [1st ed. 8, 12] Outer lintel and jambs, offering-texts. Inner lintel and jambs, texts of deceased.

DAVIES, *Rekh-mi-rēʿ*, ii, pls. viii, lxxiv, cf. vol. i, pp. 9–10; M.M.A. photos. T. 1651, 1649. See VIREY, pp. 167–9 (with texts on inner lintel and left jamb). Outer lintel, WILKINSON MSS. v. 224–5; names of some divinities, CHAMP., *Not. descr.* i, p. 510 [top].

(13) [1st ed. 13] Six registers, **I–III,** preparing, bringing, and storing provisions for the temple, before deceased seated with attendants, **IV–VI,** delivery of rations and recording of temple-serfs, before [deceased] seated with attendants. **I,** Recording grain and beans (?). **II,** Pounding beans, baking cakes, preparing honey. **III,** Bringing produce of Kharga, Punt, and the Delta, including wine, papyrus, oil, and honey and nuts with monkeys, to storehouses. **IV,** Distribution of ointment and linen, and Hittite, Nubian, and Syrian, female captives with children. **V,** Bales of cloth and men with linen. **VI,** Bringing cattle, and remains of tending cattle.

DAVIES, *Rekh-mi-rēʿ*, ii, pls. xlviii–li, lvi, lvii, lxxiii [3], and vol. i, pp. 43–8; id. *Paintings*, pls. xxiii [left], xiii–xvii; VIREY, on pl. i [left], pls. ix–xii, pp. 45–50; M.M.A. photos. T. 1625–7 [left], 1630–5 [left]. **I–IV,** WRESZ., *Atlas*, i. 324–30; FARINA, *Pittura*, pl. lxvii. Deceased and **I–III,** NEWBERRY, pls. xii–xiv, p. 35; HOSKINS MSS. i. 10, 14 [left], 17. Men with pestles and mortars, &c., in **II,** WILKINSON, *M. and C.* iii. 181 (No. 367) = ed. Birch, ii. 204 (No. 401); WILKINSON MSS. vii. 30 [top]. Men with jars in **III,** PRISSE, *L'Art égyptien*, ii, 56th pl. 'Transport d'ustensiles . . .', cf. *Texte*, p. 423; men with jar on yoke,

&c., in **III**, LHOTE and HASSIA, *Chefs-d'œuvre*, pl. 104; man with jar of oil, CAILLIAUD, *Arts et métiers*, pl. 52. Left part of **IV** and **V**, DAVIES in *M.M.A. Bull.* Pt. ii, Dec. 1928, figs. 1, 2, cf. p. 40. Texts, SETHE, *Urk.* iv. 1140–8 (332) A, B; texts of deceased and of prostrate men in **III**, ROSELLINI MSS. 284, G 24; part of text above **IV**, PIEHL, *Inscr. hiéro.* 1 Sér. cxiv [G δ]; text with cartouche of Tuthmosis III above **V**, L. D. *Text*, iii, p. 271 [top].

(14) [1st ed. 14] Eight registers, **I–IV**, industries, before deceased with attendants, **V–VIII**, temple-works, before [deceased] with attendants. **I**, Stone vase-makers and jewellers. **II**, Leather-workers, including rope-makers. **III**, Carpenters. **IV**, Metal-workers and weighing gold. **V**, Brick-making by Nubians and Syrians with man fetching water from pool, and building. **VI**, Hauling stone, and sculptors making royal colossi. **VII**, Freight-ships arriving, man decorating building, and blocks prepared. **VIII**, Gangs of men with overseers recorded by scribes.

DAVIES, *Paintings*, pls. xxiii [right], xvi; VIREY, pls. i [middle], xiii–xviii, pp. 51–65; M.M.A. photos. T. 1627–9, 1636–48; NEWBERRY, pls. xvi–xxi, pp. 36–8. **I–VIII**, DAVIES, *Rekh-mi-rēʿ*, ii, pls. lii–lv, lviii–lxii, lxxiii [2], cf. vol. i, pl. iii, facing p. 52, and pp. 48–59. **I–VII**, WRESZ., *Atlas*, i. 310–23, 5 a; parts, WILKINSON MSS. ii. 20 [top right], iii. 25 verso, 26, vii. 25, 26 [lower], 27–9, on 31. **I–VI** (incomplete) and deceased in **I–IV**, AMÉLINEAU, *Histoire de la sépulture et des funérailles* [&c.] in *Ann. Mus. Guimet*, xxix (1896), pls. lxv–lxviii, pp. 536–43; omitting **VI**, HOSKINS MSS. i. 14 [right], 21, 24. **I–IV**, FARINA, *Pittura*, pl. lxvi. **IV–VIII**, CHIC. OR. INST. photos. 10001–3; left part of **V–VIII**, DAVIES in *M.M.A. Bull.* Pt. ii, Dec. 1928, pp. 42–5 with figs. 3, 4.

Bead-makers in **I**, CAILLIAUD, *Arts et métiers*, pl. 6 B [4]; CHAMP., *Mon.* clxvi [2]; ROSELLINI, *Mon. Civ.* lii [5]; CLARK in *M.M.A. Bull.* N.S. viii (1950), fig. on p. 154 (from copy by NINA DAVIES). Leather-workers in **II**, CAILLIAUD, *Arts et métiers*, pls. 18 A, 20 A; CHAMP., *Mon.* clxiv [4], clxvi [1, 3, 4]; ROSELLINI, *Mon. Civ.* lxiv [1–3], lxv [11]; WILKINSON, *M. and C.* iii. 144 (No. 359, pt. 1), 160 (No. 361, pt. 1) = ed. BIRCH, ii. 178 (No. 393, pt. 1), 188 (No. 395, pt. 1); LARSEN, *En Egyptisk Äventyrare*, fig. on p. 57. Carpenters in **III**, CAILLIAUD, *Arts et métiers*, pls. 6 [1], 6 A [1]; CHAMP., *Mon.* clxi [4], clxiii [1], clxiv [2, 3]; ROSELLINI, *Mon. Civ.* xliii [3], xliv [5], xlv [3, 4], xlvi [1]; WILKINSON, *M. and C.* iii. 144 (No. 359, pt. 2), 160 (No. 361, pt. 2), 174 (No. 364) = ed. BIRCH, ii. 178 (No. 393, pt. 2), 188 (No. 395, pt. 2), 199 (No. 398); BADAWY in *Cahiers d'histoire égyptienne*, Sér. iv [3–4], Oct. 1952, fig. 5, cf. p. 170.

IV, Omitting weighing, PRISSE, *L'Art égyptien*, ii, 55th pl. 'Atelier . . . des Rothennou', 56th pl. 'Fabrications de vases . . .', cf. *Texte*, p. 422. Some metal-workers, CAILLIAUD, *Arts et métiers*, pls. 6 A [2], 6 B [1, 2], 10 [2]; CHAMP., *Mon.* clxiii [2–4], clxv [4]; ROSELLINI, *Mon. Civ.* l [2, a–c], lii [4]; WILKINSON, *M. and C.* iii. 224 (No. 375), 339 (No. 393) = ed. BIRCH, ii. 235 (No. 415), 312 (No. 432); WAINWRIGHT in *Man*, xliv (1944), No. 75, fig. 1 (from drawing by DAVIES); WINLOCK, *Rise and Fall*, pl. 31, pp. 166–7; DRIOTON and HASSIA, *Temples and Treasures*, pl. 8; LHOTE and HASSIA, *Chefs-d'œuvre*, pls. 101 [upper]–103, 105; VANDIER, *Egypt*, pl. xx [upper]; BURTON MSS. 25644, 132; PRUDHOE MSS. i. 186 [lower]. One furnace, KYLE in *Rec. de Trav.* xxxi (1909), fig. 1, cf. p. 52. Scales with text, L. D. iii. 39 [a]; BRUGSCH, *Thes.* 1113–14; scales, SCHOTT photo. 6114; weights, CHAMP., *Not. descr.* i, p. 510 [A, B].

V, CAILLIAUD, *Arts et métiers*, pl. 9 A; L. D. iii. 40, 41 [upper]; PRISSE, *L'Art égyptien*, ii, 59th pl. 'Captifs employés . . .', cf. *Texte*, pp. 423–4; EBERS, *Aegypten*, i, figs. on p. 116 [middle and bottom], ii, fig. on p. 286; English ed. i, figs. on p. 104 [middle and bottom], ii, fig. on p. 258. Parts, WILKINSON, *M. and C.* ii. 99 (No. 93) = ed. BIRCH, i. 344 (No. 112);

MEYER, *Fremdvölker*, 632–4; PETRIE, *Racial Types*, 781–2 (sheet xiii); CHAMP., *Mon.* clxv [1–3]; ROSELLINI, *Mon. Civ.* xlix [1]; MASPERO, *L'Arch. ég.* (1887), fig. 1, (1907), fig. 2; [OSBURN], *The Antiquities of Egypt* (1841), pl. facing p. 220; FATHY in *L'Amour de l'art*, xxviii, fig. on p. 190 [lower left]; RYDH, *Livet in Faraos Land*, fig. 52; VANDIER, *Egypt*, pl. xx [lower]; PRITCHARD, *The Ancient Near East in Pictures*, fig. 115; MEKHITARIAN, *Egyptian Painting*, pl. on p. 48; LHOTE and HASSIA, *Chefs-d'œuvre*, pls. 97–9, 101 [lower]; BADAWY in *Cahiers d'histoire égyptienne*, Sér. iv [3, 4], Oct. 1952, fig. 4, cf. p. 170.

VI, Sculptors making colossi, L. D. iii. 41 [lower]; PRISSE, *L'Art égyptien*, ii, 57th pl. 'Atelier de sculpteurs', cf. *Texte*, p. 423; HOSKINS MSS. i. 7 [upper]; incomplete, CHAMP., *Mon.* clxi [1–3]; ROSELLINI, *Mon. Civ.* xlvii [2–4]; EBERS, *Aegypten*, ii, fig. on p. 56 [top]; English ed. ii, fig. on p. 49 [top]; CAPART and WERBROUCK, *Thèbes*, fig. 188 (from WRESZIN-SKI); WINLOCK, *Egyptian Statues and Statuettes*, pl. 12; two colossi, WILKINSON, *M. and C.* iii. 336 (No. 392) = ed. BIRCH, ii. 311 (No. 431); one, CAILLIAUD, *Arts et métiers*, pl. 15.

VII, Ship, PRUDHOE MSS. i, on 186 [lower]. Men preparing blocks, CAILLIAUD, op. cit. pl. 14 [1, 1 a, 1 b]; CHAMP., *Mon.* clxiv [1]; ROSELLINI, *Mon. Civ.* xlviii [2]; part, WILKIN-SON, *M. and C.* iii. 335 (No. 391) = ed. BIRCH, ii. 310 (No. 430).

Texts (of whole scene), SETHE, *Urk.* iv. 494 (160) D b, 1148–55 (332) C, D; text of deceased in **I–IV,** ROSELLINI MSS. 284, G 25; text of deceased in **V–VIII,** L. D. *Text*, iii, p. 270 [lower left].

(15) [1st ed. 15] Ten registers, **I–X,** funeral procession (with 68 episodes) to divinities. **I,** Two rows of shrines before Western hawk. **II–IV,** Procession with rites in garden to Osiris (including butchers in **II** and **IV,** victims round pool and mummers in **II,** and *teknu* and setting up obelisks in **IV**). **V–VII,** Procession to Anubis (including bringing funeral outfit with royal statuettes and 'Nine friends' carrying coffin in **VI**). **VIII–X,** Procession with Abydos pilgrimage to Western goddess (including deceased purified by two priests, and dancers, in **VIII,** butchers, and foreleg-rite before altar with burnt-offerings in **IX,** and 'Nine friends' following sarcophagus in **X**).

DAVIES, *Paintings*, pl. xxiv [left]; id. *Rekh-mi-rēc*, ii, pls. lxxvi [left], lxxviii [left], lxxix–lxxxiv, lxxxvi [left], lxxxvii–xc, xcii–xciv, and vol. i, pp. 70–4 with fig. 9 and pl. v [1]; VIREY, pls. i [right], xix–xxviii, pp. 67–98; M.M.A. photos. T. 1495–1501, 1505–17, 1595–1601; HOSKINS MSS. i. 28, 32, 38, 42, 49, 53, 56, 59. Two women 'purifying mansion with incense' in **IV,** interpreted as women with cymbals, see HICKMANN in *Ann. Serv.* xlix (1949), pp. 472, 474. Men with funeral outfit in **VI,** DAVIES, *Paintings*, pl. xviii; lector, 'kite', and shrine carried, in **VI,** and sarcophagus dragged in **X,** LÜDDECKENS in *Mitt. Kairo*, xi (1943), pp. 46–63 [20–2], 64–72 [24–6], Abb. 16, 23–4. Two mummers in **VIII,** DRIOTON and HASSIA, *Temples and Treasures*, pl. 5. Names of divinities in **VII,** SETHE, *Urk.* iv. 1168–9 (338); text of two priests dragging shrine in **VIII,** PIEHL in *Ä.Z.* xxi (1883), p. 127 [1]. For town of Sais in **VIII,** see VANDIER in *Chronique d'Égypte*, xix (1944), pp. 40–1 with fig. 6.

(16) Four registers. **I–III,** [Sons] Menkheperracsonb, Mery, and Amenḥotp, respectively, offer to deceased and wife Meryt. **IV,** Son Senusert (?) with offering-list ritual before deceased and mother.

DAVIES, *Paintings*, pl. xxiv [right]; id. *Rekh-mi-rēc*, ii, pls. lxxv, lxxvi [right], lxxvii, lxxviii [right], lxxxv, lxxxvi [right], xci, and vol. i, p. 70; M.M.A. photos. T. 1493–4, 1502–4, 1602–7. Deceased, wife, and offerings, in **II,** HOSKINS MSS. i. 46. Texts, and priests in **IV,** VIREY, pp. 100–12. Spells behind sons in **I–III,** SCHIAPARELLI, *Funerali*, ii, pp. 280 [e], 149–54 [A'], 278 [c].

(17) [1st ed. 20] Two registers. **I**, Son with male and female relatives greets and offers bouquet to deceased with attendants and boats, on his return from acclaiming Amenophis II at Het-sekhem. **II**, Deceased with attendants receives three rows of officials and petitioners.

DAVIES, *Paintings*, pl. xxvi [right]; id. *Rekh-mi-rēʿ*, ii, pls. lxviii, lxix [1], lxx–lxxii, cf. vol. i, pp. 63–6, 68–9; M.M.A. photos. T. 1619–24. **I**, VIREY, pl. xliv, pp. 164–5; sailing-boat and text, COTTRELL, *Life under the Pharaohs*, fig. 6 (from DAVIES). **II**, NEWBERRY, pl. xv, pp. 35–6; petitioners, DAVIES in *M.M.A. Bull.* Pt. ii, Dec. 1926, fig. 4, cf. pp. 4–10. Texts of deceased in **I** and **II**, SETHE, *Urk.* iv. 1139–40 (331), 1159–60 (335); text of deceased in **II**, VIREY, p. 165. Earlier text (beneath text above boats and relatives), DAVIES, *Rekh-mi-rēʿ*, i, fig. 8, cf. p. 64. Graffiti, see VIREY, p. 166.

(18) [1st ed. 19] Eight registers, banquet, **I–IV** with daughters offering sistra to deceased and wife, **V–VIII** with [sons] offering bouquets to [deceased and wife]. **I–VIII**, Guests and musicians, including female lutist in **II**, girl shown back-view in **III**, female musicians (harp, lute, and tambourine, and two clappers) in **IV**, and male musicians (harp, lute, and clappers) in **V** and **VI**.

DAVIES, *Paintings*, pl. xxvi [left]; id. *Rekh-mi-rēʿ*, ii, pls. lxiii–lxvii, lxix [2], and vol. i, pl. iv, pp. 59–63; VIREY, pls. xl–xliii, pp. 159–63; omitting lower offering-scene, ROSELLINI, *Mon. Civ.* lxxviii [3], lxxix; M.M.A. photos. T. 1419 [right], 1518–21, 1609–18. Head of deceased in **I–IV**, PRISSE, *L'Art égyptien*, ii, 29th pl. [2] 'Types et Portraits. Hauts Fonctionnaires . . .', cf. *Texte*, pp. 406–7.

I–VIII, CHAMP., *Mon.* clxxxvii; WRESZ., *Atlas*, i. 332–3, 10 a, 89, 90. **II–VII**, incomplete, SCHOTT photos. 5125–8, 6093–6113, 8957–77. **III–VII**, incomplete, FARINA, *Pittura*, pls. lxviii, lxix. **III–VI**, CAILLIAUD, *Arts et métiers*, pl. 64 (called El-Kab). **III–IV**, incomplete, DONADONI, *Arte egizia*, figs. 113–14.

Strainer and jars in **I**, SCHOTT photo. 8956. Lutist and some guests in **II**, LHOTE and HASSIA, *Chefs-d'œuvre*, pl. 118. Guests in **III**; 1st group, SACHS, *Musikinstrumenten*, Abb. 94 [upper]; 2nd and 3rd, VANDIER, *Egypt*, pl. xxi [upper]; 3rd to 5th, CAPART and WERBROUCK, *Thèbes*, fig. 118 [upper] (from WRESZINSKI); 3rd and 5th, SCHÄFER and ANDRAE, *Kunst*, fig. on p. 349, 2nd and 3rd eds. fig. on p. 365 (from WRESZINSKI); 3rd, L. *D.* iii. 42; WILKINSON, *M. and C.* ii. 391 (No. 280) = ed. BIRCH, ii. 38 (No. 304); LANSING in *M.M.A. Bull.* xxv (1930), fig. on p. 6, cf. p. 8; LHOTE and HASSIA, *Chefs-d'œuvre*, pl. 119; SIGERIST, *A History of Medicine*, i (1951), pl. xxx [63] (from painting by NINA DAVIES); SCOTT, *The Home Life of the Ancient Egyptians*, fig. 20; WILKINSON MSS. vi. 66 [bottom]; attendants, MEKHITARIAN, *Egyptian Painting*, pl. on p. 51; WOLF, *Die Kunst Aegyptens*, Abb. 457; one, SCHOTT, *Altägyptische Liebeslieder*, pl. 16; girl, back-view, SMITH, *Art . . . Anc. Eg.* pl. 104 [B]. Musicians and some guests in **IV**, LANGE and HIRMER, *Aegypten*, pl. 140; CHIC. OR. INST. photos. 10004–5; musicians, SACHS, *Musikinstrumenten*, Abb. 94 [lower]; LANSING and HAYES in *M.M.A. Bull.* Pt. ii, Jan. 1937, fig. 9, cf. p. 8; HICKMANN, *45 Siècles de Musique*, pl. xlvii [A, B]; harpist, lutist, and some guests, VANDIER, *Egypt*, pls. xxi [lower], xxii; LHOTE and HASSIA, *Chefs-d'œuvre*, pls. 120, 122; lutist, BRUYÈRE, *Rapport (1934–1935)*, Pt. 2, fig. 64, cf. p. 118; girl with tambourine and clappers, DRIOTON and HASSIA, *Temples and Treasures*, pl. 7; some guests, CAPART and WERBROUCK, *Thèbes*, fig. 118 [lower] (from WRESZINSKI); SCHOTT, *Das schöne Fest*, pls. ix, x, p. 838; OTTO, *Ägypten. Der Weg des Pharaonenreiches*, Abb. 16 b. Harpist and lutist in **VI**, HICKMANN, *45 Siècles de Musique*, pl. xlvii [C, D]; CHIC. OR. INST. photo. 10006; harpist, HICKMANN in *Bull. Inst. Ég.* xxxv (1954), fig. 3 (from SCHOTT photo.), cf. p. 311. Group of guests, WILKINSON, *M. and C.* ii. 215 (No. 179) = ed. Birch, i. 427 (No. 204).

Texts (of whole scene), SETHE, *Urk.* iv. 1162–7 (337) A, B; text of sons, PIEHL, *Inscr. hiéro.* 1 Sér. cxiv [G β, γ]; name of wife, L. *D. Text*, iii, p. 271 [top right].

(19) [1st ed. 18] Ten registers. I–VII, Rites before statues of deceased in 50 episodes (including statue carried by nine priests and offering-list ritual in II, butchers in IV, purification of statues, each by a priest, and cloaked *sem*-priest seated on stool, in VII). VIII–X, Preparation of provisions before deceased seated, garden with boat on pool, men bringing provisions, and seated guests before [deceased and wife].

DAVIES, *Paintings*, pl. xxv [right]; id. *Rekh-mi-rēʿ*, ii, pls. xcvii–cii, civ [right]–cvii, cix–cxii, vol. i, pp. 66–8, 74–8, and pl. v [2] facing p. 72; VIREY, pls. xxx–xxxix, pp. 131–58; M.M.A. photos. T. 1399–1404, 1406–19 [left], 1584–5, 1588–92. Preparation of provisions in VIII–IX, WRESZ., *Atlas*, i. 126 (called tomb 24). Garden in VIII–IX, DAVIES, *Paintings*, pl. xx; WRESZ., *Atlas*, i. 3 a; WILKINSON, *M. and C.* ed. BIRCH, ii. 212 (No. 406); MASPERO, *L'Arch. ég.* (1887), fig. 171, (1907), fig. 180; CAPART and WERBROUCK, *Thèbes*, fig. 246 (from WRESZINSKI); FARINA, *Pittura*, pl. lxv; SCHOTT photos. 5129–30; WILKINSON MSS. v. 227; HOSKINS MSS. i. 7 [lower]. Female mourners and tumbler (left of garden), SCHOTT photo. 5131; tumbler, DAVIES in *M.M.A. Bull.* Pt. ii, Feb. 1928, fig. 12 [right], cf. p. 68. Ritual-texts, SCHIAPARELLI, *Funerali*, ii, pp. 15–27 [A'], 87–96 [A'], 121–6 [A'], 155–6 [A'], 185–206 [A'], 210–26 [A'], 264–74, 275; texts of deceased in VIII–X, PIEHL, *Inscr. hiéro.* 1 Sér. cxiii [G a]; texts of deceased, and texts of group on right of VIII, SETHE, *Urk.* iv. 1158–9 (334) 1, 2; text of offering-bringers (left of pool) in VIII, id. ib. 1167–8 (337) C, D.

(20) [1st ed. 17] Four registers. I, Son Amenḥotp before deceased and mother. II, Son Senusert before deceased and wife. III, Son Menkheperraʿsonb before deceased and mother. IV, Son with offering-list ritual before deceased and wife.

DAVIES, *Paintings*, pls. xxv [left], xix; omitting scene in III, id. *Rekh-mi-rēʿ*, ii, pls. xcv–xcvi, ciii, civ [left], cviii, cf. vol. i, pp. 74–7; M.M.A. photos. T. 1397–8, 1405, 1586–7, 1593–4. Texts and ritual scene in IV, VIREY, pp. 117–29 with fig.; ritual texts, SCHIAPARELLI, *Funerali*, ii, pp. 157–9 [A'], 276–7 [a, b], 279 [d].

(21) [part, 1st ed. 16] Three registers. I, Niche; lintel, double-scene, deceased kneels before Osiris and goddess, jambs, offering-texts, side-walls, son Menkheperraʿsonb offering to deceased and wife, ceiling, texts. II, False door, with texts at each side, in Louvre C. 74. III, Remains of false door.

DAVIES, *Rekh-mi-rēʿ*, ii, pls. cxiii [A], cxiv, cxv, lxxiii [1], cf. vol. i, pp. 5, 10–11, 13; see VIREY, pp. 3, 113. I–II, M.M.A. photo. T. 1608; elevation, HAY MSS. 29821, 1; cf. VIREY, p. 3. False door in II, VIREY, pl. xxix, pp. 113–16; HAY MSS. 29816, 175. Titles, SETHE, *Urk.* iv. 1173–4 (340); PIERRET, *Rec. d'inscr.* ii. 11; BRUGSCH, *Thes.* 1109 [middle]; names, LIEBLEIN, *Dict.* No. 914. See BOREUX, *Guide*, i, p. 67; VANDIER, *Guide* (1948), p. 16, (1952), p. 17; DE ROUGÉ, *Notice des monuments* [&c.], p. 107.

Ceiling. Texts, DAVIES, *Rekh-mi-rēʿ*, ii, pls. xlvi [2, D], cxiii [B], cf. vol. i, pp. 12–13.

101. THANURO 𓎼𓏏𓏤𓏤𓏤𓏤, [Royal butler] clean of hands. Temp. Amenophis II.
Sh. ʿAbd el-Qurna.
Plan, p. 208. Map V, D–4, e, 9.
Hall.
(1) [Deceased and wife] offering, followed by offering-bringers.

(2) [Deceased and wife] with two rows of men offering flowers and fruit to them, and four registers, **I–III**, guests, **IV**, musicians (female clappers and flutist, and blind male harpist). CHIC. OR. INST. photos. 4010, 4014. Grapes from offering-scene, and girl with bowl in **III**, SCHOTT photos. 8482–3. Musicians, SCHOTT photos. 3865–6; flutist and harpist, SCHOTT in *Mélanges Maspero*, i, fig. 3, cf. p. 460; HICKMANN, *45 Siècles de Musique*, pl. xlix [A]. Name of son in **I**, HELCK, *Urk.* iv. 1475 [near top].

(3) Stela. At sides, two registers, offerings before deceased seated.
CHIC. OR. INST. photo. 4017.

(4) [Deceased] with offerings, followed by [priest] with ritual instruments, before statue of sacred bull in kiosk with winged hawk and cartouche of Amenophis II.
CHIC. OR. INST. photos. 4012 [left], 4013, 4016. Offerings, instruments, and bull, SCHOTT photos. 3869–70; bull, DAVIES in *M.M.A. Bull.* Pt. ii, Nov. 1935, fig. 8, cf. pp. 53–4. Text, HELCK, *Urk.* iv. 1474–5.

(5) Deceased with two registers of offerings before [King] and Hathȝr, **I–II**, offering-bringers with bouquets, &c., including bull with decorated horns and man bringing honey with bees, &c., in **I**.
CHIC. OR. INST. photos. 2954, 4011, 4012 [right], 4015. Men with bouquets and bull in **I**, SCHOTT photos. 7125–31, 8484–5; bull, and man with honey, DAVIES (Nina), *Anc. Eg. Paintings*, i, pl. xxxiv (CHAMPDOR, Pt. ii, 8th pl.); DAVIES (Nina), *Eg. Paintings* (Penguin), pl. 4; KEIMER in *Egypt Travel Magazine*, No. 30, Feb. 1957, fig. on p. 22.

(6) Four registers. **I–II**, Donkeys (sketched), goats, and cattle. **III–IV**, Winnowing and measuring grain before granary.
CHIC. OR. INST. photos. 3007, 4018–19. Donkeys, cows, and calves, in **I–II**, and men and granary in **IV**, SCHOTT photos. 7118–21, 7123–4; donkeys in **I–II**, and overseer seated on heap of corn in **IV**, BAUD, *Dessins*, figs. 66–7; donkey and foal in **II**, MEKHITARIAN, *Egyptian Painting*, pl. on p. 26.

(7) Three men before [King in kiosk].

102. IMḤŌTEP ⌇⟜⚬, Royal scribe, Child of the nursery. Temp. Amenophis III. (Inaccessible.)
Sh. ʿAbd el-Qurna.
Plan, p. 208, cf. p. 106. Map VI, E–4, g, 3.
Plan, MOND in *Ann. Serv.* vi (1905), fig. 3 [top], cf. p. 67.

Façade.

(1) Deceased with hymn to Osiris-Onnophris, and small stela with Ḥetep, Bekenmut, and deceased, before Ptaḥ, and six people below.

(2) Deceased with hymn to Rēʿ.
M.M.A. photo. on T. 809.

Passage.

(3) Outer lintel, double-scene, deceased before a divinity, and jambs, remains of texts

with deceased seated at bottom. Inner thicknesses, deceased adores 'Osiris-Onnophris', and with staff adores 'Rēꜥ'.

Outer doorway, M.M.A. photo. on T. 809.

(4) Funeral procession to Osiris and Western goddess.

Shrine.

(5) Offering-scenes. (6) Deceased adores Osiris with goddess.

103. Dagi ⌐🃟🃟🃟, Governor of the town and Vizier. End of Dyn. XI.

Sh. ꜥAbd el-Qurna. (L. D. Text, No. 36.)

Wife (or mother), Maꜥetnemti 🃟🃟🃟🃟🃟.

Plan, p. 208. Map V, D–4, f, 6.

Davies, *Five Theban Tombs*, pp. 28–39, with plan and section, pl. xxix, and views of exterior, pl. xlii; L. D. Text, iii, p. 251.

Portico. Scenes much destroyed.

(1) Two registers. **I,** Man watering garden. **II,** Man picking grapes before Sebkrēꜥ, Overseer of gardeners.

Davies, pl. xxxi [2, 8, and bottom], p. 33.

(2) [Deceased leaving tomb.]

Titles, Davies, pl. xxxi [3], p. 33.

(3) Preparation of reed fibres for weaving.

Davies, pl. xxxv [lower], p. 33.

(4) [1st ed. 1 on plan, but entry moved to (9)] Men in canoe with cattle crossing water, and crocodile below.

Davies, pl. xxxviii [2], pp. 33–4; cattle, Schott photo. 7366.

(5) Men bringing wild animals to deceased. (6) [Deceased watching fowling and fishing.]

See Davies, p. 34.

(7) and (8) Abydos pilgrimage.

Davies, pl. xxxvi, p. 34.

(9) [1st ed. 1, moved here] Women spinning and weaving, with loom.

Davies, pl. xxxvii, pp. 34–5.

(10) Storing grain in granary. See Davies, p. 35.

(11) Brewing and cooking.

Fragment with part of cooking-scene, Davies, pl. xxxi [1], p. 35.

(12) Two registers, man and women baking loaves.

Davies, pls. xxxviii [lower], xxxi [4], pp. 35–6.

(13) Offerings with name of deceased. See Davies, p. 31.

(14) Two scenes. **1,** Deceased inspects two registers, men bringing produce. **2,** Deceased and mother inspect two registers, recording treasure, &c., with remains of scales.

DAVIES, pls. xxxii–xxxiv, xxxi [5], pp. 31–2.

(15) [Men] with palanquin (?).

See DAVIES, p. 31 with note 3 and pl. xxxi [9].

(16) Industries with men blowing fire, and bringing offerings.

See DAVIES, p. 31.

(17) Preparing bed (?). See DAVIES, p. 31.

Burial Chamber.

Sarcophagus, in Cairo Mus. 28024. Interior, L. *D.* ii. 147 [a, b], 148 [a, b], cf. *Text,* iii, p. 251; part, MASPERO in *Mém. Miss.* i, pl. ix, cf. p. 181. Coffin-texts, LACAU, *Sarcophages antérieurs au Nouvel Empire* (*Cat. Caire*), i, pp. 56–61; DE BUCK, *Egyptian Coffin Texts,* i, iii, and vi [T 2 c]; horizontal text at top, LEPSIUS MS. 299 [lower]; offering-list, DUEMICHEN, *Der Grabpalast des Patuamenap,* Pt. i, pls. xviii–xxvi [h], cf. *Text,* p. xvi. See MASPERO, *Guide* (1915), pp. 26–7 [34]; DAVIES, p. 28.

Fragments from Walls

In New York, M.M.A.

Two adjoining fragments with numerals, Nos. 12.180.241 B and 249. DAVIES, pl. xxxv [upper], pp. 36–7; M.M.A. photo. 3 A, 31.

Lector and butcher, and offerings, Nos. 12.180.242 and 244. DAVIES, pl. xxxviii [1, 3], p. 37; M.M.A. photos. 3 A, 28, 30.

Two men seated on ground, No. 12.180.243. DAVIES, pl. xxx [1], p. 38; WINLOCK in *M.M.A. Bull.* vii (1912), fig. 6, cf. p. 189; HAYES, *Scepter,* i, fig. 99; M.M.A. photo. 3 A, 26.

Offering-list and offerings, No. 12.180.245. M.M.A. photos. 3 A, 29.

Shoulders of deceased (?), No. 12.180.246. DAVIES, pl. xxxviii [4], p. 36.

Various.

Other fragments, DAVIES, pls. xxx [3–8], xxxi [6], xxxviii [5, 6], pp. 36–7.

Ostrich, and part of boat, in Cairo Mus. Ent. No. 48848. DAVIES, pls. xxx [2], xli [lower], p. 36; M.M.A. photo. 3 A, 25.

104. D̠HUTNŪFER. (See tomb 80.) Temp. Amenophis II.

Sh. ʿAbd el-Qurna.

Plan, p. 208. Map V, D–4, h, 7.

View of interior, M.M.A. photo. T. 2841.

Hall.

(1) [Deceased] offering [on braziers]. Sub-scene, offering-bringers.

M.M.A. photos. T. 2829, 2830 [bottom left]; details, and two offering-bringers on right, SCHOTT photos. 8486, 8489 [left].

(2) Two registers. **I** and **II,** [Man] offers to deceased, wife, and daughter, in each. Sub-scene, six offering-bringers with food, flowers, and animals.

M.M.A. photos. T. 2830–1. Deceased and family in **I,** and vase below chair in **II,** SCHOTT photos. 8487–8, 2757; last two offering-bringers, id. ib. 8489 [right].

(3) Stela with 'Address to the living'. A: sides, four registers, kneeling offering-bringers.
M.M.A. photos. T. 2832–3. Texts, HERMANN, *Stelen*, pp. 4* [24–5], 30*, cf. p. 70; of stela, HELCK, *Urk.* iv. 1609–10.

(4) [Deceased] seated with offering-bringers below, and four registers, (middle destroyed), **I** and **II,** female guests and clappers, **III** and **IV,** offering-bringers.
M.M.A. photos. T. 2834–5. Left end of **III** and **IV,** SCHOTT photos. 8490–1.

(5) [1st ed. 3] Deceased and servants in house, with spinning, weaving, and baking, on ground floor, and men carrying provisions to store-rooms on roof. Sub-scene, offering-bringers before seated man.
M.M.A. photos. T. 1683–4, 2839–40. Main scene, DAVIES, *Town House*, figs. 1 A, 1 B, cf. pp. 236–40; MACKAY in *Ancient Egypt* (1916), figs. on pp. 170–1; CAPART and WERBROUCK, *Thèbes*, fig. 117 (from MACKAY). Spinning and weaving, and two men with provisions on 2nd floor, SCHOTT photos. 2753–4, 2756; looms, ROTH, *Ancient Egyptian and Greek Looms* (*County Borough of Halifax. Bankfield Museum Notes*, 2nd ser. [2]), fig. 9 (from drawing by DAVIES), cf. pp. 15–17.

(6) [1st ed. 2] Unfinished scene, deceased fowling and fishing. Sub-scene, three rows, banquet.
M.M.A. photo. T. 2838. Part of main scene, MACKAY in *J.E.A.* iv (1917), pl. xvii [3, 4], p. 82.

(7) [1st ed. 1] Unfinished scene, deceased and [two people] with [man] offering to them, and seated relatives. Sub-scene, offering-bringers with animals and food.
M.M.A. photos. T. 2836–7. Deceased and [two people], MACKAY in *J.E.A.* iv (1917), pl. xvi [4], p. 81.

Inner Room.
(8) Three registers, funeral procession to Western goddess, **I,** carrying funeral outfit, and canoe, **II,** priests, *teknu*, and oxen dragging sarcophagus, **III,** Abydos pilgrimage, and priests before tomb. (9) [Man] with offerings before [deceased, wife], and daughter Nefertere.
M.M.A. photos. T. 2842–4. Name of daughter at (9), LEPSIUS MS. on 304 [bottom right].

(10) Three registers, rites before mummies, including two men carrying statue, and butchers. (11) [Man] with offerings before deceased, wife, and daughter.
M.M.A. photos. T. 2846–8.

(12) Deceased with wife and daughter adores Osiris.
M.M.A. photo. T. 2845. Names of wife and daughter, LEPSIUS MS. 304 [lower].

105. KHA'EMŌPET ⟨hieroglyphs⟩, Prophet of the noble ram-sceptre of Amūn. Dyn. XIX.
Sh. 'Abd el-Qurna.
Wife, Amenemōpet ⟨hieroglyphs⟩.

Plan, p. 208. Map V, D–4, h, 8.

SÄVE-SÖDERBERGH in *Private Tombs at Thebes*, iii, in preparation. View of interior, M.M.A. photo. T. 2881.

Hall.

(1) Outer thicknesses, remains of texts. Inner thicknesses, deceased offering (?) and wife on left, and deceased adoring with hymn to Rēʿ, and wife, on right.
M.M.A. photos. T. 2882–5.

(2) [Deceased, wife], and daughter (?), with offerings before Rēʿ-Ḥarakhti, Ḥathor, and Maʿet.
M.M.A. photos. T. 2887–8, on 2881.

Inner Room.

(3) Left thickness, deceased with statuette of bull, and wife, right thickness, deceased wearing collars and skin (both unfinished).
M.M.A. photos. T. 2889–90.

(4) Niche (above staircase), with seated statues of deceased and wife.
M.M.A. photo. on T. 2881.

106. PASER 𝕏🔲 , Governor of the town and Vizier. Temp. Sethos I to Ramesses II.
Sh. ʿAbd el-Qurna. (CHAMPOLLION, No. 32, L. D. Text, No. 39, HAY, No. 7.)
Parents, Nebneteru � , called Theri � , Chief prophet of Amūn, and Merytrēʿ � , Chief of the harîm of Amūn. Wife, Tiy � , Chief of the harîm of Amūn.

Plan, p. 220. Map V, D–4, h, 8.

SÄVE-SÖDERBERGH in *Private Tombs at Thebes*, iii, in preparation. CHAMP., *Not. descr.* i, pp. 520–5 with plan; L. D. *Text*, iii, pp. 253–5; BURTON MSS. 25639, 42 [bottom]; WILKINSON MSS. xvii. H. 18 verso–19; HAY MSS. 29824, 47–8 verso; ROSELLINI MSS. 284, G 40 verso–45 with rough plan. Titles and plan, WILBOUR MSS. 2 F. 32 [lower]. Text of transport of statue with 'Nine friends' from funeral procession, probably on left wall of Inner Room, SCHIAPARELLI, *Funerali*, ii, p. 298 [xxv, b].

Court. Views, WEGNER in *Mitt. Kairo*, iv (1933), pl. iii [c]; M.M.A. photos. T. 605, 608–9, 2880, 3523.

(a)–(i) Nine niches, each with statue of deceased, some inscribed, three (d, e, f) Osiride.
M.M.A. photos. T. 2891 (c and d), 2892 and 2894 (e), 2899 (f), 2898 (g and h), 2896 (i); SCHOTT photo. 9103 (h).

(1) Above stela, deceased kneeling, preceded by priests. Stela, three registers, **I,** double-scene, parents adore Rēʿ-Ḥarakhti and Maʿet, and deceased and mother adore Osiris-Onnophris and Isis, **II,** double-scene, two priests with offerings before mummies of parents, and two priests purify mummies of deceased and mother, **III,** hymn to Osiris.
M.M.A. photos. T. 2892–4. Stela, SCHOTT photos. 9101, 3576–8; priests purifying mummies in **II,** SCHOTT in *Nachr. Akad. Göttingen* (1957), No. 3, pl. iii b, p. 85.

(2) Deceased purified. M.M.A. photo. T. 2898.

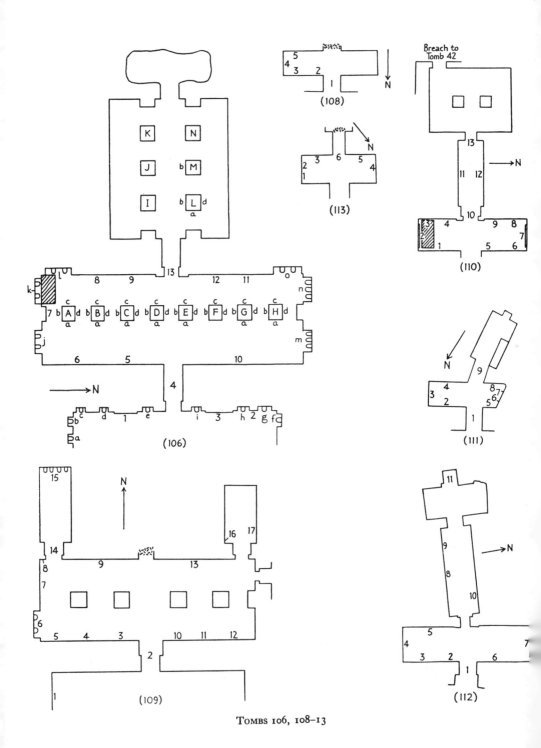

TOMBS 106, 108-13

(3) Above stela, deceased kneeling with long hymn, preceded by souls of Pe and Nekhen and baboons, adores barks of Rēᶜ. Stela, two registers, **I**, double-scene, purification of mummies, and purification of shrine containing statues and canopic-jars, **II**, hymn to the gods of the necropolis.

M.M.A. photos. T. 2896-8. Stela, SCHOTT photos. 9102, 3579–80; purification of shrine in **I**, SCHOTT in *Nachr. Akad. Göttingen* (1957), No. 3, pl. vi a, p. 85.

Hall. Views, M.M.A. photos. T. 2969–70.

(4) [1st ed. 1, 2] Outer lintel, double-scene, deceased adores Rēᶜ-Ḥarakhti and Western goddess, and adores Osiris and Anubis, with cartouches of Sethos I in centre, and jambs, texts. Thicknesses, deceased and mother on left, and deceased on right, with hymns to Rēᶜ. Inner lintel, deceased and wife (?) as *ba*s adoring, and jambs, offering-texts.

Omitting outer jambs, M.M.A. photos. T. 2895, 2900–4, 2909–10; sketch of outer lintel, WILKINSON MSS. ix. 70 [middle]. Thicknesses, SCHOTT photos. 9104–5 (omitting deceased on left); right thickness, ANTHES in *Ä.Z.* lxvii (1931), p. 2 with fig.; titles of deceased and mother, CHAMP., *Not. descr.* i, pp. 521, 846 [to p. 521, l. 7]; L. D. *Text*, iii, p. 254 [top left].

(5) [1st ed. 3] Deceased rewarded, and acclaimed by courtiers, before [Sethos I] followed by Maᶜet, with souls of Pe and Nekhen in front of him, (all in kiosk).

M.M.A. photos. T. 2907–9; WILKINSON MSS. ii. 36 verso; omitting courtiers, PRISSE, *Mon.* pl. xxx; DUEMICHEN, *Hist. Inschr.* ii, pl. xli; WILKINSON, *M. and C.* 2 Ser. Supp. pl. 80 = ed. BIRCH, iii, pl. lxiv facing p. 371; BURTON MSS. 25644, 80–2 verso; deceased with attendants and courtiers, NESTOR L'HÔTE MSS. 20413, 5th carton, A, B; deceased with attendants, HAY MSS. 29822, 80. Head of King, L. D. iii. 132 [n]. Front colonnette of kiosk, PRISSE, *L'Art égyptien*, i, 18th pl. [3] 'Colonnettes . . . XVIIIᵉ et XIXᵉ dynasties', cf. *Texte*, p. 363 [II*, 3]. Text of Maᶜet, CHAMP., *Not. descr.* i, p. 846 [to p. 521, l. 16]. Name and titles above deceased, BRUGSCH, *Thes.* 1224 [bottom]; LEPSIUS MS. 284 [bottom].

(6) [1st ed. 4, 5] Two registers. **I**, Deceased outside temple approves statue of Sethos I, and carpenters with wooden construction beyond. **II**, Deceased with attendant inspects weighing before Custodian of the House of Gold, with three rows of craftsmen (sculptors making sphinxes, vase-makers, and goldsmiths) beyond.

M.M.A. photos. T. 2905–7. Deceased and statue in **I**, L. D. iii. 132 [p]; man holding statue, NESTOR L'HÔTE MSS. 20413, 5th carton, E; carpenters, HAY MSS. 29822, 78. Craftsmen in **II**, WILKINSON MSS. ii. 36 [right]; top two rows, NESTOR L'HÔTE MSS. 20413, 5th carton, C; top row, L. D. iii. 132 [r]; HAY MSS. 29822, 79. Text of deceased in **I**, and names of sculptors in **II**, CHAMP., *Not. descr.* i, p. 846 [to p. 522, ll. 9 and 15]; text of deceased, GOLENISHCHEV MSS. 7 [c]; text of goldsmith on left in 3rd row, ERMAN in *Ä.Z.* xxxi (1893), p. 64.

(7) Pilaster. Deceased with staff 'entering and going forth in Ro-setau'.
M.M.A. photo. on T. 2936.

(8) Remains of installation-text as Vizier, and scene in judgement-hall.
M.M.A. photos. T. 2928–9; SCHOTT photo. 3569. Text and sketch, ANTHES in *Mélanges Maspero*, i, pp. 155–63 with fig. Comparison with texts in other tombs, DAVIES, *The Tomb of Rekh-mi-rēᶜ at Thebes*, ii, pls. cxxi–cxxii [P], cf. vol. i, p. 89.

(9) *Sem*-priest offers to deceased.
M.M.A. photo. T. 2930.

(10) [1st ed. 6, 7] Two registers, six scenes. **I, Book of Gates, 1,** souls of Pe and Nekhen and baboons adore bark of Atum containing Sethos I kneeling before Atum, **2,** two rows, deceased kneeling adores gates with guardians, &c., **3,** deceased with parents before [Osiris]. **II, 4,** Deceased, followed by relatives, censes and libates offerings, and blind male musicians (one a lutist) with song, and offering-bringers, below, **5,** priest with litany before deceased and mother (with monkey eating under chair), **6,** deceased and parents with relatives and *ba*s drinking in tree-goddess scene.

M.M.A. photos. T. 2910–24; right end, NESTOR L'HÔTE MSS. 20413, 4th carton, F. **1,** DUEMICHEN, *Flotte*, pl. xxxi [b]; part, WILKINSON MSS. ii. 37 [upper]; bark, WILKINSON, *M. and C.* 2 Ser. Supp. pl. 47 [3] = ed. BIRCH, iii, pl. xxxviii [1]; WILKINSON, *Materia Hieroglyphica*, pl. xxviii [3]; baboons, HAY MSS. 29822, 81. See CHAMP., *Not. descr.* i, pp. 522, 847 [to p. 522, ll. 22–4]. Deceased and relatives in **4,** WILKINSON MSS. ii. 37 [lower]; omitting text, WILKINSON, *M. and C.* i. 260 (No. 8, 1–3), 279 (No. 10, 1), iii. 348 (No. 396, 2, 4), 2 Ser. ii. 378 (No. 488) = ed. BIRCH, i. 170 (No. 8, 1–3), 182 (No. 10, 1) with 184 (No. 12), 183 (No. 11, 2, 4), 184 (No. 14), ii. 324 (No. 436, 2, 4), iii. 425 (No. 622), (i. 183 (No. 11, 2, 4), 184 (No. 14), only in Birch edition); deceased and parents, musicians with song, and offerings, SCHOTT photos. 9044–6, 3318–21, 3565–6; second son Iny 𓎛𓏏𓅱𓏤𓏭𓀀𓏦, HOREAU, *Panorama d'Égypte et de Nubie*, p. 16 verso [top, 2nd from right]; head of mother (presumably from here), PRISSE, *L'Art égyptien*, ii, 28th pl. [lower left] 'Types et Portraits. Dames...', cf. *Texte*, p. 406 [4]. **5,** SCHOTT photos. 3571–2; deceased and mother, WEGNER in *Mitt. Kairo*, iv (1933), pl. xxv [b, right]. **6,** CHAMP., *Mon.* clxxxiv [1], cf. *Not. descr.* i, pp. 523 [upper], 847–8 [to p. 523, ll. 6, 14]; ROSELLINI, *Mon. Civ.* cxxxiv [1]; WILKINSON MSS. ii. 40 [lower]; incomplete, DUEMICHEN, *Hist. Inschr.* ii, pl. xliv [a]; Nut as tree-goddess with pool, *ba*, and female relative, SCHOTT photos. 3573–5; WEGNER, op. cit. pl. xxv [b, left] (incomplete); BURTON MSS. 25644, 74 verso, 75, 78; tree-goddess and *ba*, WILKINSON, *M. and C.* 2 Ser. Supp. pl. 32 [figs. 3, 4] (reversed) = ed. BIRCH, iii, pl. xxiv [fig. 1] (reversed) facing p. 62; tree-goddess, WILKINSON, *Materia Hieroglyphica*, pl. xii [fig. 3]; HAY MSS. 29822, 77. Texts in **1, 4, 5, 6,** LEPSIUS MS. 285–7; texts in **6,** and part of text of musicians in **4,** ROSELLINI MSS. 284, G 44–5. Translation of text of deceased, and of song, SCHOTT, *Das schöne Fest*, pp. 867 [44], 871 [64].

(11) Deceased with staff 'comes to see Osiris'.
M.M.A. photo. T. 2925.

(12) Two registers, remains of scenes before divinities.
M.M.A. photo. T. 2932.

(j)–(o) Six niches containing [statues], with double-scene on lintel of (o), son offers to deceased and relatives.
Niches (k), (n), (o), M.M.A. photos. T. 2926, 2927 a, b, 2936.

Pillars. CHAMP., *Not. descr.* i, pp. 523 [lower]–524, 848 [to p. 523, l. 17]. Some texts and details, ROSELLINI MSS. 284, G 41 verso–42.

A (a) Two registers, **I,** deceased led by Horus to Osiris, **II,** deceased adores Ḥathor making *nini*. (b) Deceased with staff going forth. (c) Two registers, **I,** deceased before [god] and Ḥathor, **II,** [priest] censes before deceased. (d) Two registers, **I,** deceased adores [Osiris] with ram-standard, **II,** [sailing-boat].
M.M.A. photos. T. 2933–6.

B (a) [1st ed. 8] Two registers, **I,** deceased before Sethos I, **II,** hymn to Sethos I. (b) Two

registers, **I**, deceased before [god], **II**, priest anoints deceased. (*c*) Two registers, **I**, [deceased] adores Osiris and Isis, **II**, priest libates before deceased. (*d*) [1st ed. 9] Two registers, **I**, deceased censes and libates before [Amenophis I and ʿAḥmosi Nefertere], **II**, brother censes and libates before deceased and [mother].

M.M.A. photos. T. 2937-40. Hymn at (*a*), LÜDDECKENS in *Mitt. Kairo*, xi (1943), p. 100 [bottom] (from copy by SETHE); DUEMICHEN, *Hist. Inschr.* ii, pl. xliii [a]; ll. 9-11, BRUGSCH, *Thes.* 1225 [top]; part of line 2, L. *D. Text*, iii, p. 254. (*d*) L. *D.* iii. 132 [o, q], cf. *Text*, iii, p. 254; **I**, CHAMP., *Mon.* clxx [1]; omitting deceased, WILKINSON MSS. ix. 71-2 [upper]; texts in **I**, BURTON MSS. 25644, 77; of deceased, NESTOR L'HÔTE MSS. 20413, 5th carton, D; LEPSIUS MS. 284 [upper].

C (*a*) Two registers, **I**, [deceased] offers to Anubis, **II**, deceased with [wife] censes and libates before Anubis-emblem. (*b*) Two registers, **I**, deceased adores *zad*-headed Osiris with Wepwaut-standard and [Isis], **II**, priest censes and libates before deceased and mother. (*c*) Two registers, **I**, deceased adores Rēʿ-Ḥarakhti and Maʿet, **II**, son Taty ⌐⏋⎮⟨⟨, Head of the stable, censes and libates before deceased. (*d*) [1st ed. 10] Two registers, **I**, [King suckled by Ḥatḥor-cow], **II**, bark of Sokari on shrine.

(*a*), (*b*), (*c*), M.M.A. photos. T. 2941-3. (*d*), L. *D.* iii. 173 [a]; WILKINSON MSS. iii. 33 verso [right]; **I**, HAY MSS. 29822, 82; BURTON MSS. 25638, 68 verso.

D (*a*) [1st ed. 11] Two registers, **I**, deceased adores Osiris and Maʿet, **II**, parents with hymn to Onnophris. (*b*) Remains of two registers, **I**, deceased and mother, **II**, [brother] before [deceased?]. (*c*) Two registers, **I**, [deceased] adores Rēʿ (?), **II**, [text]. (*d*) [1st ed. 12] Deceased with staff leaving tomb, with hymn to Rēʿ above, and text of going forth to Valley Festival below.

M.M.A. photos. T. 2946-50, 2970. Part of Negative Confession at (*a*), **I**, BRUGSCH, *Thes.* 1225 [middle]; ROSELLINI MSS. 284, G 41. Upper part of (*d*), SCHOTT photo. 9047. Translation of Valley Festival text, SCHOTT, *Das schöne Fest*, p. 859 [10]; titles of deceased and parents, L. *D. Text*, iii, p. 254 [bottom].

E (*a*) Two registers, **I**, deceased adores Rēʿ-Ḥarakhti, **II**, deceased and mother adoring. (*b*) Deceased adoring with hymn to Osiris-Onnophris. (*c*) [1st ed. 13] Two registers, **I**, deceased and mother adore Osiris, **II**, [deceased] purified. (*d*) [1st ed. 14] Two registers, **I**, [deceased] adores Monthu with Maʿet, **II**, hymn to Sethos I.

M.M.A. photos. T. 2951-4. (*b*), DUEMICHEN, *Hist. Inschr.* ii, pl. xliii [b]; titles of deceased, LEPSIUS MS. 283 [bottom right]. Part of text of deceased at (*c*), WILKINSON MSS. v. 273 [middle right]. Part of hymn at (*d*), id. ib. xvii. H. 19 [upper left].

F (*b*) Text from Book of the Dead. (*c*) [1st ed. 15] Text from Book of the Dead, and pyramid-tomb with Anubis tending mummy, and *ba*. (*d*) [1st ed. 16] Two registers, **I**, [man] offering to deceased seated, **II**, harpist and song.

M.M.A. photos. T. 2955-9. (*c*), WILKINSON MSS. iii. 33 verso [left]; BURTON MSS. 25638, 69-70, 25644, 79 verso [upper]; omitting text, CAILLIAUD, *Arts et métiers*, pl. 65 [3]; CHAMP., *Mon.* clxx [2]; ROSELLINI, *Mon. Civ.* cxxxiv [2]; LANZONE, *Diz.* pl. lxiii; DAVIES (Nina) in *J.E.A.* xxiv (1938), fig. 9, cf. p. 37; Anubis, mummy, and *ba*, HAMMERTON, *Universal History of the World*, i, fig. on p. 355 [upper]; omitting text, WILKINSON, *M. and C.* Supp. pl. 44 [Pt. 1, 3] = ed. BIRCH, iii, pl. xxxv [3], p. 158; line of text above scene, LEPSIUS MS. 283 [middle right]. (*d*), SCHOTT photos. 3567-8; **II**, LICHTHEIM in *J.N.E.S.* iv (1945), pls. iii, v, pp. 202-4; HICKMANN, *45 Siècles de Musique*, pl. xlviii [A]; harpist, ROSELLINI, *Mon. Civ.* pl. xcv [3]; titles of deceased in **I**, LEPSIUS MS. 283 [middle left].

G (a) [1st ed. 17] Hymn to Ramesses II. (b) [1st ed. 18] Two registers, I, deceased and mother adore Osiris and Isis, II, deceased and [mother] offering. (c) Deceased with staff goes forth 'to see his tomb'. (d) Deceased purifies mummy of father.

M.M.A. photos. T. 2961–4.

H (a) [1st ed. 19] Two registers, I, deceased as priest censes and libates before lion-headed Mertesger in shrine, II, purification-text on behalf of Ramesses II. (b) Deceased embraced by mother. (c) Deceased with staff 'entering Ro-setau'. (d) Deceased censes and libates offerings.

M.M.A. photos. T. 2965–9. Text of Mertesger at (a), L. D. Text, iii, p. 255 [a]; purification-text, SCHIAPARELLI, Funerali, ii, pp. 297–8 [xxv, a]. Text at top of (c), SCHOTT photo. 3570.

Architraves. Line of text on east face, M.M.A. photos. T. 2933, 2937, 2941, 2951, 2961, 2965. Bark of Rēc adored by baboons, on east face between Pillars D and E, M.M.A. photos. T. 2946 [top], 2950–1; BURTON MSS. 25644, 76, 79, 79 verso [lower].

Soffits, including grape-decoration and decoration with name, M.M.A. photos. T. 2944–5, 2960, 2976.

Inner Hall. View, M.M.A. photo. T. 2971.

(13) Outer jambs, text, with deceased seated at bottom.
M.M.A. photo. T. 2931.

Pillars.

L (a) Remains of priest before deceased. (b) Deceased adores [Amen-rēc-Ḥarakhti]. (d) Woman with sistrum and menat.

(b) and (d), M.M.A. photos. T. 2984, 2986.

M (b) Deceased censes and libates before [bark of Sokari].
M.M.A. photo. T. 2985.

Architraves. Line of text on left side of central aisle, M.M.A. photos. on T. 2980–2; on right side, on T. 2983–5.

Ceiling and soffits. Texts, M.M.A. photos. on T. 2972, 2974–5, 2977–9, cf. 2971, 2983, 2985; titles, &c., as decoration on ceiling, id. ib. 29⁻3.

Finds

Brick with titles of deceased, presumably from here, in Florence Mus. 2641. Text, SCHIAPARELLI, Mus. . . . Firenze, pp. 435–6 [1687]; WILKINSON MSS. xvii. D. 10, a; title, LIEBLEIN, Dict. Supp. No. 2090.

107. NEFERSEKHERU ⟨hieroglyphs⟩, Royal scribe, Steward of the estate of Amenophis III 'Rēc is brilliant'. Temp. Amenophis III.

Sh. 'Abd el-Qurna. (CHAMPOLLION, No. 33, L. D. Text, No. 37.)
Parents, Neby ⟨hieroglyphs⟩, Judge, and Ḥepu ⟨hieroglyphs⟩.

Plan, p. 208. Map V, D–4, h, 8.

Portico.

(1) Column with titles on four faces.

M.M.A. photos. T. 2987–90. Texts, HELCK, op. cit. pp. 19–21 with Abb. B; id. *Urk.* iv. 1882–3 [E–H].

(2) [1st ed. 1] Two registers. **I,** Two scenes, **1,** large offering-list with ritual at New Year Festival before deceased, **2,** unfinished, officials before deceased. **II,** Two scenes, **1** and **2,** each with statue of deceased purified by priest with officials, including Meryuyu (or Meryu-meryu) ⟨hieroglyphs⟩, Overseer of works, and names of parents of deceased, in **1.**

M.M.A. photos. T. 2992–7. **II,** WEGNER in *Mitt. Kairo*, iv (1933), pl. xx; incomplete, SCHOTT photos. 1615–22. Offering-list and texts, HELCK, op. cit. in *Mitt. Inst.* pp. 13–19 with Abb. A, cf. pp. 25–6; texts (incomplete), HELCK, *Urk.* iv. 1881–2 [A–D], 1883 [bottom].

(3) Entrance to Passage. Outer lintel, double-scene (left half destroyed), [deceased] kneeling with hymn before Osiris-Onnophris with Anubis-emblem and [goddess], right jamb, hymn to Onnophris.

Lintel, M.M.A. photo. T. 2991; remains of texts, HELCK, op. cit. in *Mitt. Inst.* p. 12.

108. NEBSENY ⟨hieroglyphs⟩, First prophet of Onuris. Temp. Tuthmosis IV (?).

Sh. ʿAbd el-Qurna.

Wife, Sensonb ⟨hieroglyphs⟩.

Plan, p. 220. Maps IV and V, D–4, j, 9.

Hall.

(1) Outer lintel, double-scene, deceased and wife adore Osiris, and adore Anubis.

M.M.A. photo. T. 2999.

(2) Deceased, with wife holding sistrum, offers [on braziers]. Sub-scene, butchers and offering-bringers.

M.M.A. photo. T. 3000. Sistrum, braziers (below offerings), and sub-scene, SCHOTT photos. 3642, 5549, 5553–6; sub-scene, DAVIES (Nina), *Anc. Eg. Paintings*, i, pl. xlix; two offering-bringers, one with pigeons, KEIMER in *Egypt Travel Magazine*, No. 20 (March 1956), p. 29, fig. 13.

(3) [1st ed. 1] Banquet. Son offers bouquet to deceased with grandson, and wife with monkey eating dates under chair. Sub-scene, female guests.

M.M.A. photos. T. 3001–2; SCHOTT photos. 3633, 3635, 3637–40, 5550–2, 5557–9, 8575–7. Guest and attendants, WRESZ., *Atlas*, i. 28 a.

(4) At top, rites before statues (sketched).

BAUD, *Dessins*, fig. 68; M.M.A. photo. T. 3003.

(5) [1st ed. 2] Two registers, banquet. **I,** [Deceased and wife] with [man] with offering-list and offerings before [them], and two rows of guests, male harpist, and female clappers.

II, Men with bouquets (including ⁽ankh-bouquet) and women (sketched) with offerings, before seated couple.

M.M.A. photos. T. 3004–6; incomplete, SCHOTT photos. 5537–46, 8578–80. Middle of **I–II,** WRESZ., *Atlas,* i. 339; middle of **I,** FARINA, *Pittura,* pl. lxxvi; some guests in **I,** MEKHI-TARIAN, *Egyptian Painting,* pls. on pp. 110, 112; harpist, HICKMANN in *Bull. Inst. Ég.* xxxv (1954), fig. 17 (from SCHOTT photo.), cf. p. 324; id. *45 Siècles de Musique,* pl. xlviii [B]; women in **II,** BAUD, *Dessins,* fig. 69.

Finds

Block with head of deceased holding bouquet, in Berlin Mus. 13616. GR. INST. ARCHIVES, photo. 42 A. See *Ausf. Verz.* p. 156.

Two model wooden vases, painted to imitate stone, from Meux and Hearst Collections, in New York, M.M.A. 41.2.3–4. LANSING in *M.M.A. Bull.* xxxvi (1941), pp. 140–1 with fig. Texts, BUDGE, *Some Account of the Collection of Egyptian Antiquities in the possession of Lady Meux* (1896), p. 83 [18, 19]. See *Sotheby Sale Cat.* (Hearst Collection), July 11–12, 1939, No. 78.

109. MIN 🐦, Mayor of Thinis, Overseer of prophets of Onuris. Temp. Tuth-mosis III.

Sh. 'Abd el-Qurna. (CHAMPOLLION, No. 34.)
Mother, Say 𓅓𓏏𓏏𓅓 .

Plan, p. 220. Map V, D–4, i, 8.

VIREY, *Le Tombeau de Khem* [&c.] in *Sept Tombeaux thébains* (*Mém. Miss.* v, 2), pp. 362–70, with plan, p. 363, and in *Rec. de Trav.* ix (1887), pp. 27–32, with plan, p. 28; CHAMP., *Not. descr.* i, p. 525; BURTON MSS. 25639, 42 ('Bab Ezzhairy'). Titles of deceased and name of son, ROSELLINI MSS. 284, G 47.

Court.

(1) Stela, remains of double-scene, deceased and mother before a divinity, with offering-scene before deceased and mother (?) below.

Hall.

(2) [part, 1st ed. 1] Thicknesses, deceased leaving tomb, with text on left thickness.
Text, VIREY in *Mém. Miss.* v [2], pp. 364–5 [AB], and in *Rec. de Trav.* ix, p. 28.

(3) [1st ed. 2, 3] Deceased, with three rows of relatives, offering on braziers on behalf of Tuthmosis III [at temple], is met by three registers of temple-musicians, **I,** girls with fly-whisks, **II,** male singers, **III,** girls with sistra. Sub-scene, three butchers.
SCHOTT photos. 5576–9, 5581, 5764, 5766 [left], 8581–4. Musicians, VIREY in *Mém. Miss.* v [2], fig. 1; LÜDDECKENS in *Mitt. Kairo,* xi (1943), Abb. 17 (probably from VIREY), cf. p. 48. Texts, VIREY in *Mém. Miss.* v [2], pp. 365–6 [BC], and in *Rec. de Trav.* ix, p. 29; SETHE, *Urk.* iv. 977–99 (282) B, C; Opening the Mouth text from speech of deceased, SCHIAPARELLI, *Funerali,* ii, p. 295 [xix]; texts in **I** and **II,** GOLENISHCHEV MSS. 14 [c]; texts of son Senty 𓏏𓏏𓏏, called Iuty 𓏏𓏏𓏏, in 2nd row, LEPSIUS MS. 294 [bottom], No. 22; part, GOLENI-SHCHEV MSS. 14 [d].

(4) [1st ed. 4] Two registers. **I,** [Deceased] inspects building [of sacred bark]. **II,** Son Sebkmosi offers flowers to deceased and mother inspecting garden.
VIREY in *Mém. Miss.* v [2], pp. 366–7, with figs. 2 and 3 (boat-building and garden);

SCHOTT photos. 5765–7, 5582, 8585; BURTON MSS. 25638, 72–3, 25639, 42. Texts, VIREY in *Rec. de Trav.* ix, p. 30 [top]; SETHE, *Urk.* iv. 979–80 (282) D, F.

(5) [1st ed. 5, 6] Four registers. **I–III,** Deceased inspects counting of produce. **IV,** Two scenes, **1,** [deceased] teaching Prince Amenḥotp to shoot, **2,** Prince on lap of deceased.

SCHOTT photos. 5768–9. **IV, 1,** WILKINSON, *M. and C.* ii. 188 (No. 155 [left]) = ed. BIRCH, i. 406 (No. 176 [left]); WILKINSON MSS. ii. 14 verso [lower left]; CAILLIAUD, *Arts et métiers,* pl. 38 [2]; *Descr. de l'Égypte, Ant.* ii, pl. 45 [2]; DAVIES in *M.M.A. Bull.* Pt. ii, Nov. 1935, fig. 7, cf. p. 52. **IV, 2,** VIREY in *Mém. Miss.* v [2], fig. 4, cf. p. 368. Texts, id. ib. pp. 367 [bottom]–368, and in *Rec. de Trav.* ix, p. 30; SETHE, *Urk.* iv. 976–7 (282) A, 981 (283) a–d.

(6) and (7) Remains of two statues at (6), and of stela with long text at (7). See VIREY in *Mém. Miss.* v [2], p. 368 [CD], and in *Rec. de Trav.* ix, p. 30.

(8) [1st ed. 7] Deceased 'visits tomb'.
Text, VIREY in *Mém. Miss.* v [2], p. 369 [DE], and in *Rec. de Trav.* ix, pp. 30–1; SETHE, *Urk.* iv. 979–80 (282) E.

(9) [1st ed. 9] Deceased and mother with son Sebkmosi offering to them, and five registers, **I–IV,** guests and musicians (including girl-lutist, dancer, and flutist in **I,** girl-clappers and male harpist in **II,** and man with shoulder-harp in **III**), **V,** men bringing provisions, and butchers.

SCHOTT photos. 5580, 5584–8, 8586–94. Text, VIREY in *Mém. Miss.* v [2], pp. 369–70 [LM], and in *Rec. de Trav.* ix, pp. 31–2; titles of deceased, SETHE, *Urk.* iv. 982 (283) f.

(10) [Deceased offers on braziers (?).]

(11) [1st ed. 10] [Deceased fowling and fishing with mother (named) and family.]
Text, id. ib. 980 (282) G.

(12) Two rows of offering-bringers. (13) Sub-scene, bringing marsh-produce, including crane.

West Chapel.

(14) [1st ed. 8] Outer lintel, remains of double-scene, deceased with table of offerings before two divinities, and left jamb, offering-text. Left thickness, deceased with text.
Part of text on jamb, VIREY in *Mém. Miss.* v [2], p. 369 [EHIL], and in *Rec. de Trav.* ix, p. 31; title, SETHE, *Urk.* iv. 981 (283) e.

(15) Remains of four statues. See VIREY in *Mém. Miss.* v [2], p. 369.

East Chapel.

(16) Lectors in [procession]. (17) Remains of deceased on foot hunting animals in desert, including hyena.

110. DḤOUT 𓏏, Royal butler, Royal herald. Temp. Ḥatshepsut to Tuthmosis III.
Sh. 'Abd el-Qurna.
Parents, Pesediri (?) and Keku. Wife, Bakt.
Plan, p. 220. Maps IV and V, D–4, j, 8.
DAVIES in *Studies presented to F. Ll. Griffith,* pp. 279–90, with plan, pl. 38 [a].

Hall.

(1) Deceased inspects four registers, **I–IV**, preparation of wine.
M.M.A. photo. T. 3424. Text above deceased, Davies, pl. 44 [B], pp. 285-6.

(2) Stela with hymn to Amen-rēʿ-Ḥarakhti, &c. (part duplicated in tomb 164 (5)).
Davies, pls. 37, 38 [c], 40, pp. 288-9; M.M.A. photo. T. 2002; Schott photo. 4354.
Text, Hermann, *Stelen*, pp. 31*-32* (from Davies); part, Davies and Gardiner, *The Tomb of Amenemhēt*, p. 56.

(3) False door, with offering-formula and offering-bringers on left.
False door, Davies, pl. 42, pp. 282, 283; M.M.A. photo. T. 3427.

(4) [Deceased offers bouquet of Amūn to Tuthmosis III.]
Text of deceased, Davies, pl. 43 [c], pp. 282-3.

(5) Deceased offers on braziers. Sub-scene, offering-bringer and altar (continued from (6)).
Main scene, Davies, pl. 43 [B], p. 284.

(6) Four registers. **I–III,** Guests before two men and a woman. **IV,** Offering-bringers before deceased and wife. Sub-scene, offering-bringers (continued at (5)).
I and **II,** M.M.A. photos. T. 3422-3. Texts, Davies, pls. 43 [E], 44 [E], pp. 284-5.

(7) Stela, offering-texts, and autobiographical texts. At sides, four registers of offering-bringers on right, and text on left.
Stela, Davies, pls. 36, 38 [B], 39; pp. 286-8; M.M.A. photo. T. 2003; Schott photo. 4353; text, Hermann, *Stelen*, pp. 33*-35* (from Davies).

(8) Text, and two registers, **I,** man before Osiris, **II,** offering-bringers.

(9) Deceased, with three registers of offering-bringers, offers bouquets to [Ḥatshepsut] in kiosk.
M.M.A. photos. T. 2004, 3425; omitting offering-bringers, Davies, pls. 35, 41, 44 [A]; Schott photo. 4355.

Passage.

(10) Outer lintel, text of Tuthmosis III, and jambs, texts.
Davies, pls. 43 [A], 44 [c], pp. 283-4; M.M.A. photo. T. 3426.

(11) Four registers, **I–IV,** funeral procession (including rites in garden in **III**), and deceased offering to Osiris.
Remains of text, Davies, pl. 43 [D], p. 290.

(12) Deceased inspects offering-bringers and procession with musicians, including drummer and lutist.
Remains of text, Davies, pl. 44 [D], pp. 289-90.

(13) Entrance to Inner Room. Outer lintel, remains of text.
Davies, pl. 44 [F], p. 290.

III. AMENWAḤSU 〔▭⦔〕, Scribe of divine writings in the estate of Amūn. Temp. Ramesses II.

Sh. ʿAbd el-Qurna.

Parents, Simut ⦔, Head of outline-draughtsmen, and Wiay ⦔. Wife, Iuy ⦔, Songstress of Bubastis.

Plan, p. 220. Map VI, E–4, i, 2.

To be published by WILD and DE MEULENAERE.

Hall.

(1) Left thickness, two registers, **I,** deceased and wife adoring, with hymn to Rēʿ, **II,** [man (?)] offers to deceased and wife. Right thickness, deceased adoring with wife and daughter.

(2)–(8) Two registers, I and **II,** Book of Gates. **I,** Scenes. **II,** Scenes, including Negative Confession with assessors at (2), deceased with family offers to parents at (3), weighing before Ogdoad and presentation scene at (4), and Fields of Iaru at (6).

Deceased (holding statuette of Maʿet on hand), wife, and daughter at (2), and presentation scene at (4), PILLET, *Thèbes. Palais et nécropoles*, figs. 103, 99. Deceased with text at (2), scene at (3), and head of wife at (7)–(8), SCHOTT photos. 8122–5.

(9) Entrance to Inner Room. Left thickness, deceased and wife purified by priest. Right thickness, deceased and wife.

Ceiling. Text.

112. MENKHEPERRAʿSONB (see tomb 86), temp. Tuthmosis III. Usurped by ʿASHEFYTEMWĒSET 〔⦔〕, Prophet of Amūn 'Great of Majesty', Rames-side.

Sh. ʿAbd el-Qurna. (CHAMPOLLION, No. 59.)

Father (of ʿAshefytemwēset), Pentawēr ⦔. Wife of (ʿAshefytemwēset), Mutemwia ⦔.

Plan, p. 220. Maps IV and V, D–4, j, 8.

DAVIES, *The Tombs of Menkheperrasonb, Amenmosĕ and another*, pp. 18–26, with plan and section, pl. xxii; CHAMP., *Not. descr.* i, pp. 557–8 with A–D.

Hall.

(1) Outer doorway.
Fragments, one with name of ʿAshefytemwēset, DAVIES, pl. xix [D, E, H, J], p. 19.

(2) [1st ed. 1] Menkheperraʿsonb offers on braziers with offerings and braziers.
DAVIES, pls. xxiii, xxiv [extreme left], p. 21; M.M.A. photos. T. 1666–7. Titles (behind deceased), SETHE, *Urk.* iv. 926 (273) b.

(3) [1st ed. 2] Two registers. **I,** Man, with women holding sistra and *menat*s, and offering-bringers, offers bouquet of Amūn to Menkheperraʿsonb and mother with goose under chair. **II,** Priest, with seated women, before Menkheperraʿsonb and mother with monkey under chair, and maternal grandparents.

DAVIES, pl. xxiv, p. 21; M.M.A. photos. T. 1668–9. Text with name of Temple of Tuth-mosis III in I, SETHE, *Urk.* iv. 935 (274) F 3.

(4) Menkheperra'sonb and mother adore Osiris.
DAVIES, pl. xxv, p. 22; M.M.A. photos. T. 1670–1.

(5) Three registers, I–III, banquet before Menkheperra'sonb and mother. I, Priest pre-ceded by butchers, offering-list, and kneeling offering-bringers. II–III, Female guests, female clappers, and male harpist. Sub-scene, butchers and preparation of food and drink, and Menkheperra'sonb offering to maternal grandparents.
DAVIES, pls. xxvi, xxvii, xxxi, p. 22. Omitting right end, M.M.A. photos. T. 1672–4.

(6) [1st ed. 3] Three registers. I–II, Offering-list and ritual with priests and offering-bringers before Menkheperra'sonb and mother. III, Priests with ointment and tapers in Epagomenal Days Festival, and butchers, before couple, (with text usurped by 'Ashefytem-wēset). Sub-scene, funeral procession (continued at (7)).
DAVIES, pls. xxviii–xxix, pp. 22–4, with p. 24, note 1; M.M.A. photos. T. 1663–5.

(7) Two registers. I, 'Ashefytemwēset offering to palanquin, and to royal statue in palan-quin, offerings, and Termuthis as serpent. II, Funeral banquet. Sub-scene, funeral proces-sion (continued from (6)) to two mummies held by goddess.
Names of 'Ashefytemwēset and Termuthis, DAVIES, pl. xix [F, G], p. 26.

Passage.
(8) Four registers, I–IV, funeral procession to Western goddess (with scene of 'Ashefytem-wēset and family adoring divinities superimposed on left part). I, Abydos pilgrimage, and sarcophagus dragged. II, Vases and statues carried, shrine dragged, &c. III, Ritual scenes with dancers, and boats with mourners, &c. IV, Ritual scenes with buildings and rites in garden.
See DAVIES, p. 24.

(9) Priest before Menkheperra'sonb and mother.
Remains of offering-text, DAVIES, pl. xix [c], p. 24.

(10) Remains of three registers, I–III, probably Ramesside. I, Gazelle and bull (?). II, Priests and funeral outfit. III, Making funeral outfit, including false door.
III, DAVIES, pl. xxx [F], p. 25; left part, M.M.A. photo. T. 1675.

Inner Room.
(11) Niche. Ramesside graffito above and beside it, DAVIES, pp. 25–6 (from copy by GAR-DINER).

113. KYNEBU ⌐⟨⟨⥮⌐⎍⌐, *warb*-priest over-the-secrets of the estate of Amūn, Prophet in the Temple of Tuthmosis IV. Temp. Ramesses VIII.
Sh. 'Abd el-Qurna. (WILKINSON, No. 2, HAY, No. 10.)
Father, Bekenamūn ⥮⌐⟨⌐, *warb*-priest of Amūn. Wife, Ēsi ⌐⌐.
Plan, p. 220. Map V, D–4, i, 9.
WILKINSON, *Topography of Thebes*, pp. 140–1; HAY MSS. 29824, 53 verso–55.

Hall. Destroyed.

(1) [1st ed. 1] Two rows of female guests at banquet, deceased offering to Osiris with dressed *zad*-pillar, and three girls with sistra and branches.

HAY MSS. 29822, 118 verso–120, 29851, 308–10, 313–14, 317–18. Titles of brother Raʿmosi and of Mennûfer behind deceased, WILKINSON MSS. xvii. H. 19 verso [bottom].

(2) [1st ed. 2] Deceased before Amenophis I, ʿAḥmosi Nefertere, Osiris, and dressed *zad*-pillar.

HAY MSS. 29822, 116, 117, 131, 29851, 315–16, 319–21. King, Queen, and Osiris, in Brit. Mus. 37993–5, *Wall Decorations of Egyptian Tombs*, pl. 8; see *Guide to the Third and Fourth Egyptian Rooms* (1904), p. 37 [2–4]; King, VON BISSING, *Denkmäler ägyptischer Sculptur*, pl. 97; Queen, HAMMERTON, *Universal History of the World*, i, fig. on p. 706 [lower right]; Queen, and Osiris, LHOTE and HASSIA, *Chefs-d'œuvre*, pls. 113, 145.

(3) [1st ed. 3] Three registers, I–III, funeral procession. I–II, Men dragging shrine on boat, female mourners, servants with food in booths, women with papyrus, &c. III, Men with branches, two priests with ritual instruments, and offerings, before mummies with mourners, and stela in front of pyramid-tomb.

I–II, HAY MSS. 29822, 129–30, 132–4; group of female mourners, servant in booth, and four women below, WERBROUCK, *Pleureuses*, fig. 28 (from HAY), cf. pp. 48–9. III, WILKINSON, *M. and C.* 2 Ser. Supp. pl. 86 = ed. BIRCH, iii, pl. lxix facing p. 451; scene before mummies, WILKINSON MSS. v. 125 [right]. Text with date, year 1 of Ramesses VIII, id. ib. 124 [middle]; HAY MSS. 29824, 54, 54 verso.

(4) [1st ed. 8] Three registers, funeral procession. I–II, Bringing funeral outfit, including priest censing before priests with shrine and ram-headed vases. III, Three scenes, 1, son offers onions and candles to brother (of deceased) Ḥori 𓄿𓏤, called Karo 𓆄𓂋, and wife, 2, two men drinking from siphons, 3, brother, followed by female musicians (including lyre and double-pipe) and Nubian dancer with branches, and male harpist and singer, offers to deceased and wife.

HAY MSS. 29822, 121–5, 127–8, 29824, 55 [lower], 29851, 302–7. III, 1, 2, and musicians in 3, WILKINSON, *M. and C.* ii. 237 (No. 190), 291 (No. 218), iii. 341 (No. 394), 2 Ser. i. 234, ii. 382 (No. 491) = ed. BIRCH, i. 441 (No. 215), 477 (No. 243), ii. 314 (No. 433), 515 (No. 495); WILKINSON MSS. v. 123 [upper], 124 [upper]; Nubian dancer, and girl with lyre, SACHS, *Musikinstrumente*, Abb. 53 (from HAY), cf. p. 48; harp, HAY MSS. 29853, 102. Priest censing, WILKINSON MSS. v. 123 [lower]. Cartouches of Ramesses VIII on shrines, probably here, id. ib. xvii. H, on 19 verso.

(5) [1st ed. 7] Deceased with wife libates to Ptaḥ-Sokari.
HAY MSS. 29848, 79, 29851, 311–12 (probably here).

(6) [1st ed. 4–6] Entrance to Passage. Above outer doorway, offering-scene. At sides, floral columns and dressed *zad*-pillars.
HAY MSS. 29822, 113–15, 126. One *zad*-pillar, WILKINSON MSS. v. 125 [left].

114. **Head of goldworkers of the estate of Amūn. Dyn. XX.**

Sh. ʿAbd el-Qurna.

Father, a *waʿb*-priest of Anubis.

Map V, D–4, c, 10.

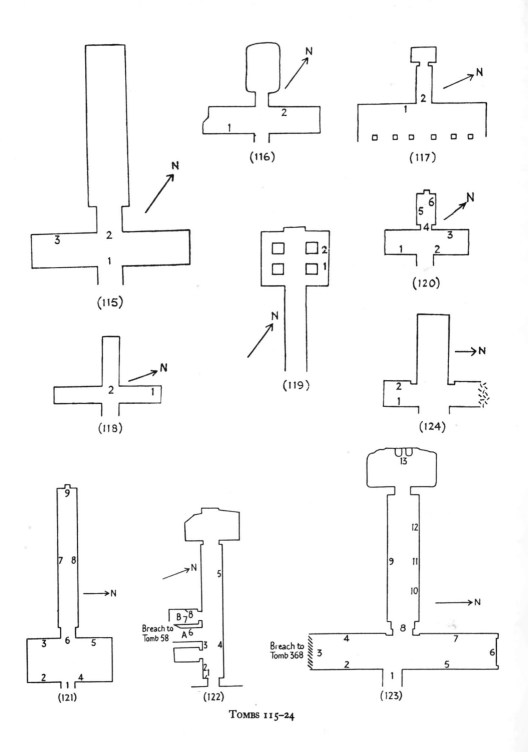

TOMBS 115–24

Entrance.

Left thickness, [deceased and wife].

115. No texts. Dyn. XIX.

 Sh. 'Abd el-Qurna.

 Plan, p. 232. Map V, D–4, c, 10.

Hall.

 (1) and (2) Lintels, each with double-scene, deceased kneeling adores Anubis-jackal.

 (3) Sketch, deceased and wife before Rēꜥ-Ḥarakhti with Maꜥet and Ḥathor in kiosk with lotus-columns, and personified *zad*-pillar beyond.

 BAUD, *Dessins*, pl. xxiv, pp. 157–8.

 Ceiling. Deceased adores bark of Rēꜥ.

116. Hereditary prince. Temp. Tuthmosis IV to Amenophis III (?).

 Sh. 'Abd el-Qurna. (CHAMPOLLION, No. 10, L. *D. Text*, No. 64.)

 Plan, p. 232. Map V, D–4, c, 10.

Hall.

 (1) Two registers. **I,** Deceased and wife with daughter offering to them, and female guests. **II,** Offering-bringers.

 Texts in **I,** HELCK, *Urk.* iv. 1602 (527).

 (2) [1st ed. 1] [Deceased], and wife (?) with flowers, before Tuthmosis IV (name changed to Amenophis).

 See CHAMP., *Not. descr.* i, p. 503; L. *D. Text*, iii, p. 273 with a.

117. Tomb, Dyn. XI, used by ZEMUTEFꜥANKH ⌑, Outline-draughtsman of the House of Gold, fashioning the gods of the estate of Amūn. Dyn. XXI–XXII.

 Sh. 'Abd el-Qurna.

 Plan, p. 232. Map V, D–4, c, 9.

Portico.

 (1) Painted stela, Dyn. XI, with later scene, grandson Amenemōpet, Scribe of Amūn, as priest, offers ointment to two mummies held by Western goddess.

 (2) Entrance to Passage. Left thickness, [son's wife], right thickness, [grandson's wife], each with genealogy.

118. AMENMOSI ⌑, Fan-bearer on the right of the King. Temp. Amenophis III (?).

 Sh. 'Abd el-Qurna.

 Plan, p. 232. Map V, D–4, d, 9.

Hall.

(1) Sketch, Asiatics with tribute, including ivory and a bear. (2) Entrance to Inner Room, outer lintel, double-scene, [deceased] before Osiris.

Ceiling near (2), remains of text with name of deceased.

119. Name lost. Temp. Ḥatshepsut to Tuthmosis III.

 Sh. ʿAbd el-Qurna.

Plan, p. 232. Map V, D–4, f, 9.

Hall.

(1) [1st ed. 2] Syrians and Keftiu bringing products, including oryx, humped bull, and metal ingots.

WRESZ., *Atlas*, i. 340; MEYER, *Fremdvölker*, 592–3; SCHARFF in *Jahrbuch für Kleinasiatische Forschung*, ii (1951), pl. iv (from WRESZINSKI), pp. 102–3; Syrian with vase and bar of ebony (?), WILKINSON MSS. v. 88 [top left].

(2) [1st ed. 1] Syrian vases and metal ingots.
MEYER, op. cit. 619.

120. ʿANEN ☐☰,[1] Second prophet of Amūn. Temp. Amenophis III.

 Sh. ʿAbd el-Qurna.

 Parents, Yuia and Thuiu (tomb 46 in the Valley of the Kings).

Plan, p. 232. Map V, D–4, e, 7.

DAVIES in *M.M.A. Bull.* Pt. ii, Nov. 1929, pp. 35–46.

Hall.

(1) Heap of grain and Amenophis III celebrating harvest-festival with stela in kiosk, all within granary.
DAVIES, fig. 7, cf. p. 41; omitting heap of grain, M.M.A. photo. T. 1942.

(2) Two women.

(3) Amenophis III (with sphinx slaying foes on side of throne) and Teye (with monkey, cat, and duck, under throne) in kiosk with Nine Bows (including Libyan and Kefti) on base.
DAVIES, figs. 1–6, cf. pp. 35–41; M.M.A. photos. T. 1943–50; SMITH, *Art . . . Anc. Eg.* pl. 107 [B]. Monkey, cat, and duck, PHILLIPS, *Ancient Egyptian Animals* (1948), fig. 25. Kefti portrayed as Hittite, VERCOUTTER, *L'Égypte* [&c.], pls. xii [116], xxvi [190], xxxiv [230], pp. 226–7, 287, 293.

Inner Room.

(4) Right thickness, deceased seated. (5) Remains of Fields of Iaru and large offering-list with ritual before [deceased and wife]. (6) Three registers, **I–III,** remains of funeral procession with rites in garden, and scenes from Book of Gates, including assessors, and deceased led by Anubis to Osiris with Western goddess and Anubis.

[1] Called MAḤU ☐☰ in GARDINER and WEIGALL, *Cat.*

121. ʿAḤMOSI 𓊝, First lector of Amūn. Temp. Tuthmosis III (?).

Sh. ʿAbd el-Qurna.

Plan, p. 232. Map V, D–4, e, 7.

Hall.

(1) Left thickness, deceased and two women. (2) Remains of four registers, bringing birds and animals, I–II, ducks, &c., III, agriculture, IV, recording [cattle].

(3)–(5) Fragments, two men kneeling with offering-list below at (3), chair at (4), and offerings before [deceased] and women squatting at (5).

Inner Room.

(6) Outer lintel, text.

(7) Barge of Tuthmosis III, with winged goddesses on side.
SCHOTT photos. 8492–4.

(8) At top, text with hymn to Ptaḥ-Sokari. Remains of four registers, I–IV, funeral procession, including funeral outfit with bows, necklaces, royal statuettes, and Horus-standards, 'Nine friends' carrying shrine, ceremonies before mummy, and chariot.

Hymn, and texts of 'Nine friends' and priests, LÜDDECKENS in *Mitt. Kairo*, xi (1943),, pp. 63–8 [23–4], 69–72 [26] (from copy by SETHE); part of hymn, SANDMAN HOLMBERG, *The God Ptah*, pp. 16* [65], 25* [118], cf. pp. 49, 99 (from copy by SETHE).

(9) Niche. Left side-wall, offering-list.

Finds

Fragments of red granite stela of deceased. M.M.A. photo. M.16.C. 81.

122.[1] [AMEN]ḤOTP, with Chapels of AMENEMḤĒT 𓇋𓈖𓇳𓀭, both Overseers of the magazine of Amūn. Temp. Tuthmosis III.

Sh. ʿAbd el-Qurna.

Parents (of [Amen]ḥotp), ʿAmethu (tomb 83) and Taʿamethu. Father (of Amenemḥēt), Neferḥōtep,[1] Prophet. Wife (of Amenemḥēt), Esnub 𓊪𓏏𓏏.

Plan, p. 232. Map V, D–4, f, 9.

Passage. Amenḥotp.

(1), (2), and (3) Remains of text. (4) Offering-bringers before woman and child.

(5) Two registers, banquet. I, Deceased, followed by son Merymaʿet, Second prophet of Amūn, and brother ʿAkheperkareʿ, Prophet of Monthu, with list of divinities, and two rows of guests, offers to brother [User] (tomb 61) and wife (with monkey under chair). II, [Deceased] offers to parents.

Chapel A. Amenemḥēt.

(6) Two registers. I, Women with incense and cloth before deceased. II, Man offers to deceased and wife.

[1] Tomb attributed to Neferḥōtep in GARDINER and WEIGALL, *Cat.*

Chapel B. Amenemḥēt.

(7) Two scenes, funeral ceremonies. **1**, Rites before mummies, and butchers below. **2**, Priest purifying deceased with wife, and similar scene below.

(8) Four registers. **I–IV**, Funeral procession, including *teknu* in **II**, rites in garden and mummers in **III**, and victim in **IV**.

123. AMENEMḤĒT ⟮🖐︎⟯⟵🖐︎, Scribe, Overseer of the granary, Counter of bread. Temp. Tuthmosis III.

Sh. ʿAbd el-Qurna. (*L. D. Text*, No. 84.)
Wife, Ḥenu(t)iri 𓎛𓏌𓇌.

Plan, p. 232. Map VI, E–4, g, 3.

SÄVE-SÖDERBERGH in *Private Tombs at Thebes*, ii, in the Press. Titles, SETHE, *Urk.* iv. 1026 (307) A, a at (10), b–d at (4), e at (12), f and g at (8). Name of wife at (12), *L. D. Text*, iii, p. 286.

Hall. Views, M.M.A. photos. T. 2726–7.

(1) Outer jambs, offering-texts and deceased seated at bottom. Thicknesses, deceased adoring with hymns to Rēʿ-Ḥarakhti on right, and to Rēʿ on left.
M.M.A. photos. T. 2728–9.

(2) Remains of scene at top, men before Tuthmosis III in kiosk.

(3) Remains of stela, with text including cartouche of Tuthmosis III.
M.M.A. photos. T. 2725–6.

(4) [1st ed. 1] Three registers. **I–III**, Priests performing offering-list ritual and large list before deceased with added text from Book of the Dead in front of him.
M.M.A. photos. T. 2722–4. Part of **II–III**, and deceased, CHIC. OR. INST. photos. 6478–82.

(5) Deceased and family inspect three registers, **I–III**, bringing fowl, fish, and cattle, including bulls with decorated horns (?) in **II**.
M.M.A. photos. T. 2730–2, 1985–6. **II–III** (incomplete), CHIC. OR. INST. photos. 6483–4. Man with bull in **II** and three offering-bringers in **III**, SCHOTT photos. 8207–8.

(6) Remains of stela, with text.
M.M.A. photo. T. 2733.

(7) Three scenes, deceased, **1**, [fishing] and fowling, **2**, spearing hippopotamus, **3**, with wife, receiving produce of marsh-lands. Sub-scene, bringing, cleaning, and netting, fish, and [net with fowl].
M.M.A. photos. T. 2718–20. Netting fish, SCHOTT photos. 7529–31.

Passage.

(8) [1st ed. 2] Outer lintel and left jamb, remains of texts.
M.M.A. photo. T. 2721.

(9) Three registers. **I–III**, Funeral procession with Abydos pilgrimage.

M.M.A. photos. T. 2713-17. Sailing-boat and rowing-boat in **I** and **II**, Schott photos. 8209-10; sailing-boat, sarcophagus dragged, man with column, &c., Chic. Or. Inst. photos. 6485-7.

(10) [1st ed. 4] Deceased in chariot with attendants hunting in desert. Sub-scene, bringing game.

M.M.A. photos. T. 1987-9, 1993, 1998; Chic. Or. Inst. photos. 6488-9. Animals in desert, Schott photos. 7532-4; three ostriches, Bankes MSS. ii. A. 14. Texts, Sethe, *Urk.* iv. 1026 (307) b.

(11) Three registers. **I,** Left half unfinished, right half, deceased inspects bulls (two fighting). **II,** Bringing fowl (including crane), fish, and flowers. **III,** Three rows of herdsmen bringing horses with foals, bulls, goats, donkeys, and pigs.

M.M.A. photos. T. 1990-2, 1994-7. Omitting deceased, Chic. Or. Inst. photos. 6490-3; Schott photos. 4407-14, 8211-13. Right part of **III,** Davies in *M.M.A. Bull.* Pt. ii, March 1932, fig. 8, cf. pp. 53-4; upper rows in **III,** Wegner in *Mitt. Kairo,* iv (1933), pl. v [c].

(12) [1st ed. 3] Man with offering-list offers to deceased and wife.
M.M.A. photo. T. 2712.

Inner Room.
(13) Seated statues of deceased and wife.

124. Rē‘y ⸻, Overseer of the magazine of the Lord of the Two Lands, Steward of the good god Tuthmosis I. Temp. Tuthmosis I.

Sh. ‘Abd el-Qurna.
Wife, Taerdais ⸻.

Plan, p. 232. Map VI, E-4, g, 2.

Hall.
(1) Four registers. **I–IV,** Offering-bringers, and priests performing offering-list ritual.
Part of **II–IV,** Schott photo. 8201. Texts of priests, Piehl, *Inscr. hiéro.* 1 Sér. cxxiv [M], cf. p. 101. Fragment of ritual, in Mond Collection, see Mond in *Ann. Serv.* vi (1905), p. 71 [bottom], (plan is of tomb 331).

(2) Two registers. **I,** Woman with mirror under her chair. **II,** [Deceased] and wife seated.

125. Duauneḥeḥ ⸻, First herald, Overseer of the estate of Amūn. Temp. Ḥatshepsut.

Sh. ‘Abd el-Qurna. (Champollion, No. 22, L. D. *Text,* No. 77.)
Mother, Tarunet ⸻.

Plan, p. 238, cf. p. 334. Map VI, E-4, g, 2.

Säve-Söderbergh in *Private Tombs at Thebes,* ii, in the Press. Champ., *Not. descr.* i, pp. 515-16; L. D. *Text,* iii, pp. 281-2. Cartouche of Tuthmosis III (said to be from Passage), Champ., *Not. descr.* i, p. 515 [bottom right]; Sethe, *Urk.* iv. 452 (144) a 3 (from Champollion). Titles of deceased and name of mother, Rosellini MSS. 284, G 31-31 verso; of deceased, Sethe, *Urk.* iv. 453 (144) c, a at (15), b at (5), c at (3).

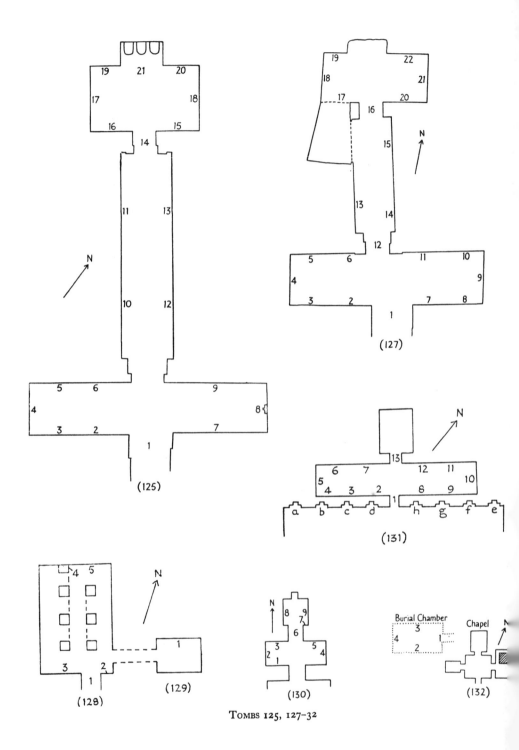

TOMBS 125, 127-32

Court.

For stela and statue, see tomb 263, (1) and (2).

Hall.

(1) Left thickness, deceased pours myrrh on offerings.

M.M.A. photo. T. 3491. Translation of text, SCHOTT, *Das schöne Fest*, p. 863 [26].

(2) [1st ed. 1] Two scenes, deceased and family, **1**, [fishing] and fowling, **2**, spearing hippopotamus.

M.M.A. photos. T. 3492–4. Catfish and turtle in fowling-scene in **1**, SCHOTT photo. 6026. **2**, SÄVE-SÖDERBERGH, *On Egyptian Representations of Hippopotamus Hunting* [&c.] in *Horae Soederblomianae*, iii (1953), pl. i, pp. 6–7; id. *Egyptiska framställningar av flodhästjakt* in *Arkeologiska Forskningar och Fynd* (1952), p. 22, fig. 4; hippopotamus, DAVIES in *M.M.A. Bull.* xxxiv (1939), fig. 6, cf. p. 284; SCHOTT photo. 6025; girl (by legs of deceased), SCHOTT photo. 6024. Heading, CHAMP., *Not. descr.* i, p. 515 [middle left]; SETHE, *Urk.* iv. 453 (144) B 2; text of **2**, ROSELLINI MSS. 284, G 31.

(3) [1st ed. 2] Deceased with family goes forth 'to the country'.

M.M.A. photo. on T. 3493. Titles from text at top of wall, CHAMP., *Not. descr.* i, p. 844 [to p. 515, l. 8].

(4) False door. At sides, three registers of offering-bringers.

M.M.A. photos. T. 3495–6.

(5) [1st ed. 3] Two registers. **I**, Brother, with male guests, offers to deceased and [mother]. **II**, Female guests and offering-bringers before [couple].

M.M.A. photos. T. 3497–8. Titles of deceased, mother, and brother, in **I**, L. *D.* iii. 26 [1, d], cf. *Text*, iii, p. 281; names of mother and brother, CHAMP., *Not. descr.* i, p. 515 [middle].

(6) [1st ed. 4] Deceased, going forth 'to see tomb', inspects five registers, **I–V**, temple-carpenters.

M.M.A. photos. T. 3498–3500. **I** and **II**, WRESZ., *Atlas*, i. 64, 341–2; SCHOTT photos. 6022–3; men polishing column, false door, and text of deceased, in **I**, L. *D.* iii. 26 [1, a]; men with door-frame in **II**, DAVIES in *M.M.A. Bull.* xxxiv (1939), fig. 4, cf. p. 284. Men drilling in **IV**, and making columns in **IV** and **V**, id. ib. figs. 2, 5, cf. p. 284 and note 10. Text, SETHE, *Urk.* iv. 453 (144) B 1.

(7) [Agriculture, inspecting Delta produce, and probably fishing with net.]

Fragment of two registers, ox-cart, and humped cattle ploughing, in New York, M.M.A. 55.92.1, ALDRED in *J.N.E.S.* xv (1956), pp. 150–2 with pl. xvii; HAYES, *Scepter*, ii, fig. 90.

(8) [1st ed. 5] Stela with cartouche of Ḥatshepsut at top, and remains of autobiographical text at bottom.

M.M.A. photos. T. 3502–3; lower part, showing basins *in situ* before it, HERMANN, *Stelen*, pl. 9 [c], pp. 35–6*, cf. p. 76. Autobiographical text, HELCK, *Urk.* iv. 1379–80; cartouche, L. *D.* iii. 26 [2], and *Text*, iii, p. 282; CHAMP., *Not. descr.* i, p. 515 [middle upper]; SETHE, *Urk.* iv. 452 (144) A 2; WILKINSON MSS. v. 121 [top]; HAY MSS. 29816, 145 [left]; ROSELLINI MSS. 284, G 32.

(9) Remains of scene, deceased offers bows and arrows, jewellery, jars, &c., to [Queen ʿAḥmosi].

M.M.A. photos. T. 3501. Gifts, and titles of Queen, DAVIES in *M.M.A. Bull.* xxxiv (1939), figs. 1, 3, cf. pp. 281–2.

Passage.

(10) and (11) Two scenes. 1, Five registers, I–V, funeral procession to Western goddess, including *teknu*, funeral outfit, standards, &c., in I, Abydos pilgrimage in I–II, and two mummers in V. 2, Deceased kneeling adores Osiris.

M.M.A. photos. T. 3504–8. Abydos pilgrimage, SCHOTT photos. 8256–7, 3925, and details in II, III, and V, 6027–8, 3926, 3929–30; lower boat, CHIC. OR. INST. photo. 6495; parts of II and V, id. ib. 6496–7. Fragments, one with *teknu*, one with lector, and one with priest setting up obelisk, probably from here, in Hildesheim Mus. 1877–9, see ROEDER, *Die Denkmäler des Pelizaeus-Museums*, pp. 86–7. Block, three priests, formerly Budapest Mus. 475, now in Uppsala, Victoria Mus. B. 475, MAHLER, *Beöthy Zsolt Egyiptologiai Gyüjteménye*, pp. 59–60 with fig.

(12) Remains of five registers, rites before mummies.
M.M.A. photo. T. 3512.

(13) Two registers. I, Banquet, two rows of guests with harpist and female clappers with song before deceased. II, Statue in shrine dragged, and [man] with offerings before couple (with puppy called Ebony under chair).

M.M.A. photos. T. 3509–11. Upper part of deceased, harpist, and clappers, in I, SCHOTT photos. 8258, 3927–8; harpist, SCHOTT in *Mélanges Maspero*, i, fig. 1, cf. p. 460; HICKMANN, *45 Siècles de Musique*, pl. li [B]; song, SÄVE-SÖDERBERGH in *Mitt. Kairo*, xvi (1958), p. 284. Offerings, and men dragging shrine in II, SCHOTT photos. 8259–60; puppy, DAVIES in *M.M.A. Bull.* xxxiv (1939), fig. 7, cf. p. 284; SMITH, *Art . . . Anc. Eg.* pl. 100 [A].

Inner Room. View, HERMANN, *Stelen*, pl. 1 [b].

(14) [part, 1st ed. 6] Outer lintel, names and titles of Queens ʿAḥmosi and Ḥatshepsut, and left jamb, titles. Left thickness, text. Inner lintel and right jamb, titles and offering-text.

M.M.A. photos. T. 3513–16. Text of outer lintel, L. *D.* iii. 26 [1, b]; royal titles, SETHE, *Urk.* iv. 452 (144) A 1 (from LEPSIUS); titles of ʿAḥmosi, CHAMP., *Not. descr.* i, p. 515 [bottom left]; HAY MSS. 29816, 145 [left].

(15) and (16) Each side of doorway, two registers, I–II, men with ointment-jars.
M.M.A. photos. T. 3516 [left], 3515 [right]; at (15), SCHOTT photo. 8271. Block, first man in I at (16), in Berlin Mus. 24043. Block, next two men in I at (16), in Hanover, Kestner Mus. 1935.200.175, WOLDERING, *Ausgewählte Werke der aegyptischen Sammlung*, pl. 33.

(17) [1st ed. 7] and (18) Side-walls, [man] with offering-list, offerings, and offering-list ritual before [deceased], on each.

M.M.A. photos. T. 3517–18; scene at (18), SCHOTT photos. 8269–70. Titles of deceased at (17), CHAMP., *Not. descr.* i, p. 516 [A]; L. *D.* iii. 26 [1, c].

(19) Three registers, banquet with guests and attendants.
M.M.A. photo. T. 3519; SCHOTT photos. 8261–5, 7630–2.

(20) Deceased on alabaster slab purified and acclaimed by priests.
HERMANN, *Stelen*, pl. 6 [c], and p. 64; M.M.A. photo. T. 3520; SCHOTT photos. 8267-8.

(21) Niche. Statues of deceased and two women, with small painted figures between the statues, and offerings below and on side-walls.
HERMANN, *Stelen*, pl. 1 [b], cf. p. 20; M.M.A. photo. T. 3521 [left]; lower part of right statue, with painted figures of girl and man, SCHOTT photo. 8266.

126. ḤARMOSI 𓎟�娃, Great commander of soldiers of the estate of Amūn. Saite (?).
Sh. ʿAbd el-Qurna. (CHAMPOLLION, No. 23.)

For position, see pp. 106, 208. Map V, D-4, e, 10.

Entrance. Left thickness, deceased with wife, and hymn. Right thickness, deceased adoring.
Name and titles of deceased on right, CHAMP., *Not. descr.* i, p. 516 [B]; ROSELLINI MSS. 284, G 32 verso.

127. SENEMIʿOḤ 𓃭𓎟𓂝, Royal scribe, Overseer of all that grows. Temp. Tuthmosis III (?), usurped in Ramesside times.
Sh. ʿAbd el-Qurna. (L. *D. Text*, No. 76.)
Parents, Wazmosi 𓅱𓎛𓏤𓀀 and ʿAḥmosi. Wives, Sensonb 𓊃𓈖𓏏 and Tetisonb 𓏏𓇋𓏏.

Plan, p. 238. Maps V and VI, E-4, h, 1.

SÄVE-SÖDERBERGH in *Private Tombs at Thebes*, ii, in the Press. BOURIANT in *Rec. de Trav.* xiii (1890), pp. 173-9. View of interior, M.M.A. photo. T. 3166. Titles, SETHE, *Urk.* iv. 513-14 (163), a at (18), b not located, c at (2), d at (15), e at (20), f at (8), g at (7), h at (11), i at (10); LEPSIUS MS. 346 [top right] at (4), [middle upper left] at (5), [middle lower] at (11), [bottom left] at (23), [bottom middle] at (17), [bottom right] at (3). Texts from various scenes, GOLENISHCHEV MSS. 14 [l]. Names, L. *D. Text*, iii, p. 281.

Hall.
(1) Right thickness, deceased adoring.
M.M.A. photo. T. 3167; SCHOTT photos. 8214-15.

(2) [1st ed. 1] Two registers. **I**, Deceased receives produce of Southern and Northern Oases. **II**, Agriculture with ploughing, &c., including plucking flax, (continued at (3)).
M.M.A. photo. T. 3172; CHIC. OR. INST. photo. 3479 [left]. Deceased, and part of **II**, SCHOTT photos. 5452, 5456-7; **II**, WRESZ., *Atlas*, i. 346 [upper].

(3) [1st ed. 2] Two registers. **I**, Two scenes, **1**, son Piay, *waʿb*-priest of Amūn, seated, and offerings, with female clappers and male harpist below, **2**, priest with offering-list offers to deceased and Tetisonb. **II**, Agriculture (continued from (2)).
M.M.A. photos. T. 3173-4. **I**, **2**, and **II**, CHIC. OR. INST. photo. 3479 [right]. Clappers and harpist, SCHOTT photos. 5453-5; harpist, HICKMANN, *45 Siècles de Musique*, pl. xlviii [c]. **II**, WRESZ., *Atlas*, i. 346 [lower]. Name of ʿAt-merert 𓃭𓏏𓈖𓏏𓀀 below chair in **I**, **2**, LEPSIUS MS. 346 [middle upper right].

(4) False door, with deceased and Tetisonb at top. At sides, three registers, **I** and **II**, offering-bringers, **III**, lector.

M.M.A. photos. T. 3175–6.

(5) Two registers. **I**, Deceased and wife facing couple. **II**, Men and woman offering, and priest libating, before deceased and Tetisonb.

M.M.A. photos. T. 3177–8.

(6) Two registers. **I**, Deceased receives produce of Faiyûm. **II**, Girls offer *menat*s to deceased.

M.M.A. photos. T. 3178–9; CHIC. OR. INST. photo. 3473. **II**, and overseer, woman, and priest, in **I**, SCHOTT photos. 5458–63.

(7) [1st ed. 7] Two registers. **I**, Two scenes, **1**, deceased inspects men bringing bulls and bulls fighting, **2**, deceased and mother seated inspect gifts from Nubia. **II**, Preparing and netting fowl (continued at (8)).

M.M.A. photos. T. 3169–71. **II**, WRESZ., *Atlas*, i. 344. Remains of text in **I**, **2**, SETHE, *Urk.* iv. 512 (162) B; names of parents in text of deceased, LEPSIUS MS. 346 [top left].

(8) [1st ed. 6] Two registers. **I**, Offering-bringers before deceased and wife. **II**, Netting fish (continued from (7)).

M.M.A. photo. T. 3168; CHIC. OR. INST. photos. 3477, 3484.

(9) [1st ed. 5] Stela with 'Address to the living' and autobiographical text.

M.M.A. photos. T. 3185–6; CHIC. OR. INST. photo. 3478. Text, SETHE, *Urk.* iv. 494–512 (161); BOURIANT in *Rec. de Trav.* xiii (1890), pp. 174–9; GOLENISHCHEV MSS. 12–13 [a, b].

(10) [1st ed. 4] Deceased and father inspect men bringing cattle and fowl. Sub-scene, bringing geese, cranes, donkeys, and cattle.

M.M.A. photos. T. 3183–4; CHIC. OR. INST. photo. 3475. Upper part of deceased and father, SCHOTT photo. 5473. Sub-scene, WRESZ., *Atlas*, i. 345 [B]. Text in main scene, SETHE, *Urk.* iv. 512 (162) A.

(11) [1st ed. 3] Deceased [with wife] fishing and deceased fowling. Sub-scene, vintage.

WRESZ., *Atlas*, i. 343, 345 [A]; M.M.A. photos. T. 3182–3; CHIC. OR. INST. photo. 3474. Main scenes, SCHOTT photos. 5464–71. Picking grapes in sub-scene, id. ib. 5472. Text of fowling-scene, SETHE, *Urk.* iv. 512 (162) C.

Passage.

(12) Outer lintel, list of festivals, and jambs, text of son Piay. Outer thicknesses, Piay adoring with hymns (to Rēʿ on left). Inner thicknesses, wife of Piay with sistrum or bouquet. Inner jambs, text of Piay.

M.M.A. photos. T. 3180–1, 3187–91.

(13) Three registers, Abydos pilgrimage and funeral procession including *teknu*, dancers, and mummers.

M.M.A. photos. T. 3199–3202; omitting boats in **I**, CHIC. OR. INST. photos. 3476, 3480. Details, SCHOTT photos. 4434–8. Description and texts, LEPSIUS MS. 347 [lower]–350 [middle].

(14) [1st ed. 9] Four registers. **I–IV**, Ritual scenes, including carrying statue to shrine in **I**, rites before mummies in **I–III**, and offerings in **IV** (with priest at right end).

M.M.A. photos. T. 3192–5 [right]. Ritual-texts, SCHIAPARELLI, *Funerali*, ii, pp. 282–5 [iv]; texts of 3rd to 5th mummies in II, LEPSIUS MS. 347 [upper]. Graffito below scenes, M.M.A. photo. T. 3211.

(15) [1st ed. 8] Son Piay offers to deceased and Tetisonb, with female relatives below.
M.M.A. photos. T. 3195–6.

Inner Room.

(16) Outer lintel, double-scene, deceased offers to parents, and brother ʿAḥmosi offers to deceased and Tetisonb, and jambs, offering-texts of son Piay. Thicknesses, men with torches. Block with uraeus, built into threshold.
M.M.A. photos. T. 3197–8, 3203–4. Thicknesses, SCHOTT photos. 4428–30; middle man on left, SCHOTT in *Ä.Z.* lxxiii (1937), pl. iii [a], p. 8.

(17) Titles of deceased at top. (18) [1st ed. 10] Two registers before deceased and Sensonb, I, lector offers incense and libation, II, lector with offerings. (19) Remains of offering-bringers at top.
M.M.A. photos. T. 3206–8.

(20) [1st ed. 11] Deceased going forth 'on earth', and deceased purified by six priests.
M.M.A. photo. T. 3205; CHIC. OR. INST. photo. 3481; SCHOTT photos. 4431–3; deceased purified, SCHOTT in *Nachr. Akad. Göttingen* (1957), No. 3, pl. iv a, p. 85.

(21) Deceased and Tetisonb.
Tetisonb, M.M.A. photo. T. 3210.

(22) Man with offering-list before [deceased] with monkey under chair.
M.M.A. photo. T. 3209.

128. PATHENFY 𝕏⟶, Mayor of Edfu, Mayor of the City. Saite.
 Sh. ʿAbd el-Qurna. (CHAMPOLLION, No. 24.)
 Father, Pedeamūn ▢⌇.
 Plan, p. 238. Maps V and VI, E–4, h, 1.
 CHAMP., *Not. descr.* i, p. 516.

Hall.

(1) Left thickness, deceased with staff leaving tomb.
M.M.A. photo. T. 3050.

(2) and (3) [1st ed. 1] Eleven remaining columns of text on each side.
M.M.A. photos. T. 3051, 3049; titles of deceased at (3), CHAMP., *Not. descr.* i, p. 844 [to p. 516, l. 15]; part, ROSELLINI MSS. 284, G 33.

(4) Pilaster, text. M.M.A. photo. T. 3055 [right].

(5) Two registers. I, Two sons and two daughters before deceased seated with dog under chair. II, Three sons and two daughters before deceased seated.
M.M.A. photos. T. 3056–8. Texts, LEPSIUS MS. 343 [bottom]–345; titles of father, ROSELLINI MSS. 284, G 33.

Architraves, inner faces [left side, 1st ed. 2], offering-formula for deceased. M.M.A. photos. T. 3052–5, 3059–60.

129. Name lost. Temp. Tuthmosis III or IV.

Sh. 'Abd el-Qurna.

Plan, p. 238. Maps V and VI, E–4, h, 1.

Hall.

(1) [1st ed. 1] Two registers, banquet. **I,** Deceased and wife (with monkey eating dates under chair), daughter offering to them, and female musicians (tambourine, lyre, double-pipe, and harp), clapper, and tumbler, with [male harpist] below. **II,** Couple seated (unfinished).

M.M.A. photos. T. 3061–3, 3083–4. **I,** SCHOTT photos. 5030–6, 7634–5, 8254–5; omitting harpist, PRISSE, *L'Art égyptien*, ii, 7th pl. [lower] 'Musiciennes . . .', cf. *Texte*, pp. 396–7; omitting left end, SACHS, *Musikinstrumente*, Abb. 52, cf. p. 47; musicians, WRESZ., *Atlas*, i. 71; HICKMANN, *45 Siècles de Musique*, pl. xlix [B]; woman with lyre, and tumbler, BRUYÈRE, *Rapport (1934–1935)*, Pt. 2, fig. 57, cf. p. 114. Translation of text, SCHOTT, *Das schöne Fest*, p. 886 [116].

130. MAY ⌐𓏤𓏤, Harbour-master in the Southern City. Temp. Tuthmosis III (?).

Sh. 'Abd el-Qurna.

Wife, Tuy 𓎼𓏤𓏤.

Plan, p. 238. Maps V and VI, E–4, j, 1.

SCHEIL, *Le Tombeau de Mâi* in VIREY, *Sept Tombeaux thébains* (*Mém. Miss.* v, 2), pp. 541–53, with plan, p. 541.

Hall.

(1) Deceased, followed by wife and offering-bringers, offers on braziers with offerings, and man below.

Offerings and texts, SCHEIL, pp. 542–3 [a]; man and offerings, and small girl with mirror among offering-bringers, BAUD, *Dessins*, figs. 70–1, pp. 158–60; part, SCHOTT photos. 8079–80.

(2) Stela, double-scene [deceased and wife adore Osiris and adore Anubis]. At left side, three registers, couples offering.

Stela, SCHOTT photo. 3440. Texts, SCHEIL, pp. 543–5 [b]; text on stela, HERMANN, *Stelen*, p. 36* (from SCHEIL), cf. p. 79.

(3) [Two registers. **I,** Two men offer bouquet of Amūn to deceased and wife. **II,** Two scenes, **1** and **2,** deceased and wife seated before offerings, with monkey under wife's chair in **1.**]

Texts, and monkey, SCHEIL, pp. 545–6 [c].

(4) Three registers, rites before mummies (unfinished).

See SCHEIL, p. 547 [e]; SCHIAPARELLI, *Funerali*, ii, p. 296 [xxii].

(5) [Two registers. I, Deceased and wife before Ḥathor-cow. II, Deceased and wife, with girl offering to them, and two rows of guests with female musicians (harpist, flutist, dancer, and clapper).]

Offerings and texts, SCHEIL, pp. 548–9 [d].

Inner Room.

(6) Left thickness, deceased with staff going forth 'to see the sun-disk'. Right thickness, deceased with bouquet and wife entering tomb.

Texts, SCHEIL, pp. 549–50 [A, B].

(7) [Man with libation-vase.]

SCHEIL, fig. on p. 550.

(8) Two registers. I, Deceased and wife adore [Osiris and Ḥathor]. II, Deceased inspects [ship] with Nubian produce.

Texts, and heads of Nubian sailors (now lost), SCHEIL, pp. 550–1 [A'].

(9) Three registers. I, Rites before statues and priest with offering-bringers before deceased and wife with cat under chair. II, Abydos pilgrimage. III, Remains of funeral procession with female mourners.

Texts, cat, and sketch of mourners, SCHEIL, pp. 552–3 [B']; cat, DAVIES (Nina), *Anc. Eg. Paintings*, i, pl. xxvii.

131. AMENUSER or USER. (See tomb 61.) Temp. Tuthmosis III.

Sh. ʿAbd el-Qurna. (L. D. *Text*, No. 87.)

Plan, p. 238. Map V, D–4, g, 10.

To be published by SÄVE-SÖDERBERGH in *Private Tombs at Thebes*. DAVIES in *M.M.A. Bull.* Pt. ii, March 1926, pp. 44–50.

Façade.

(a)–(h) Eight niches with titles of deceased. Id. ib. Dec. 1926, fig. 1, cf. p. 3; M.M.A. photo. T. 1270; sketch, BURTON MSS. 25644, 5; HAY MSS. 29842, 47–8.

Hall.

(1) Outer lintel, double-scene, deceased before cartouches of Tuthmosis III, and jambs, offering-text with deceased seated at bottom. Thicknesses, hymns to Amen-rēʿ, with deceased adoring on right thickness. Inner lintel and jambs, remains of offering-texts.

Outer doorway and upper part of deceased on right thickness, M.M.A. photos. T. 1271, 1274. Right thickness and inner doorway, SCHOTT photos. 8272, 9010. Text of deceased on left of outer lintel, LEPSIUS MS. 343 [top right].

(2) Two registers. I, Man offers to [deceased]. II, Heaps of grain.

(3) Three registers. I–II, Jewellers (?) before deceased with attendants. III, Deceased inspects cattle.

(4) Four registers. I–III, Banquet, with female musicians in I, female clapper in II, and offering-bringers with honey, &c., in III, before [deceased and wife]. IV, Deceased inspects captives and tribute of Wawat.

(5) At top, two women with bouquet before [parents, ʿAmethu (tomb 83) and wife].

(6) Two registers. **I,** Deceased with text of inspecting taxes. **II,** Judgement-hall with tax-payers and scales before scribes.

(7) [1st ed. 1] Four registers, tax-payers. **I,** Two men with animals, and heap of grain. **II,** Gold rings, scales, &c. **III,** Men with produce. **IV,** Text of duties of vizier, and men with gold.

Vizier-text, FARINA, *Le Funzioni del Visir Faraonico* [&c.] in *Rendiconti Lincei*, xxvi (1916), folding-sheet B; comparison with texts in other tombs, DAVIES, *The Tomb of Rekh-mi-rēʿ at Thebes*, ii, pls. cxix–cxxii [w], cf. i, p. 88.

(8) [1st ed. 6] Aged vizier [ʿAmethu] (tomb 83) with chamberlain, courtiers, and deceased as scribe, before Tuthmosis III with *ka* in kiosk, and text of installation as co-vizier.

Vizier, and King with *ka*, DAVIES in *M.M.A. Bull.* Pt. ii, Dec. 1926, figs. 2–3, cf. p. 3, and March 1926, pp. 48–50; M.M.A. photos. T. 1272–3. Installation-text, HELCK, *Die Berufung des Vezirs Wśr* in FIRCHOW, *Ägyptologische Studien* (*Grapow, 70. Geburtstag*), 1955, pp. 108–9, cf. pp. 107, 110; HELCK, *Urk.* iv. 1380–4.

(9) [1st ed. 5] Two registers. **I,** Tuthmosis III carried in procession in palanquin before gate of temple, with fan-bearers and attendants, and preceded by deceased as vizier with officers, and military escort with band (clapper, drummer, and trumpeter), and men with wands. **II,** Men before [ʿAmethu] (tomb 83), and text of 'teaching of ʿAmethu'.

Deceased, King, and attendants, DAVIES in *M.M.A. Bull.* Pt. ii, Dec. 1926, fig. 5, cf. pp. 3–4, and March 1926, p. 50.

(10) Remains of deceased hunting in desert.

Heads of deer, id. ib. March 1932, fig. 7, cf. p. 53.

(11) [1st ed. 4] Deceased receives six registers, **I–VI,** tribute. **I,** Keftiu, with bull's head and statuette of bull. **II** and **III,** Syrians, including woman with a child. **IV–VI,** Men with produce.

Part of **I–III,** id. ib. March 1926, figs. 1, 4–6, cf. pp. 44, 46. **I,** CHIC. OR. INST. photos. 10262–6; Keftiu, VERCOUTTER, *L'Égypte* [&c.], frontispiece [verso, top and middle], pls. ii–v [71–81], xiv–xvi [128–41], xxx–xxxi [201–12], pp. 208–11, 245–9, 290. Vases, including heads of lion, griffin, dog, and bulls, and boukrania-decoration, id. ib. pls. xxxv–lx [233, 244, 259, 264, 270, 310–11, 313, 320, 331–2, 337, 343–4, 346, 349, 368, 376, 392, 442], pp. 307–55; statuette of bull, carried by Kefti in **I,** id. ib. pl. lxi [454], p. 358; foreign objects, including whip, lapis-lazuli (?), and metal ingots, id. ib. pls. lxii–lxv [468, 481–2 (called 477 in error), 501], pp. 360–6.

(12) [1st ed. 3] Remains of installation-text of vizier.

GARDINER in *Rec. de Trav.* xxvi (1904), pp. 1–16 [w]. Comparison with texts in other tombs, DAVIES, *The Tomb of Rekh-mi-rēʿ at Thebes*, ii, pls. cxvi–cxviii; comparison with tomb 100, see SETHE, *Die Einsetzung des Veziers unter der 18. Dynastie* in *Untersuchungen*, v, Pt. 2, p. 64 (from copy by NEWBERRY).

(13) [1st ed. 2] Entrance to Inner Room. Outer lintel, text of Tuthmosis III, and jambs, text.

Titles on left jamb, L. D. *Text*, iii, p. 287; SETHE, *Urk.* iv. 1040 (316) f.

Ceiling. Texts.

Finds

Black granite stela with sons offering to deceased and wife and long text below, probably from here, in Grenoble Mus. 10. TRESSON, *Catalogue descriptif des antiquités égyptiennes de la Salle Saint-Ferriol* (1933), pl. i, pp. 16–21 [2]; MORET in *Revue Égyptologique*, N.S. i (1919), pl. ii [left], pp. 8–14 [iii]; HERMANN, *Stelen*, pl. 4 [d] (from TRESSON), cf. pp. 40, 21, note 49; DEVÉRIA squeezes, 6167. ii. 152. Texts, DURINGE in *Sphinx*, vi (1903), pp. 21–9; long text, and title from top, SETHE, *Urk.* iv. 1030–3 (312), 1041 (316) q.

132. RAʿMOSI ⊙⧨⦙, Great scribe of the King, Overseer of the treasuries of Taharqa. Temp. Taharqa.

Sh. ʿAbd el-Qurna. (L. *D. Text*, No. 83.)
Mother, Thesmeḥitpert ⌐⌐⧎⌐☐⌐⌐ .

Plan, p. 238. Map VI, E–4, f, 5.

L. *D. Text*, iii, pp. 284–5 (with name of mother).

Burial Chamber. View, LECLANT in *Orientalia*, N.S. xxiii (1954), pl. viii [fig. 2], cf. p. 66. Walls and ceiling, Books of the Day and Night.

(1) [1st ed. 4] Tympanum above inner doorway, double-scene, Isis as serpent. Left of doorway, Wepwaut, and Horus raising *zad*-pillar (rest destroyed).
LECLANT, op. cit. on pl. viii [fig. 2].

(2) [1st ed. 1] Two registers. I, Twelve hours of the day. II, Lion-headed guardians with knives, and female demon.
Texts of hours, L. *D. Text*, iii, p. 284 [bottom]; text of eight hours, and text above beheading of Apophis, PIANKOFF in *Ann. Serv.* xli (1942), pp. 151–5, 157 [middle lower].

(3) [1st ed. 3] Two registers. I, Twelve hours of the night. II, Guardians with knives. Sub-scene, divinities in shrines.
Texts of hours, L. *D. Text*, iii, p. 285 [top].

(4) [1st ed. 2] Tympanum, disk between Western and Eastern emblems. Two registers below, I, resurrection of Osiris as mummy on couch between goddesses, II, kneeling guardians with knives, one on each side of stand (for couch). Sub-scene, shrine, with man and seated demon.
Tympanum, see THOMAS in *J.E.A.* xlii (1956), p. 70 [Ci] with note 7. Osiris on couch, L. *D. Text*, iii, p. 284 [middle].

Ceiling. Demons, and divine barks, including bark of Rēʿ drawn by three souls of Nekhen as jackals in right half.
Parts, LECLANT in *Orientalia*, N.S. xxii (1953), pl. xiii [figs. 25–6], p. 88 [e], xxiii (1954), pl. viii [fig. 1], p. 66. Text down centre, and texts of demons, L. *D. Text*, iii, pp. 284 [a], 285 [middle and bottom]. Text of Apophis above bark of Rēʿ, PIANKOFF in *Ann. Serv.* xli (1942), p. 157 [middle upper].

(Cone of deceased with titles, and name of mother, then in possession of Lord Claud Hamilton, WILKINSON MSS. xxi. A. 2.)

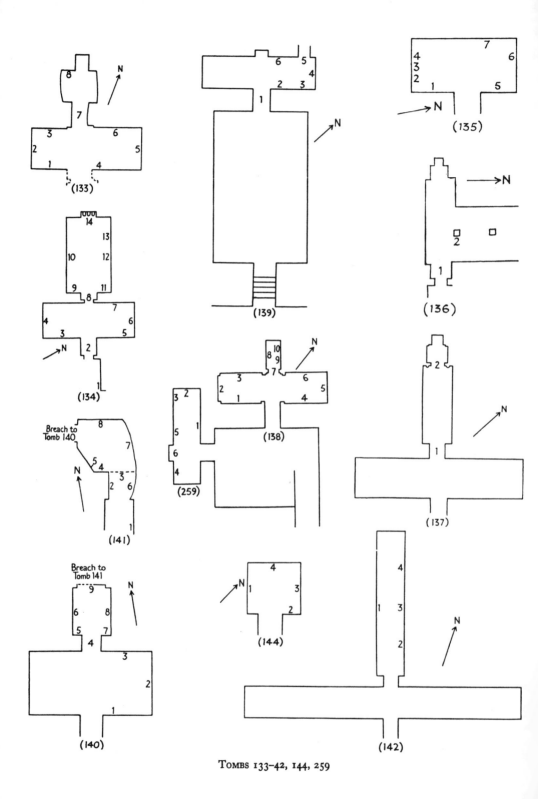

TOMBS 133–42, 144, 259

133. NEFERRONPET ⟨hieroglyphs⟩, Chief of the weavers in the Ramesseum in the estate of Amūn on the west of Thebes. Temp. Ramesses II.

Sh. 'Abd el-Qurna.
Wife, Ḥunuro ⟨hieroglyphs⟩.

Plan, p. 248. Map VI, E–4, f, 4.

DAVIES and GARDINER, *Seven Private Tombs at Ḳurnah*, pp. 49–52, with plan, pl. xxxvi [top left].

Hall.

(1) [1st ed. 1] Four registers. I and II, Remains of women and men bringing material. III, Weaving-shed with door-keeper, women stretching warp, and four looms. IV, Boat with mummy and two tugs in funeral procession.

DAVIES and GARDINER, pp. 49–51. I–III, Id. ib. pl. xxxv [bottom]; women and looms in III, ROTH, *Ancient Egyptian and Greek Looms* (*County Borough of Halifax. Bankfield Museum Notes*, 2nd ser. No. 2), fig. 16 (from drawing by Davies), cf. pp. 17–18.

(2) Book of Gates. Deceased and [wife] adore baboon-headed guardian with gate, and adore Ḥathor-cow in mountain. (3) Two registers, I, deceased and family before Osiris-Onnophris and Ḥathor, II, two women. (4) Remains of deceased offering.

See DAVIES and GARDINER, p. 51.

(5) Tree-goddess double-scene, including *ba* (on hand of deceased) drinking.
Id. ib. pl. xxxv [top], p. 51.

(6) Two registers. I, Deceased and family adore Osiris with Isis and Nephthys. II, Two scenes (right one destroyed), priest offers incense and libation to deceased and wife.
See id. ib. p. 51.

Ceiling. Texts, MOND in *Ann. Serv.* vi (1905), p. 84. See DAVIES and GARDINER, p. 52.

Inner Room.

(7) Outer lintel and jambs, offering-formulae. Thicknesses, remains of deceased and wife adoring, with hymns to Osiris on left and to Rēꜥ on right.
See id. ib. p. 52, and pl. xxxv [middle right] (outer doorway).

(8) [Man] adores Osiris.
See id. ib. p. 49.

134. (1st ed. 135) THAUENANY ⟨hieroglyphs⟩, called ANY ⟨hieroglyphs⟩, Prophet of Amenophis who navigates on the Sea of Amūn. Dyn. XIX.

Sh. 'Abd el-Qurna. (L. *D. Text*, No. 79.)
Father, Besuemōpet ⟨hieroglyphs⟩, same title as deceased. Wife, Tabēsi ⟨hieroglyphs⟩.

Plan, p. 248. Map VI, E–4, g, 2.

L. *D. Text*, iii, p. 282.

Court.

(1) Stela, three registers, I, bark of Amūn drawn by jackals, II, deceased and wife before Rēꜥ-Ḥarakhti, Atum, Osiris, and Ḥathor, III, hymn to Amen-rēꜥ-Ḥarakhti.
M.M.A. photo. T. 3212.

Hall.

(2) Outer jambs with cartouches of Amenophis I on left, and of ʿAḥmosi Nefertere on right. Left thickness, [deceased] adores bark of Rēʿ-Ḥarakhti.

Texts on jambs, L. *D. Text*, iii, p. 282 [bottom] with β.

(3) and (4) Book of Gates with divinities in shrines.

(5) Scene with bark towed towards Temple of Busiris and received by women with sistra. DAVIES (Nina) in *J.E.A.* xli (1955), fig. 4, cf. pp. 80, 82.

(6) and (7) Two registers. **I**, Divinities in shrine. **II**, Remains of woman and man kneeling and man offering at (6), and [deceased and wife before god and goddess] at (7).

Frieze, Ḥatḥor-heads, &c.
Ceiling. Text down centre.

Inner Room.

(8) Outer lintel, double-scene, deceased kneels before divinities. (9) and (10) Book of Gates, kneeling people adore Gates. (11) and (12) Remains of funeral procession with female mourners, man censing before bark, and ceremonies before mummy. (13) At top, double-scene, deceased and son adore Rēʿ-Ḥarakhti and ʿAḥmosi Nefertere, and adore Osiris and [Amenophis I].

(14) Niche with statues of King (or god), Osiris, and Queen (or goddess). Above niche, double-scene, deceased and family adore Rēʿ-Ḥarakhti and Amenophis I, and adore Osiris and ʿAḥmosi Nefertere.

Frieze. Deceased adores Anubis-jackals.
Ceiling. Name and title as decoration, and text down centre.

135. BEKENAMŪN 𓀀 ⸺ 𓊽, *waʿb*-priest in front of Amūn. Dyn. XIX.
Sh. ʿAbd el-Qurna.

Plan, p. 248. Map VI, E–4, g, 2.

Hall.

(1) and (2) Two registers. **I**, Banquet (sketched), and girl with female lutist and Nubian child with castanet before deceased and wife and couple. **II**, Boats and mourning servants (from funeral procession).

Incomplete, SCHOTT photos. 8243–5 [left].

(3) Entablature, double-scene, deceased kneels before a god, with divinities at bottom. (4) Two registers, **I**, tree-goddess scene, **II**, people seated and offerings.

SCHOTT photo. 8245 [middle and right].

(5) Two registers. **I**, Raising *zad*-pillar in presence of Isis, Anubis, Nephthys, Thoth, and gods. **II**, Funeral procession to mummy held by Anubis, stela before pyramid-tomb, and Western goddess in mountain.

I, SCHOTT photo. 8248.

(6) Remains of scene with Neith, bark of Rēʿ (?), and souls of Pe and Nekhen.

(7) Two registers. **I,** Procession with statue of Queen (?) in palanquin, women with sistra, women dancers and tumblers, and deceased offering. **II,** Remains of people offering to bark of Rēꜥ.

I, Schott photos. 6313, 8246, 2487. Women with sistra, dancers, and tumblers, Hay MSS. 29852, 244–5, 29822, 71; tumblers, Davies in *M.M.A. Bull.* Pt. ii, Feb. 1928, fig. 7, cf. pp. 65–6.

Ceiling, right part, four scenes. Front half, **1,** divine bark upheld by goddess, **2,** adoration of Rēꜥ-Ḥarakhti. Rear half, **3,** mummy on couch in shrine between hawks, with double-scene below, Nile-god kneeling before uraeus, **4,** adoration of *zad*-pillar and winged scarab by baboons and souls of Pe and Nekhen, and deceased and wife with *ba*s.

1, 3, and left half of **4,** Schott photos. 2485–6, 8249.

136. Royal scribe . . . of the Lord of the Two Lands. Dyn. XIX.
 Sh. ꜥAbd el-Qurna.
 Plan, p. 248. Map VI, E–4, g, 4.
 Hall.
 (1) Left outer thickness, deceased seated at bottom. Left inner thickness, [deceased] and text, with small scene above, deceased adoring god. Right inner thickness, deceased.

 (2) Statue in front of pillar.

137. Mosi 𓊪, Head of works of the Lord of the Two Lands in every monument of Amūn. Temp. Ramesses II.
 Sh. ꜥAbd el-Qurna. (L. D. *Text*, No. 91.)
 Parents, Bak 𓄿, Head of works in the Place of Eternity, and Tekhu 𓊖. Wife, Taikharu 𓄿.
 Plan, p. 248. Map VI, E–4, g, 4.
 L. D. *Text,* iii, p. 288 [top], (cone giving name of mother).

 Passage.
 (1) Entrance. Left thickness, two registers, **I,** deceased, **II,** deceased and wife in remains of tree-goddess scene.

 (2) Entrance to Inner Room. Outer lintel, man kneeling and cartouche of Ramesses II, right jamb, offering-formula, and deceased at bottom.

138. Nezemger 𓇋𓈖, Overseer of the garden in the Ramesseum ꞏin the estate of Amūn. Temp. Ramesses II.
 Sh. ꜥAbd el-Qurna. (Champollion, No. 29.)
 Wife, Neshaꜥ 𓄿.
 Plan, p. 248. Map VI, E–4, j, 3.
 Champ., *Not. descr.* i, p. 519, with plan; Rosellini MSS. 284, G 38–9; some texts, Wilkinson MSS. v. 148 [1–5], 271 [2–4].

Hall.

(1), (2), (3) Three registers. **I,** Book of Gates vignettes, deceased and wife adore divinities. **II,** Funeral procession, including two boats with mourners, [sarcophagus] dragged, female mourners, servants with food in booths, cow and mutilated calf, and priests before mummy held by female mourners in front of pyramid-tomb in mountain. **III,** Garden of the Ramesseum with shadûfs and temple-pylon, people selling bouquets before deceased and wife, and funeral banquet.

Incomplete, Schott photos. 3081, 5995, 7636–44, 8101–14. Boats with mourners, and mourners in front of tomb, in **II,** Werbrouck, *Pleureuses,* pls. xxvii [left], xxviii, figs. 62, 168, cf. p. 49; sailing-boat, Cailliaud, *Arts et métiers,* pl. 5; tomb, Davies (Nina) in *J.E.A.* xxiv (1938), fig. 12, cf. p. 37; Wilkinson MSS. v. 148 [8]. Garden and pylon in **III,** Baud, *Dessins,* pp. 248–9 with fig. 116; shadûfs, Davies, *The Tomb of Nefer-ḥotep at Thebes,* i, fig. 9, cf. p. 70.

(4) Two registers. **I,** Deceased and family offer to King and Horus (?). **II,** Two scenes, priest offers, and priest and wife offer, to deceased and wife.

Details, Schott photos. 8120–1.

(5) [1st ed. 1] Tree-goddess scene with deceased and wife seated.

Champ., *Mon.* clxii [1]; Rosellini, *Mon. Civ.* cxxxiv [3]; Cailliaud, *Arts et métiers,* pl. 65 [1]; Wagenaar in *Oudheidkundige Mededeelingen van het Rijksmuseum van Oudheden te Leiden,* n.r. x (1929), fig. 21, cf. p. 105; Keimer in *Egypt Travel Magazine,* No. 29, Jan. 1957, fig. on p. 21 (called Paser); Schott photo. 8119; Chic. Or. Inst. photo. 2978.

(6) Two registers. **I,** Deceased and family before Osiris, two goddesses, and god (?). **II,** As at (4).

Parts, Schott photos. 5997, 8115–18.

Inner Room.

(7) Outer jambs, texts. (8) Deceased and family before Osiris, Isis, Nephthys, and Anubis.

(9) [1st ed. 2] Two registers. **I,** Deceased and wife adore shrine with Negative Confession and assessors. **II,** Deceased and wife in weighing-scene, Thoth writing, and Anubis-jackal, and deceased led to Osiris by Ḥarsiēsi.

Description and some texts, Wilkinson MSS. v. 148 [6, 7, 9–11].

(10) Ogdoad before [Osiris] and winged Maᶜet.

139. Pairi 𝕏𓇋𓂋𓇋, waᶜb-priest in front, First royal son in front of Amūn, Overseer of peasants of Amūn. Temp. Amenophis III.

Sh. ʿAbd el-Qurna.

Father, Sheroy ═𓏛𓇋𓇋, Prophet of Ptaḥ and Hathor. Wife, Ḥenutnefert 𓏤𓍯𓏤𓏥.

Plan, p. 248. Map VI, E–4, f, 2.

Scheil, *Le Tombeau de Pâri* in Virey, *Sept Tombeaux thébains* (*Mém. Miss.* v, 2), pp. 581–90, with plan, p. 581. Sketch-plan, Youssef in *Ann. Serv.* xlviii (1948), pl. facing p. 516. Titles of deceased and son Ptaḥmosi, Wilkinson MSS. v. 161 [middle].

Hall. View, M.M.A. photo. T. 1344.

(1) Left thickness, deceased followed by family (including girl as 'Royal concubine') pours ointment on offerings.

YOUSSEF, op. cit. pls. i [1], v–vi [9–11], vii [14], pp. 513–16; M.M.A. photos. T. 1345–6; SCHOTT photos. 5029, 8144.

(2) Fragments (replaced), including son Ptaḥmosi with papyrus flower.

(3) [1st ed. 2] Two registers. **I,** Son Amenḥotp with [Ptaḥmosi and others] offers bouquet of Amūn to deceased and wife. **II,** [Deceased] offers to parents with offering-list.

M.M.A. photos. T. 1347–8; CHIC. OR. INST. photo. 6152; SCHOTT photos. 2225, 2227, 3089, 5014–16, 5022–3, 5025–6, 7656. Parents, LHOTE and HASSIA, *Chefs-d'œuvre*, pl. 40; MEKHITARIAN in *Chronique d'Égypte*, xxxi (1956), figs. 15, 19, cf. pp. 240–1, 243. Texts, SCHEIL, pp. 589–90 [D]; names, BOURIANT in *Rec. de Trav.* xiv (1893), p. 70; text above deceased in **I,** SCHOTT, *Altägyptische Liebeslieder*, pl. 1.

(4) Four registers. **I,** Deceased and wife with two rows of offering-bringers adore Osiris with bouquet. **II,** Funeral procession, dragging sarcophagus and carrying funeral outfit (including model ship). **III,** Rites before statues, and two priests with Opening the Mouth instruments before mummies. **IV,** Abydos pilgrimage.

NEWBERRY in ROSS, *The Art of Egypt*, fig. on p. 162; HERMANN, *Stelen*, pl. 11 [a] (from SCHOTT photo.), p. 92; LHOTE and HASSIA, *Chefs-d'œuvre*, pl. at end 14; M.M.A. photos. T. 1344, 1349–53; CHIC. OR. INST. photo. 6151; SCHOTT photos. 3087 (view of wall), 2217–18, 2220–3, 2228, 3066–72, 3083–6, 3088, 5008–12, 5017–21, 7651–5. **II–IV,** KEES, *Aegypten*, pl. 31; id. *Totenglauben und Jenseitsvorstellungen der alten Ägypter*, Abb. 1 (frontispiece), cf. p. 367; FARINA, *Pittura*, pls. cxxxv, cxxxvi. **II,** POUJADE, *Trois Flotilles de la VIième dynastie des Pharaons*, fig. 28, cf. pp. 44–5. Lector with Opening the Mouth instruments, and *sem*-priest offering natron to statue, in **III,** SCHOTT in *Nachr. Akad. Göttingen* (1957), No. 3, pls. ii a, ii b, pp. 79, 85. Sailing-tug in **IV,** BAUD, *Dessins*, fig. 72; rowing-tug, DAVIES (Nina), *Anc. Eg. Paintings*, ii, pl. lvi (CHAMPDOR, v, 8th pl.). Texts, SCHEIL, pp. 582–6 [B], with fig. (Opening the Mouth instruments).

(5) [1st ed. 1] Above doorway, Sons of Horus in shrines. Outer lintel, double-scene, son Amenḥotp with bouquet, and priest with family, offer to deceased and wife. Left jamb, hieratic text, year 3 of Smenkhkareᶜ ('Ankhkheperureᶜ) with hymn to Amūn, of Pewaḥ, Scribe of divine offerings of Amūn in the House of ʿAnkhkheperureᶜ. Right jamb, offering-text with deceased seated at bottom.

M.M.A. photos. T. 1354, 1356 [right], 1357, 1359; CHIC. OR. INST. photo. 6150; SCHOTT photos. 5006–7, 7650. Texts, SCHEIL, pp. 587–8 [P]. Hieratic text, GARDINER in *J.E.A.* xiv (1928), pls. v, vi, pp. 10–11, cf. pp. 3–9 (by NEWBERRY); beginning, WILKINSON MSS. v. 161 [middle left]; names and date, HELCK, *Urk.* iv. 2024 (771). See BOURIANT in *Rec. de Trav.* xiv (1893), pp. 70–1.

(6) Two registers, banquet. **I,** Two women and girl with relatives before [deceased and wife]. **II,** Son Ptaḥmosi, and relatives (unfinished), with offering-list before deceased and wife.

M.M.A. photos. T. 1355–6 [left]; CHIC. OR. INST. photo. 6136; SCHOTT photos. 2211–15, 2226, 5027, 7645–9. **II,** incomplete, FARINA, *Pittura*, pl. cxxxiv; deceased and wife, WEGNER in *Mitt. Kairo*, iv (1933), pl. xv [a]. Texts, SCHEIL, pp. 586–7 [A].

Finds

Lintel, deceased at each end adores cartouches of Amenophis III, in Brit. Mus. 1182. *Hiero. Texts*, Pt. vii, pl. 7. Texts, HELCK, *Urk.* iv. 1857. See *Guide (Sculpture)*, p. 119 [424].

140. NEFERRONPET 𓏏𓊪𓏏, probably called ḲEFIA 𓂧𓈎𓏏, Goldworker, Portrait sculptor. Temp. Tuthmosis III to Amenophis II.

Dra' Abû el-Naga'.
Wife, Tauy 𓏏𓏏𓏏.

Plan, p. 248. Map II, D–6, h, 2.

Hall.

(1) Banquet, with female clappers, [musicians], and offerings, before [deceased and wife]. (2) At top, [offering-scene] with list. (3) [Deceased as Ḳefia and wife.]

Inner Room.

(4) Thicknesses, deceased adoring with hymns (to Rēʿ on left). (5) Two registers, I, man with jars and bouquet, II, man with stick. (6) Three registers, funeral procession, I and II, funeral outfit carried and sarcophagus dragged, III, remains of two people holding mummies, and female mourner.

(7) Two registers. I, Man preparing bed. II, Girl arranging lady's hair.

BAUD, *Dessins*, pl. xxv, pp. 161–2; CHIC. OR. INST. photo. 10293. I, KEIMER in *Egypt Travel Magazine*, No. 28, Nov. 1956, p. 7, fig. 2.

(8) Four registers, I–IV, rites before mummy.

(9) Remains of stela. Two registers at right side, I, man offers to deceased and wife, II, man offers flowers to couple.

Ceiling, texts.

141. BEKENKHONS 𓎟𓈖𓏏, *waʿb*-priest of Amūn. Ramesside.

Dra' Abû el-Naga'.
Wife, Takhaʿ(t) 𓂝𓈖𓏏.

Plan, p. 248. Map II, D–6, h, 2.

Entrance.

(1) Thickness, [deceased].

Hall.

(2) Two registers, I, deceased with table of offerings, and scenes before shrines, II, seated lutist before deceased and wife. (3) Architrave, name of deceased.

(4)–(5) Two registers, banquet (unfinished). I and II, Man, with two rows of people seated on ground, offers to couple, in each.

BAUD, *Dessins*, fig. 74.

(6) and (7) Three registers, funeral procession. I, Sarcophagus in boat, boats, and deceased and wife before Amenophis I and [ʿAḥmosi Nefertere]. II, Sarcophagus dragged by

oxen, &c. **III**, Mourners, deceased, and son Heremmaʿet ⬜ ═⇗ ʃ, *warb*-priest of Amūn, and at end, man offers to Ḥathor-cow in mountain.

King and Queen in **I**, man with foreleg, cow and mutilated calf, in **II**, and female mourners in **III**, Chic. Or. Inst. photos. 10291–2. Female mourners in **I** and **III**, Werbrouck, *Pleureuses*, figs. 29, 68, 95, 104, 111, 136, cf. p. 50. Sarcophagus dragged, with priests pouring water, in **II**, Baud, *Dessins*, pl. xxvi, pp. 165–6.

(8) Fragment, deceased offering.

142. Simut 𓎛°𓃒 , Overseer of works of Amen-rēʿ in Karnak. Temp. Tuthmosis III to Amenophis II (?).

Dra' Abû el-Naga'.

Parents, Menta ══╦╗, Overseer of the granary of Amūn, and Dḥutnūfer 𓅱𓏏. Wife, Sitamūn 𓇓═══𓃒 .

Inner Room. Plan, p. 248. Map II, D–6, g, 1.

(1) Deceased and wife seated before offerings, with small son. (2) Offering-bringers. (3) Four registers, **I–IV**, banquet, with musicians (male harpist and girl-clappers) in **II**. (4) Two registers, **I**, *sem*-priest before parents, **II**, *sem*-priest before deceased and wife.

143. Name lost. Temp. Tuthmosis III to Amenophis II (?).

Dra' Abû el-Naga'.

Wife, Tentkhesbed 𓏲═══ ⊖ ═𓂋 .

Plan, p. 256. Map I, C–6, j, 10.

Hall. Remains of scenes.

(1) Male and female guests with attendants before wife.
Parts, Schott photos. 8703–5, 8794.

(2) Deceased, wife, and family, man with offerings and list before them, and three rows of people. (3) Two registers, with servants approaching store-room and mass of jars.

(4) [1st ed. 2] Six registers. **I–VI**, Agriculture including measuring crop, and boats in **I–II**, offerings before [Termuthis] in **V**, scribe recording men with flowers and offerings, and pulling flax and ploughing, in **VI**. At bottom, sketch of men and horses.

IV–VI, Wresz., *Atlas*, i. 83 [a]; Chic. Or. Inst. photos. 10321–3; incomplete, Schott photos. 4093, 4095–6, 8709. Scene sketched at right end of **IV**, and men and horses at bottom, Baud, *Dessins*, figs. 75–6; horse, Capart, *Documents*, i, pl. 67 [A]; id. *Schoonheids-schatten uit Oud-Egypte*, Abb. 26; Donadoni, *Arte egizia*, fig. 120.

(5) Three scenes (sketched). **1**, King spearing lion, **2**, King seated, **3**, King on stool drawing bow.

Baud, *Dessins*, fig. 77; Davies in *M.M.A. Bull.* Pt. ii, Nov. 1935, figs. 5–6, cf. pp. 51–2; Chic. Or. Inst. photo. 10318. **1**, Capart, *Documents*, i, pl. 68.

(6) [1st ed. 1] Five registers, tribute from Punt. **I–III**, Deceased, with chiefs of Punt bringing gold, incense-trees, &c., before King. **IV**, Arrival of deceased (with dog) at Red

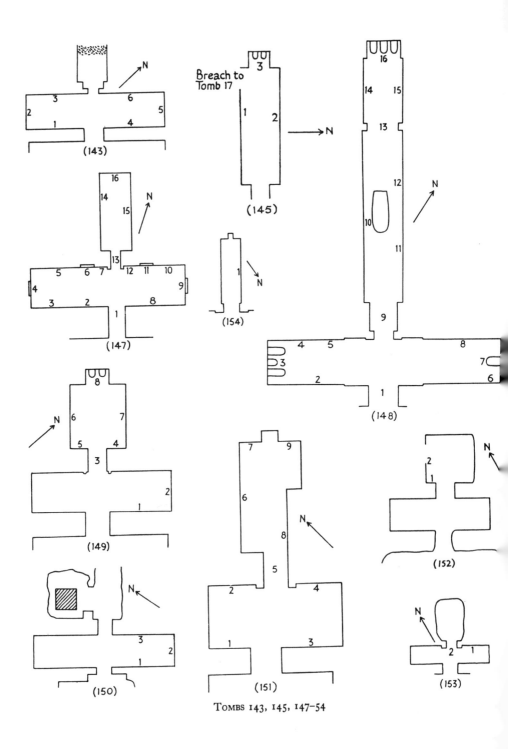

TOMBS 143, 145, 147-54

Sea, laden donkeys with goods for barter, military escort (with dog), and chariot, and inspection of incense and laden sailing-rafts. **V,** Departure of donkeys, and military escort, waiting chariot, deceased with heap of offerings, and laden sailing-raft.

Incomplete, CHIC. OR. INST. photos. 10318–21. **I–III,** MEYER, *Fremdvölker*, 723–5, 620. Parts of **II–V,** SCHOTT photos. 4094, 4097, 8706–8. Tribute in **II–III,** and escort and chariot in **V,** WRESZ., *Atlas*, i. 347–8. Two chiefs in **II,** and **IV–V,** incomplete, DAVIES, op. cit. figs. 1–3, cf. pp. 46–9. Left part of **III–V** (sketched), BAUD, *Dessins*, fig. 78. Texts, HELCK, *Urk.* iv. 1472–3.

144. NU ⚬⚬𓂝, Head of the field-labourers. Temp. Tuthmosis III (?).

Dra' Abû el-Naga'.

Wife, Ḥenuttaui ▽⚊⚊𓀀.

Plan, p. 248. Map II, D–6, h, 1.

Hall.

(1) Four registers, remains of funeral procession, **I,** carrying funeral outfit, including statuettes, **II–III,** dragging shrines and boat, **IV,** offering-bringers.

(2) At top, Eastern emblem. Three registers below, agriculture, **I,** oxen treading grain, **II,** winnowing, **III,** reaping and pulling flax.

I and **II,** CHIC. OR. INST. photo. 10270.

(3) Four registers. **I–IV,** Banquet before deceased and wife.

(4) [Painted stela.] At right side, four registers, **I–IV,** rites before mummy.

Vaulted ceiling, texts.

145. NEBAMŪN 𓇋▭▽, Head of bowmen. Dyn. XVIII.

Dra' Abû el-Naga'.

Wife, ʿAḥḥotp ▱⚊.

Plan, p. 256. Map II, D–6, g, 1.

FAKHRY in *Ann. Serv.* xliii (1943), pp. 369–79, with plan and section, fig. 63.

Hall.

(1) Two registers. **I,** [Son Paser 𓏏𓀀] with offering-list before deceased and [wife with monkey eating onions under chair]. **II,** Food-table and son offering bouquet of Amūn to deceased and wife.

FAKHRY, pl. xii, pp. 371–4. Incomplete, SCHOTT photos. 8628–31. Monkey, NORTHAMPTON, &c., *Theban Necropolis*, fig. 13.

(2) Three registers (unfinished). **I,** Deceased and family (with sketch of men preparing beer behind them), daughter offering to them, and guests. **II–III,** Recording horses, cattle, donkeys, geese, and pigs, with defaulters beaten.

FAKHRY, pls. xiii, xiv, pp. 374–5; CHIC. OR. INST. photos. 10281–3; incomplete, SCHOTT photos. 8632–9. Men preparing beer, and guests, in **I,** BAUD, *Dessins*, figs. 79, 80. Men bringing animals in **II** and **III,** DAVIES in *M.M.A. Bull.* Pt. ii, March 1932, fig. 9, cf. pp. 53–4; CAPART, *Documents*, ii, pl. 69.

(3) Niche with remains of clay statues of deceased and wife.
FAKHRY, pl. xv, p. 371.

146. NEBAMŪN ⟨☰▽, Overseer of the granary of Amūn, Scribe, Counter of grain,
tny of the god's wife (titles from cones). Temp. Tuthmosis III (?).
Dra' Abû el-Naga'. (Inaccessible.)
Wife, Suitnub ⟨...⟩ (from cone).
Map II, D-6, g, 3.

NORTHAMPTON, &c., _Theban Necropolis_, pp. 13–15, with plan, section, and elevation, pl.
xiv, and view of façade, fig. 16.
Scene, man sowing, and pigs treading grain. Id. ib. pl. xiii.
Fragment of stela (?) with representations of ushabti of deceased and wife, in Cairo Mus.
34160. Id. ib. pl. xxii [43], pp. 32 [22], 33 [43]. Text, LACAU, _Stèles du Nouvel Empire_
(_Cat. Caire_), i, pp. 202–3.
Upper part of stela, deceased adoring 'Rēʿ'. NORTHAMPTON, &c., op. cit. pl. xvii [1],
pp. 14–15, 18 [17]. Text, SPIEGELBERG DIARY, 109 [top].

147. Head of the masters of ceremonies (?) of Amūn, &c. Temp. Tuthmosis IV (?).
Dra' Abû el-Naga'.
Wife, Nefert. . . ⟨...⟩.
Plan, p. 256. Map I, C-6, j, 9.
Hall.
(1) Left thickness, deceased with burnt-offering, followed by wife and family, and hymn
to Rēʿ. Right thickness, deceased [and wife] adoring, and hymn to Rēʿ.
Translation of offering-text on left, SCHOTT, _Das schöne Fest_, p. 869 [54].

(2) Deceased offers on braziers, with wife and three registers, I–III, offering-bringers.
Man filling jar in **III**, SCHOTT photo. 8710. Translation of offering-text, SCHOTT, op. cit.
pp. 862–3 [24, 'Südteil'].

(3) Deceased and wife, with man offering bouquet to them, and three registers, I–III,
banquet, including musicians in **III**.

(4) Remains of stela. At sides, three registers of offering-bringers.
See HERMANN, _Stelen_, p. 29, note 108.

(5) Deceased inspects three registers, I–III, agriculture, including trees in I–II, and pulling
and carrying flax in **III**. (6) Remains of stela. (7) Two registers, **I**, man offers two bouquets
to deceased, wife, and daughter, **II**, man offers to deceased and wife.

(8) Deceased offers on braziers, followed by two rows of people, and seated couple.
Text mentioning Valley Festival, SCHOTT, _Das schöne Fest_, p. 863 [24, 'Nordteil'].

(9) Remains of stela, with offering-bringers at right side. (10) Man and woman offering
to deceased [and wife]. (11) Remains of stela.

(12) Girl offers bowl to deceased and wife.
Girl, SCHOTT photo. 8711.

Inner Room.

(13) Outer lintel, deceased and wife before Osiris. Inner jambs, two registers, **I** and **II,** offering-bringers.

Man with tray of food in **II** on right, SCHOTT photo. 8712.

(14) Three registers. **I–II,** Funeral procession, including statue of deceased carried by 'Nine friends', and ceremonies before mummy, with son offering bouquet of Amūn to parents beyond. **III,** Abydos and Busiris pilgrimage, with Temple of Busiris and trees at right end.

Parts of **III,** SCHOTT photos. 4092, 8713–14; Temple, DAVIES (Nina) in *J.E.A.* xli (1955), fig. 1, cf. p. 80.

(15) [Deceased] with man offering to him, and three registers, banquet. (16) Two scenes, **1,** son offers bouquet to parents, **2,** [daughter] offers to parents.

Details at (15), and bouquet and parents in **1** at (16), SCHOTT photos. 8715–23.

148. AMENEMŌPET 〔⫶△〕, Prophet of Amūn. Temp. Ramesses III to V.
Draʿ Abû el-Nagaʿ.

Parents, Thonūfer (tomb 158) and Nefertere ⫶. Wife, Tamert ⫶, Chief of the harîm [of Amūn].

Plan, p. 256. Map I, C–7, a, 8.

BURTON MSS. 25639, 40; ROSELLINI MSS. 284, G 61 verso. Titles of deceased, LEPSIUS MS. 420 [upper left], 421 [top].

Hall.

(1) Left inner thickness, remains of text.

(2) [1st ed. 1] Two registers. **I,** Remains of scenes, *sem*-priest before divinity, and deceased led by Thoth to [Osiris] with lion-headed goddess holding knives. **II,** Banquet, two scenes, deceased as *sem*-priest offering to Amenhotp and wife in **1,** and to parents in **2.** (Graffito of Amen(ḥir)khopshef, son of Raʿmosi, copied by Černý.)

CHIC. OR. INST. photos. 3915, 10333. **II,** incomplete, WRESZ., *Atlas,* i. 350. Text of Thoth in **I,** wife of Amenhotp in **II, 1,** and deceased and offerings in **II, 2,** SCHOTT photos. 6016–18, 6584–7.

(3) Seated statue-group, deceased, wife, and child, and remains of offering-bringer on wall left of group.

Statue-group, HERMANN, *Stelen,* pl. 12 [c], p. 100, note 453; MOND in *Photographic Journal,* lxxiii, Jan. 1933, fig. on p. 16 [top]; SCHOTT photo. 9250.

(4) [1st ed. 2] Three registers. **I,** Deceased rewarded, deceased rejoicing, and statue of Ramesses III, with text of year 27, deceased rejoicing, and statue of Ramesses III, protected by winged Isis, on chair in palanquin. **II–III,** Deceased before offerings, and seated relatives.

CHIC. OR. INST. photos. 3911–14, 3916, 10333. Five male relatives, WRESZ., *Atlas,* i. 349; four (first three male, and one female), SCHOTT photos. 6019–21, and details, 6579–83; first three male relatives, WOLF, *Die Kunst Aegyptens,* Abb. 593.

(5) Four registers, **I–III,** remains of scenes including deceased rewarded (?) by prince before [King] in kiosk, **IV,** priest offers to [deceased and wife (?)]. (6) Seated people.

(7) Seated statue of deceased.

HERMANN, *Stelen*, pl. 12 [d]; SCHOTT photo. 9249.

(8) Man with offering-text on right, and text of adoration of [Osiris] on left, with seated people below.

Frieze, Ḥatḥor-heads, Anubis, and texts.

Passage.

(9) Outer lintel, deceased at right end, and jambs, remains of texts. Left thickness, remains of hymn to Amen-rēʿ.

(10) Remains of funeral procession, with servants with food in booths and male mourners, to Rēʿ-Ḥarakhti, Isis, and Nephthys. (11) Two registers, **I**, deceased (?) seated, **II**, remains of scenes. (12) Longer Negative Confession.

Sarcophagus. Left side, Thoth adores baboon, hawk-headed god, and crocodile-headed divinity. Right side, Thoth adores human-headed god, Anubis, and ram.

Inner Room.

(13) Outer lintel, remains of double-scene before [Osiris] with Isis on left, and Nephthys on right. (14) Two registers, **I**, two men adoring, and Sekhmet at right end, **II**, hawk-headed god at right end.

(15) Serpent in centre, with deceased on right, and Osiris and two rows of divinities on left.

Description, name of wife, and texts above divinities, LEPSIUS MS. 420 [upper right and lower].

(16) Niche, with statue-group, deceased and two women. Side-walls, deceased adores hawk-headed god on left, and adores Amen-rēʿ-Ḥarakhti on right.

149. AMENMOSI ⟨𓈖𓏏𓏭⟩, Royal scribe of the table of the Lord of the Two Lands, Overseer of the huntsmen of Amūn. Ramesside.

Draʿ Abû el-Nagaʿ.

Wife, Sitmut.

Plan, p. 256. Map I, C–7, b, 7.

Hall.

(1) and (2) At top, Book of Gates vignettes, with frieze of Anubis-jackals, *uzats*, and Ḥatḥor on *nub*-sign, at (1).

Inner Room.

(3) Above outer doorway, double-scene, deceased before Rēʿ-Ḥarakhti and Maʿet, and before Osiris and Isis-Wert-Ḥekau. Left thickness, text. Inner tympanum, double-scene, deceased kneels before hawk-headed god and Nephthys, and before Osiris and Isis.

(4)–(7) Deceased, sometimes with wife, before Rēʿ-Ḥarakhti and Western goddess at (4), before two divinities at (5), before Amenophis I and ʿAḥmosi Nefertere at (6), and before two divinities at (7).

(8) Niche with seated statues of deceased and wife. Tympanum, double-scene, deceased kneeling adores Osiris, and adores Rēʿ-Ḥarakhti.

150. USERḤĒT †⸗⁹, Overseer of cattle of Amūn. Late Dyn. XVIII.

 Draʿ Abû el-Nagaʿ. (Unfinished.)

 Wife, Iaᶜt-ib ⟨—ᵔ≈⁹, Royal concubine.

 Plan, p. 256. Map I, C–7, d, 6.

 GAUTHIER in *B.I.F.A.O.* vi (1908), p. 131 [iii].

Hall.

 (1) Deceased and wife adore *zad*-pillar.

 See id. ib. p. 131.

 (2) Double-scene, deceased and wife before Osiris, and before Anubis. (3) At top, sketch of heaps of pomegranates, and bunches of grapes on trellis.

Finds

 Statue-base of wife, probably from here, found in Antef Cemetery B. 30, now in London, Univ. College. PETRIE, *Qurneh*, pl. xxx [6]; see WINLOCK in *J.E.A.* x (1924), p. 218, note 2.

151. ḤETY ⸗⁹⎮⟨⟨, Scribe, Counter of cattle of the god's wife of Amūn, Steward of the god's wife. Temp. Tuthmosis IV.

 Draʿ Abû el-Nagaʿ. (Unfinished.)

 Parents, Nebnūfer ⌒↓ₐ, Counter of cattle of the god's wife, and Men ≣. Wife, Nefertere ↓ₐ⌒⟨⌒ₙ.

 Plan, p. 256. Map I, C–7, d, 6.

Hall.

 (1) Two registers.ˑ I, Deceased and wife, with offering-bringer, adore [divinity]. II, Man before [goddess].

 BAUD, *Dessins*, pl. xxvii, p. 174.

 (2) [1st ed. 1] Four registers, recording of cattle. I–II, Bringing bulls. III–IV, Cattle stalls and preparation of fodder before scribe.

 WRESZ., *Atlas*, i. 351; CHIC. OR. INST. photos. 2979, 10293; SCHOTT photos. 4087–8.

 (3) Deceased with wife offers on braziers with butchers below, and text on left in [offering-scene to deceased and wife]. (4) Two registers, I, offerings before parents, II, man offers to deceased and wife.

Inner Room.

 (5) Outer lintel, texts of Sons of Horus, and right jamb, offering-texts. Left thickness, [deceased].

 (6) and (7) Two registers at (6). I, Four scenes, 1–3, priest offers cloth, torches, and offerings, to deceased and wife, 4, deceased and wife adoring. II, Three sailing-boats and three others. (7) Anubis, belonging to 4.

 (8) Three registers, funeral procession. I, Male mourners, sarcophagus dragged, priest libating mummy. II, Female mourners, and bringing funeral outfit. III, Carrying chariot, calf, &c., and ceremonies before mummy.

Mourners in **I** and **II**, WERBROUCK, *Pleureuses*, figs. 30–2, cf. p. 50. Sketch of Nephthys (on funeral boat) at right end of **I**, BAUD, *Dessins*, fig. 81.

(9) Osiris receives offerings, with three offering-bringers below.

152. Name lost, late Dyn. XVIII. Usurped in Ramesside times (?).

Dra' Abû el-Naga'.

Plan, p. 256. Map I, C–7, d, 5.

Inner Room.

(1) Two registers. [**I**, Men with offerings. **II**, Man with altar and brazier.]

(2) Three registers, remains of funeral procession with mourners to Anubis and Western goddess, and man with bulls.

See WERBROUCK, *Pleureuses*, p. 50 (called right wall).

153. Name lost. Temp. Sethos I (?).

Dra' Abû el-Naga'.

Plan, p. 256. Map I, C–7, d, 5.

Hall.

(1) Two registers. **I**, Deceased, followed by man with bouquet, priest libating, and two women, with stands of candles before temple-pylon with masts. **II**, Deceased, followed by women, censes before deified 'Ahmosi Nefertere, Amenophis I, and Tuthmosis III, in kiosk.

II, BAUD, *Dessins*, pl. xxviii (called tomb 154), and fig. 82.

(2) Entrance to Inner Room. Outer jambs, remains of text.

154. TATI 𓏏𓏏𓇯𓏭𓏏, Butler. Temp. Tuthmosis III (?).

Dra' Abû el-Naga .

Plan, p. 256. Map I, C–7, c, 6.

DAVIES, *Five Theban Tombs*, pp. 42–3, with plan.

Hall.

(1) [1st ed. 1] [Deceased] with dog under chair, and [wife], with man and woman offering to them, and two registers, **I–II** (unfinished). **I**, Remains of guests, man bringing food, and brewing. **II**, Female harpist and female [musician?], guests, offering-bringers, and men cutting stela and digging burial-shaft.

DAVIES, pl. xxxix [left, cf. right bottom], pp. 42–3. Omitting offering-bringers and digging shaft, CHIC. OR. INST. photos. 10311–12. Brewing in **I**, and cutting stela in **II**, WRESZ., *Atlas*, i. 352. Guests in **II**, CAPART and WERBROUCK, *Thèbes*, fig. 182; MACKAY in *J.E.A.* iv (1917), pl. xvi [7], p. 81.

Ceiling. Titles of deceased, DAVIES, pl. xxxix [top right], p. 42.

155. ANTEF 𓊃𓈖𓏏𓆑, Great herald of the King. Temp. Ḥatshepsut and Tuthmosis III. Dra' Abû el-Naga'. (HAY, No. 1.)

Plan, p. 264. Map I, C–7, c, 7.

SÄVE-SÖDERBERGH, *Four Eighteenth Dynasty Tombs* (*Private Tombs at Thebes*, i), pp. 11–21, with plan, pl. xx; VASSALLI, *I Monumenti Istorici Egizi* [&c.], (1867), pp. 139–41; BURTON MSS. 25639, 40; HAY MSS. 29824, 17.

Hall.

(1) Man carrying mat with food.
SCHOTT photo. 6571. See SÄVE-SÖDERBERGH, p. 13.

(2) Lower part of false door with *sem*-priest on each side.
See SÄVE-SÖDERBERGH, p. 13, pl. xix [F (priest on right), C, D].

(3) [1st ed. 1] Deceased with son, and brother 'Aḥmosi (?) in front of them, inspects four registers, I–IV, foreigners bringing produce. **I,** Remains of Keftiu. **II,** Syrians with chariot and floral vases. **III–IV,** Recording produce of the Oases.
SÄVE-SÖDERBERGH, pls. xii [B], xiii, pp. 14–15. **I–III,** DAVIES in *M.M.A. Bull.* Pt. ii, March 1932, fig. 12, cf. p. 62; MEYER, *Fremdvölker*, 728–9, 623. **IV,** and woman with basket in **III,** SCHOTT photos. 6567–8, 6570.

(4) Deceased with wife (with Nubian boy feeding monkey with dates under chair), and [brother 'Aḥmosi] in front of them, inspects four registers, I–III, officials bringing weapons, **IV,** weighing and bringing gold.
SÄVE-SÖDERBERGH, pls. xi, xii [A], pp. 13–14. Boy with monkey, CHIC. OR. INST. photo. 10315; SCHOTT photo. 6566; weapons, id. ib. 6569.

(5) [1st ed. 4, 3] Two registers. **I,** [Deceased and family fishing (with crocodile eating fish below) and fowling, and spearing hippopotamus]. **II,** Vintage, with offering to Termuthis, 'Apiru pressing grapes, overseer tasting wine brought by girl, and men bringing jars to wine-store with sleeping watchman.
SÄVE-SÖDERBERGH, pls. xiv (from HAY), xv, pp. 15–18; BURTON MSS. 25644, 115–22; HAY MSS. 29822, 4, 5, 7–11, 29851, 387–8. Spearing hippopotamus, PRISSE, *L'Art égyptien*, ii, 6th pl. [upper] 'Chasses au Marais', cf. *Texte*, p. 396; WILKINSON, *M. and C.* iii, pl. xv facing p. 71 = ed. BIRCH, ii. 128 (No. 376); DAVIES (Nina), *Anc. Eg. Paintings*, iii, fig. on p. 45 (drawn from HAY and WILKINSON); reconstruction, SÄVE-SÖDERBERGH, *On Egyptian Representations of Hippopotamus Hunting* [&c.] in *Horae Soederblomianae*, iii (1953), fig. 1, cf. p. 6; id. *Egyptiska framställningar av flodhästjakt* in *Arkeologiska Forskningar och Fynd* (1952), p. 21, fig. 3; hippopotamus, CHIC. OR. INST. photo. 10314; SCHOTT photos. 8725, 6562. **II,** SCHOTT photos. 6558–61, 6563–5, 8726–7; omitting wine-store, CHIC. OR. INST. photos. 10313–14; omitting wine-tasting and wine-store, WEGNER in *Mitt. Kairo*, iv (1933), pl. vii [a]; wine-tasting and wine-store, DAVIES in *M.M.A. Bull.* Pt. ii, March 1932, figs. 2 (partly from HAY), 3, cf. p. 52; wine-store, WILKINSON, *M. and C.* ed. BIRCH, i. 388 (No. 165); MASPERO, *L'Arch. ég.* (1887), fig. 40, (1907), fig. 41. Text above wine-press, mentioning 'Apiru, SÄVE-SÖDERBERGH, *The ᶜprw as Vintagers in Egypt* in *Orientalia Suecana*, i [1/2] (1952), p. 6 (from BURTON MSS.).

Pillars.

(6) Deceased with goose under chair.

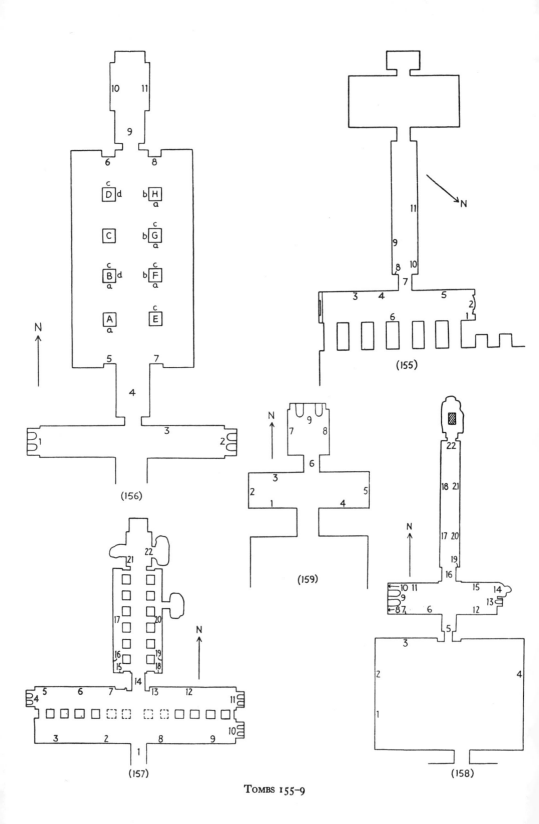

TOMBS 155–9

Goose, Säve-Söderbergh, pl. x [11], p. 12; Chic. Or. Inst. photo. 10315; Schott photo. 6572.

Fragments, Säve-Söderbergh, pl. x [1–10, 12–27], pp. 12–13, including leather-workers and chariot-makers [1–5], papyrus-gathering and jousting [19–20], freight-ships [23–5], and hieratic graffito [12, 13].

Passage.

(7) [1st ed. 2] Outer jambs, [deceased with ram-standard] before Horus-name. Thicknesses, deceased in front of pavilion with Nubians and Asiatics bound to *sma*-emblem. Inner jambs, titles.

See Säve-Söderbergh, pp. 18–19, pls. xviii (thicknesses), xix [A] (left outer jamb). Deceased (unfinished) on left jamb, Mackay in *J.E.A.* iv (1917), pl. xv [4], p. 77. Nubian with *sma*-emblem, Chic. Or. Inst. photo. 10316; Hay MSS. 29822, 6.

(8) and (9) Remains of funeral procession with purification of mummy. See Säve-Söderbergh, p. 19, cf. pl. xix [B].

(10) [1st ed. 5] Two registers. I–II, Remains of animals in hunting-scene, with wild ass giving birth, hyenas, &c., and waiting chariot.

Säve-Söderbergh, pls. xvi, xvii [B–D], p. 20. Ass giving birth in **I**, and man with ibex in **II**, Hay MSS. 29822, 19, 20; man with ibex, Wegner in *Mitt. Kairo*, iv (1933), pl. x [a]; hyenas, wild bull, &c., in **II**, Davies in *M.M.A. Bull.* Pt. ii, March 1932, figs. 4–6, 11, cf. pp. 52–6; heads of two hyenas, Smith, *Art . . . Anc. Eg.* pl. 103 [B].

(11) [Bringing cattle (?), birds, and produce of marsh-lands], including honey. Säve-Söderbergh, pl. xvi [left], pp. 20–1.

Inner Rooms. Remains of destroyed scenes, see id. ib. p. 21.

Finds

Stela, double-scene, son Teti on left, and brother ʿAhmosi on right, kneeling before deceased, with long text below, 'Appeal to visitors', autobiography, &c., perhaps from left end wall of tomb, or from court, in the Louvre, C. 26. Boreux, *Guide*, pl. xviii, pp. 154–5; Gayet, *Stèles de la XIIᵉ dynastie*, pls. xiv–xxii; Hermann, *Stelen*, pl. 4 [b], p. 40, and p. 57 note 253; Devéria squeezes 6166. i. 6; 6170. D. 15, 22; A. F. 1570, 11; Seyffarth MSS. v. 4147–53. Texts, Piehl, *Inscr. hiéro.* i Sér. v–ix [C]; Pierret, *Rec. d'inscr.* ii, pp. 25–7; Sethe, *Urk.* iv. 963–75 (280); long text, Lemm, *Aegyptische Lesestücke* [&c.], p. 53; Brugsch, *Thes.* 1479–84; ll. 21–3, Maspero in *Ä.Z.* xvii (1879), p. 51 [near top]. Names, Lieblein, *Dict.* No. 92. See Säve-Söderbergh, p. 13.

Fallen fragments, including figure of old man. Säve-Söderbergh, pl. xvii [A], p. 12; old man, Davies in *M.M.A. Bull.* Pt. ii, March 1932, fig. 1, cf. pp. 51–2; Smith, *Art . . . Anc. Eg.* pl. 104 [A] (from copy by Nina Davies).

156. Pennesuttaui ⌷ 𓏥 ⥯, Captain of troops, Governor of the South Lands. Dyn. XIX.

Draʿ Abû el-Nagaʿ. (Champollion, No. 43.)

Wife, Mia 𓄿𓏤𓄿 ·

Plan, p. 264. Map II, D–6, d, 1.

Views, Philad. photos. 40124, 34858.

Hall.

(1) and (2) Seated statues of deceased and wife. (3) [God?] in kiosk.

Pillared Hall.

(4) Outer left jamb and thickness, remains of texts. (5), (6), (7), (8) Pilasters, with deceased on each.

Pillars. A–H.

Deceased before divinities, including Maʿet at B (a), Nut at B (c) and H (a), Rēʿ-Ḥarakhti at F (a), Shu at F (c), zad-pillar at G (b), and sa-emblem at H (b).

Shrine.

(9) [1st ed. 1] Outer lintel, double-scene, deceased kneeling before Osiris and Western goddess, and before Rēʿ-Ḥarakhti and Maʿet. Left thickness, deceased with son Nekhtmin ⳹⳺, Head of the stable of his Majesty, and daughter Beketwerner ⳹⳺⳹⳺. Right thickness, deceased and wife with hymn to Osiris.

Left thickness, PHILAD. photos. 40121–2; names and titles, CHAMP., *Not. descr.* i, pp. 536 [A], 853 [to p. 536, l. 22]; ROSELLINI MSS. 284, G 55 verso.

(10) and (11) Three registers, offering-scenes.

Burial Chamber.

North wall. Seven scenes, **1–7**, including deceased adoring Western hawk in **2**, and hawk-headed god in **7**.

East wall. Four scenes, **1–4**, including Ḥathor-cow in mountain in **2**, and deceased led by goddess in **3**.

South wall. Five scenes, **1–5**, including deceased led by Sobk (?) to hawk-headed god with knife in **2**, deceased between two goddesses in **3**, Thoth in weighing-scene and deceased led by Horus in **4**, and deceased and wife led by god in **5**.

Finds

Brick of deceased, in Philadelphia Univ. Mus. 29.86.710.

For intrusive burial, Dyn. XXI–XXII, see DRAʿ ABÛ EL-NAGAʿ, *Bibl.* i², Pt. 2, in the Press.

157. NEBWENENEF ⳹⳺, First prophet of Amūn. Temp. Ramesses II.

Draʿ Abû el-Nagaʿ. (CHAMPOLLION, No. 42, L. D. Text, No. 7.)

Wife, Takhaʿt ⳹⳺, Chief of the harîm of Amūn, Songstress of Isis.

Plan, p. 264. Map II, D–6, d, 1.

FISHER in *Penn. Mus. Journ.* xv (1924), pp. 45, 47; CHAMP., *Not. descr.* i, pp. 535–6 with plan; HAY MSS. 29824, 8; ROSELLINI MSS. 284, G 54 verso–55, with plan. Reconstruction showing frieze of cones, BORCHARDT in *A.Z.* lxx (1934), Abb. 5, cf. p. 27. Titles, L. *D. Text*, iii, p. 239 with β; LEPSIUS MS. 228 [upper]. Copies of names and titles by GREENLEES are in Philadelphia Univ. Mus.

Hall. View of south end, PHILAD. photo. 34958.

(1) [1st ed. 1] Left thickness, deceased adoring and hymn to Rēʿ, with four jackals, souls of Pe and Nekhen, and baboons adoring at top.

Beginning of hymn, CHAMP., *Not. descr.* i, p. 85ᵗ [to p. 535, l. 18].

(2) [1st ed. 2] Two registers, Book of Gates. **I,** Deceased adores divinities. **II,** Five scenes, deceased, **1,** before *zad*-pillar, **2,** before Nefertem, **3,** before Imset with Ḥepy, **4,** before Duamutf with Ḳebḥsenuf, and Thoth [wall buried], **5,** purified by Inmutf before Western goddess.

Zad-pillar in **II, 1,** SCHOTT photo. 6593. Some texts, CHAMP., *Not. descr.* i, p. 852 [to p. 536, ll. 4–7]; LEPSIUS MS. 226 [except lower right]–227 [upper].

(3) Book of Gates. Deceased before Osiris and Ḥatḥor, and deceased adores Ḥatḥor-cow in mountain.

Some text, LEPSIUS MS. 226 [lower right].

(4) Statues of deceased and wife. PHILAD. photo. on 34958.

(5) Deceased before Osiris and Ḥatḥor.

(6) Two registers. **I,** Text of Festival of Sokari with [deceased] offering to [King?], &c., and man with boxes of coloured cloth. **II,** Deceased and relatives, male flutists and clappers.

Box of coloured cloth, flutists, and texts of left part of **I–II,** SCHOTT photos. 6631–2, 6669–71.

(7) Three registers. **I,** Raising *zad*-pillar by six gods, in presence of Thoth, Inmutf, and deceased on *nub*-sign. **II,** Isis and Nephthys kneeling with *nu*-pot. **III,** Stela, double-scene, deceased adores Osiris, and adores Rēʿ-Ḥarakhti, with text below.

SCHOTT photos. 6630, 6665–8.

(8) [1st ed. 3] Deceased, followed by fan-bearer and priest with text of appointment in year 1 as High priest of Amūn, before Ramesses II and (Merymut) Nefertari in palace-window.

SCHOTT photos. 6627–9. Deceased before King and Queen, BORCHARDT in *Ä.Z.* lxvii (1931), pls. i, ii, pp. 29–31. Omitting texts, HÖLSCHER, *The Excavation of Medinet Habu,* iii, fig. 22, cf. p. 44; appointment-text, SETHE in *Ä.Z.* xliv (1907–8), pls. i–iii, pp. 30–5; beginning, CHAMP., *Not. descr.* i, pp. 851–2 [to p. 535, l. 24]; LEPSIUS MS. 227 [lower]; cartouche of Queen and date, WILKINSON MSS. v. 136 [bottom left]; *L. D. Text,* iii, p. 239 [a].

(9) Two registers. **I,** Book of Gates, small scenes before divinities in shrines. **II,** Offering-bringers with trays of cakes.

(10) and (11) Two niches, each with entablature and two seated statues (deceased and wife at (11)).

(12) Book of Gates, weighing-scene, assessors, and Negative Confession. (13) Two stelae.

Passage.

(14) Frieze, deceased kneels before Anubis-jackal. Outer lintel, jambs, and outer thicknesses, texts. Inner thicknesses, deceased (?) before god and goddess on left, and deceased with family on right.

Sketch of frieze, WILD MSS. ii. A. 175.

(15) Remains of deceased with [family] fowling.

(16) [1st ed. 4] Deceased angling in pool, remains of vintage, and boat on canal at end.
Deceased, WILKINSON, *M. and C.* iii. 52 (No. 341) = ed. BIRCH, ii. 115 (No. 370); WIL-
KINSON MSS. v. 136 [bottom].

(17) Two registers. **I,** Texts. **II,** Priest with ḥes-vase and jars on stand, followed by two
rows of priests.

(18) Two registers. **I,** Offering-texts before god. **II,** Deceased with wife in canoe spearing
'tortoise of Rēʿ', and [spearing hippopotamus] beyond.

II, SÄVE-SÖDERBERGH in *Mitt. Kairo,* xiv (1956), pp. 175–80 with Abb. 1; mythological
text of hippopotamus, DAVIES and GARDINER, *The Tomb of Amenemḥēt,* p. 29 [N].

(19) Two registers, **I,** texts, **II,** funeral procession with statues dragged and carried.
(20) Osiris and winged Isis.

Pillars. Remains of texts and figures.

Shrine.

(21) Remains of mythological (?) scenes.

(22) North niche. Lintel, double-scene, deceased and wife adore Osiris and Anubis, and
adore Ḥathor and Horus.

Pyramid. See WILKINSON MSS. v. 136, 137. Views, PHILAD. photos. 34936, 40095, 40113.

West wall, Thoth before Osiris. North wall, deceased before god on each side above niche.
East wall, remains of scene, tomb with Ḥathor-cow in mountain and stela.
East wall, PHILAD. photo. 40120.

Finds

Brick of deceased, in Berlin Mus. 1618, L. *D. Text,* iii, p. 239 [bottom]; see *Ausf. Verz.*
p. 449. Another in Cairo Mus. Temp. No. 10.4.23.7, PHILAD. photo. 40064.
For Temple of deceased, see *Bibl.* ii. 147.

158. THONŪFER 𓏏𓏠, Third prophet of Amūn. Probably temp. Ramesses III.
Dra' Abû el-Naga'. (CHAMPOLLION, No. 44, L. *D. Text,* No. 9.)
Wife, Nefertere 𓏏𓄿𓅓, Chief of the harîm of Amūn.

Plan, p. 264. Map II, D–6, c, 1.

To be published by SEELE. CHAMP., *Not. descr.* i, pp. 536–8, 853 [to p. 537, l. 18], with
plan; L. *D. Text,* iii, p. 240; FISHER in *Penn. Mus. Journ.* xv (1924), p. 44; ROSELLINI MSS.
284, G 57, 57 verso. View of exterior, STEINDORFF, *Aniba,* ii, pl. 19 bis [b], p. 50; CHIC. OR.
INST. photos. 3959–62. Copies of texts by GREENLEES are in Philadelphia Univ. Mus.

Court. View, PHILAD. photo. 34848.

(1) Two registers. **I,** Offering-scene to deceased and wife. **II,** Three scenes, **1,** deceased
with hymn, **2,** deceased kneeling with hymn to bull, **3,** bull followed by deceased.
M.M.A. photos. T. 2116–17; CHIC. OR. INST. photo. 3016.

(2) Three registers. **I,** Souls of Pe and Nekhen adoring, and deceased adoring divine
barks. **II,** Scenes of deceased before gods in kiosks. **III,** Five scenes, **1,** deceased led by

Horus, **2**, Thoth before Osiris, **3**, deceased with altars before Osiris, **4**, deceased led by Anubis, **5**, Hathor-cow in mountain and Western goddess.

M.M.A. photos. T. 2111–15; Chic. Or. Inst. photo. 3009. Altars in **3**, and Hathor-cow in **5**, Schott photos. 3738–9.

(3) [1st ed. 1] Three registers, Festival of Sokari. **I**, [Bark] carried by priests and deceased with litany before bark of Sokari. **II**, Four scenes, **1**, two canoes, one with deceased and goose, **2**, priest with incense before deceased, **3**, son Amenemōpet (tomb 148) with priest before Mert, **4**, priest with Mert censes offerings before standards in shrine. **III**, Two scenes, **1**, lutist kneeling with song and deceased and man playing draughts, **2**, two rows of relatives, son Amenemōpet with offering-list consecrating offerings before deceased and wife, and at bottom, line of text with hymn.

M.M.A. photos. T. 2118–27; Chic. Or. Inst. photos. 3010, 3015, 3907–8; Philad. photos. 34899–900, 34913–14. Left half of **I**, and lutist with song and Amenemōpet before deceased and wife in **III**, Schott photos. 3732–7. Text of deceased and wife in **III**, L. *D. Text*, iii, p. 240; Wilkinson MSS. v. 135 [bottom].

(4) Two scenes. **1**, Deceased with bouquet, followed by Pahemneter, receives flowers from woman, with others. **2**, Women with tambourines leaving temple.

Omitting right end, M.M.A. photo. T. 2110; Chic. Or. Inst. photos. 3008, 3972.

Hall. Views, M.M.A. photos. T. 2136–7; Chic. Or. Inst. photos. 3970–1.

(5) Left thickness, two registers, **I**, deceased with hymn adores Rēꜥ-Ḥarakhti, [four adoring baboons], and litany, **II**, kneeling harpist (upper part in Berlin Mus. 20482) and song, and tree-goddess scene with pool and *ba*s (one drinking), before deceased. Right thickness, hymn. Inner lintel, double-scene, [deceased] adores Rēꜥ-Ḥarakhti, and deceased adores Atum (?).

M.M.A. photos. T. 2128–34; Chic. Or. Inst. photos. 3011–14, 3601, 3663, 3668. **II**, Varille in *B.I.F.A.O.* xxxv (1935), pls. i, ii, pp. 154–7. Harpist (omitting block in Berlin), Schott in *Mélanges Maspero*, i, pl. ii [3], cf. p. 460; id. *Altägyptische Liebeslieder*, pl. 21; Schott photo. 3731. Block in Berlin, Sachs, *Musikinstrumente*, Abb. 75, cf. p. 60; Schäfer and Andrae, *Kunst*, 374 [right], 2nd and 3rd eds. 388 [right]; Lange, *Äg. Kunst*, pl. 112; id. *Lebensbilder*, pl. 58; *Sculptures et textes poétiques de l'Égypte* in *Cahiers d'Art*, xxii (1947), fig. on p. 87; Ragai, *L'Art pour l'art dans l'Égypte antique*, pl. 42 [73]. Tree-goddess scene, Steindorff and Wolf, *Gräberwelt*, pl. 13 [b], p. 64; Wreszinski, *Bericht über die photogr. Expedition von Kairo bis Wadi Halfa*, pl. 73, pp. 99–100; Fisher in *Penn. Mus. Journ.* xv (1924), fig. on p. 48; Schott photos. 3740–1; omitting deceased and offerings, Laurent-Täckholm, *Faraos blomster*, pl. on p. 51; offering-table, Borchardt in *A.Z.* lxviii (1932), Abb. 1, cf. p. 77. Texts of baboons and 1st line of hymn in **I**, Lepsius MS. 225 [middle].

(6) At top, deceased and wife.
Chic. Or. Inst. photo. 3711.

(7) Remains of three registers. **I–II**, Book of Gates, scenes (with Rēꜥ-Ḥarakhti in **II**). **III**, Funeral procession with female mourners and libation-priest before two mummies.

Mourners before mummy in **III**, Chic. Or. Inst. photo. 3898.

(8) Four registers. **I–III**, Deceased offers to divinities (including Khnum and Wen in **I**, Atum in **II**, Rēꜥ-Ḥarakhti in **III**). **IV**, Western goddess in front of pyramid-tomb with portico.

CHIC. OR. INST. photos. 3602, 3666–7. Tomb in **IV**, DAVIES (Nina) in *J.E.A.* xxiv (1938), fig. 15, cf. p. 38.

(9) Colossal seated statues of deceased and wife.

(10) Four registers. **I**, Deceased adores Thoth. **II**, Deceased adores Ma⁽et. **III**, Son with bouquet and man. **IV**, Brother's wife and table of offerings.
CHIC. OR. INST. photos. 3664–5.

(11) Four registers. **I–IV**, Remains of banquet with guests, including Amenemōnet, [Official] in the Temple of Amenophis III on the west of Thebes, in **IV**.
CHIC. OR. INST. photos. 3599, 3639, 3910.

(12) Four registers, **I–IV**, scenes before gods and priests offering, including Inmutf, and deceased kneeling before Thoth holding feather, in **II**, son Amenemōpet (tomb 148) and wife, parents, priests, and table with Opening the Mouth instruments in **III**, and remains of funeral banquet in **IV**.
CHIC. OR. INST. photos. 3004, 3712. Part, M.M.A. photo. T. 2138; libation-priest and lector in **III**, PHILAD. photo. 40106.

(13) Colossal seated statue of deceased with woman standing.

(14) Deceased followed by two offering-bringers (rest destroyed).

(15) Four registers. **I**, Three men. **II**, Royal statuette, and deceased censing. **III**, [Deceased] and wife with two seated couples (one, Amenemōnet and wife). **IV**, Remains of offering-list ritual with priest kneeling, and priest libating before deceased.
CHIC. OR. INST. photos. 3638, 3905–6. **III**, M.M.A. photo. T. 2135. **IV**, PHILAD. photo. 40085; see SPIEGEL in *Mitt. Kairo*, xiv (1956), p. 199.

Passage.
(16) Left thickness, two registers, **I**, deceased and [wife], **II**, kneeling lutist. Right thickness, two registers, **I**, deceased and wife, **II**, tree-goddess scene with *ba*s and deceased drinking from pool. Inner left jamb, remains of text.
CHIC. OR. INST. photos. 3640–2. Right thickness, PHILAD. photos. 34901, 34908.

(17) and (18) Three registers, Book of Gates, &c. **I**, Seven scenes, including gods dragging barks. **II**, Eleven scenes, deceased before divinities. **III**, Eleven scenes, including weighing, and Ḥarsiēsi with assessors before Osiris and Anubis with goddess.
CHIC. OR. INST. photos. 3604, 3610, 3634–7, 3645, 3713, 3909. Deceased before Horus of Edfu, before Osiris Khentimentiu, and before Monthu of Madâmûd, in **II**, GR. INST. ARCHIVES, photos. 1965–8 (by STOPPELAËRE).

(19) Autobiographical text with deceased at bottom.

(20) and (21) Three registers, Book of Gates, &c. **I**, Seven scenes, including gods dragging bark, serpent-divinities, and statue of deceased purified. **II**, Eleven scenes, including divine barks, deceased adores bark of Sokari, deceased adores ram on shrine (twice), Ḥathor-cow in mountain with Western goddess, tomb, and Nut making *nini*. **III**, Eleven scenes, including deceased in front of *zad*-pillar, deceased opening gate, deceased led by Isis and Nephthys, and led by Anubis, Fields of Iaru, deceased and wife angling with men picking grapes above, and remains of marsh-scenes.

CHIC. OR. INST. photos. 3603, 3605–10, 3643–4. Purification in **I**, and bark of Sokari and Hathor-cow in **II**, PHILAD. photos. 34959, 40105. Deceased and wife seated with offerings in **III**, id. ib. 40103; angling and grape-picking, DAVIES and GARDINER, *Seven Private Tombs at Kurnah*, fig. 7, cf. p. 44; M.M.A. photo. T. 2139.

(22) Entrance to Shrine. Entablature, with *zad*-pillar upheld by deceased on each side. CHIC. OR. INST. photo. 3600.

Pyramid. (L. *D. Text*, No. 8.) Views, PHILAD. photos. 34840, 34845.

Bricks with cartouches of Amenophis II, in Philad. Univ. Mus. 29.86.711, 29.87.620–1, CHASSINAT in *B.I.F.A.O.* x (1912), p. 167 [middle] with note 2. See L. *D. Text*, iii, p. 240 [8].

Finds

Fragment of relief with head of deceased, and inlay from box of deceased, in Philadelphia Univ. Mus. 29.87.624 and 29.86.407. Relief, PHILAD. photo. 40159.

159. RAʿYA ⌒°◊𓎡, Fourth prophet of Amūn. Dyn. XIX.
Draʿ Abû el-Nagaʿ.
Wife, Mutemwia ⌐𓆓𓎼𓀭.

Plan, p. 264. Map II, D–6, c, 1.

Description and copies of texts (except (1) and (2)) by GREENLEES are in Philadelphia Univ. Mus.

Hall.

(1) Two registers. **I**, Book of Gates, deceased and wife before personified *zad*-pillar and other emblems in shrines. **II**, Funeral procession, with late graffito of Simut 𓅭𓎡. Below scenes, sketch of boat with coffin.
Zad-pillar, SCHOTT photo. 6000. Sketch of boat, BAUD, *Dessins*, fig. 83.

(2) Two registers. **I**, Book of Gates, [deceased and wife] before guardians with knives. **II**, Scribe, priests, and female mourners before mummies at pyramid-tomb (with frieze of cones) in mountain.
Scribe and priest in **II**, PHILAD. photo. 40111; mourners with mummy, WERBROUCK, *Pleureuses*, fig. 33, cf. p. 51; mummies in front of tomb, BORCHARDT, &c., in *Ä.Z.* lxx (1934), Abb. 1, cf. pp. 25–6; tomb in mountain, DAVIES (Nina) in *J.E.A.* xxiv (1938), fig. 14, cf. p. 38; DESROCHES-NOBLECOURT in *L'Amour de l'art*, xxviii, fig. on p. 210.

(3) Three registers. **I**, Deceased adores two barks. **II** and **III**, Offering-scenes with couples.

(4) Three registers. **I**, Book of Gates, remains of deceased and wife before divinities. **II**, Two scenes, **1**, [son], followed by people kneeling with offerings, offers [bundle of onions] to deceased and wife, with cat, and monkey, under chairs, **2**, priest, censing and libating, offers two candles. **III**, Oxen dragging shrines in funeral procession.
Deceased and wife in **II**, **1**, FISHER in *Penn. Mus. Journ.* xv (1924), pl. facing p. 29; PHILAD. drawing, 74; wife, SCHOTT photo. 5999; onions, WILBOUR, *Travels in Egypt*, fig. on p. 226. **II**, **2**, DAVIES in *J.E.A.* x (1924), pl. vi [9], p. 12, note 2; SCHOTT photo. 5976.

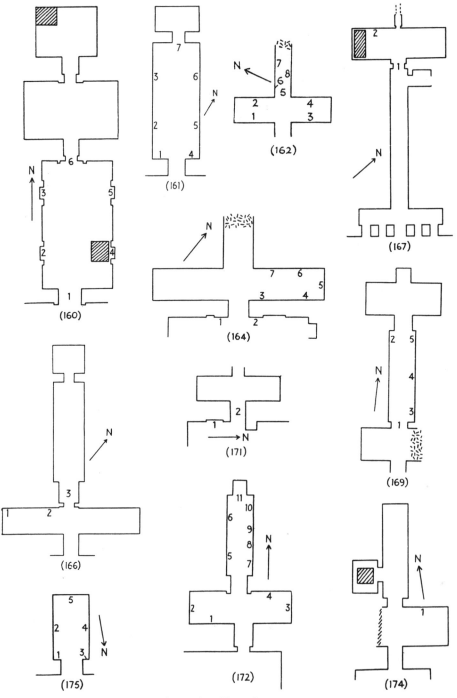

TOMBS 160–2, 164, 166–7, 169, 171–2, 174–5

Text above oxen in **III**, Lüddeckens in *Mitt. Kairo*, xi (1943), pp. 153–4 [76] (from copy by Sethe).

(5) Three registers. **I**, Book of Gates, deceased and wife before [divinities in shrines]. **II**, *Sem*-priest offers to deceased and wife. **III**, Group of female mourners, and officials. Sub-scene, servants with food-tables.

III and sub-scene, Schott photo. 6001; mourners, Capart, *Documents*, i, pl. 65; one, Werbrouck, *Pleureuses*, fig. 112, and fig. on 2nd page after p. 159.

Frieze, Anubis-jackals, Ḥatḥor-heads (sketched), and texts. Omitting texts, Baud, *Dessins*, fig. 84; Hay MSS. 29853, 128.

Ceiling. Ducks, pigeons, and lotus, as decoration, Northampton, &c., *Theban Necropolis*, p. 9, fig. 6; Werbrouck in *Mélanges Maspero*, i, fig. 2, cf. p. 24; Davies (Nina), *Anc. Eg. Paintings*, ii, pl. ci; Fisher in *Penn. Mus. Journ.* xv (1924), pl. facing p. 36; Philad. photos. 34990, 40102, and drawings, 72–3.

Shrine.

(6) Thicknesses, deceased and wife on each. (7) and (8) Son with libation-vases (sketch).

(9) Seated statues of deceased and wife, with man adoring on wall beside her. Philad. photo. 40100.

Finds

Head of statue. Philad. photo. 40138.

160. Besenmut 𓀀𓏤𓈖𓏏, True royal acquaintance. Saite.
Dra' Abû el-Naga'. (Champollion, No. 46.)
Parents, Pedemut 𓀀𓈖𓏏 and Tahibet 𓈖𓏏𓏤.
Plan, p. 272. Map II, D–6, c, 1.

Champ., *Not. descr.* i, pp. 538–9 with plan; Fisher in *Penn. Mus. Journ.* xv (1924), pp. 43–4; Rosellini MSS. 284, G 58 verso. Copies of texts by Greenlees are in Philadelphia Univ. Mus.

Hall.

(1) Outer lintel, remains of scene, right jamb, text with deceased seated at bottom. Inner lintel, deceased with wife seated, and five gods, left jamb, text.
Outer jamb, Philad. photo. 34898.

(2), (3), (4), (5) [1st ed. 1–4] Recesses. Lintels, scenes of deceased and offerings (including seven sacred oils at (5)). Jambs, text with deceased seated at bottom.
Philad. photos. 34856–7, 34956–7. Recess at (4), Philad. drawing, 75. Recess at (5), Gr. Inst. Archives, photo. 1034. Names and titles, Champ., *Not. descr.* i, pp. 538–9. Offerings and texts at (2), (3), and (5), Lepsius MS. 223 [middle and bottom], 224 [upper].

(6) Entrance to Inner Room. Outer lintel, deceased seated, jambs, texts, and beyond them three registers, deceased facing inwards.
Lintel and jambs, Philad. photos. 34849–51, and drawing, 76.

Frieze-text on all walls.
Ceiling, decoration and texts. Philad. drawing, 77.

161. NAKHT ⟦‾‾●⸛⟧, Bearer of the floral offerings of Amūn. Temp. Amenophis III (?).

Dra' Abû el-Naga'. (L. D. *Text*, No. 13, HAY, No. 9.)

Parents, Guraru ⟦𝕘⟧, Gardener of the divine offerings of Amūn, and Kay ⟦⟧.
Wife, Taḥemt ⟦⟧.

<div align="center">Plan, p. 272. Map II, D–6, d, 3.</div>

WERBROUCK and VAN DE WALLE, *La Tombe de Nakht, Notice sommaire*, passim; L. *D. Text*, iii, p. 241; HAY MSS. 29824, 50 verso–51 verso (with sketches). Name of wife, ROSELLINI MSS. 284, G 59–59 verso. A model of the tomb, painted by BAUD from HAY MSS., is in Brussels, Mus. roy. du Cinquantaire.

Hall.

(1) and (2) [1st ed. 2, 3] Deceased at (1) offers on braziers, with priest offering below, and at (2) wife with her son, followed by four sons with bouquets and four daughters with offerings.

HAY MSS. 29822, 92 [near left], 93 [left], 99, 106, 29851, 6–13, 35–44; omitting daughters, SCHOTT photos. 3716, 8728–34. Part at (2), WERBROUCK and VAN DE WALLE, pl. facing p. 9 [left], cf. p. 14. Text above deceased, and texts at (2), LEPSIUS MS. 278 [bottom]–279 [top].

(3) [1st ed. 4] Three registers. I, Son Ḥuynūfer ⟦⟧, Gardener of the divine offerings of Amūn, followed by sisters and brothers with bouquets, offers bouquet of Amūn to deceased and wife. II, Deceased and family with daughter offering to them, and two rows of musicians (male harpist and lutist, women with shoulder-harp, harp, lyre, lute, and double-pipe, and clapping), jars, and guests. III, Deceased inspects watering garden with guests seated beyond.

WERBROUCK and VAN DE WALLE, pls. facing pp. 9 [right], 16, cf. pp. 15–17; HAY MSS. 29822, 93 [right], 96, 100, 103–5, 106 verso, 107, and 29851, 55–66, 70, 74, 29853, 104, 201. I and II, incomplete, SCHOTT photos. 3705–10, 6010–11, 8735–46. Son before deceased and wife in I, SCHOTT, *Das schöne Fest*, pl. vi, p. 814; CHIC. OR. INST. photo. 10294; vase with leaping bulls decoration, CHAMP., *Mon.* clxviii [4]; ROSELLINI, *Mon. Civ.* lx [3]; PRISSE, *L'Art égyptien*, ii, 81st pl. [4] 'Amphores, Jarres . . .', cf. *Texte*, p. 434. Musicians in II, CHIC. OR. INST. photos. 10294–5; female musicians, CAILLIAUD, *Arts et métiers*, pl. 41 A [5–10]; CHAMP., *Mon.* clxxv [2]; ROSELLINI, *Mon. Civ.* xcviii [2]; male harpist, SCHOTT in *Mélanges Maspero*, i, pl. i [4], p. 464. Texts in I–III, LEPSIUS MS. 276–8 [middle], and column of text at left end with cartouche of ʿAḥmosi Nefertere, 279 [bottom].

(4) [1st ed. 9 on plan, and entry at 1] Deceased and wife returning to tomb from New Year Festival.

HAY MSS. 29822, 92 [left], 29851, 45–54; SCHOTT photos. 3728, 6014–15, 8751. Text, LEPSIUS MS. 280 [top].

(5) [1st ed. 8] Four registers, funeral ceremonies. I, Priest with offering-list before deceased and wife, [rites before mummies, foreleg-rite, shrines, and deceased and wife adore Osiris]. II, Anubis seated in shrine, Abydos pilgrimage, and deceased and wife before Anubis. III, Offering-bringers, men with funeral outfit, and deceased with wife offering bouquets to Western goddess. IV, Dragging sarcophagus with 'Nine friends', group of female mourners, offering-bringers, and priests before mummy at tomb.

W ERBROUCK and VAN DE WALLE, pl. facing p. 8 [right], cf. pp. 19–22; BARUCQ, *Religions de l'Égypte*, i, *L'Égypte pharaonique*, fig. 16 on p. 88; HAY MSS. 29822, 94 [right], 97–8, 101–2, 109 verso–112, 29851, 27–34, 67–9, 81–8, 29853, 147–51, 156–7, 200, 204–5. Parts of I–IV, SCHOTT photos. 6013, 8747–50. Sketch and texts of I–III, LEPSIUS MS. 272 [lower]–275 [middle]. Two mourners in IV, WERBROUCK, *Pleureuses*, fig. 164, cf. pp. 51–2.

(6) [1st ed. 7] Two registers. I, Deceased with wife adoring offers lotus and papyrus-bouquet of Amūn to Osiris, [Ḥathor, and ʿAḥmosi Nefertere]. II, Son Ḥuy as priest, followed by parents of deceased (twice represented), with offering-list before deceased and wife.

W ERBROUCK and VAN DE WALLE, pl. facing p. 8 [left], cf. p. 14; WERBROUCK in *Bull. des Mus. roy.* 3 Sér. 1, No. 3 (1929), p. 60, fig. 3 (by BAUD); HAY MSS. 29822, 94 [left], 109, 29848, 63 [lower]–64 [upper], 29851, 16–26, 75–80, 29853, 140–1, 143–4. Deceased with offerings in I, SCHOTT, *Das schöne Fest*, Abb. 15, cf. p. 819; CHIC. OR. INST. photo. 10295; SCHOTT photos. 3719–20, 6012. Upper part of Queen, NORTHAMPTON, &c., *Theban Necropolis*, fig. 4, cf. p. 6; cartouche and headdress, L. D. Text, iii, p. 241. Texts, incomplete, LEPSIUS MS. 271 [middle]–272 [upper].

(7) [1st ed. 5–6] Entrance to Shrine. Left of doorway, stela with double-scene, deceased and wife adoring Osiris, and adoring Anubis, and text below. Above the stela, deceased offers bouquet to Tuthmosis III, and below it, deceased as priest with female mourner libates before food-table. Right of doorway, false door. Above the false door, deceased offers bouquet to [Amenophis I and Prince ʿAḥmosi Sipaar], and below it, deceased as priest with female mourner before food-table.

W ERBROUCK and VAN DE WALLE, pl. facing p. 17, cf. pp. 14, 23; WERBROUCK in *Bull. des Mus. roy.* 3 Sér. 1, No. 3 (1929), p. 59, fig. 2 (by BAUD); WERBROUCK in *Chronique d'Égypte*, iv (1928), fig. on p. 36; HAY MSS. 29822, 92 [right], 107 verso, 108, 108 verso, 29851, 1–5, 29853, 175–9, 29824, 43–4, 46. Stela, DUEMICHEN, *Altaegyptische Kalenderinschriften*, pl. xlvii (inaccurate); SCHOTT photo. 3722. Scene above false door, CHAMP., *Mon.* clxii [2]; ROSELLINI, *Mon. Stor.* xxix [3]. Text of stela, HERMANN, *Stelen*, p. 37* (from DUEMICHEN); texts of top scenes, LEPSIUS MS. 270–1 [top]; of King and prince, L. D. Text, iii, p. 241 [a].

Ceiling. Grape-decoration, SCHOTT photo. 3724.

162. ḲENAMŪN[1] 𓉐𓂋𓏤, Mayor in the Southern City, Overseer of the granary of Amūn. Dyn. XVIII.

Draʿ Abû el-Nagaʿ. (Inaccessible.)
Wife, Mut-tuy 𓂝𓈖𓆑𓏏𓏏𓏤 (from cone).

Plan, p. 272. Map II, D–6, f, 3.

Hall.

(1) [1st ed. 1] Two registers. [I, Deceased, followed by wife and four women with sistra and flowers, offers on braziers, and three men offer to deceased (?). II, Arrival of Syrian freight-ships, with three rows of market-scenes, and Syrians bringing produce, including two humped bulls, bull's-head vase, and statuette of bull.]

DARESSY in *Rev. Arch.* 3 Sér. xxvii (1895), pls. xiv, xv, pp. 286–92; id. in *R.E.A.* iii (1931), pls. xi, xii, pp. 20–32 with figs. 1–3, cf. pl. x (from copy by LEGRAIN). II, DAVIES and

[1] Name and titles from cones. DARESSY, in *R.E.A.* iii (1931), pp. 28–9, gives owner as Ḥar. . . 𓄿𓏏, Eyes of the King in the North Land, Ears of Ḥaremmaʿet, from text in I at (1).

FAULKNER in *J.E.A.* xxxiii (1947), pl. viii, pp. 40–6; STEINDORFF, *Blütezeit* (1926), Abb. 63; BOSSERT, *The Art of Ancient Crete*, p. 290 [549]; KÖSTER, *Schiffahrt und Handelsverkehr* [&c.], pl. i, p. 20; KLEBS, *Die Reliefs und Malereien des Neuen Reiches*, Abb. 144 (from KÖSTER), cf. pp. 231–3.

(2) Fragment, probably from here, man with heap of jars, &c.

(3) Two registers. **I,** Deceased and wife with [monkey, goose, and dog] under her chair. **II,** Two scenes, **1,** son as *sem*-priest offers to deceased and wife with scribe's outfit under her chair, **2,** deceased, followed by wife, offering-bringers, and female relatives, offers on braziers. Sub-scene, offering-bringers and butchers.

(4) Deceased with two men offers bouquet and birds to King, with ploughing beyond, and dado with lotus and birds.

Passage.

(5) Thicknesses, deceased meets parents. (6) Deceased with wife and family offers to Osiris. (7) Two registers, **I–II,** funeral procession to Anubis and Ḥathor, including Abydos pilgrimage with boats containing horses in **II.** (8) Remains of three registers, funeral procession, offering-bringers, mourners, &c.

163. AMENEMḤĒT 〔☰⚊〕, Mayor of the Southern City, Royal scribe. Dyn. XIX.
Dra' Abû el-Naga'. (Inaccessible.)
Father (?), Ḥuy, Judge, Mayor. Wife, Nezemt-net 〔.
Map II, D–6, e, 1.

Scenes include the following. Hymn to Osiris, and scene below, harpist with song before deceased, wife, and parents. Man kneeling, four priests carrying statuettes, &c., and deceased and wife seated in booth with offerings. Deceased seated with hymn (on jamb?).
SPIEGELBERG squeezes, made in 1895.

164. ANTEF 〔, Scribe of recruits. Temp. Tuthmosis III.
Dra' Abû el-Naga'.
Plan, p. 272. Map II, D–6, e, 2.

Façade.

(1) [Deceased] adoring. (2) Deceased adoring with hymn.
Scene at (2), SCHOTT photo. 3730, cf. 6610.

Hall.

(3) and (4) Two registers (middle broken away). **I,** Deceased and wife seated. **II,** Sons bringing fruit, animals, &c.
I, incomplete, SCHOTT photos. 6622–3, 6625–6.

(5) Stela, hymn to Amen-rēʿ-Ḥarakhti (duplicated in tomb 110 (2)) and [autobiographical text]. At left side, column of text.
SCHOTT photos. 6611–15. Texts, HERMANN, *Stelen*, pl. 9 [a], pp. 38*–39* (from SCHOTT photos.).

(6) Deceased spearing hippopotamus, with magical text.

Schott photos. 6616–17. Magical text (in front of deceased), Davies (Nina) and Gardiner, *The Tomb of Amenemhēt*, p. 29 [An].

(7) Deceased fishing and fowling.
Details, Schott photos. 6618–21.

165. Neḥem῾away ⸻, Goldworker and portrait-sculptor. Temp. Tuthmosis IV (?).

Dra῾ Abû el-Naga῾.
Wife, Tentamentet ⸻, called Kay ⸻.

Plan, p. 30. Map I, C–7, a, 10.

Davies, *Five Theban Tombs*, pp. 40–1, with plan on pl. xv.

Hall.

(1) Deceased offers on brazier and pours incense on offerings, with butcher and offering-bringer below. See Davies, p. 40.

(2) Two registers. **I**, Three rows of banquet before deceased and wife. **II**, Abydos pilgrimage, and funeral procession with bark carried by priests before deceased and wife.
See Davies, p. 40. Wife in **I**, and deceased and wife in **II**, Baud, *Dessins*, fig. 87.

(3) Two men offer libation and cloth to deceased.
Baud, *Dessins*, on pl. xxx, p. 184. See Davies, p. 41.

(4) Deceased and family fowling and fishing. Sub-scene, sketches of netting fowl, cleaning fish, picking grapes and wine-press.
Baud, *Dessins*, pl. xxx, pp. 183–4. Remains of deceased with text, Davies, pl. xxxix [middle right], pp. 40–1. Text, Helck, *Urk.* iv. 1606–7.

(5) Two registers. **I**, Son (?) offers bouquet and offering-list to deceased with family. **II**, [Servants with food] before deceased and wife.
Baud, *Dessins*, pl. xxix, p. 183. See Davies, pp. 40, 41.

(6) Ends of sketched scenes. On left, three girls, on right, three registers, rites before mummies.
Baud, *Dessins*, figs. 85–6. See Davies, p. 40.

Ceiling, remains of text. See Davies, p. 41.

166. Ra῾mosi ⸻, Overseer of works in Karnak, Overseer of cattle. Dyn. XX.

Dra῾ Abû el-Naga῾.
Parents, Ipy ⸻, Chief prophet of Thoth, and Ḥati ⸻, Chief of the harîm of Thoth. Wife, Tay ⸻, Chief of the harîm of Thoth.

Plan, p. 272. Map I, C–7, b. 8.

Hall.

(1) Men and women with bouquets and sistra before three divinities.

Men and women, BAUD, *Dessins*, pl. xxxi and fig. 88. Two men and a woman, and grass-hoppers on sheaf of corn in bouquet, KEIMER in *Ann. Serv.* xxxiii (1933), pl. xii and fig. 78.

(1)–(2) [1st ed. 1, 2] Base, two lines of text with names of overseers of works in various temples.

Middle, BAUD, *Dessins*, fig. 89; lower line, BRUGSCH, *Thes.* 1142 [6] (from copy by ERMAN); names of some temples, NIMS in *J.N.E.S.* xiv (1955), fig. 1 [2], cf. p. 112.

Passage.

(3) [1st ed. 3–5] Outer lintel, double-scene, deceased and wife adore Osiris, and adore Anubis, and jambs, offering-texts. Left thickness, deceased and wife, and text mentioning Festival of Sokari.

Texts, PIEHL, *Inscr. hiéro.* 1 Sér. xcviii–c [a–δ (lintel), ε–η (left jamb), θ–κ (right jamb), λ (left thickness)]; texts of jambs and thickness, GOLENISHCHEV MSS. 3 [a–c]; parts, BERG-MANN, *Hieroglyphische Inschriften*, lxxxiii–lxxxiv [1–3], pp. 57–8; BRUGSCH, *Thes.* 1141 [bottom].

Frieze, Ḥathor-heads and Anubis-jackals. See MACKAY in *Ancient Egypt* (1920), p. 121.

167. Name lost. Dyn. XVIII.

Dra' Abû el-Naga'. (Unfinished.)

Plan, p. 272. Map I, C–7, a, 9.

Inner Room.

(1) Outer lintel, remains of text. (2) Two registers, offering-bringers.

Frieze-text, offering-formula.

168. ANY 𓀭▨▨, Divine father clean of hands, Chosen lector of the lord of the gods. Dyn. XIX.

Dra' Abû el-Naga'.

Wife, Merynub ▨▨.

Map II, D–6, a, 4.

Inner Room.

Remains of painted scenes, and of frieze-text.

Titles of deceased and wife, LEPSIUS MS. 228 [lower].

169. SENNA ▨, Head of the goldworkers of Amūn. Temp. Amenophis II.

Dra' Abû el-Naga'.

Parents, Sensonb ▨ and Tanub ▨. Wife, Ma'etka ▨, Divine adoratress of Amūn.

Plan, p. 272. Map II, D–6, b, 4.

Hall.

Remains of scenes, and of text on vaulted ceiling.

Passage.

(1) Left inner jamb, offering-text. (2) Priest offers to seated couple.

(3) Three registers. **I–III,** Opening the Mouth rites before mummy.
See SCHIAPARELLI, *Funerali*, ii, pp. 289–90 [ix].

(4) Deceased and wife, daughter Maʿetka (with harpist and lutist below her) offering to them, and three registers, banquet.

(5) Daughter Maʿetka offers to [deceased and wife seated with parents], with seated people below.
Texts, LEPSIUS MS. 280 [bottom], 281 [top].

Ceiling, texts.

170. NEBMEḤY(T) ⳩, Scribe of recruits of the Ramesseum in the estate of Amūn. Temp. Ramesses II.
 Sh. ʿAbd el-Qurna.
 Map IV, E–5, b, 1.
 Hall.
 Left side-wall, stela. Two registers, **I,** double-scene [deceased and wife] before Osiris, **II,** three priests before [deceased and wife], with text at bottom.

171. Name lost. Dyn. XVIII.
 Sh. ʿAbd el-Qurna.
 Wife, Ési ⳩.
 Plan, p. 272. Map IV, E–5, b, 1.
 Façade.
 (1) Stela (illegible).

 (2) Entrance. Left thickness, deceased with couple. Right thickness, deceased and wife.

172. MENTIYWY ⳩, Royal butler, Child of the nursery. Temp. Tuthmosis III to Amenophis II (?).
 Khôkha.
 Mother, Ḥepu ⳩.
 Plan, p. 272. Map IV, D–5, b, 7.
 Hall.
 (1) Deceased offers on braziers, with two registers behind him, **I,** man with incense, and deceased seated with offerings, **II,** offering-bringers with cakes and flowers. Sub-scene, butchers, men with bull, and (remaining) offering-bringer.
 M.M.A. photos. T. 3064–6. Details, SCHOTT photos. 8505–8, 8595–6. Texts, LEPSIUS MS. 264 [top and middle]. See SCHOTT, *Das schöne Fest*, p. 868 [47–8].

 (2) Stela, double-scene, offerings before Osiris, and autobiographical text. At left side, four registers, offering-bringers.

HERMANN, *Stelen*, pl. 3 [b], pp. 37, 17* [89], 40*–1* [upper]; M.M.A. photos. T. 3067–8; SCHOTT photos. 8520, 9251. Autobiographical text, HELCK, *Urk.* iv. 1466–8.

(3) Two registers. **I,** Double-scene, deceased with offerings, and with bouquet, before seated King. **II,** Imitation granite false door with offering-bringers at sides.

M.M.A. photos. T. 3071–2.

(4) [1st ed. 1] Two registers. **I,** Deceased with daughter (?) fishing and fowling, and man offering to deceased. **II,** Two rows of men bringing calves and produce of marsh-lands to deceased.

M.M.A. photos. T. 3069–70. Fishing and fowling, WRESZ., *Atlas*, i. 354; daughter (?) in fishing-scene, SCHOTT photo. 5777.

Passage.

(5)–(6) Three registers, funeral procession to Anubis, and to Osiris, including funeral outfit and lector with Opening the Mouth instruments in **I,** *teknu*, mummers, and women before pools in **II,** and bringing chariots, and butcher, in **III.**

M.M.A. photos. T. 3079–82. Details, SCHOTT photos. 5798–5800, 8597.

(7) [1st ed. 4] Deceased on foot hunting game, including ostriches, in desert. Sub-scene, ploughing.

M.M.A. photos. T. 3073–4. Main scene, WRESZ., *Atlas*, i. 353; FARINA, *Pittura*, pl. lxxxv; SCHOTT photos. · 5778–86, 7426–30. Deceased shooting, WILKINSON, *M. and C.* i. 306 (No. 29) = ed. BIRCH, i. 204 (No. 34); bow and text, WILKINSON MSS. v. 134 [middle].

(8) [1st ed. 3] Two registers, vintage. **I,** Treading grapes, and pouring wine and sealing jars with offerings to Termuthis as serpent. **II,** Picking grapes and man offering to deceased. Sub-scene, [reaping] and pulling flax.

M.M.A. photo. T. 3075. **I,** and picking grapes in **II,** WRESZ., *Atlas*, i. 355; **I,** SCHOTT photos. 8511–12, 8514. Sub-scene, WILKINSON, *M. and C.* 2 Ser. i. 98 (No. 435) = ed. BIRCH, ii. 427 (No. 478); WILKINSON MSS. v. 134 [bottom].

(9) [1st ed. 2] Deceased with man offering collars as New Year gifts to him, and three registers, carpenters, weighing gold, and goldworkers. Sub-scene, carrying corn, cows treading grain, [winnowing, and offerings to Termuthis].

M.M.A. photo. T. 3076; SCHOTT photos. 5792–4, 8509–10, 8513. Cows treading grain in sub-scene, WILKINSON, *M. and C.* 2 Ser. i. 94 (No. 434) = ed. BIRCH, ii. 424 (No. 477); WILKINSON MSS. v. 135 [top].

(10) [Man] with offerings before deceased and mother.

M.M.A. photo. T. 3077.

(11) Niche with [statues]. Tympanum, double-scene, deceased kneels before Anubis-jackal, and left jamb, four registers, **I–II,** offering-bringers, **III,** vases, **IV,** butcher.

M.M.A. photo. T. 3078.

Ceiling, with offering-text below vault. M.M.A. photos. on T. 3073, 3075–6, 3079–82.

173. KHAᶜY ⟨hieroglyphs⟩, Scribe of the divine offerings of the Gods of Thebes. Dyn. XIX.

Khôkha.

Wife, Biathefu ⟨hieroglyphs⟩.

Map IV, D–5, a, 9.

Jambs with titles of deceased.

Ramesside statues (one destroyed) in Inner Room.

174. ᶜASHAKHET ⟨hieroglyphs⟩, Priest in front of Mut. Dyn. XIX.

Khôkha.

Wife, Tazabu ⟨hieroglyphs⟩.

Plan, p. 272. Map IV, D–5, a, 8.

Hall.

(1) Two registers, I–II, banquet. I, Son Pakhiḥēt ⟨hieroglyphs⟩ (tomb 187) with relatives, offers to deceased and wife with monkey under chair. II, Deceased with sons before [Osiris].

175. No name. Temp. Tuthmosis IV (?).

Khôkha.

Plan, p. 272. Map IV, D–5, a, 9.

Hall.

(1) Three registers, offering-bringers (sketched).
BAUD, *Dessins*, fig. 90.

(2) Three registers, I–III, funeral ceremonies (II and III continued at (5)). I, Offering-bringers. II, Procession with female mourners, butcher, and priest before mummy held by priest. III, Abydos pilgrimage, and priest libating at right end.
WERBROUCK, *Pleureuses*, pl. vi, figs. 34, 66, 120–1, 134; incomplete, SCHOTT photos. 7328–32, 7437–40.

(3) As at (1). Unfinished.

(4) [1st ed. 1] Three registers, I–III (II and III continued at (5)). I, Deceased and wife with girl offering to them, and two rows of guests and female musicians (harp, flute, and lute). II, Preparation of ointment (?). III, Ploughing and oxen treading grain, and two servants at left end.
II, and right part of I, SCHOTT photos. 4026, 7322–6, 7434–6. II, WRESZ., *Atlas*, i. 356.

(5) Three registers, I–III (II and III continued from (2) and (4)). I, Family adores Osiris and Anubis. II, Space for stela, with Ḥathor and Western goddess at left side, and Isis and Nephthys at right side. III, Double-scene, deceased and wife, seated on left (with dog under wife's chair), and standing on right, with offerings.
SCHOTT photos. 4036, 7327, 7441.

176. [AMEN]USERḤĒT [⟨hieroglyphs⟩]⟨hieroglyphs⟩, Servant clean of hands. Temp. Amenophis II to Tuthmosis IV.

Khôkha.

Plan, p. 282. Map IV, D–5, a, 10.

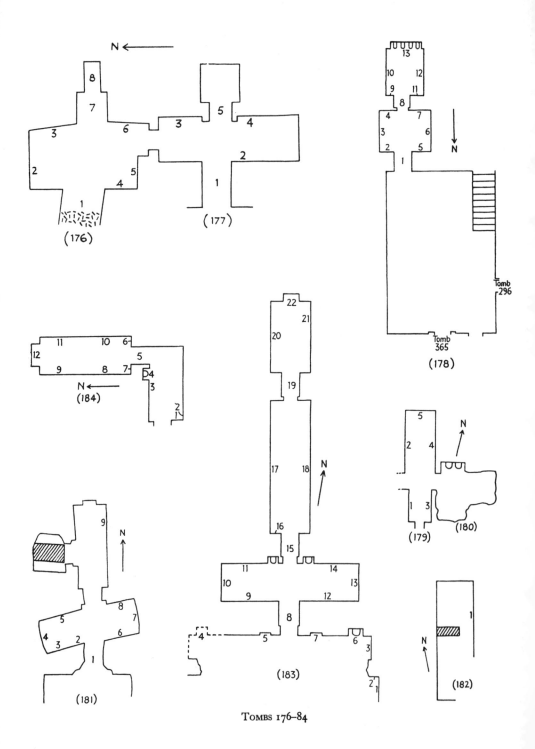

TOMBS 176–84

Hall.

(1) Left thickness, [deceased].

(2) Four registers. **I,** Rowing-boat with mourners. **II,** Men carrying corn. **III–IV,** Abydos pilgrimage.
Schott photos. 4258–60.

(3) Two registers, offering-list ritual. **I,** Priest and offering-bringer. **II,** Deceased purified by priest, followed by priests with incense.
Priests in **II,** Schott photo. 4267.

(4) Remains of three rows of guests with attendants.
Schott photos. 4261–3, 8774.

(5) Two registers, remains of banquet. **I,** Wine-jars, female attendant with fly-whisks, and [two girls dancing]. **II,** Girl offers flowers and food to deceased and wife.
Schott photos. 4254–7, 4269. Girl in **II,** Borchardt in *Ä.Z.* lxviii (1932), pl. v [middle upper], p. 77.

(6) Tree-goddess scene.
Deceased with monkey eating onions under chair, Schott photo. 4268.

Shrine.

(7) Outer lintel, remains of Anubis-jackals, jambs, offering-texts. Left wall, two registers, priest before deceased. Right wall, three registers, **I,** funeral boat on sledge, **II,** two priests, with two torches, and with *ḥes*-vase, before deceased, **III,** man and offerings.
Schott photos. 4264–6.

(8) Niche, with offering-text round entrance.

177. Amenemōpet 𓈖𓏏𓊪, Scribe of truth in the Ramesseum in the estate of Amūn. Temp. Ramesses II (?).
Khôkha. (Unfinished.)
Father, Nebked 𓂋𓏏𓊃, Scribe of the divine seal of the estate of Amūn.

Plan, p. 282. Map IV, D–5, a, 10.

Hall.

(1) Thicknesses, deceased and wife adoring. (2) Winged Maʿet. (3) Deceased and family adore Ḥathor-Mertesger as cow in mountain. (4) Sketch of seated man (probably at banquet).

(5) Entrance to Inner Room. Lintel, double-scene before Osiris and a divinity, jambs, titles.

Ceiling. Titles of deceased, mentioning father.

178. Neferronpet 𓄤𓏏, called Kenro 𓈖𓂋, Scribe of the treasury in the estate of Amen-rēʿ. Temp. Ramesses II.
Khôkha.
Wife, Mutemwia 𓅓𓏏𓅱𓇌.

Plan, p. 282. Map IV, D–5, b, 9.

Hall. View, M.M.A. photo. T. 2865.

(1) Outer lintel, cartouches of Ramesses II in centre with deceased and wife seated before Osiris on left, and jambs, remains of offering-texts. Thicknesses, deceased and wife adoring with hymns to Rēꜥ.

M.M.A. photos. T. 2849–53.

(2) [1st ed. 1], (3), (4) Two registers, **I–II**, fourteen scenes, Book of Gates. **I, 1–4,** Deceased and wife adoring shrines with guardians, **5,** deceased and wife with heap of burnt-offerings, **6,** deceased and wife led by Anubis, **7,** weighing-scene with assessors above and Horus and Thoth reporting to Osiris with Isis and Nephthys. **II, 8,** Deceased and wife drinking from pool, **9–12,** offering-scenes, **13,** harpist with song before deceased and wife playing draughts with cat eating bone under wife's chair, **14,** deceased censes and libates before Amenophis I and ꜥAḥmosi Nefertere.

M.M.A. photos. T. 2855–9, cf. 2865. Lion in **I, 2,** SCHOTT photo. 3465. **I, 7,** LHOTE and HASSIA, *Chefs-d'œuvre*, pl. 146. **II, 8, 9** (incomplete), **10–13,** SCHOTT photos. 3459, 3463, 3469–70. **8,** and deceased and wife in **12** and **13,** LHOTE and HASSIA, op. cit. pls. 37, 44, 141; **8,** and deceased and wife in **13,** DAVIES (Nina), *Anc. Eg. Paintings*, ii, pls. xciv (CHAMPDOR, v, 6th pl.), xcv; **8,** WRESZ., *Atlas*, i. 170 (called tomb 49); FARINA, *Pittura*, pl. cxlvii (called tomb 49); pigeons and palm-trees in **8,** KEIMER in *Bull. of the Faculty of Arts* (*Cairo Univ.*), xiv, Pt. ii (1952), pl. iii (from DAVIES), pp. 93–6. **13,** VARILLE in *B.I.F.A.O.* xxxv (1935), pl. iii [A], pp. 157–8 [ii].

(5), (6), (7) Two registers. **I,** Six scenes, **1,** deceased adores gate with large bouquet and heap of offerings, **2,** men adore personified *zad*-pillar supporting sun-disk with arms of Nut in mountain, **3,** deceased adores Thoth and Maꜥet, **4,** deceased and wife adore Atum and Sekhmet, **5,** deceased and wife adore Ptaḥ and Isis, **6,** deceased and wife adore Rēꜥ-Ḥarakhti and Maꜥet. **II,** Tree-goddess scene, and funeral procession, including dragging sarcophagus, 'Nine friends', female mourners, servants with provisions and with food-tables, ceremonies before mummies, tall bouquet, and stela at pyramid-tomb (with frieze of cones) and portico.

M.M.A. photos. T. 2854, 2861–4. **I, 2, 6,** and deceased and wife in **4,** SCHOTT photos. 3457–8, 3466; **2,** SCHÄFER in *Ä.Z.* lxxi (1933), Abb. 10 (sketch from SCHOTT photo.), cf. p. 26. **II,** Funeral procession, incomplete, SCHOTT photos. 3460–2, 3464, 3467–8. Part at (5), LHOTE and HASSIA, *Chefs-d'œuvre*, pl. at end 18; part at (6) and (7), CHIC. OR. INST. photos. 3949–52. Servants with provisions and with food-tables, NELSON in *J.A.O.S.* lvi (1936), pl. ii [3], p. 235; mourners, and right end of procession, WERBROUCK, *Pleureuses*, pls. xxx, xxxi, figs. 70, 147–8, 169, cf. pp. 52–3; tomb, DAVIES (Nina) in *J.E.A.* xxiv (1938), fig. 8, cf. p. 37; BORCHARDT in *Ä.Z.* lxx (1934), Abb. 3, cf. p. 26.

Frieze. Anubis-jackals and Ḥatḥor-heads.
Ceiling. Titles of deceased, M.M.A. photo. T. 2879.

Inner Room.

(8) Outer lintel, double-scene, deceased and wife adore Osiris and Isis, and adore Rēꜥ-Ḥarakhti and Maꜥet, and jambs, offering-texts. Left thickness, deceased and wife adoring. Soffit, *ba* and bird above pylon as decoration.

M.M.A. photos. T. 2860, 2866, cf. 2865.

(9) and (10) Two registers, eight scenes. **I, 1,** Deceased adores mummified god, **2,** deceased and two women adore mummified god with goddess, **3,** deceased and wife with two rows of braziers adore Tuēris, **4,** deceased and wife adore Ḥatḥor-cow in mountain with stela.

II, 5, Two priests perform offering-list ritual with list, **6,** priest censes with offerings, **7,** priest performs Opening the Mouth ceremony, **8,** priest purifies (each scene with deceased and wife).

M.M.A. photos. T. 2868–70. **II, 8,** LHOTE and HASSIA, *Chefs-d'œuvre*, pl. 35.

(11) and (12) [1st ed. 2, 3] Two registers, nine scenes. **I, 1,** Deceased and wife with offerings before bark with dressed *zad*-pillar supported by Anubis with ibis-standard of Thoth and standard of Wepwaut, **2,** deceased and wife offer to Sokari-Osiris as hawk on shrine, **3,** deceased offers to divine bark. **II, 4,** Deceased as Kenro records five rows of bead-workers, sculptors, and cooks, **5,** House of gold of Amūn with painter on top floor and eight trees beyond, **6,** Treasury of Amūn with gold weighed before scribe, **7,** men storing provisions, **8,** remains of tree-goddess scene, **9,** man before deceased and wife.

M.M.A. photos. T. 2867, 2873–8. Deceased and wife in **I, 1,** SCHOTT photos. 3665–6; bark, LHOTE and HASSIA, *Chefs-d'œuvre*, pl. 150. **II, 4–7,** SCHOTT photos. 3662–4, 3667–8, 4850–2; WRESZ., *Atlas,* i. 73 [a], 74 [a], 75 [a]. **4** and **5,** FARINA, *Pittura*, pl. clxii. **4** and **7,** LHOTE and HASSIA, op. cit. pls. 108–9. **6,** SCHÄFER and ANDRAE, *Kunst*, 358 [1], 2nd ed. 374 [1], 3rd ed. 368 [lower] (all from WRESZINSKI). **7,** CAPART and WERBROUCK, *Thèbes*, fig. 46 (from WRESZINSKI).

(13) Niche with seated statues of deceased with wife, and [N]iay, *warb*-priest of Amūn, with . . .y. Jambs, tall bouquet.

M.M.A. photos. T. 2871–2.

Finds

Brick of deceased as Kenro, from frieze. BORCHARDT in *Ä.Z.* lxx (1934), Abb. a, cf. p. 26, with note 5.

179. NEBAMŪN [𓇋𓏠]▽, Scribe, Counter of grain in the granary of divine offerings of Amūn. Temp. Ḥatshepsut.

Khôkha.

Parents, Yotef 𓈖, Steward of the Lord of the Two Lands, and ʿAḥmosi ▱𓏠𓏤. Wife, Sentnefert 𓏤𓂋𓊪.

Plan, p. 282. Map IV, D–5, c, 9.

Hall.

(1) Deceased consecrates offerings with offering-bringers below.

CHIC. OR. INST. photo. 2958. Mottled jar from offerings, SCHOTT photo. 4849. Translation of text, SCHOTT, *Das schöne Fest*, p. 861 [17].

(2) Deceased and wife with bitch under her chair, [son] with offering-list before them, and five registers, **I–V,** funeral procession to Western goddess, including 'Nine friends' with funeral outfit in **I,** two men dancing in **II,** raising the obelisk ceremony in **IV,** and rites in garden in **V.** Sub-scene, funeral ceremonies, including butchers and Western hawk.

CHIC. OR. INST. photos. 2955–6; parts, SCHOTT photos. 4843–8, 7454–5, 8515–19, 8521. Bitch, DAVIES (Nina), *Anc. Eg. Paintings*, i, pl. xv (CHAMPDOR, Pt. iv, 2nd pl.); DAVIES (Nina), *Eg. Paintings* (Penguin), p. 16, fig. 3.

(3) Remains of deceased seated and offerings. Sub-scene, two female and two male offering-bringers with bull and birds, and priest libating offerings.

Offerings and sub-scene, SCHOTT photos. 8524–7.

(4) Deceased and wife with man offering to them, and three registers, I–III, guests, with male harpist and three female singers in II, and female musicians (one with lyre) and dancer in III. Sub-scene, two rows of women, man filling jars, and guests seated on ground.

I–III, incomplete, SCHOTT photos. 7456–65, 8523. Musicians and some guests, in II and III, WEGNER in *Mitt. Kairo*, iv (1933), pl. vi [a]. Girl before couple with guests below, and part of sub-scene, CHIC. OR. INST. photo. 2957; translation of text of the girl, SCHOTT, *Das schöne Fest*, p. 887 [120].

(5) Remains of painted statue-niche. SCHOTT photo. 4271.

180. No name. Dyn. XIX.

 Khôkha. (Unfinished.) Accessible from tomb 179.

<p style="text-align:center">Plan, p. 282. Map IV, D–5, c, 9.</p>

Niche with seated statues (uninscribed) of deceased and wife.

181. NEBAMŪN 𓍹𓏏𓏤𓏏𓏤𓏤𓏤𓏏𓏤𓎼, Head sculptor of the Lord of the Two Lands, and IPUKY 𓇋𓊪𓏤𓎼𓏏𓏏, Sculptor of the Lord of the Two Lands. Temp. Amenophis III to IV.

 Khôkha.

 Parents (of Nebamūn), Neferḥēt 𓏤𓏤𓏤𓏤 and Thepu 𓏤𓏤𓏤𓏤; (of Ipuky), Senennūter 𓏤𓏤𓏤𓏤 and Netermosi 𓏤𓏤𓏤𓏤. Wife of Ipuky (and probably of Nebamūn), Ḥenutnefert 𓏤𓏤𓏤𓏤.

<p style="text-align:center">Plan, p. 282. Map IV, D–5, b, 8.</p>

DAVIES, *The Tomb of Two Sculptors at Thebes*, passim, with plan and section, pl. iv; SCHEIL, *Le Tombeau des Graveurs* in VIREY, *Sept Tombeaux thébains* (*Mém. Miss.* v, 2), pp. 555–69; DAVIES in *M.M.A. Bull.* Pt. ii, Dec. 1920 (reprinted June 1921, Oct. 1923), pp. 33–40 and figs. 3, 4. Reconstruction, showing frieze of cones, BORCHARDT in *A.Z.* lxx (1934), Abb. 7, cf. p. 31.

Hall. Views, DAVIES, *Two Sculptors*, pl. iii; M.M.A. photos. T. 567–8.

 (1) Left thickness, two registers, I, Ipuky (?) and wife leaving tomb with [hymn], II, men bringing food. Right thickness, two registers, I, Ipuky with staff returning to tomb from temple, II, priests with incense and libation before offerings.

 M.M.A. photos. on T. 567–8; DAVIES, *Two Sculptors*, pp. 27–8, pl. xviii [1] (I on right thickness).

 (2) Nebamūn, with mother and attendant with incense-cone, pours incense on offerings. Sub-scene, butcher with two offering-bringers, and four blind singers with song (hymn to Amūn).

 DAVIES, *Two Sculptors*, pls. v [left], viii, pp. 9–32; SCHEIL, pls. iv [left], v [left], pp. 560–1, 562–3; FARINA, *Pittura*, pl. cxxviii [left]. Right part, LHOTE and HASSIA, *Chefs-d'œuvre*, p. 232, fig. 14 [left]; M.M.A. photos. T. 557 [left], on 567–8. Details of mother and offerings, SCHOTT photos. 4859, 7372–6, 7380. Mother, LANGE, *Lebensbilder*, pl. 54; id. *Äg. Kunst*, pl. 119. One singer, DAVIES in *M.M.A. Bull.* Pt. ii, Dec. 1923, fig. 11 [upper right], cf. p. 46.

(3) [1st ed. 1] Nebamūn (with named dog beside him), mother, and small daughter, with wife offering to them, and three registers, I–III, banquet (with cat under chair of female guest in III). Sub-scene, [*sem*-priest] and four relatives before Ipuky and wife.

DAVIES, *Two Sculptors*, pls. v [right]–vii and frontispiece, pp. 53–7; SCHEIL, pls. iv [right], v [right], pp. 561–2, 563–4; FARINA, *Pittura*, pl. cxxviii [right]; LHOTE and HASSIA, *Chefs-d'œuvre*, p. 232, fig. 14 [right], pl. 114; M.M.A. photos. T. 557 [right]–559; incomplete, WRESZ., *Atlas*, i. 361; SCHOTT photos. 3958–61, 4048–51, 4858, 5801, 7377–9. Offering-scene, PIJOÁN, *Summa Artis*, iii (1945), pl. xxvi facing p. 448; MEKHITARIAN in *Chronique d'Égypte*, xxx (1955), figs. 24–6 (including head of mother, cut out, seen in private possession in Switzerland), cf. pp. 318–23; vessels and cloth (held by wife), SCHOTT, *Das schöne Fest*, Abb. 20–1. II and III, DAVIES (Nina), *Anc. Eg. Paintings*, ii, pl. lxi (CHAMPDOR, Pt. i, 7th pl.); DAVIES (Nina), *Eg. Paintings* (Penguin), pl. 11. II, WINLOCK, *The Private Life of the Ancient Egyptians*, fig. 11 [lower]. III, LANGE, *Ägypten*, pl. 112; id. *Lebensbilder*, pl. 41; ROGERS in *M.M.A. Bull.* N.S. vi (1948), fig. on p. 154; left group, SCOTT, *The Home Life of the Ancient Egyptians*, on cover; cat, DAVIES in *M.M.A. Bull.* Pt. ii, Dec. 1920 (reprinted June 1921, Oct. 1923), fig. 7, cf. pp. 38–9. Three relatives in sub-scene, LANGE, *Lebensbilder*, pl. 60. Texts of Nebamūn in main scene, and of parents of wife of Ipuky in sub-scene, HELCK, *Urk.* iv. 1853 [bottom]–1854 [top], 1855 [top].

(4) [1st ed. 2] Four registers, I–IV, funeral procession, including 'Nine friends' in I and II, bringing funeral outfit and boxes of food in III, and boats with coffin and mourners in IV.

DAVIES, *Two Sculptors*, pls. xx [A], xxii–xxvi, pp. 42–4, 48–9, 50–1; SCHEIL, pls. vi, vii, pp. 564–7; M.M.A. photos. T. 560–2, 1150, on 568. View showing recent damage, FAKHRY in *Ann. Serv.* xlvi (1947), pl. vi, p. 32. Details, SCHOTT photos. 3962–5, 7381–6, 7431–3. Calf in I, MEKHITARIAN, *Egyptian Painting*, pl. on p. 124. Left part of II and III, WEGNER in *Mitt. Kairo*, iv (1933), pl. xxiii [a]. II, LÜDDECKENS in *Mitt. Kairo*, xi (1943), Abb. 26–7, cf. pp. 82–5 [31–2]; coffin on sledge and mourners, LANGE and HIRMER, *Aegypten*, pl. 175 [lower]; LHOTE and HASSIA, *Chefs-d'œuvre*, pl. 27; WERBROUCK, *Pleureuses*, figs. 36, 115, 125, cf. p. 54 and fig. on 2nd page after p. 159; part, LANGE, *Äg. Kunst*, pl. 116; id. *Pyramiden, Sphinxe, Pharaonen*, pl. 38; id. *Lebensbilder*, pl. 50; female mourner beside coffin, SCHOTT, *Altägyptische Liebeslieder*, pl. 22; MEKHITARIAN, *Egyptian Painting*, pl. on p. 122; woman with cymbals (in front of oxen dragging coffin), HICKMANN in *Ann. Serv.* xlix (1949), fig. 12, cf. p. 472; id. in *Bull. Inst. Ég.* xxxvi (1955), fig. 7, cf. p. 592; id. *Musicologie pharaonique*, fig. 7, cf. p. 21. Men with outfit in III, LHOTE and HASSIA, *Chefs-d'œuvre*, pl. at end 19. Boat with mourners in IV, WRESZ., *Atlas*, i. 362; incomplete, LHOTE and HASSIA, op. cit. pl. 26; DAVIES (Nina), *Anc. Eg. Paintings*, ii, pl. lxiii; FARINA, *Pittura*, pl. cxxxi; PIJOÁN, *Summa Artis*, iii (1945), pl. xxiii, facing p. 352; MEKHITARIAN, *Egyptian Painting*, pl. on p. 130; mourner in boat with coffin, and two from group, WERBROUCK, *Pleureuses*, figs. 35, 102, 124, cf. p. 53; group of mourners, and squatting man (in boat), DAVIES in *M.M.A. Bull.* Pt. ii, Dec. 1920 (reprinted June 1921, Oct. 1923), fig. 1, cf. p. 37.

(5) [1st ed. 3] Four registers. I and II, Remains of funeral procession with offering-bringers and mourners to Western goddess, and Nebamūn and Ipuky before Osiris and Isis. III, Servants with food in booths, female mourners, and priests performing ceremonies before mummies with bouquets at tomb (with frieze of cones) and Western hawk. IV, Boats with mourners and funeral outfit, and servants with food in booths, before tomb (with frieze of cones) and Western hawk.

DAVIES, *Two Sculptors*, pls. xix, xx [B], xxi, pp. 37–41, 44–8, 49–50. II–IV, SCHEIL, pl. viii, pp. 567–9; MACKAY in *Ann. Serv.* xiv (1914), pl. ii [left], p. 93; M.M.A. photos.

T. 563–5 [left]. Mourners in **II**, WERBROUCK, *Pleureuses*, pl. ix [left], fig. 92, cf. p. 54. Mourners and servants in **III**, SCHOTT photos. 3967–8, 5804–5, 7387–91; group of mourners, LÜDDECKENS in *Mitt. Kairo*, xi (1943), Abb. 28, cf. pp. 86–7 [33]; CAPART, *Schoonheidsschatten uit Oud Egypte*, Abb. 25; WERBROUCK, *Pleureuses*, pl. x, fig. 106; priest before mummies at tomb, DAVIES (Nina), *Anc. Eg. Paintings*, ii, pl. lxiv (CHAMPDOR, Pt. iii, 3rd pl.); LANGE and HIRMER, *Aegypten*, pl. 175 [upper]; omitting tomb, LHOTE and HASSIA, *Chefs-d'œuvre*, pls. at end 16, 31; WERBROUCK, *Pleureuses*, pl. xi, figs. 145, 150, cf. pp. 53–4; scene with first mummy, and second mourner, LANGE, *Ägypten*, pl. 113; id. *Pyramiden, Sphinxe, Pharaonen*, pl. 33, facing p. 96; first mourner, MEKHITARIAN, *Egyptian Painting*, pl. on p. 128; scene with second mummy and tomb, STOPPELAËRE, *Introduction à la peinture thébaine* in *Valeurs*, Nos. 7–8 (1947), pl. 3; tomb, DAVIES (Nina) in *J.E.A.* xxiv (1938), fig. 2, cf. p. 36. Boats in **IV**, LÜDDECKENS, op. cit. Abb. 29–30, pp. 87–9 [34–5]. Texts of some officials in **IV**, HELCK, *Urk.* iv. 1855 [bottom].

(6) [1st ed. 5] Two registers. **I**, Two scenes, **1**, Nebamūn adores Amenophis I and ʿAḥmosi Nefertere, **2**, Ipuky (?) and wife adore [Ḥathor-cow]. **II**, Deceased inspects workshop, with three rows, 1st, gold weighed and carpenters, 2nd, jewellers and vase-makers, 3rd, metal-workers.

DAVIES, *Two Sculptors*, pls. ix–xiv, pp. 32–3, 57–63; SCHEIL, pls. i, ii, pp. 556–8; FARINA, *Pittura*, pls. cxxix–cxxx; omitting 3rd row in **II**, BAIKIE, *Eg. Antiq.* pl. xxi [upper]. **II**, and King and Queen in **I**, **1**, WRESZ., *Atlas*, i. 357–60; M.M.A. photos. T. 553–6; part of **I**, SCHOTT photos. 4047, 4853, 4856–7, 7392–4; King and Queen, CLARK in *M.M.A. Bull.* N.S. viii (1950), fig. on p. 155 [lower] (from drawing by LINDSLEY HALL). **II**, DAVIES in *M.M.A. Bull.* Pt. ii, Dec. 1920 (reprinted June 1921, Oct. 1923), figs. 2, 8, 10, 11, cf. pp. 38–9; VON BISSING, *Die Kultur des alten Ägyptens*, fig. 43; 1st and 2nd rows, ROSTOVTZEV, *A History of the Ancient World*, i, pl. xlvii [1, 2]; left part, DAVIES (Nina), *Anc. Eg. Paintings*, ii, pl. lxii (CHAMPDOR, Pt. ii, 3rd pl.); LHOTE and HASSIA, *Chefs-d'œuvre*, pls. 106–7; two carpenters in 1st row, MEKHITARIAN, *Egyptian Painting*, pl. on p. 125; DRIOTON and HASSIA, *Temples and Treasures*, pl. 13; part of 2nd row, CHAMPDOR, *Thèbes aux Cent Portes*, fig. on p. 158 [upper]; fragment from 3rd row, in Princeton Univ. Art Mus., see *The Art Quarterly*, xviii (Winter 1955), p. 403. Text of man painting pot in 2nd row, HELCK, *Urk.* iv. 1855 [middle].

(7) [1st ed. 4] Two registers. **I**, Ipuky with Negative Confession adores Osiris and Sons of Horus. **II**, Double-scene, [Nebamūn] before parents, and [Ipuky] before parents holding bouquets.

DAVIES, *Two Sculptors*, pls. xv–xvii, pp. 33–6; SCHEIL, pl. iii, pp. 559–60; M.M.A. photos. on T. 566, 567 [left]. Divinities in **I**, LHOTE and HASSIA, *Chefs-d'œuvre*, pl. viii; baboon-head of Ḥepy, DAVIES in *M.M.A. Bull.* Pt. ii, Dec. 1920 (reprinted June 1921, Oct. 1923), fig. 5, cf. p. 38. Head of mother of Ipuky, MEKHITARIAN, *Egyptian Painting*, pl. on p. 127. Title in **I** and names and titles in **II**, HELCK, *Urk.* iv. 1854 [middle and bottom].

(8) Remains of two registers. **I**, Man offers to [Nebamūn and mother]. **II**, Son with relatives offers bouquet of Amūn to Ipuky and wife.

DAVIES, *Two Sculptors*, pl. xviii [2], pp. 36–7; M.M.A. photo. T. 565 [right].

Inner Room.

(9) [1st ed. 6] Banquet (unfinished). Deceased and wife seated, and girl offering to couple, with blind male lutist and clapper.

DAVIES, *Two Sculptors*, pls. xxvii–xxix, pp. 64–5. Deceased and wife, and musicians,

M.M.A. photos. T. 569, 1070; head of wife, SCHOTT photo. 7395; lutist, DAVIES in *M.M.A. Bull.* Pt. ii, Dec. 1923, p. 47, fig. 11 [upper left].

182. AMENEMḤĒT 〔⎯𝕝⏝〕, Scribe of the mat. Temp. Tuthmosis III.

Khôkha.

Wife, Sit-dḥout 𓏏𓇋.

Plan, p. 282. Map IV, D–5, b, 9.

Hall.

(1) Two registers. **I**, Deceased and wife with monkey under chair, girls offering necklaces to them, musicians (harpist and clappers) and guests. **II**, Offering-bringers with calf, birds, fish, &c.

Girls before deceased and wife, SCHOTT photo. 3892.

Finds. Probably from here.

Statue of deceased kneeling holding stela with hymn to Rēᶜ, found in Khôkha. F.E.R.E. photo. 16067.

183. NEBSUMENU ⏝𝕝𝕝, Chief steward, Steward in the house of Ramesses II. Temp. Ramesses II.

Khôkha.

Parents, Paser 𓀔𓏏, Mayor of the Southern City, and Tuia 𓄿𓏏𓏏. Wife, Bekmut 𓏏𓈖𓏏. (Brother, Hunūfer 𓉐𓏏𓏤 or 𓉐𓏏𓏤, Mayor of the Southern City, Steward in the temple of Amenophis I, with wife Inihy 𓇋𓏏𓇋𓏏, may be owner of tomb 385.)

Plan, p. 282. Map IV, D–5, c, 9.

Titles in Inner Room, LEPSIUS MS. 292 [top and middle].

Court.

(1) King. (2) Hunūfer 𓉐𓏏𓏤 (woman). (3) Deceased purified by [priest]. (4), (5), (6), (7) [Four statues of deceased.]

Hall.

(8) Outer lintel, double-scene, father and deceased before Rēᶜ-Ḥarakhti and Maᶜet on left, Hunūfer and deceased before Osiris and Isis on right, with Nefertem-emblem in centre, and left jamb, text with deceased seated at bottom. Left thicknesses, remains of small scene, Maᶜet with deceased kneeling below, and deceased with hymn adoring. Right inner thickness, deceased and wife adoring.

Texts on left half of lintel, and titles on inner thicknesses, LEPSIUS MS. 289 [bottom]–290 [middle].

(9) [Ritual scenes at top.]

(10) Entablature, and stela with double-scene, deceased with [hymn to Osiris] adores Nefertem-emblem (?) with texts of father and Hunūfer, and dressed *zad*-pillar upheld by deceased on each side.

Hymn to Osiris in right scene, GOLENISHCHEV MSS. 14 [g].

(11) [Ritual scenes at top.]

(12) Three registers. **I,** Rites before mummies. **II,** Scenes from Book of Gates. **III,** Deceased with brother Paḥeripezet ⌗⌗⌗ and mother, with seated relatives beyond. Names and titles in **III,** Lepsius MS. 291 [upper].

(13) Entablature, and stela with double-scene, deceased adores Osiris. Texts of adoration of Osiris, id. ib. 291 [lower]; text on left, Golenishchev MSS. 14 [k].

(14) Three registers. **I,** Rites before mummies. **II,** Scenes from Book of Gates. **III,** Deceased offers to Hunûfer and his wife, and to couple. Texts in **III,** Hay MSS. 29848, 78; Lepsius MS. 290 [bottom]; Golenishchev MSS. 14 [j].

Ceiling, texts.

Passage.

(15) Each side of outer doorway, statue of deceased with Anubis-jackal above. Outer cornice, double-scene, deceased and wife adore bark. Inner left thickness, deceased adoring with remains of text below.

(16) Deceased (facing doorway).

(17) Book of Gates, six scenes. **1,** Priest offers to deceased and wife. **2,** Deceased and wife with assessors, and Maᶜet and Thoth writing. **3,** Weighing-scene with monster. **4,** Deceased led by Thoth to Osiris-Sokari. **5,** Deceased led by Horus. **6,** Horus reports to Osiris with Isis and Nephthys.

(18) Two scenes. **1,** Two registers, **I–II,** funeral procession, with mother and female relatives in **I,** and sarcophagus dragged, and boat with mummy in **II. 2,** [Horus] reports to Osiris with Isis and Nephthys.

Ceiling, texts.

Inner Room.

(19) Outer lintel, double-scene, deceased and wife adoring, followed by *ba,* and jambs, remains of texts. Outer thicknesses and soffit, remains of texts.

(20) Two registers. **I,** Book of Gates, two scenes, **1,** deceased censing and libating before Thoth and Maᶜet, **2,** deceased adores squatting god. **II,** Offering-scenes.

(21) Two registers. **I,** Deceased before divinities, including deceased before Osiris and two divinities on left, and deceased censing and libating before god and Western goddess on right. **II,** Remains of offering-scenes.

(22) Niche. Rear wall, Osiris and a god.

Ceiling, texts.

184. NEFERMENU ⌗⌗⌗, Mayor in the Southern City, Royal scribe. Temp. Ramesses II.

Khôkha.

Plan, p. 282. Map IV, D–5, c, 9.

Hall (in relief).

(1) Name of deceased on left jamb, and man holding statuette (?) on his head beyond. Schott photo. 8627.

(2) Three registers. **I** and **II**, Scenes from Book of Gates. **III,** Woman seated, and priest censing before deceased and wife.

III, Schott photos. 8625–6.

(3) Three registers. **I** and **II,** Scenes from Book of Gates, and deceased adoring god in shrine. **III,** Offerings (?) before deceased and wife.

(4) Niche with statue.

Inner Room (painted). See Spiegel in *Ann. Serv.* xl (1940), p. 265 [top].

(5) Left thickness, two men, right thickness, [deceased], and seated couple below. (6) and (7) Deceased on each side, facing doorway. (8) Wife (following deceased at (7)), and deceased and wife.

(9) Book of Gates, four scenes. **1,** Deceased led by Thoth to Onnophris. **2,** [Weighing-scene (?)]. **3,** Deceased led by Horus. **4,** Horus reports to Osiris with [goddess] and Western goddess.

(10) Litany and man adoring, man before bark of Sokari with Mert (?), and man with image of Maᶜet. (11) Horus reports to Osiris.

(12) [Stela.]

Frieze, text.

185. Senioḳer ⳾🀀, Hereditary prince, Divine chancellor. First Intermediate Period.

Khôkha.

Map IV, D–5, c, 9.

Entrance. Outer jambs, deceased with staff and *kherp*-sceptre. Gr. Inst. Archives, photo. 1726.

186. Iḥy 🀀, Nomarch. First Intermediate Period.

Khôkha.

Wife, Imy 🀀, Prophetess of Ḥathor.

Plan, p. 292. Map IV, D–5, d, 9.

Hall.

(1) Remains of spearing fish, with good name of woman Intefes 🀀. Text, Newberry in *Ann. Serv.* iv (1903), p. 97 [middle].

(2) Boat in marsh-scene, and fish and hippopotamus below.

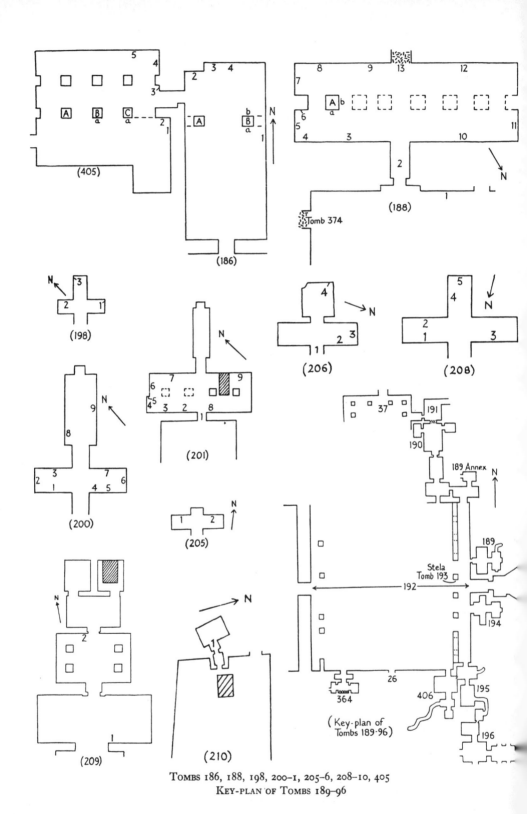

TOMBS 186, 188, 198, 200–1, 205–6, 208–10, 405
KEY-PLAN OF TOMBS 189–96

(3) Deceased with dog under chair, family, and attendants, and three registers, I–III, banquet. **I**, Male and female dancers. **II**, Three female harpists and clapper. **III**, Offering-bringers. Sub-scene, scribes, and men filling granaries.

NEWBERRY, pls. ii [extreme left], iii, p. 99.

(4) Deceased with family inspects five registers. **I**, Tending cattle. **II**, Netting fowl. **III–V**, Bringing bulls, donkeys, and goats.

NEWBERRY, pl. ii, p. 98.

Frieze-text above (3)–(4), NEWBERRY, p. 98 [middle].

Pillar B (*a*) Deceased with two small sons (?). (*b*) Wife.

Scene at (*a*) and text at (*b*), NEWBERRY, pl. i, pp. 97–8 [top].

Architraves between pillars and side-walls. Texts on outer face, west of pillar A, NEW-BERRY, p. 97 [bottom].

187. PAKHIḤĒT 𓀀𓏏𓏏𓆑 (𓀀𓏏𓆑 on jambs), *waʿb*-priest of Amūn. Dyn. XIX.

Khôkha.

Parents, ʿAshakhet (tomb 174) and Tazabu. Wife, Mutemōnet 𓏏𓏏𓏏 .

Plan, p. 90. Map IV, D–5, d, 8.

DAVIES, *The Tomb of Nefer-ḥotep at Thebes*, i, p. 7, with note 10.

Hall.

(1) Outer lintel, double-scene, deceased with two sons before [Osiris], and [scene before Ḥarakhti], and jambs, text, with palimpsest on right jamb. Left thickness, deceased, wife, and [daughter], adoring, with remains of hymn to Rēʿ.

Texts of jambs and thickness, DAVIES, pl. lxi [M, O, cf. N], p. 7, fig. 1; part of text on thickness, LEPSIUS MS. 269 [top].

(2) Servants with food-tables.

See DAVIES, p. 7.

Inner Room.

(3) Niche, with painted entablature above, and dressed *zad*-pillar on each side.

See DAVIES, p. 7.

188. PARENNŪFER 𓀀𓏏𓏏𓏏 , Royal butler clean of hands, Steward. Temp. Amenophis IV.

Khôkha.

Plan, p. 292. Map IV, D–5, c, 6.

DAVIES in *J.E.A.* ix (1923), pp. 136–45, with plan on pl. xxviii.

Court.

(1) Remains of double-scene, Amenophis IV and [Queen] before Aten-rays and altar.

See DAVIES, pp. 136–7 [B–C].

Hall.

(2) Outer lintel, double-scene, deceased adores Rēᶜ-Ḥarakhti with Aten-disk in centre, jambs and outer thicknesses, texts. Inner thicknesses, deceased and wife on each, with hymn to Rēᶜ-Ḥarakhti on left.

Lintel and texts, DAVIES, pls. xxiii [upper], xxvii [a–e, h], xxviii [D], pp. 137–8 [A, D, E]; texts, SANDMAN, *Texts from the Time of Akhenaten* (*Bibliotheca Aegyptiaca*, viii), pp. 140–2 [cxxxi–cxxxiii] (from DAVIES).

(3) [1st ed. 1] Deceased before [Amenophis IV] in balcony, and three registers, I–III, recording produce. I, Granaries with trees. II and III, Scribes recording, with men measuring grain, &c.

Parts, DAVIES, pls. xxii [2], xxv, xxvii [k, l], xxviii [B], pp. 141–3 [K]; M.M.A. photo. T. 1092. Deceased, DAVIES in *M.M.A. Bull.* Pt. ii, Dec. 1923, fig. 14 [left], cf. p. 46. Texts of King and deceased, SANDMAN, op. cit. pp. 142–3 [cxxxv] (from DAVIES); HELCK, *Urk.* iv. 1996 [upper].

(4) Deceased inspects two registers. I, Bringing grapes and sealing and stamping wine-jars. II, Bringing grapes and flowers and men sealing jars.

Texts, DAVIES in *J.E.A.* ix (1923), pls. xxvii [r], xxviii [A, C], p. 143 [middle].

(5) Remains of vintage with treading, pressing, and picking grapes, offerings to Termuthis, and [deceased reporting to Amenophis IV in kiosk].

DAVIES, pl. xxvi, pp. 143–4 [L].

(6) At top, men picking fruit from trees. (7) Deceased and wife seated.

See DAVIES, pp. 144 [M], 140 [H].

(8) Remains of two registers. I, [Deceased with decorations], and deceased seated receives gifts from servants. II, [Deceased with decorations], deceased received by female dancers and musicians (double-pipe and tambourine), and servants with tables of gifts.

See DAVIES, pp. 139 [bottom]–140 [G left].

(9) Two registers before [Amenophis IV and Queen] in kiosk. I, Deceased rewarded. II, Deceased kneeling with two prostrate followers.

Kiosk and texts, DAVIES, pls. xxiii [lower], xxiv [1], xxvii [t–v], pp. 138–9 [G right]; kiosk, M.M.A. photo. T. 1094.

(10) Amenophis IV, followed by deceased wearing collars, before Rēᶜ-Ḥarakhti on altar with souls of Pe (?) on ramp (mostly destroyed), and remains of scene with platform with *rekhyt*-birds and adoring baboons at right end.

Text, DAVIES, pl. xxvii [m], pp. 144–5 [O].

(11) Remains of two registers. I, Deceased with bouquet, offering-bringer, and men with cattle. II, Men with flowers, and deceased.

Text, DAVIES, pl. xxvii [s], p. 145 [P]; SANDMAN, *Texts from the Time of Akhenaten* (*Bibliotheca Aegyptiaca*, viii), p. 143 [cxxxvi]; text of offering bouquet, HELCK, *Urk.* iv. 1996 [lower].

(12) Eight (?) figures of deceased, with sacred staff, offering bouquet to [Amenophis IV and Queen in kiosk].

Two figures of deceased, DAVIES, pl. xxiv [2], p. 140 [J]; M.M.A. photo. T. 1093.

(13) Entrance to Inner Room. Outer lintel, left half, deceased adores [Osiris], and left jamb, offering-texts.

See DAVIES, pp. 140–1 [F]. Texts on jamb, id. ib. pl. xxvii [f, g, i]; SANDMAN, op. cit. p. 142 [cxxxiv].

Pillar A (a) Man offers cloth to deceased. (b) Man offers milk to deceased.
See DAVIES, p. 145 [N, P], pl. xxvii [o] (text of b).

189. NEKHT-ḎHOUT ⟨hieroglyphs⟩, Overseer of carpenters of the northern lake of Amūn, Head of goldworkers in the estate of Amūn. Temp. Ramesses II.
'Asâsîf.
Wives, Netemḥab ⟨hieroglyphs⟩ and Tentpa... ⟨hieroglyphs⟩.
Plan, p. 296, cf. p. 292. Map IV, D–5, a, 5.
Title of deceased, LEPSIUS MS. 247 [near top].

Main tomb.
Façade.
(1) Deceased consecrating, with 'Address to the living'. (2) Four registers, I–II, divine barks on stands, III–IV, temple 'doors of gold' with names.

Hall.
(3) Outer jambs, titles, with deceased seated at bottom. Right outer thickness, remains of text. Inner thicknesses, two registers, I, deceased and Netemḥab adoring with hymn, II, deceased and Netemḥab seated.

Translation of text of deceased going forth 'to see Amūn' in I, on right inner thickness, SCHOTT, *Das schöne Fest*, p. 860 [11].

(4)–(6) Three registers. I–II, Book of Gates, including weighing-scene in II at (5), and autobiographical text giving date, year 55, at (5)–(6). III, Remains of funeral procession with oxen dragging shrines, and mourners, at (4).

(7)–(9) Three registers. Book of Gates, including deceased and Tentpa... before Western goddess making *nini* in III at (7), and son Khensemḥab ⟨hieroglyphs⟩, Head of goldworkers in the estate of Amūn, before deceased and wife in III at (8).

Inner Room.
(10) Doorway to side-room. Outer lintel, double-scene, deceased kneels before Osiris with Isis, and before Osiris with Nephthys, and jambs, offering-text, with deceased embraced by Western goddess beyond on left, and deceased with sceptre beyond on right.

(11) and (12) Three registers, I–III, banquet. I, Two priests with altar and bouquet before deceased. II–III, Male and female guests.

(13) Remains of false door with texts, and son Khensemḥab offering to deceased and wife at bottom. At sides, two registers, I and II, offering-scenes to deceased, including son Amenemwia ⟨hieroglyphs⟩, Priest of Mut of Asher, offering bouquet, in II on left.

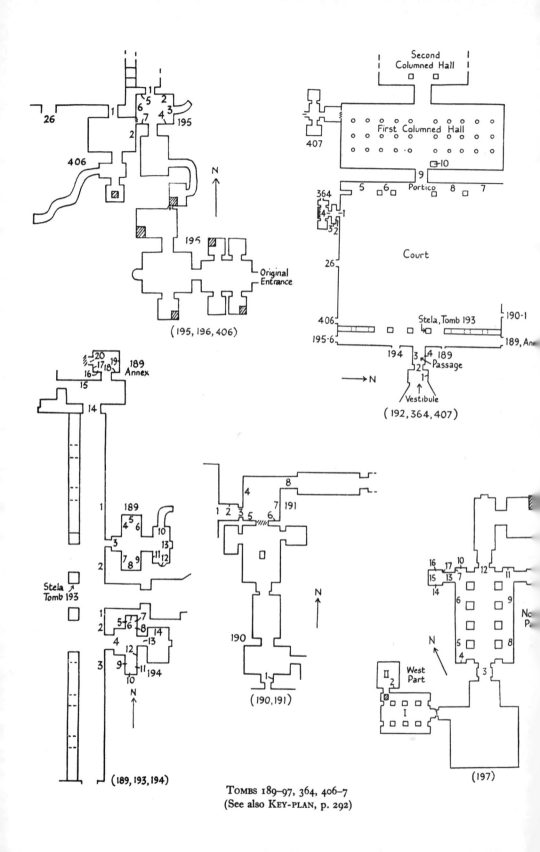

26

195

406

(195, 196, 406)

Original
Entrance

N

Second
Columned Hall

First Columned Hall

407

Portico

Court

Stela, Tomb 193

190-1

189, Ann

Passage

Vestibule

N

(192, 364, 407)

189
Annex

Stela
Tomb 193

189

194

N

(189, 193, 194)

191

190

N

(190, 191)

No.
P.

West
Part

(197)

TOMBS 189–97, 364, 406–7
(See also KEY-PLAN, p. 292)

Annex at north end of Court.

Hall.

(14) Outer lintel, double-scene, deceased and wife Netemḥab before Rēᶜ-Ḥarakhti and Maᶜet, and before Osiris and Isis, left thickness, man before a god. (15) Deceased and wife adoring.

Inner Room.

(16) Two registers, **I**, man purifying deceased and wife, **II**, offering-scene. (17) Two registers, **I**, couple seated, **II**, man offers bouquet to deceased and wife seated. (18) and (19) Remains of Book of Gates, with deceased and wife adoring.

(20) Doorway. Outer lintel, double-scene, deceased, wife, and couple before Osiris and Maᶜet, and deceased, wife, and woman, before Osiris (?) and Isis.

190. ESBANEBDED ⎡𓎛𓏤𓆓𓏏𓏏𓏏⎤, Divine father, Prophet at the head of the King. Saite (usurped from a Ramesside tomb).

'Asâsîf.

Parents, Pakharkhons ⎡𓊖𓆄𓏤𓏤⎤, Divine father, and Meramūniotes ⎡𓈖𓏤⎤, Sistrum-player of Amen-rēᶜ. Wife, Tanub ⎡𓏤𓀀𓏏⎤ .

Plan, p. 296, cf. p. 292. Map IV, D–5, a, 5.

Entrance.

(1) Right thickness. Deceased seated, followed by son Pakharkhons ⎡𓊖𓆄𓏤𓏤⎤, with text giving titles and names of relatives.

191. WEḤEBRĒᶜ-NEBPEḤTI ⎡𓇳𓀀𓎛𓋴⎤, Chamberlain of the divine adoratress, Director of the festival. Temp. Psammetikhos I.

'Asâsîf.

Parents, Pedeḥor ⎡𓂋𓂻⎤ , Head of outline-draughtsmen, and Thesmutpert ⎡𓊖𓏤𓈖𓏏⎤ .[1]

Plan, p. 296, cf. p. 292. Map IV, D–5, a, 5.

Vestibule.

(1) Lintel, son Pedeḥor, Chamberlain of the divine adoratress, before deceased (with names of parents).

Sketch of deceased with text, HAY MSS. 29853, 232.

(2) Hymn to Amen-rēᶜ.

Hall.

(3) Outer lintel, titles of deceased, and jambs, remains of text. Left thickness, hymn to Osiris. (4)–(7) Remains of scenes, including hymn to Osiris at (4), text with names of parents and son, and chair with ibex (?) under it, at (5), two cows at (6), and spell of *uza-ḥtm* at (7).

(8) Entrance to Passage. Left jamb, text.

[1] Exact form not in fount.

192. KHARUEF ▲🜚🜚←, called SENA‘A 🜚, Steward of the Great Royal Wife
Teye. Temp. Amenophis III to IV.

‘Asâsîf.

Parents, Siked 🜚🜚🜚 and Ruiu 🜚🜚🜚.

Plan, p. 296, cf. p. 292. Map IV, D–5, a, 5.

DAVIES in *J.E.A.* ix (1923), pp. 134–6; FAKHRY in *Ann. Serv.* xlii (1943), pp. 450–7, with
titles of deceased on p. 458; HABACHI in *Ann. Serv.* lv (1958), pp. 325–32, with plan and
views, pls. i–iv.

East of Court.

Vestibule.

(1) [Deceased] adoring with hymn to Rēʿ.

M.M.A. photos. T. 2628–30. Hymn, FAKHRY, pp. 461–3; omitting beginning, DAVIES,
pl. xxvii [n], p. 134.

Passage.

(2) [1st ed. 1] Outer lintel, double-scene, Amenophis IV with Teye offers wine to Rēʿ-
Ḥarakhti and Maʿet on left, and censes before Atum and Ḥathor on right, with cartouche in
centre, and jambs, offering-texts with cartouche of Teye at bottom on right.

M.M.A. photos. T. 2631–6. Right scene on lintel, DAVIES in *J.E.A.* ix (1923), pl. xxii [1],
p. 134; DAVIES in *M.M.A. Bull.* Pt. ii, Dec. 1923, fig. 5, cf. p. 44; STEINDORFF and WOLF,
Gräberwelt, pl. 12 [a]. Texts, FAKHRY, pp. 458–61; HELCK, *Urk.* iv. 1872.

(3) Two registers, double-scenes. I, [Amenophis IV] adores ‘Rēʿ-Ḥarakhti’, and libates
before Amenophis III (deified) and Teye. II, Two figures of deceased kneeling.

I, M.M.A. photos. T. 2639–40; right part, HABACHI, pl. xxii [a], pp. 347–8; details,
SCHOTT photos. 8752–7. Texts, FAKHRY, pp. 463–4, cf. 455.

(4) Two registers. I, Address by [Amenophis IV] to gods of the underworld, and [King
adoring?]. II, [Deceased adoring] with hymn to Rēʿ.

I, M.M.A. photos. T. 2637–8. Address to gods, FAKHRY, pp. 465–6, cf. 455; hieroglyph
of bark of Sokari, SCHOTT photo. 8758.

Ceiling. Texts, FAKHRY, p. 466 [bottom]; titles, HELCK, *Urk.* iv. 1872 [bottom].

West of Court.

Portico.

(5) Two registers, I–II, *heb-sed* festival. I, Two scenes, 1, [Amenophis III and Teye] in
boat dragged by priests, with [women acclaiming], 2, Amenophis III and Teye leaving
palace, preceded by priests with standards. II, Eight princesses with vases, and two rows,
upper one, female dancers with song and tumblers, preceded by baboon, flying bird, and
calf, lower one, priests (one wearing mask), female dancers and musicians with tambourines
and with flutes and song. At right end of II, hieratic graffiti.

FAKHRY, pls. xl [left], l [b], li–lii, pp. 492–500, cf. 456–7; CHIC. OR. INST. photos. 9814–25.
Princesses, SCHWEITZER, *Forschungsergebnisse in Ägypten in den Nachkriegsjahren*, Abb. 7,
cf. p. 11; COTTRELL, *Life under the Pharaohs*, fig. 18; LANGE and HIRMER, *Aegypten*, pls. 154–
5; SMITH, *Art . . . Anc. Eg.* pl. 112; WOLF, *Die Kunst Aegyptens*, Abb. 481; four princesses,
HAYES in *M.M.A. Bull.* N.S. vi (1948), fig. on p. 277; two princesses, four clappers, and two

tumblers, SCHWEITZER in *Orientalia*, N.S. xvii (1948), pls. li–liii [12–14], p. 540; three tumblers, DE RACHEWILTZ, *Incontro con l'arte egiziana*, pl. 52, p. 61; four clappers, HICKMANN in *Bull. Inst. Ég.* xxxvi (1955), fig. 3, cf. p. 496, and xxxvii (1956), fig. 1, cf. p. 69; id. *Musicologie pharaonique*, fig. 3, cf. p. 58; id. *45 Siècles de Musique*, pl. xci [A]; tumbler, FATHY in *L'Amour de l'Art*, xxviii, fig. on p. 190 [upper right]; VIKENTIEV in *Bull. Inst. Ég.* xxxvii (1956), pl. iv [A], p. 306. Texts, HELCK, *Urk.* iv. 1868–71.

(6) [Deceased with officials] rewarded, with text of year 30, before Amenophis III, Ḥatḥor, and Teye, in kiosk.

FAKHRY, pls. xl [right], l [a], pp. 488–92. Texts, HELCK, *Urk.* iv. 1865 [lower]–1867.

(7) Two registers. **I,** Two scenes, **1,** Amenophis III and Teye followed by sixteen princesses with sistra at ceremony of raising the *zad*-pillar, **2,** Amenophis III with offerings before personified *zad*-pillar on stand in kiosk. **II,** Two rows, male dancers, singers with hymn to Ptaḥ-Sokari, offering-bringers, songstresses with tambourines, clappers, female dancers from the Oases, and men, some jousting with papyrus-stalks. Sub-scene, partly at (8), boats bringing provisions, butchers, and cattle and donkeys 'driven round the wall of Memphis'.

FAKHRY, pls. xxxix [right and middle], xlv–xlix [a], pp. 476–84, 486–8, cf. 456, 468; DESROCHES-NOBLECOURT, *Religions ég.* fig. on p. 263; CHIC. OR. INST. photos. 9839–44; incomplete, BRUGSCH, *Thes.* 1190–4. Texts, HELCK, *Urk.* iv. 1860–5 [upper]; hymn to Ptaḥ-Sokari, texts on right of *zad*-pillar, and text of cattle, SANDMAN HOLMBERG, *The God Ptah*, p. 44* [219–22], cf. pp. 161–2. Block with heads of first pair of princesses, in Berlin Mus. 18526, SACHS, *Musikinstrumente*, Abb. 23, cf. p. 29; SCHUBART, *Von der Flügelsonne zum Halbmond*, pl. 27 [upper]; BRUNNER in *Ä.Z.* lxxxi (1956), pp. 59–60 with fig.; fragment (showing position in scene), VAN DE WALLE in *Studi in Memoria . . . Rosellini* (Pisa), ii (1955), pl. xxxvi, pp. 284–8. Remains of text, *Aeg. Inschr.* ii. 115.

(8) Deceased, with *ḥeb-sed* text of year 36, followed by [attendants], offers decorative floral vase and necklaces to Amenophis III and Teye, with female sphinx trampling female captives and bound female Nubian and Syrian on Queen's throne, and Nine Bows on base of kiosk. Sub-scene, deceased followed by eight officials.

FAKHRY, pls. xxxix [left], xli–xliv, xlix [b], pp. 469–75, 485; CHIC. OR. INST. photos. 9835–8. King and Queen, LANGE and HIRMER, *Aegypten*, pl. 152; WOLF, *Die Kunst Aegyptens*, Abb. 480; King, DE RACHEWILTZ, *Inçontro con l'arte egiziana*, pl. 28, p. 43; floral colonnettes of kiosk, DESROCHES-NOBLECOURT in SCHAEFFER, *Ugaritica*, iii, fig. 128, cf. p. 181. Side of Queen's throne, LEIBOVITCH in *Ann. Serv.* xlii (1943), fig. 11, cf. pp. 93–5, and fig. 14 [right]. Nine Bows, VERCOUTTER in *B.I.F.A.O.* xlviii (1949), pl. i [1], cf. pp. 111 [i], 118 with fig. 1. Texts, HELCK, *Urk.* iv. 1858–60 [top]; parts of text of year 36, BRUGSCH, *Thes.* 1120 (copied by ERMAN in 1885–6).

Ceiling and architrave. Remains of texts, including deceased as Senaᶜa, FAKHRY, pp. 500–1, cf 457; texts on ceiling, HELCK, *Urk.* iv. 1873 [A–C].

First Columned Hall.

(9) Outer lintel, [Amenophis IV and Teye] adore divinities, and jambs, offering-texts and deceased seated below, with names of parents. Left thickness, deceased and [two women] with hymn to Rēᶜ. Right thickness, deceased with text. Soffit, texts with titles of Osiris and of deceased.

CHIC. OR. INST. photos. 9826–34, 9891. Texts, FAKHRY, pp. 502–8; names of parents, HELCK, *Urk.* iv. 1873 [bottom].

(10) Lower part of seated granite statue of deceased, with names of parents. HABACHI, pl. xxi, pp. 331, 332, 345–7.

Second Columned Hall.

East wall. Graffito, Khaʿemōpet, son of ʿAshakhet, adoring, and other graffiti of scribes, HABACHI, pl. xxii [b], p. 350.

Finds

Fragments of quartzite statue of deceased. See HABACHI, pp. 331, 332.

193.[1] PTAḤEMḤAB ⬚𝄂⬚, Magnate of the seal in the treasury of the estate of Amūn. Dyn. XIX.

ʿAsâsif.

Wife, Tadetawert 𓀀𓃀𓈖𓏏 .

<div align="center">Plan, p. 296, cf. p. 292. Map IV, D–5, a, 5.</div>

Stela, three registers. **I,** Double-scene, deceased adores Osiris, and adores Rēʿ-Ḥarakhti. **II,** Deceased, priest with Opening the Mouth instruments, and lector, before mummy in front of stela with female mourners. **III,** Addresses to deceased.

JANSSEN, *Die Grabstele des Ptahemheb (Theben Nr. 193)* in FIRCHOW, *Ägyptologische Studien (Grapow, 70. Geburtstag)*, 1955, pl. 1, Abb. 1–4, cf. pp. 143–8.

194. ḌḤUTEMḤAB 𓃀𓈖, Overseer of marshland-dwellers of the estate of Amūn, Scribe of the temple of Amūn. Dyn. XIX.

ʿAsâsif.

Father, a *waʿb*-priest in front of Amūn, Scribe of divine offerings of Amūn. Wife, Nezemtmut 𓏏𓈖𓅓 .

<div align="center">Plan, p. 296, cf. p. 292. Map IV, D–5, a, 5.</div>

Façade.

(1) Two registers, **I,** deceased adoring with hymn to Amen-rēʿ, **II,** deceased seated opposite [father?]. (2) Deceased followed by woman with sistrum. (3) Deceased adoring.

Hall.

(4) Outer lintel, double-scene, deceased kneeling before Rēʿ-Ḥarakhti, and before [god], jambs, offering-texts. Left thickness, two registers, **I,** deceased and wife with hymn to Amen-rēʿ-Ḥarakhti, **II,** harpist before deceased and wife. Right thickness, two registers, **I,** deceased and wife with hymn to Osiris, **II,** priest before deceased and wife.

(5) Four registers. **I,** Deceased, followed by brother Amenemōpet, brother (name lost), and women, adores Sokari and Nefertem. **II,** Deceased offers to brother [Amen]ḥotp and wife. **III,** Wife (?) before her parents. **IV,** Deceased censes and libates to his father.

<div align="center">[1] Stela only, but numbered as a tomb.</div>

(6) Stela, three registers, double-scenes, **I,** deceased kneeling before Osiris, and before Horus, **II,** deceased adoring *zad*-pillar, with Ḥathor-head in centre, **III,** deceased kneeling. At each side, *zad*-pillar.

(7) Stela, two registers, **I,** Amenophis I, **II,** deceased kneeling with hymn to Amenophis I.

(8) Stela, two registers, **I,** Ḥathor with sistrum before Theban Triad, **II,** deceased kneeling with hymn to Theban Triad.

(9) Two registers. **I,** Thoth offering to Osiris, Isis, and Horus. **II,** Deceased adoring.

(10) Stela, three registers, similar to (6).

(11) Stela, two registers, **I,** ʿAḥmosi Nefertere with sistrum before Mut, **II,** deceased standing with hymn.

(12) Stela, two registers, **I,** ʿAḥmosi Nefertere offering to Osiris, Horus, and Western goddess, **II,** deceased kneeling with hymn.

Inner Hall.

(13) Outer lintel, double-scene, deceased adores Anubis-jackal. Thicknesses, deceased and wife with hymns (to Amen-rēʿ-Ḥarakhti on right).

(14) Entrance to Burial Chamber (?). At top, deceased and wife with hymn to Ḥathor and Nubit. Outer lintel, double-scene, deceased before [god], and before Anubis.

195. BEKENAMŪN ⟨⟨⟩⟩, Scribe of the treasury of the estate of Amūn. Dyn. XIX.
ʿAsâsîf.
Wife, Wertnefert ⟨⟨⟩⟩.

Plan, p. 296, cf. p. 292. Map IV, D–5, a, 5.

Hall.

(1) Outer lintel, double-scene, deceased kneeling before Rēʿ-Ḥarakhti and before Osiris, jambs, offering-texts. Left thickness, two registers, **I,** deceased with hymn to Rēʿ, **II,** deceased and [wife] seated. Right thickness, two registers, **I,** deceased with hymn to Amen-rēʿ-Ḥarakhti, **II,** priest offers to deceased and wife.

(2) Three registers. **I,** Deceased and wife with hymn before bark of Ptaḥ-Sokari-Osiris. **II,** Deceased and wife before [divinities]. **III,** Priest offers to deceased and wife.

(3) Two remaining registers. **I,** Deceased offers to [goddess]. **II,** Harpist.

(4) Three registers. **I,** [Deceased] offers to Rēʿ-Ḥarakhti and Maʿet. **II,** Deceased and wife before Osiris, Isis, and Nephthys. **III,** Priest offers to deceased and wife.

(5) Deceased before Western goddess making *nini*.

(6) Three registers. **I,** Deceased kneeling before Isis and Sons of Horus. **II,** Wife. **III,** Remains of offering-scene.

(7) Two remaining registers. **I,** Deceased and wife offering to Atum. **II,** Deceased (?) and wife with offerings.

196. Pedeḥorresnet 𓀀𓄿𓃭, Chief steward of Amūn. Saite.
 ʿAsâsîf.
 Parents, Ibi (tomb 36) and Shepenernūte 𓐍𓏤𓈖𓂧.

Plan, p. 296, cf. p. 292. Map IV, D–5, a, 5.

Fragment of coffin of deceased. Habachi in *Ann. Serv.* lv (1958), pls. ix [5], xii [1], p. 333.

197. Pedeneith 𓊪𓄿, Chief steward of the god's wife, the divine adoratress ʿAnkhnesneferebrēʿ. Temp. Psammetikhos II.
 ʿAsâsîf. (Champollion, No. 55.)
 Parents, Psammethek and Tadedubaste 𓍯𓄿.

Plan, p. 296. Map IV, D–5, a, 3.

Champ., *Not. descr.* i, pp. 552–3 with A. Plan, Wilkinson MSS. xlv. A. 1 [right]. Cartouche of ʿAnkhnesneferebrēʿ, Hay MSS. 29848, 68 [middle].

West Part.
Entrance.
 (1) Lintels and jambs, titles, &c. Right thickness, hymn to Rēʿ.
 Titles of deceased and name of mother, Champ., *Not. descr.* i, p. 552 [B, C]; Wilkinson MSS. v. 171 [bottom right].

Room I. Remains of texts on pillars.

Room II. Remains of texts on walls.
 (2) Bark with *Benu*-bird and bark of Rēʿ before Osiris.

North Part.
Pillared Hall.
 (3) Outer lintel, double-scene, deceased before a god, and before Osiris, left thickness, hymn to Rēʿ-Harakhti. (4) Deceased and offering-bringers before Anubis and Ḥatḥor. (5) and (6) Mythological scenes and offering-bringers before deceased. (7) Deceased (several figures) before Osiris and Isis seated.

 (8) and (9) Five scenes. **1**, Deceased before seated gods. **2**, Harsiēsi before Osiris, Isis, and ram-headed god. **3**, Man offers *uzat* to Osiris. **4**, Deceased seated. **5**, Deceased adores Osiris.

 (10) Man adores Osiris and Western goddess. (11) Osiris and Isis.

 (12) Entrance to Inner Room. Outer jambs and thicknesses, texts.

Side-room.
 (13) Outer jambs, texts.

 (14) and (15) Book of Aker.
 Remains of scenes at (14), see Piankoff, *La Création du disque solaire* in *Bibliothèque d'Étude*, xix (1953), p. 70.

 (16) Mythological scenes, with prostrate Osiris on prow of divine bark at right end.

 (17) Deceased offering.

198. RIYA 〈hieroglyphs〉, Head of the magazine of Amūn in Karnak. Ramesside.
Khôkha.

Plan, p. 292. Map IV, D–5, a, 7.

Hall.

(1) and (2) Frieze, Anubis-jackals.

Inner Room.

(3) Jars in destroyed scene.

199. [AMEN]ARNOFRU [〈hieroglyphs〉]〈hieroglyphs〉, Overseer of the magazine. Dyn. XVIII.
Khôkha. (Inaccessible.)

Map IV, D–5, a, 7.

Hall.

Rear wall, sketch of offering-scene. Ceiling, titles of deceased.

200. DEDI 〈hieroglyphs〉, Governor of the deserts on the west of Thebes, Head of the regiment of Pharaoh. Temp. Tuthmosis III to Amenophis II.
Khôkha. (CHAMPOLLION, No. 36, HAY, No. 5.)
Wife, Tuy 〈hieroglyphs〉.

Plan, p. 292. Map IV, D–5, a, 8.

CHAMP., *Not. descr.* i, pp. 527–9 with plan; BURTON MSS. 25644, 70; HAY MSS. 29824, 22; ROSELLINI MSS. 284, G 48 verso, 49 verso. Titles of deceased and wife, SETHE, *Urk.* iv. 995 (292) a, b (at (5)), c (at (3)); WILKINSON MSS. xvii. H. 19 verso [middle].

Hall.

(1) [1st ed. 1, 2] Two registers. **I**, Two scenes, **1**, [deceased and family fowling and fishing], **2**, [man] offers bouquet to deceased and wife with daughter under chair. **II**, Two rows of men netting, preparing, bringing, and recording, fowl and fish, before deceased seated in booth.
M.M.A. photos. T. 3147–8. Omitting deceased and family in **2**, HAY MSS. 29822, 62, 64–6, 68. **I, 2,** and **II**, BURTON MSS. 25644, 55 verso–57, 59 verso–68. Upper row in **II**, WILKINSON, *M. and C.* ii. 19 (No. 80) = ed. BIRCH, i. 290 (No. 99); WILKINSON MSS. v. 106. Lower row in **II**, CHAMP., *Mon.* clxxxv [1, 2]; ROSELLINI, *Mon. Civ.* iv [upper]; four men netting fish, SCHOTT photo. 8598.

(2) Remains of imitation granite stela. At sides, three registers, each with deceased seated, and vintage below, including decanting wine into jars and picking grapes.

(3) [1st ed. 3, 4] Three registers, **I–III** [**II** destroyed], deceased in each bowing with standard (in **II** and **III**, wearing collar with fly-decoration and lion amulets), and two rows, recording of soldiers, before [Tuthmosis III and Amenophis II in kiosk].
Omitting deceased and [Kings], M.M.A. photos. T. 3149–50; CHIC. OR. INST. photo. 2959; HAY MSS. 29822, 63. Soldiers in **III**, WEGNER in *Mitt. Kairo*, iv (1933), pl. xii [a]; lower row, and man and scribe from upper row, SCHOTT photos. 2465, 3477, 8599–601. Cartouches, boat-standard and gazelle-standards, and details, CHAMP., *Not. descr.* i, p. 528;

deceased with standard and collar, and cartouches, BURTON MSS. 25644, 58, 69; boat-standard, and collar, WILKINSON MSS. v. 91 [lower]; standard, WILKINSON, *M. and C.* i. 294 (No. 15, 12) = ed. BIRCH, i. 195 (No. 20, 12). Sketch of the Kings, WILKINSON MSS. xvii. H. 19 verso [middle right].

(4) Three registers. **I,** [Deceased with wife offers on braziers]. **II–III,** Men with fruit and flowers.

M.M.A. photo. T. 3146 [right]. Some men in **II–III,** SCHOTT photos. 8609, 8610 [right].

(5) [1st ed. 5] Three registers. **I,** Two sons offer flowers, and daughter offers wine, to deceased, wife, and daughters. **II–III,** Guests, and attendants with food.

M.M.A. photos. T. 3145–6 [left]. **I,** BURTON MSS. 25656, 4; jars in **I,** some guests and attendant, and two servants, SCHOTT photos. 2467, 8608, 8610 [left], 8611. Names and titles of deceased and wife, CHAMP., *Not. descr.* i, pp. 529 [top], 848 [to p. 529, l. 2 (Paroi c)].

(6) Stela, double-scene, deceased offers to Osiris, and text (damaged) below. At right side, three registers, offering-bringers.

M.M.A. photo. T. 3151; SCHOTT photos. 8607, 3476, 9100. Offering-bringers, and text of stela, HERMANN, *Stelen*, pl. 6 [d], pp. 41* [lower]–43*; text, HELCK, *Urk.* iv. 1515–39 [B] (from HERMANN).

(7) Deceased and wife seated, and remains of banquet with two male harpists (standing and seated), and female clappers with song below.

Parts of banquet, including harpists, SCHOTT photos. 2466, 8602–6. Translation of song, SCHOTT, *Das schöne Fest*, p. 896 [143].

Inner Room.

(8) At bottom, beginning of funeral procession.

(9) [1st ed. 6] Two registers. **I,** [Opening the Mouth rites before mummy]. **II,** Winnowing, threshing, bringing corn, and reaping.

I, HAY MSS. 29822, 67.

201. RĒꜤ ⟨⟩, First royal herald. Temp. Tuthmosis IV to Amenophis III.
 Khôkha.

Plan, p. 292. Map IV, D–5, a, 7.

Hall.

(1) Left thickness, two registers, **I** and **II,** deceased before a god. Right thickness, deceased. Altars with lotus-buds and jar, on left thickness, SCHOTT photo. 8612.

(2) Deceased offers on braziers, with wife and offering-bringers, including man holding bouquet with fowl, and man with garlanded oryx.

Bouquet on stand (in front of deceased), and man with bouquet, SCHOTT photos. 8613, 3478 [left].

(3) Four registers, **I–IV,** recording cattle before deceased, including bringing dogs in **II.** **III** and **IV,** CHIC. OR. INST. photo. 2960. Group of cattle with calves (sketch) in **III,** CAPART, *Documents*, ii, pl. 70; SCHOTT photo. 8614; heads of two cows, BAUD, *Dessins*, fig. 91. Papyrus-clump, SCHOTT photo. 3478 [right].

(4) Two registers, **I**, papyrus-clump and two large bouquets, and offerings before Osiris and [Isis], **II**, tree at right end. (5) Two registers, **I**, Western goddess, **II**, two offering-bringers. (6) Three registers, **I**, remains of garden with pool, **II–III**, offering-bringers, and man kneeling before [deceased]. (7) At bottom, remains of soldiers with shields and drummer.

(8) [Deceased] offers on braziers.
Two braziers with burnt-offerings and incense-jar on stand, SCHOTT photo. 8615.

(9) At top, remains of four soldiers with shields and standards [before Amenophis III?].

202. NEKHTAMŪN ⟨hieroglyphs⟩, Prophet of Ptaḥ Lord of Thebes, Priest in front of Amūn. Dyn. XIX (?).
Khôkha.

Map IV, D–5, b, 7.

Funeral ceremonies on west wall of Hall, and frieze-text with titles of deceased in Inner Room.

203. UNNŪFER ⟨hieroglyphs⟩, Divine father of Mut. Dyn. XIX.
Khôkha.

Map IV, D–5, a, 7.

Ceiling. Centre, deceased kneeling adores Wepwaut, and two men kneeling below with texts of hours and name and title of deceased. Texts, LEPSIUS MS. 263.

204. NEBʿANENSU ⟨hieroglyphs⟩, Sailor of the first prophet of Amūn (title from cone). Dyn. XVIII.
Khôkha.

Map IV, D–5, c, 8.

Ceiling. Name and remains of title of deceased.

205. ḌHUTMOSI ⟨hieroglyphs⟩, Royal butler. Temp. Tuthmosis III (?) to Amenophis II (?).
Khôkha.

Plan, p. 292. Map IV, D–5, c, 8.

Hall.
(1) Deceased as priest adores a [god]. (2) Remains of text.

206. INPUEMḤAB ⟨hieroglyphs⟩, Scribe of the Place of Truth. Ramesside.
Khôkha.

Plan, p. 292. Map IV, D–5, c, 8.

Hall.
(1) Left thickness, deceased adoring. (2) King in kiosk.

(3) Tympanum, horizon-disk in centre, adored by deceased kneeling, followed by *ba*, on each side. Shrine below, with two registers on each side, **I**, deceased adores a god, **II**, wife adores a god.

Ceiling between doors. Sun-disk on pillar in centre, adored by deceased kneeling on each side, with Isis and Nephthys below.

Inner Room.

(4) Osiris with Isis and Nephthys. Frieze, deceased kneeling, Anubis-jackal, and Ḥathor-head.

207. ḤAREMḤAB 𓈖𓊃, Scribe of divine offerings of Amūn. Ramesside.
Khôkha.
Parents, Ḳemawen 𓂝𓃀𓄿𓏤𓆱 and Nebuy 𓂋𓃀𓏤𓏥.

Map IV, D–5, b, 7.

Hall.

Entrance-wall, left of doorway. At bottom, Abydos pilgrimage.

Frieze. Remains of Book of Gates with deceased adoring.

208. ROMA 𓂋𓈖, Divine father of Amen-rēᶜ. Ramesside.
Khôkha.

Plan, p. 292. Map IV, D–5, c, 7.

Inner Room.

(1) Four registers, **I**, deceased adoring, **II**, procession of priests with vases, **III**, people adoring divinities, **IV**, banquet (?). (2) Loose block, probably from here, man and three women with table of offerings. (3) Three registers, **I**, Book of Gates with deceased and wife before gods, **II**, man offers to deceased and wife and to couple, and seated harpist with song beyond, **III**, remains of funeral procession with Abydos pilgrimage (?).

Frieze at (3), deceased kneeling adores Anubis-jackal.

Hall.

(4) At top, deceased and wife before a god and goddess. (5) Rēᶜ-Ḥarakhti seated in shrine with door, and table of offerings, with man and woman below.

Frieze at (5), Anubis-jackals.

209. SEREMḤATREKHYT 𓊪𓈖𓂋𓏥 (?) (formerly read Ḥatashemro 𓂋𓈖𓂝𓏏), Hereditary prince, Sole beloved friend. Saite.
ʿAsâsîf.

Plan, p. 292. Map VI, E–4, c, 4.

(1) and (2) Entrances to Hall and Shrine, remains of offering-formulae on jambs.

210. RAʿWEBEN 𓏸𓏸𓏸, Servant in the Place of Truth. Dyn. XIX.

Deir el-Medîna. (*L. D. Text*, No. 104.)

Parents (?), Piay 𓏸𓏸𓏸, Sculptor in the Place of Truth, and Nefertkhaʿ 𓏸𓏸𓏸𓏸.
Wife, Nebtyunu 𓏸𓏸𓏸.

Plan, p. 292. Map VII, E–3, c, 8.

Bruyère, *Rapport* (*1924–1925*), pp. 188–9, with plan on pl. x; (*1927*), pp. 16–19, with plan on pl. i.

Chapel.

(1) Outer lintel, double-scene, father with Ipuy (tomb 217, brother (?) of deceased), and family, offers on brazier to Rēʿ-Ḥarakhti, Ptaḥ, Ḥathor, Amenophis I, and ʿAḥmosi Nefertere, and deceased with family offers to Osiris, Ḥarsiēsi, Isis, Ḥathor, and Ptaḥ. Outer jambs, invocation of Amenophis I by Ipuy, and of Ptaḥ-Sokari by deceased. Left thickness, two registers, **I,** bark of Rēʿ with Ipuy and others adoring below, **II,** deceased adoring with hymn to Rēʿ, followed by father, and two sons.

Bruyère, *Rapport* (*1927*), figs. 12–14, cf. pp. 17, 19. Lintel, Černý in *B.I.F.A.O.* xxvii (*1927*), pl. vi [1], p. 175; divinities and royalties on left half, Hay MSS. 29821, 146 [lower]. Texts, Černý, *Rép. onom.* pp. 84–6; cartouches, and texts of deceased and family on right half, Lepsius MS. 399 [top]. See *L. D. Text*, iii, p. 292.

211. PANEB 𓏸𓏸𓏸, Servant of the Lord of the Two Lands in the Place of Truth. Dyn. XIX.

Deir el-Medîna.

Parents, Nefersenut 𓏸𓏸𓏸, same title as deceased, and Iuy 𓏸𓏸𓏸𓏸. Wife, Waʿbe(t) 𓏸𓏸𓏸.

Plan, p. 308. Map VII, E–3, c, 5.

Bruyère, *Tombes théb.* pp. 66–87, with plan and section, p. 69, fig. 4; id. *Rapport* (*1923–1924*), p. 60, with plan and section, pl. xvi, cf. on pls. i, ii, and (*1924–1925*), on pls. i, ii, vi. Names and titles, Černý, *Rép. onom.* pp. 87–90, with key-plan, p. 87.

Burial Chamber.

(1) Tympanum, bark of Sokari on stand, with Nefertem-emblem. Scene below, deceased with son and daughters adores [Anubis and Western Ḥathor].

Bruyère, *Tombes théb.* pl. xxv, pp. 76–7, 83 [top]. Bark, Mackay in *J.E.A.* vii (1920), pl. xxiii [1], p. 157 with note 1.

(2) [Deceased] with six daughters.

Two remaining daughters, Bruyère, *Tombes théb.* pl. xvi [lower], p. 77.

(3) Tympanum, Osiris-emblem in centre between Anubis-jackals, with deceased and wife kneeling on left, and grandfather Kasa (tomb 10) and his wife kneeling on right. Scene below, [mummy on couch], between Nephthys and Isis, and demons with torches.

Bruyère, *Tombes théb.* pl. xxii, pp. 75, 82 [middle and bottom]. Names and titles of Kasa and wife, Wiedemann in *P.S.B.A.* viii (1886), p. 227 [top].

(4) [1st ed. 1] Deceased censing, with parents and wife, before Osiris.

Bruyère, op. cit. pls. xxiii, xxiv, pp. 75–6, 81 [bottom], 82 [top]. Names and titles of relatives, Wiedemann, op. cit. p. 226 [b].

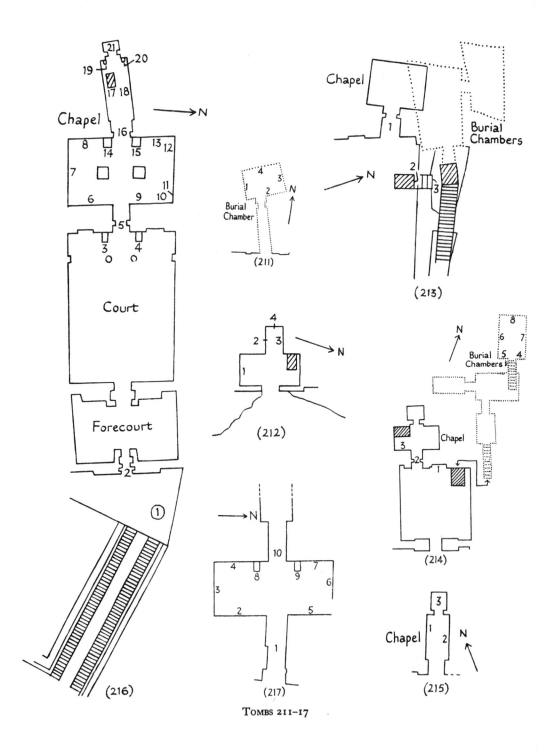

TOMBS 211-17

Vaulted ceiling. Outer half, two registers, **I**, four scenes, **1**, tree-goddess scene, **2**, destroyed, **3–4**, deceased adores [horizon-disk on *zad*-pillar supported by Akru], **II**, Thoth with Anubis-jackal facing Ḥepy, Ḳebḥsenuf, and Thoth. Inner half, two registers, **I**, four scenes, **5–6**, Western emblem, and deceased kneeling with hymn adores bark of Rēᶜ on personified *zad*-pillar with two baboons, **7–8**, deceased, wife, and son, kneeling before three divinities, **II**, Imset, Duamutf, and Thoth, facing pylon and Thoth.

BRUYÈRE, *Tombes théb.* pls. xv, xvi [upper], xvii–xxi, pp. 72–5, 80–1. Texts in outer half between and below scenes, id. ib. pp. 78–80; ČERNÝ, *Rép. onom.* p. 90; text of Thoth, WIEDEMANN in *P.S.B.A.* viii (1886), p. 227 [middle]; BRUYÈRE, *Rapport (1923–1924)*, p. 60; VARILLE in *Ann. Serv.* xxxiii (1933), p. 87 [lower] with note 4.

212. RAᶜMOSI. (See tomb 7.) Temp. Ramesses II.

Deir el-Medîna. (*L. D. Text*, No. 98.)

Plan, p. 308. Map VII, E–3, c, 5.

BRUYÈRE, *Rapport (1923–1924)*, pp. 64–6, with section, pl. xviii, and plan, on pls. i, ii, cf. *(1924–1925)*, on pls. i, ii, vi; LEPSIUS MS. 389 [bottom]–390 [top]; cf. *L. D. Text*, iii, p. 291. Names and titles, ČERNÝ, *Rép. onom.* pp. 91–2, with key-plan, p. 91.

Chapel.

(1) [1st ed. 1] Fallen blocks. Remains of agricultural scene with fruit-trees and two ploughs meeting.

BRUYÈRE, *Rapport (1923–1924)*, pl. xix [2], p. 65. Name of Ptaḥsᶜankh ⬚𓏏𓐍𓊪𓋹 , Servant, id. ib. *(1935–1940)*, Fasc. iii, p. 15 [4].

Shrine.

(2) [Deceased offers incense to Ḥarsiēsi and Thoth], probably here.

Text, WILKINSON MSS. v. 112 [lower right].

(3) Deceased and wife before Osiris and Isis.

Divinities, cf. GR. INST. ARCHIVES, on photo. 1732.

(4) [1st ed. 3] Tympanum, deceased kneeling with hymn to Rēᶜ adores horizon-disk held by arms of Nut in mountain. Double-scene below, goddess before Ptaḥ in shrine, and Maᶜet before Rēᶜ-Ḥarakhti, with [statue of Ḥatḥor-cow] in centre.

GR. INST. ARCHIVES, photos. 1732 and DM. 212 [right]; SCHOTT photos. 3591–2. See BRUYÈRE, *Rapport (1923–1924)*, p. 64 [bottom]. Tympanum, WILKINSON MSS. v. 112 [upper]; omitting most of the text, WILKINSON, *Materia Hieroglyphica*, pl. iv [fig. 5]; id. *M. and C.* 2 Ser. Supplement, pl. 29 [4] = ed. BIRCH, iii, pl. xxii [6]. Hymn, WIEDEMANN in *P.S.B.A.* viii (1886), pp. 227–8 [c].

Vaulted ceiling [part, 1st ed. 2]. Left half, deceased seated beneath fig-tree with pool, and deceased adores Rēᶜ-Ḥarakhti. Right half, remains of bark of Rēᶜ on pool with fish.

Right half, GR. INST. ARCHIVES, photo. DM. 212 [left]. See BRUYÈRE, *Rapport (1923–1924)*, p. 64 [middle]. Title of deceased, WILKINSON MSS. v. 112 [lower left].

Pyramid.

Lucarne-stela, probably from here, but possibly from tombs 7 or 250, in Bankes Collection, Kingston Lacy, Wimborne, Dorset. ČERNÝ, *Egyptian Stelae in the Bankes Collection*, No. 4, with plate; bark and titles, WILKINSON MSS. xxiii. 152 [bottom].

213. PENAMŪN ▢ ⟨⟩ 𓏏, Servant of the Lord of the Two Lands, Servant in the Place
of Truth. Dyn. XX.

Deir el-Medîna.
Parents, Baki (tomb 298) and Taysen. Wife, Nebtnūhet ▽ 𓏏𓏤𓏏() .

Plan, p. 308. Map VII, E–3, c, 8.

BRUYÈRE, *Rapport (1924–1925)*, pp. 183–4, 186–7, with plan on pl. x. Names and titles,
ČERNÝ, *Rép. onom.* pp. 93–4.

Chapel.

(1) Outer lintel, deceased and family offer to [divinities], and jambs, offering-texts. Outer
thicknesses, remains of texts.
BRUYÈRE, fig. 123, cf. p. 184.

Burial Chamber.

(2) Entrance, at bottom of shaft. Round doorway, offering-text of sons (?) Unnūfer and
Khaᶜemwēset.
BRUYÈRE, fig. 124, cf. p. 186.

(3) Above descending staircase. Tympanum, with remains of tree-goddess scene.
BRUYÈRE, on fig. 124, cf. p. 186.

214. KHAWI 𓈖𓄿𓃀𓏥𓎟, Custodian in the Place of Truth, Servant of Amūn in
Luxor. Ramesside.

Deir el-Medîna.
Wife, Tawert 𓏏𓃀𓅡 .

Plan, p. 308. Map VII, E–3, c, 9.

BRUYÈRE, *Rapport (1927)*, pp. 42–6, with plans on pl. i, and fig. 33; BRUYÈRE, *Tombes théb.*
pp. 88–97, with plan of Burial Chamber, p. 89, fig. 5. Names and titles, ČERNÝ, *Rép. onom.*
pp. 95–8, with key-plan of Burial Chamber, p. 97.

Court.

(1) Stela, with double-scene at top, deceased kneeling before Amūn, and before Rēᶜ-
Ḥarakhti, and scene below, deceased and wife before Osiris on left.
Cf. BRUYÈRE, *Tombes théb.* on pl. xxvi, and *Rapport (1927)*, p. 42.

Chapel.

Demotic graffiti on walls. SPIEGELBERG, *Demotica*, ii, in *Sitzungsb. der bayerischen Akade-*
mie der Wissenschaften, Philos.-philol. hist. Kl. 1928, 2 Abhand. pls. 1, 4, 5, (on west wall),
pp. 15–17. See BRUYÈRE, *Rapport (1927)*, pp. 44–5.

(2) Outer lintel, double-scene, deceased and wife before Osiris and serpent-headed Mert-
esger, and before Minsiēsi and Isis. Thicknesses, two registers, **I**, deceased adores bark of Rēᶜ
(much destroyed on right), **II**, deceased (with wife, on left thickness) adoring with hymns.
BRUYÈRE, *Rapport (1927)*, figs. 30–2, cf. pp. 43–4. Lintel, BRUYÈRE, *Mert Seger*, fig. 76,
cf. pp. 150, 268. Texts of deceased and wife from lintel, LEPSIUS MS. 400 [middle]; names
of Minsiēsi and Isis, and titles, WILKINSON MSS. v. 131 [middle, and bottom left].

(3) Sketches, hawk and seated man.

Fragments from wall (?). Deceased adoring, BRUYÈRE, *Rapport* (*1927*), fig. 28, cf. p. 41 [6]. Hymn to Amen-rēʿ, id. ib. p. 50 [4]; ČERNÝ in *B.I.F.A.O.* xxviii (1929), p. 185 [5].

Pyramid.

Lucarne-stela, with bark of Rēʿ, and deceased and wife kneeling below with hymn to Rēʿ. BRUYÈRE, *Rapport* (*1927*), fig. 27, cf. pp. 40–1 [5].

Burial Chamber.

(4)–(5) Guardian each side of doorway, and personified Western emblem with torches between Anubis-jackals above. (6) Two scenes, **1**, deceased kneels before cobra-goddess, **2**, deceased and wife adore Ḥarsiēsi as hawk with cobra.

Id. ib. pls. ii [left], iii [right]; id. *Tombes théb.* pls. xxviii [lower], xxix [right], pp. 93–6, 97 [3, 4, and bottom]; scenes at (6), id. *Mert Seger*, fig. 134, cf. p. 268.

(7) Two scenes. **1**, Deceased adores Maʿet and Thoth as baboon holding palette. **2**, Deceased and wife adore Ḥathor-cow on pylon.

BRUYÈRE, *Rapport* (*1927*), pl. ii [right]; id. *Tombes théb.* pl. xxviii [upper], pp 93–4, 97 [1–4].

(8) Son Ḥuy mourns mummy on couch tended by Anubis.

BRUYÈRE, *Rapport* (*1927*), pl. iii [left]; id. *Tombes théb.* pl. xxix [left], pp. 94–5, 97 [near bottom].

Vaulted ceiling. Left half, four squatting demons. Right half, Thoth, Ḥekzet, Geb, all squatting, and Gate of the West.

BRUYÈRE, *Rapport* (*1927*), pl. ii [middle]; id. *Tombes théb.* pl. xxvii, pp. 91–3, 96.

Finds

Lintel from a niche, double-scene, deceased kneeling adores ram of Amen-rēʿ, jambs, texts, in Turin Mus. Sup. 9512, 9503. Id. *Rapport* (*1927*), figs. 36–7, cf. pp. 48–9 [2, 3].

Ushabti-box of deceased. Name, id. ib. p. 50 [5].

Offering-table of deceased, probably originally from here, then in The Hague, Scheurleer Mus. S. 1098. VON BISSING in *Ä.Z.* lxviii (1932), pp. 58–9 with fig.

215. AMENEMŌPET 𓀀𓏛𓏤𓂝, Royal scribe in the Place of Truth. (Burial Chamber is tomb 265.) Dyn. XIX.

Deir el-Medîna.

Parents, Minmosi 𓏏𓁐𓏤 and Ēsi 𓆑𓎡 (names in tomb 335). Wife, Ḥathor, called Ḥunuro 𓏤𓏥𓏤 .

Plan, p. 308. Map VII, E–3, e, 6.

JOURDAIN, *La Tombe du scribe royal Amenemopet* in VANDIER D'ABBADIE and JOURDAIN, *Deux Tombes de Deir el-Médineh* (*M.I.F.A.O.* lxxiii), pp. 25–46, with plan and section, pl. xviii; BRUYÈRE, *Rapport* (*1929*), pp. 3, 107–9; plan, id. ib. (*1931–1932*), on pl. i. Names and titles, ČERNÝ, *Rép. onom.* pp. 99–101 with key-plan, p. 99.

Chapel.

(1) [Son] with offering-list before [deceased and wife (?)].

JOURDAIN, pls. xix [left upper], xxvi, pp. 35, 40.

(2) Three registers. **I**, Funeral procession with statuette of Anubis-jackal carried from temple between two sycamores. **II**, Funeral procession to [Anubis-jackal] in shrine. **III**, Deceased seated with [wife], and dog under chair, in tree-goddess scene, and remains of wife playing music with song before deceased under palm-tree.

JOURDAIN, pls. xxiii–xxv, pp. 32–4, 38–40. **I**, GR. INST. ARCHIVES, photo. DM. 215. 1 [left upper and middle]. Hieratic graffito in **I**, ČERNÝ, *Rép. onom.* p. 100 [top].

Vaulted ceiling [1st ed. 1]. Left half, remains of three registers, Fields of Iaru, with Ḥarsheri 𓀀𓏏𓏤𓀀, Royal scribe of the Lord of the Two Lands in the Place of Truth, and wife, reaping in **II**, and fragment of scene with date-palm in **III**. Right half, two registers, Book of Gates, **I**, deceased adores [guardian], **II**, wife adores guardian with knife, with remains of fish and turtles in pool beyond.

JOURDAIN, pls. xix [left lower and right], xx–xxii, pp. 29–31, 36–7, with fig. 4; GR. INST. ARCHIVES, photo. DM. 215. 1 [left bottom, and right]. Ḥarsheri and wife, WRESZ., *Atlas*, i. 14 (called tomb 212). Wife adoring guardian in **II** on right half, LHOTE and HASSIA, *Chefs-d'œuvre*, pl. 163.

Shrine.

(3) Outer lintel, double-scene, deceased and wife adore Amen-rēꜥ, and adore Rēꜥ-Harakhti, with Inmutf-priest beyond at left end. Outer left jamb, text with deceased seated at bottom, and adjoining west wall, [deceased], wife, and children. In Turin Mus. 1516 (lintel), 1517 (jamb and wall).

JOURDAIN, pls. xxvii, xxviii [middle right, and right], p. 28 with fig. 3, cf. pp. 40–3. Texts, MASPERO in *Rec. de Trav.* ii (1880), p. 168 [iii]; names, LIEBLEIN, *Dict.* Nos. 791, 801. See FABRETTI, ROSSI, and LANZONE, *R. Mus. di Torino*, p. 140; ORCURTI, *Cat.* ii, pp. 18–19 [4], 26 [22]; BRUYÈRE, *Rapport* (*1926*), p. 16 [9 (2, 3)]. Lintel, GAZZERA, *Descrizione dei monumenti egizi del Regio Museo* [&c.], pl. 12 [3], p. 54. West wall, FARINA, *R. Mus. di Torino* (*1938*), 49 [left].

Finds. Probably from here.

Fragment of jamb with text of deceased. JOURDAIN, pl. xxviii [middle left], p. 43 [bottom]. Fragments of ushabti-coffin of deceased. Id. ib. fig. 2, cf. p. 27.

216. NEFERḤŌTEP 𓈖𓏤𓄤𓊵𓏏𓊪, Foreman. Temp. Ramesses II to Sethos II.

Deir el-Medîna. (L. *D. Text*, No. 100.)

Parents, Nebnūfer (tomb 6) and Iy. Wife, Webekht 𓃀𓏭𓂝𓁹𓏏𓆑.

Plan, p. 308. Map VII, E–3, c, 6.

To be published by JOURDAIN-LAMON.

L. *D. Text*, iii, p. 291; BRUYÈRE, *Rapport* (*1923–1924*), pp. 36–40, with views, pl. x, and plan and section of Burial Chambers, pl. ix; (*1924–1925*), pp. 16–17, 35–42, with plan of ramp, courts, and Chapel, on pl. ii, cf. pl. i. Names and titles, ČERNÝ, *Rép. onom.* pp. 102–9, with key-plans, pp. 102, 109. Demotic text, SPIEGELBERG, *Demotica*, ii, in *Sitzungsb. der bayerischen Akademie der Wissenschaften*, Philos.-philol. hist. Kl. (1928), 2 Abhand. pl. 3, pp. 14–15.

Approach.

At top of Ramp.

(1) Large amphora of Tuthmosis III, re-used as water-tank.

BRUYÈRE, *Rapport* (*1931–1932*), fig. 52 [top], cf. p. 76.

Forecourt.

(2) Entrance. Fragments of a lintel, re-used as threshold, with Western hawk adored by Isis and Nephthys and baboons.

BRUYÈRE, *Rapport (1924–1925)*, figs. 27, 70, cf. pp. 39–40.

Court.

(3) and (4) Base of standing statue of Ḳaḥa (tomb 360), and lower part of seated statue of his wife Tuy, with daughter in relief on side of seat.

Texts, BRUYÈRE, *Rapport (1930)*, pp. 74, 115; names, id. ib. *(1923–1924)*, p. 40.

Chapel.
Hall.

(5) Outer thicknesses, deceased.

(6), (7), (8) [part, 1st ed. 1, 2] Remains of three registers. **I,** Temple in grove of Anukis with gazelle on Island of Elephantine, lily pool, and Ramesses II with fan-bearer and deceased before bark of Amen-rēʿ. **II,** People kneeling, Theban Triad, and three men before Osiride god and Ḥatḥor. **III,** Procession of Ḥatḥor, including fan-bearers, royal statues with captives on base, deceased with offerings, and bark of Ḥatḥor dragged.

Part at (6), GR. INST. ARCHIVES, photo. DM. 216. 1 [right]; scene with gazelle, DAVIES in *M.M.A. Bull.* Pt. ii, Dec. 1923, fig. 20, cf. pp. 51–2. Cartouches of Ramesses II, WIEDE-MANN in *P.S.B.A.* viii (1886), p. 228 [f].

(9) Three registers. **I–II,** Deceased and wife with girls offering to them, and banquet. **III,** Deceased and family fowling.

Text of one girl, BRUYÈRE, *Rapport (1923–1924)*, p. 42 [near top].

(10) Two registers. **I,** Two priests carrying head of Anukis, and Satis with Khnum. **II,** Banquet (continued at (9)).

I, Id. ib. *(1934–1935)*, Pt. 3, fig. 84, cf. pp. 189–90; GR. INST. ARCHIVES, photo. DM. 216. 1 [left].

(11) Deceased before [Rēʿ-Ḥarakhti and goddess]. (12) Two registers, **I,** woman kneeling, **II,** offerings and kiosk. (13) [Man] before Ramesses II in kiosk, and [deceased and wife] adore Rēʿ-Ḥarakhti with winged goddess.

(14) and (15) [1st ed. 3, 4, wrongly placed on thicknesses] Two statues of brother Peshedu holding standards (with wife at (15)).

Texts, BRUYÈRE, *Rapport (1923–1924)*, p. 41.

Inner Room.

(16) Outer jambs, remains of text, with deceased and wife seated at bottom. Left thickness, two registers, **I,** Abydos pilgrimage (?) with boats towed, **II,** boat on lake and birds. Right thickness, two registers, **I,** [deceased drinking below palm-tree], and remains of cow, **II,** deceased, wife, and offerings.

(17) [1st ed. 5] Two registers. **I,** Deceased followed by father, grandfather Ḳenḥirkhopshef ⌓ ♀ ⌇, Royal scribe in the Place of Truth, and another man carrying bark, and men with standards, &c., before Osiris and Anubis. **II,** [Offering-scene] to deceased and wife.

Texts of relatives in **I,** BRUYÈRE, *Rapport (1923–1924)*, p. 52, note 1.

(18) Deceased offers on brazier to Ḥatḥor-cow in mountain protecting Amenophis I, and Osiris and Ḥatḥor in kiosk with Sokari on the top of it, with five goddesses beyond and bouquet below them. Behind deceased, three registers, **I,** man offering to Osiris, &c., and offering-list, **II–III,** funeral procession to pyramid-tomb, with priests, mourners, and men and oxen dragging sarcophagus with statue of deceased in **II,** and men carrying funeral outfit on yokes in **III.**

Main scene, and part of procession in **II,** GR. INST. ARCHIVES, photo. DM. 216. 2; procession (almost complete), M.M.A. photos. T. 1913–15; female mourner, WERBROUCK, *Pleureuses,* fig. 137 (from M.M.A. photo.), cf. p. 147.

(19) [1st ed. 6] Double-statue, deceased seated (with boy Ḥesysunebef 𓎛𓎛𓎛𓏭𓂝𓏏𓏲 giving grapes to monkey in relief on side of chair), and wife standing.

BRUYÈRE, *Rapport (1923–1924),* pl. xiii [1], fig. 1, and texts, pp. 41–3; *(1924–1925),* fig. 25 [a], cf. pp. 37–8; GR. INST. ARCHIVES, photos. DM. 216. 03 and 05. Part of text from base, LEPSIUS MS. 390 [bottom left]; text from skirt, L. *D. Text,* iii, p. 291 [a].

(20) [1st ed. 7] Double-statue, deceased and wife standing.

BRUYÈRE, *Rapport (1924–1925),* fig. 25 [b], cf. p. 37; GR. INST. ARCHIVES, photo. DM. 216. 04. Texts, BRUYÈRE, *Rapport (1923–1924),* pp. 42, 44; text with names of mother and wife from side of back-pillar, L. *D. Text,* iii, p. 291 [β].

(21) Niche. Left thickness, squatting god, left wall, Ḥarsiēsi and Ḥatḥor seated, right wall, Anubis and Ḥatḥor seated, rear wall, Isis and Nephthys making *nini* to scarab on *zad*-pillar, ceiling, winged Nut. Left of niche, Osiris, and right of niche, Min, with their emblems.

See BRUYÈRE, *Rapport (1923–1924),* pp. 37–8.

Burial Chambers.
Innermost Chamber. (D of BRUYÈRE.)
Tympanum on end wall, Nephthys kneeling between Anubis-jackals.
BRUYÈRE, *Rapport (1923–1924),* pl. xi [4], p. 39 [top].

Frieze. West wall, deceased and wife adore disk in bark, baboons adore bark with *smn*-goose and Western hawk above it, four squatting demons, and cat under *išd*-tree slaying serpent. East wall, Gates and guardians with knives.
BRUYÈRE, *Rapport (1923–1924),* pl. xi [2, 3], p. 38; *smn*-goose, KUENTZ, *L'Oie du Nil,* fig. 12, cf. p. 10.

Vaulted ceiling. Centre, two scenes, **1,** Eastern and Western goddesses making *nini* before personified *zad*-pillar with scarab and horizon-disk, **2,** winged Nut as tree-goddess on *zad*-pillar pours libation drunk by two figures of deceased.
BRUYÈRE, op. cit. pl. xi [1], pp. 39–40. Nut, FOUCART in *B.I.F.A.O.* xxiv (1924), pl. xvi.

Finds
Found in Burial Chambers.
Lower part of kneeling statue of deceased holding stela with hymn to Rēꜥ. BRUYÈRE, *Rapport (1924–1925),* fig. 25 [c], cf. pp. 37–8. Texts, id. ib. *(1923–1924),* pp. 44–5.
Offering-table of deceased. Id. ib. *(1923–1924),* pl. xii [middle right], pp. 45–6 [1].

Found in Pit 1010.
Libation-table of deceased. BRUYÈRE, *Rapport (1924–1925),* fig. 24, cf. p. 37.
Fragment of lucarne-stela, with bark of Rēꜥ and name of deceased, and fragment of cornice with baboon offering *uzat* to ram-headed Rēꜥ. See id. ib. p. 38 [6, 7].

Other Finds.

Lintel, double-scene, deceased and wife kneeling adore Termuthis, and deceased and brother Peshedu adore Mertesger, both as serpents. BRUYÈRE, *Rapport (1923–1924)*, fig. 2, cf. pp. 48–50 [1]; id. *Mert Seger*, fig. 98, cf. p. 228.

Fragments of lintel with Osiris and Horus seated. BRUYÈRE, *Rapport (1927)*, fig. 26 [3], cf. p. 40 [1].

Top of jamb (?), Anubis-jackal in relief. Id. ib. *(1924–1925)*, fig. 16, cf. p. 25.

217. IPUY 𓏏𓊪𓏲𓏲, Sculptor. Temp. Ramesses II.

Deir el-Medîna.

Parents, Piay 𓊪𓏏𓄿𓏲𓏲 and Nefertkhaꜥ 𓈖𓆑𓂋𓏏𓆣𓏲𓏲 (names in tomb 210). Wife, Duammeres ✱𓄿𓏏𓈖𓊪𓏲𓄹·

Plan, p. 308. Map VII, E–3, c, 6.

DAVIES, *Two Ramesside Tombs at Thebes*, pp. 33–76, with plan and section, pl. xxi; SCHEIL, *Le Tombeau d'Apoui* in VIREY, *Sept Tombeaux thébains (Mém. Miss.* v, 2), pp. 604–12, with plan, p. 604; plan, BRUYÈRE, *Rapport (1924–1925)*, on pls. i, ii. View of exterior, DAVIES, pl. xx; M.M.A. photos. T. 853–4. Names and titles, ČERNÝ, *Rép. onom.* pp. 110–12, with key-plan, p. 110.

Hall.

(1) Part of lintel (probably from here), deceased and wife adore Rēꜥ (?). Right inner thickness, sketch of [deceased].

DAVIES, pp. 36, 38 [1], and pl. xl [1] (lintel).

(2) [1st ed. 1, 2] Remains of four registers. **I,** Deceased with officials rewarded and acclaimed before Ramesses II in palace-window with captives on sides. **II,** Two rows, funeral procession (with mummy in kiosk, funeral outfit standing and carried, and group of female mourners) to pyramid-tomb with portico in mountain. **III,** House and garden, including four men (two with dogs) watering with shadûfs, and booths with servants weighing meat. **IV,** Divine barks adored by men and women, and two rows of laundry-scenes.

DAVIES, *Two . . . Tombs*, pls. xxvii–xxix, pp. 46–55; SCHEIL, pp. 605–8 [B] with fig. 1 (part of **I**) and pl. i (house and men with shadûfs and dogs). King in **I,** DAVIES in *M.M.A. Bull.* Pt. ii, July 1920, fig. 3, cf. p. 30. Right end of **II–IV,** M.M.A. photos. T. 1229–30, 680. House and garden in **III,** SMITH, *Art . . . Anc. Eg.* pl. 162 [A, B] (from TURIN photo. before recent damage); house and man with shadûf and dog, CAPART and WERBROUCK, *Thèbes*, fig. 196 [aquar. LEGRAIN]; STEINDORFF, *Blütezeit* (1900), Abb. 87, (1926), Abb. 95; FARINA, *Pittura*, pl. clxiv; SPIEGELBERG in *Ä.Z.* xlv (1908–9), fig. on p. 87 [upper]; man with shadûf and dog, DAVIES in *M.M.A. Bull.* Pt. ii, July 1920, fig. 13, cf. p. 30; two shadûfs and house between them, MASPERO, *Hist. anc. Les origines*, fig. on p. 340; two shadûfs on left, WAGENAAR in *Oudheidkundige Mededeelingen van het Rijksmuseum van Oudheden te Leiden*, N.R. x (1929), fig. 22, cf. p. 101; HAMMERTON, *Universal History of the World*, fig. on p. 488 [lower]; one shadûf on right, WINLOCK, *Rise and Fall*, pl. 30, p. 165; PRITCHARD, *The Ancient Near East in Pictures*, fig. 95 (from painting by NINA DAVIES); man weighing meat in **III,** and laundry-scenes in **IV,** WRESZ., *Atlas,* i. 57; FARINA, *Pittura*, pl. clxv; laundry-scenes, LHOTE and HASSIA, *Chefs-d'œuvre*, pl. 110; lower one, DONADONI, *Arte egizia*, fig. 153. Fragment (recently cut out), man weighing meat in **III,** KEIMER in *Revue d'Égyptologie*, iv (1940), pl. iv, p. 62.

(3) [1st ed. 3] Two registers. **I**, Man before seated relatives. **II**, Son and daughter offer bouquet of Amūn to deceased with kitten on lap and wife with cat (full-face) under her chair.

Davies, *Two . . . Tombs*, pls. xxii [A], xxv, xxvi, pp. 42–5; M.M.A. photos. T. 681, 683, 691, 1214. **II**, Pijoán, *Summa Artis*, iii (1945), fig. 612; cat, Davies in *M.M.A. Bull.* Pt. ii, Dec. 1920 (reprinted June 1921, Oct. 1923), fig. 6, cf. p. 38; kitten, id. ib. July 1920, fig. 15, cf. p. 31. Texts, Scheil, pp. 611–12 [D].

(4) Deceased, with wife and small daughter holding bird (both on adjoining wall at (3)), offers on braziers to Osiris and Ḥathor.

Davies, *Two . . . Tombs*, pls. xxiv, xxxii [B], pp. 41–2; M.M.A. photos. T. 681 [right], 682, 684. See Scheil, p. 611 [F]. Daughter, Davies (Nina), *Anc. Eg. Paintings*, ii, pl. xcix (Champdor, Pt. iv, 7th pl.).

(5) [1st ed. 5] Five registers. **I**, Man before seated relatives. **II**, Pulling flax, ploughing, and winnowing on threshing-floor, with remains of offerings to Termuthis. **III**, Goats browsing on trees with herdsmen (one with pipe) and dog, laden boats with market-scenes, storehouse with offerings to Termuthis and boys scaring birds. **IV**, Wine-press, mending net, preparing fowl and fish, treading and picking grapes, deceased and family fowling. **V**, Fishing with net from canoes, and netting fowl.

Davies, *Two . . . Tombs*, pls. xxx, xxxi [A], xxxii [A], xxxiii–xxxv, xxxvi [upper right], pp. 55–60, 60–3; M.M.A. photos. T. 688–90, 1216–20; incomplete, Scheil, pp. 608–11 [A], pl. ii (third register) and figs. 2–5. **II–V**, Wresz., *Atlas*, i. 363–7; Farina, *Pittura*, pl. clxiii. **III–V**, Smith, *Art . . . Anc. Eg.* pl. 163 [A, B]. Scene with goats and market in **III**, Capart and Werbrouck, *Thèbes*, fig. 198 (from Wreszinski); some goats with herdsman from lower row, Davies in *M.M.A. Bull.* Pt. ii, July 1920, fig. 1, cf. p. 28; jars in stand and herdsman in upper row, Mekhitarian, *Egyptian Painting*, pl. on p. 146; offering-scene to Termuthis, Bruyère, *Mert Seger*, fig. 123. Treading and picking grapes in **IV**, Davies (Nina), *Anc. Eg. Paintings*, ii, pl. xcviii; Byvanck, *De Kunst der Oudheid*, pl. xlvii [fig. 163], cf. p. 310; Bruyère, *Rapport (1935–1940)*, Fasc. iii, fig. 13; man mending net, and picking grapes, Davies in *M.M.A. Bull.* Pt. ii, July 1920, figs. 6, 14, cf. pp. 30–2. Netting fish with canoes in **V**, Kees, *Ägyptische Kunst*, Abb. 43, cf. p. 66; left canoe and net, Davies (Nina), op. cit. pl. xcvi; right canoe, Montet in *Mon. Piot*, xliii (1949), fig. 12, cf. p. 30; Mekhitarian, *Egyptian Painting*, pl. on p. 148; Lhote and Hassia, *Chefs-d'œuvre*, pl. 93. Fragment, plucking geese, from **IV**, in Berlin Mus. 1104, Wresz., *Atlas*, i. 385 [B]; see *Ausf. Verz.* p. 156.

(6) [1st ed. 4] Four registers. **I**, [Man] before seated relatives, with bird and cat under a chair. **II**, Making funeral outfit, including man felling tree, and lector with Opening the Mouth instruments. **III**, Carpenters making royal naos and catafalque. **IV**, Fishing with net and bringing fish.

Davies, *Two . . . Tombs*, pls. xxxi [B], xxxvi–xxxix, xl [3], pp. 42, 60, 63–72; M.M.A. photos. T. 686–7, 1215, 1231–3. See Scheil, p. 612 [C]. **II–IV**, Wresz., *Atlas*, i. 368–71; details, Davies in *M.M.A. Bull.* Pt. ii, July 1920, figs. 7, 16, 19, 20, 22, cf. pp. 30–2. Catafalque in **III**, Capart and Werbrouck, *Thèbes*, fig. 187 (from Wreszinski); Bes with tambourine and Tuēris on catafalque, Lhote and Hassia, *Chefs-d'œuvre*, pl. 111; man painting another's eyelids in **III**, Riad, *La Médecine au temps des Pharaons*, fig. 63 (after Davies, but called oculist at work). **IV**, Lhote and Hassia, op. cit. pls. xix, xx, and pls. 94–5; right part,

DAVIES (Nina), *Anc. Eg. Paintings*, ii, pl. xcvii (CHAMPDOR, v, 5th pl.); two men on right in canoe, MEKHITARIAN, *Egyptian Painting*, pl. on p. 147.

(7) Deceased with wife (on adjoining wall at (6)) libates before [Anubis and Ptaḥ-Sokari]. DAVIES, *Two . . . Tombs*, pls. xxii [B], xxiii, pp. 40–1; M.M.A. photos. T. 685–6 [left]. See SCHEIL, p. 611 [E].

(8) and (9) Statues of [deceased and wife]. See DAVIES, pp. 36–7. Titles, SCHEIL, p. 604.

(10) Entrance to Passage. Right jamb and thickness, texts. DAVIES, pl. xl [4], p. 39 [top, 7].

Finds

Top of pyramid (?). BRUYÈRE, *Rapport (1923–1924)*, pls. vii [1–4], viii, pp. 32–3. See DAVIES, p. 38 [3] and note 1. One face with bark of Rēʿ-Ḥarakhti, PILLET, *Thèbes. Palais et nécropoles*, fig. 112.

Fragments of libation-table and stelae. See DAVIES, p. 38 [4–6].

Fragments of wine-jars with hieratic texts. Id. ib. pl. xix [1], pp. 39–40 [12]; M.M.A. photo. T. 697.

Fragments from walls. DAVIES, pls. xl [2, 6, 7], xli, xlii, pp. 33–4, 72–5.

218. AMENNAKHT, Servant in the Place of Truth on the west of Thebes. Ramesside.
Deir el-Medîna.
Parents, Nebenmaʿet ⌣⟿ ⌒ ꓯ, *ꜥš-mnw* of Amūn, and Ḥetepti. Wife, Iymway 𓃹𓏤 ꞊ 𓃹𓏤.

Plan, p. 318. Map VII, E–3, d, 8.

DESROCHES-NOBLECOURT and JOURDAIN-LAMON, *La Tombe d'Amennakht*, in the Press; BRUYÈRE, *Rapport (1927)*, pp. 53–68, 80, 82, with plan of Chapel on pl. i, and plan and section of Burial Chambers, figs. 53–4.

Chapel.

(1) Four registers. **I**, Man offers to deceased and wife seated, and deceased and wife adore Ptaḥ and two goddesses. **II–IV** (partly on entrance-wall), Funeral procession and priests before mummies at pyramid-tomb, including cow and mutilated calf in **II**, and female relatives as priestesses, female mourners, and group of Servants in the Place of Truth, in **III**.

BRUYÈRE, *Rapport (1927)*, figs. 41 [right], 44–7, cf. pp. 60–8; DESROCHES-NOBLECOURT and JOURDAIN-LAMON, Doc. 42–6 with pl. Cow and calf in **II**, and priestesses and two mourners in **III**, DESROCHES-NOBLECOURT in *B.I.F.A.O.* liii (1953), pls. ii, iii, pp. 26–9. Texts of cow and herdsman, and female mourners, LÜDDECKENS in *Mitt. Kairo*, xi (1943), pp. 154–6 [77–8]. Names of two mourners, BRUYÈRE, *Rapport (1926)*, p. 66.

(2) Two registers. **I**, Small scene at right end, offerings before deceased and wife with woman behind them. **II**, Three scenes, **1**, tree-goddess scene, with two *bas* flying and two *bas* on canal (partly on entrance-wall), **2**, weighing-scene, **3**, deceased led by Anubis to Osiris and [divinities].

DESROCHES-NOBLECOURT and JOURDAIN-LAMON, Doc. 50–7 with pl.; incomplete, BRUYÈRE, *Rapport (1927)*, figs. 41 [left], 42–3, cf. pp. 56–60.

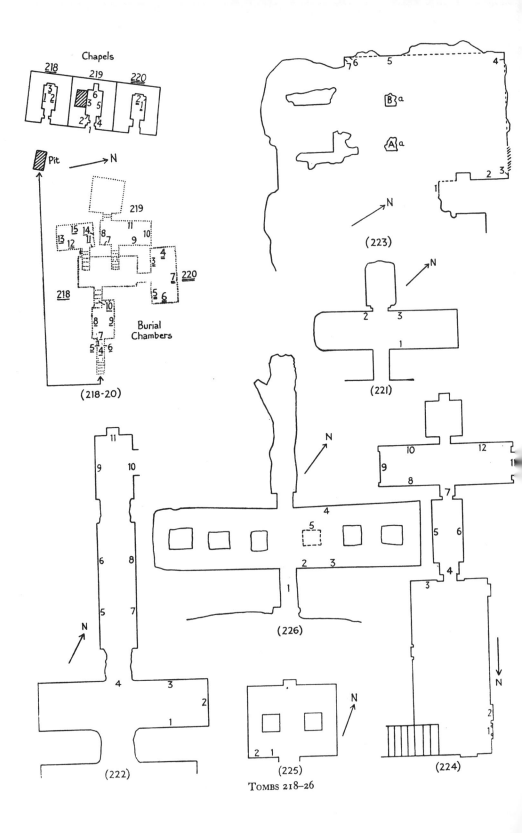

Chapels

218 219 220

Pit →N

219

218 220

Burial
Chambers

(218-20)

(223)

(221)

(226)

(222)

(225)

(224)

Tombs 218–26

(3) [Stela.] At sides, two registers. **I,** Mummiform Ptaḥ on left (right destroyed). **II,** Woman with double-pipe on left, and Sennezem (tomb 1) and woman with double-pipe on right.

Desroches-Noblecourt and Jourdain-Lamon, Doc. 47–8 with pl. See Bruyère, op. cit. p. 60.

Pyramid.

Base of stela, found in Pit 1350. Bruyère, *Rapport (1933–1934)*, fig. 50, cf. p. 119.

Burial Chambers. Complete, Gr. Inst. Archives, photos. DM. 218. a, 1–10, b, 1–11.
Passage.

(4) Outer lintel, remains of bark of Rēꜥ adored by deceased kneeling on each side, jambs, offering-texts, inner lintel, two Anubis-jackals. (5) Two registers, **I,** bark of Rēꜥ with Ḥathor and baboon adoring, **II,** relatives dragging sarcophagus, followed by priest. (6) Deceased with hymn to Rēꜥ.

Desroches-Noblecourt and Jourdain-Lamon, Doc. 1–4, 17–19, with pl.

Outer Chamber.

(7) Tympanum, Meḥitwert-cow by pool, and hawk. Scenes below, left of doorway, deceased crouching under dôm-palm drinks from pool, and wife adoring (belonging to (9)), and right of doorway, wife crouching under date-palm drinks from pool, and daughter adoring (belonging to (8)).

Desroches-Noblecourt and Jourdain-Lamon, Doc. 5, 14–15, with pl. Scene left of doorway, Davies (Nina), *Anc. Eg. Paintings*, ii, pl. cii; Schott photos. 8984–6; lower part, Vandier, *Egypt*, pl. v. Daughter, right of doorway, Schott photo. 8979. Texts of deceased, and of wife, drinking, Bruyère, *Rapport (1935–1940)*, Fasc. iii, p. 79 [middle].

(8) Two registers. **I,** Ptaḥ, Thoth, Selkis, Neith, Nut, Nephthys, and Isis. **II,** Deceased and wife kneeling with two children, and hymn to Rēꜥ.

Desroches-Noblecourt and Jourdain-Lamon, Doc. 11–12 with pl. **II,** Bruyère, *Rapport (1927)*, fig. 55, cf. p. 80.

(9) Two registers. **I,** Thoth, Neḥebkau, Geb, Horus, Nu, Shu, and Khepri. **II,** Deceased kneeling with family, and hymn to Rēꜥ.

Desroches-Noblecourt and Jourdain-Lamon, Doc. 6–7 with pl. **II,** Schott photos. 8981–3.

(10) Tympanum, Osiris seated with personified *uzat* behind him holding torches, in front of mountain with Western hawk and arms of Nut holding disk, and Tika with torches on right. Scene below, right of doorway, deceased and son Khaꜥemteri (tomb 220) kneeling, followed by son Nebenmaꜥet (tomb 219), all adoring, with hymn to Rēꜥ.

Desroches-Noblecourt and Jourdain-Lamon, Doc. 9–10 with pl.; Schott photos. 3097–9, 8980, 8987. Tympanum, omitting Osiris, Lhote and Hassia, *Chefs-d'œuvre*, pl. 164.

Vaulted ceiling, with band of text in centre. Left (south) half, deceased and wife in canoe, and bark of Rēꜥ, right (north) half, bark with hawk, and bark with *ba* between two *Benu*-birds.

Desroches-Noblecourt and Jourdain-Lamon, Doc. 8, 13, 16, with pl. Deceased and wife, Schott photo. 8988.

Innermost Chamber.

(11) Deceased, wife, and daughter adoring.
DESROCHES-NOBLECOURT and JOURDAIN-LAMON, Doc. 20 with pl.; SCHOTT photo. 8998.

(12) Western hawk on pylon, with text partly on ceiling.
DESROCHES-NOBLECOURT and JOURDAIN-LAMON, Doc. 31 with pl.

(13) Anubis tending mummy on couch between Isis and Nephthys as hawks.
Id. ib. Doc. 21–3 with pl.; BRUYÈRE, *Rapport* (*1927*), fig. 56, cf. p. 82; VANDIER, *Egypt*, pl. iii.

(14) Fields of Iaru.
DESROCHES-NOBLECOURT and JOURDAIN-LAMON, Doc. 36–40 with pl.; SCHOTT photos. 8999–9000.

(15) Gods of Zazat (conclave) with four texts.
DESROCHES-NOBLECOURT and JOURDAIN-LAMON, Doc. 24–30, 32, with pl.

Frieze-text. Id. ib. Doc. 33.

Vaulted ceiling, with band of text in centre. Outer half, text (partly at (12)). Inner half, deceased kneeling with hymn to moon, five star-gods above, and long text behind him.
Id. ib. Doc. 34–5, 41, with pl.

Finds

Lower part of jamb with deceased seated at bottom, followed by son Neb[meḥyt] ⳥[𓏏𓇋𓇋𓏤] standing, in Museu Etnológico, Belém, Lisbon.

219. NEBENMAʿET ▽𖼖 𓏤𓏭, Servant in the Place of Truth on the west of Thebes. Ramesside.

Deir el-Medîna.
Parents, Amennakht (tomb 218) and Iymway (name in tomb 218). Wife, Mertesger 𓏤𓏭𓏤𓏭.
Plan, p. 318. Map VII, E–3, d, 8.

MAYSTRE, *La Tombe de Nebenmât* (*No. 219*), (*M.I.F.A.O.* lxxi), passim, with plans of Chapel and Burial Chamber (from BRUYÈRE) and section, figs. 1–3; BRUYÈRE, *Rapport* (*1927*), pp. 53–5, 68–78, 82, with plan of Chapel on pl. i, and plan and section of Burial Chambers, figs. 53–4.

Chapel.

(1) Outer lintel, Anubis-jackal crouching before Sekhem-emblem, found in Pit 1348, and fragments of jambs. Fragment of inner (?) lintel with deceased adoring.
Outer doorway, BRUYÈRE, *Rapport* (*1933–1934*), fig. 53 (lintel), cf. p. 118. Inner lintel, see id. ib. (*1923–1924*), pp. 102–3 [2]; text, MAYSTRE, p. 5 [A].

(2) Six Servants in the Place of Truth with staves (belonging to procession at (3)).
MAYSTRE, pl. ii [upper left], p. 11 [11]; BRUYÈRE, *Rapport* (*1927*), fig. 48 [right], cf. p. 78; id. *Mert Seger*, fig. 35.

(3) Three registers. **I**, Remains of relatives (?). **II–III**, Funeral procession to pyramid-tomb.

Omitting tomb, MAYSTRE, pl. ii [lower], pp. 11–13 [12–15]; BRUYÈRE, *Rapport (1927)*, fig. 52, cf. pp. 76–8. Priests and mourners with sarcophagus in bark in **II**, LÜDDECKENS in *Mitt. Kairo*, xi (1943), Abb. 53 (from MAYSTRE), cf. pp. 156–7 [79]. Names of two female mourners, BRUYÈRE, *Rapport (1926)*, p. 66.

(4) Two registers. **I**, Remains of tree-goddess scene. **II**, Nekhtamūn (tomb 335) with his son (at (5)) offers to Nebrē‹ (brother of deceased) and wife.

MAYSTRE, pl. i [upper right], p. 9 [1, 2]; BRUYÈRE, *Rapport (1927)*, fig. 48 [left], cf. pp. 68–70.

(5) Two registers. **I**, Weighing with Thoth as baboon on pylon, and deceased led by Anubis to [Amenophis I] in palanquin. **II**, Attendants before couples (including Buḳentef ⌗⌗⌗⌗ and Iy ⌗⌗⌗), and deceased with wife offers on brazier to divinities.

MAYSTRE, pl. i [upper left, lower right], pp. 9–10 [3–7]; BRUYÈRE, *Rapport (1927)*, figs. 49, 50, cf. pp. 70–4. Cartouches in **I**, ČERNÝ in *B.I.F.A.O.* xxvii (1927), pp. 175–6. Mention of onion-feast in **II**, see SCHOTT, *Altägyptische Festdaten*, p. 971 [75].

(6) [Niche.] Left of niche, deceased and family. Right of niche, three registers, offering-scenes to seated people.

MAYSTRE, pls. i [lower left], ii [upper right], p. 10 [8–10]; BRUYÈRE, *Rapport (1927)*, fig. 51, cf. pp. 74–6.

Fragments from walls and ceiling, MAYSTRE, pl. iii, p. 4.

Outer Burial Chamber.

(7) Two registers. **I**, Anubis-jackal and vase with torches. **II**, Son as priest censes and libates to deceased and wife.

MAYSTRE, pl. iv [upper].

(8) [1st ed. 1] Tympanum, winged Isis. Scenes below, deceased, with wife playing flute, offers bouquet on censer to Osiris, Amenophis I, Ḥathor (?), and ʿAḥmosi Nefertere, in front of mountain, and (below the King, Queen, and divinities) deceased (followed by daughter) and wife playing draughts and tree-goddess scene with *ba*s and baboon adoring.

MAYSTRE, pl. vi; ČERNÝ in *B.I.F.A.O.* xxvii (1927), pl. vii, p. 175; BRUYÈRE, *Rapport (1927)*, fig. 57, cf. p. 82; NEWBERRY in ROSS, *The Art of Egypt*, pl. on p. 167; omitting King, Queen, and divinities, SCHOTT photos. 8989–90, 8997. Draughts-playing scene, WRESZ., *Atlas*, i. 49 a; CALDWELL, *The Ancient World*, pl. facing p. 83 [upper left]; DESROCHES-NOBLECOURT, *Religions ég.* fig. on p. 305; WOLF, *Die Kunst Aegyptens*, Abb. 595.

(9) Deceased and wife with son Wepwautmosi and wife offering to them, and two registers, banquet.

MAYSTRE, pls. v [upper], iv [lower]. Son offering to deceased, and kitten under wife's chair, SCHOTT photos. 8995–6.

(10) Tympanum, winged Nephthys. Scene below, Anubis with Opening the Mouth instrument tending mummy on couch.

MAYSTRE, pl. v [lower]. Scene, id. *Un Tableautin égyptien* in *Bull. Mensuel des Musées . . . de Genève*, ix [6], June 1952, fig. 3.

(11) Two registers. **I**, Four scenes, **1**, deceased offers bouquet to Satis and Neith, **2**, son Wepwautmosi and wife offer bouquet to Rēʿ and Sekhmet, **3**, priest offers on braziers to

Ptaḥ and Maᶜet, **4**, deceased led by Anubis to Osiris and Western goddess. **II,** Funeral procession (including chair with bouquet and offerings) to mummies at pyramid-tomb in mountain with arms of Nut holding disk.

MAYSTRE, pl. vii. **II,** SCHOTT photos. 8991–4; men and oxen dragging sarcophagus on sledge, LÜDDECKENS in *Mitt. Kairo*, xi (1943), Abb. 54 (from MAYSTRE), cf. pp. 157–8 [80]; priest before mummies at tomb, and arms [of Nut] in mountain, BRUYÈRE, *Rapport (1926)*, fig. 10, cf. p. 25; arms in mountain and tomb, LHOTE and HASSIA, *Chefs-d'œuvre*, pl. 170.

Vaulted ceiling. Outer half, deceased adoring Thoth, wife adoring Ḥepy, and Anubis facing Ḳebḥsenuf. Inner half, deceased adoring Rēᶜ, shadow of deceased in front of tomb, and Rēᶜ-Ḥarakhti as hawk facing Ptaḥ, and Thoth as baboon.

MAYSTRE, pls. viii, ix.

Finds

Lintel of deceased, perhaps from here. MAYSTRE, fig. 5, cf. p. 6 [c].

220. K H Aᶜ E M T E R I ⟨hieroglyphs⟩, Servant in the Place of Truth. Ramesside.

Deir el-Medîna.

Parents, Amennakht (tomb 218) and Iymway. Wife, Nefert(em)satet ⟨hieroglyphs⟩ (name from statue in Leyden Mus. D. 18).

Plan, p. 318. Map VII, E–3, d, 8.

DESROCHES-NOBLECOURT and JOURDAIN-LAMON, *La Tombe d'Amennakht*, in the Press; BRUYÈRE, *Rapport (1927)*, pp. 78–82, with plan of Chapel on pl. i, and plan and section of Burial Chamber, figs. 53–4.

Chapel.

(1) Sketch of Osiris seated.
DESROCHES-NOBLECOURT and JOURDAIN-LAMON, Doc. 10 with pl.

(2) Stela (removed). On wall right of stela, sketch of Ptaḥ, id. ib. Doc. 11 with pl.

Pyramid.

Fragment of top, BRUYÈRE, *Rapport (1928)*, fig. 19 [1], cf. p. 131.

Burial Chamber.

(3) Remains of text. DESROCHES-NOBLECOURT and JOURDAIN-LAMON, Doc. 1.

(4) Tympanum, two Anubis-jackals. Scene below, deceased (as Osiris) and Isis with food-table, and personified *zad*-pillar pouring water from vases.
Id. ib. Doc. 2 and 4 with pl.; BRUYÈRE, *Rapport (1927)*, fig. 58, cf. p. 82.

(5) Meḥitwert-cow by pool, with hawk.
DESROCHES-NOBLECOURT and JOURDAIN-LAMON, Doc. 9 with pl.

(6) Tympanum, left part, Anubis-jackal. Scene below, mummy on couch with canopic-jars, Opening the Mouth instruments, &c.
Id. ib. Doc. 6 and 8 with pl.

(7) Lower part of funeral banquet.
Id. ib. Doc. 5 with pl.

Frieze-texts. Id. ib. Doc. 3 and 7 with pl.

221. Ḥ O R I M I N 〔𓀀𓏏𓏏〕, Scribe of soldiers in the palace of the King on the west of Thebes. Ramesside.

Qurnet Mura'i.

Plan, p. 318. Map VIII, F–3, h, 3.

Hall.

(1) Three registers, **I–III**, scenes from Book of Gates, including deceased adoring Rēʿ-Ḥarakhti, and deceased and wife led by two gods to Osiris. (2) Deceased before Osiris. (3) Deceased adores Rēʿ-Ḥarakhti (unfinished).

Frieze at (2) and (3). Deceased and wife kneeling adore Anubis-jackal, and adore Ḥathor-head.

Part, BAUD, *Dessins*, fig. 93.

Ceiling. Centre, bark of Rēʿ with hymns adored by deceased kneeling, and offering-formula, giving name and titles, framing scenes.

222. Ḥ E K M A ʿ E T R Ē ʿ - N A K H T ○〔𓊪𓉔𓂝〕, called T U R O 〔𓊪𓂋〕,[1] First prophet of Monthu Lord of Thebes. Temp. Ramesses III to IV.

Qurnet Mura'i.

Wife, Wiay 〔𓊪𓀀𓏏𓏏〕, Chief of the harîm of Monthu.

Plan, p. 318. Map VIII, F–3, h, 2.

DAVIES (Nina) in *J.E.A.* xxxii (1946), pp. 69–70, with key-plan on pl. xiii; SPIEGEL in *Ann. Serv.* xl (1940), p. 265 [middle], cf. 266, note 1.

Hall.

(1) Two registers. **I,** Book of Gates, four scenes, **1–4,** deceased offers to divinities, with dressed *zad*-pillar in **1. II,** Son Userḥēt, Chief prophet of Monthu, offers to deceased and wife seated.

(2) Two registers. **I,** Two divine barks in shrines, and deceased offers to Ramesses IV. **II,** People offer to deceased and wife.

(3) Two scenes. **1,** Deceased adores Ramesses III in kiosk. **2,** Sketch of offerings and seated King.

Passage.

(4) Outer right jamb, dressed *zad*-pillar.

CHIC. OR. INST. photo. 7853.

(5) Three registers, **I** and **II,** Book of Gates, **III,** funeral procession. (6) Two registers, **I,** deceased with four calves before Rēʿ-Ḥarakhti, **II,** man offers to [deceased?].

(7) Three registers. **I** and **II,** Remains of funeral procession, with Fields of Iaru, to Western goddess. **III,** Mourners and butchers, boats on river, and island with three scenes, **1,** priest and butcher before goddess, **2,** priest purifies mummy, **3,** son Panebmonthu 〔𓊪𓂋〕, First prophet of Monthu, with goddess, purifies mummy. Sub-scene, boat, offering-bringers,

[1] See CHRISTOPHE in *Ann. Serv.* xlviii (1948), pp. 153–4 [5].

man offering to mummy on couch, and deceased libating. (Block with man holding mummy, and mourners, is in Liverpool City Mus.)

See DAVIES, pp. 69–70 [7] and pl. xiii (showing **III**).

(8) Two registers. **I**, Deceased before Osiris and goddess. **II**, Deceased and wife seated, with unfinished scene beyond.

Inner Room.

(9) and (10) Deceased and wife before [Osiris and goddess] on left wall, and deceased before Ptaḥ (cut by doorway) on right wall.

CHIC. OR. INST. photos. 7854–5, 8176.

(11) Niche, with squatting man and [person] before table of offerings below. At each side of niche, two registers, deceased before two divinities.

223. KARAKHAMŪN 𓏏𓄿𓏤𓏏𓏏, First ꜥk-priest. Saite.

'Asâsîf. (CHAMPOLLION, No. 17, L. D. Text, No. 93.)

Plan, p. 318. Map VI, E–4, c, 5.

CHAMP., Not. descr. i, p. 513. Titles, L. D. Text, iii, p. 288; part, ROSELLINI MSS. 284, G 28; WILKINSON MSS. v. 176 [bottom middle].

Court.

Block from a pilaster (?), with deceased adoring Rēꜥ-Ḥarakhti and goddess of night on front, and lion-headed goddess on adjoining left face, in Berlin Mus. 2110.

Front, L. D. iii. 282 [e]; Aeg. und Vorderasiat. Alterthümer, pl. 122; HAMANN, Ägyptische Kunst, Abb. 314 (called 341), cf. p. 290; SCHÄFER and ANDRAE, Kunst, 434 [lower], 2nd and 3rd ed. 450 [lower]. See Ausf. Verz. p. 263.

Pillared Hall.

(1) Outer right jamb and thickness, inner left jamb, and wall beyond, texts.

(2) Two registers. **I** and **II**, Jars with sacred oils, &c., and text of Opening the Mouth.
Text, GOLENISHCHEV MSS. 15 [a]; part, SCHIAPARELLI, Funerali, ii, pp. 307–8 [xxxiv].

(3)–(4) Remains of two men with jars and offering-list before deceased seated. (5) Iwn-pillar.

(6) Text of a [chancellor], L. D. Text, iii, p. 288 [bottom, right column].

(7) Man.

Pillars. A (a) and B (a). Remains of texts.

Position Unknown.

Brother Ésamenōpet on squared background with text above.
L. D. iii. 282 [d], cf. Text, iii, p. 288; omitting text, PRISSE, L'Art égyptien, ii, 2nd pl. [1], 'Nouveau Canon des proportions'.

Text from a scene. GOLENISHCHEV MSS. 11 [b].

224. ʿAḤMOSI 𓏤𓏤, called ḤUMAY 𓈖𓏤𓏤, Overseer of the estate of the god's wife, Overseer of the two granaries of the god's wife ʿAḥmosi Nefertere. Temp. Tuthmosis III or Ḥatshepsut.

Sh. ʿAbd el-Qurna. (L. *D. Text*, No. 85.)

Parents, Senusert and Taidy 𓏤𓏤𓏤. Wife, Nub 𓏤, Royal concubine (in tombs 29 and 96).

> Plan, p. 318. Map VI, E–4, g, 3.

Titles, GOLENISHCHEV MSS. 14 [m].

Court.

(1) Stela, with Ḥuy (i.e. Amenḥotp, tomb 368) and wife before Osiris-Onnophris and Isis.

(2) Stela of deceased as Ḥumay, mentioning Ḥetepdy 𓏤𓏤, Overseer of granaries of the god's wife of Amūn.

(3) Remains of deceased with titles.

Vestibule.

(4) Outer lintel, remains of text, and jambs with deceased seated at bottom. Inner right jamb, three registers, attendants and scribes.

(5) Four registers, funeral procession to Osiris. **I,** Dragging shrines and *teknu* and bringing funeral outfit. **II,** Sarcophagus dragged by men and oxen. **III,** Opening the Mouth ceremony, rites in garden, mummers, and canoe dragged. **IV,** Rites before mummies, with statue carried by two priests, and man and priest offering to deceased and wife.

Parts of **II–IV,** SCHOTT photos. 9004–9.

(6) [1st ed. 1]ʼFour registers, guests, including parents, and male harpist.

Parts, SCHOTT photos. 8216–19, 9001–3. Fragment of title of deceased, and names of parents, L. *D. Text*, iii, p. 286 [upper]; of deceased, HELCK, *Urk.* iv. 1432 [bottom] (from LEPSIUS).

Hall.

(7) Outer lintel, remains of offering-text, and jambs, remains of titles. Left thickness, deceased consecrates offerings. Right thickness, deceased censes at Valley Festival.

Translation of texts on thicknesses, SCHOTT, *Das schöne Fest*, pp. 861 [18], 865–6 [37].

(8) Marsh-scene before deceased. (9) False door with text of Tuthmosis III, and at sides, four registers, kneeling men offering. (10) Banquet or offering-scenes. (11) False door, with men offering at sides. (12) Offering-bringers (?) before deceased (?).

225. A First prophet of Ḥathor. Temp. Tuthmosis III (?).

Sh. ʿAbd el-Qurna.

Wife, Webekht 𓏤𓏤𓏤.

> Plan, p. 318. Map V, D–4, e, 10.

Hall.

(1) Deceased with wife offers on braziers.

SCHOTT photo. 8449.

(2) Deceased and wife with [table of offerings].

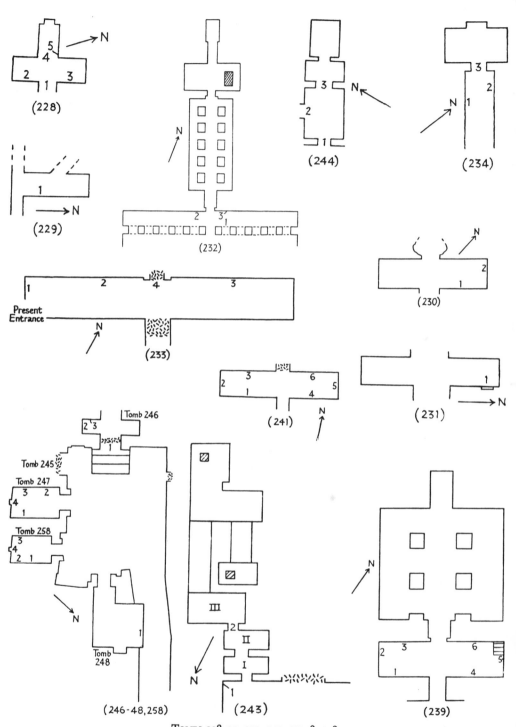

(228)

(229)

(232)

(244)

(234)

(233)

Present Entrance

(230)

(241)

(231)

Tomb 246

Tomb 245

Tomb 247

Tomb 258

Tomb 248

(246-48, 258)

(243)

(239)

Tombs 228–34, 239, 241, 243–8, 258

226. A Royal scribe, Overseer of the royal nurses. Temp. Amenophis III.

Sh. 'Abd el-Qurna.

Plan, p. 318. Map V, D–4, e, 8–9.

DAVIES, *The Tombs of Menkheperrasonb* [&c.], pp. 35–40, with plan and section, pl. xl.

Hall. Much destroyed.

(1) Left thickness, [deceased], right thickness, [deceased] and two women.
See DAVIES, p. 36.

(2) Deceased offers on braziers.
DAVIES, pl. xliv, p. 39. Text of deceased, HELCK, *Urk.* iv. 1878 [lower]–1879 [upper].

(3) Two registers, offering-bringers, with garlanded bull, sheaves of corn with quails, &c.
DAVIES, pls. xlv, xxx [A], p. 39. [Man] with bull, DAVIES (Nina), *Anc. Eg. Paintings*, ii,
pl. lix.

(4) [1st ed. 1] (removed) Deceased, preceded by fan-bearers, offers pectorals, bracelets,
&c., to Amenophis III and Queen Mutemwia in kiosk, with foreigners on base.
DAVIES, pls. xli–xliii, pp. 38–9. Head of King, and five foreigners, DAVIES (Nina), op. cit.
ii, pls. lvii, lviii; foreigners, WRESZ., *Atlas*, i. 372; MEYER, *Fremdvölker*, 734–7; FARINA,
Pittura, pl. cxviii; HAMMERTON, *Universal History of the World*, i, fig. on p. 662; PRITCHARD,
The Ancient Near East in Pictures, fig. 4 (from MEYER), cf. p. 249. Necklace with pectoral
(offered by deceased), WINLOCK in *Ancient Egypt* (1920), fig. 2, cf. p. 76; pectoral, DAVIES,
Menkheperrasonb, pl. xxx [D]. Texts (restored), HELCK, *Urk.* iv. 1877–8 [upper].

(5) Pillar (removed). Deceased with four children of Amenophis III on his knees.
DAVIES, pl. xxx [E], pp. 39–40; and in *M.M.A. Bull.* Pt. ii, Dec. 1923, fig. 3, cf. p. 43.
Fragments with names, NEWBERRY in *J.E.A.* xiv (1928), fig. 1, cf. pp. 82–3 (called sons of
Tuthmosis IV). Texts of children, HELCK, *Urk.* iv. 1879 [lower].

227. Name lost. Temp. Tuthmosis III.

Sh. 'Abd el-Qurna.

Father, Ḥepu ♦▲ ♀, Third lector of Amūn.

Map V, D–4, g, 9.

Ceiling, remains of text.

228. AMENMOSI [𓇋𓏠𓈖𓏠𓋴], Scribe of the treasury of Amūn. Dyn. XVIII.

Sh. 'Abd el-Qurna.

Father (probably), 'Amethu (tomb 83).

Plan, p. 326. Map V, D–4, g, 7.

Hall.

(1) Inner lintel, remains of offering-text. (2) Seated man. (3) Remains of banquet with
girl before female guests.

Ceiling, remains of text.

Inner Room.

(4) Inner lintel, remains of text. (5) Nephthys before Ptah-Sokari with goddess (?) (painted scene, probably Ramesside).

229. Name lost. Dyn. XVIII.

 Sh. ʿAbd el-Qurna. (Unfinished.)

<div align="center">Plan, p. 326. Map V, D–4, e, 8.</div>

Hall.

(1) [1st ed. 1] Deceased with wife offers on braziers.
MACKAY in *J.E.A.* iv (1917), pl. xv [5], p. 77; BAUD, *Dessins*, fig. 94.

230. Perhaps MEN 𓎛, Scribe of soldiers of the Lord of the Two Lands (from cones). Dyn. XVIII.

 Sh. ʿAbd el-Qurna. (Unfinished.)

<div align="center">Plan, p. 326. Map V, D–4, e, 9.</div>

Hall.

(1) Two registers, **I–II,** [banquet]. At left end, heap of vases, obelisks, and kiosk (?). Three female guests in **II,** SCHOTT photo. 7133.

(2) Osiris in kiosk.

Ceiling, offering-text.

231. NEBAMŪN 𓇋𓎛𓂋, Scribe, Counter of the grain of Amūn in the granary of divine offerings. Early Dyn. XVIII.

 Draʿ Abû el-Nagaʿ.
 Wife, Nefertere.

<div align="center">Plan, p. 326. Map II, C–6, g, 10.</div>

Hall.

(1) Stela. Text at top, and two registers, **I,** son offers to deceased, wife, and daughter, **II,** deceased seated with staff and offering-text with dates of festivals.
SCHOTT photo. 8650.

232. THARWAS 𓂋𓏤𓆑𓃀𓂻𓃀, Scribe of the divine seal of the treasury of Amūn. Ramesside.

 Draʿ Abû el-Nagaʿ.
 Father, Weshebamūnheref 𓂝𓏤𓏏𓇋𓎛𓊨 .

<div align="center">Plan, p. 326. Map I, C–7, a, 9.</div>

Hall.

(1) Frieze. Remains of scenes, deceased adoring sphinx with text.

(2) and (3) Frieze. Deceased kneeling adores sphinx on pylon.

Astronomical ceiling, centre. Outer part, divine bark. Inner part, Nut supporting disk with adoring baboons on each side, and two gods on right holding rope attached to foreleg,

with Tuēris as hippopotamus and two gods beyond between remains of Northern constellations.

Gods with foreleg and Tuēris, CHIC. OR. INST. photo. 10651.

233. SAROY 𓈙𓏏𓇋𓇋, Royal scribe of the table of the Lord of the Two Lands. Ramesside.

Dra' Abû el-Naga'.

Plan, p. 326. Map I, C–7, b, 7.

Hall.

(1) Three registers, funeral procession. **I,** Deceased with relatives and mourners before mummies at pyramid-tomb, and deceased and wife received by Ḥathor and Western goddess. **II,** Man with staff, oxen dragging sarcophagus, and remains of procession and mourners. **III,** Text.

Tomb, DAVIES (Nina) in *J.E.A.* xxiv (1938), fig. 18, cf. p. 39.

(2) Three registers, Book of Gates, with Horus reporting to Osiris at right end of **III.**

(3) Long text, and lotus in centre with priest offering incense, libation, and food, to bull, on each side.

(4) Entrance to Passage. Lintel, remains of double-scene.

Position unknown.

Remains of Opening the Mouth rites, with scene of adoration of statue, said to be in First Room. See SCHIAPARELLI, *Funerali*, ii, p. 306 [xxix].

234. ROY 𓏏𓇋𓇋, Mayor. Dyn. XVIII or XIX.

Dra' Abû el-Naga'.
Wife, Ani 𓄿𓏏.

Plan, p. 326. Map I, C–7, c, 6.

Passage.

(1) Men with funeral outfit. (2) Deceased and wife seated.

(3) Entrance to Inner Room. Outer right jamb, name of deceased.

235. USERḤĒT 𓏏𓄿, First prophet of Monthu Lord of Thebes. Dyn. XX.

Qurnet Mura'i.

Map VIII, F–3, i, 2.

See FAKHRY in *Ann. Serv.* xxxiv (1934), pp. 135–40, with plan and section, p. 137.

Red granite sarcophagus in Burial Chamber. Texts, id. ib. p. 138.

236. ḤARNAKHT 𓄿𓈔, Second prophet of Amūn, Overseer of the treasury of Amūn. Ramesside.

Dra' Abû el-Naga'.

Map II, D–5, i, 4.

Sarcophagus (inscribed) in Burial Chamber.

237. UNNŪFER ⟨glyph⟩, Chief lector. Ramesside.
Dra' Abû el-Naga'.

Map II, D–5, j, 4.

Sarcophagus (inscribed) in Burial Chamber.

238. NEFERWEBEN ⟨glyph⟩, Royal butler clean of hands. Dyn. XVIII.
Khôkha.

Map IV, D–5, c, 8.

Name and title on ceiling of Hall.

239. PENḤĒT ⟨glyph⟩, Governor of all Northern Lands. Temp. Tuthmosis IV to Amenophis II (?).
Dra' Abû el-Naga'.
Wife, Ḥetepti ⟨glyph⟩.

Plan, p. 326. Map I, C–7, a, 9.

Hall.

(1) [Deceased and wife] seated, and fragment of offering-list.

(2)–(3) [1st ed. 1] Three registers. I–III, Syrians, with tribute of floral vases and metal ingots, including man with child on shoulder in II, and horse in III, before [King].
MEYER, *Fremdvölker*, 726–7, 621–2. I and II at (3), WRESZ., *Atlas*, i. 373.

(4) At bottom, man offering to seated man.

(5) Imitation granite stela, with remains of double-scene, deceased and wife before divinities. At right side, two registers, I, man offers to couple, II, man.
See HERMANN, *Stelen*, p. 39.

(6) Three remaining registers. I, Plants. II, Deceased with military escort. III, Two sailing-boats.

240. MERU ⟨glyph⟩, Overseer of sealers. Temp. Mentuḥotp-Nebḥepetrēʿ.
'Asâsîf. (*L. D. Text*, No. 14, New York, M.M.A. Excav. No. 517.)
Parents, Iku ⟨glyph⟩ and Nebti ⟨glyph⟩.

Map III, C–5, b, 6.

L. D. Text, iii, pp. 241–2.

Burial Chamber in form of sarcophagus. View, M.M.A. photos. M.7.C. 203, M.6.C. 223.

Walls. Representations of funeral outfit and false door, with coffin-texts.
Omitting coffin-texts, *L. D.* ii. 148 [c, d]; M.M.A. photos. M.6.C. 32–7.

Sarcophagus. M.M.A. photos. M.6.C. 38–42.

Finds

Stela, year 46 of Mentuḥotp-Nebḥepetrēꜥ, in Turin Mus. 1447. Five registers, **I**, deceased seated and text with date, **II**, text with 'Address to the living', **III**, deceased and father on left, and man on right, all adoring, **IV**, priest with offerings before deceased and mother, **V**, offering-bringers.

ROSSI, *Illustrazione di una Stela Funeraria dell' xi Dinastia* in *Atti della Reale Accad. delle Scienze di Torino*, xiii (1878), pl. xxi, pp. 3–22; ORCURTI, *Discorso sulla Storia dell'ermeneutica Egizia* in *Memorie della Reale Accad. delle Scienze di Torino*, Ser. ii, xx (1861), pls. i, ii, pp. 23–5; GALASSI in *Critica d'Arte*, N.S. ii (1955), fig. 272, cf. p. 350; KLEBS, *Die Reliefs und Malereien des Mittleren Reiches*, Abb. 14, cf. p. 23; VANDIER, *Manuel*, ii, fig. 294 [right], cf. p. 478; WILKINSON MSS. ix. 165, 166 [upper, and lower left], cf. p. 146 [middle right], and vii. 88–9 [near top]; SEYFFARTH MSS. ix (1828), 9153–6. Upper part, FARINA, *R. Mus. di Torino* (1931), 40 [upper], (1938), 41 [right]. Text in **II**, BRUGSCH, *Thes.* 1231–2. Names, LIEBLEIN, *Dict.* No. 613. See FABRETTI, ROSSI, and LANZONE, *R. Mus. di Torino*, p. 117; ORCURTI, *Cat.* ii, p. 34 [45]; HAYES, *Scepter*, i, p. 166 (giving provenance).

241. ꜥAḤMOSI 🖼, Scribe of the divine writings, Child of the nursery, Head of mysteries in the House of the morning. Temp. Tuthmosis III (?).
Khôkha.
Wife, ꜥAḥmosi.

Plan, p. 326. Map IV, D–5, c, 8.

SHORTER in *J.E.A.* xvi (1930), pp. 54–62, with plan, fig. 1.

Hall.

(1) Two scenes. **1**, Deceased inspects three registers, **I–III**, recording grain and remains of harvest, including donkey beside conical granary in **I**. **2**, Priest offers to deceased and wife with monkey under her chair. Sub-scene, hacking, ploughing, and sowing.
SHORTER, pp. 54–5, pls. xv [upper] (showing **I** and **II**), xvi [A–C] (texts), and fig. 2 (monkey). **1, I**, and cattle treading grain in **II**, SCHOTT photos. 8616–19.

(2) Deceased and wife adore Osiris.
Texts, SHORTER, pl. xvi [D–F], pp. 55–6.

(3) Deceased and wife (with goose under her chair), man offering to them, and two registers, **I**, male [harpist] and song, lutist, standing harpist, and guest, **II**, female clappers with song, women with flute and tambourine, and guests. Sub-scene, offering-list ritual.
I and **II**, SHORTER, pls. xv [lower], xvi [I–K], p. 57. Parts, SCHOTT photos. 8620–2. Male musicians and song, WRESZINSKI, *Bericht über die photogr. Expedition* [&c.], pl. 74, p. 100; standing harpist and guest, HICKMANN in *Archiv Orientální*, xx (1952), pl. li, p. 453; id. *45 Siècles de Musique*, pl. l; harpist, id. in *Bull. Inst. Ég.* xxxv (1954), fig. 44, cf. p. 347.

(4) Two scenes. **1**, Priests with offerings before deceased and wife. **2**, Priest purifies deceased and wife.
SHORTER, pp. 58–9, with pl. xvii [Q, R] (texts of **2**).

(5) Remains of deceased and wife hunting on foot.
See id. ib. p. 58 [c].

(6) Two scenes. **1**, Deceased and family fowling and fishing, with men netting fish and fowl below. **2**, Man offers to deceased and wife.

SHORTER, pp. 57–8, with pl. xvii [M–P] (texts). Birds above papyrus, and men with fish in draw-net in **1**, SCHOTT photos. 8623–4.

242. WEḤEBRĒꞌ ⊙ 🔲, Chamberlain of the divine adoratress ꞌAnkhnesneferebrēꞌ. Saite.

ꞌAsâsîf. (L. D. Text, No. 22.)

Parents, Pedeamūnnai 🔲 and Mutardais 🔲. Wife, Tadepanehep 🔲 ·

Plan, p. 52. Map IV, D–5, c, 5.

BURTON MSS. 25639, 41 verso [middle upper].

Hall.

(1) [1st ed. 1, moved to entrance] Outer lintel, sons, Psammethek, Chamberlain of the god's wife, and Pedeḥorresnet 🔲 called Ḥarpemai 🔲, offer floral vases to [deceased] and mother.

BURTON MSS. 25644, 127, 129. Part of text, with names of parents and Psammethek, WILKINSON MSS. v. 165 [top], cf. 44 [bottom left]; names and titles, L. D. Text, iii, p. 245 [22].

(2) False door. At top, [deceased] adoring, and cartouche of Osiris-Onnophris between Ḥarsiēsi and Anubis adoring. Lintel of inner part of false door, winged hawk, right jamb, [Osiris] and Nephthys. Beyond right jamb, two columns of text giving title.

243. PEMU 🔲, Mayor of the Southern City, called 🔲, Royal scribe. Saite.

ꞌAsâsîf.

Father,[1] a prophet and *ḥeneku*-priest in Southern On.

Plan, p. 326. Map IV, D–4, j, 5.

See LECLANT in *Orientalia*, N.S. xxiii (1954), p. 66 [bottom].

Court.

(1) Titles of deceased.

Room III.

(2) Outer left jamb, deceased adores sacred cow and oars. Outer right jamb, titles of deceased as royal scribe. Inner right jamb, gods of constellations.

244. PAKHARU 🔲, Overseer of carpenters of the Temple of Amūn. Ramesside.

ꞌAsâsîf.

Plan, p. 326. Map IV, D–4, j, 5.

LECLANT in *Orientalia*, N.S. xxiii (1954), p. 66 [bottom].

[1] Titles of father, and name of grandfather Zementefꞌankh with the same title, are from notes made by GARDINER and DAVIES.

Hall.

(1) Left thickness, deceased adoring. (2) Deceased and wife kneeling adore Anubis-jackal. (3) Entrance to Inner Room, lintel, double-scene, deceased and wife offer flowers to [god], left jamb, offering-formula.

245. Ḥory ⳼, Scribe, Steward of the royal wife. Dyn. XVIII.

Khôkha. (Blocked.)

For position, see p. 326. Map IV, D–5, a, 10.

246. Senenrēᶜ ⳼, Scribe. Dyn. XVIII.

Khôkha.
Wife, Sitmenḥit ⳼.

Plan, p. 326. Map IV, D–5, a, 10.

Hall.

(1) [Jambs] with title. (2) Man, and frieze with four trees. (3) [Man] with fish.

247. Simut ⳼, Scribe, Counter of the cattle of Amūn. Dyn. XVIII.

Khôkha.
Wife, Sitamūn ⳼.

Plan, p. 326. Map IV, D–5, a, 10.

Hall.

(1) Two registers, I–II, remains of banquet.
Couple on right in I, Schott photo. 8775.

(2) At top, two offering-bringers.

(3) Four registers. I and II, Osiris and Western Ḥathor adored by deceased and wife, and funeral procession, including hawk-standard on mountain, and men with royal statuettes and funeral outfit. III, Offering-bringers, female mourners, and men and bull dragging canopic-box. IV, Offering-bringers with fruit and flowers before deceased and wife.
Parts of I and II, Schott photos. 3955–6, 7343–4. Mourners in III, Werbrouck, *Pleureuses*, pl. viii, figs. 110, 165, cf. pp. 57, 150; Wegner in *Mitt. Kairo*, iv (1933), pl. xvii [c]; Schott photos. 3952, 7350; first group, Stoppelaëre, *Introduction à la peinture thébaine* in *Valeurs*, Nos. 7–8 (1947), pl. 2. Translation of text of deceased and wife in IV, Schott, *Das schöne Fest*, p. 887 [118].

(4) [1st ed. 1] Two registers. I, Double-scene, three priests before offerings (one with candle in left half). II, Double-scene, two rows of priests before deceased purified by priest.
Hermann, *Stelen*, pl. 11 [c], p. 99; Schott photos. 3475, 7345–9. Man with candle, Davies in *J.E.A.* x (1924), pl. vi [5], p. 11; Schott photo. 3981; right purification-scene, Schott in *Nachr. Akad. Göttingen* (1957), No. 3, pl. v b, p. 85.

Ceiling. Line of text.

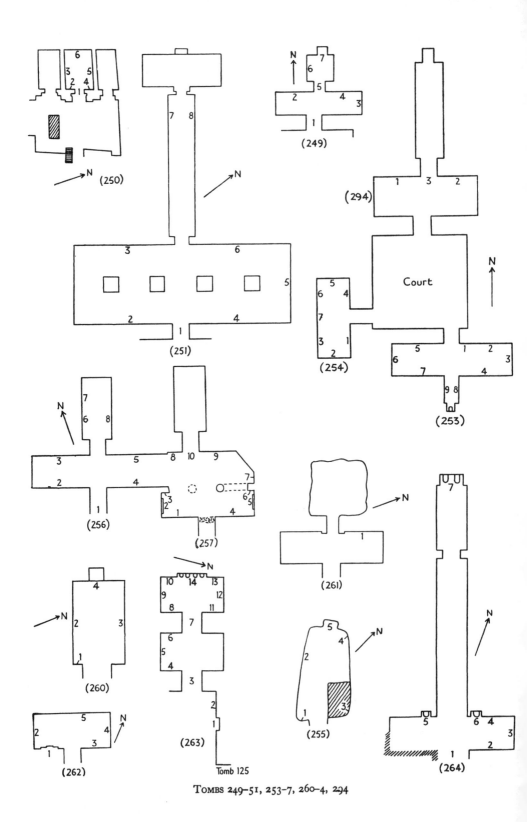

TOMBS 249-51, 253-7, 260-4, 294

248. D̲HUTMOSI 𓏏𓏏𓏏, Maker of offerings of Tuthmosis III. Dyn. XVIII.
Khôkha.
Wife, Tamert ⌐𓈒𓈖𓏥.

Plan, p. 326. Map IV, D–5, a, 10.

Hall.

(1) Deceased, wife, and children, with Khaᶜemnūter ⸻⟋, warb-priest of Amenophis II, offering bouquet and offerings to them, and two rows of guests.
M.M.A. photo. T. 1876. Omitting three male guests, SCHOTT photos. 3473, 3957, 3985–6, 8779. Texts, HELCK, Urk. iv. 1642 (557).

249. NEFERRONPET 𓏤𓏤𓏤, Purveyor (?) of date-wine. Temp. Tuthmosis IV (?).
Sh. ᶜAbd el-Qurna.

Plan, p. 334. Map VI, E–4, i, 3.

Hall.

(1) Left thickness, deceased and wife (unfinished).

(2) Two registers. **I,** Deceased adores Osiris and Ḥathor. **II,** Funeral procession with sarcophagus in bark, and man adoring at tomb.
I, SCHOTT photo. 8008.

(3) Stela (effaced). At sides, three registers, men offering to couples. At bottom, offering-bringers and female mourners before deceased and wife.
HERMANN, Stelen, pl. 8 [d]; SCHOTT photos. 8017–20. Offering-bringers and mourners, BAUD, Dessins, figs. 96–7.

(4) Two registers. **I,** Daughter (?) and three offering-bringers before deceased and wife. **II,** Couple with woman offering to them, and female harpist, flutist, and lutist, man with jars, and guests.
Omitting couple in **II,** SCHOTT photos. 8009–16. Girl sketched (beside deceased and wife) in **I,** BAUD, Dessins, fig. 95.

Inner Room.

(5) Thicknesses, deceased.

(6) Two registers. **I,** Men with offerings before deceased and wife. **II,** Two offering-bringers before seated man, and woman and man with bouquets before seated couple.
Part of **II,** SCHOTT photos. 8021–5.

(7) Niche. Side-walls, deceased and wife before Osiris, rear wall, stela, with two registers, **I,** deceased before Osiris, **II,** man before couple, and bouquets on each side. At sides of niche, two registers of kneeling offering-bringers, and below niche, double-scene, man before offerings with deceased seated behind him.
HERMANN, Stelen, pl. 2 [a, b] (from SCHOTT photos.), p. 21; SCHOTT photos. 8026–7.

Finds

Fragment of jamb of deceased, in Cairo Mus. Temp. No. 30.10.26.4.
Title, VARILLE in Ann. Serv. xxxiv (1934), p. 12 and note 1; LEGRAIN, Répertoire généa-logique et onomastique du Musée du Caire, No. 262.

250. RAʿMOSI.[1] (See tomb 7.) Temp. Ramesses II.

Deir el-Medîna.

Plan, p. 334. Map VII, E–3, d, 7.

BRUYÈRE, *Rapport (1926)*, pp. 59–66, 71–4, with plans and view, pl. v [upper].

Central Chapel.

(1) Left thickness, woman and child.

(2) and (3) Two funeral processions of men and women (right procession to four female mummies).

BRUYÈRE, pl. v [lower], pp. 72–4 [top]; GR. INST. ARCHIVES, photos. 2052–4. Right end, WERBROUCK, *Pleureuses*, pl. xlii, pp. 57–8.

(4) and (5) Three registers. I, Remains of people before Neferḥotep[1] (tomb 216) and wife. II, People before Ḥatḥor-cow in mountain. III, Two scenes, 1, man with jar of corn before seated people, 2, people before six seated women.

BRUYÈRE, pls. vii, viii, pp. 62–3; GR. INST. ARCHIVES, photos. 2044–50, 2052 [left].

(6) Stela, three registers. I, Double-scene, deceased adores Osiris, and wife adores Amen-ophis I. II, Double-scene, people adore Anubis, and adore Queen ʿAḥmosi Nefertere. III, Libation-priest with Opening the Mouth instruments, followed by lector and five women, before five female mummies mourned by daughters at pyramid-tomb.

BRUYÈRE, pl. vi, pp. 63–6, 71–2; GR. INST. ARCHIVES, photo. 2051. I and II, ČERNÝ in *B.I.F.A.O.* xxvii (1927), pl. vi [2], p. 176. Tomb in III, DAVIES (Nina) in *J.E.A.* xxiv (1938), fig. 20, cf. p. 39.

251. AMENMOSI 𓇋𓈖𓅓𓊨𓏪, Royal scribe, Overseer of the cattle of Amūn, Overseer of the magazine of Amūn. Temp. early Tuthmosis III.

Sh. ʿAbd el-Qurna.

Father, Nesu 𓈖𓋴𓅱𓃒, Head of the magazine of Amūn.

Plan, p. 334. Map V, D–4, g, 8.

Hall.

(1) Outer jambs, text.

(2) Two groups of butchers.

SCHOTT photos. 8495–8.

(3) Two registers, I–II, remains of banquet. I, Man offering, woman with lyre, and woman dancing. II, Two female clappers and male harpist.

SCHOTT photos. 8499–8500.

(4) Man filling jar.

(5) Remains of stela. At left side, agriculture, including men hoeing and felling tree at bottom. At right side, text.

Text on stela, HERMANN, *Stelen*, p. 44* [top]. Men hoeing, SCHOTT photo. 8501.

(6) [Painted scene.]

North Pillar. Remains of scenes, including [purification].

[1] Tomb attributed to Neferḥotep in GARDINER and WEIGALL, *Cat.* p. 39.

Passage.

(7) Monkey with basket of dates under [woman's] chair.
SCHOTT photo. 8527.

(8) Man with two tables of offerings before [deceased and wife], unfinished.
Man and lower table, BAUD, *Dessins*, figs. 98–9; man, MACKAY in *J.E.A.* iv (1917), pl. xv
[2], pp. 77–8; tables, SCHOTT photos. 7263–5, 8502–4.

252. SENIMEN �, Steward, Nurse of the god's wife. Temp. Ḥatshepsut.
Sh. 'Abd el-Qurna.
Parents, see tomb 71 (brother Senenmut). Wife, Senemiꜥoḥ (name in tomb 71).
Map V, D–4, f, 6.
DAVIES in *P.S.B.A.* xxxv (1913), pp. 282–5, with plan and section, pls. l, li.

Exterior.

Statues of deceased nursing small princess [Neferurēꜥ] and wife (?) standing beside him,
cut in rock-face above tomb.
DAVIES, pls. xlix, lii, liii, pp. 282, 284–5; M.M.A. photos. T. 2142–3.

Finds

Fragments of lintel and jambs, and of canopic-jars, of deceased, and fragments of relief,
including cartouche of Ḥatshepsut. M.M.A. photos. M.15.C. 64–5, 51.

253. KHNEMMOSI, Scribe, Counter of the grain (a) in the granary of Amūn,
(b) of the granary of divine offerings. Temp. Amenophis III (?).
Khôkha.
Wife, Tanūfer.
Plan, p. 334. Map IV, D–5, b, 9.

Hall. View, M.M.A. photo. T. 3124.

(1) Two registers. **I,** Deceased and wife. **II,** Man offering.
M.M.A. photo. T. 3132 [left]. Table of offerings in **II,** SCHOTT photo. 8777.

(2) Five registers. **I–III,** Recording grain, granary with trees, and King celebrating harvest-
festival beyond. **IV,** Bringing produce, and arrival of laden boats. **V,** Bringing produce, and
measuring crop.
M.M.A. photos. T. 3132–4. Parts, SCHOTT photos. 7396–7402, 8778. Granary in **I–III,**
DAVIES in *M.M.A. Bull.* Pt. ii, Nov. 1929, fig. 9, cf. p. 46; recording grain in **II** and **III,** HAY
MSS. 29851, 228–31, 234–7; granary in **III,** and boats in **IV,** CHIC. OR. INST. photo. 2961.

(3) Remains of stela. At sides, offering-scenes with couples.
M.M.A. photo. T. 3135.

(4) [Deceased and wife] with daughter and man holding bouquet before them, and male
guests with attendant.
M.M.A. photos. T. 3125–7. Offerings in front of top row of guests, SCHOTT photos. 8776,
8780.

(5) Two scenes. **1**, Deceased and wife offering, with family and offering-bringers. **2,** [Man] offers to deceased and wife. Sub-scene, agriculture, including ploughing, pulling flax, &c., before deceased.

M.M.A. photos. T. 3130–1. Details in sub-scene, SCHOTT photos. 2469–71.

(6) [Stela.] At sides, three registers (destroyed on left), **I–II**, people offer to deceased and wife, **III**, priest libating offerings.

M.M.A. photo. T. 3129. **III**, SCHOTT photo. 7403.

(7) Remains of offering-list before deceased and family, with guests and attendants below.

M.M.A. photo. T. 3128. Some offerings, BORCHARDT in *Ä.Z.* lxviii (1932), pl. v [top right], p. 77.

Shrine.

(8) Deceased and three people with hymn before Osiris-Onnophris and Western goddess with two Anubis-jackals, and butchers below. (9) Offering-bringers, and offering-list, before [divinity].

Finds

Wooden birth-chair (?), in Cairo Mus. Ent. 56353. PILLET in *Ann. Serv.* lii (1952), fig. 8, cf. pp. 90–1.

254. MOSI 𓅓𓏤𓈖, Scribe of the treasury, Custodian of the estate of Teye in the estate of Amūn. Late Dyn. XVIII.

Khôkha.

Wife, Tamert 𓏏𓄿𓅓𓂋𓏏.

Plan, p. 334. Map IV, D–5, b, 9.

Hall. View, M.M.A. photo. T. 3136.

(1) [1st ed. 1] Four registers, **I–II** in front of deceased and wife standing, **III–IV** in front of deceased and wife seated. **I**, Priest libating candle, and three men each censing and libating offerings. **II**, Reaping grain, and laden donkey with foal. **III** and **IV**, Man under tree, flax-pulling, tree-felling, ploughing, &c.

M.M.A. photos. T. 3143–4; CHIC. OR. INST. photo. 2963; SCHOTT photos. 2473, 2475, 2477–8, 7404–10, 8781–3. Priest in **I**, DAVIES in *J.E.A.* x (1924), pl. vi [6], p. 11. Group with donkey and foal in **II**, FARINA, *Pittura*, pl. clxxiii (called tomb 13).

(2) [1st ed 2] Three registers. **I**, Banquet, with offerings to three cobras, and guests with attendants. **II–III,** Funeral procession, with female mourners, and men bringing food in **II**, and boats in **III.**

M.M.A. photo. T. 3137; CHIC. OR. INST. photo. 2964; incomplete, SCHOTT photos. 2476, 7411–14. Three guests in **I**, DAVIES in *M.M.A. Bull.* Pt. ii, Dec. 1923, fig. 21, cf. p. 52, note 11.

(3) Two registers. **I**, Deceased with family before Osiris and Western goddess. **II**, People before couple.

M.M.A. photos. T. 3138–9 [left].

(4) Two registers. **I**, Man before granary, produce weighed, and [three people] offering bouquet to Osiris and goddess. **II**, Storehouse, men bringing chests and weighing with scales, and men heaping incense below, before deceased and wife.

M.M.A. photo. T. 3142; CHIC. OR. INST. photo. 2962; incomplete, SCHOTT photos. 2472, 7422–5.

(5) Stela, with deceased adoring Osiris, Anubis, and Western goddess, at top. At sides, three registers, **I** and **II**, people offering to seated couples, **III**, priest censing offerings with offering-bringer and female mourners.

M.M.A. photo. T. 3141. **III**, on right, SCHOTT photo. 7421.

(6) Two registers. **I**, Deceased and two women with man offering to them, and two rows of female musicians (harp, lyre, lute, and flute), dancers, and guests. **II**, Deceased receives bouquet of Amūn from wife at house, with dyeing and cooking beyond.

M.M.A. photo. T. 3140; CHIC. OR. INST. photo. 2965. Omitting deceased and women in **I**, SCHOTT photos. 2479–84, 7415, 7417–20, 8784–6. Deceased and wife at house, DAVIES, *Town House*, fig. 6, cf. pp. 245–6.

(7) Stela. Deceased before Osiris and Maʿet, and offering-text below.

M.M.A. photo. T. 3139.

255. ROY ⌒|◊◊, Royal scribe, Steward in the estates of Ḥaremḥab, and of Amūn. Temp. Ḥaremḥab (?).

Draʿ Abû el-Nagaʿ. (CHAMPOLLION, No. 52, HAY, No. 2.)

Wife, Nebttaui ▽≋, nickname Towey ≍ꓕ◳◊◳.

Plan, p. 334. Map I, C–7, b, 8.

BAUD and DRIOTON, *Tombes thébaines. Nécropole de Dirâʿ Abû ’n-Nâga. Le Tombeau de Roÿ* (*M.I.F.A.O.* lvii, 1), passim, with plan and section, fig. 1; CHAMP., *Not. descr.* i, pp. 554–5; BURTON MSS. 25639, 41, 41 verso; ROSELLINI MSS. 284, G 61 verso. Texts, HAY MSS. 29824, 25–42; titles of deceased and brother Ḍhout, Chief prophet of ʿAḥmosi Nefertere, and wife, at (3)–(4), and titles of Amenemōpet and wife, at (2), HELCK, *Urk.* iv. 2174 [lower].

Hall.

(1) Four registers. **I**, Man bringing calf to deceased and wife. **II**, Two ploughs meeting. **III**, Ploughing. **IV**, Pulling flax.

BAUD and DRIOTON, fig. 3, cf. pp. 24, 26; CHIC. OR. INST. photo. 10326.

(2) [1st ed. 1–2] Two registers. **I**, Five scenes, Book of Gates, **1**, Amenemōpet, Overseer of the granary of the Lord of the Two Lands, and wife adore Nefertem and Maʿet, **2**, deceased and wife adore Rēʿ-Ḥarakhti and Ḥathor, **3**, deceased and wife adore Atum with Ennead, **4**, deceased and wife led by Horus with weighing-scene, **5**, deceased and wife led by Ḥarsiēsi to Osiris with Isis and Nephthys. **II**, Funeral procession, including four of the 'Nine friends', male and female mourners, and priests, to mummy held by Anubis with stela at pyramid-tomb in mountain.

BAUD and DRIOTON, figs. 6–12, cf. 2, and pp. 9–17, 28–41 [2–26 bis]; CHIC. OR. INST. photos. 10327–30; HAY MSS. 29822, 15–17, and texts, 29824, 11–13, 15. **I**, 3–5, and **II**, BURTON MSS. 25644, 108–9, 111, 134–8, and texts, 112–13; parts, SCHOTT photos. 3796–3808. Scales in **I**, **4**, WILKINSON MSS. v. 108 [middle bottom]. **II**, CHAMP., *Mon.* clxxvii, clxxviii; ROSELLINI, *Mon. Civ.* cxxviii, cxxix [1]; omitting left end, WILKINSON, *M. and C.* 2 Ser. Supp. pl. 85, cf. 2 Ser. ii. 383 (No. 493) = ed. BIRCH, iii, pl. lxviii facing p. 449, cf. 428 (No. 625); omitting mourners with priests before mummy, CAILLIAUD, *Arts et métiers*, pl. 65 [4]; omitting right end, LÜDDECKENS in *Mitt. Kairo*, xi (1943), pp. 119–28 [54–9] with

Abb. 43–6; left end, LANE MSS. 34088, 24. Oxen dragging sarcophagus in **II**, DESROCHES-
NOBLECOURT, *Religions ég.* fig. on p. 315 [lower]; female and male mourners, WEGNER in *Mitt.
Kairo*, iv (1933), pl. xxvi [b]; WOLF, *Die Kunst Aegyptens*, Abb. 578; scene before mummy at
tomb, MASPERO, *Hist. anc. Les origines*, fig. on p. 180; female mourner before mummy, and
tomb, WILKINSON MSS. v. 108 [right bottom], 109 [top]; tomb with stela, DAVIES (Nina) in
J.E.A. xxiv (1938), fig. 23, cf. pp. 39–40. Texts in **I**, **1** and **2**, CHAMP., *Not. descr.* i, p. 545.

(3)–(4) [1st ed. 5–7] Three scenes. **1**, Priest with two female mourners censes and libates
offerings before deceased, wife, and two women. **2**, Priest censes and libates bundle of
onions before deceased and wife, and two couples with bundles of onions. **3**, Priest with
female mourner censes and libates offerings before deceased and wife.

BAUD and DRIOTON, figs. 14–16, cf. pp. 20–4, 45–8 [33–5]; HAY MSS. 29822, 12–14;
CHIC. OR. INST. photos. 10331–2. **1**, WEGNER in *Mitt. Kairo*, iv (1933), pl. xxvi [a]; WOLF,
Die Kunst Aegyptens, Abb. 577; priest and mourners, SCHOTT photos. 3793–5; upper mourner,
WERBROUCK, *Pleureuses*, fig. 69, cf. p. 59 and fig. on 2nd page after p. 159. **2**, KEIMER in
Cahiers d'histoire égyptienne, iii Sér. [4], (1951), fig. 2 (from BAUD and DRIOTON), cf. pp. 353–
4; omitting lower couple, WILKINSON, *M. and C.* i. 277 (No. 9), ii. 191 (No. 156, 2) = ed.
BIRCH, i. 181 (No. 9), 409 (No. 178, 2); SCHOTT photos. 3788–92; WILKINSON MSS. v. 108
[top]; priest, HOREAU, *Panorama d'Égypte et de Nubie*, p. 16 verso [top right] (reversed).
Skin and shrines (behind priest) in **3**, SCHOTT photo. 3787. Some names and titles, CHAMP.,
Not. descr. i, pp. 544, 853 [to p. 544, l. 15]; HAY MSS. 29824, 11, 15.

(5) [1st ed. 3–4] Niche containing stela with bark of Rēᶜ adored by baboons, and deceased
and wife with hymn to Rēᶜ. Above niche, double-scene, Ḥaremḥab with flowers and Queen
Mutnezemt with sistra before Osiris, and [Amenophis I] and ᶜAḥmosi Nefertere before
Anubis. At sides, two registers, **I**, deceased adoring, **II**, on left, Western Ḥathor in tree-
goddess scene with *ba* drinking, and on right, wife adoring.

Scenes round niche, and hymn on stela, BAUD and DRIOTON, fig. 13, cf. pp. 18–20, 41–4
[28–32]; scenes, HAY MSS. 29822, 18; tree-goddess scene, WILKINSON, *M. and C.* 2 Ser.
Supp. pl. 36 A [fig. 4] = ed. BIRCH, iii, pl. xxviii [4] facing p. 119; BURTON MSS. 25644, 110;
WILKINSON MSS. xvii. B. 9 [top]. Texts, HAY MSS. 29824, 14, 15.

Frieze on side-walls. Ḥathor-heads, Anubis-jackals, and titles of deceased and wife,
BAUD and DRIOTON, on figs. 9–12, 14–16, cf. pp. 18, 41 [27]; MACKAY in *Ancient Egypt*
(1920), fig. 8, cf. p. 120.

Ceiling. Text, BAUD and DRIOTON, figs. 4–5, cf. pp. 9, 27 [1].

Finds. Probably from here.

Statue of deceased kneeling with stela, in New York, M.M.A. 17.190.1960. WINLOCK in
J.E.A. vi (1920), pl. i, cf. pp. 1–3; HAYES, *Scepter*, ii, fig. 88; SCOTT, *Egyptian Statuettes*,
fig. 20; VANDIER, *Manuel*, iii, pl. clx [2], p. 678.

256. NEBENKĒMET ▽◁🦅◦, Overseer of the cabinet, Fanbearer, Child of the
nursery. Temp. Amenophis II.

Khôkha. (*L. D. Text*, No. 31.)

Wife, Ryu ⌢⫽🐝.

Plan, p. 334. Map IV, D–5, a, 9.

L. D. Text, iii, p. 249.

Hall. View, M.M.A. photo. T. 1103 [foreground].

(1) Outer jambs, remains of texts.

(2) Two registers. **I,** Deceased and wife with couple, man offering to them, and guests. **II,** Left part, deceased with family fowling and fishing, right part, netting fowl, and vintage with offering to Termuthis and men filling jars, before deceased and wife.

M.M.A. photos. T. 1114–15; parts, SCHOTT photos. 3895, 3899, 3900, 3902, 7333–41.

(3) Deceased and remains of three registers of Asiatics with tribute of metal ingots, gold, and vases (one floral, one with bull's head), before [Amenophis II] in kiosk.

M.M.A. photos. T. 1116–17; parts, SCHOTT photos. 3904–5, 7342.

(4) Two scenes. **1,** Deceased, with wife and two sons, offers on braziers. **2,** Seated couple, with seated relatives, butchers, and offering-bringers, below.

M.M.A. photos. T. 1112–13. Details in **1,** SCHOTT photos. 8759–61. Translation of part of text of deceased, SCHOTT, *Das schöne Fest*, p. 868 [52].

(5) [1st ed. 1] [Deceased offers to Tuthmosis III], with two offering-bringers at right end, and bull and offering-bringers with vase on yoke below.

[Texts of King and deceased], L. *D. Text,* iii, p. 249; SETHE, *Urk.* iv. 997 (293).

Inner Room.

(6) Two registers, funeral procession, including men carrying jars to building in **I,** and dragging statue and purifying statue in **II,** before deceased. (7) Offering-scenes (?). (8) Remains of hunting-scene, with sketches of animals.

257. NEFERḤŌTEP 🔲, Scribe, Counter of the grain of Amūn, temp. Tuthmosis IV to Amenophis III. Usurped by MAḤU 🔲, Deputy in the mansion of Usimarē꜄-setepenrē꜄ (= Ramesseum) in the estate of Amūn, temp. Ramesses II.

Khôkha. (L. *D. Text,* No. 32.)
Father (of Maḥu), perhaps Piay 🔲. Wife (of Maḥu), Tawert 🔲.
Plan, p. 334. Map IV, D–5, a, 9.

Titles of Maḥu, L. *D. Text,* iii, p. 250 [top left and top right].

Hall. View, M.M.A. photo. T. 1103 [background].

(1) Three registers. **I,** Maḥu before [divinities], and Horus-Inmutf with kneeling Thoth offering 🔲 reports to Osiris with Horus, Shu, Tefnut, Geb, and Nut. **II,** Ptaḥ-Sokari with Hathor. **III,** Remains of funeral procession to pyramid-tomb with mummy in sarcophagus dragged by [oxen].

M.M.A. photo. T. 1108.

(2) Stela, unfinished, with deceased and wife adoring at top and Eastern and Western emblems above. Framing, remains of offering-text. At sides, Maḥu offering on left, and wife adoring with hymn to Hathor on right (belonging to (3)).

M.M.A. photo. T. 1106.

(3) Pilaster. Maḥu.

(4) [1st ed. 1] Three registers. **I**, Three scenes, **1**, Maḥu adores Sons of Horus, **2**, adores Osiris and Isis, **3**, with wife adores Osiris. **II**, Three scenes, **1**, Maḥu adores Anubis, **2**, with wife adores Thoth as baboon on pylon, **3**, kneeling with wife adores bark of Rēᶜ-Ḥarakhti adored by baboons with jackals and *bas*. **III**, [Deceased] adores [Rēᶜ-Ḥarakhti and other divinities].

M.M.A. photo. T. 1107. **II, 2**, SCHOTT photo. 3906; Thoth and texts of scene, L. D. *Text*, iii, p. 250 [middle].

(5) Stela with text of Neferḥotep. At sides, Maḥu on right, and wife on left (belonging to (6)).

M.M.A. photo. T. 1104; SCHOTT photo. 3907.

(6) Pilaster, Maḥu adoring with hymn to Osiris. (7) Two registers, **I**, Maḥu and wife adore Osiris and Isis (?), **II**, five scenes, priest before statue of deceased. (8) Three registers, **I**, Maḥu and wife adore Thoth, **II**, Maḥu and wife adore Ḥathor, **III**, priest before Piay and wife.

M.M.A. photo. T. 1109-11.

(9) Three registers. **I**, Two scenes, Maḥu and wife before a god. **II**, [Maḥu and others (?)] before Osiris, Isis, and Nephthys. **III**, Seated relatives.
M.M.A. photos. T. 1105.

(10) Entrance to Inner Room. Remains of texts, probably Dyn. XVIII.

Ceiling. Remains of text, Dyn. XVIII.

258. MENKHEPER ⚊ 🏺 , Child of the nursery, Royal scribe of the house of the royal children. Temp. Tuthmosis IV (?).
Khôkha.
Mother, Nay 🐦𓏏𓏏𓐠.

Plan, p. 326. Map IV, D–5, a, 10.

Hall.

(1) Two registers. **I**, Deceased and mother seated, **II**, parents (?) seated. (2) Two registers, **I**, four people with fruit and flowers, **II**, stools with fruit and flowers. (3) Man with flowers, and offering-bringers below.

(4) Niche, with ointment-jars below. Left of niche, two registers, **I**, deceased and mother with hymn to Osiris, **II**, man and woman with offerings.

SCHOTT photos. 3474, 7351. Woman in **II**, BORCHARDT in *Ä.Z.* lxviii (1932), pl. v [right lower]. Texts of **I**, HELCK, *Urk.* iv. 1642–3.

Frieze and ceiling, texts.

259. ḤORI 🐦𓏛, *waᶜb*-priest, Scribe in all the monuments of the estate of Amūn, Head of the outline-draughtsmen in the House of Gold of the estate of Amūn. Ramesside.
Sh. ʿAbd el-Qurna.
Parents, Ḥuy, *waᶜb*-priest of Amūn, and Beketptaḥ 𓏏𓄿𓏛. Wife, Mutemwia 🐦𓎼.
Plan, p. 248. Map VI, E–4, j, 3.

Hall.

(1) Remains of funeral procession, including cow and mutilated calf, female mourners, sarcophagus dragged, men with standards, boats and mourners.

SCHOTT photos. 5983–9. Part, WERBROUCK, *Pleureuses*, pls. xl, xli, fig. 38, cf. pp. 60–1.

(2) Two registers. **I**, Double-scene, priest before deceased seated with palette behind him, with Western hawk in centre. **II**, Funeral procession to pyramid-tomb with stela and Western goddess making *nini* in mountain.

SCHOTT photos. 5975, 5977–82. Priest with candle in left half of **I**, DAVIES in *J.E.A.* x (1924), pl. vii [12], p. 12, note 2. Lector and male mourners in **II**, WERBROUCK, *Pleureuses*, fig. 37, cf. p. 61; tomb and stela, DAVIES (Nina) in *J.E.A.* xxiv (1938), fig. 16, cf. p. 38.

(3) Two registers, **I–II**, remains of banquet (?), **I**, man with libation-vase before deceased and [family], **II**, seated relatives. (4) Deceased adores Amen-rēᶜ-Ḥarakhti, Maᶜet, and Ḥathor.

(5) Deceased adores Osiris, Isis, and Nephthys.

(6) Niche with entablature and jambs. Side-walls, man before deceased and wife. Rear wall, deceased seated facing his father. Ceiling, grape-decoration.

Entablature, jambs, and rear wall, HERMANN in *Ä.Z.* lxxiii (1937), pl. ix [b], p. 70; SCHOTT photo. 3080. Frieze from entablature, BAUD, *Dessins*, fig. 121.

Frieze-texts with hymns, &c., and horizontal bouquet above at (3).

260. USER 𓏤𓊨, Scribe, Weigher of [Amūn], Overseer of the ploughed lands of [Amūn]. Temp. Tuthmosis III (?).

Dra' Abû el-Naga'.

Wife, Nubemwēset 𓈖𓏤𓅱𓏏 (name from cone).

Plan, p. 334. Map II, D–6, g, 1.

Hall.

(1) [1st ed. 1] Two registers. **I**, Girl preparing bed. **II**, Girl with two attendants arranging cushion on chair.

GREENLEES in *J.E.A.* ix (1923), pl. xxi, p. 131; FISHER in *Penn. Mus. Journ.* xv (1924), fig. on p. 42; CHIC. OR. INST. photo. 10271; SCHOTT photo. 4211.

(2) Deceased, wife, and small girl, with priest offering to them, and three registers, **I–III**, funeral procession to Western goddess. **I**, Abydos pilgrimage. **II**, Sarcophagus dragged, &c. **III**, Shrines, *teknu*, and mummers. Sub-scene, oxen ploughing, male lutist and female clapper, and girl offering to deceased and wife, with remains of preparing food below.

Omitting **III** and ploughing in sub-scene, SCHOTT photos. 4205–9, 8646–9; incomplete, CHIC. OR. INST. photos. 10272–4. Man dragging, male and female mourners, and text above oxen in **II**, LÜDDECKENS in *Mitt. Kairo*, xi (1943), pl. 13 [b] (from SCHOTT photo.), pp. 73–4 [28].

(3) Banquet before deceased and wife, including girl with shoulder-harp and remains of song.

Girl offering (to a guest), and girl with harp, SCHOTT photo. 4210; girl with harp, HICK-MANN in *Bull. Inst. Ég.* xxxiv (1953), fig. 6, cf. p. 239, xxxv (1954), fig. 7 [e], cf. p. 315; id. *Musicologie pharaonique*, fig. 6, cf. p. 107; id. *45 Siècles de Musique*, pl. xlix [c].

(4) Niche containing stela with offering-scene and text. At sides, Anubis-jackal at top and four registers, rites before mummy, and butchers.

HERMANN, *Stelen*, pl. 1 [d], with text, pp. 44* [middle]–45*; SCHOTT photo. 4086.

Ceiling. Offering-texts of deceased and wife.

261. KHAʿEMWĒSET ☉ 🪶 𓏏, *waʿb*-priest of Amenophis I (name and title from cones, as no texts in tomb). Dyn. XVIII.

Draʿ Abû el-Nagaʿ.

Plan, p. 334. Map II, D–6, g, 1.

Hall.

(1) [1st ed. 1] Three registers, **I–III**, vintage (including Nubians and an Asiatic) before deceased and wife. **I**, Picking and recording grapes. **II**, Treading grapes, offerings to Termuthis, sealing wine-jars, and bringing produce of marsh-lands. **III**, Rope-making, unloading boat with wine, and bringing wine.

SCHOTT photos. 4085, 4196–4204, 7442–53. **I–III**, MACKAY in *J.E.A.* iii (1916), pls. xiv, xv, pp. 125–6; CHIC. OR. INST. photos. 10274–80, 2980–1; omitting left end, DAVIES (Nina), *Anc. Eg. Paintings*, i, pl. xxviii (CHAMPDOR, Pt. iv, 8th pl.); JUNKER, *Die Völker des Antiken Orients. Die Ägypter*, pl. v, facing p. 144; CAPART, *L'Art égyptien*, iii, pl. 512; MEKHITARIAN, *Egyptian Painting*, pl. on p. 19. Vintage in **I** and **II**, LANGE, *Lebensbilder*, pl. 25; vintage in **II**, BRUYÈRE, *Rapport (1935–1940)*, Fasc. iii, p. 120, fig. 12. Rope-making in **III**, KLEBS, *Die Reliefs und Malereien des Neuen Reiches*, Abb. 118 (from MACKAY), cf. pp. 183–4.

262. An Overseer of the fields. Temp. Tuthmosis III (?).

Draʿ Abû el-Nagaʿ.

Plan, p. 334. Map II, D–6, a, 5.

Façade.

(1) Stela (removed).

Hall.

(2) Double-scene, priest offers libation-vase to deceased seated, and to wife seated. (3) [Deceased] seated. (4) Priest in skin before two seated couples. (5) Deceased seated in kiosk.

263. PIAY 𓊪𓏭𓄿𓏭𓏭, Scribe of the granary in the Temple of Amūn, Scribe of accounts in the Ramesseum. Temp. Ramesses II.

Sh. ʿAbd el-Qurna.

Wife, Webekht 𓄿[𓂧]𓏤𓏏𓏤 .

Plan, p. 334. Map VI, E–4, g, 2.

Court.

(1) Niche. Head of Ḥatḥor-cow (statue), with serpent on side of projection in front.

(2) Stela, two registers. **I**, Double-scene, deceased adores Amen-rēʿ-Ḥarakhti, and Osiris. **II**, Priests with female mourners before mummies, and text below.

M.M.A. photo. T. 3090; CHIC. OR. INST. photo. 6494. Mourners, SCHOTT photo. 3934.

Hall.

(3) Outer lintel, remains of deceased, wife, and son, and jambs, text with deceased seated at bottom. Left thickness, two registers, **I,** deceased and wife adoring, with hymn to Amen-rēᶜ-Ḥarakhti, **II,** deceased and wife playing draughts, and son offering bouquet of Rēᶜ to deceased and wife. Right thickness, two registers, **I,** deceased and wife adoring, with hymn to Osiris, **II,** harpist with song before [deceased].

M.M.A. photos. T. 3085–8, 3088 A. Left jamb and thickness, SCHOTT photos. 3935, 8250–3. Harpist and song, LICHTHEIM in *J.N.E.S.* iv (1945), pls. iv a, vi a, pp. 204–5.

(4) Two registers, **I,** remains of people, **II,** man offers to seated [man]. (5) Book of Gates, deceased and wife before shrine (?), and weighing-scene between Thoth and Maᶜet. (6) Deceased, wife, and daughter, with man censing and libating to them, and seated relatives.

Inner Room.

(7) Outer lintel and jambs, texts with hymns to Amen-rēᶜ and Rēᶜ, and mention of Valley Festival on left jamb.

M.M.A. photo. T. 3089. See SCHOTT, *Das schöne Fest*, p. 860 [12].

(8) and (9) Two registers. **I,** Three scenes, deceased and wife in each, **1,** with man offering to them, **2,** before divinities, **3,** led by a god to Western goddess. **II,** Two scenes, **1,** man, and man censing to deceased and wife, **2,** man libating to couple.

(10) Two registers, **I,** deceased and wife offer to Osiris, Ḥathor, and Ḥathor-cow in mountain, **II,** man and priest offer to deceased and wife. (11), (12), and (13) Remains of rites before statues.

(14) Niche. Statues of two couples.
M.M.A. photo. T. 3089 [background].

Ceiling. Titles of deceased.

Finds

Block of deceased, double-scene, Osiris and Isis seated, with cartouches of Ramesses II in centre (seen in tomb 125).

264. I P I Y 〈𓄿𓃾𓈖〉𓏭𓏥, Overseer of cattle, Chief of the Lord of the Two Lands. Dyn. XIX.
Khôkha.

Plan, p. 334. Map IV, D–5, a, 8.

Hall.

(1) Inner jambs, titles of deceased. (2) Scenes of offering libation-jar and incense, and lector offering candle to deceased.

(3) Remains of stela. Entablature with *zad*-pillar in centre. Left of stela, deceased.

(4) Three registers, Book of Gates, guardians with knives in shrines. (5) and (6) Statues.

Shrine.

(7) Statues of deceased and wife.

265. AMENEMŌPET. (See tomb 215, which is the Chapel.) Dyn. XIX.
 Deir el-Medîna.

<div align="center">Plan, p. 348. Map VII, E-3, c, 6.</div>

Plan, BRUYÈRE, *Rapport (1924–1925)*, on pls. i–iii.

Burial Chamber.

Walls, Book of Gates. GR. INST. ARCHIVES, photos. DM. 265. 1–8.

(1) Two registers. **I**, Man before altars. **II**, Texts.

(2) Two registers. **I**, Two demons, goose, hawk, and squatting gods, [break], cat slaying [serpent] by tree, and three squatting divinities. **II**, Texts, with hawk at right end.
Goose, KUENTZ, *L'Oie du Nil*, pl. i [1], p. 15.

(3) Two registers. **I**, [Deceased and wife seated]. **II**, Texts.

(4) Two registers. **I**, Deceased and wife playing draughts, two *ba*s on pylon, deceased kneeling adores Akru, *Benu*-bird, mummy in sarcophagus between Isis and Nephthys as hawks, kneeling god, and god holding pools. **II**, Negative Confession with assessors, and Maᶜet with goddess below at left end.

(5) Two registers. **I**, Seated demon, sarcophagus between Sons of Horus, Meḥitwert-cow, and guardian in front of gate. **II**, Double-scene, deceased adores Osiris and Ḥatḥor, and adores Ḥarsiēsi and Isis, with dressed *zad*-pillar in centre.
GR. INST. ARCHIVES, photo. 2062.

Ceiling. Rēᶜ-Ḥarakhti, and remains of text below.

<div align="center">**Finds**</div>

Double-statue of deceased and wife, probably from here, in Berlin Mus. 6910. *Aeg. und Vorderasiat. Alterthümer*, pl. 113; VANDIER D'ABBADIE and JOURDAIN, *Deux Tombes de Deir el-Médineh (M.I.F.A.O.* lxxiii), pl. xxix, pp. 44–5; STEINDORFF, *Blütezeit* (1900), Abb. 99; FECHHEIMER, *Kleinplastik der Ägypter*, pl. 59; HERMANN and SCHWANN, *Ägyptische Kleinkunst*, fig. on p. 65; PIJOÁN, *Summa Artis*, iii (1945), fig. 580; CAPART (Denise), *L'Origine africaine des coiffures égyptiennes* in *Reflets du Monde*, No. 8 (Feb. 1956), fig. 23, cf. p. 24; VANDIER, *Manuel*, iii, pl. cxliv [2], p. 648. Texts, *Aeg. Inschr.* ii. 63–71; titles, BRUYÈRE, *Rapport (1926)*, p. 16 [9], cf. (*1929*), p. 108. See *Ausf. Verz.* pp. 142–3.

Fragment of stela of deceased. BRUYÈRE, *Rapport (1926)*, fig. 7, cf. p. 16 [9].

Offering-table of deceased, probably from here, in Louvre. E. 13997. VANDIER D'ABBADIE and JOURDAIN, op. cit. fig. 5, cf. p. 44; BRUYÈRE, *Rapport (1923–1924)*, pl. xii [bottom right], p. 46 [2].

Ushabti-coffin and canopic-jar of deceased. Names, id. ib. (*1929*), p. 107 [bottom].

266. AMENNAKHT 〔⸗〕, Chief craftsman of the Lord of the Two Lands in the Place of Truth on the west of Thebes. Dyn. XIX.
 Deir el-Medîna.
Parents, Buḳentef and Iy (names in tomb 219). Wife, Ḥenutrayunu 〔⸗〕.

<div align="center">Plan, p. 348. Map VII, E-3, c, 6.</div>

BRUYÈRE, *Rapport (1924–1925)*, pp. 43–4, with plans on pls. i, ii, (*1923–1924*), on pl. i, (*1928*), on pl. i.

Chapel.

(1) Woman with jar, and man.

(2) Three registers. **I**, Deceased with wife, and others, offers to divinities. **II–III**, Agriculture, including pulling flax, reaping, laden donkeys, winnowing on threshing-floor, goats browsing on trees, and herdsman with double-pipe.

GR. INST. ARCHIVES, photos. DM. 266. 1, 2. Winnowing and [oxen treading grain], DAVIES, *Two Ramesside Tombs at Thebes*, pl. xl [5], p. 56, note 4.

(3) Man with vase before man. (4) and (5) Deceased censes before two Kings and a Queen (cartouches blank), and deceased adores Ḥathor with arms of Nut holding disk in mountain (sketch).

(6) Book of Gates. Weighing-scene with Thoth as baboon and Apophis, deceased led by Anubis, and kneeling before Osiris (sketch).

GR. INST. ARCHIVES, photo. DM. 266. 3.

(7) Deceased offers to Rēʿ-Ḥarakhti and Osiris-Onnophris.

(8) Niche with seated statues of Osiris and Ḥathor. Above niche, bark of Rēʿ (sketch).

Finds

Fragments of stela and walls. BRUYÈRE, *Rapport (1924-1925)*, fig. 29, cf. p. 43.

Offering-table of deceased, probably from here, in Louvre, E. 13995. Id. ib. *(1923-1924)*, pl. xii [top right], p. 48 [5].

267. HAY 𓀀𓏥𓇋𓇋𓊽, Officer of the workmen in the Place of Truth on the west of Thebes, Fashioner of the images of all the gods in the House of Gold. Dyn. XX.

Deir el-Medîna. (L. *D. Text*, Nos. 102–3.)

Parents, Amennakht and Tarekhʿan 𓃭𓏤𓏲𓀀𓇋. Wife, Ḥenutmet 𓎟𓏏𓏥𓈖𓏥 (from plaque of deceased in Nubar Collection, see *Bibl.* i², Pt. 2, in the Press).

<center>Plan, p. 348. Map VII, E–3, c, 6.</center>

Burial Chambers.

L. *D. Text*, iii, pp. 291–2. Plan, BRUYÈRE, *Rapport (1923-1924)*, on pl. i, *(1924-1925)*, on pls. i, ii, *(1928)*, on pl. i. Names and titles, id. ib. *(1930)*, p. 117 [top].

Outer Chamber.

(1) Left inner thickness, woman (on return wall), and deceased with wife and daughter. (2) Father. (3) [Ḥathor-cow in mountain.]

(4) Western goddess.

Titles of deceased at top, LEPSIUS MS. 391 [middle upper].

(5) *Sem*-priest with ram-headed wand, followed by scribe, before deceased and wife.

Inner Chamber.

(6) Above outer doorway, deceased kneels before arms of [Nut] and horizon-disk. Left thickness, deceased and wife before Anukis.

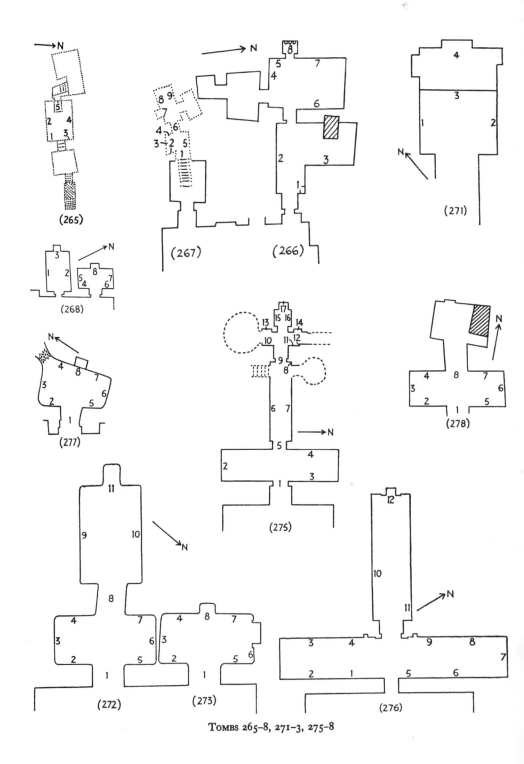

TOMBS 265–8, 271–3, 275–8

Scene above doorway, GR. INST. ARCHIVES, photo. DM. 267. 1. Deceased and wife on thickness, BAUD, *Dessins*, fig. 14, cf. p. 60.

(7) Niche with text on left jamb. Left of niche, woman, followed by man (on entrance wall).

(8) Son before deceased and wife. (9) Relatives before deceased and wife. Texts, LEPSIUS MS. 391 [middle lower]–392 [top].

Ceiling, grape-decoration and text. Part, CAPART, *Documents*, i, pl. 76 [c].

268. Family tomb of NEBNAKHT ⟨hieroglyphs⟩, Servant in the Place of Truth. Dyn. XIX.

Deir el-Medîna.

Parents, Ipy and ꜥAuti ⟨hieroglyphs⟩ (names from stela in Turin Mus. Sup. 6044). Wife, Thay ⟨hieroglyphs⟩.

Plan, p. 348. Map VII, E–3, d, 8.

BRUYÈRE, *Rapport (1931–1932)*, pp. 49–50, with plan, fig. 38; plan, id. ib. *(1924–1925)*, on pl. i, *(1926)*, on pl. i.

Chapel.

(1) At bottom, two sailing-boats, man and woman before couple, people bringing grapes, &c., to couple. (2) Deceased and wife seated, with girl offering to them, and female harpist, lutist, dancer, and guests.

(3) [Stela.] At sides, deceased, wife, small boy, and offerings on left, and two priests on right.

Finds

Fragments of stela of wife (?). See BRUYÈRE, *Rapport (1931–1932)*, p. 53 [top].

Subsidiary tomb. Name unknown.

Plan, p. 348.

BRUYÈRE, *Rapport (1931–1932)*, pp. 50–2, with plan, fig. 38.

Chapel.

(4) Two people before seated couple. (5) Banquet.

(6)–(7) Funeral procession, including offering-bringers with yokes, and mourners. Names, BRUYÈRE, p. 52.

(8) Niche. At sides, deceased offering to Osiris on left, and to Rēꜥ-Ḥarakhti on right.

269. Name lost. Ramesside.

Sh. ꜥAbd el-Qurna.

Maps V and VI, E–4, h, 1.

Only lintel of Inner Room remains.

270. AMENEMWIA ⟨𓏃𓊪𓏲𓀀𓈒𓏌𓊪⟩, *wa*ʿ*b*-priest, Lector of Ptaḥ-Sokari. Dyn. XIX.
Qurnet Muraʿi.

Map VIII, F–3, i, 2.

Destroyed. GAUTHIER in *Ann. Serv.* xix (1920), p. 6; VARILLE in *Ann. Serv.* xlv (1947),
pp. 33–4.

271. NAY 𓏃𓆑𓇋𓇋, Royal scribe. Temp. Ay.
Qurnet Muraʿi.

Map VIII, F–3, g, 3.

Chapel. Jambs with titles of deceased.

Burial Chamber. North of Chapel.

Plan, p. 348.

(1) Priest with offering-bringers lights burnt-offerings with taper before deceased and wife.
SCHOTT photos. 4319–21, 4327. Offerings, BORCHARDT in *Ä.Z.* lxviii (1932), pl. v [left
lower], p. 77.

(2) Priest with offering-bringer before deceased and wife, and text containing cartouche
of Ay.
Text, SCHOTT photo. 4323.

(3) Front of mastaba. Offerings, with deceased as priest on each side.
SCHOTT photos. 4322, 4325–6, 4328.

(4) Niche. At sides, deceased kneeling.

272. KHAʿEMŌPET 𓂓𓄿𓅓𓏌𓊪𓏤, Divine father of Amūn in the West, Lector in the
Temple of Sokari. Ramesside.
Qurnet Muraʿi.

Plan, p. 348. Map VIII, F–3, j, 2.

GAUTHIER in *Ann. Serv.* xix (1920), p. 3.

Hall.

(1) Left thickness, deceased, right thickness, [deceased and wife]. (2) Deceased and wife
before four demons. (3) [Four people] before two mummies in front of mountain. (4) De-
ceased offers to Osiris (?). (5) Two registers, **I**, deceased and wife before Osiris and Ḥathor,
II, priest with offerings and *ḥes*-vase before [deceased]. (6) Two registers, **I**, man, **II**, priest,
and woman, each before deceased. (7) [Deceased] adores [Osiris, Isis, and Nephthys].

Frieze. Ḥathor-head and deceased and wife kneeling, at (5).

Inner Room.

(8) Thicknesses, deceased and wife adoring (destroyed on right). (9) and (10) Two
registers, scenes in Book of Gates.

(11) Niche. At sides, two registers, double-scenes, **I**, Rēʿ-Ḥarakhti and goddess on left,
and Osiris and goddess on right, **II**, deceased adores a god (?).

Ceiling. Grape-decoration and text.

273. SAYEMIOTF [hieroglyphs], Scribe in the estate of his Lord. Ramesside. Qurnet Mura'i.

Plan, p. 348. Map VIII, F-3, j, 2.

GAUTHIER in *Ann. Serv.* xix (1920), p. 3.

Hall.

(1) Left thickness, two registers, **I,** deceased adoring, **II,** three mourners and three offering-bringers (belonging to funeral procession at (2)). Right thickness, wife with sistra (sketch). Mourners, WERBROUCK, *Pleureuses*, fig. 39, cf. p. 61. Wife, BAUD, *Dessins*, fig. 100.

(2)–(3) Four registers. **I** and **II,** Book of Gates, including four scenes in **II, 1,** gate with *pa*-bird and *ba* before Ḥarsiēsi and Isis, **2,** deceased (?) kneeling by pool before Osiris and god, **3,** deceased before tree-goddess, **4,** deceased. **III** and **IV,** Funeral procession, including ram on shrine in **III,** and male mourners and relatives with Anubis-jackal, and man before jars on stairs in booth, in **IV.**

Incomplete, WERBROUCK, *Pleureuses*, pl. xliv, fig. 119, and fig. on 2nd page after p. 159, cf. p. 61; SCHOTT photo. 4668.

(4) [1st ed. 1] Three registers. **I,** Deceased, wife, and three men, adore Osiris and [goddess]. **II,** [Adoration of statue], deceased and wife and *ba*s before tree-goddess in *išd*-tree, and palm-tree with *ba*s drinking. **III,** Right part, weighing-scene with deceased and wife in *meskhent*, and [Termuthis on birth-brick].

See FOUCART in *Bull. Inst. Ég.* 5 Sér. xi (1918), p. 274. Tree-goddess scene in **II,** and deceased and wife in *meskhent* in **III,** SCHOTT photos. 3970, 4667; Termuthis, see SCHOTT in VOGLIANO, *Secondo Rapporto degli Scavi . . . della R. Università di Milano nella zona di Madīnet Māḍi* (1937), p. 33, note 3.

(5) Three registers. **I,** Deceased with small son before Monthu, Raʿttaui, and goddess. **II** and **III,** Male and female relatives, including women with tambourine and with double-pipe in **III.**

Seven women adoring in **III,** SCHOTT photos. 4662–3.

(6) Deceased before Osiris on right, and [wife with sistrum before lion-headed Sekhmet] at bottom.

Wife before Sekhmet, SCHOTT photos. 4661, 4665–6.

(7) Three registers. **I–III,** Deceased, wife, and daughter, adoring Rēʿ-Ḥarakhti and Ḥathor, adoring Atum, Anubis, and Isis, and standing before [Ḥathor-cow] in mountain.

(8) Above niche on right, bark of Rēʿ.

Frieze. Deceased and wife kneeling adore Anubis-jackal.

274. AMENWAḤSU [hieroglyphs], First prophet of Monthu of Ṭôd, and of Thebes, *sem*-priest in the Ramesseum in the estate of Amūn. Ramesside. Qurnet Mura'i. (Inaccessible.) Wife, . . .y [hieroglyphs].

Map VIII, F-3, i, 3.

GAUTHIER in *Ann. Serv.* xix (1920), pp. 5–6.

Lintel (?). Double-scene, left half destroyed except goddess, right half, deceased and wife before Osiris and Ḥatḥor.

WILKINSON MSS. v. 172 [right].

275. SEBKMOSI [glyphs] (var. [glyphs]), Head *waʿb*-priest, Divine father in the Temples of Amenophis III, and of Sokari. Ramesside.

Qurnet Muraʿi.

Plan, p. 348. Map VIII, F-3, h, 3.

GAUTHIER in *Ann. Serv.* xix (1920), p. 8.

Hall.

(1) Left inner jamb, titles. (2) [Stela] with traces of texts. (3) Remains of man offering to goddess (?). (4) Remains of funeral procession (?), including boats, and rites in garden.

Passage.

(5) Inner left thickness, two men. (6) Five registers, **I**, Book of Gates (?) with Negative Confession (?), shrines, &c., and oars (?), before god and goddess, **II–V**, remains of funeral procession, including rites in garden. (7) Scenes in Book of Gates. (8) Deceased and wife adore Anubis and Western goddess.

Shrine.

(9) Entablature and jambs with remains of text. (10), (11), (12) Offering-bringers and people. (13) Girl offers to deceased and wife. (14) Deceased and wife adore mummy. (15) and (16) Two registers on each wall, **I**, deceased and wife with libation-jar, **II**, man.

(17) Niche. Rear wall, double-scene, deceased adores Ḥatḥor.

276. AMENEMŌPET [glyphs], Overseer of the treasury of gold and silver, Judge, Overseer of the cabinet. Temp. Tuthmosis IV (?).

Qurnet Muraʿi.

Parents, Nekhu (?) [glyphs] and ʿAḥḥotp [glyphs]. Wife, Ḥenutyunu [glyphs].

Plan, p. 348. Map VIII, F-3, h, 3.

WILKINSON, *Topography of Thebes*, pp. 138–9; GAUTHIER in *Ann. Serv.* xix (1920), p. 8.

Hall.

(1) Two scenes. **1,** Two women before [deceased and mother]. **2,** [Deceased] returning (?).

(2) Two registers. **I,** Offerings before deceased and wife. **II,** Two men seated with food-table, and priest censing and libating to couple.

II, incomplete, SCHOTT photos. 8787–9.

(3) At top, remains of Nubian tribute with baskets of gold rings, rolls of cloth, and three men with trays of cloth and chests.

CHIC. OR. INST. photos. 2967 [left], 10388; SCHOTT photo. 4866.

(4) Deceased and wife with monkey eating fruit under chair, priest with offering-list before them, and four registers, **I–IV,** banquet, including lutist, female clappers, and harpist.

Sub-scene, five Syrians (1st destroyed) with metal ingots, offering-bringers with garlanded bull, &c., and priest offering bouquet to couple with dog under chair.

CHIC. OR. INST. photos. 2967 [right], 2968, 10388–90. **I–III,** harpist in **IV,** and sub-scene, SCHOTT photos. 4304, 4867, 8790–2. 2nd–5th Syrians in sub-scene, DAVIES in *M.M.A. Bull.* Pt. ii, March 1932, fig. 13, cf. p. 62; details of Syrians, vases, and metal ingots, VERCOUTTER, *L'Égypte* [&c.], pls. xi [111, 112], xxvi [184–6, 189], lx [451–2], lxv [497–500], pp. 224–5, 278–9, 286, 357, 565; goose among offerings, KUENTZ, *L'Oie du Nil,* fig. 27, cf. pp. 14, 42.

(5) Seven oil-jars, and offerings.

(6) Leather-workers, jewellers, and vase-makers.
CHIC. OR. INST. photos. 3018, 10391.

(7) [Stela with purification scene.] (8) Two registers, **I,** men picking grapes, and bringing and preparing fish, **II,** remains of netting fowl.

(9) Two registers. **I,** Offerings before deceased, mother with monkey under chair, and daughter (?). **II,** Priest with two offering-bringers offers to deceased and parents.
CHIC. OR. INST. photo. 2969. Mother and daughter in **I,** HERMANN, *Stelen,* pl. 12 [a] (from SCHOTT photo.), p. 98; SCHOTT photo. 4318; offerings, id. ib. 4869, 8793. Text in **I,** WILKINSON MSS. v. 174 [bottom].

Ceiling. Offering-texts of deceased.

Inner Room.

(10) Four registers. **I–IV,** Funeral procession to Western goddess, including boat with Anubis tending mummy, and funeral outfit carried, in **I,** dancers in **II,** three of the 'Nine friends' and bandaging mummy on bier in **III,** pool with victims, setting up of obelisks, *teknu,* man with three torches on stand, and man offering to false door, in **IV.**
Bandaging mummy on bier dragged by priests in **III,** and *teknu* and torches in **IV,** SCHOTT photos. 4312–16.

(11) [1st ed. 1] [Deceased in chariot] hunting gazelle, oryx, hyenas, &c., in desert. Sub-scene, men bringing game (hares, gazelle with calf, and hyena on pole).
M.M.A. photos. T. 2644–5; CHIC. OR. INST. photos. 2966, 10392–6. Bow (held by deceased), and animals in desert, WILKINSON, *M. and C.* iii. 22 (No. 329), cf. i. 309 (No. 31) = ed. BIRCH, ii. 92 (No. 357), i. 206 (No. 36); WILKINSON MSS. v. 174 A; gazelle and leopard (in hunt), and sub-scene, SCHOTT photos. 4305–10, 4864; men with hare, gazelle, and calf, in sub-scene, LHOTE and HASSIA, *Chefs-d'œuvre,* pl. 49.

(12) Niche. At sides, Osiris on left, and two registers on right, **I–II,** deceased offering.
SCHOTT photo. 4317.

Position Unknown.

Deceased purified by Anubis, and Haroëris reporting to Osiris with goddesses. Text, WILKINSON MSS. v. 174 [middle upper].

277. AMENEMŌNET 〔☰〕〔⟲ꞓ〕, Divine father of the mansion of Amenophis III. Ramesside.
Qurnet Mura'i.
Mother, Tazesertka 𓀭 𓂀 . Wife, Nefertere.

Plan, p. 348. Map VIII, F–3, h, 4.

VANDIER D'ABBADIE, *Deux Tombes ramessides à Gournet-Mourraï* (*M.I.F.A.O.* lxxxvii), pp. 1–39, with plan and section, pl. i, cf. fig. 3; FOUCART in *Bull. Inst. Ég.* 5 Sér. xi (1928), pp. 263–73; cf. GAUTHIER in *Ann. Serv.* xix (1920), p. 2; plan, WILBOUR MSS. 2 F, 25.

Hall. View, M.M.A. photo. T. 2654.

(1) Right jamb (now lost), offering-text. Left thickness, deceased adoring with hymn to Rēᶜ. Right thickness, deceased, and wife with sistrum and bouquet.

Text of jamb, VANDIER D'ABBADIE, p. 38 [ix] (from copy by GAUTHIER), cf. p. 26 [bottom]. Thicknesses, id. ib. pls. ii–iv, pp. 27–9 [A, A′], cf. pp. 6–7; M.M.A. photos. T. 2652–3.

(2) and (3) [1st ed. 1, 2] Four registers. **I,** Three scenes, **1,** statues of Teye and Amenophis III dragged in procession, **2,** boat with shrine towed on lake, **3,** deceased censing and libating before statue of Mentuhotp-Nebhepetrēᶜ, Queen Neferys,[1] and Hathor-cow in mountain. **II,** Three scenes, **1,** priests with attendants performing funeral rites before two mummies at pyramid-tomb with stela in mountain, **2,** four men carrying mummy, **3,** priest censing, and *ba* above mummy on couch. **III,** Funeral procession, including priestesses and butchers, to Western goddess, with harpist below. **IV,** Funeral banquet.

VANDIER D'ABBADIE, pls. vi [2]–xvii [1], xxiii, pp. 31–6 [iv, v], cf. pp. 9–22 [C–E], and hieratic graffiti, pl. xxxviii [top and middle]; M.M.A. photos. T. 2656–9, 2662–3; CHIC. OR. INST. photos. 2970, 10397–9, 10401–4, 10408; incomplete, FARINA, *Pittura*, pls. clxxx–clxxxi (called tomb 58). Left and right parts of **I** and **II,** FOUCART, pls. i, ii, pp. 263–4, 266–9; right end of **II–IV,** mourners and priestesses in **III,** and two groups in **IV,** SCHOTT photos. 3971–6, 4300–3. Statues in **I, 1,** KEIMER in *Egypt Travel Magazine*, No. 26, Sept. 1956, p. 28, fig. 15. Boats on lake in **I, 2,** and deceased before royal statues and Hathor-cow, in **I, 3,** HERMANN in *Mitt. Kairo*, vi (1936), pl. 6 [a, c]; LHOTE and HASSIA, *Chefs-d'œuvre*, pls. at end 17 [upper], 136. Priests libating offerings (including honey) and mummies at tomb in **II, 1,** id. ib. pl. at end 17 [lower]; priests and offerings, KEIMER in *Egypt Travel Magazine*, No. 30, Feb. 1957, p. 27, fig. 9; mummies at tomb in **II, 1,** and mourners and priestesses in **IV,** WERBROUCK, *Pleureuses*, pl. xliii, figs. 40, 149, 167, 180, cf. pp. 61–3; stela and tomb in **II, 1,** DAVIES (Nina) in *J.E.A.* xxiv (1938), fig. 21, cf. p. 39. Female mourners in **III,** LHOTE and HASSIA, op. cit. pl. 24; harpist, BAUD, *Dessins*, fig. 101.

(4) Deceased adores Horus, with horizontal bouquet above.

VANDIER D'ABBADIE, pls. vi [1, left], xvi [2, right], xviii, pp. 22–4 [F]; M.M.A. photo. T. 2660 [left], cf. 2654. Bouquet, see DRIOTON in *Wiener Zeitschrift für die Kunde des Morgenlandes*, liv (1957), p. 32 with fig. 3.

(5) Two registers, unfinished. **I,** Deceased and wife adore Osiris and Isis. **II,** Deceased and wife adore Shu and lion-headed Tefnut, with upright bouquet behind wife, and two hieratic graffiti.

VANDIER D'ABBADIE, pls. xx [2], xxii, p. 37 [viii], cf. pp. 25–6 [H], and graffiti, pl. xxxviii [bottom]; M.M.A. photo. T. 2655. **I,** BAUD, *Dessins*, fig. 102.

(6) Double-scene, unfinished, deceased adores Osiris, and adores Maᶜet.

VANDIER D'ABBADIE, pls. xvii [2], xxi, p. 37 [vii], cf. p. 25 [G]; M.M.A. photo. T. 2661; incomplete, CHIC. OR. INST. photo. 2866 [right].

(7) Deceased censes and libates to Amenophis III and Teye, with horizontal bouquet above.

[1] Probably (ᶜAhmosi) Nefertere.

VANDIER D'ABBADIE, pls. xix, xx [I], pp. 36–7 [vi], cf. pp. 24–5 [F']; M.M.A. photo. T. 2660 [right]; CHIC. OR. INST. photo. 2866 [left].

(8) Niche. Lintel, double-scene, deceased and family adore Osiris and Anubis, and adore Amen-rēᶜ-Ḥarakhti and Isis, jambs, offering-formula, ceiling, Mut in shrine. Below niche, representation of offering-table with victims.

VANDIER D'ABBADIE, pls. v, vi [I, right], pp. 29–31 [iii], cf. pp. 7–8 [B]; M.M.A. photo. T. 2660 [middle]. Titles on ceiling, and sketch-plan, WILBOUR MSS. 2 F, 26 [bottom].

Finds

Headless statue of Amenemōnet, Royal herald (probably not deceased). VANDIER D'ABBA-DIE, fig. 4, cf. pp. 27, 38 [x].

278. AMENEMḤAB ⟨☰⟩ ⫽ ☰ ⫽ 🔾 ⫽, Herdsman of Amen-rēᶜ. Ramesside.

Qurnet Muraʿi.

Wife, Tay 🔾 ⫽⫽🔾, Songstress of Mut.

Plan, p. 348. Map VIII, F–3, h, 4.

VANDIER D'ABBADIE, *Deux Tombes ramessides à Gournet-Mourraï* (*M.I.F.A.O.* lxxxvii), pp. 39–54, with plan, figs. 5–6, cf. pl. i; GAUTHIER in *Ann. Serv.* xix (1920), p. 2.

Hall. View, VANDIER D'ABBADIE, pl. xxiv [I]; M.M.A. photo. T. 2646.

(1) Fragments of jambs with titles of deceased, found in tomb. Left thickness, [deceased and wife] adoring with remains of texts. Right thickness, deceased adoring.

VANDIER D'ABBADIE, pls. xxiv [2], xxv [I], figs. 7, 9, and p. 54, cf. pp. 43–4 [A, A'].

(2) and (3) Funeral procession (sketch).

VANDIER D'ABBADIE, pl. xxxvii, pp. 51–2 [F, G]; BAUD, *Dessins*, pl. xxxii, pp. 212–13.

(4) [1st ed. 1] Deceased and wife with bouquets adore Ḥathor-cow in mountain.

VANDIER D'ABBADIE, pls. xxvi, xxvii, pp. 52–3, cf. pp. 44–5 [B] with fig. 8; M.M.A. photo. T. 2647. Bag with scene on it (held by wife), SCHOTT photo. 4299. Texts and Ḥathor-cow, WILKINSON MSS. v. 175 [top].

(5) Two registers. I–II, Offering-scenes to couples, including priest with libation-vase and stand with candle and tapers in II.

VANDIER D'ABBADIE, pls. xxxv, xxxvi, pp. 50–1 [E]; M.M.A. photo. T. 2651. Priest, woman, and man, in I, and priest and stand in II, SCHOTT photos. 4296–8.

(6) Tree-goddess scene, with *ba*s drinking.

VANDIER D'ABBADIE, pls. xxxii–xxxiv, p. 50 [D]; STOPPELAËRE, *Introduction à la peinture thébaine* in *Valeurs*, Nos. 7–8 (1947), pl. 4; SPIEGEL in *Mitt. Kairo*, xiv (1956), pl. xv [2], pp. 204–5; M.M.A. photo. T. 2650; SCHOTT photos. 4285–6.

(7) [1st ed. 2] Two registers. I, Deceased and relatives with bouquets adore Osiris, with Isis and Nephthys. II, Abydos pilgrimage, with deceased and wife offering bouquets to Osiris-emblem between two ram-standards.

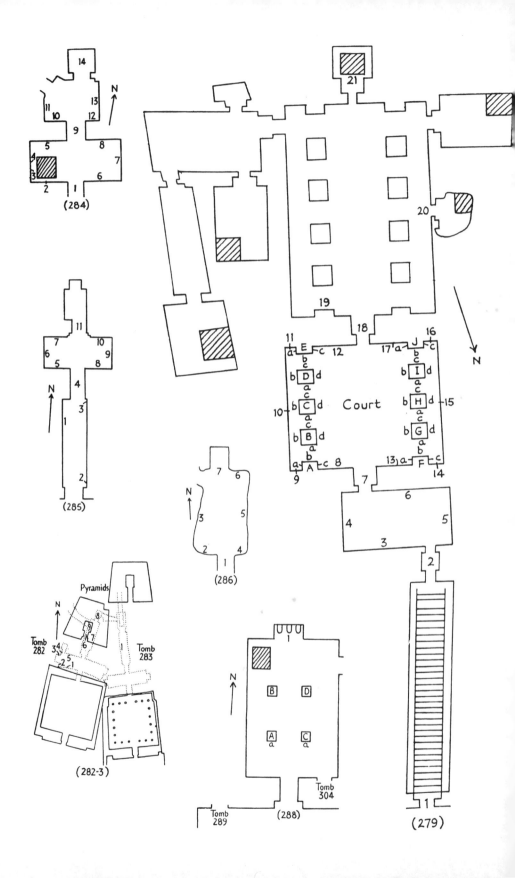

(284)

(285)

N

N

14

13

11

10

12

9

5

8

7

6

4
4
3
2

1

11

7

6

5

10

9

8

4

3

1

2

21

20

19

18

11
E
c
12
b
b
D
d
a
b
C
d
10
a
b
B
d
a
b
a
A
c
8
9
7

Court

17 a
J
c
16
b
b
I
d
a
c
b
H
d
15
a
c
b
G
d
a
b
13 a
F
c
b
14

N

7

6

4

3

5

2

6

5

4

3

2

1

N

7

6

3

5

2

4

1

(286)

Pyramids

N

8

9

7

6

Tomb
282
3
4
5
2
1

1

Tomb
283

(282-3)

N

1

B

D

A
a

C
a

Tomb
289

Tomb
304

(288)

(279)

2

1

VANDIER D'ABBADIE, pls. xxviii–xxxi, pp. 45–9 [C]; M.M.A. photos. T. 2648–9; SCHOTT photos. 4287–95. Two women in **I**, and sailing-boat in **II**, LHOTE and HASSIA, *Chefs-d'œuvre*, pls. xviii and 133.

(8) Above entrance to Inner Room, two Anubis-jackals.
VANDIER D'ABBADIE, pl. xxv [2], cf. xxiv [1], and p. 52 [H]; M.M.A. photo. on T. 2646.

279. PABASA (PBES) 𓍿𓏲𓎡𓏏, Chief steward of the god's wife. Temp. Psammeti-
khos I.

 'Asâsif.

 Parents, Pedubaste 𓍿𓇋𓊪, Divine father beloved of the god, and Tasentenḥor 𓏏𓊪𓈖𓏏𓅓
 (or 𓏏𓊪𓈖𓏏𓅓).

Plan, p. 356. Map IV, D–5, a, 3.

LANSING in *M.M.A. Bull.* Pt. ii, July 1920, pp. 16–24, with plan and section, figs. 10, 11, and views, figs. 4, 5, 9.

Entrance to staircase.

 (1) All jambs, texts.

Vestibule.

 (2) Outer lintel, bark upheld by a god with Eastern and Western goddesses, adored by soul of Pe and soul of Nekhen, and by Nitocris and deceased on left, and Amenardais II and deceased on right, jambs and thicknesses, texts. Inner jambs, texts with deceased seated below.
 Lintel and all jambs, M.M.A. photos. T. 720–1, 723.

 (3) and (4) [1st ed. 1] Long text and son Thaḥorpakhepesh 𓎡𓏤𓅡𓍿𓇋𓏏 offering to deceased seated. Sub-scene, funeral procession, including mourners in boats and Abydos pilgrimage.
 M.M.A. photos. T. 721–2, 724–6. Son before deceased, LANSING, fig. 12, cf. p. 19. Boats and mourners at (4), WERBROUCK, *Pleureuses*, pl. xlviii [lower], p. 63.

 (5) and (6) [1st ed. 2] Long text of deceased, and son as *sem*-priest offering bouquet to deceased with gazelle under chair. Sub-scene, funeral procession with mourners, sarcopha-gus dragged by oxen, and standard-bearers.
 M.M.A. photos. T. 727–33. Son before deceased, with mourners and standard-bearers in sub-scene, LANSING, fig. 13, cf. p. 19; STEINDORFF and WOLF, *Gräberwelt*, pl. 17; WOLF, *Die Kunst Aegyptens*, Abb. 682; SCHOTT photos. 5509–17; son before deceased, SMITH, *Art . . . Anc. Eg.* pl. 181; mourners and four standard-bearers, WERBROUCK, *Pleureuses*, pl. xlviii [upper], p. 63; shrine with sarcophagus, SCHOTT photos. 5518–19.

Court. Views, LANSING, p. 23, fig. 14; BULL in *Art and Archaeology*, xvii [1, 2], Feb. 1924, fig. 1, cf. pp. 22–4; M.M.A. photos. T. 764–7.

 (7) [part = 1st ed. 3] Outer lintel, offering-bringers, and jambs, text with deceased seated at bottom. Thicknesses, texts. Inner lintel, Osiris and Rēʿ-Ḥarakhti with Horus-names between them in centre, and double-scene on each side, deceased before cartouches of Psammetikhos I, and of Nitocris. Inner jambs, titles of deceased.
 M.M.A. photos. T. 727, 734–6, cf. 764.

(8) Litany and hymn to Rēʿ, with vignettes, deceased adoring Rēʿ-Ḥarakhti, and deceased with incense and libation before parents. (9) Text, with deceased adoring at top.

M.M.A. photos. T. 736, 745 [left], 752 [middle].

(10) Offering-list, with deceased standing on left, and seated with dog Ḥeknu under chair on right. Sub-scene, priests performing offering-list ritual.

M.M.A. photos. T. 756–9.

(11) Text, with deceased adoring Ptaḥ at top.

M.M.A. photo. T. 753 [middle].

(12) Two registers. I, Psammetikhos I with milk and Nitocris with sistra, followed by deceased, before Rēʿ-Ḥarakhti and Ḥathor. II, Texts.

M.M.A. photos. T. 740, 746 [right]. II, Schott photos. 7367–71.

(13) Long text of deceased, with vignettes, deceased adoring Atum, and offering to parents, (14) text, with kneeling man adoring two divinities at top.

M.M.A. photos. T. 734 [left], 748 [right], 755 [middle].

(15) Two scenes. 1, Priest with offering-list before deceased. 2, Son as priest offers to deceased with dog Ḥeknu under chair.

M.M.A. photos. T. 760–3.

(16) Text, with deceased facing scribe at top.

M.M.A. photo. T. 754 [middle].

(17) Two registers. I, Queen Nitocris with wine, followed by deceased, before Osiris-Onnophris, Ḥarsiēsi, and Isis. II, Texts.

M.M.A. photos. T. 741, 747 [left].

Pillars and pilasters.

A (a), (b), (c) Texts, and priest, shrine with ba and Benu-bird, and Anubis before mummy, at top of (b).

(b) and (c), M.M.A. photos. T. 737 [left], 745 [middle].

B (a), (b) Four registers, offering-bringers. (c) Four registers, I, preparing bed before deceased, and chest above, II, men with cloth and woman with mirror, III, men with linen, IV, men bringing chest to deceased. (d) Text, and deceased seated at top.

(d), M.M.A. photo. T. 737.

C (a) Four registers, I and II, spinning, III, cleaning fish in front of overseer, IV, netting fish. (b) Four registers, offering-bringers. (c) Four registers, I, deceased with staff, II, bee-keeping, III, man with throwstick and man with birds, IV, picking fruit before deceased and small son. (d) Text, with deceased seated and priest holding ⚍ at top.

(a) and (d), M.M.A. photos. T. 738, 749. (c), II, Steindorff and Wolf, Gräberwelt, pl. 18; Kuény in J.N.E.S. ix (1950), fig. 3 (from Steindorff and Wolf), cf. p. 85; Wolf, Die Kunst Aegyptens, Abb. 681; Keimer in Egypt Travel Magazine, No. 30, Feb. 1957, p. 27, fig. 8; M.M.A. photo. T. 751.

D (a) Four registers, I, two men with necklace, and man with beads (?), II, priests bringing stands of vases, III and IV, priests bringing jars. (b) Four registers, offering-bringers. (c) Four

registers, vintage, before deceased. (*d*) Text and tree-goddess scene at top, with deceased seated.

(*a*) and (*d*), M.M.A. photos. T. 739, 750.

E (*a*), (*b*), (*c*) Texts, and deceased before Ptaḥ at top of (*a*), deceased with *ba* and mummy on couch at top of (*b*), and deceased with personified serpent at top of (*c*).

(*b*) and (*c*), M.M.A. photos. T. 739 [right], 746 [middle].

F (*a*), (*b*), (*c*) Texts, and winged hawk and Ḥathor-cow at top of (*b*), and head on lotus-flower at top of (*c*).

(*a*) and (*b*), M.M.A. photos. T. 744 [right], 748 [middle].

G, H, I (*a*), (*c*), (*d*) Four registers, offering-bringers. (*b*) Text, and tree-goddess scene at top with deceased standing, on G, and text with deceased pouring libation at top, on H.

(*b*), M.M.A. photos. T. 742–4.

J (*a*), (*b*), (*c*) Texts, and deceased offering at top of (*a*), bark containing deceased adoring Rēꜥ-Ḥarakhti at top of (*b*), and deceased offering to Ptaḥ at top of (*c*).

(*a*) and (*b*), M.M.A. photos. T. 742 [left], 747 [right].

Architraves, texts. M.M.A. photos. on T. 737–9, 742–4.

Hall.

(18) Lintels, jambs, and thicknesses, texts.

(19) On pilaster, three registers, remains of offering-bringers, including man bringing cow in II. (20) Lintel, text and offering-bringers, jambs, text. (21) Niche. Lintel, deceased before goddess and god (?), jambs, offering-formulae, side-walls, deceased, rear wall, double-scene (sketch), Eastern (?) goddess on left, Western goddess on right, before mummiform god. At sides of niche, four registers, bull and sacred cows.

Pillars. Texts, with divinities on sides facing central aisle.

Granite sarcophagus, formerly in the possession of the Duke of Hamilton, now in Glasgow Art Gallery and Museum, 22. 86. CAMPBELL, *The Sarcophagus of Pabasa in Hamilton Palace, Scotland*, passim; BUHL, *Late Eg. . . . Stone Sarcophagi*, pp. 34–6 [c, b 1], fig. 8, pl. ii.

Finds

Red granite offering-table of deceased, in New York, M.M.A. 22.3.2.

280. MEKETRĒꜥ ⊙𓂝𓏤𓏤𓏤 (formerly read Meḥenkwetrēꜥ), Chief steward in . . ., Chancellor. Temp. Mentuḥotp (Sꜥankhkarēꜥ).

In valley south of Deir el-Baḥri Temples. D–3, i, 3.

For position, see key-map at end.

WINLOCK, *Models*, pp. 10–14, with plans and sections, pls. 54–5, and views, pls. 2, 3; id. in *M.M.A. Bull.* Pt. ii, Dec. 1920 (reprinted June 1921, Oct. 1923), pp. 12–31, with plan, section, and views, figs. 1–5; id. *Excavations*, pp. 17–20, with plan and section, fig. 2; DARESSY in *Ann. Serv.* ii (1901), pp. 134–5, with plan and section, fig. 2, cf. fig. 1 [1], showing position. Views showing position, WINLOCK, *Rise and Fall*, pl. 8, p. 53; id. in *J.N.E.S.* ii (1943), pl. xxxix, cf. p. 254, fig. 1, and p. 281.

Portico, Passage, and Chapel.

Fragments of relief, found by DARESSY. Some in Cairo Mus., M.M.A. photos. MCC. 1, 2. Some in M.M.A., New York, M.M.A. photos. MC. 199 (spotted dwarf-bull, No. 20.3.162), MC. 235-6, and M.12.C. 286 (sacred oils, Nos. 31.3.2 and 3), MC. 237-8 (man with joint), 253-6 (titles of deceased).

Burial Chamber.

Fragments of gilded wooden coffin with coffin-texts of deceased, in New York, M.M.A. 20.3.101-22, and remains of sarcophagus. See HAYES, *Scepter*, i, pp. 166, 319.

Serdab

Views of models *in situ*, WINLOCK, *Models*, pls. 4-7, with plan, pl. 55; id. *Excavations*, pl. 24, p. 22; id. in *M.M.A. Bull*. Pt. ii, Dec. 1920 (reprinted June 1921, Oct. 1923), figs. 6, 7; BULL in *Art and Archaeology*, xvii [1, 2], Feb. 1924, fig. 2, cf. p. 27; PILLET, *Thèbes. Palais et nécropoles*, fig. 94; M.M.A. photos. MC. 25-31, 35-7.

Models in Cairo Mus. See *Brief Descr*. Nos. 6077-86.

Two canoes with draw-net. Ent. 46715.

WINLOCK, *Models*, pl. 52, cf. 53, and pp. 67-8 [Y], 102-3; id. *Excavations*, pl. 29 [middle], p. 28; id. in *M.M.A. Bull*. fig. 24, cf. p. 30; BREASTED (Jr.), *Egyptian Servant Statues*, pl. 68 [a], p. 78 [C, 1]; WRESZ., *Atlas*, iii, Textabb. to pl. 95 [3]; CAPART, *Propos*, fig. 161; id. in *Chronique d'Égypte*, iv (1928), fig. on p. 246; BULL in *Art and Archaeology*, xvii [1, 2], Feb. 1924, fig. 6, cf. p. 29; BLACKMAN and PEET in ROSS, *The Art of Egypt*, fig. on p. 141 [1]; KEES, *Ägypten*, pl. 16; PILLET, *Thèbes. Palais et nécropoles*, fig. 90; BAIKIE, *Eg. Antiq*. pl. xxvii [lower]; DRIOTON and SVED, *Art égyptien*, fig. 45; GROENEWEGEN-FRANKFORT, *Arrest and Movement*, pl. xxvi; LAURENT-TÄCKHOLM, *Faraos blomster*, pl. on p. 23; PRITCHARD, *The Ancient Near East in Pictures*, fig. 109; WOLF, *Die Kunst Aegyptens*, Abb. 152; *L'Égypte. Art et Civilisation*, Sér. 57 (1951), pl. 9; M.M.A. photos. MC. 134-6.

Boat with paddles, and deceased and son Antef under canopy. Ent. 46716.

WINLOCK, *Models*, pls. 46, 49 [left], cf. 50, 79, 85-6, pp. 59-64 [U], 99; M.M.A. photos. MC. 144-6, 230, 232.

Sailing-boat with deceased under canopy. Ent. 46717.

WINLOCK, *Models*, pl. 47, cf. 80, 85-6, pp. 59-64 [V], 99-100; DRIOTON and SVED, *Art égyptien*, fig. 46; M.M.A. photos. MC. 159-60. Middle part, RANKE, *The Art of Ancient Egypt* and BREASTED, *Geschichte Aegyptens*, 295; EVERS, *Staat aus dem Stein*, i, pl. 6.

Kitchen tender. Ent. 46718.

WINLOCK, *Models*, pls. 40, 42, cf. 44, 75, 77, 84, pp. 57-8 [R], 96; CALDWELL, *The Ancient World*, pl. facing p. 55; M.M.A. photos. MC. 229 [left], 173-7.

Sailing-boat with wicker cabin. Ent. 46719.

WINLOCK, *Models*, pl. 36, cf. 38, 73, pp. 45-57 [P], 94-5; M.M.A. photos. MC. 178-80, 218 [right].

Sailing-boat. Ent. 46720.

WINLOCK, *Models*, pls. 33-4, 42, cf. 38-9, 70-1, pp. 45-57 [N], 92-3; id. *Excavations*, pl. 28 [middle], p. 27; id. in *M.M.A. Bull*. fig. 20, fig. on cover, cf. fig. 18, and pp. 28, 30; BREASTED (Jr.), *Egyptian Servant Statues*, pl. 75 [a], p. 82 [5]; CAPART, *Propos*, fig. 160;

Tomb 280 <image /> 361

BULL in *Art and Archaeology*, xvii [1, 2], Feb. 1924, fig. 5, cf. 4, and p. 29; KEES, *Ägypten*, pl. 33; PILLET, *Thèbes. Palais et nécropoles*, fig. 104; BREASTED, *Ancient Times* (1935), figs. 60–1; BAIKIE, *Eg. Antiq.* pl. xxvii [upper]; EVERS, *Staat aus dem Stein*, i, pl. 5; OTTO, *Ägypten. Der Weg des Pharaonenreiches*, Abb. 10; ROSTOVTZEFF, *A History of the Ancient World*, i, pl. xii [1, 3]; WHITE, *Ancient Egypt*, pl. 38; PRITCHARD, *The Ancient Near East in Pictures*, fig. 110; MITRY, *Illustrated Catalogue of the Egyptian Museum*, No. 6077 with fig.; M.M.A. photos. MC. 212 [left], 213 [left], 220–2, 229 [right]. Bed and chair, HAMMERTON, *Universal History of the World*, i, fig. on p. 560 [bottom right]. Prow, CLARKE and ENGELBACH, *Ancient Egyptian Masonry*, fig. 42.

House in garden. Ent. 46721.

WINLOCK, *Models*, pls. 9, 10, 12 [left], cf. 56–7, pp. 17–19 [A], 83–4; id. *Excavations*, pl. 27 [lower right], pp. 26–7; id. in *M.M.A. Bull.* fig. 16, cf. p. 28; BULL in *Art and Archaeology*, xvii [1, 2], Feb. 1924, fig. 3, cf. pp. 28–9; SCOTT, *The Home Life of the Ancient Egyptians*, figs. 4, 5; LEIBOVITCH, *Ancient Egypt*, fig. 132; LAURENT-TÄCKHOLM, *Faraos blomster*, pl. on p. 45; M.M.A. photos. MC. 108, 110, 128–9.

Carpenter's shop. Ent. 46722.

WINLOCK, *Models*, pls. 28–9, cf. 21, 24, 68–9, pp. 33–5 [J], 89–90; id. *Excavations*, pl. 27 [upper right], p. 26; id. in *M.M.A. Bull.* fig. 14, cf. p. 28; BREASTED (Jr.), *Egyptian Servant Statues*, pl. 46 [a], p. 51 [top], Type 2 [2]; CAPART, *Propos*, fig. 158; LEIBOVITCH, *Ancient Egypt*, fig. 133; ENGELBACH in GLANVILLE, *The Legacy of Egypt*, pl. 21 [fig. 11]; LAURENT-TÄCKHOLM, *Faraos blomster*, pl. on p. 76; WHITE, *Ancient Egypt*, pl. 43; BEEKMAN, *Hout in Alle Tijden*, fig. 7.66, cf. p. 511; HAMMERTON, *Universal History of the World*, i, fig. on p. 556 [lower right]; MITRY, *Illustrated Catalogue of the Egyptian Museum*, No. 6083 with fig.; M.M.A. photos. MC. 102, 121–5.

Spinning and weaving. Ent. 46723.

WINLOCK, *Models*, pls. 25–7, cf. 24, 66–7, pp. 29–33 [H], 88–9; id. *Excavations*, pl. 27 [lower left], p. 26; id. in *M.M.A. Bull.* fig. 13, cf. p. 28; BREASTED (Jr.), *Egyptian Servant Statues*, pl. 48 [b], p. 54 [B, 1]; CAPART, *Propos*, fig. 159; ROTH in *Ancient Egypt* (1921), pl. facing p. 97, and fig. 2; KEES, *Ägypten*, pl. 21; QUIBELL (A. A.), *Egyptian History and Art*, pl. viii A; ENGELBACH in GLANVILLE, *The Legacy of Egypt*, pl. 19 [fig. 9]; DE WIT, *Oud-Egyptische Kunst*, fig. 63; CROWFOOT (Grace), *Methods of Hand Spinning* [&c.], in *Bankfield Museum Notes*, 2nd Ser. No. 12 (1931), pl. 18, pp. 27–8; id. in SINGER [&c.], *A History of Technology*, i, pl. 13 [A], pp. 427, 437; LUTZ, *Textiles and Costumes*, fig. 25; MURRAY, *The Splendour that was Egypt*, pl. xv; WHITE, *Ancient Egypt*, pl. 39; LAURENT-TÄCKHOLM, *Faraos blomster*, pl. on p. 253; HAMMERTON, *Universal History of the World*, i, fig. on p. 560 [top]; MITRY, *Illustrated Catalogue of the Egyptian Museum*, No. 6084 with fig.; M.M.A. photos. MC. 33, 106, 147–51.

Inspection of cattle. Ent. 46724.

WINLOCK, *Models*, pls. 6, 13–15, cf. 16, 58, pp. 19–22 [C], 84–6; id. *Excavations*, pl. 26 [upper right], p. 25; id. in *M.M.A. Bull.* fig. 8, cf. p. 26; BREASTED (Jr.), *Egyptian Servant Statues*, pl. 6, pp. 9–10, Type 7 [1]; KEES, *Ägypten*, pl. 2; BAIKIE, *Eg. Antiq.* pl. xxvi; BLACKMAN and PEET in Ross, *The Art of Egypt*, fig. on p. 140 [2]; PILLET, *Thèbes. Palais et nécropoles*, fig. 96; QUIBELL (A. A.), *Egyptian History and Art*, pl. vii; ROSTOVTZEFF, *A History of the Ancient World*, i, pl. xii [2]; DRIOTON and SVED, *L'Art égyptien*, figs. 47–8; WHITE, *Ancient Egypt*, pl. 42; BEEKMAN, *Hout in Alle Tijden*, fig. 7.25, cf. p. 460; WILSON, *The Burden*

of Egypt, fig. 13 (*in situ*); LAURENT-TÄCKHOLM, *Faraos blomster*, pl. on pp. 72–3; HAMMERTON, *Universal History of the World*, i, fig. on p. 556 [top]; *Descr. sommaire* (1956), No. 6080, with pl.; *Egyptian Museum* (Cairo), fig. on p. 80; MITRY, *Illustrated Catalogue of the Egyptian Museum*, No. 6080 with fig.; WOLF, *Die Kunst Aegyptens*, Abb. 151; SMITH, *Art . . . Anc. Eg.* pl. 62 [A]; M.M.A. photos. MC. 112–13, 181–4, 187–92, 197, 204–5.

Female offering-bringer with drink. Ent. 46725.

WINLOCK, *Models*, pl. 30 [left], cf. 31, pp. 39–41 [K], 90–1; id. *Excavations*, pl. 25 [left], p. 25; id. in *M.M.A. Bull.* fig. 9 [left], cf. p. 26; BREASTED (Jr.), *Egyptian Servant Statues*, pl. 58 [b, left], p. 64 [15]; BULL in *Art and Archaeology*, xvii [1, 2], Feb. 1924, fig. 7 [left], cf. p. 28; EVERS, *Staat aus dem Stein*, i, pl. 7; PILLET, *Thèbes. Palais et nécropoles*, fig. 95 [left]; LEIBOVITCH, *Ancient Egypt*, fig. 134; ALDRED, *Middle Kingdom Art in Ancient Egypt*, pl. 7 [left]; TZARA and SVED, *L'Égypte face à face*, 50; PIJOÁN, *Summa Artis*, iii (1945), fig. 293 [left] (called New York, M.M.A.); RIEFSTAHL, *Patterned Textiles in Pharaonic Egypt*, fig. 17, cf. p. 11; WHITE, *Ancient Egypt*, pl. 37 [left]; *Descr. sommaire* (1956), No. 6081, with pl.; MITRY, *Illustrated Catalogue of the Egyptian Museum*, No. 6081 with fig.; DE RACHEWILTZ, *Incontro con l'arte egiziana*, pl. 48, p. 57; M.M.A. photos. MC. 86 [left], 87 [left], 88.

Models in New York, M.M.A.

Rowing-boat with musicians, and kitchen tender. Nos. 20.3.1 and 3.

WINLOCK, *Models*, pls. 43, 35, 41, cf. 38–9, 44, 72, 76–7, 84, 86, pp. 47–59 [O, S], 94, 97; id. *Excavations*, pl. 29 [top], pp. 27–8; id. in *M.M.A. Bull.* fig. 25, cf. 22, and p. 30; BREASTED (Jr.), *Egyptian Servant Statues*, pl. 77 [b], p. 83 [C, 1, 2]; HAYES, *Scepter*, i, fig. 175; WINLOCK, *The Private Life of the Ancient Egyptians*, fig. 20; M.M.A. photos. MC. 168–71, 206–11, 212 [right], 213 [right], 214, 219. Cabin in rowing-boat, HAMMERTON, *Universal History of the World*, i, fig. on p. 560 [bottom left]; musicians, HICKMANN, *45 Siècles de Musique*, pl. lxxxviii [C–E].

Rowing-boat. No. 20.3.2.

WINLOCK, *Models*, pl. 37, cf. 38, 74, pp. 45–57 [Q], 95–6; id. *Excavations*, pl. 28 [top], p. 27; id. in *M.M.A. Bull.* fig. 19, cf. p. 30; BREASTED (Jr.), *Egyptian Servant Statues*, pl. 71 [c], p. 79 [A, 5]; RANKE, *The Art of Ancient Egypt* and BREASTED, *Geschichte Aegyptens*, 86; *A Brief Guide to the Egyptian Collection* (1946), fig. on p. 9; M.M.A. photos. MC. 215–18 [left].

Sailing-boat with deceased and son Antef under canopy. No. 20.3.4.

WINLOCK, *Models*, pl. 45, cf. 49 [right], 50, 78, 85, pp. 59–64 [T], 97–9; BREASTED (Jr.), *Egyptian Servant Statues*, pl. 68 [b], p. 77 [B, 3]; HAYES, *Scepter*, i, fig. 177; WOLF, *Die Welt der Ägypter*, pl. 44 [upper]; M.M.A. photos. MC. 161–7, 172.

Boat with paddles. No. 20.3.5.

WINLOCK, *Models*, pl. 48, cf. 77, 81, 86, pp. 59–64 [W], 100–1; id. *Excavations*, pl. 28 [bottom], p. 27; id. in *M.M.A. Bull.* fig. 21, cf. p. 30; BREASTED (Jr.), *Egyptian Servant Statues*, pl. 66 [b], p. 76 [A, 4]; *A Guide to the Collections*, fig. on p. 7; M.M.A. photos. MC. 142–3.

Boat with paddles, men harpooning fish, and deceased and son Antef seated on deck. No. 20.3.6.

WINLOCK, *Models*, frontispiece, pl. 51, cf. 53, 82–3, 86, pp. 64–7 [X], 101–2; id. *Excavations*, pl. 29 [bottom], p. 28; id. in *M.M.A. Bull.* fig. 23, cf. p. 30; BREASTED (Jr.), *Egyptian Servant*

Statues, pl. 78 [a], p. 84 [D, 1]; HAYES, *Scepter*, i, fig. 176; *M.M.A. Bull.* N.S. iv (1946), fig. on cover; LANSING, *Collections of Egyptian Art in the United States* in *Egypt*, Autumn 1951, fig. on pp. 32–3; *Art Treasures of the Metropolitan Museum of Art*, fig. 24; DOW in *Archaeology*, i, Autumn 1948, fig. on p. 143 [lower right]; QUIBELL (A. A.), *Egyptian History and Art*, pl. viii B, p. 54; EICHLER, *The Customs of Mankind*, fig. on p. 69; CID PRIEGO, *El Arte Egipcio*, 3rd pl. [upper] after p. 156; M.M.A. photos. MC. 137–41.

Female offering-bringer with food. No. 20.3.7.

WINLOCK, *Models*, pl. 30 [right], cf. 31 [right], pp. 39–41 [L], 91; id. *Excavations*, pl. 25 [right], p. 25; id. in *M.M.A. Bull.* fig. 9 [right], cf. p. 26; id. *Egyptian Statues and Statuettes*, pl. 5; LANSING in *M.M.A. Bull.* N.S. i (1943), fig. on p. 269; BREASTED (Jr.), *Egyptian Servant Statues*, pl. 58 [b, right], p. 64 [16]; HAYES, *Scepter*, i, fig. 174; SCOTT, *Egyptian Statuettes*, fig. 6; id. *The Home Life of the Ancient Egyptians*, fig. 21; BULL in *Art and Archaeology*, xvii [1,2], Feb.1924, fig. 7 [right], cf. p. 28; RANKE, *The Art of Anc. Egypt* and BREASTED, *Geschichte Aegyptens*, 78; SCHÄFER and ANDRAE, *Kunst*, 279 [left], 2nd and 3rd eds. 290 [left]; HEUZEY, *Histoire du costume dans l'antiquité classique. L'Orient*, pl. xvii [1]; PILLET, *Thèbes. Palais et nécropoles*, fig. 95 [right]; PIJOÁN, *Summa Artis*, iii (1945), fig. 293 [right]; LAURENT-TÄCKHOLM, *Faraos blomster*, pl. on p. 249; RIEFSTAHL, *Patterned Textiles in Pharaonic Egypt*, fig. 18, cf. p. 13; ALDRED, *Middle Kingdom Art in Ancient Egypt*, pl. 7 [right]; WHITE, *Ancient Egypt*, pl. 37 [right]; HAMMERTON, *Universal History of the World*, i, fig. on p. 549 [right]; M.M.A. photos. MC. 86 [right], 87 [right], 89.

Four male and female offering-bringers in procession. No. 20.3.8.

WINLOCK, *Models*, pl. 32, pp. 41–3 [M], 91–2; BREASTED (Jr.), *Egyptian Servant Statues*, pl. 62 [b], p. 67 [2]; *New York. Metro. Mus. of Art Miniatures. Album T: The Life and Civilization of Egypt*, p. 3 [left, No. 5]; PIJOÁN, *Summa Artis*, iii (1945), fig. 292; LAURENT-TÄCKHOLM, *Faraos blomster*, pl. on p. 75 [lower]; BEEKMAN, *Hout in Alle Tijden*, fig. 7.107, cf. p. 556; M.M.A. photos. MC. 100–1; omitting first man, CID PRIEGO, *El Arte Egipcio*, 2nd pl. [lower], after p. 156.

Cattle in stable. No. 20.3.9.

WINLOCK, *Models*, pl. 17, cf. 59, pp. 22–3 [D], 86; id. *Excavations*, pl. 26 [lower left], p. 25; id. in *M.M.A. Bull.* fig. 11, cf. p. 26; BREASTED (Jr.), *Egyptian Servant Statues*, pl. 5 [b], p. 9, Type 6 [1]; WOLF, *Die Welt der Ägypter*, pl. 44 [lower]; M.M.A. photos. MC. 32, 107, 126–7.

Slaughter-house. No. 20.3.10.

WINLOCK, *Models*, pl. 18, cf. 19, 21, 24, 60–1, pp. 23–5 [E], 86–7; id. *Excavations*, pl. 26 [lower right], pp. 25–6; id. in *M.M.A. Bull.* fig. 10, cf. p. 26; BREASTED (Jr.), *Egyptian Servant Statues*, pl. 34 [c], p. 37, Type 2 [2]; HAYES, *Scepter*, i, fig. 170; KEES, *Ägypten*, pl. 20; WOLF, *Die Kunst Aegyptens*, Abb. 153; M.M.A. photos. MC. 104–5, 154–8; part, HAMMERTON, *Universal History of the World*, i, fig. on p. 556 [middle]; CID PRIEGO, *El Arte Egipcio*, pl. facing p. 85 [lower].

Granary. No. 20.3.11.

WINLOCK, *Models*, pl. 20, cf. 21, 24, 62–3, pp. 25–7 [F], 87–8; id. *Excavations*, pl. 27 [upper left], p. 26; id. in *M.M.A. Bull.* fig. 15, cf. p. 26; BREASTED (Jr.), *Egyptian Servant Statues*, pl. 11 [b], p. 14 [9]; HAMMERTON, op. cit. i, fig. on p. 556 [lower left]; M.M.A. photos. MC. 103, 114–18.

Brewers and bakers. No. 20.3.12.

WINLOCK, *Models*, pls. 22–3, cf. 24, 64–5, pp. 27–9 [G], 88; id. in *M.M.A. Bull.* fig. 12, cf. p. 26; BREASTED (Jr.), *Egyptian Servant Statues*, pl. 36, p. 38 [4]; HAYES, *Scepter*, i, fig. 171; SCOTT, *The Home Life of the Ancient Egyptians*, fig. 8; PRITCHARD, *The Ancient Near East in Pictures*, fig. 154; M.M.A. photos. MC. 111, 119–20, 152–3.

House in garden. No. 20.3.13.

WINLOCK, *Models*, pls. 10–12 [right], cf. 56–7, pp. 17–19 [B], 84; id. *Excavations*, pl. 26 [upper left]; HAYES, *Scepter*, i, fig. 169; VON BISSING, *Ägyptische Kunstgeschichte*, pl. xlvi [313], cf. i, pp. 77 note 2, 150 note 2; WOLF, *Die Welt der Ägypter*, pl. 41; M.M.A. photos. MC. 109, 130–3. House, WINLOCK in *M.M.A. Bull.* fig. 17, cf. p. 28; id. *The Private Life of the Ancient Egyptians*, fig. 3; *A Brief Guide to the Egyptian Collection* (1946) and (1947), fig. on p. 8; BALDWIN SMITH, *Egyptian Architecture as Cultural Expression*, pl. lxv [2]; LUGN, *Konst och Konsthantverk i Egypten*, fig. 13; PIJOÁN, *Summa Artis*, iii (1945), figs. 288–90; HAMMERTON, *Universal History of the World*, i, fig. on p. 551 [lower right]; SMITH, *Art . . . Anc. Eg.* pl. 62 [B].

Finds

Statue-base with title of deceased as Chancellor. See WINLOCK, *Rise and Fall*, p. 67 with note 39.

Mummy-cloth with hieratic text, in New York, M.M.A. 20.3.201. M.M.A. photo. MC. 243.

Adjoining tomb, son ANTEF 𝄞 (i.e. IN-YOTEF), Hereditary Prince.

WINLOCK, *Models*, pp. 11, 12; id. *Excavations*, p. 20; id. in *M.M.A. Bull.* Pt. ii, Dec. 1920 (reprinted June 1921, Oct. 1923), pp. 16, 18; DARESSY in *Ann. Serv.* ii (1901), p. 134. Plans and sections, see tomb 280.

Finds

Fragments of sarcophagus or canopic-box of deceased as Overseer of sealers. M.M.A. photo. MC. 203.

Fragments of statuette of deceased from *serdab*, in New York, M.M.A. 30.3.157. M.M.A. photo. MC. 245.

For tomb of Waḥ in Court, see *Bibl.* i², Pt. 2, in the Press.

281. Unfinished Temple of MENTUḤOTP-SʿANKHKARĒ. See *Bibl.* ii, p. 135.

For position, see key-map at end.

282. NAKHT 𝄞, Head of bowmen, Overseer of the South Lands. Ramesside.

Draʿ Abû el-Nagaʿ.

Plan, p. 356. Map II, D–6, b, 1.

FISHER in *Penn. Mus. Journ.* xv (1924), pp. 35–41, with plan, p. 46; plan, PHILAD. photos. 34986, and views, 34810, 34960. Copy of texts in Hall and on sarcophagus, and description of Passage, by GREENLEES, are in Philadelphia Univ. Mus. Scenes of rites before mummies with Opening the Mouth texts, now lost, probably in this tomb, see SCHIAPARELLI, *Funerali*, ii, p. 307 [xxxi].

Hall.

(1) Two registers, **I**, deceased and wife (?), procession, and kiosk on left, **II**, defaced text. (2) Deceased and [wife] before [god]. (3) Deceased.

(4) Deceased and [wife] adore Thoth, in Philadelphia Univ. Mus. 29.87.433. PHILAD. photo. 34895.

(5) Book of the Dead. Scenes of deceased purified, led by Anubis, and standing before [Osiris].

Passage.

(6) Remains of text and offering-scenes. (7) At top, six scenes, including deceased with staff, deceased and wife led by Horus to [god], deceased and wife adoring, and Thoth approaching tomb.

Shrine.

(8) Offering-list.

Burial Chamber.

Sarcophagus with text on side.

Pyramid. Views, PHILAD. photos. 39934–7.

(9) Tympanum in vaulted chamber. Double-scene, deceased offers to Osiris. Osiris in left half (sketch), BAUD, *Dessins*, fig. 103.

283. ROMA (ROY) ⌐𝕏⌐ (⌐𝕃𝕃), First prophet of Amūn. Temp. Ramesses II to Sethos II.

Dra' Abû el-Naga'.
Wife, Tamut 𝕃 𝕏 (name in niche in Court).

Plan, p. 356. Map II, D–6, b, 1.

FISHER in *Penn. Mus. Journ.* xv (1924), pp. 41–3, with plan on p. 46. Sections with Pyramid and Pylon, PHILAD. drawing, 80. Views, PHILAD. photos. 34811, 34961, and drawing, 40. Copies of texts by GREENLEES, in Philadelphia Univ. Mus. Lighted taper in destroyed scene, DAVIES in *J.E.A.* x (1924), pl. vi [11], pp. 11, 12 note 2.

Court.

Columns with remains of texts.

Passage.

(1) [Deceased] before Ḥathor-cow in net by canal. Ceiling. Fragments of grape-decoration, &c., PHILAD. drawing, 78.

Pyramid.

Brick of deceased, in Philadelphia Univ. Mus. 29.86.712.

Finds

Headless kneeling granite statuette of deceased, found in Court. PHILAD. photos. 34967–9. See LEFEBVRE, *Inscriptions concernant les grands prêtres d'Amon* [&c.], p. 46; cf. FISHER, p. 41.

Stela of deceased and fragments of relief, found in tomb 282.

Two fragments with name and title of deceased, found in Court, PHILAD. drawing, 79.

Sandstone reliefs, heads, in PHILAD. Univ. Mus. E. 16003–4.

284. PAḤEMNETER 𓍏𓏏𓏤, Scribe of the offerings of all the gods. Ramesside. (Re-used.)

Dra' Abû el-Naga'.

Father, Ra'y 𓂋𓏤𓏤. Wife, Bek(et)werner 𓊪𓊪𓏤.

Plan, p. 356. Map II, D–6, c, 2.

DAVIES (N. M. and N. de G.) in *J.E.A.* xxv (1939), pp. 154–6; FISHER in *Penn. Mus. Journ.* xv (1924), p. 45, with view, p. 33. Description and copies of texts by GREENLEES, in Philadelphia Univ. Mus.

Hall.

(1) Thicknesses, [deceased and wife] on each, with hymn on right thickness.

(2) and (3) Two registers. I, Two scenes, 1, deceased and wife adoring, 2, deceased adores two rows of kings, queens, princes, and princesses, with one official. II, Funeral procession (continued at (4)), including shrine and coffin carried by priests, and dragged by oxen, and *teknu* with female mourners.

See DAVIES, p. 156. I, and *teknu* and mourners in II, SCHOTT photos. 6682–9; I, and sarcophagus in II, PHILAD. drawing, 41; *teknu*, men with yokes, and mourners, PHILAD. photo. 40115.

(4) Two registers. I, Deceased and wife before Rēc-Ḥarakhti, Anubis, Thoth, Isis, Nephthys, and Ma'et. II, Funeral procession (continued from (3)) with priests before mummies at pyramid-tomb with stela.

(5) Two registers. I, Deceased adores statues of King and Queen in palanquins carried in procession, followed by fan-bearers, deceased adoring, and deceased adores god in shrine. II, Offering-scenes before deceased and wife, and priest censing offerings.

Statues, and deceased adoring beyond, PHILAD. drawing, 42; statue of Queen, PHILAD. photo. 40116.

(6) Two registers. I, Barks of Theban Triad [bark of Amūn destroyed] carried by priests in procession with people acclaiming, all in enclosure with a building. II, Deceased adores Osiris, Isis, and Nephthys, and deceased and wife with *ba* in boat.

I, DAVIES, pls. xviii, xix [bottom right], pp. 154–5; SCHOTT photos. 6672–6. Bark of Khons, PHILAD. drawing, 45.

(7) Two registers. I, Granary with heaps of corn and boys scaring birds, and harvest-festival at shrine of Termuthis as serpent, attended by [King] and Queen, all in enclosure, and deceased and wife adoring tree-goddess as serpent. II, Deceased and wife kneel before shrine with Negative Confession.

I, omitting scene before tree-goddess, DAVIES, pl. xix, p. 155; SCHOTT photos. 6677–80, with jars (below tree-goddess), 6681.

(8) Two registers. I, Book of Gates, three scenes, 1, deceased and wife led by Anubis, 2, weighing-scene before Thoth, 3, deceased presented by Horus to Osiris, Isis, and

Nephthys. **II**, Three scenes, **1**, man libates to deceased and wife, **2**, [deceased purified], **3**, tree-goddess scene with *ba*s drinking.

I, **1**, **2**, PHILAD. photo. 34955, and drawings, 43–4, 46–8.

Ceiling. Book of the Dead vignettes and text. See DAVIES, p. 156.

Inner Room.

(9) Left thickness, deceased and wife. Inner lintel and jambs, texts.

(10) and (11) Three registers, **I**, three scenes, deceased before divinities, **II**, people and offerings, and priest with incense and libation and offering-list before deceased and wife, **III**, at (10) seated women and offerings. (12) Deceased and wife purified by priests. (13) Two registers, **I**, four scenes, deceased before a divinity, **II**, deceased and wife before Osiris and cow-headed goddess.

(14) Niche. Lintel, remains of scene, jambs, texts, side-walls, priest offers to deceased and wife.

285. I N Y 〔𓀁〕, Head of the magazine of Mut. Ramesside.

Draʿ Abû el-Nagaʿ.
Wife, Tentōnet 〔𓊪〕, Songstress of Mut.

Plan, p. 356. Map II, D–6, c, 2.

View, PHILAD. photo. 34800. Description and copies of texts by GREENLEES, in Philadelphia Univ. Mus.

Passage.

(1) Row of men and women (sketch).
Three women, one with mirror, BAUD, *Dessins*, fig. 105.

(2)–(3) Three scenes. **1**, Priest before deceased with duck under chair. **2**, Deceased before Anubis. **3**, Deceased and family before Osiris and a divinity.
Women in **3**, id. ib. fig. 104.

Hall.

(4) Left thickness, bark of Rēʿ-Ḥarakhti at top, and two registers, **I**, deceased and wife with hymn to Rēʿ-Ḥarakhti, **II**, sons and daughters before deceased and wife. Right thickness, two registers, **I**, deceased and wife, with hymn, **II**, tree-goddess scene, text, and female lutist with song before [deceased and wife].

(5) Two registers, **I**, people before Rēʿ-Ḥarakhti and goddess, **II**, funeral procession, including dragging shrine with coffin, female mourners, and Opening the Mouth ceremonies. (6) Two registers, **I**, offering-bringers, **II**, man adoring. (7) Two registers, **I**, deceased, followed by two women and couple, before Osiris and Isis, **II**, people before deceased and wife.

(8) Two registers. **I**, Deceased adoring. **II**, Tree-goddess scene with *ba*s above pond with fish, deceased and wife seated, and couple seated.
II, PHILAD. drawing, 50.

(9) Two registers. **I**, Book of Gates (?). **II**, Deceased adores [god and goddess].

(10) Two registers. **I**, Two scenes, **1**, deceased and wife led by Wepwaut and goddess, **2**, deceased with Thoth before Osiris. **II**, Two scenes, **1**, deceased and wife before [Amenophis I] and ʿAḥmosi Nefertere, **2**, deceased and wife before Ḥathor-cow protecting King in mountain, with Western hawk and stela.

II, 2, PHILAD. drawing, 49.

(11) Entrance to Inner Room. Lintel and jambs, remains of texts.

286. NIAY ⸺, Scribe of the table. Ramesside.

Draʿ Abû el-Nagaʿ.
Parents, Roro ⸺ and Ési ⸺. Wife, Tabes ⸺.

Plan, p. 356. Map II, D–6, c, 1.

View, PHILAD. photo. 34829. Description and copies of texts by GREENLEES, in Philadelphia Univ. Mus.

Hall.

(1) Thicknesses, deceased and wife adoring with hymn.
Right thickness, PHILAD. photo. 40108, and drawing, 51.

(2) Mummy on couch tended by Anubis, and table of offerings.

(3) Two registers. **I**, Book of Gates, serpent on shrine, guardian with knife, deceased led by Ḥarsiēsi to Osiris, and wife (?) adoring [Anubis]. **II**, Relatives.
PHILAD. photos. 40109, 34836, and drawings, 52, 58. **II**, SCHOTT photos. 6008–9.

(4) Tree-goddess scene with deceased kneeling, and *ba* on standard.
PHILAD. photo. 34841, and drawing, 55 [lower right].

(5) Two registers. **I**, Three scenes, **1**, statue of deceased before a divinity, both in kiosks, **2**, remains of purification (?) scene, **3**, deceased and mother before Osiris-emblem with fans and standards in kiosk. **II**, Two scenes, **1**, priest censes and libates with bouquet and offerings to deceased and [wife?], **2**, deceased, with father adoring, censes offerings before bark of Sokari with standards.
PHILAD. photos. 34839, 34844, 34847. **II**, and Osiris-emblem in kiosk in **I, 3,** PHILAD. drawings, 54, 55 [left]; emblem in kiosk in **I, 3,** and bouquet with offerings, and deceased before bark in **II, 1, 2,** SCHOTT photos. 6002–5.

(6) Two registers. **I**, Osiris with two winged goddesses. **II**, Deceased kneeling adores Ḥathor-cow in mountain, with tomb and stela.
PHILAD. photo. 34838 [right].

(7) Niche. At left side, text, and at right side, deceased kneeling adoring, with bouquets on each side and below.
PHILAD. photo. 34838 [left], and drawing, 53. Two bouquets, SCHOTT photos. 6006–7.

Ceiling. Decoration and text. PHILAD. drawing, 56.

287. PENDUA ⬚ ⋆🦅⬚ , *war̔b*-priest of Amūn. Ramesside.
Dra̔ Abû el-Naga̔.

Map II, D–6, c, 1.

Description by GREENLEES, in Philadelphia Univ. Mus.

Hall.

Entrance. Jambs, remains of titles. South thickness, divine bark (unfinished).
Bark, PHILAD. drawing, 81 [upper].

Entrance wall, north of doorway. Three registers, **I**, [adoration] of Osiris, Isis, and Horus,
II, bark of Sokari on stand, **III**, deceased and wife seated with offerings (sketch).
Wife, PHILAD. drawing, 81 [lower].

Ceiling. Text in centre.

288. BEKENKHONS[1] 🦅⬚●⬚ , Scribe of the divine book of Khons. Ramesside.
Dra̔ Abû el-Naga̔.

Plan, p. 356. Map II, D–6, c, 1.

Views, PHILAD. photos. 34807, 34829, 34837. Reconstruction, showing frieze of cones,
BORCHARDT in *Ä.Z.* lxx (1934), Abb. 6, cf. pp. 27, 30. Description by GREENLEES, in Phila-
delphia Univ. Mus.

Hall.

(1) Niche. Statues of deceased and two women. PHILAD. photo. 40134.

Pillars. A (*a*) Man offers to deceased. C (*a*) Deceased and wife (?) seated with offerings.

Pyramid. Re-used by Setau (tomb 289).

Views, PHILAD. photos. 40023, 40137 (showing jambs with name of Setau).
East wall, north part, deceased and wife seated, and deceased leading wife. North wall,
east part, man adoring.

Finds

Fragments of sandstone statuette of Bekenkhons, and fragment with name of
Zementef̔ankh, all found in the tomb.

289. SETAU ⬚⬚⬚ , Viceroy of Kush, Overseer of the South Lands. Temp.
Ramesses II.
Dra̔ Abû el-Naga̔.

Father, Siwazyt 🦅⬚ . Wife, Nefertmut ⬚⬚ , Chief of the harim. of Nekhbet.

Plan, p. 370, cf. p. 356. Map II, D–6, c, 1.

Description and copies of texts from walls and fragments by GREENLEES, in Philadelphia
Univ. Mus. View of exterior, STEINDORFF, *Aniba*, ii, pl. 19 bis [a].

Corridor A.

(1) Representation of sarcophagus, with remains of text at bottom.

[1] Probably owner, see statuette under Finds.

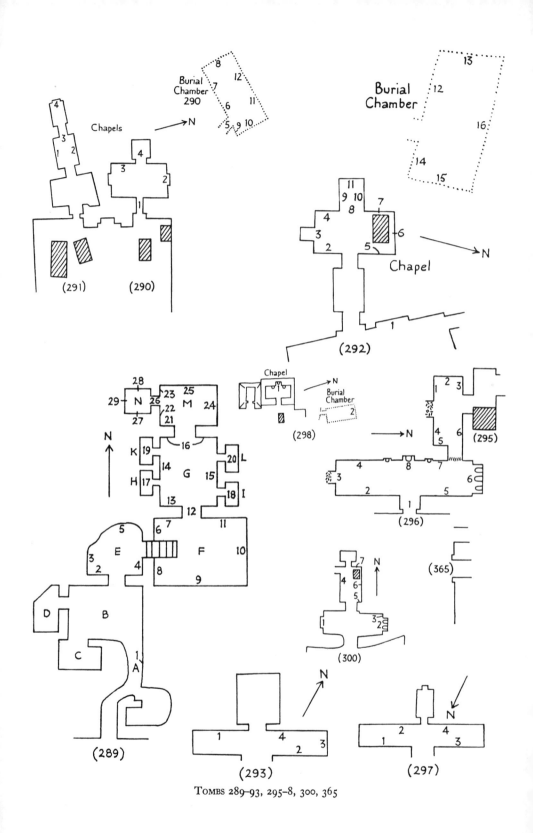

Tombs 289–93, 295–8, 300, 365

Room E.

(2) Man adoring deceased. (3) Deceased and wife seated. (4) Winged figure before deceased and wife. (5) Double-scene, deceased on left, and deceased and wife on right, all kneeling, adore *zad*-pillars.

Room F.

(6) Funeral procession with coffin carried by priests with relatives, and *ba* above. (7) Thoth 'gives book' to deceased. (8)–(11) Scenes in Book of Gates, including deceased and wife led by Thoth and Anubis, and standing before Ḥarsiēsi (?).

Room G.

(12) Outer lintel, double-scene, deceased kneeling adores Anubis. (13) Two scenes, **1,** deceased and wife, **2,** man before deceased and wife. (14), (15), and (16) Scenes in Book of Gates, including deceased kneeling beneath tree drinking from his hands at (14).

Side-rooms H–L.

(17), (18), (19), and (20) Scenes before divinities, including deceased adoring groups of divinities on side-walls.

Room M.

(21)–(22) Three registers. Funeral procession to Western goddess, and pyramid-tomb with stelae.

(23) Two registers. **I,** Deceased before Sons of Horus and other divinities, including *Benu*-bird. **II,** Double-scene, deceased and wife adore Osiris.

(24) Long serpent before bouquet at top, and two registers below, **I,** two scenes, deceased and wife kneeling adore Sons of Horus and other divinities, **II,** three scenes, priest before deceased and wife.

(25) Two registers. **I,** Three scenes, **1** and **3,** deceased, followed by *ba*, before Anubis-jackal, **2,** Nefertem-emblem. **II,** Two scenes, deceased and wife adore Osiris.

Ceiling. Titles of deceased.

Room N.

(26) Entrance. Remains of texts.

(27) Two scenes, beginning on entrance-wall. **1,** Deceased and wife adore Thoth with mummified gods in front of him. **2,** Deceased, wife, and mother, with table of offerings, adore Osiris with Isis and Nephthys.

Incomplete, PHILAD. drawings, 57, 64–7 [left].

(28) Two scenes, beginning on entrance-wall. **1,** As at (27). **2,** Deceased and wife before Anubis.

PHILAD. drawings, 58–60, 67 [right], 68.

(29) Double-scene, deceased before Osiris, and before Anubis.

PHILAD. drawings, 61–3.

Ceiling. Texts.

Pyramid. See Pyramid of tomb 288.

Finds

Fragments of granite sarcophagus with texts and figures of deceased.

Coffin-lid of wife, with figures of Thoth and Imset.

Upper part of painted stela with text of deceased as chief bowman of Kush, found in Court of tomb 283, in Philadelphia Univ. Mus. 29.87.449.

290. IRINŪFER ⟨☐⟩, Servant in the Place of Truth on the West. Ramesside. Deir el-Medîna.

Parents, Siwazyt ⟨☐⟩, Head of the bark of Amūn, and Tausert ⟨☐⟩. Wife, Meḥytkhaʿti ⟨☐⟩.

Plan, p. 370. Map VII, E–3, d, 6.

BRUYÈRE and KUENTZ, *La Tombe de Nakht-Min et la tombe d'Ari-Nefer* in *M.I.F.A.O.* liv [1], (2 unpublished), pp. 67–152, with plans, sections, views, and reconstruction, pls. xii, xiii, xxi–xxiii, and titles, pp. 110–11; BRUYÈRE, *Rapport (1922–1923)*, pp. 10–15, with plans and sections, pls. ii, vii, and titles, pp. 37–8.

Chapel.

(1) Left thickness, [deceased]. Right thickness, [deceased and wife].

See BRUYÈRE and KUENTZ, p. 74.

(2) [1st ed. 2] Stela, in Louvre, E. 12964. Three registers, I, Amenophis I and ʿAḥmosi Nefertere seated facing Osiris and Anubis, II, deceased with wife and her small son censing and libating before parents and brothers, III, relatives offering to deceased, wife, and sister.

BRUYÈRE and KUENTZ, pls. xviii, xix, pp. 77–89; BRUYÈRE, *Rapport (1922–1923)*, pl. x, pp. 15–23.

(3) Hieratic graffito of Butehamūn, Scribe, Dyn. XXI.

See BRUYÈRE and KUENTZ, pp. 71, 75–6.

Shrine.

(4) [1st ed. 1, 3, 4] Lintel, lower part of double-scene, deceased and wife before two divinities. Left wall, fragments of two registers, I, deceased kneeling and family, II, deceased and relatives before [Ḥarsiēsi and Isis]. Rear wall, stela (unfinished), with two registers of double-scenes, I, Ptaḥ and Osiris, both seated, II, deceased, and [man], both kneeling. Text round stela, with name of Wennekhu ⟨☐⟩.

BRUYÈRE and KUENTZ, pls. xiv, xvii [1], figs. 1, 2, cf. pp. 90–6. Lintel, BRUYÈRE, *Rapport (1922–1923)*, pl. ix, fig. 1, cf. pp. 23–6. Stela, id. ib. fig. 2, cf. pp. 27–9.

Burial Chamber. Scenes, GR. INST. ARCHIVES, photos. DM. 290. 1–15.

(5) [part, 1st ed. 5] Outer jambs, titles in ink. Left thickness, relatives with offerings, and Anubis-jackals at top. Right thickness, texts of Book of the Dead. Above inner doorway, winged Nut kneeling.

BRUYÈRE and KUENTZ, pl. xv [1, 2] (jambs), pp. 114, 119–21, 147–8. Nut, SCHOTT photo. 5589.

(6) [1st ed. 6, but entry moved to beginning of tomb] Two registers. I, Deceased and wife adore calf between two trees beneath disk. II, Deceased in boat with *Benu*-bird, and son on left.

LHOTE and HASSIA, *Chefs-d'œuvre*, pls. 152–3; SCHOTT photos. 5590–2. **II,** VANDIER, *Egypt*, pl. iv. See BRUYÈRE and KUENTZ, p. 152.

(7) Parents adoring, and deceased kneeling offers image of Maʿet to Ptaḥ, with mummy-mask, and head-rest with spell (both on pylons).

Parents, and head of deceased, LHOTE and HASSIA, *Chefs-d'œuvre*, pl. 148; SCHOTT photos. 5593–5. Texts, GOLENISHCHEV MSS. 11 [a, c, d].

(8) Anubis tending mummy.

SCHOTT photos. 5762–3. See BRUYÈRE and KUENTZ, pp. 130–2.

(9)–(11) Tympanum at (10), two scenes, **1,** [deceased], son, and wife, kneeling adore Sobk as crocodile wrapped on shrine, and [serpent], and Khepri seated before food-table, **2,** Inmutf before 36 gods of the Underworld. Two scenes below, (at (9)–(11)), text of Book of Gates, with deceased adoring Osiris and two guardians at gate, and deceased adoring shrine with Negative Confession, including Thoth as baboon at each end and seated Shu and Maʿet on left.

Deceased and end of shrine with Thoth, SCHOTT photos. 5596–7. Title in **2,** GOLENISHCHEV MSS. 11 [e]. See BRUYÈRE and KUENTZ, pp. 122–5, 133–5.

(12) Two scenes. **1,** Deceased adores hawk on pylon. **2,** Deceased led by Anubis to Osiris. See BRUYÈRE and KUENTZ, pp. 126–8. **1,** and Osiris in **2,** LHOTE and HASSIA, *Chefs-d'œuvre*, pls. 144, 154. Deceased in **1,** SCHOTT photo. 5761.

Vaulted ceiling. Outer half, three scenes, **1,** deceased kneeling before palm-tree drinks from pool, **2,** Mehitwert-cow with hawk by pool, **3,** deceased and son adore Ptaḥ with *ba* flying, *ba* with disk, and shadow of deceased in front of tomb. Inner half, five star-gods with disk above, and text before gods beyond.

See BRUYÈRE and KUENTZ, pp. 128–30, 135–47, 148–52. **1,** and *ba*s, shadow, and tomb, in **3,** LHOTE and HASSIA, *Chefs-d'œuvre*, pls. 138 (called Amennakht), 165; SCHOTT photos. 5598–9. **1,** DU BOURGUET in *Bull. de la Soc. française d'Égyptologie*, No. 4, Oct. 1950, pl. i [upper], p. 37; text of deceased, BRUYÈRE, *Rapport (1935–1940)*, Fasc. iii, p. 79 [top]. Star-gods and disk, SCHOTT photo. 5600.

Finds

Offering-table of deceased. BRUYÈRE and KUENTZ, pl. xvi [1–5], fig. 6, cf. pp. 99–100; BRUYÈRE, *Rapport (1922–1923)*, fig. 5, cf. pp. 31–2.

Fragment of jamb of son Siwazyt, and thickness with son Irinûfer kneeling. BRUYÈRE and KUENTZ, pl. xvi [6, 7], p. 115.

Fragments of relief, Amenmosi, Servant in the Place of Truth, probably from Niche. Id. ib. fig. 5, cf. pp. 98–9 [5]; BRUYÈRE, *Rapport (1922–1923)*, fig. 7, cf. pp. 34–5 [8].

Fragments of stela (?), probably from Niche. Text, BRUYÈRE and KUENTZ, p. 98 [4]; BRUYÈRE, *Rapport (1922–1923)*, p. 30 [4].

Fragments of stela, two sons as priests with two women before mummies, probably from Court. Id. ib. pls. xii [bottom], xiii [c], pp. 54–5 [a].

Fragment of coffin with female mourners. Id. ib. fig. 8, cf. pp. 35–6; BRUYÈRE and KUENTZ, fig. 7, cf. pp. 103–4.

374 NUMBERED TOMBS

291. NU ⟨hieroglyphs⟩, Servant in the Great Place, and NEKHTMIN ⟨hieroglyphs⟩, Servant in the Place of Truth. Late Dyn. XVIII.

Deir el-Medîna.

Parents (of Nu), Pia ⟨hieroglyphs⟩ and Mutnefert, and wife, Khaʿtnesut ⟨hieroglyphs⟩. Parents (of Nekhtmin), Minḥotp and Nefertere, and wife, Sekhmet.

Plan, p. 370. Map VII, E–3, d, 6.

BRUYÈRE and KUENTZ, *La Tombe de Nakht-Min* [&c.] in *M.I.F.A.O.* liv [1], (2, including pls. iv, v, vii, viii, is unpublished), pp. 1–65, with plans, section, view, and reconstruction, pls. i, xii, xxi–xxiii; BRUYÈRE, *Rapport* (*1922–1923*), pp. 10–15, with plan on pls. ii, viii; views (after restoration), (*1927*), figs. 80–1, cf. pp. 117–20; (*1929*), pl. ii. Titles, BRUYÈRE and KUENTZ, pp. 32–5, 60.

Chapel. View, BRUYÈRE and KUENTZ, pl. iii.

(1) Two registers, **I–II**, funeral procession (sketch), including servants with food and altars in booths, and Nekhtmin offering to mummy at pyramid-tomb in **I**.

Right part, BRUYÈRE and KUENTZ, on pl. iii, pp. 14–20; parts, SCHOTT photos. 3597–8, 6604–9; priest and female mourners in **II**, LHOTE and HASSIA, *Chefs-d'œuvre*, pl. 32.

(2) Two registers. **I** (unfinished), Nu, followed by relatives, offers on braziers to Osiris and Ḥatḥor, with hieratic graffito of ʿAnkhefenamūn, son of Butehamūn, Dyn. XXI. **II**, Relatives.

BRUYÈRE and KUENTZ, pl. vi, pp. 20–4, 42–3, pl. ix (graffito), pp. 56–8. Details in **I**, SCHOTT photos. 3595–6, 4870, 4872.

(3) Tympanum, double-scene, couple offer to Nekhtmin and wife on left, and to parents on right, with Anubis-jackals above. Left of doorway below, two registers, **I**, Nekhtmin kneeling, **II**, Nekhtmin adoring. Right of doorway, **I**, Nu and son kneeling, **II**, Nu offering.

BRUYÈRE and KUENTZ, on pl. iii, pp. 24–7, 44–7; parts, SCHOTT photos. 4874–5, 4877, 6602–3.

(4) Niche. Stela of Nekhtmin, in Turin Mus. 1619, three registers, **I**, father before Osiris and Anubis, and deceased before Western Ḥatḥor, **II**, deceased and relatives before parents, **III**, relatives before deceased and wife.

BRUYÈRE and KUENTZ, pls. x, xi [1], pp. 28–30. Texts, MASPERO in *Rec. de Trav.* iv (1883), p. 133 [xxi]; names, LIEBLEIN, *Dict.* Supp. No. 2149. See FABRETTI, ROSSI, and LANZONE, *R. Mus. di Torino*, pp. 172–3; ORCURTI, *Cat.* ii, p. 33 [42].

Vaulted ceiling with text. BRUYÈRE and KUENTZ, pp. 12–14, 39–42, cf. pl. iii.

Pyramid. View, BRUYÈRE and KUENTZ, pl. ii, pp. 4–5.

292. PESHEDU ⟨hieroglyphs⟩, Servant in the Place of Truth. Temp. Sethos I to Ramesses II.

Deir el-Medîna.

Father, Ḥeḥnekhu ⟨hieroglyphs⟩ (from stela in Brit. Mus. 262). Wife, Makhay ⟨hieroglyphs⟩.

Plan, p. 370. Map VII, E–3, c, 6.

BRUYÈRE, *Rapport* (*1923–1924*), pp. 66–71 with plan and section, pl. xviii, cf. pl. i; (*1924–1925*), on pls. i, ii, vi.

Court.

(1) Stela, two registers, **I,** double-scene, adoration of Ptaḥ and goddess, and of Rēʿ-Harakhti and goddess, **II,** couple adore Ḥathor-cow in mountain.

Fragments in Turin Mus. Sup. 6168, and others, BRUYÈRE, *Rapport (1926),* fig. 8, cf. pp. 16–17 [11], *(1923–1924),* pp. 66 [bottom], 69–70 [3].

Chapel.

(2) Three registers, **I,** sailing-boat and altars before divinity (?), **II–III,** offering-bringers.
(3) Left of niche, bark of Ḥathor, right of niche, relatives.

See BRUYÈRE, *Rapport (1923–1924),* pp. 68–9.

(4) [1st ed. 1] Three registers. **I,** Deceased with wife offers on braziers to Amen-rēʿ, Ḥathor, Khnum, Satis, and Anukis. **II** and **III,** Relatives offer to divinities.

Text of **I,** id. ib. p. 68 [middle].

(5) [1st ed. 3] Two registers. **I,** Deceased with wife offers on braziers to Anubis and Ḥathor. **II,** Funeral procession (continued at (6)).

See id. ib. p. 67.

(6) At top, personified Western emblem on horizon between Anubis-jackals. Two registers below, **I,** wife (belonging to (7)), and Abydos pilgrimage, **II,** funeral procession (continued from (5)).

See id. ib. p. 67 [bottom].

(7) [1st ed. 2] Deceased adores Osiris and Ḥathor.

Text, id. ib. p. 68 [top].

Shrine.

(8) Fragments of lintel, double-scene, couple before three divinities.

See BRUYÈRE, *Rapport (1923–1924),* p. 71 [1].

(9) [1st ed. 4] Two registers. **I** and **II,** Seated divinities and adoration of Thoth.

Part with text of Thoth, id. ib. pl. xxi [3]. Fragments with Rēʿ-Harakhti, Ḥarsiēsi, and man and child with offerings, in Turin Mus. Sup. 6150, see id. ib. p. 69 [bottom, 2].

(10) [1st ed. 6] Two registers, adoration of Triads, of Elephantine in **I,** and of Memphis in **II.**

Fragments in Turin Mus. Sup. 6150, see id. ib. p. 69 [bottom, 1].

(11) [1st ed. 5] Stela, Isis and Nephthys adore head of Ḥathor-cow.

Fragments in Turin Mus. Sup. 6155–6, id. ib. pl. xxi [2], p. 69 [middle, 2].

Vaulted ceiling, eight scenes. Outer half, **1,** calf carrying Rēʿ-Harakhti between two sycamores, **2** and **3,** destroyed, **4,** cat slaying serpent. Inner half, **5,** tree-goddess scene with *ba*s flying, **6,** Meḥitwert-cow by pool, **7,** destroyed, **8,** deceased opening Gate of the West. See id. ib. p. 69.

Burial Chamber. Scenes, GR. INST. ARCHIVES, photos. DM. 292. 1–8.

(12) and (13) [1st ed. 7, 8] Two scenes, **1,** deceased and wife adore Ḥarsiēsi (?) and Isis, **2,** Anubis tending mummy, with goddesses kneeling (on adjoining walls).

BRUYÈRE, *Rapport (1923–1924),* on pl. xx [top middle, top right, middle right], p. 70.

(14) and (15) [1st ed. 11, 10] Two scenes, **1**, [man] before deceased and wife seated, **2**, tree-goddess scene with *bas* drinking.

Id. ib. on pl. xx [top left, middle left], p. 70.

(16) [1st ed. 9] Two scenes, deceased and wife led by Anubis in **1**, and kneeling before Osiris in **2**.

Id. ib. on pl. xx [bottom], p. 70.

Vaulted ceiling. Outer half, Anubis-jackal and two demons. Inner half, deceased before Osiris, before a demon, before Anubis, and before Ḥepy.

Id. ib. on pl. xx [top and bottom], p. 70.

293. RAꜤMESSENAKHT ◯⋔‿, First prophet of Amūn. Temp. Ramesses IV.
DraꜤ Abû el-Naga'.

Father, Merubaste ⯑, Chief steward of the Lord of the Two Lands (name and title on statue in Cairo Mus. 42162).

Hall. Plan, p. 370. Map I, C–6, i, 9.

(1), (2), (3), (4) Remains of scenes, probably from Book of Gates. Frieze at (1) and (3). Deceased kneeling adores Anubis, &c.

Finds

Fragments with name of NebmaꜤrēꜤnakht ⯑, Governor of the town and Vizier, temp. Ramesses IX or XI.

294. AMENḤOTP ⟨⯑, Overseer of the granary of Amūn, temp. Amenophis III. Usurped by ROMA ⯑, *waꜤb*-priest of Amūn, early Ramesside.
Khôkha. (Unfinished.)
Wife (of Roma), Ḥatḥor ⯑.

Hall. Plan, p. 334. Map IV, D–5, b, 9.

(1) Deceased and wife before offerings. Niche (?) at bottom on left, with double-scene on lintel, Roma and wife before [two gods] and before Osiris and Isis, and text on left jamb.

(2) Unfinished. Deceased and wife with dog under chair, and table of offerings.

(3) Entrance to Passage. Left jamb, offering-text of Amenḥotp.

295. ḌḤUTMOSI ⯑, called PAROY ⯑, Head of the secrets in the Chest of Anubis, *sem*-priest in the Good House, Embalmer. Temp. Tuthmosis IV to Amenophis III (?).
Khôkha.

Parents, Sennūter ⯑, *sem*-priest in the Good House, &c., and SenemiꜤoḥ ⯑.
Wives, Nefertere ⯑ and Rennutet ⯑.

Plan, p. 370. Map IV, D–5, b, 9.

Hall.

(1) Two registers. **I,** Deceased, Nefertere, and daughter, with son Ḥuy offering bouquet to them, and guests. **II,** Son Ḥuy, with daughter and men with bouquets, offers bouquet of Amūn to deceased and Rennutet.

M.M.A. photos. T. 2796–7.

(2) Painted stela. Above it, double-scene, left half, deceased followed by son and wife (?) adores Osiris with bouquet and goddess. At sides, two registers (names lost on right), **I,** man offers to deceased and Nefertere, **II,** man offers to deceased and Rennutet.

M.M.A. photos. T. 2798–9; HERMANN, *Stelen*, pl. 9 [b] (from SCHOTT photo. 9054), p. 17* [90–1].

(3) Two registers. **I,** [Man] and relatives with offerings and offering-list before parents of deceased. **II,** Double-scene, [man] offers to seated couple.

M.M.A. photos. T. 2800–1.

(4) Two registers. **I,** Two scenes, **1,** [deceased] offers to parents with small boy, **2,** deceased offers on braziers with offerings and butchers. **II,** Two offering-scenes with couples.

M.M.A. photos. T. 2794–5.

(5) Three registers. **I,** Deceased, followed by man with bouquet, two women, and girl Yewia �‍𓎛𓃀𓏏 , adores Osiris, with two women at right end (belonging to **I, 1,** at (4)). **II,** Two rows of rites before mummies (including two cloaked priests 'sleeping' and 'waking'). **III,** Offering-list.

M.M.A. photos. T. 2804–5. **I,** HERMANN, *Ṣṭelen*, pl. 11 [b] (from SCHOTT photo. 9058), p. 92; second woman and Yewia, HAY MSS. 29851, 232–3.

(6) Two registers. **I,** Double-scene, deceased and Nefertere seated purified by [priest] and by [son]. **II,** Two offering-scenes with couples.

M.M.A. photos. T. 2802–3.

Ceiling. Decoration and offering-texts. M.M.A. photo. T. 2806.

296. NEFERSEKHERU 𓈖𓎛𓂧𓏥 , Scribe of the divine offerings of all the gods, Officer of the treasury . . . in the Southern City. Ramesside.

Khôkha.

Wives, Maᶜetmut 𓆇𓄿𓅓 , Sekhemui 𓊃𓅱𓅱 , and Nefertere 𓆓𓏏𓄿𓅓 .

Plan, p. 370, cf. p. 282. Map IV, D–5, b, 9.

PIEHL, *Inscr. hiéro.* 1 Sér. pp. 95–101, with key-plan, p. 96.

Hall. Views, M.M.A. photos. T. 2157–9.

(1) [1st ed. 1, 2] Outer jambs, offering-texts. Thicknesses, deceased adoring and wife, with hymn to Amen-rēᶜ-Ḥarakhti on left thickness, and hymn to Osiris on right.

M.M.A. photos. T. 2793, on 2157–9. Hymn to Osiris, PIEHL, cxxii [ξ].

(2) [1st ed. 3, 4] Two registers, Book of Gates. **I,** Five scenes, deceased and Nefertere,

1 and 2, before guardians, 3, with offerings, 4, led by Anubis, and 5, weighing-scene with four assessors seated at tables of offerings above, before Osiris, Isis, and Nephthys. II, Five scenes, deceased and wife, 1, drinking from pool with fish, beside trees with birds, 2 and 3, with priest libating bouquets (with female mourner) and censing to them, 4, playing draughts, 5 (wife omitted), with offerings before Amenophis I and ʿAḥmosi Nefertere in kiosk.

M.M.A. photos. T. 2146–8. I, 3, 5 (incomplete), and II, 4, SCHOTT photos. 3654, 3658–9. Texts of I, 1, 2, 3, and II, 4, PIEHL, cxxi [κ, λ], cxxiii [τ, υ], cf. p. 99 [top].

(3) Doorway. Lintel, double-scene, deceased and wife adore Osiris and Western Ḥathor, and adore Anubis and Isis. Jambs, remains of texts, with deceased seated at bottom.
M.M.A. photo. T. 2155.

(4) [1st ed. 5] Two registers. I, Two scenes, 1, deceased, Nefertere, and man, adore Osiris and Isis, 2, deceased adores Osiris seated between mummiform Isis and Ḥarsiēsi. II, Three scenes, each before deceased and Nefertere, with daughters (in 1 and 3), 1, priest offering incense, 2, priest lighting lamp with tapers, 3, priest with harpist censing offerings.
M.M.A. photos. T. 2149–50 [left]. II, 2, 3 (incomplete), SCHOTT photos. 3472, 3650, 3652–3; 3 (incomplete), HICKMANN, 45 Siècles de Musique, pl. li [A]; harpist, SCHOTT in Mélanges Maspero, i, pl. ii [5], p. 460. Texts of deceased and wife in I, 1, PIEHL, cxx–cxxi [ι].

(5) [1st ed. 8] Two registers. I, Book of Gates, two scenes, 1, deceased and wife adoring before Negative Confession, 2, deceased presented by Thoth holding emblems to Osiris and Maʿet. II, Two rows, funeral procession (including cow and calf) with priests, before mummy at pyramid-tomb, and Ḥathor-cow in mountain.
M.M.A. photos. T. 2144–5. Thoth and deceased in I, 2, and scene at tomb in mountain in II, SCHOTT photos. 3651, 3655–7; tomb with bouquet, DAVIES (Nina) in J.E.A. xxiv (1938), fig. 17, cf. pp. 38–9. Texts of I, 2, and above II, PIEHL, cxxii–cxxiii [o–σ].

(6) [1st ed. 7] Niche with seated statues of deceased and two wives (?). Lintel, Anubis-jackals and Ḥathor-heads, jambs with bouquet on each. Ceiling, grape-decoration.
M.M.A. photo. T. 2153. Two columns of text, PIEHL, cxxiii–cxxiv [φ, χ], p. 101.

(7) [1st ed. 6] Two registers. I, Two scenes, 1, disk held by arms of Nut on dressed zad-pillar adored by baboons, goddesses, and bas, and also adored by two gods with kneeling soul of Pe and soul of Nekhen, and deceased kneeling on right, and by deceased standing on left, 2, deceased and Maʿetmut adore Osiris, Isis, and Nephthys. II, Woman at right end, and tree-goddess scene on left, with deceased and Sekhemui drinking.
M.M.A. photo. T. 2152. I, SCHOTT photos. 3660–1, 3471; middle of I, 2, SCHÄFER in Ä.Z. lxxi (1935), Abb. 13 (from SCHOTT photo.), cf. pp. 27–8; adoration of zad-pillar, HAY MSS. 29851, 238–47; sketch of zad-pillar, and texts of I, PIEHL, cxviii–cxix [a–ε], p. 97; texts of tree-goddess scene in II, id. ib. cxix–cxx [ζ, η, θ].

(8) Niche containing statue of Osiris, with texts and deceased seated at bottom on jambs, and dressed zad-pillar. At each side of niche, statue of deceased with scenes below, men seated at tables (continued in II at (4)), and kneeling relatives drinking (continued in II at (7)).
M.M.A. photos. T. 2150 [right], 2151.

Frieze-texts, M.M.A. photos. on T. 2144-7, 2149-50, 2152; at (2) and (5), PIEHL, cxxi-
cxxii [μ, ν].

Ceiling. Decoration and titles of deceased, M.M.A. photos. T. 2154, 2156-9.

297. AMENEMŌPET ⟨symbols⟩, called THONŪFER ⟨symbols⟩, Scribe, Counter of grain
of Amūn, Overseer of fields (name and titles from cones). Early Dyn. XVIII.
'Asâsîf.

Plan, p. 370. Map IV, D-5, a, 7.

Hall.

(1) At bottom, loading grain into boats, and girl before deceased and wife. (2) Deceased
and wife seated. (3) Three registers, **I,** son with offering-bringers offers bouquet to deceased
and wife, **II** and **III,** measuring crop before deceased, including boundary-stone under
tree, and chariot with mules in **II,** and men bringing quails, chariot of deceased with horses,
and man with bull, in **III.** (4) Banquet before deceased and wife, with girl harpist and
girl dancing.

298. BAKI ⟨symbols⟩, Foreman in the Place of Truth, and father (probably), UNNŪFER,
⟨symbols⟩, Servant of the Lord of the Two Lands in the Place of Truth [&c.].
Ramesside.

Deir el-Medîna.

Wife (of Baki), Taysen ⟨symbols⟩ (name in tomb 213). Wife (of Unnūfer), Maia ⟨symbols⟩.

Plan, p. 370. Map VII, E-3, c, 8.

BRUYÈRE, *Rapport (1927)*, pp. 88-9, 92-3, with plans and section, figs. 53, 59, and on pl. i;
GAUTHIER in *Ann. Serv.* xix (1920), pp. 11-12.

Chapel.

(1) Niche, probably originally with statue of Ḥathor-cow protecting King. Side-walls,
deceased adoring, rear wall, [Osiris]. At each side, remains of clay statue.
See BRUYÈRE, pp. 88-9 with fig. 60.

Burial Chamber.

(2) Tympanum, Anubis tending mummy between Isis and Nephthys, with two shrines.
Two *zad*-pillars below, each between *sa*-emblems.
BRUYÈRE, fig. 61, cf. p. 92; GR. INST. ARCHIVES, photo. DM. 298.

Line of text with names of relatives, on all walls, below vaulted ceiling. BRUYÈRE, p. 92,
cf. fig. 61.

Pyramid of Baki.

Stamped brick of Baki. BRUYÈRE, fig. 59 [top right], cf. pp. 88, 93.

Finds

Lower part of seated statuette, sandstone jamb, and bricks (found in Chapel 1106), all
of Baki. See BRUYÈRE, pp. 92, 94 [bottom], 109 [top].

Part of ushabti-box of son Penamūn (tomb 213). Id. ib. fig. 39 [2], cf. p. 90.

299.[1] INḤERKHAᶜ 𓇋𓄿𓏤𓂝𓂝 , Foreman of the Lord of the Two Lands in the Place of Truth [&c.]. (Also owner of tomb 359.) Temp. Ramesses III and IV.

Deir el-Medîna.

Father, Ḥay 𓀀𓄿𓏭𓏭, Foreman in the Place of Truth. Wife, Waᶜb 𓊹𓏤.

Map VII, E–3, c, 8.

BRUYÈRE, *Rapport (1922–1923)*, pp. 67–8, with plan, pl. xiv, cf. pl. i; *(1927)*, pp. 30–2, 34–6, with plan and section, fig. 21; *(1930)*, pp. 32–3 (correcting equation of tomb).

Chapel.

Remains of sketched scenes. See BRUYÈRE, *Rapport (1927)*, p. 31.

Burial Chamber.

End walls. Tympanum, Anubis-jackals. Id. ib. fig. 23, cf. p. 36.

Vaulted ceiling, four scenes. South end, **1** and **2**, deceased adores demons. North end, **3**, Western hawk adored by Isis and Nephthys, **4**, two figures of deceased kneeling drinking water poured out by winged Nut. Texts in centre and at sides.

BRUYÈRE, *Rapport (1927)*, fig. 22, and pp. 34–6 [top]. Part of text, id. ib. *(1922–1923)*, p. 67.

Finds

Part of jamb with offering-text, and deceased on adjoining thickness, found in tomb **217**. See DAVIES, *Two Ramesside Tombs at Thebes*, p. 38 [2].

300. ᶜANḤOTP 𓈖𓊪𓏏 , Viceroy of Kush, Governor of the South Lands, Scribe of the table of the Lord of the Two Lands. Ramesside.

Draᶜ Abû el-Nagaᶜ.

Wife, Ḥunuro 𓈖𓏭𓏭𓏏 .

Plan, p. 370. Map II, D–6, c, 1.

Copies of texts by GREENLEES, in Philadelphia Univ. Mus.

Hall.

(1) Niche. Wall, left of niche, deceased and wife, and right of niche, two registers, deceased adoring.

(2) Niche containing two statues, with man on left wall offering to them.

(3) Negative Confession (?).

Ceiling. Birds between bunches of grapes.

Inner Room.

(4) Remains of scene with cartouches of Ramesses II. (5) Deceased. (6) Two registers, **I**, deceased and wife in three scenes, **1**, adoring Osiris and Isis, **2**, before a King and Queen, **3**, adoring Amenophis I and ᶜAḥmosi Nefertere, **II**, deceased and wife. (7) Three registers, **I**, man offers to deceased, **II**, deceased adoring, **III**, [son] censes to deceased and wife.

[1] Considered at first to be L. *D. Text*, No. 108, and WILKINSON, No. 10, but these are now recognized as tomb 359, where most of the references in *Bibl.* i, 1st ed. pp. 167, 169, will be found.

Pyramid.

Fragments with titles of wife, one in Philadelphia Univ. Mus. 29.86.708, one in Cairo Mus. PHILAD. photos. 40152, 40287.

301. HORI 𓆤𓏲, Scribe of the table of the Lord of the Two Lands in the estate of Amūn. Ramesside.

Dra' Abû el-Naga'.

Map II, D–6, c, 1.

Hall. Scenes and texts destroyed.

Burial Chamber.

Sarcophagus of deceased, with figures of Thoth and Sons of Horus. Name and titles copied by GREENLEES, in Philadelphia Univ. Mus.

Sarcophagus of wife, with figure of Nut (texts illegible).

302. PARA'EMḤAB 𓌾𓍑𓇳𓎼, Overseer of the magazine. Ramesside.

Dra' Abû el-Naga'.
Father, Userḥēt 𓏲𓂆, Head of the magazine of Amūn.

Plan, p. 382. Map II, D–6, f, 3.

Description by GREENLEES, in Philadelphia Univ. Mus.

Hall.

(1) Three registers. **I,** Cooking, &c., before storehouse. **II,** Chariot with sleeping charioteer, &c., before deceased, with dog under chair, beneath tree in front of house containing offerings to Termuthis and dancing women. **III,** Measuring corn, reaping, &c.

I and **II,** PHILAD. photos. 34916, 34918, and drawings, 35 (dancing women), 36 a, b (measuring corn).

(2) Four registers. **I,** Women with boxes. **II,** Uraeus and lotus, and offering-bringer. **III–IV,** Offering-bringers, with man sweeping (or watering) under tree in **III.**

Left part, PHILAD. photo. 34917, and drawing, 36.

(3) Three registers. **I,** Deceased, wife with bouquet, and three men. **II,** Deceased and parents, all kneeling, followed by daughter, offer to [Amenophis I and 'Aḥmosi-Nefertere] in kiosk. **III,** Banquet with female musicians (harp, lute, and lyre), guests, and man fanning wine-jars.

PHILAD. photos. 34993–4. **II** and **III,** PHILAD. drawings, 37–9.

(4) Man offers 𓎸 . (5) Man kneeling and boat before [Anubis-jackal].

(6) Niche. Left wall, offering-table and priest, right wall, Ḥathor-cow in mountain. Right wall, PHILAD. photo. 40087.

303. PASER 𓌾𓏏𓏤, Head of the magazine [of Amūn?], Third prophet of Amūn. Dyn. XIX–XXI.

Dra' Abû el-Naga'.

Map II, D–6, c, 1.

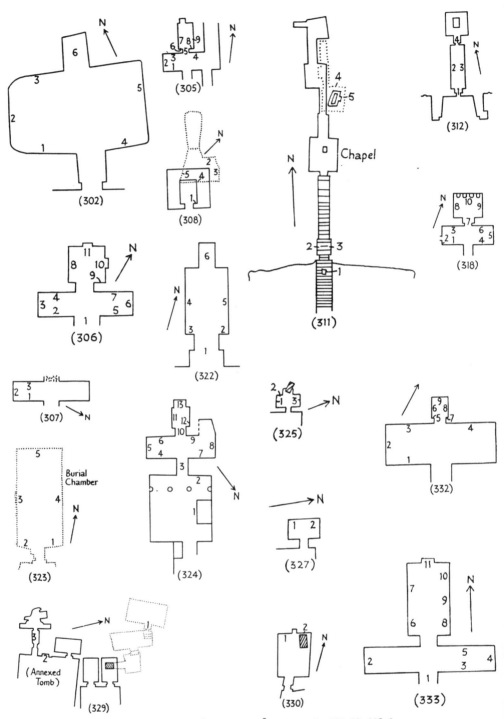

TOMBS 302, 305-8, 311-12, 318, 322-5, 327, 329-30, 332-3

Hall.

South wall. Two seated statues.

Finds

Fragment of sandstone jamb, with names of deceased as Third prophet, and of Penparēʿ ▢ 𝕏 ☉ , Third prophet of Amūn. PHILAD. photo. 34887.

Fragment of box-lid of Penparēʿ, in Philadelphia Univ. Mus. 29.86.402.

304. PIAY 〔hieroglyphs〕, Scribe of the table of Amūn, Scribe of the Lord of the Two Lands. Ramesside.

Draʿ Abû el-Nagaʿ.

<div align="center">For position, see p. 356. Map II, D–6, c, 1.</div>

View, PHILAD. photo. 34827.

Entrance.

Right thickness, two registers. **I,** Deceased with hymn. **II,** Priest offers to deceased, and kneeling harpist.

PHILAD. photo. 40002.

305. PASER 〔hieroglyphs〕, *waʿb*-priest in front of Amūn, Scribe of the divine offerings of Amūn. Dyn. XIX–XXI.

Draʿ Abû el-Nagaʿ.

Wife, Tamehit 〔hieroglyphs〕.

<div align="center">Plan, p. 382. Map II, D–6, h, 6.</div>

Copies of texts by GREENLEES, in Philadelphia Univ. Mus.

Hall. Book of Gates.

(1) Three registers. **I,** Priest with offering-list before deceased and wife. **II,** Deceased and wife and Fields of Iaru. **III,** Two women.

I and **II,** PHILAD. photo. 34923, and drawings, 11, 12.

(2) Three registers. **I,** Four scenes, deceased adoring. **II,** Deceased and wife before Maʿet with Negative Confession. **III,** Table of offerings.

I and **II,** PHILAD. photo. 34919.

(3) Three registers. **I,** Deceased and wife adoring, with offerings (including honey), *bas*, and souls of Pe and Nekhen, before Maʿet facing Rēʿ-Ḥarakhti (?). **II,** Deceased and wife, weighing-scene (cut out), and deceased led by Thoth to Osiris, Isis, and Nephthys. **III,** Purification of mummy before stela, with Ḥathor-cow in [mountain].

PHILAD. photos. 34921, 34991–2. I and **II,** PHILAD. drawings, 9, 10. Weighing-scene, FISHER in *Penn. Mus. Journ.* xv (1924), pl. facing p. 35, cf. p. 45.

(4) Two registers. **I,** Deceased and wife before Osiris. **II,** [Deceased and wife before Horus].

I, PHILAD. photo. 34924.

Inner Room.

(5) Right thickness, deceased. (6) Wife with two priests. (7) Couple.

(8) Two registers. **I,** *Sem*-priest before deceased. **II,** *Sem*-priest with offerings.
PHILAD. photo. 34922.

(9) Two registers. **I,** Deceased and wife led by Anubis [to Osiris]. **II,** Deceased and wife
before Osiris.
PHILAD. photo. 34920.

306. IRZANEN �⌉, Door-opener of the estate of Amūn. Dyn. XIX–XXI.
Dra' Abû el-Naga'.
Wife, Mutenōpet ⌣⌣⌣.
Plan, p. 382. Map II, D–6, h, 6.
Copies of texts by GREENLEES, in Philadelphia Univ. Mus.

Hall. Mostly Book of Gates.

(1) Right thickness, deceased [with wife?], and frieze, deceased kneeling before serpent-
divinity.

(2), (3), (4) Three registers. **I** (only at (4)), Deceased, with wife, *ba*s, and souls of Pe and
Nekhen, adores [Ma'et] facing Rē'-Ḥarakhti. **II,** Five scenes, deceased and wife, **1,** censing
before Ḥatḥor-cow in mountain, **2,** led by Anubis, **3,** adoring Ma'et with Negative Confes-
sion, **4,** in weighing-scene with assessors, and **5,** deceased led by Thoth and Horus to [Osiris].
III, Five scenes, **1,** deceased censes before 'Aḥmosi Nefertere and Amenophis I, **2,** tree-
goddess scene, **3** and **4,** son Nekht-ḥarerau ⌣⌣⌣ censes and libates to deceased and wife,
5, people adoring.
 I, II, and **III, 5,** PHILAD. photos. 34938–40, and drawings, 13–16.

(5) Three registers. **I,** Son Nekht-ḥarerau and wife adoring. **II,** Two rows of seven
cartouches (Queen 'Aḥmosi Nefertere, Seḳenenrē'-Ta'a, Amenophis I, Amosis, Tut'ankh-
amūn (?), Queen Tamer. . ., Queen (cartouche blank), Queen Nebttaui, Sesostris I, Queen
'Aḥmosi, Kamosi, Queen Sentsonb, In . . ., and another), and deceased censing and libating
to dressed *zad*-pillar in kiosk. **III,** Two scenes, **1,** son Nekht-ḥarerau with staff going forth,
2, tree-goddess scene.
 PHILAD. photo. 34949, and drawing, 20.

(6) Two registers. **I,** Book of Gates. **II,** Funeral procession with Abydos pilgrimage, and
continuation of **II** at (5).
 PHILAD. photo. 34953. Abydos pilgrimage, PHILAD. drawings, 18, 19.

(7) Two registers. **I,** Right part, deceased, wife, son, and man. **II,** Left part, Osiris-
emblem in kiosk, with ram-standard, deceased led by Horus and wife led by Anubis.
 PHILAD. photo. 34950. Deceased and Horus, PHILAD. drawing, 17.

Inner Room.

(8) Book of the Dead. Female mourners, and priests tending mummy on couch. (9) De-
ceased and wife adoring.
 PHILAD. photos. 34946–8, and drawings, 25, 26 [left], 31.

(10) Stela. At top, divine bark adored by *ba*s, and text below, with deceased adoring at each side. Right of stela, man adoring.

Scene at top of stela, PHILAD. drawing, 30.

(11) Stela with double-scene, son Nekht-harerau as priest libates to deceased, and son Pathenfy 𝕏⟨hieroglyphs⟩ as priest libates to wife. Left of stela, female mourner (belonging to (8)). Right of stela, Anubis supporting mummy, and daughter libating offerings beyond.

PHILAD. photos. 34941–5, and drawings, 26 [right]–29.

307. THONŪFER ⟨hieroglyphs⟩ (name from ushabti). Dyn. XX–XXI.
Dra' Abû el-Naga'. (Unfinished.)

Plan, p. 382. Map II, D–6, h, 6.

Description by GREENLEES, in Philadelphia Univ. Mus.

Hall.

(1) Book of Caverns (sketched).
PHILAD. photo. 34951.

(2) Deceased with emblem hanging from left arm (sketched).
PHILAD. photo. 40096, and drawing, 32.

(3) Two registers. **I,** Deceased and wife, with *ba*s, and souls of Pe and Nekhen, adore Ma'et facing Rē'-Ḥarakhti. **II,** [Negative Confession] with assessors.
PHILAD. photo. 34952, and drawing, 33.

308. KEMSIT ⟨hieroglyphs⟩,[1] Unique royal concubine, Prophetess of Ḥathor. Temp. Mentuḥotp (Nebḥepetrē').
Deir el-Baḥri, in the Temple of Mentuḥotp. (NAVILLE, No. 10.)

Plan, p. 382. Map III, C–4, b, 9.

NAVILLE and HALL, *The XIth Dynasty Temple at Deir el-Bahari*, i, pp. 8, 31, 49–50, ii, pp. 6, 23, with plan on pl. xxi, cf. iii, fig. on p. 9 (Burial Chamber); WINLOCK in *M.M.A. Bull.* Pt. ii, Nov. 1921, p. 39, with plan on fig. 20.

Shrine.

(1) [1st ed. 1] Two scenes. **1,** Destroyed, except head of Mentuḥotp. **2,** Man libates to deceased seated with attendant, in Brit. Mus. 1450.
NAVILLE and HALL, ii, pl. xx, p. 23; i, pl. xvii [C]. **2,** MASPERO, *Égypte*, fig. 205. Texts, CLÈRE and VANDIER, *Textes de la Première Période Intermédiaire* [&c.], (*Bibliotheca Aegyptiaca*, x), p. 32 [27 D, αα, ββ].

Block with relief, deceased and Princess Kauit, in Geneva, Musée d'art et d'histoire, 4767.
DEONNA, *Catalogue des sculptures antiques*, fig. 2, cf. pp. 8–9; part with head of deceased, NAVILLE and HALL, i, pl. xvii [B]. Texts, CLÈRE and VANDIER, op. cit. p. 43 [28 C, σ].

[1] For tombs of other royal concubines, see *Bibl.* ii, p. 133, and DEIR EL-BAḤRI, i², Pt. 2, in the Press.

Burial Chamber.

(2) [1st ed. 2] Female offering-bringers before deceased, and milking-scene. (3) [1st ed. 3] Male offering-bringers before deceased seated.

NAVILLE and HALL, iii, pl. ii [middle and bottom], p. 9; M.M.A. photos. T. 715, 719. Texts at (2), CLÈRE and VANDIER, op. cit. pp. 32 [27 D, γγ, 1], 33 [27 D, εε].

(4) [1st ed. 4] Deceased seated with girl-attendants (one doing her hair), offering-bringers, and butchers.

NAVILLE and HALL, iii, pl. iii, p. 9; M.M.A. photos. T. 717-18. Left part, GAUTHIER-LAURENT in *Mélanges Maspero*, i, fig. 4 (from NAVILLE and HALL), cf. pp. 677-8. Texts, CLÈRE and VANDIER, op. cit. p. 33 [27 D, γγ, 2, ζζ].

(5) [1st ed. 5] Man with cows and calves offers milk (?) to deceased seated.

NAVILLE and HALL, iii, pl. ii [top], p. 9; M.M.A. photo. T. 716. Texts, CLÈRE and VANDIER, op. cit. p. 33 [27 D, δδ].

Fragments of sarcophagus of deceased (base found *in situ*), with scenes including men with ointment, milking and cows with calves, granaries, female attendants, and girls offering to deceased, in Brit. Mus. 43037.

NAVILLE and HALL, i, pls. xxii, xxiii, pp. 49, 55-6, 69; M.M.A. photos. MCC. 17-18 (*in situ*). Texts, CLÈRE and VANDIER, op. cit. pp. 33-4 [27 D, ηη-u].

Coffins of deceased, in Cairo Mus. Ent. 49892. M.M.A. photos. M.7.C. 46-50, MCC. 22-3, 142-4, and 134 (mummy-cloths).

Model coffin, found in hole in east wall of Burial Chamber. NAVILLE and HALL, i, pls. ix [bottom right], xi [lower left], p. 50.

309. Name unknown. Dyn. XIX–XXI.

Sh. 'Abd el-Qurna. (Blocked.)

Maps V and VI, E–4, h, 1.

310. A Chancellor of the King of Lower Egypt. Dyn. XI.

Deir el-Baḥri. (New York, M.M.A. Excav. No. 505.)

Map III, C–4, f, 6.

Block with title, re-used in tomb 312. M.M.A. photo. M.7.C. 186.

311. KHETY ⟨⟩, Seal-bearer of the King of Lower Egypt. Temp. Mentuḥotp-Nebḥepetrēʿ.

Deir el-Baḥri. (New York, M.M.A. Excav. No. 508.)

Plan, p. 382. Map III, C–4, g, 6.

WINLOCK in *M.M.A. Bull.* Pt. ii, Dec. 1923, pp. 12-19, with plan and section, fig. 6, and views, figs. 4, 11, cf. Dec. 1924, pp. 13-14; WINLOCK, *Excavations*, pp. 68-71, with plan and section, fig. 7, and views, pls. 15 [lower left], 16 [upper]; HAYES, *Scepter*, i, pp. 163-4.

Stairway.

(1) [1st ed. 1] Red granite altar of deceased, *in situ.*
WINLOCK in *M.M.A. Bull.* Pt. ii, Dec. 1923, fig. 7, cf. p. 15; M.M.A. photo. M.4.C. 118.

Passage.

(2) and (3) Stelae. Fragments, including King, and mace, M.M.A. photos. M.7.C. 168, 177–8.

Blocks from scenes, including dancers, bowmen, netting birds, funeral procession, agriculture, and huntsman with dog, in New York, M.M.A. 26.3.354.
M.M.A. photos. M.7.C. 141–9, 151–72, M.4.C. 131 bis, 132–5; bowmen and netting, HAYES, *Scepter,* i, fig. 101, cf. p. 164.
Block from hunting-scene, dog attacking gazelle, in New York, M.M.A. 23.3.173. WINLOCK in *M.M.A. Bull.* Pt. ii, Dec. 1923, fig. 10, cf. p. 18; HAYES, *Scepter,* i, fig. 100, cf. p. 164; PHILLIPS, *Ancient Egyptian Animals* (1948), fig. 15; M.M.A. photo. M.4.C. 136.
Block with graffito of Nebneteru, High priest of Amūn, year 17 of Ramesses II, in New York, M.M.A. 23.3.26. WINLOCK, op. cit. fig. 9, cf. p. 16; M.M.A. photo. M.4.C. 172.

Chapel, with statue-base of deceased *in situ.* See supra, views of tomb.

Remains of scenes, including offering-bringers with deceased in boat below on east wall, offering-bringers and cooks on south wall, and preparation of food (?) on west wall.
M.M.A. photos. M.4.C. 114–17.

Fragment with ritual scene. M.M.A. photo. M.7.C. 150.

Top of a stela, with *sa*-symbol, &c., in New York, M.M.A. 23.3.49.
WINLOCK in *M.M.A. Bull.* Pt. ii, Dec. 1923, fig. 8, cf. p. 18; M.M.A. photo. M.4.C. 164.

Burial Chamber.

(4) and (5) [1st ed. 2, 3] Funeral outfit and coffin-texts.
WINLOCK in *M.M.A. Bull.* Pt. ii, Dec. 1923, fig. 12, cf. p. 19; id. *Excavations,* pl. 16 [lower], p. 71; M.M.A. photos. M.4.C. 110–13.

Finds

Head of wooden statuette of deceased, in New York, M.M.A. 26.3.104. WINLOCK in *M.M.A. Bull.* Pt. ii, Feb. 1928, fig. 27, cf. p. 24; id. *Excavations,* pl. 36 [upper left], p. 131.
Model, ox slaughtered, in New York, M.M.A. 26.3.103. See BREASTED (Jr.), *Egyptian Servant Statues,* p. 37, Type 3 [1].
Fragments of relief, probably from here (found at foot of causeway of tombs, New York, M.M.A. Excav. Nos. 506–8, see DEIR EL-BAḤRI, *Bibl.* i², Pt. 2, in the Press). M.M.A. photos. M.8.C. 220–3.

312. ESPEḴASHUTI ⸻, Governor of the town and Vizier. Saite.
In court of a Dyn. XI tomb.
Mother, Irterau (tomb 390).

Plan, p. 382. Map III, C–4, h, 6.

WINLOCK in *M.M.A. Bull.* Pt. ii, Dec. 1923, pp. 20–2. Views, M.M.A. photos. M.4.C. 49, 258, 267, M.7.C. 59–60.

Hall. Walls reconstructed in New York, M.M.A., drawn, and photographed; blocks now distributed.

(1) Outer and inner doorways. M.M.A. photos. M.7.C. 52–5.

(2) [1st ed. 1] Eight registers. **I–VI,** Offering-scenes to deceased. **VII,** Abydos pilgrimage. **VIII,** Offering-bringers. Graffito at bottom with copy in red ink of a boat in **VII.**
VII and **VIII,** in New York, Brooklyn Mus. 52.131.1, WINLOCK, op. cit. fig. 17 [top and middle], cf. p. 21; id. *Excavations*, pl. 91 [top and middle], p. 82; *Brooklyn Mus. Five Years*, pls. 56–7 [35 A], pp. 32–3. Graffito, M.M.A. photos. M.4.C. 208, M.7.C. 51.

(3) Eight registers. **I–VI,** Offering-scenes to deceased. **VII,** Funeral procession. **VIII,** Offering-bringers.
Block with offering-bringers from **IV,** M.M.A. photo. M.7.C. 186. Blocks from **V–VIII,** including one with offering-bringers in Chicago Univ. Or. Inst. 18236. Blocks with male, and with female mourners, from **VII,** in New York, Brooklyn Mus. 52.131.2, 3, *Brooklyn Mus. Five Years*, pls. 58–9 [35 B, C], pp. 32–3; female mourners, WINLOCK in *M.M.A. Bull.* Pt. ii, Dec. 1923, fig. 17 [bottom], cf. p. 21; id. *Excavations*, pl. 91 [bottom], p. 82; M.M.A. photos. M.4.C. 209, 276. Block with mourners, found *in situ*, M.M.A. photos. M.4.C. 210, 259. Block with upper part of offering-bringers in **V,** and title of an hereditary prince, in Cambridge, Fitzwilliam Mus. E.G.A. 3001.1943. Block, men with bulls and gazelle, in Denver Art Mus. Others in New York, Columbia Univ., and Princeton Univ. Art Mus. 50.127.

Burial Chamber.
(4) Outer doorway, in Princeton Univ. Art Mus. 50.127. Tympanum with Anubis-jackals, side-panels, bull with seven cows, and sacred oars.
Lower part, M.M.A. photos. M.7.C. 56–7.

For coffin, found in cache in Deir el-Baḥri, Temple of Ḥatshepsut, see DEIR EL-BAḤRI, *Bibl.* i², Pt. 2, in the Press.

Finds
Fragment of lintel of deceased. Text, BRUYÈRE in *Ann. Serv.* liv (1956–7), p. 21.
Head of a cow, in New York, M.M.A. 23.3.751. M.M.A. photo. M.4.C. 131.

313. ḤENENU ⟦𓏶𓎟𓎤⟧, Great steward. Temp. Mentuḥotp-Nebḥepetrēʿ and Mentuḥotp-Sʿankhkarēʿ.
Deir el-Baḥri. (New York, M.M.A. Excav. No. 510.)

Map III, C–4, i, 5.

HAYES, *Scepter*, i, pp. 164–5.

Vestibule.
Left wall. Stela A (reconstructed from fragments), deceased seated with offerings, and autobiographical text, in New York, M.M.A. 26.3.217.
HAYES in *J.E.A.* xxxv (1949), fig. 1, pl. iv, pp. 43–9; M.M.A. photos. M.7.C. 129–31.

Right wall. Stela B, fragments in New York, M.M.A. 26.3.218.
M.M.A. photo. M.7.C. 134. See HAYES in *J.E.A.* xxxv (1949), p. 43, note 6.

Passage.

Thicknesses, deceased (fragments of relief). Remains of inner lintel and jambs.
M.M.A. photos. M.7.C. 132–3.

Side-walls. Remains of stelae C and D.
See HAYES in *J.E.A.* xxxv (1949), p. 43, note 6, pp. 44–5, note 2. Fragment of C, M.M.A.
photo. M.7.C. 135.

Burial Chamber.

Inner sarcophagus. Fragments with coffin-texts, M.M.A. photos. M.7.C. 136–40.
Ushabti-coffin. Id. ib. 308.

314. HARHOTP ⟨𓃭𓏤⟩, Seal-bearer of the King of Lower Egypt, Henchman. Dyn. XI.

Deir el-Baḥri. (New York, M.M.A. Excav. No. 513.)
Mother, Sentshe ⟨𓏴𓎡⟩.

Map III, C–4, j, 6.

MASPERO, *Trois Années de fouilles* [&c.] in *Mém. Miss.* i, pp. 134–80; id. in *Bull. Inst. Ég.*
2 Sér. vi (1886), pp. 44–7.

Burial Chamber. View, MASPERO, *Égypte*, fig. 187; id. *Guide . . . Musée du Caire* (1915), on
fig. 41, cf. pp. 106–9 [300].

Walls with funeral outfit, painted false doors, offering-list, and coffin-texts, and sarco-
phagus with coffin-texts, are in Cairo Mus. 28023, and fragments, Temp. No. 5.7.22.1.

MASPERO in *Mém. Miss.* i, pls. xi–xviii. Texts, LACAU, *Sarcophages antérieurs au Nouvel
Empire* (*Cat. Caire*), i, pp. 42–56; coffin-texts, DE BUCK, *The Egyptian Coffin Texts*, i, iii–vi
[T I C]. Fragment from foot-end of sarcophagus with text in black paint, in New York,
Brooklyn Mus. 37.1507, see MASPERO in *Mém. Miss.* i, p. 172; id. in *Bull. Inst. Ég.* 2 Sér. vi
(1886), p. 46; *New York Historical Society. Catalogue of the Egyptian Antiquities*, No. 385
(text called demotic in error); WILBOUR, *Travels in Egypt*, pp. 222–3 with note 1.

Finds

Fragments of stela of deceased. M.M.A. photos. M.7.C. 187, 202.

315. IPI ⟨𓇋𓊪𓇋⟩, Governor of the town and Vizier, Judge. Temp. Mentuḥotp-Neb-
ḥepetrēꜥ.

Deir el-Baḥri. (New York, M.M.A. Excav. No. 516.)

Map III, C–5, a, 6.

WINLOCK in *M.M.A. Bull.* Pt. ii, Dec. 1922, pp. 33–4, with plan, section, and view of
exterior, figs. 31–2; id. *Excavations*, pp. 55–6, with plan and section, fig. 6.

Burial Chamber. View, WINLOCK in *M.M.A. Bull.* Pt. ii, Dec. 1922, fig. 29, cf. p. 33.

Sarcophagus of deceased, with painted false doors, funeral outfit, and coffin-texts on
interior.

View *in situ*, showing interior, M.M.A. photo. M.12.C. 8. Title from interior, BULL in
J.E.A. x (1924), p. 15.

Chamber in Court.

Embalming material of deceased on wooden platform.
Winlock in *M.M.A. Bull.* Pt. ii, Dec. 1922, figs. 33–4, cf. p. 34; id. *Excavations*, pl. 18 [top and middle], p. 55.

For tomb of Ḥesem (corrected to Meseḥ) in Court, see *Bibl.* i², Pt. 2, in the Press.
[Papyri of Ḥeḳanakht, found in hole in Passage, Winlock in *M.M.A. Bull.* Pt. ii, Dec. 1922, figs. 38–40, cf. pp. 38–48.]

316. Neferḥōtep 𓃭, Custodian of the bow. Dyn. XI.

Deir el-Baḥri. (New York, M.M.A. Excav. No. 518.)
Mother, Nebtiotef 𓃭. Wife (?), Mery(t) 𓃭.

Map III, C–5, b, 6.

Court.

Brick shrines with offering-tables. M.M.A. photos. M.4.C. 11, 13; see Winlock in *M.M.A. Bull.* Pt. ii, Dec. 1923, p. 20; id. *Excavations*, p. 72; limestone offering-table of mother and wife (?), in Cairo Mus. Ent. 47713, M.M.A. photo. M.4.C. 130; wooden offering-table, M.M.A. photo. M.7.C. 216.

Statue-chamber. In cliff above tomb.

Two block-statues of deceased, in Cairo Mus. Ent. 47708 (alabaster), 47709 (gritstone). Winlock in *M.M.A. Bull.* Pt. ii, Dec. 1923, figs. 13, 14, cf. p. 20; id. *Excavations*, pl. 35 [lower], p. 72; Vandier, *Manuel*, iii, pl. lxxx [2, 3], p. 595; M.M.A. photo. M.4.C. 18 (*in situ*). No. 47708, Senk in *Forschungen und Fortschritte*, xxvi (1950), Abb. 2, cf. p. 7; id. in *Ä.Z.* lxxix (1954), pl. xvi [3], pp. 155–6.

Finds

Statuette of tattooed dancing-girl, in Cairo Mus. Ent. 47710. Winlock in *M.M.A. Bull.* Pt. ii, Dec. 1923, fig. 15, cf. pp. 20, 26; id. *Excavations*, pl. 35 [upper], pp. 72, 74; Vandier d'Abbadie in *Revue d'Égyptologie*, iii (1938), fig. 6, cf. p. 33.
Fragment of blue faience hippopotamus, in Cairo Mus. Ent. 47711. M.M.A. photo. M.4.C. 218. See Winlock in *M.M.A. Bull.* Pt. ii, Dec. 1923, p. 20; id. *Excavations*, p. 72.

317. Ḏḥutnūfer 𓃭,[1] Scribe of the counting of corn in the granary of divine offerings of Amūn. Temp. Tuthmosis III (?).

Sh. ʿAbd el-Qurna. (Bricked up.) (Champollion, No. 25.)
Parents, Senires 𓃭, Mayor, and Taiy 𓃭. Wife, Titau 𓃭.

Maps V and VI, E–4, h, 1.

Titles of deceased, and name of wife, Rosellini MSS. 284, G 34. Names in scene of son offering bouquet to deceased and wife, Champ., *Not. descr.* i, pp. 516 and 844 [to p. 516, l. 18]: Sethe, *Urk.* iv. 135 (53) b.

[1] Attributed to his father Senires in Gardiner and Weigall, *Cat.* Supplement (by Engelbach), p. 24.

318. AMENMOSI 〔⟨𓎛𓏤𓂝〕, Necropolis-stonemason of Amūn. Temp. Tuthmosis III to Ḥatshepsut (?).

Sh. ʿAbd el-Qurna. (CHAMPOLLION, No. 26.)
Wife, Ḥenut 𓎱𓏤𓀭.

Plan, p. 382. Maps V and VI, E-4, h, 1.

CHAMP., *Not. descr.* i, pp. 516–17. Title of deceased, and name of wife, ROSELLINI MSS. 284, G 34 verso–35.

Hall.

(1) Two offering-scenes. (2) Deceased and wife adore Osiris and Western goddess, with seated couples below. (3) Offering-bringers.

(4) [1st ed. 3] Five registers. I–V, Agriculture before deceased (twice represented), including recording grain, &c., in I, and flax-harvest in III.
I, WILKINSON, *M. and C.* 2 Ser. i. 86 (No. 428) = ed. BIRCH, ii. 419 (No. 471); WILKINSON MSS. v. 222.

(5) [1st ed. 2] Two registers. I, Two rows, brewing, and butcher preparing meat, with [girl] offering drink to deceased. II, Hair-dressing scene. Sub-scene, offering-bringers.
Man and woman brewing, id. ib. 223 [bottom left].

(6) Three registers. I, Deceased fishing, and fowling. II, Netting birds. III, Vintage.

Inner Room.

(7) [1st ed. 1] Outer lintel, double-scene, deceased and wife kneeling adore Anubis and Western goddess, and adore Anubis and Eastern goddess, and jambs, offering-texts. Left inner thickness, deceased and wife.
Lintel and jambs, M.M.A. photos. T. 3047–8; goddesses, name of wife, and text of left half of lintel, WILKINSON MSS. v. 221 [bottom right].

(8) [1st ed. 4] Three registers. I–III, Banquet with musicians (including women with double-pipe and with lyre in I), before deceased and wife, with offering-bringers below.
See CHAMP., *Not. descr.* i, p. 517. Woman with lyre, WILKINSON, *M. and C.* ii. 291 (No. 217, 2) = ed. BIRCH, i. 476 (No. 242, 2); WILKINSON MSS. v. 221 [bottom left].

(9) [1st ed. 7] Deceased and wife with dog under chair, son Akh 𓄿𓐍𓀁 with table of offerings before them, and three registers, I–III, banquet.
Son and offerings, WILKINSON MSS. v. 221 [upper].

(10) [1st ed. 5, 6] Four statues, Ipu 〔𓇋𓊪𓅱〕, Necropolis-worker of Amūn, (with dog, painted, under chair), wife ʿAmeshaʿ 𓄿𓐠𓎛𓏤, deceased, and wife.
Texts, WILKINSON MSS. v. 220 [lower]; names and titles, CHAMP., *Not. descr.* i, pp. 517 (name of dog), 845 [to p. 517, l. 9]; LEPSIUS MS. 343 [middle].

319. NOFRU 𓄤𓄤𓄤, daughter of Mentuḥotp-Sʿankhibtaui and Iʿoḥ 𓇋𓏏𓇳, wife of Mentuḥotp-Nebḥepetrēʿ.

Deir el-Baḥri, in Temple of Ḥatshepsut. (NAVILLE, No. 31.)

Map III, C-4, e, 7.

HAYES, *Scepter*, i, pp. 158–60; WINLOCK in *M.M.A. Bull.* Pt. ii, Dec. 1924, pp. 12–13, and March 1926, pp. 9–12, with plan, section, and views, figs. 5, 6, 8; id. *Excavations*, pp. 101–4, with plan and section, fig. 8, and views, pls. 12 [right upper], 13 [upper], pp. 103, 130. View of ancient tourists' entrance, *I.L.N.* March 20, 1926, fig. on p. 516 [middle left]. Seventeen hieratic graffiti of scribes and others, Dyn. XVIII–XIX, see WINLOCK in *M.M.A. Bull.* Pt. ii, March 1926, pp. 12–13; HAYES, *Scepter*, i, p. 160.

Upper Corridor (bas-relief) **and Chapel** (relief).

Blocks from walls, in New York, M.M.A. 26.3.353, many now distributed.

Men bringing funeral outfit with boats, and kneeling man offering sceptres, (with graffito of two scribes), and fragment with an acacia-tree, all in New York, M.M.A. HAYES, *Scepter*, i, figs. 95–6; M.M.A. photos. M.7.C. 103–4, 97. Tree, SMITH, *Art . . . Anc. Eg.* pl. 60 [B].

Deceased with Inu [hieroglyphs] and Ḥenut [hieroglyphs], female hairdressers, in New York, Brooklyn Mus. 51.231 and 54.49, and other blocks adjoining below, in New York, M.M.A. RIEFSTAHL in *J.N.E.S.* xv (1956), pls. viii–x, pp. 10–14; blocks in Brooklyn Mus., *Brooklyn Mus. Five Years*, pls. 46–7 [27 A, B], pp. 24–5; No. 51.231, RIEFSTAHL in *Brooklyn Mus. Bull.* xiii [4] (1952), fig. 1, cf. pp. 7–16; *Egyptian Art in the Brooklyn Mus. Collection*, pl. 25; PRITCHARD, *The Ancient Near East in Pictures*, fig. 77; *I.L.N.* Oct. 10, 1953, fig. on p. 562 [top right]; blocks in New York, M.M.A., M.M.A. photo. M.7.C. 111.

Head of a girl, in New York, M.M.A. RIEFSTAHL in *J.N.E.S.* xv (1956), pl. xiv [C], p. 17.

Procession of girls with bulls below, in New York, M.M.A. Girls, WINLOCK in *M.M.A. Bull.* Pt. ii, Dec. 1924, fig. 10, cf. p. 12; SMITH, *Art . . . Anc. Eg.* pl. 60 [A]; M.M.A. photos. M.5.C. 281–2, M.7.C. 173.

Offering-bringer with tray, and female offering-bringer with basket on shoulder, in New York, Brooklyn Mus. 53.178 and 56.126. *Brooklyn Mus. Five Years*, pls. 46–7 [27 C, D], pp. 24–5; No. 53.178, RIEFSTAHL in *J.N.E.S.* xv (1956), pl. xi, p. 14; No. 56.126, see COONEY in *Brooklyn Mus. Bull.* xviii (1956), p. 19.

Head of a personified season (inundation), and two offering-bringers with bags on yoke, in Cairo Mus. Ent. 49926–7. See SMITH (W. S.), *A History of Egyptian Sculpture*, p. 237. No. 49926, SIMPSON in *J.N.E.S.* xiii (1954), pl. xix, pp. 265–8. No. 49927, M.M.A. photo. M.7.C. 174.

Part of two offering-bringers, in Edinburgh, Roy. Scot. Mus. 1953.322. *Dynastic Egypt in the Royal Scottish Museum*, pl. 3.

Girl-clappers, in the possession of Mrs. Louise J. Stark, Sharonville, Ohio. RIEFSTAHL, op. cit. pls. xii, xiv [A], pp. 14–15.

Woman with sunshade, in New Haven, Yale Univ. Art Gallery, 1956.33.87. FISCHER in *Yale Univ. Art Gallery Bull.* xxiv [2], Oct. 1958, fig. 1, cf. pp. 29–31.

Other blocks, including offering-bringers, funeral procession, &c., M.M.A. photos. M.7.C. 80–96, 98–102, 105–10, 113–27, M.12.C. 258–63.

Burial Chamber.

Views showing walls with funeral outfit, offering-lists, coffin-texts and pyramid-texts, WINLOCK in *M.M.A. Bull.* Pt. ii, March 1926, fig. 7, cf. p. 10, and Feb. 1928, figs. 2, 3, cf. pp. 4–5; id. *Excavations*, pl. 13 [lower], pp. 103, 130; *I.L.N.* March 20, 1926, fig. on p. 516 [middle right]. Coffin-texts, DE BUCK, *The Egyptian Coffin Texts*, i and vi [Th.T.319]. Pyramid-texts (variants), MASPERO in *Rec. de Trav.* iii (1882), pp. 201–16, in footnotes (from copies by NAVILLE), reprinted in MASPERO, *Les Inscriptions des Pyramides de Saqqarah*, pp. 25–40, in footnotes.

Texts on frieze and from sarcophagus, GABET in *Rec. de Trav.* xii (1892), p. 217.

Ushabti-coffins with name of mother, in New York, M.M.A. 25.3.240–4. M.M.A. photos. M.5.C. 246–9. No. 244, WINLOCK in *M.M.A. Bull.* Pt. ii, Dec. 1924, fig. 9, cf. p. 12; id. *Excavations*, pl. 14 [upper], p. 87; HAYES, *Scepter*, i, fig. 215 [lower], cf. pp. 326–7. Four are in Cairo Mus. Ent. 49086, 49088, 49090, 49092.

320. INḤAʿPI 𓇋𓈖�, perhaps wife of Amosis. (Royal Cache, Dyn. XXI, see DEIR EL-BAḤRI, *Bibl.* i², Pt. 2, in the Press.)

Deir el-Baḥri.

Map III, C-4, a, 10.

MASPERO, *Les Momies royales de Deir el Baharî* in *Mém. Miss.* i, pp. 516–19, with plan and section, fig. 1; LANSING in *M.M.A. Bull.* Pt. ii, Dec. 1920 (reprinted June 1921, Oct. 1923), pp. 5–6. View showing position, id. ib. fig. 8; COTTRELL, *The Lost Pharaohs*, pl. 35. Attribution of tomb to Inḥaʿpi, see WINLOCK in *J.E.A.* xvii (1931), pp. 107–10.

Pit. View, RUSTAFJAELL, *The Light of Egypt*, pl. xxviii, p. 55.

Each side of entrance to Passage to Burial Chamber. Three hieratic texts, one (now destroyed) concerning burial of Princess Eskhons in year 5 (formerly read as 16), probably of Siamūn, the others (one now destroyed) of Pinezem in year 10 of Siamūn.

MASPERO, *Momies royales*, figs. 2, 4, 5, cf. pp. 520–3; id. in *Ä.Z.* xx (1882), p. 134 [xxx, A–C]; ČERNÝ in *J.E.A.* xxxii (1946), pp. 25–7.

Burial Chamber.

Mummy-cloths in coffin of deceased (re-used by Rēʿi, see *Bibl.* i², Pt. 2, in the Press). Name of deceased in hieratic, MASPERO, *Momies royales*, p. 530, fig. 6; LEGRAIN, *Répertoire généalogique et onomastique du Musée du Caire*, No. 29 [1].

Finds

Clay sealing with title of a *sem*-priest of the Ramesseum, temp. Siamūn, found near, MASPERO, *Momies royales*, fig. 3, cf. pp. 521–2. See DARESSY in *Ann. Serv.* xxi (1921), p. 137 [right].

321. KHAʿEMŌPET 𓇋𓈖, Servant in the Place of Truth. Ramesside.

Deir el-Medîna.

Parents (perhaps), Bukentef and Iy (names in tomb 219 (5)). Wife, Maani 𓇋𓈖 .

Map VII, E-3, c, 5.

BRUYÈRE, *Rapport (1923–1924)*, pp. 72–3, with plan and section, pl. xviii, cf. i, and (*1924–1925*), on pls. i, ii, vi. Text in Burial Chamber, id. ib. (*1923–1924*), p. 73.

322. PENSHENʿABU 𓇋𓈖, Servant in the Place of Truth. Ramesside.

Deir el-Medîna.

Wife, Tentnubt 𓇋𓈖 .

Plan, p. 382. Map VII, E-3, c, 5.

BRUYÈRE, *Rapport (1923–1924)*, pp. 56–9, with plan, section, and elevation, pls. ii, xv, cf. i, and view showing brick pyramid, pl. iii [2].

Chapel.

(1) Fragment of lintel with bark of Rēᶜ. BRUYÈRE, on pl. xv, p. 56.

(2) [1st ed. 1, moved to entrance wall, left of doorway.] (3) and (4) Couples, once before Osiris.

Names at (2), BRUYÈRE, p. 57.

(5) [1st ed. 2] Two registers. **I,** Banquet. **II,** Book of Gates, weighing-scene and deceased and wife led by Anubis.

Text of **II,** BRUYÈRE, p. 58.

(6) Niche. Statue of deceased kneeling holding ram's head, in Turin Mus. 3032.

MASPERO, *Hist. anc. Les premières mêlées,* fig. on p. 531 [left]; PETRIE ITAL. photos. 76–7. Texts, MASPERO in *Rec. de Trav.* ii (1880), pp. 177–8 [xxxii]; titles, FABRETTI, ROSSI, and LANZONE, *R. Mus. di Torino,* p. 412; BRUYÈRE, p. 57; BRUGSCH, *Thes.* 1423 [1]. See ORCURTI, *Cat.* ii, p. 72 [39].

Vaulted ceiling. Names of deceased and wife, BRUYÈRE, p. 58.

Finds

Top of pyramid (?). BRUYÈRE, pl. vii [5–8], pp. 56–7.

Right part of a lintel with deceased and wife before [seated god]. BRUYÈRE, *Rapport (1929),* fig. 27 [4], cf. p. 64 [5].

Fragment of stela (?), deceased kneeling. Id. ib. *(1923–1924),* fig. 5, cf. p. 57.

323. PESHEDU 𓏏𓏏𓏏, Outline-draughtsman of Amūn in the Place of Truth, and in the Temple of Sokari. Temp. Sethos I.

Deir el-Medîna.

Parents, Amenemḥēt, Outline-draughtsman in the Temple of Sokari, and Mutnefert 𓏏𓏏𓏏. Wife, Nefertere 𓏏𓏏𓏏.

Plan, p. 382. Map VII, E–3, d, 5.

BRUYÈRE, *Rapport (1923–1924),* pp. 80–90, with plan and section, pls. ii, xxiii, cf. i. Titles concerning Sokari, BRUYÈRE, *Tombes théb.* p. 77.

Burial Chamber. Scenes, GR. INST. ARCHIVES, photos. DM. 323. 1–6.

(1) and (2) [1st ed. 7, 1] Western hawk at (1), and *Benu*-bird with Western emblem at (2). BRUYÈRE, *Rapport (1923–1924),* pls. xxiii [3, 4], xxiv [top right], p. 82.

(3) [1st ed. 2, 3] Two scenes. **1,** Parents and relatives before Ptaḥ-Sokari. **2,** Nut kneeling between two mummified gods and *zad*-pillars.

Id. ib. pl. xxiv [bottom], pp. 82–3, 84.

(4) [1st ed. 6, 5] Two scenes. **1,** Relatives squatting before Osiris and Western goddess. **2,** Isis kneeling between two mummified gods and *sa*-emblems.

Id. ib. pl. xxiv [middle], pp. 82 [middle], 83 [lower].

(5) [1st ed. 4] Tympanum, two *bas* adoring horizon-disk held by arms of Nut. Scene below, Anubis tending mummy on couch between Nephthys and Isis.
Id. ib. pl. xxiv [top left], pp. 84–5.

Ceiling of inner half, Nut. Text, id. ib. p. 83.

Finds

Fragments of stela, Sethos I with deceased before Osiris. Id. ib. fig. 15, cf. pp. 86–7.

324. HATIAY ⌐𓏭𓏤𓏤, Overseer of the prophets of all the gods, Chief prophet of Sobk, Scribe of the Temple of Monthu. Ramesside.
Sh. 'Abd el-Qurna.
Mother, Nefertere. Wife, Iuy 𓏭𓏤𓏤𓏤.

Plan, p. 382. Map VI, E–4, h, 3.

DAVIES and GARDINER, *Seven Private Tombs at Ḳurnah*, pp. 42–8, with plan, fig. 5; YEIVIN in *Liv. Ann.* xiii (1926), pp. 11–16, with plan and section, pl. viii (orientation reversed), cf. pl. ii [88].

Court.

(1) Blank stela with platform. Re-used block from unfinished lintel, with double-scene, deceased and wife adore [Amen-rēˁ]-Ḥarakhti-Atum, and adore Osiris.
YEIVIN, pl. vi [3], pp. 11–12. See DAVIES, p. 42.

(2) Remains of offering-scene.
YEIVIN, pl. vi [1]. See DAVIES, p. 42.

Hall.

(3) Thicknesses, [deceased with hymn to Rēˁ]. Soffit, titles of deceased.
See DAVIES, pp. 43, 47 [bottom].

(4) Remains of two registers. I, Donkeys bringing grain to granary. II, Deceased and wife with two men offering to them, and ploughing and pulling flax before [deceased].
DAVIES, pl. xxxi, p. 44, with fig. 6.

(5) Two registers. I, Deceased and wife angling with dog under chair. II, Deceased and family netting fowl.
DAVIES, pl. xxxii [lower], pp. 44–5.

(6) Three registers. I–III, Remains of banquet, with *sem*-priest before deceased, and relatives including son Penne (tomb 331).
See DAVIES, p. 45; YEIVIN, p. 14.

(7) Two registers. I, Viziers Usermontu and Nebamūn (?) seated with table of offerings between them. II, Two scenes, 1, deceased and wife in tree-goddess scene with *bas* drinking and boat on pool, 2, Fields of Iaru.
DAVIES, pls. xxxiii [lower], xxxiv, pp. 46–7. Remains of texts of Viziers, YEIVIN, p. 14 [top].

(8) Abydos pilgrimage, with chariot on board.
DAVIES, pls. xxxii [upper], xxxiii [upper], pp. 45–6.

(9) [Western goddess.] See DAVIES, p. 45.

Inner Room.

(10) Left thickness, deceased. (11) Deceased and offerings with guests beyond, and groups of women in funeral procession (?) below. (12) *Sem*-priest libates to deceased and relatives. See DAVIES, p. 47.

(13) Niche. Rear wall, deceased adores Osiris-emblem, and Hathor-cow in mountain. Left of niche, mummiform figure of deceased.
See DAVIES, p. 47.

Ceiling. Titles of deceased, see DAVIES, p. 48.

Finds

Stela, two registers, **I,** deceased before Osiris, **II,** three daughters, in Cairo Mus. 34138. LACAU, *Stèles du Nouvel Empire* (*Cat. Caire*), i, pl. lvii, pp. 188–9.
Triple-statuette, deceased, wife, and mother, (heads lost), in Cairo Mus. Ent. 71965. DAVIES, pl. xli [right], p. 43 (called F. 1965); YEIVIN, pl. vii [1], p. 15.

325. Possibly SMEN 𓏏𓏏𓆷 (from cones). Dyn. XVIII.
Deir el-Medîna.
Plan, p. 382. Map VII, E–3, d, 7.
BRUYÈRE, *Rapport (1923–1924)*, pp. 100–2, cf. 104 [7], with plan on pl. i.

Chapel. Remains of scenes.

(1) Deceased and wife before Anubis. (2) Couple offer to deceased and wife. (3) Deceased and wife before [Osiris].
BRUYÈRE, *Rapport (1926)*, pl. iv, pp. 55–6; see (*1923–1924*), p. 101.

326. PESHEDU, Foreman. (See tomb 3.) Ramesside.
Deir el-Medîna.
Map VII, E–3, d, 6.
BRUYÈRE, *Rapport (1922–1923)*, pp. 38–48, with plan on pls. ii, viii [lower].

Chapel. (Destroyed.)

Entrance wall. Fragments of three registers, Fields of Iaru.
Id. ib. fig. 10, cf. p. 42.

North wall. Priest with Opening the Mouth instruments before deceased and wife.
Id. ib. pls. xii [top], xiii [a], p. 41.

West wall. Niche. Amenophis I protected by Hathor-cow in canoe (probably from here).
Id. ib. pls. xii [middle], xiii [b], cf. p. 47.

Found in Court.

Fragments of relief with deceased adoring and titles, and of pyramidion. Id. ib. figs. 11–14, cf. pp. 42–3, 47.

327. TUROBAY 𓀀, Servant in the Place of Truth. Ramesside.
Deir el-Medîna.
Wife, Tuy 𓀀.

Plan, p. 382. Map VII, E–3, c, 7.

BRUYÈRE, *Rapport* (*1933–1934*), pp. 31–2, and plan, (*1923–1924*), on pl. i.

Chapel.

(1) Deceased with wife and son.
Text, id. ib. (*1933–1934*), p. 31 [bottom].

(2) Remains of scenes, including deceased and wife offering flowers to Osiris.
Texts, id. ib. (*1933–1934*), p. 31 [middle] (from copy by SETHE, about 1890).

Finds. Perhaps from here.

Pyramidion of deceased, in Louvre, E. 14396. BRUYÈRE, *Rapport* (*1933–1934*), pls. viii, ix, pp. 27–30; west and south faces, VANDIER, *Manuel*, ii, fig. 305 [bottom], cf. p. 522.
Part of pyramidion of deceased, from Kutorga Collection, in Leningrad, State Hermitage Mus. TURAIEV, *Opisanie egipetskikh pamyatnikov v russkikh museyakh i sobraniyakh* in *Bull. de la section orieñtale de la société impériale russe d'archéologie*, xi (1899), pl. iv, p. 133 [7]. Texts, BRUYÈRE, *Rapport* (*1933–1934*), pp. 32–3 (from TURAIEV).

328. ḤAY 𓀀, Servant in the Place of Truth. Dyn. XX.
Deir el-Medîna.
Wife, Tatemeḥet 𓀀.

Map VII, E–3, c, 7.

Chapel.

Plan, BRUYÈRE, *Rapport* (*1923–1924*), on pl. i, (*1928*), on pl. i.
Two jambs with titles, and son Ptaḥmosi kneeling below on left jamb, and deceased kneeling below on right jamb. dedicated by daughter Ḥunuro.

329. MOSI 𓀀, and Annexed tomb of MOSI 𓀀, probably his grandson, and IPY 𓀀, perhaps his son, all Servants in the Place of Truth. Ramesside.
Deir el-Medîna.
Wife (of Mosi, tomb 329), Ḥenutwaᶜt 𓀀. Father (of Mosi, Annexed tomb), Iᶜoḥnûfer 𓀀. Wife (of Mosi, Annexed tomb), Ḳatet 𓀀 (name on stela, Louvre, C. 280, see infra). Wife (of Ipy), Bakt 𓀀.

Plan, p. 382. Map VII, E–3, d, 7.

BRUYÈRE, *Rapport* (*1926*), pp. 74–80, with plan and section, fig. 55, cf. pl. i; Annexed tomb, GAUTHIER in *Ann. Serv.* xix (1920), pp. 11–12.

Innermost Burial Chamber of tomb 329.

(1) Outer lintel, horizon-disk adored by *bas* with Western emblems at each end, and jambs, texts of opening the gates of the underworld.

BRUYÈRE, fig. 56, cf. p. 76. Text of right jamb, id. *Mert Seger*, p. 269 [bottom].

Finds

Fragments of box-lid of deceased. BRUYÈRE, *Rapport (1927)*, fig. 39 [3], cf. p. 113 [1].

Annexed Tomb.

Court.

(2) Stela of deceased with Ipy and Mosi, in Louvre, C. 280. Stela *in situ*, behind last, two registers, **I,** man and children before [divinity] and Thoth, **II,** man and woman (sketch).

BRUYÈRE, *Rapport (1926)*, pl. ix (Louvre stela *in situ*), pp. 78–9, cf. *(1934–1935)*, Pt. 3, p. 43. Louvre stela, see BOREUX, *Guide*, i, p. 102; VANDIER, *Guide*, p. 6.

Chapel.

(3) Remains of funeral scene. See BRUYÈRE, *Rapport (1926)*, p. 80.

Finds

Fragments of relief, double-scene, Mosi kneeling and adoring with hymns to Rēʿ. Id. ib. fig. 57, cf. p. 81.

330. KARO 𓀀𓏛, Servant in the Place of Truth. Dyn. XIX.

Deir el-Medîna.

Parents, Simut 𓀀𓏛 and Peshedu 𓀀𓏛𓏛. Wife, Takhaʿ 𓀀𓏛𓀀.

Plan, p. 382. Map VII, E–3, d, 5.

BRUYÈRE, *Rapport (1923–1924)*, pp. 93–5, with plan and section, pls. ii, xxvi, cf. i.

Chapel.

(1) Deceased and wife before Osiris.

See id. ib. p. 94.

(2) [1st ed. 1] Three registers. **I,** Deceased and wife before Anubis. **II,** Deceased libates to parents and other relatives. **III,** Relatives before deceased and family.

Names, &c., id. ib. p. 94.

Finds

Stela of deceased in Turin Mus. 1636. FARINA, *R. Mus. di Torino* (1931), 43 [left], (1938), 45 [left]. Deceased before five divinities at top, LANZONE, *Diz.* pl. xcvi, pp. 253–4. Texts, MASPERO in *Rec. de Trav.* ii (1880), p. 196 [xcii]; names, LIEBLEIN, *Dict.* No. 707, cf. Supp. p. 965; titles of deceased, BRUGSCH, *Thes.* 1434 [38]. See FABRETTI, ROSSI, and LANZONE, *R. Mus. di Torino*, p. 179; ORCURTI, *Cat.* ii, p. 33 [44]; BRUYÈRE, *Rapport (1923–1924)*, p. 96 [3, 2nd item].

Fragment of stela of father, with Osiris and Anubis seated. Id. ib. fig. 18, cf. p. 96 [3, 1st item].

Fragments of stela of deceased. BRUYÈRE, *Rapport (1931–1932)*, p. 8, fig. 3, cf. p. 69 [23] (called tomb 340).

331. PENNE ⬚⊚, called SUNERO ⫚⧫⧦, Chief prophet of Monthu. Ramesside.
Sh. 'Abd el-Qurna.
Father, Ḥatiay (tomb 324). Wife, Maiay ⧦⧫⧦, Chief of the harîm of Monthu.
Plan, p. 106. Map VI, E-4, g, 2.

DAVIES and GARDINER, *Seven Private Tombs at Ḳurnah*, pp. 53–5, with plan on pl. xl; YEIVIN in *Liv. Ann.* xiii (1926), pp. 10–11 (called 336); plan, MOND in *Liv. Ann.* xiv (1927), on pl. ii (called 336).

Hall.

(1) Outer jambs, offering-texts with deceased seated below. Left outer thickness, deceased. Left inner thickness, two registers, I, deceased and wife, II, harpist with song before deceased and wife with monkey and cat under their chairs. Right inner thickness, [deceased adoring and wife] with hymn to Osiris.
DAVIES and GARDINER, pls. xxxvi, xxxvii, pp. 53–4. II, VARILLE in *B.I.F.A.O.* xxxv (1935), pl. iii [B], pp. 158–9 [iii].

(2) Fishing and fowling (?), and papyrus-gathering (?). See DAVIES and GARDINER, p. 53.

(3) Three registers. I–II, Scenes in Book of Gates. III, People, and man with lighted tapers and candles.
See id. ib. p. 53.

(4) Entrance to Inner Room. Remains of outer lintel with wife at right end, and of jambs with names of deceased and father. Thicknesses, deceased and [wife] adoring with hymns (to Osiris on right thickness).
Id. ib. pls. xxxviii, xxxix, pp. 54–5.

Finds

Lower part of sandstone kneeling statue of deceased. See id. ib. p. 55.

332. PENERNUTET ⬚⧦, Chief watchman of the granary of the estate of Amūn. Ramesside.
Dra' Abû el-Naga'.
Plan, p. 382. Map II, D–6, d, 3.

Hall.

(1) Deceased, with wife and priest, censes before a god. (2) A god, and deceased and wife adoring Osiris, Isis, and Nephthys. (3) Deceased adores [a god]. (4) Deceased with sistrum before 'Aḥmosi Nefertere.

Ceiling. Titles of deceased.

Shrine.

(5) and (6) Deceased with wife adores a god in kiosk. (7) and (8) Banquet before deceased and wife. (9) Deceased and offerings, with dressed *zad*-pillar on each side.

333. Name lost. Temp. Amenophis III (?).
Dra' Abû el-Naga'.
Plan, p. 382. Map II, D–6, g, 3.

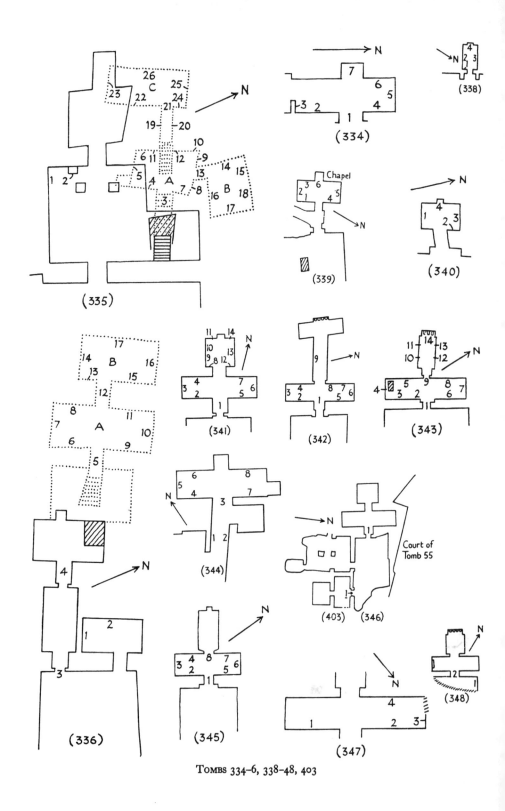

TOMBS 334–6, 338–48, 403

Hall.

(1) Left thickness, [deceased and wife]. (2) Priest, followed by three men, libates offerings. (3) [Deceased offers on braziers (?)], with sub-scene, two registers, boy fanning jars on stand, and men bringing wine-jars, &c. (4) Two registers, **I**, priest before Osiris and Western goddess, **II**, man offers to goddess. (5) Two registers, **I**, guests, **II**, wine-jars, kiosk, &c.

Inner Room.

(6) Tree-goddess scene. (7) Funeral procession (including man with candle) to mummy at pyramid-tomb. (8) Measuring grain. (9) Men with cloth and man fanning jar. (10) Girl offers to deceased and wife (?).

(11) Niche. At each side, priest with offerings and palm-branch, and squatting female mourner.

334. A Chief of husbandmen. Temp. Amenophis III (?).

Dra' Abû el-Naga'.

Plan, p. 400. Map II, D–6, g, 3.

Hall.

(1) Right thickness, two registers, **I**, cooking, **II**, offering-bringers. (2) Banquet. (3) De-, ceased and two women seated. (4) Three·registers, **I–III**, banquet, with musicians in **I**. (5) Man offers to deceased and wife.

(6) Four registers. **I**, Daughter, with others, offers to deceased and wife. **II**, Deceased seated in front of house. **III**, Deceased seated in Temple-garden. **IV**, Harvest before deceased.

II–III, DAVIES, *Town House*, fig. 9, cf. p. 248 (called tomb 324).

(7) Niche, with priest libating below.

335. NEKHTAMŪN ⸱⸱⸱, *wa⸴b*-priest of Amenophis (I) Lord of the Two Lands, Chiseller of Amūn, Servant in the Place of Truth. Dyn. XIX.

Deir el-Medîna. (L. *D. Text*, No. 105.)
Parents, Piay ⸱⸱⸱ and Nefertkha⸴ ⸱⸱⸱. Wife, Nubemsheset ⸱⸱⸱.
Plan, p. 400. Map VII, E–3, c, 7.

BRUYÈRE, *Rapport (1924–1925)*, pp. 113–73, with plan and sections on pl. viii, cf. pl. i; cf. L. *D. Text*, iii, p. 292.

Court. Views, BRUYÈRE, figs. 75–6.

(1) King (unfinished). (2) Double-statue (unfinished) of deceased and wife.
BRUYÈRE, figs. 76–7, cf. pp. 114–15.

Burial Chambers.
Chamber A.

(3) Entrance. Ceiling of staircase, two registers, **I**, Nut (full-faced) in mountain, holding disk, kneels before Osiris, **II**, deceased and wife kneeling adore Gate of the West and disk of Ennead. Left inner thickness, two registers, **I**, bark of Rēꜥ, **II**, deceased with hymn to Rēꜥ.
Ceiling, BRUYÈRE, figs. 78–9, pp. 116–17. Thickness, id. ib. on fig. 83 [middle], cf. p. 117.

(4) Daughters and son offer to deceased and family.
BRUYÈRE, figs. 82, 83 [right], cf. pp. 121–2.

(5) Three priests perform Opening the Mouth ceremonies and purify [deceased] and wife.
Id. ib. fig. 81, cf. pp. 119–20.

(6) Two mummies before pyramid-tomb in mountain.
Id. ib. fig. 80, cf. pp. 118–19; incomplete, DAVIES (Nina) in *J.E.A.* xxiv (1938), fig. 19,
cf. p. 39.

(7) Two registers. **I,** [Two sons (?)] offer to Ḳen (tomb 4) and wife Ḥenutmeḥyt. **II,** Two
sons offer to Khaꜥbekhnet (tomb 2) and wife Saḥte.
BRUYÈRE, figs. 83 [left], 84 [right], cf. p. 122.

(8) Brother Ipuy (tomb 217) with wife seated and New Year candle (continued from (13)).
BRUYÈRE, figs. 84 [middle], 85 [right], cf. p. 123; SCHOTT photo. 5752.

(9) Son Amenemōpet offers bouquet to Minmosi and wife Ēsi 𓇋𓊃𓏤.
BRUYÈRE, figs. 85 [left], 86 [right], cf. p. 124. Texts, LEPSIUS MS. 392 [middle].

(10) Wife before her parents, Peshedu (tomb 292) and wife Makhay.
BRUYÈRE, figs. 86–7, cf. pp. 124–5. Texts, LEPSIUS MS. 392 [bottom].

(11)–(12) (Partly above staircase to Chamber C) Two registers. **I,** Gods in [purifica-
tion (?)] scene. **II,** On left, projection (for statue of jackal), with Anubis-jackal on front,
left side, Zet with torches, right side, Isis kneeling.
BRUYÈRE, figs. 87 [left], 80 [right], cf. pp. 125–7.

Chamber B.

(13) Left thickness, titles of deceased. Right thickness, Neferronpet (tomb 336) and wife
adoring (continued at (8)). Inner lintel, double-scene, Anubis squatting with knife.
Thicknesses, BRUYÈRE, fig. 84 [left], cf. pp. 124, 141 [bottom], and inner lintel, on fig. 88,
and p. 128.

(14) Two registers. **I,** Deceased with wife and Sefkhet-ꜥabu offers image of Maꜥet to
Thoth. **II,** Guests at banquet, including parents and Khaꜥemteri (tomb 220) and wife, and
Ḥeḥnekhu 𓎛[𓈖𓏲𓇯𓂺].
BRUYÈRE, fig. 93, cf. pp. 138–41. Texts of **I,** LEPSIUS MS. 393 [bottom]–394 [top].

(15) Two registers. **I,** Tree-goddess scene with deceased and wife drinking from pool
below. **II,** Abydos pilgrimage.
BRUYÈRE, fig. 92 [left], cf. pp. 137–8.

(16) Three registers. **I,** Deceased and family before brother Neferḥōtep as Excellent
spirit of Rēꜥ. **II,** Funeral procession. **III,** Three squatting priestesses performing funeral
rites.
BRUYÈRE, *Rapport (1924–1925),* figs. 88–9, cf. pp. 128–33. **III,** Id. ib. *(1926),* fig. 51, cf.
pp. 65–6. Texts of **I,** LEPSIUS MS. 393 [middle right, and near bottom].

(17) [1st ed. 1] Two registers. **I,** Deceased as *waꜥb*-priest of Amenophis I purifies seated
couple. **II** (on front of platform), Three offering-scenes to seated couples, and priest offers
to statue of deceased standing on chair.

Tomb 335 403

Bruyère, *Rapport (1924–1925)*, figs. 90–1, cf. pp. 133–6. **I**, Id. *Mert Seger*, fig. 34, cf. p. 77. Texts of **I**, Lepsius MS. 393 [top and middle left]; name and titles of deceased, L. *D. Text*, iii, p. 292 [middle right].

(18) Ram-headed Rēᶜ-Ḥarakhti between Isis with uraeus on *zad*-pillar and Nephthys with Western hawk.

Bruyère, *Rapport (1924–1925)*, fig. 92 [right], cf. p. 136. Head of Isis, Lepsius MS. 394 [middle].

Passage. View of entrance, *I.L.N.* Oct. 10, 1925, fig. on p. 674 [upper left].

(19) Deceased and wife adore horizon-disk supported by two donkeys.

Bruyère, *Rapport (1924–1925)*, figs. 96–8, cf. pp. 147–51; id. *Tombes théb.* frontispiece [upper]. Upper part of adoration-text (omitting name of wife), Lepsius MS. 394 [bottom].

(20) Deceased and wife (back to back) open gates of the underworld, and of eternity, respectively.

Bruyère, *Rapport (1924–1925)*, fig. 94, cf. p. 142.

Ceiling. Nut with Osiris-emblem, and pyramid-tomb in mountain.
Id. ib. fig. 95, cf. pp. 142–7.

Chamber C.

(21) Inner jambs, offering-text.
Id. ib. on figs. 102, 111, and p. 154 [top].

(22) Three scenes. **1**, Son Piay with ram-headed Anubis. **2**, His wife with sistrum before Maᶜet. **3**, Piay offers on brazier to Ptaḥ.
Id. ib. figs. 109–11, cf. pp. 162–6. Maᶜet in **2**, and Piay in **3**, Schott photos. 5607–8. Texts, incomplete, Lepsius MS. 395 [upper].

(23) Tympanum, winged Isis. Scene below, Anubis tending mummy on couch purified by Isis and Nephthys.
Bruyère, fig. 108, cf. pp. 161–2; Lhote and Hassia, *Chefs-d'œuvre*, pl. at end, 10. Scene, Phillips in *M.M.A. Bull.* n.s. vi (1948), fig. on p. 211; Schott photos. 5601–6. Texts of scene, and vases, &c., below couch, Lepsius MS. 395 [lower].

(24) Nebmaᶜet with knife and palm-branch.
Bruyère, *Rapport (1924–1925)*, fig. 102, cf. pp. 152–3; upper part, Schott photo. 5609.

(25) Tympanum, winged Nephthys. Weighing-scene below, with deceased, wife, and Maᶜet, before Thoth as baboon on pylon.
Bruyère, fig. 103, cf. p. 154. Thoth, Schott photo. 5610. Texts of Nephthys and Thoth, Lepsius MS. 396 [middle].

(26) Four scenes. **1**, Deceased libates to Osiris in shrine. **2**, Amenophis I with Buto and Neith. **3**, Anukis and Tuēris as Taḥenutseḥen. **4**, Deceased and wife adore Rēᶜ-Ḥarakhti.
Bruyère, figs. 104–7, cf. pp. 154–60. **2**, Černý in *B.I.F.A.O.* xxvii (1927), pl. ii, p. 168. Tuēris in **3**, and deceased and wife in **4**, Schott photos. 5611–12. Texts in **2** and **3**, Lepsius MS. 396 [top].

Frieze-texts. Bruyère, *Rapport (1924–1925)*, p. 167.

Vaulted ceiling with line of text below. Centre, offering-texts. Outer half, Rēᶜ, Ḥepy, and Ḳebḥsenuf before cat slaying Apophis as serpent. Inner half, Anubis-jackal, Imset, and Duamutf, before Rēᶜ-Ḥarakhti as hawk.

Bruyère, figs. 112–13, cf. pp. 168–72. Texts, Lepsius MS. 396 [bottom]–398 [middle].

Finds

Cartonnages of deceased and wife. Bruyère, figs. 117–18, cf. p. 176 [2, 3].

Ushabti-box of deceased and wife, in New York, M.M.A. 47.139. Phillips in M.M.A. Bull. n.s. vi (1948), figs. on pp. 208–9; The Metro. Mus. of Art Miniatures. Album T: The Life and Civilisation of Egypt, p. 4 [left], No. 7; Hayes, Scepter, ii, fig. 275.

Incense-pot with name of deceased. Bruyère, fig. 119, cf. p. 177 [1].

Fragments, deceased with hymn, probably from entrance to Chapel. Bruyère, Rapport (1924–1925), fig. 114, cf. p. 174 [1].

336. Neferronpet ⌡⌐⌐⌐, Servant in the Place of Truth. Dyn. XIX.
Deir el-Medîna.
Parents, see tomb 335 (brother). Wife, Ḥuynefert ⌐⌐⌐⌐⌐.

Plan, p. 400. Map VII, E–3, c, 7.

Bruyère, Rapport (1924–1925), pp. 80–105, with plan and section on pl. viii, cf. pl. i.

Chapels.
North Chapel.

(1) and (2) Remains of scenes. Bruyère, fig. 53, cf. p. 81.

South Chapel.

(3) Fragment of left jamb, found in Court. Names, Bruyère, p. 81 [bottom].

(4) Entrance to Inner Room. Names on right jamb and thickness, id. ib. p. 81 [near bottom].

Burial Chambers.
Chamber A. View showing coffins, Bruyère, fig. 72; I.L.N. Oct. 10, 1925, fig. on p. 675.

(5) Jambs and thicknesses, titles.
Titles on north jamb, Bruyère, p. 82 [middle].

(6) Remains of banquet. Guests in bottom register, Bruyère, fig. 60, cf. pp. 91–2.

(7) Three registers. I, Arms of Nut holding [disk] in mountain, and man offering to couple with daughter. II–III, Banquet with deceased and relatives.
Bruyère, fig. 59, cf. pp. 90–1.

(8) Remains of deceased and wife before Osiris and goddess.
Bruyère, fig. 58, cf. pp. 88–90.

(9) Weighing-scene with Maᶜet, Thoth as baboon on pylon, and monster.
Bruyère, fig. 54, cf. pp. 82–3.

(10) Two registers. **I,** Anubis (on stool with steps) tending mummy between Isis and Nephthys. **II** (on front of platform), Deceased and wife kneeling adore arms of Nut holding disk in mountain.

BRUYÈRE, figs. 55–6, cf. pp. 83–6. **II,** Id. ib. (*1926*), fig. 11, cf. p. 25; id. *Tombes théb.* frontispiece [lower].

(11) Ptaḥ before Mertesger suckling child.

BRUYÈRE, *Rapport (1924–1925)*, fig. 57, cf. pp. 86–8; id. *Mert Seger*, fig. 21, cf. p. 271 [top]; FARINA, *Pittura*, pl. clxxix.

Vaulted ceiling, inner half, remains of primordial hill, and text. See BRUYÈRE, *Rapport (1924–1925)*, p. 92.

Chamber B.

(12) Left thickness, man descending from mountain received by a god in front of tomb. Right thickness, man adoring.

Left thickness, BRUYÈRE, *Rapport (1924–1925)*, fig. 61, cf. pp. 92–3.

(13) Ram-headed Rēꜥ between Isis and Nephthys, and four standards.

Id. ib. fig. 67 [lower], cf. p. 100.

(14) Tympanum, two Anubis-jackals. Scene below (on front of platform), woman offers to couple, man with offerings, and foreleg-rite.

Id. ib. fig. 66, cf. pp. 99–100.

(15) Priest, carrying chest with Anubis-jackal on it, beside mummy on couch between Nephthys and Isis as vultures, all in naos.

Id. ib. fig. 62, cf. pp. 93–4.

(16) Tympanum, Isis kneeling in front of palm-tree. Scene below, two demons on a pylon and [man adoring].

See id. ib. p. 94.

(17) Two scenes. **1,** Wife receives libation from Anubis. **2,** Deceased led by Nut to crocodile-headed Geb (purifying him), Osiris, and Western goddess.

Id. ib. figs. 63–4, cf. pp. 94–9.

Vaulted ceiling, eight scenes. Outer half, **1,** horizon-disk with scarab, **2,** Nut holding *uzat* in mountain, **3,** destroyed, **4,** deceased opens door of pyramid-tomb. Inner half, **5,** Ḥathor-cow head in mountain with Rēꜥ-Ḥarakhti as hawk above, **6,** Northern Mert on funeral sledge, **7,** bark of Rēꜥ on primordial hill, **8,** Rēꜥ-Ḥarakhti as hawk.

Id. ib. figs. 67 [upper], 68–9, 71, cf. pp. 100–3.

Finds

Fragment of coffin of deceased. BRUYÈRE, *Rapport (1924–1925)*, fig. 116, cf. pp. 175–6 [1].

337. KEN ⌂⌐, Chiseller in the Place of Truth (see tomb 4), temp. Ramesses II. Usurped by ESKHONS ⌐ ⊜⫯, Dyn. XXI or XXII.

Deir el-Medîna.

Map VII, E–3, c, 7.

BRUYÈRE, *Rapport (1924–1925)*, pp. 76–80, with plan, pl. viii, cf. pl. i.

Chapels.

Fragments of left outer jamb of North Chapel, and of lintel of South Chapel. Texts, BRUYÈRE, pp. 77 [1], 79 [1].

Burial Chamber.

North wall. Tympanum, personified Western emblem between Anubis-jackals, with kneeling Isis on left and Nephthys on right. Remains of two registers below (usurped), **I,** [deceased and relatives] ending with Shedkhons 🔺, adoring Osiris, Isis, Horus, and Anubis, **II,** [people before divinities].

BRUYÈRE, fig. 52, cf. pp. 78–9.

338. MAY ⌐ⵣ, Outline-draughtsman of Amūn. Late Dyn. XVIII.

 Deir el-Medîna.
 Wife, Tamyt 🔺.

 Plan, p. 400. Map VII, E–3, d, 6.

 BRUYÈRE, *Rapport (1924–1925)*, pp. 192–3, with plan, pl. iv, cf. i.

Chapel. In Turin Mus. Sup. 7886.

 (1) Female mourner (belonging to (2)).

 (2) Three registers, funeral procession. **I,** Sarcophagus dragged by men and oxen, &c., to pyramid-tomb. **II,** Offering-scenes to couples. **III,** Abydos pilgrimage.

 ALINARI photos. 31406–7; left part, WERBROUCK, *Pleureuses*, pl. xviii (from ALINARI), p. 65. Sarcophagus dragged in **I,** LÜDDECKENS in *Mitt. Kairo*, xi (1943), Abb. 31, cf. pp. 91–3 [37].

 (3) Two registers. **I,** Offering-scene to deceased and wife. **II,** Three boats.

 (4) Remains of two registers. **I,** Couple seated. **II,** Double-scene, priest before offerings.
 ALINARI photo. 31406.

Pyramid. (Destroyed.)

 Lucarne-stela with bark of Rēꜥ at top and deceased adoring, in BANKES Collection at Kingston Lacy, Wimborne, Dorset.

 ČERNÝ, *Egyptian Stelae in the Bankes Collection*, No. 1 with plate.

Finds

 Stela, probably from here, in Turin Mus. 1579. Three registers, **I,** deceased and wife offer to Osiris and Ḥathor, **II,** three sons and daughter offer to deceased and wife, **III,** relatives. ALINARI photo. on 31406. See ORCURTI, *Cat.* ii. 17 [3]. Texts, MASPERO in *Rec. de Trav.* iv (1883), p. 142 [viii]; names, FABRETTI, ROSSI, and LANZONE, *R. Mus. di Torino*, p. 160; LIEBLEIN, *Dict.* No. 955, cf. Supp. p. 975.

339. ḤUY ⌐ⵣ, Servant in the Place of Truth, and PESHEDU 🔺, Servant in the Place of Truth, Necropolis-stonemason of Amūn in Karnak. Temp. Ramesses II.

 Deir el-Medîna.
 Parents (of Ḥuy), Seba ✱ and Nefer[t]iyti 🔺 (names from stelae in Brit.

Mus. 446 and Louvre, C. 86). Father (of Peshedu), Ḥarmosi 𓀀𓏏𓏤. Wife (of both), Takharu 𓄿𓏏𓇋𓏏𓀁.

Plan, p. 400. Map VII, E–3, c, 6.

BRUYÈRE, *Rapport (1923–1924)*, pp. 73–5 with plan and section on pl. xxii; *(1924–1925)*, pp. 51–61, with plan on pl. iv, cf. pls. i, ii, vi; *(1927)*, pp. 120–2.

Chapel. Reconstructed.

(1) and (2) Funeral ceremonies with foreleg-rite, Abydos pilgrimage, and [weighing-scene].
BRUYÈRE, *Rapport (1927)*, fig. 82, cf. p. 122.

(3) Deceased and wife before [Ptaḥ-Sokari?]. (4) Three registers of guests. (5) Tympanum, two Anubis-jackals, and remains of three registers below, people with bouquets before [stela].
See id. ib. pp. 120–2.

(6) Niche with [stela]. Left wall, deceased and wife before offerings.

Burial Chamber.
Outer lintel and jambs, texts of Ḥuy. BRUYÈRE, *Rapport (1924–1925)*, fig. 33, cf. p. 52.

Finds

Left jamb of Ḥuy, with two columns of text, in Turin Mus. Sup. 6157, and fragments of right jamb. See BRUYÈRE, *Rapport (1926)*, p. 16 [8].
Fragments of objects of Peshedu. Jamb, with deceased kneeling, BRUYÈRE, *Rapport (1924–1925)*, fig. 34, cf. p. 54. Stools and ushabti-box, id. ib. pl. v [1, 3, 5], (called Ḥuy in error), fig. 36, cf. pp. 56 [c, 8], 57. Canopic-jar, id. ib. fig. 37, cf. p. 58. Cartonnage, id. ib. p. 55, with fig. 35.

340. AMENEMḤĒT 𓇋𓏠𓈖𓎛𓏏, Servant in the Place of Truth (perhaps also owner of tomb 354). Early Dyn. XVIII.

Deir el-Medîna.
Parents, Maʿenḥut (?) 𓂝𓈖𓉔𓏏 and Ḥut 𓐍𓏏𓀀. Wives, Reditiʿoḥ 𓏏𓇋𓂝𓎛 and Nubnefert 𓋞𓄤𓏏𓀀.

Plan, p. 400. Map VII, E–3, c, 7.

BRUYÈRE, *Rapport (1924–1925)*, pp. 64–76, with plan on pl. vii, cf. pl. i.

Chapel. Scenes, GR. INST. ARCHIVES, photos. DM. 340. 1–3.

(1) Three registers. I, Double-scene, deceased kneeling adores Anubis, and adores Osiris. II and III, Relatives at banquet before deceased and Nubnefert.
BRUYÈRE, fig. 51, cf. pp. 74–6; SCHOTT photos. 8651–9.

(2) Two registers, unfinished. I and II, Seated couples.
BRUYÈRE, on fig. 42 [right], cf. p. 66. Couple in I, SCHOTT photo. 8670.

(3) Three registers, unfinished. I, As at (1). II and III, Funeral procession with men carrying sarcophagus on shoulders in II, and men with funeral outfit in III.
BRUYÈRE, fig. 42, cf. pp. 66–8. II and III, incomplete, SCHOTT photos. 8666–9.

(4) Niche, with vases above. Left of niche, parents seated. Right of niche, daughter before deceased and Reditiꜥoḥ.

BRUYÈRE, fig. 43, cf. pp. 68–73; incomplete, SCHOTT photos. 8660–1, 8663–5.

Ceiling, grape-decoration. BRUYÈRE, on figs. 42, 43, 51, cf. pp. 65–6; SCHOTT, *Das schöne Fest*, pl. xii, p. 855; SCHOTT photos. 8671–2.

341. NEKHTAMŪN 〔𓏤𓊖𓂝𓏤𓏏𓏤〕, Head of the altar in the Ramesseum. Temp. Ramesses II.

Sh. ꜥAbd el-Qurna.
Wife, Kemenꜥa 𓂝𓏤𓏏𓏤 .

Plan, p. 400. Map VI, E–4, f, 3.

DAVIES and GARDINER, *Seven Private Tombs at Ḳurnah*, pp. 31–41, with plan on pl. xxii; MOND and EMERY in *Liv. Ann.* xiv (1927), pp. 31–3, with plan on pl. xxxiv.

Hall. View, M.M.A. photo. T. 2374.

(1) Right thickness, deceased adoring with hymn to Osiris-Onnophris.
DAVIES, pl. xxii [middle left], p. 33; M.M.A. photo. T. 2360.

(2), (3), and (4) Two registers. **I**, Book of Gates, with deceased adoring, hymn to Osiris-Onnophris, and six scenes of deceased kneeling before guardians of gates, at (2), deceased and wife jubilating and led by Horus, and weighing-scene with [ꜥAmmet] and winged figure above scales, at (3), and deceased, [wife], and Horus, with Thoth reporting to Osiris and goddess, at (4). **II**, Funeral procession (including canopic-box and coffin carried, oxen dragging, and servants with food in booths), priests before mummy at pyramid-tomb with stela, and deceased and wife adoring Ḥathor-cow protecting King in mountain. Above frieze at (2), horizontal bouquet.

DAVIES, pls. xxv–xxvii, xxii [top], pp. 35–8, cf. p. 31; M.M.A. photos. T. 2361–4; CHIC. OR. INST. photos. 3368, 3371–5, 6498–9; incomplete, SCHOTT photos. 2172–4, 2229–32, 3765–7, 3918–24, 7518–25, 7618–21. Weighing-scene, and winged figure (thought to be King) in **I**, DESROCHES-NOBLECOURT in *B.I.F.A.O.* xlv (1947), fig. 14, cf. pp. 201–4; SMITH, *Art . . . Anc. Eg.* pl. 166 [B] (from painting by NINA DAVIES); winged figure, MOND and EMERY, pl. xxxix. Left part of **II**, LÜDDECKENS in *Mitt. Kairo*, xi (1943), pls. 18 [a, b], 19 [a, b], pp. 139–44 [67–70]; female mourners, DESROCHES-NOBLECOURT, *Religions ég.* fig. on p. 315 [upper]; mummy, stela, and tomb, DAVIES (Nina) in *J.E.A.* xxiv (1938), fig. 10, cf. p. 37; deceased and wife before Ḥathor-cow, HERMANN in *Mitt. Kairo*, vi (1936), pl. 6 [b].

(5), (6), and (7) [Deceased], man with incense, and stands with fruit and incense, at (6), followed by two registers, **I**, butchers and servants with food and brooms, **II**, son, officials with bouquets, male singers, lutist and clapper with song, at (5), all before Ptah-Sokari-Osiris seated with bearded Ramesses II behind him, at (7). Sub-scenes, men hacking bushes and [ploughing] at (5), and harvest, with reaping and corn brought on a donkey to enclosure containing harvest-deity before deceased under tree with kerchief on head at (7).

DAVIES, pls. xxii [bottom]–xxiv, pp. 33–5; SPIEGEL in *Ann. Serv.* xl (1940), pls. xxxvi–xxxviii, p. 263; omitting sub-scene at (5), M.M.A. photos. T. 2359, 2365–6; omitting sub-scenes, CHIC. OR. INST. photos. 3367, 3369–70, 3376, 7860–2. **I** and **II** at (5) and details, SCHOTT photos. 2167–8, 2170, 3329, 3762–4, 7513–17, 7622–5. God and King in **II**, WEGNER

in *Mitt. Kairo*, iv (1933), pl. xxviii [a]; DESROCHES-NOBLECOURT in *Ann. Serv.* l (1950), fig. 3, cf. p. 263, note 2 (god called Sethos I); King, DAVIES (Nina), *Anc. Eg. Paintings*, ii, pl. c (CHAMPDOR, Pt. iii, 10th pl.); head, MOND and EMERY in *Liv. Ann.* xiv (1927), fig. 23, cf. p. 32; lutist and clapper with song, SCHOTT in *Mélanges Maspero*, i, pl. ii [1], p. 461, note 1; lutist and clapper, HICKMANN in *Ann. Serv.* lii (1952), pp. 177–80 with figs. 10, 11; id. *45 Siècles de Musique*, pl. lii [B]; lutist, BRUYÈRE, *Rapport (1934–1935)*, Pt. 2, fig. 62, cf. p. 117.

Inner Room.

(8) and (9) Two registers. **I,** Son, with stand of offerings, followed by women with harp and lyre (latter dancing, and tattooed with figure of Bes), offers beer to deceased and wife. **II,** Son with incense and libation and bundles of onions before deceased and wife at Festival of Bubastis.

DAVIES, pl. xxviii, pp. 38–40; M.M.A. photos. T. 2368–70; CHIC. OR. INST. photo. 3377. I and II at (9), and Festival-text at (8), SCHOTT photos. 3755–8, 3761, 7526–8, 7626. Women with harp and lyre, VANDIER D'ABBADIE in *Revue d'Égyptologie*, iii (1938), fig. 4, cf. p. 31; HICKMANN, *45 Siècles de Musique*, pl. lii [C]; with lyre, MOND and EMERY in *Liv. Ann.* xiv (1927), fig. 24, cf. p. 32.

(10) and (11) Deceased with [wife] and sons offers on brazier to Ptaḥ.
DAVIES, pl. xxx [upper], p. 41; M.M.A. photos. T. 2369 [right], 2371 [left].

(12) Deceased with kerchief on head and staff, leaving tomb.
DAVIES, pl. xxx [lower], p. 40; M.M.A. photo. T. 2367; CHIC. OR. INST. photo. 3461.

(13) and (14) Tree-goddess scene and son seated under tree.
DAVIES, pl. xxix, p. 40; M.M.A. photos. T. 2371–3; CHIC. OR. INST. photo. 6137; omitting son, WEGNER in *Mitt. Kairo*, iv (1933), pl. xxix [a], p. 162 (called tomb 342). Deceased and wife, SCHOTT photos. 3759–60, 7628–9.

Finds

Clay statuette, man kneeling with stela. MOND and EMERY, op. cit. pl. xxxvi, pp. 32–3.

342. ḌHUTMOSI 𓏏𓅓𓏠, Hereditary prince, Royal herald. Temp. Tuthmosis III.
Sh. 'Abd el-Qurna. (CHAMPOLLION, No. 19, HAY, No. 6.)
Mother, Tabenert 𓎟�J𓏏𓀁. Wife, Tepiḥu 𓊪𓋴𓏏.
Plan, p. 400. Map VI, E–4, g, 2.

MOND and EMERY in *Liv. Ann.* xiv (1927), pp. 22–3, with plan on pl. ii; CHAMP. *Not. descr.* i, p. 514; WILKINSON, *Topography of Thebes*, p. 157 [q]; PRISSE, *L'Art égyptien, Texte*, p. 421 (probably this tomb); BURTON MSS. 25639, 42 verso.

Hall. Scenes destroyed, except lower part at (1), (2), (3), and (9).

(1) Inner right jamb, titles.

(2) [1st ed. 1] Three registers. **I,** Soldiers marching. **II,** Boats in procession. **III,** Ploughing, reaping, and oxen threshing.

I, WILKINSON MSS. xix. 10; HAY MSS. 29824, 16 verso. **II,** See ROSELLINI MSS. 284, G 30.

(3) [1st ed. 2] Remains of stela.

Cartouches of Tuthmosis III, HAY MSS. 29824, 16 verso.

(4) [1st ed. 3] Deceased in chariot hunting wild bulls, ostriches, &c., and men bringing game.

HAY MSS. 29822, 69, 70, 72–4. Deceased, BURTON MSS. 25644, 93–4; gazelle, and two men carrying oryx and hyena, with two dogs, id. ib. 90–1; man with oryx and dogs, WILKINSON, *M. and C.* iii. 13 (No. 322) = ed. BIRCH, ii. 86 (No. 350); HOREAU, *Panorama d'Égypte et de Nubie*, fig. on p. 16 verso [bottom, middle left]; WILKINSON MSS. xix. 5.

(5) [1st ed. 7] Three registers. I and II, Guests and male (?) and female musicians (girl dancing with double-pipe and two clappers). III, Men bringing provisions.

Musicians and guests with names in II, WILKINSON MSS. v. 182 [top], 184 [top]; musicians, id. *M. and C.* ii. 312 (No. 228) = ed. BIRCH, i. 490 (No. 253); HAY MSS. 29822, 75. Texts, HAY MSS. 29844 A, 6 [lower], 6 verso; text in III (probably), WILKINSON MSS. v. 184 [middle lower].

(6) [1st ed. 6] Remains of stela.

(7) [1st ed. 5] Two registers. I, Deceased with family fishing and fowling. II, Netting fowl, wine-press, and offerings to Termuthis.

I, WILKINSON MSS. xix. 7–8. Fowling, WILKINSON, *M. and C.* iii. 39 (No. 335) = ed. BIRCH, ii. 104 (No. 363). Texts of I, and of trapper in II, HAY MSS. 29844 A, 6 [top, and bottom right]; texts of I, WILKINSON MSS. v. 182 [bottom].

(8) [1st ed. 4] Remains of spearing hippopotamus.

Text, HAY MSS. 29844 A, 6 [middle].

Passage.

(9) [1st ed. 8] Two registers, funeral procession. I, Sarcophagus dragged, &c. II, Female mourners, gods in shrines, men carrying chest, &c.

Sarcophagus dragged and mooring-peg rite in I, BURTON MSS. 25644, 88–9; offering-list ritual and mooring-peg rite, WILKINSON, *M. and C.* 2 Ser. ii. 376–7 (Nos. 485, 487), 386 (No. 495) = ed. BIRCH, iii. 423–4 (Nos. 619, 621), 430 (No. 627); WILKINSON MSS. v. 184 [middle upper left, and bottom right]; priest with incense before statue, id. ib. 184 [middle upper right].

343. BENIA ⟨hieroglyphs⟩, called PAḤEKMEN ⟨hieroglyphs⟩, Overseer of works, Child of the nursery. Early Dyn. XVIII.

Sh. ʿAbd el-Qurna. (CHAMPOLLION, No. 37, L. D. *Text*, No. 74.)

Parents, Irtonena ⟨hieroglyphs⟩ and Tirukak ⟨hieroglyphs⟩.

Plan, p. 400. Map VI, E–4, h, 2.

CHAMP., *Not. descr.* i, pp. 529–32, with plan; L. D. *Text*, iii, p. 280; MOND and EMERY in *Liv. Ann.* xiv (1927), pp. 28–9, with plan, pl. xxxiii. Name and titles, HELCK, *Urk.* iv. 1472 (451) A–G. Fragments of text, ROSELLINI MSS. 284, G 50 verso, 52.

Hall. Views, M.M.A. photos. T. 2220–1.

(1) Outer jambs, remains of titles. Inner left thickness, deceased adoring with hymn.

Thickness, M.M.A. photo. T. 2213. Text, WILKINSON MSS. v. 162 [top right].

(2) Deceased adoring before offerings.

M.M.A. photo. T. 2209. Deceased, MOND and EMERY, pl. xxiv [left]; SCHOTT, *Das schöne Fest*, pl. i, pp. 777, 866 [38]; SCHOTT photo. 8036; HOSKINS MSS. i. 60 [left]. Titles, LEPSIUS MS. 339 [bottom left].

(3) [1st ed. 1] Deceased inspects three registers, **I–III,** weighing and recording gold rings and treasure.

MOND and EMERY, pl. xxiv; DRIOTON in *Cahiers d'histoire égyptienne,* 3 Sér. [3], (1951), fig. 2, cf. p. 204; M.M.A. photos. T. 2210–11; HOSKINS MSS. i. 60. Deceased, scales, and treasure, in **I,** L. *D.* iii. 122 [g]. Scribe and treasure in **III,** SCHOTT photo. 2660. Texts, HELCK, *Urk.* iv. 1468 (451); parts, CHAMP., *Not. descr.* i, pp. 531 [A], 849 [to p. 530, l. 24]; text in front of deceased, L. *D. Text,* iii, p. 280 [β]; SCHOTT photo. 2648.

(4) [1st ed. 2] Stela, texts. At sides, three registers, deceased kneeling, with offerings.

MOND and EMERY, pl. xxii; HERMANN, *Stelen,* pl. 8 [b] (from SCHOTT photo.), p. 3* [17–22]; M.M.A. photo. T. 2205; SCHOTT photo. 8037; BURTON MSS. 25644, 85; HOSKINS MSS. i. 79, iii. 63.

(5) [1st ed. 3] Deceased with man offering to him, and two registers, **I,** male musicians (clappers, flutist, lutist, and harpist) and parents seated, **II,** male guests.

MOND and EMERY, pls. xxiii, xx [left]; M.M.A. photos. T. 2214–16. Man offering, musicians, and three guests, HICKMANN in *Bull. Inst. Ég.* xxxv (1954), pl. vi, p. 324; id. in *Egypt Travel Magazine,* No. 19, Feb. 1956, fig. on p. 5; id. *45 Siècles de Musique,* pl. liii; **I** and **II,** HOSKINS MSS. i. 84; **I** and right end of **II,** SCHOTT photos. 2649–53, 8038–40; **I,** WEGNER in *Mitt. Kairo,* iv (1933), pl. v [b]; musicians, BRUYÈRE, *Rapport (1934–1935),* Pt. 2, fig. 67, cf. p. 119; BURTON MSS. 25638, 75 verso. Texts, HELCK, *Urk.* iv. 1471 [top and middle]; text of deceased, WILKINSON MSS. v. 161 [bottom left]; titles of deceased and names of parents, L. *D. Text,* iii, p. 280 [middle]; names of parents, CHAMP., *Not. descr.* i, p. 849 [to p. 530, l. 7].

(6) Two scenes. **1,** Deceased with offering-bringers offers on braziers. **2,** Offering-bringers and offerings before deceased seated.

MOND and EMERY, pl. xxvi; M.M.A. photos. T. 2206–8; omitting deceased in **2,** SCHOTT photos. 2647, 8048–54. Texts of **1,** HELCK, *Urk.* iv. 1471 [bottom]; text behind deceased in **1,** LEPSIUS MS. 339 [bottom right].

(7) [1st ed. 5] As at (4).

MOND and EMERY, pl. xxv; HERMANN, *Stelen,* pl. 8 [a] (from SCHOTT photo.), pp. 2*–3* [11–16], 46*–7* [top]; M.M.A. photo. T. 2212; SCHOTT photo. 8047; HOSKINS MSS. i. 80, 87. Text of stela, HELCK, *Urk.* iv. 1469–70; part, CHAMP., *Not. descr.* i, p. 849 [to p. 530, l. 19].

(8) [1st ed. 4] Deceased seated inspects three registers, **I–III,** cattle (one humped) and produce, including group of geese in **III.**

MOND and EMERY, pls. xx [right], xxi (called wall C); M.M.A. photos. T. 2217–19; HOSKINS MSS. iii. 46; incomplete, SCHOTT photos. 2654–9, 8041–6. Humped bull and men in **I,** BURTON MSS. 25638, 76; bull in **I,** and jar slung on pole in **II,** CHAMP., *Mon.* ccccxxvii [bottom middle], with *Not. descr.* i, p. 530; bull, ROSELLINI, *Mon. Civ.* pl. xx [8].

Inner Room.

(9) Outer lintel and jambs, texts.
M.M.A. photo. T. 2220 [right].

(10) [1st ed. 6] Four registers, funeral procession to Western goddess. **I,** Sarcophagus dragged to tomb. **II,** Offering-bringers. **III–IV,** Abydos pilgrimage.
Mond and Emery, pl. xxviii [left]; M.M.A. photo. T. 2199; Hoskins MSS. i. 86. **III** and **IV,** Schott photos. 8055–8; **III** with text, Champ., *Not. descr.* i, pp. 532, 850 [to p. 532, l. 4]. Hawk on head of goddess, and part of text above boats, Wilkinson MSS. v. 162 [top left].

(11) [Man] with offering-list and offerings before deceased.
Mond and Emery, pls. xxviii [right], xxix; M.M.A. photos. T. 2200–1.

(12) [1st ed. 7] Three registers, rites before mummy.
Mond and Emery, pl. xxxi; M.M.A. photo. T. 2202; Hoskins MSS. i. 83.

(13) As at (11).
Mond and Emery, pl. xxx; M.M.A. photos. T. 2203–4; deceased and offerings, Hoskins MSS. i. 63.

(14) Niche. Statues of deceased and parents.
Mond and Emery, pls. xx [middle], xxvii; cf. M.M.A. photo. T. 2221 [left]. Texts, Wilkinson MSS. xvii. H. 16 verso [right]; name of mother, Lepsius MS. 340 [middle].

Finds

Block, sketch of a girl, probably from a jamb. Mond and Emery, fig. 22, cf. p. 29.

344. Piay ⌷⸗, Overseer of the herds of Amen-rēᶜ in the Southern City; Royal scribe of the herds of Amenophis I. Ramesside.
Draᶜ Abû el-Nagaᶜ.
Wife, Tawert ⸗.

Plan, p. 400. Map I, C–7, c, 9.
Gauthier in *B.I.F.A.O.* vi (1908), pp. 148–62, with plan, p. 149, fig. 1.

Passage.

(1) [1st ed. 1] Deceased and wife adore [divinity] with baboons adoring above.
See Gauthier, p. 150.

(2) [1st ed. 2] Hymn to Rēᶜ-Ḥarakhti. Gauthier, p. 150.

Hall.

(3) [1st ed. 3] Inner lintel, double-scene, deceased kneeling with hymn to Amen-rēᶜ on left and to Rēᶜ-Ḥarakhti on right, and winged god holding ⸗ in centre.
Texts, Gauthier, p. 151.

(4) [1st ed. 4] Two registers. **I,** Four scenes, deceased and wife, **1,** adoring a god, **2,** adoring serpent on stand, **3,** adoring Khnum, **4,** adoring. **II,** Two scenes, **1,** deceased and family before offerings, **2,** man offers incense to deceased and family.
Texts, Gauthier, pp. 161–2 [F].

(5) [1st ed. 5] Personified *zad*-pillar adored by deceased and wife kneeling on each side. Text, GAUTHIER, pl. vi, pp. 160–1 [E].

(6) [1st ed. 6, 7] Two registers. **I**, Three scenes, Book of the Dead, **1**, deceased and wife led by Anubis, **2**, weighing-scene with ten assessors, **3**, Horus presenting deceased to Osiris with Isis and Nephthys. **II**, Two scenes, **1**, deceased and wife before divinities, **2**, deceased and family adore [Rēʿ-Ḥarakhti and goddess].

See GAUTHIER, pp. 159–60. **I**, PETRIE, *Qurneh*, pl. xxxix [upper left and lower], p. 11 [24].

(7) [1st ed. 10] Two registers. **I**, Two scenes, **1**, [deceased] adores Osiris and Isis, **2**, deceased and relatives with hymn adore Osiris-Onnophris. **II**, Two scenes, **1**, deceased adores Amenophis I and ʿAḥmosi Nefertere, **2**, deceased adores offering-list (unfinished).

Texts, GAUTHIER, pp. 154–7 [B].

(8) [1st ed. 8] Remains of scene, [statues of Amenophis I and ʿAḥmosi Nefertere] in palanquins carried by priests.

PETRIE, *Qurneh*, pl. xxxix [top right], p. 11 [24].

Frieze [part, 1st ed. 9] Left half, Ḥathor-heads and titles of deceased. Right half, offering-texts, painted sarcophagus between demons, and deceased before divinities.

Part of decoration and texts, PETRIE, *Qurneh*, on pl. xxxix; texts, omitting part at (8), GAUTHIER, pp. 157–8, 154 [middle upper].

Ceiling. Titles of deceased, GAUTHIER, pp. 152–4.

345. AMENḤOTP ⟨𓏴⟩, *waʿb*-priest, Eldest king's son of Tuthmosis I. Temp. Tuthmosis I.

Sh. ʿAbd el-Qurna. (CHAMPOLLION, No. 30, L. D. *Text*, No. 75.)

Parents, Senidhout ⟨𓏴⟩ and Takhrod ⟨𓏴⟩. Wife, Renay ⟨𓏴⟩.

Plan, p. 400. Map VI, E–4, h, 2.

CHAMP., *Not. descr.* i, pp. 519–20; L. D. *Text*, iii, pp. 280–1; ROSELLINI MSS. 284, G 39–40 (tomb attributed to father). Plan, MOND and EMERY in *Liv. Ann.* xiv (1927), pl. xxxiii (called Thotsenb), p. 30. Names and titles at (1) and (6), SETHE, *Urk.* iv. 105–6 (41).

Hall.

(1) [1st ed. 1, 2] Left thickness, deceased offers on braziers. Right thickness, deceased with wife pours ointment at New Year Festival.

L. D. iii. 9 [c, d]. Names and titles on right thickness, CHAMP., *Not. descr.* i, pp. 520 [A], 845 [to p. 519, last line]. Translation of offering-text on left thickness, SCHOTT, *Das schöne Fest*, p. 861 [16] (from copy by DAVIES).

(2) [1st ed. 3] Deceased and wife with girl offering *menat* to them, and two rows of men with fat and tapers and girls with ointment and cloth.

Deceased and wife, L. D. iii. 9 [a]. Text, SETHE, *Urk.* iv. 107–8 (42) c.

(3) Stela, two registers, **I**, double-scene, [deceased] before Osiris and before Anubis, **II**, two daughters with ointment and cloth offer to deceased and wife at festival of Neḥebkau. At sides, hymns to Osiris and to Anubis.

(4) Two registers. **I**, Priest with couple censes to deceased and wife. **II**, Measuring grain.

(5) [1st ed. 6] Deceased and wife receive New Year gifts at festival of Neḥebkau, with girl offering to them, and three registers, **I**, female musicians (including double-pipe) and female guests, **II**, female clappers and male guests, **III**, harpist and male guests.

Deceased and wife, L. D. iii. 9 [b]. Text, SETHE, *Urk.* iv. 107 (42) A.

(6) [1st ed. 5] Double-scene, deceased offers to parents, and offers to brother Neferḥōtep and wife (with monkey eating onion under chair).

L. D. iii. 9 [f]. Names and titles, CHAMP., *Not. descr.* i, pp. 520, 845 [to p. 520, l. 5].

(7) [1st ed. 4] Double-scene, deceased and family fishing and fowling.

Fowling-scene, L. D. iii. 9 [e]. Text, SETHE, *Urk.* iv. 107 (42) B.

(8) Entrance to Inner Room. Outer lintel, man adores Osiris.

Ceiling. Texts of Mery ⟨𓏤𓏭𓏭⟩, Overseer of the field-workers of Amūn, Scribe, possibly original owner of the tomb.

Finds

Statues (wooden) of deceased and of wife, dedicated by son ʿAkheperkareʿsonb, Priest in front of Tuthmosis I, formerly Golenishchev Collection 1005–6, now in Moscow, State Pushkin Museum of Fine Arts, I.1.a. 2103 and 2099. PAVLOV, *Egyptian Sculpture*, pls. 23–9, pp. 47–9; id. *Egipet putevoditel*, pl. 11; id. *Iskusstvo drevnego vostoka*, figs. on pp. 12, 13; MALMBERG and TURAIEV, *Descr. de la Collection égyptienne*, i, *Statues et statuettes de la Collection Golénischeff*, pl. viii [2–4], pp. 30–3 [46–7]; MATE, *Iskusstvo drevnego Egipta, novo tzarstvo*, iii, in *Istoria iskusstva drevnego vostoka*, i, pl. xvi [2, 3]; [PAVLOV and MATE], *Pamiatniki iskusstva drevnego Egipta*, pls. 36–9; KHODZHASH, *Ancient Egyptian Art* in *Voks Bulletin*, No. 8 (103), Aug. 1956, pl. facing p. 29 [upper right]; *Moscow, Pushkin Museum. Painting, Sculpture and Applied Art* (1956), pl. 93; *Kratkiy putevoditel po museyi. Drevney mír* (1956), p. 13, figs. 5, 6; VANDIER, *Manuel*, iii, pl. clxx [4, 6], p. 679; statue of wife, PAVLOV, *Skulptur portrets*, 23rd pl. at end.

346. AMENḤOTP ⟨𓇋𓏶𓎟⟩, Overseer of the women of the royal harîm of the divine adoratress Tentōpet, temp. Ramesses IV. Probably usurped from PENRĒʿ, Chief of Mezay, Overseer of the Lands of Syria (name on cones in Pit in Court), [temp. Ramesses II].

Sh. ʿAbd el-Qurna.

Plan, p. 400. Map VI, E–4, g, 2.

DAVIES and GARDINER, *Seven Private Tombs at Ḳurnah*, pp. 55–6, with plan, on pl. xl [right]; MOND and EMERY in *Liv. Ann.* xiv (1927), pp. 23–5.

Hall.

(1) Outer right jamb, text with deceased seated at bottom. Inner right thickness, man and woman facing each other.

See DAVIES, p. 56. Jamb, id. ib. pl. xl [left]; MOND and EMERY, pl. xvi [upper], p. 23 with fig. 16.

347. HORI 𓏲𓏭, Scribe of the nome. Ramesside.

> Sh. ʿAbd el-Qurna. (CHAMPOLLION, No. 20.)
> Wife, Nefertere 𓇾𓏭𓏲.

> Plan, p. 400. Map VI, E–4, g, 2.

Names of deceased and wife, CHAMP., *Not. descr.* i, pp. 514, 843–4 [to p. 514, l. 20]; ROSELLINI MSS. 284, G 30; name and title of deceased, FAKHRY in *Ann. Serv.* xlvi (1947), p. 40.

Hall.

(1) Osiris (?) seated, with two goddesses. (2) Three registers, **I**, deceased with staff, **II–III**, remains of funeral procession, including boats with mourners, butchers, and funeral outfit. (3) Deceased censes before naos in bark carried by eight men. (4) Deceased and wife seated.

348. A Chief steward, Unique friend, Mayor, Dyn. XVIII. Usurped by Nᴀʿᴀᴍᴜᴛ-NAKHT 𓈖𓏭𓂧𓏲𓊹𓏏, Door-opener of the House of Gold of Amūn, Dyn. XXII.

> Sh. ʿAbd el-Qurna.
> Wife (of original owner), Diʿankh. . . 𓂧𓏤𓏏𓏏.
> Parents (of Naʿamutnakht), Nezem 𓈖𓏲, same title, and Suru (?) 𓋴𓏲𓏲𓏭.

> Plan, p. 400. Map VI, E–4, g, 2.

Titles, FAKHRY in *Ann. Serv.* xlvi (1947), p. 40.

Court.

(1) Deceased (original owner) and wife (?) receive [New Year gifts]. (2) Lintel, double-scene, son offers food to Naʿamutnakht, with mother in left half.

349. THAY 𓍿𓄿𓏭𓏭, Overseer of fowl-houses. Early Dyn. XVIII.

> Sh. ʿAbd el-Qurna.
> Mother, Ipu 𓄿𓊪𓏲. Wife, Amenḥotp.

> Plan, p. 416. Map V, D–4, f, 10.

Name and title, FAKHRY in *Ann. Serv.* xlvi (1947), p. 40.

Passage.

(1) [Deceased offers on] braziers, and remains of titles.

(2) [Deceased and wife], with man offering to them, and traces of banquet. Sub-scene, agriculture, including man filling basket, Nubian woman and man, both reaping.

Inner Room.

(3) Remains of text on lintel. (4) Deceased (?) offers on braziers. (5) Two women with offerings, and offerings on ground. (6) [Deceased and wife], offerings and tree. (7) Basket with offerings on ground.

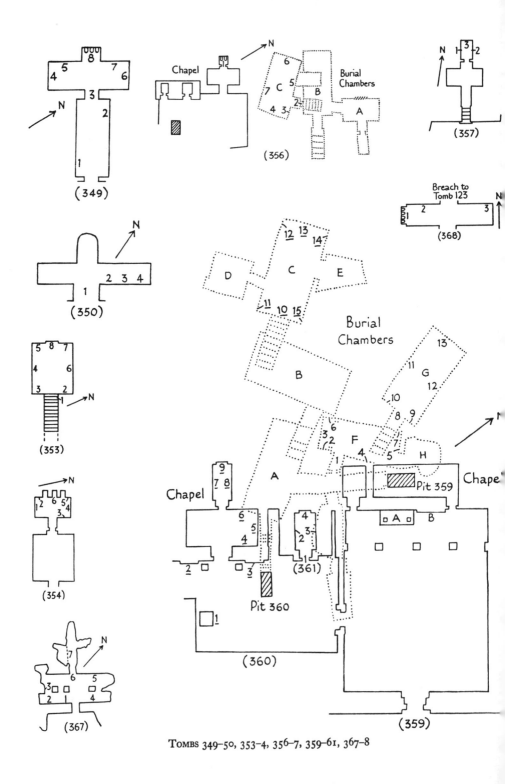

TOMBS 349–50, 353–4, 356–7, 359–61, 367–8

(8) Niche. Seated statues of deceased, mother, and wife, with small painted figures of sons and daughters between them. Side-walls, sons (Userḥēt on left).
Statues, M.M.A. photo. T. 1524.

Ceilings. Texts, including 'Address to the living' on south half of Passage.

350. . . .Y ▨◊◊, Scribe of the counting of bread. Dyn. XVIII.
Sh. 'Abd el-Qurna.
Wife, Nefertwaḥ ⳱◦⳿◊⳿, Nurse of the King's son Menkheperurēʿ (Tuthmosis IV).
Plan, p. 416. Map V, D–4, f, 10.
Name and titles, FAKHRY in *Ann. Serv.* xlvi (1947), p. 40.

Hall.

(1) Outer jambs, remains of titles. (2) Deceased with wife offering on braziers. (3) Two registers, **I,** son (?) offers bouquet (of Amūn?) to wife suckling prince (Tuthmosis IV), **II,** girl offers bowl to deceased and wife seated (unfinished). (4) *Sem*-priest before man and wife and small daughter, with monkey eating under chair (unfinished).

351. ʿABAU ⟶▨, Scribe of horses. Ramesside.
Sh. 'Abd el-Qurna. (Inaccessible.)
Wife, Ay ◊▨◊◊⳿.
Map V, D–4, i, 8.
Name and title of deceased, FAKHRY in *Ann. Serv.* xlvi (1947), p. 42.

352. An Overseer of the granary of Amūn. Ramesside.
Sh. 'Abd el-Qurna. (Inaccessible.)
Map V, D–4, i, 8.
Title, FAKHRY, op. cit. p. 42.

353. SENENMUT. (See tomb 71.) Temp. Ḥatshepsut.
Deir el-Baḥri.
Plan, p. 416. Map III, C–4, h, 9.
WINLOCK in *M.M.A. Bull.* Pt. ii, Feb. 1928, pp. 32–42.

Staircase.

(1) Sketch of head of deceased.
Id. ib. fig. 35 and cover, cf. p. 36; id. *Excavations*, pl. 63 [upper], pp. 137–9; id. in *Proceedings of the American Philosophical Society*, lxxi (1932), fig. 1, cf. p. 321; POGO in *Isis*, xiv (1930), fig. 1, cf. p. 304; BULL in *M.M.A. Bull.* xxvii (1932), fig. 2, cf. p. 131; RIEFSTAHL in *J.N.E.S.* x (1951), pl. iv [A], p. 68; LHOTE and HASSIA, *Chefs-d'œuvre*, pl. at end, 2; SMITH, *Art . . . Anc. Eg.* pl. 97 [B]; M.M.A. photo. M.8.C. 173.

Hall. View, WINLOCK in *M.M.A. Bull.* Pt. ii, Feb. 1928, fig. 36, cf. pp. 36–7; POGO in *Isis*, xiv (1930), pl. 11 (called 3rd room), p. 306; *Chronique d'Égypte*, vi (1931), p. 44, fig. 5 (from POGO); *I.L.N.* March 10, 1928, p. 375, fig. 3; M.M.A. photos. M.8.C. 92, 174–5.

(2)–(7) Text and three small scenes from Book of the Dead at top, **1** and **2,** deceased before Horus-name and cartouches of Ḥatshepsut at (2) and (3), and **3,** deceased purified by priest with man offering cloth, and Fields of Iaru, at (4).

M.M.A. photos. M.8.C. 176–83, 185–8. **1** and **3,** WINLOCK in *M.M.A. Bull.* Pt. ii, Feb. 1928, figs. 37–8, cf. pp. 34, 37; **1,** id. *Excavations,* pl. 64 [upper], p. 138.

(8) At top, double-scene, deceased kneeling. False door below, with slab, deceased seated with parents, and double-scene above it, deceased seated with offerings, and jambs with standing figures sketched at bottom. At sides, Anubis, mummified god, bull and seven cows, and gods of sacred oars.

M.M.A. photos. M.8.C. on 175, 183–4, 203–4. False door and scenes at sides, WINLOCK in *M.M.A. Bull.* Pt. ii, Feb. 1928, fig. 41, cf. p. 37; id. *Excavations,* pl. 65, pp. 138–9; slab and scene above, LANSING and HAYES in *Scientific American,* xciii, Nov. 1937, p. 268, fig. 6; slab, LANSING and HAYES in *M.M.A. Bull.* Pt. ii, Jan. 1937, fig. 25, cf. p. 15.

Ceiling. Astronomical scenes, with twelve disks for months.

WINLOCK in *M.M.A. Bull.* Pt. ii, Feb. 1928, figs. 40, 42–4, cf. p. 37; id. *Excavations,* pls. 66–7, p. 139; POGO in *Isis,* xiv (1930), pls. 12–20, pp. 306–25; KEES, *Ägypten,* pl. 59; ROEDER, *Eine neue Darstellung* in *Das Weltall,* 28 [1], Oct. 1928, Abb. 1–3, cf. pp. 1–5; *Chronique d'Égypte,* vi (1931), pp. 41–53 with figs. 6–14 (from POGO); PARKER, *The Calendars of Ancient Egypt,* pl. i; *I.L.N.* March 10, 1928, p. 375, figs. 1, 2, 4, 5; M.M.A. photos. M.8.C. 189–200, 207. Part, NEUGEBAUER, *The Exact Sciences in Antiquity,* pl. 10, p. 83; part of south half, GUNDEL, *Dekane und Dekansternbilder,* pl. 3; Tuēris and four divinities in north half, LHOTE and HASSIA, *Chefs-d'œuvre,* pl. at end, 3.

Dates of inspection of tomb in ink on walls. WINLOCK in *M.M.A. Bull.* Pt. ii, Feb. 1928, figs. 38 (behind deceased at (2)), 39 (in texts at (4)), cf. pp. 36–7; M.M.A. photos. M.8.C. on 201–2, M.11.C. 248–52.

Finds

Foundation-deposit of deceased, with alabaster saucer of deceased and five alabaster shells of Ḥatshepsut 'beloved of Monthu' (three in New York, M.M.A. 27.3.497–9, 27.3.488, two in Cairo Mus.). See WINLOCK, op. cit. p. 38, and fig. 46, cf. 45. Shells in New York, M.M.A., M.M.A. photo. M.8.C. 306.

354. No texts. Perhaps AMENEMḤĒT (tomb 340, cf. box-lid in Finds of this tomb). Early Dyn. XVIII.

Deir el-Medîna.

Plan, p. 416. Map VII, E–3, c, 7.

BRUYÈRE, *Rapport (1927),* pp. 101–8, with plan and section, fig. 67, cf. pl. i.

Chapel.

(1) Tympanum, double-scene, Anubis on left, and Osiris on right, with tables of offerings, and scene below, man offers to deceased and wife. (2) Two registers, **I,** tables of food, **II,** man and woman with flowers (belonging to (1)). (3) Two registers, **I,** four seated men, **II,** man offers to three seated men. (4) Tympanum, two Anubis-jackals, and scene below, man and woman (sketched) offer to couple.

BRUYÈRE, figs. 69–72, cf. pp. 106–8.

(5) Man and small woman (sketch).

(6) Three niches. Frieze, winged serpent. Above niches, offering-jars, and female mourners (sketch), with bouquets (unfinished) between the niches.
See BRUYÈRE, p. 106.

Finds

Box-lid of Amenemḥēt (tomb 340), found in Court. BRUYÈRE, fig. 39 [1], cf. p. 102.

355. Perhaps AMENPAḤAʿPI 〔≋✕𓐍≋≋〕, Servant in the Place of Truth. Dyn. XX.

Deir el-Medîna.
Mother, Ḥunùro ≛[𓏏𓏭𓆓?]. Wife, Ḥenutenkhune 𓂋𓅓𓏏.
Map VII, E–3, d, 8.

BRUYÈRE, *Rapport (1927)*, pp. 115–17, with plan, fig. 78.

Burial Chamber.
Painted scene, reconstructed from fragments, deceased and wife adoring with part of harpist's song.
BRUYÈRE, fig. 79, cf. p. 115.

356. AMENEMWIA 〔≋≋≋〕, Servant in the Place of Truth. Dyn. XIX.

Deir el-Medîna.
Father, ʿAmak 𓎛𓎛, Servant in the Place of Truth. Wife, Wazronpet 𓇼𓆓𓏏.
Plan, p. 416. Map VII, E–3, d, 7.

BRUYÈRE, *Rapport (1928)*, pp. 76–92, 118–19, with plan of Chapel on ₣l. i [bottom right], and plan and section of Burial Chambers, figs. 37–8.

Chapels.
North Chapel.

(1) Niche with clay statues of Osiris and Horus.
Id. ib. fig. 39, cf. p. 76.

Burial Chambers. Scenes, GR. INST. ARCHIVES, photos. DM. 356. 1–18.
Chamber A.

Vaulted ceiling, offering-texts of deceased and wife. BRUYÈRE, fig. 40, cf. pp. 77–9.

Chamber B.

View showing line of text below vaulted ceiling, BRUYÈRE, fig. 41, cf. pp. 79–80; part of text on north wall, BRUYÈRE, *Mert Seger*, p. 127, cf. 152 note 1, and 271.

Chamber C.

(2) Outer lintel and jambs, texts.
Texts of jambs, BRUYÈRE, *Rapport (1928)*, p. 79 [middle].

(3) Tree-goddess scene with *ba* drinking (continued at (4)).
Id. ib. fig. 47 [right], cf. pp. 87, 89.

(4) Tympanum, personified Western emblem holding torches between two Anubis-jackals. Scene below, son Amenemōnet and daughter before deceased and wife, with deceased on left (belonging to (3)).
BRUYÈRE, fig. 46, cf. pp. 86–7.

(5) Deceased and wife kneeling, and brother Ken and wife standing, adore Nefertem and Nut.
BRUYÈRE, fig. 48, cf. p. 89.

(6) Tympanum, as at (4). Scene below, Anubis tending mummy on couch.
BRUYÈRE, fig. 49, cf. p. 89.

(7) Book of the Dead. Osiris between his two emblems, deceased led by Anubis, weighing with Maᶜet and monster before Thoth as baboon on pylon, and Amenemōnet and wife before Ptaḥ and Isis.
BRUYÈRE, figs. 50–1, cf. pp. 90, 92.

Vaulted ceiling, eight scenes. Outer (north) half, **1**, [deceased] adores Gate, **2**, Meḥitwert-cow, **3**, Atum-Rēᶜ-Ḥarakhti as hawk, **4**, Amenemōnet and wife adoring. Inner (south) half, **5**, Gate of the West, **6**, disk and four star-gods, **7**, father and wife adoring, **8**, bark of Khepri. Below vault, offering-texts of deceased.
BRUYÈRE, figs. 42–5, cf. pp. 82, 86.

Finds

Jambs of deceased, in Cairo Mus. Ent. 40367. Texts, BRUYÈRE, pp. 118–19 (called 46367).

357. DḤUTIḤIRMAKTUF 𓀿𓇋𓎯𓂝𓏤, Servant in the Place of Truth. Dyn. XIX.
Deir el-Medîna.
Wife, Wernuro 𓄿𓈖𓏤𓏤𓏤𓏤𓀀 .

Plan, p. 416. Map VII, E–3, e, 5.

BRUYÈRE, *Rapport* (*1929*), pp. 70–85, with plans and sections, figs. 30, 33, and on pl. i, (*1931–1932*), on pl. i.

Chapel.
(1) and (2) Left wall, bottom of offering-scene, right wall, double-scene, son as priest offers to [deceased and wife], with cat below chair on left half, and monkey eating figs on right half.
BRUYÈRE, *Rapport* (*1929*), fig. 31, cf. pp. 70–2.

(3) Stela, three registers, **I**, double-scene, left half, Ptaḥ and Thoth seated, and goddess, **II**, double-scene, left half, Ḥathor-cow in mountain, Amenophis I, and ᶜAḥmosi Nefertere, right half, Ḥarsiēsi and two goddesses, **III**, deceased and wife kneeling before offerings. At sides, [a god], and deceased kneeling at bottom.
Id. ib. fig. 32, cf. pp. 72–4.

Burial Chambers.
Graffito of deceased, above entrance to innermost chamber. BRUYÈRE, *Rapport* (*1929*), fig. 34, cf. p. 76.

Finds

Fragments of cartonnage of deceased. See id. ib. p. 77 [ii, 2].
Mummy-cloth of deceased. Id. ib. (*1931–1932*), fig. 63, cf. p. 97 note 1.
Stool of deceased. Text, id. ib. (*1929*), p. 77 [iv, 1].

358. ʿAḤMOSI MERYTAMŪN, (⟦cartouche⟧) or (⟦cartouche⟧), daughter of Tuthmosis
III, wife of Amenophis II.

Deir el-Baḥri. (New York, M.M.A. Pit 65.) In Court of Temple of Ḥatshepsut.

Map III, C–4, d, 7.

WINLOCK, *The Tomb of Queen Meryet-Amūn at Thebes*, passim, with plans and sections,
pls. i–iii, and views, pls. iv–xii; id. in *M.M.A. Bull.* Pt. ii, Nov. 1929, pp. 18–32, with plan
and section, fig. 23, and views, figs. 19–21, 24–7; Dec. 1930, pp. 11–26; id. *Excavations*,
pp. 174–86, 190–5, with plan and section, fig. 10, and views, pls. 68 [lower], 70 [upper]–72;
plan, section, and views, *I.L.N.* Dec. 7, 1929, pp. 984–5, figs. 1–8.

First Corridor.

For intrusive burial of Princess Entiuny, see *Bibl.* i², Pt. 2, in the Press.

Burial Chamber.

Fragments of wooden sarcophagus (?) and of outer (3rd) coffin of deceased, in Cairo Mus.
Ent. 55170–1. WINLOCK, *Meryet-Amūn*, pl. xxvii, pp. 21–4, with figs. 7, 8; sarcophagus (?)-
fragments, M.M.A. photo. M.11.C. 309.

Middle (2nd) coffin, in Cairo Mus. Ent. 53140. WINLOCK, op. cit. pls. xxii–xxvi, frontis-
piece, pp. 19–21; id. in *M.M.A. Bull.* Pt. ii, Nov. 1929, figs. 30–2, cf. p. 27; id. *Excavations*,
pl. 73, pp. 180–1; *I.L.N.* Dec. 7, 1929, p. 986, figs. 13, 14; M.M.A. photos. M.10.C. 113–24,
132. Upper part, ALDRED, *New Kingdom Art in Ancient Egypt*, pl. 47; MURRAY, *The Splen-
dour that was Egypt*, pl. xxviii [1], p. 263; LANGE and HIRMER, *Aegypten*, pl. 144; face,
LANGE, *Äg. Kunst*, pl. 64; WOLF, *Die Welt der Ägypter*, pl. 54. See *Brief Descr.* No. 6150.

Inner (1st) coffin, in Cairo Mus. Ent. 53141. WINLOCK, *Meryet-Amūn*, pls. xviii–xxi,
figs. 5, 6, and pp. 16–19; id. in *M.M.A. Bull.* Pt. ii, Nov. 1929, figs. 28–9, cf. pp. 27–8; id.
Excavations, pl. 74 [upper], p. 180; *I.L.N.* Dec. 7, 1929, p. 986, fig. 10, Aug. 27, 1932, fig.
on p. 321 (head); M.M.A. photos. M.10.C. 111, 129–31, 133–4. See *Brief Descr.* No. 6151.

For mummy-cloths, and labels, linen, &c., used at rewrapping of mummy by Mesehert,
Dyn. XXI, see *Bibl.* i², Pt. 2, in the Press.

359. INḤERKHAʿ. (See tomb 299 with footnote.) Temp. Ramesses III and IV.

Deir el-Medîna. (L. D. Text, No. 108, WILKINSON, No. 10.)

Plan, p. 416. Map VII, E–3, c, 8.

BRUYÈRE, *Rapport* (*1930*), pp. 32–70, 84–90, with plans, sections, and elevation, on
pls. i, xxiv, figs. 17, 18, and reconstruction, pl. xxxii; L. D. *Text*, iii, pp. 292 [bottom]–301
[middle], with plan of Burial Chambers, p. 293; LEPSIUS, *Briefe aus Aegypten, Aethiopen
und der Halbinsel des Sinai*, pp. 268–9.

Burial Chambers. Scenes (omitting doorways and scenes at (9) and (10)), GR. INST.
ARCHIVES, photos. DM. 359.1. 1–10, 2. 1–15.

Outer Chamber F.

(1) Remains of outer jambs, offering-texts of deceased, wife, and son Ḳenna ⌂ 𓏏𓏥𓃀 . Inner lintel and jambs, texts of deceased, wife, and son Ḥarmosi.

Texts, BRUYÈRE, *Rapport (1930)*, pp. 36–7, 94–5 [1], and fig. 28.

(2) Anubis-jackal.

BRUYÈRE, pl. vii [upper], p. 37 [near bottom]. Text, LEPSIUS MS. 401 [top left].

(3) Tympanum [winged Isis]. Two registers below, **I**, deceased and wife kneeling adore [Ḥatḥor-cow], **II** (on front of platform), Book of Gates, deceased and wife kneeling adore nude [Herimaᶜet] and guardians with knives.

I and **II**, BRUYÈRE, pl. vii [lower], pp. 37–8. Text of **I**, LEPSIUS MS. 400 [bottom].

(4) Remains of deceased censing and wife before two rows of seated kings, queens, and princes, with Ḥuy, painter, at end of lower row.

BRUYÈRE, pl. viii, cf. ix, pp. 38–40; L. D. iii. 2 [d]; sketches, WILKINSON MSS. xi. 175–6 [upper]; WILD MSS. ii. A. 158–9; last two kings and Ḥuy, ERMAN in *Ä.Z.* xlii (1905), fig. on p. 130; SPIEGELBERG in *Ä.Z.* liv (1918), Abb. 2, cf. pp. 77–9 and Abb. 1; ROBICHON and VARILLE, *Le Temple du scribe royal Amenhotep fils de Hapou*, i, fig. 2, cf. p. 9 with fig. 1. Texts, MASPERO in *Rec. de Trav.* ii (1880), pp. 170 [lower]–171; LEPSIUS MS. 401 [except top left]–403 [top]; royal names, PRISSE, *Mon. Explication des planches*, p. 1; MASPERO in *Mém. Miss.* i [3], pp. 617–19. See DARESSY in *Recueil d'études égyptologiques dédiées à . . . Champollion*, pp. 283–96.

(5) Tympanum, remains of winged Nephthys, with [Osiris, Isis, and goddess] below, and doorway with text on jambs.

BRUYÈRE, pls. xii [2], xiii [1, left], p. 40.

(6)–(7) Two registers, eight scenes. **I**, Book of the Dead, **1**, deceased in boat holding scarf, **2**, deceased seated, **3**, deceased and wife playing draughts [with *ba*s above] and 'text of playing draughts', **4**, deceased with wife and row of [relatives] offers on braziers. **II, 5–7,** Relatives offer to deceased and wife, **8**, [deceased and wife with sons (?) in boat].

BRUYÈRE, pls. x–xii [1], pp. 40–7 (text on 47 repeats text on 42). Braziers in **4**, NAGEL, *Céramique*, p. 177, fig. 146. Texts, incomplete, L. D. Text, iii, pp. 293 [middle]–295 [bottom]; LEPSIUS MS. 403 [middle]–405 [middle], 406–7 [middle]; beginning of text in **3**, [*Rapport (1930)*, p. 43; LEPSIUS MS. 404], BRUYÈRE, *Mert Seger*, p. 158; see PIEPER in *Ä.Z.* lvi (1931), p. 17.

Ceiling. Boukrania, names as decoration, and texts, BRUYÈRE, pls. iii–vi, pp. 33–4, 47 [bottom]–48 [middle]; WILD MSS. ii. A. 162–8. Texts, LEPSIUS MS. 405 [bottom], 407 [bottom]–408 [top].

Inner Chamber G.

(8) Left thickness, deceased and son Ḥarmin holding palette. Right thickness, wife and small daughter.

See BRUYÈRE, p. 47 [middle]; L. D. Text, iii, p. 296 [top].

(9) and (10) ᶜAḥmosi Nefertere, left of doorway, and Amenophis I, right of doorway, in Berlin Mus. 2060–1.

L. D. iii. 1; *Aeg. und Vorderasiat. Alterthümer*, pl. 24; BRUYÈRE, pl. xiii [2] (from LEPSIUS), pp. 48–9; HEUZEY, *Histoire du costume . . . L'Orient*, pls. xxii, ix. See *Ausf. Verz.* pp. 156–7;

MASPERO in *Rec. de Trav.* ii (1880), p. 170 [middle]. Texts, *Aeg. Inschr.* ii. 174; LEPSIUS MS. 408 [bottom]-409 [top]. ʿAḥmosi Nefertere, No. 2060, HEUZEY in *Gazette des Beaux Arts* (1936), No. 2, fig. 8, cf. p. 28; MASPERO, *Hist. anc. Les premières mêlées*, fig. on p. 96; WRESZ., *Atlas*, i. 29 b [5]; STUART, *Egypt after the War*, pl. 41 after p. 192, cf. p. 366.

(11) Three registers, seventeen scenes. **I, 1,** Deceased with staff leaves tomb, **2,** deceased, wife, and son, in boat, and *menat* with scarab below, **3,** deceased adoring led by Thoth to Osiris, **4,** Negative Confession in shrine with assessors, **5,** deceased led by a god to lake of fire [with baboons], **6,** two divine barks, one containing hawk's head, **7,** four mythological regions. **II, 8,** Deceased kneeling adores lotus-emblem in pool, **9,** deceased kneeling adores three souls of Nekhen, **10,** deceased adores *Benu*-bird, **11,** Osiris-emblem and Anubis offering heart to mummy, **12,** deceased kneeling adores Horus as hawk, **13,** *išd*-tree with cat slaying serpent, **14,** empty net with Nekhtemmut ⟨hieroglyphs⟩, Head of works in the Place of Truth, with staff below. **III,** Three scenes, each before deceased and wife seated, **15,** two sons with brazier and *ḥes*-vases, **16,** six priests with censer and *ḥes*-vases, and stand with candles, **17,** harpist with song.

BRUYÈRE, pls. xix-xxiii, cf. xviii [1], pp. 60-70. **8, 9** (omitting deceased), **10, 13, 17** (omitting song), LHOTE and HASSIA, *Chefs-d'œuvre*, pls. 123, 130, 155, 159, 160. **10,** and lower bark in **6,** VANDIER, *Egypt*, pls. xxx, xxxi. **13,** WILKINSON MSS. xi. 176 [lower]-177. **17** (omitting song), HICKMANN, *45 Siècles de Musique*, pl. lii [A]. Texts, L. D. *Text*, iii, pp. 296 [bottom]-299 [top and middle]; LEPSIUS MS. 409 [middle]-414 [upper], 415 [upper].

(12) Three registers, fourteen scenes. **I, 1,** Deceased adores *ba* on pylon, **2,** deceased adores Ptaḥ, **3,** litany of parts of the body, **4,** swallow on hill, **5,** deceased kneeling adores Akru. **II, 6,** Ḥathor, facing out, **7,** deceased adores Sito-serpent, **8,** deceased kneeling adores four jackals, **9,** hawk-god opens mouth of mummy, **10,** *ka*-emblem before deceased seated, **11,** Western hawk. **III, 12,** Deceased and wife seated before food-table, **13,** priest with ram-headed wand, followed by five couples, before deceased seated, **14,** a Prophet of Osiris, followed by two men and a woman, offers statuette of Osiris and ushabti-box to deceased and family.

BRUYÈRE, pls. xiv-xvii, pp. 50-8. **8** and part of **14,** LHOTE and HASSIA, *Chefs-d'œuvre*, pls. 158 and 39. Three children (in front of deceased) in **14,** ROBICHON and VARILLE, *En Égypte*, pl. 121; part of ushabti-box and basket of sycamore-figs, KEIMER in *Egypt Travel Magazine*, No. 29, Jan. 1957, fig. 10 a, cf. p. 26. Texts, L. D. *Text*, iii, pp. 299 [bottom] with γ, 300-1 [upper]; LEPSIUS MS. 414 [lower], 415 [lower], 416-18.

(13) Double-scene, deceased holding brazier with son Ḥarmin before Ptaḥ, and with son Ḳenna before Osiris.
BRUYÈRE, pl. xviii [2], pp. 58-60. Texts of sons, LEPSIUS MS. 419 [top]; braziers, NAGEL, *Céramique*, p. 177, fig. 147.

Pyramid.
Lucarne-stela, with bark of Rēʿ-Ḥarakhti, and deceased kneeling below, in Chicago Univ. Oriental Inst. 403. BRUYÈRE, *Rapport (1945-1947)*, fig. 59, cf. pp. 78-9.
Double-statue, deceased and man kneeling, holding stela with bark of Rēʿ and hymn to Rēʿ, found in Medînet Habu Temple-Enclosure. Id. ib. fig. 60 (the stela), cf. p. 80 [1].

Finds
Remains of coffin of wife, perhaps from here. Name, BRUYÈRE, *Rapport (1930)*, p. 105 [near bottom], cf. 76.

Jars with hieratic texts, some from tomb 360. Nagel, *Céramique*, pp. 14–51, with figs. 8–32. For fragments in Berlin Mus., see infra, tomb 360.

360. Ḳ A Ḥ A ◁𓃭𓇋𓃭𓏤, Foreman in the Place of Truth. Temp. Ramesses II.
Deir el-Medîna.
Parents, Ḥuy (tomb 361) and Taneḥesi. Wife, Tuy 𓆇𓏏𓏏𓄿.
Plan, p. 416. Map VII, E–3, c, 9.
Bruyère, *Rapport (1930)*, pp. 71–82, 84–90, with plans, sections, and elevation, on pls. i, xxiv, pp. 74–5, figs. 17, 18, and reconstruction, pl. xxxii.

Court in front of tomb 359.
(A) Stela with altar of Ḳaḥa, restored from fragments. Cornice of stela, double-scene, bark of Rēʿ adored by baboon and deceased. At top of stela, bark with scarab and demons adored by deceased, and three registers below, **I**, double-scene, Ḳaḥa adoring divinities, **II**, funeral ceremonies (including cow and mutilated calf) before mummies at pyramid-tomb, **III**, [offering-scenes]. Cornice of altar, horizon-disk between two uraei, adored by four kneeling people, with four barks of Rēʿ below. Base with pillars, scenes and texts, with deceased and wife adoring horizon-disk, &c.
Bruyère, pls. xxxv–xxxviii, and reconstruction, pl. xxxix, pp. 84, 88–90; Gr. Inst. Archives, photos. DM. 359–60. 03–05.

(B) Remains of lower part of stela, Ḳaḥa and wife kneeling with hymn.
Bruyère, pls. xxxiii [upper], xxxiv (called south stela), pp. 86–8.

Fragments of other stelae, id. ib. pl. xxxiii [lower].

Court of tomb 360.
(1) Base of statue of deceased.
Text, Bruyère, p. 73 [bottom].

(2) Stela of deceased, dedicated to Osiris and Anubis, probably from here, in Brit. Mus. 144.
Names, Bruyère, p. 114, cf. 73. See *Guide (Sculpture)*, p. 196 [713].

(3) Stela, two registers, **I**, deceased offers on brazier to Ptaḥ of the Valley of the Queens and Mertesger, **II**, deceased and son adoring with hymn to Ptaḥ and Mertesger, probably from here, in Munich, Ägyptische Sammlung, Inv. 42.
Dyroff and Pörtner in Spiegelberg, *Ägyptische Grabsteine und Denksteine aus süddeutschen Sammlungen*, ii, pl. xix [27], pp. 37–8; Bruyère, *Mert Seger*, fig. 29, cf. p. 48; Seyffarth MSS. iii. 2559–69. Titles, Bruyère, *Rapport (1930)*, p. 114, cf. p. 73; Lieblein, *Dict.* No. 1240. See Lauth, *Erklärendes Verzeichnis*, p. 55 [10 a]; Davies in *Mélanges Maspero*, i, p. 247 note 4.

Chapel.
(4) Two registers. **I**, Man cooking and man pulling flax by pool with hippopotami. **II**, Boat-building before deceased, and Abydos pilgrimage with deceased, wife, and son, in boat approaching mountain.
Bruyère, *Rapport (1930)*, pl. xxvi, p. 75. **I**, See Säve-Söderbergh in *Mitt. Kairo*, xiv (1956), p. 179 note 2.

(5) Lower part of procession of offering-bringers. (6) [Deceased before Osiris.]
See BRUYÈRE, p. 75.

Shrine.

(7) and (8) Left wall, Abydos pilgrimage and foreleg-rite at pyramid-tomb. Right wall,
text of Negative Confession before Maꜥet.
BRUYÈRE, pl. xxvii, pp. 75–6.

(9) Remains of stela. Cf. BRUYÈRE, p. 75.

Fragments from walls, including scenes of divinities with knives from Book of Gates,
id. ib. pl. xxxi, p. 84.

Burial Chamber C. Scenes, GR. INST. ARCHIVES, photos. DM. 360. 1–6.

(10) Tympanum, Anubis-jackals. Scene below, *Benu*-bird and son Ḥuynūfer as *sem*-priest
with offerings (cut by doorway) before deceased and wife.
BRUYÈRE, pl. xxviii [1], pp. 77–8.

(11)–(12) Deceased and wife with offerings (cut by doorway) adore Osiris and Western
Ḥathor, and weighing-scene with Thoth as baboon on pylon, monster, and Maꜥet.
BRUYÈRE, pl. xxix [2], pp. 79–81.

(13) Tympanum, Western emblem between two Anubis-jackals. Scene below, deceased
led by Anubis to Osiris between his two emblems.
BRUYÈRE, pl. xxviii [2], p. 79.

(14)–(15) Anubis tending mummy on couch (cut by doorway), remains of kneeling figure,
two *ba*s on pylon, and deceased kneeling adores Akru on pylon.
BRUYÈRE, pl. xxix [1], pp. 78–9.

Vaulted ceiling. Deceased and wife in each half adore Thoth, Anubis, and Sons of Horus,
with texts between and below the scenes.
BRUYÈRE, pl. xxx, pp. 81–2.

Pyramid.
Fragments, BRUYÈRE, fig. 27, cf. p. 93 [3].

Finds

Kneeling statue of deceased holding stela. Text, BRUYÈRE, *Rapport (1923–1924)*, p. 77 [4].
Fragments of stela, Ramesses II and Paser, Vizier, adoring Amūn, with deceased and wife
below. BRUYÈRE, *Rapport (1930)*, fig. 23, cf. pp. 88, 90–1 [7].
Three fragments from wall, probably from here (possibly tomb 359), in Berlin Mus.:
No. 18545, deceased purified, No. 18546, Amenophis I seated, No. 1619, head of man and
text. Nos. 18545–6, from Rustafjaell Collection, *Sotheby Sale Cat.* Dec. 19–21, 1906, pl. viii
[14, 4], p. 26 [400, 2nd item], p. 25 [396]. Nos. 18546, 1619, GR. INST. ARCHIVES, photo. 42.
Texts of all, *Aeg. Inschr.* ii. 170–1. See BRUYÈRE, *Rapport (1930)*, p. 70. No. 1619, see
L. D. *Text*, iii, p. 301 [middle]; *Ausf. Verz.* p. 156.
Boxes and linen of deceased. BRUYÈRE, *Rapport (1930)*, figs. 35–6, cf. pp. 106–7.
Canopic-box of deceased, and box-lid of wife. Texts, id. ib. pp. 106 [middle], 106 [2].
For jars with hieratic texts, see supra, tomb 359.

361. ḤUY ⸗𓏤𓏤, Great carpenter in the Place of Truth. Temp. Sethos I.
Deir el-Medîna.
Parents, Ḥay 𓏤𓏤 and Takhaꜥ (names from stela of deceased, Turin Mus. 1609).
Wife, Taneḥesi (name from tomb 360).

> Plan, p. 416. Map VII, E–3, c, 9.

BRUYÈRE, *Rapport (1930)*, pp. 82–4, with plan on pls. i, xxiv, and reconstruction, pl. xxxii.

Chapel.

(1) Outer lintel with text, and jamb with deceased seated at bottom.
BRUYÈRE, pp. 94 [4], 95 [2], fig. 22 (jamb).

(2) Abydos pilgrimage and mountain (on entrance wall). (3) [Funeral procession] with remains of offering-bringers (beginning on entrance wall).
See BRUYÈRE, pp. 83–4.

(4) [Stela] with priests censing and libating below.
Texts, BRUYÈRE, pp. 83, 92 [16].

Finds

Three canopic-jars of deceased. NAGEL, *Céramique*, pp. 32, 34–5 [78–80] with fig. 23. Texts, BRUYÈRE, *Rapport (1930)*, pp. 102–3.
Box-lid of wife. Id. ib. fig. 34, cf. p. 106 [1].

362. PAꜥANEMWĒSET 𓊪𓏭𓅓𓊃𓏏, *waꜥb*-priest of Amūn. Late Dyn. XIX.
Khôkha.
Wife, Ḥathor.

> Plan, p. 90. Map IV, D–5, d, 8.

DAVIES, *The Tomb of Nefer-ḥotep at Thebes*, i, pp. 7–9, with plan on pl. vi.

Hall.

(1) Outer jambs, offering-texts to Anubis on left, and to Ḥathor on right.

(2) Son and priest before mummies held by son Ḥory, pyramid-tomb with stela, and Ḥathor-cow in mountain.

(3) Bark of Amūn in kiosk, adored by [people], (on adjoining wall).
Bark, DAVIES, fig. 2, cf. p. 8.

(4) Hymns to Ḥathor and Mertesger. (5) Deceased before Ptaḥ.

Frieze. Anubis-jackals.
Ceiling. East bay, ducks on nests.

Inner Room.

(6) Above outer doorway, double-scene, family before divinities.

(7) Niche with entablature, and rock-statues of deceased and wife with dressed *zad*-pillar on either side.

Ceiling. Winged scarab and two divine barks adored by baboons and by deceased kneeling.

363. PARA᷄EMHAB 𓉐⸻◦‖𓎛𓊽, Overseer of the singers of Amūn. Late Dyn. XIX.
 Khôkha.
 Wife, S᷄ankhentawert 𓅓𓆄𓏏𓂀𓇯𓏏.
 Plan, p. 90. Map IV, D–5, d, 8.

 DAVIES, *The Tomb of Nefer-hotep at Thebes*, i, p. 10, with plan on pl. vi. Name and title,
 FAKHRY in *Ann. Serv.* xlvi (1947), p. 44.

 Hall.

 (1) Niche with statues of deceased and wife, and texts on lintel and jambs.
 DAVIES, fig. 3, cf. p. 10. Titles on jambs, LEPSIUS MS. 269 [bottom right].

364. AMENEMHAB 𓇋𓅓𓏏⸻𓀭𓊽[𓊽], Scribe of the divine offerings of all the divinities
 of Thebes, Scribe of the granary of Amūn. Dyn. XIX.
 ῾Asâsîf.
 Wife, Amentawerhotp 𓇋𓅓𓏏𓅓𓅓𓏏𓊹𓏏(sic).
 Plan, p. 296. Map IV, D–5, a, 6.
 Name and titles, FAKHRY in *Ann. Serv.* xlvi (1947), p. 44.

 Hall.

 (1) Left thickness, three registers, **I**, divine bark drawn by jackals and adored by deceased
 kneeling, **II**, deceased adoring with hymn to Amen-rē῾-Ḥarakhti, **III**, deceased and wife
 seated. Right thickness, two registers, **I**, bark of Rē῾ adored by baboons and by deceased
 kneeling, **II**, deceased adoring with hymn.
 See LEPSIUS MS. 265 [middle], (giving cartouche of Tuthmosis I).

 (2) Remains of two registers. **I**, Two scenes, deceased and wife before divinities, **II**, de-
 ceased (belonging to (3)).

 (3) Two registers. **I**, Deceased before bark, and deceased offering below, with large shrine
 on right. **II**, Deceased (at (2)) led by Horus to Osiris with Nephthys and Isis. Sub-scene,
 small offering-scenes.

 (4) Entrance to Inner Room. Lintel, double-scene, deceased kneels before [divinities?].

365. NEFERMENU 𓄤𓏥, Overseer of the wig-makers of Amūn in Karnak, Scribe of
 the treasury of Amūn. Temp. Tuthmosis III.
 Khôkha.
 Wife, Amenhotp.
 For position in court of tomb 296, see p. 370. Map IV, D–5, b, 9.
 Name and titles, FAKHRY in *Ann. Serv.* xlvi (1947), p. 44.

 Hall.

 Entrance. Outer lintel, double-scene, deceased offers to cartouches of Tuthmosis III,
 and jambs, offering-texts.
 M.M.A. photo. T. 2807.

 Ceiling. Texts with titles of deceased and wife, M.M.A. photos. T. 2808–10.

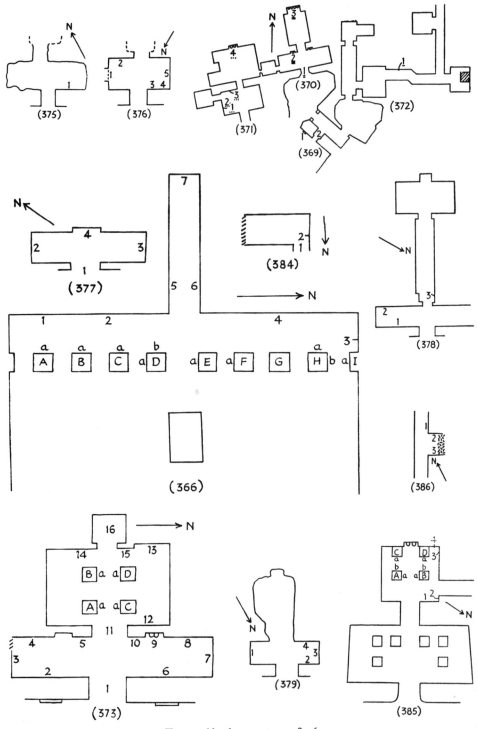

Tombs 366, 369–73, 375–9, 384–6

366. Z A R ⌊𝕝𝕜⎯, Custodian of the King's harîm. Temp. Mentuḥotp-Nebḥepetrēʿ.
ʿAsâsîf. (New York, M.M.A. Excav. No. 820.)

Plan, p. 428. Map IV, D–4, j, 5.

WINLOCK in *M.M.A. Bull.* Pt. ii, March 1932, pp. 32–4. Views, id. ib. fig. 25; M.M.A. photos. M.12.C. 25–9. Name and titles, FAKHRY in *Ann. Serv.* xlvi (1947), p. 44.

Hall.

(1) Two registers. **I,** Remains of hunting-scene (?) with quivers, &c., and man holding gazelles. **II,** Canoe with hippopotamus below.
M.M.A. photos. M.12.C. 166, 234 [left], 235–7.

(2) Two registers. **I,** Funeral procession. **II,** Two scenes, **1,** remains of trees and two bulls fighting, **2,** preparation of food and drink, with female cooks, and butchers.
M.M.A. photos. M.12.C. 40–54, 81–3, 94–6, 124, 234 [right]. Female mourners in **I,** WERBROUCK, *Pleureuses,* pl. ii [upper], pp. 67–8. Cooks, WINLOCK in *M.M.A. Bull.* Pt. ii, March 1932, fig. 26, cf. p. 34; id. *Excavations,* pl. 17 [top], p. 204. Names in hieratic, M.M.A. photos. M.12.C. 99–115.

(3) Four priests with dog before deceased, and jars on stands above.
M.M.A. photos. M.12.C. 60–3.

(4) Two registers. **I,** Men carrying animals. **II,** Netting fowl.
M.M.A. photos. M.12.C. 55–9.

Pillars A–H, and pilaster I.

A (*a*) Goats browsing on trees and men picking dates.
Goats, M.M.A. photos. M.12.C. 29 [right], 68.

B (*a*) Three registers, **I–III,** men with laden donkeys, and ploughing.
M.M.A. photos. M.12.C. 67, 79–80. Parts of **II–III,** DONADONI, *Arte egizia,* figs. 57–8; WINLOCK in *M.M.A. Bull.* Pt. ii, March 1932, figs. 27–8, cf. p. 34; id. *Excavations,* pl. 17 [middle and bottom]; SMITH, *Art . . . Anc. Eg.* pl. 58 [B].

C (*a*) Two registers. **I,** Men roping bull, **II,** man with cow calving and cow with calf.
M.M.A. photo. M.12.C. 66. **I,** WINLOCK in *M.M.A. Bull.* Pt. ii, March 1932, fig. 29, cf. p. 34; id. *Excavations,* fig. 11 [top], cf. p. 204.

D (*a*) Deceased inspects two registers of wrestlers.
M.M.A. photo. M.12.C. 65.

D (*b*), E (*a*), F (*a*) Man with crook, boat, and bird, respectively (sketches).
M.M.A. photos. M.12.C. 84–6.

H (*a*) Remains of market-scene.
M.M.A. photo. M.12.C. 64.

H (*b*), I (*a*) Boat on each (sketches).
M.M.A. photos. M.12.C. 87–8.

Inner Room.

(5) Two registers. **I**, Boat-building. **II**, Netting fish, men with traps, and man diving on to crocodile.

M.M.A. photos. M.12.C. 69–73, 78, with hieratic texts, 97–8, 167, 197. **II**, WINLOCK in *M.M.A. Bull.* Pt. ii, March 1932, figs. 30–1, cf. p. 34; id. *Excavations*, fig. 11 [middle and bottom], cf. p. 204.

(6) Craftsmen, men leading bulls, and priest before offering-table.
M.M.A. photos. M.12.C. 74–7.

(7) Inscribed stela.
M.M.A. photos. M.12.C. 254–5.

367. PASER 𓌛𓏤𓊪, Head of bowmen, Child of the nursery, Companion of his Majesty. Temp. Amenophis II.

Sh. ʿAbd el-Qurna. (*L. D. Text*, No. 66, *Bibl.* i, 1st ed. p. 193, [pp].)
Wife, Bakyt 𓎛𓏤𓇋𓇋𓂝𓏏.

Plan, p. 416. Map V, D–4, c, 10.

FAKHRY in *Ann. Serv.* xliii (1943), pp. 389–414, with plan and section, fig. 64. Titles, *L. D. Text*, iii, p. 274.

Hall.

(1) Deceased, with wife and offering-bringers, offers on braziers. Sub-scene, butchers and offering-bringers.
FAKHRY, pl. xx, pp. 400–2. Texts, PIEHL, *Inscr. hiéro.* 1 Sér. cxvii [ξ, ν]; parts, HELCK, *Urk.* iv. 1456 [middle and bottom]; titles, LEPSIUS MS. 326 [middle lower].

(2) Deceased and wife with man offering bouquet and girl offering cup with offering-list to them, and four registers, **I–IV**, banquet with musicians (female clappers, and women with lute, harp, lyre, and triangular harp, and child dancers, in **III**, and male harpists in **IV**). Sub-scene, servants with food, and male guests.
FAKHRY, pls. xxi–xxiii, pp. 402–6. **III** and **IV**, HICKMANN, *45 Siècles de Musique*, pl. liv; women with triangular goose-headed harp and lyre and two children in **III**, BRUYÈRE, *Rapport (1934–1935)*, Pt. 2, fig. 58 (called tomb 85), cf. pp. 114–15; wine-jar in sub-scene, and woman with triangular harp, WILKINSON, *M. and C.* ii. 158 (No. 144, 1), 280 (No. 210) = ed. BIRCH, i. 387 (No. 164, 1), 469 (No. 235); WILKINSON MSS. v. 160 [middle left]; woman with triangular harp, HICKMANN in *Bull. Inst. Ég.* xxxv (1954), fig. 7 [d], cf. pp. 316–17; harp, id. in *Ann. Serv.* l (1950), fig. 13, cf. p. 544. Male harpist with hawk-headed harp on right in **IV**, SCHOTT in *Mélanges Maspero,.* i, pl. i [3], pp. 459–60 note 4. Texts, PIEHL, *Inscr. hiéro.* 1 Sér. cxvii [μ]; part, HELCK, *Urk.* iv. 1457 [top]; LEPSIUS MS. 326 [middle upper].

(3) Painted stela with offering-text and *sem*-priest offering to deceased. At sides, three registers, rites before statues. Sub-scene, butchers.
FAKHRY, pl. xxiv, pp. 406–7. Texts, PIEHL, *Inscr. hiéro.* 1 Sér. cxvi–cxvii [δ–κ]; one title, HELCK, *Urk.* iv. 1457 [middle upper]; LEPSIUS MS. 326 [near bottom]. See SCHIAPARELLI, *Funerali*, ii, p. 294 [xvii].

(4) Deceased with wife and attendants pours ointment on offerings. Sub-scene, offering-bringers with bull with decorated horns, &c., and butchers.

FAKHRY, pl. xix, pp. 398–400. Texts, incomplete, WILKINSON MSS. v. 160 [bottom]; text below arm of deceased, PIEHL, *Inscr. hiéro.* 1 Sér. cxvii [o]; HELCK, *Urk.* iv. 1456 [near top].

(5) Deceased with wife and daughter, preceded by two fan-bearers and followed by four registers of men bringing ibex and cattle (including humped bull, garlanded ibex and bull, and bull with decorated horns) and offerings, offers bouquet to Amenophis II in kiosk with Nine Bows on base.

FAKHRY, pls. xvii, xviii, pp. 395–7. Humped bull, WILKINSON, *M. and C.* iii. 19 (No. 328, 5) = ed. BIRCH, ii. 90 (No. 356, 5); WILKINSON MSS. v. 161 [top left]. Head of first foreigner on base of kiosk, VERCOUTTER, *L'Égypte*, pl. xii [113], pp. 225–6. Texts, PIEHL, *Inscr. hiéro.* 1 Sér. cxvi [γ]; id. in *Ä.Z.* xxi (1883), p. 135 [12 b]; HELCK, *Urk.* iv. 1455 [middle]–1456 [top]; LEPSIUS MS. 327 [top]; part, BRUGSCH, *Recueil*, pl. lxv [6]; end, WILKINSON MSS. v. 184 [bottom left].

Inner Room.

(6) Outer lintel, double-scene, deceased with wife offers on braziers to Osiris.

FAKHRY, pl. xvi, pp. 394–5. Text, PIEHL, *Inscr. hiéro.* 1 Sér. cxvi [α]; name of wife, LEPSIUS MS. 326 [bottom].

(7) Ptolemaic painting, Osiris and remains of texts.

FAKHRY, pl. xxv, pp. 407–8.

For intrusive burials, see SHEIKH ʿABD EL-QURNA, *Bibl.* i², Pt. 2, in the Press.

368. AMENHOTP 〔▨〕, called HUY ▨〘〙, Overseer of sculptors of Amūn in the Southern City. Late Dyn. XVIII.

Sh. ʿAbd el-Qurna.

Parents, Ḥati ▨, Overseer of sculptors of the Lord of the Two Lands, and Ipy 〔▨〕. Wife, Mery[mut] 〔▨〕.

Plan, p. 416. Map VI, E–4,.g, 3.

Hall.

(1) Statues of deceased, wife, and parents, each with a child at right knee.

SCHOTT photo. 8205.

(2) Anubis and deceased in weighing-scene (sketch).

BAUD, *Dessins*, fig. 109, cf. p. 223.

(3) Four registers. I–III, A vizier, deceased and men adoring, and men with food-tables before [King] in kiosk (with later sketch of workers in tomb, in III). IV, Man offers to deceased and wife.

Omitting deceased and wife, SCHOTT photos. 8202–4, 8206. Sketch in III, BAUD, *Dessins*, fig. 110, cf. pp. 223–4.

For stela of deceased, see court of neighbouring tomb 224 (1).

369. KAEMWĒSET 🔲, First prophet of Ptaḥ, Third prophet of Amūn. Dyn. XIX.

Khôkha.
Wife, Taōne(t) 🔲.

Plan, p. 428. Map IV, D–5, a, 9.

Court.

(1) Stela with deceased adoring Osiris.

(2) Entrance to tomb. Outer lintel, double-scene, deceased and wife before Osiris and goddess, and before Anubis and goddess, and right jamb, top of offering-text. Left thickness, deceased adoring with text.

370, A Royal scribe. Ramesside.

Khôkha.
Wife, Ta . . . 🔲.

Plan, p. 428. Map IV, D–5, a, 9.

Hall.

(1) Left thickness, remains of baboons adoring [divine bark]. Right thickness, two registers, **I,** bark of Rēᶜ-Ḥarakhti dragged by jackals, **II,** deceased with text.

(2) Statue of deceased.

Inner Room.

(3) Four statues, man and three women.

371. Name unknown. Ramesside.

Khôkha.

Plan, p. 428. Map IV, D–5, a, 9.

Hall.

(1) Beginning of funeral (?) procession. (2) Three registers, **I,** two female tumblers, four kneeling women and shrine, **II,** boat, **III,** food-tables and bark of Sokari. (3) Two scenes, **1,** man with incense before deceased and wife, **2,** man with incense and two women with flowers before deceased and wife.

Frieze at (1)–(2), Anubis-jackals and Ḥathor-heads.

Inner Room.

(4) Niche with statues of seated couple.

372. AMENKHAᶜU 🔲, Overseer of carpenters of the Temple of Medînet Habu. Temp. Ramesses III.

Khôkha.
Mother, Maᶜetnefert 🔲. Wife, Nefertere-emḥab 🔲.

Plan, p. 428. Map IV, D–5, a, 9.

Passage.

(1) Deceased, followed by son Ḏḥutemḥab, *waʿb*-priest of Amūn, mother, and wife, adores Ptaḥ and goddess with hymn to Ptaḥ.

SPIEGEL in *Ann. Serv.* xl (1940), pls. xxxiv, xxxv, pp. 257–62; CHIC. OR. INST. photos. 7856–9.

373. AMENMESSU 𓂺𓏏𓏛, Scribe of the altar of the Lord of the Two Lands. Ramesside.

Khôkha.

Father, Iny 𓇋𓆑𓏛𓏤𓇋𓇋.

Plan, p. 428. Map IV, D–5, d, 8.

Hall.

(1) Left thickness, deceased adoring with hymn. Right thickness, deceased with hymn, before two barks of Rēʿ.

Barks, CHIC. OR. INST. photo. 10604.

(2) Three registers. I, Scenes, including [deceased] adoring emblems. II, Deceased adoring. III, Funeral procession with offerings to mummies and deceased adoring Sons of Horus.

(3) Tympanum, deceased prostrate adores bark of Amen-rēʿ-Atum-Ḥarakhti. Three registers below, I, [deceased] before Osiris in tree, II, [deceased] seated before Osiris, and deceased with cloths before god, III, two scenes, 1, Nefertem (?), 2, deceased adores shrine.

CHIC. OR. INST. photos. 10605–6.

(4) Deceased with table of offerings at top, and deceased adoring at bottom. (5) Row of divinities (?) at top, and text below. (6) Three registers, Book of Gates, I, Osiris and other divinities with long text, II, deceased adores divinities, III, deceased as priest adores [divinity]. (7) Three registers, deceased before divinities. (8) Three registers, I, bark of Sokari, II, [deceased], III, deceased led by Anubis.

(9) Niche with double-statue, and remains of text round niche.

(10) Two registers. I, Deceased before Osiris (?) with goddess. II, Deceased seated with sceptre and staff.

Frieze. Ḥathor-heads, and Anubis-jackals, with line of text.
Titles of deceased, CHIC. OR. INST. photo. 10607.

Ceiling. Decoration and texts.

Inner Hall.

(11) Thicknesses, texts, with hymn on right thickness.
Hymn, CHIC. OR. INST. photos. 10608–9.

(12) and (13) Texts, including list of festivals at (13).
List, CHIC. OR. INST. photo. 10612.

(14) and (15) Five registers, priests perform rites before mummies, with texts beyond at each side.

Pillars A–D.

A (*a*) and C (*a*) Deceased adores five gods of the necropolis. B (*a*) Deceased adores [Rēᶜ-Ḥarakhti]. D (*a*) Deceased adores Osiris.

Shrine.

(16) Outer lintel, Western goddess on left, goddess on right, and jambs, traces of text, with deceased seated at bottom on right. Wall, traces of texts.

Lintel, CHIC. OR. INST. photos. 10610–11.

374. AMENEMŌPET 〔≈〕=〔◦≈〕, Scribe of the treasury in the Ramesseum. Dyn. XIX.

Khôkha.

For position, see p. 292. Map IV, D–5, d, 6.

Entrance. Outer lintel, double-scene, deceased before Rēᶜ-Ḥarakhti, and before Osiris, and left jamb, text with titles of deceased.

375. Name unknown. Ramesside.

Draᶜ Abû el-Nagaᶜ.

Plan, p. 428. Map I, C–7, d, 5.

Hall.

(1) Three registers. I, Deceased and wife adore Osiris, Nephthys, Horus, Amenophis I, and ᶜAḥmosi Nefertere. II, Two scenes, 1, deceased (?) adores Ptaḥ and goddess, 2, deceased offers to Anubis and Western goddess. III, Two scenes, 1, man offers candles to deceased and wife, 2, man offers vases (?) to deceased and wife.

376. Name lost. Dyn. XVIII.

Draᶜ Abû el-Nagaᶜ.

Plan, p. 428. Map I, C–7, c, 4.

Hall.

(1)–(5) Remains of scenes, including jars on stands at (1), girl offering to deceased and wife at (4), and stela with offering-bringers on right at (5).

377. Name lost. Ramesside.

Draᶜ Abû el-Nagaᶜ.

Plan, p. 428. Map I, C–7, c, 6.

Hall.

(1) Outer right jamb, remains of painted stela.

(2) Amenophis I and ᶜAḥmosi Nefertere seated, and Ḥathor-cow protecting King (?) in mountain. (3) Two registers, I, man, followed by *ba*, offers to deceased and wife, II, man kneeling with two cats above.

(4) Stela, deceased offers to Osiris. Above stela, two figures of Anubis seated with bark of Rēᶜ at right end. At sides, deceased adores Theban Triad on left, and offers to Osiris with Isis and Nephthys on right.

378. Name unknown. Dyn. XIX.

Dra' Abû el-Naga'.

Plan, p. 428. Map I, C–7, b, 6.

Hall.

(1) and (2) Boats (sketches).

Passage.

(3) Servant with flowers, and King adoring followed by man holding stand, (unfinished). PETRIE, *Qurneh*, pl. xlviii, pp. 14–15 [31]; BAUD, *Dessins*, figs. 107–8, cf. pp. 221–2 [B]; MACKAY in *J.E.A.* iv (1918), pl. xvi [5], p. 75 note 4 (from PETRIE).

379. Name lost. Ramesside.

Dra' Abû el-Naga'.

Plan, p. 428. Map I, C–7, b, 7.

Hall.

(1) Tree-goddess scene. (2) and (3) Two registers, **I**, Book of Gates, deceased adores gods in shrines, **II**, funeral procession with two similar scenes, *sem*-priests with incense and libation before offerings and deceased and wife seated before pyramid-tomb. (4) Nine seated gods, goddess, and deceased before [god ?].

380. 'ANKHEF(EN)-RĒ'-ḤARAKHTI $\frac{0}{\wedge}$ 🜨, Chief in Thebes. Ptolemaic.

Qurnet Mura'i.

Parents, Dhout 🜨''' and Esnûter ⌐ ⸣ ⸜ 🜨.

Map VIII, F–3, h, 2.

Entrance. Outer right jamb, text, with Nile-god and small priest with *ḥes*-vase before table of offerings. Right thickness, two columns of text.

Name on thickness, BRUYÈRE, *Rapport (1931–1932)*, p. 93 [bottom].

381. Uninscribed. Perhaps AMENEMŌNET 🜨🜨🜨, Messenger of the King to every land. Ramesside.

Qurnet Mura'i.

Map VIII, F–3, g, 4.

Headless statue of Amenemōnet. Name and title, BRUYÈRE, *Rapport (1931–1932)*, p. 94.

382. USERMONTU 🜨🜨, Overseer of cattle, Overseer of the treasury, First prophet of Monthu. Ramesside.

Qurnet Mura'i.

Wife, Tiy 🜨🜨🜨🜨, Chief of the harîm of Monthu.

Map VIII, F–3, g, 3.

FAKHRY in *Ann. Serv.* xxxvi (1936), pp. 129–30.

Chapel.

Scenes from Book of Gates on walls of Passage, deceased and wife offering to divinities in shrines.

Frieze. Anubis-jackals and text.

Burial Chamber.

Black granite sarcophagus of deceased. See BRUYÈRE, *Rapport* (*1931–1932*), p. 91 [near bottom].

383. MERYMOSI ⸾⸾⸾⸾, Viceroy of Kush, son of Amenophis III.
Qurnet Mura'i.

Map VIII, F-3, h, 3.

VARILLE in *Ann. Serv.* xlv (1947), pp. 1–2; xl (1940), pp. 567–70.

Burial Chamber.

Red granite sarcophagus of deceased on sledge, in Antiquities House at Thebes. VARILLE in *Ann. Serv.* xlv (1947), pls. i–vi, pp. 2–3, 5–14.

Fragments of black granite outer coffin, in Brit. Mus. 1001 A. EDWARDS, *Hiero. Texts*, viii, pls. xviii, xix, pp. 19–21 with fig. 3; part, and fragment found by Baraize in the tomb in 1940, VARILLE in *Ann. Serv.* xlv (1947), pl. vii, pp. 3–4, 5, 14; fragment of lid, in Louvre, A F. 1692, id. ib. xl (1940), pl. lix, pp. 567–8.

Lid and fragments of black granite inner coffin, in Brit. Mus. 1001. Edwards, *Hiero. Texts*, viii, pls. xvi, xvii, pp. 15–18 (called Semna) with figs. 1, 2; VARILLE in *Ann. Serv.* xlv (1947), pls. viii–xi, pp. 4–14; see *Guide* (*Sculpture*), pp. 117–18 [420]; *Guide to the Egyptian Collection* (1909), p. 234 [420], (1930), p. 350; *A Handbook to the Egyptian Mummies and Coffins*, pp. 62–3; texts, HELCK, *Urk.* iv. 1934 (723); lid, WILKINSON MSS. xviii. 61. Fragment of right side, and adjoining fragment with Anubis, from Gödel-Lannoy Collection, now in Prague, National Museum 19/48, ŽÁBA in *Ann. Serv.* l (1950), figs. 1, 2, cf. pp. 509–14; id. *Staroegyptský Sarkofag z doby Nové Říše* [&c.] in *Časopis Národního Musea, Oddíl Věd Společenských*, cxvii–cxix (1948–50), pp. 104–8.

Finds

Fragment of stela, deceased adores [Osiris], and block of deceased from sandstone jamb, originally from here, seen in tomb 40. VARILLE in *Ann. Serv.* xxxiii (1933), pp. 83–4 with figs. See DAVIES and GARDINER, *The Tomb of Ḥuy*, p. 34.

Sandstone stela, deceased with Ḥuy, his scribe of documents, offering bouquet of Amūn, presumably from here, in Cairo, French Institute. Texts, VARILLE in *Ann. Serv.* xl (1940), p. 569 note 1; HELCK, *Urk.* iv. 1935 [D]. See GAUTHIER in *B.I.F.A.O.* xii (1916), pp. 134–5 [10].

Stela, upper part, deceased adoring Osiris and Western Ḥathor, probably from here, in Cairo Mus. 34139. LACAU, *Stèles du Nouvel Empire* (*Cat. Caire*), pl. lvii, pp. 189–90; WILBOUR MSS. 2 D. 53 [top] (gives Theban provenance). Name, LEGRAIN, *Répertoire généalogique et onomastique du Musée du Caire*, No. 231.

384. NEBMEḤYT ⸾⸾⸾⸾, Priest of Amūn in the Ramesseum. Dyn. XIX.
Sh. 'Abd el-Qurna.
Wife, Beketsekhmet ⸾⸾⸾⸾, Songstress of Amūn in the Ramesseum.

Plan, p. 428. Maps V and VI, E-4, h, 1.

FAKHRY in *Ann. Serv.* xxxvi (1936), pp. 124–6.

Hall.

(1) Frieze, Anubis-jackal and *uzat*. (2) Remains of three small registers, **I,** five women, **II,** Queen ʿAḥmosi Nefertere adoring bark of Rēʿ, **III,** Queen (?) with two feathers on her head.

Ceiling. Texts, FAKHRY, p. 125.

385. HUNŪFER ◻𝄞⸏...𝄞⸗, Mayor of the Southern City, Overseer of the granary of divine offerings of Amūn. (Perhaps brother of Nebsumenu, tomb 183.) Ramesside.

Sh. ʿAbd el-Qurna.
Wife, Nehty ⸗◻◻𝄞◻𝄞.

Plan, p. 428. Map VI, E–4, e, 2.

FAKHRY in *Ann. Serv.* xxxvi (1936), pp. 126–9, with plan, fig. 2.

Inner Room.

(1) At top, four heads. (2) At top, horizon-disk and *zad*-pillar below. (3) Man and offerings. (4) Goddess making *nini*.

Pillars and pilasters.

A (*a*) Text with titles, and [Ḥatḥor-cow] below, (*b*) deceased (with name and titles) and wife. B (*a*) Deceased and wife with jars and table of offerings before god. B (*b*), C (*a*), D (*a*) Couples.

Texts, FAKHRY, pp. 127–8.

386. ANTEF 𝄞⸗, Chancellor of the King of Lower Egypt, Overseer of soldiers. Middle Kingdom.

ʿAsâsîf. (WILKINSON, 'Bab om el Mináfed', *Bibl.* i, 1st ed. p. 190, bb.)

Plan, p. 428. Map IV, D–5, d, 4.

LECLANT in *Orientalia*, N.S. xxii (1953), p. 89 [f]. For position, see HAY MSS. 29816, 1 (No. 19 on map by BURTON).

Passage.

(1) Two registers. **I,** Offering-bringers with animals, and jars on pole. **II,** Offering-bringers.

Inner Room.

(2) Sketch of tree.

(3) Two registers. **I,** Man offers fish to deceased with staff, and men fishing with net. **II,** Fowling-scene, and netting fowl in marsh, with titles of deceased above.

Remains of **II,** including jousting in canoes and hippopotamus (?) in water, WILKINSON MSS. xix. 3 (squeeze); man cooking fish, id. ib. vii. 31 [left].

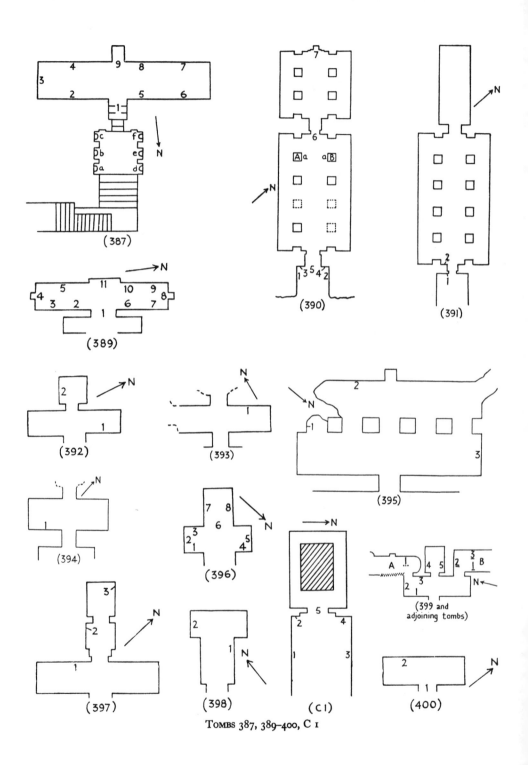

TOMBS 387, 389–400, C I

387. MERYPTAḤ ⬚⟨↖⟨⟨, Royal scribe of the table of the Lord of the Two Lands in Karnak. Temp. Ramesses II.

'Asâsîf.

Wife, Neb. . . ▽▨ .

Plan, p. 438. Map IV, D–5, b, 5.

Name and title, FAKHRY in *Ann. Serv.* xlvi (1947), p. 34 [B, 4].

Court.

Statues. (*a*), (*b*), (*d*), (*e*) Osiride royal statues. (*c*) Osiris. (*f*) Ḥathor-cow protecting [King] (removed).

Hall.

(1) Outer lintel, double-scene, deceased before a god, with cartouches in centre, and jambs, text and deceased at bottom. Thicknesses, deceased adoring with hymns (to Amen-rēʿ-Ḥarakhti on left).

(2) Two registers. **I**, Three scenes, Book of Gates, **1**, deceased presented by Thoth to Osiris and Western goddess, **2**, deceased [and wife (?)] led by Anubis and Ḥathor, **3**, Negative Confession (?) with deceased followed by two people (?). **II**, Three scenes, **4**, priest with incense and offerings before two men and woman, **5**, deceased purified by two priests, **6**, tree-goddess scene (with *bas* on knees of deceased and wife).

(3) Man before a god (?). (4) Offering-bringers, deceased adoring Osiris, and seated man below, and man pouring libation before deceased (?). (5) Two registers, **I**, deceased libating offerings followed by man, **II**, offering-bringers. (6) and (7) Remains of offering-scenes. (8) Two registers, **I**, deceased, followed by man and offering-bringer, adores Rēʿ-Ḥarakhti, Western goddess, and group of seven divinities, all seated, **II**, two scenes, each with priest offering to deceased seated with *kherp*-sceptre, with offering-list beyond.

(9) Niche. Lintel, double-scene, deceased at each end before table of offerings, and right jamb, remains of text.

Vaulted ceiling, with frieze-text below on north and south walls.

388. No texts. Saite.

'Asâsîf. (L. *D. Text*, No. 21, *Bibl.* i, 1st ed. p. 190, aa.)

Plan, p. 52. Map IV, D–5, b, 4.

L. *D. Text*, iii, p. 245. Rediscovered, see FAKHRY in *Ann. Serv.* xlvi (1947), p. 34 [B, 2].

Hall.

(1) and (2) Two registers, **I**, offering-list and ritual (sketch), **II**, doorway and row of offerings, with offering-bringers below. (3) Two registers before deceased, **I**, offering-list and offerings, **II**, offering-bringers. (4)–(7) Two registers, **I**, food-offerings, **II**, offering-bringers and butchers.

389. BASA ⌇ or ⌇, *smꜣtj*-priest, Chamberlain of Min, *ḥsk*-priest, Mayor of the Southern City. Saite.

'Asâsîf. (CHAMPOLLION, No. 57, L. D. *Text*, No. 28, *Bibl.* i, 1st ed. p. 190, cc.)

Parents, Amenemōnet, Prophet of Min, and Neferuneit ⌇. Wives, Tahert ⌇ and Beteb ⌇.

Plan, p. 438. Map IV, D–5, d, 5.

CHAMP., *Not. descr.* i, pp. 556–7; L. D. *Text*, iii, p. 248. Rediscovered, see FAKHRY in *Ann. Serv.* xlvi (1947), p. 34 [B, 1].

Hall.

(1) Outer lintel, [deceased and wife before Amen-rēꜥ]. Inner lintel and jambs, texts.

Titles of deceased and name of Tahert, probably from here, L. D. *Text*, iii, p. 248 [bottom left].

(2) Hymn. (3) Four registers, bull and seven cows, with sacred oars and Sons of Horus.

(4) Tympanum, bark of Rēꜥ adored by baboons. Niche, jambs with offering-formula and hymn to Osiris, and [deceased] standing at bottom. Left of niche, two registers, I, deceased adores Rēꜥ-Ḥarakhti, II, man libates offerings before deceased and wife (?). Right of niche, two registers, I, deceased adores Atum, II, man with food-table before deceased and wife (?).

Bark of Rēꜥ, see THOMAS in *J.E.A.* xlii (1956), p. 68 [BE] with note 5.

(5) Litany.

Names of divinities, L. D. *Text*, iii, p. 248 [bottom right with *a*].

(6) Lower part of statue.

(7) Two registers, I, [wife with family], II, Beteb seated with small daughter Ptaḥardais under chair, and daughter in front. (8) Left of niche, deceased and Beteb seated, right of niche, man before couple. (9) Two registers, I, titles of deceased, II, man with offerings before deceased.

(10) [Mummiform statue.]

(11) Niche [for statue of Ḥathor-cow probably protecting King], with four Ḥathor-pillars, and texts on lintel, jambs, and frame, with columns of titles, &c., beyond, on each side.

Remains of title of deceased, LEPSIUS MS. 262 [top].

Frieze, text.

390. IRTERAU ⌇, Female scribe, Chief attendant of the divine adoratress Nitocris. Temp. Psammetikhos I.

'Asâsîf. (CHAMPOLLION, No. 16, L. D. *Text*, No. 94, *Bibl.* i, 1st ed. pp. 193–4, ss.)

Parents, Ipwer ⌇, Divine father of Amūn, and Tashaiu ⌇.

Plan, p. 438. Map VI, E–4, c, 5.

CHAMP., *Not. descr.* i, pp. 510–12; L. D. *Text*, iii, p. 289; WILKINSON MSS. xxxvii. 170, with sketch-plan; ROSELLINI MSS. 284, G 26–7 verso. Plan showing Pillared Forecourt,

WILKINSON MSS. xlv. A. 6 [left]; sketch-plan, sketch of entrance, and name of father, id. ib. xvi. 46 [lower]. Litany and texts of Eskhons, Prophet of Amūn, probably from here, id. ib. v. 176 [top and middle]; text from a ceiling, id. ib. 169 [middle right].

Court.

(1) Ten columns of text with deceased below.

(2) Two registers, each with deceased seated.
Text of deceased with names of father and of grandfather Zeḥo, Divine father of Amūn, *L. D. Text*, iii, p. 289 [top]; WILKINSON MSS. v. 170 [top].

(3) Six columns of text.

(4) Festival-list with dates.
CHAMP., *Not. descr.* i, p. 512 [upper]; beginning, WILKINSON MSS. v. 131 [right]; ROSELLINI MSS. 284, G 27 verso. See SCHOTT, *The Feasts of Thebes* in *Chic. O.I.C.* 18, pp. 89–90.

Hall.

(5) Outer lintel, double-scene, bark of Rēᶜ in centre, adored by Nitocris followed by [deceased] with adoration of Rēᶜ on left, and by Shepenwept III followed by deceased with adoration of Atum on right, and standards of Western Horus, and of *Benu*-bird at each end.
Upper part, L. D. iii. 272 [a]; sketch, CHAMP., *Not. descr.* i, p. 511 [a]. Text on left half, WILKINSON MSS. v. 169 [bottom].

Ceiling. Offering-text of deceased with name of father, CHAMP., op. cit. p. 511 [b].

Pillars. A (*a*) and B (*a*) Remains of titles of deceased.
Name, id. ib. 511 [near top right].

Inner Room.

(6) Outer lintel, four lines of text with deceased seated before offerings at left end, and jambs, four columns of text, with names of parents on right jamb.
Upper part, L. D. iii. 272 [b]. Titles of deceased and names of parents, CHAMP., *Not. descr.* i, pp. 510 [bottom]–511 [top]. Part of text on right jamb, WILKINSON MSS. v. 169 [middle left].

(7) Niche, containing false door with scene at top, deceased with libation-vases before Osiris. Texts round niche, round false door, and on walls each side of niche.
Scene, and texts round false door, L. D. iii. 271 [b]; texts, WILKINSON MSS. v, on 169; part on jambs, CHAMP., *Not. descr.* i, p. 511 [A, B].

391. KARABASAKEN ⟨hieroglyphs⟩, Prophet of Khonsemwēset-Neferḥōtep, Fourth prophet of Amūn, Mayor of the City. Probably Dyn. XXV.
Sh. ʿAbd el-Qurna. (CHAMPOLLION, No. 18, L. D. Text, No. 95, *Bibl.* i, 1st ed. p. 194, tt.)
Plan, p. 438. Map VI, E–4, c, 6.
CHAMP., *Not. descr.* i, pp. 513–14.

Hall.

(1) Outer left jamb, remains of text at bottom.

(2) Deceased offers to Anubis.

Titles of deceased, CHAMP., op. cit. i, p. 514; L. *D. Text*, iii, p. 289; BRUGSCH, *Recueil*, pl. lxv [7]; WILKINSON MSS. v. 176 [bottom left]; ROSELLINI MSS. 284, G 29.

392. Name unknown. Saite (?).

Khôkha.

Plan, p. 438. Map IV, D–5, a, 7.

Hall.

(1) Three registers, I–III, funeral procession, with mourners and shrine containing mummy in **I,** and rites in garden in **III.**

Inner Room.

(2) Remains of Osiris and goddess.

393. Name unknown. Early Dyn. XVIII.

Dra' Abû el-Naga'.

Plan, p. 438. Map I, C–7, d, 6.

Hall.

(1) Four registers, **I–III,** male and female guests, **IV,** offering-bringers with flowers on stands. Frieze, lotus and grapes.

394. No texts. Ramesside.

Dra' Abû el-Naga'.

Plan, p. 438. Map I, C–7, d, 6.

Hall.

(1) Remains of funeral procession, with female mourners squatting behind man offering bouquets.

395. Name lost. Ramesside.

Dra' Abû el-Naga'.

Plan, p. 438. Map I, C–7, c, 7.

Hall.

(1) Deceased and wife before Maᶜet. (2) Remains of deceased adoring Osiris and Isis.

(3) God and goddess in kiosk.

Frieze at (3) and on entrance wall, right of doorway, deceased kneeling before Anubis.

396. Name unknown. Dyn. XVIII.

Dra' Abû el-Naga'.

Plan, p. 438. Map I, C–7, c, 7.

Hall.

(1) Couch on two leopards, with collar, &c., below. (2) Funeral outfit and offerings.

(3) Seated figure.

(4) Couple seated with offerings, and two registers of offering-bringers. Sub-scene, banquet with three attendants before six guests, including man vomiting.
Guests, SCHOTT photo. 8762.

(5) Two couples, offerings, and harpist at top. Sub-scene, two squatting figures.

Inner Room (vaulted).
(6) Outer jambs, texts. (7) and (8) Remains of figures.

397. NAKHT ⸚⸗, *wa'b*-priest of Amūn, Overseer of the magazine of Amūn, First King's son of Amūn. Dyn. XVIII (?).
Sh. 'Abd el-Qurna.
Wife, Senḥotp ⸗, Royal concubine.

Plan, p. 438. Map V, D–4, g, 9.

Hall.
(1) Remains of titles.

Inner Room.
(2) Boat with mourners (in funeral procession), and offering-bringers before [deceased].

(3) Deceased and wife seated.

Ceiling. Remains of text.

398. KAMOSI ⸚⸗, called NENTOWAREF ⸚⸗⸗, Child of the nursery (from cones). Probably Dyn. XVIII.
Sh. 'Abd el-Qurna.

Plan, p. 438. Maps V and VI, E–4, i, 1.

Passage.
(1) Remains of text.

Ceiling. Remains of 'Address to the living' with name of deceased as Kamosi.

Inner Room.
(2) Remains of text.

Ceiling. Remains of hymn to [Rēʿ] with name of deceased as Nentowaref.

Canopic-jar of deceased, in Oxford, Ashmolean Mus. 1922.20.

399. No name. Ramesside.
Sh. 'Abd el-Qurna.

Plan, p. 438. Map VI, E–4, j, 3.

Hall.
(1) Two registers, I, funeral procession to tomb, II, men with funeral outfit. (2) Stela, with two Anubis-jackals above, and man adoring on each side. (3) Book of Gates, deceased and wife adore guardian with knife in shrine.

Inner Room.

(4) Man adoring. (5) Text.

A. North adjoining tomb, Penrennu (?). Ramesside.

Hall. Book of Gates.

(1) Remains of two registers. **I,** Deceased (?) before shrine with Nefertem-emblem. **II,** Weighing-scene.

B. South adjoining tomb.

Hall. Book of Gates.

(1) Scenes of deceased before ram-headed god in shrine. (2) Two registers, **I,** ram-headed gods in shrines, **II,** Fields of Iaru (?).

Frieze. Anubis-jackals at (1) and (3), with Hathor-heads at (3).
Ceiling, texts.

400. No texts.

 Sh. ʿAbd el-Qurna.

<div align="center">Plan, p. 438. Map V, D–4, d, 8–9.</div>

Hall.

(1) Left thickness, sketch of man and wife. (2) Two men.

401. Nebseny ⌣⃛◌◌, Overseer of goldsmiths of Amūn (from cone). Temp. Tuthmosis III to Amenophis II (?).

 Draʿ Abû el-Nagaʿ. (Inaccessible.)

<div align="center">Map II, D–6, d, 3.</div>

Fakhry in *Ann. Serv.* xlvi (1947), p. 34 [B, 5].

402. Name unknown. Temp. Tuthmosis IV to Amenophis III.

 Draʿ Abû el-Nagaʿ.

<div align="center">Map I, C–7, d, 6.</div>

Hall.

Rear wall, left part. [Goat-herd, goats grazing under tree, and servant before deceased seated under a tree with jars cooling in shade.]

Baud, *Dessins*, fig. 106, cf. pp. 219–21 [A]. Goats, Capart, *Documents*, i, pl. 66; id. *L'Art égyptien*, iii, pl. 518.

403. MERYMAʿET 𓁹𓏤𓎛𓏏 (name from ushabti), Temple-scribe, Steward. Dyn. XVIII (?).

Sh. ʿAbd el-Qurna. (CHAMPOLLION, No. 21, *Bibl.* i, 1st ed. p. 192, mm.)

Plan, p. 400. Map VI, E–4, g, 3.

CHAMP., *Not. descr.* i, pp. 514–15; DAVIES, *Seven Private Tombs at Ḳurnah*, p. 56 [bottom], with plan, pl. xl [D]; MOND and EMERY in *Liv. Ann.* xiv (1927), p. 25, with plan, pl. ii [D]. Ushabti, id. ib. pl. xviii [b], p. 25. Name and titles, ROSELLINI MSS. 284, G 30 verso.

Hall.

(1) [Jamb, remains of text at bottom with name of deceased.] See DAVIES, p. 56.

Inner Room.

Man with table of offerings, shrines above, and remains of texts.

404. AKHAMENERAU 𓅆𓏤𓍯𓏏𓏥 (var. 𓅆𓂝𓍯𓏏𓏥), Chief steward of the divine adoratress. Temp. Amenardais I and Shepenwept II, Dyn. XXV.

ʿAsâsîf.

Parents, Pekiry 𓊪𓇋𓂋𓇋, Prophet of Amūn, and Mereskhons 𓄿𓏤𓎛.

Plan, p. 64. Map IV, D–5, a, 4.

LECLANT in *J.N.E.S.* xiii (1954), pp. 161 [x], 165 [f]; id. in *Orientalia*, xxii (1953), p. 89 [g], xxiii (1954), pp. 66–7 [top] and note 1.

Hall.

(1) Text, LECLANT in *J.N.E.S.* xiii (1954), pl. iii [bottom], p. 161 [B].

(2) Texts. (3) Resurrection of Osiris as mummy on couch and texts. (4) Architrave (?), texts.

405. KHENTI 𓏡𓂋𓇋, Nomarch. First Intermediate Period.

Khôkha.

Father (probably), Iḥy (tomb 186). Wife, Mertiotes 𓎛𓂋𓏏, Prophetess of Ḥathor.

Plan, p. 292. Map IV, D–5, d, 9.

Pillared Hall.

(1) Man driving goats. (2) Ointment-jars and titles of deceased. (3) Deceased and family fowling. (4) Three registers, funeral outfit with vases, boxes, three beds (one prepared by nude man), and scribe's outfit. (5) Male and female offering-bringers before deceased and wife seated.

Pillars.

B (a) Three registers, man feeding cow in each. C (a) Three registers, two men in each. Architrave between C and pilaster. Two lines of text with offering-formula and titles.

406. PIAY 𓈖𓂝𓄿𓏭𓏭, Scribe of the offering-table of the Lord of the Two Lands. Ramesside.

'Asâsîf.

Plan, p. 296, cf. p. 292. Map IV, D–5, a, 5.

Hall. (Unfinished).

(1) Left thickness, bark of Reʿ dragged by jackals. Right thickness, two registers, **I**, deceased and wife before Atum, Maʿet, and Western goddess, **II**, deceased with hymn to Osiris. See HABACHI in *Ann. Serv.* lv (1958), p. 349.

(2) Two registers. **I,** Priest offers to deceased (?) and wife. **II,** Remains of funeral procession with priest before mummies at tomb.

407. BINTENDUANŪTER �548𓅆𓏏, Chamberlain of the divine adoratress. Saite.

'Asâsîf.

Map IV, D–5, a, 5.

Entrance to Inner Room. Jamb of deceased. See HABACHI, op. cit. p. 349.

408. BEKENAMŪN 𓃀𓂝𓈖𓇋𓏠𓈖, Head of servants of the estate of Amūn. Ramesside. (Unfinished.)

'Asâsîf. West of tomb 28, in same court, adjoining tomb 409 on west side.

Wife, Tentwazui 𓏏𓈖𓏏𓍯𓏭𓁐.

Plan, p. 462. Cf. Map IV, D–5, c, 6.

To be published by Abdul-Qader Muhammed in *Ann. Serv.*

Hall.

(1) Outer lintel, double-scene, deceased and wife libating to Osiris and Ḥathor, and offering to Sokari-Osiris and Maʿet, with text above mentioning sons Amenemḥab 𓇋𓏠𓈖𓄿, Amenkhaʿu 𓇋𓏠𓈖𓂝𓏥, and Iufenamūn 𓇋𓅱𓈖𓇋𓏠𓈖. Left jamb, text with name of wife.

Inner Room.

(2) Outer lintel, double-scene, deceased with Amenemḥab on left half, and with wife on right half, before Osiris.

Finds

Double-statue of deceased and wife seated, found in passage to Burial Chamber of tomb 409.

409. See Addendum, p. 461.

II. TOMBS WITHOUT OFFICIAL NUMBERS

(Exact position unknown, arranged topographically)

For other burials and tombs, see *Bibl.* i², Pt. 2, in the Press

A. *DRA' ABÛ EL-NAGA'*

North Valley (Khâwi el-Âlamât)

A. 1. AMENEMḤĒT 〔𓈖𓏏𓐍𓄿𓏲〕, *ka*-servant (title from cone). Dyn. XVIII.

On north side of Valley, low down, just opposite tomb 155.
Wife, Sitamūn 〔𓈖𓏏𓆓〕.

Names, GAUTHIER in *B.I.F.A.O.* vi (1908), pp. 127–8 [ix], (called Middle Kingdom).
Sandstone jamb with texts of deceased and wife, probably from here, is in Museu Etnoló-
gico, Belém, Lisbon.

A. 2. 'Tomb of the dancers'. Dyn. XVII (?).

On south side, at mouth of Valley, low down. (*Bibl.* i, 1st ed. p. 184, a.)

Square Hall.

North wall. Left part of scene, girl followed by four rows of female dancers, in Oxford,
Ashmolean Mus. 1958.145, with man bringing bull and butchers behind them.

GAUTHIER in *B.I.F.A.O.* vi (1908), pls. vii–x, pp. 127, 162–3. Girl and dancers, PETRIE,
Qurneh, frontispiece, pp. 10–11; second row, DAVIES in *M.M.A. Bull.* Pt. ii, Feb. 1928,
fig. 10, cf. p. 64. See *Summary Guide* (1920), pp. 19, 108, (1931), p. 23.

Pillar. Remains of fishing-scene on north face, and of dancers (?) on east face.
See GAUTHIER, p. 163.

Passage.

Fragments found here, PETRIE, *Qurneh*, pl. xxxi [9, 10]. Texts, CLÈRE and VANDIER,
Textes de la Première Période Intermédiaire (*Bibliotheca Aegyptiaca*, x), p. 4 [5] (from PETRIE).

A. 3. RURU 𓃭𓃭, Chief of the Mezay. New Kingdom.

On south side of Valley, upper part.
Wife, Neferti (?).

Titles on west wall of court, GAUTHIER in *B.I.F.A.O.* vi (1908), p. 128 [x].

On Main Hill

A. 4. SIUSER 𓋴𓇼𓏏𓍑, Scribe, Counter of the grain, Mayor of the Southern City,
Overseer of the granary. Dyn. XVIII.

'A few paces' south of tomb 155, and below tomb 255. (HAY, No. 3, *Bibl.* i, 1st ed.
p. 185, b.)

BURTON MSS. 25639, 40, 46 verso; HAY MSS. 29824, 17–19 with rough plan, 31054, 135; ROSELLINI MSS. 284, G 62 (No. 54).

Hall.

Left wall, three registers. I–II, Deceased inspects recording of incense from Kush, brought by women. III, Groups of women, barter-scene before storehouses with scribes, and house behind.

HAY MSS. 29822, 21. Women and man with sacks before scribe in I, and part of house in III, WILKINSON MSS. v. 130 [upper left], 109 [middle left]; part of house, id. *M. and C.* ii. 122 (No. 111) = ed. BIRCH, i. 361 (No. 131); MASPERO, *L'Arch. ég.* (1887), fig. 17, (1907), fig. 18; men and scribes in front of house, BURTON MSS. 25644, 125.

Left wall, beyond last, remains of banquet (destroyed by attempts to cut out pieces). Female guest and attendant, and girl-clappers, BURTON MSS. 25638, 48 [top], 48 verso.

Right wall. Scenes cut out by SALT, see HAY MSS. 29824, 19.

Passage.

'Left hand of the door', deceased with staff. See HAY MSS. 29824, 17.

Left wall. Five registers, funeral procession, including 'Nine friends', sarcophagus dragged by men and oxen, mummers, male dancers, butchers, victims, rites in garden with pool, canoe with shrine attached to mooring-post, and offering-scene to deceased and wife beyond.

HAY MSS. 29822, 23, 36, 38, cf. sketches, 29824, 18, 18 verso, 29853, 105. Sarcophagus dragged, dancers, and rites in garden, BURTON MSS. 25638, 49–50; pool, WILKINSON MSS. v. 130 [bottom].

Right wall. Rites before mummy (including butchers, offering-list ritual, and priest opening door of shrine), and priest offering to deceased and wife with monkey under chair.

HAY MSS. 29822, 24–32, 34, 35. Priest with mummy, BURTON MSS. 25638, 48 [bottom].

A. 5. NEFERḤŌTEP 𓏭𓏤𓏤, Overseer of the granary. Probably temp. Tuthmosis III to Amenophis II.

Close to and south of last. ('Mr. Salt's tomb', *Bibl.* i, 1st ed. p. 185, c.)

CAILLIAUD, *Voyage à Méroé, Texte*, iii, pp. 292–8; KEIMER in *Revue d'Égyptologie*, iv (1940), pp. 49–58; HAY MSS. 29824, 19 verso–20. Name and title, WILKINSON MSS. xvii. H. 17 [bottom]; ROSELLINI MSS. 284, G 63 (No. 56).

Hall.

Left wall. Scribes recording produce of marsh-lands, and vintage, including men sealing wine-jars, and offerings to Termuthis.

CAILLIAUD, *Voyage à Méroé*, ii, pl. lxxv [2, left]; id. *Arts et métiers*, pl. 35 [2]; KEIMER, op. cit. pl. ii [2] (from CAILLIAUD). Man carrying two covered dishes of honey (?), *Descr. de l'Égypte. Ant.* ii, pl. 44 [7].

Right wall. Banquet, with two rows of musicians (male harpist and clapper, and woman with shoulder-harp in upper row, and female dancers and male harpist in lower row).

Musicians, CAILLIAUD, *Voyage à Méroé*, ii, pl. lxxv [2, right]; id. *Arts et métiers*, pl. 35 [3]; KEIMER, op. cit. pl. ii [3] (from CAILLIAUD). Woman with shoulder-harp, and female guests

(one vomiting), Wilkinson, *M. and C.* ii. 275 (No. 209), 167 (No. 147) = ed. Birch, i. 465 (No. 234), 393 (No. 168); Burton MSS. 25644, 123–4; Wilkinson MSS. v. 130 [right], 110 [top left]; Hay MSS. 29822, 41 [top], 76. Dancers, id. ib. 41 [bottom].

Rear wall. Two registers. **I,** Deceased with dog and son hunting on foot, and four rows of animals. **II,** Two rows of men bringing game (including ostrich, and hyena in trap carried on pole) to deceased with attendants and hunting dog.

 Cailliaud, *Voyage à Méroé*, ii, pl. lxxiv [2]; id. *Arts et métiers*, pl. 37; Keimer in *Revue d'Égyptologie*, iv (1940), pl. iii [2] (from Cailliaud). Deceased shooting and men with ostrich and hyena, Wilkinson, *M. and C.* i. 307 (No. 30), ii. 6 (No. 77), iii. 2 (No. 318) = ed. Birch, i. 204 (No. 35), 282 (No. 96), ii. 78 (No. 346), iii. 257 (No. 567); Wilkinson MSS. v. 110 [right and bottom left], 111 [left]; omitting hyena, Hay MSS. 29822, 43–4, cf. 29824, 19 verso (animals cut out by Salt).

Deceased with family fishing and fowling (part with birds, &c., formerly in Bibliothèque Nationale, 9, now in Louvre, E. 13101), and three rows on right, netting and preparing fowl.
 Cailliaud, *Voyage à Méroé*, ii, pl. lxxv [1]; id. *Arts et métiers*, pl. 35 [1]; Keimer, op. cit. pls. ii [1], i, (both from Cailliaud), and p. 46, fig. 1 (from Ledrain); part in Louvre, Ledrain, *Les Monuments égyptiens de la Bibliothèque Nationale*, pl. iii; Keimer in *Ann. Serv.* xxxvii (1937), pl. xxv, pp. 161–2 with fig. 212; Vandier, *Guide* (1948), pl. xiv [lower], p. 64' [bottom]; (1952), pl. xiv [lower], p. 65. Men carrying crane and geese, and kneeling man, Hay MSS. 29822, 39–40. Six fishes, Wilkinson MSS. v. 111 [right].

A. 6. Dḥutnūfer, called Seshu (or Seniu), Overseer of marsh-lands of the Lord of the Two Lands. Dyn. XX.
 On east slope. (*L. D. Text*, No. 6, *Bibl.* i, 1st ed. pp. 186, e, and 190, y.)
 Wife, Benbu.
 Gauthier in *B.I.F.A.O.* vi (1908), p. 125 (giving name and title); title, *L. D. Text*, iii, p. 239.
 Jamb of deceased in New York, M.M.A. 15.2.4. Hayes, *Scepter*, ii, fig. 91.
 Offering-text (on a jamb) of an [overseer] of weavers (?), Gauthier, op. cit. p. 139 [B].
 Kneeling headless statue with hymn to Amen-rēʿ on back, and fragment of stela. Texts, id. ib. pp. 140 [c 2], 138 [a 2].

A. 7. Amenḥotp, Scribe, Counter Dyn. XVIII.
 Near last.
 Wife, Mut[ardais].
 View, Gauthier in *B.I.F.A.O.* vi (1908), pl. i.
 Name of wife on fragment from ceiling, id. ib. p. 126 [vii].

A. 8. Amenemḥab, Royal scribe, Steward in the mansion of Amenophis I on the west of Thebes, Overseer of the granary of Amūn. Dyn. XVIII or XIX.
 A little higher than tomb 12. (*L. D. Text*, No. 4, *Bibl.* i, 1st ed. p. 186, f.)
 Parents, Maḥu and Kanuro. Wife, Tanefert.

Hall.

Rear wall, two scenes. **1**, Deceased offers to Osiris and Nephthys. **2**, Deceased, wife, and parents (?), adore Amenophis I and ʿAḥmosi Nefertere in kiosk.

Some texts, L. D. Text, iii, pp. 238 [a], 239 [top right].

Granite seated statue-group, deceased with mother and wife (called Taysennefert 𓀹𓏞𓏏⸗, in Leningrad, State Hermitage Mus. 740. [PAVLOV and MATE], *Pamiatniki iskusstva drevnego Egipta*, pl. 42. Texts, LIEBLEIN, *Die aegyptischen Denkmäler in St. Petersburg* [&c.], pp. 3–4 [3]; names, LIEBLEIN, *Dict.* No. 1646. See GOLENISHCHEV, *Inventaire de la collection égyptienne*, pp. 87–9; GUBCHEVSKY, *The Hermitage Museum. A Short Guide* (1955), p. 49.

A. 9. Name unknown. Temp. Amenophis II.

Below last. (L. D. Text, No. 3.)

Painted tomb with adoration of Amenophis II (cartouches cut out on 21 November 1844). See L. D. Text, iii, p. 238.

A. 10. DḤUTNŪFER 𓏏𓈖, Royal scribe, Overseer of the treasury, Chief lector in the Good House. Early Dyn. XVIII.

At foot of Hill. (CHAMPOLLION, No. 50 ter, *Bibl.* i, 1st ed. p. 186, g.)

Parents, Kamosi 𓄿𓈖𓏥, Judge, and Senḥotp 𓏏𓄤. Wife, Tabia 𓏏𓇋𓏭.

Lintel, double-scene, son Teti offering to deceased and wife, jambs, texts, in Florence Mus. 2576, 2598–9.

Lintel, ALINARI photo. 43846; parts of jambs, PETRIE ITAL. photos. 207 [right], 249 [right]. Texts, SCHIAPARELLI, *Mus. . . . Firenze*, pp. 341–4 [1607–8]; BEREND, *Prin. mon. . . . Florence*, pp. 77, 94–5; of lintel and right jamb, CHAMP., *Not. descr.* i, pp. 542–3 with A, B; names, LIEBLEIN, *Dict.* Nos. 765, 784, cf. Supp. pp. 968, 970. See ROSELLINI, *Breve Notizia degli oggetti di antichità egiziane* [&c.], pp. 32–3 [25], 38 [38], 48 [48]; MIGLIARINI, *Indication succinte des monuments égyptiens*, pp. 18–19, 29–30.

Hill below Deir el-Bakhît, behind Piccinini's house[1]

A. 11. AMENKHAʿEMWĒSET 𓂋𓇋𓏏. New Kingdom.

'On Piccinini's hill to the north of his house and nearly under the ruined mud pyramid with a large arch' (HAY). (CHAMPOLLION, No. 41, *Bibl.* i, 1st ed. p. 188, o.)

Wife, Takhaʿ 𓏏𓄿.

CHAMP., *Not. descr.* i, pp. 534–5; HAY MSS. 29824, 3; ROSELLINI MSS. 284, G 54 (No. 42).

Hall.

Right wall. Daughter, with nine women nursing children behind her, offers bowl to deceased and wife.

Three women, HAY MSS. 29822, 45. Names of deceased, wife, and sons Neferḥōtep and User, LEPSIUS MS. 424.

Sketch of candle between two torches, HAY MSS. 29824, 3.

[1] Piccinini's house was near tomb 161.

A. 12. NEBWENENEF ⳾⳾⳾, Overseer of marsh-land dwellers of the estate of Amūn. Ramesside (?).

'Tomb of the hill of brick pyramid of Piccinini' (WILKINSON). (CHAMPOLLION, No. 40, *Bibl.* i, 1st ed. p. 188, p.)

Wife, a prophetess of Ḥathor.

Deceased offers to Amenophis I and ʿAḥmosi Nefertere.

Text, WILKINSON MSS. v. 208 [middle]; titles of deceased and cartouches, CHAMP., *Not. descr.* i, p. 534. See ROSELLINI MSS. 284, G 54 (No. 41).

Ḥathor-cow in mountain.
WILKINSON MSS. v. 208 [top right].

Priest with incense and libation offers large bundle of onions to deceased and wife.
Text and onions, id. ib. 208 [bottom].

A. 13. PAIMOSI ⳾⳾⳾, Sealer of the storehouse of gifts; Follower of the King in all foreign lands. Dyn. XVIII.

Near last.
Wife, Sensonb ⳾⳾⳾.

Hall.

Titles of deceased, LEPSIUS MS. 425 [top middle (on left thickness), top right (on ceiling), bottom left (on right wall)]. Name of wife on left wall, and texts of wife and man offering, near door, on a stela (?), id. ib. 425 [top left and bottom right].

Rear wall. Offering-scene to deceased and wife.
Text, id. ib. 425 [middle].

A. 14. Tomb with brick-walled court. Temp. Ramesses II (?).

Behind Piccinini's house.[1] (*Bibl.* i, 1st ed. p. 188, q.)

Hall.

Rear wall, right side. [Deceased before] Ramesses II in palace-window.
See HAY MSS. 29824, 5 verso [lower], described as similar scene to tomb 157 (8).

In Plain, near Piccinini's house[1]

A. 15. AMENEMIB ⳾⳾⳾, Head of the door-keepers of the estate of Amūn. Ramesside.

A little north of Piccinini's house.[1] (CHAMPOLLION, No. 39, *Bibl.* i, 1st ed. p. 188, r.)
Wife, Irtiʿat ⳾⳾⳾.
CHAMP., *Not. descr.* i, pp. 533–4. Name of wife, ROSELLINI MSS. 284, G 53.

[1] Piccinini's house was near tomb 161.

Hall.

Left wall, two registers. **I,** Book of Gates, deceased and wife adore three guardians (one a serpent). **II,** Two scenes, priest offers to deceased and wife seated.

I, and texts of **II,** WILKINSON MSS. v. 212, 211 [bottom]; text of priest in left scene of **II,** CHAMP., *Not. descr.* i, p. 851 [to p. 534, l. 2].

Right wall. Deceased and wife led by Ḥarsiēsi, weighing-scene with Thoth writing and monster ʿAmmet, and deceased presented by Ḥarsiēsi to Osiris, Isis, and Nephthys.

WILKINSON, *M. and C.* 2 Ser. Supp. pl. 88 = ed. BIRCH, iii, pl. lxxi, facing p. 468; WILKINSON MSS. v. 211 [upper]; HAY MSS. 29851, 89–98. Texts, CHAMP., *Not. descr.* i, pp. 850–1 [to p. 533, ll. 16, 17, 18].

A. 16. ḎḤUTIḤOTP 🔲, Beloved royal scribe, Steward of the Southern City. Ramesside.

'Tomb near Piccinini's house'[1] (HAY). (*Bibl.* i, 1st ed. pp. 188–9, s.)

Scenes and texts from Book of the Dead, HAY MSS. 29851, 99, 103–27.

Double-scene, deceased before Osiris, and deceased with bouquet, id. ib. 129–39. Other scenes, including deceased before serpent, horse with serpent springing from its neck, and Akru, id. ib. 100–2. Drummer, id. ib. 128.

A. 17. USERḤĒT 🔲, Head of the measurers of the granary of the estate of Amūn.

'Near Piccinini's house'[1] (HAY). (*Bibl.* i, 1st ed. p. 189, t.)
Wife, Ḥathor 🔲.

Deceased and wife before Osiris and Ḥathor in kiosk, and deceased and wife with sistrum adoring Theban Triad. HAY MSS. 29851, 140–50.

A. 18. AMENEMŌPET 🔲, Prophet of Amen-rēʿ, Secretary, Chief of the scribes in the estate of Amūn. Ramesside.

'Behind Piccinini's house'[1] (HAY). (*Bibl.* i, 1st ed. p. 189, u.)
Father, Paʿankhemdiamūn 🔲. Wife, ʿAnkhenkhons 🔲.

HAY MSS. 29824, 1 verso–2 verso; ROSELLINI MSS. 284, G 63 verso, 64. Name of wife, LEPSIUS MS. 429 [middle].

Hall.

Left wall. Man writing on tablet held by youth, and grapes offered to Termuthis suckling child, with guests beyond. (Remains of weighing-scene, perhaps also here.)

HAY MSS. 29824, 1 verso–2 verso with sketch [top]; man with tablet, HAY MSS. 29816, 136; BAUD, *Dessins*, fig. 7 (from HAY), cf. p. 43.

Right wall, two registers. **I,** Deceased rewarded, and acclaimed by sons, Esamūn, Zement-efʿankh, Khensmosi, and Pedekhons, with captain of troops. **II,** Funeral procession with sarcophagus dragged by oxen with decorated horns, and priest purifying mummy held by Zementefʿankh.

[1] Piccinini's house was near tomb 161.

HAY MSS. 29824, 1 verso–2 verso with sketch, 29816, 137 (deceased rewarded); incomplete, ROSELLINI, *Mon. Civ.* cxxvi [7], cxxvii [1]; sarcophagus and oxen, LÜDDECKENS in *Mitt. Kairo*, xi (1943), pp. 158–60 [81] with Abb. 55 (from ROSELLINI); purification, WILKINSON MSS. v. 170 [middle]. Titles of deceased and names of two sons, LEPSIUS MS. 428.

Rear wall. Double-scene, deceased censes before Amenophis I and Queen ʿAḥmosi Nefertere, and libates to Amenophis I and Queen ʿAḥhotp.

CHAMP., *Mon.* cliii [2–4], ccxxxi [1]; royalties, ROSELLINI, *Mon. Stor.* xxix [1, 2], i [2]. Texts of deceased, id. ib. *Text*, iii, pl. i [21–2], facing p. 46; royal titles, WILKINSON MSS. v. 150 [bottom]; cartouches of King, LEPSIUS MS. 429 [top].

Middle Valley (Shiq el-Âteiyât) and el-Mandara

A. 19. An Hereditary prince of Thinis, Overseer of the prophets of Onuris, Trusted friend of the Lord of the Two Lands.

On north side of Valley. (CHAMPOLLION, No. 50, *Bibl.* i, 1st ed. p. 187, k.)

Titles of deceased and mention of garden-scene, CHAMP., *Not. descr.* i, p. 541.

A. 20. NAKHT 𓏏𓎛𓏥 or PANAKHⱼ 𓀾𓏏𓎛𓏥, Overseer of the granary of Amūn. Temp. Amosis.

Half-way down south slope of Valley. (CHAMPOLLION, No. 50 bis, *Bibl.* i, 1st ed. p. 187, j.)

CHAMP., *Not. descr.* i, pp. 541–2.

Hall.

Left wall, deceased with two children, and funeral procession with sarcophagus dragged by oxen, and three mummers. Right wall, prenomen of Amosis.

See id. ib. p. 542 with A (prenomen), and name and titles of deceased from ceiling.

A. 21. Name unknown.

On south side of Valley, near summit. (CHAMPOLLION, No. 48, *Bibl.* i, 1st ed. p. 187, m.)

Hall.

Left wall, funeral procession, right wall, rites before mummy, rear wall, uninscribed stela. See CHAMP., *Not. descr.* i, p. 540.

A. 22. NEFERḤABEF 𓃀𓄤𓏤𓎼𓂝, Scribe, Counter of grain.

On south side of Valley, 'on the side of a hill facing to the north' (HAY). (CHAMPOLLION, No. 49, *Bibl.* i, 1st ed. p. 186, h.)

Wife, Ési 𓊨𓏏𓆇.

HAY MSS. 29824, 20–1, 31054, 136 [14]. Name and titles of deceased and wife, CHAMP., *Not. descr.* i, p. 540 [bottom]; name of wife, ROSELLINI MSS. 284, G 60.

Hall.

Rear wall, right part, banquet, with guests, man with long flute, women with castanets, double-pipe, and harp, and male harpist.

Guest with attendant, flutist, and female musicians, HAY MSS. 29822, 46, 47; female musicians, man and child, and part of male harpist, PERROT and CHIPIEZ, *Histoire de l'art dans l'antiquité*, i, pl. xii, pp. 791–2 (called Louvre); female musicians and child, BURTON MSS. 25644, 141; female musicians, ROSELLINI, *Mon. Civ.* xcvi [4]; two (double-pipe and harp), WILKINSON, *M. and C.* ii. 232 (No. 183) = ed. BIRCH, i. 436 (No. 208); WILKINSON MSS. v. 158 [bottom left].

A. 23. PEN ASHEFI ⌂ ☐ 𓎡, Divine father of Amūn, of Mut, and of Amen-rēʿ. Great [writer?] of letters, Overseer of the treasury. Probably Ramesside.

Near last, lower down. (CHAMPOLLION, No. 49 bis, *Bibl.* i, 1st ed. p. 187, i.)

Scenes including adoration of Rēʿ, Osiris, and Ḥathor-cow, and name and titles of deceased, see CHAMP., *Not. descr.* i, p. 541.

A. 24. SIMUT ⌀𓈖𓆰 , Second prophet of Amūn, Overseer of the treasury of gold and silver, Sealer of every contract in Karnak. Temp. Amenophis III.

'On hill of Pyramid called el-Mandara, near Hammam's'[1] (WILKINSON). (CHAMPOLLION, No. 47, *Bibl.* i, 1st ed. p. 187, l.)

Wife, Baky 𓄿𓏏𓏏.

CHAMP., *Not. descr.* i, pp. 539–40, with name and titles of deceased and cartouche of Amenophis III; titles, HELCK, *Urk.* iv. 1950 [1], (from CHAMPOLLION).

Hall.

Right of door, man picking grapes with boy scaring birds, and left wall, deceased and family fishing and fowling.

WILKINSON, *M. and C.* ii. 149 (No. 136), iii. 41 (No. 336) = ed. BIRCH, i. 381 (No. 156), ii. 107 (No. 365); WILKINSON MSS. v. 215 [middle], 216, 217 [top], ii. 18 verso [right] (fishing and fowling).

Deceased inspects tribute from Wawat.

Text, id. ib. v. 215 [top]; ALDRED in *J.N.E.S.* xviii (1959), fig. 1 (from WILKINSON), cf. p. 115.

Men bringing grapes and bouquet.

Texts and titles of wife, id. ib. 215 [bottom]; name of one man, CHAMP., *Not. descr.* i, p. 540 [A].

A. 25. 'Inhabited tomb near Hammam's house.'[1] Dyn. XVIII.

Winnowing, oxen treading grain, and man with fork.
WILKINSON MSS. v. 107 [upper].

South Valley

A. 26. Name unknown. Ramesside.

'In the next valley or inlet towards the south, at the end and nearly at the top of the mountain' (HAY). (*Bibl.* i, 1st ed. p. 187, n.)

HAY MSS. 31054, 136 [near bottom].

[1] Hammam's house apparently lay below el-Mandara pyramid (Q on Wilkinson's map).

Burial Chamber. 'Pit about 30 feet deep' (HAY).

Funeral procession with boat carried by priests, standard-bearers, man carrying statue of Min, bouquet, *teknu*, Anubis with tambourine, &c. Ceiling, divine bark between deceased and Thoth.

See HAY MSS. 29824, 21–2, with sketch of rear wall.

B. *KHÔKHA AREA*

B. 1. MAḤUḤY ⊏⊐𝄐𝄐, *waʿb*-priest of Amūn in Karnak. Temp. Ramesses III.
 Below ʿAsâsîf tombs, in Birâbi.
 Father, Nezem 𝄐⊏.

 Deceased offers to Amūn and to Ament.
 See LEPSIUS MS. 262 [middle and bottom, No. 9].

B. 2. AMENNOFRU 𝄐⊐𝄐𝄐, *waʿb*-priest in front. Temp. Tuthmosis III.
 Probably near tomb 200. (CHAMPOLLION, No. 58.)
 Wife, ʿAḥmosi 𝄐𝄐.
 CHAMP., *Not. descr.* i, p. 557; ROSELLINI MSS. 284, G 48 verso, 50. Titles and name of wife, HAY MSS. 29821, 82 [lower], ('paintings destroyed since 1827').

 Hall.
 Brick arch with cartouche of Tuthmosis III. Id. ib. 82 [upper].

 Large offering-list, and on left wall, funeral procession with sarcophagus dragged, two mummers, and Fields of Iaru with obelisks.
 See CHAMP., *Not. descr.* i, p. 557. Text of mummers, ROSELLINI MSS. 284, G 50.

B. 3. HAUF 𝄐𝄐𝄐, Head of the kitchen of the estate of Amūn. Saite (?).
 North of tomb 200. (*Bibl.* i, 1st ed. p. 190, ee.)
 Father, Espaiʿoḥ-wēr 𝄐𝄐𝄐, same title.
 Names of deceased and father, LEPSIUS MS. 292 [bottom left, No. 20].

 Man offers *menat* to Ḥathor-Mertesger as cow in mountain.
 BURTON MSS. 25644, 70 verso [left]. Part of text, LEPSIUS MS. 292 [bottom right].

 Temple-pylon with door beside it, BURTON MSS. 25644, 70 verso [right].

B. 4. 'Mystical Tomb'. New Kingdom.
 '50 paces east of' tomb 109. (*Bibl.* i, 1st ed. p. 190, ff.)

 Hall.
 Men with bull, and weighing-scene with Apophis. BURTON MSS. 25644, 96, 97.
 Men making column. See id. ib. 25639, 42 verso.

Funeral procession, with lector, and with two rows of female and male mourners, censing before statue held by personified zad-pillar. Id. ib. 25644, 95 verso.

Inner Room.

Raising the zad-pillar between Anubis and Thoth, with Inmutf-priest and purification-text. BURTON MSS. 25644, 98, 99.

C. SHEIKH 'ABD EL-QURNA

On North-east Slope

C. 1. AMENḤOTP 𓇳𓎟𓊪, Overseer of carpenters of Amūn, Chamberlain. Temp. Amenophis III.

Probably at north end, near tombs 252 and 103. (L. D. Text, No. 34, Bibl. i, 1st ed. p. 193, qq.)

Father, Iuti 𓇋𓅱𓏏𓏭, Chamberlain. Wife, Tiyi 𓏏𓏭𓇋𓏭𓄿.

Plan, p. 438.

LORET, Le Tombeau de l'Am-Xent Amen-hotep in Mém. Miss. i, pp. 23–32, with plan, pl. i. Sketch of two scenes, and name of wife, WILBOUR MSS. 2 E, 2. Brick of deceased, in Berlin Mus. 1580, L. D. Text, iii, p. 250; see Ausf. Verz. p. 449.

Hall.

(1) Two registers. **I,** Remains of offering-bringers with flowers. **II,** Deceased and wife with monkey under chair, brother Neferḥōtep, warb-priest of Khons, with offering-list before them, and two rows of priests and offering-bringers in New Year Festival procession.

Monkey, and torch (held by a priest) in **II,** LORET, pl. ii [figs. 2, 4], and texts, pp. 29–31 [e]; texts of deceased and wife, and titles of two brothers, HELCK, Urk. iv. 1938 [middle].

(2) Four registers (two destroyed), each with a Son of Horus.
Texts, LORET, p. 25 [c].

(3) Two registers. **I,** Six representations of deceased with sceptres of gold and lapis-lazuli and a gold sphinx. **II,** Two rows of men bringing precious stones and ivory, craftsmen making wooden royal statue and red granite statues, and weighing gold and metal, before deceased with two attendants.

Head of deceased, and men melting metal in weighing-scene, LORET, pls. iii, ii [fig. 1], and texts, pp. 27–9 [f]; texts (restored) in **I,** and titles of deceased in **II,** HELCK, Urk. iv. 1936–8 [top]. Hieratic graffiti in **I** and **II,** LORET, pl. ii [figs. 3, 5, 6, 7], p. 31.

(4) Stela with text (mentioning Valley Festival), and scene below, priest before deceased.
Texts, LORET, pp. 25–7 [d], cf. 51–4; text of stela, PIEHL, Inscr. hiéro. 1 Sér. cv–cvii [c], cf. pp. 84–6; HERMANN, Stelen, pp. 47* [middle]–49* (from LORET).

(5) Entrance to Inner Room. Jambs, offering-texts, return walls, texts from Book of the Dead.
Texts, LORET, p. 24 [a, b, g, h].

C. 2. AMENEMḤĒT 𓈖𓏏𓄿, Noble at the head of the people. Temp. Amosis and Amenophis I.

Near top of hill, probably just north of tomb 61. (*Bibl.* i, 1st ed. p. 191, gg.)

SCHIAPARELLI, *Di un'iscrizione inedita del regno di Amenofi I* in *Trans. Int. Cong. Or.* viii (1889, Stockholm), Pt. iv, Sect. iii, p. 203.

Inner Room.

Lower part of autobiographical text, year 10 of Amosis and year 21 of Amenophis I, mentioning land of Mitanni, and water-clock with other calculations.

Id. ib. pp. 203–8; BORCHARDT, *Die Altägyptische Zeitmessung*, pl. 18 (from copy by GOLENISHCHEV), pp. 60–3; ll. 1–7, BRUNNER in *Mitt. Institut für Orientforschung* (*Deutsche Akad. der Wissenschaften zu Berlin*), iv (1956), p. 324, cf. 323–7; fragment with parts of ll. 2–5, in Berlin Mus. 14470, SETHE, *Urk.* iv. 42 (11).

Remains of deceased watching bulls fighting.
See SCHIAPARELLI, p. 203 [a].

C. 3. AMENḤOTP 𓇋𓏠𓈖𓊵𓏏𓊪, Deputy of the overseer of the seal, Scribe, and wife (?) RENNA 𓂋𓈖𓈖𓏛. Dyn. XVIII (?).

Probably near last.

Parents (of Amenḥotp), ʿAḥmosi, Overseer of the pool (?) of the King of Lower Egypt, Scribe, and Neḥ 𓄤𓏏. Father (of Renna), Sennūfer 𓊵𓏏, Overseer of the seal.

Plan, PIEHL, *Inscr. hiéro.* 1 Sér. p. 111. Texts on ceiling of Hall, id. ib. cxlii [x], cxliii [z].

C. 4. MERYMAʿET 𓏃𓇋𓇋𓆄𓂝, *waʿb*-priest of Maʿet. Dyn. XVIII.

'Behind Yanni's[1] house' (BURTON), 'tomb at the end of the lower line' (PRUDHOE), probably near tomb 69. (CHAMPOLLION, No. 31, L. D. *Text*, No. 49, *Bibl.* i, 1st ed. p. 191, hh.)

Parents, Sennūter 𓏏𓊵, *waʿb*-priest of Maʿet, and Ḥenut-sha 𓊨𓏏𓍿𓈖𓆄. Wife, Amenḥotp.

CHAMP., *Not. descr.* i, p. 520; L. D. *Text*, iii, p. 262; BURTON MSS. 25639, 41 verso–42. Titles of deceased, wife, and father, LEPSIUS MS. 305 [middle, and top right].

Hall.

Two registers. **I,** Two scenes, **1,** man offers bouquet to parents of deceased and their daughter, **2,** girls with sistra offer *menat* to deceased and wife. **II,** Deceased with wife holding fledgling inspects two rows (lower destroyed) of agriculture.

PRUDHOE MSS. Atlas, A. 19 a. **I, 1,** HAY MSS. 29852, 258–65; names and titles, CHAMP., *Not. descr.* i, p. 845 [bottom, to p. 520, l. 16]; of parents, ROSELLINI MSS. 284, G 40 (tomb attributed to father); names of mother and daughter, and of girls in **2,** LEPSIUS MS. 305 [bottom]; *menat* and text in **2,** WILKINSON MSS. v. 141 [top right]. Deceased and wife in **II,** ROSELLINI, *Mon. Civ.* cxxxiii [2]; HAY MSS. 29852, 266–7; pool, hoeing, sowing, and felling trees, WILKINSON, *M. and C.* 2 Ser. i. 46 (No. 425) = ed. BIRCH, ii. 394 (No. 468); WILKINSON MSS. v. 140 [lower middle].

Man with bouquets before deceased and wife seated, and son (?) before deceased and father, probably in Hall.

HAY MSS. 29852, 250–7, 29853, 154–5.

[1] = Athanasi. His house was above tomb 52.

Passage.

Left wall. Two registers, I and II, funeral procession, including 'Nine friends' in I and II, dragging sarcophagus, *teknu*, &c., to Western goddess in I, and men with funeral outfit and Per-nefer building in II.

PRUDHOE MSS. Atlas, A. 19 b (called tomb of Satea). 'Kites', text of 'Nine friends', men with outfit, and building, WILKINSON MSS. v. 180 [bottom], 181 [bottom right], 140 [middle]; 'kite' and building, WILKINSON, *M. and C.* 2 Ser. ii. 418 (No. 501), 1 Ser. ii. 123 (No. 114) = ed. BIRCH, iii. 449 (No. 634), i. 362 (No. 134). Female mourners in II, BURTON MSS. 25638, 71.

Right wall (?). Fields of Iaru, BURTON MSS. 25644, 83 verso, 84; WILKINSON MSS. v. 141. Rites before mummies (probably here), see id. ib. 140 [upper middle].

Niche.

Right wall, priest offers to deceased and wife seated, with offering-list and ritual. Rear wall, Eastern goddess.

Right wall, WILKINSON MSS. v. 140 [top], 141 [top left], 181 [middle lower and bottom left]. Rear wall, see id. ib. 181 [middle upper].

In Plain

C. 5. Name unknown. Probably Dyn. XVIII.

'Small tomb on south-west of Yanni's[1] without roof' (HAY). (*Bibl.* i, 1st ed. p. 192, jj.)

Hall.

Right wall. Banquet with female guests and dancing lutists.

HAY MSS. 29816, 139–40.

C. 6. I P Y 〈𓎛𓄿𓏤𓏥〉, Overseer of boats of Amūn in the Temple of Tuthmosis IV. Temp. Tuthmosis IV.

East of tomb 343. (CHAMPOLLION, No. 28, *L. D. Text*, No. 52, *Bibl.* i, 1st ed. p. 192, kk.) Mother, Tuy 𓏏𓇋𓏥. Wife, Mer(t)esger 𓈇𓏏𓆓𓏥.

CHAMP., *Not. descr.* i, pp. 518–19; WILKINSON MSS. xvii. H. 16 verso [left], giving position. Names and titles of deceased and family, *L. D. Text*, iii, p. 264; ROSELLINI MSS. 284, G 35 verso, 37; of deceased and wife, WILKINSON MSS. v. 121 [near top left]; HELCK, *Urk.* iv. 1632–3 (from CHAMPOLLION). Offering-formula on stela, CHAMP., *Not. descr.* i, pp. 518–19 [A, 'paroi de gauche'].

Hall.

Entrance wall, right of doorway. Deceased and wife, followed by son Denreg 𓈖𓂋𓎼, First prophet of Monthu, his wife Thepu 𓏏𓊪𓏥, and four sons with offerings.

Texts, LEPSIUS MS. 340 [bottom]–341 [top].

Left wall, two registers. I, Deceased before Tuthmosis IV in kiosk. II, Deceased and wife seated.

Name of wife, id. ib. 341 [near top].

[1] = Athanasi. His house was above tomb 52.

Rear wall, left part, banquet. Deceased, wife, and children, with three daughters offering bouquets to them, followed by female musicians (harp, lute, and double-pipe), and at left end sons Denreg and Piay 𓏞𓎗𓄿𓏤𓏤, First prophet of Tuthmosis IV, with attendants.

Texts, Lepsius MS. 341 [middle and bottom]; names of daughters, Champ., *Not. descr.* i, p. 519 [middle].

Inner Room.

Entrance. Outer lintel, offering-text with titles of deceased and sons Piay and Denreg. Left thickness, deceased.

Text on lintel, and titles and name of mother on thickness, Wilkinson MSS. v. 121 [middle right], 122 [right]; omitting bottom line on lintel, Lepsius MS. 342 [top, and middle lower]; names and titles on lintel, Champ., *Not. descr.* i, p. 518 [B].

Entrance wall, right of doorway (probably). Deceased and boat.
See Lepsius MS. 342 [middle upper].

Left wall. Funeral procession with sarcophagus dragged by oxen.
See Wilkinson MSS. v. 121 [near top right].

Rear wall, three statues.
Titles of deceased, Champ., *Not. descr.* i, p. 518 [A]. See Lepsius MS. 342 [near top].

C. 7. Ḥarmosi 𓄿𓏤𓏤𓏤, Head custodian of the treasury in the King's mansion on the west of Thebes. Temp. Ramesses II.

Probably near last. (Champollion, No. 27, *Bibl.* i, 1st ed. p. 192, ll.)
Wife, Mutemwia 𓂝𓄿𓎟.
Rosellini MSS. 284, G 35, 36.

Hall.

Rear wall, three registers. **I,** Deceased adores bark of Ramesses II, and adores bark of Ptaḥ-Sokari. **II,** Row of kings (Tuthmosis I–IV, Amenophis II and III) and Horus. **III,** Procession of barks, on canal with trees, to temple with statue of Amūn.

Text of Ramesses II and heads of kings, Champ., *Not. descr.* i, pp. 517–18; cartouches, Rosellini MSS. 284, G 36.

C. 8. Nakht 𓈖𓅱𓎼, Overseer of fowl-houses in the estate of Amūn. Dyn. XIX.

Probably near tomb 343. (Champollion, No. 38, *Bibl.* i, 1st ed. p. 191, ii.)
Wife, Irtnefert 𓇋𓂋𓏏𓄤𓂝.
Champ., *Not. descr.* i, pp. 532–3, with plan. Titles of deceased and names of relatives, Rosellini MSS. 284, G 51–2.

Hall.

Entrance wall, left part. Deceased inspects three registers, bringing and recording geese.
Text, Champ., *Not. descr.* i, p. 850 [to p. 532, last line].

Deceased and family fowling, and scenes of netting and preparing fowl, and agriculture.
See id. ib. p. 533 [top].

Inner Room.

Banquet with girl offering cup to deceased and wife.
See id. ib. p. 533 [near top].

C. 9. **Name unknown.**

Tomb adjoining tomb 342 on south. (*Bibl.* i, 1st ed. p. 192, nn.)

Draughts-playing scene, and representations of three vases, one with head of ibex, see HAY MSS. 29852, 242–3.

C. 10. PENRENNU ⬚ , Scribe of the offering-table. Dyn. XVIII.

Near tomb 124. (*Bibl.* i, 1st ed. p. 193, rr.)

Entrance. Thicknesses, hymns to Rēꜥ.
PIEHL, *Inscr. hiéro.* 1 Sér. cxxiv [L], cf. p. 101.

C. 11. NEBSENY , Overseer of the goldworkers of Amūn, Overseer of all works of silver and gold. Temp. Tuthmosis III (?).

Just east of tomb 123. (L. D. *Text*, No. 86, *Bibl.* i, 1st ed. p. 193, oo.)
Mother, Teti . Wife, Tanefert .
L. D. *Text*, iii, pp. 286–7, with texts of spearing hippopotamus, and of recording cattle.

C. 12. MAḤU , Overseer of the gate.

East of tomb 57. (*Bibl.* i, 1st ed. p. 207 'unnumbered'.)
Texts copied by SETHE, Heft 12, 112.

C. 13. **Name unknown.**

Below tomb 96. (L. D. *Text*, No. 73.)
Procession with people holding palm-branches, and female dancers.
See L. D. *Text*, iii, pp. 279–80.

C. 14. ꜥANKHEFENDḤOUT , good name NEFER[EB]RĒꜥ-SONB . Saite.

Probably near tombs 390–1.
Remains of text in Court, WILKINSON MSS. v. 176 [bottom right].

C. 15. An Overseer of the Two Houses of gold, Overseer of the Two Houses of silver. Dyn. XVIII.

Probably in Plain.
Titles of deceased and name of Neferweben , son of ꜥAmethu (tomb 83), LEPSIUS MS. 352 [middle and bottom, No. 61].

D. *QURNET MURA'I*

D. 1. NEḤI [hieroglyphs], Viceroy, Governor of the South Lands. Temp. Tuthmosis III.

Below the hill. (*Bibl.* i, 1st ed. p. 194, uu.)

Sarcophagus, in Berlin Mus. 17895. Texts, *Aeg. Inschr.* ii. 597–601; titles, SETHE, *Urk.* iv. 982–3 (284) A, a–c.

Sandstone pyramidion with deceased kneeling, in Florence Mus. 2608. WILKINSON MSS. v. 173 (seen on spot). One face, SCHIAPARELLI, *Il Significato simbolico delle piramidi egiziane* in *Reale Accad. dei Lincei. Atti:* Classe di Scienze Morali [&c.], *Memorie,* 3 Ser. xii (1884), pl. at end [1]. Texts, SCHIAPARELLI, *Mus. . . . Firenze,* i, pp. 420–1 [1676]; titles, BRUGSCH, *Thes.* 1448 [65]; SETHE, *Urk.* iv. 983 (284) B, d, e. See ROSELLINI, *Breve Notizia degli oggetti di antichità egiziane* [&c.], p. 41 [45]; MIGLIARINI, *Indication succinte des monuments égyptiens du Musée de Florence,* pp. 48–9.

D. 2. PETERSUEMḤEBSED [hieroglyphs]. New Kingdom.

'Tomb below the hill.'

Scenes with Amenophis I and ʿAḥmosi Nefertere, and Ptaḥ-Sokari. Names, WILKINSON MSS. v. 173 [bottom].

D. 3. MAḤU [hieroglyphs], Steward of Dyn. XVIII (?).

Near tomb 382.

Painted scenes in Burial Chamber. See BRUYÈRE, *Rapport (1931–1932),* p. 91 [bottom].

ADDENDUM

409. SIMUT [hieroglyphs], called KYKY [hieroglyphs], Scribe, Counter of cattle of the estate of Amūn. Temp. Ramesses II.

ʿAsâsîf. Adjoining tomb 408 on east side.

Wife, Raʿiay [hieroglyphs].

Plan, p. 462. Cf. Map IV, D–5, c, 6.

To be published by Abdul-Qader Muhammed in *Ann. Serv.*

Façade.

(1) Stela. Deceased offers bouquet to Rēʿ-Ḥarakhti and Maʿet, with hymn to Amen-rēʿ-Ḥarakhti below.

(2) Stela. Deceased and wife offer bouquet to Osiris and Isis, with hymn to Amen-rēʿ-Ḥarakhti below.

Hall.

(3) Outer lintel, double-scene, deceased and wife adore Osiris and Isis, and adore Rēʿ-Ḥarakhti and Maʿet. Left thickness, deceased with hymn to Rēʿ-Ḥarakhti, and harpist with song before deceased and wife below. Right thickness, deceased with hymn to Osiris.

(4)–(6) Three registers. I and II, Deceased adores Mut with long hymn, in each. III, Agricultural scenes at (4), priest offering to couple, and men and women facing in, at (5), three offering-scenes, 1–3, priest before deceased and wife (with candle in 2) at (6), continued at (7).

(7) Three registers. I, Deceased offers four calves to Amen-rēꜥ, with two scenes of Ramesses II adoring Amen-rēꜥ on sides of kiosk. II, Two scenes, 1, deceased kneeling before Ptaḥ-Sokari, 2, deceased and wife before Osiris and Isis. III, continued from (6).

(8) Two registers. I, Book of Gates, with deceased and wife before gates. II, Deceased inspects two rows of cattle.

(9) Two registers. I, Remains of banquet. II, Funeral procession, continued at (10).

(10) Two registers. I, Judgement scene including ꜥAmmet, and deceased and wife before Osiris. II, continued from (9).

Frieze. Deceased and wife adore Anubis, and adore Ḥathor-head.

Inner Room.

(11) Outer jambs, deceased seated at bottom. Thicknesses, deceased offering bouquet to Osiris.

(12) Two registers, unfinished. I, Raising zad-pillar. II, Tree-goddess scene.

(13) Mummy on couch with six priests (two wearing masks of Anubis and hawk), and six female mourners.

(14) Two registers, unfinished. I, Offering-scene before Rēꜥ-Ḥarakhti. II, Deceased (?) with three women led by Horus to [Osiris].

(15) and (16) Zad-pillar at each.

(17) Niche. Four statues (from left to right), wife, deceased, Mery ⸗, and Tutuia .

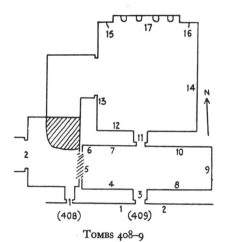

TOMBS 408–9

APPENDIXES

A. CLASSIFICATION OF SELECTED SCENES

Numbers refer to tombs, not to pages.

SUMMARY OF SECTIONS

1. King with deceased before him.
2. King without deceased.
3. Deceased kings and/or queens.
4. Royal family.
5. Foreigners.
6. Military scenes.
7. Deceased inspecting.
8. Deceased in office.
9. Acclamation of deceased.
10. Ships.
11. Chariots or carts.
12. Buildings.
13. Crafts.
14. Market or barter.
15. Agriculture.
16. Vintage.
17. Marsh-scenes.
18. Bringing and breeding animals and fowl.
19. Animals, birds, &c.
20. Hunting.
21. Sport.
22. Games.
23. Toilet-scenes.
24. Musicians.
25. Dancers and tumblers.
26. Deceased offers to relatives, &c.
27. Deceased meets relatives.
28. Deceased performs ritual.
29. Special offerings, &c.
30. Divine barks and emblems.
31. Funeral scenes and rites.
32. Festivals.
33. Deceased receives New Year gifts.
34. Bouquet of Amūn, &c.
35. Religious and mythological scenes.
36. Book of the Dead.
37. Astronomical ceilings.
38. Texts.
39. Decorative features.
40. Special people.
41. Unusual scenes and details.

1. King with deceased before him

(a) **Receives gifts.** 47, 48 (4), (7), 63 (10), 73 (2), (3), 75 (3), 76 (5), 77 (4), 92 (7), 93 (9), 96 (6), 192 (8), 226 (4).

(b) **Receives foreigners and tribute.** 40 (7), (11), 42 (5), 74 (11), 78 (8), 84 (5), (9), 85 (17), 86 (8), 89 (15), 90 (9), 91 (3), (5), 143 (6), 239 (2)–(3), 256 (3), *see also* Sects. 5, 7 (a).

(c) **Receives produce or reports on crops.** 57 (11), 86 (8), 101 (5), 188 (3), (5), 367 (5), *see also* Sect. 7 (b).

(d) **Rewards or appoints.** Rewards or decorates, 23 (18), 49 (7), 50 (2), 55 (12), 57 (15), 75 (3), 93 (17, text only), 106 (5), 148 (4), (5), 188 (9), 192 (6), 217 (2). Appoints, commissions, receives reports, &c., 40 (8), 90 (4), 93 (17), 99 (3), (5), 100 (5), 131 (8), 157 (8).

(e) **Receives bouquet.** 43 (3), (4), 56 (9), 64 (8), 78 (4), 110 (9), 116 (2), 161 (7), 162 (4), 172 (3), 188 (12), 367 (5); 'of Amūn', &c., 31 (15), 55 (7), 72 (5), 74 (6), 75 (3), 86 (8), 88 (4), 90 (9), 110 (4); from wife of deceased, 85 (9); *see also* Sect. 34. Full-blown papyrus, 64 (5), 91 (3), (5).

(f) **Adored, &c. (not cult).** 28 (1), 41 (16), 42 (11), 55 (13), 58 (5), (8), 60 (3), 77 (7), 90 (4), 101 (7), 106 (B), 123 (2), 157 (6), 188 (9), 200 (3), 216 (13), 222 (2), (3), 256 (5), 277 (7), 341 (6)–(7), 368 (3), A. 14, C. 6.

(g) **King (or Nitocris) accompanied by deceased in ritual scenes.** 7 (9), 85 (16), 131 (9), 188 (10), 216 (6)–(8), 279 (2), (12), (17), 323 (Finds), 390 (5).

2. King without deceased

(a) **Enthroned or standing.** 48 (6), 63 (5), 86 (2), 120 (3), 183 (1), 206 (2).

(b) **Before divinities or deified kings.** 4 (6), 10 (6), 23 (22), 34 (1), 36 (5), 48 (1), (3), (Finds), 188 (1), 192 (2), (3), (4), (7), (9), 255 (5).

(c) **Protected.** By goddess, 2 (11), 48 (3), 148 (4). By Hathor-cow, 2 (16), (Pyramid), (17), 4 (8), 19 (4), 23 (43), 49 (22), 216 (18), 285 (10), 298 (1), 326 (Chapel), 341 (2)–(4), 377 (2), 387 (Court), 389 (11). By hawk, 31 (4)–(6), 73 (2).

(d) **Before divine barks.** 65 (3), (4), (7), 216 (6)–(8).

(e) **Cult-statues of living king,** *see also* Sect. 3 (a). Among gifts, in treasury, or workshops, 48 (7), 66 (2), 73 (2), (3), 75 (3), 76 (5), 92 (7), 93 (9), 96 (6), 100 (7), (14), 106 (6), C. 1 (3); in funeral procession, 42 (14), 60 (5)–(6), 63 (11)–(12), 82 (10), 92 (14), 121 (8), 247 (3); in festivals and processions, 53 (5), 65 (7), (8)–(9), 148 (4), 216 (6)–(8), 277 (2)–(3); adored by deceased, 112 (7), 158 (15).

(f) **Royal barks.** 93 (3), 121 (7), C. 7, *see also* Sect. 3 (b).

(g) **Various.** Hunting, 72 (4), 143 (5). Slaying foes, 48 (4), 57 (11), (15), 73 (3), 78 (8), 120 (3). Suckled by Ḥathor-cow, 106 (C).

3. Deceased kings and/or queens

(a) **Cult.**
1. Amenophis I and/or 'Aḥmosi Nefertere, alone or with divinities; *see also* Indexes 1, 2. Adored by deceased, 2 (3), (24), 4 (7), 10 (Chapel, frieze), (6), 16 (6), 19 (6), 23 (24), 44 (5), 49 (C), 54 (5), 106 (B), 113 (2), 134 (8), (14), 141 (6), 149 (6), 161 (6), (7), 178 (2), 181 (6), 194 (7), 210 (1), 219 (5), (8), 250 (6), 285 (10), 296 (2), 300 (6), 302 (3), 306 (2)–(4), 332 (4), 344 (7), 375 (1), A. 8, A. 12, A. 18, D. 2; without deceased, 23 (44), 134 (2), 335 (26), 357 (3), 359 (9)–(10), 360 (Finds), 377 (2), 384 (2); statues carried by priests, 2 (9), (11), 14 (5), 19 (7), 65 (8)–(9), 344 (8); with other kings and/or queens, 2 (12), (25), 4 (8), 7 (3), 10 (6), 51 (9), 153 (1), 277 (3), A. 18; before divinities, 5 (Ch. B, ceiling), 15 (1), 255 (5), 290 (2), 384 (2), *see also* Sect. 2 (b).
2. Other kings and/or queens. 2 (12), (25), 4 (8), 7 (3), 10 (6), 31 (15), 41 (16), 51 (9), 53 (6), 89 (B), 153 (1), 266 (4)–(5), 277 (3), (7), 284 (5), A. 18; statues adored or in procession, 2 (Pyr.), 14 (1), 19 (4), 51 (5), 76 (5), 277 (2)–(3), 284 (5).

(b) **Festivals with barks.** 19 (3)–(4), 31 (4), (8), 51 (5), *see also* Sect. 32.

(c) **Rows of kings and queens.** 2 (10), 19 (4), 65 (4), 284 (2)–(3), 306 (5), 359 (4), C. 7; supporting Nefertem-emblem, 23 (31)–(32), 45 (3).

4. Royal family

Harîm, *see* Sect. 12 (d)

(a) **Queen.** Accompanies king, 13 (2)–(3), 47, 49 (7), 51 (9), 55 (13), 72 (5), 76 (5), 120 (3), 157 (8), 188 (1), (9), (12), 192 (2), (3), (5), (6), (7), (8), (9), 226 (4), 255 (5), 277 (2)–(3), (7), 279 (12), 284 (5), (7), 300 (6), A. 18, *see also* Sect. 3. Receives offerings, 53 (6), 65 (6), 125 (9). Rewards wife, 49 (6).

(b) **Child-king suckled or nursed by goddess.** 48 (3), 57 (8), 73 (3).

(c) **Children with nurses or tutors.** 63 (17), 64 (2), (3), (7), 78 (6), 85 (16), (B), (C), 93 (16), 109 (5), 226 (5), 252 (statue), 350 (3).

(d) **Princes and princesses.** 2 (10), 161 (7), 192 (5), (7), 284 (2), 359 (4).

(e) **Concubines.** 69 (2), 78 (6), 90 (1), (6), 139 (1).

5. Foreigners

See also Sects. 1 (b), 7 (a), 25, 40 (b)

(a) **Nubians.** Captives or with tribute, 20 (4)–(5), 39 (5), 40 (2), (6), 48 (7), 63 (9), 65 (2), 78 (8), 81 (5), 84 (5), 89 (15), 91 (3), 100 (4), (13); soldiers, 74 (5), 78 (8), 91 (5); delegates, 55 (12); workmen, 100 (14), 261 (1), 349 (2); individuals, 22 (4), 113 (4), 130 (8), 135 (1)–(2), 155 (4); princess, 40 (6).

(b) **Puntites.** 39 (11), 89 (14), 100 (4), 143 (6).

(c) **Libyans.** 48 (7), 55 (12), 120 (3).

(d) **Syrians.** 17 (7), 39 (12), 40 (11), 42 (4), (5), 55 (12), 63 (9), 74 (11, vase), 78 (8), 81 (5), 84 (9), 85 (17), 86 (8), 89 (15), 90 (9), 91 (5), 99 (5), 100 (4), (13), (14), 118 (1), 119 (1), 131 (11), 155 (3), 162 (1), 239 (2)–(3), 256 (3), 261 (1), 276 (4).

(e) **Hittites.** 86 (8), 91 (5), 100 (13), 120 (3).

(f) **Keftiu.** 39 (12), 71 (3), 85 (17), 86 (8), 93 (9), 100 (4), 119 (1), 120 (3), 131 (11), 155 (3).

(g) **Others.** 'Apiru, 39 (8)–(9), 155 (5); Kadesh, chiefs, 86 (8); Lebanon, chief, 42 (4); Mennus, 85 (17), 93 (9); Mitanni, chief, 91 (5); Retenu, 39 (11), 40 (11), 85 (17); Tunip, chief, 86 (8).

(h) **Name-rings, captives, &c.** 48 (7), 49 (7), 57 (11), (15), 58 (8), 63 (10), 64 (5), (7), (8), 77 (4), 78 (8), 93 (9), (16), 192 (8), 216 (8), 217 (2), 226 (4); with *sma*-emblem, 155 (7).

(i) **Nine Bows.** 42 (5), 47, 48 (4), 55 (7), 57 (11), (15), 63 (5), 74 (6), 120 (3), 192 (8), 367 (5).

(j) **As decoration.** 40 (6), 65 (2).

6. Military scenes[1]

See also Sects. 5 (a), 24 (g)

40 (8), 42 (4), 56 (8), (11), (13), 63 (4), 71 (2), 72 (4), 74 (5), (10), 77 (7), 78 (4), (8), 85 (2), (8), 88 (1), (3), 89 (14), (15), 90 (3), (4), (8), (9), 91 (3), (5), 93 (9), 99 (5), 100 (4), (8), 131 (9), 143 (6), 200 (3), 201 (7), (9), 239 (6), 342 (2); police, 90 (6).

7. Deceased inspecting

(a) **Foreign tribute and produce.** 17 (7), 39 (5), (11), (12), 40 (2), (6), (11), 42 (4), 63 (9), 65 (2), 71 (3), 80 (8), 81 (5), 86 (6), 89 (14), 100 (4), 127 (7), 130 (8), 131 (4), (11), 143 (6), 155 (3), 162 (1), 276 (3), (4), A. 24, *see also* Sects. 1 (b), 5.

(b) **Egyptian produce.** 17 (4), 22 (1), 39 (3), 40 (1), (3), 63 (7), 66 (6), 75 (2), 79 (5), 81 (4), 85 (3), (30), 86 (6), 88 (1), 92 (5), (6), 96 (11), 97 (2), 100 (2), (6), (10), (13), 103

Numbers refer to tombs, not to pages.
[1] See Faulkner in *J.E.A.* xxvii (1941), pp. 12–18.

(14), 109 (5), 110 (1), 131 (6), (7), 188 (3), 241 (1), 253 (2), 254 (4), 343 (8), *see also* Sects. 1 (*c*), 15, 16, 17 (*d*), 18 (*a*); of Oases, 39 (11), 86 (8), 127 (2), (6), 155 (3).

(*c*) **Workshops and treasure.** 39 (3), (6), (12), 49 (15)–(16), 66 (2), 73 (3), 75 (1), 79 (1), 81 (3), 86 (5), 95 (5), 99 (2), (4), 100 (7), (14), 103 (14), 106 (6), 125 (6), 178 (11)–(12), 181 (6), 343 (3), *see also* Sect. 13.

(*d*) **Various.** Provisions for troops, workmen, &c., 85 (2), (3), 88 (1), 100 (7), (13), (19), *see also* Sect. 6; officials bringing weapons, 155 (4); registration of slaves, 49 (15)–(16), 100 (13); building of sacred bark, 109 (4); funeral outfit, 49 (8), 79 (7), 85 (20), 96 (27)–(28), 99 (8), 100 (7), *see also* Sect. 31 (*g*).

(*e*) **Special products.** Precious stones, 40 (7), (11), 42 (4), 86 (5), (6), (8), 100 (4), 131 (11), C. 1 (3); gums and incense, 63 (8), 89 (4), 143 (6), 254 (4), A. 4; incense-trees from Punt, 100 (4), 143 (6); honey, *see* Sect. 15 (*d*).

8. Deceased in office

Reception of officials, 39 (12), 55 (12), 90 (6), 100 (2), (17), 107 (2). Judgement-hall of Vizier, 29 (4), 100 (2), 106 (8), 131 (6), *see also* Sect. 38 (*a*). Official return, 40 (1), (5), 41 (17), 99 (5), 100 (17), 143 (6), *see also* Sect. 9.

9. Acclamation of deceased

On reward or appointment, 23 (3), 40 (8), 49 (6), (7), 50 (2), 51 (3), 55 (12), 106 (5), 148 (4), 188 (8), A. 18, *see also* Sect. 1 (*d*). On return home, 40 (6), 41 (17), 100 (17). At purification of deceased, 42 (3), 55 (9), 57 (20), 85 (B), 96 (G), 125 (20). At festivals, &c., 19 (3), (7), 93 (3), 109 (3), 113 (1), 134 (5), 135 (7), 158 (4), 192 (5), 284 (6).

10. Ships

Canoes, boats, &c., *see* Sects. 17, 21, 35 (*b*). Royal and divine barks, *see also* Sects. 2 (*d*), (*f*), 3 (*b*), 28 (*f*), 30 (*a*), (*b*), 32 (*a*), (*b*).

(*a*) **Transport.** 33 (8), 40 (1), (5), 41 (17), (19), 49 (15)–(16), 53 (4), 67 (1), 78 (blocks), 90 (3), 100 (17), 103 (various), 106 (A), 121 (7), 143 (4), 151 (6)–(7), 157 (16), 216 (16), 239 (6), 268 (1), 292 (2), 302 (4), 311 (Chapel), 324 (7), 338 (3), 366 (1), (E), (H), (I), 371 (2), 378 (1)–(2), C. 6 (Inner Room). Freight-ships, 40 (3), 57 (9), 69 (2), 80 (4), (10), 100 (14), 130 (8), 155 (Hall, fragments), 162 (1), 192 (7), 217 (5), 253 (2), 261 (1), 297 (1); sailing-rafts, 143 (6). War-ships, 31 (4)–(6), 93 (12). Syrian, 17 (7), 162 (1).

(*b*) **In processions and festivals.** 19 (3), (4), 31 (4)–(6), 134 (5), 216 (6)–(8), 277 (2)–(3), 284 (6), 342 (2), C. 7; in funeral procession, 14 (3), 36 (17), (21), 44 (11), 49 (8), 54 (6), 56 (16)–(18), 57 (18)–(19), (21)–(22), 59 (2), 69 (9), 85 (22), 112 (8), 133 (1), 135 (1)–(2), 138 (1)–(3), 141 (6)–(7), 159 (1), 165 (2), 176 (2), (7), 181 (4), (5), 222 (7), 254 (2), 259 (1), 275 (4), 276 (10), 279 (3)–(4), 319 (block), 347 (2), 397 (2), *see also* Sect. 31 (*c*); carried or dragged by gods or priests, 31 (6), 33 (41), 65 (3), (7), 158 (3), (17)–(18), (20)–(21), 165 (2), 192 (5), 216 (6)–(8), (17), 224 (5), 284 (6), 347 (3), A. 26.

(*c*) **Various.** Boat-standard, 78 (4), 90 (4), (9), 200 (3); model ship, 139 (4).

11. Chariots or carts

See also Sects. 13 (*b*), 20

Daily use, 11 (7), 23 (3), 36 (20), 39 (3), 41 (17), 49 (6), 51 (3), 57 (13), 69 (2), 75 (4), 80 (10), 89 (14), 90 (3), (9), 143 (6), 155 (10), 297 (1), 302 (1). In funeral scenes, 34 (6), 36 (21), 56 (16)–(18), 57 (21)–(22), 63 (11)–(12), 78 (9), 85 (22), 121 (8), 151 (8), 172 (5)–(6), 324 (8). As tribute, 40 (7), 42 (4), (5), 73 (3), 84 (9), 86 (8), 89 (15), 93 (9), 100 (4), 155 (3). Drawn by ox, 17 (7), 40 (6), 125 (7); by mule,[1] 57 (13), 297 (1).

12. Buildings

(*a*) **Temples.** 2 (5), 16 (3), (5), 19 (3), (4), (7), 31 (6), (8), (13), 41 (20), 49 (15)–(16), 51 (3), (5), 55 (11), 65 (6), 75 (3), (6), 90 (8), 93 (3), 96 (4), 106 (6), 131 (9), 134 (5), 138 (1)–(3), 147 (14), 153 (1), 158 (4), 189 (2), 215 (2), 216 (6)–(8), 334 (6), B. 3, C. 7.

(*b*) **Granaries.** 17 (4), 18 (1), 48 (3), 54 (5), (6), 60 (2), 63 (7), 88 (1), 96 (10), (11), 101 (6), 103 (10), 120 (1), 186 (3), 188 (3), 241 (1), 253 (2), 254 (4), 284 (7), 308 (sarcophagus), 324 (4).

(*c*) **Storehouses, treasury, &c.,** *see also* Sect. 8. 23 (4), 41 (1), 49 (15)–(16), 56 (10), 65 (8)–(9), 69 (7), 78 (4), 81 (11), 85 (2), 86 (7), 88 (1), 96 (19), 100 (13), (14), 104 (5), 112 (8), 143 (3), 155 (5), (7), 178 (11)–(12), 254 (4), 256 (6), 284 (6), 302 (1), 341 (7), A. 4, C. 4; threshing-floor, 57 (5), 266 (2); weaving-shed, 133 (1); wine-store, *see* Sect. 16; cattle-stalls, *see* Sect. 18 (*b*).

(*d*) **Palace.** 49 (6), (7), 55 (13), 65 (6), 88 (1), 157 (8), 188 (3), 192 (5), 217 (2), A. 14.

(*e*) **Houses.** 21 (8), 23 (3), 25 (4), 40 (6), 41 (17), 49 (6), 72 (3), 80 (10), 81 (11), 87 (8), 90 (3), (8), 93 (15), 96 (4), 104 (5), 217 (2), 254 (6), 302 (1), 334 (6), A. 4.

Numbers refer to tombs, not to pages.

[1] Also in wall-painting from Theban tomb, Brit. Mus. 37982.

(*f*) **Tombs,**[1] *see also* Sect. 31 (*a*). Pyramidal, 2 (Bur. Ch. ceiling), 4 (3), (Finds), 9 (2), 10 (1), (4), 14 (3), 19 (4), (5), (6), (7), 23 (31)–(32), 25 (3), 30 (2), 31 (7), 32 (13)–(14), 41 (14), (A), 44 (7), 45 (3), 49 (8), 51 (3), 54 (7), 106 (F), 113 (3), 135 (6), 138 (1)–(3), 158 (8), 159 (2), 178 (5)–(7), 216 (18), 217 (2), 218 (1), 219 (3), (11), 233 (1), 250 (6), 255 (2), 257 (1), 259 (2), 277 (2)–(3), 284 (4), 286 (6), 289 (21)–(22), 291 (1), 296 (5), 333 (7), 335 (6), 335 (Passage, ceiling), 336 (Ch. B, ceiling), 338 (2), 341 (2)–(4), 360 (A), (7), 362 (2), 379 (2)–(3). Others, 14 (3), 35 (7), 41 (1), 54 (6), 55 (5), (6), 57 (21)–(22), 82 (10), 93 (3), 104 (8), 157 (Pyramid), 158 (20)–(21), 161 (5), 181 (5), 219 (Bur. Ch. ceiling), 249 (2), 282 (6), 290 (Bur. Ch. ceiling), 336 (12), 343 (10), 359 (11), 399 (1), 406 (2).

(*g*) **Forts.** 40 (8), 42 (4), 65 (2).

13. Crafts

(*a*) **Carpenters, sculptors, metal-workers, vase-makers, jewellers, &c.** 17 (3), 36 (8), 39 (3), 41 (20), 49 (8), (15)–(16), 63 (9), 65 (5), 66 (2), 75 (1), 86 (5), 93 (B), 95 (5), 100 (14), 103 (16), 106 (6), 125 (6), 131 (3), 172 (9), 178 (11)–(12), 181 (6), 217 (6), 276 (6), 366 (6), B. 4, C. 1 (3), *see also* Sect. 7 (*c*).

(*b*) **Others.** Boat-builders, 34 (Reliefs), 36 (8), 82 (8), 360 (4), 366 (5), *see also* Sect. 7 (*d*); brick-makers, 100 (14); chariot-makers and leather-workers, 36 (8), 39 (3), 60 (10), 65 (5), 66 (2), 67 (3), 75 (2), 86 (5), 95 (5), 100 (14), 155 (Hall, fragment), 276 (6); dyers, 254 (6); laundry-workers, 217 (2); net-makers, 73 (1), 217 (5); rope-makers, 100 (14), 261 (1); stone-hauling, 100 (14); tomb-workers, 154 (1), 368 (3); weavers and spinners, 49 (15)–(16), 103 (3), (9), 104 (5), 133 (1), 279 (C); makers of funeral outfit, 41 (20), 49 (8), 112 (10), 217 (6).

(*c*) **Weighing metal, &c.** 18 (3), 36 (8), 39 (6), (12), 40 (2), 65 (8)–(9), 75 (1), 80 (8), 81 (3), 86 (5), (6), 95 (5), 100 (2), (14), 103 (14), 106 (6), 131 (6), (7), 155 (4), 172 (9), 178 (11)–(12), 181 (6), 254 (4), 343 (3), C. 1 (3).

(*d*) **Butchers.** In scenes of offering on braziers, 15 (6), 22 (1), 38 (2), 45 (5), 49 (A, B, D), 52 (1), 55 (3), (8), 57 (7), 64 (6), 69 (5), 72 (1), 74 (2), (7), 79 (3), 80 (4), 88 (5), 89 (9), 108 (2), 109 (3), 151 (3), 162 (3), 165 (1), 172 (1), 181 (2), 256 (4), 295 (4), 367 (1), (4). In offering-list ritual, 33 (3), 48 (2), 66 (3), 78 (12), 100 (19), A. 4. For banquet, &c., 60 (10), 78 (6), 79 (8), 90 (6), 93 (B), 109 (9), 112 (5), 318 (5), 366 (2). In funeral scenes, 19 (4), 20 (4)–(5), 29 (9), 33 (24), (25), 42 (15), (16), 53 (13), 60 (4), 69 (9), 72 (8), 80

(10), 84 (13), 87 (8), 92 (16), 100 (15), 104 (10), 122 (7), 172 (5)–(6), 175 (2), 179 (2), 222 (7), 260 (4), 277 (2)–(3), 347 (2), 367 (3), A. 4. In other scenes, 7 (7)–(8), 34 (Chapel C), 34 (14), 39 (21), 57 (10), 60 (12), (14), 79 (2), 87 (3), 90 (8), 92 (5), 93 (3), 96 (10), 103 (Fragments), 112 (6), 172 (11), 192 (7), 251 (2), 253 (8), 308 (4), 341 (5)–(7), 388 (4)–(7), A. 2.

(*e*) **Preparation of food and drink,** *see also* Sect. 16.

Baking and brewing, 17 (4), 40 (4), 49 (15)–(16), 53 (9), (10), 59 (3), 60 (10), 92 (2), 93 (B), 100 (7), (13), 103 (11), (12), 104 (5), 154 (1), 318 (5). Cooking, 59 (3), 60 (10), 79 (8), 93 (B), 100 (7), 103 (11), 178 (11)–(12), 254 (6), 302 (1), 311 (Chapel), 334 (1), 360 (4), 366 (2), 386 (3). Weighing meat, 217 (2). Various, 22 (6), 49 (6), 56 (10), 57 (13), 60 (10), 78 (4), 82 (14)–(15), 85 (2), 92 (2), (6), 100 (19), 110 (1), 112 (5), 145 (2), 178 (11)–(12), 260 (2), 311 (Chapel).

(*f*) **Preparation of gums, incense, or ointment.** 89 (4), 93 (J), 175 (4), *see also* Sects. 7 (*e*), 29 (*c*).

14. Market or barter

54 (5), 57 (9), 89 (14), 143 (6), 162 (1), 217 (5), 366 (H), A. 4.

15. Agriculture

Including ploughing, sowing, tilling, reaping, winnowing, threshing, counting, transporting, and storing corn. For vintage and marsh-produce, *see* Sects. 16, 17.

(*a*) **General.** 15 (4), 16 (4), 17 (4), 18 (1), 21 (4), 23 (26), 24 (3)–(4), 34 (Reliefs), 36 (20), 38 (3), 39 (3), 41 (17), 52 (1), 53 (4), 54 (5), (6), 56 (3), 57 (8), (13), 59 (5), 60 (7), (8), 63 (14), 69 (2), 81 (14), (15), 86 (1), 88 (1), 96 (11), 100 (8), 101 (6), 103 (10), 121 (2), 125 (7), 127 (2), (3), 143 (4), 144 (2), 146, 147 (5), 162 (4), 172 (7), (8), (9), 175 (4), 176 (2), 186 (3), 188 (3), 200 (9), 212 (1), 217 (5), 241 (1), 251 (5), 253 (5), 254 (1), 255 (1), 260 (2), 266 (2), 302 (1), 311 (Passage), 318 (4), 324 (4), 333 (8), 334 (6), 341 (5)–(7), 342 (2), 345 (4), 349 (2), 360 (4), 366 (B), 409 (4), A. 25, C. 4, C. 8.

(*b*) **Gardens.** 13 (9), 25 (4), 39 (3), 49 (6), (15)–(16), 63 (16), 80 (10), 81 (11), 85 (30), 87 (8), 93 (15), 93 (B), 96 (4), 100 (19), 103 (1), 109 (4), 138 (1)–(3), 161 (3), 201 (6), 217 (2), 334 (6), A. 19, *see also* Sect. 31 (*h*).

(*c*) **Pools (not in gardens).** 14 (1)–(2), 19 (4), 41 (17), 51 (5), 90 (8), 93 (16), 216 (6)–(8), (16), 360 (4), *see also* Sect. 35 (*b*), and Mehit-wert-cow in Index 3.

[1] See Davies (Nina) in *J.E.A.* xxiv (1938), pp. 25–40.

(d) **Bee-keeping and honey.** Bee-keeping, 73 (1), 279 (C); preparing honey, 100 (13); bringing honey, 69 (2), 92 (2), 93 (11), 100 (2), (6), (10), 101 (5), 131 (4), 155 (11), 277 (2)–(3), 305 (3), A. 5.

(e) **Various.** Felling trees, 16 (4), 52 (1), 53 (4), 57 (13), 67 (1), 217 (6), 251 (5), 254 (1), 341 (5), C. 4. Picking fruit, 188 (6), 279 (C), 366 (A). Measuring crop with cord, 38 (3), 48 (3), 57 (8), (13), 69 (2), 75 (2), 86 (1), 96 (11), 100 (8), 143 (4), 253 (2), 297 (3).

(f) **Special details.** Pigs treading grain, 24 (3)–(4), 146. Goats browsing, 217 (5), 266 (2), 366 (A), 402. Bird-scaring, 217 (5), 284 (7), A. 24. Shadûf, 49 (15)–(16), 138 (1)–(3), 217 (2). Watering garden, 60 (2), 82 (8), 93 (B), 103 (1)́, 161 (3), 217 (2), 302 (2).

16. Vintage

Including picking, treading, straining, and filling jars. For offerings to Termuthis, *see* Index 3.

11 (13), 15 (8), 18 (6), 22 (5), 24 (8), 39 (8)– (9), 49 (15)–(16), 52 (6), 53 (7), 56 (13)–(15), 60 (2), 66 (8), 77 (12), 79 (5), 81 (8), 82 (8), 86 (7), 88 (5), 90 (8), 92 (10), 96 (4), 100 (10), 103 (1), 127 (11), 155 (5), 157 (16), 158 (20)– (21), 165 (4), 172 (8), 188 (4), (5), 200 (2), 217 (5), 256 (2), 261 (1), 276 (8), 279 (D), 318 (6), 342 (7), A. 5, A. 24. Sealing jars, 39 (8)– (9), 92 (10), 172 (8), 188 (4), 261 (1), A. 5. Wine-store, 49 (15)–(16), 86 (7), 155 (5). Wine-tasting, 155 (5).

17. Marsh-scenes

(a) **Deceased fishing and fowling from canoe.** 11 (13), 18 (6), 22 (5), 23 (7), 24 (8), 32 (10)–(11), 34 (Reliefs), 39 (8)–(9), 42 (9)– (10), 52 (6), 53 (7), 56 (13–15), 60 (8), 63 (15), 66 (9), 69 (12), 72 (6), 73 (1), 77 (11), 78 (13), 79 (4), 80 (2), 81 (8), 82 (8), 84 (17), 85 (27), 89 (2), 91 (2), 92 (11), 93 (20), 96 (14), 100 (11), 104 (6), 109 (11), 123 (7), 125 (2), 127 (11), 155 (5), 157 (15), 158 (20)–(21), 164 (7), 165 (4), 172 (4), 186 (1), 200 (1), 216 (9), 217 (5), 241 (6), 256 (2), 318 (6), 331 (2), 342 (7), 345 (7), 386 (3), 405 (3), A. 5, A. 24, C. 8.

(b) **Deceased spearing hippopotamus.**[1] 39 (8)–(9), 53 (7), 82 (8), 85 (24), 123 (7), 125 (2), 155 (5), 157 (18), 164 (6), 342 (8), C. 11, *see also* Sect. 19 (c).

(c) **Deceased angling.** 51 (4), 93 (B), 157 (16), 158 (20)–(21), 324 (5).

(d) **Deceased receiving produce of marsh-lands or Delta.** 24 (8), 39 (8)–(9), 52 (6), 53 (7), 56 (13)–(15), 65 (7), 81 (6), (8), 84 (16), 85 (26), 92 (12), 93 (11), 96 (13), 100

(10), (13), 109 (13), 123 (7), 125 (7), 155 (11), 172 (4), 261 (1), A. 5.

(e) **Netting fish and/or fowl, &c.** 18 (6), 22 (5), 34 (Reliefs), 39 (8)–(9), 52 (6), 53 (7), 56 (13)–(15), 60 (8), 66 (8), (9), 73 (1), 77 (12), 78 (13), 79 (5), 81 (6), 82 (8), 85 (26), 88 (6), 93 (20), 100 (10), 103 (6), 123 (7), 125 (7), 127 (7), (8), 165 (4), 186 (2), (4), 200 (1), 217 (5), (6), 224 (8), 241 (6), 246 (3), 256 (2), 276 (8), 279 (C), 342 (7), A. 5, 386 (3), A. 2, A. 5, C. 8.

(f) **Papyrus-gathering.** 34 (Reliefs), 39 (8)– (9), 49 (15)–(16), 155 (Hall, fragments), 331 (2).

18. Bringing and breeding animals and fowl

See also Sect. 19

(a) **Bringing animals to deceased (except by offering-bringers).** Cattle, 11 (10), 29 (9), 31 (8), 39 (3), (5), (8)–(9), 40 (6), (8), 41 (17), 56 (3), 57 (11), 60 (11), 74 (10), 76 (2), 78 (8), 79 (1), 81 (4), (9), 82 (5), 84 (2), 85 (30), 86 (4), (7), 87 (3), 88 (6), 90 (8), 93 (11), (12), (B), 95 (4), 99 (7), 100 (2), (4), (6), (8), (13), 121 (2), 123 (5), (11), 127 (7), (10), 131 (3), 145 (2), 151 (2), 155 (11), 162 (1), 172 (4), 186 (4), 188 (11), 201 (3), 297 (1), 308 (5), 308 (sarc.), 312 (3), 343 (8), 367 (5), C. 11. Dogs, 104 (4), 201 (3). Donkeys, 40 (8), 81 (9), 85 (17), 101 (6), 123 (11), 127 (10), 145 (2), 186 (4). Gazelles, 85 (30), 312 (3). Goats, 29 (9), 31 (8), 40 (8), 81 (9), 86 (4), 95 (4), 100 (2), (6), 101 (6), 123 (11), 186 (4), 405 (1). Horses, *see* Sect. 19 (b). Pigs, 81 (9), 123 (11), 145 (2). Sheep, 81 (9). Geese and ducks, 39 (8)–(9), 40 (8), 60 (11), 79 (1), 81 (9), 86 (4), 121 (2), 123 (5), (11), 127 (10), 145 (2), 343 (8), C. 8.

(b) **Tending cattle.** 100 (13), 186 (4); branding, 40 (8), 49 (15)–(16), 90 (8), 93 (11); feeding, 44 (2), 49 (15)–(16), 93 (B), 151 (2), 405 (B); milking, 308 (2), (sarc.); cow calving, 34 (Reliefs), 366 (C); cattle-stalls, 68 (1), 151 (2).

19. Animals, birds, &c.

See also Sects. 17, 18, 20

(a) **Pets.** Cat, 10 (1), (4), 50 (9)–(10), 52 (3), 55 (4), 96 (8), 120 (3), 130 (9), 159 (4), 178 (2), 181 (3), 217 (3), (6), 219 (9), 331 (1), 357 (1)–(2), *also in* Sect. 17 (a). Dog, 15 (5), 20 (4)–(5), (8), 21 (13), (14)–(15), 59 (3), 81 (9), (20), 95 (1), 125 (13), 128 (5), 154 (1), 162 (3), 175 (5), 179 (2), 181 (3), 186 (3), 215 (2), 276 (4), 279 (10), (15), 294 (2), 302 (1), 318 (9), (10), 324 (5). Gazelle, 36 (3), 279 (5)–(6). Ibex,

Numbers refer to tombs, not to pages.

[1] See Säve-Söderbergh, *On Egyptian Representations of Hippopotamus Hunting* [&c.] in *Horae Soederblomianae*, iii (1953), passim.

73 (1), 78 (6), 191 (5). Monkey, 2 (4), 11 (10), 17 (2), 20 (4)–(5), 23 (6), 35 (1), 39 (8)–(9), 50 (9)–(10), 53 (2), 56 (5), 59 (3), 68 (6), 73 (1), 85 (11), (D), 92 (3), 106 (10), 108 (3), 112 (3), 120 (3), 122 (5), 127 (22), 129 (1), 130 (3), 145 (1), 155 (4), 159 (4), 162 (3), 174 (1), 176 (6), 182 (1), 216 (19), 241 (1), 251 (7), 276 (4), (9), 331 (1), 345 (6), 350 (4), 357 (1)–(2), A. 4, C. 1 (1); dancing, 11 (10). Goose, duck, &c., 10 (1), 11 (9), 18 (4), 23 (6), 55 (4), (10), 100 (2), 112 (3), 120 (3), 155 (6), 162 (3), 217 (6), 241 (3), 285 (2)–(3).

(b) **Domestic, other than pets,** *see also* Sect. 18.

Goats and pigs, *see* Sect. 15 (*f*); mules, *see* Sect. 11. Cattle: humped, 17 (7), 42 (4), 78 (12), 86 (4), 119 (1), 125 (7), 162 (1), 343 (8), 367 (5); with decorated horns,¹ 23 (18), 40 (6), 78 (4), (9), 82 (10), 101 (5), 123 (5), 367 (4), (5), A. 18; garlanded, 8 (2), 49 (11), 73 (3), 78 (2), 86 (7), 89 (10), 90 (4), 93 (15), 226 (3), 276 (4), 367 (5); fighting, overthrown, &c., 34 (Reliefs), 56 (3), 60 (14), 81 (9), 82 (5), 123 (11), 127 (7), 366 (2), (C), C. 2; crossing water, 103 (4). Dog: in hunting-scenes, 12 (5), 53 (5), 81 (10), 100 (10), 311 (Passage), 342 (4), A. 5, *see also* Sect. 20; with herdsmen, 31 (8), 217 (5); accompanying, 89 (15), 93 (9), 143 (6), 217 (2), 366 (3). Donkey, 15 (4), 16 (4), 89 (14), 143 (6), 241 (1), 254 (1), 266 (2), 324 (4), 341 (7), 366 (B). Horse, 85 (2), 92 (5), 143 (4); with chariot, *see* Sect. 11; in funeral scene, 162 (7); as tribute or produce, 39 (8)–(9), 40 (8), (11), 74 (10), 78 (8), 90 (4), 91 (5), 99 (5), 100 (4), 123 (11), 145 (2), 239 (2)–(3).

(c) **Wild.**

Ass, 20 (7), 93 (19), 155 (10). Baboon, 39 (5), 84 (5), 100 (4), *see also* Sect. 30 (*b*). Bear, 81 (5), 84 (9), 100 (4), 118 (1). Bull, 11 (16), 53 (5), 60 (9), 100 (10), (11), 155 (10), 342 (4). Cheetah, 63 (9), 84 (5), 89 (14), 100 (4). Crocodile, 69 (12), 103 (4), 155 (5), 366 (5). Elephant, 100 (4). Gazelle, 216 (6)–(8), and scenes of offering-bringers and hunting. Giraffe, 40 (6), 84 (5), 100 (4). Hippopotamus, 60 (8), 81 (8), 186 (2), 360 (4), 366 (1), 386 (3), *see also* Sect. 17 (*b*). Hyena, 21 (10), 53 (5), 56 (13)–(15), 60 (9), 81 (10), 85 (18), 100 (10), (11), 109 (17), 155 (10), 276 (11), 342 (4), A. 5. Ibex, 72 (4), 78 (4), 85 (30), 100 (4), (10), 155 (10); garlanded, 367 (5). Leopard, 91 (3), 100 (4), 276 (11), 396 (1). Lion, 36 (20), 40 (11), 143 (5). Lynx, 60 (9). Monkey, 39 (5), 84 (5), 89 (15), 100 (2), (4), (13). Oryx, 57 (24), 100 (10), 119 (1), 276 (11), 342 (4); garlanded, 201 (2). Sheep, 20 (7), 60 (9). Turtle, 125 (2), 215 (ceiling).

(d) **Birds and insects,** *see also* Sects. 15 (*d*), 17 (*a*), 18 (*a*), 19 (*f*), 39 (*c*).

Crane, 39 (8)–(9), 60 (11), 81 (9), 82 (16), 93 (11), 109 (13), 123 (11), 127 (10), A. 5. Ostrich, 11 (16), 21 (10), 53 (5), 72 (4), 86 (6), 93 (19), 100 (11), 103 (Fragments), 123 (10), 172 (7), 342 (4), A. 5. Pelican, 78 (13). Pigeon, 52 (1), 100 (2), (6), 108 (2), 178 (2)–(4). Quail, 38 (3), 52 (1), 57 (8), 93 (24), 226 (3), 297 (3). Bees and hornets, 93 (11), 101 (5). Grasshoppers, 9 (3), 78 (13), 166 (1).

(e) **Mythological.**

For bull and seven cows, and cat slaying serpent, *see* Sect. 35 (*c*); statue of cow protecting or suckling king, *see* Sect. 2 (*c*), (*g*). *See also* cow by pool (Meḥitwert), cow in mountain (Ḥatḥor-cow), goose of Amūn (*smn*-goose), lions of the horizon (Akru), phoenix (*Benu*-bird), in Index 3.

Baboon, 6 (ceiling), 65 (12), 157 (1), 158 (5), 188 (10), 192 (5), 219 (8), 344 (1), 359 (11), *see also* Sect. 30 (*b*). Bull or calf, 158 (1), 192 (5), (7), 233 (3), 290 (6), *see also* Sect. 35 (*c*). Donkey, 192 (7), 335 (19). Goose, 60 (4), 158 (3), 265 (2). Ibis, 65 (12). Jackal: drawing bark, 30 (architrave), 132 (ceiling), 134 (1), 364 (1), 370 (1), 406 (1); adoring bark or adored, 30 (ceiling), 157 (1), 257 (4), 359 (12). Lion, 178 (2)–(4). Ram, 20 (4)–(5), 48 (6), 148 (sarc.), 158 (20)–(21), 273 (2)–(3). Serpent, 1 (ceiling), 2 (ceiling), 6 (15), 10 (ceiling), 34 (8), 34 (Reliefs), 135 (ceiling), 148 (15), 158 (20)–(21), 214 (6), 254 (2), 263 (1), 279 (E), 286 (3), 289 (24), 290 (9)–(11), 302 (2), 306 (1), 335 (18), 344 (4), 354 (6), 360 (A), A. 15, A. 16, *see also* Buto, Mertseger, Sito, and Termuthis, in Index 3. Tortoise of Rēʿ, 157 (18).

(f) **In decoration,** *see also* Sect. 39 (*c*).

Bull: vases, 39 (3), 40 (11), 66 (2), 85 (17), 86 (8), 89 (15), 91 (5), 95 (5), 100 (4), 131 (11), 161 (3, leaping bull), 162 (1), 256 (3); boukrania on vases, 71 (3), 86 (8), 131 (11); moulds, 56 (6), 89 (4). Cat on entablature, 48 (9), 93 (8). Dog: vases, 65 (2), 100 (4), 131 (11). Frog: vases, 39 (12), 42 (5), 63 (10), 86 (8), 93 (9). Gazelle: vases, 63 (9), 75 (3), 93 (9), 95 (5), 100 (4); standards, 90 (4), 200 (3). Giraffe, 40 (7). Griffin: vases, 63 (9), 65 (2), 100 (4), 131 (11). Horse: vases, 56 (16)–(18), 65 (2); standard, 85 (2). Ibex: vases, 40 (11), 63 (9), 65 (2), 66 (2), 93 (9), 100 (4), C. 9. Jackal: vase, 86 (8). Lion: vases, 42 (5), 78 (8), 86 (8), 89 (15), 100 (4), 131 (11); amulet, 200 (3). Monkey, 93 (9). Oryx: vase, 93 (9); mould, 89 (4). Pigeon: vase, 86 (8). Ram: vases, 65 (8)–(9), 75 (3), 78 (8), 113 (4); wands or staves, 75 (3), 267 (5), 359 (12); standards, 44 (4), (12), 58 (6), 106 (A), 155 (7), 278 (7), 306 (7). Insects, 31 (14), 49 (12), 50 (ceiling), 92 (4), 200 (3).

Numbers refer to tombs, not to pages.

¹ See Leclant in *Mitt. Kairo*, xiv (1956), pp. 128–45.

(g) **Statues in scenes.** Bull, 63 (9), 86 (8), 101 (4), 105 (3), 131 (11), 162 (1). Lion, 48 (4), (7). Vulture, 66 (2).

20. Hunting

In chariot, 21 (10), 56 (13)–(15), 72 (4), 84 (15), 123 (10), 276 (11), 342 (4); on foot, and/ or incomplete scenes, 11 (16), 12 (5), 20 (7), 24 (7), 36 (20), 39 (10), 53 (5), 60 (9), 81 (10), 82 (7), 93 (19), 100 (11), 109 (17), 131 (10), 143 (5), 155 (10), 172 (7), 241 (5), 256 (8), 311 (Passage), 366 (1), A. 5. Hyena-fight, 85 (18).

21. Sport

Shooting at target, 109 (5), 143 (5). Wrestling and single-stick, 19 (4), 24 (5), 31 (4)–(5), 74 (5), 366 (D). Jousting in canoes, 155 (fragments), 192 (7), 386 (3).

22. Games

Draughts, usually in Book of Gates, cf. Sect. 36 (b). 1 (5), 6 (10), 10 (frieze), 30 (5), 36 (9); 58 (6), 82 (14)–(15), 158 (3), 178 (2), 219 (8), 263 (3), 265 (4), 296 (2), 359 (6)–(7), C. 9. 'Mora', 36 (9).

23. Toilet-scenes

Preparing bed, 53 (8), 82 (14)–(15), 99 (10), 103 (17), 140 (7), 260 (1), 279 (B), 405 (4). Hairdressing, 140 (7), 308 (4), 318 (5), 319 (Chapel). Barbers, 56 (11).

24. Musicians

See also Sect. 38 (d)

(a) **Groups.** At banquet, 8 (1), 11 (10), 17 (3), 22 (4), 38 (6), 39 (5), 50 (3), 52 (3), 53 (2), 56 (5), 75 (4), 77 (6), 78 (2), (6), 79 (8), 80 (6), 82 (5), (12), 85 (11), (28), 90 (2), 92 (1), (17), 95 (1), 100 (18), 101 (2), 109 (9), 129 (1), 130 (5), 131 (4), 140 (1), 147 (3), 161 (3), 169 (4), 175 (4), 179 (4), 241 (3), 249 (4), 251 (3), 254 (6), 268 (2), 276 (4), 302 (3), 318 (8), 334 (4), 342 (5), 343 (5), 345 (5), 367 (2), A. 22, C. 6. At festivals or acclamation of deceased, 40 (1), (8), 65 (8)–(9), 109 (3), 110 (12), 188 (8), 192 (5). In funeral procession, 60 (5)–(6), 113 (4). In offering-scene, 96 (22), (23), 106 (10), 341 (8)–(9). In judgement-hall, 29 (4). In scene with games, 36 (9).

(b) **Harpists alone, or with clappers and singers.** 11 (1), 22 (3), (6), 24 (8), 29 (4), (8), 31 (11), 34 (Reliefs), 35 (6), 40 (8), 42 (2), 50 (11), 58 (3), 60 (13), (14), 66 (5), 72 (2), 81 (20), (21), 82 (14)–(15), 93 (16), 93 (B), 96 (15), 106 (F), 108 (5), 112 (5), 125 (13), 127 (3), 142 (3), 154 (1), 158 (5), 163, 178 (2), 182 (1), 186 (3), 194 (4), 195 (3), 200 (7), 208 (3),

224 (6), 260 (3), 263 (3), 277 (2)–(3), 296 (4), 297 (1), 304, 331 (1), 359 (11), 396 (5), 409 (3), A. 5.

(c) **Lutists.** 8 (1), 11 (10), 17 (3), 22 (4), 23 (26), 29 (4), 38 (6), 40 (8), 50 (3), 52 (3), 56 (5), 65 (8)–(9), 74 (2), (7), 75 (4), 77 (6), 78 (2), (6), 80 (6), 82 (12), 85 (11), 90 (2), (5), (6), 92 (1), 93 (16), 95 (1), 96 (21), (22), 100 (18), 106 (10), 109 (9), 110 (12), 135 (1)–(2), 141 (2), 158 (3), (16), 161 (3), 169 (4), 175 (4), 181 (9), 241 (3), 249 (4), 254 (6), 260 (2), 268 (2), 276 (4), 285 (4), 302 (3), 341 (5), 343 (5), 367 (2), C. 5, C. 6.

(d) **Lyre-players (female).** 22 (4), 38 (6), 39 (5), 75 (4), 79 (8), 80 (6), 85 (28), 92 (17), 113 (4), 129 (1), 161 (3), 179 (4), 251 (3), 254 (6), 302 (3), 318 (8), 341 (8)–(9), 367 (2).

(e) **Players on flute or double-pipe.** At banquet (usually female), 17 (5), 18 (4), 22 (4), 38 (6), 52 (3), 53 (2), 75 (4), 79 (8), 82 (5), (12), 84 (7), 85 (28), 90 (2), 92 (17), 101 (2), 109 (9), 129 (1), 130 (5), 161 (3), 175 (4), 241 (3), 249 (4), 254 (6), 318 (8), 342 (5), 343 (5), 345 (5), A. 22, C. 6. At festivals, &c., 157 (6), 188 (8), 192 (5). In funeral procession (female), 60 (5)–(6), 113 (4). Herdsman with pipe, 57 (13), 69 (2), 217 (5), 266 (2). Various, 36 (9), 218 (3), 219 (8), 273 (5).

(f) **Singers.** 11 (10), 17 (3), 34 (Reliefs), 36 (9), 39 (21), 49 (11), (13), (21), 55 (3), 78 (6), 86 (1), 93 (3), 109 (3), 113 (4), 179 (4), 181 (2), 192 (7), 341 (5).

(g) **Others.** Trumpeters, 74 (5), 78 (8), 90 (4), 131 (9). Drummers, 65 (7), 74 (5), 78 (8), 110 (12), 131 (9), 201 (7), A. 16. Tambourine-players, 19 (7), 22 (4), 23 (3), 40 (1), 49 (6), 75 (4), 100 (18), 129 (1), 158 (4), 188 (8), 192 (5), (7), 241 (3), 273 (5); gods as, 217 (6), A. 26. Cymbals(?),[1] 100 (15), 181 (4). Castanets or resonant sticks, 20 (4)–(5), 60 (5)–(6), 82 (5), (16), 135 (1)–(2), A. 22.

25. Dancers and tumblers

(a) **Dancers.** At banquet (usually with musicians, *see* Sect. 24), 11 (10), 53 (2), 78 (6), 79 (8), 85 (11), 95 (1), 109 (9), 130 (5), 176 (5), 179 (4), 186 (3), 251 (3), 254 (6), 268 (2), 297 (1), 367 (2), A. 5. As musicians, 8 (1), 18 (4), 75 (4), 80 (6), 82 (5), 90 (2), 92 (17), 341 (8)–(9), 342 (5), C. 5. At festivals or acclamation of deceased, 40 (1), (8), 49 (6), 82 (16), 93 (3), 135 (7), 188 (8), 192 (5), (7), C. 13. In funeral scenes, 13 (9), 42 (14), 53 (11)–(12), 60 (5)–(6), 82 (10), 92 (14), 96 (33)–(34), 100 (15), 112 (8), 127 (13), 179 (2), 276 (10), A. 4. In offering-scenes, 93 (16), 341 (8)–(9). Nubian, 22 (4), 78 (8), 113 (4). Various, 36 (9), 60 (2), 302 (1), 311 (block), A. 2.

Numbers refer to tombs, not to pages.

[1] See Hickmann in *Ann. Serv.* xlix (1949), pp. 472–7.

(b) **Tumblers (female).** 53 (2), 60 (2), 65 (6), 82 (14)–(15), 87 (8), 100 (19), 129 (1), 135 (7), 192 (5), 371 (2).

26. Deceased offers to relatives, &c.

To parents and ancestors, 2 (4), 15 (6), 17 (3), 18 (4), 23 (33)–(34), 45 (6), 64 (7), 82 (4), 93 (16), 96 (22), 111 (3), 112 (5), 122 (5), 127 (16), 139 (3), 148 (2), 181 (7), 194 (5), 279 (8), (13), 290 (2), 291 (4), 295 (4), 330 (2), 335 (10), 345 (6). To relatives and others, 22 (33)–(34), 85 (16), (B), (C), 148 (2), 183 (14), 194 (5), 290 (2), 330 (2), 335 (16), 345 (6); to vizier, 82 (6), 96 (12), 122 (5); to architect and artists, 82 (4).

27. Deceased meets relatives

23 (3), 49 (12), (15)–(16), 50 (2), 71 (11), 85 (A), 100 (9), 106 (H), 162 (5), 259 (6), 353 (8).

28. Deceased performs ritual

(a) **Offers on braziers.** To god not depicted,[1] 13 (13), 16 (5), 17 (2), 22 (1), 29 (2), 36 (5), 38 (5), 42 (6), 43 (2), 45 (5), 46 (A), 49 (A), (B), (C), 56 (6), 57 (7), (12), 64 (6), 69 (5), 72 (1), 74 (2), (7), 76 (1), 77 (5), 78 (1), (5), 79 (3), 80 (4), 85 (10), (12), 86 (3), 88 (5), 89 (9), 90 (5), 91 (4), 92 (1), 93 (2), 94 (1), 96 (1), (7), 99 (1), 104 (1), 108 (2), 109 (3), (10), 110 (5), 112 (2), 130 (1), 147 (2), (8), 151 (3), 161 (1), 162 (1), (3), 165 (1), 172 (1), 200 (4), 201 (2), (8), 225 (1), 226 (2), 229 (1), 256 (4), 295 (4), 333 (3), 343 (6), 345 (1), 349 (1), (4), 350 (2), 359 (6)–(7), 367 (1).

(b) **Pours incense or ointment.** To gods not depicted, 29 (1), 38 (2), 39 (22), 40 (8), 48 (5), 49 (13), (B), (D), 52 (1), (4), 55 (8), 64 (2), 77 (1), 89 (1), 125 (1), 139 (1), 165 (1), 181 (2), 345 (1), 367 (4). To divinities depicted, 49 (21), 51 (6), (9).

(c) **Consecrates offerings.** To gods not depicted, 34 (Chapel B), 49 (14), 55 (3), 93 (10), 95 (C), 96 (22), (23), 158 (3), 179 (1), 189 (1), 224 (7).

(d) **Embraced by Western goddess.** 23 (31)–(32), 32 (13)–(14), 41 (14), 49 (4), (20), 189 (10).

(e) **'Goes forth' or 'enters'.** 27, 33 (7), 46 (D), 49 (C), 55 (2), (14), 57 (23), 64 (9), 69 (8), 74 (1), 75 (7), 76 (C), (D), 82 (9), 84 (11), 85 (A), (C), (D), 93 (E), 95 (A), 96 (27)–(28), (32), 103 (2), 106 (7), (11), (A), (G), (H), 109 (2), (8), 125 (3), (6), 127 (20), 128 (1), 130 (6), 161 (4), 181 (1), 189 (3), 306 (5), 341 (12), 359 (11).

(f) **Adores divine barks,** see also Sect. 30 (a), and Index 3 for barks of named gods. 9 (2), 9 (ceiling), 30 (2), 30 (architraves), 58 (14), 68 (1), 158 (2), (20)–(21), 159 (3), 178 (11)–(12), 183 (15), 216 (Bur. Ch. frieze), 279 (2), 306 (10), 347 (3), 360 (A), 362 (Inner Room, ceiling), 364 (1), (3).

(g) **Adores royal name or** ka. 6 (5)–(6), 55 (14), 84 (4), 131 (1), 139 (Finds), 155 (7), 279 (7), 353 (2)–(7), 365.

29. Special offerings, &c.

(a) **Candles and torches.**[2] In offering-scenes, 2 (4), 10 (1), (4), 23 (21), 39 (23), (24), 41 (15), 42 (16), 51 (8), 52 (5), 54 (3), 69 (7), 93 (C), 96 (B), (25), (39), 113 (4), 151 (6)–(7), 159 (4), 176 (7), 247 (4), 254 (1), 259 (2), 264 (2), 271 (1), 278 (5), 283, 296 (4), 345 (2), 359 (11), 375 (1), 409 (6), A. 11. In festivals, Book of Dead, &c., 23 (8), 31 (4)–(6), 82 (17), 95 (B), 112 (6), 127 (16), 331 (3), 335 (8), C. 1 (1). Held by divinities, deceased, &c., 3 (10), 5 (5), (14), 33 (37), 82 (21), 211 (3), 214 (4)–(5), 218 (10), 219 (7), 335 (11)–(12), 356 (4), (6). In funeral scenes, 39 (17), 75 (8), 90 (7), 276 (10), 333 (7). Domestic, 99 (10). On stand or altar, 23 (8), 89 (13), 95 (B), 153 (1), 276 (10), 278 (5), 359 (11).

(b) **Sacred oils.** 33 (22), (25), 37 (8), 39 (23), 160 (5), 223 (2), 276 (5), 280 (Portico).

(c) **Ointment.** 11 (1), 20 (6), 42 (16), 46 (1), 49 (C), 52 (5), 55 (10), 60 (18)–(19), 61 (5), (7), 63 (7), 69 (7), 80 (4), 82 (12), (17), (21), 93 (A), (C), (G), 96 (B), (E), (F), 112 (6), 117 (1), 125 (15)–(16), 308 (sarc.), 345 (2), (3).

(d) **Burnt-offerings.** 17 (2), 38 (3), 39 (22), (23), 64 (2), 69 (3), (10), 100 (15), 147 (1), 178 (2), 201 (8), 271 (1).

(e) **Necklaces and collars.** 33 (22), (23), 38 (6), 47, 48 (4), 56 (5), 60 (18)–(19), 63 (10), 73 (3), 91 (5), 93 (B), 96 (25), (H), 182 (1), 192 (8), 226 (4), 279 (D), see also Sects. 1 (a), 31 (g), 33, when in treasure, gifts, or funeral outfit.

(f) **Menats, offered or held.** 11 (1), 22 (2), 39 (6), (22), (23), 45 (8), 55 (9), 63 (13), 77 (1), (2), 80 (3), (4), (6), 81 (3), 82 (16), 85 (D), 86 (1), 91 (3), 93 (A), 96 (29), 106 (L), 112 (3), 127 (6), 345 (2), B. 3, C. 4; as emblem, 359 (11).

(g) **Various, offered or held.** Boxes of coloured cloth, 23 (31)–(32), 41 (16), 157 (6). Four calves, 222 (5), 409 (7). Cartouche, 39 (6). Ka, 40 (9). Palette, 17 (5), 63 (10), 214 (7), 259 (2), 359 (8). Ushabti-box and statuette, 359 (12). Uzat, 2 (19), 216 (Finds). Wand, 267 (5). 𓌻, 1 (6), 6 (10), 302 (4), 344 (3). 𓎕, 279 (C). 𓏤, 257 (1).

Numbers refer to tombs, not to pages.

[1] See Schott, *Das schöne Fest*, pp. 776–95.
[2] See Davies in *J.E.A.* x (1924), pp. 9–14; Schott in *Ä.Z.* lxxiii (1937), pp. 1–25.

30. Divine barks and emblems

(a) **Divine barks,** *see also* Sect. 28 (*f*), and Index 3 for barks of named gods. 1 (ceiling), 2 (5), 3 (6), 132 (ceiling), 135 (ceiling), 158 (20)–(21), 189 (2), 197 (2), (16), 222 (2), 232 (ceiling), 287, 359 (11), A. 26 (ceiling).

(b) **Barks, &c.**, adored by baboons and/or Souls of Pe and Nekhen and bas, *see also* Sect. 19 (*e*). Divine barks, 1 (9), 2 (3), 23 (22), 30 (ceiling), 32 (8), 41 (4), 44 (4), 58 (Inner Room, ceiling), 106 (3), (10), 106 (architrave), 158 (2), 211 (ceiling), 216 (frieze), 218 (5), 255 (5), 257 (4),•279 (2), 306 (10), 360 (A), 362 (ceiling), 364 (1), 370 (1), 389 (4). Divinities or emblems, 28 (ceiling), 35 (4), 41 (19), (32), 45 (ceiling), 51 (3), 65 (Hall, ceiling), 135 (ceiling), 216 (2), 232 (ceiling), 296 (7).

(c) **Zad-pillar,** *see also* Sects. 35 (*f*), 39 (*b*). Adored, 3 (7), 23 (25), 28 (ceiling), 41 (24), 44 (6), 49 (1), 54 (6), 58 (17), 65 (Hall, ceiling), 113 (1), (2), 115 (3), 135 (ceiling), 150 (1), 156 (G), 157 (2), 158 (20)–(21), 159 (1), 178 (5)–(7), 192 (7), 194 (6), (10), 211 (ceiling), 222 (1), 265 (5), 289 (5), 296 (7), 306 (5), 344 (5), B. 4. With divinities or emblems, 2 (Bur. Ch. ceiling), 87 (5), 216 (21), 216 (ceiling), 220 (4), 323 (3), 335 (18), 385 (2). Personified in purification and acclaiming, 41 (1), 42 (3), 75 (5), 85 (B), 96 (G). Upheld by deceased or god, 23 (20), 158 (22), 178 (11)•(12), 183 (10), 211 (ceiling).

(d) **Horizon-disk.** 1 (5), 2 (Bur. Ch. ceiling), 9 (1), 10 (Chapel, ceiling), 35 (4), 41 (32), 65 (Hall, ceiling), 206 (3), 211 (ceiling), 212 (4), 216 (ceiling), 267 (6), 323 (5), 329 (1), 335 (19), 336 (ceiling), 360 (A), 385 (2).

(e) **Eastern and/or Western emblems.** 10 (Chapel, ceiling), 13 (2)–(3), (6)–(7), 17 (1), 28 (ceiling), 45 (ceiling), 51 (3), 75 (5), 92 (18), 93 (22), 132 (4), 144 (2), 211 (ceiling), 214 (4)–(5), 257 (2), 292 (6), 323 (2), 329 (1), 337 (1), 356 (4), (6), 360 (13).

(f) **Ka-emblem.** 359 (12).

For sacred oars, *see* Sect. 35 (*c*).

31. Funeral scenes and rites[1]

(a) **Funeral procession.** Usually includes dragging coffin, bringing funeral outfit, mourners, mummers, rites before mummy at tomb, and reception by Western goddess or Ḥathor-cow in mountain. As the funeral procession occurs in almost every tomb, only the more complete examples are given here. For pyramid-tomb, *see* Sect. 12 (*f*). 4 (3), 10 (4), 12 (1)–(2), 13 (9), 15 (2)–(3), 17 (11), 19 (3), (4), 20 (4)–(5), 21 (8), 23 (31)–(32), 24 (3)–(4), 29 (9), 30 (2), 31 (7), 34 (6), 36 (17),

(21), 39 (17), (19), 41 (1), (14), (15), 42 (14), 44 (7), (11), 45 (2), 49 (4), (8), 51 (3), 53 (11) and (12), 54 (2), (6), 55 (5), 56 (16)–(18), 57 (18)–(19), 60 (5)–(6), 63 (11)–(12), 69 (9), 78 (9), 80 (10), 81 (17), 82 (10), 84 (13), 85 (22), 92 (14), 96 (33)–(34), 100 (15), 104 (8), 112 (6)–(8), 113 (3)–(4), 122 (8), 123 (9), 125 (10), 127 (13), 135 (5), 138 (1)–(3), 139 (4), 141 (6)–(7), 147 (14), 151 (8), 161 (5), 172 (5)–(6), 175 (2), 178 (5)–(7), 179 (2), 181 (4)–(5), 215 (2), 216 (18), 217 (2), 218 (1), 219 (2), (3), (11), 224 (5), 233 (1), 247 (3), 250 (2)–(3), 255 (2), 259 (1), (2), 260 (2), 273 (1), (2)–(3), 276 (10), 277 (2)–(3), 279 (3)–(6), 284 (2)–(4), 296 (5), 338 (2), 341 (2)–(4), A. 4, C. 4.

(b) **Priests or relatives before mummy (without procession).** 4 (Finds), 9 (2), 13 (10), 14 (3), 23 (13), (15), 25 (3), 41 (6), (20), 45 (3), 50 (5), 51 (1), 54 (4), (7), 58 (3), 69 (11), 82 (14)–(15), 97 (8), 106 (1), (3), (G), 117 (1), 159 (2), 193 (stela), 250 (6), 263 (2), 272 (3), 275 (14), 290 (Finds), 305 (3), 335 (5)–(6), 360 (A), 362 (2).

(c) **Abydos pilgrimage.** 2 (5), 3 (8)–(9), 4 (3), 7 (5)–(6), 9 (4), 10 (2), 11 (15), 17 (11), 21 (8), 24 (3)–(4), 34 (6), 36 (17), 39 (17), 50 (9)–(10), 51 (7), 53 (11)–(12), 54 (2), 57 (21)–(22), 60 (4), 63 (11)–(12), 69 (11), 75 (8), 77 (9), 79 (9), 81 (17), 82 (10), 89 (5)–(6), 92 (14), 96 (19), (40), 100 (15), 103 (7)–(8), 104 (8), 112 (8), 123 (9), 125 (10), 127 (13), 130 (9), 139 (4), 147 (14), 161 (5), 162 (7), 165 (2), 175 (2), 176 (2), 207, 208 (3), 216 (16), 260 (2), 278 (7), 279 (3)–(4), 292 (6), 306 (6), 312 (2), 324 (8), 335 (15), 338 (2), 339 (1)–(2), 343 (10), 360 (4), (7)–(8), 361 (2).

(d) **Rites before mummy or statue of deceased** (usually series of small scenes). Before mummy, 11 (17), 17 (12), 21 (11), 24 (3)–(4), 33 (24), (25), 35 (7), 37 (10), 42 (15), 53 (13), 62 (4), 69 (11), 72 (8), 78 (12), 80 (10), 82 (12), 83 (1), 84 (13), 85 (29), 89 (7), 92 (16), 96 (16), 99 (14), 104 (10), 122 (7), 125 (12), 127 (14), 130 (4), 140 (8), 144 (4), 161 (5), 165 (6), 169 (3), 183 (12), (14), 200 (9), 224 (5), 260 (4), 282 (beginning), 295 (5), 343 (12), 373 (14) and (15), A. 4, A. 21, C. 4. Before statue, 23 (12), (14), 35 (6), 40 (9), 42 (14), 48 (2), 56 (4), 58 (13), 90 (7), 93 (3), (C), 94 (D), 100 (19), 108 (4), 130 (9), 139 (4), 178 (9)–(10), 233 (end), 257 (6), 263 (11)–(13), 335 (17), 367 (3).

(e) **Deceased purified** (excluding scenes in funeral procession), *see also* Sect. 9. By gods, 5 (Ch. B, ceiling), 157 (2), 276 (at end), 335 (23), 336 (17); by son or single priest, 4 (Finds), 35 (6), 40 (9), 54 (3), 56 (4), 57 (21)–(22), 74 (2), 89 (12), 90 (7), 96 (36), 100

[1] For episodes, see Davies, *The Tomb of Rekh-mi-rēꜤ at Thebes*, pp. 70–8.

(19), 107 (2), 111 (9), 122 (7), 176 (3), 178 (9)–(10), 183 (3), 189 (16), 222 (7), 241 (4), 247 (4), 295 (6), 335 (17), 353 (4), A. 18; by priests, 21 (8), 39 (Portico), 41 (1), 42 (3), 51 (6), 55 (9), 57 (20), 75 (5), 85 (B), 93 (D), 96 (H), 97 (10), 100 (15), 125 (20), 127 (20), 284 (12), 335 (5), 387 (2); unclassified, 24 (6), 46 (E), 57 (4), 106 (2), (E), 158 (20)–(21), 251 (Pillar), 276 (7), 282 (5), 284 (8), 286 (5), 305 (3), 335 (11)–(12), 360 (Finds).

(f) **Bandaging mummy.** 23 (14), 41 (20), 276 (10).

(g) **Funeral outfit (not carried in procession).** 33 (22), 39 (20), 51 (5), 78 (11), 79 (7), 82 (14)–(15), 112 (10), 217 (2), 240, 290 (7), 311 (Bur. Ch.), 314, 315, 319 (Bur. Ch.), 396 (2), 405 (4), see also Sects. 7 (d), 13 (b).

(h) **Other scenes and details.** Rites in garden, 15 (2)–(3), 21 (8), 39 (17), (19), 41 (15), 53 (11)–(12), 81 (17), 100 (15), 110 (11), 112 (8), 120 (6), 122 (8), 179 (2), 224 (5), 275 (4), (6), 392 (1), A. 4. Booths with offerings and servants,[1] 13 (9), 19 (7), 49 (4), 56 (16)–(18), 57 (18)–(19), 85 (22), (29), 87 (8), 113 (3), 138 (1)–(3), 148 (10), 159 (5), 178 (5)–(7), 181 (5), 187 (2), 217 (2), 273 (2)–(3), 291 (1), 341 (2)–(4). Setting up obelisks, 15 (2)–(3), 21 (8), 41 (14), 53 (11)–(12), 63 (11)–(12), 85 (22), 96 (33)–(34), 100 (15), 125 (10)–(11), 179 (2), 276 (10), B. 2. Rites before empty chair,[1] 57 (21)–(22), 75 (8), 219 (11). Mutilated calf, 19 (4), 23 (31)–(32), 31 (7), 36 (21), 41 (14), 45 (2), 58 (3), 138 (1)–(3), 141 (6) and (7), 151 (8), 218 (1), 259 (1), 296 (5), 360 (A). Victims, 17 (11), 20 (4)–(5), 21 (8), 29 (9), 34 (6), 36 (17), 39 (19), 57 (10), (24), 63 (11)–(12), 82 (10), 92 (14), 96 (33)–(34), 100 (15), 122 (8), 276 (10), 277 (8), A. 4. *Teknu*, 12 (1)–(2), 15 (2)–(3), 17 (11), 20 (4)–(5), 24 (3)–(4), 36 (17), (21), 39 (17), 41 (14), 42 (14), 49 (4), 53 (11)–(12), 55 (5), 60 (5)–(6), 78 (9), 81 (17), 82 (10), 92 (14), 96 (33)–(34), 100 (15), 104 (8), 122 (8), 125 (10), 127 (13), 172 (5)–(6), 224 (5), 260 (2), 276 (10), 284 (2)–(3), A. 26, C. 4. Cloaked priests, 21 (8), 42 (15), 69 (11), 100 (19), 295 (5). 'Nine friends', 5 (Finds), 15 (2)–(3), 19 (3), 20 (4)–(5), 36 (17), (21), 39 (17), 49 (4), 54 (2), 55 (5), 57 (18)–(19), 69 (9), 78 (9), 82 (10), 92 (14), 100 (15), 106 (beginning), 121 (8), 147 (14), 161 (5), 178 (5)–(7), 179 (2), 181 (4), 255 (2), 276 (10), A. 4, C. 4. Priestesses, 20 (4)–(5), 55 (5), 60 (5)–(6), 218 (1), 277 (2)–(3), 335 (16), see also Sect. 40 (b), and Hathor-festival in Index 3. Statues carried or dragged, 41 (14), 42 (14), 48 (2), 53 (5), 60 (5)–(6), 63 (11)–(12), 69 (9), 78 (9), 79 (7), 81 (17), 82 (10), 84 (13), 92 (14), 96 (17), (18), (28), (40), 100 (15), (19), 104 (10), 112 (8), 121 (8), 125 (13), 127 (14),

144 (1), 147 (14), 157 (19), 163, 224 (5), 247 (3), 256 (6), see also Sects. 2 (e), 3 (a), 41 (b). Sarcophagus or mummy carried by priests, 277 (2)–(3), 284 (2)–(3), 289 (6), 340 (3), 341 (2)–(4).

32. Festivals

For festivals of kings and of named divinities, see Indexes 1 and 3.

(a) **Processions to temple, &c.** 41 (20), 66 (4), 75 (6), (8), 93 (3), 110 (12), 131 (9), 135 (7), 208 (11), 277 (2)–(3), 282 (1), 284 (5), (6), 319 (Up. Corr.), C. 7, C. 13.

(b) **Festivals**, see also Sect. 3 (b). New Year, 23 (8), 33 (37), 46 (1), 82 (5), 85 (C), 86 (8), 95 (B), 107 (2), 161 (4), 335 (1), C. 1 (1); Epagomenal Days, 82 (17), 112 (6); see also Neḥebkau in Index 3. Harvest, 48 (3), 96 (10), 120 (1), 253 (2), 284 (7). Valley or 'River',[2] 19 (3), 24 (9), 36 (23), 49 (3), (C), 56 (5), 64 (2), 69 (1), (8), 76 (B), 79 (8), 98 (1), 106 (D), 147 (8), 224 (7), 263 (7), C. 1 (4). *Ḥeb-sed*, 192 (5), (8). Lists, 48 (Inner Hall), 81 (16), 127 (12), 231 (1), 373 (13), 390 (4).

33. Deceased receives New Year gifts

39 (14)–(15), 60 (11), 73 (3), 99 (A), 172 (9), 345 (5), 348 (1).

34. Bouquet of Amūn, &c.[3]

Offered by deceased: to divinities, 161 (6), 383 (Finds); to relatives and others, 23 (3), 49 (15)–(16), 56 (4), 64 (7), 85 (C), 96 (12); see also Sect. 1 (e). Held or received: by deceased, 6 (Finds), 17 (2), 21 (12), (13), 31 (11) and (12), (13), 39 (7), 42 (2), 45 (8), 49 (15)–(16), 55 (11), 63 (17), 73 (1), 74 (3), 76 (3), 79 (8), 80 (6), 84 (7), (14), (16), 85 (11), (13), 87 (8), 88 (6), (D), 93 (A), (23), 96 (22), 98 (1), 112 (3), 130 (3), 139 (3), 145 (1), 147 (14), 161 (3), 181 (8), 217 (3), 254 (6), 263 (3), 295 (1); by relatives, &c., 23 (3), 39 (21), 64 (3), 84 (14), 85 (C), 86 (1), 350 (3).

35. Religious and mythological scenes

See also Sects. 19 (e), 41 (c)

(a) **With goddess.** Tree-goddess scene,[4] 1 (ceiling), 3 (4)–(5), 5 (ceiling), 6 (ceiling), 7 (2), 9 (3), 16 (4), 19 (6), 23 (9), (21), 33 (6), 41 (2), (15), 49 (12), 50 (12), 51 (7), 54 (8), 58 (10), 63 (16), 93 (14), 96 (F), 106 (10), 133 (5), 135 (4), 137 (1), 138 (5), 158 (5), (16), 176 (6), 178 (5)–(7), (11)–(12), 211 (ceiling), 213 (3), 215 (2), 218 (2), 219 (4), (8), 255 (5), 273 (2)–(3), (4), 278 (6), 279 (D), (G), 284

Numbers refer to tombs, not to pages.

[1] See Davies, *Tomb of Two Sculptors*, p. 48, note 1. [2] See Schott, *Das schöne Fest*, passim.
[3] See id. ib. pp. 812–14. [4] See Spiegel in *Mitt. Kairo*, xiv (1956), pp. 203–5.

(8), 285 (4), (8), 286 (4), 292 (ceiling), 292 (14)–(15), 296 (7), 306 (2)–(4), (5), 324 (7), 333 (6), 335 (15), 341 (13)–(14), 356 (3), 379 (1), 387 (2), 409 (12), *see also* Index 3. Goddess making *nini*, 2 (22), 5 (ceiling), 23 (19), (22), 41 (19), 51 (3), 106 (A), 158 (20)–(21), 189 (7)–(9), 195 (5), 216 (21), 216 (ceiling), 259 (2), 385 (4). Goddess kneeling before tree, 336 (16).

(*b*) **With deceased.** By pool, under tree, &c., 3 (4)–(5), 10 (frieze), 10 (ceiling), 96 (E), 178 (2), 212 (ceiling), 215 (2), 216 (16), 218 (7), 273 (2)–(3), 289 (14), 290 (ceiling), 296 (2), 335 (15). In boat with family, *ba*, &c., 3 (8)– (9), 4 (3), 158 (3), 218 (Outer Ch. ceiling), 284 (6), 290 (6), 359 (6)–(7), (11), 360 (4).

(*c*) **With sacred animals.** Bull and seven cows: with sacred oars, 23 (33)–(34), 26 (5), 33 (12), 34 (7), 36 (11)–(12), 41 (24), 243 (2), 312 (4), 389 (3); bulls and cows only, 71 (11), 82 (22), 279 (21), 353 (8); oars only, 21 (8), 275 (6). Calf with god on back, on ceilings, 1, 2, 292. Cat slaying serpent, 1 (5), 10 (frieze), 216 (frieze), 265 (2), 292 (ceiling), 335 (Bur. Ch. C, ceiling), 359 (11).

(*d*) **Fields of Iaru.** 1 (9), 6 (19), 33 (blocks), 41 (15), 57 (21)–(22), 111 (6), 120 (5), 158 (20)– (21), 215 (ceiling), 218 (14), 222 (7), 305 (1), 324 (7), 326 (Chapel), 353 (4), 399 B (2), B. 2, C. 4; Fields of Peace, 23 (5).

(*e*) **Offering-list ritual.** 20 (8), 33 (3), (4), (25), (34), 34 (Chapels D, E), 35 (2), (4), (9)–(10), 39 (4), (25), 41 (21), 48 (2), 49 (11), 52 (5), 55 (10), 60 (13), 61 (9), 66 (3), (7), 69 (7), 78 (12), 81 (18), 82 (16), (17), 93 (14), 100 (16), (19), (20), 107 (2), 112 (6), 120 (5), 123 (4), 124 (1), 125 (17)–(18), 158 (15), 176 (3), 178 (9)–(10), 241 (3), 279 (10), 342 (9), 388 (1)– (2), A. 4, C. 4.

(*f*) **Raising *zad*-pillar.** 132 (1), 135 (5), 157 (7), 192 (7), 409 (12), B. 4.

(*g*) **Mummy on couch,** *see also* Sect. 31 (*f*). With Anubis, 1 (10), 2 (20), 3 (6), (11), 85 (22), 106 (F), 214 (8), 219 (10), 276 (10), 286 (2), 290 (8), 356 (6), 360 (14)–(15). With several divinities, 1 (6), 2 (23), 5 (14), 96 (37), 135 (ceiling), 211 (3), 218 (13), 292 (12)–(13), 298 (2), 323 (5), 335 (23), 336 (10), (15). Alone or with priests, *ba*, &c., 37 (7), (9), 220 (6), 277 (2)–(3), 279 (E), 306 (8), 409 (13). Resurrection of Osiris, 33 (45), 132 (4), 404 (2).

36. Book of the Dead

See also Sect. 35

(*a*) **Text, sometimes with vignettes.** 1 (10), 3 (Innermost Ch.), 6 (18), 33 (Hall I), (15)– (16), (20), (34), (36), 57 (21)–(22), (23), 71

(11), 82 (21), (22), 87 (Bur. Ch.), 96 (37), 106 (F), 123 (4), 284 (ceiling), 290 (5), 353 (2)– (7), A. 16, C. 1 (5).

(*b*) **Book of Gates.** Draughts, *see* Sect. 22.
 1. Negative Confession. 3 (11), 41 (24), 50 (4), 58 (6)–(7), 111 (2), 138 (9), 157 (12), 265 (4), 275 (6), 284 (7), 290 (11), 296 (5), 305 (2), 306 (2)–(4), 307 (3), 359 (11); text, 106 (D), 148 (12), 181 (7), 300 (3), 360 (8), 387 (2).
 2. Scenes. With guardians, usually adored by deceased 1 (3), (8), 6 (20), 13 (2)–(3), (4)– (5), 16 (1)–(2), 23 (23), (24), (26), (27), (33)– (34), 25 (4), 26 (5), 30 (2), 32 (1), (3), (5), (13)–(14), 33 (38), 33 (Corr. XIII, text only), 41 (15), (16), (24), (25), 58 (2), (3), (6)–(8), 106 (10), 111 (2)–(8), 120 (6), 133 (2), 134 (3)–(4), (9)–(10), 138 (1)–(3), 149 (1)–(2), 157 (2), (3), (9), 158 (7), (17)–(18), 159 (1), (2), (4), (5), 178 (2), 183 (12), (14), (17), (20), 184 (2), (3), 189 (4)–(6), (7)–(9), (18)–(19), 207 (frieze), 208 (3), 215 (ceiling), 216 (frieze), 222 (1), (5), 233 (2), 255 (2), 263 (5), 264 (4), 265 (Bur. Ch.), 272 (9)–(10), 273 (2)–(3), 275 (7), 284 (ceiling), 285 (9), 290 (9)–(11), 293 (1)–(4), 296 (2), 305 (Hall), 306 (Hall), 331 (3), 341 (2)–(4), 359 (3), 360 (Chapel, fragments), 373 (6), 379 (2)–(3), 382, 399 (3), 399 A (1), B (1), (2), 409 (8), A. 15. Deceased opens Gates of the West, 1 (ceiling), 5 (ceiling), 158 (20)– (21), 292 (Chapel, ceiling), 329 (1), 335 (20). Deceased adores Gates (without guardians), 33 (32), 55 (6), 65 (12), 134 (8), 178 (5)–(7), 335 (3), 356 (ceiling). Special details: 'Gate of the West', 214 (ceiling), 273 (2)–(3), 356 (ceiling); jubilation by deceased, 341 (2)–(4).
 3. Weighing and presentation to Osiris. 1 (10), 2 (5), (11), 2 (Bur. Ch. ceiling), 9 (1), (5), 13 (12), 14 (3), (4), 16 (3), 19 (5), 23 (31)– (32), (33), (34), 25 (2), (4), 31 (7), 32 (3), 33 (20), (33), 34 (13), 37 (15), (16), 41 (14), (16), (19), (A), 44 (7), (10), 50 (4), 51 (3), (6), 58 (3), (14), 69 (10), 78 (11), 106 (A), 111 (4), 120 (6), 138 (9), 148 (2), 156 (Bur. Ch.), 157 (12), 158 (2), (17) and (18), (20) and (21), 178 (2), 183 (17), (18), 184 (9), (11), 189 (5), 218 (2), 219 (5), (11), 221 (1), 233 (2), 255 (2), 257 (1), 263 (5), (8)–(9), 266 (6), 273 (4), 276 (end), 282 (5), (7), 284 (8), 285 (10), 286 (3), 289 (8)–(11), 290 (12), 292 (16), 296 (2), (5), 305 (3), (9), 306 (2)–(4), (7), 322 (5), 335 (25), 336 (9), (17), 339 (1)–(2), 341 (2)–(4), 344 (6), 356 (7), 359 (11), 360 (11)–(12), (13), 364 (3), 368 (2), 373 (8), 387 (2), 399 A (1), 409 (10), (14), A. 15, A. 18, B. 4.

(*c*) **Other books.** Aker, 33 (Corr. XIII), 197 (14)– (15). Caverns, 33 (Rms. XVII–XIX) 1, 307 (1). Day and Night, 33 (Corr. XIII), 132 (Bur. Ch.). Imi-Duat, 33 (Corr. XIII) and (Sarc. Ch. XXII), 61 (Bur. Ch.).

Numbers refer to tombs, not to pages.

(d) **Pyramid-texts and coffin-texts.** 82 (21), 93 (F), 103 (sarc.), 240 (Bur. Ch.), 280 (Bur. Ch. coffin), 311 (4)–(5), 313 (sarc.), 314 (Bur. Ch. and sarc.), 315 (sarc.), 319 (Bur. Ch.).

37. Astronomical Ceilings

33 (Rms. XIV, XIX) and (Sarc. Ch. XXII), 34 (Rm. XI), 203, 232, 353.

38. Texts

See also Sect. 36

(a) **Vizier texts.** 29 (3), 66 (6), 100 (2), (5), 106 (8), 131 (7), (8), (9), (12).

(b) **Autobiographical.** 11 (beginning), (5), (8), (12), 24 (9), 36 (11), 39 (A–H), (4), 55 (14), 71 (2), 74 (9), 75 (6), 79 (6), 81 (2), (7), 82 (14)–(15), 84 (4), (8), 85 (17), 96 (Passage, ceiling), 97 (9), 99 (9), 100 (3), 110 (7), 125 (8), 127 (9), 155 (Finds), 158 (19), 164 (5), 172 (2), 189 (5)–(6), 313 (Vestibule), C. 2.

(c) **'Address to Visitors', or 'to the Living', good wishes, &c.** 11 (8), (12), 23 (5), 24 (9), 36 (10), (23), 39 (7), 57 (16), 68 (6), 84 (4), (8), 104 (3), 127 (9), 155 (Finds), 189 (1), 240 (Finds), 349 (ceiling), 398 (ceiling).

(d) **Songs of musicians.**[1] Harpists, 11 (10), 24 (8), 50 (3), (11), 60 (13), (14), 106 (F), 158 (5), 163, 178 (2), 208 (3), 241 (3), 260 (3), 263 (3), 331 (1), 355 (Bur. Ch.), 359 (11), 409 (3). Lutists, 23 (26), 90 (5), 93 (16), 158 (3), 285 (4), 341 (5). Others, 39 (21), 53 (2), 55 (3), 69 (5), 77 (6), 82 (5), (12), 86 (1), 106 (10), 125 (13), 181 (2), 192 (5), (7), 200 (7), 215 (2), 241 (3).

(e) **Hymns,** *see also* Indexes 1 and 3. To groups of divinities, 55 (14), 106 (3), 192 (4). To royal *ka*, 55 (7).

(f) **Cryptographic.** 11 (1), (2), 57 (18)–(19).

(g) **Litany.** 3 (ceiling), 23 (37), 34 (Chapel B), 57 (10), (24), (26), (28), 65 (8)–(9), 106 (10), 158 (3), (5), 184 (10), 279 (8), 359 (12), 389 (5), 390.

(h) **Various.** Lists, 39 (6), 81 (3), (11), 122 (5), 166 (1)–(2), *see also* Sect. 32 (b). Purification-text, 106 (H), B. 4. Ritual-text concerning Nefertem-emblem, 36 (16), 39 (18). Head-rest spell, 290 (7). Text of lighting torch, 33 (37).

39. Decorative features

(a) **Decorative bouquets.** 8 (3), 16 (frieze), 31 (14), 32 (15), 41 (32), 49 (21), 85 (18), 113 (6), 178 (13), 249 (7), 259 (frieze), 277 (4), (7), 286 (7), 289 (24), 296 (6), 341 (2), 354 (6).

(b) **Zad-pillar.** 7 (2), 13 (6)–(7), 14 (frieze), 23 (30), 33 (7), 65 (10), 65 (frieze), 68 (2), (7), (9), 113 (6), 187 (3), 194 (6), (10), 222 (4), 264 (3), 296 (8), 298 (2), 332 (9), 362 (7), 409 (15) and (16), *see also* Sects. 30 (c), 35 (f).

(c) **Decoration on ceilings, soffits, &c.** Birds, 6 (4), 30, 31 (3), (14), 49 (12), 65 (Hall), 159 (Hall), 162 (4), 178 (8), 300 (Hall), 362 (Hall). Boukrania, 50 (Hall), 65 (Inner Rm.), 359 (Ch. F), *see also* Sect. 19 (f). Names or titles, 40 (Hall), 50 (Hall), 72 (Inner Rm., frieze), 106 (Hall, Inner Hall), 134 (Inner Rm.), 359 (Ch. F).

(d) **Decorative vases.** 39 (12), 40 (11), 42 (4), (5), 63 (9), (10), 65 (2), 74 (11), 76 (5), 78 (2), (6), 84 (9), 86 (8), 89 (15), 90 (2), 91 (5), 93 (9), 100 (4), 155 (3), 192 (8), 239 (2)–(3), 242 (1), 256 (3), *see also* Sect. 19 (f).

(e) **Cones.** In position on façade of actual tomb, 47, 157, 181, 288. On tomb in scenes, 49 (8), 55 (5), 159 (2), 178 (5)–(7), 181 (5).

40. Special people

(a) **Male.** Vizier, 7 (9), 23 (18), (31)–(32), 31 (4)–(6), (10), 51 (4), 82 (3), (6), 96 (12), 100 (9), 122 (5), 131 (8), (9), 324 (7), 360 (Finds), 368 (3), *see also* Sects. 8, 26, 38 (a), and owners of tombs 29, 55, 60, 61, 66, 83, 100, 103, 106, 131, 312, 315. Painter, 178 (11)–(12), 359 (4, named). Messenger, 100 (2).

(b) **Female,** *see also* Sect. 4 (c), (e).
1. Foreigners. .Syrian, 17 (7), 42 (5), 63 (9), 81 (5), 85 (17), 86 (8), 100 (4), (13), 131 (11); captives in throne-decoration, 192 (8). Nubian, 22 (4), 40 (2), (6), 63 (9), 78 (8), 81 (5), 89 (15), 100 (4), (13), 113 (4), 349 (2); princess, 40 (6); captives in throne-decoration, 192 (8). Hittite, 100 (13).
2. Priestesses, 19 (7), 31 (4)–(6), (8), 39 (22), (23), 49 (11), 51 (6), 75 (6), 82 (16), 93 (3), 218 (1), *see also* Sect. 31 (h).
3. Wife in unusual scenes: before king or queen (without husband), 49 (6), 85 (9); as musician, 215 (2), 219 (8); with husband in hunt, 53 (5), 82 (7), 241 (5); receiving or presenting bouquet of Amūn, 23 (3), 49 (15)–(16), 85 (C), 254 (6), 350 (3).
4. Various. Baking, brewing, cooking, 17 (4), 40 (4), 53 (9), 59 (3), 103 (12), 318 (5), 366 (2). Weaving, 103 (9), 133 (1). Nursing children, 34 (Reliefs), 56 (7), A. 11, *see also* Sect. 4 (c). As fan-bearer, 55 (13.) In agricultural scenes, *see* Sect. 15 (a).
5. Statuettes: as offering, 53 (6), 92 (3); of queens, 14 (5), 65 (8)–(9), 76 (5), 96 (6), 277 (2)–(3), 284 (5), 344 (8).

Numbers refer to tombs, not to pages.

[1] See Lichtheim in *J.N.E.S.* iv (1945), pp. 178–212.

41. Unusual scenes and details

(a) **Secular,** *see also* Sects. 7 (*d*), (*e*), 13 (*b*), (*f*), 15 (*f*).

Consultation of physician by Syrian chief, 17 (7). Teaching prince to shoot, 109 (5). Hyena-fight, 85 (18). Delivery of linen, 39 (5), 100 (13). Men on ladders stacking loaves, 92 (6). Drinking from siphon, 13 (11), 113 (4). Fanning wine-jars, 53 (10), 302 (3), 333 (3), (9). Selling bouquets, 138 (1)–(3). Girls quarrelling and removing thorn, 34 (Reliefs), 69 (2). Avenue of crio-sphinxes represented, 2 (5). Man writing on tablet held by youth, A. 18. Man painting another's eyelids, 217 (6). Set-pieces, 40 (7), 65 (2), 93 (9). Boundary-stone under tree, 297 (1). Man with statuette on head, 184 (1). Inscribed bed under chair, 96 (39). Tattoo on dancer, 341 (8)–(9).

(b) **Ritual,** *see also* Sect. 31 (*h*). Priest anointing deceased, 93 (A), 106 (B); lighting tapers, offerings, &c., 39 (17), (24), 69 (3), (10), 271 (1), 296 (4); purifying canopic-jars, 106 (3); opening shrine, 48 (2), A. 4. Statue of deceased: carried by several priests (in offering-list ritual or funeral rites), 33 (25), 41 (14), 48 (2), 53 (13), 100 (19), 104 (10), 147 (14),

224 (5); dragged in procession, 93 (3), (B), *see also* Sect. 31 (*h*); on chair, 335 (17). Statues of divinities in procession, 65 (7), 78 (9), 215 (2), A. 26. Priest in mask, 192 (5), 409 (13). Female offering-bringer with tree on head, 84 (19). Fish mummy, 2 (20). Island represented, 31 (4)–(5), 222 (7). Palanquin with royal statues, 2 (9), (11), 14 (1)–(2), (5), 16 (6), 19 (3), (4), (7), 65 (8)–(9), 103 (15), 112 (7), 131 (9), 135 (7), 148 (4), 219 (5), 284 (5), 344 (8). 'Raising the olive-tree', 20 (4)–(5).

(c) **Mythological,** *see also* Sects. 30, 35, 36. Donkeys and cattle 'driven round walls of Memphis', 192 (7). Spearing 'tortoise of Rēꜥ', 157 (18). Man descending from mountain received by god, 336 (12). Deceased opening door of tomb, 336 (ceiling); adoring staircase, 2 (Bur. Ch. ceiling); receiving water from Nut, 299 (ceiling). Shadow of deceased represented on ceilings, 2, 219, 290. Hawk-god opening mouth of mummy, 359 (12). Termuthis on birth-brick, 273 (4). Primordial hill, 336 (ceilings in Chs. A and B). Lake of fire and mythological regions, 359 (11). Swallow on hill, 359 (12). Horse with serpent springing from neck, A. 16.

B. TOMB-SCENES PAINTED BY NINA DAVIES IN 1907–1939

Excluding those published in colour

(Ash. = Oxford, Ashmolean Mus.; Ber. = Berlin Mus.; Chic. = Chicago Univ. Oriental Institute; Man. = Manchester Univ. Mus.; M.M.A. = New York, Metropolitan Mus. of Art; St. = Stockholm, Egyptian Mus.)

Tomb		Owner
16 (6)	Statue in scene.	M.M.A.
31 (4)	Boat with shrine.	Ash.
48	Architrave fragments.	M.M.A.
52 (3)	Female musicians.	Ber.
56 (11)	Barbers.	M.M.A.
57 (7)	Offering-bringers.	Mrs. Davies.
63 (16)	Couple in garden.	Ash.
65 (3)	King and bark.	M.M.A.
(4)	King, bark, and statues.	,,
66 (2)	Craftsmen.	,,
(2)	Chariot-makers.	,,
69 (6)	Woman adoring.	,,
(11)	Man scooping water.	,,
73 (1)	Ibex.	,,
75 (6)	Girl's head.	Ash.
76 (5)	Jewellery.	,,
77 (12)	Wine-press.	,,
78 (8)	Syrians.	,,
79 (7)	Funeral outfit.	M.M.A.
81 (10)	Hunting.	,,
(11)	House.	,,
82 (5)	Castanet-playing and dancing.	St.
(10)	Abydos pilgrimage.	Ash.

Tomb		*Owner*
82 (10)	Man with funeral outfit.	Man.
	Ceiling patterns.	Ash.
	Hieroglyphs in Corridor.	,,
(12)	Musicians.	Ber.
(14)–(15)	Mourners.	Man.
(16)	Bringing fruit and gazelle.	,,
85 (18)	Hyena.	Ash. and M.M.A.
93 (3)	Dancers.	M.M.A.
(9)	Chariot equipment.	Ash.
96 (8)	Cat.	M.M.A.
100 (2)	Hieroglyphs.	Ash.
(4)	Syrians and chariot.	M.M.A.
(4)	Keftiu with vases and tusk.	,,
(4)	Keftiu.	Chic.
(10)	Grapes, baskets, wine-jars.	M.M.A.
(13)	Cooks, &c.	,,
(14)	Various craftsmen.	,,
(18)	Musicians.	Ash.
(18)	Guests, and girl (back view).	M.M.A.
108 (3)	Banquet.	,,
120 (3)	King and queen.	,,
125 (13)	Dog.	,,
138 (1)	Making bouquets.	Ash.
143 (6)	Rafts.	,,
(6)	Puntites.	,,
151 (2)	Cattle in stalls.	M.M.A.
155 (5)	Hounds.	,,
(5)	Fragments.	,,
162 (1)	Baskets of fruit, &c.	,,
178 (5)–(7)	Rites at tomb.	Ash.
(11)–(12)	Workshops.	,,
179 (4)	Musicians.	,,
181 (3)	Wife before deceased and family.	Ash. and M.M.A.
(5)	Offering-bringers.	M.M.A.
217 (5)	Tree.	,,
226 (3)	Men with sheaf and quails.	,,
(4)	King and mother.	,,
254 (1)	Donkey.	Ash.
296 (4)	Priest with taper.	,,
341 (2)–(4)	Funeral procession.	M.M.A.
(3)	Winged figure.	,,
349 (2)	Reaping corn.	,,
366 (2)	Cooks.	,,
Pillar B	Man with donkey.	,,

C. CLASSIFICATION OF TOMBS ACCORDING TO DATE

Numbers refer to tombs, not to pages.

1st Intermediate Period, 185, 186, 405.
Mentuḥotp-Nebḥepetrēᶜ, 240, 308, 311, 313.
Mentuḥotp-Sᶜankhkarēᶜ, 280, 313, 315, 319, 366.
Dyn. XI, 103, 117, 310, 314, 316.
Sesostris I, 60.
Middle Kingdom, 386.
Dyn. XVII, A. 2.
Amosis, 12, A. 20, C. 2.
Amenophis I, 12, 81, 320, C. 2.
Tuthmosis I, 21, 81, 124, 345.
Tuthmosis II, 81.
Ḥatshepsut, 11, 65, 67, 71, 73, 81, 110, 119, 125, 155, 179, 224, 252, 318, 353.

Tuthmosis III, 11, 18, 20, 22, 24, 39, 42, 53, 61–2 78–9, 81–8, 98–100, 109–10, 112, 119, 121–3, 127, 129–31, 140, 142–4, 146, 154–5, 164, 172, 182, 200, 205, 224–5, 227, 241, 251, 260, 262, 317–18, 342, 365, 401, A. 5, B. 2, C. 11, D. 1.
Amenophis II, 8, 17, 29, 42–3, 45, 56, 72, 78–80, 84–5, 88, 92–8, 100–1, 104, 140, 142–3, 169, 172, 176, 200, 205, 239, 256, 358, 367, 401, A. 5, A. 9.
Tuthmosis IV, 8, 38, 52, 54, 63–4, 66, 69, 74–9, 90–1, 108, 116, 142–3, 147, 151, 165, 175–6, 201, 239, 249, 257–8, 276, 295, 401–2, A. 5, C. 6.

Numbers refer to tombs, not to pages.

Amenophis III, 8, 46–8, 54, 57–8, 78, 89–91,
102, 107, 116, 118, 120, 139, 161, 181, 192, 201,
226, 253, 257, 294–5, 333–4, 383, 402, A. 24,
C. 1.
Amenophis IV, 40, 55, 181, 188, 192.
Tutʿankhamūn, 40.
Ay, 49, 271.
Ḥaremḥab, 6, 50, 255.
Dyn. XVIII, 15, 59, 145, 150, 152, 162, 167, 171,
199, 204, 228–31, 234, 238, 245–8, 254, 261,
291, 297, 325, 338, 340, 343, 346, 348–50, 354,
368, 376, 393, 396–8, 403, A. 1, A. 4, A. 7,
A. 8, A. 10, A. 13, A. 25, C. 3, C. 4, C. 5,
C. 10, C. 15, D. 3.
Ramesses I, 19, 41.
Sethos I, 19, 41, 51, 106, 153, 292, 323, 361.
Ramesses II, 2, 4, 6, 7, 10, 16, 26, 31–2, 35, 45,
106, 111, 133, 137–8, 157, 170, 177–8, 183–4,
189, 212, 216–17, 250, 257, 263, 283, 289, 292,
337, 339, 341, 360, 387, 409, A. 14, C. 7.
Merneptaḥ, 23.
Sethos II, 216, 283.
Dyn. XIX, 1, 105, 115, 134–6, 156, 159, 163, 168,
173–4, 180, 187, 193–5, 202–3, 210–11, 215,
234, 264–6, 268, 270, 330, 335–7, 356–7, 362–4,
369, 374, 378, 384, A. 8, C. 8.
Ramesses III, 148, 158, 222, 299, 359, 372,
B. 1.
Ramesses IV, 148, 222, 293, 299, 346, 359.

Ramesses V, 148.
Ramesses VIII, 113.
Ramesses IX, 65.
Ramesside, 3, 5, 9, 13, 14, 25, 28, 30, 44, 112,
127, 141, 149, 152, 190, 198, 206–8, 214, 218–21,
232–3, 236–7, 244, 259, 269, 272–5, 277–8, 282,
284–8, 290, 294, 296, 298, 300–2, 304, 321–2,
324, 326–7, 329, 331–2, 344, 347, 351–2, 370–1,
373, 375, 377, 379, 381–2, 385, 394–5, 399,
399 A, 406, 408, A. 12, A. 15, A. 16, A. 18,
A. 23, A. 26.
Dyn. XIX–XXI, 303, 305, 306, 309.
Dyn. XX, 58, 68, 114, 166, 213, 235, 267, 328,
355, A. 6.
Dyn. XX–XXI, 307.
Siamūn, 68.
Dyn. XXI, 70, 337.
Dyn. XXI–XXII, 117.
Dyn. XXII, 337, 348.
New Kingdom, A. 3, A. 11, B. 4, D. 2.
Taharqa, 34, 132.
Dyn. XXV, 391, 404.
Psammetikhos I, 34, 36, 191, 279, 390.
Psammetikhos II, 197.
Apries, 27.
Amasis, 27.
Saite, 33, 37, 126, 128, 160, 190, 196, 209, 223,
242–3, 312, 388–9, 392, 407, B. 3, C. 14.
Ptolemaic, 380.

D. CLASSIFICATION OF TOMBS ACCORDING TO SITE

Dra' Abû el-Naga':
 North, 11–14, 18–20, 24, 143, 147–55, 165–7,
 232–4, 239, 255, 293, 344, 375–9, 393–6, 402.
 South, 15–17, 35, 140–2, 144–6, 156–64, 168–9,
 231, 236–7, 260–2, 282–9, 300–7, 332–4, 401.
Deir el-Baḥri, 240, 280–1, 308, 310–16, 319–20,
 353, 358.
Khôkha, 32, 47–8, 170–86, 198–206, 238, 241,
 245–8, 253–4, 256–8, 264, 294–6, 362–3, 365,
 369–74, 392, 405.
'Asâsîf, 25–8, 33–4, 36–7, 39, 49, 187–97, 207–8,
 242–4, 279, 297, 364, 366, 386–9, 404, 406–9.

Sheikh 'Abd el-Qurna:
 Upper Enclosure, 21, 43, 46, 58–101, 103–4,
 114–22, 225–30, 251–2, 367, 400.
 Lower Enclosure, 22–3, 38, 41–2, 44, 105–10,
 112–13, 351–2.
 Plain, 29–31, 45, 50–7, 102, 111, 123–39, 209,
 223–4, 249, 259, 263, 269, 309, 317–18, 324,
 331, 341–3, 345–50, 368, 384–5, 390–1,
 397–9, 403.
Deir el-Medîna, 1–10, 210–20, 250, 265–8, 290–2,
 298–9, 321–3, 325–30, 335–40, 354–7, 359–61.
Qurnet Mura'i, 40, 221–2, 235, 270–8, 380–3.

E. TOMB-NUMBERS USED BY HAY, CHAMPOLLION, AND LEPSIUS

(a) Hay MSS.

Hay No.	Tomb No.	Hay No.	Tomb No.	Hay No.	Tomb No.
1	155	9	161	17	87
2	255	10	113	18	93
3	A. 4	11	49	19	84
4	75	12	96	20	85
5	200	13	91	21	80
6	342	14	95	22	90
7	106	15	29	23	78
8	81	16	82		

(b) *Champollion*, Not. descr. i

Champ. No.	Tomb No.	Champ. No.	Tomb No.	Champ. No.	Tomb No.
A	40	19	342	43	156
1	76	20	347	44	158
2	75	21	403	45	35
3	74	22	125	46	160
4	78	23	126	47	A. 24
5	81	24	128	48	A. 21
6	80	25	317	49	A. 22
7	79	26	318	49 bis	A. 23
8	88	27	C. 7	50	A. 19
8 bis	77	28	C. 6	50 bis	A. 20
8 ter	91	29	138	50 ter	A. 10
8 quat.	93	30	345	51	12
9	98	31	C. 4	52	255
9 bis	90	32	106	53	49
10	116	33	107	54	37
11	84	34	109	55	197
12	85	35	41	56	36
13	96	36	200	57	389
14	95	37	343	58	B. 2
15	100	38	C. 8	59	112
16	390	39	A. 15	60	65
16 bis	53	40	A. 12	p. 569	64
17	223	41	A. 11		
18	391	42	157		

(c) *L. D.* Text, iii[1]

L. D. Text No.	Tomb No.	L. D. Text No.	Tomb No.	L. D. Text No.	Tomb No.
1	11	44	61	74	343
2	12	45	72	75	345
3	A. 9	46	71	76	127
4	A. 8	47	64	77	125
6	A. 6	48	63	78	53
7	157	49	C. 4	79	134
8, 9	158	50	67	80	57
10, 11	35	51	31	81	56
13	161	52	C. 6	83	132
14	240	53	74	84	123
18, 19	39	54	75	85	224
20	33	55	76	86	C. 11
21	388	56	82	87	131
22	242	57	78	91	137
23	37	58	100	93	223
24	34 [E]	59	80	94	390
25	36	60	79	95	391
28	389	61	88	96	8
29	26	62	77	97	10
31	256	63	90	98	212
32	257	64	116	99	7
34	C. 1	65	91	100	216
36	103	66	367	101	6
37	107	67	92	102–3	267
38	23	68	93	104	210
39	106	69	98	105	335
40	65	70	95	106	4
41	83	71	84	107	2
42	60	72	96	108	359
43	58	73	C. 13	110	40

[1] For tombs not in this list, see *Bibl.* i², Pt. 2, in the Press.

INDEXES

1. KINGS, PERIODS, ETC.

See also Appendix C

For members of a royal family other than the reigning queen Ḥatshepsut, see Index 2. GAUTHIER, *Le Livre des rois*, has been followed in the numbering of kings, except for Dynasty XI.

Amenophis I (Zeserkarēʿ), cult, 7, 9, 11, 13, 15, 21, 26, 28, 34, 40, 41, 84, 94, 105, 130, 223, 231, 250, 254, 260, 262, 275, 284, 288, 301, 307, 314, 321, 336, 340, 368, 372, 378, 380, 381, 384, 396, 403, 413, 420, 422, 425, 434, 450, 451, 453, 461; festival, 33; hymn, 301; statue, 12; mention, 457. In titles, 26, 28, 32, 33, 200, 249, 289, 344, 401, 402, 412, 449. Mother, ʿAḥmosi Nefertere, *see* Index 2.

Amenophis II (ʿAkheperurēʿ), in scenes, 83, 84, 112, 142, 171, 172, 180, 188, 191, 192, 198, 303, 341, 431, 450; cult, 459; hymn, 172, 173; objects, 18 (cubit-measure), 203 (pendant in scene), 271 (bricks); mention, 45, 143, 155, 170, 197, 213, 215. In titles, 47, 335. Mother, Merytrēʿ, wife, ʿAḥmosi Merytamūn, *see* Index 2.

Amenophis III (Nebmaʿetrēʿ), in scenes, 87, 88, 89, 115, 116, 119, 120, 182, 185, 234, 298, 299, 305, 327, 337; cult, 298, 354, 459; cup, 18; time of, 45 (jamb); mention, 91, 111, 155, 184, 254, 454. In titles, 224, 270, 352, 353. Children, 327. Mother, Mutemwia, wife, Teye, son, Merymosi, *see* Index 2.

Amenophis IV (Neferkheperurēʿ-waʿenrēʿ), in scenes, 109, 110, 293, 294, 298, 299; armlet, 91. Wife, Nefertiti, *see* Index 2.

Amosis (Nebpeḥtirēʿ), 384, 453, 457. Mother, ʿAḥḥotp, wives, ʿAḥmosi Nefertere, and Inḥaʿpi, son, ʿAḥmosi Sipaar, dau., Merytamūn, *see* Index 2.

Ay (Kheperkheperurēʿ), 92, 350.

Demotic, 23, 25, 310, 312.

Dyn. XI, stela, 233.

Dyn. XVIII, 204, 342; hieratic graffiti, 121, 392.

Dyn. XIX, stela, 114; hieratic graffiti, 392.

Dyn. XX–XXI, 421.

Dyn. XXI, 137, 372, 374, 393, 421.

Ḥaremḥab (Zeserkheperurēʿ), in scenes, 95, 340; cult, 15, 21; mention, 50. In title, 339. Wife, Mutnezemt, *see* Index 2.

Ḥatshepsut (Maʿkarēʿ), in scenes, 143, 228; cult, 191; shells, 418; mention, 239, 240, 337, 418. Mother, ʿAḥmosi, dau., Neferurēʿ, *see* Index 2.

Hieratic, 16, 39, 45, 75, 92, 93, 121, 126, 128, 157, 184, 253, 265, 298, 312, 317, 354, 364, 372, 374, 392, 393, 424, 425, 429, 430, 456.

Kamɔsi (Wazkheperrēʿ), 384.

Mentuḥotp-Nebḥepetrēʿ, in scenes, 49, 385, 387; cult, 9, 354; mention, 331. Wife, Nofru, *see* Index 2.

Mentuḥotp-Sʿankhkarēʿ, temple, 364 (tomb 281).

Merneptaḥ (Baenrēʿ-meriamūn), 39.

Psammetikhos I (Weḥebrēʿ), in scenes, 56, 63, 358; mention, 66, 357. Dau., Nitocris, *see* Index 2.

Ptolemaic, 23, 25, 431.

Ramesses I (Menpeḥtirēʿ), 21, 119.

Ramesses II (Usermaʿetrēʿ), in scenes, 11, 16, 21, 267, 289, 313, 315, 408, 425, 451, 459, 462; cult, 41, 380; hymn, 224; altar, 45; time of, 387; mention, 99, 251, 284, 345. In title, 289. Wife, Nefertari, *see* Index 2.

Ramesses III (Usermaʿetrēʿ-meriamūn), 259, 323.

Ramesses IV (Heḳmaʿetrēʿ-setepenamūn), 323. Wife, Tentōpet, *see* Index 2.

Ramesses VI (Nebmaʿetrēʿ-meriamūn), 143.

Ramesses VIII (Usermaʿetrēʿ-akhenamūn), 231.

Ramesses IX (Neferkarēʿ-setepenrēʿ), 130, 376.

Ramesses XI (Menmaʿetrēʿ-setepenptaḥ), 376.

Ramesses, 119.

Ramesside, 230, 281, 328.

Saite, 204.

Seḳenenrēʿ-Taʿa, 384.

Sesostris I (Kheperkarēʿ), 121, 384.

Sethos I (Menmaʿetrēʿ), in scenes, 221, 222, 395; cult, 21; hymn, 222, 223; mention, 99.

Sethos II (Userkheperrēʿ-meriamūn), 43.

Siamūn (Neterikheperrēʿ-setepenamūn), 393.

Smenkhkarēʿ (ʿAnkhkheperurēʿ), 253.

Taʿa, *see* Seḳenenrēʿ-Taʿa.

Taharqa (Khunefertemrēʿ), in title, 247. Dau., Amenardais II, *see* Index 2.

Tutʿankhamūn (Nebkheperurēʿ), 76, 77, 384.

Tuthmosis I (ʿAkheperkarēʿ), in scenes, 98, 459; cult 98, 169, 191, 459; festival, 97; mention, 427. In titles, 35, 97, 168, 200, 237, 413, 414. Wife, ʿAḥmosi, *see* Index 2.

Tuthmosis II (ʿAkheperenrēʿ), 459. Mother, Mutnefert, *see* Index 2.

Tuthmosis III (Menkheperrēʿ), in scenes, 82, 83, 168, 172, 175, 177, 205, 209, 228, 236, 246, 262, 275, 303, 341, 459; cult, 33, 48, 84, 142, 183, 262, 341, 459; festival, 48; hymn, 173; objects, 23 (vase), 177 (stand), 312 (amphora); mention, 23, 75, 155, 165, 168, 211, 226, 230, 235, 237, 245, 325, 410, 427, 455. In titles, 47, 142, 143, 156, 157, 335. Wives, Merytrēʿ and Nebtu, son, Amenhotp, dau., ʿAḥmosi Merytamūn, *see* Index 2.

Tuthmosis IV (Menkheperurēʿ), in scenes, 126, 127, 128, 129, 132, 145, 146, 147, 150, 151, 152, 153, 184, 187, 233, 417, 458; cult, 15, 459; mention, 48, 155. In titles, 230, 417, 458, 459. Mother, Tiʿa, son, Amenhotp, daus., Amenemōpet, Sitamūn, and Tiʿa, *see* Index 2.

2. PRIVATE NAMES

Tomb-numbers are in heavy type: pages in ordinary type

3. DIVINITIES

4. OBJECTS IN MUSEUMS

VATICAN, Museo Gregoriano Egizio

No.	Page
288	60

WASHINGTON (D.C.), United States Museum in the Smithsonian Institution

No.	Page
1420	55

5. VARIOUS

Aïchesi, of Prisse	Tomb 65
Athanasi's (Yanni's) house	Above Tomb 52
Bab Ezzhairy, of Burton	Tomb 109
Bab om el Mináfed, of Wilkinson	,, 386
Casa di Abu-Sakkara, of Rosellini (Passalacqua's house, possibly Piccinini's house)	Near Tomb 161
French House, built on the top of Luxor Temple Sanctuary, for French engineers engaged in removing the Paris obelisk, afterwards used by the French consul and later demolished	p. 61
Karian texts	p. 57
Mystical tomb, of Burton	Tomb B. 4
Northampton stela	p. 22
Salt's tomb	Tomb A. 5
Satea, of Prudhoe	,, C. 4
Stuart's tomb	,, 55
Tomb of the dancers	,, A. 1
Tombeau des vignes	,, 96
Wilkinson's house	,, 83

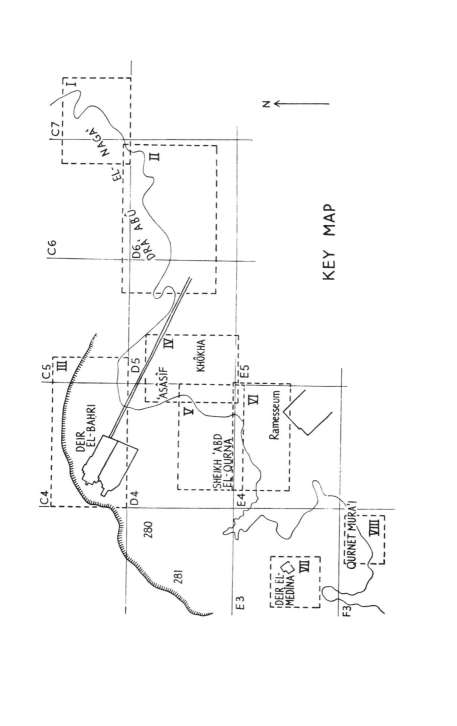

KEY MAP

N ←

C7

I

C6

II

EL-NÁGA'

DRÁ' ABÛ

D6.

C5

III

D5

IV

'ASÁSÎF

KHÔKHA

E5

DEIR
EL-BAHRI

V

VI

Ramesseum

SHEIKH 'ABD
EL-QURNA

C4

D4

E4

280

281

E3

DEIR EL-
MEDINA

VII

QÛRNET MURA'I

VIII

F3

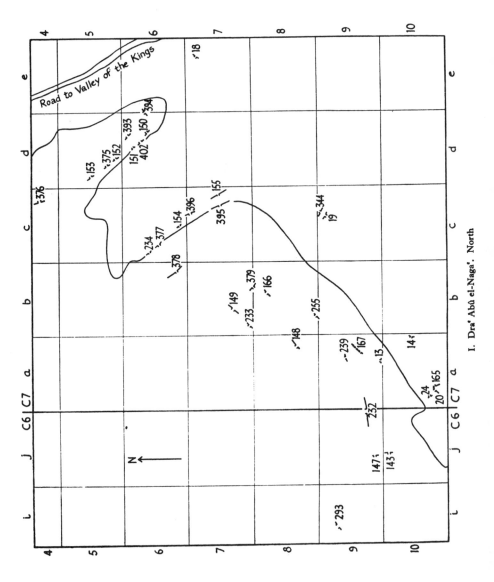

I. Dra' Abû el-Naga'. North

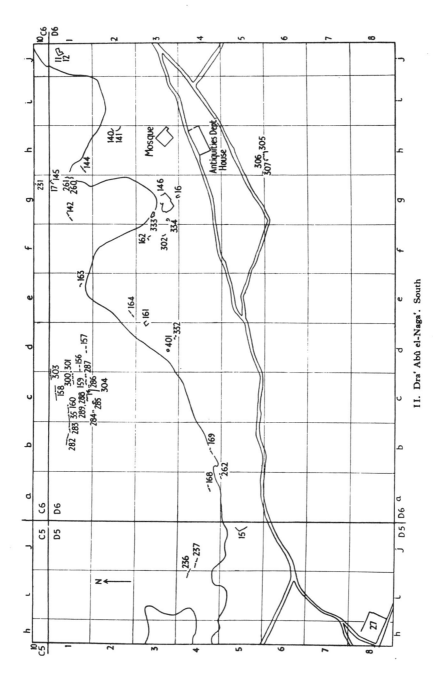

II. Dra' Abû el-Naga'. South

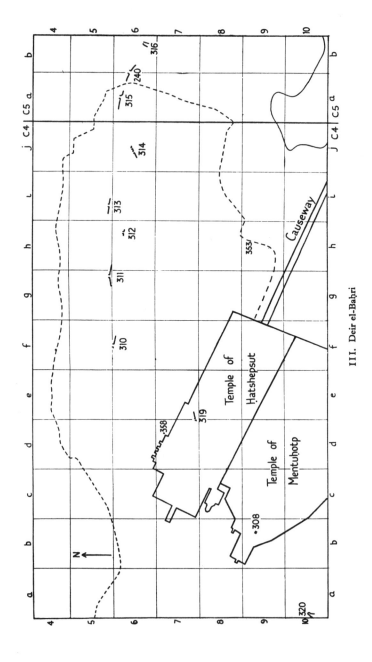

III. Deir el-Baḥri

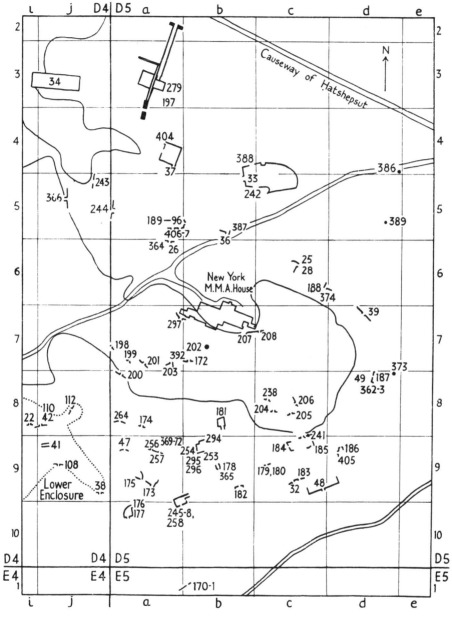

IV. Khôkha and 'Asâsîf

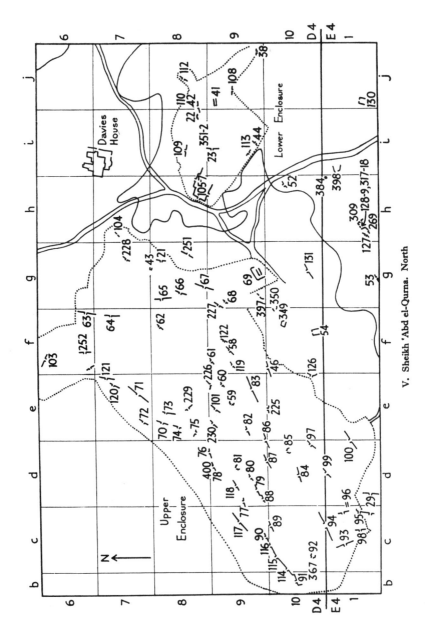

V. Sheikh 'Abd el-Qurna. North

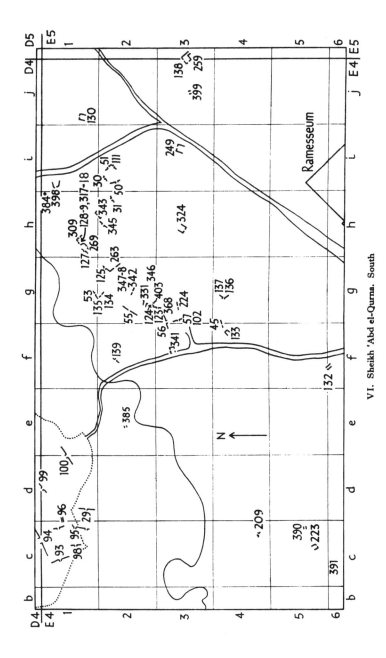

VI. Sheikh 'Abd el-Qurna. South

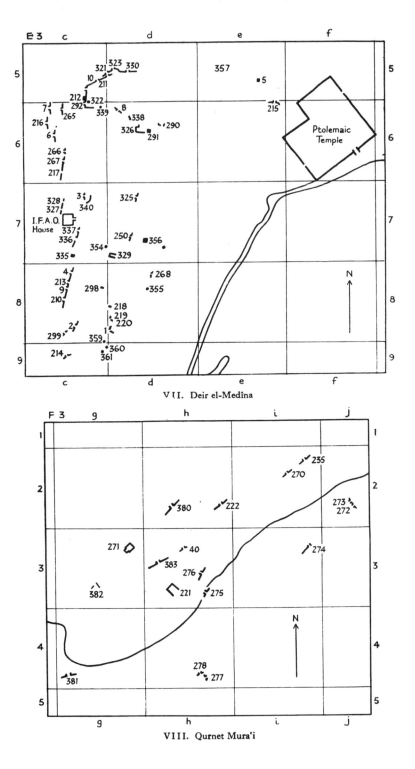

VII. Deir el-Medîna

VIII. Qurnet Mura'i